# Art
# the Ape of
# Nature

# Art the Ape of Nature

STUDIES IN HONOR OF H. W. JANSON

*Moshe Barasch and Lucy Freeman Sandler, editors*

*Patricia Egan, coordinating editor*

HARRY N. ABRAMS, INC., PUBLISHERS, NEW YORK

PRENTICE-HALL, INC., ENGLEWOOD CLIFFS, N.J.

Designer: Wladislaw Finne

Library of Congress Cataloging in Publication Data

Main entry under title:
Art the ape of nature: studies in honor of H. W. Janson.

"Bibliography of H. W. Janson": p. 805
1. Art—Addresses, essays, lectures. 2. Janson,
Horst Woldemar, 1913–    I. Janson, Horst Woldemar,
1913–    II. Barasch, Moshe.    III. Sandler, Lucy
Freeman.    IV. Egan, Patricia.
N7442.J36    700    80–15401
ISBN 0–8109–1153–1 (H.N.A.)
ISBN 0–13–046623–9 (P.-H.)

Published in 1981 by Harry N. Abrams, Incorporated, New York

Printed and bound in Japan

# Editors' Preface

One afternoon in 1977 Moshe Barasch and I were talking in my office at New York University about our friend and colleague H. W. Janson. As so often happens when Peter Janson's name is mentioned, it was followed by the question: how does he do it? His many friends will know that this question refers to his boundless energy and astonishing achievements in every aspect of our profession. Peter Janson has sustained this level of energy for more than forty-five years of his scholarly career. Thinking of all his contributions to art history, Moshe Barasch and I realized that a certain milestone would soon be reached, the occasion of our friend's sixty-fifth birthday. It seemed to us that with this event the art historical community—to which Peter Janson has given so much—had the chance to offer a gift in return, in the form of a collection of essays written in his honor. This then was the origin of *Art the Ape of Nature*. Naturally, such a gift, to which so many were eager to contribute, was a long time in the making. The editors, Moshe Barasch and I, are grateful to each individual author, to Deborah Markow for her work on the bibliography of H. W. Janson's writings, to Fritz Landshoff of Harry N. Abrams, Inc., and to Margaret Kaplan and the entire staff for producing such a handsome book. Finally, we owe a most profound debt to the coordinating editor, Patricia Egan, who has worked more continuously than anyone else on this volume; Moshe Barasch and I speak in gratitude on behalf of all the authors, whose expressions of homage to Peter Janson have received such good care in her hands.

*Lucy Freeman Sandler*
*April 1980*

# Contents

## III. *Sixteenth Century*

## IV. *Seventeenth and Eighteenth Centuries*

## V. *Nineteenth and Twentieth Centuries*

# 1

# Novelty, Ingenuity, Self-aggrandizement, Ostentation, Extravagance, Gigantism, and Kitsch in the Art of Alexander the Great and His Successors

BLANCHE R. BROWN

One of the better-known stories about Alexander the Great as art patron—of the urban arts, in this case—is told by Vitruvius:[1]

> When Alexander was master of the world, the architect Deinokrates, confident in his ideas and his skill, set out from Macedonia to the army, being desirous of the royal commendation. He brought from home to the officers and high officials, a letter from his relatives and friends that he might have more easy access; and being courteously received by them, he asked to be introduced as soon as possible to Alexander. After promising this they were somewhat slow, waiting for a suitable occasion. Therefore Deinokrates, thinking he was mocked by them, sought a remedy for himself. Now he was of ample stature, pleasing countenance, and the highest grace and dignity. Trusting then in these gifts of nature, he left his clothes in the inn, and anointed himself with oil; he wreathed his head with poplar leaves, covered his left shoulder with a lion's skin, and holding a club in his right hand, he walked opposite the tribunal where the king was giving judgment.
>
> When this novel spectacle attracted the people, Alexander saw him. Wondering, he commanded room to be made for him to approach, and asked who he was. And he replied: "Deinokrates, a Macedonian architect, who brings you ideas and plans worthy of your renown. For I have shaped Mount Athos into the figure of the statue of a man, in whose left hand I have shown the ramparts of a very extensive city; in his right a bowl to receive the water of all the rivers which are in that mountain." Alexander, delighted with this kind of plan, at once inquired if there were fields about, which could furnish that city with a corn supply. When he found this could not be done, except by sea transport, he said: "I note, Deinokrates, the unusual formation of your plan, and am pleased

1

with it, but I perceive that if anyone leads a colony to that place, his judgment will be blamed. For just as a child when born, if it lacks the nurse's milk cannot be fed, nor led up the staircase of growing life, so a city without cornfields and their produce abounding within its ramparts, cannot grow, nor become populous without abundance of food, nor maintain its people without a supply. Therefore, just as I think your *planning* worthy of approval, so, in my judgment, the *site* is worthy of disapproval; yet I want you to be with me, because I intend to make use of your services."

After that, Deinokrates did not leave the king, and followed him into Egypt. . . .

One may assume that the plan was Deinokrates's gimmick, and had no more connection with actuality than did his Herakles persona, or even that the incident never happened. But the story is still significant. Can anyone imagine such a story being told about Pericles? Could anything emphasize better how different the world of Macedonian imperialism was from the world of the classical *polis*, even at the Periclean moment when the *polis* itself was approaching obsolescence in the course of imperial aggression? In the classical world tradition was the core of expression; now a premium is placed on novelty, and the more ingenious the better. In the classical world the individual was defined by the community; now the individual dominates the landscape, aggressively and grandiosely. In the classical world moderation was the watchword; now no display is too ostentatious, no fancy too extravagant—either in idea or expenditure—to be "worthy of the renown" of the conqueror. In the classical world dimension was restricted by limitations of money and manpower; now both are multiplied so much as to seem all but limitless, and in this case a vast mountain provides the scale. In the classical world harmony and measure governed form; now anything goes, even including a level of showiness by means of sheer extravagance or other nonartistic effects, which may be permitted to go by the name of kitsch.[2]

The reasons for the change are manifest, and they are well enough known. Alexander was an ambitious, aggressive, adventurous conqueror of vast, rich lands. His power was absolute, and he commanded unparalleled resources of territory, manpower, and wealth. He was glorified by his subjects, and he glorified himself even to identification with divinity. He lived under new conditions and with new problems. He had many new things to do and to make, in order to meet new needs.

Much is made always of Alexander's indebtedness to the rich, autocratic Eastern world as the source of his grandiosity. Not enough is made, I would like to suggest, of his own Macedonian roots and of the intrinsic situation. Of course, after the time of Pericles, the Greeks themselves had been developing new attitudes and learning a greater degree of extravagance, not only tyrants in Sicily but even citizens in Athens, and later they proved themselves capable of learning a great deal more. Also, other Hellenized non-Greek monarchies expressed themselves in ways similar to the Macedonian. In Caria, for example, the satrap Maussollos had already produced the city of Halikarnassos, carved dramatically into a crescent hillside overlooking a port, with central focus on his own funerary monument, a structure that itself was so large and extravagant that it seemed a wonder of the world even to later Hellenistic listmakers.[3] But the historical fact is that Alexander the Macedonian was now in charge, and Macedonian characteristics therefore are relevant. Macedonia had been Hellenized and the royal family claimed Argive descent, but it was still Macedonian. There was no *polis* there. Alexander was the royal scion of a monarchy that had been established since c.640 B.C., and he claimed descent from

Herakles as well as Achilles. We hear of a Macedonian palace in the reign of Archelaos (413–399), in which Zeuxis painted walls (not long, please note, after Athens was outraged because Alcibiades wanted to have the walls of his own house painted by Agatharchos) [4] At death, Alexander's relatives and their Companions were buried in large, princely, barrel-vaulted chamber tombs. From the exploitation of mines in Mount Pangaios, in newly conquered territory, his father Philip already had more gold at his command than any Greek had ever had, and perhaps Philip himself or one of his Companions was buried in a solid gold, ivory-trimmed coffin weighing 24.2 pounds. [5] All of this regal tradition Alexander inherited, plus a compelling dream of world conquest. He was well on his way to grandiosity when he started, and further growth came naturally, surely, from the basics of power and wealth, as well as from example.

Gigantic would have been the scale of Deinokrates's man-mountain. Gigantism as a mode of expression was made explicit by Alexander the Great himself when he conceived a monument to mark the farthest limit of his military advance into Asia. Diodorus Siculus tells the story: [6]

> Thinking how best to mark the limits of his campaign at this point, he first erected altars of the twelve gods each 50 cubits (75 feet) high and then traced the circuit of a camp three times the size of the existing one. Here he dug a ditch 50 feet wide and 40 feet deep, and throwing up the earth on the inside, constructed out of it a substantial wall. He directed the infantry to construct huts containing beds five cubits long, and the cavalry, in addition to this, to build two mangers twice the normal size. In the same way everything else which would be left behind was exaggerated in size. His idea in this was to make a camp of heroic proportions and to leave to the natives evidence of men of huge stature displaying the strength of giants.

The altars were gigantic. Other than that we do not know anything about them, except that the vertical extension seems remarkable. The encampment was gigantic not only in its dimensions but in its very iconography, and the idea of it is so ingeniously novel that it must be unique among the monuments of the world.

Gigantic proportions continued to be characteristic of the succeeding generations as well. For example several famous third-century B.C. works of record dimensions come to mind—the tallest statue recorded in the Greek or Hellenistic world, the largest tholos now known in the Greek or Hellenistic world, the tallest building recorded in the Greek, Hellenistic, or Roman world, and a ship so big that hardly any of the existing harbors could receive it. The statue was Chares's colossal bronze of Helios which stood 105 feet high (about 10–11 stories) at the harbor of Rhodes. It celebrated Demetrios Poliorketes's withdrawal from his siege of the city in 303 B.C., and the statue itself was paid for by the 300 talents (not less than $9,000,000 and perhaps a great deal more) realized from the sale of the siege machines which Demetrios had left behind. [7] The tholos was dedicated in the Sanctuary of the Great Gods in Samothrace by Queen Arsinoe when she was the wife of Lysimachos (289–281). [8] It was over 67 feet in diameter, about 34 feet high to the cornice, and it was of singular design as well. The other building was the lighthouse, dedicated shortly after the beginning of the reign of Ptolemy II Philadelphos (283–246), which stood 440 feet high (about 44 stories) on the Island of Pharos at the harbor of Alexandria. [9] It was a novel building also, apparently the first of its kind, and very possibly furnished with ingenious devices for bringing fuel up to the lantern, for casting the light far out to sea, and for signaling the landfall to

approaching ships or the advent of enemy ships to the people on land. The record-breaking ship was a grain transport built for Hieron II of Sicily (269–215), under the supervision of Archimedes.[10] Again, it was remarkable for more than its size. Not only was it outfitted for practical purposes with, among other things, a windlass, screw-pump, and stone-hurler devised by Archimedes himself, but its living quarters for officers consisted of a three-room apartment with bathroom, library, and shrine of Aphrodite, all decorated with tessellated or opus sectile floors, fine wood siding, sculptures, and paintings, and a gymnasium and promenade with gardens and bowers. When Hieron found it unusable, he sent it, filled with grain, as a present to his friend Ptolemy, who then "pulled it up on shore" and left it there. Archimelos wrote a poem to celebrate the vessel, which begins:

> Who hath set these giant timbers on the ground? What mighty master hath hauled them with untiring cables? How was the flooring fixed to the ribs of oak, or by what axe hewn did pegs work out this hollow mass, matching in height the peaks of Aetna, or stretching with walls on both sides broad as one of the isles which Aegean waters bind together in the Cyclades? Verily the Giants have planed these timbers to traverse the paths of Heaven . . .

At the death of Hephaistion, who was Alexander's most dearly beloved friend, Alexander ordered a funeral monument for him that has gone down in history. Plutarch, when he tells of it, explicitly defines not only the gigantism that characterized Alexander's taste, but also his extravagance and ostentation, as well as his love of novelty and ingenuity.[11] "Upon a tomb and obsequies for his friend, and upon their embellishments," he says, Alexander "purposed to expend ten thousand talents (not less than $300,000,000, and perhaps a great deal more), and wished that the ingenuity and novelty of the construction should surpass the expense. He therefore longed for Stasicrates above all other artists (there is a confusion either of names or of stories here), because in his innovations there was always promise of great magnificence, boldness, and ostentation. This man, indeed, had said to him at a former interview that of all mountains the Thracian Athos could most readily be given the form and shape of a man; if, therefore, Alexander should so order, he would make out of Mount Athos a most enduring and most conspicuous statue of the king, which in its left hand should hold a city of ten thousand inhabitants, and with its right should pour forth a river running with generous current into the sea. This project, it is true, Alexander had declined; but now he was busy devising and contriving with his artists projects far more strange and expensive than this." The expenditure here is difficult to believe, but in any case it must have been one of Alexander's most extreme expenditures, since it expressed his own most profound and extravagant grief.

Diodorus Siculus describes the monument of Hephaistion in some detail, enough to inspire a reconstruction by Hirt:[12]

> Alexander collected artisans and an army of workmen and tore down the city wall to a distance of ten furlongs (6600 feet—more than a mile). He collected the baked tiles and leveled off the place which was to receive the pyre, and then constructed this square in shape, each side being a furlong (660 feet) in length. He divided up the area into 30 compartments and laying out the roofs upon the trunks of palm trees wrought the whole structure into a square shape. Then he decorated all the exterior walls. Upon the foundation course were golden prows of quinqueremes in close order, 240 in all. Upon the catheads each carried two kneeling archers four cubits (six feet) in height, and (on the deck)

armed male figures five cubits (seven and a half feet) high, while the intervening spaces were occupied by red banners fashioned out of felt. Above these, on the second level, stood torches 15 cubits high with golden wreaths about their handles. At their flaming ends perched eagles with outspread wings looking downward, while about their bases were serpents looking up at the eagles. On the third level were carved a multitude of wild animals being pursued by hunters. The fourth level carried a centauromachy rendered in gold, while the fifth showed lions and bulls alternating, also in gold. The next higher level was covered with Macedonian and Persian arms, testifying to the prowess of the one people and to the defeats of the other. On top of all stood Sirens, hollowed out and able to conceal within them persons who sang a lament for the dead. The total height of the pyre was more than 130 cubits (185 feet).

660 feet square (435,600 square feet) and 185 feet high—that is remarkably large. 10,000 talents—that is incredibly expensive. Every talent, apparently, was intended to show, since reliefs, statues, and decorations were piled one on the other and gold was added to gold. The iconography seems to have been as grandiloquent as the forms. The culminating motif of sirens from whose mouths came songs of lamentation—that is a novel idea, an ingenious one, and rather a kitschy one.

Of other plans that Alexander had in mind then, for less personal projects, Diodorus tells us also.[13] They were military or religious or commemorative, but some involved urbanism or architecture, and all were impressively ambitious:

It happened that Krateros, who was one of the most prominent of men, had previously been sent away by Alexander to Cilicia. . . . he had received written instructions which the king had given him for execution. . . .

The following were the largest and most remarkable items of the memoranda. It was proposed to build a thousand warships, larger than triremes, in Phoenicia, Syria, Cilicia, and Cyprus for the campaign against the Carthaginians and the others who live along the coast of Libya and Iberia and the adjoining coastal region as far as Sicily; to make a road along the coast of Libya as far as the Pillars of Herakles and, as needed by so great an expedition, to construct ports and shipyards at suitable places; to erect six most costly temples, each at an expense of 1500 talents (not less than $45,000,000 and perhaps a great deal more). . . . The temples mentioned above were to be built at Delos, Delphi, and Dodona, and in Macedonia a temple to Zeus at Dium, to Artemis Tauropolos at Amphipolis, and to Athena at Kyrnos. Likewise at Ilion in honor of this goddess there was to be built a temple that could never be surpassed by any other. A tomb for his father Philip was to be constructed to match the greatest of the pyramids of Egypt, buildings which some persons count among the seven greatest works of man.

Some scholars reject this passage, please note. They are concerned especially about the declared plans for western conquest, but the argument hinges on the validity of the whole story of "written instructions." However, other scholars continue to accept the passage, and therefore it is offered here, with *caveat*.[14] Before concluding the passage, let us pause to wonder at least at the concept of a temple "that could never be surpassed by any other" and a tomb "to match the greatest of the pyramids."

"Perdiccas . . . laid these matters before the common assembly of the Macedonians for consideration," Diodorus continues; ". . . the Macedonians, although they applauded the name of Alexander, nevertheless saw that the projects

were extravagant and impracticable and decided to carry out none of those that have been mentioned." This may lead us to believe that the taste of the Successors was more modest and restrained than that of Alexander. However, we soon learn otherwise. Perhaps they had felt that the moment of Alexander's death should be a time of caution. Perhaps they simply preferred projects of their own.

When they assigned Arrhidaios to the duty of "bringing home the body of Alexander,"[15] he took two years for the task of making the vehicle for it, and the result was one that surely would have satisfied Alexander himself, at least for its sumptuousness. Says Diodorus:[16]

> Since the structure that had been made ready, being worthy of the glory of Alexander, not only surpassed all others in cost—it had been constructed at the expense of many talents—but was also famous for the excellence of its workmanship, I believe that it is well to describe it.
>
> First they prepared a coffin of the proper size for the body, made of hammered gold, and the space about the body they filled with spices such as could make the body sweet smelling and incorruptible. Upon this chest there had been placed a cover of gold, matching it to a nicety, and fitting about its upper rim. Over this was laid a magnificent purple robe embroidered with gold, beside which they placed the arms of the deceased, wishing the design of the whole to be in harmony with his accomplishments. Then they set up next to it the covered carriage that was to carry it. At the top of the carriage was built a vault of gold, eight cubits wide and twelve long, covered with overlapping scales set with precious stones. Beneath the roof all along the work was a rectangular cornice of gold, from which projected heads of goat-stags in high relief. Gold rings two palms broad were suspended from these, and through the rings there ran a festive garland beautifully decorated in bright colors of all kinds. At the ends there were tassels of network suspending large bells, so that any who were approaching heard the sound from a great distance. On each corner of the vault on each side was a golden figure of Victory holding a trophy. The colonnade that supported the vault was of gold with Ionic capitals. Within the colonnade was a golden net, made of cords the thickness of a finger, which carried four long painted tablets, each equal in length to the side of the colonnade.
>
> On the first of these tablets was a chariot ornamented with work in relief, and sitting in it was Alexander holding a very splendid sceptre in his hands. About the king were groups of armed attendants, one of Macedonians, a second of Persians of the bodyguard, and armed soldiers in front of them. The second tablet showed the elephants arrayed for war who followed the bodyguard. They carried Indian mahouts in front with Macedonians fully armed in their regular equipment behind them. The third tablet showed troops of cavalry as if in formation for battle; and the fourth, ships made ready for naval combat. Beside the entrance to the chamber there were golden lions with eyes turned toward those who enter. There was a golden acanthus stretching little by little up the center of each column from below to the capital. Above the chamber in the middle of the top under the open sky there was a purple banner emblazoned with a golden olive wreath of great size, and when the sun cast upon it its rays, it sent forth such a bright and vibrant gleam that from a great distance it appeared like a flash of lightning.
>
> The body of the chariot beneath the covered chamber had two axles upon which turned four Persian wheels, the naves and spokes of which were gilded, but the part that bore upon the ground was of iron. The projecting parts of the

axle were made of gold in the form of lion heads, each holding a spear in its teeth. . . . There were 64 mules. . . . Each of them was crowned with a gilded crown, each had a golden bell hanging by either cheek, and about their necks collars set with precious stones.

 . . . Because of its widespread fame it drew together many spectators; for from every city into which it came the whole people went forth to meet it and again escorted it on its way out, not . . . sated with the pleasure of beholding it.

This was one of the imperial enterprises that was planned in part for popular consumption.

The funeral coach was reconstructed by Kurt Müller in 1905, with emendations subsequently by others, as an Ionic peripteral structure with a four-way vaulted roof, within which the coffin was visible through gold-net walls that were topped by the four scenes representing Alexander's military and naval power.[17] (The Müller reconstruction drawing—like the reconstructions of other monuments—is not reproduced here because the ancient words evoke the monument more accurately, even if they are not always perfectly clear. Müller's drawing, not surprisingly, more nearly evokes an early twentieth-century Prix de Rome project.)

The iconography in this case was straightforward, explicitly celebrating Alexander's military might. Alexander himself might have wanted more grandiloquence on that score. But surely he would have been satisfied with the gold, and with the addition of jewels. The vaulted roof was novel at the time; perhaps it recalled the vaulted chambers of the old Macedonian hypogea.

When Ptolemy took over Alexander's body and brought it to Alexandria, Diodorus continues, he prepared "a precinct worthy of the glory of Alexander in size and construction."[18] Although there is not a clue in ancient sources to the form of Ptolemy's monument, there is no reason to doubt its splendor, nor that of subsequent Ptolemaic funerary monuments, including the collective mausoleum raised by Ptolemy IV Philopator (221–205) to which were removed the remains of Alexander and of the preceding Ptolemies.[19]

The degree and kind of extravagant expenditure of which the Ptolemies were capable is described in other connections. Athenaios, for example, repeats accounts, originally written in the late third or second century B.C. by Kallixeinos of Rhodes, of a procession and banquet given by Ptolemy II (283–246) and of a luxurious riverboat belonging to Ptolemy IV (221–205).[20] So long and so extravagant is Athenaios's description—although in fact it gives only excerpts from Kallixeinos—that it is difficult to know how to present it here. It would be best to present it all, since the effect intended in this essay is exactly the accumulation of such images. But space does not permit. Athenaios's own account is breathless, and, even allowing for the most extreme exaggeration, can only leave us breathless.

The procession went on from dawn to dusk, with sections devoted first to the Morning Star, last to the Evening Star, and in between one to Ptolemy I and Berenike, one to Alexander, and others to "all the gods."[21] In each section, presumably, as in the one devoted to Dionysos that is described most fully, there were hundreds of people dressed as personalities or personifications associated with the god, in costumes which often included embroidered robes and gilt or gold accessories; thousands of people carrying gold and silver utensils, some of which were jeweled or embossed with figurative scenes or decorations; many carts carrying more such utensils, often of extraordinary dimensions, or statues up to 18 feet high, all or in part made of gilt or gold, or "remarkable scenes lavishly represented,"[22] or many other things. Apparently wheeled in the procession also were

gold altars and gold-and-ivory thrones which carried gold objects. Throughout there were many animals and many birds from many parts of the world. Of the dimensions and wealth involved, here is a vivid example: "In . . . carts . . . were carried a Bacchic wand of gold, 135 feet long, and a silver spear 90 feet long; in another was a gold phallus 180 feet long, subdivided and bound by fillets of gold; it had at the extremity a gold star, the perimeter of which was nine feet."[23] On still another cart "was seated an image of Nysa, twelve feet high; she had on a yellow tunic with gold spangles, and was wrapped in a Laconian shawl. Moreover, this image could rise up automatically without anyone putting his hands to it, and after pouring a libation of milk from a gold saucer it would sit down again."[24] Among the "remarkable scenes" was one, carried on a cart 33 feet long and 21 feet wide, drawn by 500 men, which represented "a deep cavern profusely shaded with ivy and yew. From this pigeons, ring-doves, and turtle-doves flew forth along the whole route, with nooses tied to their feet so that they could be easily caught by the spectators. And from it also gushed two fountains, one of milk, the other of wine. And all the nymphs standing round him (probably the infant Dionysos) wore crowns of gold, and Hermes had a staff of gold, and all in rich garments."[25] Athenaios exclaims at last, "What monarchy was ever so rich in gold?"[26]

Obviously the procession was as ingenious as it was expensive, as inventive as it was ostentatious, extravagant, gigantistic, and certainly self-aggrandizing. The kitsch of "inartistic showiness" seems to have been recurrent. The figure of Nysa reminds us that the technological skills of the period were devoted not only to such practical matters as windlasses and screw-pumps, curved mirrors that might project light and pulleys that could lift heavy weights, as well as to such death-dealing matters as stone-hurlers and siege machines, but also to the categories of temple miracles, tricks, toys, and special effects.[27] Sometimes the technological categories cross or coincide with the category of art, and then apparently delight was taken in the extra dimension of ingenuity that was afforded. Of course it is possible that Nysa was no more artistic than the automaton of Abraham Lincoln in Disneyland that stands up from its chair to recite the Gettysburg Address. But the tricky devices recur. In the Pharos, for example, it has been suggested that the sound warnings accompanying the light were produced by the mechanized bronze statues of Tritons blowing on conch shells which were set on the top corners of the first, rectangular section of the three-sectioned tower.[28] They would then have been mechanized variants of the sirens of the Hephaistion monument. In the funeral monument that Ptolemy II Philadelphos ordered for his wife-sister Arsinoe after her death in 270, technological ambition apparently went beyond what could actually be realized. Pliny says that " . . . the architect Timochares began to roof the temple with magnetic material in such a way that an iron image of Arsinoe might seem to float inside in mid air," but the monument was never completed. The architect died before it was finished, says Pliny, as did Philadelphos.[29]

The royal banquet given by Philadelphos following the procession was sheltered by a great tent which was spectacular enough also to be described at length by Athenaios, in enough detail to inspire a reconstruction by Studniczka.[30] The tent was large enough to "hold 130 couches in a circle." Wooden columns fifty cubits high held the scarlet, white-edged fabric ceiling, while beams were draped with tapestries and joined by painted panels. On three sides was "a portico with a peristyle, having a vaulted roof, and here the retinues of the guests could stand." Inside, the sides were covered with scarlet curtains and animal pelts and the floor was strewn with many flowers. "At the columns, which supported the pavilion,

were placed marble figures, a hundred in all, the work of the foremost artists. In the
intercolumniations were paintings by artists of the Sicyonian school, alternating
with a great variety of selected portraits; also there were tunics of cloth of gold and
most beautiful military cloaks, some having portraits of kings woven in them,
others depicting subjects taken from mythology. Above these, oblong shields were
hung all round, alternately of silver and of gold. And in the spaces above these
again, each measuring eight cubits, recesses were constructed, six on each of the
longer sides of the pavilion, and four on the narrower sides; and in these recesses
were representations of drinking-parties arranged to face one another, composed
of figures taken from tragedy, comedy, and satyric drama, wearing real clothing,
and beside them lay cups of gold. In the spaces between the recesses were left niches,
in which were set up Delphic tripods of gold, with supports beneath. Along the
topmost space in the ceiling gold eagles faced each other, 15 cubits in length.
On the two sides were set a hundred gold couches with feet shaped like sphinxes;
for the apse facing the entrance was left open. On the couches were spread purple
rugs made of wool of the finest quality, with pile on both sides; and over them were
counterpanes embroidered with exquisite art. Smooth Persian carpets covered the
space in the middle trodden by the feet, having beautiful designs of figures woven
in them with minute skill. Beside the guests, as they reclined, were set three-legged
tables of gold, two hundred in number, making two to each couch; they were set
upon silver rests. Behind them, ready for the handwashing, were a hundred silver
basins and the same number of pitchers. In full sight of the company was built
another couch also for the display of the goblets and cups and all the rest of the
utensils appropriate to use on the occasion; all of these were of gold and studded
with gems, wonderful in their workmanship . . . the weight of them all taken
together in a single mass, was about ten thousand silver talents." This speaks well
enough for itself. Let me only suggest the word "kitsch" for drinking parties in
real clothes with real cups of gold beside them.

About the pleasure ship of Ptolemy IV let it suffice to say that it was 300 feet long
and 45 feet abeam, and it was fitted with many columniated rooms richly finished in
fine woods and ivory and stones from India, including one dining room in Egyptian
style, a round shrine of Aphrodite with a marble statue of the goddess, and a saloon
with Parian marble portrait statues of the royal family.[31]

Concerning the palace of the Ptolemies we have much less detail.[32] But we can
hardly think that Ptolemy II folded his tent or Ptolemy IV disembarked from his
ship to go home to anything less luxurious, and the little that we are told confirms
this. Diodorus Siculus, who visited Alexandria in 60 B.C., says that, "Alexander
gave orders to build a palace notable for its size and massiveness. And not only
Alexander, but those who after him ruled Egypt down to our own time, with few
exceptions, have enlarged this with lavish additions."[33] Strabo, who was there from
24 to c.20 B.C. and gives the fullest account, says that the royal palaces ". . . con-
stitute one-fourth or even one-third of the whole circuit of the city; for just as each
of the kings, from love of splendor, was wont to add some adornment to the public
monuments, so also he would invest himself at his own expense with a residence, in
addition to those already built, so that now . . . 'there was building upon build-
ing,' " and he goes on to name as within the Palace Precinct the Museum, the Sema
("the enclosure which contained the burial-places of the kings and that of Alex-
ander"), the royal palace on the promontory Lochias, "the inner royal palaces,
which are continuous with those on Lochias and have groves and numerous lodges
of various kinds," a private harbor, and the offshore island of Antirrhodos, "which

has both a royal palace and a small harbor."[34] From other evidence can be added the Library, the royal botanical garden and zoo, an architectural fountain that included a rocky grotto and sculptured decoration, and the Akra, a citadel that contained a prison and, it is assumed, a garrison.[35] What is described by the sources, however sketchily, can hardly be taken as anything but an extensive, many-sectioned palatial complex, formed to suit the taste and needs, and to fit the purse "rich in gold" of each of these absolute monarchs in turn. There is no evidence for the residence of the Seleucids,[36] but we do know that in the early period of Macedonian imperialism they were the Ptolemies' closest rivals in power, wealth, and absolutism. In their rich, beautiful capitals first of Seleucia, then of Antioch-on-the-Orontes, would they have lived less than imperially? In Pella, where private houses are known to have been palatial, should we underestimate the palace of the Antigonids?[37] For Sicily, where Greek tyrants held power over more limited domains, there too is evidence at least of beautiful gardens and parks connected with their palaces,[38] and display and luxury are associated with their names. One may assume that the palace of Hieron II was scaled to the size of his ship and the elegance of its officers' quarters.

In 1924 Armin von Gerkan ignored this source evidence when he made the statement that the Hellenistic period did not produce a distinct palace type, but that the Hellenistic kings lived simply in enlarged and elaborated versions of the current private house.[39] It was the relatively modest remains of the residences found on top of the hill at Pergamon, it seems, that impressed him enough to supersede both literary evidence and historic logic, and others must have been similarly impressed, since many have repeated Von Gerkan's words. As recently as 1961 Glanville Downey accepted this assumption concerning the lost residence of the Seleucids in Antioch-on-the-Orontes;[40] and in 1966, in his account of Hellenistic architecture, John Boardman said, ". . . their palaces are no more than large versions of the usual house plan, and only with the Romans do we find palace complexes properly planned to accommodate court, offices, guard, or administration, in a setting suitable to the dignity of a king or emperor."[41]

In recent years, however, new archeological evidence has been accumulating which contradicts these statements and reinforces what the literature tells us.[42] Most notably in Palatitsa/Vergina in Macedonia[43] and Demetrias in Thessaly,[44] anaktora of the early third and late third century, respectively, have been reexcavated, and revealed as singular, palatial buildings. Both are very large, the first 79 by 104.5 meters, the second 66 to 68.6 by more than 80 meters, and finely sited on hills, with splendid views. Both are associated with fortifications. The Palatitsa building is near the city wall; the Demetrias building itself has four towers and heavy walls, and it is connected with a broad, walled citadel which in turn is connected with the city wall. Both center on spacious peristyle courts with rows of rooms on all four sides, of unequal depth and varying size, including some rooms that are unusually grand—one stately suite has been revealed so far in Demetrias, and two in Palatitsa, plus a circular reception room. Both buildings are strongly axial, and in Palatitsa, where more is known, there is evidence for a columned entranceway set centrally in what is probably a two-storied porticoed façade. Both buildings also have an area on one side, paralleling the row of rooms, which turns away from the peristyle—in Palatitsa it is either a single long room or a roofed terrace which looks out over a large vista. In Demetrias, in addition, two of the other sides are associated with broad terraces. These grand buildings are themselves free-standing structures. But there is evidence, not only in the literature

quoted above but also in Pergamon itself, and at several other sites,[45] that separate buildings serving various functions clustered together in the palatial compounds. In Palatitsa/Vergina one associated building has recently been found,[46] and in Demetrias the excavators assume that there had to be at least residences for personnel, storehouses, and stables.[47] Clearly, these are palaces with developed forms of their own, as well as variants among the forms, and they must once have been resplendent in their decorations and appointments.

There is not enough hard evidence to ascertain whether they contained accommodations for all of the functions specified by Boardman. Concerning Alexandria assumptions vary. P. M. Fraser read the evidence at hand to mean that, "We shall not be far wrong if we regard 'The Palaces' as consisting almost exclusively of royal buildings, shrines, pleasure gardens, etc.,"[48] while Antonio Giuliano assumed that within the walls "si svolgeva la vita di corte, amministrativa, giuridica, finanziaria, culturale."[49] That particular issue, apparently, must be left open. But when the records tell us that the Palace Precinct of Alexandria occupied one-fourth to one-third of the largest city in the Hellenistic world, that it had a complexity of parts beyond any known or imaginable private dwelling, and that its kings were fabled for the extravagance of both their taste and their expenditure, we can hardly doubt that this was "a setting suitable to the dignity of a king or emperor." Now, in addition, archeological remains confirm that the new palaces found their own palatial form. Therefore, among the most novel, gigantic, grandiose, and extravagant monuments of the monarchic Hellenistic world, as well as the most characteristic and significant, must have been the palaces of its kings.

*New York University*

## Notes

Work toward this article was begun under a National Endowment for the Humanities Fellowship, and it was finished under a John Simon Guggenheim Memorial Foundation Fellowship.

[1] Vitruvius, *On Architecture*, II, preface, 1–4. Trans. Frank Granger, Loeb Classical Library, London–New York, 1931. The spelling Dinocrates is changed to Deinokrates to be consistent with the text of the present article. The translation of the words "dignas tuae claritati" has been changed from "worthy of you, illustrious prince" to "worthy of your renown."

[2] Cf. *New Cassel's German Dictionary*, New York, 1958: "kitschig: inartistic, showy." Not applicable is the alternative meaning given there, "rubbishy, trashy." In English usage also the range of alternative meanings runs from "showy" to "trashy": cf. R. Mayer, *A Dictionary of Art Terms and Techniques*, New York, 1969; H. Osborne, ed., *The Oxford Companion to Art*, Oxford, Clarendon Press, 1970; *Funk and Wagnalls Standard College Dictionary*, New York, 1974. R. Mayer offers a useful phrase: "blatantly pretentious." The range includes "the blatantly sentimental" and work "of low quality, sometimes mass produced," which do not apply to the products on the regal-imperial level that are treated here. Further, it includes work "intended to appeal to popular tastes," which does sometimes apply to the works discussed here.

[3] Diodorus Siculus, *The Library of History*, XV.90–93, XVI.7.36, XVII.23; Strabo, *Geography*, XIII.611; Vitruvius,

*On Architecture*, II.8.11.

[4] Zeuxis: Aelian, *Var. hist.*, XIV.17. Agatharchos: A. Reinach, *Textes grecs et latins relatifs à l'histoire de la peinture ancienne*, Paris, 1921, *Recueil Milliet*, 180–84.

[5] N. and J. Gage, "Treasures from a Golden Tomb," *The New York Times Magazine*, Dec. 25, 1977, 14–19, 32.

[6] Diodorus Siculus, XVII.95.1. Trans. C. Bradford Welles, Loeb Classical Library, Cambridge, Mass.–London, 1963. On the altars, also: Curtius Rufus, *History of Alexander the Great of Macedon*, IX.3.19; Arrian, *Anabasis of Alexander*, V.29.1; Plutarch, *Alexander*, 62.4. On the encampment: Curtius Rufus, IX.3.19; Plutarch, 62.4.

[7] J. Overbeck, *Die antiken Schriftquellen zur Geschichte der bildenden Künste bei den Griechen*, Leipzig, 1868, 1539–54, especially Pliny, *Nat. Hist.*, XXXIV. 41; Strabo, XIV.652. W. Amelung, "Chares," Thieme-Becker, *Allgemeines Lexikon der bildenden Künstler*, Leipzig, VI, 1912, 389–90; L. Laurenzi, "Colosso di Rodi," *Enciclopedia dell'arte antica*, Rome, II, 1959, 773–74. Reckoning modern equivalents of the talent is very difficult, and consequently the range of estimates is exceedingly wide. The low number given in the text is based on Lionel Casson's estimate of $30,000 in *The Plays of Menander*, New York, 1971. A current high estimate, $120,000, is Frank Frost's, in *Greek Society*, Lexington, Mass., 1971, 57, and that is not the highest that is debatable. I thank Prof. Casson for his help with this problem.

[8] K. Lehmann, *Samothrace: A Guide to the Excavations and the Museum*, 4th ed., Locust Valley, N. Y., 1975, 54–58.

[9] A. Calderini, "Alessandria," *Dizionario dei nomi geografici e topografici dell'Egitto greco e romano*, Cairo, Società reale di geografia d'Egitto, 1935, 158–60; P. M. Fraser, *Ptolemaic Alexandria*, Oxford, Clarendon Press, 1972, I, 18–20; II, ch. 1, nn. 97–124. The basic reconstruction and publication is by H. Thiersch, *Pharos, Antike Islam und Occident*, Leipzig–Berlin, 1909. For recent numismatic discussion, cf. S. Handler,

"Architecture on the Roman Coins of Alexandria," *American Journal of Archaeology*, LXXV (1971), 58–61, pl. 11, figs. 1–3; M. J. Price, B. L. Trell, *Coins and their Cities*, London–Detroit, 1977, 181, figs. 313–17. I thank Prof. Trell for referring me to the article by Handler.

[10] Athenaios, *The Deipnosophists*, V. 206.d–209.e. Trans. Charles B. Gulick, Loeb Classical Library, London–New York, 1928. L. Casson, *Ships and Seamanship in the Ancient World*, Princeton, 1971, 185–86, 194–99. The translation of the word γόμφοι has been changed from "rivets" to "pegs," on the advice of Prof. Casson; of the word ἔκαμον, from "make" to "work out."

[11] Plutarch, *Alexander*, 72. Trans. Bernadotte Perrin, Loeb Classical Library, Cambridge, Mass., London, 1949. The confusion of names is discussed by H. Thiersch, "Deinokrates," Thieme-Becker, VIII, 1913, 562.

[12] XVII.4.1–5. Trans. Welles, Loeb.

[13] XVIII.4.6. Trans. Welles, Loeb.

[14] The strongest arguments against: W. W. Tarn, *Alexander the Great*, New York, 1947, II, 378–98. Those accepting the passage include F. Schachermeyer, "Die letzte Pläne Alexanders des Grossen," *Jahresheft des oesterreichischen archäologischen Instituts*, XLI (1954), 118–40.

[15] XVIII.26.1.

[16] XVIII.26.1–28.2

[17] K. Müller, *Der Leichenwagen Alexanders der Grossen*, Leipzig, 1905; H. Bulle, "Der Leichenwagen Alexanders," *Jahrbuch des deutschen archäologischen Instituts*, XXI (1906), 53–73; H. Thiersch, *Jahrbuch*, XXV (1910), 55.

[18] XVIII.28.4.

[19] Zenobius III.94. *Paroem. Gr.* I.81. P. M. Fraser, I, 15–17, 36, 220, 225, II, 31–42, nn. 79–92.

[20] Procession: V. 197.c.–203.a. Tent: V.196.a–197.c. Riverboat: V.203.e–206.c.

[21] V.197.d. Trans. Gulick, Loeb.

[22] V.200.b.

[23] V.201.e. The translation of the word διαγεγραμμένος has been changed from "painted in various colours" to "subdivided."

[24] V.198.f.

[25] V.200.b–c.

²⁶ V.203.b.

²⁷ M. R. Cohen, I. E. Drabkin, *Source Book in Greek Science*, New York, 1948; A. G. Drachmann, *The Mechanical Technology of Greek and Roman Antiquity*, Copenhagen, 1963.

²⁸ The Tritons: P. M. Fraser, II, 47, n. 103.

²⁹ *Nat. Hist.*, XXXIV.148. Trans. K. Jex-Blake, *The Elder Pliny's Chapters on the History of Art*, London–New York, 1896. Concerning the feasibility of the idea, this is the statement of Dr. Julius Brown, Professor of Electrical Engineering, Southern Illinois University at Edwardsville: "The magnetically suspended apparition is a clever trick (please note that some other major power-conversion devices were first proposed for similar purposes—the waterwheel and the steam engine, for example) but I feel that it could not have been implemented practically at that time. 1) The magnetic materials then available could not have provided sufficient force to suspend any reasonably sized figure—not at a distance from the roof that would have given the impression of hovering in midair. (Present-day electromagnets of course could.) 2) More significant is the fact that the equilibrium that could be established by accurate positioning (to balance the upward magnetic force and the downward force of gravity) would be unstable. Any small random displacement upward would result in further upward movement until the figure hit the roof; any downward displacement would result in acceleration toward the floor. Stable equilibrium requires a restoring force resulting from displacement from the equilibrium position and the suggested system has none."

³⁰ V.196.a–197.c. Trans. Gulick, Loeb. F. Studniczka, *Das Symposion Ptolemaios II*, Leipzig, 1914, *Abhandlungen der philologisch-historischen Klasse der König. Sächsischen Gesellschaft der Wissenschaften*, XXX, pl. 1.

³¹ Athenaios, V.203.e–206.c. Trans. Gulick, Loeb.

³² Calderini, 90–91 (Akra), 93 (Antirrhodos), 97–100 (Basileia), 126–27 (Lochias), 128–30 (Mouseion), 149–51 (Sema/Soma); Fraser, I, 14–23, II, ch. 1, nn. 70–147 (Palaces), I, 225, II, ch. 5, nn. 285–88 (Sema), I, 312–16, II, ch. 6, nn. 52–75 (Mouseion).

³³ XVII.52.4. Trans. Welles, Loeb.

³⁴ XVII.1.8. Trans. Horace L. Jones, Loeb Classical Library, London–New York, 1932.

³⁵ Library: Calderini, 102–4; Fraser, I, 320–35, II, ch. 6, nn. 97–226. Botanical garden and zoo: Fraser, I, 15, 515, II, ch. 1, n. 76, ch. 10, n. 180. Fountain: Guéraud, Jouguet, *Un livre d'écolier du IIIᵉ siècle av. J.-C.*, Cairo, 1938, 20–26; Fraser, I, 609–11, II, ch. 10, nn. 411–22; Handler, 210–11. Akra: Polybius, *The Histories*, V.39.3.

³⁶ G. Downey, *A History of Antioch in Syria from Seleucus to the Arab Conquest*, Princeton, 1961, 640–42.

³⁷ Ph. M. Petsas, *Pella*, Lund, 1964, *Studies in Mediterranean Archaeology*, XIV.

³⁸ Roland Martin, *L'Urbanisme dans la Grèce antique*, Paris, 1956, 249.

³⁹ *Griechische Städteanlagen*, Berlin–Leipzig, 1924, 108–9.

⁴⁰ Downey, 641.

⁴¹ J. Boardman, J. Dörig, W. Fuchs, *The Art and Architecture of Ancient Greece*, London, 1966, 58.

⁴² Summarized by P. Marzolff, in V. Milojcic, D. Theochares, *Demetrias*, Bonn, 1976, I, 36–40.

⁴³ M. Andronikos, Ch. I. Makaronas, N. Moutsopoulos, Y. Bakalakis, *Τὸ Ἀνάκτορο τῆς Βεργῖνας*, 1961; M. Andronikos, Ch. I. Makaronas, *Vergina*, Lund, 1964, *Studies in Mediterranean Archaeology*.

⁴⁴ Summary by P. Marzolff, 10, 17–36; excavation reports by I. Beyer, V. von Graeve, U. Sinn, 59–90, *op. cit.*

⁴⁵ Seuthopolis, Thrace, late 4th century B.C.; Pergamon, late 3rd–early 2nd century B.C.; Samos, 2nd century B.C.; Masada, 1st century B.C.: cf. our n. 42.

⁴⁶ M. Andronikos, Y. Bakalakis, *Δελτίον*, 21, 1966, II, 357 ff.; 24, 1969, II, 336 ff.

⁴⁷ P. Marzolff, *op. cit.*, 38.

⁴⁸ *Ptolemaic Alexandria*, I, 15.

⁴⁹ "Palazzo," *Enciclopedia dell'arte antica classica e orientale*, Rome, V, 1963, 859.

# 2

# *Revelation 11:7 and Revelation 13:1–10, Interrelated Antichrist Imagery in Some English Apocalypse Manuscripts*

JESSIE POESCH

In studies of the large group of illuminated Apocalypses which stem from manuscripts which seem to have had their origins in England about 1245–1250, it has long been noted that, in a small sub-group including New York, Pierpont Morgan, 524, and its sister manuscript, Oxford, Bodleian, Auct. D.4.17, the scenes depicting Revelation 11:3–7 show Antichrist as a man listening to the prophecies of the two witnesses and then ordering their execution (fig. 4, lower register; fig. 5, upper register). These are followed by several interpolated scenes showing other deeds which the Antichrist is to perform (fig. 5, lower register; fig. 6). Indeed Delisle and Meyer, in their pioneer study of 1901, differentiated between two major sub-groups partly on this basis—that one sub-group of manuscripts showed Antichrist as a man and had interpolated scenes of his life, and that the other did not.[1] This distinction has served to obscure the fact that in virtually all the manuscripts in this large group, of which there are at least forty-six manuscripts, there is some kind of reference to Antichrist imagery. At a minimum there are a number of references in the commentary that accompanies the text in a large number of the manuscripts.[2] But more importantly, in quite a few there are subtle attempts by the artists to convey these interpretations visually. Thus Antichrist imagery is integral to the entire group.

Some of the most interesting of the various ways of representing or suggesting the future presence and deeds of Antichrist can be seen in certain selected English manuscripts, beginning with examples from a generic period of about 1245 to 1265 and followed by examples created later in the thirteenth century or early in the fourteenth.[3] The two biblical passages which call forth the most explicit attempts by the artists to suggest the character of Antichrist are Revelation 11:3–7 and Revelation 13:1–10, especially the former. The depictions depend partly upon the poetic descriptions in the biblical texts themselves, and in part upon the accompanying commentaries or an understood tradition. (To make it more complicated, the depictions of the undescribed "beast" of Revelation 11:7 usually depend upon the full descriptions of the beasts who come out of the "bottomless pit" of Reve-

lation 9.) The verbal traditions for these ideas and beliefs go back to early Christian times.

The relevant passage in Revelation 11 tells of the two witnesses who first appear before the "god of the earth" and then are killed by this beast:

> And I will give power unto my two witnesses, and they shall prophecy a thousand two hundred and threescore days . . . And when they shall have finished their testimony, the beast that ascendeth out of the bottomless pit shall make war against them, and shall overcome them, and kill them.

In Revelation 13:1–10 the author describes a vision of a strange seven-headed and hybrid beast, part lion, part leopard, part bear, that emerges from the sea. This beast receives his power from the seven-headed dragon, is worshiped, blasphemes against God, and wars against the saints. This passage was long interpreted as a reference to an antimessianic figure or kingdom and very probably was intended as such by the author. The entire chapter, in fact, was believed by many commentators to be a series of veiled references to the forces of Antichrist.

The early Church had accepted from Jewish apocalyptic literature the belief that a false ruler or false Messiah and a period of intense tribulation were to occur before the Second Coming of the Messiah. Important among Old Testament sources for these beliefs were portions of Daniel 7, where the "other" horn or warrior-king speaks words against the "Most High" and makes war with saints, and Daniel 9 and 11:31–45, where the "abomination that maketh desolate" and a vile king are described. A major expression of the Christian belief in a false and deceiving opponent of Christ who will proclaim himself the Son of God is found in Paul's description of a "man of sin" and "son of perdition" in II Thessalonians 2. He will sit in the temple of God, and perform false miracles—his coming is "after the working of Satan with all power and signs and lying wonders." His power shall be ended when the Lord strikes him with the "spirit of his mouth." Passages in Matthew 24 and Mark 13 were also understood as references to this false figure. The only explicit references in the New Testament to Antichrist's coming, however, are in the Epistles of John—I John 2:18–22; I John 4:3; and II John 7—where there are warnings against both the Antichrist to come and the "many antichrists" already in this world.

Most of these texts were brought together by the early Christian writers Irenaeus, in his *Against Heresies* (before c.200), and Hippolytus, in his treatise *Christ and Antichrist* (before 236).[4] Both elaborated upon and gave a certain coherence to the always loosely defined beliefs about Antichrist and antichrists, using the veiled allegorical and metaphorical language of the biblical texts. What is remarkable is the fullness of their comments, particularly those of Hippolytus, suggesting that a strong oral tradition had come down from the apostolic period.

Irenaeus based his discussion on what he saw as parallel texts referring to the same subject, and in many cases he used Old Testament passages which he understood as foretelling events alluded to in the New. Thus the semihistorical prophecy in Daniel about the ten last kings from among whom would come the "son of perdition" (also the "little horn" and the fourth beast of Daniel 7:7–8, 23–26) is combined with Paul's prediction of the Satanic powers of the Wicked one and his ultimate end. Expounding the subject further, Irenaeus combined parts of the description of Paul's "son of perdition" (II Thessalonians 2) with the text of Revelation 13:2–10, seeing the allegorical description of the hybrid beast from the sea, which according to the text is worshiped, and blasphemes God and his tabernacle,

and wars on saints, as an amplification of Antichrist's nature and deeds. Thus in what is one of the earliest surviving treatises dealing with this theme, the description in Paul of the appearance of the "man of sin" is combined with references to John's mysterious beast from the sea, of Revelation 13.

Hippolytus created a virtual biography for this figure, opposite to Christ in all ways, by a similar method of weaving together parallel texts. These included all of the biblical texts cited above, plus others. Hippolytus, for example, also saw an intended parallel between the "little horn" of Daniel 7:8 and the "beast that ascendeth out of the bottomless pit" of Revelation 11:7, that is, the beast that kills the two witnesses. He identified the two witnesses as Enoch and Elijah. The latter is understood as an expected forerunner of the Second Coming because of the prophecy in Malachi 4:5–6, "Behold, I will send you Elijah the prophet before the coming of the great and dreadful day of the Lord." No reason is given for the identification of Enoch as the other witness, but possibly he was considered a forerunner of Christ's Second Coming because he too was translated to heaven (Genesis 5:24).

Thus by the first quarter of the third century A.D. the diverse teachings and elliptical references found in the Bible about a deceptive and fearsome opponent of Christ had been brought together, supplemented with still other seemingly parallel passages, and used in fairly ordered descriptions of the events that would precede the Last Judgment. The language was cautious and veiled in allegory. The antimessianic figure who was to come before the last times was spoken of as a man or as having one of several bestial guises; or as the embodiment of a kingdom or a force, or as singular or plural, as one who is to come yet one who was already in this world.

Though the specific writings of Irenaeus or Hippolytus may have been lost sight of, the method of linking together what can be recognized as key texts continued to pervade the patristic and medieval literature, but with much variation in emphasis and specific content. Thus whether one looks at a commentary of Origen on Matthew or at the obscure Irish medieval Book of Lismore, similar ideas and texts emerge and are reiterated.[5]

The long and complex history of commentary on the Apocalypse is intertwined with the spread of the more general beliefs about Antichrist.[6] The text of Revelation itself is both veiled history and prophecy, written in allegorical language. It was written with specific historical episodes in mind but surely was, to its writers, a revelation and a prophecy, and was accepted as such by Western Christians. It has been interpreted both as a literal or a prophetic mirror of history, and as an allegory of the Christian Faith.

The early Fathers whose writings included references to the Apocalypse, such as Irenaeus and Hippolytus, still recognized some of the contemporary events to which the author apparently referred; some prophetic elements, too, such as the millennium when Christ would reign on earth for a thousand years, were taken literally. Victorinus of Pettau in Styria (d. 304), an early commentator on the Apocalypse, interpreted St. John's Revelation not so much as an uninterrupted series of events but as a succession of visions, each revealing or recapitulating parts of the truth and the same succession of events in a different way.[7] Victorinus interpreted a number of different visions as signs of Antichrist and the events of his time. For our purposes, it should be noted that he identified one of the witnesses as Elijah (the other as Jeremiah). The allegorical reference to these as the two olive trees "standing before the God of the earth" is understood as signifying both their ul-

timate place in paradise and their presence before Antichrist, the Lord of the earth who is to slay them. The nature of this beast which ascends from the abyss and kills the witnesses is further elaborated in Paul's description of the "man of sin," whose identification as the Antichrist was already traditional. Thus the identification of the beast of Revelation 11:7 as a symbol or figure of Antichrist can be traced back at least as far as Hippolytus in the first quarter of the third century and, in commentaries on the Apocalypse, at least as far back as Victorinus, writing in the latter part of the same century.

The hybrid beast from the sea of Revelation 13:1–6 is seen by Victorinus as signifying the kingdom of the time of Antichrist. Thus the tradition of reading this passage as a reference to the events of the last times and Antichrist's rule also dates back to early Christian times. In the later literature on Antichrist is the remarkable letter of the monk, Adso, written to his queen, Gerberga of France, around 954.[8] He summarized for her the various beliefs about Antichrist of which he had heard; the original biblical texts were virtually lost in his elliptical summary. He put together several versions or variations on the "life" of this false ruler, replete with some specific miracles. The document apparently enjoyed wide circulation.

In the Middle Ages the Apocalypse became for most commentators a textbook of Christian doctrine that, properly understood, revealed and recapitulated the manifold meanings of Christ's message to man, rather than a mirror to history or a key to history. Virtually all retained, in one form or another, the expectation of Antichrist's coming at the end of time. The commentary of Berengaudus, fragments or portions of which are appended to the illustrations in a number of the manuscripts we are reviewing here, fits into this school of allegorical and, by then, monastic tradition.[9]

In a number of the earliest of the English illuminated Apocalypse manuscripts having special interest to us there are several in which the episode of Revelation 11:7 is shown literally. In the elegant Trinity College Apocalypse, Cambridge, Trinity College R.16.2 (fig. 1, upper register), one sees the beast killing the witnesses by trampling or biting them.[10] A slight variation is shown in London, Lambeth Palace 209 (fig. 2).[11] In this case the detail is richer, for a second beast ridden by the winged "king" or "angel of the bottomless pit" of Revelation 9:11 is included. The wall of the city is also shown. In both cases excerpts from the Berengaudus commentary accompany the pictures and inform the reader that the witnesses are Enoch and Elijah, the forerunners of the Second Coming, and that the beast signifies Antichrist.[12] In both cases, too, the extraordinary appearance of the beast is based on the description of the hybrid locust–horse–human-faced creatures which John describes as emerging from the bottomless pit in Revelation 9:7–10:

> And the shapes of the locusts were like unto horses prepared unto battle; and on their heads were as it were crowns like gold, and their faces were as the faces of men. And they had hair . . . of women, and their teeth were as the teeth of lions. And they had breastplates, as it were breastplates of iron; and the sound of their wings was as the sound of chariots of many horses running to battle. And they had tails like unto scorpions . . .

This is confirmed by the representation of Revelation 9:1–12, here shown as in a manuscript formerly at Metz, Salis 38 (fig. 3).[13] Except in coloring, the Metz manuscript is a sister manuscript to Lambeth 209.

The depiction of Revelation 11:3–7 in another sub-group is that which has long been identified as the special interpretative illustrations mentioned in the first

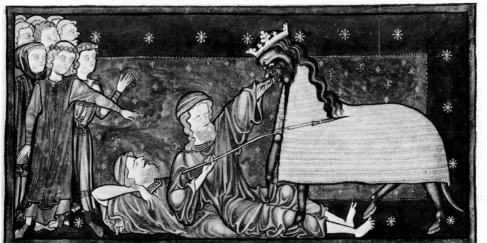

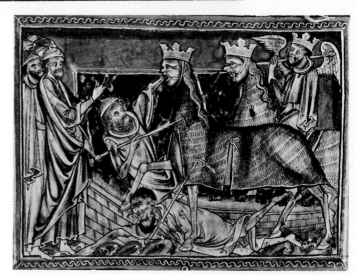

1. *Revelation 11:7.* The beast kills the witnesses. *Cambridge, Trinity College Library, MS R.16.2, fol. 12*

2. *Revelation 11:7.* The beast kills the witnesses. *London, Lambeth Palace Library, MS 209, fol. 13v*

3. *Revelation 9:1–11.* The locust beasts from the bottomless pit and their king, "the angel of the bottomless pit." *Formerly Metz, MS Salis 38*

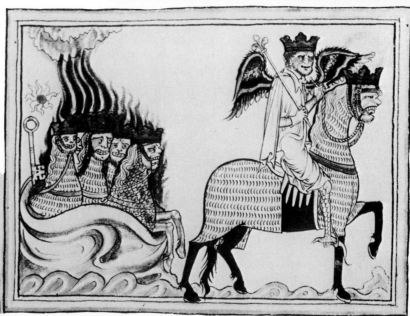

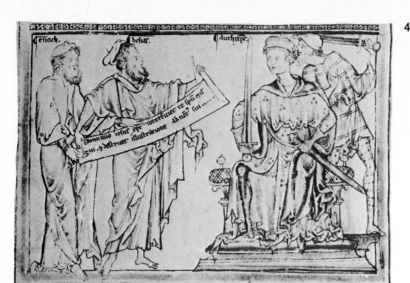

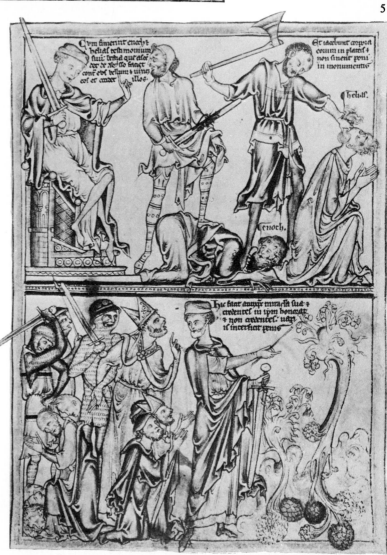

*4. Revelation 11:3–6.* The two witnesses, Enoch and Elijah, before Antichrist. *New York, Pierpont Morgan Library, MS 524, fol. 6v, lower register*

*5. Upper register: Revelation 11:7.* The witnesses killed at command of Antichrist. *Lower register:* Antichrist performs miracles and tortures those who will not believe in him. *New York, Pierpont Morgan Library, MS 524, fol. 7*

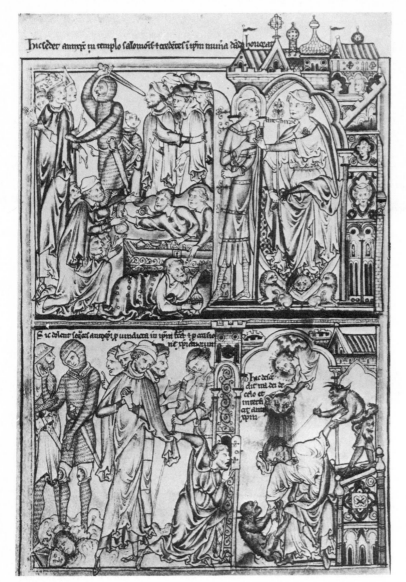

*6. Upper register:* Antichrist sits in Temple of Solomon and gives money to those who believe in him. *Lower register:* Antichrist struck down. *New York, Pierpont Morgan Library, MS 524, fol. 7v*

paragraph of this article (figs. 4–6), as seen in Morgan 524 and in its sister manuscript, Oxford, Bodl. Auct. D.4.17. First the witnesses are shown preaching or prophesying as they stand before the "god of the earth" or Antichrist, then their execution is depicted, and then the interpolated scenes of his life.[14]

In Morgan 524 (and Oxford, Bodl. Auct. D.4.17) there are pictures in sequence on two registers on each page and no text per se. However, on the pictures themselves there are edited excerpts from the biblical text and from the Berengaudus commentary. Thus the tersest of inscriptions identifies the two witnesses, they who "shall prophesy a thousand two hundred and threescore days," as Enoch and Elijah (fig. 4). The artist shows the "beast" incarnated as a man-ruler, Antichrist. The words on the scroll which the two prophets hold are based upon Paul (II Thessalonians 2), the classic Christian description of his coming and his destruction.

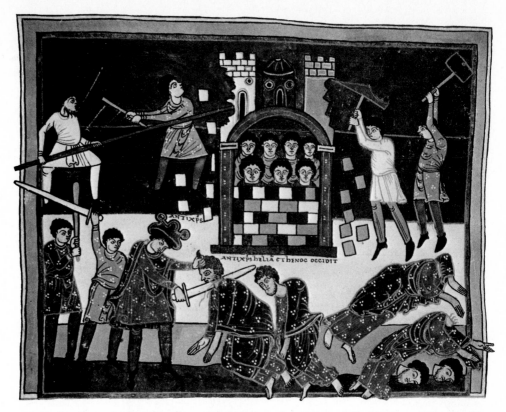

7. *Revelation 11:1–7.* The Temple of God, and Antichrist kills Elijah and Enoch. *The Apocalypse of Saint Sever. Paris, Bibliothèque Nationale, MS lat. 8878, fol. 155v*

In the next scene (fig. 5, upper register) Revelation 11:7 is depicted. The witnesses have finished their testimony and the "beast," once again as a man-ruler–Antichrist, makes "war against them" and, in this instance, is shown as he orders and presides over their execution. He sits regally on his throne, cross-legged, sword upraised in his right hand, his left arm and hand extended in a gesture of command. In the next three registers (fig. 5, lower register; fig. 6) the artist elaborates on the deeds of Antichrist. (Interestingly, in these three registers the scenes read from right to left rather than the usual left to right. Also, Antichrist is shown bearded. These two differences support the idea that the scenes are interpolations beyond the Berengaudus commentary, though perhaps implicit in it.) Antichrist makes bloom the roots of a tree, and tortures those who will not believe in him. He sits in the Temple of Solomon and gives money to his followers. He is struck down by the breath of the Lord (II Thessalonians 2:8), and those who believed in him mourn his death. Though not based directly on Adso's letter, this is the kind of detail which was included in it.

There is some visual precedent for each of the above scenes, though none can be identified as a direct source. The earliest visual interpretations of the "beast" in Revelation 11:7 as a man, Antichrist, of which I am aware, are found in the Spanish illuminated Apocalypses with the commentary of Beatus of Liébana. In the example from the eleventh-century Apocalypse of St. Sever in Paris, Bib. Nat. lat. 8878 (fig. 7), the creature that kills the witnesses is a warrior-ruler, a concept

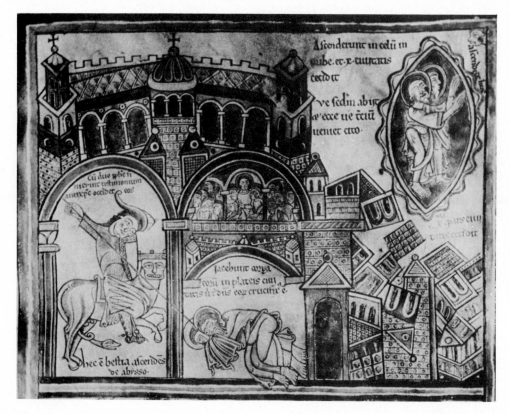

8. *Revelation 11:7–13.* The witnesses killed by a warrior-Antichrist riding the beast from the abyss; the witnesses ascend. Liber Floridus. *Wolfenbüttel, Herzog August Bibliothek, Cod. Guelf. 1 Gud. lat., fol. 14, upper register*

rooted in the passages in Daniel, and identified by the inscription as Antichrist. Here too the victims are identified as Enoch and Elijah. In the illuminated Apocalypse scenes found in the spiritual encyclopedia of Lambert of St. Omer, the *Liber Floridus,* the one who slays the witnesses is a warrior who rides a beast (fig. 8) in Wolfenbüttel, Herzog August Bibliothek, Cod. Guelf. 1 Gud. lat., a twelfth-century copy of the original 1120 Ghent manuscript. There is no accompanying commentary, but a short inscription indicates that the witnesses are killed by Antichrist. In this latter case the beast ridden by the Antichrist-warrior is shown as a winged horse with human face, wearing a crown and having a tail ending in a snake's or scorpion's head, one of the creatures described by John in Revelation 9, a precedent for the creatures in Trinity, Lambeth, and Metz.

Twelfth-century depictions of Antichrist were found in the *Hortus Deliciarum* of Herrad of Landsberg, known to us only through nineteenth-century drawings.[15] Here was presented a partial narrative sequence of nine scenes of Antichrist's "life," the first three of which are illustrated in figure 9. First the youthful, bearded warrior-ruler is shown slaying the two prophets, and they lie dead. Then he is shown offering gifts to kings, and in the lower register he performs miracles—he causes the roots of trees to bloom, rain to come down, and he controls the direction of waters. The subsequent scenes show further miracles, then his destruction (as described in Paul), and his believers in mourning. The surviving inscriptions indicate that these episodes are derived from "diverse sources." Several of them

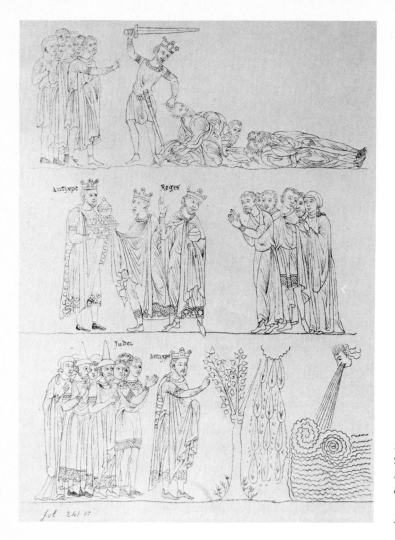

9. *Upper register:* Antichrist kills witnesses and they lie dead. *Middle register:* Antichrist gives gifts to kings. *Lower register:* Antichrist performs miracles (*Straub and Keller,* Hortus Deliciarum, *Pl. XLII*)

were among those included in the tenth-century summation of Adso. The creators of the English Apocalypse manuscripts very probably had a model similar to this for the interpolated scenes.

Returning to the English Apocalypse manuscripts, the depictions of the sequence of episodes described in Revelation 13:1–10 do not differ so much between the two pairs of sub-groups, Metz–Lambeth and New York–Oxford. There are differences in pacing and therefore differences between the exact episodes as shown within each frame.

In the Metz manuscript (fig. 10) we first see John as he watches the unfolding of the scene. The dragon (interpreted in the commentary as signifying the devil) hands the scepter to the beast from the sea, "and the dragon gave him his power, and his seat, and great authority." The seven-headed beast from the sea is here shown literally, as if it had just risen out of the waters. The commentary below indicates that the beast signifies Antichrist and the sea the wicked; thus Antichrist will emerge from the society of the wicked. Reference is made to the seven vices of Prudentius.

The comparable scene in New York, Morgan 524 (fig. 11, upper register), is in this case reversed and somewhat simplified. Again the dragon gives the scepter to the sea beast; he also places a crown on one of the heads with a forceful gesture. John, the tree, the water, and the boat are not present, perhaps to make room for the inscriptions. We are told that the leopard-like creature from the sea represents Antichrist and his heads the seven deadly sins.

The creatures in the two manuscripts are remarkably alike in appearance, and in both the depictions depend upon the description in the text itself.

The next two scenes in Metz show first the worship of the dragon, then that of the beast from the sea (figs. 12, 13). Under the first is given the text of Revelation 13:3–7 and under the second, Revelation 13:4–6, so there is some repetition in order to illustrate the two events fully. In the first the dragon is in the center and a group of people on the right worship it: "And they worshipped the dragon which gave power unto the beast. . . ." Sitting on the far left is the leopard-like sea beast. What is interesting here is that this creature is shown in an anthropomorphic pose, seated upright. The same is true for the next scene, where the group of people on the left now worship the beast: ". . . and they worshipped the beast, saying, who is like unto the beast? who is able to make war with him?" Now the anthropomorphic creature sits on a hillock in the center of the scene, grasping its scepter with both hands, while the dragon stands by. It is as if the artist wants to suggest the beast's character as the potential man-Antichrist in these two episodes.

The excerpts from the commentary below the first of these two pictures continue the theme of the interrelation between the devil and Antichrist: ". . . How will men worship the devil, that is, the devil whom they will not see? But those who are designated by the earth will worship antichrist, and in antichrist, the devil, saying there is no one like antichrist, nor is there any one who can equal his fortitude."

The illustrations for the same two texts in Morgan 524 are somewhat simpler. First we are shown a group of people worshiping the dragon (fig. 11, lower register), then a group of people worshiping the beast from the sea (fig. 14, upper register). The condensed text and commentary inscribed on the pictures convey the same ideas. In the second of these scenes the beast from the sea is simply shown as a

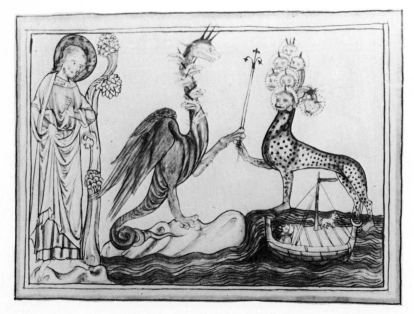

*10. Revelation 13:1–3.* The dragon gives scepter to the beast from the sea. *Formerly Metz, MS Salis 38*

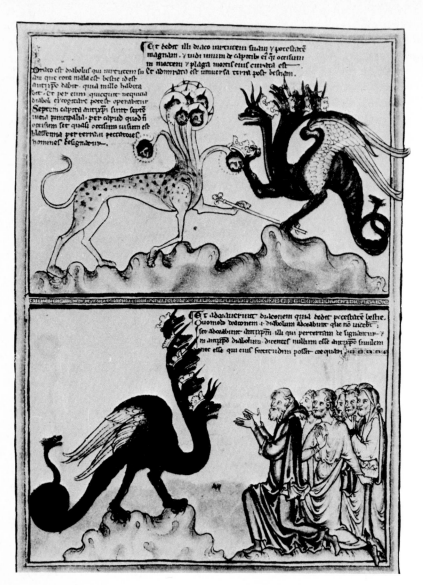

11. *Upper register: Revelation 13: 2–3.* The dragon gives scepter and crown to the beast from the sea. *Lower register: Revelation 13:4.* Worship of dragon. *New York, Pierpont Morgan Library, MS 524, fol. 10v*

12. *Revelation 13:4.* Worship of dragon. *Formerly Metz, MS Salis 38*

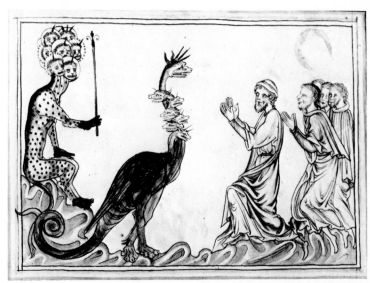

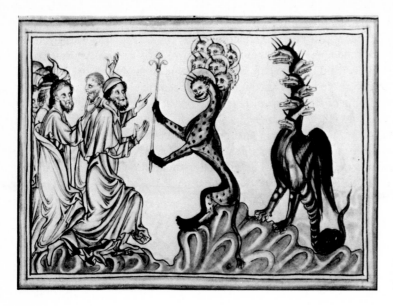

13. *Revelation 13:4.* Worship of the beast from the sea. *Formerly Metz, MS Salis 38*

four-footed creature (as it is also in the next scene in the lower register, "And it was given him to make war with the saints," with no attempt to render the nuances of the commentary).

The artist of the Ludwig-Perrins manuscript must have been familiar with the depictions in the models of the above two pairs of manuscripts, for he makes what I read as intelligent conflations when he represents both Revelation 11:3–7 and when he illustrates Revelation 13:4.[16]

In the first episode (fig. 15) the artist has conflated what had been two scenes in Morgan 524 (figs. 4, 5), the appearance of the beast (Antichrist) from the pit and the two witnesses before it, and the creature slaying the witnesses. Neat, didactic labels indicating Antichrist, Enoch, and Elijah are there, as is the scroll with the prophecy based on II Thessalonians 2. The beast is anthropomorphic, a bestial man with hoofed feet and demonic face, and clothed in a coat of armor (Revelation 9:7), as was the beast in the same scene in those manuscripts with the literal depictions of this scene (figs. 1, 2). Thus the depiction of the beast is in itself a conflation of the images in Trinity and in Metz–Lambeth, combined with Antichrist's executioners as shown in New York–Oxford.

Equally interesting is the conflation of ideas found in the depiction of Revelation 13:4–6, ". . . and they worshipped the beast. . . . And he opened his mouth in blasphemy against God, to blaspheme his name, and his tabernacle, and them that dwell in heaven" (fig. 16). The seven-headed beast from the sea is leopard-like and bestial, but he is shown seated upright, cross-legged on a low throne. His gesture of command is a direct parody of those of the Antichrist-as-man shown in Morgan 524 (fig. 5, upper register). Thus the artist of this manuscript clearly shows visually his understanding of the interrelatedness of the several passages which were traditionally associated with Antichrist.

The manuscripts we have discussed so far are all relatively large and relatively elegant in the drawing, painting, and calligraphy. Among the large group of English or Continental manuscripts which derive from one or another of the models apparently used by the artists who created an initial group of surviving manuscripts during an important generic period, about 1245–1265, is a group of English manuscripts made in the late thirteenth or early fourteenth century which has been

identified as the "French metrical group."[17] This is because, in addition to excerpts from the biblical text under the pictures, there is a French metrical version of Revelation included as well. These manuscripts are carelessly drawn and colored, albeit full of vitality. One can imagine that more manuscripts at this level once existed but were destroyed through use or because they were of no great beauty. The addition of the doggerel text may possibly have been intended for children to read. Though it has not been noted, the iconography in most of the manuscripts in this group depends in part on that in Ludwig-Perrins or its model. What is remarkable is that this dependence is fairly free, with each artist often modifying details, sometimes perhaps deliberately, sometimes perhaps accidentally. It is often as if the artists knew more than one model; the changes are not necessarily the simple eliminations of uncomprehending copyists. Small but interesting modifications are introduced into the illustration of Revelation 11:7. Two examples demonstrate this.

In Cambridge, Magdalene College, Pepys 1803 (fig. 17), the scene for Revelation 11:3–7 closely parallels that in Ludwig-Perrins, but now the beast-Antichrist is

*14. Upper register: Revelation 13:4.* Worship of the beast from the sea. *Lower register: Revelation 13:5–7.* The beast from the sea makes war with the saints. *New York, Pierpont Morgan Library, MS 524, fol. 11*

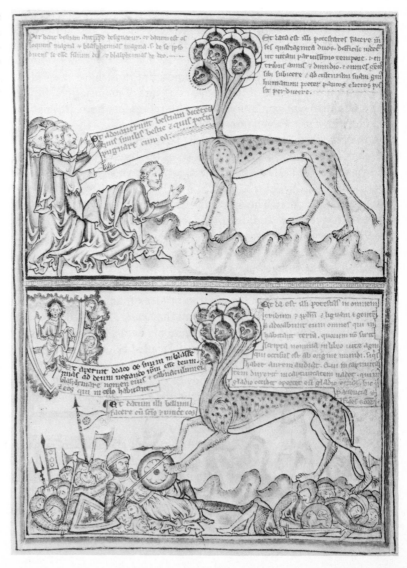

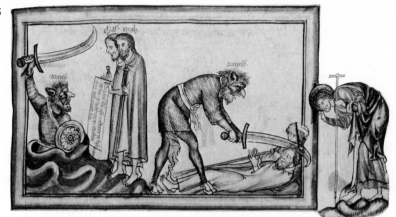

16

15. *Revelation 11:7.* The "beast" ascends from the pit, witnesses (Elijah and Enoch) testify, and beast-Antichrist kills them. *Aachen, Ludwig-Perrins, fol. 17*

16. *Revelation 13:4–6.* Worship of the beast, and it speaks blasphemy against God. *Aachen, Ludwig-Perrins, fol. 24v*

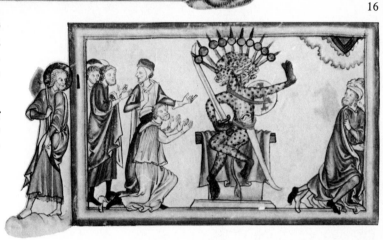

shown first seated on the top of the "pit," in a kingly pose very like those of the man-Antichrist found in Morgan 524 (figs. 4, 5).[18] His sword is still unsheathed, unlike any of the extant prototypes. He is more manlike, less bestial, than the creature in the Ludwig-Perrins model, as he wears a king's loose gown and a crown.

In the second half of this picture the man-Antichrist again slays the witnesses with his own sword. Here he is shown winged, suggesting that the artist wishes to include the idea that this creature might also be the "king over them [the locust-beasts of Revelation 9] which is the angel of the bottomless pit," shown in Metz and Lambeth, both in the depiction of that passage (fig. 3) and in the depiction of Revelation 11:7 itself (fig. 2). These depictions were rooted in the imagery found in the Apocalypse sequence in the *Liber Floridus* (fig. 8).

In Cambridge, Magd. Coll. Pepys 1803, the imagery in the scene showing the worship of the beast, Revelation 13:4 (fig. 18), is very close to that in Ludwig-Perrins (fig. 16). The artist (or was it in one of his models?) has seemingly emphasized the bearlike nature of the aqueous creature rather than the leopard-like character, creating an even more human-looking figure. It has an elongated stem-like neck, and the seven crowns are placed so as to appear almost as a single band.

Still another of the artists of the manuscripts with the French metrical text, Oxford, Bodl. Auct. D.4.14 (fig. 19), made an even bolder conflation of images in his representation of Revelation 11:7.[19] As in the scenes in manuscripts just described, he shows on the left the beast emerging from the pit or "abyss." It is not the con-

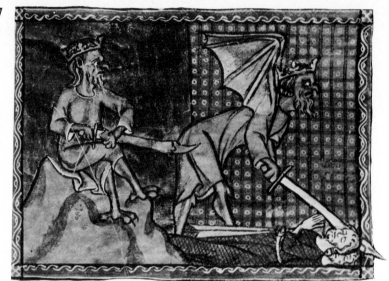

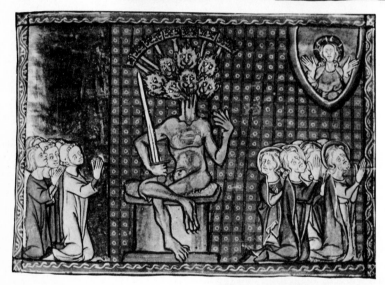

17. *Revelation 11:7.* The beast-king on its pit, and slaying the witnesses. *Cambridge, Magdalene College Library, Pepys MS 1803, fol. 20*

18. *Revelation 13:4–6.* Worship of the beast from the sea, and it speaks blasphemy against God. *Cambridge, Magdalene College Library, Pepys 1803, fol. 26*

19. *Revelation 11:7.* The beast comes out of pit, and the witnesses are killed. *Oxford, Bodleian Library, MS Auct. D.4.14, fol. 28*

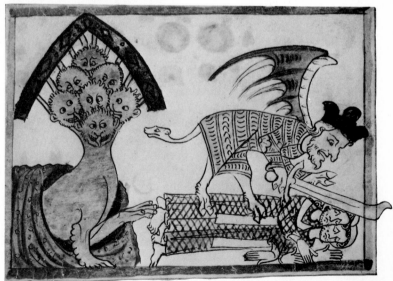

flated bestial-man, however, but the sea beast of Revelation 13 in its bearlike guise, and with its seven crowns welded into a single, inverted V-shaped band. On the right the winged-king, bestial-man–Antichrist slays the witnesses. Thus in one picture he has combined the interrelated representations of the beast from the sea of Revelation 13 and the "king of the abyss" locust-beast of Revelation 9, and suggested the man-Antichrist who slays the two witnesses of Revelation 11. In this crudely done drawing the artist shows he fully understood the portent of this passage in John's Revelation, and that he believed the author often recapitulated the same expected events in his visionary description of the last times.

*Newcomb College, Tulane University*

**Notes**

[1] Leopold Delisle and Paul Meyer, *L'Apocalypse en français au XIII* siècle*, Société anciens textes Français, 2 vols., Paris, 1901. See text, i–ix, esp. viii. There is a large literature overall on this group of manuscripts, including a number of studies of individual manuscripts. Among the most useful references are M. R. James, *The Apocalypse in Art*, The Schweich Lectures of the British Academy, 1927, London, 1931, and the articles by George Henderson, "Studies in English Manuscript Illumination. Part I: Stylistic Sequence and Stylistic Overlap in Thirteenth-Century English Manuscripts. Part II: The English Apocalypse, I," *Journal of the Warburg and Courtauld Institutes*, XXX (1967), 71–137; and *idem*, "Studies in English Manuscript Illumination. Part III: The English Apocalypse, II," *JWCI*, XXXI (1968), 103–47. I have prepared for publication a study dealing with the problems of classification of this whole group of manuscripts and defining pictorial continuities within them.

For Morgan 524 and Oxford, Bodl. Auct. D.4.17, see also H. O. Coxe, *The Apocalypse of St. John the Divine*, Roxburghe Club, London, 1876; Belle da Costa Greene and Meta P. Harrsen, *The Pierpont Morgan Library, Exhibition of Illuminated Manuscripts Held at the New York Public Library*, New York, 1934, nos. 44, 23; Otto Pächt and Jonathan J. G. Alexander, *Illuminated Manuscripts in the Bodleian Library.*

*III. British, Irish and Icelandic Schools*, Oxford, 1973, no. 438.

[2] The commentary accompanying the picture cycles in several of the manuscripts referred to in this article is that of Berengaudus, Migne, *PL*, XVII, cols. 765–970. For more concerning this commentary, see below, n. 9.

Another commentary found in a number of these manuscripts is the "French prose" or "non-Berengaudus" commentary, a thirteenth-century Anglo-Norman commentary. This has been published in Delisle and Meyer, *L'Apocalypse*, 1–131. See also John Fox, "The Earliest French Apocalypse and Commentary," *Modern Language Review*, VII (1912), 445–68; and Günter Breder, *Die Lateinische Vorlage des Altfranzösischen Apokalypsenkommentars des 13. Jahrhunderts (Paris, B.N. fr. 403)*, Forschungen zur Romanischen Philologie, IX, Münster, 1960. References to portents of the Antichrist's future coming are threaded through both these commentaries. For the listing of which commentary is in which manuscript, see Delisle and Meyer, *L'Apocalypse*, and James, *Apocalypse in Art*.

[3] I should emphasize that I am discussing only a few selected examples. Many other manuscripts in this large group have still other nuances of Antichrist imagery.

[4] Irenaeus, V, xxv–xxx: Migne, *PG*, VII, 1188–1208; *The Writings of Irenaeus*, trans. Alexander Roberts and W. H.

Rambaut, Ante-Nicene Christian Library, 2 vols. (V; IX), Edinburgh, 1869, II (IX), 121–39. Hippolytus: Migne, *PG*, X, 725–88; *The Extant Works and Fragments of Hippolytus, Bishop of Porteus and Martyr*, trans. S. D. F. Salmond, Ante-Nicene Christian Library, 2 vols. (VI; IX), Edinburgh, 1869, II (IX), 121–39.

5 Origen: Migne, *PG*, XIII, 1642–46; Douglas Hyde, "A Medieval Account of Antichrist," *Medieval Studies in Memory of Gertrude Schoepperle Loomis*, New York, 1927, 391–98. See also Horst Dieter Rauh, *Das Bild des Antichrist im Mittelalter; von Tyconius zum deutschen Symbolismus*, Münster, 1973.

6 For the history of the commentary on the Apocalypse, among the most useful are William Kamlah, *Apokalypse und Geschichts Theologie, Die mittelalterliche Auslegung der Apokalypse vor Joachim von Fiore*, Historische Studien, Heft 285, Berlin, 1935; Henry B. Swete, *The Apocalypse of St. John*, London, 1907, cxvii–ccxix, with bibliography; and Barbara Nolan, *The Gothic Visionary Perspective*, Princeton, 1977, 3–34.

7 Johannes Haussleiter, ed., *Victorini episcopi Petavionensis opera, Corpus Scriptorum Ecclesiasticorum Latinorum*, Vienna, 1916, XLIX; *The Writings of Quintus Sept. Flor. Tertullianus with the Extant Works of Victorinus and Commedianus*, trans. Robert E. Wallis, Ante-Nicene Christian Library, XVIII, Edinburgh, 1870.

8 Ernst Sackur, *Sibyllinische Texte und Forschungen*, Halle, 1898, 104–13; Robert Konrad, *De ortu et tempore Antichristi*, Kalmünz über Regensburg, 1964; and John Wright, *The Play of Antichrist*, Toronto, 1967, 100–110.

9 The Berengaudus commentary has been identified as one of the first of the "historico-prophetic" interpretations of the Apocalypse, since, as compared with early medieval predecessors, the author places relatively more emphasis on the interpretation of some of the "sevens" of the Apocalypse (seven seals, seven horns, seven trumpets, etc.) as seven ages of the Holy Church, from the age before the Flood to the end of the world when the elect will wage war against Antichrist. Despite this emphasis on the interpretation of the Apocalypse as a series of visions pertaining to the history of the Church, the content is essentially traditional and conservative. Nolan, *Visionary Perspective*, 9–12. For the problem of the identification of Berengaudus and the dating of the commentary, see E. Levesque, "Berengaud," in F. Vigouroux, ed., *Dictionnaire de la Bible*, I, Paris, 1895–1912, 1610–11.

10 The Trinity Apocalypse has been reproduced twice in facsimile: M. R. James, *The Trinity College Apocalypse*, Roxburghe Club, London, 1909, and Peter Brieger, intro., *The Trinity College Apocalypse*, London, 1967.

11 For a description of the Lambeth Apocalypse, Eric G. Millar, *Les principaux manuscrits à peintures du Lambeth Palace à Londres, Bulletin de la Société Française de Reproductions de manuscrits à peintures*, VIII, Paris, 1924, 38–66.

12 Cambridge, Trinity College, R.16.2, fol. 12 recto. (See Brieger, *Trinity*, 30–31.) London, Lambeth Palace, 209, fol. 13 verso. I am grateful to Prof. Graydon Regenos for a complete transcription and translation of the text and commentary in Lambeth 209. The manuscript formerly in Metz, Salis 38, had virtually word-for-word the text and excerpts of commentary as found in Lambeth 209. In Trinity the pictures are scattered throughout the text; in Lambeth the text and commentary are below the pictures.

As has been often noted, the two scenes shown here represent the "literal" interpretation of this passage, and the pictures are a part of the regular sequence of scenes. In Lambeth 209 several marginal scenes were added to the lower margins of fols. 11 verso, 12 recto, 12 verso, and 13 recto, depicting the prophets before Antichrist as a man, etc.—i.e., simplified scenes but as in Morgan 524 (figs. 4–6). From this one can guess that the artists, having faithfully followed an earlier model, decided to include the manner of representing this passage as found in the contemporary manuscripts, Morgan 524 and Oxford Bodl. Auct.

D.4.17, or their model. These lower marginal scenes in Lambeth 209 appear to have been added fairly soon after the upper scenes had been completed.

[13] E. Paulus, "Supplément au catalogue des manuscrits, Metz," *Le bibliographe moderne*, VII (1903), 406. The manuscript was destroyed by fire. Photographs are available for study in the Manuscript Room of the British Library, at the Courtauld Institute, University of London, and at the Pierpont Morgan Library, New York.

[14] Among the group of English illuminated Apocalypse manuscripts which were created in a generic period, c.1245–65, one can thus identify two important pairs of sister manuscripts, Lambeth 209 and former Metz Salis 38, and Morgan 524 and Oxford Auct. D.4.17. These are important because they or their models were copied frequently by later artists. Cambridge, Trinity College R.16.2 and Paris, Bib. Nat. fr. 403 also belong to this generic period and are both manuscripts of great distinction, but they or their models were apparently not directly copied later. In this important generic period there are many cross-references among a group of manuscripts—overlapping similarities in imagery, in formats, in use of commentaries, etc.—so that one must assume a common milieu or communication among ateliers. It is also highly probable that more manuscripts were made at this time than now survive. My research and conclusions about the interrelationships and continuities to be found among these manuscripts will appear in my forthcoming study. Some of these ideas are developed (now partially modified) in my review of Brieger, *Trinity*, in *Art Bulletin*, L (1968), 199–203.

[15] A. Straub and E. Keller, eds., *Herrade de Landsberg, Hortus Deliciarum*, Strasbourg, 1901, Pl. LXII, opposite p. 212.

[16] This manuscript is now owned by Dr. Peter Ludwig of Aachen. It was formerly owned by Dyson Perrins and was reproduced in facsimile: M. R. James, *The Apocalypse in Latin, MS. 10 in the Collection of Dyson Perrins, F.S.A.*, Oxford, 1927.

[17] Paul Meyer, "Version Anglo-Normand en vers de l'Apocalypse," *Romania*, XXV (1896), 174–257; Delisle and Meyer, *L'Apocalypse*, cxxiii–cxxvi; James, *Apocalypse in Art*, 64.

[18] The manuscript is briefly described in M. R. James, *A Descriptive Catalogue of the Library of Samuel Pepys, Part III, Medieval Manuscripts*, London, 1923, 40–47.

[19] Pächt and Alexander, *Illuminated Manuscripts, Bodleian, III, British*, no. 542.

# 3

# St. Peter's Chair in Venice

STAALE SINDING-LARSEN

The inclusion of Arabic inscriptions, whether correct ones or imitations of approximate affinity to prototypes, as a symbolic or decorative motif in the art of the Christian world is apt to reveal itself, on closer inspection, as a rewarding field of studies. Why for instance did fourteenth-century painters in Venice, like Maestro Paolo, adorn the mantles or even the haloes of figures of the Virgin or of Christ with pseudo-Arabic inscriptions? Did these painters—and numerous later ones, and not only in Venice—choose such a feature because they confused it with ancient biblical idioms? Certainly there was no liturgical text to induce them to include the exotic lettering—as the Breviary did for Caravaggio with regard to the Hebrew edition of St. Matthew's Gospel (in the painting for San Luigi dei Francesi, Rome). Perhaps one should dismiss the issue as a mere question of decorative value, of creating an "oriental" atmosphere? After all, the Arabs themselves occasionally employed meaningless inscriptions for objets d'art.[1] At any rate very few medieval Christians seem to have been able to distinguish between pseudo-Arabic and correct Arabic inscriptions, and so we should presumably be justified in studying the existence of both alternatives in a Christian context under the same perspective, whichever this may be.

Nevertheless the acceptance in a Christian ecclesiastical, or even liturgical, context of sacred objects bearing unmistakably genuine Arabic inscriptions seems particularly puzzling. It somewhat perplexes the orderly mind of a modern scholar to come across medieval Christian reliquaries with Qur'anic quotations in Arabic, or even amorous or straightforwardly obscene epigrams in Arabic.[2] In an age when liturgical exegesis imposed allegorical interpretation or at least some kind of meaning with regard to most liturgical objects and accessories, how did the clergy explain to themselves and to others the presence of such inscriptions? This problem remains even when, as was certainly generally the case, they were unable to decipher them.

Still more remarkable is the instance of the so-called Chair of St. Peter in Venice. This stone chair had been venerated in the cathedral of Venice, San Pietro di Castello, perhaps since the thirteenth or the late twelfth century (figs. 1–3). The chair, believed to have served St. Peter when he was a bishop of Antioch, was placed in the apse behind the high altar of San Pietro, where it was employed in the liturgy (see below, page 37); and it thus formed a striking counterpart to the so-called Chair of St. Mark in the Government Church of San Marco.[3] The front and rear of the back of St. Peter's chair are covered with inscriptions integrated in

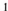

1. Chair of St. Peter. San Pietro di Castello, Venice

2. Chair of St. Peter (detail of front). San Pietro di Castello, Venice

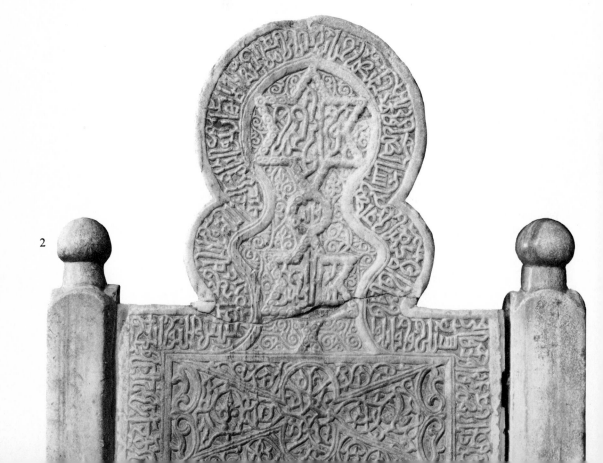

geometrical patterns, and today we know that they give quotations from the Qur'an in Arabic. That is to say, here are Qur'anic quotations not on a reliquary but on a relic. Published recognition of this fact occurred only at the end of the eighteenth century; around 1740, experts on Semitic languages were still confidently interpreting the inscriptions in a Christian sense (see below, page 38).

The general background to this peculiar story may be outlined under two headings: a very limited understanding in the medieval Christian world, except for Spain and Sicily, of course, of most aspects of Islamic and Arab culture;[4] and in consequence of this, a lack of interest in, and hence of familiarity with, Arabic palaeography.[5] The latter topic would hardly have seemed a tempting field of study in itself, considering the extreme flexibility of the different styles of Arabic script and the persistent exploitation of this flexibility by Arabs, Persians, and Turks, at times to the detriment of understanding among themselves. The history of the attempts at an interpretation of the inscriptions of the Chair of St. Peter in Venice is symptomatic of the general situation even as late as the eighteenth century. However, the physical makeup of the chair will have to be briefly noted, as a prerequisite to an examination of the inscriptions.

Since the sixteenth century the chair has had its place in the nave of San Pietro, and since the eighteenth(?), upon a dais very close to a pilaster facing the nave, so that one cannot obtain a satisfactory view of the rear side of the back of the chair. To see this, one must consult the photograph of a plaster cast, available at the firm of the late Dottore Osvaldo Böhm, Venice (fig. 3). The chair is pieced together; whether this was done in the Middle East or in Venice, it is impossible to say. The provenance of the green soapstone of the curved sides cannot be ascertained; the red (Istrian?) slabs making up the front are of very uncertain origin; nor can the grayish marble of the seat (61.7 cm wide, 46 cm deep) be localized with sufficient precision. The raised back consists, from seat level up, of a marble slab with ornaments and inscriptions on both sides (height 89 cm; total height of chair, 137 cm). This marble slab is fitted into the two flanking posts (height 109 cm), which are apparently of Arab design (they are of the same marble as the back).

In the 1740s Flaminio Cornaro reported earlier information and comments on the chair.[6] He cites two earlier traditions according to which the Byzantine emperor Michael III (842–867) had given the chair, respectively, to Doge Giovanni Particiaco, who died in 829, and to Doge Pietro I. Gradenigo in 1310. Needless to say, Cornaro notes the discrepancy here and corrects the latter reference to Pietro Trandonico. Already the Legenda Aurea reports the story of the donation of a chair to St. Peter by Theophilus of Antioch. According to Doge Andrea Dandolo, who wrote in the first half of the fourteenth century, and to Carlo Sivos, who wrote in the sixteenth, the chair stood behind the high altar of San Pietro.[7]

Cornaro also cites records of liturgical and devotional activity connected with the chair: "Item die Sancto Pentecostis Cathedra S. Petri, quae est retro B. Petri Altare, debet preparari et fieri processio"; "Item in festo S. Petri preparatur Ecclesia, Cathedra et fit processio."[8] Francesco Sansovino emphasizes popular devotion surrounding the chair: "Collocata in luogo alto, & appoggiata al muro ⟨si vede⟩ quella Cathedra, sopra la quale sedè San Pietro in Antiochia, la quale è tutta di marmo, & fu donata alla Republica da Michele Paleologo Imperatore di Costantinopoli. Vi si ascende a lei per alcuni gradi, & uiene riuerita, & baciata da pie, & diuote persone; & specialmente nelle solennità di San Pietro, & in tutte le Domeniche di Quadragesima, ne i quai giorni ui è gran frequenza di popoli, per riceuer la Indulgenza, che in tai giorni si acquista ogni anno da tutta la Città per antica

consuetudine."[9] This popular veneration is attested as late as in the 1680s by F.M. Misson, who reports having seen in San Pietro di Castello "une chaise de pierre, que j'ai vû baiser à quelques Devotes, & qui étoit, dit-on, à l'usage de S. Pierre, lors qu'il étoit à Antioche."[10] The date of the removal of the chair from the site behind the high altar to the present site is uncertain, and it is also hard to tell what Cornaro means when he states that between 1725 and 1734 the chair was reerected in its present site, having been transferred "ex humili loco in eminentiorem ornatioremque situm."

No wonder that the chair raised Cornaro's curiosity and also his skepticism: how could or would St. Peter, he asks, under the poor conditions of the Church in those days, have provided for himself such a splendid chair? Cornaro also is puzzled—and seems to be the first to note it—by the peculiar inscriptions which he takes to be "in the Eastern idiom" (*in Orientali plaga*). He sends a drawing of it to the famous orientalist Giuseppe Assemano, a Syrian residing at Rome, one of whose merits, Cornaro asserts, is a "singularis Orientalium linguarum peritia." Cornaro gratefully and uncritically publishes Assemano's interpretation. Briefly, it is as follows. The text "in medio Cathedrae" is: *Civitas Dei Antiochia* (he is speaking of the *front* of the chair back), and the surrounding text is Psalm 2:8 and Psalm 44:7, with *Opus Abdallae Serui Dei* in between.

It would have been interesting to know by which process of thought Assemano could arrive at such a result. How did he, for example, hit upon Abdullah for the maker of the chair, when the text of the corresponding inscription is in fact a quotation of the very last words of Surah 23 of the Qur'an: "⟨grant you forgiveness⟩ and mercy, for you are the best of those who show mercy":

وارحمروانت خيرالرّحمين.

Nevertheless, Assemano correctly saw that the inscription was Arabic, and that consequently the chair must be of a relatively late date (after the Arabs had taken Antioch, he suggests); and Cornaro for his part concludes that the chair must have been constructed not for St. Peter himself but in his *memoriam et cultum*. In 1787, finally, the inscriptions on the front of the chair were read correctly by the scholar Olav Gerhard Tychsen (whose father, I am amused to note, was a Norwegian, "in oppido Nidrosiae"). He published in that year and once more the year after all available material concerning the chair and also a drawing of the front inscriptions (fig. 4).[11] He respectfully and somewhat apologetically rejected Assemano's reading; but the latter is reported to have stated rather generously that "⟨Voi⟩ siete un portento nel decifrare cio che ad altri sembra indicifrabile. Vi siete talmente addimesticato colla scrittura cufica, che non vi è alcuno che possa ugugliarvi."[12]

Tychsen tells how, after he had succeeded in reading the inscription on the front of the chair back, he took a quick glance through the Qur'an—"Alcoranum consulens celeriter"—and to his utmost joy identified the quotations. Having no concordances at his command, Tychsen could not, as we can today, go about it inelegantly but surely, by deciphering a word or two and then looking them up (as I have done myself for the inscriptions on the rear side of the chair). Tychsen's reading shows that the inscriptions (compare fig. 4 with fig. 2), which start in the lower right (from our viewpoint) and move counterclockwise up the lobe-shaped chair back and down again, commence in the middle of verse 195 of Surah 3 (*al-'imrān*), with من ديارهم ("away from their dwellings"). This quotation terminates with the last word (الثواب) of this verse horizontally in the upper left corner of the rectangular part of the back; from here it is immediately followed by Surah 23, last verse (118), which runs down the left-hand vertical band, then con-

*3. Chair of St. Peter, plaster cast of rear side of chair back (negative). San Pietro di Castello, Venice*

*4. O. G. Tychsen,* Interpretatio inscriptionis cuficae, *cufic inscription on front side of Chair of St. Peter with parallel text in naskh. University Library, Oslo*

tinues in the upper six-pointed star ( وارحم : "and show us mercy"), into the little circle ( وانت : "and you" = Allah), and ends in the lower six-pointed star ( خيرالراحمين ) : "the noblest one of those who show mercy"). Comparing this inscription with numismatical legends which he believed to be Sicilian, Tychsen concluded that the chair is a Sicilian work (the legends are reproduced in the upper part of fig. 4). This conclusion does not seem tenable; the cufic style rather points to the Middle East or neighboring countries.[13] Grohmann dates it to the twelfth century.[14]

The inscriptions on the rear side of the chair have to be studied from the Böhm photograph of a plaster cast referred to above. The cast of course is a negative, so that the inscriptions had to be redrawn converted (fig. 5). They are in part illegible. The inscriptions start (here, too) in the upper right corner of the rectangular field:

 : "Our Lord, verily we have heard ⟨a herald⟩," which is the beginning of Surah 3, 193. The inscription continues counterclockwise up the lobe and

down, then goes across the left-hand horizontal band of the rectangular field to the upper left corner of the rectangle and down the left-hand vertical band; then from right to left along the bottom band; down the right-hand vertical band; and, finally, through the six fields in the center, from upper right to lower left, where the inscription terminates (in the three lower fields) with:

فآتّذين هاجرواداخرجوا ﴿من ديارهم...﴾

—"those who have left their homes or been driven ⟨away from their dwellings⟩," which is in the middle of verse 195, and is directly continued on the front of the chair, as quoted above. Thus the inscriptions on the Chair of St. Peter contain one long Qur'an quotation running from the rear of the back (in the present arrangement of the chair) to the front of the back, and, as a termination, one short quotation.

The present writer is not in the position to venture a qualified opinion as to the original function of the inscribed slab, but even so, a few observations may be made. The existence of inscriptions on both sides of the slab seems to exclude the possibility of its having originally formed part of a chair.[15] And with regard to commemorative contexts including funerary ones, we may note that the usual elements are missing: the *bismillah* ("In the name of God"), personal name or names, and date.[16] The slab may have belonged, together with a counterpart bearing such inscriptions, to a cenotaph (with one slab raised at either end of the "body box").

Even though such a famous orientalist—and "Oriental"—as Assemano failed in his attempt to read the inscription—and no workable research method appears

*5. Chair of St. Peter, inscription on rear side of chair back (tracing from cast). San Pietro di Castello, Venice*

to have been available to him—it is quite possible that Venetians in an earlier age were aware of its content; they could have had such information directly from Arabs. In the twelfth and thirteenth centuries Venetians, like other Christian nations and institutions, were in more or less continuous contact with Arabs in Egypt, Palestine, and Syria, and for long periods they, like their alleged fellows, had access even to the interior of Palestine, including Jerusalem. From a Christian point of view the content of the inscriptions would have seemed really quite innocuous. There is no explicit mention of Muhammad. A herald (literally, "one summoning to belief ⟨saying⟩"), who could very well be an angel, calls upon us to believe; punishment and reward on the day of the Resurrection are evoked. *Allah*, of course, could easily mean the Christian God, as it did to Assemano (*'Abdullah* he translated, correctly, as *Servus Dei*). Even in the contingency that the Venetians should have recognized the Qur'anic source for the inscriptions, this would—possibly—not have created a great problem for them, seeing that the Qur'an itself includes numerous references or even semiquotations from biblical texts. The difficulty of localizing such possibly biblical references by book, chapter, and verse would hardly have bothered them in a period when they had grown used, through the mosaics in San Marco, to accepting religious inscriptions that were not specifically biblical or liturgical (i.e., not in a textual, though in a functional, sense).

On the other hand the cufic inscriptions on the chair are of an especially difficult style, since the essential features of each letter are often obscured or distorted to a greater degree than that found in the majority of the cufic inscriptions of which the Venetians may have had direct or indirect experience. Compared to the simpler styles of cufic inscriptions, the one on the chair could very easily have been taken to represent not Arabic but some other "Oriental" language; even to Cornaro, it was *in Orientali plaga*. There is thus the alternative to be considered, that the Venetians did not trouble themselves much over the precise content of the inscription, because they took it to be simply a specimen of an Eastern idiom relating particularly to St. Peter and his days and ambience, perhaps even to those of Christ himself. Testimony to such a tradition would seem to be the existence of pseudo-Arabic inscriptions adorning the figures of Christ and the Virgin referred to above. In 1779 the orientalist Norberg noted an earlier opinion according to which the inscriptions on the Chair of St. Peter are in *antiquae litterae Samaritanae*.[17] On the Chair of St. Mark in San Marco there is also a medieval inscription in oriental style; modern scholars have established that it is in inverted Hebrew, but until very recently there has been disagreement as to its meaning.[18] Indeed, disagreement on meaning there has been even with regard to the Greek monograms on the two columns from the Polyeuktos Church in Constantinople, now at San Marco; there are other similar monograms among the spoils used for this church in Venice. At any rate it would seem that the exotic inscriptions were believed to be "oriental" and to fit a Christian context. The relevance and value of "oriental" languages may have been increased by the rather widespread belief, voiced for example by Ibn Wahshiyya around 900 A.D. and the Nestorian Christian 'Abd-Isho' in the thirteenth century, that Syriac, the writing of which has a superficial resemblance to that of Arabic, was the first language, the language in which Adam spoke with God. Other medieval writers, among them Abu 'Ibn al-Maghribi, believed that the Syrians were the oldest people in the world and that Adam spoke Syriac, and also that their religion was Sabian or Sabaean. Of course such conceptions may have been underscored, in the Christian context, by the liturgical commonplaces referring to "orientals," including Arabs and "Sabaeans": "Stella quam viderant—

Omnes de Saba veniunt"; "Reges Tharsis et insulae munerae offerent—Reges arabum et Saba"—subjects represented also in pictorial arts, such as in the Pentecost cupola of San Marco at Venice, with the accompanying inscription: "Romani, Judaei, Cretes, Arabes, Parthi, Medi, Aelamitae, Mesopotamia, Judaea, Cappadocia, Pontum, Asiatici, Phrygia, Pamphylia, Aegyptus, Lybia." The subject is evoked also in the Pentecost liturgy (including that of San Marco, Venice): "Iudaei quoque, et proseliti, cretes, et arabes, audivimus eos loquentes nostris linguis magnalia Dei."[19]

Venetian tradition appears to have been consistent in claiming that the Chair of St. Peter had been donated to the Venetian government (which is the meaning of such phrases as "to the doge"). Why then was the chair placed in San Pietro di Castello and not in San Marco, the government church, where there was also an altar dedicated to St. Peter? In San Marco, the chair could have been placed either close to the high altar, that is, in the main apse, or in the adjoining Chapel of St. Peter. The latter alternative would however have been excluded if the Chair of St. Mark was already placed near the high altar—a position it did in fact occupy as early as our earliest sources take us—for the episcopal relic of St. Peter would thereby have been given a position secondary to that of his disciple (according to Venetian legend) and follower. On the other hand, in consideration of the religio-political color of Venice, one would hardly believe her government capable of removing the Chair of St. Mark to give place to one of St. Peter. Had the latter chair been acquired before that of St. Mark, it would no doubt have been placed in the apse and remained there (until official interest in both chairs faded). The cathedral of San Pietro di Castello was a convenient place for St. Peter's Chair, but presumably this choice could have been taken only after the Chair of St. Mark had already been placed in San Marco.

Both chairs must have been interpreted as outstanding bequests in Venice's heritage from the apostles, and also as symbols of her affinity to, and even her claims in, the Holy Land and the adjoining regions in which the apostles had been active. Very likely the two "oriental" inscriptions were thought to be proofs that the chairs were genuine.

Church, State, and cities in the Christian world have made broad use of collections of relics and quasi-relics with the purpose of influencing devotion, inciting to political homage, or creating connections with alleged origins or sources in justification of this or that creed or policy, and have often provided for individual commemorative features, such as an imitation of the Anastasis dome on a ciborium, or an "apostolic" number for a set of columns. In a church liturgical, and through them theological, concepts would bring coherence and unity among such variegated objects and features—and correspondingly, so would political ideology, as in the case of Florence, where the city's topographical layout was thought to repeat that of Rome.[20] In some cases, however, objects or features of this sort have been arranged, all at once or gradually, into some specific overall pattern which is so striking visually that the implied concepts stand out, to be perceived in an almost literal sense. This applies, for example, to the combination of martyrium-rotunda with basilica in the churches at Dijon and Trondheim, in imitation of the Anastasis and Basilica structures at Jerusalem, and to the re-creation of the "Lateran" at Aachen.[21] It is therefore conceivable that one should ask whether the apostles' chairs in Venice were considered in relation to a greater design. The accentuation of a relationship—by means of an iconography of chairs of apostles—between the cathedral dedicated to St. Peter and the government church dedicated

to St. Mark, would bring into topographical evidence the determinant and the determined quantities of what the Venetian regarded almost as a simple function: the foundation and spread of Christianity and its alleged reactivation in Venice. Naturally, our attention will be led to the Government Center of medieval Venice—the little we know about it.[22]

A relatively early source, the *Chronicon altinate*, tells us that San Marco was built "secundum exemplum quod ad Domini tumulum Jerosolimis viderat," but so it says about the Venetian church of San Salvatore, too. Any church will imply a direct reference to Golgotha and the Holy Sepulcher—and hence frequently also to these respective buildings—on account of the sacrificial and commemorative character of the Mass (a *memoria passionis*). Particular liturgical and ceremonial or, indeed, technical exigencies or norms will frequently adduce further terms of comparison in any given building or complex of buildings. By virtue of the medieval principle of imitation *typice et figuraliter*,[23] San Marco, for instance, may easily have been conceived of as an image, in addition to that of the Holy Sepulcher, of the Apostoleion at Constantinople,[24] or indeed of Hagia Sophia, with which there are numerous analogies also in a functional sense.[25] Such a multiplicity of references would have been still easier to accept when attention shifted from one aspect to another: in the case of San Marco, from the building itself to the building as seen under particular ceremonial circumstances or seen in its architectural surroundings, with the Platea or piazza in front of it.

At least since the thirteenth-century interpolation into the *Chronicon altinate* and through later vernacular writings such as those by Marin Sanudo and Pietro Dolfin, the Venetians used a special term for "cupola" and "semicupola," namely, *cuba*, occasionally *cua*.[26] The vocable appears to have been used originally for the government structures of San Marco and San Todaro (Theodore, the former's predecessor with regard to patronage for Venice). The word *cuba* is of Arabic origin:[27] it derives from *qubba*—قبة—which means, among other "round" things, a round structure of skin or hides, a tent, an architectural dome or cupola of stone or brick, and a building covered by a dome or cupola; hence, buildings of the category we are used to calling *martyria*. The town Basrah was called *qubbat al-islām*, which is translated as "sanctuary" or "tabernacle"[28] of Islam.

To medieval Christians familiar to some extent with the Middle East, the term *qubba* would have been associated in particular with a spectacular and famous building in Jerusalem that the Christians themselves connected more or less directly with the ancient Jewish Temple and the Temple of Solomon, namely, the so-called Dome of the Rock, the *qubbat as-sakhra*, in reality the earliest extant large Islamic sanctuary (680s–690s).[29] It is erected over a rock holy both to Jews and Muslims, and to a certain extent even to Christians. In 333 A.D. a visitor could report that the Jews anointed the Rock, while in the Arabic text called al-Marāsid, of 1300 A.D., it is told that the ancient Jews performed sacrifices on the Rock—and others tell how the Christian clergy, when they had access to the Rock, used to chip off bits of it to sell to the "Franks."[30]

However, let it be suggested here that not only have the single buildings of Jerusalem served as a model for architectural thinking in the Roman West, but so indeed has also the entire Temple area, the Islamic Haram ash-Sharif with its walls, its numerous small structures, and its two large buildings, the octagonal Dome of the Rock and the basilical mosque al-Aqsa facing one another across the open square. To medieval Christianity the whole area of the Haram was considered representative of the Temple, and when the Christians were masters of the area

they used the two large structures liturgically. Numerous Western and Arab sources testify to these circumstances, as well as to the alleged historical background for them. Photius, for example, writing between 867 and 878 A.D., says that "The Porch of Solomon, like what was once the Holy of Holies, now that they are occupied by the godless Saracens and serve as their mosque, are no longer known [read: accessible] to any of the Christians in Jerusalem . . . " We are told by other Christian sources that the Dome of the Rock is or represents the Temple of the Lord, the cave beneath the rock the Holy of Holies, and the mosque al-Aqsa the Temple of Solomon. "Soon a new liturgy grew up in them, since we are told by the *Typicon* (in the recension of 1122 A.D. . . . ) that whereas the Palm Sunday procession used to be to the Sheep Pool, it is now to 'the Temple, to the Holy of Holies'." The Arab traveler al-Idrisi, writing in 1154 for King Roger of Sicily, says, in Marmardji's French translation, that "Près de la porte orientale de cette coupole [i.e., the Dome of the Rock] se trouve (celle) qu'on appelle le saint du saint." But al-Idrisi does not explicitly mention here a second cupola ("celle" in Marmardji's translation), he mentions the Holy of Holies directly ("wa-bil-qarb min al-bab al-sharqi min abwab hadha al-qubbat al-musamaat [= the named, entitled] bi-quds al-qudsi"), and he must refer to an altar. In 1173 al-Harawi can tell us that in front of "the cave of the souls" there was an image of "Solomon son of David," and above the western door an image of Christ, while Ibn al-Athir in 1232 mentions a cross surmounting the dome and furthermore speaks of how the Templars use the mosque al-Aqsa as a church. In 1300 A.D., finally, the text al-Marāsid refers to the Rock as "the Holy."[31]

It may be noted that even the Basilica and the Anastasis (Holy Sepulcher) structures, as they were built, together made up a combination of a centralized and a basilical building. In Christian tradition, the Haram or Temple system and that of the Anastasis and Basilica were often identified with one another or confused with each other, a conception facilitated by the idea of the concord between the Old and New Testaments and also by the wish to locate the famous *omphalos* or *umbilicus mundi* in both places to render justice to Psalm 73:12: "Deus autem rex noster ante saecula operatus est salutem in medio terrae."[32]

In the twelfth-century plan of Jerusalem, in the Bibliothèque Municipale at Cambrai, the entire Haram, with the roads leading up to it, appears to be condensed into one structure dominated by the Dome of the Rock, which is labeled *Templum Domini*. The Templars, while residing there, occupied the mosque al-Aqsa as well as the Dome, but on their seals it is the latter which represents the entire Temple.[33] On much later pictorial views, such as those of the late fifteenth century by Schedel and Breydenbach, the bipartite disposition of the Temple, with the al-Aqsa and the Dome facing one another, is set out clearly: the Dome is labeled *Templum Salomonis* and the mosque *Templum Mariae* and *Symeonis*.[34]

The Cambrai plan, the Templars' seals, and numerous other pictorial representations up to the sixteenth century of either the Dome of the Rock or the Anastasis, or both, give a very peculiar shape to the cupolas or domes, as if these consisted of raised narrow, convex barrel vaults tapering upward while curving toward the apex; a kind of structure not uncommon in Islamic architecture and exemplified in the cupola above the prayer niche in the great mosque at Qairawan (862–63), and in the cupola on the shrine of Sayyida al-'Atiqa at Cairo (1120–25).[35] As for the Dome of the Rock itself, the original cupola collapsed, probably by 1016–17 A.D., but Christian representations of it and of the Anastasis cupola adopt the shape just described and reserve this shape for this particular context. We noted

that the Venetians, for the cupolas of San Marco, had adopted the term *cuba*

derived from *qubbat* and probably did so with direct reference to the Dome of the
Rock *quasi* Templum Domini. By the middle of the thirteenth century, if not
earlier, the specific "Temple-Anastasis" shape of cupola was introduced: the shape
was reproduced in the small cupolas surmounting the five big cupolas of San
Marco as a "loan word" from Jerusalem (or from traditions concerning Jerusalem)
along with that of "cuba."[36]

The Platea Sancti Marci, the square in front of San Marco, was restructured
after the middle of the twelfth century. It was enlarged and apparently also
straightened out, and the basilical church of San Geminiano was reerected at its
western end, facing San Marco (its original position, either on the south side of
the piazza or farther to the west, behind a canal and a wall, is a matter of dispute).[37]
The twelfth-century church of SS. Geminiano e Mena (to give its full title) was
demolished under Napoleon to make room for the Ala Napoleonica. It must have
been evident then as now that this particular layout, a centralized sacred building
and a basilica that face one another across a space, all three elements being con-
tained within an enclosure or wall, was characteristic not only of the Haram *quasi*
Templum Domini but also of the various systems by which the Anastasis rotunda
and the adjoining basilica were connected with each other. For this new urban
feature the prototype should be sought in Jerusalem rather than in some Early
Christian "quadriportico" or atrium in front of a church,[38] and it is possible that
the intention was to create a unity of the images of the two main structures at
Jerusalem, the one belonging to the world *sub lege* and the other to the world *sub
gratia*. After all, the mosaic programs in San Marco are very explicit with regard to
the *concordantia* between the two Testaments. Certain specific architectural fur-
nishings of the Piazza San Marco do suggest a direct association with the Haram
area at Jerusalem. Until 1291 the ciborium-like "Capitello" chapel stood in the
piazza, and this arrangement may have brought to mind the sacred *qubbats* in
the Haram, these too of ciborium-like shape and possibly subjected to a Christian
interpretation along with the whole Haram area; such *qubbats* were described
there by al-Maqdisi in 985 A.D. and by Nasiri-Khosro in 1047.[39] Possibly, too, the
open system of pillars made up by the so-called Acre pillars close to San Marco
would remind the Venetians of the numerous free-standing arcades, some of the
Roman period, in the Haram area and evoke the concept of the Porticoes of Solo-
mon. The two columns had been taken from the Polyeuktos Church at Constan-
tinople, but the Venetians reidentified their provenance to Acre, i.e., to the Middle
East.

The question remains, whether San Geminiano was connected with San Marco
in any other way than the admittedly hypothetical iconographical one. There was
in fact a marked liturgical and ceremonial connection between the two churches at
either end of the piazza. In the government liturgy and ceremonial, which was
based in San Marco but included several other churches in the city, the parish
church of San Geminiano was defined, by implication, as second to San Marco
itself in the urban context. San Marco did indeed comprise a small parish church
(the *Ecclesia fontis*). But it was in the parish church of San Geminiano that the
annual achievement of the Easter celebration, and the baptismal rites that had
taken place in San Marco from Palm Sunday to Easter Morning, were rendered
effective, so to speak, among the people of Venice. On the first Sunday after
Easter—the *Dominica post albas*, thus named because those newly baptized had
just laid off their white robes—the government, headed by the doge, visited San

Geminiano for the chanting of the Terce in full "triumphal" procession (*cum Triumphis*).[40] In Venice this Sunday was also called "Dominica apostolorum," on account of the accentuation on the missionary work of the apostles in the day's liturgy. Probably the government's participation in this as symbolized through the ritual visit to San Geminiano recalls the traditional concept of any state's apostolic mission, and perhaps also its adoption of the Byzantine idea that the ruler was "similar to the apostles" (*ἰσαπόστολος*).[41] In the procession a cross and candles were carried *covered* from San Marco to San Geminiano; after Terce at the latter church, the *uncovered* cross and lighted candles were carried back again. It was at the altar of San Geminiano on this occasion that the doge formally received the silver candlestick with the white candle, which was one of the official government symbols carried *in triumphis*. As an unusual feature after Terce, the *Regina Coeli* was included on this occasion, and one is tempted to note in a hypothetical way the connections between the Virgin and the Temple, and especially with its basilical structure, which was occasionally labeled *Templum Symeonis* or Temple of the Presentation of the Virgin. There are numerous liturgical and ceremonial and hence also political aspects of this ceremony that will have to be investigated more carefully and in the context of a comprehensive study of the rites of San Marco, but one thing seems certain. The church of San Geminiano was considered to some degree to be functionally and ideologically an extension of San Marco herself.

If the religious government center of Venice—San Marco, the piazza, and San Geminiano—was conceived as an image of Jerusalem, then, in full accordance with traditional urbanistic principles, the two chairs of St. Mark and St. Peter would each denote an additional *topos*: that of Antioch, the site where the missionary work among the peoples had started, and that of Marcian Veneto and Venice, where the fulfillment of that work took place. A sixteenth-century Venetian manuscript, apparently relying on earlier sources (a question to be dealt with in the future), describes Christ's mandate to the apostles, and continues: "In this way the Church of Antioch was founded, in which for the first time the Holy Name of Christ was heard by the new peoples and then by the Romans. Peter, the prince of the apostles, intending to establish the Church of Aquileia, sent there Mark the Evangelist . . . "[42] Surely the "oriental" inscriptions on both chairs would have suited such a context, and the best proof that plainly Arabic inscriptions were accepted in Christian liturgical surroundings is provided by al-Harawi, who reports in 1173 that the "Franks" in Jerusalem had left in full display the Qur'anic inscriptions in the interior of the Dome of the Rock as well as in that of the mosque al-Aqsa,[43] while using both buildings for religious service.

*The Norwegian Institute of Technology*

*Notes*

[1] Two examples: Fatimidic pottery of the eleventh century: Nos. 32 (Pl. 4a) and 105 (Pl. 32) in *Islamic Art in Egypt 969–1517* (exhibition catalogue), United Arab Republic, Ministry of Culture, Cairo, April, 1969. On pseudo-Arabic inscriptions in the Christian world, see R. Ettinghausen, "Kufesque in Byzantine Greece, the Latin West, and the Muslim world," *A Colloquium in Memory of G. C. Miles*, American Numismatic Society, New York, 1976, 28 ff.

[2] U. Monneret de Villard, *Lo studio dell'Islām in Europa nel XII e nel XIII secolo,*

*Studi e Testi 110*, Vatican City, 1944, 30. Since this publication, a vast number of contributions on the Western concept of Islam and Islamic culture have appeared, culminating with Edward W. Said's important and witty *Orientalism*, New York, 1978; a good bibliography in Maxime Rodinson, "The Western Image and Western Studies of Islam," *The Legacy of Islam*, 2nd ed., ed. J. Schacht and C. E. Bosworth, Oxford, 1974, 9–62.

3 C. Cecchelli, *La cattedra di Massimiano ed altri avorî Romano-orientali*, Rome, 1935, 39 ff.; A. Grabar, "La 'Sedia di San Marco' à Venise," *Cahiers archéologiques*, 7 (1954), 19–34. For St. Peter's Chair, see below. My present contribution is a *ballon d'essai* preparatory to a comprehensive study of San Marco and its liturgy and place in medieval Venice.

4 Monneret de Villard, *op. cit., passim*. Christians even insisted that the Muslims worshiped idols of Muhammad. Tancred entering Jerusalem reportedly found in the Temple a "simulacrum argenteum Machumeth," and a report from 1257 speaks of an "imago Machomethi, quae pependit solempniter apud Mecham veneranter adorata" (*op. cit.*, 33 f., 60). I would suggest two causes for these rumors: first, a confusion between ṣura ( صورة : image) and sura ( سورة : Qur'anic chapter); quotations from the latter, often lettered in gold, constituted the normal ornament of mosques and other sacred buildings. Secondly, at Mecca there did hang, in the sanctuary, votive donations in the shape of thrones, crowns, and even a discarded idol (not indeed venerated); for these votive donations, see O. Grabar, "The Umayyad Dome of the Rock in Jerusalem," *Ars Orientalis*, III, Washington, D.C., 1959, 46 ff. (reprinted with identical pagination in O. Grabar. *Studies in Medieval Islamic Art*, London, 1976, No. III).

5 See the chapter on "Die Entwicklung der arabischen Paläographie im Abendlande," A. Grohmann, *Arabische Paläographie*, (Österreichische Akademie der Wissenschaften), I, Graz, Vienna, Cologne, 1967, 32 ff.

6 Flaminio Cornaro, *Ecclesiae venetae*

*antiquis monumentis*, quoted in Tychsen (see below, n. 11).

7 Cited in Tychsen (see below, n. 11).

8 Cited in Tychsen (see below, n. 11).

9 Francesco Sansovino, *Venetia città nobilissima*, Venice, 1581.

10 Cited in Tychsen (see below, n. 11).

11 Olav Gerhard Tychsen, *Interpretatio inscriptionis cuficae in marmorea templi S. Marci* [!] *cathedra, qua S. Apostolus Petrus Antiochiae sedisse traditur*, Butzow, 1787; site of chair corrected in the second edition: *Interpretatio inscriptionis cuficae in marmorea templi patriarchalis S. Petri cathedra qua S. Apostolus Petrus Antiochiae sedisse traditur. Editio secunda emendatior*, Rostock, 1788.

12 Quoted in Vol. 2, ii, 22, of A. Th. Hartmann, *Oluf Gerhard Tychsen oder Wanderungen durch die mannigfaltigen Gebiete der biblisch-asiatischen Literatur. Ein Denkmal der Freundschaft und Dankbarkeit*, 5 vols., Bremen, 1818, with a considerable amount of historical material on the studies of Hebrew, Chaldaic, Samaritan, Syriac, Canaanite, Phoenician, and Arabic (the distinctions used by Hartmann).

13 For the cufic styles, see Grohmann, *op. cit.*; Aida S. Arif, *Arabic Lapidary Kūfic in Africa*, London, 1967. For Sicilian Arab or arabizing coins, see Lagumina, "Studi sulla numismatica Arabo-Normanna di Sicilia," *Archivio Storico Siciliano*, Palermo, 1891; R. Spahr, *Le monete siciliane dai bizantini a Carlo I d'Angiò (582–1282)*, Zürich and Graz, 1976, in *Publications de l'Association Internationale des Numismates Professionels*, No. 30. The concordances referred to above are: G. Flügel, *Concordantiae Corani arabicae. Ad librarum ordinem et verborum radices disposuit G. Flügel*, Leipzig, 1842 (reprint 1971); Muhammad Fuad 'Abd al-Baqi, *Al-mu'jam al-mufahras li-alfāz al-qur'ān al-karīm*, Dar wa-matab' al-sha'ab, rev. ed., 1945.

14 Grohmann, *op. cit.*, II, 49.

15 The rear of the Chair of St. Mark also has decorations, namely, the eagle of St. John and the lion of St. Mark, but this chair is a reliquary.

16 See E. Lévi-Provençal, *Inscriptions arabes d'Espagne*, Leyden and Paris,

1931, xvii ff. (foundation inscriptions); xxi ff. (funerary inscriptions). Generally: E. Combe, J. Sauvaget, and G. Wiet, *Répertoire chronologique d'épigraphie arabe*, 16 vols., Paris, 1931–64.

[17] Tychsen, *op. cit.*, 9.

[18] A. Grabar, *op. cit.*, 21.

[19] For the theories on Syriac, see P. Crone and M. Cook, *Hagarism. The Making of the Islamic World*, Cambridge, 1977, 208 f. (ns. 41, 54). See also W. Strothmann, *Die Anfänge der syrischen Studien in Europa*, Wiesbaden, 1971: Göttinger Orientforschungen, Reihe I, Syriacae, 1.

[20] W. Braunfels, *Mittelalterliche Stadtbaukunst in der Toskana,* Berlin, 1966, 3rd ed., 134.

[21] For combined centralized and basilical structures and references to the Anastasis, see W. Götz, *Zentralbau und Zentralbautendenz in der gotischen Architektur*, Berlin, 1968, 31 (bibliography) and *passim*. For the "Lateran" at Aachen, see L. Falkenstein, *Der 'Lateran,' der karolingischen Pfalz zu Aachen*, Cologne and Graz, 1966.

[22] For the unspecified references on the following pages to Venetian official rites and iconography, the reader is referred to the Index of my *Christ in the Council Hall. Studies in the religious iconography of the Venetian Republic, Institutum Romanum Norvegiae, Acta, V*, Rome, 1974. A text publication and study of the extant medieval source material relating to the liturgy of San Marco is being prepared by the present writer.

[23] For the *Chronicon* see below, n. 26. Similar references to Jerusalem in sources cited by O. Demus, *The Church of San Marco in Venice. History. Architecture. Sculpture*, Washington, D.C., 1960, 45. For imitations *typice et figuraliter*, see R. Krautheimer, "Introduction to an 'iconography of medieval architecture'," *Journal of the Warburg and Courtauld Institutes*, V (1942), 1–33; reprinted in Krautheimer, *Studies in Early Christian, Medieval and Renaissance Art*, New York, 1969, 113 ff.

[24] R. Krautheimer, "A note on Justinian's Church of the Holy Apostles in Constantinople," *Mélanges Eugène Tisserant*, II, Vatican City, 1964, 265 ff.; reprinted in Krautheimer, *Studies, op. cit.*

[25] See my publication cited above in n. 22, and my forthcoming article "Venezia e le componenti bizantine e medio-orientali," *Ateneo Veneto*, 1979–80. For example, the Palm Sunday triumphal entry of the Venetian government into San Marco under the golden quadriga (as suggested by the four bronze horses above the main entrance) may bring to mind the Palm Sunday triumphal procession of the emperor of Byzantium in a golden chariot at Nicaea after the Fourth Crusade (for this procession, see the article in Russian by M. A. Andreeva, *"Ocherki po kulture vizantijskovo dvora v XIII veke,"* in *Rozpravy král. české spol. nauk tř. fil. hist. jazykozpyt.*, nová řada (VIII), 3, Prague, 1927, 56 f.

[26] The *Chronicon* speaks of "Cuba depingnere preciosissime . . ." R. Cessi, *Origo civitatum italie seu venetiarum* (*Chronicon altinate et chronicon gradense*), a cura di R. Cessi, Rome, 1933, 80.

[27] Medieval Latin terms were *cupula* or *cupola*, and, for smaller structures, *tholus*, which was later used alternatively with *cupola* for great domes. For *cuba*, see N. Tommaseo, *Dizionario della lingua italiana*; and S. Battaglia, *Grande dizionario della lingua italiana*, III, Turin, 1964, s.v. *"cuba"* ("dall'arabo qubba 'volta,' voce d'area veneta"); C. Battisti and G. Alessio, *Dizionario etimologico italiano*, II, Florence, 1951, s.v. *"cuba,"* citing also the Cuba at Palermo and the Sicilian *cubba* = cupola-like lid on cistern (this, however, is a Syrian technical term borrowed directly; cf. Lane's *Lexicon* cited below, n. 28). Furthermore, *cubatto* (cage) and *alcova*: Sicily's connections with the Arabs were, of course, of a special order. Turkish *kubbe* for dome, cupola, is an Arabic loan word, too, but the Venetians could hardly have borrowed it from the Turks at such an early date (nor, presumably, from the Persians, who used *qubba* in the same sense). The references in A. Preti, *Etimologie venete*, Venice and Rome, 1968, s.v. *"cuba,"* do not seem

to argue against the Arabic origin of the term (and he believes the Arabic *qubba* to mean exclusively *vault*). G. B. Pellegrini, *Gli arabismi nelle lingue neolatine con speciale riguardo all'Italia*, Brescia, 1972, 90 f. The Greeks (Procopius, Mesarites, and Evagrius) used various terms based on the root *sphair*.

28 E. W. Lane, *Arabic-English Lexicon*, 4 vols., London, 1863, s.v. "*qubba*"; and R. Dozy, *Suppléments aux dictionnaires arabes*, I, Leyden, 1881, who cites numerous Spanish cases. For the translation "tabernacle," see A. J. Arberry, *Arabic Poetry*, Cambridge, England, 1963, 62 f. (poem on Basrah by Ibn al-Rūmi, 836–896 A.D.).

29 O. Grabar, *op. cit.*

30 For the visitor of 333 and the "Franks," see K. A. C. Creswell, *Early Muslim Architecture. Umayyads*, A.D. *622–750,* I, i, Oxford, 1969, 30, 65; for the Marasid, see Marmardji, cited below, n. 31.

31 For the Christian sources, see J. Wilkinson, *Jerusalem Pilgrims before the Crusades*, Warnminster, 1977, Index; for the Arab and Persian sources, see A.-S. Marmardji, *Textes géographiques arabes sur la Palestine*, Paris, 1951, 210–60; *idem, Buldāniya filastin al-'arabiya*, Beirut, 1948. There are numerous references to the Temple in medieval ecclesiastical and architectural sources; probably not only the existing buildings but also such early descriptions as that of Flavius Josephus of Herod's restoration, had a great impact. For medieval imitations of Solomon's Temple, even later substitutes or restorations appear to have been considered valid; already Eusebius (*Hist. Eccles.*, 10:4; see J. Sauer, *Symbolik des Kirchengebäudes*, 1924, reprint Münster/W, 1964, 105) found the Temple as rebuilt for Christian worship valid for symbolical exploitation. See also C. H. Krinsky, "The Temple of Jerusalem before 1500," *Journal of the Warburg and Courtauld Institutes*, 33 (1970). The cave presumably is a prototype for the confessio and crypt in the Christian church.

32 For the *omphalos* at Jerusalem, see O. Grabar, *op. cit.*, 39 f., and Wilkinson, *op. cit.*, 177.

33 See my "Some functional and iconographical aspects of the centralized church in the Italian Renaissance," *Institutum Romanum Norvegiae, Acta*, II (1965), Pl. IV a–b: 1214, 1255, British Museum.

34 Respectively, Hartmann von Schedel, *Weltchronik*, 1493 (*Destruccio Iherosolime*) and Bernhard von Breydenbach, *Peregrinationes in Terram Sanctam*. A view of Jerusalem in the second half of the sixteenth century by an anonymous Italian shows the Dome of the Rock as *Il tempio di Salomone* and al-Aqsa as *Il tempio della presentazione di Maria Vergine: Undique ad Terram Sanctam* (exhibition catalogue), Eran Laor Collection, University Library, Jerusalem, Oct.–Nov. 1976, No. 70. This tradition would seem to explain numerous representations in painting of the Presentation of the Virgin, including that by Titian in Venice (for the Scuola della Carità): with the al-Aqsa on the right, the Mount of Olives in the background, the Porticus Salomonis to the left, and an obelisk-pyramid marking out Jerusalem as the *umbilicus* or *omphalos mundi*. An important source for the Presentation was the *Protoevangelium Sancti Jacobi* (G. M. Roschini, *Dizionario di mariologia*, Rome, 1961, s.v. "Presentazione"). We read here that Mary was invested with the grace of God while ascending the steps: this concept appears to be alluded to by the light emanating from Titian's Virgin. Probably the light also refers to the historical culmination of this scene: the Purification. At her Presentation she meets Joseph and remains in the Temple as servant; after the Nativity she returns there at her Purification, a feast celebrated liturgically with spectacular allusions to light (e.g., the hymn *Lumen gentium*). In such an important painting for the Scuola della Carità, which, like the other *scuole grandi* at Venice, took an active part in the governmental liturgy, liturgical references would be a matter of course. For another approach to Titian's painting, see D. Rosand, "Titian's *Presentation of the Virgin in*

the Temple and the Scuola della Carità," *Art Bulletin*, LVIII (1976), 55–84. Apparently we are concerned with two different traditions for the Virgin's relation to the Temple structures, one accentuating the centralized dome (see my "Some functional and iconographical aspects," referred to in n. 33), and one emphasizing the basilical feature of al-Aqsa (seen *from* the latter, the distance of the Dome, as in Perugino's and Raphael's paintings of the *Sposalizio*, becomes understandable).

[35] And cupolas of the Zaytuna Mosque at Tunis, the Kutubiyya minaret at Marrakesh, and the Great Mosque minaret at Qairawan. The question concerning the significance of this type of cupola in Christian art and architecture was raised in my "Some functional and iconographical aspects" (n. 33; some examples illustrated). Of the Qairawan cupola, Creswell says that it "is treated externally like a Cantaloupe melon with twenty-four very bold convex ribs (corresponding to the concave flutes of the interior) which taper away to nothing at the apex" (*A short account of Early Muslim Architecture,* Harmondsworth, 1958, 298 f.). I prefer a more technical description of it, since it seems obvious that the vaults (concave inside and hence convex outside) are a rather easy construction of bricks over a simple and removable system of wooden ribs; or a system of copper hide over permanent ribs, as on San Marco. The interior brick construction of the Zaytuna and Qairawan (mihrab) cupolas is well illustrated in A. Hutt, *Islamic Architecture. North Africa*, London, 1977, 36, 60. Apparently, however, the type goes far back beyond the Arabs: see Roman medals of 251–54 A.D. with Juno Martialis, and the city view with three such domes on a silver dish of about 350 A.D.

from the Kaiseraugst Treasure, Switzerland, and on one of the fronts of "Celestial Jerusalem" in the mosaics of Hagios Georgios, Salonica.

[36] F. Forlati, *La basilica di San Marco attraverso i suoi restauri*, Trieste, 1975, 110, 156 ff. Another medieval case: the Jerusalem reliquary of Heinrich Löwe of about 1175 (Berlin, Kunstgewerbemuseum).

[37] References in Demus, *The Church of San Marco*, 101; E. Miozzi, *Venezia nei secoli. La città*, I, Venice, 1957, 128–38.

[38] This comparison in Demus, *op. cit.,* 101.

[39] Marmardji, *op. cit.* (French version), 215, 217 (cupolas on free-standing columns without walls). The Capitello has a pyramidal roof.

[40] Biblioteca Marciana, Venice, MS lat. III, 172, *Rituum caeremon.*, fols. 13v (Domin. apostol.), 52v (Dom. in albis); Archivio di Stato, Venice, Procuratori de supra, Cerimoniali 99 (In Dominica Apostol.); see also Giov. Dandolo, *Cronicon, Rer. Ital. Script.*, XII, 1, 263, and M. Sanudo, *Vite dei Dogi, Rer. Ital. Script.*, IV, 271. The feasts of the Purification and of Sts. Peter and Paul were celebrated in San Marco exclusively, as far as the government was concerned.

[41] O. Treitinger, *Die oströmische Kaiser- und Reichsidee nach ihrer Gestaltung im höfischen Zeremoniell*, 3rd ed., Darmstadt, 1956, reprint Bad Homburg, 1969, 81, 129 ff., see 160.

[42] Venice, Archivio di Stato, Procuratori de supra, Cerimoniali 98, fol. 132, which also mentions that St. Mark's Gospel, written by himself, came into the hands of the Venetians. In a less condensed version, the story appears in the *Chronicon altinate.*

[43] Marmardji, *op. cit.* (French version), 225 f.

# 4

## *Reflections on the Construction of Hybrids in English Gothic Marginal Illustration\**

LUCY FREEMAN SANDLER

In 1932, Eric Millar, Keeper of Manuscripts in the British Museum, published a comprehensive study of the early fourteenth-century English Luttrell Psalter, of whose marginal illustrations he said: "The mind of a man who could deliberately set himself to ornament a book with such subjects . . . can hardly have been normal."[1] He gave several examples, saying that among the "worst" is a creature with houndlike head who chews up a spray of foliage (fig. 1). It has a petaled collar joined to a birdlike body with talons, and a tail changing in form from serpentine to foliate. On the same page a duck-billed bird head with diaphanous dragonfly wings is attached to a parti-colored beast's body whose tail is replaced by a piglike head with a snout clasped by a golden ring.[2] On another page, Millar cited a human skull, with circular openings for the eyesockets and mouth, which is attached to two vertebrae and a pair of wings seen from the rear, then a vaselike body also in rear view, out of which emerges a foliate tail of clover flowers (fig. 2). In the bottom margin of this page a mild and mournful doglike head is attached to a crouching body protected by shell-like armor from which a leafy tail grows.[3]

I believe Millar's diagnosis of the Luttrell Psalter artist's mental state to be quite wrong. Indeed, the only sense in which this particular illuminator may be said to depart from the norm is that he is far above average in artistic imagination. The types of creatures which Millar saw as the hideous products of a disturbed mind are in fact so normal in fourteenth-century English manuscript illumination that they are repeated from one manuscript to another. For example, the leonine-human head atop animal legs on the *Beatus* page of the Vaux Psalter (fig. 3)[4] is duplicated exactly on the Penitential Psalms page of the Grey-Fitzpayn Hours (fig. 4),[5] a manuscript from the same workshop. Such hybrids may also be traced from one side of a leaf to the other, as occurs consistently in a book of hours in the British Library, Harley MS 6563,[6] and some of them in the Luttrell Psalter itself were copied from the main text into the margins of the calendar.[7]

Moreover, in one and the same manuscript and sometimes on one and the same page, hybrid monsters are associated on an equal basis with scenes of daily life, *fabliaux*, religious themes, foliage, flowers, fruit, and real animals and birds. The *Exultate deo* page from the Ormesby Psalter, for instance (fig. 5), has a lush foliate border with stylized and real leaves and flowers, among which are oak, strawberry,

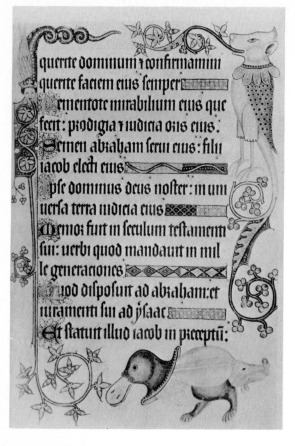

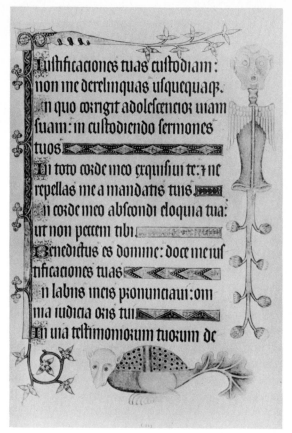

*1. Luttrell Psalter, London, British Lib. MS Add. 42130, fol. 186 (after Millar, The Luttrell Psalter)*

*2. Luttrell Psalter, London, British Lib. MS Add. 42130, fol. 213 (after Millar, The Luttrell Psalter)*

*3. Vaux Psalter, London, Lambeth Palace Lib. MS 233, fol. 15 (detail)*

3

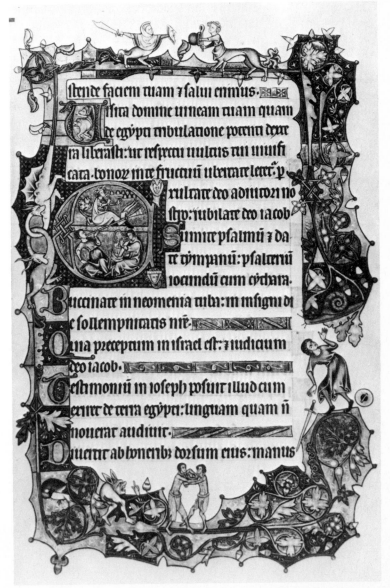

4. *Grey-Fitzpayn Hours, Cambridge, Fitzwilliam Mus. MS 242, fol. 55v (detail)*

5. *Ormesby Psalter, Oxford, Bodleian Lib. MS Douce 366, fol. 109*

and sweet pea. In the right-hand margin the plantlike stalk or tendril to which these leaves are attached forms itself into an interlace knot, and in the left-hand margin the same vegetal substance is transmuted into two battling dragons, necks intertwined and biting their own backs. Among the other creatures incorporated into the border are a naturalistic bird, a pair of wrestlers harangued by a humanoid hybrid, a young man who has dropped sword and shield in fear of a giant snail, and a pair of battling hybrids—both human above and animal below—whose weapons consist of a fairly orthodox sword and shield for the left figure and a pot and spoon for the right.[8] These examples from the Ormesby Psalter show that the normal in the margins of English Gothic manuscripts is a mélange of the real, the unreal, the parodic, the playful, the nightmare, the spiritual, the profane, and even the obscene. It is a world in which composite creatures—animal and human hybrids—appear to play a rightful and accepted part.

Some Gothic marginal animal or human hybrids would not, I imagine, have offended Eric Millar, since long pictorial and literary traditions lie behind them. In this category I would put ancient Mediterranean and Oriental composites—centaurs, mermaids, dragons, griffins, harpies, and the like, all of which survived into the Middle Ages. The Rutland Psalter, for example[9]—the earliest manuscript with copious marginalia—contains a number of centaurs, dragons, and harpies, and the Luttrell Psalter—among others—has a mermaid and a griffin.[10] The focus of this essay, however, is not the kind of English Gothic hybrid for which there is a traceable ancestry, pictorial or literary, but the kind for which names do not exist—which in fact are sometimes called non-descripts[11]—the kind which are, I believe, the products of medieval artistic invention, working nevertheless in accordance with certain discernible principles of order and construction.

It seems to me that what these hybrids require first to raise them to a level of comprehensibility, if not acceptability, is a descriptive vocabulary which would attempt to characterize their fundamental patterns of construction, or, in other words, to answer the question: Are there any general rules for the ways the component parts of these hybrids are put together? This, of course, would be only the first step in a complete account of Gothic hybrids. The subject also demands an analysis of the character of their individual components and a survey of common choices for juxtaposition. Which animals, for example, occur most frequently in

*6. Ormesby Psalter, Oxford, Bodleian Lib. MS Douce 366, fol. 131 (detail)*

7. *Rutland Psalter, Belvoir Castle, Duke of Rutland, fol. 45v (detail, after Millar,* The Rutland Psalter)

hybrid combinations? Are the parts drawn from real animals—perhaps defined broadly as any creature described in the Bestiary, whether really real or not—or are they new inventions, or somehow altered or deformed? Next, what are the hybrids doing? Are they battling, biting, grimacing, playing, or working? Finally, are the hybrids represented in isolation, or do they interact with other pictorial material, hybrid or otherwise? While attempts to answer some of these questions can be made with the aid of Lilian Randall's invaluable corpus of Gothic marginal illustrations,[12] much remains to be done. The present essay is limited to the first question alone, that is, the underlying patterns of construction of hybrid creatures, and further limited to examples from English Gothic manuscripts.

As I see it, there are six different modes of construction. The first, and most common, may be called sequential. Sequential hybrids are composed of two or three sections, comparable to the head, the trunk, and the limbs of human beings, or the head, body with appendages, and tails of beasts and birds. In the case of hybrids, each section is of a distinctly different kind. Again the Ormesby Psalter provides characteristic examples, such as the head of an owl, the body and legs of a camel, and an oak-leaf tail; or a human head and hands—those of a cripple— emerging from the shell of a snail (fig. 6).[13]

The most frequent sequence is human to animal to foliate. Found in numerous examples in the Rutland Psalter, one instance shows a capped human torso with human arms, and a serpentine lower body which ends in a spiral of foliage; another has a capped and bearded human head, and a reptilian body again ending in a foliate spiral framing a vignette of a cat captured by mice; a third is a Neanderthal-faced human torso, with reptilian lower parts, picking fruit from his own luxuriant foliate tail (fig. 7).[14]

The juncture of the human with the animal part is often masked by a neckerchief, cowl, cape, or some folded piece of drapery. And when an entire human torso

is joined to animal legs, a skirt may split apart to reveal the emerging limbs while hiding the exact manner of their joining, as in an ursine creature with human arms in the Luttrell Psalter.[15] But with animal-headed hybrids the juncture of the head of one beast with the body of another is usually marked sufficiently by the difference in form, color, and surface pattern so that neckerchiefs and the like are not always supplied. In the Luttrell Psalter a bearded human head, with a spirelet hat, is joined to the serpentine body by a scarf and a protective shield (fig. 8), while a pale, bovine head is connected directly to a feathered body (fig. 9).[16]

Because the body portion of sequential hybrids is so often reptilian, the joining of the tail to the rest is often a matter of gradual transformation of animal substance into vegetal. This kind of metamorphosis is common in the historiated initial frames and decorative borders of contemporary manuscripts, as, for example, on the framed *Beatus* page of the Peterborough Psalter in Brussels, in which a snaky animal substance undergoes a transformation into vinelike tendrils tipped by leaves.[17] One further observation about the tails of sequential hybrids: while the upper or front portion of a hybrid is often animal, the back or lower portion is rarely human, and when it is, as in the Luttrell Psalter, where a bovine-humanoid head and a lizard-like body end in the exposed posterior of a crawling human being (fig. 10), the result is a heightened degree of monstrosity.[18]

Sequential hybrids seem to be constructed rationally because they are comparable to the order of parts of animals or human beings. As far as I know, almost all the hybrids inherited by the Middle Ages from the Classical literary or pictorial tradition are of the sequential type. Pliny, for example, described the Leucrocota as having the head of a badger, the neck, breast, and tail of a lion, and cloven hoofs;[19] and Aristotle, citing Ctesias, described the Mantichora as human-headed, lion-bodied, and scorpion-tailed.[20] This is also the mode of construction St. Bernard referred to in his catalogue of "these ridiculous monsters . . . a four-footed beast with a serpent's tail, a fish with a beast's head, the forepart of a horse trailing half a goat behind it, or a horned beast bearing the hinder parts of a horse."[21] But Bernard also railed against another type of hybrid construction which was most uncommon in Antiquity—"many bodies," he says, "are seen there under one head."[22] This mode of construction, typically medieval, may be called bifurcation. A two-bodied female centaur in the Rutland Psalter[23]—an example of

8. *Luttrell Psalter, London, British Lib. MS Add. 42130, fol. 79v (detail, after Millar,* The Luttrell Psalter)

9. *Luttrell Psalter, London, British Lib. MS Add. 42130, fol. 155v (detail, after Millar,* The Luttrell Psalter)

10. *Luttrell Psalter, London, British Lib. MS Add. 42130, fol. 177 (detail, after Millar,* The Luttrell Psalter)

Gothic bifurcation—is a complete aberration from the Classical type. Bifurcated hybrids, then, consist of one head, usually frontal, joined to two identical bodies, each shown in profile. Striking examples may be drawn from the Luttrell Psalter. In one, the necks of two beast bodies emerge from the enormous circular mouth opening of a single doglike head (fig. 11).[24] In another, identical foliate-tailed animal bodies are joined to a bald human head with a projecting tongue of exaggerated length.[25] No wonder that the bifurcated hybrid was the type that disturbed

ırent in ciuitatem habitacionis.

11. *Luttrell Psalter, London, British Lib. MS Add. 42130, fol. 194v (detail, after Millar,* The Luttrell Psalter)

12. *Cartoon in* Penthouse *magazine, February, 1977*

"One of us is an asshole!"

Eric Millar more than others. Not only are the parts individually and conjointly outrageous, but the very mode of construction is an offense against nature and tradition.

Equally outside natural law is a third mode of construction found in Gothic hybrids. This is a kind that survived until—or was reinvented in—the twentieth century and named the Pushmipullyu by Hugh Lofting's Dr. Dolittle.[26] Pushmipullyus have a single body, to the extremities of which are attached two identical heads—in the case of Dr. Dolittle's creation, those of horses. A more ribald modern example comes from a cartoon in *Penthouse* magazine showing a two-headed stork with the caption, "One of us is an asshole!" (fig. 12).[27] Again the Luttrell Psalter provides medieval hybrid examples. One has two humanoid heads, two serpentine necks ending in jackets, and a single body with bearlike claws; another shows two club-wielding human torsos attached to a single animal body (fig. 13).[28]

The fourth mode of hybrid construction may be called dual orientation. Unlike sequential hybrids, whose components all face in the same direction, these creatures consist of parts reversed in relation to each other. Some of them seem to reflect the contorted beasts of ancient steppe art, such as the Scythian gold bear, or the multiple twists of the composite beasts in the cross pages of the Lindisfarne Gospels.[29] But in many Gothic examples the reversal of direction is less sinuous and more abrupt. In the Luttrell Psalter, for instance, there is a pale frontal face out of whose mouth emerges the hindquarters of a beast seen from the rear, and in another case, a frontal human lifts his arms to display the rear view of a long-tailed beast whose feet are again seen frontally (fig. 14).[30] Or, in a different kind of reversal, the same manuscript provides a profile dog head—facing right—attached to a profile beast body—facing left.[31]

The last-mentioned hybrid has human hands where the feet should be. Just this kind of misplacement of parts characterizes the fifth mode of hybrid construction. One variant is the substitution of hands for feet, as above, or, in another example

*13. Luttrell Psalter, London, British Lib. MS Add. 42130, fol. 211 (detail, after Millar,* The Luttrell Psalter)

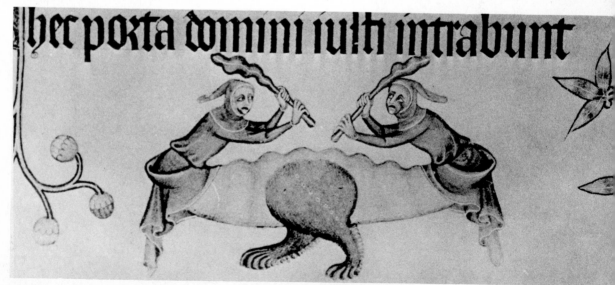

14

14. *Luttrell Psalter, London, British Lib. MS Add. 42130, fol. 201 (detail, after Millar,* The Luttrell Psalter)

15. *Ormesby Psalter, Oxford, Bodleian Lib. MS Douce 366, fol. 72 (detail)*

16. *Treatise of Walter de Milemete, Oxford, Christ Church MS 92, fol. 44v (detail, after James,* The Treatise of Walter de Milemete)

15

16

from the Luttrell Psalter, a fish walking on human hands.[32] Hands or heads can
also be misplaced at the tips of tails, as in the Ormesby Psalter where a doglike
head, twisted back over a rear-view human body, peers at its own long tail tipped
with a human index finger pointing with a vulgar gesture at its human backside (fig.
15).[33] But still more striking is the type of hybrid which may be called two-faced,
the kind in which a face or head—not just a finger—is actually found in the position
ordinarily occupied by the posterior of a creature. When one or both heads have
human elements, their conjunction is fraught with lewd connotations, as witness
the pair of woodwoses in the Treatise of Walter of Milemete (fig. 16).[34] A balding,
bearded male in the Ormesby Psalter has a shirt folded back to reveal the head of a
fierce creature biting a branch of foliage.[35] A pale female head in the Luttrell
Psalter, with translucent batwing headdress, is attached to a bestial body whose
rear end is replaced by a menacing blue humanoid head, beetle-browed, knobby-
nosed, and open-mouthed, either swallowing its own tail or sticking out an extraor-
dinarily long tongue (fig. 17).[36] One page in the Yale Cluniac Psalter shows two
"addorsed" two-faced hybrids (fig. 18); the left creature actually has three heads,
two at one end and one at the other, all different, and the whole composition offers
a catalogue of features suggesting an anal-oral fixation—vomiting and open mouths
being particularly notable.[37]

Finally, I would like to include the kind of hybrid characterized by absence or
excess of parts. It was not beyond the Classical imagination to conceive of races of
mankind lacking parts of the body, such as sciapods or acephalic men, or races
having parts extremely misproportioned, such as dwarfs, and these creatures recur
in the manuscripts under discussion here.[38] Hybrids based on the same principles
are common in manuscripts, too, sometimes in pointed juxtaposition with entirely
human examples. One page in the Milemete Treatise, for instance, shows both an
axe-bearing dwarf, itself an anachronism, and a creature whose bearded human
head rests between animal hindquarters which end in human hands using a crip-
ple's crutches, surely an allusion to the truncation of the body (fig. 19).[39] The most
common deformation, in fact, is the elimination of the trunk so that the head of a
hybrid rests directly on top of the lower portion of the body. Further examples

*17. Luttrell Psalter, London, British Lib. MS Add. 42130, fol. 184 (detail, after*
*Millar,* The Luttrell Psalter)

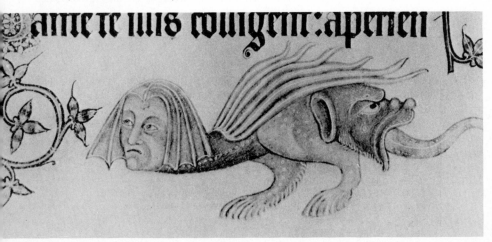

occur in the Ormesby Psalter, one of which has a haranguing human head atop human legs between which an animal tail tipped with pointing finger emerges (fig. 5),[40] and in the Milemete Treatise, where an armless acrobat has animal legs attached to his chin, or a leonine mask fiercely grips his legs between his teeth.[41]

The opposite of absence of parts is their excess. Here too the Middle Ages inherited from Antiquity the conception of three-headed dogs, seven-headed dragons, and the like. Usually it was the head that was multiplied, and often misplaced as well. The Yale Psalter, for example, offers several cases of creatures with as many as five different heads (fig. 20), including squawking, predatory birds and grotesque human caricatures, some with knobby noses, some with hooked noses, some with projecting tongues, some open-mouthed and vomiting.[42] It may be remembered that the Apocalyptic beast and dragon, the Devil, and the mouth of Hell all follow the same principle of construction in the Gothic period.

In conclusion, I would like to return to the question of the normality of hybrid monsters. At the beginning of this essay I tried to justify my own conviction on what might be called statistical grounds. Artistic forms so common and so transferable cannot be abnormal. Next, I have attempted to make these hybrids comprehensible by showing that they follow orderly systems of construction. Artistic forms that appear to obey rules cannot be abnormal either. But the worrying question remains: Even if normal, what is their meaning? Are hybrids purely playful, idly capricious, smuttily titillating—in other words, lacking in seriousness commensurate with that of the sacred texts whose margins they decorate? It does seem that marginal hybrids offer all-too-human relief from the unremitting seriousness of religious texts; and their boundless variations represent individualistic creative efforts by artists for whom comparable freedom to innovate would not be dreamed of in illustrating standard religious subjects. And yet I believe that these hybrids also reflect a spiritual world view which, in the Gothic period, was highly conscious of the sinfulness and evil that beset mankind. How appropriate are such obscenely two-faced creatures, with their open mouths, their projecting tongues, their spitting and vomiting actions, as visual embodiments of sins such as blasphemy and gluttony! To quote a fourteenth-century sermon, "and the blasphemer stykinge out his tongue in a mervaylous horryble ugsome and ferefull manner, as black as pytche, so that no persone durst come nere hym. . . . And he contynued ever swerynge, blasphemynge and bledynge tull he expired and was deed."[43] Or on gluttony, the English Dominican John Bromyard preached, "One day they stuff; on the next they send for the doctor to relieve them. . . . These glotons beth never glad bot that they mowe waste much mete and drynke, and studye in what manner they mowe adraw here fulness to be again hungre ofte for to ete and drynke."[44] It seems to me that the serious and pessimistic dark side of medieval thought that asks "What is man . . . but a stynkynge slime, and after that a sake ful of donge, and at the last mete to wormes. . . ."[45] is revealed in the most graphic—and uniquely visual—manner by the hybrids discussed in this essay.

*New York University*

18

19

18. *Yale Psalter, New Haven, Yale University, Beinecke Rare Book and Manuscript Lib. MS N.417, fol. 64v (detail)*

19. *Treatise of Walter de Milemete, Oxford, Christ Church MS 92, fol. 55v (after James,* The Treatise of Walter de Milemete)

20. *Yale Psalter, New Haven, Yale University, Beinecke Rare Book and Manuscript Lib. MS N.417, fol. 64v (detail)*

20

*Notes*

* A version of this article was presented at a symposium on fantastic medieval animals held at Mount Holyoke College in 1977.

1 Eric G. Millar, *The Luttrell Psalter*, London, 1932, 16. London, British Lib. MS Add. 42130, made for Geoffrey Luttrell, of Irnham, Lincs., before 1340, probably in the 1320s.

2 Fol. 186.

3 Fol. 213.

4 London, Lambeth Palace Lib. MS 233, fol. 15. Sometimes called the Bardolf-Vaux Psalter, executed c.1310 (see D. D. Egbert, *The Tickhill Psalter*, New York, 1940, 101–8, 189–204).

5 Cambridge, Fitzwilliam Mus. MS 242, fol. 55v. Probably made for the marriage of Joan Fitzpayn and Richard Grey, c. 1300–1310 (see Egbert, *Tickhill Psalter*, 90–94, 175–81).

6 Executed probably in the 1320s, with prolific marginalia on every page, but not yet studied in detail. For reproductions see Lilian M. C. Randall, *Images in the Margins of Gothic Manuscripts*, Berkeley and Los Angeles, 1966, figs. 35, 98, 99, 161, 232, 233, 434, 435.

7 Cf. fols. 1 and 86, 2 and 93, 3 and 91v, etc. (Millar, *Luttrell Psalter*, 23, n. 4).

8 Oxford, Bodleian Lib. MS Douce 366, fol. 109, Psalm 80. Begun in the late thirteenth century, the page in question was decorated c. 1310, and the book was altered and given by the monk Robert of Ormesby to Norwich Cathedral Priory in the 1320s (see S. C. Cockerell and M. R. James, *The Ormesby Psalter, the Bromholm Psalter, Two East Anglian Psalters at the Bodleian Library, Oxford*, Oxford, 1926).

9 Belvoir Castle, Duke of Rutland; e.g., fols. 33, 58v (centaurs), 12v, 20v, 91 (dragons), 44v, 86v (harpies). Mid-thirteenth century, of uncertain provenance (see the facsimile, Eric G. Millar, *The Rutland Psalter*, Oxford, 1937).

10 Fols. 70v and 160v (Millar, *Luttrell Psalter*, pls. 21c, 73).

11 E.g., Eric G. Millar, *English Illuminated Manuscripts of the XIV^th and XV^th Centuries*, Paris and Brussels, 1928, 7.

12 Randall, *Images in the Margins of Gothic Manuscripts*, with 739 illustrations from approximately 230 manuscripts.

13 Fol. 131.

14 Fols. 99, 61, and 45v (Millar, *Rutland Psalter*).

15 Fol. 207v (Millar, *Luttrell Psalter*, pl. 167).

16 Fols. 79v, 155v.

17 Brussels, Bibl. Royale MS 9961–62, fol. 14. Made for Geoffrey of Crowland, Abbot of Peterborough, between 1299 and 1318 (see L. F. Sandler, *The Peterborough Psalter in Brussels and Other Fenland Manuscripts*, London and New York, 1974, fig. 296).

18 Fol. 177.

19 Pliny, *Hist. Nat.*, Bk. VIII, ch. 30 (see Pliny, *Natural History*, III, Loeb Classical Library, London and Cambridge, 1956, 55).

20 Aristotle, *Historia animalium*, Bk. II, ch. 1 (see *Works of Aristotle*, trans. D. W. Thompson, IV, Oxford, 1910, 501a).

21 From the letter of St. Bernard to William, Abbot of St.-Thierry (see Elizabeth G. Holt, *A Documentary History of Art*, I, Garden City, N.Y., 1957, 21).

22 *Ibid.* I wish to thank my colleague Prof. Larissa Warren Bonfante for calling to my attention the occasional appearance of single-headed, double-bodied lions, griffins, and sphinxes in Orientalizing ceramics and gems.

23 Fol. 111 (Millar, *Rutland Psalter*).

24 Fol. 194v.

25 Fol. 175v (Millar, *Luttrell Psalter*, pl. 103).

26 Hugh Lofting, *The Story of Doctor Dolittle*, 1st ed., London, 1920, ch. X. The Amphisbaena—a snake with heads at either end—is the only Bestiary animal of this sort (see *The Bestiary*, ed. T. H. White, New York, 1960, 177). An Amphisbaena in the Rutland Psalter (fol. 82) causes an adjacent crouching nude man to scratch his head in amazement.

27 *Penthouse* magazine, Feb. 1977, 66.

28 Fols. 195, 211 (Millar, *Luttrell Psalter*, pls. 142, 174).

29 See, for example, the Treatise of

Walter of Milemete, Oxford, Christ Church Lib. MS E 11, fols. 31v, 36, 57v, 58 (M. R. James, *The Treatise of Walter de Milemete*, Oxford, 1913, pls. 62, 71, 114, 115), made c. 1326 for Edward III.

[30] Fols. 146v (Millar, *Luttrell Psalter*, pl. 45), 201.

[31] Fol. 193v (Millar, *Luttrell Psalter*, pl. 139).

[32] Fol. 173 (Millar, *Luttrell Psalter*, pl. 98).

[33] Fol. 72.

[34] Fol. 44v.

[35] Fol. 55v (Cockerell and James, *Two East Anglian Psalters,* pl. VII).

[36] Fol. 184v.

[37] New Haven, Yale Univ., Beinecke Lib. MS N. 417, fol. 64v. Executed in the 1320s probably for the Cluniac priory of Thetford, Norf. (see K. V. Sinclair, *Descriptive Catalogue of Medieval and Renaissance Western Manuscripts in Australia*, Sydney, 1969, 257–58).

[38] Sciapod, Treatise of Walter of Milemete, fol. 44v (James, *Milemete*, pl. 88); acephalic man, Rutland Psalter, fol. 57 (Millar, *Rutland Psalter*). The Rutland Psalter contains an especially piquant human example of absence and excess of parts in the confrontation of a nude man with one leg and another nude with four legs and a crutch (fol. 64; see Millar).

[39] Fol. 55v.

[40] Fol. 109.

[41] Fols. 59, 58v (James, *Milemete*, pls. 117, 116).

[42] Fol. 43, and another example on fol. 52v.

[43] Quoted by G. Owst, *Literature and Pulpit in Medieval England*, Cambridge, 1933, 424.

[44] *Ibid.*, 446.

[45] G. Owst, *Preaching in Medieval England*, Cambridge, 1926, 341, quoting a sermon in which the phrase is attributed to St. Bernard.

# 5

# *The Wilderness Journey:*
# *The Soteric Value of Nature in*
# *Japanese Narrative Painting*

PENELOPE E. MASON

A rare theme in Japanese narrative painting, but one which expresses on its deepest and most complex level a basic Japanese attitude toward the natural world, is the theme of spiritual enlightenment achieved through contact with nature. Implicit in this theme are two ideas common to some forms of Buddhist thought but by no means to all. First is the belief that a human being can through his own efforts achieve enlightenment or salvation from the cycle of reincarnation and karma. This idea was first enunciated in Japan by Kūkai (774–835), the founder of the Shingon sect of Buddhism, in his *Sokushu Jōbutsu Gi, Attaining Enlightenment in This Very Existence*, and was gradually accepted by Tendai theologians.[1] It gave way in the mid-thirteenth century to the belief in salvation through faith alone among the sects which revered Amida, the Buddha of the Western Paradise, and to the concept in Zen Buddhism of enlightenment through a sudden insight. The second idea implicit in the theme of salvation through contact with nature is that elements in the natural world—trees, plants, grasses, the moon, and so on—inherently possessed the Buddha-nature, in other words that they were enlightened nonsentient beings.

The original model for the achievement of salvation in nature through one's own efforts was the historical Buddha Sakyamuni (c. 563–483 B.C.). This Indian prince, after seeing four examples of human suffering, left his wife and child and the comforts of his father's palace to wander in the wilderness, endure physical hardships, and meditate on the meaning of life, until under a Bodhi tree at Bodhgaya he reached enlightenment by understanding the eight-fold chain of causation which leads man to be caught up in the cycle of reincarnation and karma. After his enlightenment Sakyamuni traveled through India preaching his new religion and died in his eighties, whereupon he passed into a state of nonbeing or nirvana.

Kūkai, in the early ninth century A.D., seeking acceptance for a new system of esoteric as opposed to exoteric Buddhist doctrine in Japan, denied the validity of Sakyamuni's teaching, saying:

> There are three bodies of the Buddha and two forms of Buddhist doctrine. The doctrine revealed by the Nirmanakaya Buddha [Sakyamuni Buddha] is called Exoteric; it is apparent, simplified, and adapted to the needs of the time and to the capacity of the listeners. The doctrine expounded by the Dharmakaya

Buddha [Mahāvairocana] is called Esoteric; it is secret and profound and contains the final truth.[2]

However, he supported the ideal epitomized by the historical Buddha, that the individual could achieve salvation within one lifetime. He also accorded to nonsentient beings, such as trees, plants, grasses, and even rocks and mountains, the quality of enlightenment.[3] Later theologians found this doctrine difficult to accept. A formal debate on the question was held in 963 in which the priest Ryōgen (912–985) argued that only living things, because they go through a biological life cycle comparable to that of human beings, could achieve enlightenment and a state of nonbeing or nirvana. But in the early twelfth century the subject was raised again by the priest Chūjin (1065–1138), who enunciated the view that trees and plants were already enlightened, that they possessed a being independent of man and therefore did not have to follow the same path toward enlightenment. Thus in Chūjin's view the elements constituting the natural world possessed original enlightenment, while it was man's fate to have to strive to achieve it. However, man through contact with nature could profit from its example and facilitate his own enlightenment. The soteric value of nature became an even more important theme as the world of the Heian nobility crumbled in the rebellions of 1156 and 1160 and the Gempei civil war of 1180. Faced with the destruction of the world as they had known it, courtier and commoner alike turned increasingly to the natural world as a source of values to replace those they had come to rely on before the political upheaval of the third decade of the twelfth century.

The theme of salvation through contact with the natural world was not depicted in the format of the horizontal, illustrated, narrative scroll, the *emaki*, before the twelfth century, as far as one can judge from pre-twelfth-century documents. However, from the second half of that century on into the pre-modern period (1600–1868), the idea appears as a leitmotif in several scrolls dealing with the spiritual or emotional maturation of the protagonist. The earliest of these is a three-roll set of scrolls known as the *Shigisan Engi Emaki* or *The Illustrated Legend of the Founding of the Temple on Mount Shigi*, which is dated to the period 1156 to 1180. Because the text of the *emaki* is included in several collections of folk tales, the most complete version being the *Uji Shūi Monogatari*, the *emaki* itself is normally regarded as a tale illustrated for the benefit of the common people to promote belief in the efficacy of worshiping at the temple on Mount Shigi, Chōgosonshiji, and of honoring the chief deity of the temple, Bishamonten, the Guardian King of the North, and the temple's founder, the priest Myōren. There is no question that this element is present in the scrolls, but a careful evaluation of the text and pictures suggests that the *emaki* was intended to transmit a more complex religious doctrine. It is nothing less than an illustrated tract on the stages and the means of achieving enlightenment in one's lifetime, one measure of this being the perception of the Buddha-nature of nonsentient beings. The protagonist of the *emaki* is usually said to be Myōren, a priest from Shinano province, who went to Nara to be ordained before the Mahāvairocana Buddha at the temple of Tōdaiji and who then established himself in a simple hut on Mount Shigi; there he practiced his priestly duties, worshiped Bishamonten, and attained such magical powers that he was able to perform miracles. However, in actuality there are two protagonists: Myōren, who established a pattern for enlightenment and teaching Buddhist doctrines, and his sister, who as an elderly nun searched for her brother, achieved enlightenment, and joined him on Mount Shigi where the two lived out their days until they could accomplish their nirvana.

The *emaki* as it exists today has no opening text, and some scholars question whether or not it ever did possess one.⁴ But the text in the *Uji Shūi Monogatari* gives so much information about Myōren and his life before he performed his first miracle, the subject of the first scroll, that it seems inconceivable the scroll could have been produced without this prologue. Indeed the opening passage of the *Monogatari* text sets the pattern for achieving enlightenment, one which will be repeated in the last scroll by the nun. The *Uji Shūi Monogatari* text begins:

> In times now long ago there lived in Shinano Province a priest who, having entered the priesthood in a remote country district, had never been properly ordained. He determined that he would somehow go up to the capital [the former capital, Nara] and receive ordination at the Tōdaiji. At last he succeeded in making the journey and the ceremony was duly performed. He had intended to return to his native province afterward, but it really seemed a mistake to go back to so heathenish a place where no one even knew about the Buddha, and he therefore decided to remain in the neighborhood of the [former] capital. He sat down in front of the Buddha of Tōdaiji and looked all about him at the surrounding countryside to see whether he could detect any suitable place where he might live peacefully and perform his devotions. At last his eye hit upon a certain mountain which could be dimly seen off to the southwest. "That is where I will live and pray," he thought, and went there.⁵

The key elements in this passage are: 1) the long journey which the priest made from Shinano, a mountainous province in central Honshu often referred to as the Japan Alps, to the city of Nara on the fertile plains of the Kansai region; 2) his meditation in front of the Buddha of Tōdaiji, an image of Mahāvairocana, the Buddha representing the essence of Buddhahood and the deity most revered by the Shingon sect to which the temple of Chōgosonshiji belongs; and 3) the revelation of Mount Shigi as the site of his home, a vision which came to him after his meditation as he was looking out at the surrounding countryside.

The first two scrolls in the set depict miracles performed by Myōren as a result of the magic powers he gained from practicing rituals and austerities, and suggest his efforts to teach other humans the self-denial which can lead to salvation. In the first scroll a wealthy country squire, his granary full of rice bales, neglects to place one bale in Myōren's begging bowl when the bowl flies magically down from the summit of the mountain into the squire's yard.

> "What a very greedy bowl you are!" he said, and picking it up tossed it into a corner of the storehouse instead of filling it immediately.⁶

However, it is not Myōren living frugally on top of the mountain who is greedy, much less his bowl, but rather the squire who is too busy tending to his property. As punishment Myōren causes the storehouse to shake strangely and finally to rise into the air and fly away. The granary soars up to the top of Mount Shigi with the squire on horseback and his foot servants in pursuit. At first they travel along a path beside a river, then they begin to climb through the trees and mist higher and higher into the mountains until they reach Myōren's simple hut. The effect on the squire of the long journey through the wilderness can be seen by comparing his appearance as he rides out of the gate of his house with that as he sits on the veranda of Myōren's house (figs. 1, 2). In the first scene he is mounting his horse, his hands grabbing the reins and the back edge of the saddle, his face turned upward to see the granary flying through the air held aloft by Myōren's golden beg-

ging bowl. The squire's mouth is open and his expression is one of dismay and anger, but at the same time an aggressive and effective response to the problem of retrieving his property. By the time he has reached Myōren's house, his anger has cooled and he sits facing the priest in a slightly stooped and deferential posture. His words are carefully chosen and apologetic, but reveal his intention to secure the return of his granary:

> "What an astonishing thing to have happened! Whenever your bowl has come to my house I have always filled it with food, but today I was so busy that I forgot all about the bowl and locked my storehouse without removing it. Then the storehouse began to shake and sway, and now it has flown all the way here. Please return it to me."[7]

Myōren, realizing that the squire has not yet been properly chastened, refuses to return the storehouse, but offers him instead the return of his rice. This is accomplished by placing one bale of rice into the begging bowl and sending it flying into the sky, the other bales following after it. This act of magic so impresses the squire that he finally recognizes the dangers of alienating this priest, if not the evils of greed, and offers Myōren two or three hundred measures of rice for his own use. Myōren refuses:

> "That may not be," said the holy man. . . . He made certain that every last bale landed at the rich man's house.[8]

The scroll ends with a scene of the rice bales flying over the wild mountain landscape and landing in the squire's yard, to the great joy of his household. The squire does not appear again in the scroll, but the implication is that he is left to descend from the monastery along the steep mountain path thinking about the lesson he has been taught.

The second scroll deals with the illness of Emperor Daigo, who ruled from 897 to 930. Every effort was made to insure his recovery—exorcisms, prayers, and scripture readings—but none was successful. Finally Myōren's mystical powers were brought to the attention of the court, and an archivist was sent as an imperial messenger to summon him to the capital. The moral of this tale is less directly stated than that of the flying granary scroll, perhaps because the person being chastened is the emperor himself. However, the point of the story seems clear. Myōren cures the emperor by magic and then refuses the honors and wealth the latter wishes to bestow on him. In other words, true religious understanding and the power to perform miracles cannot be commanded or bought; they can only be acquired by long years of study and self-denial. In the scroll the emperor is not depicted explicitly, but he is represented by the figure of the archivist who journeys twice from the capital to Mount Shigi, first to summon Myōren to the capital and second to offer him rewards for his success in curing the emperor. The landscape in this scroll is more rugged than that in the first, symbolizing the distance between the world of the capital and the pure realm of Myōren's life. The dialogue between the messenger and Myōren reveals the latter's selflessness. The messenger asks Myōren to come to the capital to pray for the emperor, but Myōren, having no desire to leave Mount Shigi, offers to perform the rituals in his own monastery.

> "In that case," objected the messenger, "if His Majesty should recover, how would we know that it was due to the efficacy of your prayers?"
> The holy man said, "So long as his health is restored, it hardly matters whose miraculous powers are responsible."[9]

1. *The Squire*, Shigisan Engi Emaki *(detail)*. *Chōgosonshiji. Reproduced from a facsimile scroll published by Yamato-e Dōkōkai, Tokyo, 1921*

2. *The Squire*, Shigisan Engi Emaki *(detail)*. *Chōgosonshiji*

The messenger insists, and Myōren finally agrees to send a deity known as the sword guardian as a sign to the emperor when he performs his healing ritual. Again at the end of the scroll, when the messenger offers Myōren a high religious rank or the donation of a revenue-yielding manor, his reply is sharp:

"I cannot possibly become an archbishop or a bishop, and if a manor were made over to my temple, it would certainly entail having an intendant and other people to manage it. That would be as unwelcome to me as being tormented for my sins. Let me remain as I am." And so the matter was dropped.[10]

One Japanese art historian, Kobayashi Taichirō, has postulated a theory that the *Shigisan Engi Emaki* details Myōren's growth toward spiritual perfection, overcoming his own sense of greed in the encounter with the squire, rejecting the wealth and fame he might have acquired as a result of his efforts to cure Emperor Daigo, and finally in the last scroll controlling physical lust through a purely platonic relationship with his sister.[11] However, it seems to me that this theory imposes a structure on the tale which only the second scroll can support and totally misses the point of the third scroll. In this last roll the protagonist is not Myōren but his sister, a nun who has not seen her brother since he was a young man and now in her old age wishes to find out what has become of him. In the course of the scroll she repeats the pattern of Myōren's journey to Nara, his communication with the great Buddha of Tōdaiji, and the ultimate enlightenment which comes to him when he decides on Mount Shigi as the place to establish his monastery. The nun, in fact, exemplifies the idea that salvation is possible for anyone, man or woman, who practices religious austerities and eschews the temptations of the secular life. Furthermore, it is in this scroll that the soteric value of nature is most clearly presented.

The illustration begins with the nun on horseback and a companion on foot clad in a straw raincoat and hat and leading the horse down a steep winding mountain path (fig. 3). The nun has remained until now in the mountainous regions of Shinano where she and her brother were born; hence her journey through the mountains has a specific *raison d'être* in the story. However, of the three scrolls this is the only one to begin with figures moving through the wilderness; the other two are conceived as units of architecture separated by passages of landscape. Not only does the nun descend from the mountains to the plains of Nara, she also moves increasingly into the secular world. The first stop she makes on her journey is at a small temple where she inquires after her brother; her second stop is at the house of a farmer, and her third at the home of a merchant. Each scene is enlivened by genre depictions of life just outside the capital: women drawing water from a well, a woman planting vegetables, children peeping through a window at the old woman, and dogs fighting in the yard outside a house. After a brief climb through more mountains, these much less steep than the ones first depicted in the scroll, the nun arrives at Tōdaiji, a building which overwhelms her by its size and awesome solidity.

. . . That evening she prayed all night long before the Great Buddha of the Tōdaiji, asking that she be shown where Myōren was. At last she fell into a doze, and in her dream Buddha said to her, "The priest whom you seek lives on a mountain southwest of here. Go there and look for him on the side of the mountain from which a cloud is trailing."

When she awoke it was already close to dawn, and she waited impatiently for the day to break. As soon as the first pale light appeared, she gazed off to

the southwest, and could see the faint outlines of a mountain from which
trailed a purple cloud. Overjoyed, she made her way in that direction.[12]

The vision she has of the mountain entwined with a purple cloud is the final moment of her enlightenment in which she realizes the Buddha-nature of the natural world (fig. 4). Kūkai in his *Hizōki, Record of the Secret Treasure*, referred to this new way of seeing:

> The Dharmakaya consists of the Five Great Elements within which space and plants and trees are included. Both this space and these plants and trees are the Dharmakaya. Even though with the physical eye one might see the coarse form of plants and trees, it is with the Buddha-eye that the subtle color can be seen.[13]

In other words, the ability to perceive the Buddha-nature of the natural world is an indication that one has reached a state of enlightenment, the state of possessing the Buddha-eye. Having achieved this vision the nun starts off toward Myōren's house. It is indicative of her enlightened state that she of all the people making this journey is not shown walking up a steep and tortuous mountain path. At the beginning of the last illustration, the nun is depicted at the bottom of the scroll within a small passage of landscape, the rounded tops of hills, and immediately after she appears outside Myōren's house calling out to him as he sits inside reading a sutra. She presents him with a padded jacket she has made, and they settle into a quiet life of religious worship together awaiting death and the accomplishment of their nirvana.

That the scroll was intended in part as propaganda for worship at Chōgosonshiji is proved by the last lines of the text:

> He [Myōren] wore the padded underjacket constantly for many years until it fell into shreds. The storehouse which was carried to the mountain by his begging bowl is called the Flying Storehouse. The tattered remains of the jacket and other relics of the holy man are kept inside and are said still to be there. Those who happen, through some fortunate karma affinity, to obtain even so much as a scrap of that underjacket use it as a charm. The storehouse is now in a very dilapidated state, but is still there. People who manage to get hold of even a splinter of the wood from which it was built, make it into a charm, and those who obtain larger pieces and have them carved into images of Bishamon never fail to become rich and prosperous. It is no wonder that everyone who hears this story is anxious to buy a piece of wood from the storehouse. The name of the mountain where the holy man lived all those years is Shigi; it is a place so rich in wonderful miracles that even today it is crowded morning and night with pilgrims. The image of Bishamon enshrined there is said to be the very one that the holy man Myōren miraculously produced through his devotions.[14]

The miraculous powers of the relics of Myōren are touted and with them the virtue of worshiping at the temple on Mount Shigi. However, the scrolls themselves go beyond the simple celebration of magic and suggest two roads to enlightenment: the road of study, of prayer, and the performance of religious rituals adopted by Myōren; and the second road of selfless love and openness of spirit which permitted the nun to achieve her spiritual realization. The set taken in its entirety demonstrates the dogma of Shingon belief as it had developed by the twelfth century,

namely, that salvation was possible within this lifetime and that the natural world, having already achieved enlightenment in its own way, could provide the examples which would lead the individual to the realization of the Buddha-nature within himself.

Less than a century later another set of scrolls was produced which deals explicitly with the theme of enlightenment achieved through contact with nature. The *Saigyō Monogatari Ekotoba* or *The Story of Priest Saigyō in Pictures and Words* details events in the life of a low-ranking nobleman, Sato Norikiyo (1118–1190), who early in his career established himself as a poet of great talent but decided at the age of twenty-three to resign his post and become a priest, taking the name Saigyō. He spent the rest of his life alternately stopping for short periods of time at temples to visit sites of religious importance near the capital, or traveling to distant regions in Japan, to the northern provinces of Honshu and to the island of Shikoku. Throughout his life he continued to compose poetry, prfeecting his skill at the craft, and at the same time to involve himself in the religious life of a wandering ascetic. He died in the middle of the second month of 1190 when the moon was full and the cherry trees in blossom. What made his life immediately remarkable to the laity and religious intelligentsia of the time was that in a poem written several years before his death he forecast correctly when this would occur, on the anniversary of the death and nirvana of the historical Buddha Sakyamuni.

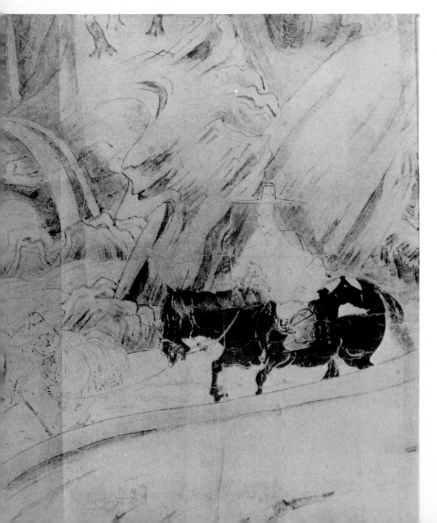

*3. The Nun and Her Companion,* Shigisan Engi Emaki *(detail)*. Chō-gosonshiji

**4.** *Mount Shigi Wreathed in Purple Clouds,* Shigisan Engi Emaki *(detail).*
Chōgosonshiji

| | |
|---|---|
| negawaku wa | Let it be this way: |
| hana no shita nite | Under the cherry blossoms, |
| haru shinan | A spring death, |
| sono kisaragi no | At that second month's midpoint |
| mochizuki no koro | When the moon is full.[15] |

*Sono kisaragi,* that second month, is a specific reference to the death seventeen centuries before of Sakyamuni, and the death in the third line of the poem is an allusion to his own future demise. It was felt by his contemporaries that if Saigyō's death paralleled that of Sakyamuni and that he had willed it to be so, there must also be other parallels between the two lives, including the achievement of enlightenment and nirvana. From this documentable link between Saigyō and Sakyamuni there developed the "life" of Priest Saigyō, based in large measure on events in the priest's own life but structured around the life of Sakyamuni. Thus the *Saigyō Monogatari Ekotoba,* probably the first version of his "life" to be produced, depicts the spiritual maturation of a real human being through prolonged contact with the natural world and the creation of poetry which would communicate to others

his view of the Buddha-nature of the cherry blossoms and the moon, the elements of nature in the midst of which he had lived.

Finally, the "life" of Saigyō was seen to have didactic value for later generations of Japanese. Not only was Saigyō able to echo some elements of the life of the historical Buddha, but he also was able to embody in his own existence attributes which the Japanese prized most highly, a life of self-denial and the creation of excellent poetry. Thus when the noblewoman known today as Lady Nijō, the author of a remarkably candid and detailed diary of her life as a court lady and later a nun, recalled her feelings at seeing a *Saigyō Monogatari Ekotoba* at the age of nine, she wrote:

> I remembered looking at a scroll when I was only nine years old called "Records of the Travels of Saigyō." It contained a particular scene where Saigyō, standing amid scattering cherry blossoms, with deep mountains off to one side and a river in front of him, composed this poem:
>
> > Winds scatter white blossoms,
> > Whitecaps breaking on rocks;
> > How difficult to cross
> > The mountain stream.
>
> I have envied Saigyō's life ever since, and although I could never endure a life of ascetic hardship, I wished that I could at least renounce this life and wander wherever my feet might lead me, learning to empathize with the dew under the blossoms and to express the resentment of the scattering autumn leaves, and make out of this a record of my travels that might live on after my death.[16]

Lady Nijō wrote the above passage in a section of her diary dealing with her life as a lady-in-waiting to the emperor, but clearly even then she saw in Saigyō's life a model for achieving spiritual quietude and recognition as a creative talent. Judging from the copies of the *emaki* and the text which were made in succeeding centuries, other Japanese too saw in Saigyō's life a paradigm for achieving religious salvation. Thus the *Saigyō Monogatari Ekotoba*, like the *Shigisan Engi Emaki*, is a tract on achieving enlightenment in this lifetime. The chief difference between the two works is that the older *emaki* had to appeal to its audience on two levels, first through awe-inspiring miracles and second through illustrations which conveyed a more complicated meaning than could be set forth in the text. The *Saigyō Monogatari Ekotoba* was intended for a better-educated audience, one which could appreciate the hardships and the strict self-discipline of his life but also the beauty and depth of his vision of nature expressed through his poetry.

The story was extremely popular and was reproduced in *emaki*, handwritten, and printed text versions. In all there are six different versions or *bon* detailing the life of Priest Saigyō:[17]

1. The *Saigyō Monogatari Ekotoba*. This earliest extant *emaki* version, dated to the first half of the thirteenth century, survives in incomplete form. Only two rolls of what was probably a four- or five-roll set are preserved today, the first in the collection of the Tokugawa Reimeikai, the second among the holdings of the Ohara family.

2. The *Saigyō Monogatari* of 1480, a work in three scrolls. The original composition of this text is thought to date to the late thirteenth or early fourteenth century.[18]

3. The *Saigyō Isshōgai Sōshi*, a work in six scrolls.

4. The *Saigyō Monogatari Emaki* by Kaida Uneme, which was copied twice by Sōtatsu around the year 1630. The text was published in printed form in the late seventeenth and early eighteenth centuries as the *Saigyō Shiki Monogatari*, a four-scroll work dealing with the events of Saigyō's life in the four seasons.

5. A printed *Saigyō Monogatari* in three scrolls published in the late seventeenth and early eighteenth centuries. This work bears a close relationship to a recently discovered *emaki* belonging to the Kubo family of Osaka and dated to the fourteenth or fifteenth century.[19]

6. The *Saigyō Shōnin Hosshinki*, a work very similar to the fifth version.

Thus even though we lack the greater part of the original *Ekotoba*, the events of Saigyō's life and the general structure of the narrative can be adduced through the other versions of the tale.

The first scroll of the original *Saigyō Monogatari Ekotoba* lacks at least one passage of text, and the illustrations have become disordered, but the basic elements of the story are well known. Sato Norikiyo, Saigyō's name before he became a priest, and another courtier, Noriyasu, decide that they want to leave the service of the retired emperor Toba and devote themselves to a life in religion. On the day they are to go together to petition the retired emperor, Norikiyo arrives at Noriyasu's house to find that his friend has died suddenly during the night. This graphic proof of the ephemeral nature of human existence strengthens Norikiyo's arguments; permission is granted, and he returns home to inform his family of his decision. He has a daughter of four whom he loves very much and who clings to him begging him not to leave, but in order to achieve enlightenment according to the Buddhist view of life, one must renounce all ties with the secular world. Desire for material possessions must be curbed, and ties of affection to other human beings must be broken. Consequently, Norikiyo takes the strongest and probably the most difficult step he could: he kicks the child off the veranda, then spends the night convincing his wife of the firmness of his resolve to leave her.

Research on Saigyō's life suggests that some of these opening episodes may be fictitious. About the death of his friend Noriyasu there is no record. Also it seems likely that Saigyō was not married but had a common-law wife by whom he had a son, later to become a priest himself.[20] The reason for this fictionalization of the details of Saigyō's life lies in the need felt by the author to extend the connection between Saigyō and the historical Buddha Sakyamuni beyond the concurrence of their death dates. Thus in the "life" of Saigyō, the courtier is turned toward religion through the sight of a dead man; Sakyamuni had actually seen four different stages of life which caused him to renounce the world: a sick man, an old man, a dead man, and an ascetic. Nevertheless for those familiar with the life of the historical Buddha, it was necessary only to suggest the pattern of experience which led both men to renounce the world. As for the rejection of wife and child, this too parallels the life of the historical Buddha, who crept away in the middle of the night leaving behind his wife and his son Rahula. After these early fabrications the "life" of Saigyō adheres closely to the events experienced by the priest, while structuring them in such a way as to suggest his spiritual maturation.

In the *Ekotoba* the first scene to show Saigyō in close contact with the natural world is the third illustration in the Ohara scroll. The text begins as follows:

Since I have become a priest and entered the path indicated by the Bodhisattva

precepts, wishing to repent for the evils I have already committed, I think of what I have continually done and find that my deeds are all of the three unpleasant realms. My good thoughts are few and my evil thoughts are many. Evil deeds are a millstone, repentance a vessel. Though the weight of my evil deeds is heavy, I will place them in the vessel of remorse, and experiencing the cessation of evil passions, I must surely reach the shore of Buddhahood. I throw my body of repentance on the ground and single-mindedly intone the *nembutsu.*[21]

After reciting a Chinese poem Saigyō looks at a swiftly rushing river which he must cross in order to reach Mount Yoshino. His thoughts drift back to his visits to Yoshino when he was still in the court, riding on horseback in an assembly of noblemen clad in elegant costumes. Then he looks ahead and realizes that no one has yet journeyed here this spring, and that by crossing the river and climbing the mountain he will be able to see Yoshino as he has never seen it before, untouched by other human presences.

| | |
|---|---|
| dare ga mata | No one has yet |
| hana o tazunete | Visited the blossoms at |
| Yoshino yama | Mount Yoshino, |
| koke fumiwakuru | Trampled through the moss |
| iwa tsuta furan | Disturbed the ivy on the rocks.[22] |

The moment is significant, for it is Saigyō's first step along the path to Buddhahood, and its importance is reinforced by the parallel between the water imagery in the prose introduction and the rushing river which Saigyō must cross to attain his immediate goal. The past, however, is still with him, and it is only when he has exhausted his memories of previous visits to Mount Yoshino that he realizes he is being permitted a whole new view of a part of the natural world he has always loved. The text ends with the poem:

| | |
|---|---|
| Yoshino yama | "He'll return," they think, |
| yagate ideji to | "When the blossoms all are fallen," |
| omou mi o | But he they wait for |
| hana chirinaba to | Himself is thinking now that he'll |
| hite ya matsuran | Never leave Mount Yoshino.[23] |

The accompanying illustration is a long one depicting Saigyō twice, at first walking rather jauntily leftward along a wide path leading to the foothills of the mountain, and later, having crossed the Yoshino River, walking more deliberately, the lower half of his body obscured by mountain forms (figs. 5, 6). There is an additional narrative element present in the text but not in the illustration: When Saigyō reaches the cherry trees on one side of the mountain he discovers that their branches are still covered with snow, and the trees have not yet begun to flower. Remembering that they bloom first on the east side of the mountain, he continues around until he reaches his ultimate goal, the cherry blossoms as yet unviewed by other human beings.

Unfortunately the remaining illustrations in the Ohara scroll do not indicate great spiritual maturation on Saigyō's part. In the next section he prays at the Shinto shrine of Yagami Oji where the cherry blossoms are in full bloom. Then he meets a group of itinerant priests like himself, and they travel together for a while toward Mount Omine. At one point along the way Saigyō has a dream that his friends in the capital lament his absence, missing the pleasure of his poetic talents

*5. Saigyō Walking Toward Yoshino,* Saigyō Monogatari Ekotoba *(detail). Ohara Collection. Reproduced from a facsimile scroll published by Yamato-e Dōkōkai, Tokyo, 1927*

*6. Saigyō Having Crossed the Yoshino River,* Saigyō Monogatari Ekotoba *(detail). Ohara Collection*

in their midst. It is clear that Saigyō has still not shed the past, for he takes the time to write a poem and send it back to Kyoto.

Turning to the Kubobon version of the *Saigyō Monogatari Emaki* for further information on the content of the narrative (see above, 5), we find no mention of Saigyō's first crossing over the Yoshino River to begin his pilgrimage. Rather the emphasis is shifted to a trip he made in 1186 to the northern provinces at the request of Abbot Chōgen of Tōdaiji to solicit gold for the regilding of the Great Buddha.[24] This journey to the north begins, as did his trip to Yoshino, with the difficult crossing of a river, the Tenryūgawa, followed by a scene in which he visits a Shinto shrine at Saya no Nakayama. The meaning of the place name is perhaps more important than the scene itself. *Nakayama* means deep in the mountains, and *saya*, the dead of night. The poem accompanying this sequence combines a sense of increasing age with the image of the soul in the darkest night passing through a mountain wilderness.

| | |
|---|---|
| toshi takete | Little did I guess |
| mata koyubeshi to | I'd ever pass either so many |
| omoiki ya | Years . . . or this mountain |
| inochi narikeri | Again in one, now long, life: |
| Saya-no-naka yama | Over Mount Dead-o'-Night![25] |

A poem included in the text of a later scene in the second Kubo scroll suggests that Saigyō recognizes the shallowness of his earlier life and the spiritual progress he has made since becoming a priest.

| | |
|---|---|
| miyako nite | Back in the capital |
| tsuki o aware to | We gazed at the moon, calling |
| omoishi wa | Our feelings "deep"— |
| kazu ni mo aranu | Mere shallow diversions |
| susabi narikeri | That here don't count at all.[26] |

Ultimately Saigyō returns to Kyoto, visits an old friend, but quickly moves away from the center of the city to a simple hut in Ohara where he awaits his death in a state of enlightenment. It is in this last passage of text from the Kubo version that the famous death-predicting poem is included and his final request.

| | |
|---|---|
| hotoke ni wa | When gone in death, |
| sakura no hana o | I'll have cherry blossoms |
| tatematsure | As your rite for me . . . |
| waga nochi no yo o | If any wishes to make memorial here |
| hito toburawaba | For me in my life over there.[27] |

The accompanying prose in the Kubobon passage is somewhat at variance with what we might have expected in that it has strong overtones of Amidism, which was not the basic orientation of Saigyō's religious thinking. This is also true of the closing passage of the text version of 1480 (see above, 2). Apparently under the influence of the Amidist sects in the fourteenth century, this new element was added to the account of Saigyō's life. It is regrettable that more of the original scroll set does not exist because one suspects that it might have contained a simpler, more symbolic account of Saigyō's development and an ending true to his own Shingon beliefs. Nevertheless it is clear that the *Saigyō Monogatari Ekotoba* was created as an illustrated tract on the achievement of enlightenment, not through the performance of rituals or acts of magic, but through an existence which permitted the

soul to attune itself to the natural world and to discipline itself through the act of creating poetry, communicating to others the individual's developing understanding of nature.

Although, as has been noted above, numerous versions of the *Saigyō Monogatari* were produced in later centuries, the theme of salvation through contact with nature was not given new expression in *emaki* primarily because the emphasis in religious scrolls shifted to Amidism and to a preference for more literal priest biographies. However, in the first half of the seventeenth century, the idea resurfaces in an *emaki* called *Oguri*, which combines the recitation text prepared for a *kojōruri* or old-style puppet play with illustrations which draw on the classical traditions of twelfth- and thirteenth-century narrative painting. This *emaki* is one of six sets which were produced in Kyoto and Echizen by a school of artists traditionally associated with Iwasa Matabei (1578–c. 1650). Little is known about Matabei's professional life besides the facts that he was active in Kyoto until 1615, when he moved to Echizen to serve the daimyo Matsudaira Tadanao and his son, and that approximately twenty years later he left for Edo, modern-day Tokyo, where he died about 1650. Five of the six scrolls—the *Jōruri* and the *Yamanaka Tokiwa Emaki* now in the Kyūsei Atami Art Museum; two versions of the *Horie Monogatari*, one in the Kyūsei Atami Art Museum, the other in a private collection; and the *Oguri*, a fifteen-scroll work—have been studied by the Japanese art historian Tsuji Nobuo, who judges them to be works of the Kan'ei era (1624–44) by three or four different artists, the most talented of the school having executed the *Yamanaka Tokiwa* and one version of the *Horie Monogatari*.[28] The sixth *emaki* in the group, the *Muramatsu Sōshi Emaki*, recently came to light in an incomplete form in the Chester Beatty Library in Dublin, Ireland.

An element common to most of these *kojōruri emaki* is the *michiyuki* or journey, in which a character leaves his familiar abode and walks through villages, over mountains, and across streams in order to reach a particular goal. One of the most moving of these episodes occurs in the *Yamanaka Tokiwa Emaki* in which Tokiwa, the mother of the famous military hero Minamoto Yoshitsune, is worried about the fate of her son who is being sought by the rival Taira clan, and decides to journey to the stronghold of Fujiwara Hidehira at Hiraizumi to see him again. Tokiwa and her maid Shishu start out when the plum trees begin to bloom, signaling the end of the harshness of winter. Text passages which had been very long become quite short and are written in vertical lines at the top of the scroll so as not to interrupt the leftward flow of the illustration symbolizing the temporal and physical progress of the two women. The journey begins with the lines:

> Finally the two women, both in tears, left the Palace in the Purple Field where they had lived so long.
>
> · · · · ·
>
> Arriving at Awataguchi, the gateway on their journey to visit their dear and noble Ushiwaka [Yoshitsune], they were happy. [*Awata* is a variant of *au*, to meet, and *guchi* means entryway; thus the place name seems to forecast the success of their journey.] (fig. 7)
>
> · · · · ·
>
> Approaching Surihari Pass, they looked back to the south. The capital was still close and the far-off province toward which they were hurrying was not visible in the landscape before them.[29] (fig. 8)

7. *Awataguchi*, Yamanaka Tokiwa Emaki *(detail)*. *Kyūsei Atami Art Museum*

8. *Surihari*, Yamanaka Tokiwa Emaki *(detail)*. *Kyūsei Atami Art Museum*

8

The journey continues with passages such as those cited above and finally the two women reach a place called Yamanaka where they stop for several days. Lady Tokiwa becomes ill, and word gets around that a wealthy noblewoman with expensive clothes is staying at the inn. One night a band of robbers breaks into Tokiwa and Shishu's room, and strips and kills them both. Ultimately Yoshitsune learns of his mother's fate, kills the robbers, and rewards the innkeeper who had built a tomb memorial for the two women.

Clearly the passage through the wilderness in the *Yamanaka Tokiwa Emaki* does not lead to the maturation of the soul or to salvation. Instead it serves to distance the women from their familiar environment and to make them much more vulnerable to attack than they otherwise would have been. However, in the *Oguri* the *michiyuki* or journey serves a very different function. It depicts the return to life of a murdered warrior through a long journey in the wilderness and an immersion in the hot springs of the holy site of Kumano. It is in essence a resurfacing of the theme of salvation through contact with nature, but the way in which the theme is treated reveals a great deal about changes in Japanese spiritual values.

The story, like the *Yamanaka Tokiwa*, deals with love and revenge, but the plot is much more complicated. Oguri is a child born in response to the prayers of his father to Bishamonten at the temple of Kuramadera, but though he has been carefully raised, he behaves in an unfilial way, first rejecting seventy-two different women his father puts forward as prospective brides and finally keeping company with the dragon of Mizoro Pond, who has disguised herself as a beautiful young girl. His father, enraged, orders him exiled to the far-off province of Hitachi. There he hears of the beautiful Terute, daughter of her Yokoyama, a strong warrior clan. The two exchange letters, fall in love, and in spite of the fact that Oguri has been warned not to ignore the wishes of the family, he abducts Terute and marries her. Because Terute's father has not given his permission for this match, he vows to kill Oguri and all his men. Various means are tried, including asking Oguri to ride Onikage, a man-killing horse. Finally at the suggestion of his third son, Saburō, Yokoyama poisons Oguri and all his men and commands the murder of his delinquent daughter Terute. The sons sent to drown her cannot bring themselves to do it and set her wicker cage free and unweighted on the surface of a river. She is washed up on the further shore and eventually sold to the Yorozuya, a house of prostitution in Mino Province. Out of loyalty to her husband Oguri she refuses to service the inn's customers, and is forced to do all the kitchen work for the inn. Meanwhile Emma, the chief judge of Hell, is persuaded by Oguri's men to try to help them and Oguri return to life and avenge themselves. Investigation reveals that the retainers have been cremated and cannot be resuscitated, but Oguri has merely been buried in a shallow grave:

> "If that is the case I will return the one person Oguri," wrote Emma with his own brush. "Turn this person over to the itinerant priest Meitō, the disciple of the holy man Fujizawa. Take him to the summit of the hot springs of the Main Shrine at Kumano. If you place him in the hot springs of the Main Shrine at Kumano, you will receive medicinal hot spring water from Paradise," wrote Emma himself. With his stick called "Ninwajō," he struck the empty air with a menacing glare and—Heavens, what a difficult thing to do!—Oguri's grave, built three years ago, exploded in all directions. The wooden grave marker fell forward with a splat and a flock of crows laughed. (fig. 9)

The holy man Fujizawa was off to the south but a lone man in Uwanogahara

*9. Oguri Emerging from His Grave, Oguri Emaki (detail)*

hearing the laughter of kites and crows went closer and looked. "My God! How pitiful! Lord Oguri!" His hair was disordered, his legs and arms as thin as thread, his stomach like a ball of yarn. He crawled this way and that. He thrust both arms up as if to write something. What he wrote, "The third month in the wind," perhaps should be understood to mean that his six senses were disordered. In any case it was the Oguri of old. The man, thinking that it was important to keep this fact from the Yokoyama clan, gathered up Oguri's hair and cut it. Because this creature looked so much like a hungry ghost, he named it Gaki Amida Bu, the Hungry Ghost Amida Buddha.

When the holy man Fujizawa read the note Emma had written, he decided to add a message of his own.

"If you pull this person once you will receive the prayers of one thousand priests. If you pull him twice the prayers of ten thousand priests." He ordered his followers to make a cart like that for carrying the sick and place the Gaki Ami [the Gaki Amida Bu] in it. They attached a pair of two-thong ropes. Everyone, even the holy man, took the ropes in hand and with a cry of "ei sara ei" began to pull.[30]

The text above is coordinated with short scenes in which groups of figures hover around Oguri's misshapen body. Once the holy man and his entourage begin to pull the cart, the quality of the text and illustrations changes to that characteristic of the *michiyuki*, with one significant variation: the figures move to the right instead of to the left, as is normal in *emaki* illustration (fig. 10). Because a horizontal narrative scroll must be rolled and unrolled moving from right to left, the depiction of action moving rightward "against the grain" tends to slow the pace of the narrative and gives the story an episodic quality. Every instinct tells us this is the wrong way to treat an illustration of a journey. However from the viewpoint of the narrative content, even though Oguri is experiencing the passage of time which in a scroll is a leftward movement, he is also returning from the dead, the end of finite human time and space, which might well be symbolized by movement to the right.

The holy man and his friends pull the cart for days until, after passing Mount
Fuji, they leave the Hungry Ghost Buddha at the Shinto shrine of Sengen in Fuji no miya. There a pilgrim and his family decide to pull the cart as they return home. It is they who pull Oguri through Sayo no Nakayama, the same mountain pass visited by Saigyō (figs. 11, 12).

The moon rose, Sayo no Nakayama.
By day they crossed Nissaka [sun descending] Pass.
Because the rain was falling in great rivulets, the road was bad.[31]

The pilgrim finally leaves the Hungry Ghost Buddha in the yard of the Yorozuya in Mino, where Terute is living. For three days the cart remains in the yard, and finally Terute, hoping to gain merit for her dead Oguri and his men, decides to pull the cart. Gaining the permission of her master, she sets out disguised as a crazy woman, because it is dangerous for a beautiful girl to travel alone, stopping at country inns (fig. 13). She pulls the cart for several days and on the last night sleeps with her head pillowed on the shafts of the Gaki Ami's cart as if realizing intuitively that this misshapen creature is her husband. Others wishing to gain merit for pulling the cart continue the journey through the mountains until at last the

*10. The Holy Man Fujizawa Pulling the Gaki Ami,* Oguri Emaki *(detail)*

11

12

13

Gaki Ami reaches Kyoto. He is pulled through the grounds of the temple of Tōji in
the southern part of the city, past the three Shinto shrines within the grounds, and
then toward Toba. In the passage following the depiction of Tōji temple, reference
is made to the Karukaya of Toba, a tomb built by the priest Mongaku to mourn
his beloved, another man's wife whom he had accidentally killed (figs. 14, 15).

14

*14. Karukaya Tomb
and the Mountains of
Autumn,* Oguri Ema-
ki *(detail)*

*15. The Katsura River,*
Oguri Emaki *(detail)*

15

16. *The Gaki Ami Abandoned at Mount Kumano*, Oguri Emaki *(detail)*

17. *Oguri Restored to Normal*, Oguri Emaki *(detail)*

17

The Karukaya of Toba.
The mountains of autumn.
Making the moonlight their lodging for the night
With an "ei sara ei" they pulled the cart across the Katsura River.[32]

At this point the direction of action reverses itself, and the figures are depicted moving to the left. The cart finally reaches the base of the Kumano mountains, but the path is too steep, and the people pulling the Gaki Ami are forced to abandon him (fig. 16). However, a group of itinerant priests soon come along and carry the Hungry Ghost Buddha on their backs to the hot springs at the top of the mountain. There in forty-nine days, after a wilderness journey of some four hundred and forty-four days, Oguri is restored to his human form (fig. 17).

There is little in this *michiyuki* to suggest the maturation of a human soul. The Hungry Ghost Buddha does not change shape; he does not seem to react to the environment. He remains throughout an inert and subhuman being, incapable of effecting his own salvation without the help of others. However, Oguri's change of character is revealed by two elements. The first is the fact that the reversal of the direction in which the figures move occurs when the Gaki Ami passes the Karukaya tomb, a monument to the love of a man for the woman he had accidentally killed. Oguri, by violating local customs and marrying Terute without her father's consent, had endangered her life. But for the kind hearts of her brothers, Terute would have been drowned. At the moment when Oguri is in front of the tomb, his passage ceases to be a return from the dead and becomes a movement toward rebirth. The second element is Oguri's temperateness, his newly acquired forgiving nature. After his stay at the shrine of Kumano he visits his family and forgives them for disinheriting him. He next goes to Mino, a fiefdom granted him by the emperor, and meets Terute again at the Yorozuya. At first he wants to kill the master of the inn for treating the beautiful young woman so harshly, but he accedes to her pleas on the master's behalf. He next decides to punish Terute's father for poisoning him and his men, but again Terute is able to persuade him to desist. The father in gratitude sends him ten horses loaded with gold, the man-eating horse Onikage which Oguri had tamed, and the third son, Saburō, who was responsible for the plan to poison Oguri and his men. Oguri responds to his father-in-law by saying:

"Repay a favor with a favor, revenge with revenge. As for the gold on the ten horses, though I am by nature an acquisitive person, I do not need it." He built a golden worship hall and temple. He made an image in black lacquer of Onikage and worshiped it as the Horse-headed Kannon. . . . When others asked "Why this too?" Oguri, saying it was because of Saburō's deeds, rolled him in a rough mat and put him in the Western Sea. Oguri eloquently demonstrated that he had learned what it meant to live a temperate life.[33]

The *Oguri Emaki* can hardly be said to be a tract on achieving enlightenment through contact with nature, but the climate of the times had changed considerably since the twelfth and thirteenth centuries. With the institutionalization of feudalism it was no longer possible to believe in the ability of a human being to affect his own destiny. The highest value in life was no longer found in achieving enlightenment and nirvana but instead in functioning within the social system. Oguri did not do this. He flouted his father's wishes and the customs which prevailed in his place of exile. His punishment was severe, and the time his soul required to reorient itself was lengthy. We may not feel that his final statement, "Repay a favor with a favor, revenge with revenge . . .," reflects the highest ideals of Buddhist

enlightenment. It does not. It is an expression of the code of behavior appropriate for a warrior, and it symbolizes Oguri's acceptance of his responsibility within the social system. Nevertheless, in spite of the enormous change in values which occurred between the creation of the *Shigisan Engi Emaki* and the *Saigyō Monogatari Ekotoba* in the twelfth and thirteenth centuries and the *Oguri Emaki* in the seventeenth, one idea remained constant in Japanese thought and found expression in narrative painting: the belief in the power of the natural world to exert an effect on mankind, to help him achieve a deeper insight into the nature of human existence.

*Florida State University, Tallahassee*

## Notes

[1] Yoshito S. Hakeda, *Kūkai: Major Works*, New York, 1972, 225–34.

[2] Hakeda, *Kūkai: Major Works*, 151.

[3] The following discussion is based primarily on the research presented in William R. LaFleur, *Saigyō the Priest and His Poetry of Reclusion: A Buddhist Valorization of Nature in Twelfth-century Japan*, unpublished Ph.D. dissertation, University of Chicago, 1973, 212–35.

[4] Sawa Taka'aki, *Shigisan Engi Emaki*, Nihon Emaki Taisei, IV, Tokyo, 1977, 138–39.

[5] Donald Keene, *Anthology of Japanese Literature*, New York, 1955, 218. The text of the extant *emaki* may be found in Kadokawa Shōten Henshōbu, *Shigisan Engi Emaki*, Shinshū Nihon Emakimono Zenshū, III, Tokyo, 1976, 54–60.

[6] Keene, *Anthology*, 219.

[7] Keene, *Anthology*, 219–20.

[8] Keene, *Anthology*, 220.

[9] Keene, *Anthology*, 221.

[10] Keene, *Anthology*, 222.

[11] Kobayashi Taichirō, "Shigisan Engi no Bunseki: Hiite Sono Etoki no Kokoromi," *Bukkyō Geijutsu*, L, 1962, 91–92.

[12] Keene, *Anthology*, 222.

[13] LaFleur, *Saigyō the Priest*, 217, and Mikkyō Bunka Kenkyū Jo, *Kōbō Daishi Zenshū*, Koyasan, 1965–68, II, 37.

[14] Keene, *Anthology*, 223.

[15] William R. LaFleur, *Mirror for the Moon: A Selection of Poems by Saigyō (1118–1190)*, New York, 1978, 7.

[16] Karen Brazell, *Confessions of Lady Nijō*, New York, 1973, 52.

[17] Miya Tsugio, "Kenkyū Shiryō: Saigyō Monogatari Emaki," *Bijutsu Kenkyū*, CCLXXXI, 1972, 19.

[18] William R. LaFleur, "The Death and 'Lives' of the Poet Monk Saigyō," in Frank Reynolds and Donald Kapps, *The Biographical Process: Studies in the History and Psychology of Religion*, The Hague, 1977, 344.

[19] Miya, "Kenkyū Shiryō: Saigyō Monogatari Emaki," 19–41.

[20] Kubota Shōichirō, *Saigyō no Kenkyū*, Tokyo, 1961, 99–101.

[21] Translations unless otherwise noted are my own. The original text appears in Kadokawa Shōten Henshōbu, *Saigyō Monogatari Emaki; Taema Mandara Engi*, Shinshū Nihon Emakimono Zenshū, Tokyo, 1977, 44.

[22] Kadokawa, *Saigyō Monogatari Emaki*, 44.

[23] LaFleur, *Mirror for the Moon*, 51.

[24] Kubota, *Saigyō no Kenkyū*, 347.

[25] LaFleur, *Mirror for the Moon*, 87.

[26] LaFleur, *Mirror for the Moon*, 20. This poem has two versions: one is Poem 460 in the *Sankushū*, Nihon kolen Zensho, XLII, Tokyo, 1957, 80; the other is in the Kubo text of the *Saigyō Monogatari Emaki*, published in Miya, "Kenkyū Shinyō: Saigyō Monogatari Emaki," 33, and as Poem 937 in the *Shinkakinshū*, Nihon kolen Zensho, XLIV, Tokyo, 1959, 215. I cite the latter transliteration rather than that reproduced in LaFleur, *Mirror for the Moon*.

[27] LaFleur, *Mirror for the Moon*, 7.

[28] Tsuji Nobuo, "'Matabei-fu' Shosaku-hin no Kentō," *Bijutsu Shi*, XLII, 1961, 34–57.

[29] Author's translation of the calligraphy of the scroll text.

[30] Muroki Yatarō, *Sekkyōshū*, Tokyo, 1977, 270–73. The translations of this *kojōruri* text are my own, but I would like to acknowledge my debt to Frank Hoff of the University of Toronto, who made available to me his partial translation of *Oguri*.

[31] Muroki, *Sekkyōshū*, 274.

[32] Muroki, *Sekkyōshū*, 281.

[33] Muroki, *Sekkyōshū*, 297.

# 6

# *A Florentine* Scrittoio *for Diomede Carafa**

EVE BORSOOK

Throughout the last quarter of the fifteenth century, the rulers of Naples were oriented toward Florentine taste and craftsmen in the furnishing and design of their palaces, villas, and chapels. Instrumental in this was the Strozzi bank in Naples; not only did it import Florentine work of all kinds but on occasion brought down the artists themselves to the city.[1] Usually, this state of artistic affairs is associated with the late 1480s, when Giuliano da Maiano was involved with the royal villa at Poggioreale while his brother, Benedetto, supplied sculpture for two chapels at Monteoliveto.[2] To this period too belongs Giuliano da Sangallo's Palazzo dei Tribunali.[3] Actually, the Neapolitan connections with these and other Florentine artists began much earlier and usually through the agency of the Strozzi. Take the case of Giuliano da Maiano. It was the Strozzi who first introduced his work to Naples. Giuliano's earliest known commission was for Filippo Strozzi's brother-in-law, Marco Parenti, who in 1451 had already commissioned from the nineteen-year-old artist a wooden tabernacle "*all'anticha*."[4] It was painted by Masaccio's stepbrother, "Scheggia,"[5] and was to contain a *Madonna* to go in Marco Parenti's bedroom. In 1466 Filippo Strozzi had Giuliano make an intarsiaed chest for his personal use.[6] Soon afterward Filippo began ordering works by the Da Maiano brothers for Neapolitan clients. Among the earliest of these was Diomede Carafa, the newly created Count of Maddaloni, a staunch member of the Neapolitan court, collector of antiquities, and friend of Lorenzo de' Medici.

By 1466, Diomede Carafa had completed the renovation of his palace, which still stands at No. 121 Via San Biagio dei Librai.[7] According to Roberto Pane, it is the earliest Neapolitan example of domestic architecture in the Tuscan Renaissance style. Its tame rustication and classical window frames mildly recall Florentine palaces such as those recently completed for the Rucellai and Medici.[8] Carafa had a famous collection of antiquities including forty-odd marble statues, some of which adorned the main entrance: imperial busts were set at either end of the lintel and a niche at the center once contained a figure of Venus.[9] As for the furnishing of the palace interior, what little is known all concerned Florentines—several of whom were procured by the Strozzi. During 1467, Giuliano da Maiano made a "*lettuccio*," a throne-like bench, for Diomede at the cost of twenty-five florins.[10] Six years later, the king of Naples ordered a far more elaborate "*lettuccio*," this time from Giuliano's brother Benedetto—again via the Strozzi and Marco Parenti—at a cost of 150 florins.[11]

At about the same time he ordered his *lettuccio*, Diomede Carafa must have initiated a more ambitious project. He asked the Strozzi to obtain a painted copy of Piero de' Medici's *scrittoio* in Florence which had been completed about ten years earlier.[12] Perhaps Vasari had Diomede in mind when he wrote in his biography of Luca della Robbia, that throughout Italy and Europe Florentine merchants were kept busy trying to supply their clients with the same kind of decorations which had made Piero's room famous.[13] Knowledge of the *scrittoio* must have reached Diomede either through the Strozzi or distinguished visitors to the Medici Palace. A letter written on July 20, 1465, by Piero de' Medici to Filippo Strozzi in Naples reported on the recent visit of the duchess of Calabria, whose husband was a friend of Diomede Carafa and godfather to Strozzi's first-born son.[14] At the same time, Piero announced his intention of sending his son Lorenzo to visit King Ferrante in Naples. Written accounts of the *scrittoio* are known in verses of 1459 and in Filarete's treatise, finished in 1464.[15] What we know of Piero de' Medici's gaudy, slightly old-fashioned taste[16] perfectly coincides with Neapolitan esthetic inclinations.

To see what Carafa had in mind, one must briefly summarize what is known of Piero's *scrittoio*, which was demolished soon after 1659 when the ownership of the Medici Palace changed hands.[17] It was a small, windowless room, about four by five and one-half meters, used as a private treasury for the Medici collection of gems, coins, books, and vases.[18] The Robbia-ware which, according to Vasari, covered its floor and ceiling must have brightened what would otherwise have been a very gloomy interior. All that now remains are Luca della Robbia's roundels of the *Labors of the Months* in the Victoria and Albert Museum in London.[19] These once belonged in the vaulted ceiling. The theme of time and the seasons had already been used in a study built in the palace of Belfiore for Leonello d'Este, another great collector of gems and coins.[20] That the Medici were well aware of D'Este precedents in Ferrara is borne out by a letter to Piero of 1451 referring to the carpenters he sought to obtain from Belriguardo, another D'Este residence, for a ceiling in the new family palace in Florence.[21] Evidently, the seasons, or time, belonged to a fixed program for humanist *scrittoii*, because they were used again a century later in Francesco I de' Medici's *Studiolo* in the Palazzo Vecchio, which in form and function resembled its lost quattrocento prototype in the Medici Palace on the Via Larga.[22]

Besides the Robbia-ware, Piero's *scrittoio* had intarsiaed panels arranged in perspective compositions which illusionistically enlarged the room.[23] These evidently inspired the decorations of Federigo da Montefeltro's *studioli* at Urbino and Gubbio, carried out during the 1470s.[24] The structure of Piero's study probably served as the model for Federigo's so-called "*Tempietto delle Muse*"—a room situated between the chapel and the intarsiaed study at Urbino.[25] It may be that this vaulted, coffered, and richly inlaid room is the closest thing we have to Piero's lost *scrittoio*. As for Diomede Carafa's, a copy was made of the Medicean decor by an unnamed painter who carried out the work on sheets of paper ("*dipintura in su fogli del'asenpro*").[26] On March 10, 1468, this artist was paid two florins for the job, which also included a copy of the blue and gold "*palcho*" in a room near the *scrittoio* of which today a few traces survive.[27] The only other known decorations in Diomede's palace involved two minor Florentine painters, Piero and Ippolito Donzelli, who also worked at Poggioreale.[28]

Like many other Neapolitans, Diomede Carafa evidently shared Piero de' Medici's love of glazed terracotta ornament. Not only Piero's private study but also

the tabernacles which he had Michelozzo build during the 1440s in SS. Annunziata and San Miniato al Monte are lined with Robbia-ware. It was not by chance that the two chapels at Monteoliveto in Naples were based upon the Cardinal of Portugal's Chapel at San Miniato in Florence, finished during 1468[29] in the same rich, polychromed style—including a Robbia-ware vault—which characterized so many of Piero de' Medici's commissions. In Naples, maiolica pavements had been common throughout the fourteenth and fifteenth centuries. But until the advent of the Florentines, most of the best work had been imported from Spain.[30] Fragments of a Valencian pavement were found in Diomede's palace, but judging from the mottoes it predates his remodeling of the building.[31] Whether Diomede's *scrittoio* would have included either genuine Robbia-ware or local imitations is unknown, but certainly his *scrittoio* project marks the beginning of the fashion for such Florentine decorations in Naples. His friend the duke of Calabria is said to have had Luca della Robbia supply for his younger brother a tomb made of marble sculpture and glazed terracotta[32]—a combination reminiscent of Luca's Federighi Tomb now in Santa Trinita. In the spring of 1485, the duke of Calabria brought Giuliano da Maiano to Naples for an unspecified project.[33] Tradition has it that at just this time, the duke had a *scrittoio* of his own made by Benedetto da Maiano.[34] By then, glazed terracotta tiles were imported in great quantities from Florence for the pavements of Castelnuovo and Castelcapuana, and more were subsequently made for Poggioreale and the floor of the Terranuova Chapel at Monteoliveto.[35] Among the Neapolitans, such work came to be called "*ala usanza fiorentina.*"[36]

Diomede Carafa's connections with Medicean Florence involved not only matters of mutual artistic interest, but also of personal friendship which may have sprung from the latter. In 1471, he received as a present from Lorenzo de' Medici the magnificent ancient bronze horse's head that is now in the Museo Nazionale at Naples.[37] It was given a place of honor in the courtyard of Diomede's palace where it could be seen on top of a column to the right as one entered.[38] This is how Diomede described its installation in a thank-you letter to Lorenzo of July 12: ". . .*llo ben locato in la mia casa dove se vede da omne canto certificandove che non solo del Vostro Signoria ad me ne starà memoria, ma ad mei filliolj . . .*"[39] Lorenzo must have sent this bronze shortly before his departure as the leader of a Florentine embassy to Rome which congratulated the new pope, Sixtus IV.[40] It was during this visit that he acquired some of the greatest antique treasures, such as the Tazza Farnese and other cameos which were to be added to the *scrittoio* built for his father.[41] It is unknown what motives there might have been which enabled Lorenzo to part with the bronze horse's head. For centuries it was often attributed to Donatello—perhaps due to an unconscious recollection of the original location of Donatello's bronze *David* in the courtyard of the Medici Palace.[42] Altogether, the case of Diomede Carafa and his *scrittoio* raises the question of how much Naples was in his and the Strozzi's debt for the introduction of the Renaissance style to the city.

*Florence, Italy*

*Documents*  1. Florence, Archivio di Stato, *Strozziane V, 17 bis*, Ricordanze di Marco Parenti, c. 28v.

<center>MCCCC°LI</center>

1° tabernacholo di legname all'anticha per 1ª Vergine Maria per la chamera mia, alto braccia 3½ de' dare adì xiiii° di luglio per detto tabernacholo lire sedici soldi x pagai a Giuliano da Maiano legnaiuolo per fattura del legname ____ fiorini ____ lire xvi, soldi x denari ____

E de' dare adì xviiii° di luglio lire una die a Giovanni vocato Scheggia dipintore che la amettere denari i quali mi chiese per la inchollatura ____ lire l.

E adì xxvi detto fiorini due larghi dia allo Scheggia sopradetto, i quali mi chiese per oro ____ fiorini ____ lire viiii° soldi xii

E adì v agosto fiorini iiii° i quali pagai allo Scheggia sopradetto che mi chiese per chomperare azurro ____ fiorini ____ lire lª soldi ii denari ____

E adì detto lire tredici pagai a Giovanni vocato Scheggia dipintore per resto di mettitura d'oro e dipintura del sopradetto tabernacholo ____ fiorini ____ lire xiii soldi ____

<center>0. 41. 4. 0</center>

2. Florence, Archivio di Stato, *Strozziane V, 17*, c. 149v (1467–Filippo e Lorenzo Strozzi di Napoli):

E adì [March 10, 1468, st. c.] fiorini ii paghati a uno mio dipintore per dipintura in su fogli del' asenpro del palcho dela sala e scrittoio di Piero, domandai e detti per lo signore Conte di Matalone ebbe contanti a cassa in questo, c. 145 ____ fiorini 2.

*Notes*

\* I have been unable to incorporate relevant information from Wolfgang Liebenwein, *Studiolo: Die Entstehung eines Raumtyps und seine Entwicklung bis um 1600*, Berlin, 1977, which was published after my essay had been sent to press.

1 Eve Borsook, "Documenti relativi alle Cappelle di Lecceto e delle Selve di Filippo Strozzi," *Antichità viva*, IX, 3 (May–June 1970), 3–4, 9, 13 (nn. 111, 112), 14 (docs. 2–12), 15, 17–18. The latter two items refer to Antonio Rossellino's visit to Naples in the spring of 1477. *Idem*, "Documents for Filippo Strozzi's Chapel in Santa Maria Novella and other related Papers," *Burlington Magazine*, CXII (1970), 742–43.

2 George L. Hersey, *Alfonso II and the Artistic Renewal of Naples 1485–1495*, New Haven–London, 1969, 2, 50 ff., 60 ff., 109 ff.

3 *Ibid.*, 75 ff., and C. von Fabriczy, "Toscanische und oberitalienische Künstler in Diensten der Aragonezen zu Neapel," *Repertorium für Kunstwissenschaft*, XX (1897), 85–120.

4 See our Document 1.

5 For "Scheggia" see Ugo Procacci, *Tutta la pittura di Masaccio*, 2nd ed., Milan, 1952, 8; Luciano Berti, *Masaccio*, Milan, 1964, 133, nn. 69, 73. Scheggia also painted the "*sopracielo*," or cloth panel spanning the top of Marco Parenti's four-poster bed. He was paid a little over a florin for painting it in gold and silver; see c. 28v of the volume cited above, in Document 1.

6 Borsook, *Antichità viva*, 1970, 3, 14 (doc. 1).

7 Giuseppe Ceci, "Il Palazzo dei Carafa di Maddaloni poi di Colubrano," *Napoli nobilissima*, II, 9 (1893), 149–52, 168–70; Roberto Pane, *Architettura del Rinascimento in Napoli*, Naples, 1937, 105–7. The inscription over the entrance reads: IN HONOREM OPTIMI REGIS, ET NOBILISSIMAE PATRIAE / DIOMEDES CARAFA, COMES

[8] Pane, 1937, *loc. cit.*, who also refers to the Albertian character of the portal which he sees as derived from San Sebastiano in Mantua; Hersey, 1969, 12.

[9] Ottavio Morisani, *Letteratura artistica a Napoli tra il '400 ed il '600*, Naples, 1958, 106–7; G. C. Capaccio, *Il Forastiero*, Naples, 1634, 173–74, 854–55; Ceci, 1893, 150–51.

[10] Borsook, *Antichità viva*, 1970, 3, 14 (docs. 2, 4, 7–8). For other *lettuccii* and their forms, see John Shearman, "The Collections of the Younger Branch of the Medici," *Burlington Magazine*, CXVII (1975), 18.

[11] Borsook, *Antichità viva*, 1970, 4, 14 (docs. 9–11).

[12] See Document 2. That the "*scrittoio di Piero*" refers to that belonging to Piero de' Medici is inferred from several factors. Aside from being the best-known *scrittoio* of that time, ". . . del palcho dela sala e scrittoio . . ." mentioned together recurs in several quattrocento descriptions of just this suite of rooms in the Medici Palace; see Wolfger A. Bulst, "Die Ursprüngliche Innere Abteilung des Palazzo Medici in Florenz," *Mitteilungen des kunsthistorischen Institutes in Florenz*, XIV (1970), 378–79, 384, citing Filarete and a poem by an anonymous author; Detlef Heikamp and Andreas Grote, *Il Tesoro di Lorenzo il Magnifico, II: I Vasi,* Florence, 1974, citing the inventory of the palace's contents in 1492. For the dating of Piero's *scrittoio*, see John Pope-Hennessy and Ronald Lightbown, *Catalogue of Italian Sculpture in the Victoria and Albert Museum*, London, 1964, 107; and Isabelle Hyman, *Fifteenth Century Florentine Studies: the Palazzo Medici and a Ledger for the Church of San Lorenzo*, New York University Ph.D. dissertation, 1968, 177.

[13] Vasari–Milanesi, *Le Vite de' più eccellenti pittori, scultori ed architettori*, Florence, 1878, II, 174.

[14] Florence, Archivio di Stato, *Strozziane III, 131*, c. 159. Lorenzo de' Medici stood as the duke's proxy at little Alfonso's baptism in Florence on December 13, 1467; *Strozziane V, 17,* c. 189v.

[15] Peter Tigler, *Die Architekturtheorie des Filarete*, Berlin, 1963, 7–8; Bulst, 1970, *loc. cit.*; Heikamp–Grote, 1974, 4–5, 48. It is generally agreed that Filarete was last in Florence in 1456 and that his account of the room was written from memory. The treatise was dedicated to Piero de' Medici. This copy was lent out in 1482 for another copy to be prepared for a Neapolitan cardinal ("*pel cardinale d'aragone*"); Marcello del Piazzo, *Protocolli del Carteggio di Lorenzo il Magnifico per gli anni 1473–74, 1477–92*, Florence, 1956, 229.

[16] E. H. Gombrich, "The Early Medici as Patrons of Art: A Survey of Primary Sources," in *Italian Renaissance Studies: A Tribute to the Late Cecilia M. Ady*, ed. E. F. Jacob, London, 1960, 302 f.

[17] Pope-Hennessy–Lightbown, 1964, 107; Bulst, 1970, 370 ff. and fig. 4.

[18] *Ibid.*, 390; Heikamp, 1974, 47–51.

[19] Pope-Hennessy–Lightbown, 1964, 104–8.

[20] Roberto Longhi in *Officina Ferrarese 1934*, Florence, 1956, 18, 176–77, describes Ciriaco d'Ancona's admiration of some of these paintings then in the atelier of Maccagnino; see also Werner L. Gundersheimer, *Ferrara: The Style of a Renaissance Despotism*, Princeton, 1973, 237–38, 243. The theme was, of course, greatly expanded later in the Palazzo Schifanoia, also at Ferrara. It is unknown what, if any, particular function this room had.

[21] Bulst, 1970, 391. According to Hyman (1968, 146, 206 f.), the Medici Palace was begun c. 1446.

[22] Compare the plan of Piero's *Scrittoio* (Heikamp–Grote, 1974, figs. 2, 8a) to that of Francesco I's *Studiolo*, in Alfredo Lensi, *Palazzo Vecchio*, Rome–Milan, 1929, 295. For general remarks on the programs of *scrittoii* and *studioli*, as well as a likely classical source, see Heikamp, 1974, 49–50; cf. Pope-Hennessy–Lightbown, 1964, 108. See also Detlef Heikamp, "Zur Geschichte der Uffizien Tribuna und der Kunstschränke in Florenz und Deutschland," *Zeitschrift für Kunstgeschichte*, XXVI (1963), 196–97.

[23] Bulst, 1970, 384–85; Heikamp, 1974, 48–49.

24 Bulst, 1970, 385; Heikamp, *loc. cit.*; Pasquale Rotondi, "Ancora sullo studiolo di Federico da Montefeltro nel Palazzo Ducale di Urbino," *Studi Bramanteschi, Atti del Congresso Internazionale, 1970*, Rome, 1974, 257–58.

25 Rotondi noted that the proportions of Federigo's chapel and the adjacent chamber now known as the "*Tempietto delle Muse*" resemble the plan and shape of Piero's *scrittoio*; *idem, Il Palazzo Ducale di Urbino*, Urbino, 1951, I, 333; II, figs. 389–90. The "*Tempietto delle Muse*" also included intarsiae and paintings of Apollo, Pallas Athena, and the nine muses—a Parnassus; *ibid.*, 368–69, 403 (n. 3).

26 Document 2.

27 *Loc. cit.* For the remaining fragments of the *palcho* in Palazzo Medici, see Bulst, 1970, 378.

28 Alfred von Reumont, *Die Carafa von Maddaloni*, Berlin, 1851, 210; Fabriczy, 1897, 94, 97; D. E. Colnaghi, *A Dictionary of Florentine Painters*, London, 1928, 94; Hersey, 1969, 65.

29 Frederick Hartt, Gino Corti, and Clarence Kennedy, *The Chapel of the Cardinal of Portugal, 1434–1459*, Philadelphia, 1964, 20–24, 115, 162–63; Hersey, 1969, 112.

30 Guido Donatone, *Maioliche Napoletane della Spezeria Aragonese di Castelnuovo*, Naples, 1970, figs. 64–65; *idem*, "La Maiolica Napoletana dalle Origini al Secolo XV.," in *Storia di Napoli*, IV, pt. 1, Naples, 1974, 601.

31 *Ibid.*, 597, fig. 241; *idem*, 1970, 26. The motto in the pavement reads "*Temps Espenedir*," whereas Diomede's mottos were "*Fine in tanto*" and "*Hoc fac et vives*"; Reumont, 1851, 203.

32 Vasari–Milanesi, II, 175.

33 Fabriczy, 1897, 87; Hersey, 1973, 52.

34 Lorenzo Cèndali, *Giuliano e Benedetto da Maiano*, San Casciano Val di Pesa, 1926, 175.

35 Fabriczy, 1897, 96–97; Donatone, 1970, 14, 23–24; *idem*, 1974, 601–2.

36 Donatone, 1970, 14.

37 Gaetano Filangieri, "La Testa di Cavallo in bronzo già di Casa Maddaloni in Via Sedile di Nido ora al Museo Nazionale di Napoli," *Archivio storico per le province Napoletane*, VII (1882), 416–17.

38 Ceci, 1893, 152.

39 Filangieri, *loc. cit.* The archival signature has changed since Filangieri saw the document; it now is M.A.P., *XXVII, no. 386.* Our quotation is taken from the original.

40 Ludwig von Pastor, *Storia dei Papi*, rev. ed. by Angelo Mercati, Rome, 1961, II, 439, 442; G. M. Mecatti, *Storia Cronologica della Città di Firenze*, Naples, 1755, II, 446–47; Angelo Fabroni, *Vita Laurentii Medicei*, Pisa, 1784, II, 57–58.

41 Pastor, *loc. cit.*; Ulrico Pannuti in *Il Tesoro di Lorenzo il Magnifico: I, Le gemme*, Florence, 1973, 70 ff.

42 *Il Libro di Antonio Billi*, ed. Carl Frey, Berlin, 1892, 38; Pane, 1937, 108, citing Summonte; Filangieri, 1882, 418–19. For the installation of Donatello's *David* in the Palazzo Medici, see H. W. Janson, *The Sculpture of Donatello*, Princeton, 1957, II, 77, 79.

# 7

# *Das Statuettenpaar über Ghibertis Matthäustabernakel*

GERT KREYTENBERG

Im Auftrag der Arte del Cambio, der Wechslerzunft, hat Lorenzo Ghiberti in den Jahren von 1419 bis 1422 die Bronzestatue des Evangelisten Matthäus geschaffen. Ghiberti entwarf auch die zugehörige Tabernakelnische (fig. 1) am nordwestlichen Eckpfeiler von Or San Michele in Florenz; die Steinmetzen Jacopo di Corso und Giovanni di Niccolò waren 1422 mit deren Ausführung beschäftigt.[1] Die Statuetten neben dem Giebel stammen offenkundig nicht von Ghiberti, der möglicherweise an ihrer Stelle Fialen oder Vasen wie im Entwurf für das Stefanustabernakel vorgesehen hat.[2] Jedenfalls übernehmen die Statuetten eine architektonische Funktion: sie verlängern die Vertikalen der seitlichen Tabernakelpilaster bis zur Scheitelhöhe des Giebels. Damit wird der Giebel, der im Gegensatz zu jenem von Donatellos Ludwigstabernakel sozusagen unselbständig ist, in ein querrechteckiges Feld eingespannt. Dieses Feld entspricht in seinen Ausmaßen genau demjenigen, das den Nischenbogen mit der Muschel aufnimmt. Zusammen bilden diese beiden Abschnitte exakt die obere Hälfte der Nischenrahmung.

Ob die Auftraggeber dem Figurenpaar (fig. 1) einen Sinn im Zusammenhang mit der Matthäusstatue zugedacht haben, erscheint durchaus zweifelhaft; ein solcher Inhalt wäre noch zu entschlüsseln.[3] Die Statuetten werden zumeist als Verkündigung bezeichnet, in jüngerer Zeit noch von Krautheimer, der allerdings einräumt, daß eine Verkündigungsgruppe in keiner verständlichen Beziehung zum Matthäus steht.[4] Janson hingegen nimmt an, daß es sich um Propheten handelt, weil die Figuren Schriftrollen in Händen haben;[5] das ist durchaus überzeugend, vermag aber die Figuren nicht in einen ikonographisch sinnvollen Zusammenhang mit dem Matthäus zu bringen. Gegen die Deutung der Statuetten als Verkündigungsgruppe hat Janson zudem eingewandt, was Milanesi zuerst bemerkte:[6] daß der Kopf der linken Figur mit weiblichen Zügen nicht original, sondern eine moderne Ergänzung sei. Diese Annahme, der widersprochen wurde,[7] ist jedoch zweifellos richtig. Beim Studium der Figuren aus der Nähe, zu dem ich im Herbst 1975 Gelegenheit hatte, fällt auf, daß die linke Halskontur unterhalb der Schnittlinie abknickt, wie auch in Abb. 6 deutlich sichtbar ist; die Fotographie läßt allerdings kaum erkennen, daß die Kalotte unter- und oberhalb der Schnittlinie sehr unterschiedlich gearbeitet ist. Die Statuetten, geschaffen als Propheten, die in jüngerer Zeit in eine Verkündigung umgedeutet wurden, dürften ihren Sinn primär als Figuren im architektonischen Kontext haben.[8]

Vasari hat die Statuetten (figs. 3, 5, 6, 8) dem Niccolò di Pietro Lamberti zuge-

1. *Ghiberti. Matthäustabernakel.*
*Or San Michele, Florenz*

schrieben, der sie noch vor der Entstehung der Matthäusstatue (fig. 2) für das Tabernakel der Wechslerzunft geschaffen habe;[9] diese Meinung hat sich bis zum Ende des vorigen Jahrhunderts gehalten. Da man "diese ganz der Renaissance angehörigen"[10] Statuetten nicht dem noch im Trecento geprägten Niccolò di Pietro Lamberti zutrauen mochte, hat Gamba dessen Sohn Piero di Niccolò als Meister namhaft gemacht, und Venturi schlug Nanni di Bartolo il Rosso vor. Planiscig, der der Attribution an Piero di Niccolò widersprach, ist Venturi gefolgt, dessen Zuschreibung wiederum von Brunetti abgewiesen wurde. Die vor rund vierzig Jahren zuerst von Heydenreich und Middeldorf mündlich vertretene Auffassung, es handelte sich um Werke Michelozzos, wurde vor allem von Paatz, Valentiner und Krautheimer verbreitet und ist heute weithin anerkannt. In der Datierung gehen die Meinungen ein wenig auseinander. Während Valentiner für das Statuettenpaar in Anlehnung an die Entstehungszeit der Matthäusstatue die Angabe "um 1420" anbot und auch Paatz "um oder nach 1419/21" vorschlug, vertrat Krautheimer die Auffassung, daß die Figuren an Michelozzos späten Stil erinnern und "möglicherweise erst hinzugefügt wurden, nachdem er 1437 in Ghibertis Werkstatt zurückgekehrt war."

*2. Ghiberti.* Matthäus.
*Or San Michele, Florenz*

*3. Ciuffagni zugeschrieben.*
Prophet. *Or San Michele,*
*Florenz*

Unvorstellbar ist es, daß die beiden Statuetten über dem Matthäustabernakel (figs. 3, 6) Vorstufen zu jenen Figuren sind, die Michelozzo rund 1427 ungefähr gleichzeitig für das Cosciagrabmal im Florentiner Baptisterium und für das Brancaccigrabmal in S. Angelo a Nilo in Neapel geschaffen hat, die sich allerdings beträchtlich voneinander unterscheiden. Nichts verbindet die beiden Statuetten mit den Figuren des Cosciagrabmals. Wenn überhaupt, lassen sie sich den robusteren Neapolitaner Figuren gegenüberstellen. Dann wird aber die eigentümlich unentschiedene, kraftlose Modellierung der Statuetten besonders augenfällig, die es ausschließt, daß Michelozzo sie gearbeitet hat: er bewies in seinen besten Skulpturen, den Statuen und Reliefs des um 1437 entstandenen und fragmentarisch überkommenen Grabmals des Bartolomeo Aragazzi im Dom in Montepulciano, eine hohe bildhauerische Begabung. Von dieser müßte Michelozzo plötzlich viel eingebüßt haben, sollte er die Statuetten im Anschluß an den monumentalen Bartholomäus in Montepulciano gemeißelt haben. Der qualitative Abstand zwischen den Skulpturen ist viel zu groß, als daß sie von einer Hand stammen könnten; zurecht hat Janson[11] die Attribution der beiden Statuetten an Michelozzo zurückgewiesen.

Welche Aufschlüsse geben die Statuetten über ihren Bildhauer? Die rechte

Statuette (fig. 3) wirkt eigenartig additiv zusammengesetzt. Der antikisierende Kopf und der schlanke Oberkörper, der in ein sehr bewegt gefälteltes, in Brusthöhe gegürtetes Kleid gehüllt ist, ferner der linke, herabhängende Arm bilden eine Einheit, eine Figur für sich. Der erhobene rechte Arm ist unproportioniert groß und zu mächtig für diese Figur, die gleichsam mit dem unteren Teil einer anderen, verhältnismäßig größeren Figur zusammenmontiert ist. Nach dem Vorbild für den unteren Teil der insgesamt zu sehr in die Länge gestreckten Statuette braucht man nicht lange zu suchen: bei Verlust der plastischen Energie sind formale Anleihen offenbar bei Ghibertis Matthäusstatue (fig. 2) gemacht worden. Zwei Anhaltspunkte bietet die Statuette für die Entstehung des Skulpturenpaares: einerseits fehlte es dem Bildhauer also an Originalität und Kreativität, und andererseits dürfte er die Figuren erst nach 1422 gearbeitet haben, da Ghibertis Matthäus als Voraussetzung gelten darf.

Beim Vergleich der beiden Statuetten miteinander ist nicht zu übersehen, daß die rechte (fig. 3) durchaus straffer und plastischer artikuliert ist als die linke (fig. 6). Die Fältelung im Kleid der rechten Figur ist weitaus bewegter als bei der linken und weist ein kräftigeres Relief auf; während rechts durch die Schürzung eine Stufe entsteht, hängt der geschürzte Teil des Kleides bei der linken Figur schlaff herab. Die kleinteilige, nervöse Fältelung des Kleides kontrastiert bei der rechten Statuette mit der großzügigen "ghibertianischen" Drapierung des Obergewandes; bei der linken Figur hingegen heben sich Kleid und Obergewand kaum voneinander ab, weil sie gleichermaßen unentschieden und kraftlos mit vielen Brechungen, Buckeln und Muldungen modelliert sind. Ein weiterer Detailvergleich kann die Minderung der Plastizität in der linken gegenüber der rechten Statuette beleuchten: vor dem Standbein der rechten Figur markieren Bein, Kleid und Obergewand drei räumlich unterscheidbare Schichten, während das Kleid vor dem Standbein der linken Figur dicht oberhalb des Fußes in gerader Linie endet und die Differenz zwischen Hinten und Vorne zudeckt. Möglicherweise werden die Statuetten durch diese Hinweise auf stilistische Unterschiede bereits zu weit auseinandergerückt. Die Differenzen erlauben keinesfalls die Annahme, daß es sich um die Arbeit verschiedener Bildhauer handelt; bezeichnenderweise sind die Figuren stets zusammen gesehen worden. Die Unterschiede zwischen den Statuetten dürften eine Entwicklungstendenz ihres Bildhauers anzeigen.

Das Niveau dieses Bildhauers liegt gewiß weit oberhalb desjenigen eines guten Handwerkers; die Versuche, die Statuetten Michelozzo zuzuschreiben, beweisen das. Michelozzos künstlerischen Rang erreicht dieser Meister jedoch nicht. Von dem Bildhauer läßt sich sagen, daß er ein Epigone war. Da das Jahr 1422 als terminus post quem für die Entstehung der Statuetten gelten kann, stellt sich die Frage, ob ihr Stil mit gesicherten Werken eines während des dritten oder vierten Jahrzehnts in Florenz tätigen Bildhauers übereinstimmt. Der schwächste der am Beginn der Renaissance tätigen Meister war Bernardo Ciuffagni, dessen Grenzen vor rund zwanzig Jahren insbesondere gegenüber seinem großen Vorbild Donatello von Janson und Wundram deutlich abgesteckt worden sind.[12] Ein Überblick über Ciuffagnis Oeuvre ergibt einsichtige stilistische Gründe für eine Zuschreibung der beiden Statuetten.

Die monumentale Sitzfigur des Evangelisten Matthäus von der alten Florentiner Domfassade, heute im Dommuseum, ist Ciuffagnis erstes dokumentiertes Werk, das zwischen 1410 und 1415 entstand.[13] Den Aufbau der Figur übernahm Ciuffagni von Donatellos Johannes in derselben Skulpturenreihe.[14] "Stilistisch freilich verleugnet die Figur Ciuffagnis ihre andersartige Herkunft nicht: in der weichen

Stofflichkeit des Gewandes, in der dekorativen Verschlingung des Mantelknotens
unter dem Hals, in den ungebrochen schwingenden Schüsselfalten zwischen den
Knien, in den weich gewellten Säumen vor dem Oberkörper und seitlich der Unter-
schenkel verrät sich weitaus stärker als in dem zerklüfteten, unruhig flackernden
Gewandstil Donatellos die Verwurzelung im 'weichen Stil,' und wir werden uns
in diesem Zusammenhang daran erinnern, daß die erste urkundliche Erwähnung
Ciuffagnis ihn 1407 als Gesellen in Ghibertis Werkstatt nennt. Aus der Nordtüre
des Florentiner Baptisteriums dürfte Ciuffagni denn auch seine grundlegenden
Eindrücke empfangen haben."[15]

Die Matthäusfigur dürfte die Aufträge zu zwei weiteren monumentalen Statuen
nach sich gezogen haben. Für die Tabernakelnische der Arte di Beccai (Metzger)
an Or San Michele hat Ciuffagni die Petrusstatue von etwa 1415 bis 1417 geschaf-
fen, wie Janson dargelegt hat.[16] Die Arbeit an dieser Statue erklärt, warum die
Ausführung der Statue des Josua, zu der die Domopera im Oktober 1415 den
Auftrag erteilt hatte,[17] sich lange hinzog; im März 1417 hatte Ciuffagni die
Statue unfertig in Florenz zurückgelassen.[18] Bevor der Bildhauer 1422 wieder
zurückkehrte,[19] hatte Nanni di Bartolo il Rosso die Figur 1420/21 vollendet, die
mit der heute Poggio Braccioloni genannten Statue im Dommuseum identisch sein
dürfte; der separat gearbeitete Kopf scheint aber wiederum von Ciuffagni um 1424
gemeißelt worden zu sein, wie Wundram erkannte.[20] Im April 1425 bereitete Ciuf-

5

4. *Ciuffagni.* Isaias. *Dom, Florenz*

5. *Ciuffagni zugeschrieben.* Prophet.
*Or San Michele, Florenz*

4

 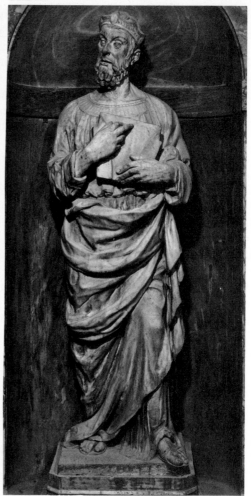

6. *Ciuffagni zugeschrieben.* Prophet. *Or San Michele, Florenz*

7. *Ciuffagni.* David. *Dom, Florenz*

fagni in Carrara einen großen Marmorblock vor und erhielt den Auftrag zur Ausführung der Statue eines Isaias, der im Oktober 1427 vollendet war und 1434 an der Domfassade aufgestellt wurde;[21] dieser Isaias wird mit einer heute im Dom befindlichen Statue (fig. 4) identifiziert.[22] Unter dem Einfluß Donatellos werden in der Entwicklung von Ciuffagnis Skulpturen nach dem Matthäus die gotischen Elemente zurückgedrängt, während sich realistische Züge vor allem in der Durchbildung von Köpfen durchsetzen. Der Versuch, es dem Vorbild gleich zu tun und "den realistischen Fall von Kleidung darzustellen, der bei Donatellos hl. Markus so überzeugend wiedergegeben worden ist,"[23] führt zu eigentümlich manierierten Faltungen und Stauungen in der Drapierung.

Die letzte bekannte Skulptur Ciuffagnis, die seine zweite dokumentarisch gesicherte ist, stellt den König David dar (figs. 7, 9); sie wurde 1435 vollendet.[24] Aus dem noch folgenden Lebensabschnitt des Bildhauers, der im Alter von 76 Jahren 1457 in Florenz starb, ist kein Werk identifizierbar.[25] Die Davidstatue unter-

scheidet sich beträchtlich von Isaias und allen voraufgehenden Skulpturen. Die Draperie ist derart aufgewühlt, daß Janson die drastische Metapher eines ungemachten Bettes einfiel.[26] Und Wundram betonte zurecht: "Wüßten wir nicht mit Sicherheit, daß dieser (Ciuffagni) zwischen 1430 und 1435 den König David gearbeitet hat, der sich heute im linken Seitenschiff des Florentiner Domes befindet, der Einordnung in sein Oeuvre würden sich auf den ersten Blick Schwierigkeiten entgegenstellen."[27]

Gerade diese Lücke, so scheint es mir, die nach bisheriger Kenntnis in der Entwicklung Ciuffagnis zwischen dem Isaias und dem David (figs. 4, 7) klafft, wird durch die beiden Statuetten über Ghibertis Matthäustabernakel (figs. 3, 6) überbrückt. In ihrem figürlichen Aufbau, speziell im Standmotiv, gleicht die linke der Figuren (figs. 6, 8) dem König David (figs. 7, 9). Vor allem aber kommt sie ihm in der kraftlosen, schlaffen Modellierung sehr nahe, wie ein Blick auf die Fältelung der Kleider und die Bildung der Faltenwülste im Obergewand zeigt. Die Auflösung glatter Flächen in Licht fangende und Schatten bildende Buckel und Muldungen von teigartiger Weichheit hat bei der Statuette aber noch nicht jenen überaus unangenehmen Grad erreicht wie bei dem König David, dem die andere Statuette (figs. 3, 5) etwas ferner steht, die mehr dem Isaias (fig. 4) vergleichbar ist. Aus der Mittelstellung zwischen Isaias und David ergibt sich für die beiden Statuetten eine Datierung in die Jahre zwischen 1427 und 1430.

*Ruhr Universität Bochum*

8. *Ciuffagni zugeschrieben.* Prophet. *Or San Michele, Florenz*

9. *Ciuffagni.* David. *Dom, Florenz*

8

9

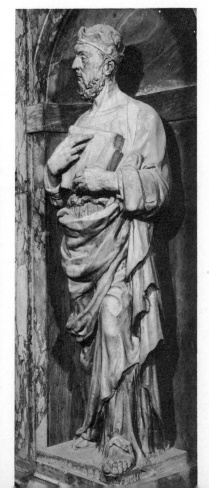

*Notes*

[1] Alfred Doren, "Das Aktenbuch für Ghibertis Matthäus-Statue an Or San Michele," *Italienische Forschungen*, ed. Kunsthistorisches Institut in Florenz, Berlin, 1906, I, 13 f., 19 f., 46 f.; Walter und Elisabeth Paatz, *Die Kirchen von Florenz*, Frankfurt, 1952, IV, 492, 520 f., nn. 85, 86; Richard Krautheimer, *Lorenzo Ghiberti*, Princeton, N.J., 1956, 254 f.; Artur Rosenauer, *Studien zum frühen Donatello*, Wien, 1975, 38 f.

[2] Doren, "Aktenbuch," 17; Hans Kauffmann, "Eine Ghibertizeichnung im Louvre," *Jahrbuch der preussischen Kunstsammlungen*, 50 (1929), 7.

[3] Es gibt im späten Trecento mehrere Beispiele dafür, daß der ästhetische Aspekt einer Dekoration entschieden den Vorrang vor dem ikonographischen hatte; vgl. Gert Kreytenberg, "Tre cicli di apostoli dell'antica facciata del duomo fiorentino," *Antichità viva*, XVI, 23 ff.

[4] Paatz, *Kirchen*, IV, 492, 521 f., n. 87; Krautheimer, *Ghiberti*, 87 ff., n. 5.

[5] Krautheimer, *Ghiberti*, 87 f., n. 5.

[6] Giorgio Vasari, *Le Vite*, ed. Gaetano Milanesi, Firenze, 1878, II, 138, n. 2.

[7] Krautheimer, *Ghiberti*, 87 f., n. 5.

[8] Die beiden Statuetten gehörten jüngst zu den Exponaten der Ausstellung zum 600. Geburtsjahr Ghibertis in Florenz (Oktober 1978–Januar 1979). Im Ausstellungskatalog (*Lorenzo Ghiberti, materia e ragionamenti*, Firenze, 1978) identifiziert Marisa Rinaldi (pp. 189–90) die Statuetten überzeugend als zwei Sibyllen. Giulia Brunetti hat sich in einem Vortrag im Juni 1979 im Kunsthistorischen Institut in Florenz eingehend mit den beiden Statuetten befaßt und ist zu Schlüssen gelangt, die nicht mit den hier vorgelegten übereinstimmen. Eine Diskussion der verschiedenen Auffassungen wird nach der Publikation des Vortragstextes in den Mitteilungen des Institutes möglich sein; ich danke Dott.ssa Brunetti für eine Kopie ihres Textes.

[9] Vasari—Milanesi, II, 138.

[10] Paatz, *Kirchen*, IV, 521, n. 87. Dort und bei Krautheimer, *Ghiberti*, 87 f., n. 5, die Literaturhinweise zum nachfol-genden knappen Überblick über die verschiedenen Attributionen. Laut mündlicher Mitteilung hält Prof. Middeldorf die Statuetten nicht mehr für Werke von Michelozzo.

[11] Krautheimer, *Ghiberti*, 87, n. 5.

[12] H. W. Janson, *The Sculpture of Donatello*, 2. Aufl., Princeton, 1963, 222 f., insbesondere durch die Ausgrenzung der Petrusstatue an Or San Michele aus dem Oeuvre Donatellos sowie durch die völlig überzeugende Zuschreibung dieser Statue an Bernardo Ciuffagni; Manfred Wundram, "Donatello und Ciuffagni," *Zeitschrift für Kunstgeschichte*, XXII (1959), 85 f.

[13] Dokumente: Giovanni Poggi, *Il Duomo di Firenze*, Berlin, 1909, 29–37.

[14] Wundram, "Ciuffagni," 88.

[15] Wundram, "Ciuffagni," 88.

[16] Janson, *Donatello*, 224.

[17] Poggi, *Duomo*, No. 221.

[18] Poggi, *Duomo*, No. 225.

[19] Poggi, *Duomo*, No. 428.

[20] Wundram, "Ciuffagni," 85 f.

[21] Poggi, *Duomo*, Nos. 271, 291, 320.

[22] Paatz, *Kirchen*, III, 372, 504, n. 263.

[23] Janson, *Donatello*, 224.

[24] Poggi, *Duomo*, Nos. 298–306, 308, 312–15, 317, 319–21.

[25] Zur Biographie, einschließlich der Arbeit in Rimini 1447/50: F. Schottmüller, "Ciuffagni, Bernardo," Thieme–Becker, *Künstler-Lexikon*, VII, Leipzig, 1912, 17 f.; zur Arbeit in Rimini: Corrado Ricci, *Il Tempio Malatestiano*, Milano–Roma, 1925, 371 f. Keine der vorgeschlagenen Attributionen, weder der Sitzfigur des hl. Sigismund in der Cappella di Sigismondo, noch der Statue des Erzengels Michael in der Cappella d'Isotta, noch irgendeiner anderen Skulptur im Tempio Malatestiano, läßt sich mit einsichtigen Gründen stützen. Es ist unbekannt, wie sich Ciuffagnis Skulptur unter dem Einfluß von Matteo de' Pasti veränderte; allein auf stilistischer Grundlage wird es schwerlich gelingen, Ciuffagnis Arbeitsanteil in Rimini abzugrenzen.

[26] Janson, *Donatello*, 224.

[27] Wundram, "Ciuffagni," 93.

# 8

# *Examining a Fifteenth-Century "Tribute" to Florence**

ISABELLE HYMAN

A small fifteenth-century Italian plaquette that exists in two versions—one of silver with traces of enamel in the Louvre, and the other of bronze in the National Gallery in Washington, D.C.[1] (figs. 1, 2)—has been thought at various times to be the work of Caradosso, Pietro da Milano, Brunelleschi, Donatello, or Castagno, or possibly to be based on a lost painting by Masaccio.[2] It depicts in low relief one of the healing miracles of Christ[3] wherein a bat-winged demon is made to depart from the body of a possessed person, to the astonishment and praise of the Apostles and other onlookers. The miracle takes place in an impressive piazza framed by large civic and ecclesiastical buildings. The relief is an example of a tradition in which miracles, or other dramatic or celebratory events, portrayed in a city square against an elaborate architectural setting, are given a vernacular context. Particularly well suited to the format of predellas and cassone paintings,[4] where they abound, these compositions lend themselves to the inclusion of large numbers of figures and to the display of an abundant variety of buildings. Equally adaptable to relief sculpture, the theme is found both in small-scale ornamental objects like this anonymous plaquette, and in larger important works by major sculptors, such as Donatello's *Miracle of the Irascible Son* and Ghiberti's *Miracle of the Strozzi Boy*.

Nothing is known about either the Paris or the Washington version of the plaquette before each appeared in nineteenth-century private collections.[5] If the history of the plaquette is obscure, however, the provenance of its design clearly can be traced to fifteenth-century Florence, for it is a remarkable amalgam of quotations and borrowings[6] from monumental Florentine painting, sculpture, and architecture, rendered in drastic changes of scale, context, and medium, and united harmoniously within a tiny area of roughly two and one-half by four inches. The plaquette has received some critical attention, but it remains an elusive object. The bronze and silver versions have been confused with each other, attributions and dating have covered a wide and erratic range, and detailed photographs were never taken. It is the purpose of this paper to make a fresh examination of this interesting relief and, with new photographs and a reconsideration of past literature, to attempt to bring it closer to its proper place in the history of art.

The designer of the plaquette appropriated from Masaccio's frescoes in the Brancacci Chapel the renowned composition of the Apostle group from *The*

105

1

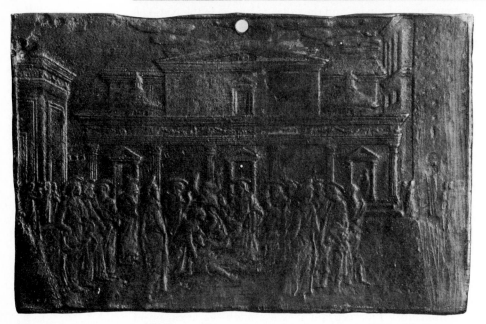

2

*1. Plaquette, silver and enamel (enlargement).* Christ Healing a
Possessed Person. *Louvre, Paris*

*2. Plaquette, bronze (enlargement).* Christ Healing a Possessed
Person. *National Gallery of Art, Washington, D.C.*

*Tribute Money,* with the distinctive posture and gesture of the central Christ. The
image of the shivering neophyte awaiting baptism by St. Peter is another of Masac-
cio's impressive innovations in the Brancacci Chapel; the neophyte, with arms
folded, and appropriately clothed, and also the baptizing Peter are included in the
plaquette, placed among subordinate groups of onlookers far to the right and left

(figs. 4, 5). The formula of a cluster of four figures in a circle to the left of the central narrative has been lifted from Ghiberti's *Isaac* relief on the Gates of Paradise. One of the few bald figures in quattrocento Florentine sculpture is Donatello's *Zuccone*; in the plaquette, cleverly cast as Judas in the Apostle group and therefore without the halo that would have hidden this idiosyncratic feature, is such a bald person, seen from the rear, in a pose borrowed from the tax collector in *The Tribute Money*. The position (one leg bared and bent, one arm stretched out) and the drapery of the possessed person lying in front of Christ are derived (in reverse) from Donatello's Paduan relief of *The Miracle of the Irascible Son*. The emotional gesture of the excited woman, although traditional in art since antiquity,[7] seems, in the flying hair and the angles of the arms, to be related particularly to the despairing woman in *The Entombment of Christ*, another of Donatello's Paduan reliefs. The first Apostle on our left stands with hand on hip, palm out and fingers curled up, a motif that belongs to Donatello's bronze *David* and its derivative, Castagno's *Farinata degli Uberti* in the frescoes from the Villa Volta di Legnaia. The way in which the Apostle, behind the woman who supports the possessed, raises his hands in surprise is a quotation from Castagno's fresco of *The Last Supper*. The spatial amplitude created by Masaccio's semicircular composition has been combined with classic fifteenth-century Florentine perspective construction, made by the orthogonals and transversals of a pavement grid, and with the suggestion of an "atmosphere" provided by ribbons of clouds to produce the illusion of a capacious stage for the many figures and the large buildings that comprise the design of this miniature object.

*3. Pietro da Milano. Reverse, Portrait Medal of King René d'Anjou and Jeanne de Laval (enlargement). Bibliothèque Nationale, Paris*

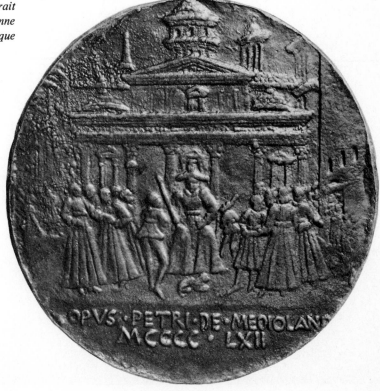

If the figures, the composition, and the rendering of space are characteristic of the Florentine Early Renaissance, all the more so is the architecture. The miraculous event is enacted before a monumental church façade of the most modern Brunelleschian design. But whereas the other elements of the plaquette are related to identifiable avant-garde works of art in existence by mid-century, neither the church nor its flanking buildings is a portrait of any known structure in Florence.[8] The church façade is radically different in appearance from that of earlier Florentine churches, either real or imagined in painting and sculptural relief, that were made with slanted roofs flanking a taller nave, often preceded by a colonnaded narthex, and with unarticulated mural surfaces. The lower portion of the plaquette façade stretches across the presumed "nave" and lateral spaces; it is separated from the upper section—the nave elevation—by a frieze decorated with a relief of garland swags. All three portals (the side portals leading to domed spaces) are equal in height and width, and, like the window in the upper wall, surrounded by aediculated frames. Each bay of the lower façade is defined by evenly spaced "Corinthian" pilasters with fluted shafts that rise from the base of the building to the lower fascia of the architrave. Visible in the precisely chased surface of the silver version of the plaquette and absent in the bronze specimen are narrow rectangular panels into which the symmetrical compartments between the applied order have been divided. On either side of the upper portion of the façade is a dome

*4. Detail of fig. 1*                         *5. Detail of fig. 1*

on a drum, covered with scalloped tiles and crowned with a lantern. Beyond the domed spaces are a transept that appears to be made of two arms equal to the nave in width and a low dome over the crossing covered by a quadrangular sheath of masonry with a tiled roof.

The architectural elements of the church façade are precisely those that were current in, or emanated from, Florence, and nowhere else in Italy, from about 1425 to 1460. The framing aedicules, the fluted pilasters, and the garland swags were common features of the architectural sculpture—niches, pulpits, tombs, tabernacles, and lavabos—produced by Brunelleschi and Donatello about 1420 and propagated and elaborated by Michelozzo and other of their associates and followers immediately after. The porticoes resemble those that frame Donatello's bronze doors in the Old Sacristy of San Lorenzo, possibly designed by Michelozzo;[9] the domes combine features from three of Brunelleschi's buildings—the cupolas of the Old Sacristy and the Pazzi Chapel with their hemispherical profiles, exterior overlapping tiles, and lanterns, and most directly the exedrae of the Cathedral, which have deeply excavated niches like those in the drums of the domes in the plaquette. Walls with fluted Corinthian pilasters beneath a fasciated architrave are found in almost all of Brunelleschi's works, appearing early in the end bays of the Ospedale degli Innocenti porch and the interior of the Old Sacristy, and used in

*6. Detail of fig. 1*

7

8

9

7. *Detail of attic, Baptistery, Florence*

8. *Detail of cupola tambour, S. Maria del Fiore, Florence*

9. *Garden wall, Palazzo Medici, Florence*

the interiors of S. Lorenzo, the Palazzo di Parte Guelfa, and the Pazzi Chapel, to name the most obvious. They compartmentalize the original façade of the Pazzi Chapel; above the columns of the narthex preceding that façade the wall is divided into rectangular panels between (double) pilaster frames. There is the question of whether the design of this wall, known to have been executed long after Brunelleschi's death, was his conception. The composition, in any case, is not only "Brunelleschian" in character but historically Florentine, for its sources are the Baptistery, S. Miniato al Monte, and the Duomo. The exterior of the Baptistery attic (and of the lower portion of S. Miniato) has, between fluted Corinthian pilasters, rectangular compartments defined by green marble outlines (fig. 7). In the upper part of the façade wall on the church in the silver plaquette (fig. 6), narrow rectangular compartments run uninterrupted on two levels. This device is none other than the revetment pattern on the flanks of the Cathedral and on the tambour of its dome (fig. 8).

A date toward 1500 for the plaquette was implied by the first attribution, made in 1883 by Eugène Müntz, of the bronze version to Caradosso, supporting the opinion of Wilhelm von Bode and Gustave Dreyfus, the latter a prominent collector and owner of the bronze.[10] The Milanese Caradosso was the most important medalist of the late fifteenth century and the early years of the sixteenth. His friendship and collaboration with Bramante are well established, and the use of architecture is one of the signatures of his style in the plaquettes and medals attributed to him. Although the style of this plaquette has little if anything to do with Caradosso's work, Müntz, Bode, and Dreyfus apparently wished to attach a famous Renaissance name to the anonymous object. Müntz went so far as to describe qualities in the plaquette as most characteristic of the Milanese master, "l'harmonie du groupement," and "la noblesse de l'architecture, évidemment inspirée de Bramante."[11] More surprising, he recognized in the drapery folds ("encore assez anguleuses") the influence of the intensely emotional style of the late fifteenth-century Milanese sculptors Cristoforo and Antonio Mantegazza.[12] He made no connections with Florence.

Müntz's attribution to Caradosso was contested by Emile Molinier, who moved the bronze plaquette further back into the fifteenth century by claiming it for Pietro da Milano (c.1435–1473),[13] whose works as a medalist are described by G. F. Hill as "mediocre in conception, lifeless, and wholly lacking in technical accomplishment."[14] If, however, an attribution to Pietro da Milano was less impressive than one to Caradosso, it was certainly more reasonable and convincing since it was based on an awareness of the relation between the plaquette (the bronze) and a relief on the reverse of a double portrait medal (fig. 3), in bronze, of King René d'Anjou and his wife Jeanne de Laval, signed by Pietro da Milano and dated 1462.[15] The subject of the Anjou relief is not clear (it has been proposed as a coronation, or a judgment scene, or as King René surrounded by his courtiers).[16] Before a large building, possibly meant to be a palace, a king with scepter is seated on an elevated chair; clusters of figures are on either side of him, and a dog is at his feet. Although the image is faint in all extant specimens of the medal, the building can be discerned as almost a replica of that in the bronze plaquette (lacking the careful detailing of the silver plaquette). As a result of the undeniable similarity of the two structures, and of the relation of the figure group to the architecture in both examples, Molinier deduced the authorship of the closely related but anonymous work of art from the signed example, and concluded that both the plaquette and the medal were by Pietro da Milano. The Paris version of

the plaquette has also, by association, taken on this attribution.[17] Molinier, like Müntz before him, did not recognize (or ignored) the Florentine aspects of the plaquette and its architecture. Referring to the medal and the plaquette, Molinier wrote of "la présence dans ces deux pièces d'un édifice dans le style de Bramante. . . ."[18] He did not observe that in the medal an unmistakably Florentine building type had been transformed into a "northern" structure more appropriate for a royal French patron by the addition of turrets, spires, finials, and a distinctly Lombard dome—in fact, a Filaretean creation. It is not possible that the Anjou medal preceded the design of the plaquette, or that an uninspired medalist, not a Florentine and not known ever to have been to Florence, invented for a small circular format an architectural design that in 1462 was as advanced in conception as it was possible for architecture to be.[19] Since the design of the plaquette must precede the medal, and since there is nothing in the body of work produced by Pietro da Milano comparable to the high quality of the plaquette, the attribution of both the bronze and silver specimens of the plaquette to Pietro da Milano, based on nothing more than the signature on the medal, must be abandoned and replaced with a more convincing proposal.

The plaquette, or the design of the plaquette, was made before 1462, the date of the medal. If two of the figures—the possessed, and the excited person standing behind—are quotations from Donatello's Paduan reliefs in the Santo, then the plaquette was designed after the completion of those reliefs and the dedication of the high altar of which they were a part, in 1450.

The dating of the plaquette to the 1450s (and up to 1462) raises some questions about the identification of the architectural setting. So obviously "Florentine" are the elements discussed in the relief so far, that it might be assumed it was the intention of the artist to use a recognizable and important location in Florence as the setting for his tableau. The most satisfactory Florentine piazza in the mid-fifteenth century for this purpose would have been Piazza S. Lorenzo, simultaneously abutting (although not in quadrangular form) the venerable basilica which was the Medici parish church, and the family's newly rising palatial residence. That this is meant to be so is borne out not only by the location, importance, and Brunelleschian character of the church façade and by the flanking palace, but by the inclusion (although not in its correct location) of the crenellated stone wall that identifies the Medici Palace rear garden (fig. 9), which was used in quattrocento cassone paintings and woodcuts depicting the palace.[20] But the church was still under construction in the 1450s and without a façade, the palace was not yet finished, and the irregular piazza itself was the location of stoneworkers' sheds and hoisting machines used for the simultaneous construction of these two fabrics, and probably resembled a disorderly quarry.[21] Nor were there any constructed church façades by Brunelleschi in the 1450s (or ever, for that matter); there were not even any finished Brunelleschian façades, at least not in Florence. Florentine churches begun in the 1420s and '30s were not yet nearly complete, and the great trecento structures were also still "faceless" or, as in the case of S. Maria Novella and S. Maria del Fiore, only partially finished. Troubled and embarrassed by this architectural malady, the Florentines, at least in their paintings and graphics until well into the sixteenth century, provided finished and presentable, although imaginary or temporary, façades for churches (often S. Lorenzo) when these were used to symbolize the city.[22]

In this category of imagined or planned but unrealized architectural and urban projects (frequently Medicean in nature) depicted in works of art (and literature),[23]

our plaquette can be counted as an early example. It combines, I believe, a version
of some mid-century project for the façade of S. Lorenzo and a known plan for a
regularized Medici piazza[24] with the pair of fictitious and rather strange structures
that close the lateral boundaries of the square, to which we will return shortly. In
the years before 1460 it still must have been a strong possibility to the Florentines,
particularly to the Medici, that S. Lorenzo would soon be completed with its
façade, even though the construction was taking much longer than anyone might
have predicted. If for no other reason than for presentation to the patron, a *disegno*
for a S. Lorenzo façade probably existed in some form—a wooden model, draw-
ings, or at least sketches—by the middle of the century, when it had become clear
that the entire Romanesque basilica was to be rebuilt and not just the western end
as far as the high altar of the old church, which was the extent of the Brunelleschi
plan of about 1420 and of the original financial commitment of Cosimo de' Me-
dici.[25]

Albertian in principle, its grammar Brunelleschian, the plaquette façade might
very well document a design produced by Michelozzo after Brunelleschi's death in
1446 when, it now seems clear, Michelozzo supervised the church construction[26]
(and before he left for Ragusa in 1461). At that time a façade scheme would have
been not only an important matter but also Michelozzo's responsibility. There is
no certainty that Brunelleschi, either before work on the church ceased in 1429 or
before his death, five years after the building campaign resumed in 1441, had fore-
seen that a new façade for the church would be necessary. It is therefore possible
that a façade design could have been produced after his death without reference to
a Brunelleschi prototype, except in the most general sense of the style that he had
"invented." With its highly modeled aedicules, tondi within triangular pediments,
fluted pilasters, and garland swags, the architecture of the façade carries the imprint
of a Michelozzo design in addition to resembling, with its framed rectangular
panels between the applied order, the lower level of one existing Early Renaissance
façade (outside of Florence) known to have been designed by Michelozzo in the
1430s, that of S. Agostino in Montepulciano (fig. 10). To these elements are added
two levels of running framed panels, the leitmotif of the revetment of the Cathedral
where Michelozzo worked from 1446 to 1452 as Capomaestro of the Lantern.
Furthermore, an hypothesis that the façade design can be traced to Michelozzo is
reinforced by the fact that Cosimo de' Medici lived until 1464, and that any project
for a façade produced before that date would have had to reflect his still authorita-
tive presence and his relation to the church and its architects, Michelozzo in par-
ticular.

After the erroneous associations with Bramante were cleared away, it did not
go unnoticed that the church in the plaquette was intended to represent S. Loren-
zo.[27] Indeed, the most salient identifying aspect of the church is the quadrangular
sheath of masonry that encloses the dome (fig. 11)—a feature that existed in no
other Florentine church at the time. Yet not only does the two-level rectangular
facade in the plaquette have little to do with the cross section of S. Lorenzo's
three-tiered elevation (although it later became important for the façade designs of
Giuliano da Sangallo),[28] but the basilican plan of the church is replaced on the
plaquette by a centralized design (a Greek cross within a square) that is even more
puzzling, given the dating of the relief to the period 1450–62. The only centralized
structures built or projected before 1460 were Brunelleschi's Old Sacristy, S. Maria
degli Angeli, and the Pazzi Chapel (modified by barrel-vaulted extensions that
turn the central square into a rectangle); Michelozzo's Tribune for SS. Annunziata;

the anonymous Chiesa di Villa at Castiglione d'Olona; and Alberti's S. Sebastiano in Mantua. None of these is formed as a Greek cross, although the design of S. Sebastiano with arms extending from a central square prefigures what will become a true Greek cross plan. A church designed as an inscribed cruciform with corner chapels covered by some superstructure, as it appears in the plaquette, exists in this period only in the drawings in the treatise of Antonio Averlino, Filarete, composed in Milan in 1460–64. Filarete's treatise contains seven central-plan structures, and the centralized design he preferred above all others is the inscribed cruciform. In a recent interesting study of Filarete, Claire de Reineck Sreenivasan has demonstrated that the inscribed Greek cross in the fifteenth century was, apart from being the characteristic Filarete plan, "the exclusive property of the architectural designer working with pencil and paper," and that its origin was graphic and two-dimensional, derived from a "method of design" that had little or nothing to do with actual three-dimensional construction or "the architectural translation of such a plan" (designed from modular grids).[29]

The introduction of Antonio Averlino, Filarete, provides a new possibility for the understanding of the character of the plaquette and its architectural and other oddities. It is relevant here that the silver plaquette appears to be the original, and the Washington bronze and its reflection in the Anjou medal specimens (also bronze) to be unrefined descendants of the beautifully chased silver relief. Plaquettes of silver are extremely rare. Silver was a precious and expensive material reserved for special purposes. Not only is the Paris specimen made of silver, but it carries traces of enamel polychromy and was probably originally enclosed in, and made with or for, the elaborate and beautifully wrought silver-gilt and enamel frame in which it is now displayed (fig. 12). The cursive linear filigree design of this frame, with corner tondi, bespeaks a heritage from North Italian or Milanese goldsmithwork based on Byzantine prototypes like those of the numerous silver-gilt book covers in the Treasury of San Marco, Venice.[30] Little is known about the purpose of plaquettes; some were used to ornament metal objects, such as inkstands or boxes, or to embellish costumes—worn on hats or belts, dangling by a strap or chain from the neck—but others were made and also meant to be collected as works of art.[31] The Louvre plaquette—precious, polychromed, exquisitely chased, prominently framed, and carrying Medicean associations—has all the aspects of a work made possibly as a gift or for a collector, or as a compliment to a Florentine patron. Its subject also goes beyond that of Christ's miracle, for it is an obvious and purposeful tribute to the great Florentine masters of art and architecture of the first half of the fifteenth century, an homage to "modern" Florence—"this our city, adorned above all others" in the words of Alberti, who in *Della Pittura* praised the contemporary artistic achievements of the city as being no less illustrious than those of antiquity.[32] The references and quotations in the relief are so direct that it appears to have been the artist's intention that they be recognized and appreciated; it is therefore unlikely that a piece so derivative and unoriginal would have been designed by a Florentine artist of consequence or individuality. It could, however, be the work of either a minor Florentine master (although it is interesting that the superior quality of the object has always led away from that hypothesis)[33] or an artist not active in Florence but having a particular admiration for Florentine art and architecture as well as connections in the 1450s and '60s with the Medici family. Antonio Averlino, Filarete, is this kind of artist, and in many ways the silver relief, with its figural citations and architectural anomalies, can be regarded as a visual counterpart of sections of his *Trattato*. The

10

11

10. *Façade of S. Agostino, Montepulciano*

11. *Exterior of crossing dome, S. Lorenzo, Florence*

12. *Plaquette (fig. 1) set into silver-gilt and enamel frame. Louvre, Paris*

12

13. *Frame, silver-gilt and enamel. Victoria and Albert Museum, Inv. 3269–1856, London*

question then arises, whether it is reasonable to think of Filarete as the author of this plaquette. The architecture in the Anjou medal already has suggested his association with the design. A stylistic comparison between the squat and chunky figures in the few plaquettes of which Filarete is possibly the author[34] and the Louvre example (a venture difficult because the Paris object is so diminutive—the figures are about half an inch high—and because the silver material yields more fluid and incisive effects than does bronze) reveals little similarity. But what did Filarete's sculpture look like? Although this subject is being increasingly studied and significant progress toward a definition of Filarete's work as a sculptor is under way,[35] there is still little stylistic consistency (except when architectural forms are involved) in the varied body of sculptural work proposed or known to be by this artist.[36] Do we even know what his drawings looked like? Those in the *Trattato* are copies of the originals,[37] and how faithful these are can only be guessed. There are persuasive reasons for pursuing the possibility that the author of the design, and even the execution, of the Louvre plaquette, could be Filarete.

Filarete is one of the few Italian artists who produced medallic art before the later decades of the century, when that occupation became more popular, particularly in North Italy. He was knowledgeable about sculpture in metal,[38] and worked in silver as well as bronze.[39] His Bronze Door at St. Peter's in Rome was embellished with polychrome enamel on the relief surface; the equestrian statuette in Dresden also was enameled. He was trained, according to Vasari, as a goldsmith in Florence. This training may have taken place in Ghiberti's shop[40] (and the overall debt, sometimes greater and sometimes less, of what is known to be Filarete's sculpture to the pictorial reliefs and to the compositional aspects of Ghiberti's Baptistery Doors, is immediately apparent). The architecture in reliefs attributed to him (figs. 14, 15), either that in the compositions or of the frames, is handled with an authority and a precision often lacking in the figures.[41] The only example I have found where garland swags are hung from bulls' heads, apart from that of the frieze on the structure to our left in the Paris plaquette, is in the relief of the *Martyrdom of St. Paul* on Filarete's St. Peter's Door (fig. 16). On the plaquette

14

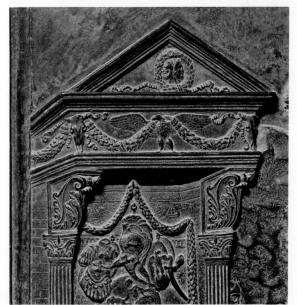

14. *Filarete (attr.). Plaquette, bronze.* Battle of Odysseus and Eros. *Kunsthistorisches Museum, Vienna*

15. *Filarete (attr.). Marble relief (detail).* Discovery of the Miraculous Image of the Virgin. *Basilica of S. Maria, Impruneta (Florence)*

16. *Filarete.* Martyrdom of St. Paul *(detail). Bronze Door, St. Peter's, Rome*

16

17

18

17. *Filarete. Panel with figure of St. Paul (detail). Bronze Door, St. Peter's, Rome*

18. *Palazzo di Parte Guelfa, Florence*

19. *Campanile, Basilica di S. Ambrogio, Milan*

19

church façade the garlands in the frieze are suspended from the heads of fat-
cheeked, round-eyed putti remarkably resembling those above Filarete's single
figures in the upper four panels of the Door in Rome (fig. 17). Fluted pilasters,
triangular pediments, classicizing details, and a ground plane divided by sharp
incisions into a perspective grid are all found in Filarete's reliefs (fig. 14). The
centrally planned buildings in his *Trattato* have already been mentioned. Donatello,
Masaccio, Castagno, Ghiberti, Brunelleschi, and Michelozzo were all singled out
in the treatise;[42] S. Lorenzo, the Old Sacristy, Palazzo Medici, and, separately,
its walled garden[43] were especially esteemed in the treatise, which was dedicated to
their "owner."[44] The author describes, with admiration and respect, the method
and invention of perspective, and gives instructions for its use in works of art.[45]
Filarete's presence in Venice around 1449–50[46] provided him with a knowledge of
Donatello's reliefs for the altar of S. Antonio in Padua, which many Florentines
might not yet have known; his well-known sojourn in Florence, his native city,[47]
in 1456 (before returning to Milan and the subsequent composition of the *Trattato*),
and earlier periods there, would have given him the other components of the
relief—the frescoes of Masaccio and Castagno, Ghiberti's second doors, the
free-standing sculptures, the perspective formulas, and the current solutions for
the S. Lorenzo façade problem. He is a known "copier" of works he admired.
It has often been observed that Filarete's treatise, written several years after his
visit to Florence (a first draft that he intended to rewrite later but never did),[48]
contains passages with vague descriptions of half-remembered but admired Floren-
tine monuments, probably included to compliment Piero de' Medici and his
father. Some of the architectural peculiarities of the relief might be explained in
the same way. In 1456 many Florentine achievements in architecture were still
three-dimensionally incomplete and known only from drawings, models, or talk.
To create a modern Florentine setting, therefore, required the "invention" of a
number of buildings. The two important structures that flank the church and
balance the composition are weaker in design than any of the other elements of the
relief and less immediately familiar. To the left (fig. 4) stands a strange structure,
odd in its proportions, boxy in shape, with panels, fat moldings, rounded corners,
and a heavy projecting cornice and sculptured frieze. A doorway is cut into the
front of the structure. The building to the right (fig. 5) is equally peculiar: a partially
finished palace-tower with thick-framed roundels and openings in the brickwork
like those used for scaffolding support during construction. It does not resemble
any known Florentine structure, although with its thick roundels and unfinished
condition it could be Filarete's vaguely recalled image of the Palazzo di Parte Guelfa
as it stood at mid-century (fig. 18), combined with the appearance of Lombard
towers (fig. 19) with interstices in the brickwork. Since it is intended, I believe, to
"stand for" the Palazzo Medici, Filarete combined a memory of "something tall"
with "something unfinished" to produce an approximation of the new Florentine
residence. That the roundels also suggest associations to the appearance of the
Tomb of Eurysaces the Baker would not be inconsistent with Filarete's familiarity
with the monuments of Rome.[49]

The building on the left incorporates elements of tomb structures, tabernacles,
and loggias without being any of these, or any other recognizable quattrocento
building type. It, too, could be an imperfect recollection of a number of new
structures to be seen in Florence around 1450, again with reminiscences of ancient
monuments. Its low proportions and its door reflect Alberti's replica of the Holy
Sepulcher built for the Rucellai in S. Pancrazio (fig. 20); the bulbous moldings,

paneled articulation, and rounded corners suggest features of both the interior and exterior of Brunelleschi's unfinished (and therefore low) S. Maria degli Angeli (fig. 21); its heavy projecting cornice and carved frieze recall the appearance of the splendid Tabernacle to the Virgin in SS. Annunziata, designed by Michelozzo and executed by Pagno di Lapo Portigiani, for, interestingly, Piero de' Medici and completed not long before Filarete's visit to Florence. He singled it out for special praise.[50]

If, indeed, the church in the center of the relief is meant to be S. Lorenzo, the artist depicted it from its (c.1450–60) "finished" side on the west. Photographs published by Parronchi in *Studi su la dolce prospettiva* comparing the plaquette church and the exterior of the Old Sacristy convincingly document the intentional relationship of the two images.[51] The western end of S. Lorenzo, however, did not provide the ideal centralized elevation desired by the theoreticians of the middle of the century and promoted by Filarete. In the plaquette, therefore, S. Lorenzo was transformed into a symmetrical Greek cross plan by the addition of a domed chapel on the north to correspond in form and dimension to Brunelleschi's Sacristy. Before Michelangelo's construction in the sixteenth century of a chapel that, as Ackerman puts it, "was to be a sister, if not a twin, of Brunelleschi's Old Sacristy,"[52] the only document of an idea for a more or less symmetrical pair of sacristies for the church was Giuliano da Sangallo's S. Lorenzo plan in his Sienese notebook.[53] Since the Paris plaquette precedes the Sangallo design, it is the earliest record of such a concept and therefore can be considered the only serious reflection of fifteenth-century thinking about the completion of the church. The designer of the relief—Filarete, I propose—invented a composite view of S. Lorenzo made up of its

20

20. *Replica of the Holy Sepulcher, Rucellai Chapel, former Church of S. Pancrazio, Florence*

21. *Interior of S. Maria degli Angeli, Florence*

21

finished portions plus projects or proposals that he knew about for the façade and the western end. In this manner he was able to provide a proper and consistent Florentine architectural setting for the relief to correspond to the unassailable Florentine character of the composition in the narrative elements.

This design may thus have been an early carrier of information about the appearance of the Florentine *stile nuovo* of sculpture, painting, and architecture, and, as such, admired by Pietro da Milano and perhaps even by King René, who was aware of developments in the art of Florence in the 1440s sponsored by the Medici.[54] The existence of the prized silver-and-enamel original of the plaquette, and of a bronze aftercast which suggests that it was reproduced in a cheaper and more accessible material, and of three specimens of a medal derived from the bronze version, indicates the admiration offered to this tiny Florentine tribute or, perhaps, souvenir.[55] Its design, which I believe was transmitted to Pietro da Milano through Filarete, who intended it as a Medici gift[56] and developed it in Milan after leaving Florence, was considered appropriate for a royal patron,[57] himself a progressive and discerning connoisseur.

*New York University*

## Notes

*I am indebted to Professors H. W. Janson, Lawrence J. Majewski, and Marvin Trachtenberg for enlightening conversations pertaining to the technical and formal aspects of the plaquette that is the subject of this paper. Particular thanks are due to M. Bertrand Jestaz, Conservateur au département des Objets d'art, Musée du Louvre, for his generous and detailed answers to my many questions about the Louvre specimen of the plaquette. For his kindness in permitting me to examine the bronze specimen at the National Gallery in Washington, D.C., I am indebted to Dr. Douglas Lewis, Curator of Sculpture at the National Gallery.

[1] The Paris version of the relief measures 10.7 by 6.9 cm across the back, and is inserted into an ornate frame (see below, n. 30). The surface of the relief is finely chased, and carries traces of enamel. Not *repoussée*, the relief was either cast in silver from a wax original by the *cire-perdue* process, or cast from a female mold made from the wax model. The bronze specimen in Washington measures 9.3 by 5.8 cm, and was probably cast from a mold made from the silver original, with the difference in dimension the result of shrinkage. Although this is not the opinion of contemporary experts, in 1886 E. Molinier believed the bronze to be a proof for the silver (which he knew only from hearsay; see below, n. 2). According to Eric Maclagan, however, "If one example of a plaquette is definitely smaller than the other, it may be assumed that it is an aftercast" (*Victoria and Albert Museum, Catalogue of Italian Plaquettes*, London, 1924, 4). Due partly to the difference of material, the quality of the bronze version is considerably inferior to that of the softer, more malleable silver; the casting was indifferently executed, surface details chased on the silver were not included in the bronze, there are a number of blemishes, and the top center is perforated, probably so that the plaquette could be suspended or attached. Unless otherwise stated, in this paper the relief described is the silver version, from which the clearest reading of the forms can be made.

[2] The first attribution of the bronze was to Caradosso, and was made by E. Müntz (without knowledge of the ex-

istence of the silver version) in 1883: "L'orfèvrerie Romaine de la Renaissance, avec une étude spéciale sur Caradosso, deuxième article," *Gazette des Beaux Arts*, XXVII, 493. Its attribution to Pietro da Milano was made by E. Molinier, *Les Bronzes de la Renaissance, Les Plaquettes*, Paris, 1886, I, 67, xvi, xvii, n. 2; II, 152. Molinier had learned of a related silver object but had not seen it. The silver plaquette was published for the first time in 1905 by G. Migeon, who noted the bronze "double" and, basing his conclusions on Molinier's analysis, attributed the silver, too, to Pietro da Milano: "Deux oeuvres de la Renaissance Italienne," *Fondation Eugène Piot, Monuments et mémoires publiés par l'Académie des Inscriptions et Belles-Lettres*, Paris, 1905, 234–36; and also in "Les Accroissements des Musées, Musée du Louvre," *Les Arts*, 1906, L (Feb.), 10. The Florentine character of the plaquette was recognized by R. Longhi who first believed that it (referring to the one in the Louvre where, he said, it "hides under the name of Pietro da Milano") "preserved exactly" *The Possessed Woman*, a lost painting by Masaccio: *Piero della Francesca,* Florence, 1931, 65. Reconsidering it later, in 1940, after his attribution had been challenged by Salmi, Longhi proposed Brunelleschi as the "ideatore" of the plaquette, stressing an "amicizia spirituale" with Masaccio, for whom, Longhi said, he had claimed only the composition: "Fatti di Masolino e di Masaccio," *Critica d'Arte*, V, 3–4 (1940), 161 f. Salmi's response to Longhi's Brunelleschi proposal was to reject it by dating the frame to the middle rather than the early part of the fifteenth century, as Longhi had done, and to advance the name ("se un nome si dovesse avanzare") of Andrea del Castagno: Salmi, *Masaccio*, 2nd ed., Florence, 1947, 121, 226–27. Both Longhi and Salmi confused the bronze and silver versions, believing there to be only one; they both recognized features of Donatello's sculpture in the relief. P. Sanpaolesi ascribed the plaquette to Donatello in *La Sacristia Vecchia di San Lorenzo,* Pisa, 1950, 6 f.

This attribution was rejected by H. W. Janson in his *Donatello*, Princeton, 1963, 131, n. 5. Brunelleschi's name was attached to it once again by A. Parronchi, who, writing of the relief in his *Studi su la dolce prospettiva*, Milan, 1964, 177, 245 ff., saw it as a version of Brunelleschi's lost perspective panel. It is ascribed to Brunelleschi once again and dated around 1420 in C. Ragghianti's *Filippo Brunelleschi, un Uomo un Universo*, Florence, 1977, 325; see also C. Verga, *Diapositivo Brunelleschi 1420*, Crema, 1978, 71–85. At both the Louvre and the National Gallery, however, the objects are still considered, on the basis of their relation to a medal made for Rene d'Anjou by Pietro da Milano (first recognized by Molinier; see above, p. 111), to be the work of this sculptor. In the National Gallery catalogue by J. Pope-Hennessy, *Bronzes from the Samuel H. Kress Collection: Renaissance Bronzes*, London, 1965, 80 f., some of the literature has been summarized.

[3] It is difficult to determine which of the biblical accounts of healing is depicted here, for it is not clear whether the possessed person is male or female. Matthew (9:32–34; 15:21–28; 17:14–18), Mark (9:14–29), and Luke (9:37–43; 11:14) all recount stories of healing, but the nature of the affliction varies as does the gender of the "possessed" and of the accompanying parent. Probably no specific representation was intended for the plaquette; the person supporting the "possessed" is female, and apparently (based on the costume) so is the person afflicted.

[4] For example: Domenico Veneziano's *Miracle of St. Zenobius* (Fitzwilliam Museum, Cambridge), from the predella of the St. Lucy Altarpiece; or the cassone panels depicting the *Adimari-Ricasoli Nuptials* (Florence, Accademia) and *Solomon and Sheba* (London, Victoria and Albert Museum), both illustrated in P. Schubring, *Cassoni, Truhen und Truhenbilder der Italienischen Frührenaissance*, Leipzig, 1915, Pl. XLI, No. 193; Pl. LVI, No. 256.

[5] The Louvre plaquette and its frame were both owned by M. Alfred André, an

eminent restorer of art objects in Paris, who before 1904 sold the frame alone to Baron A. de Rothschild; Rothschild then donated it to the Louvre. In 1904 André gave the relief to the Louvre and proposed that it should once again be placed inside the frame for which he believed it to have been made; the two parts have been reunited since that time. I am grateful to M. Jestaz of the Louvre for this information.

The bronze also belonged to a private French collection, that of M. Gustave Dreyfus; in 1930 Sir Joseph Duveen acquired the collection from Dreyfus's executors; in turn the plaquette became the possession of Mr. Samuel H. Kress, and is now part of the Samuel H. Kress Collection of Renaissance Bronzes at the National Gallery in Washington.

[6] Some of the elements of quattrocento Florentine art and architecture cited in the following two paragraphs, and others not mentioned here, have been noted by Longhi, Salmi, Sanpaolesi, and Parronchi. See above, n. 2.

[7] See M. Barasch, *Gestures of Despair*, New York, 1976, chs. III, VI.

[8] The tall palazzo with arched windows, on the right, however, is taken from Ghiberti's architecture in the relief on his Reliquary of St. Zenobius.

[9] Michelozzo's authorship of the porticoes was convincingly proposed by Janson, *Donatello*, 138–40.

[10] Müntz, *Gazette des Beaux-Arts*, XXVII, 493.

[11] *Ibid.*

[12] *Ibid.*

[13] Molinier, *Plaquettes*, I, 66.

[14] G.F. Hill, *A Corpus of Italian Medals of the Renaissance Before Cellini*, London, 1930, I, 15.

[15] Three specimens of the medal exist: Berlin, Staatliche Museen; Paris, Bibliothèque Nationale; Marseille, Cabinet des Médailles. The diameters vary from 101 to 104 mm.

[16] See: Hill, *Corpus*, I, 15; Molinier, *Plaquettes*, I, 66; and G. L. Hersey, *The Aragonese Arch at Naples, 1443–1475*, New Haven–London, 1973, 57.

[17] G. Migeon was the first to deal with the silver plaquette; see above, n. 2.

[18] Molinier, *Plaquettes*, I, 66.

[19] Writing of the bronze version of the plaquette, Pope-Hennessy says that "it is to be inferred that the medal depends from the plaquette and not the plaquette from the medal since the building is shown on the circular field with a superstructure in the form of a tower which is incompatible with the Brunelleschian forms of the façade"; *Bronzes from the Kress Collection*, 81.

[20] See, for example, Schubring, *Cassoni*, Pl. LII, No. 233, and also the woodcut illustration of a May Festival in front of Palazzo Medici, from an edition (c.1500) of the *Ballatette* of Lorenzo de'Medici, Angelo Poliziano, and Bernardo Giambullari (Bibl. Naz., Florence) publ. in *Mostra del Poliziano nella Biblioteca Mediceo Laurenziana*, ed. A. Perosa, Florence, 1955, frontispiece.

[21] I. Hyman, "Notes and Speculations on S. Lorenzo, Palazzo Medici, and an Urban Project by Brunelleschi," *Journal of the Society of Architectural Historians*, XXXIV (1975), 101.

[22] See A. Parronchi, "La Prima Rappresentazione della Mandragola," *La Bibliofilia*, LXIV (1962), 37–86; *idem*, "Una Piazza Medicea," *La Nazione*, Aug. 24, 1967, 3; *idem*, "Due Note," *Rinascimento*, VIII (1968), 358 f.; C. Pedretti, *A Chronology of Leonardo da Vinci's Architectural Studies after 1500*, Geneva, 1962, 112–18; *idem*, *Leonardo da Vinci, The Royal Palace at Romorantin*, Cambridge, Mass., 1972, 58–63, 307–12; C. H. Krinsky, "A View of the Palazzo Medici and the Church of San Lorenzo," *Journal of the Society of Architectural Historians*, XXVIII (1969), 133–35; and E. Borsook, "Art and Politics at the Medici Court, II: The Baptism of Filippo de'Medici in 1577," *Mitteilungen des kunsthistorischen Institutes in Florenz*, XIII (1967), 95–114, in which is described a celebration in honor of the baptism of the long-awaited son and heir of Grand Duke Francesco I de' Medici. Borsook publishes an illustration (her fig. 10) of the festivities in Piazza S. Lorenzo, where the unfinished façade of the church was concealed by a temporary colonnaded arcade.

[23] A number of *encomia* written in the 1450s as Medici tributes contain fanciful descriptions of Palazzo Medici: Don Timoteo Maffei's "In Magnificentiae Cosmi Medicei Detractores," of c. 1450, published in G. Lami, *Deliciae Erudito-rum*, Florence, 1742, XIII, 155; Alberto Avogadrio's "De Religione, et Magnificentia Illustris Cosmi Medices Florentini," also published by Lami, *op. cit.*, 141 ff.; and the anonymous "Ricordi di Firenze dell'Anno 1459," ed. G. Volpi, in L. A. Muratori, *Rerum Italicarum Scriptores*, Città di Castello, 1907, XXVII, Pt. 1, fol. I. See also R. Hatfield, "Some Unknown Descriptions of the Medici Palace in 1459," *Art Bulletin*, LII (1970), 232–49.

[24] See Hyman, *JSAH*, 1975, 106–9.

[25] *Ibid.*, 98, n. 3.

[26] *Ibid.*, 105.

[27] For the most extensive analyses of the Brunelleschian aspects of the structure represented in the relief and their particular relation to S. Lorenzo, see Sanpaolesi, 1950, 6 f., and Parronchi, *Studi*, 245–50.

[28] Stylistic similarities between the church façade in the plaquette and the three colored ink drawings in the Uffizi (*Arch.* 276, 280, 281) considered to be Giuliano da Sangallo's projects for the façade of San Lorenzo (R. Pommer, *Drawings for the Façade of San Lorenzo by Giuliano da Sangallo, and Related Drawings*, M.A. thesis, unpublished, New York University, 1957) warrant further study. See also G. Scaglia, "Three Renaissance Drawings of Church Facades," *Art Bulletin*, XLVII (1965), 173–85, in which the author analyzes the articulation and proportions of the façades in these drawings, and discerns important ties between Ghiberti and Giuliano da Sangallo by way of Brunelleschian-Albertian practice and theory.

[29] C. de Reineck Sreenivasan, *The Central-plan Churches of Filarete's Trattato*, unpublished M.A. thesis, New York University, 1972, 60.

[30] Another Byzantine example, a book cover of silver and ivory from eleventh-century Ravenna, is illustrated in O. von Falke, *Sammlung Alter Goldschmiede-werke in Zürcher Kunsthaus*, Zurich, 1926, Pl. VII. The frame was first discussed by Longhi, *Critica d'Arte*, 1940, 161, who saw it as an ostentatious and "Italianized" Late Gothic piece of the first decades of the quattrocento. That it was instead an example of the retardataire traditions that existed in the minor arts during the fifteenth century was recognized by Salmi (*Masaccio*, 1947, 226), who noted that these traditions were still sustained in the fourth to sixth decades of the century. For Janson (*Donatello*, 1963, 131, n. 5) the frame, which he dates to the early part of the century, precedes the plaquette, "a product of the second half of the century." Parronchi, in *Studi*, 177, put the frame and the plaquette together, dating both of them to 1427–30 and attributing them to an "architect-goldsmith" (Brunelleschi) for reasons that include the similarities in the design of the frame to patterns in the oculi of the cupola of the Old Sacristy and marble intarsia patterns on the exterior of the Duomo. I am inclined to see the design of the frame in the same light as Salmi, as belonging to retardataire currents in the minor arts of the mid-fifteenth century, characteristic of North Italy but also found in Florence. The leaf pattern of the inner border, that immediately adjacent to the plaquette, is used in the frames of many Florentine Renaissance reliefs—Luca della Robbia's *Cantoria* and Buggiano's *Pulpit* in S. Maria Novella, to name two examples. A telling comparison can be made between the plaquette frame and the painted border of the sixteenth-century (c. 1515) Medici Book of Hours illustration of *The Visitation*, depicted on Piazza San Lorenzo in front of a fictitious, completed church façade (see Krinsky, *JSAH*, 1969, ill.). Also of interest here is a silver-gilt quadrangular frame with circular center (6 5/8 × 7 1/2″), chased with foliage and with Medici insignia in the corner tondi (Victoria and Albert Museum), believed to be from the mid-fifteenth century. Once again I am grateful to M. Jestaz of the Louvre, who informed me about the existence of this object and connected it

to the Paris plaquette.

[31] The best account of the nature of plaquettes is found in Maclagan, *Catalogue of Italian Plaquettes*, 1–10.

[32] Leon Battista Alberti, *On Painting*, rev. ed., trans. with introd. and notes by John R. Spencer, New Haven–London, 1970, 33.

[33] See the history of the attributions, above, p. 111. It is also of interest that among the published plaquettes and medals that survive from Renaissance Italy, only one bears any compositional or stylistic relation to the Paris and Washington plaquettes and to the Anjou medal reverse. It is an oval bronze plaquette (8.8 × 10.2 cm) depicting a Baptism Before the Walls of a City, formerly in the Staatliche Museen in Berlin and now possibly in East Berlin, acquired in 1883 in Florence from Stefano Bardini. The relief is very flat, and the figures are arranged in a kind of semicircle in front of the architecture. See Molinier, *Plaquettes*, II, 153 f., No. 670, and the illustration in E. F. Bange, *Die Italienische Bronzen der Renaissance . . .*, Berlin, 1904, II, Pl. XLIV.

[34] Plaquettes attributed to Filarete are: *Triumph of Julius Caesar* (Louvre); *Virgin and Child with Angels* (Louvre); *The Battle of Odysseus and Eros* (Kunsthistorisches Museum, Vienna); *Lion and Bull* (Hermitage). On these see M. Lazzaroni and A. Muñoz, *Filarete, Scultore e Architetto del Secolo XV*, Rome, 1908, 140–53; V. Rakint, "Une Plaquette du Filarete au Musée de l'Hermitage," *Gazette des Beaux-Arts*, X (1924), 1–10; Pope-Hennessy, *Italian Renaissance Sculpture*, 332. Paxes, medals, and other reliefs, aside from plaquettes, by and attributed to Filarete, should also be taken into account. See below, n. 35.

[35] Recent significant works concerning Filarete's sculptural style that make convincing attributions and provide additional bibliography with important illustrations of reliefs attributed to the artist are U. Middeldorf, "Filarete?" *Mitteilungen des Kunsthistorischen Institutes in Florenz*, XVII (1973), 75–86; C. Seymour, "Some Reflections on Filarete's Use of Antique Visual Sources," *Arte Lombarda* 38/39 (1973), *Il Filarete*, 36–47; J. R. Spencer, "Filarete, the Medallist of the Roman Emperors," *Art Bulletin*, LXI (1979), 549–61. For bibliography through 1972 for Filarete as sculptor (and architect) see Antonio Averlino, Filarete, *Trattato di Architettura*, eds. Anna Maria Finoli and Liliana Grassi, Milan, 1972, xcii-civ.

[36] In addition to references in nn. 34 and 35 above, see A. M. Romanini, "Averlino," *Dizionario Biografico degli Italiani*, IV, 662–67.

[37] *Trattato*, lxii.

[38] *Ibid.*, Bk. XXIV, 678 ff.

[39] One of Filarete's few certain works, signed, and dated 1449, is a silver processional cross in the cathedral at Bassano.

[40] Romanini, *Dizionario*, 662.

[41] This can be seen most forcefully in the marble relief in the Basilica in Impruneta attributed to Filarete by Middeldorf, *Mitteilungen*, 1973. See also ill. 14 in the same article.

[42] From the *Trattato*: Donatello—Bk. III, 75; Bk. VI, 170; Bk. IX, 252; Bk. XIV, 391; Bk. XXIII, 658; Bk. XXV, 693; Masaccio—Bk. IX, 265; Castagno—Bk. IX, 265; Ghiberti—Bk. VI, 170; Bk. IX, 252; Brunelleschi—Bk. VI, 171; Bk. VIII, 227; Bk. XXIII, 623, 657; Bk. XXV, 693; Michelozzo—Bk. VI, 170.

[43] *Trattato*, Bk. I, 3–4; Bk. XXV, 684, 693, 695 ff.

[44] "Perché ho conosciuto tu essere eccellente e dilettarti di virtu e di cose degne, come degnamente è usanza negli animi gentili, e massime di quelle che danno perpetua e degna fama, o magnifico Piero de' Medici, considerando questo, io stimai doverti piacere intendere modi e misure dello edificare." *Trattato*, Bk. I, 3. See also Bk. XXV, 685 f.

[45] *Trattato*, Bk. XXIII, 655–57.

[46] See Romanini, *Dizionario*, 663.

[47] In his dedication Filarete writes: ". . . dal tuo filareto architetto Antonio Averlino fiorentino." *Trattato*, Bk. I, 5.

[48] P. Tigler, *Die Architekturtheorie des Filarete*, Berlin, 1963, 11–13.

[49] This and other references to Roman monuments in the plaquette were noted

by Longhi, *Critica d'Arte*, 1940, 162.

[50] *Trattato*, Bk. XXV, 685. The Tabernacle, consecrated in 1452, was completed in 1448.

[51] Parronchi, *Studi*, 233, figs. 92 a and b.

[52] J. S. Ackerman, *The Architecture of Michelangelo*, London, 1961, 22.

[53] R. Falb, *Il Taccuino Senese di Giuliano da San Gallo*, Siena, 1902, Tav. 22.

[54] King René was in Florence for several months in 1442, and an interesting document, published in the nineteenth century, survives from this visit. He was provided with a house in the city, and the canons of S. Lorenzo presented him with a crucifix. The crucifix was stolen, and the Priors of the Comune ordered Florentine goldsmith Guarento di Giovanni to replace it with another of the same form and quality (et quod dictus Guarenta teneatur et debeat dictam crucem reficere de illo pondere et cum illis qualitatibus et modo et forma prout erat illa que fuit furata). At the same time, and perhaps to mitigate their embarrassment about the theft, the Priors offered the king one of the lionesses belonging to the city, as well as a cage for her made at the expense of the Comune. See A. Lecoy de la Marche, *Le Roi René*, Paris, 1875, II, 252, doc. 18. One of the purposes of the king's sojourn in Florence was to receive from Cosimo de' Medici, to whom it had been entrusted by Pope Eugenius IV, a Papal Bull investing René with the fief of Naples. See J. S. Gill, *Eugenius IV, Pope of Christian Union*, Westminster, Md., 1961, 88.

[55] Professor Marvin Trachtenberg pointed out to me that there is an old tradition of city souvenirs in silver. Pilgrims brought back silver *ampullae* filled with consecrated oil and decorated with reliefs of the Holy Land: "[These] must have helped to spread the iconography of monumental art in the Holy Land": W. F. Volbach, *Early Christian Art*, New York, n.d., 361.

[56] Filarete claims that he presented his treatise to Piero de' Medici along with other "operette" (which may or may not have been literary): *Trattato*, Bk. I, 7. His bronze statuette of Marcus Aurelius, in Dresden, was, according to the inscription, a gift to Piero de' Medici in 1464, the same year in which he presented the treatise. If the plaquette was a Medici gift, the choice of the subject of a healing miracle would have been relevant to the ailment that caused great suffering to Piero de' Medici and that resulted in his death in 1469, only five years after that of his father. See Filarete's references to Piero de' Medici's infirmity in *Trattato*, Bk. XXV, 685 f.

[57] There was a tenuous connection between King René and Filarete in Milan in 1453 when Filarete was working on the tower of the Sforza Castello di Porta Giovia in Milan and the king, on September 17, 1453, visited the castle. See L. Beltrami, *Il Castello di Milano sotto il dominio degli Sforza (1450–1535)*, Milan, 1885, 143. In his edition of Filarete's *Treatise*, John R. Spencer believes Filarete's reference to "uno re che oggi vive è bonissimo disegnatore" is to René of Anjou: *Filarete's Treatise on Architecture*, New Haven–London, 1965, 81, n. Finoli and Grassi, who mention that Oettingen, in his edition of the treatise, believed the reference was to King Ferrante of Naples, do not support either view: *Trattato*, 183, n.

# 9

# The Tomb of
# Doge Nicolò Tron and
# Venetian Renaissance Ruler
# Imagery*

DEBRA PINCUS

One of the major avenues of political expression in the fifteenth century still remains to be fully explored: the monumental tomb. Interest has focused on the Bruni and Marsuppini tombs, done around the middle of the fifteenth century, as humanist tombs—monuments to the individual—with the civic import of these monuments, one of which, the Bruni tomb, seems very likely to have been partially financed by the state, played down. Shifting the discussion to include the political component, one might well consider these important sculptural productions of the early Renaissance as presentations of the Florentine chancellor as modern hero.[1] Our understanding of the political aspect of fifteenth-century tomb production in Rome is hampered by the widespread destruction of monuments. Enough remains in the way of drawings and extant fragments, however, to view the grandiose tomb of Paul II (d. 1471), probably completed by 1477,[2] as a carefully considered piece in the papacy's attempt to reestablish itself as a major power on the peninsula. By the 1470s, a number of key Italian ruling centers were exploiting the possibilities of the large-scale tomb as it could serve that newly developing entity, *lo stato*.

It is against this background that one turns to the tomb of the Venetian doge Nicolò Tron (1471–1473), the largest surviving tomb monument of the early Renaissance (fig. 1). Rising some fifteen meters high in the Cappella Maggiore of the church of the Frari in Venice, the Tron tomb is conspicuous within the lineage of fifteenth-century Venetian tombs for its size and the complexity of its imagery. Particularly striking is the duplication of image types. The effigy of the deceased appears twice, standing and recumbent. There are some twenty free-standing figures, of which at least twelve fall into the category of Virtue figures. Seven Virtues appear near the top of the structure; two additional Virtues flank the standing effigy; a group of three Virtues, on a smaller scale, stand against the front face of the sarcophagus. Additional allegorical figures are provided which relate to the standing and the recumbent effigy. Completing it all is a zone of religious imagery at the top of the structure.

The Tron tomb has long been recognized as a work of major importance. One of the early notices, Marcantonio Sabellico's reference in *De venetae urbis situ* of 1494/95, praises the work—to quote the Italian translation—as "*cosa da vedere*

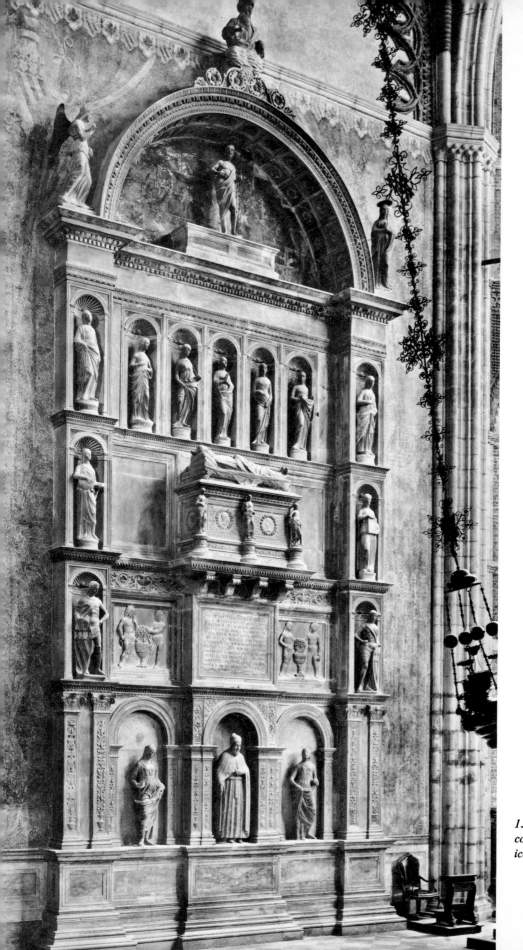

*1. Tomb of Doge Nicolò Tron. Frari, Venice*

*per mirabile.*"[3] In the deluxe edition of engravings of Venetian tombs published in 1839, the text accompanying the Tron plate, written by Francesco Zanotto, explores the classical detailing of the sarcophagus level but takes a dubious view of any attempt to decipher fully the program: "*ma chi potrebbe dare dopo quattro secoli spiegazione adeguata di codeste allegorie . . .?*"[4] Pietro Selvatico, in his study on Venetian architecture and sculpture of 1847, gives a thoughtful analysis of the tomb, taking particular care with the components of the sarcophagus zone.[5] The early responses to the tomb are fused in Pietro Paoletti's magisterial compendium of material on Venetian Renaissance architecture and sculpture which appeared at the end of the nineteenth century. Paoletti was able to see the tomb in terms of a coordinated program dealing with the themes of life, death, and afterlife. For Paoletti, however, the sarcophagus was an infelicitous intrusion: "*una pomposa o pretenziosa allegoria dell'educazione, delle opere, delle virtù e della nobile prosapia del Doge . . . con idea e forme tutto pagane. . . .*"[6] Attempts at penetrating the message of the iconography have been largely foregone by modern scholars, the interest having shifted to style. After a period of some controversy, this issue seems on the way to being resolved. Most scholars now agree on a general attribution of the tomb to Antonio Rizzo, with, however, large workshop participation.[7] In instances where the tomb has been looked at from the point of view of its imagery, attention has focused on the use of the standing effigy.[8] The question which interested earlier scholars of the meaning of the sarcophagus decoration—a question that I believe to be of major importance in seeing the meaning of the tomb as a whole—has been largely bypassed in current literature. I made a start in the direction of deciphering the program of the tomb in an article published some years ago.[9] The more complete study which follows is in large part a response to the question Peter Janson posed to me when, as a student, I was working on the style of the tomb: "And now," he asked, "what does it all mean?"

In contrast to the Della Scala tombs in Verona or the tombs of the Angevin dynasty in Naples,[10] elaborate ruler tomb display was a relatively late development in Venice. A rather severe wall-hung sarcophagus, without effigy, served as the dominant ducal tomb type until well into the fourteenth century. There appears to have been an early tradition for reusing sarcophagi of antique and Early Christian date. One of the earliest ducal tombs to have survived relatively intact is the double tomb of doges Jacopo (1229–1249) and Lorenzo (1268–1275) Tiepolo (fig. 2), mounted on the facade of SS. Giovanni e Paolo. A second- or third-century sarcophagus has been used, reworked so that the lugs at the corners of the lid present the Phrygian cap of the Tiepolo arms and, above it, the "other" hat worn by these Tiepolos, the ducal *corno*.[11] A long inscription emphasizing the military achievements of the two rulers, flanked by censing angels of rather rude workmanship, is the major decorative component. In ducal tombs of the first half of the fourteenth century, the extended Latin inscription, one of the most constant elements of the Venetian ducal tomb, moves to a plaque on the wall below, and the front face of the sarcophagus is increasingly given over to figural decoration.[12] The first extant ducal tomb to include an effigy is the tomb of Doge Andrea Dandolo (1343–1354), in the Baptistery of S. Marco,[13] where the boxlike sarcophagus form is expanded to incorporate some of the funeral imagery brought into Italy at the end of the thirteenth century and popularized by Arnolfo di Cambio and his followers.[14]

A line of showy ducal tombs may have been initiated with the tomb of Doge

Marco Cornaro (1365–1368), in the choir of SS. Giovanni e Paolo, although it is difficult to determine from the present arrangement whether the figures in an arcaded setting above the tomb chest are in fact part of the original format.[15] However, it is clear that by the beginning of the fifteenth century the tradition for prominent tomb display had been established. The tombs of doges Michele Morosini (June–October 1382), Antonio Venier (1382–1400), and Michele Steno (1400–1413) present a type of wall-hung tomb with architectural surround, large figural complement, long inscription, and prominent display of arms.[16] The Morosini tomb in the choir of SS. Giovanni e Paolo rather dazzlingly combines mosaic and sculptural components, and is interesting for the importance given to the arms of the deceased, placed within the "sacred" field of the crowning gable. The Venier tomb has been rearranged as part of the sixteenth-century portal leading into the Cappella Rosario in SS. Giovanni e Paolo, but the sarcophagus unit remains intact and is to be noted as the first extant example in Venetian tomb imagery of the seven canonical Virtues—the three theological and the four cardinal—a motif that remains popular to the end of the Quattrocento.

In the group of tombs prepared for the three doges who follow Steno in the ducal succession—Tommaso Mocenigo (1414–1423, SS. Giovanni e Paolo), Francesco Foscari (1423–1457, Frari), and Pasquale Malipiero (1457–1462, SS. Giovanni e Paolo)—the format, changing to emphasize the funeral ceremony, presents a further step in symbolic aggrandizement.[17] The architectural gable has turned into a canopy of honor, a reflection of the Trecento tomb's funeral curtains, reinterpreted under the influence of the funeral catafalque. The Mocenigo tomb tentatively introduces a number of classicizing elements into the ducal tomb repertoire. A pair of small putti support the architectural backdrop and present the Mocenigo arms; two warrior figures of different ages, youth contrasted with experienced

*2. Tomb of Doges Jacopo and Lorenzo Tiepolo. SS. Giovanni e Paolo, Venice*

maturity, mark the corners of the sarcophagus. The Foscari and Malipiero tombs both present problems in terms of possible alteration (and concomitantly, of dating), but they are essentially wall-hung tombs that still relate to the late four-teenth-century type although the vocabulary is now largely Renaissance. There is continued and increasing emphasis on the architectural surround. In the Foscari tomb columns have been added which, in effect, bring the architecture to floor level; these columns support warrior figures who function as pages for the deceased, bearing his arms and holding open the canopy.

A major break in the concept of the ducal tomb comes with Tron's immediate predecessor, Doge Cristoforo Moro (1462–1471). Moro's tomb is located in the choir of S. Giobbe, a deceptively simple tomb slab—inscribed only with the words: CRISTOPHORVS MAVRVS PRINCEPS—set in the center of the choir space. San Giobbe was rebuilt under Moro's auspices, given a large bequest in his will, and very likely planned during his lifetime as the site of his burial.[18] A triumphal arch, with the Moro ducal arms in the spandrels, frames the opening into the chancel, and declares the space beyond to be, in effect, a tomb chapel. The blessing God the Father appears in a roundel in the center of the choir vault in obvious relation to the tomb below. It is the kind of aggressive appropriation of space that one thinks of as beginning in the sixteenth century, as in Raphael's free spatial manipulations in the Chigi Chapel.[19] Moro takes full possession of the choir, in a skillful handling of the useful contradiction of the self-effacing/omnipresent ruler.

Thus the Tron tomb comes at a point when the form of the ducal tomb in Venice has been opened up, and when the message of the tomb is one of egregious glorification. In it some of the traditional elements are recovered: the wall-hung tomb chest with recumbent effigy, the long inscription tablet below the chest, the use of the seven canonical Virtues, as well as the capping of the ensemble with sacred figures. But these elements are melded together with a new freedom, on a new scale, and in a program of a complexity as yet unequaled in the Renaissance tomb. The detail with which the program has been worked out suggests the influence of the layered, upward-moving narrative of the Trecento tomb, as, for example, in the well-known tomb of Charles of Calabria, or the related but more grandiose tomb of Robert of Anjou, both in S. Chiara, Naples.[20] More immediate Renaissance developments have also had a decisive effect. The tradition of pageant and festival imagery probably lies behind the curious posturing stance assumed by many of the tomb's figures. There is also something pointedly theatrical in the way in which both the architectural units and the gestures of the figures are handled in order to dramatize the upward-moving dynamic of the program. The monumental Moro arch in S. Giobbe is, however, a key model in the development of the architecture of the Tron tomb, with Moro's understanding and application of triumphal imagery operating as a major factor in establishing the general imagery of triumphal celebration in Venice.[21]

Within the Tron program, three distinct levels are to be distinguished: a highly elaborated life zone covers the first two tiers; a spiritual zone is at the top; an intermediary zone, represented by the sarcophagus tier—the dynamic center of the tomb—brings the other two together in terms of an idealized conception of the Venetian ruler.

The first unit (fig. 1) is the zone of the "living effigy." The zone as a whole is defined by a foliate richness that sets it apart from the more austerely decorated upper levels. A triple archway, densely covered with plant life, frames the doge and the flanking allegorical figures. In panels above, putti remove fruit from urns filled

to overflowing. Horizontal moldings with acanthus mark the upper limit of this zone. The most forceful life image is given by the deceased himself (fig. 3). The standing effigy is a figure designed to impress the viewer as a vital presence. Leaning slightly forward out of his arched frame, he stares intently at the viewer, literally pointing to himself with one hand, calling attention to his ducal robes with the other. In the pair of female allegorical figures standing on either side of Tron, the designer of the tomb has given visible form to the dual thrust of the life force, the earthly and the spiritual, expressed here through the virtue of Charity. The figure on the doge's right, who casts her glance down to earth and would, in her original presentation, have offered the contents of a largish bowl held in her right hand, is a reference to the earthly concerns of life, *Caritas: amor proximi.* The figure on the doge's left is barefoot, turns her glance heavenward, and holds a flaming bowl. She symbolizes the spiritual life, *Caritas: amor Dei.*[22] The special presentation of these three figures—doge and complementary Charities operating as a tightly united group, isolated under the triple archway—establishes a pointed relationship among them. The attendant Charities transcend the category of Virtue figure and operate as a kind of double *alter ego* of the doge, suggesting the two-fold responsibility—worldly and spiritual—of the ducal office.[23] All three figures also escape, in an interesting way, from the category of statue: they do not stand on bases but directly on the ground of their niches, with an immediacy that is quite different from the presentation of the figures in the niche compartments above.[24]

The message of ongoing life is stated in emblematic form by the putti plaques above the Charity figures. Pairs of young male figures remove fruits from urns brimming over with a rich assortment. In Renaissance imagery, the urn operates as a way of making reference to the human life-span. The motif appears on Renaissance medals, in such proto-emblematic works as the *Hypnerotomachia Poliphili,* as well as in the fully developed emblem literature of the sixteenth century.[25] Behind the use of this kind of vegetable imagery one should also see the complex vegetable imagery of the antique Seasons sarcophagi. A relevant example is provided by the Albright-Knox sarcophagus (fig. 6), where the urn, heaped to overflowing with seasonal fruits being consumed by birds, becomes—together with the winged putti who personify the seasons—a graphic symbol of the passing year.[26]

Above his head and between the putti, Tron is lauded in a long inscription in handsome Roman Imperial capitals (fig. 7). The inscription is focused on the events of Tron's short ducal reign:

NICOLAVS · THRONVS · OPTIMVS
CIVIS · OPTIMVS · SENATOR · OPTIMVS
ARISTOCRATIAE · PRINCEPS · FVIT ·
QVO FELICISS · DVCE · FLORENTISS[IMA]
VENETORV[M] · RES · P · CYPR[VM] · IMPERIO
ASCIVIT · CVM · REGE · PARTHOR[VM]
CONTRA · TVRCHVM · SOTIA · ARMA
CONIVNXIT · FRAVDATAM · PECU
NIAM · VIVA · ILLIVS · EFFIGIE · RESIGN
AVIT · CVIVS · INNOCENTISSIMIS
MANIBVS · HANC · MERITA[M] · DIVINI ·
OPERIS · MOLEM · PHILIPPVS · FILIVS
PE[RE]NNI · ET[ER]NITATE · POSVIT ·

4

3

5

3. *Tron tomb, standing effigy*

4. *Tron tomb, recumbent effigy*

5. *Silver "trono."* Museo Civico Correr, Venice

6. *Season sarcophagus. Albright-Knox Art Gallery, Buffalo*

6

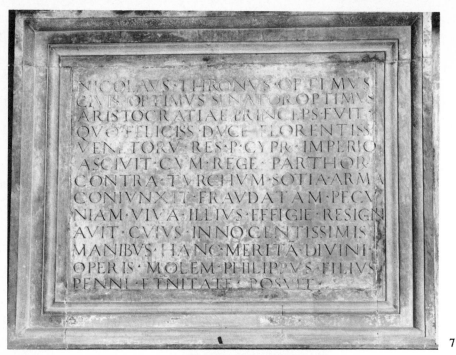

7. *Tron tomb, inscription plaque*

8. *Tomb of Neri Capponi.*
*S. Spirito, Florence*

Nicolò Tron was an unexcelled citizen, an unexcelled senator, an unexcelled prince of the aristocracy. Under his most blessed leadership, the most flourishing state of the Venetians received Cyprus into its empire. With the king of the Parthians, he joined allied arms against the Turks. He restored the value of money with his living image. His son Filippo has erected this well-earned monument to his most innocent shades for divine aid in everlasting perpetuity.[27]

Particularly to be noted in this inscription is the reference made to what was perhaps the major political action that distinguished Tron's short ducal career, the passing of a series of measures directed against the large-scale counterfeiting of Venetian coinage both in Italy and abroad. The reform of the currency carried out under Tron involved the minting of a silver coin of a weight which would mediate between the gold ducat and the smaller silver and copper coinage of the *soldini* and *bagattini*. The new coin was stamped with Tron's portrait image—"*viva effigies*" in the language of the tomb inscription. Technically designated as a lira piece, it became popularly known as the "*trono*" (fig. 5).[28]

The effigy and the inscription are complemented by a third ducal reference: paired warrior figures who carry Tron arms. These figures connote Tron's ducal power. The Tron warriors are the first arms-bearing warriors *all'antica* to appear in a tomb context. The type is undoubtedly influenced by the "genius-putto" arms bearer of the Florentine tomb either directly or at second hand, with the Tron warrior carrying the particular significance of military and ducal virtue, enhanced by antique authenticity.[29] Consistent with the use of complementary pairings throughout the tomb, the warriors are differentiated in type, offensive versus defensive. The warrior on the right is at the ready with a drawn weapon; the warrior at the left, his arm akimbo, appears in the more relaxed posture of confident *prontezza*.

This zone of life imagery is answered at the top of the tomb by a zone of religious imagery focused on resurrection (fig. 1). The Risen Christ appears under a coffered lunette-canopy with strong dome of heaven associations, on axis with the living effigy of Tron below. Along the vertical axis of the tomb—between the two poles of life and afterlife—are situated the inscription plaque, the sarcophagus with the recumbent effigy, and, directly above it, the virtue of Hope. With her gaze fervently directed upward, hands clasped in prayer, Hope makes the transition between the sarcophagus level and the resurrection zone. The upward-moving succession of elements is capped by a half-length figure of God the Father emerging from a cloud bank above the lunette-canopy. The religious imagery in the top zone of the tomb also functions to restate, in remarkably compressed terms, the movement from mortal time to immortal time that takes place along the length of the tomb. The Annunciation on the outer pilasters frames the Resurrected Christ within the lunette, presenting, as Paoletti pointed out, "*l'alfa e l'omega della vita di Cristo*."[30] The full span of Christ's life is encompassed within a three-figure grouping, the kind of resonant compression that pervades the imagery of the tomb as a whole.

Mediating between the life zone and the resurrection zone is the sarcophagus tier. This zone of the tomb, which earlier had attracted attention for its overt use of classical material, is perhaps the most innovative part of the program. While rooted in an imagery appropriate to Tron himself, it knits together a number of references to present a closely argued statement setting the ducal ruler in a universal context. Projecting forward from the front plane of the tomb, the sarcophagus

commands attention visually. As will be argued, it also commands attention intellectually.

The sarcophagus with the recumbent effigy (fig. 4) rises on bracket consoles directly out of the life zone, remaining suspended in the middle of the tomb structure. Arrayed in niches above the sarcophagus are the three theological and four cardinal Virtues. The Tron tomb departs from the earlier ducal tomb tradition by elevating the seven Virtues above the tomb chest so that they become, in effect, apotheosis Virtues, overseeing the passage from the intermediate zone of the sarcophagus level to the apotheosis zone of the Resurrected Christ.[31] The turn in the sarcophagus zone is away from the living energy of the zone below toward a more abstract presentation. The putti plaques give way to empty panels, just as in the center field the living effigy and the achievements of the *dogado* give way to the sarcophagus and the recumbent effigy. The sarcophagus presents two sets of images. Decorating the surface of the sarcophagus are four relief medallions of profile heads enclosed within fruit garlands, two on the front side and one on each end (figs. 9–12). Against the front face of the sarcophagus are placed three statuettes of women wearing classical dress, with small but important variations in costume (figs. 13–15).

The meaning of the two sets of decoration has puzzled scholars. On one hand, the tomb is already well supplied with Virtue figures. An additional set of Virtues, not strikingly distinguished in their attributes, has seemed redundant. The four profile heads present another kind of problem. They bear no relationship whatever to the portrait features of Tron, as he appears in the effigies of the tomb and on his coinage (figs. 3–5). Nor can they be linked to the portrait features of any specific Roman emperor, despite the obvious care that has gone into duplicating the Imperial coin type. The juxtaposition of Virtues and medallions together with the

*9. Tron tomb, medallion: Youth*

*10. Tron tomb, medallion: Old Age*

shared classical vocabulary suggests that the two sets of images should relate to each other, but a convincing association has not come readily to hand.

The profile portrait *all'antica* was a familiar piece of Renaissance imagery by the 1470s. Renaissance medals provided close adaptations of the Imperial emperor head and gave the type widespread exposure. By the 1450s the profile portrait had entered the repertoire of tomb imagery. The tomb of Neri Capponi (d. 1458) in S. Spirito, Florence, includes winged putti carrying a memorial image of the deceased in the form of an enlarged profile portrait medallion (fig. 8).[32] In the Tron tomb, the idealized ruler head of the Renaissance medal merges with the idea of the commemorative portrait medallion as seen on the Capponi tomb. The depiction of the Tron heads is, however, pointed along quite particular lines. Looked at as a group it becomes apparent that the same idealized Roman head—beardless, with close-cropped hair, and closely related physiognomies—is shown at four separate life stages. The softly rounded facial contours and firm chin line of Youth (fig. 9) begin to fill and swell out in Prime (fig. 11), thicken into the heavy, flabby jaw and neck line of Middle Age (fig. 12), and tighten into the parchment-creased skin surface of Old Age (fig. 10). Age imagery was already present in the Venetian ducal tradition by the early part of the fifteenth century in the tomb of Tommaso Mocenigo in SS. Giovanni e Paolo, as mentioned above. More or less contemporary with the Tron tomb, the tomb of Doge Pietro Mocenigo (d. 1476) in SS. Giovanni e Paolo uses three ages in the form of a warrior guard-of-honor carrying the sarcophagus of the deceased.[33] In its use of the four ages, the Tron tomb connects with the four-part system initiated in antiquity and developed into the thoroughgoing system of correspondences between man and the universe, between microcosm and macrocosm, that stands as one of the great monuments of medieval thinking.[34] The four ages, the four seasons, the four humors, the four winds, the four rivers

*Tron tomb, medallion: Prime*

12. *Tron tomb, medallion: Middle Age*

  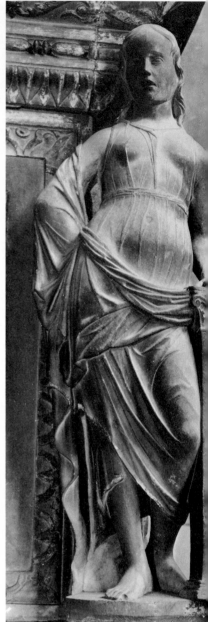

13                                                   14                                                   15

*13. Tron tomb, Pax*

*14. Tron tomb, Abundantia*

*15. Tron tomb, Securitas*

of paradise are seen as partaking of that larger system of order represented above
all by the four elements. The nub of the fully developed four-part system was that it served to establish a resonant relationship between the natural order and the divine order. The reference to the four ages on the tomb chest thus takes the imagery of the middle level into an abstract realm which emphasizes the point of contact between man's world and God's world.

There is a further level of meaning attached to these medallion heads. The separate ages, established graphically, have been placed on the tomb chest so that they call forth another layer of correspondences within the tetradic order, the correspondence between the four ages of man and the four humors. The four medallions are arranged in relationship to the body within the tomb chest, with each age matching the part of the body appropriate to the established humor of that life stage. Thus Youth, the springtime of life, characterized as warm and moist, associated with the blood of the body and the element of air, and classed with the sanguine humor, the most desirable of humors, appears in top position—corresponding to the head of the body, on the short end of the sarcophagus. Old Age, the winter of life, cold and moist in its qualities, linked to the element of water, the bodily liquid of phlegm, and the phlegmatic humor, appears opposite the chest, on the front face of the sarcophagus. Prime, the summer of life, warm and dry in its qualities, linked to the element of fire, the bodily liquid of yellow bile, and the choleric humor, appears in third position—on the front face, corresponding to the genitals. At the bottom of the sarcophagus—that is, at the short end corresponding to the feet—is Middle Age, the autumn of life, cold and dry in its qualities, linked to the element of earth and the bodily liquid of black bile, companion to the least prized of humors, melancholia. In its use of the four ages topos, the Tron tomb expands upon the ages motif seen on other fifteenth-century ducal tombs. Not until the sixteenth century, in Michelangelo's final version of the Julius II tomb as erected in S. Pietro in Vincoli, does the suggestive ages–seasons–humors statement of the Tron medallions find a real successor.[35]

Tetradic systems persisted in Renaissance thought in a variety of ways. The reclothing of the system in antique dress that takes place on the Tron tomb is paralleled in other aspects of Renaissance expression.[36] What is to be particularly noted on the Tron tomb is the amalgamation of the four ages theme with Roman Imperial imagery and, specifically, with Roman Imperial coin imagery. The reference is entirely in keeping with that key event of Tron's ducal career—the important money reform commemorated in the inscription. The Roman coin thus provides not only a ruler image, but one particularly appropriate to Tron.

Coin imagery also lies behind the three figures attached to the sarcophagus (figs. 13–15). Personifications from Roman coin reverses have been adapted to a set of figures that function as civic virtues, providing, in Venetian terms, an image of the well-ordered state. At the right corner of the sarcophagus lounges the relaxed figure of Securitas, barefooted, bareheaded, wearing a scanty covering (fig. 15). Her column denotes constancy; her negligent pose, the absence of danger—or, as Joseph Addison succinctly summed it up: "as Security is free from all pursuits, she is represented leaning carlesly [sic] on a pillar."[37] Securitas was paramount as a civic virtue in the early period of the Italian city-states. Ambrogio Lorenzetti's *Allegory of Good Government* in the Palazzo Pubblico, Siena, includes a Securitas— labeled as such, but having the form of an antique winged Victory—who hovers over the prosperous countryside; in the more hierarchical "council of virtues" of the fresco, it is Pax who assimilates the noble ease of the seated Securitas of Roman

coinage.[38] In the Tron tomb, the Roman type is revived in its Roman configuration—the same Roman type that was to later serve Cesare Ripa in his presentation of "*Sicurtà*" in the *Iconologia* (fig. 17).[39] Securitas as a personification specifically linked to the emperor—*Securitas Augusti*—enters Roman coinage under the Flavian emperors to become one of the key personification types. It is a sturdy, long-lived image, one of the personifications still in use by the late emperors when the coinage itself became debased in content.[40] Antonio Agostino's *Dialoghi intorno alle medaglie*, written toward the end of the sixteenth century and containing one of the first systematic treatments of antique coin reverses, includes a long entry on the type, reproducing two pages of woodcut illustrations. The mid third-century coin minted under Trebonianus Gallus, reproduced by Agostino (fig. 16), provides an example of the kind of Securitas personification that the Tron designer might have looked at.[41]

Marking the other end of the sarcophagus is a more contained, religious figure, also barefooted but wrapping her cloak around her (fig. 13). Part of the cloak is held close in her left hand, a small palm branch discreetly cradled in her right: the cloak is secured across the chest by a brooch that bears a smiling putto face. The palm is also used on the reverse of Doge Pasquale Malipiero's medal, where personified Peace, her Imperial associations underlined by the legend PAX AUGUSTA, appears seminude, with sword and shield at her feet, brandishing a palm branch in her right hand (fig. 20).[42] In Roman coin imagery, the concept of Pax was a complex one, highly religious in nature, and used with a number of pointed variations. Under Hadrian, interest in giving new vitality to the concept of peace produced a new coin type: *Hilaritas Populi Romani*—the rejoicing of the Roman people.[43] The Hilaritas personification carried ceremonial and religious overtones

*16. "Securitas." Woodcut from Antonio Agostino,* Dialoghi intorno alle medaglie . . . , *Rome, 1592*

*17. "Sicurta." Woodcut from Cesare Ripa,* Iconologia, *Padua, 1611*

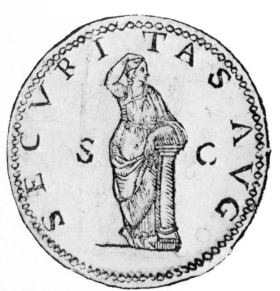

16

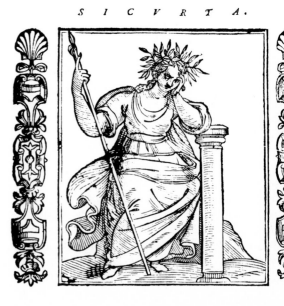

17

similar to those associated with Pax, but with the emphasis turned to prosperity,

well-being, and public gladness of a kind related to the coming of spring. A large
palm branch, offered by Hilaritas with her right hand to a nude putto at her feet,
served as the major attribute of the new personification, supplemented by a cornu-
copia held in the left hand. It was Hadrian's Hilaritas that the suave numismatist
Pope Paul II (1464–1471) appropriated for one of his own medals, motif for motif,
under the legend "*Hilaritas Publica*" (fig. 21).[44] The Hilaritas Publica medal is
perhaps to be associated with the pope's repeated efforts during his pontificate to
unite the warring factions of Italy in his self-styled role as "Founder of the Peace
of Italy."[45] On the Malipiero medal one finds an approximation of the antique
Pax, antiquizing rather than authentically antique. The Tron Virtue uses Roman
sources to produce a more "genuine" Pax, decorous and modest in manner, Paul
II's Hilaritas medal very likely serving as an intermediary.[46]

Pax and Securitas at opposite ends of the sarcophagus function as another of
the complementary pairs that are basic to the program of the tomb—the casual
ease of Securitas answered by the ceremonial dignity of Pax. Between the two and
in a sense generated by them is the fruitful Virtue, Abundantia (fig. 14). This center
Virtue holds a bunch of grain in her right hand and, as appropriate to her more
earth-bound nature, wears sandals. The association of the ruler with the food supply
and general prosperity was a dominant theme of Roman coinage, stressed by
Augustus in his propaganda policy and early introduced as a major component of
Imperial coinage.[47] The intimate connection between the emperor and the food
supply is seen in the coin issued in honor of Livia, Augustus's wife, who is divinized
under the aspect of Ceres. This coin is singled out and explicated in Sebastiano
Erizzo's handbook of 1559 (fig. 18).[48] The Ceres-Abundantia type becomes well

18. *Livia as Ceres. Woodcut from Sebastiano Erizzo*, Discorso
sopra le medaglie antiche, *Venice, 1559*

19. *"Ceres Augusta." Woodcut from Enea Vico*, Discorso so-
pra le Medaglie de gli antichi, *Venice, 1558*

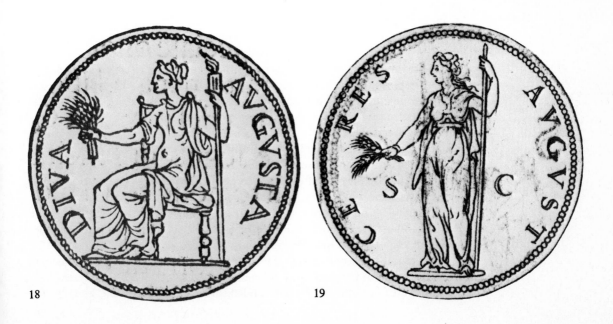

18                                        19

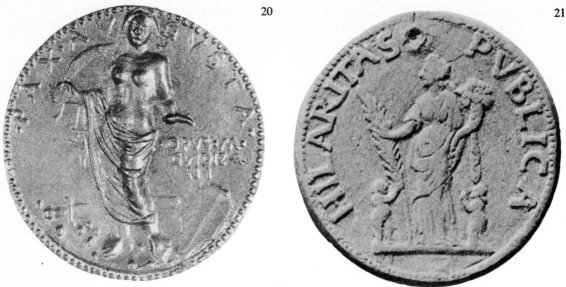

20. "PAX AUGUSTA." *Medal of Doge Pasquale Malipiero, reverse.*
*Museo Civico Correr, Venice*

21. "HILARITAS PUBLICA." *Medal of Pope Paul II, reverse*
*(from Hill,* Corpus, *no. 785)*

established in the Flavian period and continues into the late empire. Enea Vico, in
his *Discorso sopra le medaglie de gli antichi*, publishes a woodcut illustration after
a coin of Domitian which shows one common version of Ceres-Abundantia: a
standing female figure in classical dress, with a bunch of grain held in the right hand
(fig. 19).[49] The antique Abundantia figure on the model of the Livia-Ceres personi-
fication was being used in Venice in a program of state imagery at the beginning
of the sixteenth century, on the center bronze flagpole base in Piazza S. Marco.[50]

By means of the personifications of Roman coinage the designer of the program
has created a set of civic virtues, something entirely new to Renaissance tomb
imagery. What gives point to the Virtues applied to the Tron sarcophagus is that—
over and beyond their general importance for the Italian city-states—each has
particular importance in the Venetian political consciousness. The concern for a
secure government, in which the tyranny of either a faction or of an individual
would be neutralized, appears to have been a dominant element in Venetian polit-
ical thinking from the early fourteenth century. Peace was, of course, a major
consideration to a Venice deeply involved in the power politics of the mainland
and embroiled in an ongoing war with the Turks, and from early in the fifteenth
century, peace is the key motif of Venetian political rhetoric. The question of the
food supply is again a long-term Venetian concern, a particularly pressing concern
to a city dependent on importing its food from the mainland and points along the
trade route. These are carefully chosen references—a set of civic virtues that spe-
cifically links the ruler to the Venetian body politic.[51]

It is important to recognize that the sarcophagus decoration has been planned
as a single system of imagery, both formally and conceptually. Formally, the dec-
oration operates in terms of obverses and reverses of an accessible and, by the

1470s, familiar body of classical material. This adapted classical vocabulary then functions as a concentrated, conceptually ambitious commentary on the role of the Venetian doge. The tetrad of the ages and the temperaments, expressed via the four medallions, is extended by a reference to the physical world, stated in terms of Venice, and expressed through the civic virtues. What we have here is a model of the universe—*mundus, annus, homo*[52]—presided over by the doge. The large ambitions of the sarcophagus decoration were intuitively sensed by Paoletti, but he saw the "*pomposa . . . allegoria*" as centered on Tron as a specific individual rather than on Tron as the all-unifying ruler. That the message of the sarcophagus is intended to place this kind of importance on the ruler becomes still clearer when one adds to the argument the two figures in the outer niches on either side of the sarcophagus, figures who complement the imagery of the sarcophagus itself.

On the left is a figure playing a lute, her gaze directed upward as if for inspiration (fig. 22); on the right, a figure who presents a more level gaze—looking out rather than up—and who displays a large booklike tablet (fig. 23). In another of those resonant pairings that permeate the imagery of the tomb, an analogy is set up between human order—that is, the order of the state—and divine order, the

*22. Tron tomb, figure with lute*       *23. Tron tomb, figure with tablet*

harmony of the spheres. Human order, symbolized through the tablet of the law, serves as the complement to cosmic order, symbolized by the music of the lute. The use of musical instruments to indicate, visually, divine harmony is an established medieval tradition.[53] Alongside this long-term association should be set the fifteenth-century type of the perfect or prototypical ruler modeled on the image of Apollo. It is Apollo as Apollonian head of state who rules at the top of the well-known woodcut that serves as the frontispiece to Franchinus Gafurius's *Practica musicae,* published in Milan in 1496. Crowned and in royal robes, Gafurius's Apollo holds the lute as the badge of authority, the commanding of a universal harmony. With broad gestures Apollo encompasses both the spiritual (as signified by the three Graces) and the sensual (the flowering pot) while presiding over a complex harmony of the cosmos and the arts that funnels, by means of Macrobius's triple-headed beast, into human time (past, present, and future) and human substance (the four elements) as they are depicted at the bottom of the engraving. The all-pervasive authority of Apollo in the scheme is made clear by the inscription: MENTIS · APOLLINEAE · VIS · HAS · MOVET · VNDIQVE · MVSAS (The power of the Apollonian mind sets these Muses in motion on all sides).[54] In Venice the lute was the instrument par excellence for celebration of the divine, as is indicated by the omnipresent lute-player, either singly or in combination with other musicians, seen in Venetian altars of the late fifteenth and early sixteenth centuries.[55] On the tomb, the symbolism of the lute is answered by the symbolism of the tablet. As used here the tablet would appear to combine the idea of the "first" codification of human law supplied by Moses, laws of direct divine manufacture, with the ruler emblem of the open book. The book as a ruler emblem had begun to take on a certain broad popularity in the fifteenth century. As used by Alfonso of Aragon it became a multivalent image that had as one of its significations, as Paolo Giovio was later to put it, *"pratica nel civil governo."*[56] In narrative terms—to use the words of Kantorowicz in discussing Renaissance applications of Apollonian imagery—the message is that of "the Prince who by means of the law attunes the state to the harmony of the Cosmos."[57]

The Tron tomb represents a brief moment in Venetian ducal iconography. Succeeding tombs, while grandiose and idealizing, do not become involved in presenting the doge as the central figure in effecting the harmonious workings of the state. The closely contemporary Pietro Mocenigo tomb in SS. Giovanni e Paolo handles the theme of ducal glorification from the standpoint of the exercise of power, in particular military power. In a sense the Pietro Mocenigo tomb is an alternative to the closely reasoned argument of the Tron tomb, choosing as it were another rhetorical mode, the message achieved through repetitions of the antique warrior type.[58] In Venice the fullest echo of the Tron tomb is to be found in the decoration scheme of the last years of the fifteenth century inside the Palazzo Ducale complex, and in particular in the sculptural program of the Arco Foscari.[59]

The persuasive rhetoric of sixteenth-century political theorists—where the success of the Venetian state is explained as the result of a system of finely interlocking segments which ensures the division of power[60]—has made it difficult to hear the message which monuments such as the Tron tomb proclaim, a message of the doge as ideal, universal ruler. Yet the development of this kind of strong ruler statement is entirely consistent with what is happening in other parts of Italy during the second half of the fifteenth century. While the Tron tomb operates out of the tradition of aggrandizement that shows itself developing in Venetian ducal

tombs from Michele Morosini on, the ruler image that is being presented must also be seen as intimately tied up with Venice's history, her turn toward the mainland during the fifteenth century, and her involvement in a network of power politics that necessitated new kinds of political statements.[61] It is significant that the real successor to the imagery of the Tron tomb is to be found in the line of papal tombs and, above all, in the tomb of that first consciously great ruler-pope of the new era, Julius II.

*The Tomb of Doge Nicolò Tron*

*The University of British Columbia*

*Notes*

* This material is part of a larger investigation I am engaged in on the development of the Venetian ducal tomb in the medieval and Renaissance periods. I am indebted to a number of people who have generously offered assistance in connection with the present study. I would like to express particular thanks to the students in my graduate seminar on Renaissance tomb imagery at The University of British Columbia, 1976–77, whose discussion of many issues helped clarify my thinking. My colleagues JoAnne Gitlin Bernstein, Jack Freiberg, Robert Munman, Anne Markham Schulz, and Wendy Stedman Sheard have offered invaluable assistance on a number of occasions. In Venice, Padre Luciano Marini and Umberto Bognolo of the church of the Frari have facilitated photographing of the monument. The detail photographs, published here for the first time—and taken under somewhat difficult conditions—are by Aldo Targhetta of the firm of Giacomelli. For long-term assistance and encouragement I would like to thank the Fondazione Giorgio Cini, and in particular, Dott. Alessandro Bettagno and Raggionere Silvano de Tuoni. Generous financial support has been provided by the American Council of Learned Societies and the Humanities Grants Fund of The University of British Columbia. Finally, it is with pleasure that I acknowledge the assistance, in all aspects of the preparation of this article, of my husband, Joseph Pincus.

1 For sources and the program of the Bruni tomb, see Anne Markham Schulz, *The Sculpture of Bernardo Rossellino and His Workshop*, Princeton, N.J., 1977, 32–51, 99–104. The interest of Florence in erecting monuments at public expense to its important citizens is discussed by Schulz, 33, n. 9.

2 The vicissitudes of the tomb are covered by Hugo von Tschudi, "Giovanni Dalmata," *Jahrbuch der königlich preussischen Kunstsammlungen*, IV (1883), 169–90, esp. 169–81. Among the later literature are to be noted Fritz Berger, "Neuaufgefundene Skulptur- und Architekturfragmente von Grabmal Pauls II," *Jahrbuch der königlich preussischen Kunstsammlungen*, XXVII (1906), 129–41, with a reconstruction drawing based on Venetian tomb types, and Giacomo De Nicola, "Il sepolcro di Paolo II," *Bollettino d'arte*, II (1908), 338–51. A partially reliable summary of data on the tomb is given by Gianni Carlo Sciolla, *La scultura di Mino da Fiesole*, Turin, 1970, esp. 124–27. One awaits now the full study being prepared by Michael Kühlenthal in connection with his corpus of fifteenth-century Roman tombs.

3 *Del sito Venezia città*, ed. G. Meneghetti, Venice, 1957, 16.

4 Antonio Diedo and Francesco Zanotto, *I monumenti cospicui di Venezia*, Milan, 1839, text accompanying pl. II.

5 *Sulla architettura e sulla scultura in Venezia dal medio evo sino ai nostri giorni*, Venice, 1847, 179 f.

[6] Pietro Paoletti, *L'architettura e la scultura del Rinascimento a Venezia*, Venice, 1893, 142.

[7] The attribution of the tomb to a certain "Antonio Bregno" given in Francesco Sansovino's early guide, *Venetia città nobilissima et singolare*, Venice, 1581, 66, is now almost entirely discounted, largely as a result of the stylistic personality of Rizzo laid out by Paoletti, *L'architettura e la scultura*, 141–63. The earliest association of Rizzo with the Tron tomb appears to be by Giuseppe Cadorin, *Notizie storiche della fabbrica del Palazzo Ducale e de'suoi architetti nel secoli XIV e XV*, Venice, 1837, reprinted in *Pareri di XV architetti*, Venice, 1838, 138. Recent discussions of the tomb from the standpoint of isolating autograph Rizzo components are provided by Giovanni Mariacher, "Profilo di Antonio Rizzo," *Arte veneta*, II (1948), 67–84, esp. 73–76; Wiebke Pohlandt, "Antonio Rizzo," *Jahrbuch der Berliner Museen*, XIII (1971), 162–207, esp. 180–91; Robert Munman, "Antonio Rizzo's Sarcophagus for Nicolò Tron: A Closer Look," *Art Bulletin*, LV (1973), 77–85. Also to be noted is Munman's general discussion of problems relating to the tomb in his *Venetian Renaissance Tomb Monuments*, Ph.D. dissertation, Harvard University, Cambridge, Mass., 1968, 79–108.

[8] Werner Weisbach, *Trionfi*, Berlin, 1919, 100, with a connection made to Trecento tomb programs; Henriette s'Jacob, *Idealism and Realism, a Study of Sepulchral Symbolism*, Leiden, 1954, 182.

[9] Debra Dienstfrey Pincus, "A Hand by Antonio Rizzo and the Double Caritas Scheme of the Tron Tomb," *Art Bulletin*, LI (1969), 247–56.

[10] For the tomb of Cangrande della Scala (d. 1329), S. Maria Antica, Verona (equestrian statue now removed to Verona's Museo Civico d'Arte), and related Scaliger tombs, see Costantino Baroni, *Scultura gotica lombarda*, Milan, 1944. The Angevin tombs are dealt with by William R. Valentiner, *Tino da Camaino*, Paris, 1935, 16–42. These works are discussed in the general context of Trecento tomb programs by Erwin Panofsky, *Tomb Sculpture*, New York, 1964, 67–86.

[11] Fernando Rebecchi, "Sarcofagi cispadani di età imperiale romana: Ricerche sulla decorazione figurata, sulla produzione e sul loro commercio," *Römisches Mitteilungen*, LXXXIV (1977), 107–58, has drawn attention to the important sarcophagus production of the second and third century A.D. that comes out of Ravenna, characterized by the export of semiworked pieces which would be finished to order by local sculptors at destination points in various North Italian centers. The Tiepolo sarcophagus follows the model of the Ravenna-based workshops, and it is likely that one of these unfinished sarcophagi of Ravennate type was adapted in the thirteenth century for the Tiepolo family. I am grateful to James Russell, Department of Classics, The University of British Columbia, for supplying me with this reference. See also Andrea da Mosto, *I dogi di Venezia nella vita pubblica e privata*, Milan, 1960, 102 f. For a discussion of the Tiepolo sarcophagus and its decoration as, for the most part, a genuine Late Antique piece of debased workmanship, see Hans von der Gabelentz, *Mittelalterliche Plastik in Venedig*, Leipzig, 1903, 68.

[12] Work on Trecento and early Quattrocento ducal tombs is now greatly facilitated by the publication of Wolfgang Wolters's *La scultura veneziana gotica (1300–1460)*, Venice, 1976, with full references to earlier literature. For the early tombs of doges Giovanni Soranzo (1312–1328, Baptistery of S. Marco), Francesco Dandolo (1329–1339, Frari), and Bartolomeo Gradenigo (1339–1342, atrium, S. Marco), see Wolters, 156, fig. 51; 163 f., fig. 100; 165, fig. 111. A checklist of ducal tombs is given by Bartolomeo Cecchetti, *Il doge di Venezia*, 1864, 298–301.

[13] Wolters, *Scultura veneziana*, 190, fig. 311. As noted by Wolters, 190, Andrea Dandolo is the last doge to be buried in S. Marco—i.e., in the "private chapel" of the doge—a statement prohibiting burial in S. Marco being written into the *promissione* of his successor. It is interesting to speculate whether the moving of the ducal tomb out from the Palazzo Ducale complex signifies a more private

attitude toward ducal burial, as Wolters suggests, or a more public one.

14 Julian Gardner, "The Tomb of Cardinal Annibaldi by Arnolfo di Cambio," *Burlington Magazine*, CXIV (1972), 136–41, 143; and "Arnolfo di Cambio and Roman Tomb Design," *Burlington Magazine*, CXV (1973), 420–39.

15 Wolters, *Scultura veneziana*, 198–200, fig. 329.

16 Wolters, *Scultura veneziana,* 205 f., fig. 343; 226 f., fig. 475; 233 f., fig. 538. The Steno tomb, preserved in reduced and altered form in SS. Giovanni e Paolo, was moved from the church of S. Marina in the eighteenth century. Jan Grevembroch shows it (*Monumenta veneta*, Biblioteca Correr, MS Gradenigo 228, II [1754], fol. 69) similar to the Morosini tomb in size and format.

17 For the Tommaso Mocenigo tomb, see Wolters, *Scultura veneziana*, 239 f., fig. 568. For the Foscari tomb, see Anne Markham Schulz, *Niccolò di Giovanni Fiorentino and Venetian Sculpture of the Early Renaissance*, New York, 1978, with full reference to earlier literature. For the Malipiero tomb, see Munman, *Tomb Monuments*, ch. 2, with a summary of earlier discussions.

18 Umberto Franzoi and Dina Di Stefano, *Le chiese di Venezia*, 1976, 108–10. A suggestive discussion of Moro's patronage is presented by Julia Keydel, *A Group of Altarpieces by Giovanni Bellini Considered in Relation to the Context for Which They Were Made*, Ph.D. dissertation, Harvard University, Cambridge, Mass., 1969, 75–81. For the choir of S. Giobbe designated as a "choir-mausoleum," see Wendy Stedman Sheard, *The Tomb of Doge Andrea Vendramin in Venice by Tullio Lombardo*, Ph.D. dissertation, Yale University, New Haven, 1971, 22.

19 John Shearman, "The Chigi Chapel in S. Maria del Popolo," *Journal of the Warburg and Courtauld Institutes*, XXIV (1961), 129–60.

20 See above, n. 10.

21 For Moro's transformation of the Arco Foscari into a twin-tower triumphal gateway marking the interior end of the entranceway into the Palazzo Ducale, see Debra Pincus, *The Arco Foscari: The Building of a Triumphal Gateway in 'Fifteenth-Century Venice*, New York, 1976 (Outstanding Dissertations in the Fine Arts), 104–68.

22 Pincus, "A Hand by Antonio Rizzo," 247–56.

23 Information on the doge as *princeps in republica/princeps in ecclesia* is provided by Paolo Prodi, "The Structure and Organization of the Church in Renaissance Venice: Suggestions for Research," John R. Hale, ed., *Renaissance Venice*, London, 1973, 409–30; see also William J. Bowsma, *Venice and the Defense of Republican Liberty*, Berkeley, 1968, 71–83, 112–16.

24 For an emphasizing of the immediate contact which these three figures make with the viewer, see Munman, *Tomb Monuments*, 97 f.

25 The printer Geofroy Tory's use, c. 1525, of the vase as a life metaphor, and its probable relationship to the *Hypnerotomachia*, are discussed by Ludwig Volkmann, *Bilderschriften der Renaissance*, Leipzig, 1923, 62–65 (reprinted Nieuwkoop, 1962). Among early Renaissance patrons to make use of the fruitful vase/basket motif as part of their medal imagery is Leonello d'Este; George F. Hill, *A Corpus of the Italian Medals of the Renaissance Before Cellini*, 2 vols., London, 1930, nos. 27, 30. The vase is specifically designated as "la vita humana" by Lodovico Domenichi in his discourse appended to Paolo Giovio, *Dialogo dell'imprese militari et amorose*, Lyon, 1559, 147 f.

26 George M. A. Hanfmann, *The Season Sarcophagus in Dumbarton Oaks*, Cambridge, Mass., 1951, cat. 435: I, 235; II, 173. The antique motif of the fruitful urn flanked by putti appears to have been known to the Renaissance in the form of "independent" examples, as in the fragment in Ravenna, possibly the short end of a sarcophagus, cited by Robert Corwegh, *Donatellos Sängerkanzel im Dom zu Florenz*, Berlin, 1909, 33, 39, as the source for the left-hand marble putto relief of the Donatello Cantoria, Florence, Museo dell'Opera del Duomo, done in the 1430s (H. W. Janson, *The Sculpture of Donatello*, Princeton, N.J., 1957, II, 119–31). The differences be-

tween the Tron and Cantoria plaques are sufficiently pronounced to rule out the possibility that Rizzo modeled his work on the Donatello piece, although Rizzo may well have known and been influenced by Donatello's adaptation. Rather, we have here an instance of two artists making intelligent adaptations of a related antique type, in each case pointed along lines that serve the needs of the specific program.

[27] I wish to thank Elizabeth Bongie, Department of Classics, The University of British Columbia, for her assistance in working out this translation.

[28] Nicolò Papadopoli Aldobrandini, *Le monete di Venezia*, II, Venice, 1907, 1–17.

[29] In the second half of the fifteenth century in Venice, the warrior *all'antica* becomes established not only as a carrier of arms but also as an accepted part of ducal imagery, as can be seen from the use of the figure on the Arco Foscari. It is undoubtedly because of ducal associations that the Foscari tomb adapts the arms-bearing warrior—in semi-antique armor—to a holder of the funeral canopy, a post that on the earlier ducal tomb of Tommaso Mocenigo had been occupied by an angel. For discussion of the fifteenth-century Venetian warrior figure, see Pincus, *Arco Foscari*, 342–46, 424–27; and Sheard, *Tomb of Andrea Vendramin*, 197, n. 15. The interesting use of the arm-akimbo pose in the left-hand warrior presents still another association with Florence, in this case to two important warrior images: Donatello's bronze *David* in the Bargello and Castagno's warrior hero *Farinata degli Uberti* in the *Uomini Famosi* cycle of the Villa Pandolfini-Carducci at Legnaia.

[30] Paoletti, *L'architettura e la scultura*, 142.

[31] The Virtues may be identified from left to right as: Fortitude (in armor); Faith (one hand to the chest in a gesture of affirmation); Prudence (gazing into a mirror-like object); Hope (stressed upward gaze, hands pressed together in prayer); Temperance (head wreathed in laurel, cloak decorously pulled forward); Charity (skirts filled with a bountiful offering); Justice (in full, magisterial-like robes). The two Virtues with the strongest state associations—Fortitude and Justice—are placed in the outer pilasters, providing a civic frame, as it were, for the group as a whole. The placing of the Virtue figures above the effigy as a separate tradition in tomb programs is the subject of a study currently being prepared by Robert L. Mode of Vanderbilt University.

[32] Schulz, *The Sculpture of Bernardo Rossellino,* 69–74, 114–17. Important stylistic links are to be noted between the Capponi portrait—generally seen as a work of Antonio Rossellino—and the Tron medallion to the left on the front face of the sarcophagus (fig. 10).

[33] Munman, *Tomb Monuments*, 110–34, esp. 120 f.

[34] Summaries of the tradition of tetradic associations are provided by Raymond Klibansky, Erwin Panofsky, and Fritz Saxl, *Saturn and Melancholy*, London, 1964, and S. K. Heninger, Jr., *Touches of Sweet Harmony: Pythagorean Cosmology and Renaissance Poetics*, San Marino, Cal., 1974. Readily available then in nearby Padua was a monumental statement schematizing the life of man, virtually a visual encyclopedia of macrocosm/microcosm associations, in the frescoes decorating the grand hall of the Palazzo della Ragione, a work of the fourteenth century, substantially restored in the early fifteenth.

[35] Karl August Laux, *Michelangelos Juliusmonument*, Berlin, 1943, 284–95, identifies the herms in the final version of the Julius tomb as the four temperaments, and by extension, the four elements, based on a character analysis of the facial types. To Laux's reading one can add a clear set of references to the four seasons. I am preparing a study of Michelangelo's use of the herm-temperaments in the Julius II tomb project: "The Four Temperaments in the Final Version of the Julius II Tomb." Charles De Tolnay's rejection of a tetradic layer of meaning in the herms (*Michelangelo*, IV, Princeton, N.J., 1954, 127 f.) on the grounds of the absence of important distinguishing characteristics is countered by the visual evidence.

[36] Heninger, *Touches of Sweet Harmony*.

[37] *Dialogues Upon the Usefulness of Ancient Medals*, London, 1726, 46 [reprint, New York–London, 1976].

[38] George Rowley, *Ambrogio Lorenzetti*, Princeton, N.J., 1958, 95.

[39] Illustrated in the Padua edition of 1611, 481.

[40] Michael Grant, *Roman Imperial Money*, London–Edinburgh, 1954, 166 f. The column associated with Securitas on Roman Imperial coinage also carried with it connotations of Salus—well-being—a concept of Republican coinage that had already merged with Securitas in the coinage of Caligula: Grant, 141–43.

[41] *Dialoghi intorno alle medaglie, inscrittioni et altre antichità*, trans. Dionigi Ottaviano Sada, Rome, 1592, Dialogo Secondo, 48.

[42] Hill, *Corpus*, no. 415. I wish to thank Dott.ssa Attilia Dorigato of the Biblioteca Correr and Abraham Rogatnik of the School of Architecture, The University of British Columbia, for their assistance in providing me with photographs of the Malipiero medal.

[43] Grant, *Roman Imperial Money*, 261; Harold Mattingly, *Coins of the Roman Empire in the British Museum*, III, London, 1936, cxxxiii, 446–48, 548.

[44] Hill, *Corpus*, no. 785; see also George F. Hill, "Classical Influence on the Italian Medal," *Burlington Magazine*, XVIII (1910–11), 259–68, esp. 262–67.

[45] Roberto Weiss, *Un umanista veneziano Papa Paolo II*, Venice and Rome, 1958, 54 f. Paul II is designated as "Founder of Peace" on several of his medals; see Hill, *Corpus*, nos. 769, 774.

[46] It is not beyond the realm of possibility that we are being given in this figure a representation of Pax with added associations of Pudicita—moderation, good sense. The modest gesture of Pudicita, who holds her cloak, was, as Grant shows, assimilated with Pax on a coin type minted under Claudius (*Roman Imperial Money*, 160 f.).

[47] Grant, *Roman Imperial Money*, 166–69. For the metaphor of abundance in Augustan imagery, see Hans Peter L'Orange, "Ara Pacis Augustae: La zona floreale," *Likeness and Icon*, Denmark, 1973, 263–77.

[48] *Discorso sopra le medaglie antiche*, Venice, 1559, 118, which identifies the figure as "*effigie di Cerere . . . il simolacro di Livia*." The coin in question was struck under Claudius, with the obverse a portrait of Augustus; see Grant, *Roman Imperial Money*, 147 f.

[49] Venice, 1558, 58.

[50] Paoletti, *L'architettura e la scultura*, 268.

[51] Frederic C. Lane, "Medieval Political Ideas and the Venetian Constitution," *Venice and History*, Baltimore, 1966, 285–308, emphasizes the active role of these practical concerns in the shaping of the Venetian government, taking precedent over the theoretical models; see in particular Lane's discussion (306 f.) of the *serrata*, the 1297 reform of the Great Council, a practical move in the interests of a secure government as opposed to an ideal one. The importance of the food supply comes up in one of Venice's early political writers, Fra Paolino of Venice (Lane, 299), writing in 1314, and it remained still a major concern of the government in the sixteenth century (see Brian Pullan, *Rich and Poor in Renaissance Venice*, Cambridge, Mass., 1971, esp. the many entries under "Famine"). The well-established association between Venice and peace may be suggested by Cesare Ripa's characterization of *Marca Trivisana*—the province of Venice—as a female figure with the prominent attribute of an olive branch: "*Il ramo dell'olivo che tiene . . . significa la pace, che gli conserva il suo Principe, & Signore*" (*Iconologia*, Rome, 1603, 279).

[52] The Renaissance predilection for cosmological diagrams is fully illustrated by S.K. Heninger, Jr., *The Cosmographical Glass*, San Marino, Cal., 1977. Particularly relevant to the imagery of the Tron sarcophagus is the Isidore of Seville MVNDVS • ANNVS • HOMO diagram, available in an elegant version prepared for the first printed edition of *De natura rerum*, Augsburg, 1472 (Heninger, 108 f.).

[53] Kathi Meyer-Baer, *Music of the Spheres and the Dance of Death*, Princeton, N.J., 1970, esp. 87–115, 130–87.

[54] Edgar Wind, *Pagan Mysteries in the Renaissance*, rev. ed., New York, 1968,

265–69; Irwin Young, *The "Practica musicae" of Franchinus Gafurius*, Madison, Wis., 1969, xxix, 1.

[55] A good example, one among many, is offered by Vittore Carpaccio's *Presentation of the Christ Child* of 1510, Accademia, Venice, where the lute player, the central musician, is elevated to project into the action above. In sixteenth-century Venice, the divine connotations of the lute are utilized in order to distinguish between the higher and lower forms of poetry (Patricia Egan, "*Poesia* and the *Fête Champêtre*," *Art Bulletin*, XLI [1959], 303–13). That music itself is a key component in Venetian political thinking is persuasively argued by Ellen Rosand, "Music in the Myth of Venice," *Renaissance Quarterly*, XXX (1977), 511–37.

[56] *Dialogo dell' imprese militari et amorose*, Rome, 1555, 23, "*libro aperto*."

[57] Ernst H. Kantorowicz, "On Transformations of Apolline Ethics," *Selected Studies*, Locust Valley, N.Y., 1965, 399–408, esp. 406.

[58] Munman, *Tomb Monuments*, 124 f., argues that the Mocenigo tomb was begun after the Tron tomb was sufficiently advanced to serve both as a model and a challenge.

[59] For ducal sculptural programs of the later fifteenth century in the Palazzo complex, see Pincus, *Arco Foscari*, 169–206, and Michelangelo Muraro, "La Scala senza Giganti," *De artibus opuscula XL: Essays in Honor of Erwin Panofsky*,

ed. Millard Meiss, New York, 1961, 350–70. A thorough overview of the political implications of the Palazzo Ducale decorations is provided by Staale Sinding-Larsen, *Christ in the Council Hall*, Rome, 1974 (Institutum romanum norvegiae, *Acta ad archaeologiam et artium historiam pertinentia*, V).

[60] For the development of the "canonical" sixteenth-century vision of the perfection of the Venetian mixed form of government, see Felix Gilbert, "The Venetian Constitution in Florentine Political Thought," *Florentine Studies*, ed. Nicolai Rubenstein, London, 1968, 463–500; for its impact, see William J. Bowsma, "Venice and the Political Education of Europe," *Renaissance Venice*, ed. John R. Hale, London, 1973, 445–66.

[61] The same dynamic prompted Venice to set up, c.1484, the office of "public historiographer" in order to provide itself with what it considered an appropriate public image; see Gaetano Cozzi, "Cultura politica e religione nella 'pubblica storiografia' veneziana del '500," *Bollettino dell'Istituto di storia della società e dello stato veneziano*, V–VI (1963–64), 215–94, and, on the hostile reactions to Venetian fifteenth-century politics that lie behind this literary statecraft, Nicolai Rubenstein, "Italian Reactions to Terraferma Expansion in the Fifteenth Century," *Renaissance Venice*, 197–217.

# 10

# *Verrocchio and the* Palla *of the Duomo*

DARIO A. COVI

Although the gilt copper ball, or *palla,* that Verrocchio made for the Duomo of Florence is mentioned in all surveys of his art, and in most descriptions of the Duomo and some accounts of Brunelleschi's work on the cupola, it has never received more than cursory attention.[1] Perhaps this should not be surprising, for the *palla* does not fit the conventional definitions of either architecture or sculpture—it has been characterized as an engineering feat[2]—and, moreover, was knocked down by lightning in 1601 and completely rebuilt afterward.[3] No doubt, largely because it has received such scant attention, some errors and misconceptions about the commission and execution of the work have been allowed to enter the literature and remain unchallenged.[4] To some extent, this has been made easier by the fact that when, in 1857, Guasti published the documents about the cupola, he included only a few of those pertaining to the *palla,* and later writers have not done much more than reprint some of his transcriptions.[5] A closer reading of the documents, both published and unpublished, reveals that Guasti made an unwarranted assumption about two of the relevant ones,[6] in consequence of which he placed them out of proper sequence and overlooked altogether a phase of work that unquestionably influenced the instructions laid down in Verrocchio's contract for this project.

The object of this article is to describe, by referring mainly to the original documents,[7] of which the essential ones are transcribed below,[8] certain details about the project that have not been noticed before and thus provide a more complete and accurate account of this work of Verrocchio's. As a by-product we shall also be able to document a heretofore unknown journey by the master that may, on a later occasion, help to shed new light on both the formation and the influence of his art.

For our purpose the narrative of the *palla* begins on June 8, 1467, when Giovanni di Bartolomeo, *intagliatore,* signed a contract, with the goldsmith Bartolomeo di Fruosino as his collaborator, to cast in one piece the *bottone* or knob on which the *palla* was to rest.[9] The kind of metal to be used was not specified, but copper is listed in the contract among the materials for which the artists were to be reimbursed by the Opera and a payment of June 30, 1467, is recorded for "old copper" purchased from different persons.[10] The two artists must have completed, or nearly

completed,[11] the *bottone* by the end of the year, for on January 19, 1467/68, the Operai formally decided to proceed with the making of the *palla* itself. They had obtained the counsel of various citizens and masters, who had met on two separate occasions (January 5 and 19) and on both had advised that the *palla* should be cast, that it should be cast in one piece, and that it should be made of copper as pure as possible, alloyed with fine brass. Under no circumstances, they had counseled, should it be made by hammering.[12]

Although the contract is not preserved—at least none was published by Guasti and none appears among the documents I had the opportunity to study—the account books of the Opera show that work on the *palla* began almost at once and proceeded without interruption until August.[13] On January 21 payment is recorded for the transport of an elm to the Opera to make a mast for the form of the *palla* (Document 1); in January and February tile was delivered to roof over the area where the *palla* was to be made and provide gutters and downspouts; and in March flues were constructed for venting. From February until May there are records of the purchase of old brass and copper to alloy[14] and of tin to add to the alloy; clay, cloth shearings and straw to make the form of the *palla*; rope and wire to bind the form; and charcoal and wood to melt the metal. In May and June bellows were brought to the site and the metal was alloyed (Documents 3 and 4). During June the furnace was bricked, in July the form was rebaked and the pit in which to cast the *palla* was dug, and between July 27 and 29 the *palla* was cast (Document 5). By August 5 the clay core was extracted (Document 5), and the *palla* must have been ready for the final finishing. However, even though tests for gilding copper had been conducted at the time the preparations to alloy the metal were under way (Document 2),[15] there is no evidence that any gilding took place. In fact, the cast *palla* is not mentioned again until autumn of the following year, when it was broken up (Document 10).[16] Apparently it was never finished.

In these records the name of Andrea del Verrocchio appears but once. On January 27, 1467/68 he was remunerated for his skill and effort to make and test a model of the *palla* (Document 1).[17] However, on April 12 payment is also recorded to a certain "Bartolomeo . . . orafo" (Bartolomeo di Fruosino?) for making a model of the *palla* (Document 2).[18] Verrocchio must have been only a competitor who submitted a model, and he was not the one who received the commission. It is the names of Giovanni di Bartolomeo and Bartolomeo di Fruosino that are recorded on June 30, 1468, as receiving payment "pro certa palla pro Lanterna" and "pro certa palla et aliis" in one of the two documents that Guasti transcribed and grouped wrongly—as it is now clear—with those pertaining to the *bottone*.[19]

Within six weeks after the *palla* was cast, the Operai drew up a contract with Verrocchio to make another *palla*. Dated September 10, 1468, the contract stipulated that Verrocchio was to make the new sphere of eight pieces, according to the model he gave to the Opera, the sphere to measure slightly under four *braccia* across and to be gilt; copper would be used and the eight pieces, evidently sheets intended to be hammered to shape, were to be soldered together around an armature of copper, which in turn was to be fixed to the *bottone* below by a tubelike construction of cast bronze ("uno colaretto con uno cannone, di getto di bronzo").[20] Payments begin, in an account of Verrocchio, on September 13 and continue to November 12, then again at different intervals from January 18, 1468/69, to December 23, 1469, and so on until June 1471, by which time the new *palla* was in place on the lantern [21]

It thus transpires that the *palla* made by Verrocchio was in reality the second to

be executed. The first, cast in 1468, was made by Giovanni di Bartolomeo and Bartolomeo di Fruosino and was rejected. Why was it rejected? A clear-cut answer does not appear in the documents. Possibly the cast had failed. Or it may have been discovered that when the clay core was extracted it was not possible to install an armature in the sphere to insure its stability and secure it to the *bottone*. Finally it is possible that the cast sphere could not be gilt. As we have already noted, gilding tests were conducted on different alloys of copper. It may well be that the alloy used in the cast contained too much lead or other metal that would not take gilding well.[22] That the gilding of the *palla* was important is suggested not only by these tests, but also by the fact that the contract with Verrocchio for the second *palla* stipulated that it was to be gilt and gilding tests were conducted at the time of its fabrication (Document 16).

Though the documents do not indicate clearly what had gone wrong, there are some hints that the cast may indeed have failed. In a payment authorized to the

*1. The Cupola of S. Maria del Fiore, Cathedral of Florence*

two artists on December 24, 1468—the second of the two documents which Guasti wrongly placed with those pertaining to the *bottone*[23]—the entry explicitly states that there was nothing wrong with the form on which the *palla* was cast and that the artists should be awarded 100 *lire* for their effort on the *palla*. Equally if not more indicative, it seems to me, is the wording of a document of December 2, 1468, when the *bottone* was appraised; for the language of one, possibly two, of the appraisals leads one to understand that the knob had been cast successfully but that probably more than just the knob had been attempted. Banco di Filippo judged that the artists should receive eighty florins for their labor "per insino dove è condotto il bottone" and Luca della Robbia declared that they should receive sixty florins for the *bottone* "per insino dove è condotto di bono maestero."[24]

Regardless of whether only one, two, or all three of the reasons adduced lay behind the rejection of the cast *palla*, making a sphere of separate sheets of copper could avoid all three potential risks. In the first place, the armature would be constructed before the sheets were soldered together.[25] Second, while for purposes of casting, copper must be alloyed with tin or other metal to make it flow easily as well as to make it hard,[26] when it is to be worked by hammering it must be as nearly pure as possible.[27] And pure copper, finally, can be readily gilt by mercury process.[28]

The decision to construct the *palla* of hammered sheets of metal, with the concomitant requirement that the metal be pure or nearly pure copper, may explain another aspect of the project that has never been noticed before. While the payments on Verrocchio's account with the Opera began soon after he had signed the contract (Document 6),[29] it was not until the following spring that work on the new *palla* got seriously under way, beginning in April with the purchase of an elm for a new mast—this time on which to construct the *palla* itself (Document 8)—and continuing through the summer, fall, and following winter with the purchase, delivery, and hammering of the metal sheets. What accounted for the long delay, when there had been every indication the previous year that the Operai desired to get on with the work as quickly as possible?[30] It may have been due in part to the need to carve the stone form or forms on which to hammer the sheets.[31] More likely, instead, the delay was necessary in order to find the proper metal. The old copper and brass melted together to make the alloy used in casting the first *palla* was purchased locally (with the exception mentioned below in note 14), but the eight large copper sheets required to make the second *palla* were obtained in Venice. In fact, Verrocchio was in the Veneto in June 1469, when a courier going to Venice for the Opera was charged to seek him at Treviso ("Travigi") with certain letters from the Operai (Document 7). Verrocchio must have been looking after the procurement of the metal, since money was disbursed to him in Venice through an account with Filippo Inghirami (Documents 7, 9, and 12). Fees for the transport of, and customs duty on, six of the sheets, shipped to Florence via Bologna, are recorded in August (Document 7) and for two more sheets in October (Documents 11 and 12). Five of the sheets had been delivered to Verrocchio's workshop on July 29 (Document 11), and on October 7 a porter was paid to carry the last two sheets of copper from the customs office to the master's workshop (Document 11).[32] Hammering of the metal began in August, with three stonecutters (Luca di Piero, Salvestro di Paolo di Stefano, and Giovanni di Tomè) assisting Verrocchio (Documents 11, 13),[33] and was completed the following January. The stonecutters continued to receive salaries from Verrocchio through the winter and spring of 1469–70.[34] By the summer of 1470 the copper sheets were soldered

together[35] and the gilding got under way (Document 15), with tests being conducted before the Operai (Document 16).[36] Money was allocated to Verrocchio to buy gold to be used for the gilding (Document 14), and gold florins were obtained, ground, and reduced by mercury to a paste to apply to the copper (Document 16). For this part of the project Verrocchio had the help of Bartolomeo di Fruosino; and the *bottone*, which had been cast by the latter and Giovanni di Bartolomeo in 1467, was also gilt (Document 17). Payments for gilding and polishing both the sphere and the knob are recorded between August and October (Documents 15, 16), and in December samples of the gold left over from the gilding were sent to the assayer to be assayed (Documents 16, 17). Although we know from other sources that the *palla* was raised in place on May 27, 1471,[37] Verrocchio's account with the Opera continued active through that year and the next two and one-half years, until June 1474.[38] However, none of the expenses entered in the account after June 1471 refers to the *palla*.

It remains to consider why the copper that Verrocchio used to make the *palla* was purchased in Venice. The obvious explanation is that a high grade of copper in large sheets was available in Venice and not in Florence or possibly elsewhere in Tuscany. But the copper to be found in Venice would not have been produced there. In antiquity, indeed, highly prized copper—said to be pure and therefore malleable—came from the island of Cyprus, a fact reflected in the Latin word *cuprum* (from *aes cyprium*, for pure copper, as opposed to *aes*, for brass, bronze, or any copper alloy).[39] Cyprus was almost the sole source of copper to the Romans. And long before the island came under Venetian domination, in 1489, the trade ships of Venice had a large share of the commerce in the eastern Mediterranean and regularly carried cargo to and from Cyprus.[40] However, the evidence is that by the end of the Middle Ages salt, grain, cotton, sugar, and wine were the main exports of Cyprus,[41] whereas metal from European mines, especially iron and copper, was more likely to be imported.[42] By the second half of the fifteenth century vast reserves of copper and silver in the eastern Alps had been opened up and new methods of working the ore gave fresh stimulus to the mining and metallurgical industries of Central Europe.[43] Before the end of the century German merchants had a thriving business sending copper from the Tyrol, Hungary, Carinthia, and other Central European mines to Venice,[44] whence it could be shipped by sea to the Levant or by inland routes to other parts of Italy. Thus, whether the metal came from Cyprus or from Central Europe, Venice was without doubt the leading place in Italy where new, unalloyed copper could be most readily obtained.

It lies beyond the scope of this article to consider the artistic consequences of Verrocchio's 1469 visit to Venice and the Veneto. However, I hope to be able to show elsewhere that although Verrocchio was in Venice for not more than seven months[45] and his principal objectives were to obtain copper to make the *palla* and to observe at first hand the technique of working the metal by hammering, nevertheless the recollections he brought back with him to Florence of things seen in Venice were sufficiently vivid to affect his art. At the very least it will be possible to demonstrate that certain formal features in the *Christ and St. Thomas*,[46] *Colleoni Monument*, and possibly the *Putto with the Dolphin*, as well as the landscape background of the Berlin 104A *Madonna and Child*,[47] may be referred in part to Venetian models. At a higher level, it will be seen that the unprecedented richness of color in the Medici Tomb which Verrocchio undertook to design in the first year or so after his return from Venice,[48] and the change from the relatively chaste modeling of the Amsterdam *Candlestick* (1468) and the San Lorenzo *Lavabo*

(probably between 1467 and 1469)[49] to the deeper shading practiced in the modeling of the plant forms on the Medici Tomb and the drapery of the *Christ and St. Thomas,* the *Decollation* relief, and other sculptures after 1469, may well reflect the inspiration of this Venetian experience.

It should not detract from Verrocchio's reputation as the leading sculptor and the master of one of the most important workshops of the second half of the fifteenth century in Florence if we now propose that some remarkable features of his style may be indebted to Venetian sources. On the contrary, it expands this role, for he may be seen as one of the earliest essential links in the transmission of the pictorial ideals of Venice to Florentine soil before the High Renaissance.[50]

*University of Louisville*

*Documents*

*Note*: All the documents are in the Archivio dell'Opera di S. Maria del Fiore, Florence. I have retained the original spelling and orthography throughout, but for the sake of clarity I have made a few corrections and insertions, enclosed in brackets, and added some punctuation.

1. VIII.1.47 (*Quaderno di cassa di Bernardo d'Antonio Ridolfi*) [January 1467/ 68–June 1468], c. 9, left page:

+ MCCCCLXVII [n. s. 1468]
Palla di rame che s'à a porre in sulla lanterna
de' dare adì 21 di gennaio s. due d. otto
dati [*lacuna*], charettaio, per arechatura
d'uno olmo da bottegha di Giovanni di Tano,
legnaiuolo, per fare lo stille per la forma di
detta palla ............................ f. . . . L. . . . s. 2 d. 8

. . . . .

E adì 27 detto f. uno larghi demo ad
Andrea del Verrochio scultore per sua
rimuneratione e faticha di modello e pruova
fece per sopradetta palla, portò e' detto .... f. 1 L. 1 s. 2 ...........

. . . . .

2. *Ibid.,* c. 54, left page:

+ MCCCCLXVII
Palla di rame che' a stare in sulla lanterna di
Santa Maria del Fiore de' dare . . .

. . . . .

E adì XII d'aprile 1468 f. sei larghi, pagati a
Bartolomeo di [*lacuna*], orafo, sono per
sua ritributione e merito e sua faticha d'una

palla di bronzo dorata dette all'Opera per
modello della palla a stare in sulla lanterna,
che chosì dissono gl'Operai, e per lui a
Bernardo di Tadeo dall'Antella, e per lui a
Zanobi Girolami e chompagni, vaglono a
22 1/2 per cento ...................... f. 7 L. 1 s. 13 d. 10

. . . . .

E adì 5 detto [May] s. II d. IIII pìccioli, portò
il Baccio, orafo, disse per comperare ariento
vivo per fare una pruova in dorare certi
quadretti di rame ...................... f. . . . L. . . . s. 2 d. 4

. . . . .

3. *Ibid.*, c. 63, left page:

<div align="center">

+ MCCCCLXVIII.

</div>

Spesa d'Opera deono dare . . .

. . . . .

E adì VIIII di magio L. una s. otto pìccioli,
pagati a due garzoni per menare mantici il
dì si fonde la materia per allegare, portorono
contanti ............................. f. . . . L. 1 s. 8 d. . . .

. . . . .

4. *Ibid.*, c. 71, left page:

<div align="center">

+ MCCCCLXVIII.

</div>

. . . . .

Palla di rame che' a stare in sulla lanterna di
Santa Maria del Fiore de' dare adì 3 di giugno
s. dieci pìccioli, dati a Piero fachino per 1ª
opera[51] a menare mantici per allegare il rame    f. . . . L. . . . s. 10 . . .

. . . . .

E adì detto [June 11] L. una s. XII, dati a
Giovanni di Bartolomeo detto Pilisora e
III compagni per menare mantici a legare
rame e ottone ......................... f. . . . L. 1 s. 12 . . . .

. . . . .

E adì 15 di giugno s. VIII pìccioli, portò
Giovanni del Bonzo [sic: elsewhere Bronzo],
disse per comperare pane e vino per dare bere
alla brigata gl'aiutava fondere il rame, cioè
l'ultimo ebbe a llegare .................. f. . . . L. . . . s. 8 . . .

. . . . .

5. VIII.1.48 (*Quaderno di cassa di Agostino di Gino Capponi*) [July–December 1468], c. 7, left page:

+ MCCCCLXVIII

Pala di rame per metere in sula lanterna de' dare adì otto di luglio L. quarantaquatro, demo a Domenicho da Biselmo ad . . . bietto [sic], portò e' detto contanti, per quatro cataste di legne conperate da lui per richuocere la forma e fondere el metallo . . . . . . . .   f. . . . L. 44 s. . . . . . .

E adì XI di luglio L. tre s. VIII, dati a Pipo d'Antonio manovale, portò e' detto contanti, sono per opere cinque [e 2/3] aiutò fare la fosa dove si mise detta palla . . . . . . . . . . . . . . .   f. . . . L. 3 s. 8 d. . . .

. . . . .

E adì XXVIIII detto L. sei s. due d. VIII, portò Giovanni famiglio per vyno, pane, formagio, poponi chonperò adì 27 e 28 e 29 per fare la spesa a' uomini quando si fè el focho e gitò la pala . . . . . . . . . . . . . . . . . .   f. . . . L. 6 s. 2 d. 8

E adì V d'aghosto de' dare L. una s. VIII, portò e' detto, cioè Martino, sono pe'l dì di San Vetorio[52] e'l primo dì d'aghosto, aiutò fondere e votare la palla gitatta . . . . . . . . . .   f. . . . L. 1 s. 8 d. . . .

. . . . .

6. VIII.3.8 (*Entrata e uscita di Agostino di Gino Capponi, cominciato adì 1 di luglio 1468*), c. 19r:

+ MCCCCLXVIII
+ Sabato adì XXXI di dicembre

. . . . .

10.y/    A Andrea di Michele di Francesco detto Veroc[h]io, schultore, L. cientonovantauno s. XI, posto debi avere al quaderno, c. 46, stanziati chome di sopra; sono per parte dela pala alogatagli ch'[à] a stare in su la lanter [n]a, posto a libro giallo, c. 44 . . . . . . . .   f. . . . L. 191 s. 11 d. . . .

. . . . .

7. VIII.1.49 (*Quaderno di cassa d'Andrea di Lotteringo della Stufa*) [January 1468/69–June 1469], c. 12, left page:

+ MCCCCLXVIII .

. . . . .

Andrea di Michele detto Verochio de' dare . . .

E adì XXVI di giugnio [1469] fiorini uno
larghi soldi X a oro di fiorini larghi, per lui
a Romeo di Jacopo, choriere, portò chontanti,
e quali gli diamo per vantagio gli facemo
che andando a Vinegia andasi a trovare a
Travigi [sic: Treviso] detto Andrea cho' nostre
lettere .............................. f. . . . L. 8 s. 11 d. . . .

E adì VIII di luglio fiorini ciento ottantadua,
facemo buoni per lui a Piero di Chosimo de'
Medici e compagni, posto debbino avere in
questo, c. 59, per altretanta n'ebbe in
Vinegia da Filipo Inghirami per chome-
sione di Piero di Chosimo e chompagni, in
fiorini 152 larghi meno soldi 8 a oro: mon-
tano ................................ f. . . . L. 864 s. 12 d. . . .

E adì VIIII d'aghosto fiorini otto d'oro larghi
e lire dua pìccioli, per lui a Francesco di Bor-
giani, sono per vettura di pezzi 6 di rame e
per spese si fece a Bolognia e provedigione.. f. . . . L. 47 s. 12 d. . . .

E adì XXI d'aghosto lire ventiquatro s. IIII
d. IIII, paghamo per lui a Michelozzo
Michelozzi, kamarlingo di doana, per
ghaghabella [sic] di 6 pezzi di rame fece venire
da Vinegia per la palla, c[i]oè in fiorini 4
larghi lire 3 soldi 0 denari 4 a grossi...... f. . . . L. 25 s. 19 d. 4

. . . . .

8. *Ibid.*, c. 50, left page:

<div align="center">+ MCCCCLXVIIII</div>

*Resto*    Spesa d'Opera deono dare . . .

. . . . .

E deono dare adì XXIIII d'aprile L. cinque
paghamo a Giovanni di Bartolomeo, legniaiu-
olo, sono per uno holmo s'ebbe da lui per fare
lo stile [in su che] si fa la palla della lanterna,
chome disse Maso Suchiegli ............. f. . . . L. 5 s. . . . . . .

. . . . .

9. *Ibid.*, c. 59, left page:

<div align="center">+ MCCCCLXVIIII .</div>

Piero di Chosimo de' Medici e chompagni
deono dare adì III di giugno . . .                    f. ⎫
                                                       ⎬ 182 s. . . . . . . .
E adì VIII di luglio . . .                            f. ⎭

Sopradetti denari sono per ducati 150 a fiorini
21 1/3 per cento meglio, trase loro da Vinegia
Filipo Inghirami e chonpagni per altretanti

paghorono e sopradetti a Vinegia a [A]ndrea
del Verochio, schultore, per chomesione di
Lorenzo di Piero di Chosimo [sic], per loro
lettera de' dì 29 di marzo 1469.

. . . . .

10. VIII.1.50 (*Quaderno di cassa di Filippo di Francesco Cambi*) [July–December 1469], c. 10, left page:

+ MCCCCLXVIIII

. . . . .

Spese d'Opera deono dare . . .

. . . . .

E adì 13 detto [September] L. una s. uno d. IIII,
paghati a Matteo di Domenicho, sono per
libbre 175 di charboni per rompere [una]
parte della palla . . . . . . . . . . . . . . . . . . . . . .     f. . . . L. 1 s. 1 d. 4

. . . . .

E de' dare adì 27 detto L. due s. II, paghati a
[A]ndrea di Nenc[i]o, charbonaio, portò chon-
tanti, sono per libbre 384 di charboni avemo
da llui per ronpere la palla . . . . . . . . . . . . . .     f. . . . L. 2 s. 2 . . .

. . . . .

11. *Ibid.*, c. 21, left page:

+ MCCCCLXVIIII .

. . . . .

Andrea di Michele del Verochio de' dare adì
29 di luglio lire—soldi XV, paghati per llui
a' fachini di doana per arechare 5 pezzi di
rame della palla a bottegha sua . . . . . . . . . .     f. . . . L. . . . s. 15 d. . .

E adì 5 d'aghosto lire due soldi XI, per llui
a Lucha di Piero, scharpellatore, portò con-
tanti, per 3 opere lavorò in sulla pietra le
piastre del rame della palla . . . . . . . . . . . . . .     f. . . . L. 2 s. 11 . . . . .

. . . . .

E de' dare soldi XV per isc[i]operìo di 2
maestri gli aiutorono ripulire un[a] pietra
di macingnio del modello degli schachi della
palla, posto ispese d'Opera debbi[no] avere
in questo, c. 10 . . . . . . . . . . . . . . . . . . . . . .     f. . . . L. . . . s. 15 . . .

. . . . .

E de' dare adì 3 d'ottobre fiorini uno larghi,

per llui a Antonio di Piero, leghatore in
doana, chome disse Francesco di Morone per
parte di Filippo Inghirami, per vettura e
passi da Bolognia a Firenze di 1° pezo di
rame della palla, rechò Giovanni Capponi da
Valdifartone, vetturale .................. f. . . . L. 5 s. 13 . . .

E de' dare dì 5 d'ottobre fiorini uno larghi,
per llui a Barttolomeo di Salvestro, vetturale,
portò contanti, per vettura e passo da Bolo-
gnia a qui di 1° pezo di rame della palla, cioè
uno il saccho [sic: scacco] .............. f. . . . L. 5 s. 13 . . .

. . . . .

E adì 7 detto soldi 5, dati a 1° facchino per
arechare 2 pezi di rame della palla da doana
a bottegha d'Andrea Verochi.............. f. . . . L. . . . . s. 5 . . .

. . . . .

12. *Ibid.*, c. 46, left page:

. . . . .

Andrea di Michele del Verrochio de' dare adì
14 d'ottobre lire cientotredici soldi VIII
denari VII pìccioli, per llui a Filippo Inghira-
mi, portò chontanti, per valuta di duchati 19
di Vinegia, è per chosto di Vinegia e spacc[i]o
di pezzi 2 di rame ebe da loro, a r[agi]one di
lire 5 soldi 14 denari 1 l'uno, e per valuta di
lire 2 s. 10 d. 6 di Bologna per ispese di Fer-
rara e Bolognia ...................... f. . . . L. 113 s. 8 d. 7

E de' dare adì 16 d'ottobre lire sette s. — d.
VIII chol meglio de' grossi, per ghabella di
pezzi 2 di rame per lla palla, pesorono libre
543, misse adì primo e dì 4 detto; posto Aghos-
tino Biliotto, kamarlingo, debbi avere in
questo, c. 47 .......................... f. . . . L. 7 s. . . . . d. 8

. . . . .

13. *Ibid.*, c. 62, left page:

[1469]

. . . . .

Andrea di Michele del Verrochio de' dare adì
23 di dicembre lire quarantacinque soldi II,
per lui a Salvestro di Pagholo da Ssettigniano,
sono per opere 54 2/3 gli à aiutato lavora[re]
in sulla palla da dì 16 d'ottobre a tutto

161
*Verrocchio
and the* Palla *of
the Duomo*

dicembre 1469, a soldi 16 denari 6 il dì, posto debbi avere in questo, c. 53 .............. f. . . . L. 45 s. 2 . . .

E adì detto [lire] quarantaquattro soldi V denari VI, per lui a Lucha di Piero ischarpellatore, per opere 53 2/3 aiutatogli come di sopra, a soldi 16 denari 6 il dì, posto debi avere in questo, c. 53 ................... f. . . . L. 44 s. 5 d. 6

E adì detto lire trenta soldi II, per lui a Giovanni di Tomè, ischarpellatore, per opere 43 aiutatogli per tutto dicembre come di sopra, a s. 14 il dì; avere in questo, c. 53.. f. . . . L. 30 s. 2 . . .

. . . . .

14. *Ibid.*, c. 72*bis*, right side:

+ MCCCCLXVIIII .

Andrea di Michele del Verrochio, condottore della palla di rame della lanterna, f. dugientonovantuno L. due, messi a uscita, c. 20; e detti denari n'à [a] chomperare oro per dorare sopradetta palla e in altro nogli possa ispendere, abattesi s. 40 per la partita, resta f. 291. L. . . . s. . . .d. .

15. VIII.1.52 (*Quaderno di cassa di Galeotto di Michele del Caccia*) [July–December 1470], c. 6, left page:

+ MCCCCLXX

. . . . .

Andrea di Michele del Verochio de' dare . . .

. . . . .

E adì 20 d'aghosto f. tre larghi, portò e' detto, disse per dare a' gharzoni gli avevano aiutato dorare la palla ........................ f. . . . L. 16 s. 7 d. . . . .

E adì 22 d'aghosto L. dua e s. 13 d. 4, portò Bartolomeo di Fruosino, orafo, sono per aiutare dorare la palla .................. f. . . . L. 2 s. 13 d. 4

. . . . .

E adì primo di setenbre lire quatro e s. 18 d. 6, per lui a Francesco di Veneri, orafo, disse ch'erano per ariento per saldatura pe'lla palla, portò e' detto contanti .................. f. . . . L. 4 s. 18 d. 8

. . . . .

E de' dare adì detto [September 20] L. sei s. XV, per lui a Bartolomeo d'Antonio, orafo, portò contanti, gli aiutò a dorare e a pomi-

ciare la palla ........................ f. . . . L. 6 s. 15 . . .

. . . . .

E adì 10 d'ottobre L. quatro, per lui a
Giovanni di Piero, orafo, portò e' detto, sono
per l'aiutar dorare e pomiciare la palla e'l
botone .............................. f. . . . L. 4 s. . . . .

. . . . .

16. *Ibid.*, c. 23, left page:

### MCCCCLXX

Palla grande che à a stare in sulla lanterna de'
dare adì 31 di luglio fiorini tre larghi, portò
Bartolomeo di Fruosino, orafo, e Andrea di
Michele del Verochio, orafo, presente Barto-
lomeo Ubertini, Operaio, per disfare e per
dorare parte di sopradetta palla, cioè per
fare 1° pocho di mostra ................ f. 3 larghi ............

E adì deto soldi 6 pìccioli, portorono e deti,
per chonprare oncie 3 d'ariento vivo per
disfare sopradeti fiorini larghi ............ f. . . . L. . . . s. 6 .....

E chon sopradeti fiorini, presente sopradeto
Bartolomeo Ubertini e Ghaleoto del Chacia,
kamarlingo, vedemo dare a' sopradetti da
Giovanni Zati, proveditore, circha 2/3 di
fiorino largho, co' 1° pocho d'oro macinato,
disse gli avanzava di mostra, cioè dorare certo
rame per mostra di detta palla, e quali si
missono a spese d'Opera al kamarlingo
passato ...............................

E de' dare adì 3 d'agosto fiorini treciento
larghi, portò Bartolomeo di Fruosino, orafo,
e Andrea del Verochio, e quali macinorono in
presenza di Bartolomeo Ubertini e Bartolo-
meo di Nicholò Chorbinegli, Operai, e di me
Ghaleotto del Chaccia, kamarlingo, e di due
notai del'Opera e di Giovanni Zati, provedi-
tore; el quale oro s'à adoperare per dorare la
palla ................................ f. 300 larghi ...........

E de' dare adì detto fiorini dugiento larghi,
portorono e detti di sopra, in presenza de'
sopradetti e per farne detta chagione ...... f. 200 larghi ...........

E de' dare adì 4 detto lire tre soldi XV, portò
Mino di Iachopo, sono per libre 25 di pomicie
per impomiciare la palla per doralla ....... f. . . . L. 3 s. 15 .......

E de' dare adì 14 d'aghosto soldi XII, dati a

G[i]uliano di Pollonio per libre 1ᵃ di banbagia
per istropiciare la palla quando si dorò...... f. . . . L. . . . s. 12 . . . .

. . . . .

E de' dare adì 23 d'aghosto lire una soldi 16,
sono per pezzi tredisci d'oro batutto si misse
in sur uno pezzo di rame per farne la prova al
dorare la ditta palla, portò i detti danari
Domenicho di Bartolomeo, battiloro ...... f. . . . L. 1 s. 16 d. .....

. . . . .

E adì 12 di dicenbre lire una soldi 1°, dati a
Bartolomeo Tazzi: s. 20 per fare 1° saggio
del'oro si ritrasse di terra quando si dorò la
palla e s. 1° per pasta al saggio .......... f. . . . L. 1 s. 1 ........

. . . . .

17. *Ibid.*, c. 23, right page:

MCCCCLXX

Palla di chontro de' avere adì—[53] di dis-
cienbre f. quarantatre larghi lire una, avemo
da Piero Melini e chompagni, portò Michele
di Ghaleotto, sono per tib. [word canceled as
shown] cioè per oncie cinque danari disciotto
grani sei di legha di charati ventidua e mezo,
fatta per sagiatore del Chomune, cioè Barto-
lomeo Tazzi, a fiorini novanta larghi la libra.
El detto oro si ritrasse di terra quando si dorò
la palla e'l bottone, e più vi fu drentto raditura
di più pezzi d'arientto dorati, di sagrestìa, che
si disfeciono per fare una pasta di detta
sagrestìa ............................ f. 43 larghi L. 1 ........

. . . . .

18. VIII.3.10 (*Entrata e uscita, cominciato il 1° luglio 1470*), c. 25r:

+ MCCCCLXX .

+ Lunedì adì 31 di dicembre 1470

. . . . .

15. / A 'ndrea di Michele del Verocchio, maestro
della palla, L. trecentoquarantaquattro s.
IIII d. 4, posto debbi avere al quaderno, c. 62,
sono per partte della palla e della crocie,
istanziati chome di sopra e a detto libro,
c [*lacuna*], posto a libro giallo segnato
N, a c. 111 .......................... f. . . . L. 344 s. 4 d. 4

. . . . .

[1] See, for instance, Hans Mackowsky, *Verrocchio*, Bielefeld and Leipzig, 1901, 16 and 19; Maud Cruttwell, *Verrocchio*, London, 1904, 31–32; Leo Planiscig, *Andrea del Verrocchio*, Vienna, 1941, 43; Günter Passavant, *Verrocchio*, trans. Katherine Watson, London, 1969, 6; Charles Seymour, Jr., *The Sculpture of Verrocchio*, Greenwich, Conn., 1971, 53; Walter and Elisabeth Paatz, *Die Kirchen von Florenz*, Frankfurt a. M., 1952, III, 465, n. 113; Wolfgang Braunfels, *Der Dom von Florenz*, Olten, Lausanne, and Freiburg i. B., 1964, 47; Piero Sanpaolesi, *Brunelleschi*, Milan, 1962, 155 and 164.

[2] Cruttwell, *Verrocchio*, 31–32.

[3] To the extent possible, the original metal was salvaged and used again in the restoration of the *palla*. For a detailed account of the *palla*'s destruction by lightning, on January 27, 1600 (n. s. 1601; hereinafter whenever apposite the Florentine year will be given followed by a slash and the year in modern style), see especially Ferdinando Leopoldo Del Migliore, *Firenze città nobilissima illustrata*, Florence, 1684, 14; or Giuseppe Richa, *Notizie istoriche delle chiese fiorentine*, Florence, 1757–62, VI, 30 (who quotes from Del Migliore). In the recent literature, see Passavant, *Verrocchio*, 6. For the reconstruction of the *palla* in 1601–2, see the documents published by Cesare Guasti, *La cupola del Duomo di Firenze*, Florence, 1857, 161–68, Docs. 373–79.

[4] Some discrepancies occur in the date given for Verrocchio's work on the project; the metal used is variously described as copper, brass, or bronze; and the *palla* is sometimes said to have been made by hammering, sometimes by casting.

[5] Cruttwell, *Verrocchio*, 244–46, App. VII, and Günter Passavant, *Andrea del Verrocchio als Maler*, Düsseldorf, 1959, 222–24, Docs. XIII–XVIII.

[6] *Cupola*, 110–11, Docs. 327, 329. See above, pp. 151 and 152.

[7] The documents are in the Archivio dell'Opera di Santa Maria del Fiore, Florence. A few were not accessible to me; damaged by the 1966 flood, they were still in restoration as recently as the present year. For permission to study and transcribe the documents, and for help on some of the terminology, I am indebted to the director of the Archivio, Sig. Enzo Settesoldi. I also wish to thank Dott. Gino Corti, who called my attention to some of the unpublished documents concerning Verrocchio and the *palla* and at my request provisionally transcribed them for me. Finally I wish to thank Prof. Alan A. Johnson, Speed Scientific School, University of Louisville, for a number of helpful suggestions about metallurgy, and for the loan of his personal copy of the edition of Agricola's *De Re Metallica* cited in note 39, below.

[8] Prof. Howard Saalman, in his forthcoming book, *Filippo Brunelleschi: The Cupola of Santa Maria del Fiore*, will transcribe excerpts from some of the same documents and summarize others. Specifically my Documents 1, 2, and 8 include full transcriptions of four entries that he quotes in part, and Documents 11–16 include transcriptions of selected entries from itemized records that he summarizes. His book was already in press and my article in an advanced stage of preparation when we learned that we were using the same documentary material, but with different intentions.

[9] Guasti, *Cupola*, 110, Doc. 325. In the study of Brunelleschi referred to in note 8, Prof. Saalman cites documents showing that the knob had been commissioned once before, in December 1463, from Bartolomeo di Fruosino, to be cast in two pieces, and that the casting took place in 1466; but the experiment of welding the two parts apparently failed.

[10] Guasti, *Cupola*, 110, Doc. 326.

[11] The final appraisal did not take place until December 1468 (see above, p. 154).

[12] The deliberation was published by Guasti, *Cupola*, 111–13, Doc. 330, and reprinted by Passavant, *Verrocchio als Maler*, 222–23, Doc. XIII. Verrocchio himself was among the masters who took part in the discussions. On January 23, 1467/68, an entry in the cashbook of the Opera (VIII.1.47, c. 9, left page) records payment to a spice merchant for

pepper to give "a più orafi e'ntagliatori furono alla disputa della creazione della palla."

[13] However, payments continued until October. The various expenses are charged to three different accounts ("Copper sphere to be placed on the lantern," "Expenses of the Opera," and "Copper and brass bought to make the sphere . . .") in two cashbooks: VIII. 1. 47, cc. 9, 31, 50, 54, 63, 67, 71, 73, and 76; VIII.1.48, cc. 7 and 21.

[14] The purchases of the old copper and brass are itemized in VIII.1.47, cc. 9, 31, 67, and 71, left pages, and a summary of the amount spent for the metal is given under date of June 30, 1468, in an entry in the *Libro di Deliberazioni* (document published by Guasti, *Cupola*, 113, Doc. 331, and reprinted by Passavant, *Verrocchio als Maler*, 223, Doc. XIV). The total given in the *Libro di Deliberazioni* differs by 6 *soldi* from that in the cashbook (L. 372. 1. 9, as compared with L. 372. 7. 9 in the cashbook). Additional brass in rods, to make up for loss during melting, was purchased in Venice and delivered to the Opera as late as June 11 (VIII.1.47, cc. 71 and 73, left pages), and the final alloying apparently took place on or about June 15 (see Document 4).

[15] There is a further reference to the gilding tests in a statement of balance due ("resto") in the account of the *palla* on June 28: "E de' dare f. uno larghi, portò Bartolomeo di Fruosino, orafo, insino adì 5 di magio per fare pruove a dorare rami di più leghe . . ." (VIII.1. 47, c. 71, left page).

[16] Other entries in the account "Expenses of the Opera," under date of October 6, 1469, also refer to the breaking up of the *palla* (VIII.1.50, c. 44, left page). In that document there is also a record on October 14 of the purchase of old tin ("stagno vecchio") to give to Verrocchio to melt ("istrugere") for the *palla*, but this probably refers to metal needed in the construction of the second *palla*.

[17] In a 1490 inventory of Verrocchio's Florentine studio, drawn up during a litigation over the disposition of his estate after his death, there are listed a model of the cupola and a sphere of un-

specified size or material (cf. Dario A. Covi, "Four New Documents Concerning Andrea del Verrocchio," *Art Bulletin*, XLVIII [1966], 99 and 103).

[18] From the documents it appears that Bartolomeo di Fruosino received considerably more for his model than did Verrocchio. The difference may have been due in part to the kind of material employed by the two artists. Verrocchio's model is not described, but Bartolomeo's is referred to as a "palla di bronzo dorata."

[19] *Cupola*, 110, Doc. 327. In a footnote to that document Guasti observed that the scribe had started to write "bottone" instead of "palla," and expressed his opinion that he really should have written "bottone" because the two artists had been commissioned to make the knob. Yet when the *bottone* was commissioned, and again when it was appraised, it was unambiguously referred to as "bottone"; and the date of the payment in question accords completely with the time of the work on the *palla*.

[20] Guasti, *Cupola*, 113–14, Doc. 332; also Cruttwell, *Verrocchio*, 244–45, App. VII, 1, and Passavant, *Verrocchio als Maler*, 223–24, Doc. XV. Actually it is the deliberation of the Operai that is published. The contract, in the *Libro di Allogagioni* for 1438–75 (I.1.4, cc. 80v–81v), has not been published, but it is substantially the same as the deliberation. The contracting parties must have had tacit understanding that the copper forming the sphere would be hammered to shape; for, as will be noticed, though not stipulated in the deliberation or contract, this was the technique that was used, evidently with the consent of the Operai.

[21] VIII.1.48, c. 46; VIII.1.49, c. 12; VIII.1.50, cc. 21, 46, 62, 65, 72*bis*; VIII. 1.51, cc. 5, 43, 50; VIII.1.52, cc. 6, 62; VIII.3.8, c. 19r; VIII.3.9, c. 22r; VIII.3. 10, c. 25r. Other entries are found in the accounts "Expenses of the Opera" and "Large sphere to be placed on the lantern" (VIII.1.50, cc. 10, 44; VIII.1.51, c. 38; VIII.1.52, c. 23), in separate accounts of the stonecutters and others who assisted Verrocchio (VIII.1.50, c. 53; VIII.1.51, cc. 18, 24; VIII.1.52, c. 32),

and in an account of Piero di Cosimo de' Medici and Partners, through whom certain payments were made to Verrocchio (Document 9; also Guasti, *Cupola*, 114, Doc. 333, and Passavant, *Verrocchio als Maler*, 224, Doc. XVII).

22 Cf. J. Tavenor-Perry, *Dinanderie. A History and Description of Mediaeval Art Work in Copper, Brass and Bronze*, London, 1910, 44. See also *On Divers Arts. The Treatise of Theophilus*, trans. John G. Hawthorne and Cyril Stanley Smith, Chicago, 1963, ch. 68, 145–46.

23 *Cupola*, 111, Doc. 329. The document explicitly states that it is the sphere that is the object of payment: ". . . et intellecto quod fecerunt dictam formam dicte *palle*, et omnia oportuna, et non venit causa form: et intellecto quod massimum laborem habuerunt in dicta *palla* . . ." (my italics).

24 Guasti, *Cupola*, 110–11, Doc. 328; Passavant, *Verrocchio als Maler*, 224, Doc. XVI.

25 Leonardo, who was in Verrocchio's workshop at the time of the project, recalls the soldering but does not mention the armature (MS G, fol. 84v; Carlo Pedretti, *Leonardo da Vinci. The Royal Palace at Romorantin*, Cambridge, Mass., 1972, 12, and, in translation, Edward MacCurdy, *The Notebooks of Leonardo da Vinci*, New York, 1939, 1178); while Vasari, praising the ingenuity with which Verrocchio constructed the *palla*, remarks on the armature without describing it (*Le opere di Giorgio Vasari*, ed. Gaetano Milanesi, Florence, 1878, III, 365). Perhaps Richa's description may give an idea of how the armature was constructed, though it refers to the restored *palla* of 1601–2. He describes the armature as consisting of four iron poles passing through a framework ("intelaiatura") of bronze, to which is fixed another iron pole that passes into the cross above (*Notizie*, VI, 29). For a cross section of the reconstructed *palla*, with its armature, see Bernardo Sansone Sgrilli, *Descrizione e studi dell'insigne fabbrica di S. Maria del Fiore Metropolitana fiorentina*, Florence, 1733, fig. XI.

26 Cf. Tavenor-Perry, *Dinanderie*, 40; also Arturo Pettorelli, *Il bronzo e il rame nell'arte decorativa italiana*, Milan, 1926, 62; and Lawrence Addicks, "The Background of the Copper Industry," in *Copper. The Science and Technology of the Metal, Its Alloys and Compounds*, ed. Allison Butts, New York, 1954, 2. See also Ottavio Vittori and Anna Mestitz, "Artistic Purpose of Some Features of Corrosion on the Golden Horses of Venice," *Burlington Magazine*, CXVII (1975), 132, n. 2, who explain certain repairs in the surface of the "bronze" horses of St. Mark's as necessitated by imperfect casting due to the poor fluidity of the metal, here described as "almost pure copper" (cf. also Pettorelli, *Bronzo e rame*, 56, who states that the copper alloy used in casting the four horses has only 1.1 percent tin).

27 Cf. Tavenor-Perry, *Dinanderie*, 44–45. Addicks, "Background," 2, states: "Pure copper is so malleable that it can be beaten to a fine edge without cracking . . ."

28 Tavenor-Perry, *Dinanderie*, 44; *On Divers Arts*, ch. 68 (Hawthorne and Smith, 145).

29 Document 6 gives a summary of the amount allocated to Verrocchio through December 1468; the itemized disbursements, beginning on September 13, are entered in a cashbook (VIII.1.48, c. 46, left page).

30 Cf. the deliberation of January 19, 1467/68, already referred to (above, p. 152).

31 The form or forms were carved of *macigno* (see Document 11).

32 The payment of customs duty on these last two sheets is recorded under date of October 16, 1469 (Document 12).

33 Payments to *garzoni* are also recorded in VIII.1.50, c. 21, left page.

34 Other payments to the three stonecutters who assisted Verrocchio, as well as the number of days they worked, are recorded in VIII.1.50, c. 53 and VIII.1.51, cc. 18, 24, and 43.

35 A payment recorded on January 30, 1469/70, to pump the bellows "per fare e gietti della palla" (VIII.1.51, c. 5, left page) must refer to the casting of the bronze tube needed to fix the *palla* to the *bottone*, as stipulated in the contract.

36 Although the sphere was gilded by

mercury process, at least one test was conducted with the application of gold leaf (see Document 16).

[37] Luca Landucci, *Diario fiorentino dal 1450 al 1516 continuato da un anonimo fino al 1542*, ed. Iodoco del Badia, Florence, 1883, 10. On May 30 the cross, for which Verrocchio was also responsible (see Document 18), was set in place on top of the *palla* (Landucci, *Diario*, 11).

[38] VIII.1.53, c. 51; VIII.1.54, cc. 12, 64; VIII.1.55, cc. 14, 69; VIII.1.56, c. 4; VIII.1.59, c. 59.

[39] For the primacy of Cyprian copper in antiquity, and the derivation of the word *cuprum*, see, *inter alia*, the translators' historical note on copper smelting in Georgius Agricola, *De Re Metallica*, trans. from the Latin edition of 1556 by Herbert Clark Hoover and Lou Henry Hoover, New York, 1950, 402, n. 42. Denis Diderot, *Encyclopédie ou Dictionnaire raisonné des sciences, des arts et des métiers*, Paris, 1754, IV, 540, refers to the copper mines of Cyprus as "les plus riches que les anciens connussent." Pliny states that all Cyprus copper is malleable (*Nat. Hist.*, XXXIV, xx, trans. H. Rackham, Cambridge, Mass., 1952, IX, 196 and 197).

[40] See Frederic C. Lane, "Venetian Shipping during the Commercial Revolution," in *Crisis and Change in the Venetian Economy in the Sixteenth and Seventeenth Centuries*, ed. Brian Pullan, London, 1968, 45, Table B, which compares the number and the capacity of Venetian ships clearing annually for voyages to Syria and/or Cyprus, to the English Channel and the "West," and to Constantinople and/or the Black Sea about 1448–49 and in 1558–59. However, Lane points out (p. 38), in 1450 the majority of the Syria–Cyprus clearances were for Syria; Cyprus was of secondary importance until the sixteenth century. For a general description of Venetian trade in the Levant during the Middle Ages, see Henri Pirenne, *A History of Europe*, trans. Bernard Miall, Garden City, N. Y., 1958, I, 185–87; also N. J. G. Pounds, *An Economic History of Medieval Europe*, London–New York, 1974,

234, 363, and 365; Robert-Henri Bautier, *The Economic Development of Medieval Europe*, trans. Heather Karolyi, London, 1971, 104.

[41] These products are specifically mentioned as the most important of the island during the period of Venetian domination, 1489–1570 (Sir George Hill, *A History of Cyprus*, Cambridge, 1948, reprint 1972, III, 813–14; cf. also Brian Pullan, "The Occupations and Investments of the Venetian Nobility in the Middle and Late Sixteenth Century," in *Renaissance Venice*, ed. J. R. Hale, Totowa, N.J., 1973, 382). For the importance of the sugar industry of Cyprus during the fourteenth century, see Bautier, *Economic Development*, 193, 197, and 242.

[42] Pounds, *Economic History*, 365–66.

[43] *Ibid.*, 401; Johan U. Nef, "Mining and Metallurgy in Medieval Civilisation," in *The Cambridge Economic History of Europe*, Cambridge, 1952, II, 462–64.

[44] Bautier, *Economic Development*, 212–13, 223, and 225; Pounds, *Economic History*, 414–15.

[45] The *palla* documents suggest that Verrocchio had not yet left Florence on January 19, 1469 (VIII.1.49, c. 12, right page), and he was almost certainly back from Venice by July 29, when the first sheets of copper were delivered to his workshop (Document 11). A document of March 29, 1469, printed from Guasti by both Cruttwell (*Verrocchio*, 246, App. VII, 3) and Passavant (*Verrocchio als Maler*, 224, Doc. XVII) can now be understood to mean that Verrocchio was either already in Venice on that date or that he was expected to go there shortly.

[46] Although the *Christ and St. Thomas* had been commissioned of Verrocchio by January 1467 and regular monthly payments to him were authorized on March 30, 1468, metal for the sculpture was not weighed until August 1470 and as late as 1479 only the figure of Christ had been cast (cf. Passavant, *Verrocchio*, 176–77).

[47] In spite of some recent denials of the Berlin 104A *Madonna and Child* to Verrocchio himself (John Shearman, "A

Suggestion for the Early Style of Verrocchio," *Burlington Magazine*, CIX [1967], 127; Sheldon Grossman, "Ghirlandaio's 'Madonna and Child' in Frankfurt and Leonardo's Beginnings as a Painter," *Städel Jahrbuch*, N. F., VII [1979], 102–3), I remain convinced that it is for the most part an autograph work of Verrocchio and datable about 1470 or shortly after (cf. also Passavant, *Verrocchio*, 45; Seymour, *Sculpture of Verrocchio*, 27; Konrad Oberhüber, "Le problème des premières oeuvres de Verrocchio," *Revue de L'Art*, No. 42 [1978], 71).

48 The tomb must have been ordered soon after the death of Piero de' Medici (December 2, 1469); an inscription on the plinth indicates that it was completed in 1472.

49 The *Lavabo* is not documented, and both its authorship and its date have been thorny issues in Verrocchio scholarship (cf., for instance, Passavant, *Verrocchio*, 197–99). Nevertheless, stylistic evidence favors the attribution to Verrocchio or his workshop, and the emblematic device of Piero de' Medici carved on the background argues strongly for a date by 1469.

50 Professor Craig H. Smyth, with whom I was able to share the information about Verrocchio's 1469 trip to Venice soon after I had it in hand, has independently advanced a number of observations and raised provocative questions about the influence of Venetian pictorial ideas and motifs on Florentine art of the late quattrocento, and the crucial role that Verrocchio may have played in their transmission. He was kind enough to allow me to read his paper, "Venice and the Emergence of the High Renaissance in Florence: Observations and Questions," *Florence and Venice: Comparisons and Relations*, Florence, 1979, I (Quattrocento), 209–49, while it was in page proof.

*The following three notes pertain to the Documents:*

51 (Document 4) "Opera" means a day's work. Throughout these documents payments for manual labor are made by the "opera," and the rate of pay given as so much per "opera" or day.

52 (Document 5) The "dì di San Vetorio" (St. Victor) may refer to July 28, the feast of St. Victor I, Pope and Martyr (*Breviarium Romanum*, s. d. July 28). Another payment, recorded under date of September 12 to Domenico di Nichollo fabro, refers to help at the furnace ("fornello") specifically on July 28 and August 1 (VIII.1.48, c. 7, left page).

53 (Document 17) The date written here is either 20 or 26, but with a slash drawn through as if to change or cancel it.

# 11

# Pietro Lombardo's Barbarigo Tomb in the Venetian Church of S. Maria della Carità*

ANNE MARKHAM SCHULZ

Despite circumstances hardly favorable to the flourishing of art, like the defeats of the long and costly Turkish war, Venice spent lavishly on works of art from the later fifteenth through the beginning of the sixteenth century. Whether or not this diversion of capital from trade to objects of conspicuous consumption was pernicious is a question which economic historians must answer. In either case, such expenditures reflect an extraordinary economic prosperity. Thus, even by the 1460s salaries of Venetian masons were twice what they were in Milan, and Venetian stonecarvers bitterly complained of foreign competition. Until the precipitate decline in artistic production at the end of the first decade of the sixteenth century, caused by the wars of the League of Cambrai, the quantity of newly erected churches, *scuole*, and palaces rose steadily. In new construction Istrian stone and Carrara marble replaced the cheaper native brick. Architectural surfaces were concealed beneath ornamental carvings of unparalleled luxuriance and refinement whose execution drew troops of craftsmen from Lombardy to the lagoon. Bronze made its first appearance in Venetian monumental sculpture in the Colleoni Monument and thereafter continued to be used in both public and private works. Altars, chapels, choir screens, and tombs were commissioned in far greater numbers than during preceding decades. Ducal tombs increased in size and in wealth of decoration. None was more ambitious than the Tomb of Doges Marco and Agostino Barbarigo.

The double tomb was dedicated to Marco, born c. 1413, and Agostino, born c. 1420, second and fourth sons of Francesco Barbarigo and seventy-third and seventy-fourth doges, respectively. The Barbarigo Tomb no longer exists. Originally it occupied three bays of the right aisle wall to the west of the *barcò* in the church of S. Maria della Carità. When in 1807 the church, school, and convent of the Carità were chosen as the new seat of the Accademia di Belle Arti, the tomb was demolished: only fragments of it survive today. They comprise the *Kneeling Effigy of Doge Agostino Barbarigo* in the ante-sacristy of S. Maria della Salute; the relief of the *Resurrection* exhibited on the ground floor of the Scuola di S.

171

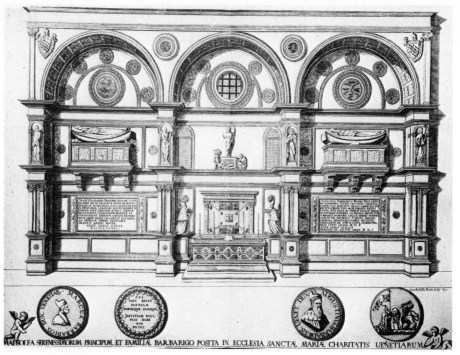

1

2

*1. Suor Isabella Piccini. Engraving of the Barbarigo Tomb. 1692. Venice, Museo Civico Correr, Raccolta Gherro, iii, no. 435*

*2. Engraving of a Medal of Agostino Barbarigo, from G. F. Barbarigo, Numismata virorum illustrium ex Barbadica gente, Padua, 1732, 91, no. xxxxvi*

Giovanni Evangelista; and three bronze reliefs depicting the *Assumption* and *Coronation of the Virgin* in the Galleria Giorgio Franchetti alla Ca' d'Oro.[1]

The original appearance of the tomb is preserved in a detailed engraving of 1692 by Suor Isabella Piccini (fig. 1).[2] An engraving of c. 1710 by Vincenzo Coronelli is more summary.[3] On a much smaller scale the tomb was engraved in a book of 1732 on medals commemorating the Barbarigo family, reproduced from the reverse of a medal struck or cast under Agostino Barbarigo (fig. 2).[4]

The tomb encompassed three contiguous shallow barrel-vaulted bays, the central one of which was illumined by an oculus and two arched windows. The central bay contained an altar with an altarpiece flanked by the kneeling figures of

Marco on the left and Agostino on the right; in the second story, between the windows, was the *Resurrection*. The epitaph of Doge Marco Barbarigo, surmounted by a console-borne sarcophagus, bier, and reclining effigy, occupied the left-hand bay. The arrangement of these same elements was repeated in the right bay dedicated to Marco's brother, Doge Agostino. The sculptural decoration was completed by four free-standing statues installed in the niches of the four piers between the bays; from left to right the statues represented *St. Mark*, the *Angel Annunciate*, the *Virgin Annunciate*, and *St. Augustine*.

Historical evidence regarding the construction of the tomb is abundant. In a codicil made on August 3, 1486, eleven days before he died, Doge Marco Barbarigo annulled a previous disposition according to which he was to be buried in the Cappella Barbarigo, constructed by his father in S. Andrea della Certosa.[5] Convinced that now, as doge, his person no longer belonged to him but to the dignity of his high office, he freed his executors to fix his place of burial where they wished.[6] His executors chose the church of S. Maria della Carità, where in 1451 distant relatives from the same branch of the Barbarigo family had been granted the privilege of erecting a tomb for themselves and their family.[7] (S. Maria della Carità was not far from the palace of Marco and Agostino Barbarigo in the parish of S. Trovaso.) To the chapter of Franciscan Observants at the Carità, Marco left, coincidentally, an unrestricted bequest of two hundred ducats invested in state bonds.[8] None of this sum was used for the construction of a tomb. The doge died on August 14, 1486. In his *Vite de' duchi* Marin Sanudo reported that Marco's corpse was brought to the Carità, where it was placed in a temporary grave. At length his tomb was built but at the time of writing, stated Sanudo, it was still not finished.[9] Since the *Vite de' duchi*, completed in 1530, was actually begun forty years earlier, all we can safely deduce from Sanudo's report is that the Tomb of Marco Barbarigo was not yet finished in 1490. It is often assumed that Marco's tomb was finished by 1493, when Sanudo listed "l'archa di Marco Barbarigo Doxe" among the notable things in Venetian churches.[10] But in a codicil of April 3, 1499, Marco's son, Pier Francesco, gave detailed instructions for financing the completion of his father's tomb if, at his own death, it should not yet be finished.[11]

Agostino Barbarigo succeeded his brother as doge on August 30, 1486. The omission of any mention of Agostino's tomb from Sanudo's list of 1493 strongly suggests that it did not yet exist. But by July 17, 1501, when Agostino Barbarigo wrote his testament, the Altar of the Virgin Mary and his tomb were complete.[12] For the decoration of the altar Agostino left four wall hangings. To the chapter at the Carità he bequeathed one thousand ducats in state bonds plus one hundred and fifty ducats to be paid out in fifteen annual installments.[13] Agostino died on September 20, 1501. Sanudo tells us that Agostino's body was interred on September 23 in the doge's newly erected tomb.[14]

Only adornments of the altar are recorded after this date. In 1515 Vincenzo, son of the future Doge Antonio Grimani, had a gilded copper grill with many bronze figures made for the Barbarigo Altar at a cost of three hundred ducats. He also donated three gilded and embellished lamps at a cost of one hundred ducats to hang in front of the altar, as well as two antependia, the first of cloth of gold, the second of gold filigree (?) with embroidered borders.[15] In 1518 Grimani gave a porphyry jar, a ship in a crystal vase, and a gilded copper basin to be displayed on solemn feast-days at the Altar of the Virgin Mary.[16] Along with others in the church, the Barbarigo Altar was finally consecrated on October 18, 1544.[17]

It has been thought that a portion of the tomb—that part dedicated to Marco Barbarigo—was not yet finished in 1548 because a cadaster of the church, dated 1548 on its cover, begins its description of the Altar of the Virgin Mary with the words: "dato che quello (deposito) de messer Marco non sia finito al presente."[18] Although the cadaster is precisely dated, changes in the handwriting show that it was not all written at one time: by the 1540s the handwriting of the earlier entries has become exceedingly infirm in the notations of events. The handwriting of the passage concerning Marco's tomb is not infirm. It is followed, moreover, by an entry which records the date of 1526. Therefore there is reason to believe that the statement regarding the unfinished tomb was made considerably earlier than 1548. Francesco Sansovino's ample description of the tomb, published in 1581, contains no reference to anything still incomplete.[19]

From this evidence it is possible to conclude that the Tomb of Marco Barbarigo was begun some time after the doge's death in 1486. It was spoken of as finished in 1493. Yet some work remained to be done on it in the spring of 1499. We do not know when that work was accomplished. Agostino's tomb, on the other hand, was not yet built in 1493. By July 1501 both his tomb and the altar were finished. Agostino's testament tells us that the tomb was his own commission. That he undertook to have it built himself, rather than delegating that responsibility to his heirs as was Venetian practice, is explained by the fact that Agostino was not survived by any male descendants, his only son having died many years before. The cadaster of 1548 records the commission for the altar twice, once as jointly given by Marco and Agostino,[20] and once as Agostino's alone.[21] Probably only the latter is correct, for neither Marco's will nor the wills of his sons mentions it. In any case, a central altar is not likely to have been planned before a second tomb symmetrically flanking it was envisaged. In sum, the Barbarigo Tomb may well have been conceived initially as a conventional single tomb commemorating Marco alone. Perhaps that first tomb was not merely a truncated version of the double tomb we know but had a different form. If Agostino's decision to add his own tomb and an altar involved the reconstruction of his brother's tomb as well as an addition to it, then the paradoxical references to Marco's tomb as finished in 1493 but unfinished six years later would be explicable.

The form which the Barbarigo Tomb came to assume under Agostino is unusual. It is justly claimed that the tomb represents the first monumental double tomb in Venice and that it is the first to incorporate windows within a tomb.[22] Equally extraordinary is the fact that although not dedicated to a saint or holy person, it includes an altar. But to make such claims of uniqueness is to perceive the Barbarigo Tomb within the wrong tradition. For while the Barbarigo Tomb is unusual in the context of tombs, it is much less anomalous in the context of funerary chapels. There one often finds two matching tombs of relatives facing one another on the lateral walls of the chapel, flanking an altar situated at the chapel's head. Examples include the Chapel of Erasmo and Giannantonio da Narni in the Santo, Padua; the Sassetti Chapel in S. Trinita, Florence; the Maffei Chapel in S. Maria sopra Minerva, Rome; the Oliva Chapel in S. Francesco, Montefiorentino; and in Venice, the Corner Chapel in SS. Apostoli. Before the wholesale destruction of Venetian churches there must have existed many more. Indeed, in one of these chapels—the Sassetti Chapel—images of the two patrons, dated 1486, frescoed but otherwise identical in scale, position, pose, and view to the kneeling effigies of Marco and Agostino Barbarigo, flank a rectangular altarpiece. Since the plan of the Carità did not provide for individual chapels in the nave, the customary three-dimensional

chapel arrangement was opened outward and thus adapted to a flat wall. Appropriate to a chapel setting is the omission of an independent framework detaching the Barbarigo Tomb from the architecture of the bays. Rather, the three-bay system, enriched with statuary, a relief, marble incrustation, and free-standing columns, was made to serve the same dual function served by architecture in the Corner Chapel, for example—of architecturally defining and articulating a particular portion of the church while providing frames and ground for the sepulchers.

Piccini's engraving of the Barbarigo Tomb shows, incorporated within the central altarpiece, a grill, three bronze reliefs depicting the *Assumption* and *Coronation of the Virgin*, four angels, and four seated figures (Evangelists or Fathers of the Church). The grill and bronze reliefs are certainly those commissioned by Grimani in 1515. It is therefore generally assumed that Piccini's engraving of 1692 records the appearance of the altarpiece from 1515 onward. The pilasters and entablature of the altarpiece's framework are early Renaissance in style and therefore probably original. But the combination of grill and reliefs inside is visually unsatisfactory and in an altarpiece would certainly have proved anomalous: the arrangement cannot be original. In fact the inventory of 1548 clearly states that the grill went "in front of the Madonna of said altar of the Barbarigo": the phrase "davantj la madonna" suggests a *sportello* in front of a sacred image of the Madonna inside the altarpiece. The subjects of the bronze reliefs would have suited such a purpose but their size, shape, and weight would not.[23] Unfortunately, the evidence is not sufficient to permit the reconstruction of a *sportello* or any other sort of grill around either the altar, altarpiece, or tomb that would credibly unite all the elements contained within the altarpiece shown by Piccini. Nevertheless, some such grill must have existed.

The engraving of the Barbarigo medal, which records the appearance of the tomb prior to the execution of the grill, shows at the center of the altarpiece what seems to be a single statue. But apart from the difficulty of reading the image, such an indirect and miniature record is not likely to be entirely reliable. The marble frame portrayed in Piccini's engraving seems here to project very little. Therefore, if the *Madonna* which it contained was not a painting or relief, as seems more likely, but a statue in the round, that statue must have been recessed within a niche. The record of dedication of the altar to SS. Vincent and Anastasius Martyrs as well as to the Virgin Mary makes it likely that by 1544 those saints too were represented somewhere in the altar. Unfortunately, sixteenth- and seventeenth-century guides to Venice do not describe the Barbarigo Altar. Nor can any paintings or sculptures known to come from the Carità be connected with that work.

The excessive width and the late Renaissance design of the altar table represented in Piccini's engraving suggest that it is a later—probably a late sixteenth-century—addition.[24] Indeed, the engraving of the medal shows an altar table which is hardly wider than the altarpiece and has no incrustation of any sort. The original altar table, covered by Grimani's gorgeous antependia, was probably very simple. In the pavement before the altar lay the tomb slabs of Agostino's and Marco's heirs.[25]

There is no consensus today regarding the attribution of either the architecture or the sculptural components of the tomb. Mauro Codussi,[26] Antonio Rizzo,[27] and Tullio Lombardo[28] have each been credited with the architecture of the tomb; strangely, Pietro Lombardo's name has never been advanced. The attribution of the kneeling doge, in part or in entirety, to Antonio Rizzo or to a close follower of his, is most often met with in the literature.[29] But the attribution has been vigorous-

ly contested by a few knowledgeable critics:[30] their opposition seems all the more determined in view of the fact that no credible alternative has ever been proposed. On the rare occasions when the *Resurrection* has been thought worthy of remark, it has been given to an incompetent sculptor,[31] sometimes identified as a follower of Rizzo's.[32] Attribution of the three bronze reliefs, with which eight other small bronzes have been linked at one time or another, has been more fiercely disputed than any other portion of the tomb. I believe the reliefs are by Antonio Lombardo. But proof of this—a chapter in itself—would take us beyond the limits of this essay.

In view of the kinship of the Barbarigo Monument with funerary chapels, it is not surprising that the tomb's closest formal analogy is found in a work of architecture rather than a tomb—Pietro Lombardo's S. Maria dei Miracoli. In the superposition of two trabeated stories crowned by a high arch, the tomb recalls the articulation and proportions of the Miracoli façade (fig. 3). In the lunettes of both, a large central oculus is encircled by four or five smaller roundels. The large roundels of the Barbarigo Tomb are framed by heavy double moldings, the inner one of which is fluted. Very similar frames, including an inner ring of fluting, surround the Evangelists in the spandrels of the choir of the Miracoli. In the central bay of the Barbarigo Tomb and at the east end of the Miracoli choir the narrow arched windows, pushed to either side until they touch the corners of the room,

*3. Pietro Lombardo. Exterior, S. Maria dei Miracoli, Venice*

*4. Pietro Lombardo. Interior, S. Maria dei Miracoli, Venice*

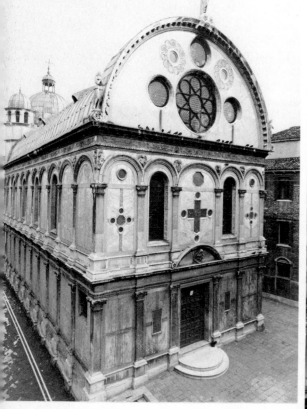

3

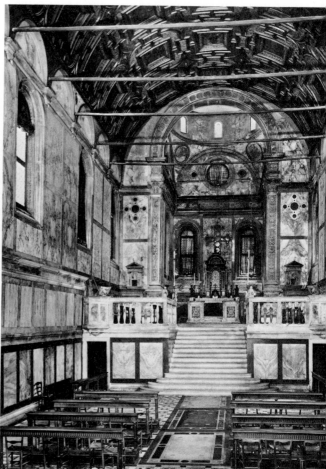

5. *Antonio Rizzo*. Rio *facade,*
*Ducal Palace, Venice*

liberate as much as possible of the center of the wall. The large expanses of the
tomb's flat wall, embellished principally by a facing of veined marble applied in
large upright slabs having small framed *tondi* of porphyry and serpentine in
their centers, also characterize the interior and exterior of the church. The square
reliefs decorating the fronts of the doges' sarcophagi must have resembled very
closely the carved panels in the plinths beneath the pilasters at the entrance to the
choir of the Miracoli. An arrangement of epitaphs flanked by lesenes carved with
hanging bunches of fruit or trophies analogous to that of the Barbarigo Tomb can
be seen in the Lombardesque Cappella Corner in SS. Apostoli. The niches in the
piers of the Barbarigo Tomb recur in almost identical form in the vertical range
of niches in Pietro's Tomb of Doge Pietro Mocenigo.

Paired free-standing Corinthian columns were a favorite motif of Mauro
Codussi's and point to the influence of his buildings on the tomb. In other respects,
however, the design of the tomb is antithetical to Codussi's highly compartmen-
talized plans and elevations, to which strongly projecting members often lend
emphasis when they do not actually replace the solid wall. The logic and con-
sistency with which Codussi used the orders contrast with the disregard of archi-
tectural proprieties evinced in the corner piers of the Barbarigo Tomb by the
vertical succession of double columns, niche with statue, and single elongated
pilaster.

Even less does the Barbarigo Tomb resemble the architecture of Antonio Rizzo. Rizzo's Tomb of Doge Nicolò Tron in S. Maria dei Frari, the courtyard and *rio* facades of the east wing of the Ducal Palace (fig. 5), and the Scala dei Giganti all present continuous flat façades where the projection of members or the recession of the background is reduced to a minimum. To his flat facades Rizzo invariably applied pilasters—never engaged or free-standing columns. Entablatures are almost never broken forward over vertical members. Façades have so many horizontal divisions that the stacking of stories ultimately produces a vertical effect, as in the facades of High Gothic cathedrals. In the *rio* façade of the east wing of the Ducal Palace even the mezzanine stories received a distinctive horizontal articulation. Vertical members, on the other hand, almost never extend beyond a single story. Each story was conceived as a separate unit: no larger motif, scaled to the entire height of the façade, links two or more stories, and the composition of each story is independent from the rest. As a consequence the length of Rizzo's façades seems infinitely extensible. Even in the Tron Tomb the integrating function of the high enframing arch is neutralized by the uniform extension of the series of niches across the enframing piers and background of the niche. The surfaces of Rizzo's façades are articulated throughout by geometrical compartments, generally rectangular in shape. Units are small and repetitive. They blanket the entire surface with an equal density of form. As a result, Rizzo's façades and tomb lack a compelling focus: the projection of a balcony or sarcophagus affects us as an interruption—not a climax.

A very different aesthetic governed the design of the Barbarigo Tomb. While the absolute height of the tomb was probably less than that of the Tron Tomb, the scale of its individual components was considerably larger. The niches formed by the three main arches were much deeper than the niche of the Tron Tomb. The effect of the projection of the piers was not reduced by the projection of the whole basement, nor was the protrusion of the sarcophagi minimized by projecting epitaphs, as in the Tron Tomb. Individual stories were higher in the Barbarigo Tomb and there were fewer of them. The articulation of each story was not continuous across the entire face: the piers introduced a definitive interruption and the central bay was distinguished from the lateral bays by a variety of elements. The surface of the tomb was not as densely filled with geometrical compartments, statuary reliefs, and ornament. Simplicity combined with larger scale endowed the Barbarigo Tomb with a monumentality lacking in the Tron Tomb. Where the architecture of the Tron Tomb was subordinated to its sculptural decoration, here, architecture was paramount.

The *Resurrection* (fig. 6) does not deserve the obloquy invariably bestowed on it.[33] To be sure, no part of the work was brought to a final state of finish. The summary treatment of the soldiers reveals that they especially were executed hastily (fig. 7). Nevertheless, the competence with which their foreshortened poses are presented, the accuracy with which the lines of armor of the central soldier reveal anatomical forms, and the recession of limbs, the description of creases in the neck produced by drooping heads, and the exuberance of waving locks of hair bespeak a master's hand.

A number of stylistic elements prove that master to have been Pietro Lombardo. The relief was carved with a technique derived from that of Desiderio da Settignano in which flattened forms are raised and ostensibly detached from the background. Indeed, Pietro carried this technique to its logical conclusion by cutting away large portions of the ground. The surfaces of forms are pressed flat—

those of the soldiers even more than those of Christ. Even the usually cylindrical staff of Christ's banner has become a square stake. Flattened forms are attached to the ground or to the surfaces they overlap by a perpendicular or inward-slanting facet. No extant portion of the relief is free-standing. Therefore pools of shadow cannot form, but lines of shadow pursue all internal and external contours. Dependent on the linear devices of overlapping, perspective, and foreshortening available to draughtsmen, Pietro nevertheless contrived to suggest considerable space and volume. Although Pietro is known to have carved many *schiacciato* and high reliefs, he evidently preferred this composite technique, whose use he introduced at Venice. Among Pietro's works the composite relief technique of the *Resurrection* can be documented in his relief from the Tomb of Dante in Ravenna, the lunette above the entrance portal at S. Giobbe, the Loredan relief in the Camera degli Scarlatti in the Ducal Palace, and the narratives on the sarcophagus from the Tomb of Pietro Mocenigo in SS. Giovanni e Paolo.

In Venetian sculpture reliefs are more often placed well above the eye level of the spectator than at or below his point of sight. Yet Pietro Lombardo was unique among early Renaissance sculptors in Venice in his partial adaptation of the composition of his relief to a low point of sight. In accordance with a point of sight below the bottom of his relief, Pietro eliminated the ground in the *Resurrection* as he did in the portal lunette at S. Giobbe and the Loredan relief: in all three works the baseline of the figures coincides with the lower edge of the relief. The descending orthogonal of the sarcophagus in the *Resurrection* recalls similar orthogonals in the relief of the *Three Marys at the Tomb of Christ*, from the Tomb of Pietro Mocenigo, and the tomb relief of Dante. Such devices were, no doubt, inspired by Donatello's reliefs for the High Altar of the Santo, which Pietro had ample opportunity to know. In the *Resurrection* the foreshortening of the sarcophagus indicates an ideal point of sight far to the right of the relief. To this point of sight correspond the orientation of Christ's blessing hand, the direction of his glance,, and the foreshortening of the face and shoulders of the middle soldier. Indeed, the wavy border of the fold draped over the lowered wrist of Christ is visible only from the right. Thus the design of the relief was accommodated to an observer who had just entered the church. The atypical orientation away from the high altar may be explained by the existence of a *barco* in the Carità which effectively hid the nave from an observer in the eastern portion of the church.

The treatment of Christ's drapery (fig. 8) strongly resembles that of the figures in the lunette of Pietro's documented Tomb of Antonio Roselli in the Santo, Padua (fig. 9). The readiness with which the garment clings to an advancing limb and the fine facet produced at the edge of the cloth denote a thin material; sparse folds consisting of thin sharp ridges which hardly project from the surface of the cloth testify to its brittleness. The tops of ridges occasionally are rounded; their lower contours are undercut or incised. Ridges follow variable paths: short ridges traverse the projecting limb in straight lines, curves frequently suffer slight contractions. Where folds break they form angles—often acute angles as the fold suddenly reverses its direction. At the edge of the figure the folds continue for a certain distance, then halt abruptly before retreating behind the figure. Sometimes, just beyond the contour, folds curve up or down, providing narrow strips of framing along the silhouette. Sometimes ridges stretched along the outer contour of the limb accentuate the silhouette with a cordlike edge. This pattern, which fractures the visible and continuous surface of a projecting limb, is complemented by the unified pattern of drapery covering an invisible limb. Extremely tempered

6

6. *Pietro Lombardo.* Resurrection. *Barbarigo Tomb, Scuola Grande di S. Giovanni Evangelista, Venice*

7. *Pietro Lombardo.* Resurrection *(detail). Barbarigo Tomb, Scuola Grande di S. Giovanni Evangelista, Venice*

7

arcs, evenly spaced and parallel, rise to a raised arm over which the cloth is draped
or beneath which it is pinioned. Flat folds laid on top of one another endow the
border of the drapery descending from the upraised arm or hand with a regular
zig-zag pattern. Drapery thus confers upon the closed contour of the figure a
silhouette which is alternately smooth and nearly straight, and very jagged.

Christ's gesture in holding his banner is nearly identical to the gesture with which
Mary Magdalene holds her martyr's palm in the Roselli lunette. Christ's beard and
mustache framing barely parted lips recur in the bishop saint—probably St.
Augustine—in the Loredan relief (figs. 10, 11). Eyelids have the same configuration.
The regular arcs which constitute the eyebrows of both figures, the smooth con-
tours of the crown of the head of Christ and of the figures in the Loredan relief,
are corollaries of Pietro Lombardo's procedure in carving surface forms. For an
examination of his unfinished works, or works on whose execution Pietro expended
little effort, reveals that the sculptor only gradually refined and varied what began
as perfect stereometric forms and precise geometric contours. This can easily
be seen in *Justice* from the Tomb of Pasquale Malipiero in SS. Giovanni e Paolo
(fig. 12). Here, as in the head of Christ, traces of a claw chisel have not been
smoothed away at all. In contrast to Antonio Rizzo, Pietro Lombardo was not
especially attentive to the surface finish of his sculptures, and a high proportion
of his works show signs of the use of the claw chisel and drill.

The sleeping soldiers bear a striking resemblance to *Daniel* from the choir screen

*8. Pietro Lombardo.* Resurrection
*(detail). Barbarigo Tomb, Scuola
Grande di S. Giovanni Evangelista,
Venice*

9. *Pietro Lombardo*. St. Mary Magdalene. *Lunette of the Tomb of Antonio Roselli, Santo, Padua*

10. *Pietro Lombardo*. Resurrection *(detail)*. *Barbarigo Tomb, Scuola Grande di S. Giovanni Evangelista, Venice*

11. *Pietro Lombardo*. Madonna and Child Enthroned with Saints and Doge Leonardo Loredan *(detail, Bishop saint)*. *Camera degli Scarlatti, Ducal Palace, Venice*

12. *Pietro Lombardo*. Justice *(detail)*. *Tomb of Doge Pasquale Malipiero, SS. Giovanni e Paolo, Venice*

of S. Maria dei Frari (figs. 13, 14). The faces of all three figures are short and squarish; all possess broad, blunt chins, a second chin, and heavy jowls, and from the corners of identically formed mouths a fold of flesh descends obliquely. Large, slightly bulbous eyes are placed very far apart; long eyebrows follow the regular curve of sockets. In all three the bridge of the nose is similarly furrowed and the tip of the nose is squashed against the face.

A comparison of the heads of Agostino Barbarigo[34] and Doge Nicolò Tron (figs. 16, 17, 19) proves that those elements of style which distinguished the architecture of Antonio Rizzo and Pietro Lombardo apply also to their sculpture. The head of Tron is wrought on a smaller scale, and in more detail; by comparison, the head of Barbarigo appears simplified and generalized. Whereas the curvature of a brow or wrinkle, or the pathway of a strand of hair is sometimes repeated over and over in the head of Barbarigo, every detail in the head of Tron has its own characteristic conformation. The thorough, precise, and graphic delineation of each contour in Tron's face makes the contours of Barbarigo's features seem, by contrast, slightly blurred. In the head of Tron transitions between forms are accomplished much more smoothly, as can be seen most clearly in the cheeks. Tron's wrinkles are subordinate to the changes of form that they accompany; Barbarigo's wrinkles often substitute for a plastic modulation of the form. Running pointmarks used to define Barbarigo's wrinkles are not disguised; a line engraved with a point interrupts the pattern of his beard; the drill holes forming the tear ducts

14

*13. Pietro Lombardo.* Resurrection *(detail).
Barbarigo Tomb, Scuola Grande di S. Giovanni Evangelista, Venice*

*14. Pietro Lombardo.* Daniel, *from choir
screen (detail). S. Maria dei Frari, Venice*

13

*15. Pietro Lombardo.* Kneeling Effigy of Doge Agostino Barbarigo. *Barbarigo Tomb, Ante-sacristy, S. Maria della Salute, Venice*

*16. Pietro Lombardo.* Kneeling Effigy of Doge Agostino Barbarigo *(detail). Barbarigo Tomb, Ante-sacristy, S. Maria della Salute, Venice*

*17. Pietro Lombardo.* Kneeling Effigy of Doge Agostino Barbarigo *(detail). Barbarigo Tomb, Ante-sacristy, S. Maria della Salute, Venice*

18. *Pietro Lombardo.* St. Mark *(detail).*
*Cappella Giustiniani, S. Francesco della*
*Vigna, Venice*

19. *Antonio Rizzo.* Standing Effigy of Doge
Nicolò Tron *(detail). Tron Tomb, S.*
*Maria dei Frari, Venice*

remain recognizable as such. The virtuoso realization in Tron's head of a variety
of textures—the hair of the brows, mustache, and beard, the differentiated flesh
of lips, cheeks, and forehead, and even the suggested color in the iris and pupil
of Tron's eyes—contrasts forcibly with the uniform stoniness of the head of
Barbarigo. Unlike Pietro, Rizzo revealed the outline of hair and ear beneath
the doge's *camauro.* The finer fragile ornament of Tron's ducal bonnet is more
attenuated, more open, more complex and convoluted. The difference in plane
and texture between stippled background and raised pattern is much more marked.
Technically the head of Tron seems as much the work of a goldsmith as a sculptor:
behind it stands the obsessive author of the Scala dei Giganti.

The head of Barbarigo, on the other hand, manifests the virtues of a synoptic
vision. The features of the face are schematic: they follow more closely regular
geometric paths and their repetition produces a more symmetrical visage. Forms
are simpler, lines more likely to be parallel. The hair of brows and beard occupies a
single plane. Contours of wrinkles, strands of hair, and individual features are
longer, smoother; they bridge gaps more easily and thus endow the face with a
higher degree of uniformity and integration. Where the head of Tron predom-
inantly records the sitter's accidental, fleshy integument, the portrait of Bar-
barigo makes visible the essential and immutable bony structure of the subject's
head.

It might be thought that these differences are due to the diverse physiognomies
of the respective sitters. And yet so many of the features depicted in the heads of
Tron and Barbarigo recur in other heads by their respective authors that we begin
to doubt the veracity of certain elements at least. If we compare the head of Tron
with the much earlier and therefore less refined visage of *St. Paul,* from Rizzo's
documented altar in the Basilica of St. Mark, we find the same concentration on
surface forms at the expense of underlying structure. The long, horizontal furrows

20. *Antonio Rizzo*. St. James,
*from Altar of St. James (detail)*.
*S. Marco, Venice*

in the forehead and the curvature of the brows, with their wayward hairs flaming upward at the bridge of the nose as though to consume the vertical folds of flesh which crease the forehead, occur in both. The face of *St. James* from Rizzo's companion altar in St. Mark's (fig. 20) possesses Tron's curved lids, the pouches beneath his lower lids, his prominent cheekbones placed very low, the same deep furrows enclosing nostrils and mustache, and lips of analogous morphology and texture. Concurrently, a comparison of Barbarigo and *St. Mark* (fig. 16–18) from the Giustiniani Chapel in S. Francesco della Vigna (or *Elias* from the choir screen of the Frari, or *St. Mark* from the Tomb of Pietro Mocenigo in SS. Giovanni e Paolo) shows an uncanny similarity in the skeletal structure of the face. The features of the face are vertically compressed but horizontally expanded. Thus the distance from low eyebrows through short nose to mouth is relatively short, while the eyes are located far apart and the cheekbones are pulled so far to either side that they confer upon the face a second, inner silhouette. In both, the knobby cheekbones, placed very low, are exceedingly protuberant and are separated from the emphatically projecting jawbones and beard by multiple cavernous indentations. The configuration of the wrinkles around *St. Mark*'s left eye recur in the portrait of Barbarigo. The arrangement of Barbarigo's frown-lines and brows, his thin-lipped narrow mouth, and the symmetrical pattern produced by his wavy beard and mustache reappear in the head of St. Augustine from the Loredan relief

(fig. 11). In the portraits of both Barbarigo and Loredan the geometric eyebrows
look like strips appliquéed to the surface of the forehead.

The attribution of the Barbarigo Tomb to Pietro Lombardo testifies to the
hegemony of the Lombardo workshop in Venetian sculpture of the late fifteenth
and early sixteenth century. With only one exception every one of nine doges,
from Pasquale Malipiero (d. 1462) to Agostino Barbarigo, was commemorated by
a tomb commissioned from either Pietro or Tullio Lombardo. Because Antonio
Rizzo was given charge of the rebuilding of the Ducal Palace after the fire of 1483
he is generally thought to have dominated artistic life in Venice. But as a con-
comitant of his employment at the Ducal Palace Rizzo was compelled to close his
shop: he produced very little sculpture in the remaining fourteen years of his
career. Can his have been so enviable a position? Although his salary was raised
twice it never sufficed him, and ultimately he took matters into his own hands by
embezzling ten thousand ducats. Indeed, Rizzo's nomination to the post of *pro-
tomaestro* so effectively eliminated him from the field of competition that one might
almost suppose his appointment to have been engineered by his major rival. With
Rizzo at the Ducal Palace, there was hardly a commission for marble sculpture
and very few for architecture—not only in Venice but in Padua, Treviso, and
other centers of the Veneto as well—that was not secured by the Lombardo shop.
And when Pietro Lombardo followed Rizzo as *protomaestro* of the Ducal Palace
he, it seems, did not give up his workshop but continued to accept commissions
as willingly as ever.

**Notes**

* This paper has benefited from the
criticism of Prof. Robert Munman, for
which I am grateful.

1 Formerly immured in the Sala Canoviana
of the Galleria dell' Accademia and cur-
rently stored in the Magazzino della
Dogana of the Soprintendenza alle Gal-
lerie in Venice are two dozen or so small
slabs of porphyry, *verde antico*, and red-
veined marble in various geometric
shapes—*tondi*, elongated hexagons,
rhomboids, squares, rectangles—thought
to have come from the tomb. Engravings
of the tomb, however, show that all
inlaid colored stones were circular.
Perhaps some of the extant slabs belonged
to the pavement of the tomb's floor and
altar steps.

2 Venice, Museo Civico Correr, Raccolta
Gherro, iii, no. 435.

3 Vincenzo Coronelli, *Singolarità di
Venezia, Le chiese di Venezia, Depositi*

*più singolari di Venezia*, Venice, n.d. (c.
1710).

4 Giovanni Francesco Barbarigo,
*Numismata virorum illustrium ex
Barbadica gente*, Padua, 1732, 91, no.
xxxxvi. The obverse of the medal is in-
scribed: AVGVSTINVS BARB[ADIC]VS DVX
VENETIARVM. The reverse is inscribed:
RELIGIONI ET ORNAMENTO BARBADICO-
RVM. The medal is not catalogued by G.
F. Hill, *A Corpus of Italian Medals of
the Renaissance before Cellini*, London,
1930, and I have not succeeded in find-
ing a specimen.

5 Vincenzo Coronelli, *Isolario del-
l'atlante veneto*, I, Venice, 1696, p. 45:
"v'è un Chiostro minore [at S. Andrea
della Certosa] vicino alla Chiesa, nel
quale molti Patritij hanno voluto essere
sepolti; . . . Si vede frà questi la Cap-
pella eretta da Francesco Barbarigo
Procuratore, Padre delli due Dogi

Marco, ed Agostino, nella quale sono depositati esso, e molti della sua Casa, essendovi anche la Sepoltura della Dogaressa, Moglie d'Agostino, che contribuì molto con le sue elemosine alla fabbrica della nuova Chiesa."

The Certosa also housed the tomb slabs of Marco's brother, Girolamo (d. 1467), and of Jacopo Barbarigo (d. 1466) from another branch of the Barbarigo family. See Emmanuele Antonio Cicogna, *Delle inscrizioni veneziane*, II, Venice, 1827, 53 ff., nos. 2, 3.

[6] Archivio di Stato, Venice (hereafter ASV), Archivio Notarile, Testamenti 1060 (Not. Marino di Martini): "Item quia per testamentum nostrum ordinavimus deponi corpus nostrum in sepultura in quam nobis construi fecimus in capella nostra in Sancto Andrea ad littus: ex nunc volumus et ordinamus quod nobis decedentibus sit in libertate commissariorum nostrum decernere locum sepulture nostre pro ut voluerint: et hoc dicimus quia persona nostra non est nostra sed dignitatis. Item quod possint expendere quantum eius placuerit pro elymosina loci illius ubi decreverint corpus nostrum deponi."

The testaments relevant to the construction of the Barbarigo Tomb were reviewed with less than perfect accuracy by Andrea Da Mosto, *I dogi di Venezia nella vita pubblica e privata*, Milan, 1966, 259.

[7] Gino Fogolari, "La chiesa di Santa Maria della Carità di Venezia," *Archivio veneto*, series 4, V (1924), 90. The brothers Giovanni and Andrea di Piero Barbarigo were related to Marco and Agostino through their great-great-grandfather, Thoma di Piero Barbarigo: Venice, Museo Civico Correr, MS Cicogna Cons. XI-E 2, Marco Barbaro, *Discendenze patrizie*, I, fols. 104v, 108v.

[8] ASV, S. Maria della Carità, Busta 2 (Cartacee), *Catastico di 1548*, fol. 77v: "hano lasato al monasterio il serenissimo messer Marco ducatj 200 de Imprestidj. Tamen li suoj heredj solo a scripti Ducatj 150. in sextiero de orso duro che se scuode a rason de du per cento che viene ducatj 1° lire 12 per paga e durera fino che stara la Camara, . . ."

Of this bequest Marco's heirs paid out only 150 ducats. In 1524 Andrea and Marc'Antonio di Gregorio Barbarigo, grandsons of Marco, donated 25 ducats each to make up the 50 ducats which Marco's heirs had retained from his legacy to the church. See *ibid.*, fols. 9, 77v.

Some relevant passages from the *Catastico di 1548* were partially published by Pietro Paoletti, *L'architettura e la scultura del rinascimento in Venezia*, II, 1893, 84, n. 7 from the preceding page.

[9] Marin Sanudo, "Vite de' duchi di Venezia," in Lodovico Antonio Muratori, *Rerum Italicarum scriptores*, XXII, Milan, 1733, col. 1239: "Il Corpo suo [Marco Barbarigo's] fu portato a sepellire alla Carità, come avea ordinato, e fu posto in un deposito. Demum gli fu fatta un'Arca, la quale ancora non è compiuta."

[10] *Idem, De origine situ et magistratibus urbis Venetae* (*Cronachetta*), quoted by Paoletti, II, 1893, 185, n. 1.

[11] ASV, Archivio Notarile, Cancelleria inferiore, Busta 29, II (Not. Bernardino Bono): "Iterum hoc modo codicilavit, mutavit ac declaravit ubi in suo testamento dixit Corpus suum seppelirj in suo monumento ad ecclesiam sancti andree de litore. Ad praesens dimisit et vult sia S. Marie caritatis: Item dimisit quod commissarij et maxime Dominus Andreas, Dominus Bernardus et Dominus Gregoris eis fratres mittant ad executionem omnia sua legata. Et casuquo non posit aliter fieri vendere debeant primo modo suam possessionem et domum da fies pro solutionem fienda dictorum legatorum, et restum remaneat in sua comissaria. Item dimisit quod si occurerit complere archam quondam Serenissimi patris suj si aliquod inveniretur de bonis suis, de illis expendatur per rata sua in ipsa archa, non derogando tantum aliquod supradictorum legatorum suorum. Et remitit se in totum ad dulcissimam fraternitatem supradictorum fratrum suorum."

In his testament of April 11, 1497, Pier Francesco's brother, Gregorio, provided for his own burial in the Barbarigo Tomb in the Carità. ASV, Archivio Notarile, Testamenti 1183 (Not. Giacomo

Grasolario), no. 217, and *ibid.*, Testamenti 1185 (Not. Giacomo Grasolario), c. 79: "elegendo la sepultura mia ala charitade loco dei frati observanti nelarcha dove sono li miei passati, volendo el corpo mio sia sepelido humelmente et solum cum la compagnia del capitolo della mia contrada e quello de' Castello et de mie' fradeli de madona Santa Maria della Carità nela qual io son, et questo mio ordino non se contravegna ad algun modo. Lassando al monestier prenominado dela charita per remission de lanima mia ducato uno alanno de' mie' imprested de' monte' vechio con el suo cavedal in perpetuo azo pregano dio per lanima mia." Gregorio's testament is found incorporated into a codicil of his son Marc'Antonio's will dated February 6, 1524.

[12] ASV, Archivio Notarile, Busta 416, no. 6: "horderemo che elchorpo nostro sia sepultto in larcha che habiamo fatto fare in la giexia di santa maria dila charitade in tera e non altramente et in labitto dila nostra schuolla et per i nostri chomissarij sia fatto dire avantj che elchorpo nostro sia sepultto conla quantita di messe che i parerano si a frattj observantj che conventuallj et in quella pancho che li parerano pagando le predete messe quello che sono consente di pagaesse . . . . Item nuj lasamo ai fratti observantj di el monestiero di santa Maria dila charitade dove che la nostra sepultura ducati mille di imprestidj de el chavedal nostro de el monte vechio i quallj habiano essere condisionatij che i non se posson ni vendere nj alienare i quallj siano schritj per i nostrij chomissarij dapoi la nostra morte. Li sia schritto ducatj cenatocinquanta di pro a ducati diexe per paga che sia impaga quindexe. Item nuj i lasamo ducati vinticinque doro per i bixognj de el suo monestiero e sia llj dado quatro di i nostri banchallj per hornamentto di laltare di nostra dona pagando el priore prexente et i altrj che suzederano di tempo in tempo fazano dire la messa di mortj uno zorno di la setemana et el sabado la messa di nostra dona alaltar che estatto fabrichatto de nuovo cum tutj quellj venerabillj fratj che

sarano di tempo in tempo. Voliano pregar el nostro signor Idio per lanima nostra et per tutj i altrj nostrj che sono pasattj di questa vita."

[13] The financial arrangements are spelled out in the *Catastico di 1548*, fol. 77v: "Lo Serenissimo messer Augustino a lassado ducati 150 in sextiero di osso duro in 15. page de essere scosse a ducatj 10 per paga le quale tutte sono statte scosse fina al 1526 . . .

"Item ha lassato ducati 1000 di imprestitj scriptj in ditto sextiero di osso duro e la prima paga sara quando se pagera la paga di setembro 1504 a ducatj 10 per paga e dio sa quando sarano questo per che al presente coreno le page 1486 dove passarano piu di 30 anni avantj che se comenza la partida."

Not included in Agostino's testament was the enigmatic gift of 25 ducats to the Carità recorded in the *Catastico di 1548*, fol. 9v, "per il suo manto."

[14] Marin Sanudo, *I diarii*, Venice, IV, 1880, 113: "il corpo dil prefato principe fo portato a la Charitade, dove fu sepulto in la soa archa nuova, dove etiam in una altra è suo fradello, missier Marco Barbarigo."

[15] *Catastico di 1548*, fol. 78: "Lo Magnifico messer Vincenzo Grimanj del serenissimo messer Antonio feze fare la grada davantj la madona del ditto altar dj Barbarigi la quale e de Rame dorata de oro de ducati cum molte figure de bronzo. Et costo ducati 300 doro.

"Item lo ditto ha donato tre lampade dorate cum li suoj adornamentj quale costo ducatj 100. e poste davantj al ditto Altar della madona." (In the margin: 1515.)

*Ibid.*, fol. 31v: "1515 . . . Item [Vincenzo Grimani] fece uno pallio de' panno d'oro per ditto altare, quale fo robbato, e poi fo fatto uno de' restagno d'oro con lo friso de' sopra recamado, et lo mo inesse li frisi recamadi, che sono 4 con figure detro."

[16] *Ibid.*, fol. 78: "1518. Lo ditto [Vincenzo Grimani] donò al monasterio una Idria de profido Item una bellissima ńave posta in una balla de' vedro. Et uno basilo de rame dorado de oro de ducatj le qual cose fece donatione cum condi-

tione che le fusse poste le feste solenne al ditto altare per adornamento de esso cun pacto e che non si possa donare ne imprestare a niuno come apar per instrumento rogato per messer bonifatio soliano notaro . . . " Cf. *ibid.*, fol. 31v f.

[17] *Ibid.*, fol. 78v: "1544. Adj 18 octubrio. Il Reverendo padre Do' Titto da Venetia Canonico nostro Rettore et Episcopo olim chiriosensis di lixola di Candia. In questo giorno ha consagrato il ditto Altare a laude di dio e de la Virgene Maria et di Santo Vincentio et di Santo Anastasio Martirj."

[18] *Ibid.*, fol. 77v.

[19] Francesco Sansovino, *Venetia città nobilissima et singolare descritta in XIIII. libri*, Venice, 1581, 95v f. "Vi si veggono similmente due statue de Principi Barbarighi, i quali havendo le stanze loro nella presente contrada, vollono esser riposti in questo nobilissimo tempio: & furono, Marco Barbarigo, & Agostino, amendue fratelli; percioche havendo occupato tre volti non forati, & congiunti insieme con colonne doppie, vi sono tre belle figure in piedi di tutto tondo, & nel volto di mezo è collocato un'altare, alla cui destra è situata la statua di marmo del predetto Doge Marco inginocchioni, & dalla sinistra di suo fratello Agostino simile al primo: & sotto il primo de volti predetti sotto un sepolcro di marmo, dove si vede disteso Marco Doge 72. che visse l'anno 1485. vi si legge in campo d'oro:

Marci Barbadici Principis ossa hic sunt, eiusdem recte factorum inter homines nunquam interitura laus. Quem cum diu in Principatu admirari non potuissent, eundem penè viuentem Patriae iterum restituerent, Augustinum fratrem ei suffecerunt, debitum virtuti testimonium, quod antea inauditum, posteros ad gloriam semper excitauit. Praefuit Menses IX. Vix. Ann. LXXII. M CCCC LXXXVI.

Sotto all'altro volto oltra all'altare in sepolcro simile a mez'aria, & di pari lavoro, & bellezza, vi è riposto Agostino fratello Doge 73. che gli successe nel Principato, & vi si legge:

Augustinus Barbadicus, fratri Duci optimo incredibili totius ciuitatis consensu suffectus Rhetico bello confecto, Cypro recepta, Piratis toto mari sublatis, rebus Italie post fusos ad Tarum Gallos, Ferdinandumque Iuniorem in Regnum resti tutum compositis, maritimis Apuliae oppidis, Imperio adiunctis, Hetrusco tumultu sedato, Cremona, Abduanaque Glarea receptis, Cephalenia de Turcis capta, florentiss. Reipub. statu viuens M. H. P. Vixit ann. LXXXII. praefuit XV. D. XXIII. Obiit M. D. I.

[20] ASV, *Catastico di 1548*, fol. 77v: "Li Serenissimi principi vz. messer Marco et messer Agustino suo fratello da cha barbarigo da San gervaso hano edificato solenemente lo ditto altare a honore e laude della Vergine Maria et posto da le bande li suoi honoratj depositj . . ."

[21] *Ibid.*, fol. 42v: "Il Serenissimo Dose messer Augustin Barbarigo ha fatto lo altare della madonna con la sua dignissima sepoltura . . . ."

[22] Robert Munman, "The Last Work of Antonio Rizzo," *Arte lombarda*, n. s., XLVII/XLVIII (1977), 89, 97.

[23] The relief with the twelve Apostles measures 30 cm high by 83 cm wide. The *Assumption of the Virgin* measures 36 cm high by 25 cm wide. The *Coronation of the Virgin* measures 25 cm high by 70 cm wide. Adriana Augusti Ruggeri, *Giorgione a Venezia*, Gallerie dell'Accademia, Venice, catalogue by Ruggeri, *et al.*, Milan, 1978, 208, also doubted that the composition of the three reliefs was exactly as it appears in the engraving. Gilding is visible only in the relief of the *Coronation*. The left hand of the Virgin is missing from the *Assumption of the Virgin*. A deep cleft in the Virgin's wrist suggests that at one time the hand was pieced.

[24] This suggestion originated with Robert Munman, *Venetian Renaissance Tomb Monuments*, unpublished Ph.D. dissertation, Harvard University, Cambridge, Mass., 1968, 264, n. 4. However, he subsequently repudiated it, in *Arte lombarda*, 1977, 96.

[25] ASV, *Catastico di 1548*, fol. 77v: "Et

davantj lo altar' le sue arche per li suoi heredj: . . . "

26 Paoletti, II, 1893, 184, 185; Fogolari, *Archivio veneto*, 1924, 90; Luigi Angelini, *Le opere in Venezia di Mauro Codussi*, Milan, 1945, 72, 132; Raban von der Malsburg, *Die Architektur der Scuola Grande di San Recco in Venedig*, dissertation, Ruprecht-Karl-Universität, Heidelberg, 1976, 188, n. 185. Accepted with reservations by Leo Planiscig, *Venezianische Bildhauer der Renaissance*, Vienna, 1921, 209; Giovanni Mariacher, "Profilo di Antonio Rizzo," *Arte veneta*, II (1948), 80, n. 1; *idem, Antonio Rizzo (I maestri di scultura*, 35), Milan, 1966, n.p. (p. 5); Ruggeri, *Giorgione a Venezia*, 208.

27 Michelangelo Muraro, "La Scala senza Giganti," *De artibus opuscula XL: Essays in Honor of Erwin Panofsky*, ed. Millard Meiss, New York, 1961, 357; Munman, 1968, 267 ff.; *idem*, "Antonio Rizzo's Sarcophagus for Nicolò Tron: A Closer Look," *Art Bulletin*, LV (1973), 85, n. 11; *idem, Arte lombarda*, 1977, 93 ff. Accepted with reservations by Wendy Stedman Sheard, *The Tomb of Doge Andrea Vendramin in Venice by Tullio Lombardo*, Ph.D. dissertation, Yale University, New Haven, 1971, 80 f.

28 Adolfo Venturi, "IV. Museo del Palazzo Ducale in Venezia. I. Raccolta medioevale e del rinascimento," *Le gallerie nazionali italiane*, II, 1896, 56.

29 Paoletti, II, 1893, 142, 185; Giulio Lorenzetti, *Venezia e il suo estuario*, 1st ed., Venice, 1926, 503; Mariacher, *Arte veneta*, 1948, 80 f.; John Pope-Hennessy, *Italian Renaissance Sculpture*, 1st ed., London, 1958, 349; Muraro, "La Scala senza Giganti," 361; Angiola Maria Romanini, "L'incontro tra Cristoforo Mantegazza e il Rizzo nel settimo decennio del Quattrocento," *Arte lombarda*, IX (Jan.–June 1964), 91, 98; Munman, 1968, 262, 267; Antonio Niero, *Chiesa di S. Maria della Salute*, Venice, 1971, n.p.; Munman, *Art Bulletin*, 1973, 85, n. 11; Venice, Procuratie Nuove, *Arte a Venezia dal medioevo al settecento*, June 26–Oct. 31, 1971, catalogue by Giovanni Mariacher, Venice, 1971, 139; Munman, *Arte lombarda*, 1977, 91. Accepted with reservations by Angelini, *Mauro Codussi*, 71.

30 Adolfo Venturi, *Storia dell'arte italiana*, Milan, VI, 1908, 1072, n. 1; Planiscig, *Venezianische Bildhauer*, 209; Fogolari, *Archivio veneto*, 1924, 90 f.; Wiebke Pohlandt, "Antonio Rizzo," *Jahrbuch der Berliner Museen*, XIII (1971), 207. The attribution to Rizzo does not figure in Planiscig, "Rizzo, Antonio," *Allgemeines Lexikon der bildenden Künstler*, eds. U. Thieme and F. Becker, XXVIII, Leipzig, 1934, 408–10, or in Erich Hubala's description of the church of the Salute in Erich Egg, Erich Hubala, Peter Tigler, Wladimir Timofiewitsch, Manfred Wundram, *Oberitalien Ost (Reclams Kunstführer*, ed. M. Wundram, *Italien*, II), 1st ed., Stuttgart, 1965, 911.

31 Paoletti, II, 1893, 184, 185. Calling it mediocre or modest, Planiscig, *Venezianische Bildhauer*, 209, and Pohlandt, *Jahrbuch der Berliner Museen*, 1971, 205, no. 83, forebore assigning it any author.

32 Lorenzetti, 1926 (1), 573; Munman, 1963, 261; *idem, Arte lombarda*, 1977, 91. Fogolari, *Archivio veneto*, 1924, 90 f., thought that the relief, like the effigy of Barbarigo, had hardly been begun when Rizzo was forced to flee Venice.

33 The *Resurrection* proper measures 190 cm in height. The molding below is 72.8 cm wide. The relief was apparently carved from a single block of limestone. There is no evidence of polychromy or gilding. The relief is poorly preserved. The right corner of the relief, most of the raised arm and hand of the rearmost soldier, the top of Christ's banner, and half of Christ's left foot are missing. Chips are visible in the right corner of the sarcophagus, the foot of the central soldier, Christ's right foot, and the end of the banner. The entire surface is scarred, pitted, and abraded. Several fissures are evident in the lower part of the relief.

34 The statue of the doge measures 120 cm in height. It is carved from a single block of marble. There are traces of dark paint in the eyeballs of the doge. The decoration of the left side of the ducal bonnet was omitted. In all other

essential respects the carving of the figure is complete. A crack and chip at the juncture of the figure's neck and shoulders indicates that the doge's head was once dislodged. Where the doge's mantle covers the figure's left wrist the mantle is badly cracked and chipped. The nose of the statue is severely chipped and the thumbs are missing. Minor chips are visible in the figure's right eyebrow, the tips of the fingers, and in the doge's mantle. Otherwise the surface of the statue is well preserved.

# 12

## The Joy of the Bridegroom's Friend: Smiling Faces in Fra Filippo, Raphael, and Leonardo

MARILYN ARONBERG LAVIN

One of the most familiar features of the curly-headed pug-nosed little boy who looks over his shoulder in Fra Filippo Lippi's *Madonna and Child with Two Angels* (fig. 1) is his broad, knowing smile.[1] Appealing and direct, this expression is at the farthest distance one could imagine from the abstract, spiritualizing masks that angels wear in medieval art. While noted as a characteristic of Early Renaissance naturalism, the very element of spontaneity has frequently been found inappropriate from a religious point of view, once even inciting a kind of mild social outrage when Van Marle called the figure "a little guttersnipe off the streets of Florence."[2] In more recent times he is still described as "far from angelic in appearance."[3] Such judgments seem to be based on reasonable standards of angelic decorum, yet they fail to consider the possibility that a smiling angel could have other than anecdotal value. The purpose of this study is to place this and two other smiling faces in relation to an important aspect of angelology heretofore overlooked in post-medieval art.[4]

In an atmosphere of domestic intimacy, Fra Filippo's smiling angel, along with his partially visible companion, is engaged in holding the Christ Child up to his mother. Supporting his weight with their chests and hands and steadying him at the back, they lift him up to the Madonna who, though seated, towers above them. It is the performance of this task that motivates the angel to turn his head and smile with evident pleasure and satisfaction. He looks directly at the spectator and seems to ask for reciprocal joy. What is puzzling about his joyful response is the contrast it makes to the sober reserve of both the Madonna and the Child.

Seated heavily on a backless chair, her legs spread to accommodate the angel, the Madonna does not respond directly to the proffering of her Son. She inclines her head with lowered eyes and prays with palms together. While equally expressionless, the Child reaches out to her with filial anticipation, left arm stretched toward her bosom, right hand resting on her shoulder. A small detail within this gesture gives a clue to the solemn mood. The thumb and forefinger of Christ's right hand prepare to grasp the veil that falls from Mary's head and is tucked into her bodice. Traditionally, the Madonna's veil symbolizes both the birth and death

of Christ. It is the "kerchief of her head in which she wrapped the new-born Child," as well as the "veil from her head" with which she will gird the loins of her naked, dead son after the Crucifixion.[5] These phrases are quoted from the *Meditations on the Life of Christ*, the widely read thirteenth-century Tuscan text and frequent source for painters of religious narratives.[6] As a visual motif, the Child reaching for or manipulating his mother's veil as a premonition of the Passion is known in panel painting from the mid-fourteenth century throughout Tuscany, and is ubiquitous still in the fifteenth and sixteenth centuries.[7] Here, the gravity of the pair is generated, in part, by this evocation of the sad events to come.

More important, however, is the implication of impending embrace in the whole gesture, for it is a sign of Christ taking Mary as his bride.[8] The theological concept of the Marriage of Christ and the Church, elucidated by the Church Fathers and woven into liturgy and art from earliest times, by the twelfth century was applied also to Mary. Thereafter, the persons of the Madonna and *Ecclesia Mater* are often indistinguishable.[9] In our painting, this identity is manifested in Mary's relatively large scale.[10] Moreover, her elaborate coiffure, including transparent veil and diadem of pearls, refers to nuptial dress.[11] These elements, combined with Christ's gesture, demonstrate marital union between Christ, the Bridegroom, and Mary-Ecclesia, the Bride.

Beginning with St. Paul (Ephesians 5:28–32), the typological prototype for the "Royal Wedding" was found in the Old Testament Song of Songs. With rabbinical teaching as precedent for interpreting this passionate love song as an allegory for Yahweh's love for the Jews, the Christian Fathers throughout the Middle Ages, in both the East and the West, found there premonitions of Christ's love for, and his mystic marriage with, humanity. Most of the direct representations of the Marriage of Christ and Ecclesia/Mary illustrate texts of the Canticle, with a variety of motifs developed to express the union: a mature male figure takes a female by the hand or wrist; they embrace and/or kiss; or one takes possession by grasping the other's shoulder. Just as frequently, moreover, the Madonna and the Child, as opposed to the adult Christ, are depicted as the *Sponsus-Sponsa*.[12] In these cases for the most part, Mary is seated holding the Child. They embrace and kiss, and take possession of each other as do the adult Christ and his Mother.[13] By the thirteenth and fourteenth centuries these motifs were lifted out of Bible illustration and used in independent easel painting.[14] There can be no doubt that Fra Filippo's figures, reflecting the medieval prototypes, also allude to the theological marriage. It is within the same marriage theme that we shall find the deeper meaning of the smiling angel.

The first full-scale commentary on the Song of Songs is that by Origen written in the mid-third century. Origen saw the text as a marriage song in dramatic form with the following cast of characters: Christ as the Bridegroom representing the Word of God; the Church as the Bride representing the aggregate of Souls; the Daughters of Zion, in attendance as Friends of the Bride, representing souls of believers; and, as Friends of the Bridegroom, the angels. Concerning the last in the list, Origen says, "We propose to show how the holy angels, who before the coming of Christ, watched over the bride while she was still young, are the friends and companions of the Bridegroom, who speak the words in the poem directed to the Bride."[15] The outlines of Origen's mystic analysis set a form that was followed and developed for centuries, the role of the angels as Friends of the Bridegroom becoming a basic constituent of the theory of angelology. Gregory of Nyssa, for example, whose Commentary on the Canticle was written about 398, further

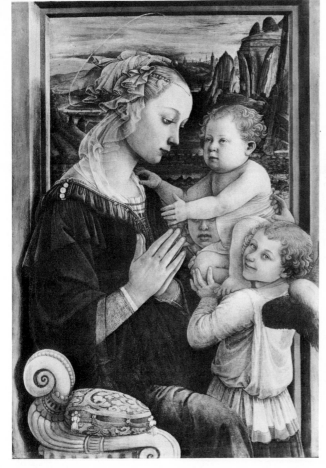

*1. Fra Filippo Lippi.* Madonna and Child with Two Angels. *Uffizi, Florence*

*2. Illustration to the Sermons of St. Bernard. Rome, Biblioteca Casanatense, Cod. 970, fol. 274 (after* Mostra *catalogue)*

defines their function as preparing the holy bridal chamber.[16] St. Bernard of Clairvaux (1091–1153) continued the pattern in his more than eighty sermons on the Canticle. In his Thirty-first Sermon, Bernard tells how one's personal "angel, who is one of the companions of the Bridegroom . . . rejoices, turning to the Lord with gladness and delight . . . the faithful messenger goes back and forth between the Bridegroom and the Beloved, offering devotion and giving back gifts. . . . And sometimes it may happen . . . that he presents them to each other in like manner either carrying off the one or bringing the other to him."[17] In a late fourteenth-century manuscript of Bernard's Canticle sermons, we find these ideas given graphic form (fig. 2). To the left, Christ holds a book symbolic of the Word, and gestures in blessing to the crowned figure of Ecclesia, who folds her arms over her breast in devotion. Christ is physically carried by an angel standing below and holding him by the feet. He is the Friend of the Bridegroom, as are three other wingless haloed youths supporting Christ from behind. Ecclesia is carried in the same way by a female Friend of the Bride and a group of other Daughters

3

3. *Donatello.* Annunciation *(detail, terracotta putti). Santa Croce, Florence*

4. *Jacopo della Quercia. Miniature Stone Triptych. Museo Civico, Bologna*

4

of Zion. The theme of marriage is expressed in the gilt inscriptions in the four corners of the miniature: xps and spo[n]sus (top and bottom left) and spo[n]sa and ecc[lesi]a (top and bottom right).[18]

I propose that the configuration in Fra Filippo's painting represents the same series of ideas. His angels, too, perform as Friends of the Bridegroom, physically bringing the Infant *Sponsus*, the Word Incarnate, to his crowned Beloved as she offers devotion.[19] The very passage from Bernard's Thirty-first Sermon is quoted in full in the *Meditations on the Life of Christ*,[20] and thus may be the direct source for the arrangement of Fra Filippo's figures. In fact, the painting goes beyond the symbolic representation in the manuscript to make explicit with the smile Bernard's words, "the angel rejoices, turning to the Lord with gladness."

One of the great themes in Christian angelology is the joy of the angels at the prospect of the salvation of mankind.[21] The doctrine, which properly begins with angelic assistance in the Old Testament, involves the good angels who remained in heaven after the rebellion and fall. These angels were given protective roles over the various parts of the universe, but were powerless to stem the tide of evil that engulfed the Jewish people.[22] With the announcement of the coming of Christ, who would be the Saviour not just of the Jews but of all mankind, the joy of the angels began. The Church Fathers propounded the idea that as they descended with Christ, the angels began their choruses of gladness, their joy increasing at each step in the scheme of salvation.[23] Cardinal Jean Daniélou, in his study called *The Mission of the Angels*, gives the following synthesis: "There are many . . . images which describe [the] same reality of the angels' joy . . . one more important than the rest . . . is connected with . . . the most remarkable representation of the role of the angels . . . as friends of the Bridegroom in the Canticle of Canticles. . . . As [such] they conduct the Bridegroom to his Bride and . . . withdraw at once. Their joy is complete when their task is accomplished and the Bride is with the Bridegroom. . . . [They] have prepared the way of the Lord and have led humanity to Him. . . . What, then is their joy when they see the Word of God who has joined Himself to humanity by the Incarnation, leading it into the house of His Father at the Ascension, after having purified it in the blood of the Cross."[24]

Almost any representation of angels making music, singing, or dancing implies reference to the theme of angelic joy.[25] But it was not until the Early Renaissance, in the 1420s and 1430s, that the boundaries were crossed between symbolic body-gesture and the expression of emotion through the face. Donatello, on both the Prato Pulpit and the Florentine Cantoria, seems to have been the first to take this step, representing joyful angels singing, dancing, making music, and also smiling.[26] Although the Madonna and Child are not present in the reliefs and the scenes are devoid of narrative, the putti in these works celebrate the Royal Wedding by carrying wreaths, traditional accouterments of marriage festivities.[27] In addition, Donatello represented joyful angels without the other physical manifestations of gladness in the pairs of terracotta putti that form the finals on the Santa Croce *Annunciation* (fig. 3): standing and embracing each other, they look down on the moment of the Incarnation and smile with foreknowledge of the coming marriage.[28] Jacopo della Quercia, probably under Donatello's inspiration, also represented angelic joy with smiles on a miniature stone triptych, where an intertwined triad of angels looks happily down from the pinnacle at the Royal Couple (fig. 4).[29]

These sculptured "smilers" are surely the prototypes for Fra Filippo's equally

joyful putto.[30] However, his scene displays a unity between stimulus and response lacking in the sculptured arrangements. He portrays the joy of the Bridegroom's friend in an actual moment of the Christian drama, and the domestic intimacy conveys the direct relationship between "copulatio Christi et Ecclesiae" and angelic joy. His knowledge of mankind's coming salvation makes the angel smile. And fulfilling his function as messenger of divine revelation, he directs his gaze at the worshiper to broadcast this knowledge to the world.

Once we have understood the theme of the figures in the foreground, the meaning of the rest of the painting and of the compositional structure as a whole begins to fall into place. As Pittaluga observed, our panel is taller than usual for mid-fif-teenth-century Madonna paintings, with Mary's full torso and part of her legs visible.[31] This elongated format produces several important effects. First, the three-quarter cutoff point is responsible for the monumentality of Mary we noted above; were she to stand up, we would find she has the gigantic size of a traditional Ec-clesia figure.[32] Secondly, the low cutoff point gives a view of her seating arrange-ment. The chair is elaborately carved and painted in gold, with a cushion of gold damask over green velvet caught with tassels and pearls. The seat is thus evidently designated as a royal throne, and identifies the occupant with the traditional Marian epithet *Sedes Sapientiae,* the Throne of Wisdom. Fra Filippo may indeed be referring to a specific form of this medieval type, namely, those examples showing the Christ Child between Mary's legs and lifted off the ground by two angels (fig. 5).[33] Moreover, the peculiar Ionic scrolls, gadroons, and other decora-tive carvings of the seat rest on a base shaped like the drum of a fluted classical column. The arrangement, therefore, might be read as symbolizing paganism over-come by Christianity.

As has also been observed,[34] the figure group is enclosed within a painted architectural embrasure, and the third effect of the elongated format is to show that this painted frame continues down toward ground level. The embrasure is thus a long rectangle and is established not as a window, as has been claimed, but as a doorway. On the left jamb are shadows cast by the Madonna and the throne.[35] The figure group, however tightly compressed and held on the picture plane, is not in front of the door, but in its passageway and identified with it. This com-positional device recalls another medieval formula where the Madonna and Child are shown in a doorway inscribed with the prophesy of Ezechiel (44:1–3). It portrays the epithet naming Mary as *Porta,* the Eastern Door, the Door through which God Enters, the *Janua Caeli,* the Door to Heaven.[36]

Through the door opening we see a second spatial realm, a landscape sweeping into the distance, its juncture with the doorway effectively masked by the bulk of the figures. By comparison with them, the landscape forms seem miniaturized and therefore very far away. Many details within this vista further describe Mary's theological status. Half-hidden by her veil is a small domestic building with peaked roof and round-arched windows, a reference to the Santa Casa, Mary's house miraculously transported to Loreto by angels.[37] The green area in the middle distance, planted in regular patterns and bound by roads, is the *Hortus Conclusus,* image of Mary's virginity taken from the Canticle.[38] On the right the rocks and cliffs behind Christ visualize lines from the Canticle, spoken by the Bridegroom to his beloved: "Arise, my love, my beautiful one, and come! O my dove in the clefts of the rock, in the secret recesses of the cliffs, let me see you, let me hear your voice" (Canticle 2:13–14).[39] The distant walled city, with one prominent tower outside the walls, refers to Mary as the Impregnable Fortress, the City of

5. La Diège. *Jouy-en-Josas, Yvelines (formerly Seine-et-Oise)*

God or Mysterious City, and the Tower of David, the last a reference to the neck of the bride in the Song of Songs.[40] And finally, the large body of water in the farthest distance is the sea, referring again to Mary as the *Stella Maris*.[41]

Compositionally, the background space has an upward tilt reminiscent of Northern panoramic landscapes. As they recede into space, the forms rise up and fill most of the painted field creating a high horizon. This vista differs from the fluid Northern views, however, in that our point of sight is stabilized. The stabilization is achieved by the perspective of the painted door frame, seen directly from in front and slightly below. From this fixed point, we know we are looking down on the landscape, and more important, we are made aware that the foreground figures exist in a unified space high above the earthly vista. Through this rational structure Fra Filippo has differentiated the sensory world from the eschatological realm where the holy personages exist as archetypes concerned with the great objectives of Redemption.

In this respect, the painting as a whole is the visual correlative of an ancient prayer, an antiphon dedicated to the Blessed Virgin Mary, sung frequently throughout the liturgical year and known to have been especially popular in the mid-fifteenth century.[42]

| Ave, Regina Caelorum, | Hail, Queen of heaven; |
|---|---|
| Ave, Domina Angelorum: | hail, Mistress of the Angels; |
| Salve, radix, salve, porta, | hail, root of Jesse; hail, the gate |
| Ex qua mundo lux est orta: | through which the Light rose over the earth. |

6. *Raphael and assistants.*
Madonna of the Veil.
*The Art Museum,
Princeton University*

| Gaude, Virgo gloriosa, | Rejoice, Virgin most renowned |
| Super omnes speciosa, | and of unsurpassed beauty. |
| Vale, o valde decora, | Farewell, Lady most comely. |
| Et pro nobis Christum exora. | Prevail upon Christ to pity us. |

In the antiphon we greet the Virgin and ask her to exhort Christ on our behalf. In the painting, as in the prayer, the *Lady most comely, Mistress of the Angels,* who is the *gate* for Christ's entrance into the world, intercedes with the Saviour, the *Light* [which] *rose over the earth.* His rise assisted by angels, he answers her prayer by taking her and all humanity as his bride. As the wedding takes place, the Bridegroom's angelic friend acknowledges our supplication with his glance and, translating Christian doctrine into human expression, confirms the answer to our prayer with his smile.[43]

Fra Filippo's use of the outward-glancing smile as a vehicle of expression for the joy of the Bridegroom's friend, though one of the earliest, did not remain an isolated case. To conclude this study, I shall discuss briefly two other Renaissance

examples in which the "smiler" is St. John the Baptist, precursor, prophet, and friend of the Bridegroom, who by his very nature is the messenger of salvation.

The composition by Raphael known as the *Madonna of the Veil* comes down to us in a number of versions. One exemplar, in the Art Museum, Princeton University (fig. 6), thought to be at least in part by Raphael himself, shows the Madonna kneeling and lifting at transparent veil from the head of the Child asleep on the ground, his back supported by stones.[44] The Infant St. John, whom Mary embraces, leans across her body to point at the Child, and turns his head toward the observer in an openmouthed grin. In spite of an air of sweetness and health, the scene is rife with birth/death symbolism: Mary kneels in the position described by St. Bridget in her vision of the Nativity;[45] Christ lies asleep on a blood-red cloth, under which is a white sheet identifiable as his future shroud. The veil that Mary lifts from his head may be identified as the napkin or sudary that was to cover Christ's face in burial and was left in the tomb after his Resurrection (John 20:7).[46]

In the context of this calm, symbolic foreboding, John's hilarity strikes what seems to be a discordant note. In fact, this discord has been explained by attributing the figure to Giulio Romano.[47] Yet we can find the source of John's joy in the Baptist's own words. In the Gospel, the multitude demands to know John's identity, asking whether, if he is not the prophet Isaiah or the prophet Elias, is he the Messiah? To this question he responds, "He that hath the bride is the bridegroom: but the friend of the bridegroom, which standeth and heareth him, rejoiceth greatly because of the bridegroom's voice: this my joy therefore is fulfilled" (John 3:29).[48] John's reference is to the marriage of the Canticle, naming himself as the bridegroom's friend. This passage is one of the main sources that inspired the Church Fathers and later writers to mark the Baptism of Christ as the moment of the Marriage of Christ and the Church.[49] Thus every Baptism, and in a sense, every representation of the Baptist, carries within it the theme of the Royal Wedding. Traditionally shown as a haggard hermit, since the mid-fifteenth century in Tuscan art St. John represented as an infant was given all the functions and meanings previously reserved for the mature Baptist.[50] Here the infant hermit is the precursor, he who points the way, designating Christ as the *Agnus Dei*, the Lamb of God. As the infant friend of the Infant Bridegroom, he smiles to express his metaphysical joy at the revelation of Christ's future sacrifice. As in the case of Fra Filippo's angel, the direction of his gaze transmits the happy message to those who will profit by it.

St. John as the messenger of glad tidings becomes the central focus of Leonardo da Vinci's painting of the *Baptist* (Paris, Louvre; fig. 7). An isolated figure cut off at the hips, he looms out of darkness without connotations of narrative or setting. He is loosely wrapped in the traditional camel's hair raiment, slung from one shoulder and passing under the other, leaving half of his upper body bare. Weight on the left leg, he leans forward dropping his right shoulder, the arm crossing over his chest in an arc with the hand raised to point directly upward.[51] The left hand is lifted to the heart in a gesture professing faith. Mats of curled and braided hair engulf the skull, throwing the deep-set eyes into wells of shadow. Light falls from above, illuminating the face and emphasizing the flexible, smiling mouth.[52]

Some years ago Kenneth Clark noted that this figure composition, including the smile, was tried out by Leonardo in the form of an Angel of the Annunciation (fig. 9).[53] The angel wears a chiton-like dress that bares the right shoulder and breast, prefiguring John's half-naked state.[54] He likewise confronts the observer and raises his arm to point directly upward to the source of his message. While

7

*7. Leonardo da Vinci. St. John the Baptist.
Louvre, Paris*

*8. Illustration to John 3:27–31, Gospel
Book of the Bulgarian King John Alexan-
der. London, British Museum Add. MS 39627,
fol. 215v (after Filov)*

*9. Leonardo da Vinci, Angel of the An-
nunciation (detail). Charcoal, pen and wash
drawing. Royal Library, Windsor Castle,
No. 12328*

8

9

the pointing motif had a long history in Annunciation scenes, the frontal pose of the angel was unprecedented. As Clark observed, its effect is to cast the spectator in the role of the Virgin Mary.[55] In transferring the motif to John the Baptist, Leonardo made only one significant change. He crossed the right arm over the torso, thereby intensifying the contrapposto and introducing a new sense of inner urgency. But the upward direction of the pointing hand has the same meaning, indicating the divine source of his prophecy.

The relationship to an angel, however, goes far beyond such formal similarities. It is based on dogmatic thought. In the Gospel, when the disciples ask Christ to identify John for them, Christ names John as his ἄγγελός, the Greek for messenger. In Latin translation, the line reads "angelum meum" (Matthew 11:10, quoting Malachi 3:1). The Church Fathers exploited this play on words, and in their lists of titles praising the Baptist they call him "an angel, elect among angels."[56] On this basis, in Byzantine art John is frequently depicted with wings.[57] Leonardo has made the same identification without creating a hybrid being. With the elements of youth, physical softness, and above all sweet sensitive emotion—the very qualities that make the figure objectionable to most modern critics—he portrays John in angelic guise.[58]

But the deepest association between John and the angels is their parallel roles as friends of the Bridegroom. Like the angels, John assists in the mystic marriage. Like their joy, his is in the knowledge that the nuptials will bring man's salvation. Like the angels, he is the messenger of the Word. Leonardo's figure of the Baptist turns to the worshiper as to the historical multitude to whom he preached. His prophetic message takes visible form as a golden evanescence that literally illuminates him from above.[59] His bodily shape reaches a degree of abstract perfection that moves beyond naturalism, and his glowing face moves the symbolic smile beyond happiness to bliss. The painting represents the Friend who stands and hears the voice of the Bridegroom, the epitome of "gaudium impletum."

*Princeton University*

## Notes

[1] For the earliest representations of smiles that connote happiness, cf. Maurice Vloberg, *La Vierge et l'Enfant dans l'art français*, Grenoble, 1936, II, "Le Sourire de la Vierge-Mère," ch. VII, 76 ff.

[2] Raimond Van Marle, *The Development of the Italian Schools of Painting*, The Hague, 1928, X, 432, who further describes the Madonna "as a smug, worldly-looking woman, the Child fat and stupid . . ." Edward C. Strutt, *Fra Filippo Lippi*, London, 1901, 120, says the angel "looks out of the picture with a roguish smile more expressive of mischief than of seraphic perfection . . .,"

and Robert Oertel, *Fra Filippo Lippi*, Vienna, 1942, 44, says the angel has "a gnome-like nastiness and challenging smile. . . ."

Nothing is known about the commission of the painting or where it was originally placed. There is an inscription on the back reading "Imperiale 13 maggio 1796," which puts the provenance in the eighteenth century at the Medicean Villa del Poggio Imperiale. Bernard Berenson, "Fra Angelico, Fra Filippo e la cronologia," *Bollettino d'arte*, XXVI (1932), 56, dated the work 1455; Henriette Mendelsohn, *Fra Filippo Lippi*, Berlin, 1909, 137–40, placed it in 1457; Igino

Supino, *Fra Filippo Lippi*, Florence, 1902, 93–95, dated it 1459. The last date is based on the belief that the Madonna and Child are portraits of Lucrezia Buti, Fra Filippo's mistress and then wife, and of their son Filippino, who was born in 1457. This chronology was corrected when Georg Pudelko, "Per la datazione delle opere di Fra Filippo Lippi," *Rivista d'arte*, XVII (1936), 51, proposed a date of about 1465 by comparison with the documented frescoes at Prato Cathedral.

[3] Frederick Hartt, *History of Italian Renaissance Art*, New York, 1970, 174.

[4] This note is a preliminary sounding of a subject which I hope to study further in terms of theological background, other contemporary examples, and later extensions and amplification in sixteenth- and seventeenth-century art.

[5] Dorothy C. Shorr, *The Christ Child in Devotional Images*, New York, 1954, 117, 158.

[6] Trans. Isa Ragusa, eds. Isa Ragusa and Rosalie B. Green, Princeton, 1961; the first passage is from ch. VII, "Of the Nativity of Our Lord Jesus Christ," 33; the second is in ch. LXXVIII, "Meditation on the Passion of Christ at the Sixth Hour," 333.

[7] Cf. Shorr, *The Christ Child*, Type 24: "He grasps the Virgin's drapery at her breast," 158–63. One sees the motif, among many other places, in a bronze relief attributed to Donatello, *Madonna and Child with Angels*, Kunsthistorisches Museum, Vienna, and in a drawing of the *Madonna and Child with Angels* by Michelangelo (pen, Paris, Louvre, Collection Bonnat, N.R.F. 4221r), both of which are discussed and reproduced by Charles de Tolnay, "Le Madonne di Michelangelo: Nuove Ricerche sui disegni," *Accademia Nazionale dei Lincei*, Rome, 1968, CCCLXV, No. 117. The motif exists earlier than the fourteenth century in manuscript illumination but has not yet been studied systematically.

[8] Leo Steinberg, "The Metaphors of Love and Birth in Michelangelo's *Pietàs*," *Studies in Erotic Art*, ed. Theodore Bowie, New York, 1970, 231–85, esp. n. 33, points out the possession-taking aspect of this gesture in Fra Filippo's painting, and its significance as a token of marital status. As its source, he suggests the Roman concept of *manus*, referring to Richard Brilliant, *Gesture and Rank in Roman Art* (Memoirs of the Connecticut Academy of Arts and Sciences, XIV), New Haven, 1963, 215–16, where, however, no comparable visual representations are cited. More likely sources are to be found in medieval art; cf. above, pp. 194–95.

[9] Cf. Henri De Lubac, *The Splendour of the Church* [1st ed., *Méditations sur l'Eglise*, Paris, 1953], trans. Michael Mason, New York, 1956, ch. IX, "The Church and Our Lady," 238–89; Gertrud Schiller, *Ikonographie der Christlichen Kunst*, Kassel, 1976, IV, 1, "Mater Ecclesia," 84–89, figs. 205–34. Also Adolf Katzenellenbogen, *The Sculptural Programs of Chartres Cathedral*, Baltimore, 1959, 59 ff.

[10] Medieval representations of Mary-Ecclesia regularly involve representing the female figure on a much larger scale than the elements surrounding her. Cf. Erwin Panofsky, *Early Netherlandish Painting*, Princeton, 1953, I, 320–23; II, figs. 435–36.

[11] Cf. Isaiah 61:10: "I will greatly rejoice in the Lord, my soul shall be joyful in my God; for he has clothed me with the garments of salvation . . . as a bride adorneth herself with her jewels," and the custom that the bridal couple wear crowns, still practiced in the Orthodox Church. The jewels of Mary's diadem, pearls and seed pearls, plus one pearl of enormous size on the crown of her head, carry Christian symbolism. One tradition identifies Mary as the shell that bore Christ, the Divine Pearl (cf. Constantin Marinesco, "Échos byzantins dans l'oeuvre de Piero della Francesca," *Bulletin de la Société nationale des Antiquaires de France*, 1958, 199 ff.). See also the pearl as the Word of God (Matthew 7:6) and as Salvation (Matthew 13:45); cf. George Ferguson, *Signs and Symbols in Christian Art*, New York, 1954, 57.

[12] These representations usually illuminate the first initial of the poem known as the Canticle of Canticles and the Song

of Solomon, as well as the Song of Songs. Cf. *Reallexikon zur deutschen Kunstgeschichte*, Stuttgart, 1948, II, 1110 ff.; *Lexikon der christlichen Ikonographie*, Freiburg, 1968, I, 318–24; Schiller, *Ikonographie*, IV, 1, 94–106, figs. 235–42.

[13] An example of the Christ Child taking possession of the Madonna is found in the thirteenth-century Bible in the Museo Lázaro Galdiano, Madrid, No. 15289, fol. 197v. For an illustration of this miniature and others upon which the above generalizations are based, consult the Index of Christian Art, Princeton, N.J., *s.v.* Song of Solomon: Illustrations.

[14] Examples found in Evelyn Sandberg Vavalà, *L'iconografia della Madonna col Bambino nella pittura Italiana del Dugento*, Siena, 1934, pl. XXX: A, Bologna, Chiesa dei Servi, attributed to Cimabue; B, Turin, Gualino Collection, thirteenth-century altarpiece. In both examples, the Child takes possession by placing his hand on Mary's shoulder near the neck. Steinberg, "Metaphors," 254 f., discusses a sixteenth-century example.

A more obvious type of the Virgin and Child as Bride and Groom is found in a few fourteenth-century French sculptures, where the Infant places a wedding ring on his mother's finger; cf. Maurice Vloberg, *La Vierge et l'Enfant*, I, ch. 3, "La Vierge-Mère, Epouse du Fils de Dieu," 131 ff., and illustrations.

[15] Jean Daniélou, *The Angels and Their Mission* [1st ed., *Les Anges et leur Mission*, Chevetogne, Belgium, 1953], trans. David Heimann, Westminster, Maryland, 1956, 11. Cf. also R. P. Lawson, *Origen: The Song of Songs, Commentary and Homilies*, Westminster, Maryland (Ancient Christian Writers, No. 26), 1957.

[16] Jean Daniélou, *From Glory to Glory, Texts from Gregory of Nyssa's Mystical Writings*, trans. and ed. Herbert Musurillo, New York, 1961, 205 (Commentary on the Canticle, Sermon, 6, Migne, *PG*, 44, 896b–897d).

[17] Sermon XXXI, Migne, *PL*, 183, 942 f. The contemporary and minor rival of Bernard, Philip of Harvengt (d. 1183), in

his writings on the Song of Songs says the dramatic dialogue is between the Word as Bridegroom escorted by angels, and Our Lady as the Bride accompanied by the Apostles and the faithful; *Tituli Cantici Canticorum,* Migne, *PL*, 203, 185–490; *In Cantica Canticorum Moralitates, ibid.*, 490–584. A second contemporary, Richard of Saint Victoire (d. 1173), follows the same outline; *In Cantica Canticorum Explicatio, ibid.*, 405–524. Cf. De Lubac, *Splendour of the Church*, 279–80, with other references.

[18] The figures in the lower half of the illumination represent Solomon and Synagogue, the Old Testament types. Three other inscriptions in the miniature read as follows: VOX X (center above Christ and Ecclesia), VOX ECC[LESI]A (below the same figures), and VOX SINEGOGA (between Solomon and Synagogue). The underlying structure of this full-page composition is again the letter "O" (in the form of a pointed oval), the initial of the first word of the Canticle (cf. above, n. 12), the complete text of which is included following the sermons. Biblioteca Casanatense, Rome, Codex 970, "S. Bernardus, Expositio super Cantica Canticorum, 274 ff." Thought to be Roman in manufacture, it was originally in the monastery at S. Maria in Ara Coeli, Rome. Cf. *Mostra Storica Nazionale della Miniatura, Palazzo Venezia, Roma*, Florence, 1953, 262, no. 414, pl. LX b.

[19] The act of carrying Christ on the shoulders has obvious relations to the "Christophoros" theme, as well as eucharistic overtones in reference to the elevation of the Host during the sacrifice at the altar. The latter point has been made in public lectures by Leo Steinberg, who relates the Fra Filippo painting, along with other examples of the Child as the Elevated Host, to the similar motif in Michelangelo's *Doni Madonna*. See our figure 5 for another important medieval prototype for the Christ Child physically supported by two angels.

[20] Chapter 37, "Of the Canaanite Woman," 222. What is perhaps the most complete illustration to the dramatic narrative interpretation of the Song of

Songs is an early block book published in Holland with thirty-two woodcut illustrations. Dating c. 1465 and therefore contemporary with Fra Filippo's painting, one scene shows the Daughters of Zion attending the Bride, and angels as friends of the Bridegroom. Cf. *Canticum Canticorum, facsimile from the Scriverius copy in the British Museum*, J. Ph. Berjeau, London, 1860, and Otto Clemen, *Canticum Canticorum* (Zwickauer Facsimiledrucke, No. 4), Zwickau S., 1910, ill. 10b.

[21] "The angels are in the service of your salvation . . . ": Origen, *Homiliae in Ezechielem*, I, 7 (Migne, *PG*, 13, 674); cf. Daniélou, *The Angels*, 28. Cf. also Luke 15:7, 10. Dionysius the Areopagite speaks of the angels' "boundless joy at the providential salvation of those who are turned to God": Denys l'Aréopagite, *La Hiérarchie Céleste*, trans. Maurice de Gandillac (Sources Chrétiennes, No. 58), Paris, 1958, 190.

[22] "Before the birth of Christ these angels could be of little use to those entrusted to them and their attempts were not followed by success . . . "; Origen, *In Lucan Homilia*, XII (Migne, *PG*, 13, 1828–30); cf. Daniélou, *The Angels*, 25.

[23] "There is great joy among the angels over those who have been saved from sin . . . "; Gregory of Nyssa, *Contra Eunomium*, 4 (Migne, *PG*, 45, 615 ff.); cf. Daniélou, *The Angels*, 50. On Christian joy in general, cf. *Lexikon für Theologie und Kirche*, Freiburg, 1960, IV, 361–63, *s.v.* "Freude"; and Albert Bessières, *L'Évangile et la Joie*, Paris, 1946.

[24] Daniélou, *The Angels*, 51–53. It has been pointed out that the Friend of the Bridegroom in Old Testament matrimonial customs was somewhat analogous to the "best man," but more. He took the place of parents in negotiations, was the chief agent of communication in the period of betrothal, made preparations for the wedding, sometimes presided at the marriage feast, and conducted the married pair to the bridal chamber; cf. *A Dictionary of the Bible*, ed. James Hastings, *et al.*, Edinburgh, 11th ed., 1931, I, 327.

[25] "The Hebrew word for joy in the Old Testament usually includes not only a mental state, but some outward expression such as shouting, singing, leaping, dancing, sometimes with the accompaniment of musical instruments," *Dictionary of the Bible*, 9th ed., 1928, II, 790, *s.v.* "Joy."

[26] H. W. Janson, *Donatello*, Princeton, 1957: Prato Pulpit, c. 1433–38, II, 108–18; I, pls. 158–61; Cantoria, c. 1433–39, II, 119–29; I, pls. 163–78.

[27] For other interpretations of these contorted figures, see H. W. Janson, *Sixteen Studies*, New York, 1973, "Donatello and the Antique," 249–88, esp. 254–55.

[28] The Santa Croce *Annunciation*, c. 1428–33, is discussed by Janson, *Donatello*, II, 103–8; I, pls. 141–57. Professor Janson very kindly lent me the photograph reproduced here. My thanks are due to Jack Freiberg for pointing out these "smilers" to me. Another major example by Donatello is the *Atys-Amorino*, Florence, Museo Nazionale, c. 1440 (Janson, *Donatello*, II, 143–47; I, pls. 237–41), whose smile will remain mysterious until it is known what was the focus of the figure's attention in his upraised hand; cf. Maurice L. Shapiro, "Donatello's *Genietto*," *Art Bulletin*, XLV (1963), 135–42, esp. 138; Christopher Lloyd, "A Bronze Cupid in Oxford and Donatello's 'Atys-Amorino'," *Storia dell'arte*, XXVIII (1976), 215–16, with further references.

[29] Part in the Museo Civico, Bologna, part in the Schnütgen Museum, Cologne; reproduced in Charles Seymour, Jr., *Jacopo della Quercia, Sculptor*, New Haven, 1973, figs. 111, 113. Carlo Del Bravo, *Scultura senese del Quattrocento*, Florence, 1970, 55, fig. 152, dates it 1435–38. For other smiling angels dependent on Donatello, cf. Anne Markham Schulz, *The Sculpture of Bernardo Rossellino and His Workshop*, Princeton, 1977, 49, figs. 194–96, dated 1430s and '40s.

[30] If the attributions to Fra Filippo are accepted, he would have already painted two "smilers" earlier in his career: the seated monk in the *Confirmation of the Carmelite Rule*, fresco from the cloister

of Santa Maria del Carmine, Florence, and the smiling angel in the *Madonna of Humility with Saints and Angels*, Milan, Castello Sforzesco (Mary Pittaluga, *Fra Filippo Lippi*, Florence, 1947, 179–80, figs. 1–4; 181–82, figs. 5–7).

31 Pittaluga, *Lippi*, 127–30.

32 See above, n. 10.

33 Ilene Haering Forsyth, *The Throne of Wisdom: Wood Sculptures of the Madonna in Romanesque France*, Princeton, 1972, 22–30. Two examples of the type with two angels holding Christ are known: Jouy-en-Josas (Yvelines, formerly Seine-et-Oise), *La Diège*, Reg. 103, fig. 183 (I am grateful to Prof. Forsyth for lending me her original photograph for our figure 5); and Limay (Yvelines, formerly Seine-et-Oise), Reg. 104, fig. 184. Donatello and Michelozzo had used this very type on a relief carved by Michelozzo for the Aragazzi Tomb, c. 1426–36, in the Duomo of Montepulciano (reproduced in R. W. Lightbown, *Donatello and Michelozzo: An Artistic Partnership and Its Patrons in the Early Renaissance*, London, 1980, I, 190 ff., II, fig. 50). *Sedes Sapientiae* is among forty-nine titles in the Litany of the Blessed Virgin Mary (Litania Loretana), known to be used at Loreto and published for the first time in 1558, ed. St. Peter Canisius, Dilligen, Germany, but traceable to the early Middle Ages with variations; cf. *New Catholic Encyclopedia*, New York, 1967, VIII, 790–91. Other aspects of Fra Filippo's image also refer to Litany titles: Mary sheltering angels between her thighs is *Regina Angelorum*, Queen of the Angels; married to Christ, she is *Causa Nostrae Laetitiae*, Cause of Our Joy. See pp. 198–99 for more references to the Litany.

34 Oertel, *Lippi*, 44, found analogies to Donatello's low-relief Madonnas, likewise bordered by sculptured frames. A prime example is the so-called *Pazzi Madonna* in Berlin (Janson, *Donatello*, II, 44–45, I, pls. 64–65: c. 1422). Janson points out (II, 45, n. 1) the close relationship between this composition and the Massa Marittima *Madonna Enthroned* by Ambrogio Lorenzetti, in the poses of the Madonna and the Child.

In both, the two faces touch *en face*, almost in a kiss, and the Child grasps the Virgin's garment, specifically her veil in the Donatello, at the neck. I may add that these very features repeat motifs of medieval manuscript illuminations of the Canticle of Canticles, illustrating the first line, "Osculetur me osculo oris sui," and therefore the theme of the Royal Wedding. See above, nn. 12, 13.

35 Oertel, *Lippi*, 44, pointed out the illusion of what he called a window and the cast shadows.

36 Maurice Vloberg, *La Vierge, Notre Médiatrice*, Grenoble, 1938, 174, citing the example of the twelfth-century relief, the *Virgin of Dom Rupert*, Liége, Musée archéologique, ill. p. 176, where Mary is seated on a throne with a large rolled cushion. Her knees are spread, and she holds the Child, who touches her breast. They are under an arched door jamb on the molded lip of which the passage from Ezechiel is inscribed. *Janua Caeli* is a title in the Litany of the Blessed Virgin Mary.

37 For the traditions concerning the Casa Santa, cf. *New Catholic Encyclopedia*, VIII, 993–94. All fourteenth-, fifteenth-, and sixteenth-century depictions and replicas of the relic show it with a peaked roof and round-arch windows; cf. Arduino Colasanti, *Loreto*, Bergamo, 1910, and Floriano Da Morrovalle, *Loreto nell'arte*, Genoa, n.d. (c. 1962). We should recall, further, that Santa Maria di Loreto, which enshrines the Santa Casa, is on a hill overlooking the sea, as is the house in the painting.

38 Yrjö Hirn, *The Sacred Shrine*, London, 1912, 446–47; *Lexikon der christlichen Ikonographie*, II, 77 f.

39 These lines form the Gradual of the Mass of Feb. 11, and the Little Chapter at Lauds on the same day (since the late nineteenth century, the Feast Commemorating the Apparition of the Immaculate Virgin Mary at Lourdes, 1858). Hartt, *Italian Renaissance Art*, 174, who also finds religious symbolism in the landscape, has another explanation.

40 Cf. De Lubac, *Splendour of the Church*, 241, n. 9; 258 and n. 8; 255.

[41] Another title from the Litany of the Blessed Virgin Mary. Hartt, *Italian Renaissance Art*, 174, connected this detail with the titles Star of the Sea and Port of our Salvation.

[42] One of the four Marian Antiphons, this one's original role in the liturgy seems to have been to precede and follow the chanting of a psalm. In the twelfth century, it was apparently assigned to None on the Feast of the Assumption. At precisely the time of Fra Filippo's painting, the antiphon and its chant melody were shown special veneration by the composer Guillaume Dufay (d. 1474). In 1463 Dufay wrote his four-part motet *Ave Regina Caelorum* with the text troped with many personal allusions. A year later he built his *Missa Ave Regina Caelorum* on this piece, the chant melody appearing in all sections. By his own request, the motet was sung at his deathbed. That Dufay's work was familiar in Florence, at least at an earlier period, is shown by the fact that during his second stay in Italy he had been commissioned to compose a motet for the consecration of the Duomo (1436). See Charles E. Hamm, *A Chronology of the Works of Guillaume Dufay*, Princeton, 1964, 141 ff.; *New Catholic Encyclopedia*, I, 1124; IV, 1092–93.

[43] An interesting variation on the Uffizi painting was made by a younger contemporary of Fra Filippo: *Madonna and Child with Two Angels*, attributed to Botticelli, National Gallery of Art, Washington, D.C., Kress Collection, No. 714 (wood, 35 × 23 5/8"). While the composition is quite similar, among various changes that transform the meaning of the image, the forward angel no longer smiles. He has a portrait-like physiognomy, and his expression is quite mournful. The figure is thereby returned to a more traditional reference to the future Passion. The painting is reproduced in *Painting and Sculpture from the Kress Collection*, National Gallery of Art, Washington, D.C., 1945, 54.

[44] Three versions of this theme are known. The first, called by the late title *Madonna di Loreto* (cf. version in Paris, Louvre; Luitpold Düssler, *Raphael*, London [1st ed. German, 1966], 1971, trans. Sebastian Cruft, 27 f., pl. 73), shows the Christ Child awake, lying on a mattress. He reaches up to Mary, who draws back a transparent veil from his body as St. Joseph observes from behind. John Pope-Hennessy, *Raphael*, New York, n.d. (c. 1970), 206, rightly interprets the scene as an allegory of the revelation of Christ's divinity. The second version shows the Christ Child asleep. There are two variants: the composition known as the *Madonna of the Diadem* (Paris, Louvre; Düssler, *Raphael*, 28 f., pl. 74) pictures Christ in an Endymion-like pose, and a smiling youthful St. John the Baptist kneeling in profile; Mary, wearing a heavy crown, removes a veil from Christ's head. The other variant is represented in the Princeton painting; cf. Frank Jewett Mather, Jr., "The Princeton Raphael," *Art in America*, XIV (1925), 73–80. Mather believed the painting was started in Florence by Raphael in 1508, with the landscape, face, and hands of the Madonna and Child completed there. The work was finished in Rome by 1512 by students, Penni being responsible for the draperies and Giulio Romano for the figure of St. John. Cf. below, n. 47.

[45] Henrik Cornell, *The Iconography of the Nativity of Christ* (Uppsala Universitets Arsskrift), Uppsala, 1924.

[46] Gizella Firestone, "The Sleeping Christ-Child in Italian Renaissance Representations of the Madonna," *Marsyas*, II (1942), 55, in discussing the death symbolism in this painting, says that the veil refers to the corporal that covers the chalice during the sacrament at the altar, symbol of the winding sheet of Christ. My interpretation differs in that it accounts for both the sheet and the head-cloth. For earlier representations of the sudary, cf. Jan Gerrit van Gelder, "An Early Work by Robert Campin," *Oud-Holland*, LXXXII (1967), 177; and for liturgical practice involving the sudary, see Barbara G. Lane, " 'Depositio et Elevatio': The Symbolism of the Seilern Triptych," *Art Bulletin*, LVII (1975), 21–30, esp. n. p. 27.

[47] "The Saint John spiritually and ma-

terially is an intrusive and sensational element in an idyllic creation. His ecstatic expression is exaggerated to vulgarity, his hot and ruddy skin swept by cross lights, heavy shadows vanishing in cleverly arranged lost contours. The modelling is firm with disagreeable puffiness, the mouth and eyelids have a characteristic rubbery tension. Withal everything is robust and well understood, a consummate expression of great technical ability completely disjoined from taste. . . . I have discussed the style of Giulio Romano" (Mather, "The Princeton Raphael," 78). Nothing in this description militates against the conception and design of the figure having been Raphael's own.

[48] This passage is unique to St. John's Gospel. For an example of commentary on the passage, see St. Augustine, *Lectures or 'Tractates' on the Gospels According to St. John*, trans. J. Gibbs and I. Innes (*Nicene and Post Nicene Fathers*, VII, ed. Philip Schaff), Grand Rapids, 1956, 86–99, "Tractate XIII," ch. 3, 29–36.

[49] Cf. *Meditations on the Life of Christ*, ch. 16, "Of the Journey of the Lord Jesus to the Baptism," 114: "Now see carefully how the Lord of majesty undressed like every other man and entered the Jordan, into the waters in this period of great cold, and all for love of us. To effect our salvation He instituted the sacrament of baptism to wash away our sins. He wedded to Himself the universal Church and all faithful souls individually." See also the recently published French translation of the *Meditations* made for the Duke de Berry, *La Vie de Nostre Benoit Sauveur Ihesuscrist & La Saincte Vie de Nostre Dame, translatee a la requeste de tres hault et puissant prince Iehan, duc de Berry*, Millard Meiss and Elizabeth H. Beatson, New York, 1977, 41 ff.

[50] Cf. Marilyn Aronberg Lavin, "Giovannino Battista, a Study in Renaissance Religious Symbolism," *Art Bulletin*, XXXVII (1955), 85–101; idem, "Giovannino Battista, a Supplement," *Art Bulletin*, XLIII (1961), 319–25.

[51] John's costume is the *tunica exomis* or

desert garb. Thus, except for the upward direction of the pointing gesture, all the elements of the pose and dress of this figure can be found in medieval narrative illustrations to John 3:27–31. See, for example, our fig. 8, Gospel Book of the Bulgarian King John Alexander, written in 1356, British Museum Add. 39627, fol. 215v; reproduced in Bogdan Filov, *Les Miniatures de l'Evangile du Roi Jean Alexandre a Londres*, Sofia, 1934, pl. 104 (284). The Baptist speaks to his followers on the left and points to Christ on the right. The complex pose of Leonardo's *St. John the Baptist* thus had its genesis in narrative illustration; he transforms it into a devotional image by changing the eye-shot and making the stance completely self-contained.

[52] In his project for a book on anatomy, Leonardo describes joy as one of the four universal conditions of mankind, saying he plans to show "various modes of laughing and represent the cause of the laughter." In his chapters on the muscles of the mouth, he describes how they function to form laughter (Edward MacCurdy, *The Notebooks of Leonardo da Vinci*, New York, n.d., I, 139–40).

[53] Kenneth Clark, *Leonardo da Vinci*, Cambridge, 1939, 174. Cf. A. E. Popham, *The Drawings of Leonardo da Vinci*, New York, 1945, no. 202: c. 1505. The painting is recorded in France in 1517 (Ludwig Goldscheider, *Leonardo*, London, 1944, 39, No. 100, and Doc. XVI), but is believed to have been begun in Milan before Leonardo's departure in 1513; cf. Cecil Gould, *Leonardo, the Artist and the Non-Artist*, London, 1975, 125.

[54] This mode of dress makes the angel a relative of another, by Piero della Francesca in his *Baptism of Christ*, London, National Gallery. I shall discuss Piero's angel, his dress, and his role as a Friend of the Bridegroom in a forthcoming book on the Baptism.

[55] Clark, *Leonardo*, 174, repeated by Gould, *Leonardo*, 124. New in terms of its visual formulation, this idea has deep ties to dogma: since Mary is the prototype of all humanity, each indi-

vidual is prepared to hear the words of Gabriel.

[56] "... he was incarnated in the ninth order of the angels, carried even to the height of the seraphim": *Sermo in nativatates S. Joannis Baptistae* (Migne, *PL*, 184, 1000), attributed to although not by St. Bernard, and quoted in the *Meditations*, ch. XXXX, "Of the Death of the Blessed John the Baptist," 183. See also Origen, who saw John as "representing the visible preparation for the coming of the Word, just as the angels represent the invisible one"; cf. Jean Danielou, *Origen*, trans. Walter Mitchell, New York, 1955, 246. It should be pointed out that the Hebrew name Malachi also means messenger.

[57] Walter Haring, "The Winged John the Baptist," *Art Bulletin*, V (1922–23), 35–40, and Alexandre Masseron, *Saint Jean Baptiste dans l'art*, Vichy, 1957, 29, pl. 2.

[58] He has been called an "effete, almost obscene ephebe," by Gould, *Leonardo*, 125; a "creature of dubious sex, some minister of vice . . . lampoon . . . calculated to wound the feelings of sincere Christians," by R. Langton Douglas, *Leonardo da Vinci, His Life and His Pictures*, Chicago, 1944, 104 f. More sympathetic, if somewhat wide of the mark, are the comments of Clark, *Leonardo*, 175, "a curiously personal conception . . . the eternal question mark, the enigma of creation. He has the smile of the Sphinx and the power of an obsessive shape . . . but it remains an unsatisfactory work"; and Ludwig H. Heydenreich, *Leonardo da Vinci*, New York (trans. Dora Jane Janson), 1954, I, 56, "St. John's smile is not transfigured, but occult; he does not prophesy deliverance, but expresses the inscrutable will which forever haunts our existence." The most curious explanation of the figure's androgynous qualities is that of Raymond S. Stites, *et al.*, *The Sublimations of Leonardo da Vinci*, Washington, D.C., 1970, 354, 357–59, who identifies the figure as a portrait of Leonardo's mother in the guise of St. Mary Magdalene.

[59] The light symbolism in the painting again expresses Christian dogma. The feast day of the Baptism of Christ, January 6, was originally and in the Orthodox Church is still called the Feast of Holy Lights, referring to the illumination of the world on that day by the public revelation of Christ's divinity; cf. Joseph A. Jungmann, *The Early Liturgy: To the Time of Gregory the Great*, trans. Francis A. Brunner, Notre Dame, Ind., 1959, 149 ff.

# 13

## Raum–Fläche–Bild: Beobachtungen zur Entwicklung der autonomen Form in den Fresken Raffaels

MANFRED WUNDRAM

Vier Jahrhunderte hindurch galt Raffael, unabhängig von allen sich wandelnden Stilerscheinungen, als Gipfel der nachantiken Kunst. Noch am 18. Dezember 1895 schrieb Jacob Burckhardt an Heinrich Wölfflin: nur zu Beginn des 16. Jahrhunderts gab es "den Einen höheren Sonnenblick," in dem man durch "Vereinfachung und höhere Oeconomie . . . zunächst dem realistischen Individualisieren auswich." Und ein Jahr später, ebenfalls an Wölfflin: ". . . constatieren Sie— vielleicht zum hundertsten Male—(bei Raffael) den Verzicht auf das Viele (selbst wenn es sehr schön war) zugunsten des Mächtigen und namentlich des Bewegten." Raffael ist für Burckhardt der einzige Höhengrat, der der griechischen Klassik ebenbürtig erscheint. Aber nur zehn Jahre später begann eine Abwertung Raffaels im Zuge der Abwendung vom "Gegenstandssehen" (Max Imdahl) zugunsten einer "Bildautonomie," die vom Gegenstand unabhängig ist. Raffael wurde in zunehmendem Maße als "Realist" interpretiert—wie mir scheint, in einem tiefgreifenden Mißverständnis seines Werkes. Heute, unter dem Einfluß neuer realistischer Tendenzen auf der jüngsten Kunstszene, ist Raffaels Stern wieder im Steigen begriffen—freilich offenbar wiederum aus einem tiefgreifenden Mißverständnis seines Werkes heraus. Im Folgenden sollen einige Bemerkungen mitgeteilt werden, die Raffael als einen sehr modernen Künstler im Sinne des 20. Jahrhunderts zeigen—und zwar unter dem Aspekt einer Bildautonomie, die einerseits naturgemäß nicht unabhängig vom Gegenstand sein kann, während aber andererseits der Bildgegenstand durch die Bildautonomie stark mitbestimmt wird. Dem heutigen Besucher der sogenannten "Stanzen," der Privatgemächer Papst Julius' II. im Vatikan, kommt unter dem Eindruck der Wandbilder Raffaels meist kaum zum Bewußtsein, daß es sich um verhältnismäßig kleine, zum Teil schiefwinklige und schlecht beleuchtete Gemächer handelt, deren Wände allseits von Fenstern bzw. Türen unregelmäßig durchbrochen werden (fig. 1). Raffaels Fresken suggerieren den Eindruck von Weiträumigkeit, und die Kunst seiner Komposition läßt vergessen, wie ungünstig die vom Bildträger her für den Maler gegebenen Bedingungen waren. Hier soll am Beispiel der Fensterwände in der 1509–11 ausgemalten Stanza della Segnatura und der räumlich wie zeitlich folgenden

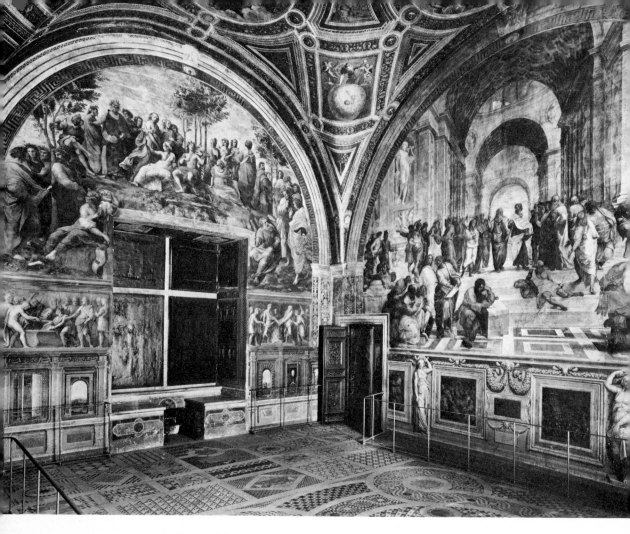

1. *Stanza della Segnatura, Vatikan, Rom*

Stanza d'Eliodoro, deren Freskenausstattung 1512–14 entstand, gezeigt werden, wie Raffael sich in zunehmend souveräner Weise mit den Widerständen der Bildformate auseinandersetzte, ja sich durch eben diese Widerstände zu immer neuen gestalterischen Leistungen steigerte.[1]

Die verhältnismäßig schmalen Fensterwände der Stanzen setzten der Ausgestaltung mit Wandmalereien insofern besonderen Widerstand entgegen, als die breiten und hohen, von tiefen Laibungen begleiteten Fensterdurchbrüche lediglich schmale seitliche, zum Teil asymmetrische Wandstreifen und ein flaches Lünettenfeld für die Ausmalung bereitstellten. In einem Falle hat Raffael diese Situation überhaupt nicht problematisiert: an der der Verbildlichung der juristischen Fakultät gewidmeten südlichen Fensterwand der Stanza della Segnatura, die ursprünglich vermutlich als Bibliotheksraum des Papstes bestimmt war—jedenfalls steht ihre Ausstattung mit den Darstellungen der vier Fakultäten ikonologisch in der Tradition von Bibliotheksräumen der Frührenaissance. Raffael beziehungsweise Mitglieder seiner Werkstatt haben hier, der vorgegebenen Aufteilung der Wand folgend, rechts der Fensternische die Übergabe der Dekretalen (der Papstbriefe als eines Bestandteiles des *Corpus iuris canonici*) durch Gregor IX. an den

Heiligen Raimund von Pennaforte dargestellt, links der Fensternische die Übergabe der Pandekten—des *Corpus iuris Justinianus*—durch Kaiser Justinian an Trebonianus. In beiden Fällen wird von der Forschung eine Beteiligung Raffaels nur in geringem Umfang angenommen beziehungsweise überhaupt ausgeschlossen. Den flachen Lünettenbogen hat Raffael mit den Kardinaltugenden—Stärke, Weisheit, und Mäßigung—gefüllt. Ein zyklischer Zusammenhang zwischen den seitlichen Feldern und der nach oben hin abschließenden Lünette ist kompositionell nicht angestrebt.

Anders auf der Gegenseite, der nördlichen Fensterwand, wo an Stelle der in der ikonographischen Tradition üblichen Medizin die Poesie verherrlicht wird: Apollo ist auf dem Parnaß im Kreise der Musen und bedeutender Dichterpersönlichkeiten der Antike und des Mittelalters dargestellt (fig. 2). Schon eine frühe Entwurfszeichnung, deren Kopie von Schülerhand sich heute im Ashmolean Museum in Oxford befindet,[2] beweist, daß Raffael von Anfang an eine Zusammenfassung der seitlichen Wandstreifen mit der abschließenden Lünette zu einer einheitlichen Komposition plante. Der in das Gesamtbildfeld nach oben hineinstoßende Rahmen der Fensternische wurde dabei in geschickter Weise als aufgipfelnder Hügel motiviert. Vollends die Ausführung zeigt, wie Raffael die Bedingungen des vorgegebenen Bildfeldes flächensyntaktisch scheinbar spielend in seiner Darstellung verarbeitet. Zugleich freilich wird deutlich, daß sich die Komposition vornehmlich zur Höhe hin, weniger dagegen in die Tiefe entwickelt: es bleibt eine spürbare Diskrepanz zwischen der wesentlich der Zweidimensionalität der Fläche verpflichteten Figurengruppierung einerseits und dem außerordentlich starken Tiefenzug der Fensternische andererseits, der die bildliche Darstellung gleichsam "tunnel"-artig durchstößt. Diese optische Situation wird verschärft durch die in der Entwurfszeichnung noch nicht vorgesehenen Figuren der Sappho und der männlichen Dichtergestalt, vielleicht des Horaz, die in einem artifiziellen Spiel mit der "ästhetischen Grenze," das heißt der Grenze zwischen Bildraum und

2. *Raffael*. Parnaß. *Stanza della Segnatura, Vatikan, Rom*

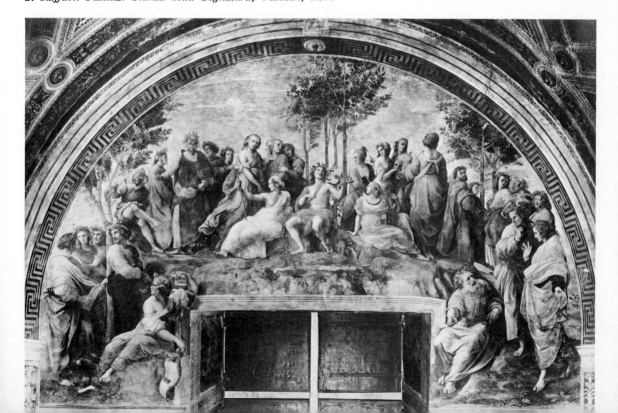

Realraum, scheinbar teilweise *vor* der inneren Rahmung des Fensters placiert sind, auf diese Weise die ganze Darstellung für den Blick noch einmal nach vorne ziehen und so den Kontrast zwischen Bildfläche und Nischenraum noch fühlbarer machen. Photographen scheinen dieses Problem häufig erfühlt zu haben und retouchierten den Fensterdurchbruch hinweg. Zusammenfassend darf gesagt werden, daß Raffael in seiner Darstellung des *Parnaß* den Fenstereinbruch als flächenbestimmendes Element aufgreift, dagegen der räumlichen Situation der Fenster*nische* nicht Rechnung trägt.

1511 waren die Arbeiten in der Stanza della Segnatura abgeschlossen; zu Ende des gleichen Jahres oder zu Beginn des folgenden Jahres 1512 begann die Ausmalung der sogenannten Stanza d'Eliodoro, die nach dem Fresko der *Vertreibung des Heliodor aus dem Tempel* benannt und deren ursprüngliche Bestimmung unbekannt ist. Raffael sah sich hier hinsichtlich der Aufteilung der Wände vor das gleiche Problem gestellt wie in der Stanza della Segnatura: wiederum sind die beiden Schmalwände des in der Grundfläche etwa 10 × 8.5 m. messenden Raumes von hohen und tiefen Fensternischen durchbrochen. Wie beim *Parnaß* hat Raffael in beiden Fällen die Wände als Einheit aufgefaßt, geht aber in der Auseinandersetzung mit den Vorbedingungen der Bildfelder ganz neue Wege. Laut Inschrift ist das Fresko mit der Darstellung der *Messe von Bolsena* 1512 entstanden (fig. 3). Das abgebildete Ereignis geht in das Jahr 1263 zurück: ein junger böhmischer Priester, der an der Wandlung der Hostie zweifelte, begab sich auf eine Pilgerfahrt nach Rom, um sich von seiner Glaubensnot zu befreien. Als er in S. Cristina am Bolsena-See die Messe feierte, färbte sich das Corporale in Kreuzesform mit Blut. Das blutgetränkte Tuch wurde anschließend in das benachbarte Orvieto gebracht, dort als Reliquie verehrt und gab den Anstoß zum Neubau des Domes von Orvieto. Durch die Einfügung der Gestalt Julius' II., der zu Orvieto und zu der Reliquie des Heiligen Corporale besonders enge Beziehungen hatte, gewann die Darstellung für den Betrachter des frühen 16. Jahrhunderts einen starken zeitgeschichtlichen Akzent.

Raffael sah sich hinsichtlich der Bewältigung des Bildformates vor potenzierte Schwierigkeiten gestellt: die Fensternische durchbricht die Wand asymmetrisch, es bleiben auf der linken und der rechten Seite ungleich breite Wandstreifen stehen. Daß Raffael das Problem nicht im ersten Anlauf löste, beweist die Kopie einer Studie im Ashmolean Museum in Oxford (fig. 4).[3] Raffael motiviert hier in ähnlicher Weise wie beim *Parnaß* den in das Wandfeld hineinragenden Fensterrahmen innerbildlich als ein Hochstufen—nur daß er sich hier entsprechend dem Thema nicht landschaftlicher, sondern architektonischer Elemente bedient: von links und rechts führen Treppen zu dem über der oberen Rahmenkante gemalten Altarraum hinauf. Der Ausblick in die Apsis der Bildarchitektur korrespondiert mit dem Fensterrahmen, ist also aus der Mittelachse nach links verschoben.

Erst nach weiteren künstlerischen Überlegungen, für die bildliche Dokumente nicht erhalten sind, gleicht Raffael in ingeniöser Weise die Differenz zwischen den Mittelachsen von Fensternische und Wandfeld aus: erstens erweitert er die Architektur des Fensters nach rechts hin durch ein gemaltes Podest so weit, daß die Gesamtheit der Plattform symmetrisch ins Bildfeld rückt. Die Suggestion der Zusammengehörigkeit von Fensterrahmung, Podest und Treppen wird verstärkt, indem das Rahmenprofil des Fensters in die gemalte Architektur übernommen wird. Zweitens dient dem optischen Ausgleich zwischen dem schmaleren linken und dem breiteren rechten Wandstreifen die Anordnung der Figuren: dem ruhig knienden, weiträumig placierten Gefolge des Papstes auf der rechten Seite werden

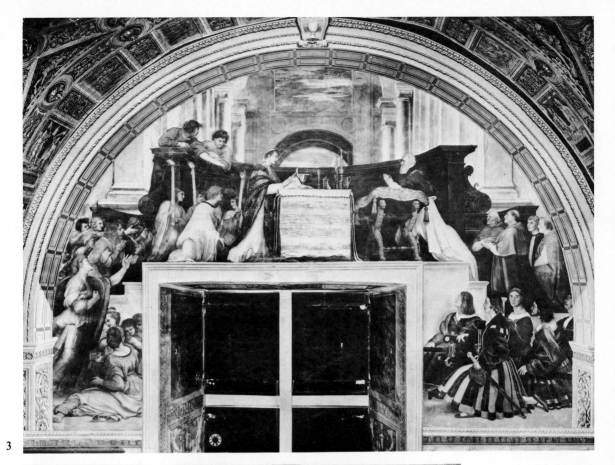

3

4

3. *Raffael*. Messe von Bolsena. *Stanza d'Eliodoro, Vatikan, Rom*

4. *Nach Raffael*. Studie für die Messe von Bolsena. *Ashmolean Museum, Oxford*

5. *Raffael.* Befreiung Petri. *Stanza d'Eliodoro, Vatikan, Rom*

zur Linken heftig bewegte, räumlich eng gedrängte Gestalten gegenübergestellt und damit dem schmalen linken Streifen ein kräftiger Akzent verliehen.

Raffaels ganze Kunst der Komposition zeigt sich darin, daß gleichwohl auch die Form des Fensterrahmens berücksichtigt wird: die linke Kante des Chorgestühls bezieht sich auf die linke Rahmenleiste des Fensters, die linke Altarkante auf die mittlere Vertikale des Fensterkreuzes und der Betstuhl des Papstes mit seiner rechten Begrenzung auf die rechte Kante der Fensternische.

In Bezug auf die Bild*fläche* setzt sich also Raffael in ähnlich souveräner Weise mit den Bedingungen der Wand auseinander wie im *Parnaß*—hier, in der *Messe von Bolsena*, freilich unter den erschwerten Bedingungen der asymmetrischen Durchbrechung des Bildfeldes. Anders jedoch als im *Parnaß* reflektiert Raffael jetzt auch die durch die Tiefe der Mauerlaibungen vorgegebene räumliche Situation: die Figuren links und rechts des Fensterrahmens befinden sich optisch weder *vor* der Architektur noch verhalten sie sich neutral zu ihr, sondern sie sind auf einer Art von Bühne eindeutig *neben* dem oberen Abschnitt des Fenstereinbruches placiert, der—durch Überschneidung eindeutig gekennzeichnet—als dreidimensionaler Körper dem Bild inkorporiert wird. Entsprechend ist der Altar mit den Gestalten von Priester und Papst nicht lediglich *über* der vorderen Kante des oberen Rahmenstreifens, sondern auf einer Plattform, die der Tiefe der Nische zu entsprechen scheint, postiert. Raffael geht aber in der Einbeziehung des dreidi-

mensionalen Fenstereinbruches und des durch diesen ermöglichten Ausblickes ins Freie noch einen Schritt weiter: die Architektur fluchtet hinter dem Chorgestühl in die Tiefe—in Fortsetzung der von den Laibungen des Fensters vorgegebenen Richtung—, und durch die Öffnung der gemalten Rückwand wird mit dem Ausblick in das Blau des Himmels scheinbar der Freiraum sichtbar—in Entsprechung zu dem Ausblick durch das der Realarchitektur zugehörige Fenster.

Zusammenfassend darf gesagt werden, daß Raffael in seiner Darstellung der *Messe von Bolsena* den Fenstereinbruch sowohl als flächenbestimmendes Element aufgreift als auch der durch die Laibungstiefe dieses Fenstereinbruches vorgegebenen *räumlichen* Situation Rechnung trägt. In dieser Beziehung geht das Fresko der Bolsena-Messe einen wesentlichen Schritt über den *Parnaß* der Stanza della Segnatura hinaus.

Auf der der *Messe von Bolsena* gegenüberliegenden Schmalwand der Stanza d'Eliodoro ist die *Befreiung Petri* aus dem Kerker dargestellt (fig. 5). Am Architrav des Fensters wird als Entstehungsjahr 1514 angegeben. Das Fresko wurde also zwei Jahre später als die Darstellung der *Messe von Bolsena* gemalt. Die Gestalt Petri zeigt Portraitzüge Papst Julius' II., auch hier erhält das Fresko einen pronociert zeitgeschichtlichen Bezug: S. Pietro in Vincoli in Rom, das als kostbarste Reliquien die Ketten des Heiligen Petrus bewahrt, war die Kardinals-Titularkirche Julius' II. gewesen; auch als Papst blieb er mit S. Pietro in Vincoli eng verbunden: am 23. Juni 1512 pilgerte er zu der Kirche, um seinen Dank für die Befreiung des Kirchenstaates von den Franzosen zu bekunden, und von hier aus hielt er seinen triumphalen Einzug in den Vatikan.

Die Beschaffenheit der Wand entspricht der des *Parnaß*: das Fenster durchbricht die Fläche in der Mittelachse und stößt weit in den Bereich der Lünette nach oben hinein. Der vorgebenen Dreiteilung des Bildfeldes trägt die Dreiteilung der Komposition Rechnung: links sind die aus dem Schlaf auffahrenden Gefängniswärter dargestellt; im Zentrum erscheint der Kerker Petri mit dem Engel, der den Apostel aus dem Schlaf weckt, und zwar in wörtlicher Entsprechung zum XII. Kapitel der Apostelgeschichte bis hin zu dem Satz: ". . . und ein Licht erschien in dem Gemach. . . ." So weit ich sehe, ist in der ikonographischen Tradition der Darstellung der Befreiung Petri dieses Lichtphänomen zum ersten Mal veranschaulicht worden. Auf der rechten Seite ist der Engel noch einmal dargestellt und geleitet den Apostel ins Freie, wiederum in genauer Anlehnung an den Schrifttext: ". . . sondern es deuchte ihm, *er sähe ein Gesicht.*"

Wie im Fresko der *Messe von Bolsena* berücksichtigt Raffael die Bedingungen des Bildfeldes sowohl in flächenmäßiger wie räumlicher Hinsicht: der Kerker Petri setzt über der oberen Kante des Fensterrahmens auf—mit architektonischen Elementen wird die Darstellung von den Seiten zur Mitte hochgestuft. Jedoch erfolgt der Aufbau nicht in Angleichung an die Bildfläche, sondern die Figuren des Vordergrundes sind *neben* dem wiederum als stereometrischer Körper in das Bild inkorporierten oberen Teil des Fenstereinbruches postiert. Nicht nur die Überschneidungen der Wächter durch die seitlichen Rahmenkanten suggerieren diesen Eindruck, sondern auch die Anlage der Treppen, die sich hier vom vorderen Bildrand unmittelbar bildeinwärts verkürzen und nicht, wie in der *Messe von Bolsena*, flächenparallel zur Plattform aufsteigen. Entsprechend erscheint die Kerkerarchitektur wiederum nicht lediglich *über* der vorderen Kante der Fensterrahmung, sondern auf einer Plattform, deren Tiefenerstreckung der Laibungsstärke der Fensterrahmung zum mindesten gleichzusetzen ist.

Wie in der *Messe von Bolsena* geht Raffael hinsichtlich der Einbeziehung des

dreidimensionalen Raumes in die bildliche Darstellung aber noch einen Schritt weiter: dem Fensterdurchbruch des Realraumes entspricht die Öffnung des Bildraumes auf der Mittelachse in eine scheinbar unbegrenzte Tiefe.

So weit steht die Darstellung der Befreiung Petri in der Berücksichtigung der von der Wand vorgegebenen Bedingungen prinzipiell auf der Stufe der *Messe von Bolsena*, geht in feinen Differenzierungen—den seitlich bildeinwärts führenden Treppenstufen und der Öffnung der Mitte—allerdings über das zeitlich vorangehende Wandbild hinaus.

Hinzukommt jetzt aber ein grundlegend neues Phänomen: Wir haben davon auszugehen, daß alle der hier angesprochenen Wandbilder nur bei starkem, durch die großen Fenster bedingtem Gegenlicht wahrgenommen werden können. Die Beleuchtungsverhältnisse der Fresken an den Schmalwänden von Stanza della Segnatura und Stanza d'Eliodoro sind also für den Betrachter extrem ungünstige. Nicht zufällig wurden nahezu alle photographischen Aufnahmen bei geschlossenen Fensterläden und künstlicher Beleuchtung angefertigt. Raffael pariert in seiner Darstellung der Befreiung Petri das durch das Fenster einströmende Licht durch das *gemalte* Licht—tatsächlich bietet sich dem Betrachter der vatikanischen Stanzen kein anderes der Fresken an den Fensterwänden in gleicher Anschaulichkeit wie die *Befreiung Petri*.

Zusammenfassend darf gesagt werden, daß Raffael in seinem Fresko der *Befreiung Petri* den Fenstereinbruch erstens als flächenbestimmendes Element aufgreift und zweitens eben diesem Fenstereinbruch in seiner räumlichen Qualität Rechnung trägt, und daß er drittens die Bedingungen des durch den Fenstereinbruch gegebenen Gegenlichtes in der Wiedergabe des gemalten Lichtes berücksichtigt. In dieser letzteren Beziehung geht die *Befreiung Petri* über alle anderen Darstellungen an den Fensterwänden der Stanzen hinaus. Daß dieses Phänomen des innerbildlichen Lichtes zugleich einen Markstein hinsichtlich der Entwicklung der Farbe innerhalb der italienischen Malerei bezeichnet, sei hier nur angedeutet.

Welchen Schluß erlauben die Beobachtungen über die Entwicklung des Verhältnisses zwischen Wand, Raum und Bild in den Fresken an den Fensterwänden der vatikanischen Stanzen? Anders als seine großen Vorgänger in der Geschichte der italienischen Wandmalerei—Giotto, Masaccio, Piero della Francesca etwa—entwickelt Raffael seine Kompositionen nicht primär aus dem Kern der Handlung heraus, sondern geht von abstrakten, vorgegebenen Prinzipien der Flächen- und Raumgestaltung aus; autonome, nicht gegenstandsbezogene formale Faktoren sind der Motor der künstlerischen Gestaltung. Daß Raffael gleichwohl der jeweiligen abgebildeten Handlung höchste Anschaulichkeit zu geben weiß, ist ein Teil seiner persönlichen Größe.

*Ruhr Universität Bochum*

*Notes*

[1] Das im Folgenden erörterte Problem ist meines Wissens in der Literatur über Raffael niemals behandelt worden. Hinsichtlich der Datierungen und der ikonographischen Deutungen stützt sich dieser Aufsatz auf Luitpold Dussler, *Raffael. Kritisches Verzeichnis der Gemälde, Wandbilder und Bildteppiche*, Munich, 1966, 79 ff.

[2] Oskar Fischel, *Raphaels Zeichnungen*, V, Berlin, 1924, Pl. 221; K. T. Parker, *Catalogue of the Collection of Drawings in the Ashmolean Museum, 2, Italian Schools*, Oxford, 1956, No. 639.

[3] Abbildung bei Oskar Fischel, *Raphael*, Berlin, 1962, Pl. 122; cf. Parker, *Italian Schools*, No. 641.

# 14

## *Pentimenti in the Chigi Chapel*

JOHN SHEARMAN

This brief contribution in honour of a good friend whose scholarly interests remain so fortunately concentrated on sculpture would have been the better for his advice, for it is intended as the framing of a new question about the most eccentric of High Renaissance tombs. At first sight, and on further reflection too, the two pyramidal tombs which Raphael designed for the side walls of Agostino Chigi's mortuary chapel in S. Maria del Popolo in Rome seem to offer nothing of interest to the historian of Renaissance sculpture (fig. 1); the marble relief-medallions with portraits of Agostino and his brother Sigismondo were added by Bernini and so far there has appeared no evidence to help us visualize the gilt bronze medallions intended by Raphael.[1]

When the Chigi Chapel was cleaned in the 1960s it was possible to see—indeed, it became difficult to miss—a pentimento in the architecture which should make us think again about those pyramids.[2] That they were both executed according to Raphael's designs is not, I think, to be doubted.[3] But the architecture was designed and erected about seven years before the artist's and the patron's deaths and it seems very likely that in the course of those years the project was quite radically changed, and that its rather startling novelties were not all conceived at once.

The point is clearer if we look at the left wall, which bears Sigismondo's monument. To right and left the brilliant white marble of the Corinthian cornice and architrave has a diagonal cut in the sections which now return into the wall (figs. 2, 3). With imperfect skill an additional section of cornice has been inserted on each side, the addition itself being of the same beautiful quality as the rest, so that the return continues until it meets at right angles the much-flattened and simplified entablature which runs across the side wall. The lesser projection of the architrave evidently gave less concern, and on the right no real junction with the flattened entablature is effected; the diagonal cut is most obvious at this point.

On the right wall, at either side of Agostino's monument, changes are in principle the same but the patches have been quite differently made. With the experience, perhaps, of the clumsy solution on the left wall behind him, the mason has more cleverly masked the join by inserting rectangular pieces of cornice; his joins on this side are stepped back, and being partly coincidental with longitudinal junctions of the mouldings they are much less obtrusive. However, the extent of the return of the cornice supplied by the rectangular patch is exactly that which would be marked by a diagonal slice from the corner like those visible on the left wall.

*1. The Tomb of Sigismondo Chigi. Chigi Chapel, S. Maria del Popolo, Rome*

*2. The Tomb of Sigismondo Chigi (detail, left)*

*3. The Tomb of Sigismondo Chigi (detail, right)*

On both walls, that is to say in all four corners, the additional pieces of cornice look as if they had been cut from an identical but spare section of entablature.

It seems better demonstrated visually than verbally that the change of mind we see in these corners came about by the elimination of a complete entablature in full relief which, after the briefer return into the tomb recess, would have continued across the side walls; initially, then, it was intended that the entablature would be interrupted only on the longitudinal axis, by the entrance arch and by the altarpiece. On the left wall each cornice-return remains exactly as it was made to receive at right angles the continuation of itself; on the right wall a greater effort of concealment was made but the conclusion may be the same. Now, it is the difference between the full entablature and its low-relief, schematic substitute in the tomb recesses which allows the presence of the pyramids. At the point where the face of the pyramid crosses the topmost cyma of the relief-cornice the superior projection of the former is slight. If the full entablature had been in place where it was at first intended the cornice would have projected considerably more than the pyramid, and would have cut it brutally. It seems rather obvious that when the architectural membering of the chapel was designed and made the pyramids were not part of the scheme.

The Chigi Chapel, however, was planned as a mausoleum from the moment Julius II conceded the previous Mellini Chapel to Agostino in 1507, and the side walls must have been intended to receive tombs. In fact it seems probable that the statues and niches which now frame the pyramids on either side should be interpreted as the lateral parts of tombs, like the *Virtues* on Andrea Sansovino's Della Rovere and Sforza tombs in the Cappella Maggiore of S. Maria del Popolo. The tomb recesses now occupied by the pyramids would in that case be equivalent to the similarly proportioned arched recesses in the centre of these and other tombs in the church; in each of these recesses an entablature continues across the back wall and divides a lunette, generally provided with a *Madonna* in relief, from the rectangular lower part, against which is placed a sarcophagus with a recumbent

*4.* Memoria Augusti. *Bibl. Ap. Vat., Ms. Vat. Lat. 3439, fol. 65 (detail)*

effigy. To walk about in S. Maria del Popolo is to meet a rich repertory of motives and subjects from which Agostino Chigi and Raphael might, at first, have selected, but perhaps the hint is already taken too eagerly. We cannot guess how traditional the first ideas of artist and patron might have been. It can only be suggested that the suppression of the full cornice across the recesses indicates a progression during the execution of the project from a more conventional kind of tomb to one of astounding novelty, and that this is one of those many cases in which we have been wrong to assume that patron and artist initially intended what they eventually achieved.

It is almost fruitless to ask why, in this case, Agostino or Raphael changed his mind; it could have been the inspiration of what either of them saw or read in the interval between about 1513, when the architecture was begun, and 1520. But one possibility came accidentally to my notice and with some reservations I should like to produce it. When I wrote about the Chigi tombs in 1960 I believed that Raphael was the first to use the now familiar pattern of pyramid over rectangular base, by synthesis of pyramid and obelisk. That supposition was certainly wrong, for the combination can be found on Greek coins, most strikingly, perhaps, on a silver tetradrachm with a representation of the tomb of Sardanapalus.[4] However there is one such image which if it is authentic, or if it was thought to be in Agostino's day, would surely have appealed to him: it was, or it purported to be, one of the medals struck by Nerva (A.D. 96–98) in memory of Augustus, and it was drawn in a numismatic compilation in a Vatican manuscript, probably of the eighteenth century (fig. 4).[5] Some reason for doubt as to its authenticity may lie in an apparent conflation on one face of inscriptions normally on obverse and reverse of comparable medals. If, however, such a medal were known to Agostino he might have found irresistible its title: MEMORIA AUGUST.[6]

*Princeton University*

*Notes*

[1] References for these and similar points simply stated here can be found in my earlier article: "The Chigi Chapel in S. Maria del Popolo," *Journal of the Warburg and Courtauld Institutes*, XXIV (1961), 129 ff.

[2] The pentimento has been noticed by Stefano Ray, "La Cappella Chigi in Santa Maria del Popolo a Roma," *L'Architettura*, XIV (1969), 758, who suggested that the architect might have intended at first a double break in each return—a solution which is not reconcilable with the line of the cut, which is directly out of the corner.

[3] Domenico Gnoli, "La Sepoltura d'Agostino Chigi," *Archivio Storico del-*

*l'Arte*, II (1889), 317 ff. There is a new reading, clarifying some details, of the 1552 description of the unfinished tombs by Raffaello da Montelupo in Enzo Bentivoglio and Simonetta Valtieri, *Santa Maria del Popolo a Roma*, Rome, 1976, 113.

[4] T. L. Donaldson, *Architectura Numismatica*, London, 1859, 171.

[5] Biblioteca Apostolica Vaticana, MS Vat. Lat. 3439, fol. 65. There is no explanatory text.

[6] Salviati's drawing of one of the Chigi tombs (Shearman, *op. cit.*, n. 1, Pl. 22b) shows it completed at the apex by a ball of the same proportions as the one on this medallic tomb.

# 15

# *Bandinelli and Michelangelo: A Problem of Artistic Identity**

KATHLEEN WEIL-GARRIS

Baccio Bandinelli's notorious reputation as one of the most temperamental artists of the cinquecento flourishes today even as it did during his lifetime. His contemporaries thought the Florentine sculptor was so perpetually angry, vain, aggressive, and jealous that Vasari wrongly accuses him of having destroyed one of the most famous and valued works of his time: Michelangelo's cartoon of the *Bathing Soldiers*.[1] In a period that was relatively tolerant of extravagant behavior, Bandinelli's ways were so unbearable that he made enemies of all those who should have been his friends. Vasari concludes that it was the sculptor's unfortunate nature that prevented him from reaping the rewards of esteem and fame to which his great artistic talents entitled him in Medicean Florence.[2] On the other hand, we know from contemporary sources that all his actions as an artist and as a man were aimed at claiming exactly these rewards. In fact, his personality problems—in so far as we know about them—do not coincide with the conventional idea of the artistic temperament. Bandinelli was not a victim of Platonic *furor divinus* as Leonardo was said to be; he was neither melancholy and withdrawn like Pontormo, nor socially or sexually eccentric as artists are sometimes thought to be. Indeed, as the Wittkowers rightly suggest in *Born Under Saturn*,[3] Bandinelli was ultimately a special kind of social conformist who chose art as his creed.

This does not mean, however, that Bandinelli was inartistic or that his personal temperament had nothing to do with his art. It is, indeed, something of a truism to say that an artist's personality is always, in some way, related to his work. Unfortunately, though, we usually know too little about historical personalities to define that relationship or to evaluate its possible meaning for their art. I doubt that we can psychoanalyze the past. Neither are we entitled, I believe, to assume that a given action or kind of behavior meant the same thing in the context of sixteenth-century Italian society that it does in our own post-Freudian world. In Bandinelli's case, however, an unusual amount of contemporary information about his personality survives. We have his letters and autobiography, as well as extended accounts by Vasari, who had studied with him and hated him; by Cellini, who also hated him; and by the humanist Anton Francesco Doni, who revered him.[4] These sources tell us that Baccio's behavior was indeed perceived as egregious and peculiar, precisely in sixteenth-century terms. They also allow us to reconstruct some

of Bandinelli's most important life experiences and to suggest that they offer striking prototypes for characteristic patterns in Bandinelli's artistic style, his choice of iconography, and his beliefs about art.

Some of these experiences were private to Bandinelli—although I want to stress that I shall discuss only his everyday conscious life. Other experiences, like the challenge of Michelangelo, were common to Baccio's whole artistic generation. When we compare his reactions to these events with those of his contemporaries, it may be possible to indicate something about the situation of Central Italian sculpture in a crucial period. At the same time, we may hope to learn more about one of the most influential and still least known of Michelangelo's contemporaries.

Bandinelli's reputation as a bad man has also done his reputation as an artist much harm. Indeed, it seems to me that, in the plan of his *Lives*, Vasari made Baccio into a kind of satanic counterpart to Michelangelo. Bandinelli is characterized as the flawed, ambitious imitator and usurper whose defeat is necessary to the full triumph of Il Divino. It may therefore be prudent, in order to gain our own perspective, to remind ourselves of the outlines of his career. Baccio was born in Florence in 1493.[5] In the 1530s, when he needed proof of nobility to secure a knighthood, he took the name of the Bandinelli, the aristocratic Sienese family from which he claimed descent. Baccio was a precocious talent, especially adept at drawing, and his earliest drawings mark him as a follower of Sarto and Fra Bartolommeo. His early style is also closely associated with that of Rosso and Pontormo and he occupies a comparable pioneer place in the early development of post-classical style in Florence. By 1520, after a good deal of experience in Rome, Baccio developed, in works like his *Orpheus* (fig. 1), a classicism that considerably antedates similar developments in the art of the *maniera*, and has reminded scholars of Canova. His best-known work is the colossal *Hercules and Cacus* (fig. 2) of 1534 which still struts in futile challenge to the copy of Michelangelo's *David* at the entrance of the Palazzo Vecchio. In the 1540s, Bandinelli became the prime spokesman of Medici art policy in both Florence and Rome and propagated a *maniera* style in sculpture that has important links with the painting of Bronzino. The sculptor began to fall from favor in the 1550s when the cold, abstract elegance of works like his *Adam and Eve* (fig. 3) came to seem inappropriate to tastes shaped by the Counter Reformation and the later Medici regime. He died in 1560, leaving a school of pupils such as Ammanati, who influenced art in Florence and Rome for the rest of the century.[6]

Bandinelli was the son of Michelangelo di Viviano and Caterina di Taddeo Ugolini. We know little about Baccio's mother except that he writes of her as his *amatissima madre*. In later life, Baccio evidently got along well with women. He claimed deep attachment to his wife (fig. 4) and, apparently, to the other woman living in his house on whom he fathered a son, Clemente. Eleanora da Toledo, duchess of Florence, continued, furthermore, to champion his cause even when her husband publicly rejected him.[7]

Baccio's three siblings died or left home early, leaving Baccio in the position of only child as well as eldest son. Baccio's father was the most successful goldsmith and jeweler of his time in Florence. Baccio remembered him as an extremely forceful personality and as an educated man who began Baccio's training as an artist while the child was still in diapers.[8] As an old man, Baccio still recalled that he had been terrified of his father and said that he slept little throughout his childhood for fear of him and because his father continually pushed him to work harder. Baccio was, in fact, a compulsive worker, and, he claims a lifelong insomniac and a

1. *Baccio Bandinelli*. Orpheus. *Palazzo Medici, Florence*

2. *Baccio Bandinelli*. Hercules and Cacus. *Palazzo Vecchio, Florence*

3. *Baccio Bandinelli*. Adam and Eve. *Museo Nazionale, Florence*

tireless reader. Elsewhere, Baccio says that a violent temper was a family characteristic: one which he adopted.[9]

Baccio's family was not well off and, worse still, considered itself *nouveau pauvre*: a good family ruined by the extravagance of relatives.[10] Later, Baccio was often criticized as a rapacious miser. The family's view of itself (which has interesting parallels with the view of the Buonarroti household) may well have been a kind of status-saving myth. Nonetheless, it must have been formative for Baccio. In his case, moreover, the indissoluble link between his pride of family and the idea of its Sienese origins[11] was to have direct consequences for his art. The social ambitions of Baccio's father were, in any case, highly developed, and he pushed his son to recoup the family position by means of a brilliant and lucrative career. This situation must have fueled the feverish tenacity of Bandinelli's later quest for wealth and status which seemed exaggerated even to contemporaries who had fundamentally similar personal and professional aspirations. Certainly, we may say that Baccio sought all his life to obey his father's early demands and to mimic the model of personality that his father had chosen for him. One might suggest that this situation, in turn, hindered Baccio in achieving a genuine inner conviction of his own identity, but we shall see, in any event, that a similar anxious obedience to external, preexisting standards and models is characteristic of Bandinelli's art as well and distinguishes him from his closest contemporaries.[12]

For Baccio, the situation was further complicated because he got his first training in his father's own atelier together with a group of talented apprentices. Thus he lived the classic dilemma of the teacher's child. No longer automatically the center of paternal attention, he must attempt to outshine his rivals in the competition for love and approval.[13] He fears paternal rejection if he is not specially favored; he is despised by his peers, who feel he has unfair advantage.

This situation reinforced the artist's dependency and insecurity with respect to a demanding father, in a context that invited conflict with his peers. Another man might not have been marked by this experience. Indeed other artists had

*4. Baccio Bandinelli.* Portrait of Jacopa Doni, *on the Tomb of Bandinelli. SS. Annunziata, Florence.*

happily survived it. But as an adult in the art milieu of Medici Florence, which was—quite objectively—highly competitive and hostile, Bandinelli was universally considered to be the artist most servile to his superiors and most aggressive toward his equals. It would seem that his later professional behavior was the public equivalent of the emotional habits acquired in his earliest years.

Another of Bandinelli's basic attitudes can also be traced to his father: the profound attachment to the Medici family and cause, which his contemporaries thought excessive even at a time when sycophancy was the universally accepted means to advancement. Baccio's family had worked for the Medici banks in the time of Cosimo Vecchio, and Michelangelo di Viviano's business as a goldsmith had been financed by Medici capital. When the Medici were expelled from Florence in the revolutions of 1494 and 1527, the goldsmith kept Medici valuables safe for them. He was ostracized as a result of this unpopular allegiance, but when the Medici returned their gratitude was tangible and enduring. Thus a central experience of Baccio's childhood was at once political and psychological. He learned that to be a vilified outsider for the Medici's sake brought rewards of security and triumph over enemies.[14] He saw, moreover, every day that his family was in fact totally dependent on Medici favor. At the same time, exclusive Medici protection may have led Baccio to fear what others said quite openly: that his success was due, not to genius, but to good connections. Here, paradoxically, was another factor that could undermine Bandinelli's sense of artistic identity.

When young Baccio began to show aptitude for sculpture, his father apprenticed him to a family friend, the sculptor Gian Francesco Rustici. In this way, Vasari tells us, Baccio met the aging, already mythical Leonardo da Vinci, who encouraged the young sculptor's endeavors. Baccio, in turn, imitated Leonardo, as one can see in Baccio's early drawings and sculpture.[15] I think Baccio also learned from Leonardo's ideas. Leonardo was, of course, in the forefront of those who put into practice the ideal of art as a secular religion which transformed the artisan into an earthly imitator of the Divine Creator Himself. Leonardo's behavior too showed that it behooved the artist to demand recognition from society appropriate to his high mission.[16] Here were ideas that could be seen as philosophical justification for powerful personal ambitions and that suggested that art might well be the best available channel of social mobility in Florentine society.

If art was, theoretically, the noblest profession, for Leonardo painting was the noblest of the arts. It was superior to sculpture because of its greater intellectual difficulty and complexity of artifice—and because it was cleaner and involved less physical effort. If one had to do sculpture at all, low relief was the best kind, since it most closely resembled painting, being flatter and involving more drawing and design. Bandinelli was the only cinquecento sculptor other than Michelangelo to become a prolific draftsman. His compositions are, indeed, always governed by considerations of line and plane. Unlike Michelangelo, however, who spurned relief just *because* it resembled painting,[17] Baccio became the most prolific practitioner of his time in the mode, extending its use far beyond its traditional function. In a project for the unexecuted *Tomb of Clement VII* (fig. 5) Baccio actually proposes that the large monument be done entirely in varying modes of relief.[18] For that matter, even Baccio's sculpture in the round tends to have a relief-like character.

What I am suggesting is that Baccio's unique preference for relief sculpture, which is otherwise unexplained, is an example of how conscious and unconscious experiences shaped his art. His social ambitions, as they were given intellectual form by Leonardo, led him—I think—to the conclusion that relief was not only

5. *Baccio Bandinelli.* Project for the Tomb of Clement VII. *Pen and ink. Museum of Art, Rhode Island School of Design (Museum Works of Art Fund, 1951), Providence*

6. *Andrea del Sarto.* Portrait of Baccio Bandinelli. *Uffizi, Galleria degli Autoritratti, Florence*

more art-theoretically correct but actually more *gentlemanly* than sculpture in the round.[19] It may even be that Leonardo's ideas actually undermined Baccio's confidence as a sculptor more generally, by enlarging—if I may say so—the chip on his shoulder. All his life, Baccio seems to have feared that sculpture might not be good enough for him. Even as an old man, he wrote that it was poverty that had driven him to sculpture, that his real desire in life was only to be a scholar and a gentleman.[20] I think this attitude helped to make him so strangely willing to hand over the execution of his designs to assistants and prevented him from acquiring a more boldly personal and flexible marble-carving technique.[21] These concerns may also explain puzzling quarrels, such as those with Andrea Sansovino at Loreto. Baccio first slandered Andrea, saying that he lacked *disegno*, and then nearly killed the sweet-natured old man when the latter remarked that *buon disegno* was to be found in the finished work, not in preliminary drawings. An established sculptor who cared less for theory than for the old-fashioned virtues of marble craftsmanship was a threat to Baccio's very existence in the identity he had assumed.[22] In this, Baccio makes a sharp contrast with Michelangelo. Michelangelo, too, was an idealist, but he realized that artistic ideas are only as good as their material embodiment in the work of art. Unlike Bandinelli, moreover, Michelangelo stoutly affirmed that he *was* a sculptor and set out to transform the standards of society through the force of his art.[23] Baccio, instead, tried to mold his sculptor's profession into something that would be acceptable to society as it was.

Bandinelli did, in fact, even try to take on the more socially acceptable role of painter, but with singular lack of success. Baccio probably learned basic fresco techniques as early as 1512, but it must have been around 1516 that the sculptor asked Andrea del Sarto to paint his portrait. Vasari says Baccio did so because he wanted to learn how the painter worked in oils by watching him on the sly rather than by asking his instruction which the good-humored painter would gladly have given him. A portrait of Baccio done by Sarto (fig. 6) provides a revealing glimpse of the sullen, somewhat coarse-grained features and shadowed gaze of the young sculptor.[24]

Vasari's anecdote, told to show Bandinelli's treacherous nature, also reveals an easily wounded self-esteem—expressed as the pride of the young *bravo* who cannot bear to show that he needs to be taught anything. He wishes to appear a full-fledged prodigy, beholden to no one, lest it be thought his merits are not entirely his own. Now the desire to be an artistic orphan, a self-created genius, is not unique to Bandinelli. We find it in Renaissance artists as different in temper as the anarchic Rosso Fiorentino (one of Baccio's few known friends in his youth) and Michelangelo himself.[25] It is part of the conscious ideology of the artist who rejects the traditional status of the artisan. Bandinelli's style, however, was always to remain more multiform and erratic than theirs. Indeed, his "cervello più instabile che una foglia"[26] was remarked by contemporaries. It is as though his need to assert the independent self could only be reconciled with his need for artistic security by a series of searching appeals to one authoritative model after another.

The factors that were conducive to artistic insecurity in Baccio's early personal life were undoubtedly also heavily reinforced by the objective problems that confronted anyone of his generation training to be a sculptor. By about 1505, when Baccio began to study with Rustici, most of the older sculptors had died or left Florence. Even Rustici had not the artistic authority to provide a single dominant example equivalent to the new High Renaissance style in painting. Thus, scattered examples of antique sculpture and works by earlier masters such as Donatello

continued to have unabated influence. The wide variety of options created a fluid artistic situation that could encourage free experimentation but could also provoke anxiety.

This artistic constellation became acutely complicated both for Baccio and for sixteenth-century sculpture as a whole through the fateful appearance on the scene of Michelangelo Buonarroti. The brute force of Michelangelo's genius made it seem hopeless to outdo him or even to equal him through imitation. He had, furthermore, failed to organize an atelier where one could learn his methods and principles. Instead, he had gone to Rome by 1506, leaving behind the mute challenge of his works, and when he returned to Florence in 1516 to undertake the great sculptural façade planned for San Lorenzo, he violently rejected the aid of Bandinelli and all other sculptors. This situation was certainly a problem for every young Florentine sculptor but no one else seems to have been as bitterly obsessed by Michelangelo as his contemporaries thought Baccio to be. According to Vasari and Cellini, Baccio maligned Michelangelo's achievements and boasted with ritual regularity whenever he began a work of his own that he would surpass him. In his autobiography, however, he speaks of Michelangelo only with reverence and love. He is humbly proud when the sculptor praises him, and he actually accepts criticism from him, calling him "the good Buonarroti."[27] What is the meaning of this seeming contradiction, dependence on Michelangelo and aggression toward him?

It is, of course, only coincidence that Baccio's father was also named Michelangelo and that the young Bandinelli was known only as "Baccio di Michelangelo"; but it is coincidence with meaning. For Baccio did, in fact, face problems in regard to the sculptor that were similar to those potential in his experience with his father. He depended for approval on an older revered authority, whose dominance he may also have resented and from whom he needed to gain independence in order to establish his own identity. But whereas Baccio could hope to imitate his father's goals and to identify with him, this was objectively impossible in relation to the great sculptor: the artistic authority of Michelangelo's works was absolute and demanding while, at the same time, his example and attitudes were frustrating and rejecting. Bandinelli may thus have been especially sensitive to the radical existential problem Michelangelo posed for all sixteenth-century sculptors: "If I am not Michelangelo, who am I?" Bandinelli's entire life and art were to be shaped by his desperate search for the answer to this question. Throughout his career, Baccio sought to execute commissions similar to those given Michelangelo in ways polemically opposite to the formulations chosen by the great sculptor.[28] In pursuit of this goal Bandinelli imitated older revered artistic models, to enlist their powerful prestige on his behalf.

Baccio's first major Florentine work, a statue of St. Peter for the Florentine Duomo, can indeed be seen as emulating Michelangelo's *St. Matthew,* originally carved for the same location (fig. 7). This was, of course, true also for the other young sculptors who were commissioned to carve other such *Apostles.*[29] Baccio, however, approached the problem in what was to be typical fashion. He secured the commission through Medici intervention and his sculpture, unlike the other *Apostle* figures, incorporates a mélange of motifs taken from Donatello's *St. Matthew* and his *Prophets* on the Campanile. Michelangelo's *St. Matthew* is also strongly Donatellesque (in its reference to the *Abraham and Isaac*) but what for Michelangelo was a phase became a lifelong touchstone of value for Bandinelli and lends a curiously archaic flavor even to his last reliefs for the choir of the

Cathedral of Florence. He was an intensely conservative and loyal adherent to artistic prototypes as well as to patrons.[30]

Vasari reports that Baccio intended in his stucco *Hercules,* done for Leo X's 1515 visit to Florence, to emulate Michelangelo's nearby *David,* the visible symbol of Michelangelo's artistic dominance in Florence.[31] As several scholars have pointed out, Baccio's colossus counters Michelangelo's by its references to Leonardo and to the antique.[32] The *St. Peter* also displays a restraint of pose and violence of facial characterization that betray the influence of different aspects of antique art.

This re-creation of the look of antiquity is by no means unique to Bandinelli and was later to become a basic characteristic of *maniera* art, but Baccio began with it earlier, and was more persistent, extreme, and specific than his contemporaries—as in his early *Orpheus* (fig. 1), which was understood to imitate the *Apollo Belvedere* in a highly original way, and in his equally remarkable copy of the *Laocoön,* finished in 1525.[33] Why should it have been Bandinelli who pushed the imitation of antiquity to such lengths? In a sense, antiquity represented the supreme paternal principle of the Renaissance as a whole. In the varied and confusing situation of Florentine art, ancient sculpture, no matter what its style, offered a standard of unassailable traditional authority. Also, I think, some of its forms and poses offered an ideal of tension and rigidity which appealed especially to Bandinelli as an adequate formal symbol for the intense, personal desire for certitude with which he approached the making of art. Bandinelli's early works already reveal his nascent intuition that antique authority might be enlisted to combat Michelangelesque imperatives.[34] They suggest, moreover, that an appeal to a variety of alternative authorities might constitute a strategy for artistic survival. The happy circumstance that Bandinelli had early and repeated opportunities to work in the more cosmopolitan setting of papal Rome enabled him quickly to develop precisely these methods for breaking the Florentine stalemate.

This resolution of the sculptor's artistic and personal conflicts came about through the agency of still another great authority figure, Raphael, who played a somewhat similar role for young Florentine painters like Rosso and Pontormo. Among artists not working directly in Raphael's shop, it was, however, Bandinelli who took certain of the master's lessons most quickly, intensively, and enduringly to heart. Although a tendency toward imitation seems to have been a basic component of Bandinelli's character and artistic strategy, Raphael himself invited such an attitude if only because—in contrast to Michelangelo—he did have a large atelier where many students could participate in the actual creation of the master's work and learn the principles of his art. I suspect, also, that the very fact that Raphael was a painter rather than a sculptor recommended him to Baccio.

Bandinelli absorbed Raphael's teaching in successive phases of ever more exclusive imitation. Before 1518 or 1519 he seemed to restrict himself to using single figures, individual motifs, and graphic techniques: one might compare a figure on the far right of Baccio's *Birth of the Virgin* in his Loreto relief of this period (figs. 8, 9) with Raphael's group from the Farnesina (reversed). Only a year or two later, however, an important change had taken place. Bandinelli now sought to master Raphael's compositional structures and methods as well. Significantly, he did so in designs for prints, rather than in sculpture. It has often been said that Bandinelli's design for a *Massacre of the Innocents* (fig. 10) is generally related to Raphael's earlier composition of the same subject, with its centralized yet dy-

7

7. *Baccio Bandinelli.* Saint Peter. *Cathedral, Florence*

8. *Baccio Bandinelli.* Birth of the Virgin *(detail). Basilica della Santa Casa, Loreto*

9. *Raphael and assistants.* Venus with Ceres and Juno *(detail of Venus). Villa Farnesina, Rome*

9

8

namic structure and its eurythmic arrangement of dramatic yet graceful figures. Works like Raphael's tapestry cartoon of the *Death of Ananias* may also have helped to inspire the architectonic grouping of the figures in Bandinelli's design. Within this basic structure, however, Bandinelli can now introduce rushing figures taken from Michelangelo's cartoon for the *Bathing Soldiers* and motifs taken from antique sculpture. This process of assimilation is even more complete in Bandinelli's *S. Lorenzo* print of about 1525, and many other examples of this method could be cited in Bandinelli's work.[35] They all indicate that Raphael's art had seemed to Baccio a way out of the Michelangelo dilemma in particular and the solution to the general problem of fidelity to sources. Michelangelo's formal ideal could now be seen, not as an exclusive challenge, but as one of several kinds of models to be unified in an extremely flexible Raphaelesque ideal of style.

This had been Raphael's own way of arriving at artistic maturity and independence. Vasari says that Raphael had first, rashly, tried to imitate and surpass Michelangelo in the depiction of the nude. Finding this to be impossible, Raphael wisely decided, instead, to imitate the best parts of many masters, ancient and modern in the creation of his own alternate manner. What we see in Bandinelli is nothing less, I believe, than the sculptor's attempt to follow the painter's way. If Baccio cannot be Michelangelo, he will become the Raphael of sculpture.

Let me say here that I think Baccio could come to this saving idea precisely because he approached the art of Raphael as a draftsman and not with the mind of a sculptor. Raphael's emphasis on drawing as part of the creative process ratified the young sculptor's obsessive adherence to drawing—to *disegno*—as the prime artistic activity. It is also easy to see why Raphael's prints were so particularly important for him, as they were also for Raphaelesque painters.[36] The fact that

10. *Marco Dente after Baccio Bandinelli.* Slaughter of the Innocents. *Engraving*

11

12

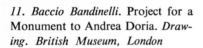

*11. Baccio Bandinelli.* Project for a Monument to Andrea Doria. *Drawing. British Museum, London*

*12. Baccio Bandinelli.* Monument to Andrea Doria. *Piazza del Duomo, Carrara*

*13. Niccolò della Casa.* Portrait of Baccio Bandinelli. *Engraving. Museum of Fine Arts, Boston*

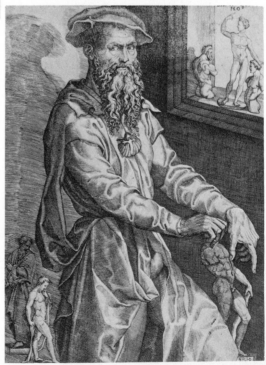

13

Raphael's ideals could be conveyed by simplified, relatively crude means, and by assistants, could encourage Baccio to draw the conclusion (not drawn by Raphael himself) that formal ideas were more essential to art than their execution. Here was sanction for Baccio's besetting temptation to be a gentleman-sculptor, to restrict himself to drawing, to let assistants do the "dirty work," and to leave works unfinished. The result in its most extreme form becomes clear when we compare one of his elegant drawings for a monument to Andrea Doria with the ignominious nubbin that was the final outcome (figs. 11, 12). From this point of view, Baccio was sometimes very nearly a practitioner of Conceptual Art *avant la lettre*.

Bandinelli drew a further conclusion, particularly from Raphael's prints, that art was a language of form that could be learned, and then be reduced to a limited vocabulary of linear symbols and reproduced at will, much like the text of a printed book. Once this vocabulary had been learned, it could be reused in an infinite number of visual "sentences." I think such reflections gave theoretical validation to Bandinelli's instinctive, acquisitive hoarding of all sources and motifs, even those derived from his own work. In one *Self-Portrait,* for instance (fig. 13), the artist is surrounded by models of his past works: they are his dictionary and treasury.[37] No wonder he had less of a stylistic development than most artists of his caliber.

The parallel drawn by Bandinelli between art and language as early as 1520 was later drawn by other artists as well. In fact, it is one of the fundamental insights of *maniera* art. But how are we to account for this extreme tendency in Bandinelli to conserve and reuse motifs? This may have been a traditional goldsmith's procedure, but his use of it may also have been another expression of Baccio's need to identify with secure models of demonstrated authority. Raphael's art and practice provided a variety of these verifiable precedents to assuage any doubts Baccio might have had about the quality and correctness of his own ideas. Here, of course, is a fatal and characteristic difference between Bandinelli and artists like Raphael and Michelangelo. While these undeniably greater artists evolve through continual search and exploration, Baccio fears that any change is only an admission that the "correct" solution has not yet been found.

Bandinelli's enthusiastic artistic adherence to Raphael may also have been enhanced by the various symbolic roles that Raphael could fill in the sculptor's life. Raphael lived the life of a prince in Roman society. Here was a model Baccio could aspire to without reservation, whereas Michelangelo's more ascetic lifestyle had too many uncomfortable resemblances to poverty. Vasari says that Raphael had the divine gift of harmonizing the rivalries of all the artists who worked under him, and that he treated them not like students or peers, but as a loving father treats his sons. In other words, the spectacle of Raphael's atelier presented Baccio with the ideal of social, artistic, and personal acceptance that seems to have been denied him first in the competitive atmosphere of his father's shop and later in the shadow of the rejecting and irascible Michelangelo.

The broader, more viable artistic and personal identity that Baccio tried to forge for himself through his Roman experience is reflected in the famous prints showing Bandinelli teaching in his own atelier. The second of these prints probably dates from about 1550 (fig. 14). Much has been written about the historical importance of this highly inventive forerunner of art academies. Baccio was precocious in this idea as he was in respect to cinquecento style, and, I believe, for many of the same reasons. From our point of view, his *Accademia* is the institutional expression of his continuing search for an art of clear authoritative

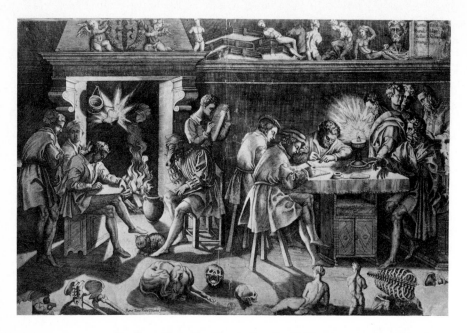

14. *Enea Vico after Baccio Bandinelli.* The Accademia of Baccio Bandinelli. *Engraving. Uffizi, Florence*

guidelines which may be securely followed and taught, and which provide the intellectual foundation to the artist's claim to high social status.[38] Drawing, melancholic introspection, and teaching are the only artistic activities allowed in this pristine workshop of the mind. Students draw from skeletons, antique sculpture, Bandinelli's own works, or the imagination, *not* from the living model. Only artificial light shines on these intellectual labors, and that is significant too: the radiant candle on the table is the visible sign of the higher illumination that guides the art of sculpture, conveyed through the theoretical teachings of the master.[39] Over the fireplace the heraldry of Bandinelli's hard-won title of nobility is the only ornament in the room.[40] It is the most desired of all seals of approval and the ideal definition of his identity.[41]

The secure, benevolent, intellectual ideal that Bandinelli propagates in these prints makes a sad contrast with his real experiences during this period. The first of a series of recurring, painful crises took place in connection with his *Hercules and Cacus* (fig. 2) which he completed in 1534. It should have been the crown of all his efforts. The group was to stand opposite Michelangelo's *David*. Even better, the commission had originally been given to Michelangelo. Bandinelli obtained it in 1525 but in 1528 the short-lived Florentine popular government returned it to Michelangelo. When the Medici were reinstated as rulers, after the siege of Florence in 1530, the commission was restored to the ever-loyal Bandinelli. One sees how this situation would have appealed to all of Bandinelli's deepest and oldest feelings. With fatal insensitivity to all aspects of the matter, Bandinelli now began to boast that he would finally outdo Michelangelo. Baccio's statue, for all the rigidity and brutality which many still find displeasing, was a boldly innovative alternative to the easeful power of Michelangelo's figure, integrating sophisticated references to Donatello, Leonardo, and Raphael within a formal ideal derived from a mode of Hellenistic sculpture.

For the Florentines, however, Michelangelo's *David* was not only a miracle

of art, but the symbol of the Republican liberties they had just lost. Hercules, too, was a traditional symbol of civic freedom and virtue; but the hero was also a Medici family emblem which they now interpreted as the image of their restoration to power and of their victory over rebellious Florence. Since it was more prudent to vent political dissatisfaction on the artist than on the patron, an avalanche of written and spoken abuse now descended on Bandinelli and his statue. The worst offenders were quickly jailed by the Medici—but that only seemed to make it clearer still that favor, not talent, had made Bandinelli an artist. Such a public rejection would have been a crushing humiliation for any man, but for Bandinelli, who habitually tied self-esteem to external approval, Vasari thought that the blow would have had shattering impact.[42]

Whether or not there was a causal link between the *Hercules* fiasco and the new departure in Bandinelli's artistic activities, is hard to say. But, where another man might have tried to make the public forget the recent disaster and its political background, Bandinelli now took on the Medici *Hercules* as his own personal emblem. In doing so, he was acting as his father had often done: in time of trouble, identify with the source of power even if this makes you unpopular. At the same time, Baccio could idealize and thus accept his personal tribulations by identifying them with the troubles and triumphs of the Medici. Bandinelli, indeed, holds a statue of Hercules in all his later self-portraits.[43]

It would seem to be no accident that Bandinelli made more self-portraits than any other artist of the cinquecento and that so many of these were engraved, to be dispersed publicly in numerous copies. It seems a logical conclusion that such an obsessive desire to redefine and affirm his own image and to impose it on society was another sign of his sensitivity about the nature and strength of his identity. As we know, this problem was especially acute in regard to Michelangelo and it was complicated still further by the curious fact that—even in profile—the two artists have what might almost be called a family resemblance to each other. Bandinelli was obviously aware of this, since he produced a number of self-images in which his own features are subtly adjusted to the point of being sometimes misidentified as portraits of Michelangelo (e.g., fig. 15).[44] Here we have further

*15. Baccio Bandinelli.* Self-Portrait *(after E. Steinmann,* Die Porträtdarstellungen des Michelangelo)

evidence of the other aspect of Baccio's continued ambivalence toward this greatest artistic father-figure: raging self-assertion alternates with self-denying attempts to identify totally with the authoritative model. With the passage of time, artistic expressions of this conflict become more overt, for despite Baccio's grandiose projects he seemed to be coming no closer to his goal of matching Michelangelo's position and fame.

When news came to Bandinelli from Rome that Michelangelo was carving a *Pietà* with four figures which he intended for his tomb, Bandinelli immediately began to think about his own tomb and he worked up a model of a *Pietà,* Vasari says, in imitation of Michelangelo (figs. 16, 17). Busy with many commissions, Baccio first gave over the execution of his model to his talented sculptor-son, Clemente, but ultimately finished the group himself, shortly before he died.[45] The resulting work looks, at first glance, entirely different from—even programmatically opposed to—Michelangelo's great sculpture, now in the Cathedral of Florence. That is what we have come to expect from Bandinelli. But, when we compare the two works we shall see that they are in fact closely related. Bandinelli's *Pietà* can illuminate the meaning of Michelangelo's famous work, and it, in turn, can help us to understand the profound emotional content that made Baccio's last and most powerful sculpture his ultimate personal confession.

Both groups participate in a tendency important in cinquecento tomb sculpture, to suppress the effigy of the deceased. Yet both *Pietàs* include an idealized self-portrait of the artist in the guise of a figure variously identified as Joseph of Arimathea, who buried Christ in his own tomb, and as Nicodemus, the sculptor present at the Crucifixion.[46] In Bandinelli's group the sculptor, like Joseph, offers his tomb—that is, his own death—to Christ, who died for our sins, in a composition reminiscent of Savoldo's earlier painting, *The Dead Christ with Joseph of Arimathea,* now in Cleveland.[47] Thus Bandinelli's *Pietà* is an important reminder that Michelangelo's group was also meant to be understood as an integral part of a funerary context. Michelangelo's *Christ* is, in fact, shown to us in loving farewell, at the moment before he is lowered into the sepulcher—which is also the altar and the artist's tomb.[48] We find more explicit confirmation for this interpretation in the *Trinity,* commissioned as early as 1567 for the altar of the Chapel of the Accademia del Disegno in the SS. Annunziata and executed by Allori in 1571 (fig. 18). In a composition based on Michelangelo, God the Father lowers the Son into the altar-tomb, between portraits of Pontormo and Bronzino, who are buried there.[49]

I stress this iconographical point here in order to make us aware that both Michelangelo's and Bandinelli's *Pietàs* represent acts of loving and hopeful identification with Christ's sacrifice as a means of achieving reconciliation with their own deaths. Thus the contrasting interpretation of the theme by the two artists is especially revealing of their personal attitudes.

The comparison of the two works becomes even more fruitful when we recall that Baccio's *Pietà* was also planned as a four-figure group.[50] The flanking figures in Michelangelo's sculpture are the Virgin and the Magdalen, the women closest to Christ, who embody two aspects of Christian love for him. They embrace and support Christ; they are united physically and spiritually with the central mystery of his death. Bandinelli's flanking figures were to be, respectively, Catherine of Siena and John the Baptist, Bandinelli family saints and the patron saints of Siena and Florence. Separate from the main group, the saints would have helped to associate the death of Christ with the personal heraldry of Bandinelli's tomb, and thus testify to his lineage and his place in Tuscan society.

16. *Baccio Bandinelli.* Pietà. *SS. Annunziata, Florence*

17. *Michelangelo.* Pietà. *Cathedral, Florence*

18. *Alessandro Allori.* Trinity. *SS. Annunziata, Florence (after Meiss, The Great Age of Fresco, no. 70)*

17

18

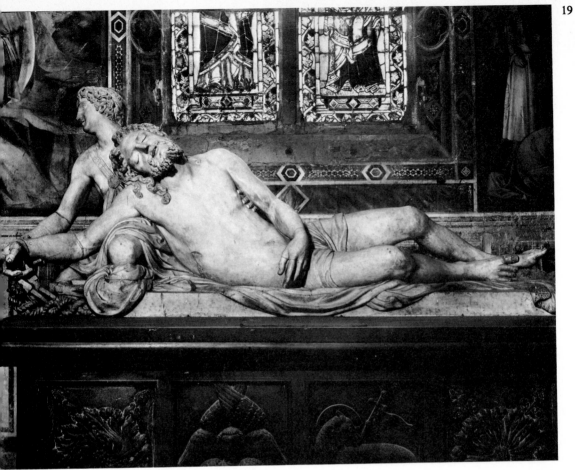

19. *Baccio Bandinelli*. Pietà. *S. Croce, Florence*

20. *Baccio Bandinelli.* Design for a Pax. *Formerly C.R. Rudolf Collection, London*

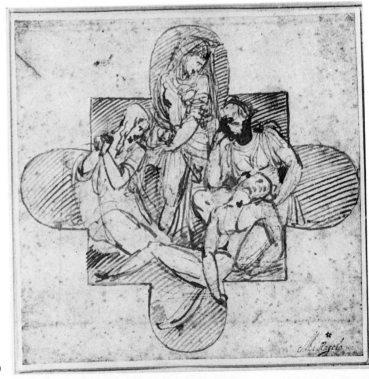

Finally, let us look at the way in which the two artists characterize themselves and their roles in the *Pietà*. We know that Michelangelo carved his Florentine group at a time of intense emotional and spiritual upheaval in the artist's life. His late poems tell us of his fear that his former, quasi-religious devotion to ideals of beauty and the power of art might have been a fatal distraction from the contemplation of death and the growth of the self-annihilating love of Christ necessary for Christian salvation. Tortured by an increasing sense of waste and sinfulness, he feared that his faith might be insufficient to win divine forgiveness. A wall of ice, he says, isolates him from divine love.[51] These alienating personal conflicts are, however, resolved in the work of art. As Joseph of Arimathea or Nicodemus, Michelangelo is united in body and spirit with the sacred mystery. Shrouded, weightless, half hidden, he shelters and embraces the Virgin and Christ. He achieves complete self-transcendence as he shares in the loving union of the Mother and her Son. Bandinelli's self-surrogate in the *Pietà* is equally revealing. He does not contemplate Christ but looks out at the spectator. He does not embrace Christ but presents him to us, contrasting his own staunch, upright strength with the weighty passive relaxation of the dead figure. In fact, his attitude less resembles a self-effacing Joseph offering his tomb to his Saviour than it recalls God the Father who supports his dead Son, in representations of the Trinity.[52] Even in the face of death, an intransigent self-affirmation rather than a yearning self-transcendence seems to be Baccio's final statement.

The pose has, however, broader implications. Baccio seems closer here, indeed, to the character of Nicodemus as sculptor. He presents his last work of art to the spectator and to the ultimate authority, God the Father. This may also explain why, in contrast to Michelangelo's thin, ascetic Christ, Bandinelli makes of the Saviour a youthful athlete, an interpretation which seemed shockingly pagan and indecorous to his contemporaries.[53] Certainly Baccio did this to invoke the dignity of antique art on behalf of his own monument, but he must also have felt that nothing less would be appropriate here to represent the incarnation, the veritable *Corpus Christi* offered on the altar.[54] It is true that almost any depiction of Christ's body may be seen to have Eucharistic significance, but Michelangelo places his hope for heaven in personal communion with Christ's suffering humanity, whereas Bandinelli presents Christ's invulnerable deity, trusting in the ritual efficacy of the Mass to redeem God's pledge of salvation. This same attitude informs the pose of the group with its hieratic balance of horizontals and verticals. In Baccio's earlier versions of such compositions, the body of Christ lies on the ground (e.g., figs. 19, 20); here it is raised and displayed by the kneeling donor. This nearly monstrance-like arrangement would have had special sense had Bandinelli succeeded in his plan to install the group on the steps of the central altar of the SS. Annunziata, where the sacrament was housed.[55] Even in its present site above the chapel altar, however, the sculpture shows the donor assisting at the Masses which he offers for the souls of his family. The inscription carved on the marble block which supports the corpus makes the same sort of double statement at the center of the composition: "In dedication to the Pietà (and in the hope of divine mercy) the donor wrought his tomb with skillful art."[56]

For all its formal and emotional restraint, the work has a solemn, muted poignancy which gives authentic and moving expression to the personal circumstances in which the sculpture was created. When Bandinelli began the *Pietà* he was, once again, the target of violent criticism from his peers in connection with his most ambitious projects: the decorations for the choir of Florence Cathedral and for the

Udienza at the Palazzo Vecchio. When Baccio asked Duke Cosimo de' Medici to visit the unfinished choir in order to silence the sculptor's enemies as he had done in the past, the duke—finally angered by Bandinelli's boasting and dilatoriness—refused, and began at the same time to support other artists for the Udienza project. Thus, in one stroke, the benevolent authority which had sustained Bandinelli from childhood was withdrawn. As a direct result of these experiences, Vasari tells us, Bandinelli became disturbingly introverted and bitter—and more quarrelsome than ever before. But, most amazing to those who knew him, he began to maltreat Clemente, the illegitimate son whom he loved fiercely and for whom he had the highest professional ambitions. To escape Baccio's rage the young Clemente broke off work on his father's *Pietà* and fled to Rome, hoping to make his own way as a sculptor. Within the year he had fallen ill and died, far away from his family.[57]

To modern ears this episode sounds as though Bandinelli, reacting in frustration and rage to the rejection he had suffered from the Medicean father-figure, had projected this situation onto his own paternal relation with the only one of his sons in whom he saw himself reborn. We certainly know from his autobiography and from Vasari that Bandinelli was grief-stricken at his son's death. And surely feelings of guilt and remorse must have haunted Baccio as he worked to finish the *Pietà* which his son had left behind, as a constant reminder of these tragic events.

It seems to me that the mark of these circumstances is reflected in the *Pietà* as Baccio finished it. He does, indeed, represent himself as we first thought, as the grieving father who mourns the death of his young and best-loved son.[58] His version of the *Pietà* theme tells of the loneliness and guilt of the survivor, not of transfiguring sacrifice. Yet by offering the Son to the heavenly Father, by identifying his own sorrows with holy grief, and by idealizing them in an image of stoic nobility, Bandinelli may have hoped finally to be reconciled in the immortal realm of art with the child he had rejected, and with all his own enduring conflicts of identity as a father and a son.[59] When all was ready, Baccio exhumed the body of his own father and buried it in his own tomb as well.[60] He had done all he could.

Where Michelangelo had used all the resources and energies of his personality in the creation of his art, Bandinelli ultimately thought he could marshal the resources of art as a means of creating himself. He strove all his life, with power and imagination, to achieve that goal and to shape it according to the highest models and standards of his world. But, as Bandinelli kneels amid the trophies of fame and social recognition, above the body of his father and holding the idealized image of his son in his arms, the artist still looks out at us with the tortured and puzzled gaze of a man who has always tried to do what was right and finds that, somehow, it was never enough.

*New York University*

\* This is an edited and annotated version of a lecture first given at the Frick Collection in 1975 and, under the auspices of the Institute for Advanced Study at Princeton University in 1976, and elsewhere. Later phases of the work were supported by grants from the National Endowment for the Humanities and the John Simon Guggenheim Memorial Foundation. In a recently published lecture, "The Sculptor's Last Will and Testament," *Allen Memorial Art Museum Bulletin*, XXV, 1–2 (1977–78), Oberlin, 4–39, Irving Lavin makes observations that harmonize closely with some of those offered here. It was no longer possible to integrate this work in mine, but I would like to point to Lavin's informative footnotes which include an unpublished will by Bandinelli which dates his plans for a tomb in SS. Annunziata to May 9, 1555, but makes no mention of the *Pietà*. Lavin's remarks on the relation of Vecchietta's *Christ* to sacrament altars are also illuminating in respect to my suggestions about Bandinelli's tomb.

Finally, I agree fully with Lavin's emphasis on the importance of the ideal of the masterpiece carved from a single block in the Cinquecento. Perhaps, indeed, it may help to explain Michelangelo's destructive fury against the Florentine *Pietà* once the marble was found to be flawed. Bandinelli's *Pietà* also appears to be carved from a single block.

[1] See Vasari, "Vita di Baccio Bandinelli," ed. D. Heikamp, in *Le Vite de' Più Eccellenti Pittori, Scultori ed Architettori*, Club del Libro, VI, Milan, 1964, 18 (hereafter Vasari, VI). Also see A. Colasanti, "Il Memoriale di Baccio Bandinelli," *Repertorium für Kunstwissenschaft*, XXVIII (1905), 412; Vasari, VI, 56, for two other alleged destructive acts by Bandinelli against Michelangelo and Montorsoli. Further, H. Utz, "A Note on the Chronology of Ammanati's Fountain of Juno," *Burlington Magazine*, CXIV (June 1972), 395, also challenges Vasari's report that Bandinelli damaged the block intended for the *Neptune* fountain so that Ammanati could not use it.

[2] Vasari, VI, 85.

[3] R. and M. Wittkower, *Born Under Saturn*, London, 1963, 231 ff.

[4] Vasari's "Vita" and Bandinelli's *Memoriale* provide the information used in this paper unless otherwise indicated. Vasari studied with Bandinelli and both accounts reflect the lifelong enmity between the two men. Vasari seems, however, to have made some use of the *Memoriale* in his own account. Cellini's "Vita," in *Opere di Baldassare Castiglione, Giovanni della Casa, Benvenuto Cellini*, ed. C. Cordié, Milan, 1960, was written between 1558–62, and contains motifs and references that suggest it might have been composed in competition with Bandinelli's *Memoriale*. Bandinelli's friendship with the humanist Anton Francesco Doni goes back at least to 1528. Bandinelli is a protagonist in Doni's *Il Disegno*, published in Venice in 1549 (facsimile edition, ed. Mario Pepe, Milan, 1970), and the sculptor is also praised in Doni's *I Marmi*, Academico Peregrino, Venice, 1552. For interesting contrasts between Michelangelo and Bandinelli see Giorgio Spini, "Politicità di Michelangelo," *Rivista Storica Italiana*, LXXVI (1964), 557–600. I am indebted to A. Hayum for this reference.

[5] The problem of Bandinelli's birthdate was solved by James Holderbaum, "The Birthdate and a Destroyed Early Work of Baccio Bandinelli," *Essays in the History of Art Presented to Rudolf Wittkower*, London, 1967, 93–97. The fact remains, however, that Bandinelli (*Memoriale*, 419) says he was made his father's heir in a will of 1491. It seems odd that Bandinelli himself would have made such a mistake.

[6] The abundant but fragmentary bibliography on Bandinelli can be found through A. Venturi, *Storia dell'arte italiana*, X, 2, Milan, 1936, 191 ff., and M. Hirst, *Dizionario biografico degli italiani*, V, Rome, 1963, 688–92, as well as in Heikamp's notes on the Vasari "Vita" (see above, n. 1). A useful résumé of the sources and literature is contained in the notes to the *Memoriale* in *Scritti d'Arte del Cinquecento*, ed. P. Barocchi, II, Milan–Naples, 1973, 1359–1411, 2351.

The predominantly negative assessment of Bandinelli's accomplishments is eloquently perpetuated by J. Pope-Hennessy, *Italian High Renaissance and Baroque Sculpture*, London–New York, 1970, 362–66, and by C. Avery, *Florentine Renaissance Sculpture*, New York–London, 1970, 194 ff. Earlier, W. R. Valentiner, "Baccio Bandinelli, Rival of Michelangelo," *Art Quarterly*, XVIII, 3 (1955), 241–62, sympathetically reexamined Bandinelli's relationship to the great sculptor; more recently, articles and lectures by Holderbaum and, above all, by Heikamp have presented a frankly positive evaluation of Bandinelli. See also V. L. Bush, *Colossal Sculpture of the Cinquecento*, New York, 1976, and, in the same Garland Press series, my own *Santa Casa di Loreto* (1977), as well as my (K.W.-G. Posner) *Leonardo and Central Italian Art*, New York, 1974, 38–41.

[7] *Memoriale*, 415, 438; Vasari, VI, 49, 72, 73. Little seems to be known of his wife, Jacopa Doni. Bandinelli claims she was of noble family and she may have been related to Anton Francesco Doni although he came of humble stock despite his claims to the contrary (Doni, *Il Disegno*, 12, n. 3; 13, n. 1). The marriage took place before 1530 and she was still alive in 1559. She is, however, buried in Baccio's tomb and her portrait in bas relief decorates the back of the sarcophagus. Clemente was named, in typical Bandinelli fashion, for Pope Clement VII, Baccio's greatest patron, who had just died in 1534; the boy was legitimized in 1552. For the role of women in Florentine family life, see E. Sestan, "La famiglia nella società del Quattrocento," in *Convegno internazionale indetto nel V° centenario di Leon Battista Alberti*, Rome, 1974, 241 ff., and also the bibliography in the notes.

[8] *Memoriale*, 418, 419, 422, 428; Vasari, VI, 13 ff. Bandinelli's later founding of an artist's academy (see pages 235–36) was also a natural development from his father's early example of study of drawing and keen interest in the antique.

[9] *Memoriale*, 418, 422, 428, 435. Vasari, VI, 20 ff., also dilates at length on Bandinelli's obsessive diligence from his earliest years.

[10] This theme is woven throughout the *Memoriale* but see particularly 427, 440, 442.

[11] *Memoriale*, 418, 422, 427, 438, *et passim*. A major theme of the *Memoriale* is to explain this idea. Enemies thought Bandinelli's pretentions a hoax. Cellini, *Vita*, 938, says Bandinelli should, like himself, have been proud of being a self-made man instead of hiding the fact.

[12] See R. C. Trexler, "In Search of Father: The Experience of Abandonment in the Recollections of Giovanni di Pagolo Morelli," *History of Childhood Quarterly*, III, 2 (Fall 1975), 225–52, for Renaissance beliefs about the effect of parents on their sons and on the problem of self-definition. Also J. B. Ross, "The Middle-Class Child in Urban Italy, Fourteenth to Early Sixteenth Century," in *The History of Childhood*, ed. L. de Mause, New York, 1974, 183–228, and Sestan, "La famiglia," *passim*.

Cellini makes an interesting contrast with Bandinelli. He recounts how his early rebellion against his father's wishes helped him to become an artist: Cellini, *Vita*, p. 508. Michelangelo's experience was, in this respect, similar. See Spini, "Politicità," 557–60.

[13] Vasari, VI, 14 ff., sees the competition as strong but useful. Cellini was one of these competitors but must have studied later than Bandinelli. Nonetheless, Cellini was the one who most closely followed Michelangelo da Viviano's footsteps and this fact forms part of the prelude to the rivalry between Benvenuto and Baccio in the 1540s and 1550s.

[14] *Memoriale*, 436: ". . . ma vero o no, sempre si hanno a difendere i padroni e gli amici." Also Vasari, VI, 13 ff., 41.

[15] *Memoriale*, 422; Vasari, VI, 16. For an early copy by Bandinelli of Leonardo's *Angel of the Annunciation*, see K. W.-G. Posner, *Leonardo*, fig. 48.

[16] See, for instance, K. W.-G. Posner, *Leonardo*, 21 ff. In a forthcoming piece on the theme of *Deus Artifex* in Bandinelli's work, I expect to deal more fully with this question.

[17] See Michelangelo's famous letter to Benedetto Varchi in *Trattati d'arte del*

*Cinquecento*, ed. P. Barocchi, I, Bari, 1960, 82. Leonardo praises relief sculpture in the *Paragone* (ed. J. P. Richter, *The Literary Works of Leonardo da Vinci*, 3rd ed., I, 1970, 93), but elsewhere (*ibid.*, 94, 99) he points out its limitations in comparison with painting. Bandinelli (*Memoriale*, 430) wrote treatises on the Paragone between painting and sculpture and on *disegno*. *Ibid.*, 433 ff., Bandinelli affirms "tutto il mio intento era nel disegnare"; see also Vasari, VI, 85.

[18] Project for the Tomb of Clement VII, Museum of Art, Rhode Island School of Design. See C. Wilkinson *et al.*, *Drawings and Prints of the First Maniera* (exhibition catalogue), Rhode Island School of Design, Providence, 1973, 12 ff., and V. Goldberg, "Leo X, Clement VII and the Immortality of the Soul," *Simiolus*, VIII (1974/75), 16–25. By the same token it is suggestive that Bandinelli prepared a cartoon as well as a model for his *imitazione* of the antique *Laocoön*; i.e., a two-dimensional scheme for a three-dimensional sculpture.

[19] See Richter, *Leonardo*, I, 91–101, and "Lucian's Dream," in *Sources and Documents: The Art of Greece 1400–31 b.c.*, ed. J. J. Pollitt, Englewood Cliffs, N.J., 1965, 226 f.

[20] Bandinelli did, apparently, write a great deal both in prose and poetry. See above, n. 17, and *Memoriale*, 422–31, especially 428, 430.

[21] *Memoriale*, 434, where Bandinelli discusses his tendency to leave the execution of his work to others. Bandinelli admits that Michelangelo's criticism of him on this score was just. Bandinelli's use of full-size stucco figures to show the appearance of works to be finished in marble is noted by Heikamp in Vasari, VI, 68, n. 2. Bandinelli, in contrast to Michelangelo, worked only incidentally, "per forza di levare."

[22] Vasari, VI, 24, for the story. A similar sensitivity to the problem of design vs. execution is revealed in his quarrels about the *Hercules*.

[23] Even Michelangelo ultimately (1543) wished to be addressed like a gentleman by his family name. Indeed he also sought and gained the titles and privileges

that Bandinelli thought so important. Leo X, for instance, made Michelangelo a Count Palatine in 1515. Bandinelli (*Memoriale*, 417) says Frederick III made Bandinelli's great-uncle and his descendants Counts Palatine in perpetuity. Cellini, who was also ennobled in 1554, does not mention the fact in his *Vita*

[24] For Bandinelli's beginnings as a painter see J. Shearman, "Rosso, Pontormo, Bandinelli and others at SS. Annunziata," *Burlington Magazine*, CII (1960), 152–56; and for other early artistic endeavors see Shearman, "The Florentine Entrata of Leo X, 1515," *Journal of the Warburg and Courtauld Institutes*, XXXVIII, (1975), 136–54. Also Vasari, "Vita," 19. The Sarto portrait was identified by S. J. Freedberg, *Andrea del Sarto*, II, Cambridge, Mass., 1963, 56 ff.

[25] Vasari, VI, 19, and VII, 238, for Michelangelo's "chi va dietro a altri, mai no li passa innanzi." This attitude informed many of his actions.

[26] Baldassare Turini in a letter to Duke Cosimo, April 6, 1546, in G. Gaye, *Carteggio inedito d'artisti, etc.*, II, Florence, 1840, 286, quoted by Heikamp, "Baccio Bandinelli nel Duomo di Firenze," *Paragone*. XV, 175 (1964), 41, n. 5.

[27] Vasari, VI, 18, 22, 23, 33, 35, etc.; Cellini, *Vita*, 891; *Memoriale*, 412, 425, 432, 433, 434. Colasanti had already pointed out the disparity between Vasari's and Bandinelli's accounts of the sculptor's relationship to Michelangelo.

[28] Bandinelli seems to have approached Michelangelo in the role of "aemulus," much as Charles Seymour says Verrocchio did in respect to Donatello: *The Sculpture of Verrocchio*, Greenwich, Conn., 1971, 25. I also wonder if Baccio's public bad temper was not partly a distorted imitation of Michelangelo's *terribilità*.

[29] For the history of the commission see Pope-Hennessy, *High Renaissance*, 43–44; 310–11. Interestingly, Michelangelo's figure measures $4\frac{1}{2}$ braccia, and Vasari (VI, 22) gives Bandinelli's statue as $4\frac{1}{2}$ braccia.

[30] It may also be significant that Bandi-

nelli's sculpture resembles a *Saint Peter* attributed to Antonio Federighi in S. Martino in Siena. Perhaps Baccio was, already here, alluding to his Sienese origins with the implication that this set him above his native Florentine competitors. See C. del Bravo, *Sculture senese del quattrocento*, Florence, 1970, pl. 214.

[31] Vasari, VI, 22; Holderbaum, "Birthdate," 96, fig. XIII, 1. Bandinelli also made a model of a *David*, intended to replace that of Donatello (Vasari, VI, 23). A small marble *David* in the Victoria and Albert Museum which does not correspond to Vasari's description was tentatively attributed to Bandinelli by Pope-Hennessy. If this proves correct, the figure would represent one of Bandinelli's most interesting attempts to come to terms with Michelangelo. The artist follows traditional Renaissance practice by learning through direct imitation of a great prototype. At the same time, however, he counters with an older great model, the *David* of Donatello. This tactic is particularly significant here since Michelangelo had also designed a Donatellesque bronze *David*.

For the defining role the *David* played in Michelangelo's own life and "search for identity," see C. Seymour, Jr., *Michelangelo's David: A Search for Identity*, Pittsburgh, 1967.

[32] For example, K. W.-G. Posner, *Leonardo*, 40 ff. For the history of the statue, V. Bush, *Colossal Sculpture*, 124–30. For its iconography, L. D. Ettlinger, "Hercules Florentinus," *Mitteilungen des Kunsthistorischen Institutes in Florenz,* XVI (1972), 119–42.

[33] Vasari, VI, 24 ff.; Holderbaum, "Birthdate," 97, also recognized the originality of these imitations. Bandinelli was unusual among his contemporaries in choosing known individual works to imitate rather than combining various ancient sources into a new image; something he did with modern prototypes. There may well be a significant parallel with contemporary arguments about antique imitation in language and literature.

[34] Cellini, *Vita*, 890, says, however, that Bandinelli even criticized antique anatomy as being "full of errors," to spite Benvenuto.

[35] Compositional themes taken from sources as different as Donatello's Paduan reliefs (a source Raphael also favored), Michelangelo's Sistine *Sacrifice of Noah*, his *Battle* cartoon, Rosso, and ancient sculpture are integrated into a basically Raphaelesque canon of body form and compositional structure. See Wilkinson, *et al.*, *First Maniera*, 90 ff.

[36] See B. Davidson, "Marcantonio's Martyrdom of San Lorenzo," *Bulletin of the Rhode Island School of Design, Museum Notes*, XLVII, 3 (1961), 1–6, and Wilkinson, *et al.*, *First Maniera*, 94 ff. and *passim*.

[37] British Museum 1866–12–8–640 is an anonymous print used as a frontispiece for an anatomical sketchbook and seems to be a cruder version (in reverse) of the portrait engraved by Niccolò della Casa, Museum of Fine Arts, Boston, reproduced by R. Hadley, "A Portrait of Bandinelli," *Fenway Court*, I, 3 (1966), 20 (and our figure 13). Uffizi 1496F seems to be a copy after the original engraving rather than a preparatory sketch for the Gardner Museum painting. The engraved portrait may also have symbolic meaning, like that of the *Academy* prints and the Gardner portrait. See pages 235–36. The artist, wearing the order of Santiago, firmly holds a figure of Hercules which is probably to be identified as antique because one arm is missing. Baccio's left hand also indicates this figure. The sculptor is strongly lighted from a window where antique torsi flank a figure whose exhorting Baptist-like gesture points up to the sculptor's name.

[38] In the same way, Bandinelli's founding of an academy corresponds to the humanists' desire to purify and standardize language. See N. Pevsner, *Academies of Art, Past and Present*, Cambridge and New York, 1940 and 1973, 39–43. See also D. Heikamp, "Drawings by Vincenzo de' Rossi, *Paragone*, XV, 169 (1964), 38–42.

[39] Cellini ("Sopra i Principe e 'l Modo d'Imparare L'Arte del Disegno," Cordié, 1117) recommends that students

draw bones exactly like those in the print. As he and Leonardo ("Sopra l'arte del Disegno," Cordié, 1106; Richter, *Leonardo*, 99) make clear, sculptors actually did use artificial light in their studios to bring out the relief of forms. However, the man gazing into the candlelight indicates that its meaning is symbolic. The same image appears in the *Academy* print of 1531. In Doni's *Disegno*, 44, Bandinelli says that he agrees with Michelangelo that painting is to sculpture as is "l'ombra al vero." Cellini makes a similar comment, and both reflect Michelangelo's statement to Varchi in 1547 (Barocchi, *Trattati*, 82), that both arts stem from *disegno* but that sculpture is the "lamp" of painting. In Doni, *Disegno*, 11, Bandinelli also quotes Michelangelo as saying that painting derives from shadows and sculpture from idols. The remark has a Plinian cast. Indeed, the earlier print, with its stronger cast shadows, may allude directly to Pliny's story that drawing originated when a line was drawn around a man's shadow and that modeled portraits were invented when the traced outline of a shadow cast on the wall by a lamp was filled in with clay by the potter Boutades (K. Jex-Blake and E. Sellers, *The Elder Pliny's Chapters on the History of Art*, Chicago, 1968, 85, 175). Bandinelli claimed to have written treatises on *disegno*, the *Paragone* and one called *L'Accademia* (*Memoriale*, 430), now lost, which might have provided clues to these matters.

For the importance of the knighthood in Bandinelli's life see Cellini's *Trattato dell'oreficeria* in Cordié, 973.

[40] The struggle for the knighthood is reported in detail in the *Memoriale*, *passim*. When Bandinelli was considered for the Imperial order of Santiago, knights already in the order protested, "dicendo come scu[l]tore non lo meritass[e]," not realizing, says Bandinelli, that the visual arts were already thought noble in antiquity. Bandinelli's uncle fought a duel in France against the Vidame de Chartres, who claimed there was no real nobility in Florence, for there they called those noble who

practiced the mechanical, not the liberal, arts (*Memoriale*, 423, 438). Indeed, this difficulty continued to plague artists proposed for the order of Santiago even in the seventeenth century. See M. M. Kahr, "Velàzquez and *Las Meninas*," *Art Bulletin*, LVII (1975), 225–46, and J. Brown, *Images and Ideas in Seventeenth-Century Spanish Painting*, Princeton, 1978, 106–9. Bandinelli's knighthood was an extraordinary accomplishment. His papal knighthood of St. Peter, given by Pope Clement VII, was more closely tied to merit. Aretino, for instance, also received one and it brought only a small income of 70 to 80 scudi a year (*Le lettere sull'arte di Pietro Aretino*, ed. E. Camesasca, III, 1, Milan, 1957, 45–46). For its socio-economic implications, however, see P. Partner, *Renaissance Rome: 1500–1550*, Berkeley, Cal., 1976, 61–63.

[41] It has been assumed that Bandinelli was the imposing Moses-like figure seated at the table. His robes of knighthood, however, identify Bandinelli as the unobtrusive figure on the far right who listens to the speaker with benevolent patronage. Which contemporary could the pathologically self-assertive Bandinelli portray as an authority higher and more directly "illuminated" than himself? Michelangelo comes to mind but the resemblance is far from conclusive. Perhaps the speaker is a scholar and not an artist at all.

[42] Vasari, VI, 48; see also 30–35, 40, 41, 43, 48. Actually Vasari (VI, 47, 83) accords the statue enthusiastic praise. See above, n. 37.

[43] This symbolism is particularly clear in the portrait of Bandinelli in the Gardner Museum, Boston (Hadley, "Portrait," 17–24). Robed as a Knight of Santiago, Bandinelli sits on a stone cube before two large columns, all likely symbols of fortitude. Bandinelli points to a *drawing* of a Hercules and Cacus group which much resembles a Samson subduing a Philistine. Beneath are masks, traditional symbols of envy. The moral seems to be: through fortitude, nobility, and *disegno*, Bandinelli triumphs over barbarous detractors. (Louvre Inv. 154 may be a

chalk study for the portrait but it is unlikely that Bandinelli painted the picture himself.) See also Heikamp, "Vincenzo de' Rossi," 38. For the same reasons and with much the same meaning, Baccio had also adopted the personal emblem of Clement VII, "candor illaesus." See *Memoriale*, and, for the Medicean meaning, Marilyn Perry, " 'Candor illaesus'; The 'Impresa' of Clement VII and Other Medici Devices in the Vatican Stanze," *Burlington Magazine*, CXIX (October 1977), 676–86.

44 As in E. Steinmann, *Die Porträtdarstellungen des Michelangelo*, Berlin, 1913, 50. This drawing at Windsor is, however, a version of the central head in Baccio's pen-and-ink *Three Male Heads* in the Metropolitan Museum. J. Bean and F. Stampfle in *Drawings from New York Collections I: The Italian Renaissance*, New York, 1965, 52, no. 75, suggest convincingly that the New York head is a portrait of Bandinelli, and connect it with Titian's later tricephalic *Allegory of Prudence*. The Metropolitan drawing is surely also to be read in a symbolic sense. See also D. Redig de Campos, *Raffaello e Michelangelo: studi di storia e d'arte*, Rome, 1946, 151–57. The Gardner Museum portrait (see above, n. 43) was also thought to represent Michelangelo.

45 See Pope-Hennessy, *High Renaissance*, 364, but uncertainties remain. Clemente apparently began putting his father's model mentioned in 1563 (see Heikamp in Vasari, "Vita," 76) into execution in 1554 or conceivably 1555, depending on how one interprets Vasari's text. Vasari takes over Bandinelli's claim that the carving was well under way when Clemente stopped work in the same year. Bandinelli may, however, have maximized his son's role out of paternal pride, for Bandinelli continued to work on the group until his death in early 1560 (*Memoriale*, 433, 435; Vasari, VI, 60 ff., 73, 76, 79). Thus Bandinelli was responsible for both the initial composition and the epidermis of the work. An idea of the changes made by Bandinelli can, perhaps, be derived from Vasari's statement (p. 79), that Bandinelli heard about

Michelangelo's *Pietà* and undertook to imitate it only when his own group was already well along. Since Bandinelli designed compositionally similar groups much earlier (discussed below), one may hypothesize that the Michelangelesque elements (self-portrait, flanking saints, and perhaps the intention to use the group for the sculptor's tomb) were added only in the second phase of the work. Cellini, *Vita*, 948, asserted that Bandinelli began the *Pietà* in emulation of the *Crucifix* (which Benvenuto began carving for his own tomb only in 1556) and that Bandinelli's group was unfinished at his death. Cellini's model may well have existed at least a year earlier. The sources of Bandinelli's *Pietà*, however, lie deep in his own oeuvre. In the late 1520s, Bandinelli made cartoons for paintings of the dead Christ with Nicodemus and other figures, including the Virgin and an angel holding the crown of thorns and the nails (Vasari, VI, 35). These compositions are lost but may be relevant. Two reliefs in the Victoria and Albert Museum depict related subjects (J. Pope-Hennessy, *Catalogue of Italian Sculpture in the Victoria and Albert Museum*, II, London, 1964, 445–46). There, the motif of Christ's figure draped over the knee of a supporting figure appears, as it does in a drawing for a *Pax* begun by Bandinelli's father about 1524–28 (Vasari, VI, 42, n. 2). The motif reappears in a *Deposition* relief given to Charles V in 1530 (replica in the Louvre), while a number of drawings show poses related to that of the Annunziata *Christ*, as do other drawings of the *Drunkenness of Noah*, probably related to the Duomo reliefs. Indeed, a lost version of the Duomo *Pietà* as well as the completed work itself (finished 1552) are the most immediate precursors of Bandinelli's funerary monument. The block on which the Annunziata *Christ* rests is also a recurrent motif.

46 Vasari, VI, 75, calls both figures Nicodemus. For the sources of the legend and for the implication in the identity of the figures see W. Stechow, "Joseph of Arimathea or Nicodemus," in W. Lotz and L. Möller, *Festschrift für L. H. Hey-*

denreich, 289–302, and Hibbard, *Michelangelo*, 283–86. Scholars have tended to believe Michelangelo's figure includes elements of both characters, and the same may be true for Bandinelli. The emphasis on nails, hammer, pliers, and sponge might, however, strengthen the Nicodemus aspect of Bandinelli's figure. His bitter enemy, Alfonso de' Pazzi, in a vituperative epitaph (text in *Memoriale*, 429, n. 52), apparently mistook the instruments for sculptor's tools, perhaps a significant error.

[47] J. Pope-Hennessy, *The Portrait in the Renaissance*, London–New York, 1966, 296–97, and Stechow, "Joseph," 297 ff. We cannot be sure, however, that Savoldo's painting was intended for his own tomb.

[48] See C. de Tolnay, *Michelangelo*, V, Princeton, 1960, 88, 150, for the sources of our information. Michelangelo intended the *Pietà* to be placed on an altar at S. Maria Maggiore and wished to be buried at its foot. The suggestion that Christ is lowered into the artist's tomb was made by Frederick Hartt, *Michelangelo: The Complete Sculpture*, New York, 1968, 284, 285, and was recently taken up again by Hibbard, *Michelangelo*, 284.

[49] M. Meiss, *The Great Age of Fresco*, New York, 1970, 214. There Meiss noted that the fresco belonged to a series symbolizing the three arts and suggested that "one person of the Trinity represents sculpture along with the statues that line the walls of the chapel," a stimulating observation in the light of Bandinelli's sculpture.

John Shearman, *Pontormo's Altarpiece in S. Felicità* (Charlton Lectures on Art), Newcastle-upon-Tyne, 1971, 10–14, proposed that Pontormo's Christ was being lowered into the altar-tomb at whose foot the patron of the chapel lies buried. The argument has not found universal acceptance but has been extremely fruitful in drawing the attention of scholars to Eucharistic relationships between altarpiece and altar mensa. It is worth noting that Vasari planned a clearly similar arrangement for the Del Monte Chapel in S. Pietro in Montorio (drawing illustrated in P. Barocchi, *Vasari Pittore*, Florence, 1964, fig. 40, Uffizi 639F. See also P. Barocchi, *Mostra di Disegni del Vasari e della sua cerchia*, Florence, 1964, no. 15), and also for the tomb of Michelangelo himself (*Pietà* by Naldini, 1578). Also see below, n. 53.

[50] Vasari twice mistakenly says Michelangelo's *Pietà* has five figures. For Bandinelli's patron saints, see *Memoriale*, 413, 440, 443.

[51] J. Pope-Hennessy, *The Portrait in the Renaissance*, 300; *Complete Poems and Selected Letters of Michelangelo*, trans. and ed. C. Gilbert and R. Linscott, New York, 1963, 85.

[52] This impression, conveyed by the photograph, is mitigated when the group is seen *in situ*, i.e., slightly from below. As Stechow, "Joseph," 294, points out, both Joseph and Nicodemus images are ultimately derived from Trinity representations and are often based also on antique Meleager sarcophagi (see Shearman, "Pontormo," figs. 7, 8). In painting, the kneeling figure who supports Christ is not unusual. See both Northern and Italian examples in Stechow, *passim*, as well as works like the homeless painting by Bernardino da Asola (B. Berenson, *Italian Pictures of the Renaissance: Venetian School*, II, London, 1897, no. 798), or the drawing of the subject by the young Salviati. See E. Carroll, *The Drawings of Rosso Fiorentino*, New York, 1976, 518–19.

Perugino's *Lamentation* in the Pitti (1495) and works influenced by it may be among Bandinelli's sources, as may Marcantonio's print (B. XIV, no. 37) after a drawing for Raphael's Borghese *Entombment*. Sarto's engraved *Pietà* has generic similarities to the sculpture as does his *Pietà* in the Pitti, which includes the exposed Eucharist and was made for the high altar of the church at Luco (J. Shearman, *Andrea del Sarto*, II, London, 1965, 68, pl. 126). Altarpieces by Pontormo for the Capponi Chapel and by Bronzino for the Eleanora Chapel in the Palazzo Vecchio are also antecedents in form and meaning. In the latter, Bandinelli also appears as Nicodemus or Joseph of Arimathea. A many-figured *Lamentation* by Bronzino of 1565 (Uffizi)

apparently reflects a fusion of Bandinelli's Duomo and Annunziata *Pietàs*. In sculpture, the Bandinelli motif is rare. The most significant images occur, interestingly enough, in the North Italian tradition of Lamentation tableaux, e.g. Alfonso Lombardo's destroyed relief (G. Medri, *Scultura a Ferrara, Atti e Memorie*, n.s. XVI [Ferrara, 1957], XXIX) or Begarelli's *Pietà* in Modena (Venturi, X, 2, fig. 503). Bandinelli seems to unite this type with Holy Sepulcher groups. As Heikamp, "Duomo," 36, rightly noted, Bandinelli's art has important parallels with popular art. For the influence of Michelangelo, see above, n. 44. Bandinelli's *Pietà* is notable for its exclusion of the Virgin Mary but this cannot be interpreted without further knowledge of the arrangements intended for the chapel (see below, n. 54). Bandinelli did, however, set a self-portrait relief into the base of the Duomo *God the Father* (Heikamp in Vasari, VI, 71, n. 1). Bandinelli's Annunziata *Pietà* parallels his paternal salutation at the end of the *Memoriale*: "And may (Our Lord), just as I give you my blessings on earth, give you his both in heaven and on earth" (trans. in Pope-Hennessy, *High Renaissance*, cat. p. 365).

53 For the reactions of contemporaries see D. Heikamp, "Poesie in Vituperio del Bandinelli," *Paragone*, XV, 175 (1964), 59–68. The figure was thought highly indecorous in its insistent physicality and because it seemed "tired" rather than dead. Both the celebration of the beauty of Christ's body and its subtle aura of life could be derived from Michelangelo's Roman *Pietà*, the only treatment of the theme by the master that Bandinelli had actually seen which was also made as a tomb monument. It is also conceivable that the much-criticized athleticism of Bandinelli's Christ was a deliberate allusion to the athlete of virtue (see C. Eisler, "The Athlete of Virtue: The Iconography of Asceticism," *De artibus opuscula XL: Essays in Honor of Erwin Panofsky*, New York, 1961, 92–97).

54 The most striking immediate forerunner of Bandinelli's idea in this respect is Rosso's *Pietà* in the Museum of Fine Arts, Boston. See J. Shearman, "The 'Dead Christ' by Rosso Fiorentino," *Boston Museum Bulletin*, LXIV (1966), no. 338, 148–72. It appears that Bandinelli also emphasized the Eucharistic aspect of the group by making his Christ considerably larger in scale than the supporting figure.

55 See Heikamp in Vasari, VI, 75, n. 3. This would have imitated the placement of Bandinelli's *Pietà* in the Duomo. That group was, moreover, also at one time to include a statue of Duke Cosimo as donor (Heikamp, "Duomo," 37). Bandinelli's plan was rejected by the Annunziata Chapter (November 13, 1558) as too presumptuous: only popes could be buried in the middle of a church. Another proposal, to install the tomb in the choir near the lectern, also failed. The present plan was adopted on May 2, 1559. Initially (February 28, 1558), Bandinelli had persuaded Lelio Torelli to write to Duke Cosimo requesting that Bandinelli's tomb replace Ammanati's Nari Monument on the inner façade of the Annunziata in the first chapel on the right (P. Kinney, *The Early Sculpture of Bartolomeo Ammanati*, New York, 1976, 68–72). Because the miraculous cult image of the Annunziata was frescoed on the left side of the same wall, the entire inner façade was considered especially holy. Had Bandinelli's plan succeeded, he would have bested a rival sculptor and captured the most prestigious chapel site in the church, and the ensemble would have acquired the Marian component now so strikingly absent. It is possible that the present arrangement allows the figure of Baccio to gaze toward the Michelozzo tabernacle.

56 DIVINAE PIET(ATI) B. BANDINELLI H(OC) SIBI SEPUL(CHRUM) FABREF(ACIEBAT). On all other occasions, Bandinelli used the form "faciebat," perhaps in homage to Pliny's report that Apelles used this form (M. Baxandall, *Giotto and the Orators*, Oxford, 1971, 64). "Fabrefaciebat" or "fabrefecit" stress the skill of the artist and, perhaps, also his authorship. Vasari, VI, 79, says Bandinelli used as-

sistants in finishing the work. The inscription on the tomb chest emphasizes the same theme. In 1559, neither the sarcophagus nor the inscription had been carved (*Memoriale*, 443). Thus the wording represents a late comment on the tomb's meaning either by the artist himself or by his heirs. Characteristically, the sides of the tomb are decorated with Medici symbols: *broncone*, ring, eagle, and winged capricorns.

[57] Vasari, VI, 73–76; *Memoriale*, 433, 439; and Heikamp, "Duomo," 60 ff.

[58] Apparently, contemporaries saw this too. See the anonymous satiric poem in Heikamp, "Poesie," 64: "Dico questa figura/Qual regge questo giovan stanco afflitto/Non saper quel che sia se no gli è ditto./Leggete quel ch'è scritto:/Egli è mio allevato e io son quello/Che son chiamato Baccio Bandinello." The versifier also implies that Bandinelli tries to make himself noble through his art, and notes that he is shown in "altra effigie."

[59] The treatment in Renaissance literature of a father's grief over his dead son also seems relevant to Bandinelli's restatement of the *Pietà*. See J. R. Banker, "Mourning a Son: Childhood and Paternal Love in the Consolateria of Giannozzo Manetti," *History of Childhood Quarterly*, III, 3 (1976), 197, 351–62. Manetti and other writers in the genre see the son's death as diminishing the father's immortality. They sanction intense paternal grief as both natural and holy because "God the Father knows the impact of a son's death . . . " Baccio mourns Clemente and records Michelangelo's praise of the young sculptor in the *Memoriale*, 433.

[60] Vasari, VI, 80, speculates that the shock of handling his father's bones contributed to Baccio's last illness. Michelangelo had also repeatedly voiced his wish to be buried with his father. It seems likely, however, that both instances are simply expressions of filial piety typical for the period.

# 16
# *The Mask*
# *in European Art:*
# *Meanings and Functions*

MOSHE BARASCH

In offering to Peter Janson this outline of a larger work I am, in fact, introducing a personal element in what should be an "objective" study. Years ago I showed Professor Janson a first draft of my discussion of masks, and he read it with that combination of serious criticism and encouraging interest we all know and love in him. Whatever progress I have made in the study of masks, their meanings and functions, owes a great deal to Peter's constant interest. I, therefore, take the liberty of presenting him this outline today.

The title of this paper may sound a little puzzling. We are familiar with the mask used in children's plays, and in some forms of rather light adult entertainment. Is this object serious enough to have either a meaning or a function in the vast and sublime realm we call "European Art"? And, even if it should turn out to have some kind of meaning or some sort of function, why do we speak in the plural, of meanings and functions?

I shall start by presenting some examples. My first will be that famous allegorical painting by Bronzino that has challenged the ingenuity of iconologists. The picture is usually dated about 1546—that is, in a period that witnessed an intense interest in, and a strong increase of, emblematic literature. The painting is, indeed, full of puzzles. Vasari described it as "A nude Venus with Cupid who kissed her, and Pleasure *(piacere)* was on one side as well as Jest *(giuoco)* and other Cupids, on the other side was Deceit *(fraude)*, Jealousy *(gelosia)* and other passions of love." In order to indicate Deceit *(fraude)* Bronzino painted two masks (fig. 1). In so doing he was not being "original," as one would say today; he was following tradition rather closely and speaking in an inherited language.

About half a century later, Annibale Carracci painted his *Hercules at the Crossroads,* now in the Museum of Capodimonte in Naples. As everybody knows, the subject was popular in that learned century, the cinquecento. *Virtus* and *Voluptas* are each trying to convince the pondering Hercules to follow her, Virtue asking him to climb a steep mountain, Voluptuousness offering him the pleasure of a lush landscape. But the pleasures Vice offers us are deceitful, and the artist, again in accordance with tradition, indicates this by placing a mask behind *Voluptas*.

The tradition according to which the mask as such indicates deceit was so well

253

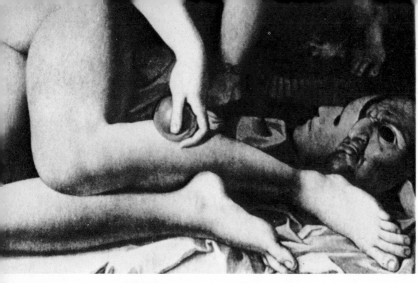

1. *Bronzino.* Exposure of Luxury (*detail*). *National Gallery, London*

2. *Raphael.* Parnassus (*detail*). *Stanza della Segnatura, Vatican*

2

established that Cesare Ripa, the great codifier of Renaissance iconography, describes in his *Iconologia* the personifications of *Fraude (Inganno)* as follows: "A lady, richly ornamented, and with the mask of a most beautiful youth under which is hidden the face of an old woman, deformed and ugly."

But is the indication of deceit the only and single function of the mask? Let us now look at one of the most famous works of Renaissance art, Raphael's *Parnassus,* which was certainly regarded by both Bronzino and Carracci as some kind of Bible. In the *Parnassus* muses and poets surround the inspired Apollo. One of the muses holds a mask in her hand (fig. 2). This mask does not hide anything. In fact, the mask identifies the figure, the muse herself who holds it in her hand.

Another interesting example of the "revealing" character of the mask is found

in Vasari's *Allegorical Portrait of Lorenzo de' Medici* (fig. 3). Here we see four
masks, differing from each other in shape and expressive quality. It would be very difficult to elucidate the meaning of these masks without some guide, but we are fortunate enough to have Vasari's own interpretation in his long letter to Alessandro de' Medici.[1] From the letter we learn that the ugly mask, with its distorted features and foreshortened position, represents vice involuntarily supporting virtue. The inscription on the ugly mask reads "Vice is subjacent to Virtue" *(vitia virtuti subiacent);* the glass vase, supported by the mask, stands for virtue, and bears the inscription *VIRTUTUM OMNIUM VAS.* Next to the vase there is a beautiful mask crowned with a laurel wreath and suspended from the spout of the vessel. Lorenzo de' Medici leans his head toward this mask, so that the two faces almost merge. Note the smooth surface, the regular features, and the youthfulness of this mask. These features stand in marked contrast to the contorted traits of the ugly mask. Further, while the ugly mask is seen in a bold foreshortening that distorts its proportions, the beautiful mask is fully displayed and softly lighted. From Vasari's letter we know that the beautiful mask represents *Praemium virtutis.* We see then that Vice is ugly, Virtue is beautiful. Can we still say that every mask is nothing but an indication of deceit? These two masks obviously have the opposite function: they reveal rather than deceive.

Ripa, too, knew of some masks' functions. Thalia, the muse of Comedy, holds "a ridiculous mask" *(una maschera ridicolosa)* in her hand, and this mask, as Ripa points out, suggests the "ridiculous subjects" of Comedy. Melpomene, the muse of Tragedy, also holds *una maschera,* but this time the mask is *in segno della Tragedia.*

How can this conflict be explained? How can one culture have held such widely differing, such clearly conflicting shapes and concepts of the same object? Perhaps a look at the history of the object can help us.

*3. Vasari.* Allegorical Portrait of Lorenzo de' Medici. *Uffizi, Florence*

4

5

*4. Mycenaean Funerary Gold Mask.*
*National Museum, Athens*

*5. Mycenaean Funerary Gold Mask.*
*National Museum, Athens*

Masks were known in antiquity as votive gifts, such as those discovered in a
sanctuary near Sparta or the Punic masks found in Carthage. Perhaps a mask was presented to a temple in the hope that some malady of the head would be cured (as pieces representing hands or feet were given with the request that these parts of the body be healed). The exaggerated, distorted features of these votive masks indicate a tendency that is frequently found in the ancient world: a type is made manifest in such exaggerations.

The tomb is another place where masks are found. An early and interesting example is the Mycenaean gold masks. They are equally fascinating in several different contexts: historians of religion have discussed their religious significance, other scholars have found in them evidence for the belief in the magic properties of gold. Our interest in them lies mainly in their manner of characterization. Let us compare, for instance, the morose, sullen face of one mask (fig. 4) with the cheerful countenance of another mask (fig. 5). (Note the upward-turned lips of the smiling mouth, a definitely established physiognomic formula for smiling.) The difference between these two faces is so striking and their characterization so convincing that a well-known classical scholar has called these masks "the first portraits."

Funerary art yields additional types of masks. There are the life masks found in Scythian tombs; their shape and character show Greek influence. Another type of funerary mask is the so-called face helmets (*Gesichtshelme*). Thracian face helmets are, of course, not portraits, but they often do indicate different types. We could compare two such helmets from the same period, probably the first century A.D.[2] The face of one looks somewhat mongolic, the other is Greek. This difference is not only one of general character, it can be found even in details. Thus the nose in the "Mongol" mask is fuller and softer, in the Greek mask it is straighter and more sharply cut. The lips in the one mask are full and fleshy, in the other they are thin and hard. The eyes in the one mask are narrower than in the other; their form, too, is different. I do not dare offer an explanation for these differences. What I would like to stress is only what we can see: the masks do show different types.

The problem of Roman ancestor masks has played an important part in classical scholarship. There is the well-known testimony of Polybius, the Greek historian who lived in Rome in the second century B.C., and became an enthusiastic supporter of Roman rule and values. One of the values that deeply impressed him was the Romans' veneration of ancestors, which also took the form of the preserving of ancestor masks. When a noble Roman citizen was carried to his grave, Polybius relates (VI, 53), his ancestors escorted him in an impressive procession: actors, resembling the deceased's forebears as closely as possible, wore the ancestral masks. Roman ancestor masks were also carried in other processions: thus, when a bride moved into the bridegroom's house, she brought with her a set of her ancestor masks. The actual masks, cast in perishable materials, have not survived; but they were frequently made into busts. Some perhaps still carry the flavor of actual life casts, though even these were certainly also gone over by some artist's hand. Probably the best-known example of this theme is the famous statue (in the Capitoline Museum in Rome) of a patrician holding in his hands two images of his ancestors.

The most important development of the mask in classical art is certainly to be found in the theater. Theater masks were also made of perishable materials and few of them have survived; we know, however, many classical representations of figures

wearing masks. On the stage articulate masks probably appeared for the first time in Aeschylus's plays (a Byzantine source describes him as the "inventor" of the stage mask), but they rapidly developed and ramified. In all these ramifications the essential function of the mask did not change, that of showing, of revealing and manifesting. When an actor entered the stage, his mask—large in size and exaggerated in feature—immediately revealed to the audience what his character was, his social or religious status, and sometimes also his ethnic origin.

Precisely because the mask was meant to communicate, the tendency was to give it conventional forms, to let it crystallize into definite shapes. In the process a variety of clear-cut types emerged, all of which had firmly established facial shapes. An author of the second century A.D., Pollux, has left us a catalogue of stage masks; though incomplete, it lists seventy-six in all, twenty-eight belonging to tragedy, four to satire, and forty-four to comedy (especially the New Comedy). Pollux's list is dominated by the concept of the type. The theater mask is never a portrait, but it does show genetic types. Take for example the mask of the Mourning Virgin, with pallid skin and short hair. This mask, as we know from Pollux and from the *Greek Anthology*,[3] could be used for both Antigone and Electra, that is, for any noble, tragic young woman.

Masks were usually meant to show the hero's character. As in so many other respects, here, too, Greek culture was focused on stable, unchangeable structure. However, there were also attempts to use the mask for showing emotions. A famous example is the asymmetrical mask, one half laughing, the other weeping (fig. 6). According to the emotions to be expressed (cheerful or sad), the actor would turn his head and show the suitable side of the mask. This type of mask made a deep impression in antiquity and several copies of it have come down to us.

One additional type of classical mask, employed in the theater as well as outside it, should be mentioned: the racial or ethnic mask. Blacks were certainly the most striking racial type known in the Greco-Roman world, and their typical features impressed themselves on the minds of Greeks and Romans. They found their expression also in masks. Look at the terracotta mask produced in the late sixth or early fifth century B.C., found in Agrigento, Sicily (fig. 7). It unmistakably indicates a black. We know that such masks of blacks were sometimes used in the Greek theater. Thus, in Euripides's *Andromeda* the chorus figures wore masks of blacks, in order to indicate that the plot was situated in the country of the Ethiopians.

Now, let me summarize these examples in a few words. As I have already said, their main function was to reveal, to make manifest whatever the playwright intended to show. Their function was thus diametrically opposed to the function of the masks in the Bronzino and Carracci paintings. But in order to make qualities of character or mood or ethnic affiliation visible in the face, the mask producers also had to articulate facial types and cast them into sharply defined, immediately recognizable shapes. Classical masks, especially those of the theater, present us with an almost complete scale of expressive types. The exaggeration of facial traits serves, in fact, the purpose of articulation. If we were to discuss the fascinating subject of the legacy of the classical mask in European imagery, we would have to emphasize precisely these two elements: the showing of character in the face, and the articulation of features so that they can serve the function of revealing.

The profound changes that took place in the early Christian period, changes that proved to be the most radical revolution in European history, also had an impact on masks. Both the shapes of masks and their emotional and symbolic connotations were affected by these transformations. Let me again start with some visual examples.

**6**

*6. Terracotta Mask. Museum, Taranto*

*7. Terracotta Mask. Museo Nazionale Archeo-
logico, Agrigento*

7

Already in the second century A.D. masks like the one here reproduced (fig. 8) had become predominant in certain parts of Europe.[4] This is a lifesize terracotta mask, produced in Germany; it was used in a ritual performance of one of the indigenous cults. Its slightly devilish appearance was probably not meant to portray a specific god, but this gradually became the characteristic appearance of the mask as such. The grinning mouth, the pointed teeth, the deformed nose are not typical of the Greco-Roman tradition (though individual features, in an exaggerated form, are certainly derived from that tradition), but these features were to become the dominant traits of masks during the next thousand years.

Careful observation of early Christian art discloses some very interesting influences of classical masks on the portrayal of Christian saints. A sixth-century mosaic image of St. John, in the Monastery of St. Catherine in Sinai (fig. 9), reveals a close affinity to the tragic mask of the Greek classical theater (fig. 10). The face of a wailing woman in the *Entombment of Jacob* in the Vienna Genesis is perhaps also influenced by a tragic mask. There probably was a thin trickle of such influences throughout the Middle Ages.

*8. Terracotta Mask. Cologne*

*9. St. John the Baptist. Mosaic. Monastery of St. Catherine, Sinai*

*10. Tragic Mask. Marble. Pompei*

8

10

But whenever in the Middle Ages the mask became more explicit, its medieval transformations had diabolic connotations. Everybody recalls the most characteristic medieval transformation of the mask, the "Mouth of Hell." As a fully articulated motif it emerged around the year 1000, though its beginnings are already found in the ninth century. It rapidly branched out into a variety of themes. Thus, from apocalyptic imagery emerged the combination of the Gate and the Mouth of Hell. Among the earliest examples is probably an illumination from the Winchester School (fig. 11), done in 1016. Illustrating chapter 20 of Revelation, the artist shows the angel hurling "the dragon, that primeval serpent which is the devil and Satan" (20:2) into the abyss and shutting the entrance by locking a door with a key. By the middle of the twelfth century the motif had become one of the central themes of book illumination. In a technical sense the Mouth of Hell is perhaps not a mask, yet there can be little doubt of the affinity between them, and perhaps also regarding the derivation of the Mouth of Hell from masks. The specific features of the mask—the head or face as an independent unit, the predominance of the mouth, the exaggerated and deformed traits—are found here in an almost pure form.

In French and German sculpture of the twelfth century we find attempts to isolate the motif from any narrative context. In a capital in the Church of Cunault (Maine-et-Loire) we see the lion—a creature frequently representing sin—reduced to his face (fig. 12). The lion's gorge has been split open by the column, as it were, and the capital weighs down so heavily on him that his head is squashed into a broad, horizontal shape. Again, in the precise sense of the word, this is not a mask. Yet its kinship to masks seems obvious. The notched line of the lion's teeth vividly reminds us of the second-century German masks discussed above (fig. 8). One should also mention briefly the wonderful demon heads in the Cathedral of Reims, all of them created in the thirteenth century. In the literature on medieval sculpture, especially on the sculpture at Reims, these diabolic heads are usually called "masks." I think the term is here correctly applied, although the actual relationship of the Reims heads to masks, especially to classical masks, seems never to have been properly studied.

Let me now pause for a moment and draw some tentative conclusions. The mask imagery of the Middle Ages seems to have three characteristic features:

1. The distinctions among different types, so important in classical art, were obviously lost: medieval masks look very much alike, and we certainly cannot speak of different types consistently portrayed as differing from each other.
2. Deformity, ugliness, and contortion are the overwhelming formal and expressive qualities in all medieval masks.
3. Usually medieval masks appear in a frightening and repulsive context: they are images of sin, the devil, and hell.

How are we to understand the dramatic shift from the classical mask to the medieval one? What were the motives that brought about such a radical transformation? We can perhaps get an intimation of the motives, and of a new attitude toward the mask, by reading the treatises, letters, and sermons of the Church Fathers.

Even at a rather early period the mask is considered as a means of hiding rather than of revealing. In a letter written by St. Jerome in 382 A.D. we read: "For while we were created in God's image and likeness, by reason of our own perversity we hide ourselves behind changing masks, and as on the stage one and the same actor now figures as a brawny Hercules, and now relaxes into the softness of a Venus or

the quivering tone of a Cybele, so we . . . have a counterfeit mask for every sin to which we are inclined."[5] The assuming of a false identity is here clearly described as a characteristic of the mask. This is also the reason for condemning Proteus, the hero of self-transformation and of assuming different shapes, and for seeing in him the origin of sin, as did St. Jerome: the heretics, he says, are "Protei" because their new, false religions appear in the guise of the old one. Another Father of the Church, Clement of Alexandria, condemns the use of cosmetics by women for precisely the same reason: it is, as he says, a "dissemblance of truth."

The "dissemblance of truth" is not only immoral, it also interferes with the divine design. Says Clement of Alexandria: "It is monstrous for those who are made in 'the image and likeness of God,' to dishonor the archetype by assuming a foreign ornament, preferring the mischievous contrivance of man to the divine creation."

Another Church Father, Tertullian, specifically applies this attitude to the mask, particularly to the theater mask. In the violent attack on the theater, in his short

11

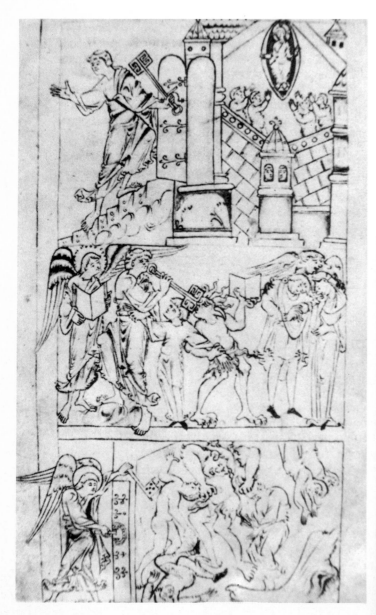

11. *MS Stowe 944. British Museum, London*

12. *Capital. Cunault (Maine-et-Loire)*

but very interesting treatise *De Spectaculis*, he says that the devil makes the tragic actor appear taller than he really is by using the cothurnus, the high shoe. "And then all this business of masks, I ask if God can be pleased with it, who forbids the likeness of anything to be made, how much more of His own image? The Author of truth loves no falsehood; all that is feigned is adultery in His sight" (ch. 33). In *De Spectaculis* Tertullian perhaps also refers to Roman ancestor masks and their display, the "long series of idol images, the band of ancestor images," as he says. "We know that the names of dead men are nothing—just as their images are nothing—but we are not unaware of who are at work under those names and behind the images set up for them, what joy they take in them, and how they feign deity,— I mean, evil spirits, demons." Here we have the combination of falsehood and demonic nature in connection with masks.

I should like to mention only one additional source, the learned sixth-century bishop, Isidore of Seville. An interesting chapter in his *Etymologia*, one of the earliest encyclopedias we have, is devoted to the "Gods of the Gentiles," the pagan gods. He calls these gods *larvae*, that is, by the term used to designate masks, especially ancestor masks; *Larvae*, he says, are men who have been turned into demons. The medieval connotation of the mask has here already crystallized. It is this connotation that we have seen visually expressed in works of art from the tenth to the thirteenth centuries. The demonic connotation of the mask survived throughout the Middle Ages. In the early fourteenth century the bishop of Nantes speaks against the *histriones* and *ioculatores* who wear *monstra larvarum*. And as late as 1608 a French author says: "The proof that the devil is the author of the masks is derived . . . from the word: *momo* in Greek, *masca* in Tuscan and *larva* in Latin designate a demon and a mask."[6]

We have now come back to the period from which we started, the Renaissance. In the Renaissance both the attitudes I have tried to outline were alive; the classical attitude was revived, the medieval continued its existence. But they did not exist side by side in complete isolation; they interacted, and as a result they sometimes produced new, original themes. I should like to conclude this outline by adducing one example of such an original creation, resulting from the interweaving of different historical traditions.

We remember that the mask as an implement of concealment was always sinful. In the medieval tradition, as it survived in the Renaissance, the concealing mask itself is always beautiful and attractive, but what it conceals is hideous and repulsive. This notion, of course, also survived in the Renaissance. Cesare Ripa pictures the personification of Death as wearing a mask; the skeleton is hidden behind a gold-brocaded mantle, the scraggy skull is concealed by a "delicate mask of most beautiful physiognomy and color." But in the Renaissance the significance of concealment is also inverted. I shall illustrate this by a text of rare fascination, which, incidentally, also has something to do with the visual arts. The author of this text is none other than Erasmus of Rotterdam.

Already in his *Praise of Folly* (1508) Erasmus hesitates to condemn the concealing mask altogether. In chapter 29 Folly speaks, referring to actors wearing masks (a curious combination of what Erasmus knew from literary sources about Greek actors, and perhaps also his knowledge of contemporary practice), and says: "If someone should unmask the actors in the middle of a scene on the stage and show their real faces to the audience, would he not spoil the whole play? And would not everyone think he deserved to be driven out of the theater with brickbats as a crazy man? For at once a new order of things would suddenly arise. He who played the woman is now seen to be a man; the juvenile is revealed to be old; he who a

little before was a king is suddenly a slave; and he who was a god appears now as a little man. Truly, to destroy the illusion is to upset the whole play. The masks and costumes are precisely what hold the eyes of the spectators." Previously Erasmus said that human affairs have two opposite aspects. What follows from all this is that the masks, although concealing, are not altogether false, and we cannot simply dispose of them.

Almost ten years later, in 1517, Erasmus published a new edition of his *Adagia*. This book, printed in many editions throughout the Renaissance, is a collection of brief proverbs, culled from Greek and Roman literature, combining Erasmus's famous erudition and his unsurpassed wit. In the 1517 edition there is one long essay which bears the title *Sileni Alcibiades*. You will remember that in Plato's *Symposium* the drunken Alcibiades, having to make a speech in honor of Socrates, begins by describing him as a Silenus. In fact, even an idealized version of Socrates's portrait shows Silenus traits. In Erasmus's vivid language: "Anyone who took him at face value, as they say, would not have offered a farthing for him. He had a yokel's face, with a bovine look about it, and a snub nose always running; you would have thought him some stupid, thick-headed clown." But Sileni, Erasmus remembers, were also small images divided in half, and so constructed that they could be opened out and displayed; when closed they represented some ridiculous, ugly flute player, but when opened they suddenly revealed the figure of a god. And now Erasmus, still paraphrasing the Platonic Alcibiades, goes on to say about Socrates: "But once you have opened out this Silenus, absurd as it is, you find a god rather than a man, a great, lofty and truly philosophic soul." This Silenus character is not restricted to Socrates. Erasmus finds the same character in prophets, in saints, and in sages. Wearing the humble mask is not a deception, it is part and parcel of their essence. In what is perhaps the most daring text Erasmus ever wrote, he says: "But is not Christ the most extraordinary Silenus of all?"[7]

The wearing of a mask does not here any longer carry a sinful connotation: it is part of a significant mystery, and "unmasking" does not have the meaning of revealing sinfulness, it rather acquires the connotation of penetrating into the mysteries; it is some kind of initiation.

*The Hebrew University of Jerusalem*

## Notes

Since I hope to publish an extensive and documented discussion of this subject, I am keeping the references here to a bare minimum.

[1] For the text of the letter, cf. Bottari-Ticozzi, *Raccolta di lettere*, Milan, 1822–25, III, 17.

[2] The helmets were shown in an interesting exhibition, *Thrakische Kultur und Kunst auf bulgarischem Boden*, Vienna, 1975, and reproduced in the exhibition catalogue.

[3] *Greek Anthology*, VII, 37. Cf. also Pollux, *Onomasticon*, IV, 138–41.

[4] I owe my acquaintance with this mask (and the photograph of it) to Professor Janson.

[5] *Selected Letters of St. Jerome*, Loeb Classical Library, London–New York, 1933, 174–75.

[6] E. Martene, *Thesaurus novus anecdotorum*, Paris, 1717, IV, col. 993 (and see also A. Nicoll, *Masks, Mimes and Miracles*, London, 1931, 165). *Traité contre les Masques par M. Jean Savaron*, Paris, 1608, as quoted in E. Welsford, *The Court Masque*, Cambridge, England, 1927, 33, n. 2.

[7] For an English translation, cf. Margaret Mann Phillips, *The 'Adages' of Erasmus: A Study with Translations*, Cambridge, England, 1964, 269 ff.

# 17

# A Bronze Bust
# of Cosimo I de' Medici for
# the Courtyard of
# the Pitti Palace*

DETLEF HEIKAMP

Cosimo I commissioned Bartolomeo Ammannati to create a marble fountain for the Sala Grande in the Palazzo Vecchio, although it was never erected there. After Cosimo's death in 1574 his son, Francesco I, had the fountain built to embellish the garden of his villa at Pratolino. Later, in 1588/89, it was transferred to the terrace above the Pitti Palace courtyard. But the meanderings of its statues were not yet completed, for they remained at the Pitti Palace only a few decades; in the seventeenth century the fountain was dismantled and replaced by Antonio Susini's Fontana del Carciofo (fig. 3). When Ammannati's sumptuous decorations were erected on the Pitti terrace, however, another work, installed nearby only shortly before, had to relinquish its place.[1]

Above the arched entrance to the grotto of the courtyard there had been affixed an epitaph in memory of Cosimo I, carved in marble and crowned by a bronze bust. Cosimo's son Francesco planned that the epitaph for his father should occupy this central position, in order to be highly visible. Though the project entailed no small expense and extended over several years, the finished epitaph itself remained *in situ* for little more than a year.

On 11 January, 1583, Ammannati and the archducal *provveditore*, Veri de' Medici, contracted with the stonemason Francesco Todeschi from Seravezza to have two roughly dressed white marble slabs of the finest quality placed on board ship before March 15. These two marble slabs were destined for the epitaph of Cosimo.[2] In April 1584 one slab was unloaded at Porto a Signa and transported to Florence.[3] Subsequently, on January 11, 1586, an agreement was made with the stonemason Matteo Caroni of Settignano to carve the epitaph from white and colored marbles, following a model by Ammannati. Caroni, however, was not to make the capricorns and the putti that decorate the epitaph, nor was he charged with the inscription.[4] Nonetheless, by the end of 1586 Caroni had completed his work, and in October 1587 the epitaph was installed.[5] In January of the following year Giovanni Battista del Tadda made the marble capricorns with their bronze horns,[6] and one hears nothing more of the putti planned in the initial stages of the project. Also in 1587, Del Tadda had made the bust into which would be set the portrait head of Cosimo

1. *Circle of Ammannati (attr.)*. Bust of Cosimo I de' Medici. *Palazzo Pitti, Florence*

2. *Circle of Ammannati (attr.)*. Bust of Cosimo I de' Medici *(profile without crown)*. *Palazzo Pitti, Florence*

3. *Courtyard of Palazzo Pitti, Florence*

I, which was to crown the epitaph. By January 1588 the head itself was completed and delivered to the *guardaroba*.[7] In 1589 the *archibusiere* Filippo d'Antonio was paid for having done the chasing on the Grand Duke's bronze crown for the bust.[8]

Despite all these elaborate preparations, the epitaph was taken down in the beginning of 1589[9] and reinstalled above the door on the central axis of the Sala delle Statue in the Palazzo Pitti.[10] In June a console was placed above the epitaph to support a bronze bust. This sculpture was not, however, the same large bronze bust originally planned for the Pitti courtyard (figs. 1, 2), but a different one that Baccio Bandinelli had made between 1556 and 1558.[11] The original bronze bust was now set instead above a portal in the Loggiato of the Pitti courtyard.[12]

The epitaph itself is still in place, where it has been since 1589, above the north portal of the Sala delle Statue (fig. 4), but for its new position the epitaph had to be simplified. The capricorns were omitted, perhaps because they would have seemed redundant, as there were already capricorns serving as consoles on Ammannati's doorway.[13] The epitaph tablet consists of two marble slabs, in accordance with stipulations of Caroni's contract. Unfortunately the inscription itself was erased at a later date.

Giovanni Battista del Tadda is documented, however, as having made the model of the bust section for the large bronze portrait of Cosimo. Giovanni Battista came from a family of sculptors, the Ferrucci from Fiesole, who flourished from the fifteenth to the eighteenth centuries, but he was one of its least-known members. In 1565 he, together with other artists, worked under Vasari's direction creating stucco decorations for the columns in the Palazzo Vecchio courtyard at the time of the marriage of Francesco de' Medici. In 1581 he worked at S. Maria della Spina

*4. Bartolomeo Ammannati. Portal of the* Sala delle Statue *crowned with an epitaph. Palazzo Pitti, Florence*

in Pisa.[14] Giovanni Battista's father, Francesco del Tadda, on the other hand, had been famous for his ability to carve porphyry.

The posthumous bronze portrait of Cosimo is dependent on a type created by Bandinelli.[15] The bronze head itself is superior in quality to the schematic bust, which indeed lacks any anatomical articulation. Thus, it seems likely that the head itself was not made by Giovanni Battista del Tadda, but by a more distinguished artist who is probably to be placed in the circle of Ammannati. In any event, the portrait was not very highly esteemed by its contemporaries, as is evidenced by its later location above an imposing portal in the Pitti courtyard. In this position the work was barely visible and thus largely neglected.

*Technische Universität Berlin*

*Documents*

## ABBREVIATIONS

ASF: Archivio di Stato, Florence

c.: carta

st.f.: stile fiorentino. Former Florentine method of reckoning time, according to which the calendar year began on March 25. Thus January, February, and most of March belong to the preceding year, according to the modern calendar

st.c.: stile comune. Modern time reckoned according to the modern calendar

br.: braccio, braccia. The Florentine *braccio* equals 58.36 cm.

libb.: libbra, libbre. A Florentine *libbra* is equivalent to 339.3 gr.

f.: fiorino

L.: Lira, Lire

sc.: scudo, scudi

s.: soldo, soldi

**1.**

1583, Jan. 11 (st.c.). ASF, Fabbriche Medicee, vol. 90, c. 12.

Addì 11 di Giennaio 1582.

Copia. Richordo chome questo dì sopradetto Messer Veri de' Medici provveditore et messer Bartolomeo Ammannati Architetto della fabbrica de' Pitti di S.A.S. ànno fatto merchato con Francesco di Vincenzo Todeschi scharpellino a Saravezza di dua pezzi di marmi bianchi della Cappella, di lunghezza b.ª cinque et mezo l'uno, larghi b.ª uno et uno terzo il mancho, grossi dua quinti di braccio; per prezzo di scudi diciotto di moneta tutta dua e pezzi, per darcieli cavati et abbozzati et condotti in barcha a tutte sua spese. Et debbino essere marmi bianchi della migliore sorte che si cavino in detto luogho, et ce li debba avere condotti alla marina per tutto dì 15 di marzo 1582 [st.f.]. Li quali debbino essere saldi et in tutte le parte merchantili, et abbozzati debbino restare le sudette misure et non mancho. Li quali marmi ànno a servire per l'epitaffio che va nel cortile de' Pitti, nella testata sopra la grotta, et la fabbrica li debba paghare scudi sei subito che arà cavati detti marmi et abbozzati et scudi sei quando saranno tirati alla marina et sc.ᵈⁱ sei per suo resto quando saranno messi in barcha. Et come si è detto, li debba dare condotti alla marina per tutto dì 15 di marzo prossimo 1582 [st.f.], et caso che detto Francesco manchassi, la detta fabbrica possa et li sia lecito farli cavare ad altri et condurli alla detta marina a

tutte sua spese. Et io Michele di Giulio Caccini scrivano di detta fabbrica, d'ordine di detti messer Veri et messer Bartolomeo, ò fatto questa scritta di mia propia mano questo dì sopradetto nel palazzo de' Pitti in Firenze, la quale sarà soscritta da detto Francescho.

Io Francescho di Vincenzo Todeschi affermo quanto di sopra si contiene et m'obbrigho et per fede i' ò [io ho] fatto di mia mano in Firenze questo dì sopra detto.

**2.**

1584, April–1584, Oct. 12. ASF, Fabbriche Medicee, vol. 61, c. 52v.

Antonio et Michele di Bastiano dal porto, navicellari, deono havere addì 12 di ottobre 1584 L. trentasette s. 13.8 piccioli, sono per nolo da Seravezza al porto a Signia d'uno pezzo di marmo biancho per l'epitaffio, condottoci sotto dì . . . [vàcat] da aprile 1584, pesa libb. 5140 . . . a L. 7 s. 6.8 piccioli il migliaio di nolo, monta, libbre 5140 . . . . . . . . . . . . . . . . L. 37.13.8

**3.**

1584, Aug. 6. ASF, Fabbriche Medicee, vol. 61, c. 27v.

Francesco di Piero Gambacciani carradore de' havere . . . addì detto [6 agosto 1584], uno pezzo di marmo per l'epitaffio, lungho br. 5 $^2/_5$, largho b$^a$ 1 $^3/_5$, grosso soldi 8 $^1/_2$, in tutto pesa libbre 5140 a L.3 migliaio . . . libb. 5140 L.—

**4.**

1585, Nov. 2–1586, Dec. 31, ASF, Fabbriche Medicee, vol. 63, c. 86v.

Matteo di Simone Coroni scarpellino a Settignano de' avere addì 31 di dicembre 1586 L. cinquecentocinquantadua piccioli, sono per la valuta del-l'appiè pietre e manifatture fatte in questa fabbricha da addì 2 di novembre 1585 a questo dì et prima:

Per fattura di uno epitaffio di marmo bianco e mistio, che va murato sopra la grotta del cortile de' Pitti, scudi 56, per merchato fatto d'achordo con Veri de' Medici et messer Bartolomeo Ammannati . . . . . . . . . . . L. 392—

**5.**

1586, Jan. 11 (st.c.). ASF, Fabbriche Medicee, vol. 90, c. 24.

Richordo questo dì 11 di giennaro 1585 [st.f.] come messer Bartolomeo Ammannati architetto della fabbrica de'Pitti di S.A.S. et messer Veri de' Medici provveditore ànno fatto merchato com' [sic] Matteo di Simone Caroni schar-pellino da Settignano della manifattura et lustratura d'une [sic] epitaffio di marmo biancho et mistio, conforme al modello fatto da detto messer Barto-lomeo salvo che non à fare né putti né li asciendenti né le lettere, ma ogni altra cosa à fare a sua spese di manifatture et lustrature, et caso che ci sia marmi o misti o' bianchi che si abbino a seghare, s'intenda che la fabbrica l'abbia a fare a sua spese, et questo potrebbe nasciere per avanzare pietra. Et tutto quel che debbe fare detto scarpellino s'intenda per prezzo di scudi cinquantasei di moneta, avvertendo anchora che nel modello non vi è cierto intaglio che vi debba andare, che lo debbe fare detto scarpellino a sua spese nel sudetto prezzo nella maniera che li ordinerà messer Bartolomeo sopradetto. Et per fede si soscriverà di sua propia mano di così essere contento

Io Mateo sopra ischrito sono contento a quanto di sopra è ischrito e per fede ò fato questo dì 11 di genaio 1585 [st.f.] di mia propia mano.

**6.**

1586, Feb. 20 (st.c.)–1586, March 22 (st.c.). ASF, Fabbriche Medicee, vol. 43, c. 8.

Addì XXII di marzo [1585 st.f.]

Assi a far debitore spese generale di f. 9 di moneta e creditore Francesco di Vincenzo Tedeschi da Seravezza scarpellino, se li fanno buoni per la valuta di uno pezzo di marmo bianco di Serravezza, lungho br. 5 2/5 largho br. 1 1/5, grosso br. 8 1/2, pesa libb 5140, auto dal detto più dì fa et condotto a Pitti sotto dì 20 di febbraio 1585 [st.f.], per detto prezzo d'acordo, per servitio dell'epitaffio del cortile . . . . . . . . . . . . . . . . . . . . . . . . . f.9 L.—

**7.**

1587, July 16. ASF, Fabbriche Medicee, vol. 64, c. 46.

Rede di Francesco di Gio. Batista Gabburri e Compagni linaiuoli deono havere . . . E addì 16 detto [luglio 1587] braccia otto di canovaccio rozzo, recò Maso di Domenico, consegniato a Gio. Battista del Tadda, per fare il modello del petto della testa che va sul'epitaffio . . . . . . . . . . . L. 4—

**8.**

1587, Oct. 31. ASF, Fabbriche Medicee, vol. 64, c. 45v.

Domenico del Zuta fornaciaio a Grassina de' havere addì 31 di ottobre 1587 moggia dua di calcina . . . per murar l'epitaffio et altro . . . . . . . moggia 2, L. 14—

**9.**

1588, Jan. 30 (st.c.). ASF, Fabbriche Medicee, vol. 64, c. 58v.

Lionardo di Bancho fabbro a Fiesole de' havere addì 30 di giennaio 1587 [st.f.] l'appiè robe, recò detto, consegniate a maestro Gio. Batista del Tadda schultore per far 2 caprichorni di marmo per l'epitaffio.

Ferri sottili da schultori n° 16 libb. 6 a s. 32 libb . . . . . . . . . L. 9.12—

Mazuoli da schultori n° uno di libb. 4 a s. 8 libb . . . . . . . . . . L. 1.12—

**10.**

1588, Jan. 12 (st.c.). ASF, Guardaroba Medicea, vol. 132, c. 215 left.

Inventario generale della guardaroba del Ser.ᵐᵒ Cardinale Gran Duca di Toscana Don Ferdinando Medici.[16]

Statue, figure, teste e bassi rilievi di bronzo et altri metalli

Una testa di metallo del Gran Duca Cosimo, con corona in testa e mezzo busto, hauta da detto [M. Giovanni Battista da Cerreto] . . . in dì 12 di gennajo [1587, st.f.].

**11.**

1588, June 23. ASF, Fabbriche Medicee, vol. 64, c. 93v.

Martino di Bartolomeo, merciaio al Gambero, de' havere . . .

Addì 23 di giugno [15]88 l'appiè robe recò Gio. di Giomo manovale, consegniate a Gio. Batista del Tadda per fare il modello del busto della testa di bronzo che va sul'epitaffio del cortile et prima:

filo di ferro grosso b. 4 libb. 1 oncie 8 . . . . . . . . . . . . . L. —.17.—

filo di rame libbre 3 oncie 3, as. 38 libb . . . . . . . . . . . . L. 4. 11.—

**12.**

1588, July 30 ASF, Fabbriche Medicee, vol. 53, c. 80v.

A spese d'opere che hanno lavorato questa settimana alla fabrica de' Pitti
sc. undici di moneta L. tre s. 18 piccioli, pagati a più persone per opere 66 ¹/₃
lavorate a fare capricorni et altro per l'epitaffio et altri affari . . . sc. 11 L. 18—

### 13.

1588, Sept. 24. ASF, Fabbriche Medicee, vol. 53, c. 86.
A spese d'opere che hanno lavorato questa settimana alla fabrica de' Pitti
sc. quattro di moneta L. cinque s. IIII piccioli pagati a più persone per opere
12 lavorate a rimettere le corna di bronzo de' capricorni del' epitaffio et altro
· · · · · · · · · · · · · · · · · · · · · · · · · · · · · · sc. 4 L. 5.4—

### 14.

1589, Feb. 23 (st.c.). ASF, Fabbriche Medicee, vol. 64, c. 151.
Giovanni di Domenico e compagni fabbri a' Ricci deono havere . . . sino
addì 23 detto [febbraio 1588 st.f.] una sprangha di libb. 18 ¹/₂ per la cornicie
dov'era l'epitaffio del cortile . . . . . . . . . . . . . . . . . . L. —

### 15.

1589, Feb. 28 (st.c.). ASF, Fabbriche Medicee, vol. 64, c. 154.
Filippo d'Antonio archibusiere de' havere addì 28 di febbraio [1588 st.f.]
L. 42 piccioli per havere rinetto una corona di bronzo per la testa di bronzo del
ser.ᵐᵒ gran Duca Cosimo messa nella sala delle statue de' Pitti, tutto d'ac-
cordo . . . . . . . . . . . . . . . . . . . . . . . . . . . . . L. 42—

### 16.

1589, March 6 (st.c.). ASF, Fabbriche Medicee, vol. 67, c. 4.
Scharpellini a cavar pietre nelle buche sul prato dalla tazza per la cornicie
del cortile dov'era l'epitaffio, et sassi per il condotto della fonte et altro, et
prima:
A Donnino Mannelli carradore L. otto piccioli per haver tirato dalla cava
al cortile 4 pietre grande per la cornicie dov'era l'epitaffio . . . . . . . . L. 8

### 17.

1589, March 6 (st.c.). ASF, Fabbriche Medicee, vol. 65, c. 28 left.
E addì 6 detto [Marzo 1587 st.f.] libb. 15 di detto [paletto] dato a maestro
Domenico di Francesco muratore per fare biette per lo epitaffio sopra la porta
nel mezo della loggia de' havere per tanto posto dare per resto di questo
conto . . . . . . . . . . . . . . . . . . . . . . . . . . . libb. 15—

### 18.

1589, March 6 (st.c.). ASF, Fabbriche Medicee, vol. 67, c. 3v.
Listra d'opere che lavoreranno questa settimana alla fonte de' Pitti di S.A.S.
da rassegniarsi per Michele Caccini Ministro da pagarsi per Raffaello Batini
Camarlengo et prima:
Muratori et manovali a murar l'epitaffio di marmo nella loggia rinchontro
a detta fonte
maestro Domenico di Francesco Mugiellini l.m.m.g.v.s. opere 6 a s. 42
· · · · · · · · · · · · · · · · · · · · · · · · · · · L. 12.12—

Manovali
Marcho di Giovanni Gherardi l.m.m.g.v.s. opere 6 a s. 15 . . . . L. 4.10—
Raffaello di Bernino da Narcietro l.m.m.g.v.s. opere 6 a s. 15 . . .L. 4.10—

A murar la cornicie di pietra forte dov'era il detto epitaffio di detta
fonte Matteo di Betto Masini l.m.m.g.v.s. opere 6 a s. 16 . . . . . L. 4.16—
Giovanni di Biagio Bardocci l.m.m.g.v.s. opere 6 a s. 16 . . . . . . L. 4.16—
Matteo di Niccolò dal Ponte a Ema l.m.m.g.v.s. opere 6 a s. 16 . . L. 4.16—
Giovanni di Francesco del Lungho l.m.m.g.v.s. opere 6 a s. 16 . . .L. 4.16—
Niccolò di Giovanni da S.ᵗᵒ Ghaggio l.m.m.g.v.s. opere 6 a s. 16 . .L. 4.16—
Giulio di Legrante di Firenze l.m.m.g.v.s. opere 6 a s. 16 . . . . . .L. 4.16—

### 19.

1589, June 19. ASF, Fabbriche Medicee, vol. 67, c. 49v.
Muratori et manovali a mettere e viticci et la testa di bronzo sopra l'epitaffio.
maestro Francesco Mugellini . . . . . . . . . . . . . . . . . . . . . L. 4.4—
Francesco di Ceseri . . . . . . . . . . . . . . . . . . . . . . . . . L. 1.16—
Domenico di Gabbriello . . . . . . . . . . . . . . . . . . . . . . L. 3.8—

*Notes*

* While this article was in press the bust of Cosimo I from the circle of Ammannati was exhibited in the Medici show in Florence: see *Firenze e la Toscana dei Medici nell'Europa del Cinquecento. Palazzo Vecchio* (exhibition catalogue), Florence, 1980, 348 ff., No. 714. In this catalogue entry the author published two newly found documents concerning the bust.

[1] On Ammannati's fountain, see the author's article, "Bartolomeo Ammannati's Marble Fountain for the Sala Grande of the Palazzo Vecchio in Florence," *Fons Sapientiae: Renaissance Garden Fountains,* Dumbarton Oaks Colloquium on the History of Landscape Architecture, V., Washington, D.C., 1978.

[2] See Doc. 1.

[3] See Doc. 2, 3, 6.

[4] See Doc. 5.

[5] See Doc. 4, 8.

[6] See Doc. 9, 12, 13.

[7] See Doc. 7, 10, 11.

[8] See Doc. 15.

[9] See Doc. 14, 16.

[10] See Doc. 17, 18.

[11] Bandinelli's bust and the one which we attribute to the circle of Ammannati were both kept in storage during World War II, and only recently was Bandinelli's reinstalled above the epitaph (fig. 4). This bust was published by the author in: "In margine alla 'Vita di Baccio Bandinelli'," *Paragone*, 191 (1966), 57–61 and pls. 45, 47. It is regrettable that a modern copy was not substituted above the portal, since this significant example of Florentine cinquecento sculpture is nearly impossible to see at its present height. To complicate matters, the following document suggests that the epitaph was planned much earlier and that Bandinelli's bust was already intended for it at that time: 1576, March 31 (ASF, Fabbriche Medicee, vol. 41, c. 68r): "Far debitore spese gienerale della fabbrica di L. settanta piccioli e creditore Raffaello di Davitte Fiorentini scultore per avere rinetto la corona di bronzo che va al ritratto della felicie memoria del gran Duca Cosimo che va nella testata del cortile, pregiata per Bartolomeo Amannati architetto . . . . sc. 10 L—." The present crown of the Bandinelli bust is not the original, for it does not have the characteristic forms established in 1569 by the papal bull of Pius V. Even further difficulty is created by another payment of October 2, 1574: "per costo di dua lime da limare e condotti della corona di bronzo per il ritratto di felicie memoria del gran Duca Cosimo" (ASF, Fabbriche Medicee, vol. 30, c. 60 left). This crown was either for the marble bust of Cosimo by Bandinelli, or for Cellini's bust of Cosimo, which was at Portoferraio on Elba after 1557.

[12] The bust is at present in the storage of

the Soprintendenza ai Beni Artistici. It is illustrated, although faintly visible, in its former setting in the Loggiato of the Palazzo Pitti courtyard (in A. Venturi, *Storia dell'arte italiana*, Milan, 1939, XI, 2, 257).

[13] The capricorns, which served as consoles supporting the entablature of the portal, are very similar to those in the vestibule of Palazzo Budini-Gattai (see Venturi, XI, 2, 286). According to seventeenth-century tradition the facture of the latter was executed by Giovanni Bologna (see E. Dhanens, *Jean Bou-logne*, Brussels, 1956, 93). The doors in the Sala delle Statue, also designed by Ammannati, were painted and partially gilded later.

[14] L. Tanfani, *Della chiesa di S. Maria del Pontenovo*, Pisa, 1871, 96, 229.

[15] See Heikamp, "In margine," pls. 44–47.

[16] See E. Müntz, "Les collections d'antiques formées par les Médicis au XVIe siècle," *Mémoires de l'Académie des Inscriptions et Belles Lettres*, 35, 2 (1895), 155.

# 18

# A Document for the Studiolo of Francesco I

MICHAEL RINEHART

Since the eighteenth century the paintings from the Studiolo of Francesco I have been considered representative of a certain moment in the history of Florentine art: "On peut les regarder comme une histoire animée de ce qu'étoit la peinture à Florence après l'époque heureuse & brillante de frère Barthélemi, d'André del Sarto, & du Buonarroti."[1] These remarks of Zacchiroli merely served to popularize a (not entirely unequivocal) judgment already expressed by Pelli[2] and handed down in innumerable Uffizi guidebooks throughout the nineteenth century. Codified by Luigi Lanzi in his *Storia pittorica*,[3] it is a view which survives to this day: "The Studiolo thus became . . . a *Kunstkammer* that enclosed not just a treasury of precious objects but a set of paintings—jewel-like artefacts in themselves—that crystallized the situation of the time in Florentine art."[4]

It is not surprising that the Studiolo paintings should have acquired a fixed place in the history of art just in the period when they finally lost their status as elements in a decorative scheme.[5] This was the period when the Medici *gallerie* were rearranged to illustrate the history and development of Italian art by examples.[6] Indeed the foundations of this interpretation had been laid by Vasari himself in the second edition of his *Vite* (1568) when he placed the *accademici del disegno* in the concluding position previously occupied by Michelangelo, and added a lengthy description of the decorations for the wedding of Francesco I.[7] The question of how Vasari used the Studiolo commission and others like it to shape contemporary artistic activity according to his conception of art history is one I should like to examine elsewhere. The present article concerns only one aspect of the Studiolo: the original arrangement of the panel paintings.

The restoration of the Studiolo paintings to their original setting in the Palazzo Vecchio had to await the discovery of the Vasari *Nachlass* in the Rasponi Spinelli archive by Giovanni Poggi in 1908. Among these papers Poggi found a series of six letters dealing with the program for the Studiolo, written between August 29 and October 5, 1570, to Vasari by his intimate friend and adviser Vincenzo Borghini. Two *invenzioni* which originally constituted part of this correspondence were also preserved.[8] These documents enabled Poggi to identify the room with its vaulted decoration and niches still *in situ,* and to reconstitute its dismembered parts: eight bronze statuettes and thirty-four panel paintings.[9]

The bronzes could be identified[10] and correctly situated on the strength of Borghini's *invenzioni,* which dealt at length with the overall program, the vault, and the statues. The paintings, too, were easily identified,[11] but their precise disposition in the room could not be determined on the basis of the documents. Borghini's *invenzione* breaks off at a moment when the design apparently still called for a single frieze between the niches in the upper register *ed altri spartimenti intorno agli armadi.*[12] Still, certain guidelines were supplied by the overall program:

> L'invenzione mi pare si dimandi conforme alla materia et alla qualita della cose che si hanno a riporre, talche la renda la stanza vaga et non sia interamente fuor di questo proposito, anzi serva in parte come per un segno et quasi inventario da ritrovar le cose, accennando in un certo modo le figure et le pitture che saranno sopra et intorno negl'armadij quel che e serbono dentro da loro . . . considerando che simil cose non sono tutte della natura ne tutte dell'arte, ma vi hanno ambedue parte, aiutandosi l'una l'altra . . . però havea pensato che tutta questa inventione fusse dedicata alla natura et all'arte, mettendoci statue che rapresentino quelli che furno ò inventori o cagione ò . . . tutori et preposti à tesori della natura, et historie di pittura che mostrino anche loro la varietà et l'artificio di quelle. . . .[13]

This program was conceived as a microcosm of art and nature, expressing their relationship to the elements, the humors, and the seasons as exemplified in mythology, literature, history, and contemporary technology. The documents served to interpret the extant mural decoration in the vault, to associate each wall with one of the four elements, and to place the bronzes in their appropriate niches. Although the evidence did not deal specifically with the panel paintings, the self-evident subjects of many of them, together with traditional identifications provided by Uffizi inventories, enabled Poggi to effect a reconstruction apparently consonant with Borghini's general statements. This reconstruction was completed in 1910. Based as it was on a careful study of the available evidence, it has remained unchallenged (fig. 1).

It is the objective of this article to consider certain problems in Poggi's reconstruction and to propose solutions in the light of a previously unpublished document. The first of these problems concerns a conspicuous inconsistency in the overall decorative scheme as we now see it. The decoration was clearly conceived as completely covering the vault and wall surfaces in uninterrupted sequences of rectangular paintings and statuary niches in an upper register, and oval paintings in rectangular intarsia frames in a lower register. These are bound in an interlocking symmetrical rhythm undifferentiated by windows or doors, without any stated relationship to the adjoining rooms. The source of the self-contained scheme can be traced to Michelangelo's Medici Chapel, though the purity of Michelangelo's design is here embellished according to a different taste, reflecting a conscious application of the theoretical unity of the three *arti del disegno,* architecture, sculpture, and painting.[14] The Studiolo is totally clothed in decoration: "In spirit (and incidentally, in function) it is like the Farnese casket turned inside out," writes John Shearman;[15] "an encrusted jewel box—inhabitable, with its ornament inside," according to Freedberg.[16]

And yet this striking design is not sustained throughout. In the context of the total scheme the presence of two asymmetrically placed undecorated panels in the lower register is obtrusive.[17] One might conclude that two paintings are missing

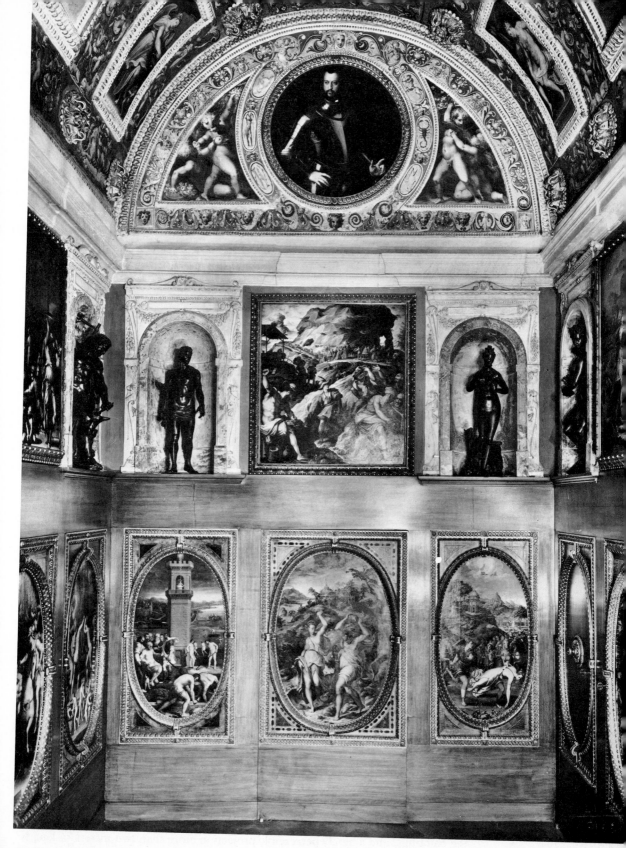

1. *View of the East Wall of the Studiolo of Francesco I. Palazzo Vecchio, Florence*

2. *Vincenzo Borghini. Sheet of manuscript notes. Archivio Storico Fiorentino*

from the series, were it not that the documents clearly state that there were no more than thirty-four *storie*,[18] the same number we see today. In the present reconstruction the undecorated panels correspond to two of the four original doors: the entrance from the prince's bedroom at the west, and the door to a secret staircase in the southeast corner. The two concealed doors (second and seventh from the left on the south wall) lead to the *tesoretto*, a small vaulted chamber immured in the fourteenth-century outer wall of the palace along the via della Ninna.[19] Presumably the rationale behind Poggi's arrangement is that the *tesoretto* doors were in some way more secret than the others, but this seems inconsistent with the fact that the door to the staircase provided a concealed exit from the palace. In any case, secrecy hardly seems a significant consideration for the internal disposition of a room the very existence of which was secret. The Studiolo was never included in sixteenth-century inventories of the palace. The real issue here is not the function of the doors, but rather the logic and coherence of the decorative scheme.

A number of other perplexing points are observable: the iconographical identification of several of the subjects is either unclear or unconvincing, and their relation to one another and to the overall scheme of the elements is not always evident;[20] there are unaccountable variations in the lateral measurements of the paintings; and a barely perceptible projection more than two meters in length

in the center of the cornice of the south wall seems curiously purposeless. A truly satisfactory reconstruction would have to account for the place of each subject in the overall physical and iconographical context, taking into consideration such features as the projecting cornice and the differences in measurement, while remaining true to the concept underlying the decorative scheme as a whole.

The known evidence provides little help in dealing with these problems; there exists, however, a heretofore unpublished document[21] which helps to solve them (fig. 2; Appendix). This is a sheet of notes in Vincenzo Borghini's "execrable hand"[22] consisting of a list of potential subjects for the Studiolo paintings. The sheet is divided by horizontal pen lines into four sections corresponding to the four walls of the Studiolo. In each of these four sections Borghini jotted down a preliminary list of subjects for paintings in the upper register in a column on the left side of the sheet, and for paintings in the lower register in a column on the right. Each group of subjects is annotated with a reference to its place in the iconographical scheme of the four elements and to the number of paintings required (e.g., *Fuoco p[er] di sopra 8* in the top left margin). Two auxiliary lists, whose relationship to the rest is not immediately clear, appear at the top center and the upper right of the sheet.[23] Finally, an unintelligible sketch (a group of figures?) occurs in the right margin about halfway down the page.[24]

Two significant facts emerge from a reading of this document: there was to be a *studiolo* (or cabinet) on the lower Water (south) wall, and the paintings were to be paired vertically with one another (and where relevant, with the statues) according to subject. The word *studiolo* at the bottom of the second column on the right refers to a cabinet intended to stand on the south wall. Its place on the page indicates that this is not a reference to the room as a whole. Indeed the term *studiolo*, applied to the whole room, was first generally used after the reconstruction in 1910. With one exception[25] the documents call it a *stanzino*, and the term generally applied in the early literature is *scrittoio*.[26] It is clear that the cabinet referred to in the document was to occupy the lower register of the Water wall, and it is probable that it was to have been the equivalent of two paintings in width.[27] This hypothesis is reinforced by the fact that precisely two spaces are not accounted for by the thirty-four paintings, and that the cornice projects slightly for a length of just over two meters, approximately equivalent to the width of two panels, along the center of the wall in question. This gentle punctuation repeats the treatment of the cornice above the niches.

We know nothing more about this piece of furniture. In the second edition of the *Vite* (1568) Vasari records that Buontalenti was at work on "*uno studiolo con partimenti d'ebano . . .*"[28] for Francesco de' Medici and that it was nearly finished at the time of writing. It is possible that the destination of this cabinet was the Studiolo of Francesco I. A few years later Buontalenti provided a second cabinet, for the Tribuna of the Uffizi, and the Studiolo was plundered of six of its bronzes for the decoration of the new room. Heikamp has shown the sequential connection between the Studiolo and the Tribuna.[29]

Borghini's list clearly reflects an early stage in the planning of the Studiolo. In the second of the two *invenzioni*, datable between September 18 and October 3,[30] he was not yet aware of the number and arrangement of the paintings. He believed there would be a continuous frieze between the niches: "Restonci quattro storie ne vani che rimangono fra queste statue nel fregio che rigira intorno la stanza tutta, come nel disegno."[31] He had apparently been provided with a design along

these lines. In the meantime, he received additional and contradictory information from Vasari. On October 3 he wrote his penultimate letter from Poppiano, displaying some confusion and impatience:

> Voi mi dite che le sono 34 storie, che son un buondati et da non venir' a capo cosi per fretta. Pero ci bisogna arte et giudicio di non entrar' in qualche gran lecceto et anche di non lasciar' nulla vuoto; et questo non posso far', s'io non veggo il sito et la forma degli armarii et le corrispondentie loro di sopra et da lato; et notate che non mi dicessi: trovate le storie et poi l'accomodemo, che e bisogna a rovescio accomodare le storie a luoghi et non i luoghi alle storie; perche queste si possono mutare et le stanze et le mura nò.[32]

Shortly after October 5, when the correspondence ends, he must have returned to Florence where he could see the room and consult his library.

The idea of pairing the subjects vertically seems to have come to Borghini as he was actually working on the sheet, probably in the days immediately following the letter just quoted. The words *Trovata d(e)l vetro* in the top left column were canceled and entered again in the right column alongside the fourth entry on the left, which reads *una fornace da vetri*. The next entry after the canceled *Trovata d(e)l vetro* in the left column reads *Fucina di fabri a ca(n)to Vulcano*, and serves to establish a similar relationship between the bronzes and the paintings below them. Subsequent entries bear out this pairing of subjects in the two columns, indicating that they are to be placed one above the other. *Getti di rame et Medagli* appears alongside *Alessandro ch(e) no(n) si lascia ritrarre se no(n) da Z(euxis)*; *Bottega di la(m)bicchi* appears alongside *Ulisse ch(e) ha il moly da Minerva; Orerie: anelli, smalti* alongside *onfile (o le tre dea col pome)*, *pioggia d'oro* having been canceled in the same place; *pesca di porpora* alongside *la historia d(i) Hercole; pesca di perle* alongside *la historia di Cleopatra et Ant(oni)o*. Each of these paired entries is singled out by a symbol jotted beside both items in the pair: #, //, Ø, ꜰ/. Not all the items listed in the document are paired, and not all the subjects indicated were eventually used. However, the mixture of mythological, historical, natural, and technological subjects so characteristic of the final decoration is already present.

Applying the document to the paintings themselves we find that four pairs mentioned in the list occur with only slight modifications in the executed series. These are:

| | | |
|---|---|---|
| Butteri | Glass Factory<br>Discovery of Glass (fig. 3) | *una fornace da vetri*<br>*Trovata d(e)l vetro*[33] |
| Poppi | Foundry<br>Alexander and Campaspe | *Getti di rame et Medagli*<br>*Alessandro ch(e) no(n)*<br>*si lascia ritrarre se*<br>*no(n) da Z(euxis)*[34] |
| Stradano | Alchemist's Laboratory<br>Ulysses and Mercury | *Bottega di La(m)bicchi*<br>*Ulisse ch(e) ha il moly*<br>*da Minerva*[35] |
| Allori | Pearl Fishing<br>Banquet of Cleopatra | *pesca di perle*<br>*La historia di Cleopatra*<br>*et Ant(oni)o.* |

Each of these pairs consists of a rectangular and an oval painting. The first three

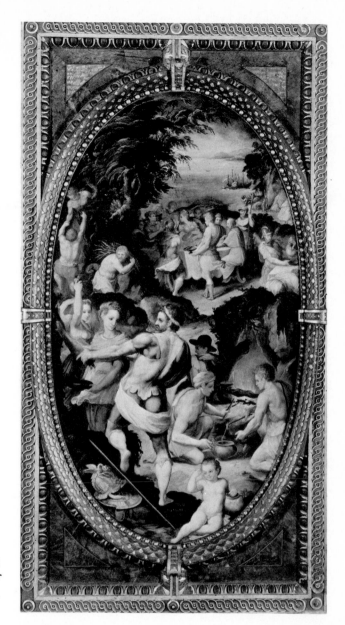

*3. G. M. Butteri*. The Discovery of Glass. *Studiolo of Francesco I, Palazzo Vecchio, Florence*

are associated in the document with the element of fire, the fourth with water. Only the fourth pair is presently installed together and correctly located.

Each of these pairs is by a single painter. Turning to the remaining paintings, there are twelve which can be grouped as six pairs, each pair by a single artist and each consisting of a rectangle and an oval:

| | |
|---|---|
| Macchietti | Baths of Pozzuoli |
| | Medea and Aeson |
| Maso da San Friano | Diamond Mining |
| | Fall of Icarus |

| Santi di Tito | Crossing of the Red Sea |
| | Discovery of Purple |
| Cavalori | Wool Refinery |
| | Sacrifice of Lavinia |
| Coppi | Discovery of Gunpowder |
| | Alexander and the Family of Darius |
| Naldini | Whale Fishing |
| | Allegory of Dreams |

At least one of the subjects in three of these pairs can be traced to the document: *acque di bagni salubri che risponda alle medicine* in the fourth line of the "auxiliary" list at the top of the page prefigures Macchietti's *Baths of Pozzuoli;*[36] *naschino* (?) *in diamanti* in the third section of the list, designated *aria di s(opra),* suggests Maso's *Diamond Mining;*[37] and the two subjects *pesca di porpora* and *la historia d(i) Hercole* indicated under *acqua* in the list are conflated into one in Santi di Tito's *Discovery of Purple.*[38] The first and third of these pairs are linked to water, the second to air. Of these only the two paintings by Maso are paired and presently installed in the correct place; Macchietti's paintings are paired but incorrectly located on the Fire wall.

The subjects of the remaining three pairs (by Cavalori, Coppi, and Naldini) do not appear in the document. Although their connection with one or another of the elements (Cavalori and Coppi with fire, Naldini with water) seems fairly evident, the iconographical relationships within each pair are not quite so obvious. Given the precedent established by the other pictures, however, it is reasonable to assume that such relationships do exist.[39] It is worth noting that (with the single exception of Santi di Tito's *Crossing of the Red Sea*) the technological, industrial, and natural subjects are depicted in the upper (rectangular) series, while the mythological and historical subjects occur in the lower (oval) series.

Two of the oval *sportelli* can be related to the bronze statues on the strength of the documents: Casini's *Forge of Vulcan* corresponds to the *Fucina di fabri a ca(n)to Vulcano* already mentioned; and Portelli's *Oceanus and Tethys* takes its place beneath the statue of Amphitrite, following the suggestion of the document in the last line in the second section of the left column: "un trio(n)fo di nettunno co(n) amphitrite che ignuda si presenti" (?).[40] Iconographical correspondences for the remaining six statues are not indicated in Borghini's list, but they are not difficult to establish:

| Apollo | Buti | Apollo Delivering Chiron to Aesclepius |
| Ops | Marsili | Atalanta[41] |
| Plutus | Sciorina | Hercules and the Dragon |
| Venus | Coscia | Juno Borrowing Venus's Girdle |
| Juno | Fedini | Policrates's Ring[42] (fig. 4) |
| Boreas | Traballesi | Danae[43] |

There remain four rectangular panels and two ovals, whose disposition is not difficult to determine. Two rectangular panels are required for the upper register of the south wall above the *studiolo;* these are Vasari's *Perseus and Andromeda* and Santi di Tito's *Sisters of Phaeton,* the subjects of which are obviously associated with water. The remaining four paintings fall into two pairs, exceptional only in that each pair is the work of two different artists. These are Zucchi's *Gold Mining*

and Minga's *Deucalion and Pyrrha*, which belong on the Earth wall; and Fei's *Goldsmithing* and Betti's *Sack*, which belong on the Fire wall.

It only remains to consider in what sequence the four pairs of paintings on the Water wall and the six pairs of paintings on the Fire wall were originally arranged. (The Air and Earth walls, each with only one pair of paintings, present no problem.) In this connection the slight variations in measurement in width within the two series, oval and rectangular, and also between the vertical pairs, is puzzling.[44] If the differing measurements do reflect a conscious part of the design, it would seem consistent with the rhythmic scheme of the overall composition that the wider panels be placed next to the niches. The single panels on the two shorter walls are both in a wide format. The resulting rhythmic sequence would be: aba/abccccba/aba/abccccba. This arrangement would serve to link wall to wall by the repetition of the proportional relationships of wide panels to niches. It would

283

*The Studiolo of Francesco I*

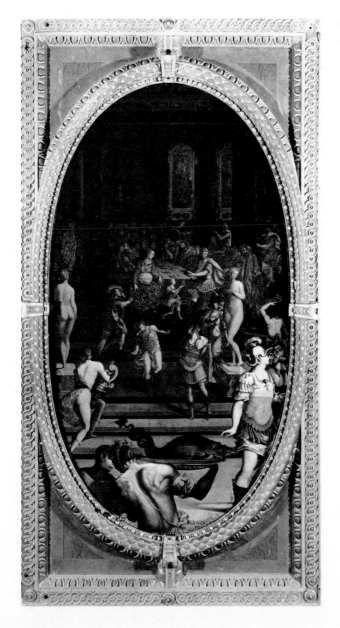

4. *G. Fedini*. Polycrates's Ring. *Studiolo of Francesco I, Palazzo Vecchio, Florence*

echo a feature of the iconographical program made explicit in Borghini's *invenzione*: "quella mirabil catena della natura,"[45] as demonstrated through the connection between the elements via the shared qualities (hot/cold/dry/wet) represented in the pairs of embracing putti in the corner fields of the vault and the common gender of the adjacent statuettes.

Borghini's list carries the primary evidence for the Studiolo program one step beyond the previously known evidence, and makes a more plausible reconstruction possible. Taken together with the rest of the documents it provides a vivid picture of a program in the making. The result is impressively encyclopedic, but it did not spring fully grown from its author's head. Whereas the two *invenzioni* are more finished essays, almost qualifying as drafts for a formal equivalent of Vasari's *ragionamenti*, the correspondence—and to an even greater extent the document published here—reveals Borghini's flexibility and willingness to experiment, his responsiveness to function, circumstance, and aesthetic demands as well as to the pleasures of erudition. In his letters and notes we see him drawing on fertile resources of learning and imagination to shape a program which is comprehensive, intellectually coherent, and also sensitive to contemporary aesthetic standards. Like the paintings of the artists for whom he worked, his method displays "una licenzia che, non essendo di regola . . . , " is nevertheless "ordinato nella regola."[46]

*Sterling and Francine Clark Art Institute and Williams College*

## *Appendix*

Archivio Storico Fiorentino, *Carte Strozziane*, prima serie, **CXXXIII**, fol. 139

### *1. Transcription*

Sale che si fa [—] in più modi
acqua salmacif
Mar morto la naphta al bitume che risponda alle minere
acque di bagni salubri che risponda alle medicine

attrita ligna [—]
pietre focaie
specchi da fuoco
  pulimenti

Getti d'Artiglerie
~~Trovata del Vetro~~
Fucina di fabri a canto Vulcano    Fuoco
Una Fornace da Vetri    per di so    Trovata del vetro    ~~Intagli~~ a Ruote di diamanti
La Fonderia della Miniera    tto

Fuoco per di sopra 8

Getti di Rame et Medaglie    6    Alessandro che non si lascia ritrarre se non da Z.    Intagli di Gioie

Bottega di lambicchi
Polvere [a farci un diamante che]    Ulisse che ha il moly da Minerva
Orerie : anelle, smalti    ~~pioggia d'oro~~ onfile (o le tre dea col pome)

---

Acqua di s
ƒ5

Acqua di sott ƒ4    ~~pioggia d'oro~~

pesca di Coralli con andromeda et col capo di medusa    la historia di policrate
pesca di porpora et    la historia di Hercole
pesca di perle    la historia di Cleopatra et Antonio

<div align="center">Fibuli</div>

una caverna di Tartari per [—]           historia di narciso o simile
un trionfo di nettuno con amphitrite       studiolo
[che ignuda si presenti]

---

| Aria di s | | di sotto | |
| 1 | [uno schiavo] in diamanti | 3 | historia di pigmaleone |

---

Terra di s     s la germania o Francia qualcosa
<div align="center">Caverne et [F]</div>

1        Miniere                          la pioggia d'oro

## 2. Translation

Salt manufactured [—] in various ways
water [—]
Dead Sea bituminous naphtha corresponding to mines
waters of health-giving baths corresponding to medicine

|  |  |  |  | [—] |
|--|--|--|--|-----|
|  |  |  |  | flints |
|  |  |  |  | mirrors for solar furnaces |
|  |  |  |  | polishing |
|  | casting of artillery |  |  | ~~engraving~~ of diamonds |
|  | ~~discovery of glass~~ |  |  | with wheels |
|  | blacksmith's forge beside Vulcan | Fire |  | engraving of gems |
|  | a glass furnace | below | discovery of glass |  |
| Fire | the mineral foundry |  |  |  |
| above | casting of copper and medals | 6 | Alexander refusing to be painted by any but Zeuxis |  |
|  | alchemist's workshop |  | Ulysses receiving the moly from Minerva |  |
| 8 | powder [to make a diamond which] |  |  |  |
|  | goldsmith's work: rings, enamels |  | ~~the rain of gold~~ Omphale (or the three goddesses with the apple) |  |

---

| Water above |  | Water |  |
| ¢5 |  | below | the rain of gold |
|  | coral fishing with Andromeda and the head of Medusa | ¢4 | the story of Polycrates |
|  | fishing for purple and | | the story of Hercules |
|  | pearl fishing | | the story of Cleopatra |
|  | fibulas |  |  |
|  | a Tartars' cave for [—] |  | story of Narcissus or the like |
|  | a triumph of Neptune with Amphitrite [who is shown nude] |  | studiolo |

---

| Air above |  | below |  |
| 1 | [a slave] in diamonds | 3 | story of Pygmalion |

---

Earth above     Germany or France or something
<div align="center">caverns and [—]</div>

1       Mining                         the rain of gold

---

The preparation of this article was made possible in part by a grant from the Leopold Schepp Foundation and a fellowship from the Harvard University Center for Italian Renaissance Studies (Villa I Tatti) in 1974. I am grateful to Paola Barocchi for first drawing my attention to the document published here, and to Gino Corti

<div align="right">*Notes*</div>

and Randy Starn for assistance in reading it. I am also grateful to Shirley Ariker, Julius Held, Edith Howard, Meg Licht, John Shearman, and Dustin Wees for their help.

1 Francesco Zacchiroli, *Description de la galerie royale de Florence*, Florence, 1783, 7.

2 Giuseppe Pelli, *Saggio istorico della real galleria di Firenze*, Florence, 1779, 144 ff.: "Questo monumento . . . pone in vista lo stato della pittura a tempi di detto sovrano, ed in consequenza fa l'istoria della scuola del tante vòlte rammentato Giorgio Vasari."

3 Luigi Lanzi, *Storia pittorica*, 1792 (ed. Capucci, 1968, 150): "Se aspersero in quell'opera difetti o comuni al secolo, o particolari di ognuno, pur mostrarono che il valore nella pittura non era ancora spento in Firenze."

4 Sydney J. Freedberg, *Painting in Italy 1500–1600*, Harmondsworth, 1971, 311.

5 The dismantling of the Studiolo actually began in 1586, hardly more than a decade after its completion, with the removal of six of the bronzes to the Tribuna. See Detlef Heikamp, "Zur Geschichte der Uffizien-Tribuna und der Kunstschränke in Florenz und Deutschland," *Zeitschrift für Kunstgeschichte*, XXVI (1963), 245, doc. 5; and Biblioteca della Soprintendenza alle Gallerie MS 70, *Inventario di tutte le figure, quadri et altre cose della Tribuna*, 1589. In Baldinucci's time the paintings had been removed to other rooms in the *palazzo ducale* where, however, they still served a purely decorative purpose: "ed è da sapersi come furon poi in tempo tutte le dette pitture levate da quel luogo, e servirono per ornamento d'un nuovo Gabinetto fra l'appartamento terreno, e le Regie Camere del Gran Duca del primo piano principale, et parte ancora al presente veggonsi per entro le medesime Camere terrene" (*Notizie de' professori del disegno*, V, Florence, 1702, 125). Coppi's *Discovery of Gunpowder* was in the Sala delle Armi of the Uffizi in 1759 (Giuseppe Bianchi, *Ragguaglio delle antichità . . . nelle gallerie mediceo-imperiale*, Florence, 1759, 185). Nineteen of the paintings were in the Pitti in 1771 (Archivio della Soprintendenza, filza IVB inserto 25: *Inventario dei diversi quadri ritrovati esistere in alcuni Mezzanini del Real Galleria de Pitti, i quali . . . atteso la qualità loro . . . sono stati riconosciuti meritevoli di esser prescelti e collocati nella medesima*). In 1782 they were in the Gabinetto delle Medaglie of the Uffizi ([Luigi Lanzi] *La real galleria di Firenze*, Florence, 1782, 101).

6 Germain Bazin, *The Museum Age*, New York, 1967, 162.

7 Giorgio Vasari, *Delle vite . . .*, 1568, III, 861–981, followed by the author's autobiography.

8 These documents are now in the Casa Vasari at Arezzo; they were published by Karl Frey, *Der Literarische Nachlass Giorgio Vasaris*, II, Munich, 1930, 522–35 *passim*, and 886–91.

9 A photograph of the Studiolo as it appeared before the restoration is reproduced in Cosimo Conti, *La prima reggia di Cosimo I de' Medici*, Florence, 1893, opposite 32. For a diagram of the decoration as presently reconstructed see Walter Vitzthum, *Lo Studiolo di Francesco I a Firenze* (*I grandi decoratori*), Milan, 1969, 14.

10 The six bronzes which had been removed to the Tribuna (see above, n. 5) were in the Museo Nazionale at the Bargello. The correct attribution of all eight bronzes was not established until Herbert Keutner's publication of the Danti *Venus* ("The Palazzo Pitti 'Venus' and Other Works by Vincenzo Danti," *Burlington Magazine*, C [1958], 427–31, esp. n. 10).

11 Pelli's inventory of 1784 (Biblioteca della Soprintendenza MS 113) unites and fully itemizes all thirty-four paintings for the first time. The inventory is accurate except that one signature (Marsili) is overlooked, and one (Fedini) misread. Of the five remaining unsigned and unattributed paintings Pelli might have identified two (Fei's *Goldsmithing* and Naldini's *Whale Fishing*) on the basis of Raffaelle Borghini's *Il Riposo* (Florence, 1584, 614, 635). The others (Portelli, Zucchi, and Santi di Tito's *Crossing of*

the *Red Sea*) are modern attributions‘ though the Portelli and Zucchi are confirmed by the Vincenzo Borghini correspondence (Frey, II, 578). Pelli's identifications of the subjects are substantially correct, too, with three exceptions: Portelli's *Oceanus*, Butteri's *Discovery of Glass*, and Fedini's *Story of Policrates*; see below, ns. 33, 40, 42.

[12] Frey, II, 887.

[13] Frey, II, 886 f. "I think the program should conform to the substance and quality of the things which will be placed there, so as to make the room pleasing and not wholly inappropriate. Indeed it should serve partly as an indication and classification for finding things, the statues and paintings above and upon the cupboards alluding in some way to their contents. . . . Considering that such things are the work of neither nature nor art alone, but a little of each, the one helping the other . . . I thought that the whole program might be dedicated to nature and art, with statues representing the inventors or the cause or . . . teachers and provosts of nature's treasures, and narrative paintings which would also show their diversity and skill."

[14] Vasari planned to adapt the Medici Chapel to these same theoretical principles by "completing" it with mural paintings *inter alia*, so that it might better fulfill its role as seat of the newly founded Accademia del Disegno. Cf. Frey, I, 719–21.

[15] John Shearman, *Mannerism*, Harmondsworth, 1967, 153.

[16] Freedberg, 311.

[17] First panel on the left of the south (Water) wall, and first on the right of the west (Air) wall. The carved and inlaid oval frames of these two panels are modern imitations of those on the painted *sportelli*.

[18] Frey, II, 533, letter of October 3, 1570.

[19] For a plan of the Studiolo and the adjoining *tesoretto* see Wolfgang Liebenwein, *Studiolo*, Berlin, 1977, 150, fig. 40.

[20] E.g., the so-called *Aeneas Landing in Italy* by Butteri, presently located under the statue of Juno on the west (Air) wall; or the painting generally identified as

*Belshazzar's Feast* by Fedini, now under Giovanni Bologna's *Apollo* on the north (Fire) wall. These identifications first appear in the inventory of 1784; see above, n. 11.

[21] Archivio Storico Fiorentino, *carte strozziane*, prima serie, CXXXIII, fol. 139.

[22] Review by Peter Brown in *Italian Studies*, XXVIII (1973), 121 ff., of Vincenzo Borghini, *Scritti inediti o rari sulla lingua*, ed. J. R. Woodhouse, Bologna, 1971, with an interesting discussion of Borghini's manuscripts and his contributions as a philologist.

[23] These "auxiliary" lists can be associated with the elements of Water (top center list) and Fire (upper right list).

[24] Edmund Pillsbury has dealt with Vincenzo Borghini as an amateur draftsman in the *Yale University Art Gallery Bulletin*, XXXIV (1973), 6–11.

[25] Letter of August 30, 1570 (Frey, II, 523): "Stamattina a buon'hora mandai la lettera con tutta l'inventione dello studiolo del principe."

[26] E.g., Raffaelle Borghini, *Riposo*, 1584, *passim*, and esp. 610: the terms *studiolo* and *scrittoio* both appear, clearly distinguished from one another. Baldinucci (see above, n. 5) also uses the term *scrittoio*. As late as 1872 Aurelio Gotti (*Le gallerie di Firenze*, Florence, 1872, 61) still referred to the room as *lo scrittoio*, whereas Alfredo Lensi, *Palazzo Vecchio*, Florence, 1929, 349, calls it *Lo Studiolo di Francesco de' Medici*.

[27] The numbers given in the margin of each section of Borghini's list are problematic, presumably reflecting his lack of firsthand knowledge of the room. *Fuoco di sopra* and *fuoco de sotto* are designated as having eight and six paintings respectively, whereas actually the reverse is true. Under *a(c)q(u)a di s(otto)* the number 6 has been reduced to 4 to allow for the addition of the *studiolo* at the bottom of the list. The reduction by two seems significant even though the numbers themselves are mistaken.

[28] Vasari, *Le opere* . . . (ed. Milanesi), Florence, 1906, VII, 615.

[29] See above, n. 5.

[30] These dates are determined by the

document's reference to the vault as already begun (September 18, according to Vasari's *ricordo*; cf. Frey, II, 881) and Borghini's letter of October 3 (Frey, II, 530), which refers to the prince's favorable reception of the *invenzione*.

[31] Frey, II, 891.

[32] Frey, II, 532 f. "You tell me there are 34 narrative paintings, which is a good deal and not to be thought up in a hurry. Skill and judgment will be needed not to be led into some great thicket and also not to leave anything empty; and this I cannot do until I see the site and the form of the cupboards and how they are related vertically and horizontally. Take care not to say to me: find the subjects and then we will accommodate them, because on the contrary the subjects must be accommodated to the site and not the site to the subjects. These can be changed, but rooms and walls cannot."

[33] Butteri's *Discovery of Glass* (fig. 3) has been identified as *Aeneas Landing in Italy* ever since the inventory of 1784 (see above, n. 11), even though the essential feature of Virgil's account (*Aeneid*, VII, 25 ff.), the *mensae*, are not present. The picture actually represents the accidental discovery of glass as told by Pliny (*Nat. Hist.*, XXXVI, 65). The scene is the mouth of the river Belus at the foot of Mount Carmel where the quality of the sand lent itself to the making of glass.

> There is a story that once a ship belonging to some traders in natural soda (*nitrum*) put in here and that they scattered along the shore to prepare a meal. Since, however, no stones suitable for supporting their cauldrons were forthcoming, they rested them on lumps of soda from their cargo. When these became heated and were completely mingled with the sand on the beach a strange translucent liquid glowed forth in streams; and this, it is said, was the origin of glass (Eng. trans. by D. E. Eichholz, Loeb Classical Library, 1962).

[34] Borghini mistakenly ascribes this anecdote to Zeuxis. In fact it was Apelles to whom Alexander gave the exclusive right to paint his portrait (Pliny, VII, 125). The subject was subsequently changed to illustrate how Alexander commissioned Apelles to paint his mistress, Campaspe, and presented her to the artist on perceiving that he had fallen in love with her (Pliny, XXXV, 85–87). In his letter of October 5 Borghini warned against using too many *botteghe* as subjects, and suggested instead of a mint "Alexandro magno a seder' con quel pictore, scultore, intagliator' intorno, a quali solo per privilegio era permesso ritrarlo o in pictura o in bronzo o in medaglia et marmo" (Frey, II, 534). The specific connection between princely iconography and the casting of medals in the document was transformed into a general illustration of magnanimous princely patronage.

[35] Borghini has confused Minerva with Mercury. The story illustrated occurs in the *Odyssey* (X, esp. 274 ff.): Mercury gave Ulysses a branch of the herb moly to protect him from the spells of Circe. The power to transform is of course related to the alchemist's laboratory.

[36] The salubrious waters of the baths are clearly linked to the rejuvenation of Aeson by Medea (Ovid, *Metamorphoses*, VII, 251–94). The identification of these baths with Pozzuoli stems from Raffaelle Borghini, *Riposo*, 604–5.

[37] The first word is not entirely legible. The subject of Maso's painting is clarified by Borghini's second *invenzione*: "sotto l'aria ne vorrei una bizzarra et stravagante, cioè che fingessi monti asprissimi più che la nostra pietra pana o la vernia o il caucaso degli antichi dove con fune scale di corda (che questa è la catena che fingono di Prometeo) et [con] altri ingegni: fussin persone che andassin cercando i diamanti i cristalli et fussino appiccati a que balzi come picchi etcetera" (Frey, II, 891). The relation of the subject to the element of Air is explained by Borghini's interpretation of Juno in the double role of *signora dell'aria* and protectress of rings and precious stones, and of Boreas as the cold North wind who was thought to have created diamonds and rock crystals by freezing (Frey, II, 887).

[38] The story of the accidental discovery

of purple is told by Pollux (*Onomasticon*, I, 45): Hercules's dog attacked a murex along the shore and returned to his master with a purple-stained mouth. When his mistress saw this, she longed for a dress of the color.

39 Cavalori's painting illustrates the *Aeneid*, VII, 71–77. The miraculous blaze of Lavinia's hair at the altar as Aeneas landed in Italy was taken as an omen of fame to herself and war to her people. There is a possible connection with the subject of his other painting, the *Wool Refinery*, in the subsequent narrative: Latinus, Lavinia's father, troubled by the portent, visited the oracle of Faunus. "Hither the priestess brings the offerings, and as she lies under the silent night on the outspread fleeces of slaughtered sheep and woos slumber, she sees many phantoms. . . . Here then also King Latinus himself, seeking an answer, duly slaughtered a hundred woolly sheep and lay couched on their hides and out-spread fleeces" to await the oracle's explanation of the portent. Naldini's *Whale Fishing* is mentioned by Raffaelle Borghini (*Riposo*, 614), who calls it "il modo che si tiene à far l'Ambracane," that is, the collection of ambergris. Ambergris was valued for medicinal purposes in antiquity. There is a link suggested between this and Naldini's other picture, the *Allegory of Sleep* (itself based on Ovid, *Metamorphoses*, XI, 592 ff. and Homer, *Odyssey*, XIX, 560 ff.), in a passage in Pliny, in which inhalations of the rennet of a whale are recommended as a remedy against lethargy (*Nat. Hist.*, XXXII, 116).

40 This last phrase is not quite legible. I owe the identification of Portelli's subject to Scott Schaefer, *The Studiolo of Francesco I . . .*, unpublished Ph.D. dissertation, Bryn Mawr, 1975.

41 After the race between Atalanta and Hippomenes, the couple defiled a temple

sacred to Cybele, *turrita Mater* identical with Ops, who transformed them into lions. This scene is depicted in the background of Marsili's painting.

42 The painting (fig. 4) is identified as *Daniel at Belshazzar's Feast* in the inventory of 1784, but there is no justification for this, since the writing on the wall, without which the subject has no meaning, does not appear (Daniel 5: 5–30). The presence of the fisherman and the prominence of the fish in the foreground indicate that the subject is the recovery of Polycrates's ring, a subject proposed by Vincenzo Borghini in his letter of October 5: "quando Policrate, signor di Samos, havendo preso a caso un bellissimo pesce et parendogli un dono da signori, gliene presentò et li fu trovata in corpo quella gemma" (Frey, II, 534). The story, familiar to German readers through Schiller's poem, comes from Pliny (XXXVII, 3–5). The subject had initially occurred to Borghini as appropriate for the Water wall (cf. *la historia di Policrate* in the second section of the righthand list), but its connection with Juno is already made clear in the first *invenzione*: "Giunone, tenuta da gl'antichi signora dell'aria et governatrice de matrimonii, in protetione della quale sono gl'anelli et le gioie . . . che si legano in anello" (Frey, II, 887).

43 *La pioggia d'oro* appears in three places in the document, under Fire, Water, and Earth.

44 Variations of as much as 25 cm in width exist among the rectangular panels. The rectangular series seems to fall into wider (99–107 cm) and narrower (79–89 cm) groups. However, a detailed exploration would require more reliable measurements than are presently available.

45 Frey, II, 889.

46 Vasari (ed. Milanesi), IV, 9, from the introduction to the third part.

# 19

# Pearls from a Dungheap: Andrea Alciati's "Offensive" Emblem, "Adversus naturam peccantes"*

W. S. HECKSCHER

Ernst H. Kantorowicz, when reading an
ambitious essay, observed: ". . . it were
better had not all problems been solved. Perhaps
the backbone of history: the insolubilia, the
latent antinomies and aporiae."

The father of emblematics, Henry Green, may have reacted in a typical Victorian manner when he referred to Alciati's emblem, whose woodcut shows a naked youth using a precious vessel as a chamber pot, as "offensive." Green's aversion, fortunately, did not prevent him from publishing the emblem as it appeared, in a less shocking form to be sure, for the first time in the Aldine edition of 1546. There the perpetrator is shown as a bearded gentleman, hovering over an anything but luxurious open keg (fig. 1).[1]

My study of the emblem offered here, riddled as it may be with insolubilia, offering at the same time inescapable contradictions and ambiguities, should primarily be regarded as an attempt to continue where Henry Green left off. The objections to Alciati's emblem antedate Henry Green and the nineteenth century by far. At first, it seems, no one bridled when confronted with its woodcut or when being confronted with the emblematic motto and epigram, which after all deal with the rather formidable subjects of scatology, adultery, homosexuality, and incest. The emblem is a latecomer. Alciati, to the end of his life (he died in 1550), continued to add to his book of emblems. Between 1546 and 1549 he almost doubled the number of his emblems by adding totally new ones. Our emblem, it seems, appeared for the first time in the Aldine edition, Venice 1546. This edition received a ten-year approbation from both the Pope and the Venetian Senate.

It seems that on account of the "offensive" emblem, Alciati's entire emblem book was placed on the *Index librorum prohibitorum* of the Spanish Inquisition. Our only source for this bit of intelligence, Conte Giammaria Mazzuchelli, the learned Italian antiquarian of the eighteenth century, notes that the mitigating

ANDREAE ALCIATI

*Aduersus naturam peccantes.*

*Turpe quidem factu, sed & est res improba dictu,*
*Excipiat si quis chœnice uentris onus.*
*Mensuram legisq; modum hoc excedere sanctæ est,*
*Quale sit incesto pollui adulterio.*

1. *"Aduersus naturam peccantes."* Alciati, Emblematum libellus, *Venice (Aldus), 1546, fol. D ii v.* "Cum privilegio Pauli III. Pont. Max. & Senatus Veneti." First appearance of the emblem. Courtesy The Newberry Library, Chicago

2. *"Aduersus naturam peccantes."* Alciati, Emblemata *(ed. optima), Padua (Tozzi), 1621, 353. Courtesy Princeton University Library, Dept. of Rare Books*

3. *"Aduersus naturam peccantes."* Alciati, Emblemata, *Padua (Frambotti), 1661, 353. In all essentials a twin of ed. 1621 (fig. 2). Courtesy Princeton University Library, Dept. of Rare Books*

Emblemata. 353

Aduerſus naturam peccantes.
EMBLEMA LXXXI

TVRPE quidem dictu, sed & est res improba factu,
Excipiat siquis chœnice ventris onus.
Mensuram, legisque modum hoc excedere sanctæ est,
Quale sit incesto pollui adulterio.

2

Emblemata. 353

Aduerſus naturam peccantes.
EMBLEMA LXXX.

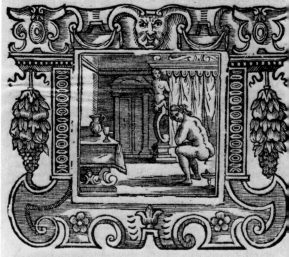

TVRPE quidem dictu, sed & est res improba factu,
Excipiat siquis chœnice ventris onus.
Mensuram, legisque modum hoc excedere sanctæ est,
Quale sit incesto pollui adulterio.

3

proviso "donec corrigantur"—"until they have been corrected" had been added.
This particular phrase at least offers a terminus post quem since it was first introduced in March of the year 1564.[2]

Any work on Alciati's *Emblemata* must start with the editio optima, Padua (Tozzi), of the year 1621.[3] This edition, magnificent in every respect, was produced under the all-over supervision of the German medicus and orator Joannes Thuilius (c. 1590–1630) who had been invited to shoulder this task by the publisher, Petrus Paulus Tozzi of Padua. Thuilius crowned his editorial work with the most elaborate as well as competent commentary Alciati's emblems had elicited.[4]

Joannes Thuilius was aware of the fact that, on the whole, the Italians looked down upon the Germans with undisguised disdain. They apparently knew all about German perfectionism, German verbosity, and German lack of imagination. Someone asserted that "the Germans' brains were in their behinds," and that "for genius the Germans substituted hard, sweating labor."[5] This notwithstanding, Thuilius, as he put it, preferred to cling to truth, native truth, rather than prostitute his work with superficially added splendor, for the sake of the uncultured masses.[6] I intentionally mention Thuilius's disdain of the masses, because our emblem deals (as do many others in Alciati's oeuvre) with the concept of dangers involved when one tries to cater to shallow and vulgar minds—a procedure that evokes the image of either committing precious matter to an unworthy vessel, or its opposite, when a precious vessel is soiled by some unworthy substance.

In analyzing the Motto of our emblem, "Adversus naturam peccantes" (see figs. 2, 3), we soon discover that it has a venerable pedigree. Where, e.g., St. Thomas Aquinas uses, in his *Summa de veritate catholicae fidei contra gentiles* (III, 122), the phrase "contra naturam," we can be pretty certain that he borrowed it from Aristotle's παρὰ φύσιν (*Phys*. V, 6, 230.a.20). For St. Thomas's use of "contra cursum naturae," see his *Summa Theologiae* (II. II. 154, 2 ad 2). In the Vulgate (Romans 1:26), St. Paul introduces the expression, "In eum usum qui est contra naturam," thereby alluding to Lesbian women who have inverted the natural custom: "Nam feminae eorum immutaverint naturalem usum in eum usum qui est contra naturam." Wherever we look, we may encounter expressions such as "secundum naturam vivere," "naturam sequi," "à natura discedere."[7]

The text of Alciati's Epigram, as it appears on page 353 of the 1621 edition and its progeny, is as follows:

Aduersus naturem peccantes.
### EMBLEMA LXXX.
Tvrpe quidem dictu, sed & est res improba factu,
  Excipiat siquis choenice ventris onus.
Mensuram, legisque modum hoc excedere sanctae est,
  Quale sit incesto pollui adulterio.

My intentionally literal translation of Alciati's Epigram reads line by line:

On those sinning against nature.
### EMBLEM LXXX.
It is quite shocking to relate, but even more so, it is a foul deed,
  If anyone were to evacuate the burden of his bowels into a choinix [i.e.,
    a vessel intended for measuring the daily food ration].

This means transgressing beyond the measure and canon of divine law,
Just as it would be to allow oneself to be defiled by sexual aberration.

At this point I must draw attention to a strange discrepancy in the first line of Alciati's Epigram: the interconnecting phrase "sed & est" was obviously meant to introduce a qualifying afterthought which, in a faithful translation, would have required a "but also," rather than my "but even more so"; then the first line would have to read: "Scandalous to say but also monstrous when done"—in every respect a lamentable hysteron proteron.

The solution of this puzzle came by sheer accident. As I attended a Christmas party in the Rare Book Department of the Princeton University Library, I felt tired and made my way to the reading room where, almost instantly, I fell asleep. As I awoke, my eyes fell on an early edition of Alciati's emblem book which my friend Agnes Sherman had left for me on the table. It was the Roville-Lyon edition of the year 1548, in which the text of the Adversus emblem occurs. And here the first line of the Epigram reads quite differently:

Turpe quidem factu, sed et est res improba dictu.

Checking this line (in which "factu" precedes "dictu") in all available editions—preceding and following that of Padua 1621 and its dependents—it dawned on me that Thuilius-Tozzi with their "dictu"—"factu" sequence were by no means alone but simply following in this transposition all the editions that were provided with Claude Mignault's commentaries. As a result I came to realize that in the cases where the "Adversus naturam" emblem did appear, the "factu"—"dictu" sequence had to be considered in keeping with Alciati's original intentions, while the reversal was obviously the case of a persistent flaw. The first line in its better wording should be translated:

It is perfectly hideous as a deed and it is also a matter of impropriety even to mention it.[8]

Whatever the ultimate statistics, editions carrying the Adversus emblem are in the minority. Of the total of 170-odd Alciati editions between 1531 (Augsburg) and 1661 (Padua) I have examined about sixty. Among those, twenty-one incorporated the emblem but only two (1546 and 1621 + 2 repeats) had the emblematical picture. The vast majority therefore have only motto and epigram; those lacking the woodcut have been referred to as "nude."[9]

As we turn to Thuilius's commentary which follows the emblem, we realize to what extent his truly cultured and original mind was able to trace Alciati's sources of inspiration. Thuilius observes:

No one has thus far produced a picture for this emblem.[10] As for the epigram itself, commentators have brushed it aside "in a cavalier way," as the saying goes.[11] I shall, however, by no means shy back from tackling the somewhat unseemly subject with quite unrestrained words, especially since this trifle requires a rather thorough weeding out.

For this reason I have instructed the artist as follows: Let there be a bed—on all sides closed with curtains—and beside it, let there be a naked man who unburdens his belly into a golden vessel.[12]

Close by him, let there stand on a table an earthenware pitcher and a goblet made of glass. . . . Yet, what goes on in the screened-off bed, let that be my and the artist's concern. I am anxious to spare chaste eyes and—in doing so—

*Ma la ragion non m'è ſcouerta a pieno,*
*Forſe, perch'ei natura haue laſciua;*
*E libidine molta? o perche adorna*
*Le Romane Matrone con la pelle?*
*Appellan molti Zibellino il Sorcio*
*Sarmatico: Et è celebre, e famoſo*
*L'Arabo muſchio per ſoaue vnguento.*

Aduerſus naturam peccantes.

EMBLEMA LXXX.

TVRPE quidem dictu, ſed & eſt res improba factu,
Excipiat ſiquis chœnice ventris onus.

H Men-

Menſuram, legisque modum hoc excedere ſanctæ eſt,
Quale ſit inceſto pollui adulterio.

*Sopra Quelli, che peccano contra natura.*

EMBLEMA LXXX.

BRVTTA *certo a parlar, ma ſcelerata*
*E' coſa a far, ſe ne la coppa d'oro*
*Scarchi, e riceua, alcun, del ventre il peſo.*
*E' queſto Vn traſgredir de la Natura,*
*E de le Sante Leggi il Modo, e'l Giuſto;*
*Qual fia'l macchiarſi d'adulterio inceſto.*

De-

4 a, b. *"Aduersus naturam peccantes." Alciati, Emblemata, Padua (Tozzi), 1626–Latin and Italian. Sm. 8ᵛᵒed. without introductory matter & Indexes, 113–14. Courtesy Princeton University Library, Dept. of Rare Books*

minds. For this reason to be sure the emblem was "relegated to the end"—"ad calcem reiectum fuit"—by Minos since it seemed to him unsuited for chaste ears, and in his judgement unseemly for circumstantial interpretation.[13]

But I won't be ashamed to retrieve pearls from a dungheap. . . . Ergo ad rem: I notice an allusion to one of Pythagoras' symbols which Plutarch interprets as follows in his "Concerning the Education of Children":[14] "Cibos non ponendos in matella"—"Food must not be committed to a chamberpot."[15] This, certainly, signifies that "It is improper to allow lofty words to be transmitted to an empty mind. Speech, after all, is food for the intellect—and this human vulgarity renders impure."

As we shall see, Thuilius established that Alciati had compounded his "offensive" emblem basically from three quite different sources: 1) Pythagoras's obscure symbola, of which two will have to be considered (as well as a number of supporting texts drawn from other authorities) as they had been codified by Plutarch in the

first century A.D. and given prominence by Erasmus in his *Adagia* in the years 1508 ff.;[16] 2) the poet Martial's fetid Bassa epigram, which will be discussed in detail; 3) Artemidorus's *Dream-Book* (late second century A.D.), which will also be discussed shortly. What is important to realize is that, while sources 1) and 2) derived directly from Erasmus, 3) was unknown to Erasmus, so that we owe it to Thuilius that we are aware of this indispensable third ingredient of the emblem.

For our understanding of Alciati's emblem it is necessary to see with what solemn emphasis Erasmus treated the Pythagorean symbola in his *Adagia*. In the year 1508 there appeared in Venice (Aldus) the first consolidated edition of this work— better organized by far than the preceding collectanea. The book now was for the first time divided into Chiliades and Centuriae; the individual adages were given consecutive numbers which make it easy to cite as well as to retrieve particular adages. Margaret Mann Phillips referred to the *Adagia* of 1508 as "the edition of learning."[17]

To continue Thuilius's commentary:

> Furthermore it appears that this emblem was drawn from Artemidorus' fifth book of the *Dream-Interpreter*,[18] who has this to say: "Somebody had a dream to the effect that he had evacuated his bowels into a choinix.[19] He was tried and convicted as one who had had intercourse with his sister. The choinix is 'a measure,' and its meaning is therefore commensurate with 'a law.' He confessed to something he had perpetrated which infringed upon that which was considered to be enjoined by binding law in all of Greece."

Abruptly, Thuilius leads over to the third source of inspiration:

> I am quite prepared to bet that Alciati, when he conceived his emblem, had in mind a distich by Martial on Bassa [sic]:
>
> > Ventris onus misero, nec te pudet, excipis auro,
> > Bassa. Bibis vitro—carius ergo cacas.
>
> > Bassa, you are not even ashamed to empty the burden of your belly into pathetic gold.
> > Inasmuch as you drink from glass—you do some precious shitting.[20]
>
> And that the epigram [i.e., Alciati's] had been intended as being directed against that execrable perversion, male venery, reveals—quite apart from the Motto (epigraphen)—a comparison [i.e., with Martial's epigram]. What else is indeed more of the nature of a *hysteron proteron*?[21] for does a more scandalous abuse exist than to commit one's excrements to gold, while drinking from simple glass and earthenware? In this sense, such detestable interchange of vessels is surely "against nature" (and in keeping with the definition of this kind of perversion as it is accepted by the majority of Jurisconsults).
>
> So much for my view concerning this emblem to which I have provided this picture. What concerns the remainder, I let the reader be the judge.[22]

If we approach the various paraphernalia in Alciati's woodcut as carriers of hidden messages, it becomes clear that the motif "worthy vessel befouled "holds a key position. Here, as we have seen from the evidence offered by Alciati's sources, the tradition which equates the Vessel with the human Body will help to deepen our understanding. Depending on which philosophical or religious outlook stood behind the pronouncement, the human body when regarded as distinct from the

human soul could be considered "a noble container of the soul"—a "receptaculum animi" (thus Cicero); it might also be a sacred possession, a vessel which its owner had to keep "in sanctification and honor,"—"ut sciat unusquisque vas suum [his own body] possidere in sanctificatione et honore" (I Thessalonians, for which see below); or, being worthless and perishable if compared to the immortal soul, it might be rated as "vas sterquilinii"—"a container for dung"; or finally, in the words of Lactantius, the human body was "as it were a vessel which served the heavenly spirit as a temporal domicile"—"quasi uasculum quo tamquam domicilio temporali spiritus hic caelestis utatur." The equation Vessel = human Body had been formulated by Cicero. Dealing with the *Γνῶθι σεαυτόν*-inscription on Apollo's temple at Delphi, the "Know Thyself," Cicero (*Tusculanae disputationes*, I, 22, 52) spoke in his usual pregnant form of the idea of self-knowledge by saying: "This means 'know thy own mind' because your body is as it were a vessel or some such container for the human soul"—" 'nosce animum tuum,' nam corpus quidem quasi vas est aut aliquod animi receptaculum."[23] We may assume that the "corpus quasi vas" tradition was intimately known to Alciati and his contemporary readers, both from its classical formulation and through Christian sources. For the latter I would like to single out one striking example, St. Paul's First Epistle to the Thessalonians (4:3 ff., written about 65 A.D.). Here we find the apostle's passionate attack, inveighing against the inherent paganism of the newly converted Christians of Macedonia: "For this is the will of God, your sanctification, that you should abstain from fornication: That every one of you should know how to govern his vessel (*σκεῦος*) in sanctification and honour; not in the lust of concupiscence . . ." —"ut sciat unusquisque vestrum vas suum possidere in sanctificatione et honore, etc."[24]

Et aurum eorum in sterquilinium erit . . . (Ezech. 7:19)

Vellem quidem eos per totam vitam aurum stercora existimare
(Clement of Alexandria)

Alciati was indebted to Martial's Bassus-Bassa epigram, and this dependence allows us to assume (with Thuilius as our guide) that the choinix misused was a precious vessel made of gold. Gold seen *in bono* was a symbol of power and wealth but also of spiritual qualities—the manifest presence of the divinity and of the divine light.[25] The opposite view permeates classical literature, especially where gold becomes the target of attacks launched against luxury and concomitant decadence.[26] When in 98 A.D. Tacitus published his *Germania*, he undoubtedly was anxious to hold up a moralizing mirror to his compatriots. Thus he said in Section V, that lacking evidence of silver and of gold among the natural resources of the Germans might either be the result of the wrath of the gods—or of their favor. "Argentum et aurum propitiine an irati dii negaverint dubito."[27] In the same vein, Amerigo Vespucci reported in his *First Voyage* (Florence 1505/6), "the wealth that we enjoy in this our Europe such as gold and jewels, pearls and other riches, they hold as nothing, etc."[28] It is from these sentiments, projected into faraway lands, that we must understand Thomas Morus's Utopians,[29] who are systematically conditioned by their authorities to feel disdain of gold. "Inasmuch as they eat and drink from vessels fashioned out of clay and glass which, though handsomely shaped, are nevertheless of the cheapest kind, they (not only in their communal halls but even in their homes) make night-jars and all kind of squalid receptacles out of gold and silver"[30]—"Nam cum in fictilibus è terra vitroque,

elegantissimis quidem illis, sed vilibus tamen, edant bibantque, ex auro atque argento (non in communibus aulis modo, sed in privatis etiam domibus) matellas passim ac sordidissima quoque vasa conficiunt, etc., etc."[31]

It goes without saying that we cannot expect much of a *Nachleben* of Alciati's emblem. Even when printed, it was not easy to find. Even when encountered it might be obscure, especially where there was no picture and where the commentary was either absent or meager. Not to mention that generally speaking sexual deviation wasn't everyone's forte. And yet, an exception occurred in the year 1596 in a work of great ingenuity, written by an English nobleman. The very heart-piece of this work consists of a practical, down-to-earth account with apposite plumber's "blue-

*5 a, b. "Sprinto non spinto"—"More feard then hurt." [Sir John Harington (1560–1612)] "A godly father sitting on a draught."* The Metamorphosis of AJAX, *London, 1596, fol. C 6r and v. Courtesy Robert H. Taylor, Princeton, N.J.*

*Of AIAX.*

Sprinto non spinto.  More feard then hurt.

*A godly father sitting on a draught,*
*To doe as neede, and nature hath vs taught,*
*Mumbled (as was his maner) certain prayr's,*
*And vnto him the diuel straight repayr's:*

*And*

*The Metamorphosis*
*And boldly to reuile him he begins,*
*Alledging that such praiers are deadly sins;*
*And that it shewd, he was deuoyd of grace,*
*To speake to God, from so vn meete a place.*
*The reuerent man, though at the first dismaid,*
*Yet strong in faith, to Satan thus he said.*
*Thou damned spirit, wicked, false and lying,*
*Dispairing thine owne good, and ours enuying:*
*Ech take his due, and me thou canst not hurt,*
*To God my pray'r I ment, to thee the durt.*
*Pure prayer assends to him that high doth sit,*
*Downe fals the filth, for fiendes of hell more fit.*

Wherefore, though I graunt many places and times are much fitter for true deuotion, yet I dare take it vpon me, that if we would giue the' deuill no kinder entertainment in his other suggestions, then this father gaue him in his causlesse reproofe (for he gaue it him in his teeth, take it how he would.) I say wee shoulde not bee so easily ouerthrowne with his assaults, as dayly we are, for lacke of due resistance. But come wee nowe to more particular & not so serious matter, haue not many men of right good conceit, serued themselues with diuers pretie emblemes, of this excrementall matter. As that in Alciat, to shewe that base fellowes oft-times swim in the streame of good fortune, as well as the worthiest.

*want of good take.*

*Nos*

prints" and cost estimates, as well as a socio-economic discourse with side-glances at much-needed environmental improvement, all of which served as an advertisement for the newly invented Water Closet. Its author, Sir John Harington (1560–Nov. 1612), was not only the proud inventor of the first valve-equipped flushing toilet; he was also a godson of the Queen, an erudite poet, translator of Ariosto's *Orlando Furioso*, a prolific composer of epigrams, a renowned letter writer, a hunter, a valiant soldier (Captain of Horse in Essex's Irish Expedition), a lawyer, a landowner, Justice of the Peace, politician, historian, a genuine antiquarian with interest in the history of medicine in the Middle Ages (Salerno), a mathematician who corresponded with Newton on harmonious intervals, a sheriff of Somerset, a diarist, a hagiologist, a theologian (who failed in his bid for the archbishopric of Dublin), and the operator of his own printing press, as well as a classical scholar. His highest ambition: preferment at court. The work which responded to Alciati's emblem—the echo was strictly confined to its scatological aspects—was *The Metamorphosis of Ajax* (no doubt to be pronounced: [ə'dʒeiks]), which while highly informative on the new invention, was at the same time a treasure-house of scatological jokes, puns, and innuendos—in all, it has been acclaimed as the first significant response on English soil to François Rabelais. Sir John boasted that he was "a proper scholer, and well seen in *latrina lingua*." In his manor house, built after a plan of Vignola, three and one-half miles northwest of Bath, at Kelston (Somerset), Sir John had set up a working model of his invention which he had adorned with an emblem inspired upon, as he expressed it, Alciati's "contribution to excremental matter." The lengthy epigram referred to a fine device (figs. 5 a, b), showing a venerable senex seated on a stool underneath a water tank graced by fish (simply to indicate that it was filled with water). He was reprimanded by the Devil for addressing his prayers to God from such a disrespectful place. To which the godly father, by no means intimidated, counters: "To God my pray'r is meant, to thee the durt." The emblematic motto "Sprinto ma non spinto" Elizabeth S. Donno rendered in her immaculate edition of the *Metamorphosis* as "kickt but not prickt."[32] Whatever that may mean, we can accept it as a Motto so that, along with epigram and picture, we have a complete emblem in celebration of a new invention. Sir John was an omnivorous reader and, as we have seen, he had a substantial number of Alciati editions to choose from in which the Adversus emblem occurred.[33] It is characteristic of Harington and it illustrates his understanding of Alciati's emblem, perhaps more persuasively than his own flushing-toilet emblem, that with Alciati's emblem before him he should have been reminded of Martial's scatological epigram.

What strikes us as odd is that with this publication Sir John, a man after all of much savoir faire, should have hoped for preferment at court. Instead, as he confides in a letter (October 9, 1601), a "sharp message" was conveyed to him by the Lord Treasurer (Lord Buckhurst) to whom the Queen had said: "Go, tell that witty fellow, my godson, to get home: it is no season now to foole here." Moreover, he was threatened with a Star Chamber suit and finally he was indefinitely banished to Kelston.

What is clear and of significance is that the objections to the book were preeminently of a political nature. The Queen "did conceive much disquiet on being tolde that [the author] had aimed a shaft at Leicester."[34]

Once again our contemplation of Alciati's "Adversus naturam peccantes" and its echo has shown that in an attempt at pinpointing "objectionable" qualities in

a work of the sixteenth or seventeenth century—as in all historical study—we cannot hope to make much headway by relying upon the criteria of our own time. Common sense is a poor guide into the past.

*Princeton University Library*

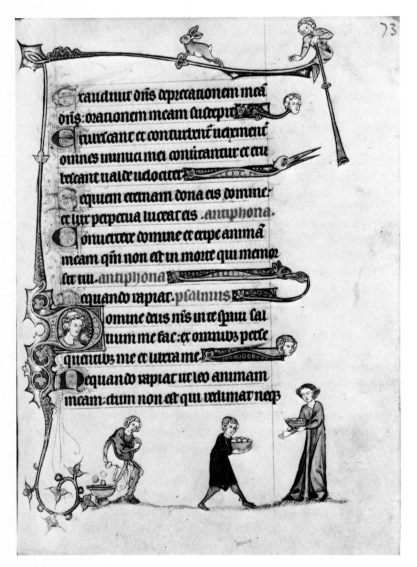

*"Man defecating into a golden vessel." Marginal drôlerie, Flemish Hours, early 14th century. MS B.11.22., fol. 73, Trinity College Library. Courtesy the Master and Fellows of Trinity College, Cambridge*

\* *Von Kindesbeinen an* I have been encouraged and stimulated in my work, directly and indirectly, by my friend H. W. Janson. I hope that he will accept the margaritae as an homage and that he will shut his eyes (and nose) to the effusions of the sterquilinium.

Mrs. Virginia W. Callahan, whose critical edition and translation of Alciati's *Emblemata* is nearing completion, has given me as so often before the benefit of her counsel without carrying the slightest responsibility for the mendae et errores of my article. Mrs. Julia Holloway (Princeton University) alerted me to the importance of Thomas Morus's golden night-jars. Richard M. Ludwig (Rare Books and Special Collections, Princeton University Library) has put me under obligation by liberally admitting me to the materials under his authority which are of particular importance to my emblematical pursuits. Winfried Schleiner (University of California, Davis) invited me to read a paper on Alciati's emblem here under discussion before a critical audience of M.L.A. members (Dec. 1977) at his session "Renaissance Literature and the Emblem."

I wish to acknowledge help and advice that have come my way from the following friends and colleagues: Frank Baron (University of Kansas), Mrs. Sarah Bartning (Berlin-Dahlem), J. L. Beijers, publishers (Utrecht), Mrs. Nancy Coffin (Taylor Collection, Princeton), Donald D. Eddy (Cornell University), Stephen Ferguson (Curator of Rare Books, Princeton University Library), A. C. Hamilton (Queen's University, Kingston, Ontario), Mrs. Roxanne Sanossian Heckscher (Institute for Advanced Study), S. K. Heninger, Jr. (University of British Columbia), John Landwehr (Voorschoten, Holland), Kenneth A. Lohf (Curator of Rare Books, Butler Library, Columbia University), Lawrence Parke Murphy (Keeper of Rare Books, N.Y. Public Library), Mrs. Agnes B. Sherman (Emblem Project, Princeton University Library), Frank M. Sommer (Director of the Library, Winterthur Museum, Delaware), Gerhard F. Strasser (Northwestern University), Alan A. Tait (Glasgow University), Robert H. Taylor (Princeton, N.J.), Owsei Temkin (The Johns Hopkins University), and Mrs. Neville Thompson (Winterthur Library).

I was privileged to have received far-ranging assistance from staff and members of the following libraries: The Cornell University Library, Ithaca; The Folger Shakespeare Library, Washington, D.C.; The Glasgow University Library; The Newberry Library, Chicago; The New York Public Library (Astor, Lenox, and Tilden Foundations); The Princeton University Library (especially my friends in the Marquand Library and in the Department of Rare Books).

[1] Henry Green (1801–1873) was, in his last phase, at which time he applied himself to Renaissance emblems, a Presbyterian minister; for the facsimile of the 1546 edition, see his *Andreae Alciati Emblematum fontes quatuor*, London and Manchester, 1870. (See also below, n. 9, 1.)

[2] Cf. Luigi Firpo, "The Flowering and Withering of Speculative Philosophy," in *The Late Italian Renaissance: 1525–1630*, ed. E. Cochrane, New York, 1970, esp. 266 f. For the Spanish Index see Conte Giammaria Mazzuchelli Bresciano, (1707–68), "Alciati," in *Gli scrittori d'Italia*, I, i, Brescia, 1753, 354–68, esp. 366, n. 112: "In alcune impressioni anche migliori se ne leggono solamente 211 [i.e., emblemi] e ciò perchè se n' è omesso uno d'argomento poco modesto; al qual proposito avvertiremo che gli Emblemi dell'Alciati si veggono [sic] proibiti nell'Indice di Spagna, *donec corrigantur*." The *Index of Prohibited Books . . . Revised by Pope Pius XI*, Vatican, 1930, lists on p. 8 a decree of March 23, 1700, concerning Alciati but, as elsewhere, censures only his diatribe *Contra vitam monasticam*. Of course I am grieved that with the limited resources at my disposal I have failed in tracing the specific Index that Mazzuchelli must have had in mind. The *Indice general de los libros prohibidos* (hasta fin de diciembre 1789), ed. Madrid 1844, stipulates complete prohibition under "Andr. Alciatus": "Opus *em-*

*blemata* ex quacumque ed., vel cum omnibus ejus operibus."

[3] This edition comprises 1001 pages. It features all 212 of Alciati's emblems, leaving not a single emblem "nude," i.e., without its device. It includes all the important commentaries of the sixteenth century and was immaculately printed with very legible woodcuts in the Paduan officina of Laurentius Pasquati. The edition of Padua 1661 is an identical twin as far as letterpress and the woodblocks used are concerned; compare our figures 2 and 3. The Tozzi edition of Padua 1626 also uses the original woodblocks, our figures 4 a, b.

[4] Relatively little seems to be known about Thuilius. He refers to himself as Germanus (was his Germanic name "Zwiel"?) and speaks of his origin as "Mariamontanus." I have little doubt that his birthplace was Mals ("im oberen Vintschgau") in the Tyrol; the twelfth-century Benedictine "Monasterium montis Mariae" was situated in Mals. The list of his learned publications is meager. An ambitious work on anatomy remained unfinished at his premature death in Padua, where in 1630 he died of the plague. Thuilius tells us himself that, while first in Venice and subsequently in Padua, he was stricken by a disease which resulted in "crurum debilitate et abcessu periculosissimo"—"a weakness of his limbs and a most dangerous abscess"; on the nature of this sickness we can only speculate. While those two ailments may not have been interconnected (as Dr. Temkin was kind enough to point out to me), I like to toy with the possibility of Thuilius's having been the victim of some kind of psychosomatic affliction, similar in character to the totally imagined "softening of the bones" which seems to have stricken Rembrandt in or about the year 1640, or to the hallucinations which beset Rembrandt's contemporary, Caspar Barlaeus, who believed that his behind was made of glass, which resulted in a phobia that prevented him from sitting down. See Nicolaus Tulp, *Observationes*, I, xviii, quoted in extenso by W. S. Heckscher, *Rembrandt's Anatomy*, New

York, 1958, 179–81 and 77 f. See also H. de la Fontaine Verwey, "De dichter die dacht dat hij van glas was," *Amstelodamum*, XXXVII (1950), 60. It was Petrus Paulus Tozzi's great merit to have discovered the ailing Thuilius and to have sensed his extraordinary gifts. I have not come across any references to Thuilius in modern reference works; there are short articles on him in Christian Gottlieb Jöcher's *Allgemeines Gelehrten-Lexikon* (IV, 1751), in Johann Heinrich Zedler's *Universal-Lexicon* (XLIII, cols. 1800 f.), and in Henning Witten's *Diarium Biographicum* (no pagination), *s.v.* "1630 Thuilius obiit," dating from 1688; this seems to be the first detailed reference to our author.

[5] "Germanos cerebrum in dorso gestare, id est 'scripta proferre magis laboriosa quàm ingeniosa,' " Praefatio, p. vii. For a more detailed account of Thuilius's peregrinations and sickness, cf. p. viii.

[6] See Praefatio, p. vii.

[7] Cf. André Pellicer, *Natura: Étude sémantique et historique du mot latin* (Publication de la Faculté des Lettres et Sciences humaines de l'Université de Montpellier, XXVII), Paris, 1966, 420–22 and 267 f. "Peccare" signifies all kinds of errors, lapses, or sins. The word, and this is the case in Alciati's motto, specifically alerts to a hazardous crossing of borderlines which leads into forbidden territory—"peccare est tanquam transilire lineas" (Cicero, *Paradoxa Stoicorum*, 3, 1, 20).

[8] What did this teach me? 1) when getting tired at a cocktail party, escape and find an undisturbed place to sleep; 2) on awakening, pounce on the book nearest at hand; 3) when solemnly declaring a given edition to be "optima," think twice before allowing this to hypnotize you into uncritical acceptance, or expect heavenly retribution for your hybris. Thuilius, as we shall see in notes 9 and 10 below, stoutly maintained that no one before him had commented on the Adversus emblem. And yet I cannot doubt that Thuilius had been familiar with Minos's commentary which, in edition after edition, featured the unacceptable transposition of "factu" and

"dictu" in the first line of the epigram and which, apart from this flaw, offered clear hints at the influence of Plutarch-Pythagoras as well as Martial's Bassus, anticipating thereby the quintessence of what Thuilius would have to say in his own commentary.

9 The somewhat confusing term "nude"—current only in the nineteenth century—was used by Henry Green when speaking of an emblem lacking its device or picture. I have examined some sixty editions of Alciati's emblem book, forty-nine of which are in the Princeton University Library. About a third of these carry the Adversus emblem; it is found in the majority of the editions which were edited and commented upon by Claudius Minos. With the exception of the Paduan Tozzi editions, the Adversus emblem and its commentary are tucked away toward the end of the book, where, preferably, they appear unnumbered on an unnumbered page; in those instances the emblem is hardly ever listed in the index or indices, so that the idea to conceal it from the eyes of prudes and censors becomes very clear. Green, as I think, errs when overlooking or at least not counting the Adversus emblem in those cases, to the detriment of his otherwise flawless descriptions. Printers and editors must have used all their ingenuity to circumvent the Inquisition and the censors of *libri prohibiti*. In the following listing, an asterisk indicates the (rare) instance of a device; "Green" followed by a number refers to the numbered entries of Henry Green's "Bibliographical Catalogue" in his *Andrea Alciati and his Books of Emblems*, London, 1872:

1) * 1546 Venice (Aldus)–Green 28 (our fig. 1); also: facsimile in Henry Green, *Andrea Alciati. Emblematum fontes quatuor*, London and Manchester, 1870 (no pagination).

2) 1548 Lyon (Roville), p. 66–Green 31; apart from being nude, our emblem has the correct "factu"–"dictu" sequence; this edition was corrected (a multis mendis expurgatus) after Alciati's original MS—εἰς του αὐτο-γραφου.

3) 1549 Lyon (Bonhome), p. 102–Green 39; Barthelemi Aneau's second French trans. (ed. princ. Green 38), which also offers the first commentary as well as the epoch-making arrangement according to commonplaces; Aneau was the editor, Roville the publisher, Bonhome the printer (Coll. Frank M. Sommer, Winterthur Museum, Delaware).

4) 1556 Lyon (Tornaesius and Gazeius), p. 203–Green 60; edited by Seb. Stockhamer which, being in Book II, lacks a commentary.

5) 1566 Antwerp (Plantin), pp. 55 f.–Green 73; with Seb. Stockhamer's German translation which renders choenix as "ein Korb mit Brot."

6) 1573 Lyon (Roville)–Green 85; ed. and comment. Franciscus Sanctius (Sanchez); Latin text and Sanchez's commentary, pp. 259 f. Plutarch-Pythagoras mentioned. A rather detailed commentary in which Plutarch is quoted in Greek.

7) 1575 Antwerp (Plantin)–Green 87; this may well serve as archetypus of Minos's commentaried edition where we encounter for the first time the commentary to the Adversus emblem which begins with the words "Ad calcem . . . "—"Having come to the end . . . "

8) 1581 Antwerp (Plantin)–Green 99; p. 732.

9) 1583 Paris (Marnef and widow Guilaume Cavellat)–p. 672–Green 104.

10) 1591 Leiden (Plantin and Raphelengius)–Green 118; unnumbered page at end: Minos's "Ad calcem" (N.Y. Public Library).

11) 1600 Lyon (Roville heirs), p. 800: "Ad calcem" as an unnumbered emblem, which is not listed in the index–Green 127.

12) 1608 Antwerp (Plantin), pp. 697 f. "Ad calcem" as an unnumbered emblem, not listed in the index–Green 133.

13) 1614 Lyon (Roville heirs), p. 800. "Ad calcem" not listed in the index–Green 141.

14) 1615 Cologne (Iean de Tournes), pp. 208 f. French trans. with brief

moralizing commentary where Adversus is listed as Emblem XLVIII–Green 143; mentioned by Elizabeth Story Donno, *A New Discourse,* New York, 1962, 96 (Butler Library, Columbia University).

15) * 1621 Padua (Tozzi–Thuilius), Emblem LXXX, pp. 353 f.–Green 152; here referred to as editio optima: Minos's "dictu"–"factu" transposition accepted and perpetuated by further Paduan editions; for Thuilius's extensive commentary, see below, n. 22; J. L. Beijers's Catalogue 136 (Utrecht, 1968) reproduces the woodcut of Emblem LXXX ("since 1549 rejected in all editions"); see also Mario Praz's commentary, p. 251.

16) * 1626 Padua (Tozzi), prints woodcut from same block as ed. 1621; a restricted, small-size ed.;–Green 155.

17) 1648 Antwerp (Plantin-Moretus), p. 392: "Ad calcem"–Green 160.

18) * 1661 Padua (Paulus Frambotti), virtually identical with Padua 1621 (same woodblock used)–Green 165.

19) c. 1675 MS, Glasgow University Library S.M.M.9, by Aurelio Amateo, Lat. and It., fols. 16v–62–Green 166.

20) 1781 Madrid (The Royal Society), reprints "Ad calcem" on last two (unnumbered) pages; this ed. carries an Antwerp approbation of Nov. 9, 1621, at the end–Green 176.

[10] No one will blame Thuilius for being unaware of the woodcut of the Adversus emblem in the Aldine edition of 1546 (see above, n. 9, 1). There is, of course, always the possibility of another woodcut before Padua 1621 that to my knowledge hasn't surfaced as yet.

[11] There existed before, notwithstanding Thuilius's protestations, valid commentaries—none as rich and exhausting as his. Barthelemi Aneau in his interesting line-by-line translation into French (titled "Contre les bougres") may have limited the sense of the emblem to homosexuals, but his brief commentary made an attempt at linking the befouling of the "vaisceau oul'on mange" to the concept of perversion and thereby constituted the first and only commentary published

while Alciati was still alive (1549; see above, n. 9, 3). Sanchez (1573; see above, n. 9, 6) and Claude Mignault (1574; see above, n. 9, 7), independently (?), hinted at Plutarch–Pythagoras as well as Martial-Bassus as a source of inspiration, thereby anticipating Thuilius. As I have pointed out on page 294 and above, n. 8, Thuilius in all likelihood was influenced by Mignault, whose transposition of words in the first line of the epigram he followed too slavishly for us to believe in an accident.

[12] The question arises whether the naked person in the 1621 woodcut is supposed to be a male or a female. As the text preceding n. 20 below will make clear, a fundamental source for the emblem and its iconography, including the suggestion of a receptacle of gold (a circumstance not mentioned by Alciati who only refers to the "choinix"), is found in book I of the *Epigrams* of M. Valerius Martialis (epigram xxxvii [xxxviii], composed c. 85 A.D. or after). Here we find an attack on a certain Bassus or Bassa (depending on which edition of the epigrams we consult). Erasmus in his *Adagia* seems to stand practically alone among the early editors and commentators of the epigram in making the addressee of the epigram a man: Bassus. This view is shared by all modern editors. Older editions and many MSS seem to prefer Bassa. Thuilius's view appears divided. The "naked man who unburdens his belly" prescribed to the artist is countered by "Bassa" in his quotation after Martial's poem. The distinction is by no means unimportant since Bassus and Bassa are, in the body of Martial's *Epigrams*, two quite distinct personalities. Bassus is a good-natured tottering man, who can do nothing quite right; Bassa is met, in every epigram where she appears, with nothing but abusive scorn. Martial rails at Bassus for preferring an ugly old woman with one foot in the grave to a radiantly beautiful young girl (III, lxxvi); he is a habitual drunkard (VI, lxxi) as well as a poor husbandman when it comes to tending his sterile country estate. Bassus, pretending to be a knight (V, xxiii) and

possibly a writer of tragedies (V, liii; III, lxxvi), belongs to the conventional laughingstock of Roman comedy by failing to respond sexually when joining his wife (XII, xcvii)—all in all a fairly consistent figure, even though we cannot always be sure whether Martial had in mind one or two personalities called Bassus. Bassa, on the other hand, poor girl, is constantly demolished and humiliated. All of Martial's verse dealing with Bassa belongs, without exception, to the epigrammatic sub-group "foetidae," intended to shock the reader by their calculated foulness. Bassa, e.g., gets a cruel epigram of twelve lines (IV, iv), holding her up to disdain on account of her revulsive stench, and, while she may be at heart a Lesbian (I, xc), she is in essence a prostitute of the lowest kind. In short, we can very well visualize a debased Bassa straining on a golden chamber pot while drinking from ordinary glass and earthenware vessels, but we can hardly see tottering Bassus cast in this role.

Martial's *Epigrams*, as Julius Caesar Scaliger elegantly demonstrated, can be divided into several sub-categories into which most will fit: i) "foetidae," foul and obscene; ii) "fel," treating with "gall," i.e., the pungent, maledictory kind; iii) "acetum," biting like "vinegar" yet not overly abusive; iv) "sal," full of wit as well as satirical laughter, with only "a modicum of mordacity"—"haud multa mordacitate," as befits "salt." Clearly the Bassa epigrams, including the one that influenced Alciati, belong to the "foetidae," a group which Scaliger on account of their unmitigating foulness wishes to banish altogether from the civilized world. Bassus, on the other hand, evokes satirical laughter and thus becomes the victim of the wit that comes under "sal." See J. C. Scaliger (1484–1558), *Poetices libri septem*, Heidelberg, 1581[2], III cxxvi, "Appendix pro Epigrammate," p. 431, a spirited set of observations that deserves to be edited and translated in full.

13 We must note that Claude Mignault, who, from edition Antwerp (Plantin) 1573 onward, accompanied numerous editions with his magisterial commentaries, added—beginning with the Antwerp-Christopher Plantin edition of July 1577—his fascinating essay titled *Syntagma de symbolis*. The "symbola" of the title were the ten strange sayings believed to have been uttered by Pythagoras which had been recorded by Plutarch, who provided them with a succinct commentary of his own. These had been worked by Erasmus, Alciati's and Mignault's immediate source, into the mature editions of his *Adagia* to exercise an all-pervading influence on the secular and humanistic thinking of the Renaissance. Mignault discussed in his *Syntagma* the very "symbolá" that may well have furnished the original stimulus to Alciati when he resolved to add "Adversus naturam peccantes" to his ever expanding collection of emblems. By the time Mignault appeared on the scene, a generation after Alciati's death, ecclesiastical authorities had become increasingly averse to moral transgressions, and in the camps of both Reformation and Counter Reformation the concept of the "pictor errans" had strengthened the hand of censors and inquisitors alike. Fortunately Mignault, who wanted to be known as Minos (in allusion, we may assume, to the Minos who was a harsh judge over the souls of the dead in the underworld), was anything but a timid or puritanical soul. Being a jurisprudent, he must have been aware of the dangers he incurred by printing the Adversus emblem, even though he relegated it to the penumbra of an unnumbered page. On one occasion he declared that "in referring to improprieties, improper words are called for"—"rem enim turpem turpia verba decent" (commentary to Emblem V); for a more detailed discussion of the Pythagorean symbola, see below, n. 17.

14 The treatise known as Περὶ παίδων ἀγωγῆς (*De educatione puerorum*), originally considered part of Plutarch's *Moralia*, is no longer accepted as belonging to the canon of his original writings; this, of course, in no way diminishes the importance for the sixteen and seventeenth centuries.

15 The Greek original uses the word ἀμί-

δα—chamber pot, which the Latin translation renders with the less colloquial "scaphio"—"tureen," a term already found in Sanchez's commentary to Emblem LXXX (ed. 1573; see above, n. 9, 6.)

[16] Pythagoras's so-called σύμβολα or ἀκούσματα (terms coined c. 530 B.C.), here signifying "auguries" and "pronouncements," were recorded at a later date and allegorically interpreted; see below, n. 17. How deeply Alciati was indebted to Erasmus and his writings has been beautifully shown by Virginia W. Callahan in her lecture "The Erasmus-Alciati Friendship," *Acta Conventus Lovaniensis*, Louvain and Munich, 1973, 133–41.

[17] See Margaret Mann Phillips, *The "Adages" of Erasmus. A Study with Translations*, Cambridge, England, 1964, 62 ff. The vast introductory part of the streamlined *Adagia* is devoted to a theory of the proverb (paroemia), and its pièce de résistance is a set of the current ten Pythagorean "Symbols" as transmitted by Plutarch, each provided with a far-ranging commentary: *Adagiorum Chiliades tres, ac Centuriae fere totidem*, Venice (in aedibus Aldi), mense Sept. 1508, "Pythagorae symbola," fols. 5v ff. (ed. Basel [Froben] 1523, 14–21). See also S. K. Heninger, Jr., "Pythagorean Symbola in Erasmus' *Adagia*," *Renaissance Quarterly*, XXI (1968), 162–65.

The ten symbola are: 1) "do not touch black-tails," i.e., keep no company with the malignant; 2) "do not step over a beam," i.e., limits set by the law must be respected; 3) "do not sit on a choinix," i.e., shun idleness (cf. our Emblem LXXX but also Alciati's "Desidia," Emblem LXXXII); 4) "do not give everyone your right hand," i.e., avoid rash commitments; 5) "do not wear a tight finger ring," i.e., don't chain yourself; 6) "do not poke the fire with a sword," i.e., leave the angry unprovoked; 7) "do not eat the heart," i.e., avoid worry; 8) "abstain from beans," i.e., keep away from public affairs; 9) "do not put your food into a chamber pot," i.e., "food"="speech"; unclean vessel/chamber pot=a vulgar mind (see Alciati's Emblem LXXX); 10) "when you

have reached the border, do not look back," i.e., meet death in a calm frame of mind: Plutarch, *Selected Essays* (trans. Thomas G. Tucker, Oxford, 1913, 262). To see how in the second half of the sixteenth century a critical mind reacted upon the symbola, we may turn to one of Julius Caesar Scaliger's epigrams:

Pythagorae symbola

Quae Pythagorae symbola dicuntur: eorum/Partim sapidam ambagibus contegunt medullam:/Partim subolent quid puerile et obsoletum./Verum illa tuetur hominibus sacra vetustas./Vt inane sepulcrum putrido situ cauendum.

The Symbols of Pythagoras

What goes under the name of Pythagorean Symbols: some of them/Conceal under their covering a savory kernel:/Others smell of what is puerile and worn out./While sacred Antiquity preserves for mankind that which is true,/We should shy away from an empty sepulcher in a decaying site.

Scaliger, "Epidorpidum libri" IV, *Poemata*, ed. Heidelberg (apud Santandreanum), 204. Erasmus had been fortunate in having had access to a Plutarch manuscript on his visit to Venice (Phillips, 87). Here he might well have encountered the symbola. Possibly, however, Erasmus was also acquainted with Philip Beroaldo the Elder (1453–1505), *Symbola Pythagorae moraliter explicata*, ed. princ. Paris (Johannes Petit), Jul. 14, 1505, a splendid and exhaustively detailed conspectus (copy: Folger Library). Three dicta found in the *Adagia*, two of which are Pythagorean, have exerted their influence on Alciati's emblem: 1) As we have already seen, the being seated on a choinix as an emblem of Sloth (Desidia), but naturally also as a suggestion that Alciati took up in the Adversus emblem (see *Adagia*, ed. 1523, 15). 2) "Do not place food into a chamber pot"; the idea, apart from the symbolum, may have been based on a saying found in Horace (*Epistolae* I, ii, 54): "Sincerum est nisi vas, quodcumque infundis ace-

scit"—"if a vessel is not pure, you may pour into it what you will, it shall turn to vinegar." Erasmus furthermore found in Aulus Gellius, *Noctes Atticae* XVII, xix, a saying by Epictetus (c. 77 A.D.) in which the position is taken that an unclean vessel (i.e., a vulgar mind) will turn the noblest doctrine into urine or worse. Having cited Epictetus, Gellius sums up: "Nil profecto iis uerbis grauius, ni uerius quibus declarabat maximus philosophorum, litteras atque doctrinas philosophiae, cum in hominem falsum atque degenerem, tanquam in uas spurcum atque pollutum influxissent, uerti, mutari, corrumpi: & quod ipse κυνικώτερον dixit, urinam fieri, aut si quid est urina spurcius"—"Nothing indeed could be more profound or more truthful than those words with which the greatest among the philosophers declared that no sooner had the teaching and philosophy been infused into the mind of a dishonest and depraved man—as it were into a filthy and polluted Vessel (*uas*), than teaching and doctrine would change, be transformed, corrupted, and, as he expressed it even more in the trend of the Cynics, turn into urine or, if such exists, into something even filthier than urine." 3) Outside the initial section of the *Adagia* that was devoted to the Pythagoras–Plutarch *paroemia*, we find in the main part of the book (I, V, lxviii, ed. Basel 1523, 167) "in matellam immeire"—"to urinate into a chamber pot." We might profit here by being alerted to the possibility of an additional allusion to sexual abuse; "immeire," as was generally known, did service as "verbum obscenissimum" (i.e., "semen emittere"). In order to elucidate this adage, Erasmus makes use of two examples: he refers us to his great favorite (cited 335 times in the *Adagia*), Lucian (2nd century A.D.), who, in his "De mercede servientibus"— "On those (paedagogues) who hold salaried positions (in great houses)" (cf. *Lucian*, Loeb Classical Library, III, 420) —nicely illustrates the commonplace that beggars can't be choosers. Dependent as they are, the noble teachers cannot help but submit to being treated in a humiliating way. This is why Lucian compares

them to chamber pots which, whether they like it or not, have to submit to their conventional employ: "itaque nec hi quicquod indignum aut acerbum patiantur, neque illi eos contumeliis afficere videantur si, quod aiunt, in matellam immingant." This, if we take Lucian literally, closely corresponds to the fate of the golden choinix in Alciati's epigram. In the second place, Erasmus, at the end of this entry, introduces Martial's Bassus epigram. According to Erasmus it is directed against someone who is being reproached in jest "because he defecates into a golden vessel, while he drinks from glass"—"Bassum quendam ioco taxat, qui in aureum vas incacaret, cvm uitro biberet." In our further discussion of Thuilius's commentary we shall come back once more to Bassus.

The critical reader will have noticed how Alciati in his emblem (if for a moment we exclude the lamentable fate of Lucian's paedagogues) had to deal with sources such as Erasmus's *Adagia* in which his motif appears in the reverse: Those sources deal with the pollution of some substance of noble and spiritual value as it is committed to an unclean and unworthy vessel. Alciati's vessel, in contrast, is precious; it is made of gold and dignified, while what is committed to it constitutes the negative effect of a pollutant. We can explain such absolute reversal of inherent values only by reminding ourselves of the almost limitless ability and willingness of those dealing with symbolical matter to accept a given symbol either *in bono* or *in malo*. In order to understand how already in mediaeval thinking such transposition was handled, we may consider the concept "tree." According to the principle of interchangeability this concept will, on the one hand, apply to the "Tree of Knowledge," signaling "Damnation," while, on the other, referring with equal force to the "Tree of the Cross," signaling "Salvation." Consequently the legend of the Invention of the True Cross claims that the Cross of the Passion was made of the wood of the Old Testament Tree of Knowledge. Thus we must

understand the almost compulsive application of this black-to-white method by Petrus Berchorius (fl. c. 1340), who in his *Repertorium morale* might observe under SANGUIS: ". . . et quia sanguis quasdam habet bonas & quasdam malas proprietates, hinc est, quòd spiritualiter loquendo sanguis in Scriptura in bono sumitur & in malo"—"and thus, because Blood has certain good and certain bad characteristics, it results from here that spiritually speaking blood is taken in Scripture in both a good and in a bad sense." Alciati himself, in some of the editions which group the emblems according to commonplaces (1549 ff.), lists two mutually exclusive mottoes in direct succession: i) "Vino prudentiam augeri"—"To increase one's intelligence through wine"; ii) "Prudentes vino abstinent"—"The intelligent keep away from wine."

Without stating this expressis verbis, Thuilius undoubtedly found Alciati's sources in Eramus's *Adagia*. But aided by his wide reading, Thuilius discovered a third source without telling us how he had managed to discover it, the *Oneirocriticon* of Artemidorus. See below, n. 18.

[18] The reference is to Artemidorus Daldianus (2nd century A.D.), ’Ονειροκριτικά V (dream 24), ed. Rudolph Hercher, *Oneirocriticon*, Leipzig, 1864, 258, ll. 11–14:

’Εδοξέ τις εἰς χοίνικα χέζειν. ἑάλω ἀδελφῇ τῇ ἑαυτοῦ μιγνύμενος. μέτρον γὰρ ἡ χοινιξ, τὸ δὲ μέτρον νόμῳ ἔοικε. τρόπον οὖν τινὰ παρενόμει παρὰ τὰ νενομισμένα κοινῇ τοῖς ’Ελλησι πράττων.

Erasmus of Rotterdam was unaware of Artemidorus, at least when he developed his *Adagia*; see Mrs. Phillips's list of classical authors cited in *The "Adages" of Erasmus*, App. III, 395. There is, on the other hand, circumstantial evidence which makes it attractive to speculate on Alciati having had access to the work of Artemidorus in its second edition, brought out by Janus Cornarius (Hagenbut, 1500–1558) in 1539. Ten years earlier, the same Cornarius had issued (or reissued) a large number of contemporary translations from the *Planudean*

*Anthology*, itself an anthologia variorum manuum, titled *Selecta epigrammata*, Basel (Bebellius/Bebelius), August 1529, containing several of Alciati's early epigrams (such as the Washing of the Aethiopian) which later on he worked into his emblem book. See James Hutton, *The Greek Anthology in Italy to the Year 1800* (Cornell Studies in English, XXIII), Ithaca–New York, 1935, esp. 196–98, 283–86.

[19] Thuilius, having cited Artemidorus's original Greek version, starts his Latin translation: "Quispiam sibi visus est in choenicem aluum exonerare"; we may compare this to line two of Alciati's epigram: "Excipiat si quis choenice uentris onus," to sense how close Alciati comes to echoing Artemidorus, whose dream offered the only source that equated the befouling of a vessel with the crime of incest.

[20] "Cacare" (Martial) or "incacare" (Erasmus) and their English equivalent, as I have rendered it in keeping with the "foetidas" of Martial's epigram, belong to the "mots du vocabulaire populaire"; see: Herman Huisintveld, *De populaire elementen in de taal van Martialis* (Diss. Nijmegen), Roermond, 1949, 71, *s.v.* "cacare."

Literary passages directed at frivolous misuse of golden vessels naturally are apt to turn up wherever Christian moralizing voices are raised against luxury. A fine example of this attitude we encounter in Clement of Alexandria's *Paedagogue* (early 3rd century A.D., ed. Migne, *P.G.*, VIII, 439: "Quod in sumptuosam vasorum supellectilem non sit studium conferendum"—"That we should not be preoccupied with a lavish array of household vessels"). It is here that Clement berates "rich, brainless women who have receptacles for their excrements which are made of gold, so that even in voiding themselves they should not miss out on pride"—"et hae, quae sine ratione sunt, divites mulieres, ex auro excrementorum faciant receptacula, ut ne egerere quidem eis liceat absque superbia"; it seems there is a kind of immortality about Bassa and the defecatory pursuits of her sisters.

**21** Use of the Greek phrase, meaning "reversal of the natural sequence," illustrates Thuilius's use of "sal" operating at the expense of homosexuals; this is very much in keeping with his characterization of the sexual embrace of boys as "preposterous"—"putting what is in front behind." Ursula Kirkendale convincingly argued that Quintilian's statement "ne quid naturae dicamus adversum"—"that we should utter nothing that is contrary to nature" (IV, ii, 52) is echoed by J. S. Bach in his *Musical Offering* (reverse canon à 2) to serve as a disguised allusion to the homosexual propensities of King Frederick of Prussia; see her brilliant article in *Journal of the American Musicological Society*, XXXIII (1980), 104.

**22** Of Thuilius's *commentarii* to Emblem LXXX, I have presented in the following only the introductory remarks (pp. 353 f.), which are followed by a detailed word-for-word analysis of the epigram and its motto (here omitted), in which the vast range of perversions "contra naturam" is carefully documented:

Huius Emblematis picturam nullus hactenus dedit, atque ipsum etiam epigramma leui (quod aiunt) brachio perstrinxerunt commentatores: ego verò nihil verebor rem turpiculam liberioribus impetere verbis, praesertim cum haec zizania [cf. Matthew 13: 25 f.] non perfunctoriam requirat runcationem. Quapropter sic pictori praeiui: Fiat lectus vndique peripetasmatis velatus, iuxta hunc homo nudus ventrem in pateram auream exoneret, coram quo in mensa quadam stet fictile poculum, & cyathus vitreus. . . Quid autem in lecto velato agatur, sufficit illud me & pictorem scire. parco enim castis oculis, & cum his etiam mentibus. Ob id quoque à Minoe hoc emblema ad calcem reiectum fuit, quod non videbatur committendum auribus tersis, tum quòd ipsi indignum visum sit explicatione prolixiore. Ast me non pudebit . . . ex stercore margaritas legere. Ergo ad rem:
Video allusum ad symbolum

Pythagorae, quod sic explicat Plutarchus de educatione puerorum:

Σιτίον εἰς ἀμίδα μὴ ἐμβάλλειν. ἐπισημαίνει γὰρ ὅτι εἰς πονηρὰν ψυχὴν ἀστεῖον λόγον ἐμβάλλειν λόγος τροφὴ διανοίας ἐστί, τοῦτον δ᾽ἀκάθαρτον ἡ πονηρία ποιεῖ τῶν ἀνθρώπων.

id est: "*Cibos in scaphio* [a less genteel term would have been "matella"] *non ponendos*. Significat autem in animum nequam vrbanos sermones immitti non oportere: sermo enim intelligentiae cibus est, quem impurum reddit hominum nequitia." Vide adagium [*Adagia* I, I, ii, ed. Basel 1523, p. 17; see also above, n. 17], "Cibum in matellam ne immittas. . . ." Caeterum id tractum videtur ex Artemidori 5. de insomnijs, cuius haec sunt verba: [here follows in the Commentary the Greek text of Artemidorus's dream, for which see above, n. 18: this Thuilius translates into Latin:] "Quispiam sibi visus est [i.e., in somnio] in choenicem aluum exonerare, conuictus de eo, quòd cum sorore cubitasset, damnatus est. Mensura enim est choenix: at quidem mensura legi similis est. Quodam itaque modo legem transgressus erat, qui nimirum admisisset aliquid praeter leges totae Graciae communes."

Ego verò pro pignore certare paratus sum, Alciatum, dum hoc emblema cuderet, respexisse ad illud Martialis de Bassa [see above, n. 20, and page 296] . . . Idque torsisse in nefandum illud masculae Veneris flagitium, quod praeter epigraphen satis quoque indicat comparatio. Quid enim magis est ὕστερον πρώτερον, et quis alius turpior abusus, quam auro excrementa excipere, ast è vitro vel fictilibus bibere? Sic quoque est contra naturam (sic enim plerumque Iurisconsulti hoc vocant flagitium) tam execranda vasorum permutatio. Haec mea est opinio de hic Emblemate, cui etiam hanc picturam accommodaui. De reliquo, Lectoris esto iudicium.

Alciati emerges as an epigrammatist whose great gift it was to work a number of diverse strands into a unified texture,

presenting us with a sparse yet eloquent quatrain and motto. Thanks to Thuilius we are familiar with the sources, but what we do not know is whether he or anyone else responded to the epigram as an independent contribution to poetry. A possible answer may come from J. C. Scaliger who, speaking of Alciati's *Emblemata*, has this to say in his *Poetices*, (ed. Heidelberg 1581², IV, iv, pp. 796 f.): "ea verò talia sunt, vt cum quouis ingenio certare possint. Dulcia sunt, pura sunt, elegantia sunt: sed non sine neruis"—"They are indeed of such quality that they can match anyone else's talents. They are sweet, they are pure, they are elegant, and yet: they are by no means lacking in vibrant energy." Scaliger's "Judicium de Alciati emblematis" has been reprinted in extenso in many editions of the latter part of the sixteenth century, including the Tozzi editions (beginning 1621).

[23] I am referring the reader to a remarkable recent study by Ute Davitt Asmus, CORPUS QUASI VAS. *Beiträge zur Ikonographie der italienischen Renaissance*, Berlin, 1977. Mrs. Asmus draws our attention to the way in which, speaking of a vase, we will make reference to its "body," "neck," "mouth," "lip," and "foot"; see her p. 16, n. 18. For the term "Vas sterquilinii," cf. E. Garin, "La *dignitas hominis* e la letteratura patristica," *La Rinascità*, I (1938), 102–46. The term makes a striking comeback in Buñuel's misogynic film "Cet obscure objet du désire" (1977).

[24] For by far the best modern commentary, see Béda Rigaux, O.F.M., *Saint Paul: Les épîtres aux Thessaloniciens*, Paris, 1956, esp. 504. What to us is of greater importance is the fact that the *Glossa ordinaria* (ed. Strasbourg [Rusch], c. 1480) to our passage echoes, in the interlinear gloss by Anselmus of Laon (A. Laudunensis), Cicero's dictum: "Corpus vas animae" (fol. a 8). Cf. W. H. Auden, "In Memory of W. B. Yeats": "Earth receive an honoured guest:/William Yeats is laid to rest,/Let the Irish vessel lie/Emptied of its poetry."

[25] See Dorothea Forstner, O.S.B., *Die Welt der Symbole*, Innsbruck, etc., 1961, 193–97. The Old Testament is rich in passages eulogizing vessels. Petrus Berchorius in his article VAS (*Repertorium morale*, c. 1340) mentions their incomparable value when fashioned of gold, and equates to them the Just, "quorum valori non potest aliquid comparari"—"whose intrinsic value cannot be matched by anything else."

[26] For example: a) the blessings of "undiscovered gold"—"aurum inrepertum," Horace (23 B.C.), *Carmina* III, iii, 49–53; b) "accursed lust for gold"—"auri sacra fames," Vergil (19 B.C.), *Aeneid* III, 56 f.; c) "there was a time when poetic talents rated as more precious than gold"—"ingenium quondam fuerat pretiosius auro," Ovid (after 16 B.C.), *Amores* III, viii, 3; d) "riches—the incitements to vice"—"opes—irritamenta malorum," Ovid (c. 7 A.D.), *Metam.* I, 140 f.—et tanta multa alia.

[27] Tacitus, *De origine et situ Germanorum*, ed. Ioannes Forni, Rome, 1965, V, 2–3, 75 f.

[28] *The First Four Voyages*, ed. London, 1893: "le riccheze che in questa nostra Europa usiamo/come oro/gioie perle & altre diuitie/non trauagliano per hauerle, etc.," fol. 4 v; see also below, n. 29. I somewhat condensed Vespucci's text.

[29] For the influence exerted on Thomas Morus by Amerigo Vespucci's report, cf. Arthur J. Slavin, "The American Principle from More to Locke," *First Images of America*, ed. F. Chiappelli, Berkeley, etc., 1976, 139–64, esp. 142.

[30] Reading this passage we may possibly be justified in sensing a premonition of Alciati's emblem which—though in a different key—plays on the contrast between glass and earthenware on one side and, on the other, a golden night-jar. All Alciati had to do was to place his accents differently.

[31] For a serviceable reprint of the 1516 edition of the *Utopia*, see V. Michels and Theobald Ziegler, Berlin, 1895, 64 f. The demeaning employment of gold—prisoners' fetters, punitive finger rings, neck-chokers—is treated in great detail. We should note that this edition of 1516, the editio princeps, refers in its title to the *Utopia* as "a truly golden book"—

"libellus vere aureus," revealing a use of the word "aureus" which, needless to say, is quite out of character with the Utopian attitude. It seems in fact very difficult to determine to what extent and in what parts the *Utopia* was meant to be taken seriously. The title described it as being "no less wholesome than humorously entertaining"—"nec minus salutaris quam festivus." Erasmus and his circle regarded the *Utopia* it seems, in the first place as a humorous book, comparable no doubt to the *Praise of Folly*, for which see Mrs. Phillips, *The "Adages" of Erasmus*, 106 f. ("if you haven't seen More's *Utopia*, get hold of it if you want to laugh"). Of course "festivitas" may have served a good purpose: to act as a protective screen covering more serious and that means more dangerous and vexing questions. Precisely the long passage on the Utopians' disdain of gold, which explicitly gives them an opportunity to mock the Europeans for their shameless cult of gold, may have been used by Morus to speak out against a very real target—the extravaganzas under Henry VIII and his court, "where gold is valued highly and gathered with such avidity."

[32] Elizabeth Story Donno, *Sir John Har-*
*ington's A New Discourse of a Stale Subject, Called the Metamorphosis of Ajax. A Critical Annotated Edition*, New York—London, 1962, esp. 91–98, 195–97, the latter showing two technical designs for the benefit of "the workeman": our figures 5 a, b. The hero of John Dickson Carr's mystery story *The Devil in Velvet* (1951), set in Restoration London, is delighted to encounter Sir John's book, "written over a hundred years ago."

[33] Cf. above, n. 9, 1–10. I have not come across even the faintest echo of Alciati's "offensive" emblem in any of the English emblem books that Sir John Harington might have known.

[34] See Sir John Harington, *The Letters and Epigrams of Sir John Harington together with The Praise of Private Life*, ed. with an Introduction by Norman Egbert McClure, Philadelphia, 1930, 16. Queen Elizabeth would never have dreamed of censuring Rabelaisian indelicacies. When by accident she discovered that Sir John had recited an improper episode from Ariosto's work to her ladies-in-waiting, she "punished" him by obliging him to translate the *Orlando Furioso* in its entirety.

# 20

# *Der Indianische Hahn in Europa*

LISE LOTTE MÖLLER

Die Tierfabel stellt ihn 1567 als *een Turckschen Haen* vor und behandelt ihn 1579 unter der Überschrift: Ius hospitalitatis violatum. Das Bild zeigt den Amerikaner (Gallopavus seu Gallus Indicus) auf einer Anhöhe vor einem niederländischen Dorf, in noch abwartender, aber schon etwas cholerisch gereizter Haltung, und den Europäer (Gallus gallinaceus, Mitteleuropäer seit der späten Hallstattzeit), der ihm mit agressiver Gebärde entgegentritt (fig. 1). Die Moral lautet: Si habitaverit advena in terra vestra, et moratus fuerit inter vos, non exprobretis ei (Lev. 19, 33); in Luthers Deutsch: Wenn ein Fremdling bei dir in eurem Lande wohnen wird, den sollt ihr nicht schinden.[1]

Die Angaben über das Ankunftsdatum des *Gallus Indicus* schwanken zwischen 1519/20 und 1525. Einige behaupten, er sei sogleich nach Hernán Cortes' Einzug in Tenochtitlan (8. November 1519) auf die Reise nach Spanien gegangen; an anderer Stelle steht das Jahr 1525 zu lesen.[2] Als Albrecht Dürer bei seinem Brüsseler Aufenthalt vom 27. August bis zum 2. September 1520 mit der größten Bewunderung die "dienge" ansah, "die man dem könig auß dem neuen gulden land hat gebracht" und auch "jns königshauß zu Prüssel hinden hinaus die brunnen, labyrinth, thiergarten" besichtigte, war der "Indianische Hahn" jedenfalls dort noch nicht eingetroffen, denn sonst fänden wir ihn gewiß in Dürers Skizzenbuch.[3]

Zu Beginn der dreißiger Jahre muß der Vogel in Deutschland bekannt geworden sein; unter der Bezeichnung *indianisch han* wird er 1531 in Nürnberg genannt, ein Name, der noch im 17. Jahrhundert gebräuchlich blieb, wenn auch bereits 1553 daneben die Bezeichnung *kalekutisch hûn* (kalekutisches Huhn) auftauchte; der heute übliche hochdeutsche Name "Truthahn" ist 1673 zuerst nachgewiesen.[4] Nach alten Quellen waren 1540 in Frankreich einige Indianische Hühner vorhanden; deutsche Sprachforscher stellten den Namen *coq d'Inde* für das Jahr 1548 fest.[5] Um 1541 sollen die "turkeys" nach England gekommen sein.[6] Über Italien, Holland und weitere europäische Länder fehlen (mir) genauere Daten.[7]

Bildliche und schriftliche Zeugnisse vermitteln den Eindruck, daß es in der Tat lange gedauert hat, bis der Indianische Hahn sich hier recht zu Hause fühlen konnte. Das mag sich ebensowohl aus der von dem Fabulisten gerügten mangelhaften Gastfreundlichkeit der Alten Welt als auch aus dem wenig verträglichen Verhalten und dem auftrumpfenden Benehmen des Fremdlings[8] erklären; und

wäre die Kenntnis von seiner Bedeutung in der magisch-religiösen Bilderwelt der Azteken über jenen engen Kreis spanischer Mönche hinausgedrungen, die um erfolgreicher Mission willen die fremden religiösen Vorstellungen zu begreifen trachteten, so hätte die Aufnahme des mexikanischen Vogels in dem Europa des 16. Jahrhunderts, wo der leibhaftige Teufel noch eine Rolle spielte, leicht noch ungastlicher ausfallen können.

Unter dem Bilde des Indianischen Hahns auf einem besonders prächtigen Thron wurde Chalchiuhtotolin, eine Form der Hauptgottheit der Azteken, Tezcatlipoca, dargestellt (fig. 2). In diesem Bilde des Chalchiuhtotolin, speziell in der Adlerklaue, die auf der Emanation nächtlicher Dunkelheit aus dem Schnabel der Vogelfigur sichtbar ist, erblickte die katholische Geistlichkeit in *Nueva Spagna* den Teufel selbst.[9]

Die Vögel, die nach Spanien geschickt wurden, waren domestizierte Exemplare der Gattung *Meleagris gallopavo*.[10] Die Eroberer hatten den gastronomischen Wert dieses von den Azteken in begrenzter Zahl gehaltenen Hausgeflügels am Hofe Montezumas kennen gelernt, und in Spanien wurden die eingeführten Vögel anscheinend nicht so sehr als exotische Sehenswürdigkeit, sondern vielmehr von Anfang an zur Verwendung in der Küche gehalten.[11]

Kunstgeschichtliche Daten lehren, daß die Indianischen Hühner in Europa bald nach der Mitte des 16. Jahrhunderts allgemeiner bekannt waren. Durch die Aufnahme in Conrad Gesners *Historia animalium* (1551–57) wurden sie in die Wissenschaft eingeführt. Früher schon fanden sie das Interesse der Meister des bizarren Ornamentstils der Schule von Fontainebleau. Da die 1543 datierte Radierung des Antonio Fantuzzi, die das Rahmenwerk des Freskos *L'Ignorance chassée* an der Nordwand der Galerie François Ier wiedergibt, die Vögel nicht aufweist,[12] und die 1541–50 entstandene Wandteppich Folge in Wien nur sechs Felder der Südwand wiedergibt,[13] war es fraglich, ob der Indianische Hahn und die beiden Hennen unten links in der *inquadratura* zum ursprünglichen Bestande (Ausführung 1534–37) gehörten, bis die jüngste Restaurierung (1961–64) darüber positiven Bescheid ergab.[14] Durch ihre Wiedergabe in der *inquadratura* des Freskos *L'Ignorance chassée* also wurde den Indianischen Hühnern ihre—soweit wir sehen—früheste sinnbildliche Bedeutung in der Alten Welt zugeteilt: *Stupidité*.[15] In Blatt 19 der Stichfolge *Historia Jasonis* von René Boyvin nach Léonard Thiry ist im Rahmenwerk sowohl ein Indianischer Hahn, der sich über eine Schnecke aufregt, als auch eine Henne zu sehen (fig. 3).[16] Boyvin's Stiche erschienen, als Album, 1563, doch die Vorlagen entstanden vor 1550 (Thiry, seit 1536 in Fontainebleau, starb 1550 in Antwerpen).

An der Vorderseite des sogenannten Wrangelschranks, eines 1566 datierten Meisterwerks der Augsburger Intarsienkunst in farbigen Hölzern, erscheint der Vogel, auf einer tellerförmigen "Plinthe" stehend, zwischen einem unter einer Blumenvase gelagerten Putto und einem als Statuette gekennzeichneten Pferd (fig. 4).[17] Die besondere Bedeutung des Indianischen Hahns in diesem im Zeichen der Vanitas-Idee und der Künste stehenden Zusammenhang ist nicht enträtselt. Einflüsse aus französischer Quelle sind an dem hochmanieristischen Werk deutlich wahrzunehmen. Arbeiten der Schule von Fontainebleau werden den Zeichner der *visierungen* für die Intarsientafeln auch auf den Einfall gebracht haben, den Indianischen Hahn einzuseten; vermutlich kannte er Boyvin's 1563 erschienenen Stiche.[18]

Mit ganz sicherer sinnbildlicher Bedeutung befrachtet tritt der Vogel in der 1557 entstandenen Zeichnung Pieter Brueghels d.Ä. zu dem Blatt INVIDIA der

1

2

1. *Marcus Gheeraerts.* Der Indianische und der europäische Hahn *(aus Freitag,* Mythologia ethica, *1579)*

2. Chalchiuhtotolin *(aus Codex Vaticanus 3773)*

3. Historia Jasonis. *1563. Kupferstich von René Boyvin (nach Léonard Thiry)*

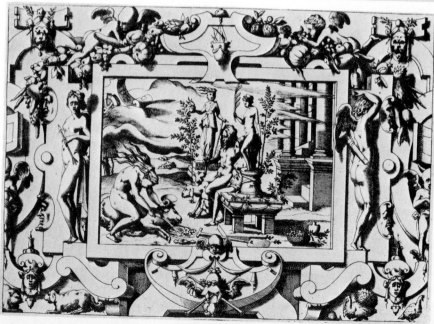

3

4

4. *Augsburger Meister. "Wrangelschrank" (detail). 1566*

5. *Pieter Brueghel d.Ä.* INVIDIA. *Kupferstich von Pieter van der Heyden. 1558*

5

INVIDIA HORRENDVM MONSTRVM, SÆVISSIMA PESTIS

Folge der *Sieben Todsünden* auf, die, von Pieter van der Heyden gestochen, in
Hieronymus Cocks Verlag *Aux Quatre Vents,* 1558 in Antwerpen erschien.
INVIDIA frißt ihr Herz auf, mit der Linken auf den Indianischen Hahn weisend,
der mit gespreiztem Gefieder, aufgerichteten Brustborsten und geschwollenem
Kopf vor ihr steht. Auf den obersten Zweigen eines hinter INVIDIA befindlichen
geborstenen dürren Baumes entfalten sich nach und nach vier Truthahn-Schwanz-
gefieder. Vor dieser Hauptgruppe streiten sich zwei Hunde um einen Knochen
(fig. 5).[19] Daß der Neid sein eigenes Herz auffrißt, gehört zu Andrea Alciato's
Charakterisierung dieses Lasters, und Cesare Ripa berief sich bei der Übernahme
dieser Handlung in einer seiner Anweisungen zur Darstellung der *Invidia* auf den
Vater der emblematischen Lehre.[20] Als Tiersymbol des Neides ist der Indianische
Hahn in Brueghels Folge neben der Figuration des Lasters in Menschengestalt
übergroß wiedergegeben, ähnlich wie der stattliche Pfau neben der puppenhaften
Frauenfigur SUPERBIA in der Todsünden-Folge.[21] Die *Invidia*-Bedeutung, die Brue-
ghel dem offenbar "nach dem Leben" gezeichneten Vogel zuteilte, hat in Emblem-
büchern keine Beachtung gefunden.

Schon aus dem Grunde, daß er spät nach Europa kam, hat der Indianische
Hahn in dem Reich der Sinnbilder der Alten Welt eine gewichtige Stelle nicht mehr
gewinnen können. Gegenüber. dem sinnbildlichen Bedeutungsreichtum des Affen
oder des Elefanten oder—um bei den Hühnervögeln zu bleiben—des Hahns, die
ein antikes und mittelalterliches Erbe zu ungemein komplexen Figuren machten,
wirken die dem Indianischen Hahn beigelegten allegorischen, moralistischen,
emblematischen Bedeutungen schlicht und geradezu. Es zeigt sich, daß sie vor-
nehmlich von eben den hervortretenden Charakterzügen hergenommen wurden,
die auch in den Redensarten der europäischen Völker über den Indianischen
Hahn (und die Henne) im Vordergrund stehen. Welche Eigentümlichkeiten der
Indianischen Hühner in den Redensarten besonders bedacht wurden, das wiederum
ist nach der Natur der europäischen Völker verschieden.

Es erweckt den Anschein, als hätte den Franzosen die Zuordnung der Indiani-
schen Hühner zu dem Fresko *L'Ignorance chassée* in der Galerie François Ier ganz
besonders eingeleuchtet. "Dindon" ist ein figürlicher Ausdruck für *homme stupide,*
"Dinde" für *femme sotte, niaise.* (Die Deutschen beschränken sich mit dieser In-
vektive auf das "andere" Geschlecht: "Die dumme Pute.") Die französische
Redensart "Être le dindon de la farce": *être victime dans une affaire* ou *être la risée
des gens* fügt zu dem Verdikt Dummheit das der Lachhaftigkeit; "le dindon de la
farce" ist der Geprellte, eine Art von "dummem August." "Dindonner quelqu'un"
bedeutet soviel wie: Jemanden anführen, prellen. "Bête comme un dindon"
besagt: schrecklich dumm, "c'est un (franc) dindon": er ist ein grosser Dumm-
kopf. Die hervorragende Stelle, die Frankreich im Laufe der Zeit in der Aufzucht
wohlschmeckender Truthühner erreichte—in Deutschland war deswegen eine
Zeitlang die Bezeichnung "welsche Hühner" gebräuchlich—führte zu "garder les
dindons" als Ausdruck für "auf dem Lande leben." "Dindonnière" (Puterhirtin)
wurde in figürlicher Redeweise für "Einfalt vom Lande" gebracht. "Je n'ai
pas garder les dindons avec Vous!" entspricht dem deutschen "Haben wir zusam-
men die Schäfe gehütet?" als Zurückweisung plumper Vertraulichkeit. Weniger oft
als in anderen Ländern wurde in Frankreich auf die Zornwütigkeit des Vogels
angespielt: "colère comme un dindon." Den ungemein Gefräßigen verglichen die
Franzosen mit dem Truthahn: "gourmand comme un dindon." Nur im Fran-
zösischen gab es die Bezeichnung "jésuite" für den Puter, überliefert insbesondere
für den gebratenen Vogel.[22]

Die deutschen Ausdrücke "wütend wie ein Truthahn," "sick opregen as een Kunhån" (niederdeutsch), (vor Ärger) "rot werden wie ein Puter," "puterrot werden," und "aufgeblasen wie ein Truthahn," "sich aufplustern wie ein Truthahn" zielen ungefähr auf das gleiche wie einige englische: "red as a turkey-cock," und "turkey-cock" in figürlicher Redeweise für *a pompous or self-important person.* Außerdem haben Engländer (und Amerikaner) aus der Essensweise und den Lautäußerungen des Vogels, die sie mit dem Verbum *to gobble* bezeichnen, nicht nur den Namen *gobbler* für den Puter,[23] sondern auch zwei auf den Menschen angewandte Ausdrücke abgeleitet: "to gobble" gilt auch für jemand, der vor Wut Laute wie ein Puter ausstößt; und unter *"gobbledegook"* wird *a pompous official jargon* verstanden. In Amerika soll es die Redensart geben: "to have got a turkey on one's back," sinngleich mit der italienischen "pigliare l'orso": betrunken sein, oder (wenigstens) einen Schwips haben. In der Geschäftssprache von Hollywood wird ein Film, der das Gegenteil von einem "hit" ist, als "turkey" bezeichnet. Das spanische *pavonearse* (einherstolzieren, sich brüsten) und das italienische *pavoneggiare, pavoneggiarsi* (einherstolzieren, sich in die Brust werfen, das bildlich gebraucht wird für *gloriarsi,* sich rühmen, sich breit machen, dick tun) ist vermutlich mehr vom Pfauen als vom Truthahn hergeleitet.

In den Emblembüchern sind von den Charakterzügen des Indianischen Hahns, die in den europäischen Sprachen hervorgehoben werden, nachdrücklich die Zornwütigkeit und der Hochmut und beiläufig schließlich auch die Eitelkeit bedacht worden. Die (eigentliche) emblematische Literatur—in Unterscheidung von der Tierfabel, die sich manchmal der emblematischen Form bediente[24]—wartet zunächst mit einer Irrläufer-Truthenne auf. Im II. Buch von Nicolaus Reusners *Emblemata,* Frankfurt, 1581, steht in Nr. 16 ein Bild (Icon) mit einer Truthenne über dem Lemma HEU CADIT IN QUENQUAM TANTUM SCELUS. IN ALTHAEAM; das Epigramm beklagt das Geschick der untröstlichen Schwestern des toten Meleager, die am Ende in "syrische Vögel" verwandelt wurden, und verurteilt den Frevel der Althaea, seiner Mutter.[25] Jene "syrischen Vögel" sind die Perlhühner, *Numidae meleagrides;* daß das Bild von Reusners Emblem statt eines Perlhuhns eine Truthenne vor Augen stellt, ist schwerlich ein Versehen des Zeichners, sondern erklärt sich sicherlich aus der langlebigen Meleagriden-Verwirrung. In der Ikon des reusnerschen Emblems hat sich augenscheinlich die "Entdeckung" der "wahren Meleagriden des Altertums" niedergeschlagen. Als solche nämlich wollten manche Gelehrte, deren Sinn fast ausschließlich auf die antike literarische Überlieferung gerichtet war, die Indianischen Hühner verstanden wissen.[26] Da Carl von Linné ihn absegnete, trägt der Vogel aus Amerika noch heute den Gattungsnamen *Meleagris.*

Der Jähzorn des Indianischen Hahns ist Gegenstand von Emblem Nr. 47 in Joachim Camerarius jr., *Symbolorum & Emblematum ... centuria tertia,* Nürnberg, 1596.[27] Das Lemma lautet: RABIE SVCCENSA TVMESCIT. Die Ikon, ein kreisförmiger Kupferstich von Hans Sibmacher, zeigt einen zornwütig aufgeplusterten Truthahn (fig. 6). Das Epigramm erläutert: *Quam deforme malum ferventi accensa furore/Ira sit, iratis Indica monstrat avis.* Wutentbrannt schwillt er an. Welch scheußliches Übel ein von kochender Wut entflammter Zorn ist, das zeigt den Zornigen der Truthahn. In seinem Prosa-Kommentar bemüht Camerarius vor allem die Autoren Varro, Claudianus, und Conrad Gesner.[28]

Filippo Picinelli, *Mundus symbolicus in Emblematum Universitate,* Köln, 1687, verzeichnet zwei emblematische Bedeutungen des Gallopavus seu Gallus Indicus. Die erste ist die von Camerarius vorgetragene: *Iracundus,* der Zornwütige; das

RABIE SVCCEN-
SA TVMESCIT.

*Quam deforme malum ferventi accensa furore*
*Ira sit, iratis Indica monstrat avis.*

N          COLV.

6. *Hans Sibmacher. Ikon zu*
*Camerarius,* Symbolorum et
Emblematum . . . , *Emblem*
Nr. 47. 1596

Lemma lautet auch hier RABIE SUCCENSA TUMESCIT, doch fügt Picinelli dem von
Camerarius gleichfalls herangezogenen Claudianus-Zitat eines von Ovid und
eines von Johannes Chrysostomus hinzu. Die zweite Bedeutung ist *Superbus,* der
Hochmütige, Hoffärtige. Dem Lemma EXACERBATUR RUBEO folgt ein Prosa-
Kommentar und ein Augustinus-Zitat.[29]

Beide Laster, den "erboßten Zorn" und des "Hochmuts eitlen Trotz," ver-
körpert der Truthahn, mit Lachen erregender Wirkung, in Johann Andreas Pfef-
fel, *Güldene Äpfel in silbernen Schalen,* Augsburg, 1746, Nr. 107: RIDENTUR
TUMOR & IRA. "Seht den erboßten Zorn, das stolze Angesicht, Den aufgeblähten
Leib; wer lacht darüber nicht? Des Hochmuts eitler Trotz ist allzeit zu verlachen;
Kan nicht ein Augenblick denselben niedrig machen?" Die Kartusche enthält
das Bild eines sehr zahmen Puters.[30]

Wer zuerst dem Indianischen Hahn die Bedeutung *Superbia* beilegte, ist
eine offene Frage. William Shakespeare rief am Anfang des 17. Jahrhunderts in
*Was ihr wollt* den Indianischen Hahn als Musterbild von eitler Eingebildetheit:
"Here's an over-weening rogue!" "Contemplation makes a rare turkey-cock of
him: how he jets under his advanced plumes!"[31] Auf einem 1626 datierten Kupfer-

stich von Andriesz Stock nach Hendrik Hondius (fig. 7) steht ein Indianischer Hahn in voller Pracht neben dem vom Tode bedrohten jungen Falkner zu Pferde; zweifellos steht er da als Verkörperung der *Superbia* in Tiergestalt.[32]

In den allegorischen Darstellungen der Weltteile sind die Indianischen Hühner als "Attribute" des vierten Erdteils, *America*, nicht nachgewiesen.[33] Als die französischen und englischen Entdecker Nordamerikas in der zweiten Hälfte des 16. Jahrhunderts von den wilden *turkeys* berichteten, die in großen Scharen das Land bevölkerten,[34] übten diese Nachrichten offenbar keinen Einfluss mehr auf das Bild der *America* aus. Die Ikonographie des neuen Erdteils war bereits durch Quellen des früheren 16. Jahrhunderts festgelegt, und zwar im wesentlichen durch Illustrationen zu ersten Reiseberichten über Gebiete, wo die Indianischen Hühner nicht zahlreich oder gar nicht zu Hause waren.[35] Als Charaktervogel für die Gegend steht der Indianische Hahn nordwestlich von Nieuw Amsterdam (seit 1666 New York) auf einer Karte von Blaeu, Amsterdam, 1635 (fig. 9).[36]

Dem fürstlichen Vergnügen an den Bewohnern der Tiergärten und dem naturkundlichen Interesse haben wir zwei hervorragende plastische Darstellungen des Indianischen Hahns zu verdanken. Um 1567 entstanden die lebensgroßen Bronzen von Vögeln, die Giovanni Bologna für die Grotte der herzoglichen Villa in Castello nahe Florenz liefern sollte, unter ihnen auch der Truthahn (heute im Museo Nazionale, Florenz), der—zusammen mit dem Adler—"zu den großartigsten Tierdarstellungen in Jahrhunderten gezählt werden darf" (fig. 8).[37]

Am 25. Februar 1732 bestellte August der Starke bei der Porzellan-Manufaktur Meißen für das Japanische Palais in Dresden u.a. einhundert acht und neunzig große und kleine Tiere und einhundert acht und neunzig große und kleine Vögel. Die Porzellantiere sollten die im Japanischen Palais hängenden Gemälde von Tieren an Originalität und Kostbarkeit überbieten.[38] Diese Order erhielt die Manufaktur zu einer Stunde, da sie große Porzellane noch nicht ohne Fehler zu brennen verstand, die Masse noch unrein, schmutzig grau ausfiel und die "feinen emaillierten Farben" für die Staffierung großer Stücke zum größten Teil noch zu erfinden waren. Die meisten frühen Porzellantiere wurden daher zunächst weiß geliefert. Johann Joachim Kändler, im Februar 1733 zum Modellmeister der Fabrik ernannt, machte 1733 die Aktennotiz: Ein Truthahn in Lebensgröße. Von dem auf einem kleinen, mit Blüten-und Blattauflagen geschmückten Sockel hockenden Truthahn gibt es ein unbemaltes Exemplar in der Dresdener Porzellansammlung und ein prächtig staffiertes Exemplar mit blau, rot und braun gehöhtem weißen Gefieder und grau, weiss und schwarz geperltem Schwanz in Frankfurt am Main (fig. 10).[39] August der Starke, der seine "Porcelain-Manufactur" mit unerhörten Anforderungen zu unübertroffenen Leistungen trieb, starb am 1. Februar 1733 in Warschau, ehe seine Wünsche erfüllt werden konnten. Die Möglichkeit des Naturstudiums exotischer und einheimischer Tiere boten die königlichen Tierhäuser und ausgestopfte Tiere in der Kunstkammer. Auf Augusts Befehl war eine sechsköpfige Expedition 1730–33 bis nach Afrika unterwegs, um "die möglichsten Arten derer Thiere lebendig oder in Häuten und Esqueletten oder auch gemahlt zu überkommen." Kändler beobachtete und zeichnete ausgiebig in Dresden und Moritzburg lebendige und ausgestopfte Tiere, um dem "Großtierauftrag" gerecht zu werden.[40] Und in der Tat überbieten die großen Meißener Tiere heute auf dem Kunstmarkt an Kostbarkeit bei weitem die meisten Tiergemälde. Während der Indianische Hahn zur Zeit der Entstehung von Giambologna's Bronze für Castello noch ein merkwürdiger fremdländischer Vogel war, gehörte er, als die Meißner Figur modelliert wurde, längst zu den Haustieren

7. *Hendrik Hondius*. Der Tod. *Kupfer-stich von Andriesz Stock. 1626*

8. *Giovanni Bologna*. Der Indianische Hahn. *c. 1567. Bronze. Bargello, Florenz*

9. *Willem Janszoon Blaeu*. Karte von Niev Nederlandt *(detail)*. Amsterdam. *1635*

7

*Non curat genus et formam, non robur, et annos*
*Nescia Mors ulli parcere, cuncta necans.*
  *H: inv. A.S. sculp. 1626.*

8

9

10

11

10. *Johann Joachim Kändler.* Truthahn
*(Modell, 1733). Meißener Porzellan. Mu-
seum fur Kunsthandwerk, Frankfurt am
Main*

11. AER. *Zeichnung nach Giuseppe Arcim-
boldi (c.1530–1593). Ehemals Sammlung
Vincent van Gogh*

in Europa. In den fürstlichen Fasanerien wohnten Truthühner und Haushühner in dem Hühnerhaus; sie wurden dort zum Ausbrüten der Fasaneneier gehalten.[41] Kändler mag Gelegenheit gehabt haben, in den Fasanengehegen des Großen Gartens und von Moritzburg auch Truthähne im Freien zu beobachten.

Der Tiergarten Kaiser Rudolfs II. im Graben der Prager Burg[42] enthielt wahrscheinlich auch Truthühner. Als exotische Merkwürdigkeit werden sie zu Roelant Saverys Zeit, im frühen 17. Jahrhundert, da sie als Haustiere schon allgemeiner bekannt waren, nicht mehr gegolten haben. Die wahre Sehenswürdigkeit unter den Vögeln war damals sicherlich der—zwischen 1605 und 1610 eingetroffene— erste "Dodo" in Mitteleuropa.[43] Der Indianische Hahn begegnet mehrfach in den Kompositionen der rudolfinischen Hofmaler Arcimboldi und Savery, woraus wohl zu schließen ist, daß sie ihn vor Augen hatten.

Giuseppe Arcimboldi, Hofmaler in Prag—im Dienste dreier Kaiser—von 1562 bis 1587, gab dem Indianischen Hahn in einigen seiner vielbewunderten, heute gerne als "surrealistisch" bezeichneten Erfindungen[44] an markanten Stellen Platz. Von der Elemente-Folge aus kaiserlichem Besitz, die 1722 von Prag nach der Wiener Hofburg überführt wurde, sind nur noch AQUA und IGNIS vorhanden. AER wurde als "von Vögeln im Fluge" dargestellt beschrieben.[45] Eine Zeichnung nach Arcimboldi, ehemals in der Sammlung van Gogh (fig. 11),[46] zeigt AER in Gestalt einer aus Vögeln zusammengesetzten menschlichen Büste im Profil, deren Nase und Wange ein Indianischer Hahn bildet. In einem Arcimboldi zugeschriebenen kleinen Bild in genuesischem Privatbesitz, das den Vorwurf AER durch teils eingefügte, teils zugefügte Vögel und Insekten an einer menschlichen Büste in Dreiviertelansicht—weniger entschieden zur "Kompositfigur" gediehen als es bei Arcimboldi zu erwarten steht—veranschaulicht, ist der Vogel einer Brusthälfte aufgelegt.[47]

Roelant Savery, Hofmaler in Prag 1604–12, in Wien 1612–15, belebte seine teils urweltlichen, teils idealen Waldlandschaften mit fast miniaturmäßig gemalten Menschen- und Tierfiguren, die das von ihm besonders geschätzte Orpheus-Thema oder die biblischen Geschichten vom Paradies oder der Arche Noah ins Bild bringen.[48] Auch in den Niederlanden malte Savery diese Art von Bildern, wie er sie in Prag und Wien ausgebildet hatte, noch weiter. In dem 1615 datierten Gemälde der Nationalgalerie in Prag lauscht der Truthahn im Mittelgrund, mit Strauß und Hirsch als Nachbarn, der Musik.[49] Ein 1937 im Kunsthandel befindliches, 1617 datiertes *Orpheus*-Bild zeigt den Truthahn im Vordergrund (fig. 12).[50] Anders als der fromme amerikanische Maler Edward Hicks, der sich verpflichtet fühlte, sein *Peaceable Kingdom* nach dem Buchstaben von Jesaias 11: 6–9 einzurichten,[51] sahen sich europäische Maler des 17. Jahrhunderts nicht gehalten, den amerikanischen Vogel, von dem die Antike noch nichts und die Bibel nichts melden konnte, von dem Genuß der Musik des thrakischen Sängers, aus dem Paradies oder von der rettenden Arche auszuschließen.

In der mit Tieren und Pflanzen reich belebten Paradieslandschaft von Jan Brueghel, in die Peter Paul Rubens die Stammeltern einsetzte, erscheint, links im Vordergrund, der Indianische Hahn unter den Tieren, die Adam speziell zugesellt sind (fig. 13).[52] Das Pferd, das mit kühnem und aufmerksamem Ausdruck aus dem Schatten des Baumes hervortritt, ist ein Sinnbild des Übermuts, der *Temeritas,* und auch des zügellosen *Appetitus,* der *Libido.*[53] Was Affen im Sündenfall-Bild zu bedeuten haben, ist schwarz auf Weiß nachzulesen.[54] Der Indianische Hahn steht aller Wahrscheinlichkeit nach hier für *Superbia,* das oberste Laster nach der scholastischen Lehre, das vor allen anderen den Stammvater des Menschenge-

13

12. *Roelant Savery*. Orpheus musiziert für die Tiere. *1617 (1927 im Kunsthandel)*

13. *Peter Paul Rubens und Jan Brueghel*. Der Sündenfall. *c.1615. Mauritshuis, Den Haag*

schlechts zum Essen der Frucht vom Baum der Erkenntnis bewog. Jan Brueghel konnte offenbar der Versuchung nicht widerstehen, auch den Paradiesvogel, der lebend eine seltene Neuheit war, im Paradies vorzustellen. Ikonologisch war der Vogel aus Neu-Guinea und von den Gewürz-Inseln wohl noch ein unbeschriebenes Blatt;[55] da er seine prächtigen Schmuckfedern aufgerichtet und gespreizt zur Schau stellen kann, mag es dem Maler statthaft erschienen sein, ihn als exotischen Vertreter des Hochmuts neben dem Indianischen Hahn zu präsentieren.

Einige italienische Barockmaler in Genua und Neapel, die mit niederländischer Kunst vertraut waren, schenkten dem Indianischen Hahn besondere Beachtung. Der Genuese Giovan Benedetto Castiglione (um 1610–um 1663/65) stellte den *Tacchino* häufig in jenen Gemälden dar, worin er auf seine charakteristische Art das Historienbild in ein bukolisch gestimmtes Genrebild übersetzte.[56] In Castiglione's Werk sind es das Orpheus-Thema—bei dem auch Roelant Savery den Indianischen Hahn mit Vorliebe bedachte—sowie die *Arche Noah* und *Gottvater am vierten Schöpfungstag*, die den Vogel, nicht selten mit besonderem kompositionellen Gewicht, aufweisen.[57] In *Noahs Aufbruch*, Schloß Schleißheim (fig. 14),[58] steht der *Tacchino* im Vordergrund, bei den Vierbeinern, während der Pfauenhahn im Geäst eines Baumes auf das Aufbruchsignal wartet; als mächtiger Wanderer bekannt, ist der Indianische Hahn zu den großen Tieren gesellt worden, die zu Fuß den Weg nach der Arche neben dem schwer bepackten Esel zurücklegen sollen.

Ein weiteres "Historienbild" dieser Richtung, das Antonio Maria Vassallo, einem um 1640–60 in Genua tätigen Nachahmer Castiglione's zugeschriebene *Circe*-Bild in den Uffizien, Florenz,[59] zeigt einen von Odysseus' Gefährten als in einen *Tacchino* verwandelt. Auf dem *Orpheus*-Bild des Neapolitaners Andrea Vaccaro, Neapel, Palazzo Reale, finden wir den *Tacchino*, mit erhobenem Schwanz und gesenktem Flügel vor dem Musizierenden.[60]

*14. Giovan Benedetto Castiglione (c.1610–c.1663/65).* Noahs Aufbruch.
*Bayerische Staatsgemäldesammlungen, Schloß Schleißheim*

Der Kampf zwischen dem Hahn und dem Kalekuter des Antwerpener Malers Paul de Vos (um 1596–1678), Hamburg, Kunsthalle (fig. 15), kann ebenso wie Frans Snyders' *Hahn und Edelstein*, Aachen, Suermondt-Museum,[61] als Zeugnis der Nachwirkung von Marcus Gheeraerts' Radierungen zur Tierfabel gelten. Gheeraerts' Radierungen wurden als Illustrationen zu Edeward de Dene, *De warachtighe fabulen der dieren*, Brügge, 1567, zuerst veröffentlicht; dank ihrer Wiederverwendung in den Fabelbüchern von Arnoldus Freitag (1579), Pierre Heyms (1587), Joost van den Vondel (1617; zahlreiche weitere Ausgaben bis 1786) u.A., blieben sie Generationen von Fabellesern vertraut.[62] Paul de Vos, Schwager Frans Snyders' und gleich diesem gelegentlich von Rubens als Mitarbeiter herangezogen, setzte die beiden Vogelfiguren zu ähnlicher Wirkung in die weite, offene Landschaft mit dem niedrigen Horizont ein, wie Snyders in seinem um 1620 entstandenen großfigurigen Hahn-Bild. Wie ein Blick auf das Vorbild (fig. 1) zeigt, dramatisierte Vos das Gegenüber der Streithähne auf barocke Art, indem er den kleinen gelbgefleckten Angreifer gleich einen David gegen einem Goliath anrücken läßt, die dunkle Masse des in zorniger Defensive verharrenden Kalekuters durch den überhangenden Baumstamm bedrohlich betonend. Die zu Gheeraerts' Illustration stimmende "Moral" Denes oder Freitags[63] hat für Paul de Vos' Gemälde sicherlich keine Geltung mehr: der Indianische Hahn hatte zu der Zeit den "Ausländerstatus" mit seinen Vorrechten und Nachteilen eingebüßt.

Um 1600 waren die Indianischen Hühner in Mittel- und Westeuropa auf dem Lande keine Seltenheit mehr. Jan Saenredams Kupferstich nach Abraham Bloemaert (fig. 16), um 1606 entstanden, gibt unter den Haustieren und dem Geflügel

*15. Paul de Vos (c.1596–1678). Der kalekutische und der niederländische Hahn. Hamburger Kunsthalle*

16. *Abraham Bloemaert.* Der Verlorene Sohn. *Kupferstich von Jan Saenredam. c.1606*

des niederländischen Bauerngehöfts, auf dem der Verlorene Sohn zu den Schweinen verwiesen wird, den *kalkoensche Haan* wieder.[64]

Wenigstens einige Zeugnisse der gastronomischen Bedeutung des Indianischen Hahns sollten hier bedacht werden. Sie geben sichere Auskunft darüber, seit wann er nicht mehr als "Fremdling" angesehen wurde, und sie bekunden, daß die Europäer nach Montezuma die Ersten waren, die ihn auf der Tafel zu besonderen Ehren kommen ließen.[65] 1609 wurden "Indianische Hanen" bei der Beschreibung eines fürstlichen Hochzeitsmahls in Stuttgart unter dem "heimischen Geflügel" aufgeführt.[66] Auf einem prächtigen "Vorratskammer"-Bild von Frans Snyders, ehemals in Privatbesitz in Kristiania,[67] hängen Indianische Hühner als Hauptstücke an der Wand. Daß der Vogel um die Jahrhundertmitte längst "eingebürgert" war, erhellt aus der "Überschrifft" zu der Schautracht mit dem Indianischen Hahn im ersten Gang des Kaiserlichen Friedensmahls zu Nürnberg, 1650: VIVENTIS PARS ERO VILLAE, von Georg Philipp Harsdörffer verdeutscht in dem Reim: "Durch mein stoltzes Feder schweben/Wird der Meyerhof auch leben."[68] Von dem gravitätischen Stil eines großen Schauessens gibt ein Kupferstich mit der Darstellung einer Partie des Schwedischen Friedensmahls im Nürnberger Rathaus am 25. September 1649 einen Eindruck (fig. 17). Die Pasteten zum vierten Gang werden hereingetragen; an dritter Stelle, hinter Schwan und Pfau, ist der mit hochgebundenen Flügeln aufgesetzte Indianische Hahn sichtbar.[69]

Als nicht mehr das natürliche Federkleid des Vogels zur Tafelzier gehörte,

17. *Anonymer Kupferstich. Das Schwedische Friedensmahl in Nürnberg, 1649. c.1650*

18. *Straßburg, Paul Hannong. Terrine. c.1754. Fayence. Badisches Landesmuseum, Karlsruhe*

18

entstanden, im 18. Jahrhundert, die prächtigen Geflügel-Terrinen aus Porzellan

und Fayence. Die großartigsten Fayence-Geschirre in Form eines Vogels sind die Truthahn-Terrinen von Höchst und Straßburg (fig. 18).[70]

Die Niederländer des 17. Jahrhunderts haben dem "Kalekuter" viel mehr Aufmerksamkeit gewidmet als die Franzosen, die Deutschen, die Italiener[71] und die Spanier. Nachdem die Flamen ihn im Antwerpener Tierbild der Rubenszeit stattlich in die Landschaft gesetzt und sein farbenprächtiges Federkleid in den Vorratskammer- und Marktstilleben zu dekorativer Wirkung gebracht hatten, malten ihn einige Jahrzehnte später die Holländer im Beieinander oder im Streit mit den übrigen Bewohnern ihrer Hühnerhöfe. Der hervorragende Vertreter dieses Genre, Melchior d'Hondecoeter (1636–1695), wegen seiner kraftvollen Zeichnung, Qualität seines Farbensinns, und der Komposition als "Raphael der Tiermaler" gepriesen, hat den "Kalekuter" gerne als schweres Gewicht an Form und Farbe verwendet. In dem Bild mit der weißen Henne, Kassel, einer seiner Unternehmungen mit dem Weiß im Bilde, stellte er ihn mit der dunklen Pracht seines Gefieders in den Vordergrund.[72] Wie dieses Gemälde in der Kasseler Sammlung, stammen auch Bilder mit dem alten, hochgeschätzten Vorwurf des Kampfes von Hahn und Puter, wovon eines in die Kasseler, ein anderes in die Schweriner Galerie gelangte, beide 1668 datiert,[73] aus seinem ersten Amsterdamer Jahrzehnt.

Der "*Spaziergang*" in der Alten Pinakothek, München (fig. 19), bis zum Jahre 1943 allgemein als eigenhändige Arbeit von Rubens betrachtet,[74] verlangt, da das Bild im Vordergrund den Puter im familiären Verbande mit einer Pute und vier Kücken zeigt, Beachtung in dem hier behandelten Zusammenhang. Peter Paul Rubens, seine Frau Helene Fourment, und sein Sohn Nicolaus sind im Begriff,

*19. Flämischer Meister.* Peter Paul Rubens und Helene Fourment im Garten. *c.1650. Alte Pinakothek, München*

MAUPAS

N° 24

LE DINDON (Vanité-Stupidité).

20. *Paul Hadol.* La Ménagerie Impériale. Maupas. *1899/1900. Paris*

21. *V. Le Nepveu.* Musée des Horreurs. *1899/1900. Paris*

einen Gang durch den Garten ihres Hauses in Antwerpen zu beenden. Rubens, dessen Augen auf den Betrachter des Bildes gerichtet sind, sucht Helene Fourment, die, stehen bleibend, den Blick zurückwendet auf einen auf dem Gartenweg heranjagenden Hund, zum Weitergehen nach rechts zu bewegen, während Nicolaus, hinter dem Paar, unbeirrt vorwärtsgeht. Eine alte Magd steht auf den flachen Stufen neben dem Pavillon und streut einem Pfauenpaar Körner aus ihrer Schürze hin, nachdem sie offensichtlich vorher schon den Truthühnern Futter hingeworfen hatte, das von der Henne und einem der Kücken aufgepickt wird. Verwunderlicher Weise nehmen die immer zur Aufregung bereiten Truthühner keine Notiz von dem stürmischen Hund, so nahe er ihnen schon ist, und auch der Pfauenhahn wendet den Kopf zänkisch gegen die Spaziergänger, nicht gegen den Hund. Zu den Einwendungen, die der Kritiker seinerzeit gegen die alte Zuschreibung des Gemäldes machte, gehörte auch diese Ungereimtheit im Verhalten des Geflügels. Von der Darstellung des Indianischen Hahns in der niederländischen Kunst her wird der Schluß nahegelegt, daß dieses flämische Bild unter dem Eindruck holländischer Genrebilder von den Geflügelhöfen, erheblich später als 1631, gemalt wurde. Jan Steens "Geflügelhof" im Mauritshuis, 1660 datiert,[75] als Teil eines herrschaftlichen Besitzes charakterisiert, belebt von der zehnjährigen Jacoba Maria van Wassenaer,

die ein Lamm tränkt, während Diener, die den Hühnerhof zu versorgen haben,
sich mit ihr unterhalten, ist in der Auffassung eines solchen Bildvorwurfs recht
verwandt. Es ist wohl richtig, vor dem "Spaziergang" in München an "die Ver-
änderung der Malerei gegen 1650" zu denken.[76]

Unter den flämischen Truthahn-Malern des 17. Jahrhunderts verdient noch
Pieter Boel Erwähnung, ein Neffe Frans Snyders', der in den vierziger Jahren in
Genua im Castiglione-Kreis zu finden war. 1668 ging er von Antwerpen nach Paris.
Als Mitarbeiter an der Manufacture des Gobelins war er als Tiermaler z.B. an den
Kartons für die Folge *Les Mois* oder *Maisons royales* (vor 1680) beschäftigt.[77]

Als Verkörperung von "Vanité" und "Stupidité" setzte der Zeichner Paul
Hadol (1835–1875) den Truthahn ein, um den Politiker Maupas in einer 1871
erschienenen Folge von Karikaturen, "La Ménagerie Impériale" zu kennzeichnen
(fig. 20).[78] Dieser im Zweiten Kaiserreich beliebten Art, Zeitgenossen durch
Versetzen in die Tierfigur zu karikieren, folgte V. Le Nepveu in seiner Plakatfolge
"Musée des Horreurs," die in insgesamt 51 (statt der vorgesehenen 200) Blatt
1899/1900 in Paris erschien. Plakat No. 9 dieser Folge stellt einen Streiter für die
Revision des Dreyfus-Prozesses, den ehemaligen Gesandtschaftssekretär, Journa-
listen, und Mitbegründer der Liga für Menschenrechte, Francis Dehaut de Pressen-
sée, in Gestalt eines "Dindon" mit dem Portraitkopf des Karikierten, auf einem
Müllkasten stehend, dar; sein linker Fuß ruht auf einem Papierstreifen mit dem Wort
L'ORDURE (fig. 21).[79] Vermutlich soll die Truthahn-Figur hier, wie in der Karikatur
von 1871, vor allem *vanité* und *stupidité* des Karikierten anzeigen. Die zur Krawat-
te stilisierte Halshaut des Hahns ist geeignet, die Eigenschaft "Eitelkeit" zu unter-
streichen. Überdies wollte der Zeichner durch die gesenkten Flügel, den erhobenen
Schwanz, die Röte des langen Halslappens anscheinend die alte emblematische
Bedeutung des Indianischen Hahns, "Zornwütigkeit," mit zur Geltung bringen.
Dehaut de Pressensée war ein Mitarbeiter der Zeitung *L'Aurore*, er hatte sich heftig
geäußert zu der Affaire Dreyfus; deswegen wurde er in dieser aus dem antisemiti-
schen Lager kommenden Plakatfolge attackiert. In der Folge erreichten seine
Gegner seinen Ausschluß aus der Ehrenlegion, doch 1902 wurde er zum Depu-
tierten gewählt und Präsident der Liga für Menschenrechte.

Eine "Truthahn-Verwirrung" gab es in den späten dreißiger und frühen vierziger
Jahren des 20. Jahrhunderts in Deutschland. Die frühere, breite "Meleagriden-
Verwirrung," die aus Voreingenommenheit für die klassische Antike angesichts
einer amerikanischen Erscheinung zu erklären war, bewegte recht viele Gemüter
über eine lange Zeit; die neuere, begrenzte Verwirrung, die aus Voreingenommen-
heit für die Wikinger zu erklären war, war von kurzer Dauer. *Pièce de résistance*
für die Verfechter der These "Truthahn entthront Columbus" waren zwei Paar
Truthahn-Medaillons, die der Restaurator der mittelalterlichen Wandmalereien
im Schwahl des Doms zu Schleswig um 1888/90, im Wechsel mit zwei Paar Fuchs-
Medaillons, als Fries unter das Wandbild vom "Kindermord" gemalt hatte, "um
Herodes zu charakterisieren."[80]

*Museum für Kunst und Gewerbe, Hamburg*

Vremde lieden die niet en hinderen,
Salmen lijden, als eyghen kinderen.
Icon (Radierung von Marcus Gheeraerts; fig. 1).

Levite. 19.

E Ist dat een wtlander of van ander gheslachten
Onder v verkeert of woond, en zult mids desen
Hem niet verwijten, versteken, of veraghten,
Maer sal als een ingheboren onder hulien wesen:
Ende sal by v zijn bemindt en ghepresen
Ghelijck ghy v zeluen lief hebt zonder benijden
Want al zijt ghy by fortune hoogh gheresen
Ghy hebt zelue vremdelijnghen gheweest voortijden
Dus wilt hem paeyslick onder v verdraghen en lijden.

Vlaemsche ende Turcksche Hane.

Een Vlaemschen Hane/clouck vueghel craeyere
Int Landt gheen fracyere
Zoo hy ghijngh wandelen meest alleene:
Zijnen cam lustich root stondt als der Hinnen pacyere
Cam daer by een Turckschen Haen wel te beene
Vremt faetsoenich/want wonderlicker isser gheene
Dies d'Hennekens en tÿtkens waren verwaert
Nochtans wandelde paeystick/mesde groot noch cleene
Maer heeft hem vriendelick by hemlieden ghepaert:
Den Vlaemschen ghijngh al steppende t'hemwaert
Stack met spooren/en heeft hem zeere ghepijnt/.
Menich lett dat de zonne in d'water schijnt.

d'Wtlandtsche Hane zach dat hy niet vrij zijn mochte
Al heeft hijt ghezocht/
Heeft hem zeluen ter noodtweere vp ghestreken:
Den Vlaemschen viel niet slijner/hy is daer gherocht
Maer wierdt ter deghen van d'ander ghesteken
d'Onnoosel tÿtkens t'ghevecht van verre keken
Emmers den Vlaemschen behieldt de bane/
Dies zangh hy victory/en de zijn vlercken queken
Midts dien auenthuerden d'Hinnekins wt te ghane/.
Zy boghen hen onder hueren Coppin den Hane
Hij bevlerctese/zy ghedoochdent/en waren blijde:
d'Wtlandtsche vreesde noch eens an te stane
Dies vertrack hy beschaemt an d'een zijde/
Een goet Huusman oyt gheern zyn ghezelschap bevrijde.

*Insghelijcx zommich ziet een van vremder natie*
*Den noodtdurst bezouckende om mucghen leuen*
*Zij doender afionstich op murmuratie*
*Niet rustende voor zij hem hebben verdreuen.*

Arnoldus Freitag, *Mythologia ethica*, Brügge, 1579, 236–37.

Ius hospitalitatis violatum. /*Si habitaverit advena in terra vestra, & moratus fuerit inter vos, non exprobretis ei.* Lucae 19: 33 (*recte*: Lev. 19: 33).

### GALLOPAVI ET GALLI GALLINACEI.

GALLVS *quidam gallinaceus inflati tumidique animi tanta philautia aestuabat, ut sui generis volucrem toleraret nullam: quare cum Gallopauum (quem Indicum pavonem alio nomine indigetant) iisdem commorari locis quibus ipse, gallinis item & pullis ob tranquillam & pacatam vitae consuetudinem gratum esse resciceret, aemulatione quadam crudele & atrox contra eum bellum suscipit: quod cùm tantopere incrudesceret, ut pullastris etiam metum incuteret atque à galli conspectu longè arceret, gallopauus uti quietis amans, ita continuae pugnae ac litium osor acerrimus, veteri renuntians domicilio, nouos lares eligit, bene eum vixisse iudicans qui bene latuerit.*

In ἀξενίαν & barbaram inhospitalitatem, rudesque eorum mores qui peregrinum secum commodè habitare neminem tolerant. quo vtinam vitio solus Euxinus pontus ab Apollonio notaretur, neque Christianae sectae pleraeque nationes (contra Pauli doctrinam, cum tamen barbariem exuisse videri velint, barbaris ipsis extrema quadam barbarie turpissimo inhospitalitatis crimine peiores) adeò infectae essent.

Joachim Camerarius, *Symbolorum et Emblematum Centuriae quatuor*, Mainz, III, 1668, 94–95: Emblem No. XLVII.

RABIE SUCCENSA TUMESCIT. *Quam deforme malum ferventi accensa furore/Ira sit, iratis Indica monstrat avis.* Icon: Der Indianische Hahn in der Landschaft [fig. 6].

*Varro lib. III. de re rustica cap. IX. Meleagridas vocat gallinas Africanas, quae aliis sunt Numidicae, quae ad nos quoque deferuntur. Quamquam vero Gesnerus nostras vulgo dictas Indicas gallinas ad Meleagridas recenseri posse existimet (sicuti quoque Turnerus Anglus, et Bellonius Gallus) rectim tamen pavonem Indicum vel Gallopavum nominari, idem Gesnerus putat. Sed Gellius interpres et commentator Aeliani lib. XVI. de Animal. cap. II. existimat, Gallinaceum Indicum debere appellari. His verò avibus quasi peculiare hoc est insitum, ut ad iram provocatis, cutis circa collum sanguineo colore splendescat, et crista ipsius varii coloris infletur, et ad nares usque propenditur, caputque nudum pelle purpurascente obducatur, quam antea laxam et quasi vacuam, cum irrita tur sic inflat, ut ad brachii nonnunquam crassitudinem accedat, actum vox cum fragore aliquo per collum redditur. Quae omnia in hac ave peregrina vere ἦδρος et mores iracundiae exprimunt, ut vix aliquid accommodatius excogitari posset. Est autem hoc dictum ex Claudiano de IV. consulatu Honorii desumtum, ubi ait:*

> Iram sanguinei regio sub pectore cordis
> Protegit, imbutam flammis, avidamque nocendi,
> Praecipitemque sui, rabie succensa tumescit.

*Cum quo convenit Persius lib. III.*

> Nunc face supposita, fervescit sanguis et ira

Scintillant oculi, dicisque facisque quod ipse
Non sani esse hominis, non sanus jure Orestes.

*Seneca quoque in lib. de ira eam luculenter describit his verbis: Nam in ea facies turbatior ora pulcherrima foedat, torvos vultus ex tranquillitate reddit, linquit decor omnis iratos. De remediis verè contra hunc tam impetuosum affectum aliorum scripta consulantur.*

## *Appendix 4*

Filippo Picinelli, *Mundus symbolicus*, Köln, 1687, 299.

GALLOPAVUS, seu Gallus Indicus.
*Caput. XXXII.*

| | |
|---|---|
| Iracundus | 379. Quantùm vultus humani venustas iracundiâ ac commotâ bili devastetur, è Gallo Indico haud obscurè conjicere licet, qui in iram concitatus, tumescere, livere, ac monstro similis, |
| Claud. de 4.<br>Honorii Consul.<br>Ovid. 1. 3. de<br>Arte. | jactari solet: ut adeò iratam hanc volucrem illo Claudiani lemmate scitè insignias: RABIE SUCCENSA TUMESCIT. Ovidius:<br>*Pertinet ad faciem rabidos componere mores,*<br>*Candida pax homines, trux decet ira feras.*<br>*Ora tument irâ, nigrescunt sanguine venae,*<br>*Lumina Gorgoneo saevius angue micant.* |
| S. Chrysost.<br>hom. in Acta.<br><br>Senec. l. 2. de<br>Ira. c. 36. | S. Joan. Chrysostomus: *Quid in iracundo non turpe? oculi insuaves, os distortum, membra tremula, lingua infraenis, mens stupida, figura indecens, multa insuavitas &c.* Seneca inter caetera irae extirpandae remedia suadet, ut homini excandescenti speculum objicias; fore enim, ut omni studio.sibi imposterum ab hoc vitio caveat, à quo se tantopere defoedatum cernit. *Quibusdam iratis profuit aspexisse speculum, perturbavit illos tanta mutatio sui.* |
| Superbus | 380. Gallopavus, rubri coloris penitus impatiens, viso illo gravissimè exasperatur. Lemma: EXACERBATVR RVBEO. Superborum haec est indoles, qui è crucibus & aerumnis, à Deo immissis, non tantùm non ad frugem redeunt, sed magis inde exacerbantur, contra Deum & homines insurgunt, obmurmurant, suaeque famae plurimùm inde derogatum queruntur. |
| S. Aug. de<br>Pastor. c. 5. | S. P. Augustinus: *Qui doctus fuerit sperare prospera hujus saeculi, ipsâ prosperitate corrumpitur, supervenientibus adversitatibus sauciatur, aut fortassis extinguitur.* |

## *Notes*

[1] Edeward de Dene, *De warachtighe Fabulen der Dieren*, Brügge, 1567, 190 f. (Mario Praz, *Studies in Seventeenth-Century Imagery*, 2. Ausg., Rom, 1964, 314 f.; J. Landwehr, *Fablebooks Printed in the Low Countries*, Nieuwkoop, 1963, Nr. 119); Arnoldus Freitag, *Mythologia ethica*, Antwerpen, 1579, 236 f. (Praz, 1964, 341). Beide Fabelbücher sind mit der gleichen Illustration, einer Radierung von Marcus Gheeraerts, versehen. Die Texte siehe im Anhang (Appendices 1, 2).

[2] *Encyclopaedia Britannica*, XXII, 1963, 610 f.; *Die Kunstdenkmäler des Landes*

Schleswig-Holstein, Stadt Schleswig, II, Der Dom, München, 1966, 250.

[3] "Und ich hab aber all mein lebtag nichts gesehen, das mein hercz also erfreuet hat als diese ding. Dann ich hab darin gesehen wunderliche künstliche ding und hab mich verwundert der subtilen jngenia der menschen in frembden landen." Albrecht Dürer, *Das Tagebuch der niederländischen Reise 1520. 1521*, Einleitung von J.-A. Goris und G. Marlier, übersetzt von Dieter Kuhrmann und Rüdiger Becksmann, Brüssel, 1970, 65.

[4] Friedrich Kluge, *Etymologisches Wörterbuch der deutschen Sprache*, 18. Aufl., Berlin, 1960, 796. Vermutlich ist der Name "kalekutische Hühner" darauf zurückzuführen, daß Portugiesen den Europäern die Vögel brachten. Bei der Verwendung der Bezeichnung "indianisch" sowohl für ostindische Dinge als auch für die der Neuen Welt werden die Vögel mit dem wichtigsten Handelsplatz der Portugiesen in Indien, der Hafenstadt Calicut (heute Koshikode) an der Malabarküste, wo Vasco da Gama 1498 gelandet war, in Zusammenhang gebracht worden sein. Im Deutschen sind mancherlei weitere Namen für den Vogel aus Amerika nachzuweisen: Puter (niederdeutsch, zuerst 1559), Kalekuter, kūn hān (niederdeutsch), kuter, Kauter, welscher Hahn, türkischer Hahn, windischer Spatz, das Pockerl (bayerisch), Bibergockel (bayerisch), Kalekuten (niederdeutsch), Pipen oder Pippen (Nürnberg); für die Henne: Kalekuthenne, Pute, Schrute (mitteldeutsch).

[5] Johann Beckmann, *Beyträge zur Geschichte der Erfindungen*, III, Leipzig, 1792, 258 (unter Berufung auf Scaliger); siehe dort auch Anm. 30 auf S. 259. Über Bildzeugnisse aus der Schule von Fontainebleau siehe S. 314. Die geläufige Bezeichnung für den Truthahn: le dindon, zeitweilig in einigen Provinzen auch: le jésuite; für die Truthenne: la poule d'Inde, la dinde. *A propos* "jésuite" siehe F. Chr. Eugen von Vaerst, *Gastrosophie oder Lehre von den Freuden der Tafel*, München, I, 1975 [erste Ausgabe: Leipzig, 1851], 285; und Beckmann, *Beyträge*, III, 260; Kluge, 1975, 795.

[6] *Encyclopaedia Britannica*, XXII, 1963, 616 f. Vgl. auch Henry Greene, *Shakespeare and the Emblem Writers*, London, 1870, 356. Zu den englischen Namen turkey-cock, kurz turkey; turkey-hen, erklärt *The Concise Oxford Dictionary*, 5. Aufl., 1964, 1402, daß sie, ursprünglich den Perlhühnern (guinea fowl) als über die Türkei eingeführten Vögeln gegeben, irrtümlich auf den amerikanischen Vogel übertragen worden seien. Weitere englische Bezeichnungen: gobbler, tom, pownie-cock (schottisch).

[7] Italienische Namen für die Truthühner: gallo d'India, gallo pavone, gallo di Calicut, tacchino, gallinaccio; gallina d'India, gallina di Calicut, tacchina. Holländisch: Kalkoensche Haan, Hen; Kalkoen; Kalkoentje (junge Truthühner). Norwegisch: Kalkun. Russisch: калкун, индюк, индейский пемух; индюшка, индейка. Der Name "pavo" zeigt an, daß die Spanier, an naturkundlichen Beobachtungen bei der Eroberung der Neuen Welt in der Regel nicht sonderlich interessiert—Oviedo macht darin eine Ausnahme—den Indianischen, wohl wegen seines ähnlich "prahlenden" Gehabes, als ein Gegenstück zum Pfauenhahn (*pavo real*) ansahen. "Amerikanisch" nimmt sich alleine das portugiesische "peru" aus. Über die europäischen Namen für den Indianischen Hahn siehe Edward F. Tuttle, "Borrowing versus Semantic Shift: New World Nomenclature in European Languages," in Fredi Chiappelli u. A. (Hrsg.), *First Images of America, The Impact of the New World on the Old*, Berkeley, Los Angeles, London, II, 1976, 598–600, 606 Anm. 1; 607 Anm. 9, 13; 608 Anm. 15, 18.

[8] "Anderm Geflügel gegenüber ist das Truthuhn unverträglich und bösartig." "Seines jähzornigen, zanksüchtigen Wesens halber wenig beliebt," urteilen Beobachter des Hühnerhofs.

[9] *Magic Books from Mexico*, Introduction and Notes on the Plates by C. A. Burland, Harmondsworth–Baltimore–Melbourne, 1958, 30 f., Taf. 16 (aus Codex Vaticanus 3773) und 16 f., Taf. 3 (aus Codex Ríos). Dort auch, S. 30 f. und 16 f., Zitate geistlicher Auslegungen

des "Jewelled Turkey."

[10] Bernhard Grzimek (Hrsg.), *Enzyklopädie des Tierreichs*, VIII, Zurich, 1969, 25 f. (Alexander Skutch, *Truthühner*).

[11] Giovanni Battista Ramusio, *Delle navigatione et viaggi*, III, Venedig, 1556, Kap. 37, faßt zusammen, was Gonzalo Fernández de Oviedo y Valdès, Historiograph Karls V. für *Las Indias*, über den Vogel, sein Aussehen, die Qualität seines Fleisches und seine Schätzung als Hausgeflügel in Spanien schrieb. Abgedruckt in Beckmann, *Beyträge*, III, 246 f., Anm. 8.

[12] Kurt Kusenberg, *Le Rosso*, Paris, 1931, 69 f., Taf. XLVI: Travée *L'Ignorance chassée*. Fabbri/Skira, *L'Arte racconta*, Nr. 39, *Rosso e Primaticcio al Castello di Fontainebleau*, Text von Sylvie Béguin, Mailand/Genf, 1965, 14–15. Henri Zerner, *Die Schule von Fontainebleau. Das graphische Werk*, Wien und München, 1969, 39 und Abb. A.F. 33: Antonio Fantuzzi, B. 30, H. 1 (Félix Herbet, "Les graveurs de l'Ecole de Fontainebleau," *Annales de la Société archéologique du Gâtinois*, II, Cat. de l'Oeuvre de Fantuzzi, 1896, 257–91).

[13] *L'Ecole de Fontainebleau*, Paris, 1972 (Ausst.-Kat.), 339–42, Nr. 443–48.

[14] *Revue de l'Art*, num. spéc., 16–17, 1972: *La Galerie François Ier au Chateau de Fontainebleau*, III: Oreste Binenbaum, Sylvia Pressouye, "Dossier technique," 45–96. Abbildung 129 auf S. 95 zeigt die Travée *L'Ignorance chassée* mit den Tieren: "en bas, des sujets plus incongrus: à gauche un dindon et deux dindes; à droite quatre rongeurs."

[15] Dora and Erwin Panofsky, "The Iconography of the Galerie François Ier at Fontainebleau," *Gazette des Beaux-Arts*, September 1958, 165 f., Anm. 14, wiesen dem Truthahn (sofern er "authentisch" sei) in diesem Kontext die Bedeutung "stupidity" zu.

[16] *L'Ecole de Fontainebleau*, 1972, 198 f.; 28, 248. Richard Berliner, *Ornamentale Vorlageblätter*, Leipzig, 1925–26, Tafelband I, 135, 1; 137, 2.

[17] Lieselotte Möller, *Der Wrangelschrank und die verwandten süddeutschen Intarsienmöbel des 16. Jahrhunderts*, Berlin, 1956, 42, Taf. 1, 2.

[18] Möller, *Wrangelschrank*, 56–61.

[19] Charles de Tolnay, *The Drawings of Pieter Bruegel the Elder*, London, 1952, 70. René van Bastelaer, *Les Estampes de Pierre Brueghel l'Ancien*, Brüssel, 1908, Nr. 130. Louis Lebeer, *Cat. raisonné des Estampes de Bruegel l'Ancien*, Brüssel, 1969, Nr. 23. *Europe in Torment: 1450–1550* (Ausst.-Kat.), Providence, R.I., 1974, 50, Nr. 11, Abb. 11.

[20] Cesare Ripa, *Iconologia*, Padua, 1611, 263.

[21] R.v.B. 127–L.L.20.

[22] Vaerst, *Gastrosophie*, München, 1975, I, 285.

[23] *The Concise Oxford Dictionary*, 5. Aufl., 1964, 1402.

[24] Über den Aufbau eines Emblems: *Reallexikon zur deutschen Kunstgeschichte* (hereafter *RDK*), V, 1967, "Emblem, Emblembuch" (William S. Heckscher und Karl-August Wirth), Sp. 88–96.

[25] Zu Reusner, II, Nr. 16: Artur Henkel und Albrecht Schöne (Hrsg.), *Emblemata, Handbuch zur Sinnbildkunst des XVI. und XVII. Jahrhunderts*, Stuttgart, 1976, Sp. 846. Dort ist auch das Epigramm wiedergegeben; zur Ikon heißt es: "Das Bild zeigt zwar eine Truthenne, muss aber sinngemäß ein Perlhuhn (*meleagris*) meinen." Mario Praz, *Studies in Seventeenth-Century Imagery*, 2. Ausg., Rom, 1964, 469 f.

[26] Mit der Verwirrung hinsichtlich der Indianischen Hühner befaßten sich noch Autoren des 18. und 19. Jahrhunderts: Beckmann, *Beyträge*, III, Kap. V.; Vaerst, *Gastrosophie*, 285–88.

[27] Praz, 1964, 295 f. Beschreibung der Emblembücher des Camerarius: Henkel und Schöne, *Emblemata*, CLXXXII–CLXXXIV; Charakterisierung: *RDK*, V, Sp. 181 f. Zu "Ira," "Iracundia," dem Vorwurf des Truthahn-Emblems, vgl. auch die Blütenlese in *Epitheta Joannis Textoris Nivernensis, Opus Absolutissimum . . .*, Genf, 1638, 245v–247.

[28] Zu Camerarius: Text im Anhang (Appendix 3).

[29] Picinelli, 1687, Lib. IV, 299, Cap. XXXII, Nr. 379. Praz, 1964, 455. Die Texte im Anhang (Appendix 4).

[30] Praz, 1964, 453.

[31] William Shakespeare, *Twelfth Night*,

II, 5, 25–27; die Komödie wurde um 1601 verfaßt (1623 gedruckt). Henry Green, *Shakespeare and the Emblem Writers*, London, 1870, 357 f., zitiert die Stellen, verknüpft sie indessen unzutreffend mit Arnoldus Freitag und Joachim Camerarius (und bemerkt selbst, dass es nicht recht stimmt).

32 Museum für Kunst und Gewerbe Hamburg, Sammlung Hermann Dürck (Bilder des Todes). Blatt 2 einer Folge. Unterschrift: Non curat genus et formam, non robur, et annos/Nescia Mors ulli parcere, cuncta necans.

33 *RDK*, V, Sp. 1107–1202, "Erdteile" (Erich Köllmann und Karl-August Wirth u. A.); unter den Sp. 1166–68 verzeichneten Attributen gibt es die Truthühner nicht.

34 W. P. Cumming, R. A. Skelton, D. B. Quinn, *The Discovery of North America*, New York, 1972, 129, 164, 188, 260.

35 Zu frühen Berichten über die Neue Welt siehe *RDK*, VII, Sp. 1491–97, "Exoten" (Baron Ludwig Döry) und William C. Sturtevant, "First Visual Images of Native America," in: F. Chiappelli (Hrsg.), *First Images of America*, 1976, I, 417–54. Das Truthuhn (*Meleagris gallopavo*) und das Pfauentruthuhn (*Meleagris ocellata* oder *Agriocharis ocellata*), beide auf dem amerikanischen Kontinent, in Mittel- und Nordamerika bzw. in Yucatan, Guatemala und Belize, ursprünglich beheimatet, werden der Unterfamilie der Fasanenartigen Vögel (*Phasanidae*) zugeordnet. Grzimek, *Enzyklopädie des Tierreichs*, 19–25, Taf. S. 40, 34–35; 33.

36 *Le Theatre / du Monde / Ou / Nouvel Atlas*/Mis en lumière/Par/Guillaume et Jean Blaeu./Seconde Partie. Amsterdami/Apud Guiljelmum et Johannem Blaeu. Anno MDCXXXV, Folio C2: Nova Belgica et Anglia Nova. (Jr. C. Koemen, *Atlantes Neerlandici*, I, Amsterdam, 1967, 110.)

37 Hans R. Weihrauch, *Europäische Bronzestatuetten*, Braunschweig, 1967, 223. Elisabeth Dhanens, *Jean Boulogne*, Brüssel, 1956, 159 f., Abb. 66. Nachdem dieser großartige *ritratto dal naturale* von ihm vorlag, wurde der Indianische Hahn auch *en relief* wiedergegeben:

Ingrid Weber, *Deutsche, Niederländische und Französische Renaissanceplaketten 1500–1650*, München, 1975, Textband, 245, Nr. 486, 11; Tafelband, Taf. 145; 289, Nr. 659, 8, Taf. 179. *Sechs Sammler stellen aus* (Ausst.-Kat.), Hamburg, 1961, Nr. 160, 161: Bronzebeschläge.

38 Jean Louis Sponsel, *Kabinettstücke der Meißener Porzellan-Manufaktur von Johann Joachim Kändler*, Leipzig, 1900, 57. Carl Albiker, *Die Meissener Porzellantiere im 18. Jahrhundert*, Berlin, 1959. Rainer Rückert, *Meissener Porzellan 1710–1810* (Ausst.-Kat.), München, 1966, 189 f., 18.

39 Albiker, *Porzellantiere*, 12, Abb. 55, 56. *Figürliche Keramik aus zwei Jahrtausenden* (Ausst.-Kat.), bearbeitet von Peter Wilhelm Meister und Franz-Adrian Dreier, Frankfurt am Main, 1964, 40, Nr. 73.

40 Albiker, *Porzellantiere*, 5. Rückert, *Meissener Porzellan*, 189 f.

41 *RDK*, VII, "Fasanerie," Sp. 437–61 (Elisabeth Herget und Werner Busch), Sp. 438 (Truthühner), Sp. 450 (Fasanerien und Fasanengehege in Sachsen).

42 Beschreibung in: Braun, *Theatrum urbium*, 1593.

43 Der Vogel in kaiserlichem Besitz, meistens als "Dodo" (✝*Raphus borbonicus*) bezeichnet, nach zoologischer Ansicht vielmehr eine Dronte (✝ *Raphus cucullatus*) von der Insel Mauritius (Johannes Lüttschwager in: Grzimek, *Enzyklopädie des Tierreichs*, 278 f., Abb. 2 auf S. 260 nach einer indischen Miniatur in Leningrad, Institut für Orientalistik), wurde von Roelant Savery in dem *Orpheus*-Bild im Mauritshuis wiedergegeben (*Musée Royal de la Haye, Cat. raisonné des Tableaux et des Sculptures*, 2. Aufl., 1914, 336, Nr. 157. Jan Białostocki, "Les Bêtes et les Humains de Roelant Savery," *Bulletin des Musées Royaux des Beaux-Arts*, VII, 1958, 87; figs. 4, 5. "Dead as a dodo," sagen die Engländer. Die Drontevögel, früher den Tauben-, neuerdings den Kranichvögeln zugeordnet, wurden im 18. Jahrhundert ganz und gar ausgerottet.

44 Benno Geiger, *Die skurrilen Gemälde des Giuseppe Arcimboldi (1523–1593)*, Wiesbaden, 1960, 73–74 (Italienische

Ausgabe: Florenz, 1954). Was den "Surrealismus" betrifft, siehe Rudolf und Margot Wittkower, *Born Under Saturn*, New York, 1969, 283–86. R. Barthes, *Arcimboldo*, 1977, und André Pieyre de Mandiargues, *Arcimboldo the Marvelous*, New York, 1978, sind mir noch nicht zugänglich gewesen.

[45] Wien, Kunsthistorisches Museum: AQUA, Nr. 350; IGNIS, 1566, Nr. 351 (*Verzeichnis der Gemälde*, 1973, 9, 8; Taf. 32). Geiger, *Arcimboldi*, Abb. 84, 85. Über das verlorene Bild AER siehe Geiger, 74 f.

[46] Versteigerung der Sammlung van Gogh, Amsterdam, Dezember 1913, Nr. 318, Taf. XIV.

[47] Geiger, *Arcimboldi*, Abb. 86 und 86ᵃ, Text S. 74, 158.

[48] Białostocki, "Savery," 69–89.

[49] Białostocki, "Savery," Abb. 1. Auch unter den Tieren des *Orpheus*-Bildes in Wien ist ein Indianischer Hahn (*Verzeichnis der Gemälde*, 1973, 155, Taf. 77).

[50] Anzeige in *Burlington Magazine*, Winter 1937.

[51] L.D., "The Peaceable Kingdom," *Bulletin of the Worcester Art Museum*, XXV, 1934, 25–30.

[52] *Adam und Eva im Paradis*, um 1615, Mauritshuis (*The Royal Cabinet of Paintings, Illustrated General Catalogue*, The Hague, 1977, 252, Nr. 253). Zur Rekonstruktion des Torso Belvedere (in dem sitzenden Adam) vgl. Heinz Ladendorf, *Antikenstudium und Antikenkopie*, Berlin, 1953, 31 f., Taf. 19–24. Zum sitzenden Adam (ikonographisch) und einigen Tieren im Paradies siehe Erwin Panofsky, *Problems in Titian, Mostly Iconographic*, New York, 1969, 27–29, Abb. 29–32.

[53] Beispiele aus Emblembüchern: Henkel und Schöne, *Emblemata*, Sp. 1069–73.

[54] H. W. Janson, *Apes and Ape Lore*, London, 1952, 107–44: The Ape and the Fall of Man.

[55] Im *vivarium* Kaiser Rudolfs gab es Paradiesvögel; Jacob Hoefnagel konterfeite sie um 1610. In Henkel und Schöne, *Emblemata*, ist nur ein vor dem vermutlichen Entstehungsdatum (um 1615) des Rubens/Brueghel-Gemäldes erschienenes Emblembuch verzeichnet

(Sp. 800: Sebastian de Covarrubias Orozco, *Emblemas morales*, Madrid, 1610, III, Nr. 72), worin der Paradiesvogel nicht ausdrücklich als fußlos charakterisiert ist. Embleme mit fußlosen Paradiesvögeln: Henkel und Schöne, *Emblemata*, Sp. 799–800. Ehe—im frühen 17. Jahrhundert—die ersten lebendigen Vögel nach Europa kamen, glaubte man an die Legende von den fußlosen Paradiesvögeln, die entstanden war, nachdem Portugiesen 1522 präparierte Bälge ohne Füße mitgebracht hatten. In übertragener Bedeutung begegnet der Paradiesvogel in Georg Friedrich Lichtenbergs *Ausführlichen Erklärungen der Hogarthischen Kupferstiche*: "The Harlot's Progress," 5. Blatt: "Und wo sind nun die Irrwisch-Füßchen? Antwort: das hüpfende, elastische Rotkehlchen in den dornigen Lusthecken von Drurylane hatte sie nötig zu seinem Unterhalt, der tiefbehangene Paradies-Vogel, *dort auf dem Armsessel, braucht sie nicht mehr!." Anm. *: Des Erklärers Glaube an ein geflügeltes Pferd gibt ihm schlechtweg das Recht, an Paradiesvögel ohne Füße zu glauben.

[56] Uber die *maniere* Castiglione's und deren Nachahmer siehe Rudolf Wittkower, *Art and Architecture in Italy, 1600–1750*, Harmondsworth, 1958, 228 f. *Giovanni Benedetto Castiglione* (Ausst.-Kat.), Philadelphia, 1971, Vorwort von Anthony Blunt, Einleitung und Katalog von Ann Percy.

[57] *Castiglione*, Figs. 1, 14, 29, 30, 35; Nos. 2, 11, 12, 89, 90, 109, 121.

[58] Bayerische Staatsgemäldesammlungen, Schloß Schleißheim, Inv. Nr. 2250. *Il Seicento Europeo* (Ausst.-Kat.), Rom, 1968, 101, Nr. 56, Taf. 37. Delogu, *G. B. Castiglione*, Bologna, 1928, 51. Ein weiteres Exemplar dieser Komposition: Louvre, Nr. 1252. Über die Umbenennung zweier Bilder in Schleißheim von G. B. Castiglione auf Pieter Boel siehe *Castiglione*, 54, Anm. 82.

[59] A. Pigler, *Barockthemen*, II, Budapest–Berlin, 1956, Abb. auf S. 293., *Dedalo*, III, 2, 1922/23, 513. Wie unbedenklich Vassallo den *Grechetto* nachahmte, ergibt sich aus dem Vergleich der Hundefigur hier und in *Noahs*

*Aufbruch* (fig. 14). Über Vassallo siehe Wittkower, *Art and Architecture*, 229. *Castiglione*, 32 und 53, Anm. 80 f.

[60] Zu Andrea Vaccaro (1604–1670): Pigler, II, Abb. auf S. 187; Wittkower, 1958, 232.

[61] *Katalog der Alten Meister der Hamburger Kunsthalle*, 5. Aufl., 1966, 172, Nr. 420. Ernst Günther Grimme, "Das Suermondt-Museum, eine Auswahl," in: *Aachener Kunstblätter*, XXVIII, 1963, 290 f., Nr. 164 (m. Farbtafel). Das Gemälde in Aachen ist Gegenstand einer eindringlichen Untersuchung der Beziehungen zwischen Tierbild und Fabelillustration: Karl Arndt, "De Gallo et Iaspide. Ein Fabelmotiv bei Frans Snyders," in: ARGO, *Festschrift für Kurt Badt*, Köln, 1970, 290–96, Abb. 95–97.

[62] Praz, 2. Ausg., 1964, 314: Dene (mit Hinweis auf nachfolgende Autoren). J. Landwehr, *Fablebooks printed in the Low Countries, a concise bibliography until 1800*, Nieuwkoop, 1963, Nr. 119 (über die Nachwirkung siehe "Gheeraerts" im Register).

[63] Denes und Freitags Texte siehe im Anhang (Appendices 1, 2).

[64] Saenredam nach Bloemaert: F. W. H. Hollstein, *Dutch and Flemish Etchings, Engravings and Woodcuts, c. 1450–1700*, Amsterdam, 1950, II, 68, Nr. 528 (R. Grosse, *Die holländische Landschaftskunst 1600–1650*, 1925, 14, Abb. 4). Von Melchior Küsel nachgestochen für seine *Icones Biblicae*, Wien, 1679 (Illustration zu Lucas, Cap. XV). Auch auf Bloemaerts Gemälde *Bauerngehöft mit rastenden Landleuten*, heute in den Staatlichen Museen zu Berlin, Gemäldegalerie, stolziert ein *Kalkoen* (Abb. in: *Staatliche Museen Berlin, Die Gemäldegalerie, Abbildungen*, 4. Bd., *Die holländischen Meister, 17. und 18. Jahrhundert*, Berlin, 1932, 14, Nr. 1995). Bloemaert zeichnete schon im späten 16. Jahrhundert draußen auf dem Lande. Stiche nach Studien Bloemaerts: Hollstein, II, 65, Nr. 74–87 und 85, Nr. 16–29.

[65] Später wurde in den Vereinigten Staaten Puterbraten zum traditionellen Festmahl am *Thanksgiving Day*. Diese Rolle hat dem um 1900 angeblich fast ausgerotteten nordamerikanischen Wildputer wieder zu starker Vermehrung verholfen (Dale Brown u. A., *Die amerikanische Küche*, 3. Aufl. in deutscher Übersetzung, Time-Life-Bücher, 1972, 20 f., 30–35).

[66] Stefan Bursche, *Tafelzier des Barock*, München, 1975, 79 (nach Johann Oettingers Beschreibung des Festes, Stuttgart, 1610).

[67] R. Oldenbourg, *Die flämische Malerei des XVII. Jahrhunderts* (Handbücher der Staatlichen Museen zu Berlin), 2. Aufl., Berlin und Leipzig, 1922, 189 und Abb. 86. Lebende *Pavos, pollos y capones*, die ihre Verwendung in der Küche zu erwarten haben, malte Juan Bautista del Mazo (um 1614–1667), Diego Velazquez' Schüler (Julio Cavestany, "Sobre Juan Bautista del Mazo," *Arte Español*, XX, 1954, 4–9, Taf. 1, 3).

[68] Bursche, *Tafelzier*, 83–88 (nach G. P. Harsdörffer, *Vollständig vermehrtes Trincir-Buch*, Nürnberg, 1665). Bursche, 86: der Indianische Hahn war "von Plicatur/oder gefaltetem Cammertuch."

[69] Das Programm dieses Friedensmahls ist—gleichfalls nach Harsdörffer—abgedruckt in: Bursche, *Tafelzier*, 80–83. Unsere Abbildung 16 gibt den Kupferstich (Staatliche Museen–Preußischer Kulturbesitz, Berlin, Kunstbibliothek [Lipperheidesche Kostümbibliothek]) ohne das Namensverzeichnis der an der Haupttafel sitzenden Festteilnehmer wieder.

[70] Höchst, um 1750, Terrine mit Schüssel. Truthahn mit gesenkten Flügeln und entfaltetem Schwanz; oberhalb der Beine der Terrinenboden. H. 44 cm. Mit Muffelfarben staffiert von Johannes Zeschinger, Museum für Kunst und Gewerbe Hamburg, Konrad Hüseler, *Deutsche Fayencen*, Stuttgart, 1956–58, I, 155, Abb. 26. Bursche, *Tafelzier*, Farbtafel II (nach S. 48). Straßburg, um 1754/60, Terrine in Form eines Truthahns in ganzer Figur. H. 47 cm. Schloß Favorite, Baden (fig. 17) (*Kunstschätze in badischen Schlössern* [Ausst.-Kat.], Karlsruhe, 1968, Nr. 96, Abb. 6).

[71] Italienische Maler niederländisch beeinflußter Schulen, vor allem in

Genua und in Neapel, bilden darin Ausnahmen.

[72] M. d'Hondecoeter, *Die weiße Henne*, Kassel (Kat. 1958, 162, Nr. 379). Siehe auch Rijksmuseum, Amsterdam, *Catalogus van de Schilderijen*, 1956, 95, Nr. 1227. Einen weißen Truthahn zeigt ein Bild Hondecoeters im Louvre. Die Rötelzeichnung mit zwei Pfauen, in Amsterdam (*Holländische Zeichnungen der Rembrandt-Zeit* [Ausst.-Kat.], Hamburg, 1961, 106, Nr. 142 [m. Abb.]), eines der seltenen Studienblätter von Hondecoeter, enthält auf der Rückseite einen Truthahn.

[73] Kassel, Kat. 1958, 74, Nr. 380; Karl Voll, *Die Meisterwerke der Kgl. Gemälde-Galerie zu Cassel*, 1904, Abb. 63. Schwerin, Kat. *Holländische Maler des XVII. Jahrhunderts*, Schwerin, 1952, 72, Nr. 104; Wilhelm Bode, *Die Großherzogliche Gemälde-Galerie zu Schwerin*, Wien, 1891, Abb. S. 91.

[74] Früher Peter Paul Rubens zugeschrieben, *Rubens und Helene Fourment im Garten*, München, Alte Pinakothek (Inv. Nr. 313). Rubens' Autorschaft und das Entstehungsjahr 1631 wurden von Hans Gerhard Evers, *Rubens und sein Werk, Neue Forschungen*, Brüssel, 1943, 336–41, mit triftigen Gründen in Frage gestellt; beides hält die Verfasserin des Textes zu Nr. 780 des Ausst. -Kat. *Kurfürst Max Emanuel, Bayern und Europa um 1700*, München, 1976, II, aufrecht. Siehe

dagegen Martin Warnke, *Peter Paul Rubens*, Köln, 1977, 29.

[75] *De Kippenhof*, Mauritshuis, *Katalog*, The Hague 1977, 224, Nr. 166.

[76] Evers, *Rubens*, 341.

[77] Ein Stilleben von Pieter Boel mit dem Truthahn an auffälliger Stelle bewahrt die Kasseler Galerie (Kat., 1958, 33, Nr. 162, mit Abb.). Über neuere Zuschreibungen von Gemälden aus der genuesischen Periode: *Castiglione*, 32 f.; 54, Anm. 82. Über Boels Tätigkeit in der Pariser Teppich-Manufaktur: *Musée des Gobelins*, 1938, Paris, 15, 49; Nr. 55, Taf. XXIII.

[78] Das Album *La Ménagerie Impériale* von Paul Hadol, 31 Blatt Farblithographien, erschien während des deutsch-französischen Krieges, 1870/71, in Paris. Nr. 24 der Folge: Maupas.–Grand-Carteret, *La Caricature en France*, Paris, 1888, 649. *Bestiarium* (Ausst.-Kat.), Hamburg, 1962, 93, Nr. 52, Abb. 23 (irrtümlich statt Hadol "Henriot" als Autor angegeben). *Das frühe Plakat in Europa und den USA, II, Frankreich und Belgien*, Berlin, 1978, 362.

[79] V. Le Nepveu, *Musée des Horreurs*, Nr. 9: Francis Dehaut de Pressensée, Paris, 1899/1900. Aus einer Serie von 51 Plakaten (statt 200, wie ursprünglich vorgesehen). *Das frühe Plakat*, II, 146–53, Nr. 524 (S. 150 f.); 566.

[80] *Kunstdenkmäler Schleswig*, II, *Der Dom*, 1966, 250 f.: "Der Truthahnstreit."

# 21

# *Veronese's Decorum: Notes on the* Marriage at Cana

PHILIPP P. FEHL

The world is agreed that Paolo Veronese is rich. He therefore has his detractors. But he is true as well, and tactful, opulence being the medium of his discretion. Veronese indulges in artistic license with such mastery that the truth of the tale he tells is enhanced in faithfulness the more we allow his fancy to guide ours.

Ever since the *Marriage at Cana* (fig. 1) was torn from its original setting in Palladio's refectory of the convent of S. Giorgio Maggiore in Venice and brought to Paris as one of Napoleon's spoils of war it has been the plaything, and sometimes even the origin, of conflicting theories of art. It is one of the largest pictures, if not the largest, in the Louvre; its effect upon the senses—the eye, the ear, the touch, even the very taste in the mouth (so rich is the banquet)—as well as upon the heart, is instantaneous.

A wealth of color and a world of festive action are contained within a noble architecture, a theater at once crowned and joined unto infinity by a serene sky. This better world, richer than ours, as only art can enrich nature, is yet a part of our world as well. It is linked to us (as we are to it) by the wings of the classical porticoes which invite us into the picture and define our place in it (at the foot of the banqueting hall, that is, in the refectory in which we stand or sit, the picture being, as it were, an elevated outdoor extension of it); by the conciliatory three-partite perspective that eases all constraint of looking from a fixed point of view, and is gently just right, no matter where in the refectory we may be seated; and most of all, perhaps, by the abundance of little jokes, and by the conviviality that makes the life at the covered table, by art, so artlessly festive. There is the beautiful young woman (often noted in the literature) who uses a toothpick and looks at us in oh so bored a way (figs. 2, 4)—her partners at table are far too serious to do justice to her charms; the gentleman explaining the use of the newfangled fork to his neighbor; the little lapdog on top of the table to get his share of the meal; the cat clawing at the water vessel that contains the newly created miraculous wine; and above all, commandingly placed in the right foreground, the splendidly garbed drinker in a pose of bliss who looks at his glass and marvels at the wine's excellence (fig. 3).

All these traits make us love the picture but, clearly, they also tease the decorum of its sacred subject. When the picture came to the Louvre the response to it was

1. *Veronese.* Marriage at Cana. *Louvre, Paris*
2. *Veronese.* Marriage at Cana *(detail, lower left)*

*3. Veronese.* Marriage at Cana *(detail)*
*4. Veronese.* Marriage at Cana *(detail, lower right)*

already set by a *paragone,* then much favored in France, between Le Brun's *Tent of Darius* and another painting by Veronese, *The Feast in the House of Simon,* both works having long ago been enshrined in Versailles as great treasures of art.[1] In this standard comparison Veronese was praised for color and truth to nature, the excellences generally accorded to the Venetian school by Tusco-Roman-oriented critics, and faulted on historical truthfulness, costume, and dignity. How much greater the excellence of Le Brun, who not only had acquired all the art that the example of Venice could teach, but also was superb in *disegno,* history, and decorum!

This condescending view of the art of Veronese could not, at length, prevail within range of the radiance of his *Marriage at Cana.* Its very pedantry offended. Free spirits who think of decorum as inhibition and regard the representation of miracles as an appeal to superstition came to see in the picture a celebration not of its religious subject (which was a mere pretense on the part of the painter), but of the glory of a Venetian banquet. Others, in turn, in a view perhaps not so unrelated to the first as it might seem, have seen in the *Marriage at Cana* a triumph of pure painting, art freed from the contamination of narrative. Both positions were first elaborated well over a hundred years ago when they found a principal source of support in the record of Veronese's examination by the Inquisition, which was discovered by Armand Baschet and published by him with an interpretation of the "banqueting view" in 1867.[2]

Quite a few years ago I tried to show that the record of Veronese's interrogation can be read rather differently and that decorum (for which Veronese himself tried to break a lance before his judges) is really at the heart of Veronese's art if, that is, it is construed imaginatively, attentive to the mutual give and take of laughter and tears, and to the joining of highmindedness and little jokes.[3] In the case of the *Marriage at Cana* a teasing of decorum (which is but a demonstration of Veronese's loving respect for it) also opens the gate for us through which we may gain access to an ever finer comprehension of a work of art that some, with the accuracy of exaggeration that only love can inspire, have called the greatest painting in the world.[4]

My suggestions have since been more fully developed and supported with a wide range of observations by others, most notably David Rosand.[5] If I return to the task once more it is not to come to the rescue of a cause that, if perhaps still not widely espoused, at least is now respectable, but rather to draw attention to two works of art, one a literary source, the other a painting, which, I am persuaded, played a considerable role in the genesis of Veronese's *Marriage at Cana.* My hope is that this will allow us to review the nature of Veronese's choices, and his purpose, without having to depend as much as we have heretofore on surmises and special pleading.

The primary source for any representation of the *Marriage at Cana* is, of course, the Gospel of St. John. Veronese surely never forgot this. For the ornamentation and the enlargement of his scene, however, he relied primarily (as I trust the text will presently show by itself) on the account of the miracle as it is given in Pietro Aretino's once much admired and now either ignored or despised devotional paraphrase of the Gospels, *La Humanità di Christo.*[6] Veronese acknowledged this source of his inspiration by including a quite unmistakable portrait of Pietro Aretino among the guests present at table in the *Marriage at Cana* (fig. 4). It is a happy translation into the *ambiente* of his painting of Titian's portrait of Aretino, clearly the version that is now in the Frick Collection (fig. 5) and at the time was

*5. Titian.* Portrait of Aretino. *Copyright Frick Collection, New York*

in Venice. (It was painted about 1548 for Aretino's publisher, Francesco Marcolini.[7]) We find Aretino at the table on the right, the second figure from the head of the table. He looks up as if greatly astonished, and his neighbors share in his silence.

In those days in Cana of Galilee they were celebrating a wedding where with royal pomp there appeared the most distinguished, noblest, and most elegant persons in the city. To solemnize the occasion Christ had been invited with His brethren, and Mary, driven by her desire to see Him, also came. The tables were laden with elaborate vessels of pure gold and silver. The most important guests sat at their ease in ornate chairs and looked at Christ, who, retiring within His quiet humility, sat beside His Mother in the lowest place. But as the master of the house insisted He rose together with the Virgin and moved to a seat of greater honor. Thus Christ taught the true value of humility—for meekness rises to Heaven in the act of bowing upon this earth.

He tasted the victuals sparingly and with the glance of His eyes offered correction to everyone. Whoever looked at Him was moved to trepidation and remorse and, touched by an indefinable sense of awe, forgot the feasting.

Jesus from time to time sighed with such feeling that each guest's heart trembled. And when He spoke His voice stilled that freedom and merriment which wine and food bring forth from the souls of those who delight in the joys

of feasting. Both the groom and the bride, resplendently arrayed in their nuptial garments, attentively looked at Him as He said: "Do not ever contemplate divorce, and be more tender with each other than you are with your own father and mother. Unite yourselves in both body and soul so that the fruit you bear will be of a single choice, and in so doing love God and honor your parents. Let not man put asunder what God has joined together, and violate not your marriage bed with the stain of adultery. And do you, bridegroom, respect your consort like the field of the just which is cultivated not for the sake of greed but to bring forth fruit that will sustain life. Be temperate in the act of joining together, and without carnal pleasure beget your children so that they may desire to serve God as much as you desire to have them. May your delight be in the love of the soul and in the pleasures which increase understanding, and may you rejoice in the studies that teach the way to find the key that opens the gates of Heaven." Anyone capable of seeing how the words of Christ affected the feasting guests would have seen a crowd so enthralled that they clung to every word and listened as one listens to the teller of a story full of marvels and joy. The waiters too who changed the plates and vessels were overwhelmed and marveled at what they heard. Surely, the most exquisite food which the guests partook of was those sacred words. For no other reason did Christ accept many an invitation but to open the eyes of the mind which are blinded by the splendor of the pleasures of this world.

He came, He stayed, and He departed as a man ready to give succor to those in need, no matter where they might be. He was aggrieved by the ignorance of men and would exclaim: "I came to call not the righteous, but the sinners to repentance." But the Elders of Cana, when Christ was silent, returned to their food, and just when their thirst was at its peak there was no wine to quench it. Then Mary, who is the mother of her father and the daughter of her son, spoke to Jesus and said: "They have no wine." And He said to her: "And even if they had wine, what is that to us? Know that my hour has not yet come."

But as He spoke He put it in her heart to say to the waiters: "Do as He shall bid." As is the custom of the Jews there were set six urns of stone, and they were of no mean price. Christ commanded that they be filled with water to the brim. Having been obeyed, He said: "Draw forth now and bear unto the governor of the feast." And they drew it and took it to the head steward. As he smelled the bouquet of the wine which was made from grapes gathered in the vineyards of Heaven he was revived like a man who awakens from a faint when his wrists are bathed in vinegar. Tasting the wine he felt the trickle of its sharp sweetness down to his very toes. In filling a glass of crystal, one could have sworn it was bubbling with distilled rubies. He taunted the groom by saying to him: "Every man at the beginning sets forth good wine, but you have kept the good wine to the end"—but as he spoke, it dawned on him that a miracle had taken place. This was the beginning of the miracles Jesus did in this region to manifest His glory. It left everyone marveling and His disciples believed in Him.[8]

In 1562, when Veronese began his *Marriage at Cana*, Aretino was six years dead. The reversal of Aretino's fame to public infamy had followed almost immediately upon his death, and his books, the spiritual ones as well as the worldly and the all too worldly, were placed on the Index of Prohibited Books.[9] Not that his religious writings as such were disapproved of (they continued to be published under pseudonyms, as devotional literature, well into the seventeenth century); only the

name of the author compromised them.[10] That Veronese used Aretino's text as a libretto for his painting may have been but a matter of convenience and artistic license, but that he added Aretino's portrait to the picture was an act of courage, a declaration of loyalty and affection beyond the grave in uncertain times.

Veronese was not alone among the artists of Venice to uphold the memory of a man they loved. In 1565 Tintoretto included Aretino's portrait in his *Crucifixion* in the Scuola di San Rocco,[11] and Jacopo Sansovino elected not to "go with the times" when in 1569 he assembled the casts for the bronze door of the sacristy of S. Marco (fig. 6) and let the likeness of Aretino (fig. 7) stand among the other artist portraits—Sansovino himself, Titian, and, perhaps, Tintoretto—which frame the Gospel stories represented in the two reliefs.[12]

If decorum mattered to Sansovino (and how could it not, in such a place?), we must see his approximation of these artists unto the Evangelists not as a forward attempt to invade their sacredness, but rather as a declaration of the artists' devotion to the truth of the Gospels. The artists serve by proclaiming this truth with the vividness of their art. Like chancel orators they make visible and, in ornamenting their images, celebrate the stories the Evangelists tell sparingly, only in outline as it were. If what the Evangelists tell us is the "Gospel truth" it does not mean

6. *Sansovino.* Sacristy Door. *San Marco, Venice*
7. *Sansovino.* Sacristy Door *(detail)*

7

6

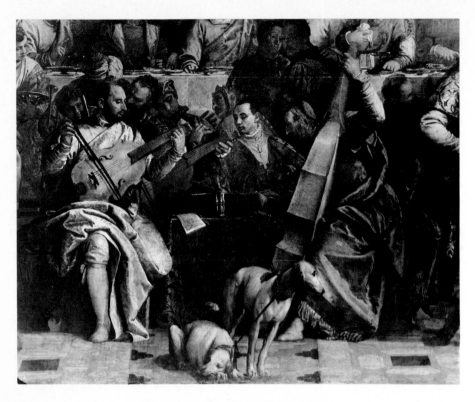

*8. Veronese.* Marriage at Cana *(detail, center)*

that this is all there is to tell. For the Christian their reticence provides the spur for his spiritual exercise; it encourages his imagination to move, in a loving search, at the core of the sacred events and to behold them as if they were happening directly before him—not as visions, of course (this would be a presumptuous quest), but in a poetical presence. Here the artists become his principal guides. They do not usurp the stories of the Evangelists but rather bring the viewer—or the reader of Aretino's marvelously pictorial prose—closer to them.[13] As the music of instrumentalists who play at a Mass may support the chanted word and in elaborating on it makes it more precise, so does the fiction of the discerning artist reveal to us the truth we seek in a frame of beauty.

This would seem to have been one of Veronese's reasons for including his orchestra of painters in the service of the feast at the marriage at Cana (fig. 8). Devotion, supported tenderly by the paradox of fiction in which the living, the dead, and the timelessness of Revelation are joined in a moment in time, and not licentiousness, governs his smiling art. Veronese continued to live and paint by this conviction. No wonder the Inquisition, unsmiling like all administrators in pursuit of a mission, watched him with a wary eye.[14]

But we must now for a time turn to the second work of art which affected the genesis of Veronese's picture, Francesco Salviati's *Marriage at Cana* in the former refectory of the convent of S. Salvatore in Lauro in Rome (fig. 9).[15] The rather obvious similarities of the "machines" of the two pictures will not appear fortuitous when we consider them in the light of a few dates. Salviati's work was finished no later than 1554 or 1555, when the artist left Rome for France. Twenty months

later, Vasari tells us, he returned to Rome, where he was to spend most of his re-
maining life until it ended in 1563.[16] Veronese was in Rome, a member of the
entourage of the ambassador Gerolamo Grimani, in 1560, "*non tanto per veder
secondo il comune costume le grandezze della Corte, ma—come pittore—le magni-
ficenze degli edificij, le Pitture di Raffaello, le scolture di Michel-Angelo e le celebri
statue in particolare, pretiose reliquie della Romana grandezza.*"[17] Salviati, when he
was in Venice, had made an extraordinary impression with the éclat of his art.[18]
His *Psyche* for the Palazzo Grimani was considered by his admirers as a Tusco-
Roman challenge to Venetian painting (Vasari calls it *la più bell'opera di pittura che
sia in tutta la Venezia*), and, indeed, Veronese's response to the art of Salviati, in
the form of "borrowings," has been noted before.[19] In Rome Veronese certainly
must have looked with interest at the celebrated works of Salviati, some of them
still in progress, and the two artists readily could have met.[20] However much their
approaches to the art of perfecting art differed, both painters were joined (as we
shall see) in a common allegiance to Aretino's memory, or, at least, a common
concern for his art, for Salviati's *Marriage at Cana* is based on Aretino's paraphrase
of the Gospel account as much as is Veronese's.

In 1553 when Aretino came to Rome together with Duke Guidobaldo II of Ur-
bino to call on Pope Julius III, Aretino had long been sponsoring the art of Salviati

*9. Salviati.* Marriage at Cana. *San Salvatore in Lauro, Rome*

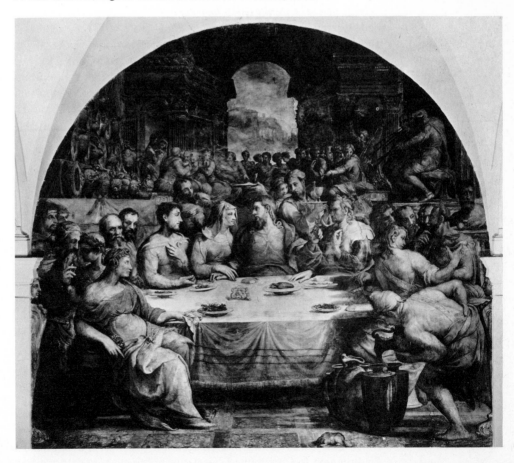

and Salviati in turn had painted a now lost portrait of Aretino.[21] Salviati's work on the *Marriage at Cana* may still have been in progress in 1553. We can therefore not exclude the interesting possibility that Aretino in person advised Salviati on the perfection of his work.

Let us now look at Salviati's picture in some detail and at the same time recall certain telling passages from Aretino's text.

Christ and Mary are in the center of the scene. They have moved there from the humblest place at the table at the behest of the bridegroom, who then, with the bride, moved from the place of honor to the two chairs vacated by Christ and Mary. We see them at the extreme left (fig. 10).[22] The chairs at the table were ornate, says Aretino, *nei seggi ornati adagiatisi i piu degni*, and Salviati particularly lets us see the chairs *all'antica* now occupied by the bride and groom, for the bride herself, still the queen of the feast, is shown reclining in her seat. On the tables were noble vessels, *uasi d'oro e di argento puro et scolpito*. Salviati puts them on a grand sideboard; they are complicated triumphs of the gold-and silversmith's art (fig. 11).[23] How splendidly they could have been employed at table, if only there had been enough wine to serve! *Con pompa reale comparasero le piu graui, le piu nobile et le piu leggiadre persone della città*: we see them everywhere, guests at the meal below, attendant guests in the room above. And the *pompa reale* is enhanced by the music of three trumpets and one *zink* (fig. 12).[24] The man standing behind them, with his hands raised up, suggests utter astonishment, but all have eyes and ears only for the wonder of Christ's sweet presence at the wedding: *Chi ha esse ueduto in che guisa le parole dette da Giesu haueuano recate le genti che desinauano, hauria uisto molte persone appese per le orecchie, ala bocca di uno, che conta cose piene di marauiglia, et di diletto*. To show this wonder Salviati almost literally quotes elements from Raphael's *School of Athens*: the disciples marveling at the wisdom of the philosophical discussion of the masters. We are at the highpoint of the drama, the transformation of the water into wine, but the artist presents it in such a fashion that several moments of the narrative account are concentrated into one, to make it possible for the picture to give its own account of the coherence of events in their proper sequence. Mary has just pointed out to Christ that the wine is lacking.[25] Her hand still rests on his (fig. 13). Christ rebukes her, but with his left hand he already directs the servants to fill the vessels with water: *Erano iui sei uasi di pietra di non piccol prezzo* (these are the "six waterpots of stone . . . containing two or three firkins apiece" of the Gospel; *di non piccol prezzo* not only makes the scene more festive but gets around the difficult job of defining a firkin, i.e. the *metretum* of the text of St. Jerome).[26] And the servants draw forth wine, and a young man at the right holds up a glass of the wine and marvels at the miracle (fig. 14). The *scalco* or carver (the *architriclinus* of St. John)—a portly man in an apron, with his carving knife hanging at his side—now speaks to the groom and praises the quality of the wine (fig. 10): if a portrait of Aretino is in this picture it surely is this man, and, indeed, our expectation is confirmed by a comparison with a famous engraving (fig. 15).[27] Salviati's own portrait is not far from him, the second man at the table to the bridegroom's left (fig. 11). We may identify it by referring to the documented self-portrait of about eight years earlier in Salviati's *Triumph of Camillus* in the Palazzo Vecchio (fig. 16).[28] The groom addresses the *scalco*—both are deeply moved—as if to explain to him what really happened, for the *scalco* clearly did not know about the miracle of the wine, he only knew the wine was marvelously good; but now he learns the truth: *gli fu fatto fede del miracolo*.

We now come to a grand elaboration which is the painter's own invention: directly next to Christ stands a servant holding a tray with wine and water, at the

10. *Salviati.* Marriage at Cana *(detail, lower left)*

11. *Salviati.* Marriage at Cana *(detail, upper left)*

level of his forehead (fig. 13). Above Christ's head a covered plate is held up and, to the left of it (behind Mary's halo), another waiter carefully holds a flat dish with a scallop-edged linen cover. Surely these objects are references to the instruments of the Mass—the chalice, paten, and corporal.[29] They are submerged in the story of the picture, and yet they clarify its sacred importance. "Mine hour is not yet come," says Christ to Mary, but the miracle he is now effecting brings it nearer. We see a prefiguration of the Last Supper, and the proximity of the Passion dawns on us.[30] As once more we see—and just now hear—the trumpets bursting forth we realize they celebrate and announce the moment of the transformation of the water into wine, just as silver trumpets would announce the consecration of the Eucharist at a pontifical Mass.[31]

Like Aretino's account, so the painting is at once rich and attentive to the Gospel text. The recent cleaning of the work also has brought to light again the beautiful and delicate harmony of its color.[32] We are no longer in the habit of welcoming golden elaborations of the Gospels as acts in the service of God, just as the modern clergy avoid richly embroidered garments (as if these were, for being ornate, luxurious) and just as we no longer hear or care to hear—unless we imagine ourselves transported into another age—instrumental church music in churches and

12

*12. Salviati*. Marriage at Cana *(detail, upper right)*

*13. Salviati*. Marriage at Cana *(detail, center)*

*14. Salviati*. Marriage at Cana *(detail, lower right)*

*15.* Portrait of Aretino. *Engraving (reversed)*

*16. Salviati*. Triumph of Camillus *(detail). Palazzo Vecchio, Florence*

13

14

15

16

prefer the concert hall as a more appropriate place for its performance. Looking, as we do, with a jaundiced or timorous eye at wealth freely offered in the celebration of divine things, we, perhaps, also become the poorer as we stubbornly place our confidence in the trimmings of poverty. What Aretino, and with him Salviati and Veronese, did or attempted to do was what was said of Lactantius, to tell the tale of the Gospels in the language of Cicero.[33] Not an undeserving aim; not that the Gospels need the support of eloquence (*invenzione* and *adornamenti*, to use the terms Veronese invoked before his judges),[34] but we need it, sinners that we are, so that the divine quietude of which the Gospels are the witnesses and transmitters also may be heard by our only too mortal ears. They need the tuning of art, just as (on another level of the perception of perfection) we can only hear the sounding of the spheres when music will produce for us its echo.

How far did Aretino and Salviati succeed in their purpose? We cannot judge Aretino's work from a mere excerpt and here must leave the question open. Still, we should point out that Aretino's variations on the Gospel texts are not, as is often alleged, free inventions of his fancy but rather adornments in keeping with traditional exegesis. In the *Marriage at Cana* Christ's address to the bride and groom is, in fact, based upon the ritual of the nuptial Mass, such as it is described in the *Missale Romanum*.[35] Salviati's picture, in turn, when all is said and done, is perhaps more beautiful in its details, and more artfully labored, than it is convincing.[36] But what the genre is capable of we may see in Veronese's response to both Aretino's and Salviati's *Marriage at Cana.*

Let us begin (since one must begin somewhere in the abundance of this picture that is a world) with the figure in the right foreground looking at the freshly drawn and miraculous wine (fig. 3). His model, in the very contemplation of the wine, surely is Salviati's beautiful youth gazing at his glass (fig. 14). But now the words of Aretino turn into song for us, as if Aretino were describing, with all the melodious accuracy of a poet, the experience of this inspired master drinker: *"al cui naso giugnendo l'odore di quel uino, che fu ricolto ne le uigne celesti, rauiuò gli spiriti quasi huomo; i cui sensi si riuocano con la uertu de lo aceto, di che egli ha bagnati i polsi; E guastandolo sentì stillarsi de la sua dolcezza mordente, fino a le unghie dei piedi. Et empiendone una coppa di Christallo; si saria giurato, ch'ella fosse stata piena di rubini stillati."*

In Aretino's work these words describe the sensations of the *scalco*. Salviati divided the celebration of the perfection of the wine and the address of the *scalco* to the bridegroom into two separate actions which reinforce one another: the beautiful youth at the right looking at his glass, and the *scalco* on the left in conversation with the groom (fig. 10). Veronese took note of Salviati's example. The *scalco* (fig. 2), more nobly dressed than his counterpart but identified by the carving knife hanging from his belt, is at the left, boldly stepping forward and, with outstretched arm, waving a tip of his garment in his hand, haranguing the groom (*"proverbiando il nuovo sposo"*).[37] The wine, which he has already tasted, is now being offered to the groom—who knows that it must be miraculous, for none knew better than he that the cellars had run out of wine.

Salviati's cat and dog eyeing each other are here again, now marvelously elevated and improved (even if Salviati's animals strike one as perfect portraits of a cat and a dog) in naturalness, style, and action. The dogs allude to faith, surely, but more strikingly are they true to the life of their singular elegance, as one dog strains nervously to look toward the cat on the right and the other crouches and looks to the left, where another, sturdier dog attentively observes the pouring of the wine

(figs. 8 and 2). The cat claws with a fury at the lion's head on the most ornate stone vessel on the floor, as if the diminutive sculptural representation she attacks were another living cat (fig. 13). Since the vessel contains the miraculous wine the action is not without its symbolic overtones, but their meaning is not "pushed" in the tit-for-tat, readily identifiable language of the iconographical dictionary; instead it is gently hidden in naturalness, hidden and yet palpably self-evident. It is an allegorization *en passant;* it does not interfere with the cat-ness of the cat, nay it even supports it. Not that the cat is more important than the allegory; quite the contrary: it is for the latter that the cat is there—but *qua* cat. The same is true of the vessels with the wine ("*sei uasi di pietra di non piccol prezzo*"). They are here for the sake of the story, not lined up one, two, three, four, five, six like Salviati's but casually—that is, naturally distributed about the floor, as they would be in the service of the table. In fact we can only see four; two must be offstage, but the real stage extends beyond the picture.

The wonder of Veronese's sideboard with its gold and silver plate: it is in the background, it does not attract attention by its fancy work, but it shines and it is involved in the action, casually again, but with art. Servants come and go bearing vessels or asking for new ones, and a scribe is engaged busily at the table, registering each precious object as it is taken away or returned. There is, happily, no symbol in this, just the orderly pace of life at the service of a great banquet. The miracle is hidden to the many at the table, but it is also shown at the moment of its unveiling; the truth dawns on the participants in the scene as it dawns on us as we look at the picture. The nature of Christ's impending sacrifice is made clear to us by allusions so delicate that they tint rather than define our awareness of what matters. The face of Christ, as has often been pointed out, rules the entire picture; it draws us to him and yet, when first we approach it, it is barely noticed in the festive splendor and hubbub of the banquet (fig. 17). Christ now does not speak, but Aretino's words help us, as it were, to see the breath of speech which hovers about his face, and is addressed to us: "*Et gustando i sapori de le uiuande parcamente, corregeua*

17. *Veronese.* Marriage at Cana *(detail)*

18

*18. Palladio.  Anteroom of Refectory,*
*San Giorgio Maggiore, Venice*

*19. Palladio.  Refectory, San Giorgio*
*Maggiore, Venice*

19

*ogn'uno con gli occhi. Chi lo guardaua, sentiua un certo timore, una cosi fatta com-
puntione, che obliato il mangiare, restaua sbiggotito da un non so che. Giesu talhora
forma a un sospiro col suon de quale scoteua i cori di ciascuno, et parlando atempo
acqueta a la licentia, che nasce ne le lingue, quando la giocondità del uino, et del
cibo rallegra gli animi di quelli, che godano del prandio."*

And directly above this head, in the upper story, we see a waiter lifting up his
knife to divide the lamb for the meal into portions. In a straight line down from him
is the hourglass on the table of the musicians, denoting death, the counterpart of
the gift of life—and its price—alluded to in the scene above. Both of these momen-
tous details are so subtly stated that, in print at least, they have escaped notice until
quite recently.[38] There is, perhaps, a lesson in this. Veronese transformed Salviati's
rather direct allusion to the institution of the mass into a grander statement, but
one so finely wrought, moreover, that it is submerged altogether in the picture and
has its effect on us by a subtlety of presence, a *non so che* rather than a definition.
Once the motif is identified and explained it becomes, of course, unforgettable,
and it proves to us that we understand the artist well. But the discovery of what is
definable also deprives us of the reality of the delicacy of the *non so che*, unless,
that is, we are willing to let what is tangible in our discoveries be submerged once
more in the pleasure of the banquet, not because our discoveries are unimportant
but because they gain their importance by their meaningful subordination to the
wonder of the picture, where feasting is at once the prelude to the miracle, its oc-
casion, and its celebration.

Let us, in our mind's eye, return the painting once more to Palladio's refectory
at S. Giorgio Maggiore. We ascend to the meal laid out for the monks in the re-
fectory and to the presence of Christ along a noble staircase which leads us to an
anteroom with two classically decorated lavabos, a pause before we enter (fig. 18).
Inside the anteroom, above the door, as the late Ferdinando Forlati once kindly
pointed out to me in conversation, Veronese painted two angels bidding silence.
Their gesture of restraint must have affected all who sat at table. Not a trace re-
mains of these heavenly guardians of the decorum of the place.[39] As we enter
Palladio's great hall the reticence of its form and the pristine whiteness of its walls
impose a background of silence of their own (fig. 19). However, we find ourselves
not just in Palladio's building but, happily suspending disbelief, in an extension of
the open courtyard of the picture (fig. 20), guests from a passing world, at the
wedding at Cana. We are on a level lower than that of the musicians but still linked
to the picture, even by the very portraits which greet us from the world of mem-
ory.[40] As we join the monks at table we also eat with the members of the banquet
at Cana, and we too are blessed by the miracle of the wine. The banquet goes on
all around us, but only the people in the picture speak; we eat in silence and are
grateful for the gift of Christ and for his and Mary's gentleness. The divine presence
is not overpowering, but it is all-pervading. Veronese's art encourages us and makes
it possible for us to eat and drink heartily and to love God, all at once. The decorum
Veronese observes is that of a good host, a lover of men who is also a lover of
God. Musician that he was, he paints his own image into the picture playing a
tenor viol, serving the banquet and, together with Titian, his master, and perhaps
other painters in the ensemble, also serving the Lord.[41] If the artists did not
attend in their imagination upon the events they depict, how could they represent
them convincingly or celebrate them with the music of their art?

Let us assume now that a reader ascends the pulpit in the refectory and reads
while we eat. Certainly his text is not from Aretino but instead a didactic work,
and sparing in its diction.[42] In counterpoint to such a text, as to the reticence of

*20*. Monks at Dinner in Refectory, San Giorgio Maggiore. *Engraving*

Palladio's walls, the painted opulent ornament of the picture makes the silence heard (fig. 1). And Aretino himself, long dead and dishonored but painted before us as he was and lived, rejoices in the banquet. What is it that makes him look up? The two men to his left also look up, one with keen interest, and the man to Aretino's right looks at him as if he wondered what was the matter. And so we too are concerned, and, together with Aretino and his neighbors, we see on the upper balcony directly above them a girl looking down and gesticulating, as if answering the questioning gesture of the man below. As we follow the plumb line joining these two gestures we may also see (as did my friend Marilyn Perry, to whom I owe this splendid observation) two sprigs of white roses falling through the air. The girl above has just tossed the roses to the diners below—and Aretino sees the lower bunch, surely, coming toward him.

As we look up with Aretino we also look once more, as he does, into the blessed sky. Two flights of birds are winging their way about the tower in the distance. One, the flight behind the tower, is wheeling off to the right. Perhaps it is an omen; if so, a good one. It is in the nature of Veronese's delicate realism that we shall never know. But we can assuredly see, with a different kind of wonder, that there is a sense of inspiration and longing subtly cast over Aretino's features. In the delicacy of its rendition—as much as in the homage of the roses—we may recognize the expression of Veronese's gratitude and his loving understanding of a poet who had joined the guests at the Marriage at Cana on the wings of his imagination, and whose example Veronese followed. With no discredit to Aretino we may perhaps permit ourselves to add that in emulating Aretino Veronese also surpassed him.

*University of Illinois at Urbana-Champaign*

[1] The locus classicus is Charles Perrault, *Parallèles des anciens et des modernes*, Paris, 1692, I, 119, 220–32. There were (and in part still are) other paintings by Veronese in the king's rooms in Versailles, all chosen and appreciated for their "color." See C. Costans, "Les tableaux du Grand Appartement du Roi," *La Revue du Louvre et des Musées de France*, III (1976), 157–73, and, on the acquisition and fortuna of Veronese's *Feast in the House of Simon the Pharisee*, Ricciotti Bratti, "La cena di Paolo Veronese al Museo del Louvre," *Nuovo Archivio Veneto*, n.s. XXXV, no. 75 (1909), 321–33. On the *Tent of Darius* by Le Brun see Donald Posner, "Charles Le Brun's 'Triumphs of Alexander'," *Art Bulletin*, XLI, 237–48. Note also Jonathan Richardson's rule of thumb in matters of decorum: "Nothing absurd, indecent or mean, nothing contrary to religion or morality, must be put into a picture, or even intimated or hinted at. A dog with a bone, at a banquet, where people of the highest character are at table, a boy making water, in the best company, or the like, are faults which the authority of Paul Veronese or a much greater man [i.e., Titian] cannot justify" (*Works*, London, 1773, 34–35). Venetian authors, on the other hand, to the end of the eighteenth century, never would agree to the "French" arguments and delightedly praise Veronese for his *decoro*. On the endurance of this view see Philipp Fehl, "Farewell to Jokes: the last *capricci* of Giovanni Domenico Tiepolo and the tradition of irony in Venetian painting," *Critical Inquiry*, V (1979), 761–91.

[2] Armand Baschet, "Paul Veronese appelé au Tribunal du Saint Office à Venise (1573)," *Gazette des Beaux-Arts*, XXIII (1867), 378–82. For examples of the two positions in modern restatements see Anthony Blunt, *Artistic Theory in Italy*, London, 1940, 116 (Veronese the decorator-artist), and R. Marconi-Moschini, *Gallerie dell'Accademia di Venezia, Opera d'Arte del Secolo XVI*, Venice, 1962, 83–85. See also Théophile Gautier, *Souvenirs de Théâtre, d'Art et de Critique*, Paris, 1904, 41. For a bibliography see Terisio Pignatti, *Veronese*, Venice, 1976, I, 126.

[3] Philipp Fehl, "Veronese and the Inquisition," *Gazette des Beaux-Arts,* 1961, 326–54. On the *Marriage at Cana* see 335–36.

[4] *Serie degli uomini i più illustri nella pittura, scultura . . . con i loro elogi e ritratti*, Florence, 1773, VII, 122, n. 1.

[5] David Rosand, "Theatre and Structure in the Art of Paolo Veronese," *Art Bulletin,* LV (1973), 217–39. For new contributions see the bibliography in Pignatti, *Veronese,* I, 126, and, for Pignatti's own discussion of the *Marriage at Cana, Veronese,* I, 73–74, 79, 126. See also Creighton Gilbert, "Last Suppers and their Refectories," *The Pursuit of Holiness in Late Medieval and Renaissance Religion*, ed. Charles Trinkaus and Heiko A. Oberman, Leiden, 1974, 371–402, esp. 397–400.

[6] First published in Venice, 1535. Veronese's reliance on Aretino's text was discovered by Maurice Cope who presented his findings in a paper, "Pietro Aretino and Veronese," which he read at the 64th Annual Meeting of the College Art Association of America held at Chicago, 1976; see the *Abstracts of Papers* published by the College Art Association. Since I independently had made the same observation ("Veronese als Historienmaler," lecture at the Kunsthistorisches Institut, Florence, 1972, and in earlier lectures at the universities of Graz and Braunschweig) and the directions of our interpretations differ, Professor Cope and I agreed simply to note the happy coincidence of discovery when and if we had occasion to speak of Veronese's source in print, each with a salute to the other. Professor Cope will return to the subject in a forthcoming publication.

[7] Harold E. Wethey, *Titian: II, The Portraits*, London, 1971, 76–77. In Veronese's picture—as in both portraits of Aretino by Titian—Aretino's inability to use his right hand (the result of an attack on him in 1525), even though it is represented with subtle discretion, becomes clearly evident when we look for it as an identifying mark.

[8] My translation is based on Pietro Aretino, *Opere diverse . . . La Humanità di Christo*, n.d., n.p. (?1539), Houghton Library, Harvard University, 29r–29v. (The first edition of the *Humanità di Christo* was published in Venice, 1535. See also Johannes Hösle, *Pietro Aretinos Werk*, Berlin, 1969, 231–33.) I am most grateful to Professor William A. Zanghi who kindly assisted me in the preparation of a first draft.

[9] On the fortuna of Aretino, see Hösle, *Aretinos Werk*, 1–35, 226–37. Aretino's *Opera omnia* appear in the first (unpublished) Index Librorum Prohibitorum of 1557. See also Paul F. Grendler, *The Roman Inquisition and the Venetian Press, 1540–1609*, Princeton, N.J., 1977, 116, 133, 147, 165, 258, 285.

[10] This does not mean they were above suspicion. See Hösle, *Aretinos Werk,* 13. On Aretino's position in the fluctuating world of religious reform and confrontations, see Paul F. Grendler, *Critics of the Italian World (1530–1560): Anton-Francesco Doni, Nicolò Franco, and Ortensio Lando*, Madison, Wis., 1969, 7–10, 110. See also Giorgio Petroccho, *Pietro Aretino tra Rinascimento e Controriforma*, Milan, 1948, 72–81.

[11] The figure in question is the splendidly garbed, portly personage on horseback at the right, looking at Christ. See Eduard Hüttinger *Die Bilderzyklen Tintorettos in der Scuola di S. Rocco zu Venedig*, Zurich, 1962, 75–79. The figure probably represents or alludes to the centurion at the Crucifixion: there are two men with lances riding directly behind this man, who is in an obvious position of command. The conversion of the centurion forms the moving epilogue of Aretino's account of the Crucifixion: "Onde il Centurione e gli altri che lo guardauano confessarono lui essere ueramente figliol di Iddio." Tintoretto, in so honoring Aretino, must have recalled Titian's portrait of Aretino as Pilate in the Vienna *Ecce Homo* (1543), which perhaps also is obliged to Aretino's *Humanità*. But be that as it may, Titian's casting Aretino in the guise of Pilate probably can best be understood as a compliment to the author of the *Humanità di Christo*. It is Pilate who says "Ecce Homo"—and that is what Aretino's book is about. For passages possibly relevant to' this picture and to Tintoretto's *Crucifixion*, see *Prose Sacre di Pietro Aretino*, ed. Ettore Allodoli, Lanciano, 1914, 72–73, 80–81.

[12] The figures, except for the presumed Tintoretto, are identified by Francesco Sansovino. For Sansovino's explanation of the door and an account of the several castings and the final assembly of the work, see John Pope-Hennessy, *Italian High Renaissance and Baroque Sculpture,* London, 1963 (catalogue), 105; see also Bruce Boucher, "Jacopo Sansovino and the Choir of St. Mark's," *Burlington Magazine*, CXXI (March 1979), 161, n. 40, 167–68.

[13] Aretino advanced the declaration of this aim to a *non plus ultra* of paradoxical daring by referring to himself as the "Quinto Evangelista." See Hösle, *Aretinos Werk*, 116–17. Sansovino's artists' portraits on the sacristy door of S. Marco surely reflect the sense of this pronouncement. The title Aretino wrote for one of his engraved portraits characteristically reads: "Son l'Aretin censor del mondo altero/E de la verità nunzio e profeta." See Romeo de Maio, *Michelangelo e la controriforma*, Rome, 1978, 23, 49 n. 19, and notes to 24–26.

[14] For an annotated transcript of Veronese's interrogation, see Fehl, "Inquisition," 348–54.

[15] E. Fanano, *S. Salvatore in Lauro (Le Chiese di Roma)*, Rome, n.d., 105–9; Walther Buchowiecki, *Handbuch der Kirchen Roms*, III, Vienna, 1974, 813–29.

[16] Giorgio Vasari, "Vita di Francesco Salviati," *Le Vite de' più eccellenti pittori, scultori, e architettori* (Club del Libro), VI, Milan, 1964, 535–49; Catherine Dumont, *Francesco Salviati au Palais Sacchetti de Rome et la decoration murale italienne (1520–1560)*, Rome, 1973, 121–22.

[17] Carlo Ridolfi, *Le maraviglie dell'arte*, Venice, 1648, ed. Detlev von Hadeln, Berlin, I, 1914–24, 310. Grimani also went to Rome in 1555, and it is possible (though not likely) that Veronese accompanied him on this mission rather than on the one in 1560. For the argu-

ments pro and con see Pignatti, *Veronese*, I, 58–59.

[18] Iris Hofmeister Cheney, "Francesco Salviati's North Italian Journey," *Art Bulletin*, XLV (1963), 337–49; Michael Hirst, "Three Ceiling Decorations by Francesco Salviati," *Zeitschrift für Kunstgeschichte*, XXVI (1936), 146–65.

[19] Pignatti, *Veronese*, I, 35, 107. Iris Hofmeister Cheney, *Francesco Salviati, 1510–1563*, unpublished Ph.D. dissertation, New York University, 1966, 88–89.

[20] The convent of S. Salvatore in Lauro was the home of a Venetian congregation (S. Giorgio in Alga) closely associated with the service of S. Lorenzo Giustiniano and the memory of the Venetian pope Eugenius IV. It may for that reason have held particular interest for visitors from Venice. See Pompelio Totti, *Ritratto di Roma Moderna*, Rome, 1638, 251, and Buchowiecki, *Handbuch der Kirchen Roms*, III, 814–15. In 1560 Palladio was already at work building the refectory at S. Giorgio Maggiore. If Veronese was already concerned about the commission for a *cena* to decorate this great hall he must have found Salviati's painting particularly interesting because the task was almost the same. For a photograph of Salviati's picture *in situ* see Fanano, *S. Salvatore in Lauro*, fig. 24. The light in the painting corresponds to the light entering through the windows in the refectory (all on the right). On Palladio's and Veronese's management of the light uniting room and picture, see below, n. 39.

[21] Guidobaldo went to Rome to receive the *bastone* of a captain-general of the papacy. According to Aretino the duke insisted on Aretino's coming along. See Pietro Aretino, *Lettere*, VI, Paris, 1609, 159v–160, and *Lettere sull'arte*, ed. Fidenzio Pertile and Ettore Camesasca, Milan, n.d. (I, 1957), II, 432. Guidobaldo also was the patron under whose auspices Titian had gone to Rome in 1545. See Wethey, *Titian*, II, 137. Aretino's return to Rome resembled a triumph. Julius III, at their encounter, kissed Aretino on the forehead. See Hösle, *Aretinos Werk*, 13, 26. The relations between the pope and Aretino

were, perhaps, enhanced by patriotic affection, for Julius's family came from Monte San Savino, not far from Arezzo. Upon Julius's accession (1550) Aretino dedicated congratulatory poems to him and, in 1551, a combined edition of his *Genesi, Humanità di Christo*, and the *Salmi*. In return the pope dubbed him a knight of St. Peter and made him a generous present of money. He does not, however, seem to have seriously considered him for the cardinalate, even if Aretino, perhaps not altogether without reason, entertained such a hope. Aretino's stay in Rome lasted approximately from May 1553 to August of that year. See his *Lettere*, ed. 1609, VI, 169v–170, and *Lettere al Aretino*, II, Paris, 1609, 345, 391 f., 408. On Salviati's portrait of Aretino see Cheney, "Salviati's North Italian Journey," 338, and Jean Adhémar, "Aretino: artistic advisor of François I," *Journal of the Warburg and Courtauld Institutes*, XVII (1954), 315.

[22] They are identified as the bridal couple not only by their prominence but also by the wreaths of myrtle on their heads.

[23] Salviati was famous for his designs of tableware. See Hildegard Bussmann, *Vorzeichnungen Francesco Salviatis*, Ph.D. dissertation, Freie Universität Berlin, 1969, 86–93. See also Benvenuto Cellini, *Autobiography*, I, ch. 5.

[24] Actually there are five players. The instrument of one (the second from the left) cannot be seen. The long trumpets resemble the silver trumpets from the Temple in Jerusalem, as depicted on the Arch of Titus.

[25] Note also Mary's gesture with the thumb of her left hand. She seems just now to have said, *sotto voce*, to the waiter by her side: "Fate quello che egli ui dirà."

[26] "Ogni misura teneva due o trecento libre. Fu adunque la somma del vino d'intorno a mille ottocento libre; il che è degno di consideratione per il miracolo": Antonio Brucioli, *La Bibia*, Lyon, 1562, "S. Giovanni," 38v. It surely needs no other encouragement to conclude that there was a large gathering of guests at the wedding. As far as Veronese's paint-

ing is concerned we may note also that there were relics in Venice which provided corroborating evidence of the *luxe* at the historical Marriage at Cana. In the sacristy of the Carità visitors could see "un vase de porphyre beau quoyque le pied soit cassé, et un plat fort pesant d'or et d'un metal inconnu. L'on dit vulgairement que l'une et l'autre de ces pièces ont servi aux Noces de Cana." Anne Claude-Philippe Tubières, Comte de Caylus, *Voyage d'Italie*, 1714–1715, ed. Amilda-A. Pons, Paris, 1914, 86–87.

27 Note also the splendid woodcut of the identical image (reversed) which served as frontispiece for vol. II of the *Lettere*, Venice, 1542, and was used again in Doni's *I Mondi*, Venice, 1552, that is, at just about the time when Salviati was working on the *Marriage at Cana*. Our figure 15 may in some measure reflect Salviati's (lost) first portrait of Aretino. Salviati, in painting Aretino's portrait in the *Marriage at Cana*, surely recalled his own work and simply brought it up to date according to the latest evidence he had. He must have known, from Aretino's *Lettere*, that Aretino ceased dyeing his beard in 1548 (see Wethey, *Titian*, II, cat. no. 6), and, of course, he had the opportunity to correct his image against nature when Aretino came to Rome. On the relation of Aretino to Francis I see Adhémar, "Aretino," 311–18. According to Vasari's description of Salviati's work at the refectory of S. Salvatore in Lauro, Salviati painted "dalle bande alcuni santi e Papa Eugenio quarto che fu di quell' ordine et altri fondatori." The sentence is unclear; *dalle bande* may refer to the sidewalls of the refectory or to the sides of the principal painting, the *Marriage at Cana*. Buchowiecki (*Handbuch der Kirchen Roms*, III, 827) assumes that the picture is intended, and sees the pope represented in the figure of the *architriclinus* "links im Bilde." Vasari cannot mean the figure we here identify as the *scalco*, because Eugenius IV— as a glance at his tomb nearby on the wall to the left of the picture, will show, clearly was not bearded. Buchowiecki—who sees the picture in the terms of the text of the Vulgate, probably has

in mind the figure we identify as the bridegroom (the figure is seated, as the Gospel text suggests), but that man is far too young and too unlikely a personage for a papal portrait, as, in turn, our *scalco* is far too old and too much in a serving position to be the pope. If, on the other hand, *dalle bande* refers to the side walls (which seems to conform better to the construction of the long sentence), then they bore separate paintings which, together with the other pictures mentioned by Vasari, now must be considered lost. The tomb of Eugenius IV was placed in its present position in 1859. Could it have been inserted in the place where one believed one knew (even if only from reading Vasari) that there once had been the portrait of the pope? But to return to our *scalco*. In his right hand, barely visible in the photograph, he holds a glass of wine. The color of the wine in the glass is all gone. The *scalco* may already have finished what was in the glass, or, more likely, judging from the lack of color in the glass held up by his counterpart on the right, the tint of the wine was added in the form of a glaze and has disappeared. It is an old scholastic question whether the miraculous wine was red or white. Aretino and Veronese, as we know, opted for red.

28 The self-portrait is identified by Vasari, "Vita di Salviati," 537. It also appears, reversed, in the woodcut introducing Salviati's *vita*: Vasari, "Vita di Salviati," 506. It is touching to see how in the seven to nine years that intervened between the two self-portraits Salviati had not only aged but surrendered to the fears and moods of depression by which, Vasari tells us, he was plagued—surrendered, but not to the point of compromising the truth he saw in his mirror.

29 The waiter's index finger pressing down on the cloth is quite in keeping with the way in which a priest holds the corporal over the chalice when he brings it to the altar.

30 In the background of the picture a number of people are leaving the scene. It is the epilogue: "La marauiglia del

quale [il miracolo] per essere stato il primo, che Giesu facesse in quella regione per mostrare la sua gloria fece stupire ognuno, tal che i discepoli credettero in lui." The guests go away talking of the miracle. Note also the subsequent transition in John 2: 12: "After this he went down to Capernaum, he and his mother, and his brethren, and his disciples."

31 The practice continued into modern times. See Ludwig von Pastor, *Tagebücher, Briefe, Erinnerungen*, Heidelberg, 1950, 403 (entry for March 3, 1903).

32 See *Mostra dei Restauri, Palazzo Venezia 1969*, Rome, 1970, 15, figs. 10–13. The photographs here used show the work before cleaning simply because new photographs were not available to me. In its present state all the wine is gone from the glasses and all the food has disappeared from the table. The arch in back is also now much more dilapidated.

33 Edward Gibbon, *The Decline and Fall of the Roman Empire* (ch. XX), New York, 1899, II, 201.

34 Fehl, "Inquisition," 350 (p. 3, ll. 19–20).

35 The interlude of Christ's changing seats at the Wedding at Cana is traditional. See St. Bonaventura, *Meditations on the Life of Christ*, eds. and trans. Isa Ragusa and Rosalie Green, Princeton, 1961, 140–50. The passage is based on Luke 14:8–11. I hope to offer a more detailed demonstration of the essential orthodoxy of Aretino's paraphrase in a separate publication.

36 Salviati's approach to the representation of the feast probably was influenced, if only in the spirit of competition, by two works by Vasari which unquestionably he knew and of which Vasari, justifiably, was proud: *The Feast of St. Gregory the Great* (Bologna) and *The Marriage of Esther and Ahasuerus* (Arezzo). Vasari's description of these works instructs us, perhaps even more handsomely than the pictures themselves, in the appreciation of the good sense that joins the depiction of opulence and the pleasures of the table to the pursuit of a high purpose in history painting. For reproductions and Vasari's text see Paola Barocchi, *Vasari pittore*, Firenze, 1964, pls. V, XVII, pp. 92, 102–3, and "Descrizione dell' opere di Giorgio Vasari," *Vite*, VIII (1966), 215–16, 242–43. In the "Vita di Cristoforo Gherardi detto il Doceno" Vasari gives full credit to Cristoforo for having painted in *The Feast of St. Gregory the Great* "tutto l'apparecchio del mangiare molto vivamente e naturalissimo" (*Vite*, VI [1964], 113).

37 For a comparable carving knife and purse see the *scalco* (identified as such by Veronese at his Inquisition hearing) in *The Last Supper* (renamed, under the pressure of the Inquisition, *The Feast in the House of Levi*; Academy, Venice). Aretino's text and Salviati's painting convince me that I was in error when I first described Veronese's *Marriage at Cana* and took the beautiful drinker at the right to be Veronese's *architriclinus*. See Fehl, "Inquisition," 336, 347, n. 42. The real *scalco*, to fill the measure of his initial insolence, steps with his right foot on the platform reserved for the guests at table. The garment of which he uses the tip to point to the groom may have served him as a sort of apron. We see better how such an apron worked in Veronese's *Marriage at Cana* at Dresden, where the *scalco* (surely a portrait) has tucked two ends of his long serving gown (identical with the one worn by the *scalco* in *The Last Supper*) into his belt in order to have an apron and to be able to move about more freely. See also the *scalco* in the mosaic after Veronese's design in S. Marco (below, n. 41). Our *scalco*, then, in the heat of his excitement, has pulled the tucked-up ends of his mantle from his belt and waves one end of it at the groom, to point at him and give emphasis to his harangue.

38 The allusion to the Passion in the preparation of the meat for the feast was discovered by Rosand, "Theatre and Structure," 232. The appropriate Bible text would seem to be John 1:29 (and its parallel passage, Isaiah 53:5–7), which occurs directly before John's account of the miracle at Cana. Note also Peter's dividing the lamb on the plate before Christ in the so-called *Feast in the House*

*of Levi.* See Fehl, "Inquisition," 332. Rosand quite correctly links his interpretation with the irresistible observation of Patricia Egan that the hourglass on the table of the musicians is there to remind us of Christ's words "mine hour is not yet come" (Patricia Egan, "Concert Scenes in Musical Paintings of the Italian Renaissance," *Journal of the American Musicological Society*, XIV [1961], 192). More recently A. P. De Mirimonde has taken up the hourglass again and interpreted it as a symbol of "the vanity of pleasures such as music and dancing which are limited by time and vanish with it . . .." ("Le Sablier, la Musique, et la Danse dans les 'Noces de Cana' de Paul Veronese," *Gazette des Beaux-Arts*, LXXXVIII [1976], 129–36). This strikes me as implausible. The wedding and its feast are not disapproved of by Christ but elevated and sanctified by his presence. The *memento mori* of the hourglass may rather more directly be joined to the scene of the cutting of the meat above. Like the skull of Adam at the foot of the Cross, it reminds us of our mortality but also, as does the skull as it is touched by the blood of Christ, of salvation from Death. This is what the miracle, as a prefiguration of the Crucifixion and its saving Grace, in a veiled form offers to the guests and the musicians at Veronese's *Marriage*—as, of course, it does to every attentive reader of the Gospel or Aretino's paraphrase. But this is just one possible "meaning" of the hourglass. It will, once we have identified it as an instrument to help us "hear" Christ's words to his mother, continue to let us hear them, like an echo, not so much of what is painted as of what we know and are reminded of. The images here discussed are not allegories or symbols but allusions capable of expanding or contracting, as our imagination responds to detail and order in this inexhaustible picture.

[39] Cf. Ferdinando Forlati, *S. Giorgio Maggiore: il complesso monumentale e i suoi restauri (1951–1956)*, Padua, 1977, 76: It appears that Palladio walled up the upper windows whose frames are still defined on the exterior of the refectory in order not to disturb the illusion that Veronese's painting was the source of all true light in the room. See G. Zorzi, *Le Chiese e i Ponti di Andrea Palladio*, Vicenza, 1967, 38. See also James S. Ackerman, *Palladio*, Baltimore, 1966, 126, 153.

[40] Veronese's concern for joining the two worlds becomingly goes so far that he repeated in the picture, suitably ennobled, the wooden platforms on which the tables and chairs are set in the refectory. See above, n. 37. The repetition would seem to indicate also that the woodwork represented in our figure 20 is still the original woodwork (now altogether lost, with the possible exception of a section in the Victoria and Albert Museum). Presumably it was designed by Palladio. Some of the principal actors at the *Marriage at Cana* are still frequently identified in the most extravagant manner (as Francis I, Sultan Soleiman I, Vittoria Colonna), probably the result of *ciceroni* legends. For an influential printed statement, see A. M. Zanetti, *Della pittura veneziana*, Venice, 1771, 172. Protests demonstrating the absurdity of these claims usually go unheeded. Cf. Philipp Fehl, "Questions of Identity in Veronese's 'Christ and the Centurion'," *Art Bulletin*, XXXIX (1957), 302, n. 6. But I still should here like to draw attention to two of the earliest protests, one by Otto Mündler, *Essay d'une analyse critique de la notice des tableaux Italiens du Musée National du Louvre*, Paris, 1850, 155, and the other by Domenico Campanari, who tried, unsuccessfully, to correct the London *Times*: see his *Appendice all'opuscolo intitulato Ritratto di Vittoria Colonna dipinto da Michelangelo Buonarotti*, text in Italian and English, London, 1853, 13. See also Fehl, "Inquisition," 347, n. 14, and Wolfram Prinz, "Veronese 'istoriato'," *Festschrift Ulrich Middeldorf*, ed. Antje Kosegarten and Peter Tigler, Berlin, 1968, 333–41. On the other hand, the portrait of Aretino (though it is unmistakable) is not mentioned in the old accounts (Boschini, 1664; Zanetti, 1771), pre-

sumably, at least in Boschini's case, for fear of or respect for the Inquisition. The pen being mightier than the brush, the false portrait identifications continued victorious over the true portrait of Aretino into the age of art history. Still, art itself seems to have noticed what art history did not see. Anselm Feuerbach derived the milieu for his *Death of Aretino* (Basel, 1854) from the *Marriage at Cana* and evidently made the most of Aretino's portrait there. For a reproduction see Aretino, *Lettere sull'arte*, III, Pl. 12. For a dismissal of the scurrilous tale which is the source of Feuerbach's history, see Erwin Panofsky, *Problems in Titian, Mostly Iconographical*, New York, 1969, 10, n. 9; also Hösle, *Aretinos Werk*, 13–14.

41 On the identification of the instruments and the insufficiency of the musical notation offered or preserved see Egan, "Concert Scenes," 192; Mirimonde, "Le Sablier," 132–35; and Volker Scherliess, *Musikalische Noten auf Kunstwerken der Renaissance*, Ph.D. dissertation, Universität Hamburg, 1972, 28, 73. Scherliess proposes that the musicians also represent an allegory of the three ages of man, but see the end of n. 38 above for possible reasons for the shortcomings of such an interpretation. See also René Jullian, "Peinture et musique à Venise vers la fin de la Renaissance," *Arte Veneta*, 1954, 236–41. There is considerable excitement among the musicians, as if momentous news were suddenly being communicated to them. The player immediately to the right of Veronese whispers earnestly into his ear (but both go on playing); the boy behind Veronese and playing the *violino piccolo* looks concerned; the turbaned man in back, holding his trumpet in his right hand, bends down to listen in; and the jester to the right (not a "*danseur des moresques*," as Mirimonde suggests—he would have no room in which to effect his contortions) no longer jests but is awed, startled in a sublime way. In short, we see not, as Mirimonde proposes, an allegory of vanity expressed by music, presided over by an hourglass and joined by levity which is overcome by the manifestation of the divinity of Christ, but rather, in keeping with the language of the *historia* of the picture, the announcement of the miracle to the musicians ("*la maraviglia fece stupire ognuno*"). Everything in the picture suggests that they will go on playing, their music celebrating the gift of the wine and the grace of God. Musicians are traditionally present at representations of the Marriage at Cana. See particularly a mosaic in S. Marco, Venice, the design of which is sometimes given to Tintoretto but which, as Professor Otto Demus very kindly informed me, more probably is the work of Veronese, who may have composed it in keeping with the design of a decaying Byzantine mosaic which was to be replaced with a new picture. For a reproduction see Carlo Bernari, *L'Opera completa del Tintoretto*, Milan, 1970, 84.

42 On the nature of such texts see David Wilkins, "Intervention on Creighton Gilbert's 'Last Suppers and their Refectories'," in Trinkaus, *Pursuit of Holiness*, 406–7.

# 22

# *Tintoretto's*
# *Bamberg* Assunta

## W. R. REARICK

Although Tintoretto's painted oeuvre has not yet been accorded a definitive catalogue raisonné, one assumes that there are few if any major unpublished masterpieces to be added and that scholarship might comfortably turn to other aspects of his role in Venetian cinquecento art. It was therefore with a startled pleasure that, one January afternoon in 1957, during a desultory visit to the Obere Pfaarkirche in Bamberg, I turned to confront, high to the right of the entrance, the painting here reproduced (fig. 1).[1] A utilitarian photograph taken then has allowed me to consider this picture of the years that followed, but only recently have I been able to procure a photograph of quality adequate for publication.[2] My immediate impression of the painting was that it must be by or closely related to Tintoretto, but an exploration of the literature failed to turn up any mention of it, and it was, indeed, only after I had completed the present study in draft that I found that it is identical with a painting alluded to in 1938 by Johannes Wilde as in the Bamberg Cathedral, but not discussed in subsequent literature in relation to Tintoretto's work and presumably regarded as missing.[3]

The Bamberg *Assunta* is evidently an altarpiece, its scale and round-topped format corresponding to similar Venetian altar pictures of the period. Given its location in Bamberg Cathedral since an early date, it is possible that, like several other South German commissions from Tintoretto, it was done originally for that great Romanesque monument.[4] It is also possible that a local collector acquired it and donated it later to the church. Of Tintoretto's recorded treatments of the theme which cannot today be identified with security, only the altar described by Boschini as " . . . la tavola dell'Altare Maggiore e Maria, che ascende al Cielo, di mano del Tintoretto," in the Venetian church of Sta. Maria Formosa, might qualify as the present picture.[5] In any case, the early history of the Bamberg *Assunta* remains uncertain.

Since Tintoretto's *Assunta* has several unusual iconographical elements, it might be useful to suggest the general lineaments of the evolution of this theme in the Veneto during the cinquecento. The principal prototype does not even represent the Assumption of the Virgin, but is rather Giovanni Bellini's *Vision of the Immaculata* (Murano, S. Pietro Martire), in which the static frontal Virgin is suspended above (and behind, as befits a vision) a semicircle of saints who gaze

upward.[6] This format persists in Palma Vecchio's *Assunta* (Venice, Accademia), which has recently been dated to 1514.[7] Here the motive of the *cintola* figures prominently, as usually it does not in Venetian treatments, another exception being Domenico Campagnola's 1517 engraving.[8] It was, of course, Titian's heroic high altarpiece for the Frari, of 1516–18, with the tripartite division into a crowd of apostles, the soaring but still vertical Virgin surrounded now by adolescent angels in addition to the traditional putti, and, above, the welcoming God the Father in a radiance with an angel and a putto, which would dominate until almost midcentury.[9] Depictions of the *Assunta* are rather rare in these years; Titian's own more placid revision (Verona, Duomo) of about 1531–34 includes only the Virgin kneeling, the apostles, and the motive of the *cintola*.[10] Still later he and his shop returned to the 1516 format in the polyptych of 1549 (Dubrovnik, Cathedral) with the modification of the upper part to a simple God the Father who moves diagonally forward to crown the Virgin.[11] Lorenzo Lotto's treatments (Milan, Brera Gallery, 1512; Celano, Sta. Maria Assunta, 1527; Ancona, Pinacoteca, 1550), except for the early painting (Asolo, Duomo) of 1506 which reflects Bellini's picture on a reduced format, are all for patrons outside the Veneto and conform to a conservative format with little departure from conventional iconography.[12] Perhaps the most important symptom of a Mannerist-inspired transition in the representation of this theme is Giuseppe Porta's grandiose canvas (Venice, SS. Giovanni e Paolo, Cappella del Rosario), which synthesizes the Romanità of his master Salviati and the example of Titian's Frari altarpiece.[13] It may be dated to about 1550. When, about 1546, Tintoretto painted his small altarpiece (Venice, Accademia) he did not depart notably from the Venetian tradition of Titian except to pile up the apostles into a dense grouping which extends almost to the Virgin's waist.[14] What is distinctive about Tintoretto's modest early treatment is his severity of color, deep reds and almost-black blues set against dense shadow, and the metallic abstraction of sharply defined patterns of highlight which slash across the claustrophobic massing of figures.

The Bamberg *Assunta* presents, in the context of the preceding paintings of this subject, a number of iconographic anomalies. The lower portion is traditional even to the omission of the *cintola* motive. The Virgin, however, rises weightily from the diagonal tomb, inclining in a gentle counterthrust toward the left, her position suggestive of an effortful, slowly revolving movement toward the foreground and over the heads of the apostles. She is accompanied in her flight by five figures who depart from any previous depiction of attendant angels or putti. They are undoubtedly female, rather opulently dressed in rose, blue, yellow, etc., winged, and with rich jewels entwined in their plaited hair. During the first half of his career Tintoretto gave his angels either a distinctly masculine character or at most a somewhat androgynous form and costume. Never had he depicted them as luxuriantly bosomy females in stylish garb. That he intended these as such is clear when we contrast them with the distinctly male angels above them. Their number suggests that they might represent five Virtues, but none is given an explicit attribute and their meaning must be left to conjecture. An even more striking departure from standard iconography occurs in the area above the Virgin and her attendants. The seminude figure of Christ—and the clearly indicated stigmata leave no doubt about his identity—sweeps downward diagonally from upper left to greet his Mother, the two trajectories suggesting an imminent head-on collision. He is accompanied by a pair of decidedly masculine angels who physically support his body in its aerial course. Previous depictions of the *Assunta* by Venetian painters were divided

*1. Jacopo Tintoretto.* Assunta. *Oil on canvas, 92 1/2 × 56 1/8″. Obere Pfaar-kirche, Bamberg*

about evenly on including God the Father or allowing the Virgin to dominate the upper part of the scene; in none that I know does Christ appear in God the Father's stead. Tintoretto was not to repeat this unusual iconography, henceforth limiting himself simply to angels and putti; nor does Veronese depart from convention in his *Assunta* altars. The Bassano family, Palma Giovane, and other later cinquecento painters appear never to have adopted this unusual inclusion of Christ in the *Assunta*.

In composition the Bamberg *Assunta* marks an important advance in Tintoretto's development of the theme. The Virgin's tomb is not used to establish an illusionistic, space-defining recession, but rather tilts precariously from lower left to upper right, establishing an inclined plane against which the apostles are disposed. Some of them display a familiar rhetorical repertory of gesture, but others surge forward and reinforce the tomb's diagonal, or conversely draw back at lower left and emphasize the spatial complexity of the counter diagonals which grow from the powerfully impressive young apostle at bottom center, whose spiraling contrapposto dominates our visual entry into the picture's space. The Virgin and her entourage begin the primary counter direction to that of the apostles, revolving slowly upward and forward over the apostles' heads to redirect the diagonal toward the upper left. There they are met by the drastically foreshortened Christ, whose right foot disappears behind the frame, thus establishing that the limits set by the head of the apostle at lower left have been observed above as well. This integrity of the picture plane is then reasserted by the flying angel at top, whose compression to a Mannerist planarity is emphasized by the powerful illumination concentrated on it.

A wide range of motival associations link the *Assunta* with Tintoretto's earlier paintings. From the Accademia version come the kneeling apostle tilted backward at lower left, and the seated apostle at right, both revised in costume and the latter in a modified pose. The raised arms of the figure at far left are close to those of St. George in the 1553 Camerlenghi picture (Venice, Accademia),[15] and various of the apostles recall types found in such pictures as the 1559 *Last Supper* (Paris, St. François Xavier).[16] The figure of the Virgin bears some resemblance to that of the *Vision of St. Jerome* (Venice, Accademia), a work usually dated too late and more likely to be from about 1562–65;[17] her female attendants are of a type familiar in such paintings as the *Vision of St. Peter* (Venice, Madonna dell'Orto) of shortly before 1556,[18] as well as many other works of the decade of the 1550s. The flying Christ is a direct descendant of St. Mark in the *Miracle of the Slave* (Venice, Accademia) of 1548,[19] but the foreshortened figure had originated as early as the *Venus, Vulcan, and Mars* (Modena, Galleria Estense) of about 1541[20] and was a stock figure in Tintoretto's repertory by 1560. His angels point up the associations, both motival and stylistic, which are most suggestive of the place occupied by the Bamberg *Assunta* in Tintoretto's development. Both of them appear, most explicitly the brightly lighted angel at top, in the grandiose pair of canvases in the choir of Madonna dell'Orto, Venice.[21] These vast murals of the *Golden Calf* and the *Last Judgment*, disparaged by Vasari, who saw them in 1566, for their lack of drawing, were probably begun by 1562 and were certainly finished by 1564 and more likely 1563, when the artist was already engaged on the three great canvases for the Scuola di S. Marco[22] that were followed in 1564 by intensive work in the Sala dell'Albergo of the Scuola di S. Rocco.[23] Beyond the evident motival resemblances between the *Assunta* and the Madonna dell'Orto murals, they all share a marked concern with the human figure in dynamic motion, a floating world in

which forms seem to be drained of weight and mass and to revolve upward in response to an orchestrated mobility dominated by an arbitrary pattern of zigzag projections in and out of space.

No drawings are known for the Bamberg *Assunta*, although several are close to details of pose and form found there. This is probably due to Tintoretto's well-known use of wax or clay models, a stock of mannequins which he disposed and modified as his compositions required, draping them differently and in various lights to explore formal interrelationships. If drawings for the *Assunta* exist, they might be expected to resemble the rather numerous figure studies for the Madonna dell'Orto canvases.[24] These are marked by the use of a dense, oily chalk which is employed with exceptional brevity to indicate only the scallop-shaped bulges of anatomical contour. They are among the crudest, the least concerned with elegance or finish, of Tintoretto's sketches, and no doubt reflect the feverish and improvisational energy with which he approached these demanding projects.

During the thirty or so years of his career which remained after painting the *Assunta*, Tintoretto would repeat many details of that composition, but its influence is clearly evident in the third of his treatments of the same theme.[25] This altarpiece, somewhat larger than its predecessor, was painted for the church of the Crociferi (Venice, Gesuiti) under circumstances suggested by Ridolfi, who reports that the priors wanted an *Assunta* by Veronese and that Tintoretto obtained the commission by promising to paint it in the manner of Paolo and, by implication, for a cheaper fee. The later version of the subject is, indeed, rather in the Veronese style. It is conventional in most elements, with the Virgin almost vertical at top center, surrounded by a bouquet of pink angels who range from putti to the mature, masculine angels which flank her. The grandiose spread of apostles gesticulate rhetorically around the slightly tilted tomb. A richly clouded sky and the glittering display of liturgical still life add to the cheerfully decorative character of the painting. This occasional character makes the dating of the Gesuiti *Assunta* a complex problem. The painting does not, however, fit with the openly decorative sensuality of paintings of the 1550s, such as the *Presentation of Christ in the Temple* (Venice, Accademia)[26] painted a decade earlier for the same church as the *Assunta*. In place of the emphatically massive forms and their broad and colorful slashes of paint in the *Presentation*, the *Assunta* fragments the brushwork into a scintillant evocation of atmosphere suggestive precisely of Veronese's mature pictorialism. It contains, in fact, several near-quotations from Paolo's *Assunta* for Sta. Maria Maggiore (Venice, Accademia).[27] It seems, therefore, clear that Tintoretto made conscious reference to this as well as the Umiltà ceiling *Assunta* (Venice, SS. Giovanni e Paolo, Cappella del Rosario)[28] in formulating the Gesuiti picture. This in turn clarifies its date, since, while the Umiltà ceiling may be dated to almost the same time as the Bamberg *Assunta*, that is, about 1562, the Sta. Maria Maggiore altarpiece must be dated to about 1581–82. This, in fact, points to the proper context for the Gesuiti altar: the cycle of mural votive paintings for the Sala del Collegio of the Palazzo Ducale, which Tintoretto and his shop produced between 1581 and 1584. Tintoretto would return once more to this theme of the Assunta in one of the large murals in the lower hall of the Scuola di S. Rocco. Here one finds distant reflections of his earlier treatments, but the horizontal format creates a distinct order, and the dry and ghostly exclusion of sensual pleasure from its material surface sets this late interpretation apart from its predecessors. Tintoretto's son Domenico essayed the subject at least once in a lost altarpiece for S. Stae, a concept which might survive in a fine preliminary study in the Albertina.[29]

The years between 1561 and 1568 were perhaps the most fertile and productive in all of Tintoretto's career. Although a few pictures dated to 1561–62 betray routine invention and listless execution,[30] their dull character might well be due to their having been relegated to his shop in the press of new and more stimulating challenges. Others, such as the ceiling of the Atrio Quadrato of the Palazzo Ducale and the Umiltà *Pietà* (Venice, Accademia),[31] show a dramatic contrast of chiaroscuro, a firm sense of plastic integrity, and deeply resonant color keyed to blue, red, and gold. Probably begun in 1562 and extending in execution well into 1563, the giant canvases for Madonna dell'Orto elicited from the artist his most elaborately convoluted Mannerist experiments and loosened his brushwork to veils of diaphanous gray-green and bronze. Returning to a comparatively more moderate scale, the three canvases for the Scuola di S. Marco were commissioned shortly after June 1562, while the Madonna dell'Orto paintings were still in progress, but they were no doubt complete by June 1564, when the artist made his audacious donation of the ceiling of the Sala dell'Albergo to the Scuola di S. Rocco, a gesture which inaugurated not only the murals for that hall but his long association with the Scuola. The *Crucifixion* followed in 1565, and the walls were complete by 1567. In the same year comes *St. Roch in Prison* (Venice, S. Rocco),[32] and in 1568 the pendant canvases for the choir of S. Cassiano.[33] With this extraordinary cycle Tintoretto seems to have momentarily spent his powers of invention and his excitement with pictorial effect, since the few dated paintings of the following six years suggest a general stagnation which would only abate with the resumption of work in the Scuola di S. Rocco in 1575.

As we have suggested, the Bamberg *Assunta* may be dated close to 1562 at about the time of the Madonna dell'Orto murals. Its definition of form is clear and details such as hands are decisively drawn. Heads are, for the most part, strongly characterized and in certain cases, such as the radiance-surrounded profile at left center, heroic in mold. The subtle distribution of illumination is most striking in the tremulous half-light cast by Christ on the wondering face of the Virgin. The chromatic range is wide and varied, but the group of apostles is dominated by a deep bottle-green, warm rose, rust, and golden yellow; the upper part is rather more pallid with oyster, dull blue, and rose predominant. There is a certain range of quality in the *Assunta* which suggests that Tintoretto followed his usual practice of relegating peripheral portions of his larger pictures to his shop assistants. Here this shop participation must be limited but is, perhaps, to be detected in the apostles at far left, in portions of the Virgin's attendant angels, and in the somewhat opaque blue sky.

*University of Maryland*

*Notes*  [1] Oil on canvas, rounded at top, 4.37 × 2.65 m. Painted on three vertical strips of canvas, with at least one horizontal seam visible at upper left. Its condition is generally satisfactory, with extensive inpainting evident only along one strip about 26 cm wide running the entire height at right, and a somewhat narrower strip at left. A rather dense, yellowed varnish covers the entire surface. The frame of simple molding seems of an early date, but is not, probably, coeval with the painting. Early guidebooks describe the picture as in the south

choir of Bamberg Cathedral; it seems to have been transferred to the Obere Pfaarkirche after World War II.

[2] I am most grateful to Drs. Kultzen and Meinschel of the German museums administration, to the photographer Emil Bauer, and to C. B. Thompson for their kind assistance in procuring photographs and information about the painting.

[3] Ludwig Burchard first attributed the *Assunta* to Tintoretto himself and pointed it out to Johannes Wilde, who noted it as authentic and distinctively Mannerist. Johannes Wilde, "Die Mostra del Tintoretto zu Venedig," *Zeitschrifte für Kunstgeschichte*, VII (1938), 145. This was confirmed, with a dating in the mid-1550s, by Erich von der Bercken, *Die Gemälde des Jacopo Tintoretto*, Munich, 1942, 104. The most recent catalogue of the artist's paintings, Pierluigi De Vecchi, *L'opera completa del Tintoretto*, Milan, 1970, does not mention it.

[4] The *Deposition with Saints* (Munich, Theatinerkirche), the vast *Crucifixion* (Schleissheim, Staatsgalerie), the *Raising of Lazarus* (Lübeck, Katharinenkirche), and other church altarpieces seem to have been commissioned directly from the artist. Their various destinations in the provinces may account for the predominant participation of Tintoretto's shop.

[5] Marco Boschini, *Le ricche minere della pittura veneziana*, Venice, 1674, 31.

[6] Giles Robertson, *Giovanni Bellini*, Oxford, 1968, 121.

[7] Philip Rylands, "Palma Vecchio's 'Assumption of the Virgin'," *Burlington Magazine*, CXIX (1977), 245–50.

[8] Konrad Oberhuber, *Early Italian Engravings from the National Gallery of Art*, Washington, D.C., 1973, 420–21.

[9] Francesco Valcanover, *L'opera completa di Tiziano*, Milan, 1969, 99, no. 82.

[10] *Ibid.*, 108, no. 171.

[11] *Ibid.*, 120, no. 324.

[12] Bernard Berenson, *Lorenzo Lotto*, London, 1956, 5–6, 26, 68–69, 129.

[13] This important but little-known altarpiece is mentioned, but not reproduced, in Adolfo Venturi, *Storia dell'arte italiana*, Milan, 1934, IX (7), 427.

[14] De Vecchi, *Tintoretto*, 93, no. 72.

[15] *Ibid.*, 96, no. 98.

[16] *Ibid.*, 101, no. 133.

[17] *Ibid.*, 115, no. 215.

[18] *Ibid.*, 96, no. 94–B.

[19] *Ibid.*, 92, no. 64.

[20] *Ibid.*, 86, no..12–L.

[21] *Ibid.*, 103, nos. 156–A, 156–B.

[22] *Ibid.*, 105–6, nos. 162–A, 162–B, 162–C.

[23] *Ibid.*, 107, nos. 167–A ff.

[24] Paola Rossi, *I disegni di Jacopo Tintoretto*, Florence, 1975, 9–10.

[25] De Vecchi, *Tintoretto*, 98, no. 110.

[26] *Ibid.*, 97, no. 107.

[27] Remigio Marini, *L'opera completa del Veronese*, Milan, 1968, 126, no. 258.

[28] Marini, *Veronese*, 110, no. 132–B.

[29] Alfred Stix and Lili Fröhlich-Bum, *Beschreibender Katalog der Handzeichnungen in der Albertina. I, Zeichnungen der venezianischen Schule*, Vienna, 1926, 61–62, no. 97.

[30] De Vecchi, *Tintoretto*, 102, nos. 145, 148.

[31] *Ibid.*, 106, no. 163–A, 100, no. 130.

[32] *Ibid.*, 111, no. 177–A.

[33] *Ibid.*, 111, nos. 178–A, 178–B.

# 23
# Caravaggio, Lizard, and Fruit

JANE COSTELLO

In writing an article for such a close friend as Peter Janson, formality does not seem to be the order of the day. I hope no one will mind if this essay is sometimes personal and discursive.

My interest in this subject began many years ago. While working for my graduate degree, I had the luck to find a very minor job in the Metropolitan Museum of Art. Although it wasn't much, having been duly signed in and validated I had the run of the building from cellar to attic.

For a while I made the Print Room my home. There, by chance, I came upon the series of prints designed by Frans Floris representing the *Five Senses* (engraved by H. Cock, 1561). I was struck by what seemed the very clear iconographic similarities between the Floris plate for *Touch* (fig. 3) and Caravaggio's *Boy Bitten by a Lizard* (fig. 1). The same was true of the Floris *Taste* (fig. 4) and Caravaggio's *Boy Peeling Fruit* (fig. 2), now known only through the copies in Hampton Court and elsewhere. I believed that Caravaggio had seen the Floris prints and incorporated basic features from them in his paintings. Consequently it seemed reasonable to assume that the two compositions that we know today are all that remain of a series of the *Five Senses* that Caravaggio had painted (or planned to paint) as five separate pictures.[1]

I did not know that on another continent, then separated from ours by a world war, a German scholar, Hans Kauffmann, had published an article on the *Five Senses*.[2] He included a brief but excellent discussion of the series of prints by Floris, and traced the later manifestations of the theme, but only in Northern painting, not in Italian.

Twelve years later, in direct response to Kauffmann's article, another article was published by Kurt Bauch on the iconography of Caravaggio's early works.[3] The greater part of Bauch's attention was given to Caravaggio's *Lute Player* in the Hermitage. Then, at the very end of his article, he devoted two paragraphs to other genre paintings by Caravaggio, among them the *Boy Bitten by a Lizard*, the *Boy Peeling Fruit*, and the *Boy with a Fruit Basket* (fig. 5). Following Kauffmann's lead, Bauch suggested that they were "perhaps" influenced by Northern prints. He saw them as being reminiscent of a series, and conjectured that "perhaps"

1. *Caravaggio*. Boy Bitten by a Lizard.
*Fondazione Roberto Longhi, Florence*

2. *Caravaggio*. Boy Peeling Fruit *(copy)*.
*Hampton Court*

1

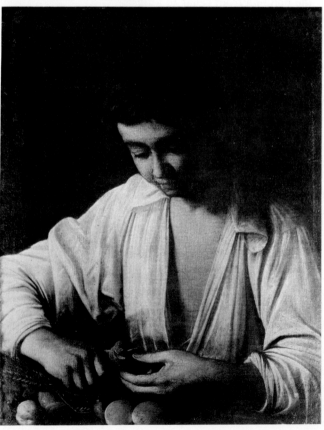

2

3. *Frans Floris.* Touch. *Engraving by Hieronymus Cock, 1561*

the *Boy with a Fruit Basket* represented *Taste* (and here he cited an illustration provided by Kauffmann). He proposed that the *Boy Bitten by a Lizard* "perhaps" could be *Touch;* for this he provided a reproduction of the Floris print of *Touch.* He passed over the *Boy Peeling Fruit* in silence.

In short, Bauch took the content of Kauffmann's article and applied it uncritically to Caravaggio. In so doing he made one serious mistake. While his identification of the *Boy Bitten by a Lizard* as *Touch* was correct, his choice for *Taste* was wrong. *Taste* is not the *Boy with a Fruit Basket,* it is the *Boy Peeling Fruit.*[4] This one point aside, I have no doubt that Bauch was otherwise correct.

However, this one error, and the general hesitance of Bauch's presentation, were troublesome to later scholars, and tended to undermine confidence in his whole hypothesis. In some publications he has been ignored. During the last ten years especially, things have taken what is to my mind a turn for the worse. New readings have been provided for the Caravaggio paintings that seem unconvincing and confusing to our understanding of the painter's intent.

The erosion has come about in two ways. One was the pursuit of stylistic analysis in the continuing effort to arrive at an exact chronology of early works by Caravaggio.[5] The other stems from iconographic investigations, and the attempts to find symbolism and concealed meanings in what appear to be genre paintings by Caravaggio.

Stylistic analysis had led us astray in ways that are clear and easy to define. Of the paintings that we have today, the Longhi *Boy Bitten by a Lizard* is accepted as an original. The *Boy Peeling Fruit,* on the other hand, is known only in copies. To give them equal weight in a stylistic comparison seems on the face of it to be improper, or at the least very dangerous. Yet that is what has been consistently

done. An earlier date is assigned to the *Boy Peeling Fruit,* and the *Boy Bitten by a Lizard* is placed somewhat later. Some writers have set up a chronological sequence that separates the two paintings by as many as four or seven intervening works.[6] This is one of the imps plaguing us, because once the pictures were conceived as having been made at some removal in time, their relationship as a pair, or as part of a series, became easily overlooked.

This imprudent procedure also assumes that it is permissible to overrule a contemporary source, Mancini, at will.[7] Mancini described Caravaggio's hardships following his arrival in Rome. Of our two pictures he wrote, ". . . for sale he made a boy who cries because of being bitten by a lizard that he holds in his hand, and after that a boy who is peeling a pear with a knife. . . ." Clearly Mancini links the two pictures as having been made in close sequence, and as both showing a boy or youth with an attribute, one a lizard, the other a pear.[8]

As might be expected, the authors who are more concerned with iconography still tend to regard the pictures as part of a set, since they are interested in related meanings. Their solutions are becoming abstruse and difficult to follow. For that reason it is necessary to be very specific in retracing their steps.

In 1969, at the International Congress of Art Historians in Budapest, Leonard Slatkes gave a talk entitled "Caravaggio's Painting of the Sanguine Temperament."[9] The painting in question was Caravaggio's *St. John in the Wilderness,* the versions in Rome in the Doria-Pamfili Gallery and the Capitoline Museum. However, at the end of his talk Slatkes made a general plea for Caravaggio as a painter of humanistic imagery in the guise of genre. He closed with a reference to "the well-known *Sick Bacchus,* a melancholic winter type, and the choleric *Boy Bitten by a Lizard.*" It is his last sentence, and there are no footnotes.

In 1971 Donald Posner wrote an article on "Caravaggio's Homo-Erotic Early Works."[10] He called attention to the expressions of homosexuality that pervade many of Caravaggio's early works, and he also arranged them into a new chronological sequence. But Posner, too, at least partook of the tendency to seek out hidden symbols in the genre paintings. Among these compositions, he noted flowers as being commonly associated with *luxuria* or *voluptas,* and pears and apples with Venus, while the cold-blooded lizard stands in sixteenth-century art and literature for shyness and coolness in love, and so on.[11]

For all that, in the Posner article the idea of Caravaggio's two paintings as representations of *Touch* and *Taste* was still alive. He reviewed Bauch's article and found it "speculative," but passed on the identification of *Touch* with the *Boy Bitten by a Lizard,* and *Taste* with the *Boy with a Fruit Basket.*[12]

The same year that Posner wrote, Richard Spear published a note in the *Burlington Magazine.*[13] The object of his concern was a painting of a *Boy with a Vase of Roses* in Atlanta, High Museum.[14] He put forward this painting in conjunction with the *Boy Bitten by a Lizard* as possible reflections of of what had once been an allegorical set. He suggested that the *Boy Bitten by a Lizard* could be *Touch* if the two were *Senses,* or an allegory of *Fire* "since the salamander was equated with that element—were the elements (or by extension the seasons) the overriding subject." He made reference to Slatkes's passing suggestion that the *Boy Bitten by a Lizard* represented the choleric temperament.[15] Finally, according to Spear's scheme, the *Boy with a Vase of Roses* could fit into the series as *Scent.*

This is confusing, because the argument shifts back and forth among various allegorical identifications, and to cap it all off, he says that it is premature to attempt to determine the iconographic intentions of Caravaggio until other pictures

4. *Frans Floris*. Taste. *Engraving by Hieronymus Cock, 1561*

5. *Caravaggio.* Boy with a Fruit Basket. *Borghese Collection, Rome*

are discovered which may expand our knowledge of the series. Yet he omits the *Boy Peeling Fruit,* and even Bauch's *Boy with a Fruit Basket.*

Finally, in 1976, Slatkes wrote again on "Caravaggio's *Boy Bitten by a Lizard.*"[16] He challenges Posner on the lizard, its species and significance. Instead he, too, identifies the creature as a salamander, who lives unharmed by fire, and he reads the painting as probably part of a program relating to several aspects of fire. These include the heat of passion and lust, the vice *Ira,* anger or wrath, the summer season, the hot and dry humor, and the choleric temperament. Goltzius, he points out, included the salamander in his print of *Fire* in the set of the *Four Elements* that is dated 1586–88. Slatkes deduces that Caravaggio intended the picture to have a dual meaning, that of burning with lust and anger.

Slatkes does not discuss the painting as one of a series. As for its representing *Touch,* he mentions this only as a remote possibility, and refers the reader to Posner's summary of Bauch.[17] As he sees it, only after 1620 did the artists of the Netherlands take up the general pose of Caravaggio's boy and use it for their locally popular theme, *Touch.*

If I have emphasized the writings of Posner, Slatkes, and Spear, it is because their articles constitute a kind of family. They interact with each other. But it would be wrong not to look beyond this group, to see what other scholars have hypothesized.

It is not a long story, because few other authors have taken any interest in the iconography of the *Boy Peeling Fruit* and the *Boy Bitten by a Lizard.* When they have, they tend to concentrate on the *Boy Bitten by a Lizard* and rely heavily on Posner's analysis of its erotic symbolism. This is true of Frommel, who read the painting with great sensitivity but looked to Posner for the explanation of its content.[18]

Röttgen accepted Posner's interpretation, and incorporated it into a much more extensive analysis. On the other hand, Röttgen rejected Spear's thesis that the Atlanta painting might be a copy of a Caravaggio painting of one of the *Senses,* and even the notion that Caravaggio would have made a true series, thematically related, at all.[19]

Calvesi did propose a new and original interpretation of the two paintings. He put forward the *Boy Peeling Fruit* as symbolizing Christ redeeming humanity from original sin, and the *Boy Bitten by a Lizard* as an expression of *vanitas.* His material is copious and most interesting, but does not, to my mind, bear out these conclusions.[20]

Now all of this is treacherous ground. The flowers in the *Lute Player* meant *luxuria* or *voluptas* to Posner, but to Bauch they meant *vanitas.*[21] The lizard to Posner is cold-blooded, and stands for coolness in love. To Slatkes the same beast is a salamander, choleric, related to fire, and therefore to wrath, passion, and warmth in love. He also notes five different interpretations that have been provided for figs, and several for cherries.[22] Such conflicting and multiple variations of interpretation as these surely indicate a wide margin for error. The cause, I believe, is the overemphasis being put upon the symbolism of single features, such as a lizard or flower, without examining the pictorial tradition in which these symbols regularly appeared, namely, the Northern prints.

During the second half of the sixteenth century the printing houses of the

North were churning out an amazing quantity and variety of prints in sets. Even aside from religious themes, they produced, for example, the *Liberal Arts*, the *Muses*, the *Temperaments*, the *Senses*, the *Times of Day*, the *Seasons*, the *Elements*, *Planets*, *Months*, and so on. Each set of prints had a single unifying theme, but some of the same symbols might occur in sets having different themes. The symbol received and contributed different meanings according to the context in which it occurred. Posner himself repeats a warning by Lomazzo that one and the same animal can, depending upon the action and content, represent many things.[23] Or, to go further back, Kauffmann points out that Floris, in designing his *Senses*, assigned to *Sight* the mirror that had belonged to *Prudentia* and to *Superbia*.[24] Therefore it may be that the context determines the meaning of the symbol, whereas the presence of the symbol does not necessarily identify the subject.

The time has come, I believe, to review the evidence afresh. The place to begin is with Mancini. His descriptions of the compositions of the *Boy Bitten by a Lizard* and the *Boy Peeling Fruit* are too exact to refer to any compositions other than those we know today. In one continuous statement he says that they were made in close sequence. In fact his language suggests that they may have been made one after the other.[25] So the *Boy Bitten by a Lizard* and the *Boy Peeling Fruit* go together in Mancini's mind, and he dates them together. This testimony by Mancini cannot be overlooked or refuted.

Next there is the question of the subjects of these paintings, and whether they do or do not represent two of the *Five Senses* (even nonbelievers have never troubled to disprove this). We would do well, I think, to return to the approach of Kauffmann, who regarded the *Five Senses* as a pictorial tradition. The contribution of Bauch should be acknowledged, and his incorrect intrusion of the *Boy with a Fruit Basket* eliminated. All this may be accomplished by comparing these paintings by Caravaggio with a representative selection of Northern prints of the *Five Senses*.

For our purposes by far the most important series of the *Five Senses* is that designed by Frans Floris of Antwerp, and engraved by Hieronymus Cock in 1561. As an Italianate Northerner, Floris gave the *Senses* a proper humanist stamp, and a fashionable Mannerist style. The compositions he formulated became the prototypes for many other artists who followed. Marten de Vos, who studied with Floris, made three or more sets. Some resemble Floris's. Another, engraved by Pieter Cool probably in the 1570s, is very different in being exquisitely elaborate, with chariots drawn by symbolic beasts and a treasury of meaningful reptiles, mammals, insects, crustaceans, and birds. Next, Hendrick Goltzius is credited by Kauffmann as having been the first to transfer the *Senses* from Antwerp to Holland in his series of 1578.[26] These compositions are simpler, but still echo the formulations of Floris. There were others by artists familiar and unfamiliar, earlier and later: George Pencz, Erasmus Hornick, Jost Amman, Crispin de Passe. These were augmented by copyists and imitators. It is a welter, but a welter from which a pattern emerges.[27]

The protagonist in each case is an allegorical woman, be she seated, standing, or riding on a chariot. *Taste* is expressed by the eating of fruit. There may be a basket of it in her lap or on the ground, or a cornucopia of it. In all the examples the ape, age-old symbol of Taste, is also present, and also eating fruit. These human and animal actors may be joined by a creature that looks like a lizard

(Marten de Vos), and is decked out with a plethora of additional fruits and vegetables. The chariot carrying *Taste* by Marten de Vos (Cool series) is drawn by elephants. According to classical sources, apes and elephants like wine and can be captured while drunk.[28]

*Touch* is conveyed by the action of biting. Usually it is a bird (sometimes recognizable as a parrot) that sits on the extended hand of the woman and bends down to give her a nip. In the case of Goltzius, it is a serpent around *Touch's* right arm that bites her hand.[29] This primary action is reinforced by other forms of life. A spider in a web and a turtle are standard. A scorpion, lizard, or snake may make an appearance. All are recognizable as creatures who bite (except the turtle, who presents a problem).[30] Even the spider, the weaver who flees at a touch to his web, may also bite.

Taken together, the prints provided a considerable body of motives and actions from which an artist might choose. But here we are brought up short by history, and by the personalities involved. The printmakers of the second half of the sixteenth century were imbued with the attitudes of their time. Their minds were attracted to the abstract, the allegorical, and the erudite. Their compositions are decorative, and, in varying degree, Manneristic. The picture they show is not one of this world.

In all these respects they would have been repugnant to Caravaggio. He chose from them just enough of the traditional imagery to make the subjects of his two

*6. Frans Floris.* Taste *(detail)*

*7. Frans Floris.* Taste *(detail)*

pictures recognizable. For *Touch* he continued the salient idea of biting, the *Boy Bitten by a Lizard,* and selected one of the reptiles that sporadically surface in these compositions. Instead of a fairly serene allegorical lady, however, his youth recoils in pain at the bite of the lizard. This physiological response is the artist's main preoccupation. To him a sensory stimulus is a physical experience. The same is true of his *Taste.* The meaning is conveyed by the eating of fruit. He needs no monkey or cornucopia. His *Boy Peeling Fruit* is the simple and fragrant projection of the sensuous experience.

Naturally one wonders whether Caravaggio made use of one set of prints in particular. In his *Taste* the evidence strongly favors Floris. Floris's allegorical woman is still holding the knife in her right hand, having just finished peeling the fruit she is eating (fig. 6). In Caravaggio's *Taste*, the boy is still peeling it. A second, and separate, motive connects Floris's print to Caravaggio (fig. 7). The basket of fruit at the feet of *Taste* is startlingly similar to those painted by Caravaggio, such as the Ambrosiana *Fruit Basket* or especially that in the *Supper at Emmaus* in the National Gallery, London.[31]

*Touch* is a different matter. The act of biting and the presence of the lizard occur in the prints very often. But it is not the lizard who does the biting. This combination was chosen by Caravaggio, and its closest precursor would be Goltzius, whose *Touch* is bitten by a serpent.[32]

There is one last thing to be said. If Caravaggio's two pictures represent *Taste* and *Touch,* it is natural to think that he made, or intended to make, the whole series of the *Five Senses.* Possibly he did, but possibly he did not. There was a tradition, going back as far as Pliny, that various creatures surpassed others in the acuteness of a given sense.[33] This concept is still to be found in sixteenth-century prints: the ape surpassing in taste, the eagle in sight, the stag in hearing, the dog in scent, and so on. However, Pliny did not go so far as to create a program that embodied all five of the senses in beasts, birds, or reptiles. He was much more cautious and scientific. "Among the senses," he wrote, "that of touch in man ranks before all other species, and taste next; but in the remaining senses he is surpassed by many other creatures."[34] Caravaggio may well have been acquainted with this classical tradition, and chosen to paint only those two senses that were believed to be keenest in mankind, *Taste* and *Touch.*

*New York University*

*Notes*

[1] Alfred Moir, *Caravaggio and His Copyists*, New York, 1976, no. 50, *Boy Peeling Fruit*, and no. 51, *Boy Bitten by a Lizard*. Taking both paintings together, Moir lists some thirteen copies of them, known or recorded (surprisingly he regards the Longhi *Boy Bitten by a Lizard* as a copy). In proposing that these paintings were two of a series, the question of dimensions naturally arises. Working with copies makes certainty impossible, but all appear to range from 60 to 70 cm in height, with the preponderance of them measuring 65 to 70 cm. Width is harder to nail down, but most run from 50 to 60 cm. These variations are true of both compositions.

[2] Hans Kauffmann, "Die Fünfsinne in der niederländischen Malerei des 17. Jahrhunderts," *Kunstgeschichtliche Studien Dagobert Frey*, Breslau, 1944, 133–57.

[3] Kurt Bauch, "Zur Ikonographie von Caravaggios Frühwerken," *Kunstge-*

schichtliche Studien Hans Kauffmann, Berlin, 1956, 252–60. For all information cited here, see 260 and fig. 7.

[4] Bauch made this mistaken choice even though Mancini, writing in 1619–1621, closely links the *Boy Bitten by a Lizard* with the *Boy Peeling Fruit*. Bauch had access to Mancini's text in Walter Friedlaender, *Caravaggio Studies*, Princeton, 1955, a book he cited in another connection.

[5] The exact dates assigned to the two paintings naturally vary from author to author. They tend to settle on one or another of the early years of the 1590s. For my purposes, however, it is more important to realize that the works were made in direct sequence.

[6] The only author I can recall who quotes Mancini and his references joining the two paintings is Kitson, *Complete Paintings of Caravaggio*, New York, n. d., 85, no. 1. Even so, in the catalogue raisonné the *Boy Peeling Fruit* is listed as no. 1, and the *Boy Bitten by a Lizard* as no. 4.

[7] Giulio Mancini, *Considerazioni sulla Pittura*, eds. Marucchi and Salerno, I, Rome, 1956, 59: ". . . per vendere, un putto che piange per esser stato morso da un racano che tiene in mano, e doppo pur un putto che mondava una pera con il cortello . . ." Mancini is the only contemporary source that mentions both paintings. Baglione describes only the *Boy Bitten by a Lizard*.

[8] The kind of fruit being peeled is hard to see in the paintings. In one codex Mancini (*Considerazioni*, II, note 88³) calls it an apple (mela). To call it a pear, though, is interesting. In prints representing *Taste*, the pear is sometimes subtly emphasized. It may appear as a fruit hanging from a tree (an example of this by Marten de Vos is reproduced in H. W. Janson, *Apes and Ape Lore*, London, 1952, pl. XLIV, fig. 3). In the Floris print shown in our figure 7 the pear is the only fruit lying on the ground in front of the fruit basket.

[9] Leonard J. Slatkes, "Caravaggio's Painting of the Sanguine Temperament," *Actes du XXIIᵉ Congrès International d'Histoire de l'Art*, Budapest, 1969, published 1972, II, 16–24.

[10] Donald Posner, "Caravaggio's Homo-Erotic Early Works," *Art Quarterly*, XXXIV (1971), 304 ff.

[11] Posner, "Homo-Erotic Early Works," 314 and n. 17. He refers to the significance of the flowers in the *Lute Player* in the Hermitage, and cites Julius Held's "Flora," *De artibus opuscula XL: Essays in Honor of Erwin Panofsky*, New York, 1961. For the significance of the lizard he refers to sixteenth-century art and emblematic literature, but without naming a specific example. This created a vacancy into which rushed a salamander, as we shall presently see.

[12] Posner, "Homo-Erotic Early Works," 318.

[13] Richard E. Spear, "A Note on Caravaggio's 'Boy with a Vase of Roses'," *Burlington Magazine*, CXIII (1971), 470–73.

[14] *Boy with a Vase of Roses* is similar in size and composition to *Boy Bitten by a Lizard*. It is so similar, in fact, as to suggest that it is a derivative from it, rather than a copy of a lost composition, as Spear proposes.

[15] See above, n. 9.

[16] Leonard J. Slatkes, "Caravaggio's *Boy Bitten by a Lizard*" (*Tribute to Wolfgang Stechow*, ed. Walter L. Strauss), *Print Review*, 5 (Spring 1976), 148–53. Unless otherwise specified, the material discussed here can be found on 149 and 151.

[17] Slatkes, *Lizard*, 153, referring to Posner, "Homo-Erotic Early Works," 318 and ns. 69, 71.

[18] Christoph Luitpold Frommel, "Caravaggios Frühwerk und der Kardinal Francesco del Monte," *Storia dell'arte*, IX–X (1971), 5–52. For the discussion of the *Boy Bitten by a Lizard*, cf. 26, 27.

[19] Herwarth Röttgen, *Il Caravaggio: Ricerche e interpretazioni*, Rome, 1974, 193–95, and n. 157.

[20] Maurizio Calvesi, "Caravaggio o la ricerca della salvazione," *Storia dell'arte*, IX–X (1971), 93–142. For *Boy Peeling Fruit*, 95, 141; for *Boy Bitten by a Lizard*, 106, 107, 142.

[21] Posner, "Homo-Erotic Early Works," 304, 318 and n. 68. Bauch, "Frühwerken," 255. Also Patricia Egan, "Concert

Scenes in Musical Paintings of the Italian Renaissance," *Journal of the American Musicological Society*, XIV (1961), 194, n. 40.

22 Slatkes, *Lizard*, 152, 153.

23 Posner, "Homo-Erotic Early Works," 319, quoting Lomazzo, *Trattato della Pittura*, II, 423, 430.

24 Kauffmann, "Fünfsinne," 137.

25 My thanks to Professor Kathleen Weil-Garris for joining me in mulling over the time interval between the paintings as expressed by Mancini. Also see above, n. 7.

26 Kauffmann, "Fünfsinne," 139.

27 Dates for these series of prints are few and far between. Therefore I have emphasized those for which exact or approximate dates can be provided. Perhaps I should explain the grounds for my dating of the Marten de Vos series engraved by Pieter Cool. None of the standard sources such as Nagler, *Künstler-Lexikon*, Munich, 1850, or later publications gives any dates for the several series by Marten de Vos. However, the engraver, Pieter Cool, is listed in F. W. H. Hollstein, *Dutch and Flemish Etchings, Engravings and Woodcuts 1400–1700*, IV, Amsterdam, 1950, 225, who places the activity of Cool at c. 1570. There is a built-in safety factor in dealing with the group of prints as a whole, in that the influence of the Frans Floris compositions is pervasive and predominant.

28 Janson, *Apes and Ape Lore*, 254, n. 6.

29 This interesting variant was pointed out by Slatkes, *Lizard*, 153 and n. 51. For the series as a whole see *Hendrick Goltzius 1558–1617. The Complete Engravings and Woodcuts*, ed. Walter L. Strauss, New York, 1977, I, 84–89. At the time of writing, this book is in the binderies at the New York Public Library and the Metropolitan Museum of Art. The Print Department of the Metropolitan Museum allowed me to use a preliminary unbound copy, and I wish to thank them, and the Print Room of the Public Library, for their unusual kindness and help.

30 Kauffmann, "Fünfsinne," 135, calls the turtle an attribute of Venus Urania, crushed under the feet of Venus Pandemos, probably signifying proprietary feelings of love. Still, I want to investigate the turtle. (The snapping turtle may be ruled out; it does not occur in Europe.) The turtle's reaction to being touched is one clear justification for its presence in these pictures.

31 Paolo della Pergola, "Note per Caravaggio," *Bollettino d'arte*, XLIX (1964), 253, 254, and figs. 6, 7, reproduces two small paintings on copper attributed to Jan Breughel in the Galleria Borghese. They represent glass vases of flowers that are so similar to the one in the *Boy Bitten by a Lizard* that Caravaggio must have known and imitated them. The resemblance between Floris's basket of fruit and those by Caravaggio then constitutes a second instance of his use of Northern prototypes for his still lifes.

32 It may be noticed that I have omitted all reference to the painting by Sophonisba Anguisciola in Dijon showing two children, one of whom is bitten by a crawfish. The reason is that I believe her composition to be an independent derivative from the Northern prints, not necessarily having any relationship to Caravaggio's *Boy Bitten by a Lizard*.

33 Janson, *Apes and Ape Lore*, 239 f.

34 Janson, *Apes and Ape Lore*, 239, n. 4, quoting Pliny, *Hist. Nat.*, X, cap. 69, called attention to Pliny's reservation of Touch and Taste to man. I am not certain which edition of Pliny Janson was using. The quotation here is taken from the Loeb Classical Library edition of Pliny, *Nat. Hist.*, X, 88.

Throughout this study I have had occasion to thank persons and institutions for their helpfulness. I cannot close, however, without acknowledging a special indebtedness to Professor Donald Posner for his generous loan of photographs and for his bibliographical suggestions.

# 24

## *Lizards and Lizard Lore, with Special Reference to Caravaggio's Leapin' Lizard\**

DONALD POSNER

One of the candidates in the 1977 election for mayor of Aspen, Colorado, was Sal A. Mander. He lost, receiving only eight percent of the vote. Many of those going to the polls, however, were probably dissuaded from voting for him because, after the previous November campaign, in which he ran for Pitkin County sheriff, he was declared "ineligible . . . after city officials noted that lizards can't vote"[1] and therefore, presumably, cannot hold office.

Leaving the question of the constitutionality of lizard-exclusion aside, the declaration of the Aspen officials was herpetologically indefensible. Sal A. Mander may appear lizard-like to the casual observer, but he has no family connection to the Lacertidae. In fact, a degree of class-consciousness is in order here: Sal A. Mander and his relatives, among them newts and frogs, are amphibians, and—so most zoologists would maintain—definitely low class by comparison to the reptilian lizards.

The zoological identity of the beast biting the finger of the youth in Caravaggio's well-known picture (figs. 1, 2) has been the subject of some art-historical confusion. One writer, while calling it a lizard, assumed, despite all evidence of comparative anatomy to the contrary, that it is first cousin or closer to the scorpion. This enabled him to conclude that the animal's bite is like the arachnid's terrible sting, and that the picture symbolizes death waiting in ambush to strike those who surrender themselves to the immoral pursuit of sensual pleasures, the latter represented in the painting by fruits and flowers.[2] But since lizards don't generally bite people, and since the only one whose bite is dangerous is the Gila monster of Mexico and the southwestern United States, it would seem, on the face of it, difficult to sustain this conclusion. Recently, however, Leonard Slatkes, who, like the Aspen authorities, mistakenly supposes that salamanders are just another species of lizard, states that "Caravaggio had the salamander specifically in mind when he created his composition."[3]

Now the salamander does release a milky fluid from its pores that is poisonous to some animals, but it is usually harmless to man. Still, no one seems to like salamanders much, and historically they have been thought dangerous, most nasty,

387

1. *Caravaggio*. Boy Bitten by a Lizard. *Fondazione Roberto Longhi, Florence*

2. *Caravaggio*. Boy Bitten by a Lizard *(detail)*

pestilent, and venomous beasts whose bite is deadly. Slatkes quotes an old French saying as translated by the English naturalist Edward Topsell in his 1608 *History of Serpents*: "If a Salamander byte you, then betake you to the coffin and winding sheete."[4] Understandably, Hugo van der Goes pictured Satan in the Garden of Eden in the guise of a salamander.[5]

It is true that it was not quite clear in Caravaggio's time whether salamanders were or were not lizards. Topsell, who did not himself believe they were and so discussed them in a section apart, separately from lizards, nevertheless would not "contrary their opinion which reckon the Salamander among the kinds of Lyzards, but leave the assertation as somewhat tollerable." Regarding classification, the only thing he would say with certainty is that the salamander is not "a kinde of Worme."[6] For all that, one knew perfectly well what salamanders look like, and it is evident that Caravaggio did not have one in view or in mind when he painted his picture.

There are two European species of salamander: the black salamander, which is restricted to Alpine regions, and the spotted black-and-yellow salamander, which is commonly found almost everywhere in Europe. The latter is the one Caravaggio would have known, and it is the one described by Topsell as "very like a small and vulgar lyzard," but "thicker and fuller . . . , with a blacke line going all along their backs . . . ; the skin is rough and balde . . . and all the body over it is set with spots of blacke and yellow."[7] Topsell published a woodcut illustrating this animal (fig. 3, below), which is clearly not the beast seen in Caravaggio's work.

Slatkes, however, has deepened the confusion surrounding the painting by asserting, as if on the authority of Topsell, that around 1600 all lizards (whether or not salamanders be counted among them) "were believed to be deadly poisonous animals whose bite, or excrement, could kill."[8] This is not true.

Among the few lizards Caravaggio was probably familiar with, the green lizard (fig. 3, middle), common in Italy, had no reputation for biting or poisoning. On the contrary, one was sure, according to Topsell, that it will "never set uppon man," and will suffer itself to be handled by children. In fact, it was reputed to be disgustingly fond of humans, so that "if it chance a man do spet, they [the green lizards] licke up the spettle joyfully."[9] The characteristics of this animal were apparently taken to typify the whole race of lizards by the explorer and zoologist Sir Joseph Banks in the eighteenth century. "I have," he wrote, "taken the Lizard, an Animal said to be Endow'd by nature with an instinctive Love of Mankind, as my Device. . . ."[10] It was even believed that the green lizard would do its utmost to warn men of the approach of poisonous serpents,[11] which may explain why lizards appear in the Garden of Eden at the foot of the Tree of Life in a print by Schongauer.[12]

Of course, the lizard in Caravaggio's painting is not the friendly green variety. It is plainly the same beast that Topsell illustrates (fig. 3, top) and describes as the "vulgar" lizard, which he says goes in Italy by the names "Lucertula . . . , Racani and Ramarri."[13] This is the "wall lizard," the commonest species of the animal in Europe. It has scales and "certain rusty spots . . . with long strakes or lines to the taile,"[14] which can be seen in Caravaggio's painting, if not very well in photographs of it.

Is this common lizard poisonous? Well, yes, one thought so. If eaten. Topsell reports that "the flesh of Lezards eaten do cause an inflamation and apostemation, the heate of the head-ach, and blindnesse of the eyes."[15] This is why the witches in *Macbeth* throw a lizard's leg along with a howlet's wing into their bubbling

*3. Top to bottom:* "Vulgar" Lizard; Green Lizard; Salamander *(from E. Topsell,* The Historie of Serpents, *London, 1608, 204, 209, 217)*

cauldron (IV, i, 17). But all this is beside the point, for the youth in Caravaggio's picture is not there interested in culinary peculiarities.

From what Topsell says, lizards, except when eaten, were not thought venomous. Their excrement was not only believed harmless, it was considered medicinal: one could use lizard's dung for cleansing wounds, improving eyesight, and banishing pimples.[16] However, lizards were reputed to bite. Their bite was not imagined to be fatal, but, one was sure, it hurt. Shakespeare, when he has the Duke of Suffolk curse his enemies, makes him wish that "Poison be their drink! . . . Their chiefest prospect murdering basilisks!" and "Their softest touch as smart as lizards' stings!" (*Henry VI*, Part 2, III, ii, 320–25). Topsell says that the place bitten by a lizard "continually aketh." The lizard's teeth, he adds, "are very weake," and when it bites it leaves its teeth in the wound.[17]

Some years ago, when discussing Caravaggio's painting, I referred to the cold-bloodedness of lizards, which was taken in the sixteenth and seventeenth centuries to symbolize inability to love. I suggested that the homosexual youth who reaches for beguiling fruits on the table confronts not death but the painful experience of rejection in love.[18] Topsell's herpetological report confirms this reading: the lizard's bite hurts; its marks remain and ache for a long time; but it is not fatal.[19]

*New York University*

\* I am grateful to Mary Taverner Holmes, who kindly pursued some serpentine routes for me.

[1] From the UPI account as printed in the Charlottesville (Va.) *Daily Progress*, May 5, 1977, A6. The report, headlined "Lizard Wins Votes in Mayoral Contest," charges that Mander is retained by the Aspen *Times* and manipulated by cartoonist Chris Cassatt.

[2] L. Salerno, "Poesia e simboli nel Caravaggio: I dipinti emblematici," *Palatino*, X (1966), 108. Cf. D. Posner, "Caravaggio's Homo-Erotic Early Works," *Art Quarterly*, XXXIV (1971), 318 f.

[3] L. Slatkes, "Caravaggio's *Boy Bitten by a Lizard*" (*Tribute to Wolfgang Stechow*, ed. Walter L. Strauss), *Print Review*, 5 (Spring 1976), 149.

[4] *Ibid.*; and E. Topsell, *The Historie of Serpents or the second Booke of living Creatures*, London, 1608, 220.

[5] R. Koch, "The Salamander in Hugo van der Goes' *Garden of Eden*," *Journal of the Warburg and Courtauld Institutes*, XXVIII (1965), 323 ff.

[6] *Historie of Serpents*, 217.

[7] *Ibid.*

[8] "Caravaggio's *Boy*," 149.

[9] *Historie of Serpents*, 209 f.

[10] A. M. Lysaght, *Joseph Banks in Newfoundland and Labrador, 1766*, Berkeley and Los Angeles, 1971, 58.

[11] *Historie of Serpents*, 210.

[12] R. Koch, "Martin Schongauer's Dragon Tree" (*Tribute to Wolfgang Stechow*), *Print Review*, 5 (Spring 1976), 118 f.

[13] *Historie of Serpents*, 203.

[14] *Ibid.*, 203 f.

[15] *Ibid.*, 208.

[16] *Ibid.*, 204, 209.

[17] *Ibid.*, 204, 208.

[18] "Caravaggio's Homo-Erotic Early Works," 304 f. Herwarth Röttgen (*Il Caravaggio: Ricerche e interpretazioni*, Rome, 1974, 193 f.) has tried to approach the picture from a psychohistorical viewpoint. He sees the lizard's bite as an allusion to the aggressive, sadistic behavior of the dominant lover in a homosexual relationship. His interpretation is partly based on a seventeenth-century notion recorded by Filippo Picinelli (*Mondo simbolico*, Milan, 1653, 272). Lizards, Picinelli says, having bitten, will not let go. Therefore the animal appeared in a love emblem with the motto *Aut Morte, aut Nunquam*. Picinelli does not, however, seem to have imagined that the "bite" of the loving lizard would be a painful, nasty surprise. It seems to me that if Röttgen is right the meaning of Caravaggio's picture would have been accessible only to the painter's analyst.

[19] In the title of this article I have referred to Caravaggio's "leapin' lizard." It is true that the lizards known as "flying dragons" in Asia and the East Indies, which can spread out a fold of skin along each side of their bodies, leap or "fly" from tree to tree. It is probable, though, that Caravaggio's lizard is not leaping, but is being carried aloft by the finger to which it has momentarily attached itself. In general, lizards may be biters, but they are not leapers. This was already recognized by 1768 when Laurenti, in his *Synopsis of Reptiles*, divided the class of reptiles into three orders: "Leapers, as the frogs; Walkers, as the lizards; and Serpents" (*Oxford English Dictionary*, s.v. "Leaper," 2b.). Of course, Orphan Annie was known to exclaim, fairly frequently, "Leapin' Lizards!" But the child was probably trying to get her tongue to do "Lipizzans," which are horses of a different color, with a real lust for leaping.

Quite recently, it has been discovered that in the rain forests of Panama there are lizards which are carriers of malaria (*New York Times*, November 3, 1977, B12). One recalls that the young Caravaggio has been thought to have suffered from malaria, and that his early works have been taken for self-portraits. I wish to state here that I reject the hypothesis that has as yet not been put forward.

# 25
# Van Dyck's
# Early Paintings of
# St. Sebastian

JOHN RUPERT MARTIN

In an article written more than half a century ago Gustav Glück observed that the development of the early style of Van Dyck could be exemplified by three paintings of the Martyrdom of St. Sebastian.[1] All three works represent the saint being tied to a tree by bullying soldiers under the supervision of one or more officers on horseback. For the sake of brevity I shall refer to these three compositions as Types A, B, and C.

Type A, the earliest of the group, is represented by the painting in the Louvre (fig. 1), which with its heavy and vigorous brushwork and coarse draughtsmanship is typical of the so-called "rough style" of Van Dyck. The work is usually thought to date about 1615–16, though it might indeed have been painted a year or two later. The figure of the saint, thickset and glowering, possesses none of the slender grace and idealized proportions that were soon to become the distinctive characteristics of the Van Dyck male nude. One of the executioners, a dark-haired bowman of ferocious appearance,[2] lays a hand on the saint's shoulder and brandishes a pair of arrows, while a half-naked older man ties a cord about Sebastian's wrist and a third soldier at the left gathers up the victim's discarded armor, which is sniffed at by a dog. At the upper right an officer on a white horse watches the scene.[3]

The second composition—Type B—is to be seen in the large painting in Munich (fig. 4), which, though it illustrates the same moment in the binding of the saint for martyrdom, exhibits a striking change in style and mood. Here, instead of the sullen youth of the Louvre canvas, who stares out at us with an expression of deep resentment, Van Dyck presents a hero of slim and elegant build, raising his eyes to heaven as he submits without protest to his ordeal. Once again the task of binding Sebastian to the tree is carried out by three soldiers, one of whom kneels in order to fasten a rope about his feet. A mounted officer of grim aspect, carrying a red standard with the letters S.P.Q.R., looks down at the saint. The animal on which he rides, seen from the rear in three-quarter view, provides a useful indication of date, because it plainly derives from the horse of the centurion Longinus in Rubens's *Coup de Lance* of 1620.[4] Behind the banner may be seen the heads of a second rider and his horse—a motif reminiscent of the Louvre painting (fig. 1).

Type C may be illustrated by a painting also in Munich (fig. 6). It shows the

1. *Van Dyck*. St. Sebastian
*(Type A, 1)*. *Louvre, Paris*

martyr in an attitude not unlike that in Type A and reintroduces the inquisitive
dog. But the composition as a whole is more animated than the two preceding
works. A furious archer, his breastplate only half fastened to his body, lunges for-
ward to place his hand on Sebastian's head, and the saint's ankles are bound by a
muscular athlete who fills much of the foreground. Behind him, at the extreme
right of the picture, a helmeted bowman selects arrows from a sheaf held by a boy.
The two mounted officers, one holding a banner and the other a spear, are still
present; the nearer rider's horse tosses its head and flowing mane.

It is now generally agreed that this work was painted after the artist's arrival in
Italy late in the year 1621.[5] A date in the Italian period is supported by the con-
nection that can be shown to exist between this Munich picture and a painting by
Van Dyck of the *Man of Sorrows* in the collection of Count Antoine Seilern. The
work in question, which is painted in oil on paper, is so Titianesque in character
as to leave no doubt of its having been done in Italy, probably between 1622 and
1625.[6] It represents Christ standing with arms bound before him while a mocking
soldier drapes the royal mantle over his shoulders. The brutal features and
outstretched arm of the tormentor are virtually duplicated in the figure of the

2

3

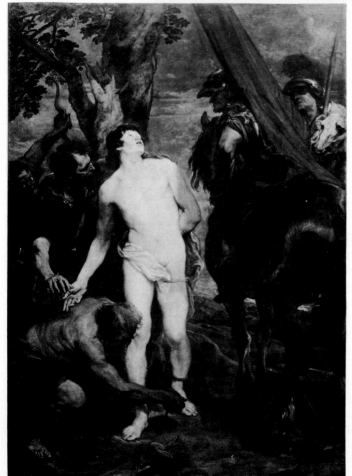

*2. Van Dyck. X-ray mosaic of* St.
Sebastian *(Type A, 2). National
Gallery of Scotland, Edinburgh*

*3. Van Dyck.* St. Sebastian *(Type B,
1). National Gallery of Scotland,
Edinburgh*

executioner who grasps Sebastian's head in the Munich painting. But even more important is the fact that on the verso of the Seilern picture there are several sketches by Van Dyck in black and red chalks which may be identified as preparatory studies for what I have called Type C of the *Martyrdom of St. Sebastian* (fig. 7).[7] The principal drawing is a study from the nude model for the kneeling executioner; a second drawing, inverted on the sheet, represents the archer who in the Munich painting picks arrows from the bundle carried by a boy; there is also a second sketch of his hand clutching the arrows.

It is a curious fact, and one that sheds some interesting light on Van Dyck's working method, that the three compositions which I have designated Types A, B, and C were not created as single paintings. In each case the artist painted both a preliminary version (not to be confused with an oil sketch) and a more finished picture on a somewhat larger scale. It should be noted in passing that Van Dyck followed the same practice in illustrating the Betrayal of Christ. There are two paintings of this subject—a preliminary picture now in the Minneapolis Institute of Arts and the larger, more detailed canvas in the Prado in Madrid.[8]

The Louvre *St. Sebastian* (fig. 1) is beyond question the first, or preliminary, version of Type A, and is recognizable as such both by its sketchlike handling and by its relatively small size (144 by 117 cm). It was followed by an appreciably larger version of the same composition (226 by 160 cm), the existence of which we know solely through radiographic analysis, since it was subsequently painted over by Van Dyck himself and is now concealed beneath another *St. Sebastian* in the National Gallery of Scotland in Edinburgh (fig. 3). An X-ray mosaic of the central area of the canvas (fig. 2)[9] reveals unmistakable evidence of an earlier composition, in which the saint appears in the pose established in the Louvre picture. Near his shoulder can be discerned the scowling face of the swarthy executioner, and a little further down the bare shoulder and arm of the older man who is tying a cord about the saint's wrist. It is apparent, in short, that this painting was carried out by Van Dyck as a second, larger, and probably more finished version of the Louvre painting. How long it remained visible we have no way of knowing— perhaps for as long as several years.

At length, however, having perhaps grown dissatisfied with his first conception of the Sebastian theme, Van Dyck decided to paint an entirely new composition over the original layer on the Edinburgh canvas. The resulting picture, which we may term the preliminary version of Type B, is of course the one now visible on that canvas (fig. 3). Though not as rough in execution as the Louvre painting (fig. 1), it was manifestly not intended as a finished picture. The same composition was now in turn used with very little change for the large and carefully detailed painting in Munich, which measures 260 by 185 cm and which may be described as the second and final version of Type B (fig. 4).[10]

There remains Type C, a composition almost certainly developed, as we have seen, during Van Dyck's Italian period. Once more the artist took the trouble to establish his design in a preliminary version, which is surely to be identified with the canvas now in the Chrysler Museum at Norfolk (189 by 144 cm; fig. 5).[11] And that design was then repeated in the second of the Munich paintings of St. Sebastian, which measures 199 by 150 cm (fig. 6). It will be recalled that there is a preparatory drawing for this composition in Count Seilern's collection (fig. 7).

It is not known for whom or for what purpose these pictures were painted; their early history is unrecorded. In none of them does the artist follow the conventional iconography of St. Sebastian. They represent neither the archers loosing

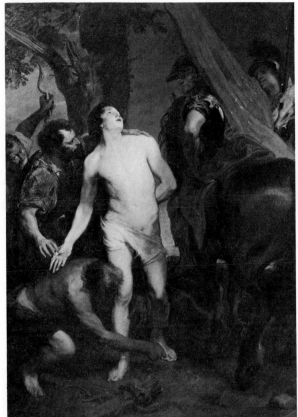

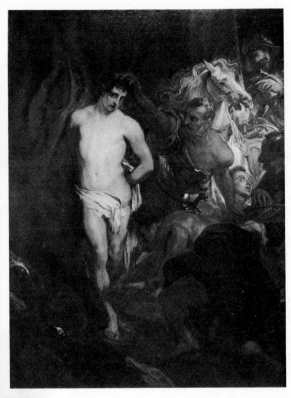

4

5

4. *Van Dyck*. St. Sebastian *(Type B, 2)*.
*Bayerische Staatsgemäldesammlungen,*
*Munich*

5. *Van Dyck*. St. Sebastian *(Type C, 1)*.
*Chrysler Museum, Norfolk*

6. *Van Dyck*. St. Sebastian *(Type C, 2)*.
*Bayerische Staatsgemäldesammlungen,*
*Munich*

6

**7**

*7. Van Dyck. Sheet of studies.
Collection Count Antoine Seilern,
London*

*8. Wenzel Cobergher. St. Sebas-
tian. Musée des Beaux-Arts,
Nancy*

**8**

their arrows at the victim nor the martyr pierced with darts and left for dead. Van Dyck selects another moment altogether, when Sebastian, having been stripped of his armor, is prepared for execution by being bound to a tree. It is the anticipation of suffering, not the martyrdom itself, that gives to these pictures their unique quality of pathos. In choosing not to illustrate the horror of Sebastian's martyrdom Van Dyck was disregarding the recommendation of Counter Reformation theologians such as Gilio da Fabriano, who argued that artists must not allow their aesthetic delight in the beauty of the human form to prevent them from giving a truthful rendering of the sufferings of the saints, no matter how ugly. Sebastian, wrote Gilio, ought to be shown "full of arrows, so as to resemble a hedgehog."[12]

Van Dyck was not of course the first to represent St. Sebastian being bound in preparation for his torment. There are, to cite two examples, paintings of this subject by artists as diverse as Palma Giovane[13] and Joachim Wtewael.[14] For Van Dyck, moreover, a source of inspiration was to be found close at hand. In the Cathedral of Antwerp he could not have failed to see the altarpiece by Wenzel Cobergher which likewise represents *St. Sebastian Bound for Martyrdom* (fig. 8). This work, now in the Museum at Nancy, was painted for the Guild of Longbowmen (the Jonge Handboog) in 1598–99.[15] An old man urges the saint to recant, while two executioners bind his feet to the tree. Though Cobergher's Late Mannerist style and naïve prolixity of detail could have held no attraction for Van Dyck, the naked and defenseless figure of the condemned saint being pinioned to a tree by callous soldiers evidently made a deep impression on him. In his own paintings of St. Sebastian Van Dyck offers what might be called a set of variations on this theme. Of these it is not the early Louvre picture of Type A (fig. 1) that shows the closest resemblance to Cobergher's figure group, but the paintings of Types B (figs. 3, 4) and C (figs. 5, 6), in which a kneeling soldier ties a rope about the saint's feet. It is hardly necessary to add that in all these versions Van Dyck far surpasses Cobergher in his ability to realize the emotional possibilities of the subject.[16]

*Princeton University*

### Notes

1 "Van Dycks Anfänge. Der heilige Sebastian im Louvre zu Paris," *Zeitschrift für bildende Kunst*, LIX (1925/26), 257–64; reprinted in Gustav Glück, *Rubens, Van Dyck und ihr Kreis*, Vienna, 1933, 275–87.

2 Surprisingly, Van Dyck used for this figure the features of the apostle Judas Thaddeus in Metz; see Gustav Glück, *Van Dyck, Des Meisters Gemälde, Klassiker der Kunst*, Stuttgart, 1931, 44 (hereinafter cited as Glück, *Van Dyck, K.d.K.*), and Horst Vey, "De Apostel Judas Thaddeus door Van Dyck," *Bulletin Museum Boymans–van Beuningen*, X (1959), 93, fig. 6.

3 Two works which are sometimes regarded as preliminary studies for the Louvre *St. Sebastian* are the painting of a nude youth in the National Gallery of Ireland in Dublin (Michael Jaffé, *Van Dyck's Antwerp Sketchbook*, London, 1966, I, pl. XVII) and the sketch of a soldier on horseback in Christ Church, Oxford (Glück, *Van Dyck, K.d.K.*, 4).

4 Rudolf Oldenbourg, *Rubens, Des Meisters Gemälde, Klassiker der Kunst*, Stuttgart–Berlin, 1921, 216.

5 Glück, *Van Dyck, K.d.K.*, 531.

6 Antoine Seilern, *Flemish Paintings and Drawings at 56 Princes Gate, London. Addenda*, London, 1969, 20 f., pl. XIII; John Rupert Martin, "Van Dyck as History Painter: The Mocking of

Christ," *Proceedings of the American Philosophical Society*, CXXI (1977), 229–31.

[7] Seilern, *Flemish Paintings and Drawings. Addenda*, 22f., pl. XIV. Though the drawing is here attributed to Rubens, Count Seilern informed me that he considered it to be unquestionably the work of Van Dyck.

[8] Wolfgang Stechow, "Anthony Van Dyck's Betrayal of Christ," *Minneapolis Institute of Arts Bulletin*, XLIX (1960), 5–17. A third painting of this subject by Van Dyck in the collection of Lord Methuen at Corsham Court presents a different composition (Glück, *Van Dyck, K.d.K.*, 70).

[9] For a concise account of this remarkable discovery and an analysis of the X-ray evidence see Colin Thompson, "X-Rays of a Van Dyck St. Sebastian," *Burlington Magazine*, CIII (1961), 318. I am indebted to Mr. Thompson for kindly sending me a photograph of the X-ray mosaic.

[10] Several paintings have been considered to be preliminary studies by Van Dyck for the *Martyrdom of St. Sebastian*. The sketch in oil on paper in a private collection in Strasbourg showing only the left half of the composition (Hermann Voss, "Eine unbekannte Vorstudie Van Dycks zu dem Münchener Sebastiansmartyrium," *Kunstchronik*, XVI (1963), 294–97, fig. 2) appears to be a copy after the Edinburgh painting (our fig. 3). An oil sketch on canvas in the Warwick Collection shows the whole composition (reproduced in the exhibition catalogue *Van Dyck*, Thomas Agnew & Sons Ltd., London, 1968, 19, No. 14, pl.). As Horst Vey has noted ("Anton Van Dycks Ölskizzen," *Bulletin des Musées Royaux des Beaux-Arts de Belgique*, 1956, 203), this work is surely a copy after the Munich picture (our fig. 4).

[11] John Rupert Martin and Gail Feigenbaum, *Van Dyck as Religious Artist*, Princeton, 1979, 114. This had already been suggested by Glück, *Van Dyck, K.d.K.*

[12] G. A. Gilio da Fabriano, *Due dialoghi . . . nel secondo si ragiona degli errori de' Pittori circa l'historie*, Camerino, 1564, 87v–88r.

[13] Adolfo Venturi, *Storia dell'arte italiana*, IX, pt. 7, 1934, 204, fig. 119.

[14] C. M. A. A. Lindemann, *Joachim Anthonisz Wtewael*, Utrecht, 1929, No. VII, pl. XI.

[15] Hans Vlieghe, "Het Altaar van de Jonge Handboog in de Onze-Lieve Vrouwkerk te Antwerpen," *Album Amicorum J. G. van Gelder*, The Hague, 1973, 342–46; David Freedberg, "The Representation of Martyrdoms during the Early Counter-Reformation in Antwerp," *Burlington Magazine*, CXVIII (1976), 135.

[16] St. Sebastian bound for martyrdom was also represented in a lost painting by Cornelis de Vos, known only through engravings by Egbert van Panderen (repr. in F. W. H. Hollstein, *Dutch and Flemish Etchings, Engravings and Woodcuts*, XV, 98, No. 44) and by Pieter de Jode (repr. in E. Greindl, *Corneille de Vos*, Brussels, 1944, pl. 87). It appears from these prints that De Vos's composition was based on one of Van Dyck's painting of the subject.

# 26
# Two Allegories of
# the Seasons
# by Simon Vouet and
# Their Iconography[1]

WILLIAM R. CRELLY

During recent years a very substantial number of paintings has emerged from
seclusion to enlarge the catalogue of Simon Vouet's oeuvre. Of these, two variant
representations of the *Four Seasons* now in Glasgow and Dublin respectively are
most impressive for their exquisite quality, and they are also of interest because of
their unusual iconography (figs. 1–4).[2] Both pictures show Adonis accompanied by
Flora (or, as we shall see, by Flora in the semblance of Venus) and Ceres, with a
curious little child Bacchus completing the composition below the main figures.
Although both canvases are now circular in format, there is some reason to think
that the Glasgow painting may originally have been rectangular.[3] An engraving of
1645 by Vouet's son-in-law Michel Dorigny reproduces in reverse the composition
of the painting in Dublin.[4] In my opinion both pictures are quite surely from
Vouet's own hand and together typify his method of revising and re-forming his
pictorial imagery as his art developed.[5] A parallel reworking of a theme is seen in
two versions of another allegorical subject: *Time Vanquished by Hope, Love, and
Beauty*, one now in Madrid, painted at the end of the artist's Italian sojourn in 1627,
and the other, now in Bourges, done about 1643 for a cabinet in the Hôtel de
Bretonvilliers in Paris.[6]

Though the *Seasons* painting in Glasgow is clearly much earlier than the version
in Dublin, it does present some problems of dating. The full, corporeal figures and
the smoky, bronzed shadows, dilutions of Vouet's early Caravaggesque chiaroscuro,
relate it to his mature Italian works, for example, the *Cupid and Psyche* in Lyon
or the *Caritas Romana* in Bayonne.[7] The Adonis, with his profusion of dark, curling
locks and his meltingly beautiful, even effeminately voluptuous face, is closely
akin to the messenger in the Kassel *Sophonisba* or to the youth who personifies
Intellectus in the Capitoline *Allegory of the Human Soul*.[8] The Ceres is particularly
intriguing. Her face is far more individualized than that of the corresponding figure
in the Dublin picture, recalling the Madrid *Time Vanquished*, where Vouet used his
young wife Virginia da Vezzo as the model for Venus seizing Saturn by the fore-
lock. It seems possible in fact that the Ceres in the Glasgow *Seasons* is another
mythological portrait of Virginia. There is at least a general resemblance between

1. *Simon Vouet*. The Four Seasons.
*Glasgow Art Gallery*

2. Adonis *(detail of fig. 1)*

3. Flora *(detail of fig. 1)*

this Ceres and the portrait of Virginia engraved by Claude Mellan in 1626.[9] In spite
of these close connections with Vouet's Italian production, however, I am inclined
to see the Glasgow painting as a work executed after his return to France in 1627.
It lacks the formal vigor usually found in his Italian works, and the shadows are
less emphatic, more transparent than those in his last Italian pictures. The Glasgow
painting has a decorative lightness more closely akin to the *Allegory of Wealth* in
the Louvre than to the robust formal animation of the Madrid *Time Vanquished*.[10]
In the *Seasons* picture all of the compositional elements except for Adonis's spear
are woven into a pattern of intertwining curves: the figures themselves, their
draperies and tendril-like fingers, the branching tree with its leafy vine, the bil-
lowing clouds edged with golden light, and even the small detail of the bristly cord
of the dog circling around Adonis's left hand. Indeed, were it not for the altera-
tions to the canvas and the cut tip of the spear, one could easily surmise that the
work had been conceived as a circular composition. The complex curvilinear grace
of the painting and also its lack of spatial depth suggest that it was done not
as an independent easel picture, like Vouet's Italian allegories, but as a decorative
piece for a wall or ceiling, possibly as a component of a larger ensemble. When he
returned to France Vouet was employed extensively in the decoration of the royal
residences, especially the châteaux of St. Germain-en-Laye.[11] And he also executed
two very grandiose ceiling allegories celebrating the union of Henrietta Maria,
Louis XIII's sister, with Charles I of England, one at the Château de Colombes and
the other for Oatland Palace.[12] These ceilings, known from engravings, and such
paintings as the allegories of *Wealth* and *Faith* in the Louvre, are vestiges of the
early decorative commissions for the royal family. It seems to me that the style

*4. Simon Vouet.* The Four Seasons. *National Gallery of Ireland, Dublin*

of the Glasgow *Four Seasons* accords very well with those post-Italian decorations, and it may well have been a crown commission. In any case, Vouet seems rarely to have done such decorative work in Italy. If my assessment of the Glasgow picture is correct, it would most probably date at the end of the 1620s and no later than the very early 1630s.

The *Four Seasons* in Dublin was probably executed in the early 1640s, not long before Dorigny's engraving of 1645. It is done in the highly refined linear style characteristic of the late phase of Vouet's career. The dark tonalities of the Glasgow *Seasons* have now disappeared in favor of clear, bright colors—chalky blue, red, and lavender-rose. Flora's garlands are lightly variegated, and Ceres is the quintessential blond goddess with golden ears of grain. The little Bacchus is flushed with crimson as though burned by the sun. The figures have lost their voluptuous corporeality, and the contours of the forms are now sharp and precise. The entire composition is simplified formally and spatially into a delicate and graceful network of curves playing across the picture surface rather than emphasizing solid forms in space. The diagonal of Adonis's spear, which counters the circularity of the Glasgow composition, is here eliminated. In the earlier work one can read the three main figures across the circle and against the tree and clouds in the background. In the later version the background is a neutral, flat plane and the forms are strictly coordinated with the circle. Its shape is echoed in the long curves of Adonis's drapery, in the head of the hound and in Bacchus's right arm, and in the wreath of flowers held by Flora. The fabric of the picture is thus purified and abstracted to an almost two-dimensional surface embellishment. It is as though in his late style Vouet was reacting consciously against the rich, sensuous Italianism of his earlier years and retrieving something of the elegant, courtly mannerism of Primaticcio and the other Fontainebleau painters of the sixteenth and early seventeenth centuries. In this way his art departed from the so-called early Baroque style and gravitated to a more rarefied sensibility which is peculiarly French, even though it was rooted in the traditions of Italy.

The changes between the earlier and later versions of these two *Seasons* pictures may also be understood to suggest iconographical revision. In the Glasgow painting Flora is shown on the left in profile and Ceres on the right with her head turned slightly toward Adonis, yet looking out of the picture in the direction of the spectator. Indeed, her glance establishes a strong psychological link between the spectator and the image. The painting in Dublin removes this psychological connection, objectifying the image away from the spectator and at the same time reversing the positions of the two goddesses. Ceres is now on the left, holding her sickle, while Flora is on the right, touching Adonis's shoulder and in the act of crowning him with the wreath of flowers. These include the roses sacred to Venus and the anemone into which Adonis's blood was transformed at the moment of his death. Whereas in the Dublin picture the hound is held on a cord wound around Adonis's hand and upper arm, in the Glasgow painting the dog licks its master's breast as though beckoning him away to the hunt. The youth looks wistfully at Flora as he turns from her in the direction indicated by his spear. By contrast, in the later representation Adonis seems passively languorous, with heavy-lidded eyes and a somnambulant expression, and he also wears a small beard. The stylized idealization reduces the figures in the Dublin picture almost to psychological ciphers, and the subject is presented without the slightest hint of dramatic pathos. The painting is an emblematic Triumph of Adonis, with Flora crowning the god and Ceres removed to the background as a secondary

observer. The little Bacchus is also changed: instead of lying voluptuously on his basket of grapes, he is upright and pulling away from the hound. The Glasgow *Seasons,* though conceived as a gracefully paced decorative composition, reveals a subtle sense of mythological narration. The Dublin picture is an abstractly crystallized iconographic emblem, nearly as cool, polished, and calligraphic as an Ingres or a Flaxman.

Vouet's interpretations of the *Seasons* theme provide a curious footnote to the long iconological history of the subject, and they also afford a revealing insight into the workings of his creative intellect. In Italy he had been on very close terms with the famous antiquarian Cassiano dal Pozzo. The inventories of Vouet's household in the Louvre, compiled in 1639 and 1640, mention a library of "deux cens vollumes . . . la plupart en italien, de diverses histoires."[13] In fact, Vouet appears to have been a highly literate artist, and his *Seasons* pictures, as well as many of his other single canvases and decorative cycles, suggest iconographical formulae culled and concocted from literary sources, especially from the mythographic and iconological writings of Italian authors. However, in contrast to the learned and inspired Poussin, whose great *Four Seasons* landscapes in the Louvre are unparalleled in their personal, inventive power, Vouet seems more inclined to be simply bookish, sometimes even in a rather pedantic way, though he often succeeded in producing quite poetic imagery.[14]

The symbolism which Vouet formulated for his paintings of the *Four Seasons* descends from traditions reaching far back into the ancient past. Fortunately the history of the concept in literature and in the visual arts has been investigated most extensively, especially in a monumental work of Dr. George Hanfmann.[15] Personified seasons are, of course, summations of recurrent changes in natural phenomena: changes in weather, vegetation, and astronomical relationships, the solar year marked by the vernal and autumnal equinoxes and the summer and winter solstices. Because of local custom and climatic variation in different regions, the seasons have not always been defined as four in number. The ancient Jewish year had only two seasons, while Egypt traditionally counted three.[16] Until the fifth century B.C. in Greece the number of seasons varied from two to three or four, or even seven.[17] With the increased knowledge of astronomy in the fifth and fourth centuries the tropical solar year of four seasons became the accepted norm in Greece. The tetradic system was reinforced by writers on science who may also have connected the four seasons with the Pythagorean worship of the number four, the τετρακτύς, "source and root of eternal nature," and by Hippocratic medical writers who associated them with seasonal diseases.[18] From very early times the seasons were personified by Greek poets as female "powers or spirits," the lovely Horae. In Attica the Horae were deities of vegetation, named Thallo "the Flower," Karpo "the Fruit," and perhaps Auxo for "growth," suggesting that only the fruitful seasons were recognized. Sacrifices were traditionally made to them in times of drought. In Homer the Horae roll aside the cloud gates of Olympus, thus effecting changes in weather.[19] Other early writers depict the Horae as beautiful women who bring to men the pleasant gifts of nature, the *horaia,* making presents of garments decorated with flowers and of wreaths of flowers.[20] They also make marriages fertile, protect the growth of small children, and bestow special charms upon the newborn. In Greek art of the archaic and classical periods the Horae, usually three in number, have flowers, ears of wheat, and fruit as their attributes. When the series of four seasons was first represented in Hellenistic art as

a procession of Horae, Spring carried flowers, Summer ears of grain, and Autumn grapes. Winter was shown with her cloak drawn over her head or with attributes associated with hunting—a dead boar, a dead hare, or dead birds (fig. 5).[21] The Hellenistic period also introduced in illustrated texts the image of the year in circular format with the Sun God in the center surrounded concentrically by signs of the zodiac and the months, and in the four corners the seasons marking the turning points of the year. This scientific calendar circle, used afterward in many Roman decorations (fig. 6), was transmitted to the post-Roman era as a symbol of the Christian universe, for example, in Romanesque paintings and cosmos pages Byzantine Octateuch manuscripts.[22] The standard Greek attributes for spring, summer, and autumn, alluding to the cycle of vegetation, are those used for the corresponding figures in Vouet's pictures. And his circular compositions, possibly made as ceiling decorations, could be seen as late descendants of the antique concentric scheme, though they are certainly more decorative than scientific.

The four seasons were not clearly personified by artists as symbols of the annual cycle until the early Hellenistic period. In the late Hellenistic period and in the time of the Roman Empire representations of the four seasons became ever more popular and widespread. They continued to be shown as idealized female figures, standing, dancing, and running. They were also depicted, however, as heroic youths, as playful amorini, and as busts in medallions. Such figures, nearly always as tetrads, were employed in fresco and mosaic decoration (often in radial form on ceilings). They were placed in the service of imperial propaganda, for example on the arches of Septimius Severus and Constantine, and they became a favorite form of sarcophagus decoration. Associated with them, in combination or separately, were representations of seasonal activities. Thus peasants, shepherds, hunters, and even small genre scenes came to stand for the four seasons and were later to influence the genre elements of months and seasons in medieval sculpture and manuscripts.[23] What we do not find in ancient art, however, are the seasons

*5.* Dionysus and the Horae, *reconstruction of early Hellenistic Seasons reliefs (from G. Hanfmann,* The Season Sarcophagus in Dumbarton Oaks, *no. 23, fig. 80)*

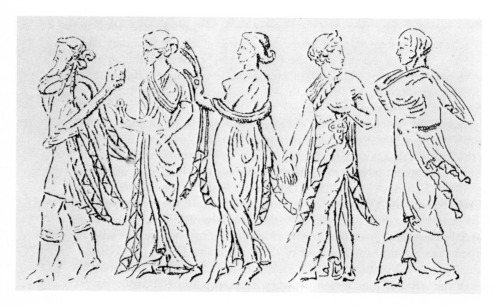

6. The Four Seasons, *stucco vault from Hadrian's Villa, Tivoli, after an engraving published by M. Ponce,* Arabesques antiques des bains de Livie et de la ville Adrienne, *Paris, 1789 (from G. Hanfmann,* The Season Sarcophagus in Dumbarton Oaks, *no. 16, fig. 105)*

represented as gods and goddesses, although they often appear in the company of deities. This kind of portrayal was known for the months and was customary for the days of the week, but it was rarely, if ever, used for the seasons.[24] Rather, it was in ancient literature that the seasons were assigned presiding deities, and it was from those literary traditions that later artists drew their deified seasons.

As has been said, the mythical Horae became fully equated with the four seasons in early Hellenistic imagery, with each personification distinguished by individual attributes. Henceforth, through later Hellenistic times, the late Roman Republic, and the Empire, representations of the four Horae-Seasons were increasingly frequent. The abstract Greek concept of the cosmic seasonal tetrad gradually gained ascendancy in Roman thought and art, as against the more disjunctive seasonal divisions based on native Italic religious festivals: *ver sacrum,* "Sacred Spring," and *brumalia,* the winter festival; the festivals of Ceres, *cerealia,* in spring, and Liber-Dionysus, *liberalia,* in autumn.[25] The tetradic system was propagated into Roman culture by scholars and poets of the late Republican and Augustan eras. Varro, Cicero, Vergil, Horace, and other writers make reference to the four-seasons system. The seasons are associated with the four winds, the four ages of man, and the signs of the zodiac; and such tetradic equations were taught in Roman schools.[26] The four seasons were also discussed by Roman writers on medicine who were concerned with theories of heat, light, and nourishment through the cycle of the year. Related to this is Vitruvius's description of Roman houses, with four dining rooms disposed in accordance with the seasons.[27] The notion of

the eternal regularity of seasonal recurrence had been taken as proof for the Stoic tenet that "the world is a divine, active, and rational being," and this interpretation was adopted by Roman writers sympathetic to Stoicism.[28] The Epicurean Lucretius used the Stoic argument of seasonal regularity to support the theory of Epicurean atoms. In the context of these proliferating meanings and associations given to the four Horae-Seasons, Roman writers provided the seasonal formulations which later writers and artists drew upon for their conceptions.

Lucretius (probably 94–55 B.C.) made a definitive connection between the seasons and a set of classical deities in the following passage of his *De rerum natura*, where he is speaking of the fixed order of things:

> On come Spring and Venus, and Venus' winged harbinger marching before, with Zephyr and mother Flora a pace behind him strewing the whole path in front with brilliant colors and filling it with scents. Next in place follows parching Heat, along with him Ceres his dusty comrade and the Etesian Winds that blow from the north-east. Next comes Autumn, and marching with him Euhuis Euan [i.e., Bacchus named from the cry of his worshipers]. Then follow other seasons and winds, Volturnus thundering on high and Auster lord of lightning; at length Shortest Day brings the snows and Winter restores the numbing frost; after these comes Cold with chattering teeth.[29]

It has been suggested that these lines may have been inspired by a ceremonial procession of seasons which Lucretius actually saw. While Spring, Summer, and Autumn are assigned their attendant deities here, no deity is present for Winter, unless, as Hanfmann says, Algor-Cold could be considered a deity.[30]

In the *Georgics* (I, 258) Vergil (70–19 B.C.) speaks of "how th'impartial year in four distinguished, equal seasons flows," and he recounts in detail the seasonal occupations of farmers. Although he does not formulate a concise tetrad of seasons and deities, he acknowledges such connections when at the opening of his poem he says:

> O universal lights, supremely fair,
> That through the welkin guide the circling year,
> Ye first I call. Then your celestial grace,
> Bacchus and blessèd Ceres, by whose gifts
> Earth changed Chaonia's scanty acorn-crop
> To full-eared, golden corn, and new-trod grape
> Mixed red with Achelous' storied stream.

Or here, to Bacchus:

> Draw nigh, O Sire Lenaeus! thy good gifts
> On every side abound; the teeming land
> Blooms with autumnal vines, the foaming vats
> Run o'er with vintage . . .[31]

In the *Fasti* Ovid (43 B.C.–17 A.D.) associates the Horae with Janus, whom they attend at the gate of heaven, and with the goddess Flora.[32] In a more famous passage from the *Metamorphoses* he provides a complete and concise tetradic personification of the Horae-Seasons flanking the throne of Apollo in the Phaëton story:

> To the right and left stood Day and Month and Year and Century, and the Horae set at equal distances. Young Spring was there, wreathed with a floral

crown; Summer, all unclad with garland of ripe grain; Autumn was there, stained with the trodden grape, and icy Winter with white and bristly locks.[33]

Ovid's beautiful word images could hardly fail to attract artists in search of a classical basis for depicting the four seasons. Moreover, the attributes he gives to the Horae could be readily transposed to figures of Venus or Flora, Ceres, Bacchus, or a Boreas for Winter.

These literary conceptions of the seasons, like seasonal images in mosaics and catacomb paintings or on sarcophagi, remained current into Christian times. The *Anthologia Latina*, a large collection of poems made at Carthage by a certain Octavianus seemingly around 532–534 A.D., contains many seasonal verses (they may have been mnemonic school exercises), including one which is clearly Ovidian:

Bountiful Spring plucks alluring gifts from her rose gardens.
Parched Summer exults in her gathered fruits.
The head bound with vine-sprig makes known Autumn.
Winter is pale with swift cold, denoting the season.[34]

In another section of the *Anthologia*, known as the "Rhymes of the Twelve Wise Men" (*Carmina duodecim sapientum*), Ovid's lines from the *Metamorphoses* are repeated and followed by twelve variational tetrastichs on the seasons theme. Pagan deities are connected with the seasons throughout the series, and the selection ascribed to a poet named Euphorbius is a compressed variant of Lucretius's set of seasons and deities:

In Spring, golden Venus rejoices with garlands of flowers.
Blond Ceres has the Summertime for her realm.
You, Bacchus, have your greatest power in grape-bringing Autumn;
In Wintertime the rule belongs to the raging winds.[35]

The *Anthologia Latina* preserves the writings of many minor Latin poets, ranging from earlier Roman examples to the verses of the anthologist Octavianus himself. The collection enjoyed great esteem during the Middle Ages and continued to be influential during the Renaissance and afterward.

A more expansive evocation of the seasons—and one of far greater literary merit than the verses from the *Anthologia Latina*—is that found in the *Dionysiaca*, an epic poem written in Greek in the fifth century A.D. by Nonnos of Panopolis in Egypt. Although Nonnos was less well known in the sixteenth and seventeenth centuries than the other poets we have discussed, the *Dionysiaca* had its editio princeps in 1569 at the Plantin Press in Antwerp. The passage in question might almost be called Baroque in its poetic exuberance:

And the rosycheek Seasons, daughters of the restless Year their stormfoot father, made haste to the house of Helios. One wore a snowy veil shadowing her face, and sent forth a gleam of subtle light through black clouds; her feet were fitted with chilly hailstone shoes. She had bound her braids about her watery head, and fastened across her brow a rain-producing veil, with an ever-green garland on her head and a white circlet of snow covering her frost-rimed breast.

Another puffed out from her lips the swallow-wind's breath which gives joy to mortal men, having banded the spring-time tresses of her zephyr loving head with a fresh dewy coronet, while she laughed like a flower, and fanned through

her robe far abroad the fragrance of the opening rose at dawn. So she wove the merry dance for Adonis and Cytheria together.

Another, the harvest-home Season, came with her Sisters. In her right hand she held a head of wheat with grains clustering on the top, and a sickle with sharpcutting blade, forecrier of harvest; her maiden form was wrapt in linen shining white, and as she wheeled in the dance the fine texture showed the secrets of her thighs, while in a hotter sun the cheeks of her drooping face were damp with dewy sweat.

Another leading the dance for an easy plowing, had bound about her hairless temple shoots of olive drenched with the waters of sevenstream Nile [i.e., thé Nile in flood]. Scanty and withering was the hair of her temples, dry was her body; for she is fruitpining Autumn, who shears off the foliage from the trees with scatterleaf winds. For there were no vinebranches yet, trailing about the nymph's neck with tangled clusters of golden curls; not yet was she drunken with purple Maronian juice beside the neatswilling winepress; not yet had the ivy run up with wild intertwining tendrils . . .[36]

Vouet may have been familiar with some or all of these ancient writings on the seasons. But it seems clear that, like other artists of his time, he turned to the standard mythographic and iconological compilations for his interpretations of the theme, especially to Vincenzo Cartari's *Imagini de gli dei de gli antichi* (Venice, 1556) and Cesare Ripa's *Iconologia* (Rome, 1593). Boccaccio in his *Genealogia deorum* had given a short discussion of the Horae, but he followed closely the old Homeric conception of them as divine benefactresses who open the cloud gates of heaven and attend upon the chariot of Apollo. Though (referring to the mythographer Theodontius) he called them daughters of the Sun and of Chronos, he defined them not as the seasons but as regulators of the light of day.[37] Cartari provides a more detailed account of the Horae in his chapter on the Graces, with whom he equates them.[38] In an earlier passage of his book he discusses Janus with four faces; there he quotes Ovid's lines from the *Metamorphoses* (translated not quite exactly into Italian) and introduces the requisite deities connected with the seasons, including Vulcan or the winds for Winter:

> Mettesi Venere per la Primauera, Cerere per la Estate, per l'Autunno Bacco, e per l'Inuerno talhora Volcano, che stà alla fucina ardente, e talhora i venti con Eolo Rè loro, perche questi fanno le tempeste, che nell'Inuerno sono piu frequenti, che ne gli altri tempi.[39]

In the *Iconologia* Ripa offers his generous selection of recipes (he was also a cook) for depicting the seasons with their various traditional attributes. He gives extensive quotations from Horace and Ovid and refers his reader to Vergil for further descriptions of the "frutti, ed effetti delle quattro stagioni."[40] In one description of the four seasons together he quotes the two tetrastichs cited above from the *Anthologia Latina* including the verse which assigns the seasons to Venus, Ceres, Bacchus, and the winds.[41] Thus Ripa summarizes most of the standard seasonal associations back to antiquity. His description of Flora for Primavera corresponds exactly to Vouet's personification of spring in the Glasgow picture: "Si dipinge anco per la Primauera Flora, coronata di fiori, de' quali hà anco piene le mani. . . ."[42]

Lucretius in his poetic image of spring had placed Flora in the train of Venus. Vouet has fused the two spring goddesses in his paintings by giving Flora the

place of Venus in the standard seasonal tetrad, and by suggesting an amorous relationship between Adonis and Flora. Flora is not shown as the voluptuous nude Venus who tried to hold Adonis back from the hunt, but in her close union with the youth that story is recalled, especially in the Glasgow version.[43]

A rather surprising detail in Vouet's pictures is that Bacchus is shown as an infant; although this maintains the circularity of the compositions, it makes him subordinate to the three other deities. In a similar and still more surprising way Vouet created an infant Mercury, complete with caduceus, winged helmet, and winged feet, in his painting of the *Chariot of the Moon* for the ceiling of the gallery of the Château de Chilly (1631–32).[44] That little god probably symbolized Hesperus, the evening star. It is possible that these infant deities of Vouet were inspired by the putti with Olympian attributes who accompany the main scenes of the Cupid and Psyche story in the loggia of the Villa Farnesina in Rome.[45] However, another source for Vouet's infant Bacchus may have been Francesco Colonna's *Hypnerotomachia*. Vouet would probably have known the French edition of that work, illustrated with woodcuts by Jean Cousin and Jean Goujon after Mantegna; the section describing the Triumph of Vertumnus and Pomona contains a famous description of the seasons as they appear singly with traditional attributes on the four faces of a marble altar. The illustration for Autumn shows a standing putto with the attributes of Bacchus:

> En la tierce face estoit figuré un beau simulachre d'un jeune homme riant, tout nud et ressemblant du visage à un enfant, coronné de feuilles de vigne, tenant de la main gauche un sep chargé de raisins et de l'autre une corne d'abondance pleine de grappes et de feuilles. . . .[46]

Such seasonal amorini are, of course, very similar to figures carved on ancient season sarcophagi. It is not impossible that such an ancient object could have caught Vouet's attention when he was in Italy.[47]

In representations of the seasonal tetrad winter was always the least standardized in its symbolism. As we have seen, ancient artists personified winter with a figure bundled up against the cold, or carrying dead animals in reference to hunting. The figure of a man warming himself by a fire, which occurs often in medieval imagery and continued afterward as a standard symbol of winter, also appears to derive from antique precedent.[48] The association of winter with Vulcan (for fire) or with Aeolus and the winds was based on poetic tradition and appears infrequently in visual representations. The most unusual iconographical feature of Vouet's pictures is his use of Adonis to symbolize winter. Not only does Vouet replace the more typical winter references with the youthful god, but he makes Adonis the iconographical focus of his two paintings. This, too, he has from antiquarian literary sources, and rather abstruse ones at that.

From earliest times the myth of Adonis seems to have been connected with the annual cycle, with the growth and death of vegetation.[49] He probably originated as a corn spirit (perhaps Sumerian) symbolizing the grain which was annually destroyed, ceremonially lamented, and then returned to life. His festivals may have begun as harvest rites celebrated in the spring when grain was harvested in the Levantine regions where he was first worshiped. Throughout the eastern Mediterranean and the Near East in ancient times his death was mourned each year, and images of his corpse were carried out and thrown in the sea or into springs. In the famous Adonis festival of Alexandria images of Adonis and Aphrodite were dis-

played on marriage couches surrounded by cakes, ripe fruits, and various plants.[50] The festivals were also marked by the making of so-called Adonis Gardens. Plants such as wheat, barley, and fennel, and different flowers were tended in pots or baskets by women for eight days, during which time they grew rapidly and then died. The plants were then carried with images of the god and thrown into the sea. Adonis's vegetable nature is likewise attested by the story of the anemone or wind-flower which sprang up as his blood fell upon the earth when he was slain—or, according to the poet Bion, it was his tears that produced the anemone, while his blood became the rose.[51] Adonis's principal centers of worship were in ancient Phoenicia, and his Greek name derives from the Semitic form of address, *Adon*, "Lord," or *Adoni*, "My Lord." Adonis is the same as the Babylonian Tammuz. His myth is parallel in many ways to those of the Egyptian Osiris and the Phrygian Attis. Like them he was closely associated with a mother goddess, the Babylonian Ishtar and the Phoenician Baalat (i.e., "Lady") of Byblos and Astarte of Sidon (the Ashtoret of the Old Testament). In the old Semitic myth Tammuz was believed to die each year and descend into the underworld; and every year his divine mistress went there in search of him. During her absence all the generative functions of nature ceased. A divine messenger was therefore sent to rescue her and, with permission of the goddess of the underworld (Allatu or Eresh-Kigal), she was sprinkled with the Water of Life, which allowed her to return with her lover to the earth. Thus the revival of nature was assured. Each year at midsummer in the month named for Tammuz (Tammuz is still a summer month in the Hebrew calendar) he was mourned in Babylon. Dirges were chanted over his effigy which, after being washed and anointed with oil, was dressed in a red robe, perfumed with incense, and urged to return to life. In Babylonian hymns he is lamented and compared to plants which quickly die.[52]

The Phoenician city of Byblos was of special importance for the cult of Adonis and one of the most ancient centers of his worship.[53] The city stood on a height above the sea and had a great sanctuary of Baalat. The river Nahr Ibrahim, which flows into the sea near Byblos, was called Adonis in ancient times. According to an old tradition reported by Lucian of Samosta (born c.120 A.D.) the river was annually tinged with a red so intense that it changed the color of the sea.[54] This discoloration was believed to be caused by the blood of the slain Adonis. The river has its source at a place called Aphaca (or Aphka) high up on Mount Lebanon above Byblos. In a spectacular natural setting the river emerges from a cavern under towering cliffs and begins its descent in a series of cascades through a gorge where cedars and anemones grow (fig. 7). Here, according to legend, Adonis and Baalat-Aphrodite were together and he was killed and buried. In antiquity there was a temple of the goddess at Aphaca (destroyed by Constantine but later restored) and a sacred grove of Adonis. Such Phoenician temples appear to have been holy precincts open to the sky with altars upon which were conical stones (phallic cult objects) called betyls. The most famous of these was at Byblos. At Aphaca a light in the sky near the temple called worshipers to the rites of Adonis, probably in the spring, since that is when anemones bloom in the region and when the river has been observed to change its color. As we will see, the worship of Adonis at Aphaca has an unexpected significance for Vouet's *Seasons* pictures.

The cult of Adonis was carried to Cyprus by Phoenician settlers and became known in Greece at an early date. Hesiod mentions Adonis, and Sappho wrote a poem in his honor.[55] The earliest preserved account of his myth in Greek is that by the poet Panyassis from the first half of the fifth century B.C.[56] The Greek literary

imagination transformed the Semitic myth into the charming story of the beautiful and tragic young hunter who was the beloved of Aphrodite and was killed by a boar, or by Hephaestus or Ares in the form of a boar. The Greek version preserves the seasonal meaning of the myth. Adonis was born of a tree since his mother Myrrha had been changed into the myrrh tree after her incestuous union with her father King Cinyras. Aphrodite protected the infant, concealing him in a box which she entrusted to Persephone, queen of the underworld. Looking into the box and recognizing her prize, Persephone refused to return the boy to Aphrodite. Zeus settled the dispute between the goddesses by decreeing that Adonis should spend one part of the year in the underworld with Persephone and the other part with Aphrodite on earth. A most beautiful version of the story of Myrrha and Adonis is given by Ovid in the *Metamorphoses*.[57] In the classical world the rites of Adonis, the Adonia, were observed at midsummer in Athens, apparently, and on July 19 under the Roman Empire. Adonis Gardens were set out on the rooftops, and the death of the god was mourned with funeral chants and the sound of the Phoenician flute. Nowhere were these rites associated with winter.

Although from its earliest beginnings the Adonis myth was related to the growth and decline of vegetation, it was only through literary accident that Adonis himself came to personify winter in the tetradic cycle of the seasons as he appears in Vouet's pictures. Indeed this implied some dislocation of the myth's meaning, since Adonis stood for positive generative forces and it was his absence that was

7. The Source of the Adonis River at Aphaca, *from G. Perrot and C. Chipiez,* History of Art in Phoenicia, *fig. 18*

connected with winter. The source of the conceptual alteration was evidently in a passage from the *Saturnalia* of Macrobius which was repeated and finally misinterpreted by scholars of mythology. Ambrosius Theodosius Macrobius, who flourished around 400 A.D. and may have been a Christian, wrote the *Saturnalia*, a compilation of religious, philosophical, and literary knowledge, as an imaginary dialogue for the instruction of his son. The passage in question occurs in a section of the dialogue in which a learned and pedantic senator named Praetextatus delivers a long discourse demonstrating that all the Greek and Roman gods represent attributes of one supreme deity—the sun. Calling upon the authority of Assyrian and Phoenician religious tradition, he identifies Adonis as the sun, and the boar which killed Adonis as winter:

> That Adonis too is the sun will be clear beyond all doubt if we examine the religious practices of the Assyrians, among whom Venus Architis [i.e., *Aphacitis*, Aphacan] and Adonis were worshiped of old with the greatest reverence, as they are by the Phoenicians today.
>
> Physicists have given to the earth's upper hemisphere (part of which we inhabit) the revered name of Venus, and they have called the earth's lower hemisphere Proserpine. Now six of the twelve signs of the zodiac are regarded as the upper signs and six as the lower, and so the Assyrians, or Phoenicians, represent the goddess Venus as going into mourning when the sun, in the course of its yearly progress through the series of the twelve signs, proceeds to enter the sector of the lower hemisphere. For when the sun is among the lower signs, and therefore makes the days shorter, it is as if it had been carried off for a time by death and had been lost and had passed into the power of Proserpine, who, as we have said, is the deity that presides over the lower circle of the earth and the antipodes; so that Venus is believed to be in mourning then, just as Adonis is believed to have been restored to her when the sun, after passing completely through the six signs of the lower series, begins again to traverse the circle of our hemisphere, with brighter light and longer days.
>
> In the story which they tell of Adonis killed by a boar the animal is intended to represent winter, for the boar is an unkempt and rude creature delighting in damp, muddy, and frost-covered places and feeding on acorn, which is especially a winter fruit. And so winter, as it were, inflicts a wound on the sun, for in winter we find the sun's light and heat ebbing, and it is an ebbing of light and heat that befalls all living creatures at death.

Praetextatus then describes a mourning statue of Venus on Mount Lebanon which is explained as a symbol of the earth in winter.

> On Mount Lebanon there is a statue of Venus. Her head is veiled, her expression sad, her cheek beneath her veil is resting on her left hand; and it is believed that as one looks upon the statue it sheds tears. This statue not only represents the mourning goddess of whom we have been speaking but is also a symbol of the earth in winter; for at that time the earth is veiled in clouds, deprived of the companionship of the sun, and benumbed, its springs of water (which are, as it were, its eyes) flowing more freely and the fields meanwhile stripped of their finery—a sorry sight. But when the sun has come up from the lower parts of the earth and has crossed the boundary of the spring equinox, giving length to the day, then Venus is glad and fair to see, the fields are green with growing crops, the meadows with grass and the trees with leaves. That is why our ancestors dedicated the month of April to Venus.[58]

8. Rock Sculptures at Guineh,
*(from W. W. Baudissin,* Adonis
und Esmun, *Pl. 1)*

Macrobius, or the written source upon which he drew, must have had in mind here
the kind of giant rocks with reliefs carved into their faces found along the River
Adonis at Maschnaka and Guineh, or possibly a statue in the round related to
these. The parallel of Macrobius's description with the archeological remains was
noticed long ago by Ernest Renan.[59] For our consideration the most interesting of
these reliefs is one located near Guineh (fig. 8): in a large sculptural field stands
a heroic male dressed in a short tunic, undoubtedly Tammuz or Adonis, who
raises a spear against the attack of a wild animal. As Renan asserted, this animal,
because of its size and form, seems more like a bear than a boar. In a smaller field
to the right of this scene the shrouded figure of Venus is shown seated in a mourning
pose. On another face of the stone is a standing male figure leaning on a spear and
accompanied by two dogs. It is probable that these sculptured monuments served
the worship of Adonis in the valley that Renan called the "holy land" of his cult.
The reliefs are badly eroded and difficult to date exactly, but they are generally
believed to be from Roman times.

Macrobius was well known in the Middle Ages, and Boccaccio's *Genealogia*,
written in the third quarter of the fourteenth century, repeats the explanation of
the Venus and Adonis story in the *Saturnalia*, giving stronger emphasis to the
contrast between the fruitful seasons when the earth produces "fiori, fronde, e
frutti" and autumn and winter "nel qual tempo il Cinghiale . . . si diletta."[60] In
his *Imagini* Cartari also gives the information from Macrobius, and his text, more-
over, is accompanied by an illustration showing the veiled and shrouded Venus
of Mount Lebanon mourning beside the fallen Adonis, ". . . intesa per la stagione
hiemale e fredda" (fig. 9).[61] A further step in the transformation of the Adonis
symbolism occurred in Pierio Valeriano's *Hieroglyphica*, published in 1556, the

same year as Cartari's *Imagini*, although Valeriano was some forty years older than Cartari. In the *Hieroglyphica* Adonis is simply catalogued as the image of winter: *Hyemis figura*. And although Valeriano takes over almost verbatim Macrobius's description of the mourning figure on Mount Lebanon, he presents it not as Venus but as Adonis, thus making Adonis himself a personification of mournful winter:

> Qua demum effigie ostentaretur Adonis iste in hyemalis temporis hieroglyphicum, recitare non pigeat. Simulachrum enim eius in Libano monte olim tali habitu visebatur, obnupto scilicet capite, specie tristi, faciem manu laeva, dextra amictum sustinente, in quem lacrymae confluere videbantur: quae omnia speciem hyemis describunt.[62]

Finally, this mistaken interpretation was repeated in Ripa's *Iconologia* (credited to Valeriano) under the heading *Inverno*, separate from Ripa's extensive descriptions of the four seasons together:

> Si dipingerà per l'Inuerno Adone bellissimo giouane in habito di cacciatore, la statua del quale già era nel monte Libano col capo coperto, con apparenza mesta, tenendo la sinistra mano alla faccia, e con la destra sostenendo il vestimento, pareua, che in esso cadessero le lagrime, le quali cose tutte descriuono la figura del Verno . . .[63]

Most probably it was this passage in Ripa that prompted Vouet to use Adonis as the deity symbolizing winter in his pictures.

I have been unable to connect the two *Seasons* pictures with any of Vouet's re-

*9. Illustration from V. Cartari's* Imagini de gli dei, *Venice, 1625*

corded decorative cycles. His oeuvre includes a number of other subjects from the Adonis legend. A. J. Dézallier d'Argenville describes a whole room (no longer extant) at the house of Président Perrault in Paris, decorated by Vouet with Venus and Adonis stories.[64] The six subjects in the series are specified quite exactly, however, and nothing suggests that either of the *Seasons* pictures belonged there—unless, of course, the room included a ceiling composition which d'Argenville failed to include in his account. The Adonis legend would have been especially popular in Vouet's day, following the publication in Paris in 1623 of Giovanni Battista Marino's great epic poem *L'Adone*, a signal literary event of the decade.

Seen in comparison with other representations of the seasons, Vouet's interpretations are, I think, surprisingly fresh and inventive.[65] More often than not the theme had been depicted by allegorical figures brought together mainly for symbolic convenience. For example, in the second quarter of the sixteenth century a series of three round panels, attributed to Matteo Balducci, represent spring, summer, and autumn as graceful, miniature-like figures set in landscapes and holding appropriate attributes: flowers and twigs, ears of grain, and the vine (the panel for winter appears to be lost). It has been suggested very convincingly that such seasonal figures derive from allegories of the months in medieval calendar illuminations.[66] In Mannerist fresco cycles the seasons were also shown as disjunctive allegorical figures. This is seen in Cristofano Gherardi's ceiling decorations in the Sala della Dea Opi at the Palazzo Vecchio in Florence, of 1555, and in Jacopo Zucchi's vault of the Sala delle Stagioni at Palazzo Firenze in Rome, done just after 1572.[67] In these decorations the Four Seasons, painted in separate compartments, are shown as standard allegories, with Winter symbolized as old men heavily draped and warming themselves at braziers. Similarly in a French ceiling project by Toussaint Dubreuil, which contains the monogram of Henri IV and probably dates from the late 1590s, the seasons are personified as groups of figures occupying four compartments within the larger divisions of the scheme.[68] An exception to these more routine representations of the seasons is seen in Veronese's wonderful frescoes on the vault of the Stanza dell'Olimpo at Maser, executed around 1560–61 (figs. 10–11).[69] Here Vulcan (with Venus) and Flora personify winter and spring in one lunette, while Ceres and Bacchus represent summer and autumn in the opposite one. Although Veronese's grand and voluptuous compositions are certainly among the most genial of all Seasons paintings, even they are somewhat artificial in their iconography.

Vouet may well have known at first hand Veronese's work at Maser, and he could have seen the decorations by Gherardi and Zucchi in Florence and Rome. However, the first of his *Seasons* pictures, that in Glasgow, is closer in conception and style to paintings which stand in the tradition of Caravaggesque realism. One can compare the Glasgow painting, for example, with a composition given to Bartolommeo Manfredi and known in several versions, including one, presumably the original, which formerly belonged to Feodor Chaliapin, and another in the Dayton Art Institute (fig. 12);[70] Manfredi's work was painted between 1610 and 1620, while Vouet was in Italy, and though Manfredi's interpretation of the Four Seasons has none of the lyric grace which later characterizes Vouet's picture, it does concentrate the figures into a compressed space, and uses strong contrasts of light and shadow to dramatize the scene. Also comparable to Vouet is the amorous reference which Manfredi injects into his painting by showing Bacchus kissing the young flower-crowned Flora (or Venus?) who is playing the lute. At the same time Ceres, who stares vacantly out of the painting, and Winter shivering

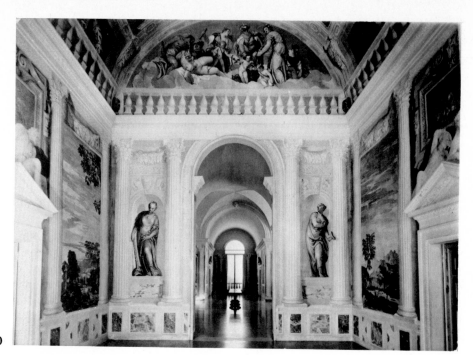

10

11

*10. Paolo Veronese.* Stanza dell'Olimpo, *Maser*

*11. Paolo Veronese.* Stanza dell'Olimpo, *Maser*

in his cloak and fur cap both seem isolated and almost extraneous to the action of the piece.

In contrast to Manfredi's and the other interpretations we have cited, Vouet brings to both of his *Seasons* pictures a quite exceptional narrative unity. Instead of personifying Winter by Vulcan or by an incongruous old man bundled up against the cold, he centers his compositions on Adonis, a god always associated with the generative powers of nature and thus an appropriate companion for the deities who represent the fruitful seasons. In the Glasgow picture he emphasizes the tragic aspect of the Adonis story by suggesting the approaching death of the youth as he draws near the fatal encounter with the boar. In the Dublin version the narrative focus is shifted to the triumph of Adonis, as Flora-Venus coaxes him awake from his hibernal slumber and crowns him with flowers. Both interpretations indicate that Vouet was keenly sensitive to the mythological and literary subtleties of the old Adonis tale. In neither picture does Adonis symbolize the negative aspects of the winter season; these, in fact, are omitted from Vouet's scenes. What Vouet gives instead are allegorical images of the life forces of sun and earth and vegetation, whose winter decline is merely a prelude to rebirth. This iconographical intention is reiterated in the Vergilesque distich which was added to Dorigny's engraving of the Dublin composition:

> Quod Natura negat, potuit praestare tabella:
> Frugibus et sertis jungere frigus iners.[71]

*Emory University*

12. *Bartolomeo Manfredi.* Allegory of the Four Seasons. *The Dayton Art Institute, Gift of Mr. and Mrs. Elton F. MacDonald*

**Notes**

[1] For their generous assistance to me in the preparation of this article I would like to thank Ms. Anne Donald and Mr. Roger Billcliffe of the Glasgow Museums and Art Galleries and Mr. James White, Director of the National Gallery of Ireland. I am also grateful to Professor and Mrs. Gregor Sebba and Professor Joseph M. Conant for their help in translating classical quotations.

[2] Both paintings are on canvas. The version in Glasgow (No. 218 in the gallery) measures 140.3 × 129.5 cm; that in Dublin, 113 cm in diameter. The first was acquired by the Glasgow Art Galleries in 1854 with the Archibald McLellan Collection and carried an attribution to Carle van Loo; cf. Louis Réau, "Carle van Loo," *Archives de l'Art Français,* XIX (1938), 60, No. 69. The attribution to Vouet was discussed and questioned by Anne Donald, "Some Re-Attributions in the French Collection at Kelvingrove," *Scottish Art Review,* XII, 4 (1970), 11–14, 34. The painting was recently cleaned. The picture in Dublin was acquired by the National Gallery of Ireland in 1970 from Neville Orgel in London. It had hung earlier in the residence of Mr. W. P. Odlum at Huntington, Portarlington. It has also been cleaned and provided with a new frame; see James White, *National Gallery of Ireland, Catalogue of Paintings,* 1971, No. 1982; and "La Chronique des Arts," *Gazette des Beaux-Arts,* s. 6, LXXVII (1971), sup., 133.

[3] Ms. Donald ("French Collection at Kelvingrove," 14 f.) notes that the canvas "has only been made circular by trimming and additions." She adds, however, that the paint on the additions is homogeneous with that on the rest of of the picture. It seems very possible, as she suggests, that Vouet himself tailored the painting to fit a circular location.

[4] Alexandre Pierre François Robert-Dumesnil, *Le peintre-graveur français,* Paris, 1839, IV, 290, No. 102; and William R. Crelly, *The Painting of Simon Vouet,* New Haven and London, 1962, 254, No. 233. The composition was listed in my catalogue of lost paintings as an Allegory of Fecundity because of the inscription on Dorigny's engraving. See below, n. 71.

[5] The Glasgow picture is still exhibited with the designation "Follower of Simon Vouet." Cf. Donald, "French Collection at Kelvingrove," 34. It was accepted by Dr. Pierre Rosenberg as an autograph work. Vouet's authorship is confirmed, I believe, by the facial types, the drawing of the contours of the forms, the chiaroscuro, and his characteristic way of laying highlights rather loosely and dryly upon broad, solid planes of darker color.

[6] Crelly, *Simon Vouet,* 177, No. 62, fig. 39; and 152, No. 12, fig. 135.

[7] Crelly, *Simon Vouet,* 176, No. 60, fig. 26; and 149, No. 6, fig. 27.

[8] Crelly, *Simon Vouet,* 167, No. 43, fig. 24; and 212, No. 132, fig. 21.

[9] Crelly, *Simon Vouet,* fig. 41.

[10] Crelly, *Simon Vouet,* 201, No. 111, A, fig. 101.

[11] Crelly, *Simon Vouet,* 83 f.

[12] Crelly, *Simon Vouet,* 254–55, Nos. 237, 238, figs. 91, 92.

[13] G. Brière and M. Lamy, "Inventaire du logis de Simon Vouet dans la Grande Galerie du Louvre (1639 et 1640)," *Fédération des Sociétés Historiques et Archéologiques de Paris et de l'Île de France: Mémoires,* III, 1953, 132.

[14] On Poussin's *Four Seasons* see Anthony Blunt, *Nicolas Poussin,* New York, 1967, 332 f. Cf. Elizabeth Cropper, "Virtue's Wintry Reward: Pietro Testa's Etchings of the Seasons," *Journal of the Warburg and Courtauld Institutes,* XXXVII (1974), 249–79.

[15] George M. A. Hanfmann, *The Season Sarcophagus in Dumbarton Oaks,* Cambridge, Mass., 1951. See also Wilhelm Heinrich Roscher, *Ausführliches Lexikon des Griechischen und Römischen Mythologie,* Leipzig, 1886–1890, I, s.v. "Horai"; Charles Daremberg and Edmond Saglio, *Dictionnaire des antiquités grecques et romaines,* Paris, 1877–1919, III, 1, s.v. "Horae"; August Friedrich von Pauly and Georg Wissowa, *Real-Encyclopädie der classischen Altertumswissenschaft,* Stuttgart, 1913, VIII, s.v. "Horai"; and Raimond van Marle, *Iconographie de l'art profane au Moyen Age*

*et à la Renaissance*, The Hague, 1931–1932, II, 314 f.

[16] Hanfmann, *Season Sarcophagus*, I, 110–11, 192; II, 59, n. 40.

[17] Hanfmann, *Season Sarcophagus*, I, 88.

[18] Hanfmann, *Season Sarcophagus*, I, 89 f.

[19] *Iliad*, V, 749 f.; VIII, 393 f.

[20] Hanfmann, *Season Sarcophagus*, I, 80; II, 45, n. 23.

[21] Hanfmann, *Season Sarcophagus*, II, 49, n. 93.

[22] Hanfmann, *Season Sarcophagus*, I, 114 f., 264 f., 269 f.; van Marle, *Iconographie*, II, 311 f.

[23] Hanfmann, *Season Sarcophagus*, I, 222. See also Doro Levi, "The Allegories of the Months in Classical Art," *Art Bulletin*, XXIII, 4 (1941), 251–91.

[24] Hanfmann, *Season Sarcophagus*, I, 128 f., 254 f. A possible exception is the ceiling design published in the eighteenth century as being from Hadrian's Villa: M. Ponce, *Arabesques antiques des bains de Livie et de la ville Adrienne*, Paris, 1789, Pl. 10; cf. Hanfmann, II, 136, No. 16.

[25] Hanfmann, *Season Sarcophagus*, I, 119.

[26] Hanfmann, *Season Sarcophagus*, I, 120 f.

[27] Vitruvius, *De architectura*, VI, 4, ed. Frank Granger, Loeb Classical Library, London and New York, 1931–34.

[28] Hanfmann, *Season Sarcophagus*, I, 107, 122 f.

[29]     it Ver et Venus et Veneris praenuntius ante/pennatus graditur, Zephyri vestigia propter/Flora quibus mater praespargens ante viai/cuncta coloribus egregiis et odoribus opplet./inde loci sequitur Calor aridus et comes una/ pulverulenta Ceres et etesia flabra Aquilonum./inde Autumnus adit, graditur simul Euhius Euan./inde aliae tempestates ventique secuntur,/ altitonans Volturnus et Auster fulmine pollens,/tandem Bruma nives adfert pigrumque rigorem./ reddit Hiemps, sequitur crepitans hanc dentibus Algor.

Lucretius, *De rerum natura*, V, 737–47, ed. William Henry Denham Rouse, Loeb Classical Library, London and New York, 1931. Cf. Hanfmann, *Season Sarcophagus*, I, 254.

[30] Hanfmann, *Season Sarcophagus*, II, 63, n. 98.

[31]     . . . Vos, o clarissima mundi/ lumina, labentem caelo quae ducitis annum,/Liber et alma Ceres, uestro si munere tellus/Chaoniam pingui glandem mutauit arista/poculaque inuentis Acheloia miscuit uuis . . .

    Huc, pater o Lenaee (tuis hic omnia plena/muneribus; tibi pampineo grauidus autumno/floret ager, spumat plenis uindemia labris) . . .

Vergil, *Georgics*, I, 5–9, II, 4–6, ed. Eugène de Saint-Denis, Paris, 1956. Trans. from Theodore C. Williams, *The Georgics and Eclogues of Virgil*, Cambridge, Mass., 1915, 23, 34, 46.

[32] *Fasti*, I, 125, V, 217, ed. James George Frazer, Loeb Classical Library, London and New York, 1931.

[33]     a dextra laevaque Dies et Mensis et Annus/Saeculaque et positae spatiis aequalibus Horae/Verque novum stabat cinctum florente corona,/ stabat nuda Aestas et spicea serta gerebat,/stabat et Autumnus calcatis sordidus uvis/et glacialis Hiems canos hirsuta capillos.

Ovid, *Metamorphoses*, II, 25–30, ed. Frank Justus Miller, Loeb Classical Library, Cambridge, Mass., and London, 1951. Cf. Ovid's reference to the seasons in the *Remedia Amoris*, 187, ed. John Henry Mozley, *The Art of Love, and Other Poems*, Loeb Classical Library, Cambridge, Mass., and London, 1969.

[34]     Carpit blanda suis ver almum dona rosetis./Torrida collectis exultat frugibus aestas./Indicat autumnum redimito palmite vertex./Frigore pallet hiems designans alite tempus.

Ed. Alexander Riese, *Anthologia Latina*, Amsterdam, 1964, I, 132, No. 116.

[35]     Vere Venus gaudet florentibus aurea sertis./Flava Ceres aestatis habet sua tempore regna./Uvifero autumno summa est tibi, Bacche, potestas;/ Imperium saevis hiberno frigore ventis.

Riese, *Anthologia Latina*, II, 77, No. 570.

36 —ἀσταθέος δὲ/θυγατέρες Λυκάβαντος,
ἀελλοπόδοιο τοκῆος,/εἰς δόμον Ἠελίοιο
ῥοδώπιδες ἤιον Ὧραι·/ὧν ἡ μὲν
νιφόεντι κατάσκιον ἀμφὶ προσώπῳ/
λεπταλέον πέμπουσα κελαινεφέος σέλας
αἴγλης/ψυχρὰ χαλαζήεντι συνήρμοσε
ταρσὰ πεδίλῳ,/καὶ διερῷ πλοκαμῖδας
ἐπισφίγξασα καρήνῳ/ὀμβροτόκον
κρήδεμνον ἐπεσφήκωσε μετώπῳ,/καὶ
χλοερὸν στέφος εἶχε καρήατι, χιονέῃ
δὲ/στήθεα παχνήεντα κατέσκεπε
λευκάδι μίτρῃ/ἡ δὲ χελιδονίων
ἀνέμων τερψίμβροτον αὔρην/ἔπτυε
φυσιόωσα, φιλοζεφύρου δὲ καρήνου/
εἰαρινὴν δροσόεντι κόμην μιτρώσατο
δεσμῷ,/ἀνθεμόεν γελόωσα, διαιθύσσουσα
δὲ πέπλου/ὄρθριον σιγομένοιο ῥόδου
δολιχόσκιον ὀδμὴν/διπλόον ἔπλεκε
κῶμον Ἀδώνιδι καὶ Κυθερείῃ·/ἄλλη
ἅμα γνωτῇσι θαλυσιὰς ἔστιχεν Ὥρη,/
καὶ στάχυν ἀκροκόμοισι περιφρίσσοντα
κορύμβοις/δεξιτερῇ κούφιζε καὶ
ὀξυτόμου γένυν ἅρπης/ἄγγελον ἀμητοῖο,
δέμας δ' ἐσφίγγετο κούρῃ/ἀργενναῖς
ὀθόνῃσιν, ἑλισσομένης δὲ χορείῃ/
φαίνετο λεπταλέοιο δι' εἵματος ὄργια
μηρῶν,/καὶ νοτερούς ἱδρῶτας
ἀνιεμένοιο προσώπου/θερμοτέρῳ
Φαέθοντι καθικμαίνοντο παρειαί·/ἄλλη
δ' εὐαρότοιο προηγήτειρα χορείης/
θαλλὸν ἐλαιήεντα λιπότριχιδήσατο
κόρσῃ/ἑπταπόρου ποταμοῖο διάβροχον
ὕδασι Νείλου,/καὶ φεδνὴν μεθέπουσα
μαραινομένην τρίχα κόρσης/καρφαλέον
δέμας εἶχεν, ἐπεὶ φθινοπωρὶς ἐοῦσα/
φυλλοχόοις ἀνέμοις ἀπεκείρατο
δενδράδα χαίτην·/οὔ πω γὰρ χρυσέων
ἑλίκων πλεκτοῖσι κορύμβοις/βότρυες
ἀμπελόεντες ἐπέρρεον αὐχένι νύμφης,/
οὐδέ μιν οἰνωθεῖσα φιλακρήτῳ παρα
ληνῷ/πορφυρέης ἐμέθυσσε Μαρωνίδος
ἰκμὰς ἐέρσης,/οὐδὲ παλινδίνητος
ἀνέδραμε κισσὸς ἀλήτης·

Nonnos, *Dionysiaca*, XI, 485–519, ed.
William Henry Denham Rouse, Herbert
Jennings Rose, and Levi Robert Lind,
Loeb Classical Library, London and
Cambridge, Mass., 1940.
37 I have used an Italian translation of
Boccaccio's book: *Della genealogia de gli
dei*, Venice, 1585, 59v. Cf. Jean Seznec,
*The Survival of the Pagan Gods*, trans.
B. Sessions, New York, 1961, 220 f.

38 Cartari, *Imagini*, ed. quoted here,
Venice, 1625, 406 f.
39 Cartari, *Imagini*, 32.
40 Ripa, *Iconologia*, ed. quoted here,
Padua, 1625, 637–43.
41 Ripa, *Iconologia*, 638. Ripa credits the
first of these tetrastichs (No. 116) to the
*Catalectorum* of Joseph Scaliger.
42 Ripa, *Iconologia*, 638.
43 Cf. Vouet's *Venus and Adonis*, known
from an engraving and a variant copy in
the Hermitage (Crelly, *Simon Vouet*, 170,
No. 50, fig. 185; 253, No. 230).
44 Crelly, *Simon Vouet*, 94, fig. 118; cf.
fig. 117, *The Chariot of the Sun*, where
three Seasons, including Ceres and prob-
ably Venus, dance around the car of
Apollo.
45 Oskar Fischel, *Raphael*, London, 1948,
I, 167; II, Pls. 208–11, especially Pl. 210
in which a putto carries the attributes of
Bacchus.
46 The *Hypnerotomachia* was first pub-
lished in Venice in 1499. The edition
quoted here is the reprint (Paris, 1926) of
the Kerver edition published in Paris in
1546, 121–23. Cf. Aby Warburg, "Die
Geburt Venus," in *Gesammelte Schrif-
ten*, I, Leipzig, 1932, 18; and Hanfmann,
*Season Sarcophagus*, II, 123–24, n. 109.
47 Hanfmann, *Season Sarcophagus*, I, 3f.
The *Season Sarcophagus* now at Dum-
barton Oaks was formerly in the Palazzo
Barberini in Rome; it was studied in the
seventeenth century by Giovanni Pietro
Bellori, who recognized its Seasons ico-
nography; see P. Bartoli and P. Bellori,
*Admiranda Romanorum Antiquitatum*,
Rome, 1693. Vouet could well have seen
the sculpture when he was in Rome.
48 Hanfmann, *Season Sarcophagus*, I, 269
f., 272; II, 118, n. 67.
49 On the Adonis legend see Roscher,
*Lexikon*, I, 1, s.v. "Adonis"; Daremberg
and Saglio, *Dictionnaire*, I, 1881, s.v.
"Adonis"; August Baumeister, *Denk-
mäler des Klassischen Altertums*, Munich
and Leipzig, I, 1885, s.v. "Adonis";
Pauly and Wissowa, *Real-Encyclopädie*,
I, 1894, s.v. "Adonis" and "Adonia";
James George Frazer, *Adonis, Attis,
Osiris* (*The Golden Bough*, Part IV), 2nd
ed., London, 1907; Wolf Wilhelm Bau-
dissin, *Adonis und Esmun*, Leipzig, 1911;

Georges Perrot and Charles Chipiez, *History of Art in Phoenicia*, London, 1885, especially I, 56–83; and Sabatino Moscati, *The World of the Phoenicians*, London, 1968, 30–41.

[50] Theocritus, XV: *The Women at the Adonis Festival*, ed. John Maxwell Edmonds, *The Greek Bucolic Poets*, Loeb Classical Library, London and New York, 1912, 175 f. Theocritus (c. 310–250 B.C.) describes the festival of Adonis in the palace of Ptolemy II Philadelphus, and gives the text of the important hymn sung on the occasion which describes the Horae as bringing Adonis back to Aphrodite from the underworld. Cf. Hanfmann, *Season Sarcophagus*, I, 105.

[51] Bion, I: *The Lament for Adonis*, 64–67, ed. Edmonds, *The Greek Bucolic Poets*, 385 f.

[52] Frazer, *Adonis, Attis, Osiris*, 7; Baudissin, *Adonis und Esmun*, 100. The Phrygian Attis was also a god of vegetation whose death was mourned each spring. He was a shepherd beloved of Cybele and was killed by a boar or died by emasculating himself; at his death he was changed into a pine tree. See Frazer, 219 f., and Hanfmann, *Season Sarcophagus*, I, 228 f., 240–242.

[53] Strabo, *Geography*, XVI, 2:18, ed. Horace Leonard Jones, Loeb Classical Library, London and New York, 1917–1932. On the cult of Adonis in the region of Byblos, see Ernest Renan, *Mission de Phénicie*, Paris, 1864, I, 153 f., and Baudissin, *Adonis und Esmun*, 71 f.

[54] Lucian, *The Goddess of Syria*, 8, ed. Austin Morris Harmon, Loeb Classical Library, London and New York, 1925, IV, 347.

[55] Hugh G. Evelyn-White, *Hesiod, The Homeric Hymns and Homerica*, Loeb Classical Library, Cambridge and London, 1974, 171. Willis Barnstone, *Sappho*, New York, 1965, 34, No. 35.

[56] Victor J. Matthews, *Panyassis of Halikarnassos*, Leiden, 1974, 121–25.

[57] *Metamorphoses*, X, 298 f.

[58] *Saturnalia*, I, 21, 1–6, eds. Henri Bornecque and François Richard, Paris, n.d.; English trans. from Percival Vaughan Davies, *Macrobius, The Saturnalia*, New York and London, 1969, 141 f. In this astrological explanation of the myth, Adonis and Venus would represent the generative interaction of sun and earth. Frazer (*Adonis, Attis, Osiris*, 197) denied that in the lands where Adonis was worshiped he could have symbolized the sun, since his daily reappearance would contradict his death. Cf. Perrot and Chipiez (*History of Art in Phoenicia*, I, 68), who accepted the interpretation for Phoenician religion. Cf. Charles Dempsey, "The Classical Perception of Nature in Poussin's Earlier Works," *Journal of the Warburg and Courtauld Institutes*, XXIX (1966), 228 f.; Cropper, "Pietro Testa's Seasons," 251 f.; and Hanfmann, *Season Sarcophagus*, I, 122, on the primal importance of the sun for Stoic doctrine.

[59] *Mission de Phénicie*, I, 292 f; and Baudissin, *Adonis und Esmun*, 78 f., Pls. I–III.

[60] *Genealogia*, 37v.

[61] *Imagini*, 402 f. The illustration also shows the bearded Venus supposed to have been venerated on Cyprus as a symbol of the bisexual nature of the goddess who presided over universal generation. And the bearded goddess holds a comb in reference to a tradition according to which Venus cured the baldness of the women of ancient Rome.

[62] Giovanni Pierio Valeriano, *Hieroglyphica*, ed. Lyon, 1602, reprinted New York and London, 1976, 88.

[63] *Iconologia*, 332.

[64] Crelly, *Simon Vouet*, 170, No. 50; 261, No. 253; 267, No. 270.

[65] Cf. Anton Pigler, *Barockthemen*, Budapest, 1956, II, 492–99.

[66] Tancred Borenius, "Unpublished Cassone Panels—IV," *Burlington Magazine*, XLI (1922), 18–21.

[67] Adolfo Venturi, *Storia dell'arte Italiana*, Milan, 1932, IX, v, 624, figs. 377–80. Hermann Voss, *Die Malerei der Spätrenaissance in Rom und Florenz*, Berlin, 1920, 318; Renzo U. Montini, *Palazzo Firenze*, Rome, 1958, 29, fig. 22.

[68] *L'Ecole de Fontainebleau* (exhibition catalogue), Paris, 1972, 99, No. 104. The drawing is in the Louvre, Cabinet des Dessins.

[69] Giuseppe Fiocco, *Paolo Veronese*, Bologna, 1928, 70, Pl. 42; Rodolfo Pal-

lucchini, *Veronese*, Bergamo, Milan, and Rome, 1943, 22 f., Pls. 50–53; Paola Ojetti, Fausto Franco, Rodolfo Pallucchini, and Alba Medea, *Palladio, Veronese e Vittoria a Maser*, Milan, 1962, 51 f.

70 Alfred Moir, *The Italian Followers of Caravaggio*, Cambridge, Mass., 1967, I, 42; II, 84, No. 8. Cf. the Seasons allegories connected with Manfredi in London and Rome: Benedict Nicholson, "Bartolomeo Manfredi," *Studies in Renaissance and Baroque Art Presented to Anthony Blunt*, London, 1967, 108 f., figs. 3–5; and Richard E. Spear, *Caravaggio and His Followers*, (exhibition catalogue), Cleveland Museum of Art, 1971, 192, No. 77.

71 What nature denies, a picture has been able to show:

The union of sluggish cold with fruits and wreaths of flowers.

# 27
## Liévin Cruyl:
## The Works for Versailles

GUY WALTON

Although there were great personalities such as Jules Hardouin-Mansart or Charles Le Brun who played fundamental roles in the creation of Louis XIV's Versailles, it has been evident for some time that the actual design of the palace and its dependencies was more often than not in the hands of secondary figures or, at the least, the result of a complicated process of interaction. It is generally said that the real creative design of Versailles was by men who worked behind the scenes for the big names. This tradition is an old one. An important step toward its formulation came from Louis's younger contemporary, the Duke de Saint-Simon, who, in anger, asserted that Hardouin-Mansart was primarily an adventurer and courtier and left his architectural designing to Lassurance, who was given no public credit for this work.

In a fundamental study of Versailles, one somewhat hidden in an essay written to explain the origins of the French Rococo style of interior decoration, Fiske Kimball made the first attempt to clarify this complex creative process.[1] His discussion of the workshop of Mansart goes a long way toward explaining how things were done in the important area of interior design from the late 1670s onward. Kimball's study suggests that Saint-Simon's version of things was simplistic. He demonstrated that the operation of the creative process at Versailles was unique in its period (it strikes us as surprisingly modern in its committee approach to creativity), and he also made it clear that what was done was the result of the operation of a collective intelligence which was able to work to produce excellent results through administrators and leaders of real genius.[2]

However, Kimball's most important contribution may not have been his defense of the genius of such figures as Mansart, but rather the complimentary presentation he made of beautiful works by secondary figures; the book introduces many of those who actually made the designs. Through Kimball we meet a whole group of little-known personalities who produced, in certain instances, first-quality work. Since Kimball's book it has been obvious that the study of such secondary figures is absolutely necessary if the full story of Versailles is to be told. Liévin Cruyl has not up to the present been associated with the building of Versailles, but a document and two unpublished drawings indicate that for the period of a few years he had a position of some importance in the artistic establishment of Versailles. The possibility must also be entertained that he should be counted among that group of designers to which Kimball has begun to do justice.

1

2

Fortunately, in the case of Cruyl, it is not a matter of upgrading some ungratefully treated hard worker, kept secret in the background in order to enhance the glory of Hardouin-Mansart. Cruyl was an interesting man with an international reputation who, if he did not receive wide public recognition as far as we know, was at least very well paid for his work in France.

At present only scattered details of his life, education, travels, and works are known.[3] Inscriptions in his hand indicate that he was born in Ghent, and later became a priest.[4] A drawing of 1662 indicates that he was vicar at Wettern (to the east of Ghent in Flanders).[5] This drawing was apparently a project for the completion of the towers of the church of St. Michael in Ghent. It indicates a proficiency in architecture by that date. If the hypothetical date of Cruyl's birth around 1640 is correct, the drawing for St. Michael's would indicate the early achievement of competence in architecture, but, in fact, Cruyl's birthdate seems to be a matter of pure conjecture. Unfortunately nothing is known of his family or schooling, nor of whether he was a lay priest or the member of some order which might have played a role in his artistic education.

There can, however, be no doubt whatever that Cruyl spent the greater part of the years 1664–67 in Rome. A group of drawings now divided between the Cleveland Museum and the Rijksmuseum in Amsterdam are inscribed as being made in Rome between August 1664 and April 1665.[6] Seven of these were engraved and published with the title *Prospectus locorum urbis Romae insignium* in Rome in 1666 along with three other views by Cruyl for which the drawings are now lost. The title page of the collection of 1666 states that the views in question are by Mattheo de' Rubeis, though all seem to be after Cruyl's drawings.[7] A second folio is also mentioned by Bergmans which contained, among other views, one of the Pantheon dated 1667.[8] This suggests a high level of activity at this period. It also seems possible, though not certain, that during this same period Cruyl did the fifteen draw-

*1. Cruyl.* Bird's-eye View of Versailles from the East. *Pen on velum, signed. Musée, Château de Versailles*

*2. Cruyl.* Bird's-eye View of Versailles from the West. *Pen on velum, signed, dated 1684. Musée, Château de Versailles*

*3. Cruyl.* Piazza Barberini. *Pen on paper, signed, inscribed: Romae mense Febr. 1665. Cleveland Museum of Art*

3

*4. Cruyl.* View of Ghent. *Dated 1678. Width 207 cm; pen on paper, signed and inscribed. Administration Générale du Mobilier National et des Manufactures Nationales des Gobelins et de Beauvais, Paris*

ings acquired by the burgomaster of Leiden, Conrad Ruysh, which are well known from their inclusion in the *Thesaurus antiquarium romanorum* of 1697.[9] Thus it can hardly be doubted that by about 1667 Cruyl was well established in Rome and on the way to achieving an international reputation as both a draftsman and a purveyor of views of Rome.

The Roman views of Cruyl are often impressive artistically, particularly for their command of perspective. Some of them possess as well a certain charm by including picturesque scenes of Roman life (fig. 3). If he does not quite reach the standard of his older French contemporary, Israel Silvestre, the quality of Cruyl's art is clearly on a level with, if not superior to, that of Perelle and Le Pautre. It is therefore not surprising that Cruyl should have come to France in the late 1670s or early 1680s as he must have done, since the need was clear for draftsmen both to record the many achievements of the period and to project the three-dimensional appearance of the great architectural projects of the time. A good draftsman of this sort was a much-sought-after commodity in Europe in the seventeenth century, as the Cronström–Tessin correspondence indicates.[10]

Cruyl's competence as an architect seems to have been remembered in Ghent, since in 1668, while he was in Rome, he received the important commission for the design of a new high altar for the great church of St. Bavo in Ghent. A presentation drawing for this altar project survives in the Ghent City Archive, and it is signed and dated 1668 (fig. 5).[11] Cruyl's own remarks make it clear that he was in Rome at the time of the project. Under these circumstances the design is a curious one. Its style belongs more to that of the sixteenth century than to contemporary Rome. Not a trace of Bernini or even of a more classicizing artist such as Domenico Guidi is to be found. Cruyl's altar most resembles the somewhat austere style of the time of Sixtus V in the 1580s.

The next surviving document which gives important information on Cruyl's career is the great view of Ghent (fig. 4) which is signed and dated: "Delineatus a Livino Cruyl Ph'o Gandarensi 1678."[12] The place where it was made is now in

doubt, since the deciphering of a key passage of an inscription is difficult. The passage may be read either that the drawing was made in Italy while he was there for ten years or simply that the drawing was not made *in situ* since he had been in Italy for ten years (thus explaining his absence from Ghent but not excluding his execution of the drawing somewhere other than in Italy, though during the years of his Italian sojourn). The possiblility that the Ghent view was made in France cannot be excluded, since that hypothesis would explain the otherwise curious reference to the conquest of Ghent by "Magni Ludovici Galliae et Navarra Regis Christianissimi" by a native of the subdued city, and the presence of the drawing in France in the collections of the Gobelins.

The inscription makes several important points. First, Cruyl says that he spent ten years in Italy before 1678, which adds significantly to what we know of his Italian sojourn between 1665 and 1667. Second, the remarks leave little doubt that whether made in Italy or in France, the design was inscribed and sent to the French king to demonstrate the artist's abilities as a draftsman of views. Cruyl is at pains to explain that the drawing may be inaccurate in some details due to his lengthy absence from the place and his inability to make firsthand observations. Yet the drawing itself is minutely detailed and the inscription shows Cruyl's knowledge of certain of the monuments of the city. The inscription, which mentions the style and quality of the design of several buildings, excludes the possibility that the design was made for a military purpose. Rather it calls the viewer's attention to features of artistic and commercial importance in a city recently conquered by the French king.[13] Whether or not this was a commissioned work it was certainly intended to flatter the king and to demonstrate the talents of the artist in recording the appearance of important monuments of architecture. The view was entitled "prospectus Geometricus Urbis Gandavi Ruditer," which underscored the mathematical competence of the artist.

If Cruyl did not arrive in France in 1678, he was certainly there in 1681.[14] It is equally clear that he was back in Ghent in April of 1684.[15] During this last

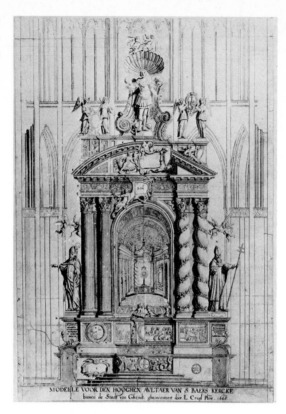

*5. Cruyl.* Project for the High Altar of St. Bavo's Church, Ghent. *Dated 1668. Pen and wash on paper. City Archives, Ghent*

year at home he was apparently in demand as an architect since drawings exist relating to the rebuilding of the municipal bell tower.[16] In February 1685 he was about to leave Ghent to go to Italy.[17] Whether or not he actually got there is unknown, but there can be no doubt that sometime during 1686 Cruyl arrived in Paris again and worked on projects there and at Chantilly.[18] Inscribed drawings of these places are dated 1686 and 1687. Cruyl's continued presence in Paris until 1689 is documented by two fine drawings of the city and of the completed Pont Royal, now in the collection of the Louvre, which are dated 1688 and 1689.[19] One other drawing of 1689 is known to have existed.[20] It is of interest in that it is the representation of a scene from the history of the Maccabees and is thus a pictorial rather than architectural work; unfortunately it in no way fixes the date of Cruyl's presumed return to Flanders, where it is conjectured that he died about 1720.[21]

These facts conjure up a well-traveled man of some general education. The specialty he developed in the area of perspective, particularly an ability to construct bird's-eye views, indicates an education which may well have included some mathematics. But the surviving evidence seems to suggest that as an architect he was well known only in his native Flanders, perhaps just in Ghent, and that his international reputation was that of an unusually gifted draftsman. This latter talent may well have seemed far more important than any potential he might have had for architectural design, since his view drawings are outstanding, a rarity in that category for their period. The *View of Ghent* (fig. 4) done far from its subject (apparently from memory, or on the basis of drawings now lost but then in the artist's possession), in its character and inscription strongly bespeaks a tour-de-force gesture by the artist to prove his worth. It is tempting to imagine that, indeed,

it was with this work that he established himself at the French court.[22]

A document relevant and important to the story of the life of Cruyl and of his sojourns in France has heretofore been overlooked by his biographers. Among the payments listed in the *Comptes des Bâtiments du Roi* published by Guiffrey is the following entry for May 25 to November 4, 1681:

> à Livinus Cruils, prestre flamand, dessinateur, sur le dessin des advenues, châteaux, jardins et parcs de Versailles. 2500 livres.[23]

This entry leaves no doubt that Cruyl was employed at Versailles, although no connection between him and the place has ever been made. Furthermore, the sum mentioned is large, approaching for its six-month period the basic rate of wage of Hardouin-Mansart, and substantially exceeding that of François Dorbay, the principal architectural draftsman of Versailles of the 1670s. The sum is particularly striking if it is realized that the pay is for drawings, and probably includes only a small portion for materials or help.

The project in question was obviously a very important one, appearing to be nothing less than a series of views which would depict the whole of Versailles. Of the possible use of such drawings, the most plausible would be for publication, but they were never published. The date, however, would favor such use, since major campaigns of construction and refurbishment of the gardens were at that time no longer at their inception but nearing completion. It would seem that Cruyl might have been chosen to make known to the world what Louis had caused to be made. If so, his prestige was considerable.

None of these drawings has survived, yet given the description and our knowledge of Liévin's Roman views and that of Ghent, we may surmise that they would probably have been the kind of view which was often made of Versailles, from Patel's oil painting of 1668 to many others spaced throughout the late decades of Louis's reign.[24] They were most likely broad vistas and bird's-eye compositions. The emphasis would doubtless have been on the château in its park setting, with Le Nôtre's gardens probably granted equal stature with the architecture. It would appear most likely that Cruyl was used in his capacity as a specialist in perspective. Cruyl would then seem to have rapidly established himself as a counterpart of Israel Silvestre and possibly even as a competitor.[25] Cruyl's importance at court in the early 1680s might have been surmised even without the above document, since it has long been said that he furnished designs for the engravings of the Marly pump machine for the fountains of Versailles.[26]

It is not possible to give a definitive answer to the question of the nature of Cruyl's exact role at Versailles during his sojourn of the 1680s, but a pair of unpublished drawings, one dated 1684, in the collection of the Museum of the Château of Versailles (which the Direction du Musée has graciously given me permission to publish) indicate that by that date Liévin was intimately involved with the planning of projects, though it is impossible to determine whether he actually furnished any designs for buildings himself.[27] He had at the very least been given the task of making a visualization of *l'état de la question,* or the depiction of the château and its surroundings including certain projects only under consideration. This would suggest a close relationship with the Superintendent which might have led to other opportunities.

The drawings themselves (figs. 1, 2) are moderately large, finely executed in pen on velum, and would have been well suited for presentation to the king for his consideration. They show in minute detail a considerable area, including much

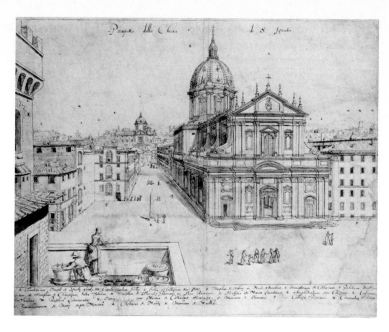

*6. Cruyl.* Sant' Ignazio. *Pen on paper, signed, inscribed: Romae mense
Febr. 1665. Cleveland Museum of Art*

of the town and park as well as the château. Close comparison of the two drawings
leaves no doubt that they are intended to be two views, one from the east, the other
from the west, of exactly the same combination of buildings and projects. They
are thus two views of the same projected plan and must be contemporary pendant
works.

Though one sheet, the view from the west, carries the date 1684, both can be
even more precisely dated. They must have been made early in the year, since
Cruyl was back in Ghent by April 22, 1684,[28] and in all probability they were made
in January. The reasons for this conjecture are the following: A striking feature
of the plan is a pair of large domed churches in the seventeenth-century Roman
manner, somewhat like. S. Ignazio (fig. 6), shown on either side of the large area
before the gate of the château, the Place d'Armes. One of these buildings must have
been intended to serve as the new parish church for the town; the other was almost
surely a project for the convent church of the Récollets. By February 6, 1684, work
had begun on both the present parish church and the church of the Récollets,
but on quite different sites from those of the churches on Cruyl's plan.[29] It seems
certain that shortly before this event, either a few days or at most a few weeks,
the projects depicted by Cruyl had been rejected by the king and other plans were
selected.

This dating may in turn shed light on the original function of Cruyl's drawings.
Colbert, who had served as head or Superintendent of the Buildings Office since
the start of the refurbishing of Versailles, died suddenly in September 1683. Shortly
thereafter Louvois, the ambitious Minister of the Army, assumed the superintend-
ency. Cruyl's drawings are thus a product of this particular transition.

One of the new superintendent's main problems in asserting himself at the Build-
ings Office was clearly that little major work remained to be designed at the time
he assumed power. Versailles had largely taken on its definitive appearance in works

which were well under way. But the two churches on the Place d'Armes would have
made a highly noticeable addition to the approach to the château. Certainly, as far as it is possible to judge from such small-scale renderings, the designs for the twin buildings were of good quality.[30] It also seems significant that the plan which was finally adopted banished the two churches to side streets, where they were, and are today, unseen by most visitors to the château.

The clearly ambitious character of the overall project for Versailles as drawn by Cruyl is also affirmed by the project seen on Cruyl's Versailles drawing for a new *Orangerie* to replace a much smaller structure by Le Vau of the 1660s. This work would have called for excavations more vast than even the extraordinary ones with which Le Nôtre had developed his great parterres two decades earlier. The ambitious author of the project proposed to excavate the area of the entire *Parterre du Midi* so as to bring the *Orangerie* right up to the central area of the château, and to double the width of the previous *Orangerie*.[31] The cost involved in the preparation of this site would have been truly fantastic, yet it is not entirely foreign to schemes which were to prevail under Louvois a short while later; the mentality behind the *Orangerie* project strikes one as resembling that of the man who sought to divert the River Eure from Chartres to Versailles. Cruyl's drawings seem to give us our first taste of the stupendous achievements and expenditures of 1685–90 at Versailles.

The actual design of what can be seen of the *Orangerie* in Cruyl's views is also interesting. It is very different from Hardouin-Mansart's smaller but still magisterial structure which was actually built. In detail it most resembles certain projects by M. Sallé engraved by Aveline in three prints (fig. 7), though these have never been taken seriously by students of Versailles.[32] The visual effect of what can be seen in Cruyl's drawing is hardly commensurate with the enormous expense which would have been involved in realizing the project. The question certainly arises as to whether the design could have come from Hardouin-Mansart's studio; one remote possibility is that the project may be by Cruyl himself. But whatever the case, this rather weak project may throw some light on the situation at the

7. *Sallé*. Project for a new Orangerie for Versailles. *Engraving. Biblio-thèque Nationale, Paris*

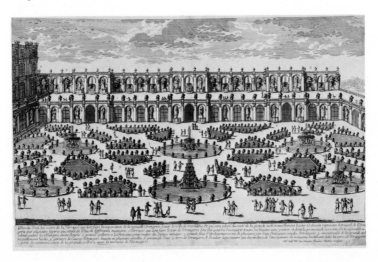

superintendency after Louvois's assumption of power. It does seem possible that a modest challenge to Mansart's all-powerful position might be indicated, one which preceded the establishment of an excellent relationship between the architect and Louvois later in the decade.

This discussion of details in Cruyl's drawings leaves no doubt that at least by 1684 he was drawn into the area of serious planning at Versailles. The next question, at the moment unanswerable, is whether Cruyl's involvement at that time, and his departure to Flanders so soon after the completion of this work, meant that he formed a part of some new alternative team which broke up after the rejection of the project shown in the Cruyl drawing. There is some possibility that this was in fact what happened. It is clear that Cruyl's French connection did not entirely crumble. The commission he received to draw the construction of the Pont Royal in Paris in 1686–87 shows that he continued to be esteemed in high places, since the Pont Royal was one of the king's important public works made for his capital. But it is also significant that both the Pont Royal job and the exactly contemporary work at Chantilly fall outside the authority of the King's Buildings Office. It could be conjectured that Cruyl remained in Louvois's good graces, but ruined his chances at Versailles just when he had established an important place for himself with the superintendent. This would explain his unexpectedly hasty departure from the scene of his very recent success, and underscore the possibly controversial nature of the projects shown in the 1684 drawings.

Given the facts presently known, it must be admitted that it is impossible to understand Cruyl's real importance for the history of Versailles. On the other hand, there can be no doubt that the last drawings of Versailles of 1682 and those of 1684 published here were probably the major achievements of his career. Only at this point in his life did he seem to have been involved with architectural projects of this level of international importance and to have been something more than a highly competent *vedutista* or provincial architect. It would also seem important to keep his name in mind while investigating the surviving documents on Versailles, since the works mentioned here may not be all that he did. Even if no more of his drawings for Versailles are found, written documents relating to Cruyl might well shed light on some obscure areas of the extraordinarily complicated building history of Versailles at an important moment of transition in the history of its creation.

*New York University*

## Notes

[1] Fiske Kimball, *The Creation of the Rococo*, Philadelphia, 1943 (also Norton paperback photo reprint edition, New York, 1964).

[2] The fundamental study of the King's Buildings Office (Bâtiments du Roi) is by R. Guillement, *La Surintendance des bâtiments du roi, 1662–1715*, Paris, 1912.

[3] Two short modern biographies of Cruyl have been published which complement one another, the first by Paul Bergmans in Thieme-Becker, *Allgemeines Lexikon der Bildenden Künstler*, VIII, Leipzig, 1913, 179–80; the second by E. Mareuse, at the beginning of his article "Trois Vues de Paris de Liévin Cruyl en 1686" in the *Bulletin de la Société de l'Histoire de Paris*, Paris, 1919, 65–67 (hereafter

referred to as Mareuse, "Trois Vues").
Bergmans gives a full bibliography, but
special mention should be made of the
MS by Hye-Schoutheer, bibl. Ghent
G11507 5-6, which is quoted extensively
by Mareuse and in turn cited here.

4 See for example the inscription on the
great view of Ghent (fig. 4).

5 This author does not know the present
whereabouts of this drawing for St.
Michael's towers. It was apparently
shown in Ghent in 1975 at the exhibition
"Gent Duizend Jaar Kunst en Cultuur."
The mention of it in the section on archi-
tecture by McLaleman (p. 76 of the
exhibition catalogue) does not give the
present location. It was given to the City
of Ghent by the University Library in
1934. The following inscription on the
drawing has been published: Quadrangu-
laris ichonographia $2^{dae}$ stationis p. $3^a$
turris D. Michaelis Gandivi ex qua cetere
octogonales sequuntur inv. Wettern
1662, 17 $7^{bris}$.

6 A drawing in Cleveland of the Piazza
Colonna is inscribed "1664 Ag." It was
among those published in 1666. Two
other drawings, likewise at Cleveland
but unpublished in 1666, are inscribed
"Aprili 1665." The latest date on one of
the published drawings is March 1665,
that of the Campo Vacchino, also at
Cleveland. The set of prints was re-
printed by Gregorio de Rossi in 1692–
98, and a third edition by Carlo Losi
in 1773. See: T. Ashby, "Liévin Cruyl e
le sue vedute di Roma," Atti della Pon-
tificia Accademia Romana di Archeolo-
gia, serie III, memorie, I, 1, 1923, 221–29;
D. Bodart, Les Peintres des Pays-Bas
méridionaux et de la Principauté de Liège
à Rome au XVII Siècle, Brussels, 1970,
I, 346; and H. Francis, "Drawings by
Liévin Cruyl of Rome," Bulletin of the
Cleveland Museum of Art, XXX, 152–
59, 163. I would like to thank Jane
Glaubinger, Research Assistant in the
Drawings Department at the Cleveland
Museum, who shared with me the re-
search she has done on the Cruyl draw-
ings there. She sent me Xeroxes of the
full entries in the museum's drawings
files and her notes on the 1666 publica-
tion, and kindly gave me permission to
use this material. My thanks also go to
Mary Myers, who showed me the title
page of the 1666 edition which is in the
collection of the Metropolitan Museum.

7 This edition of Roman views would
appear to be the one of 50 plates dated
between 1665 and 1667, published in
1667, that is referred to in F. W. H.
Hollstein, Dutch and Flemish Etchings,
Engravings and Woodcuts, V, Amsterdam,
n.d., 99. He notes that three editions
were eventually published of this work.
This author has not had the opportunity
to examine any of these rare early bound
editions of Cruyl's views.

8 On these drawings and their publica-
tion, see Bergmans in Thieme-Becker,
VIII, 179.

9 See above, n. 8.

10 R. Weigert and C. Herrmarck, eds.,
Les Relations Artistiques entre la France
et la Suède 1693–1718, Correspondance
Tessin et Cronström, Stockholm, 1964,
passim.

11 The drawing is inscribed "Modelle
voor den Hooghen Avltaer van S. Baefs
Kercke binnen de Stadt van Ghendt
gheinventeert door L. Cruyl Phre 1688."
I would like to thank the staff of the
Ghent City Archive for their help in
finding this design, and in searching,
alas unsuccessfully, for that of the tower
of St. Michael's church.

12 In addition to the title, the drawing
contains two inscriptions. One in the
lower left is simply the key to the num-
bers on the drawing for the identification
of buildings and other important fea-
tures of the city. In the lower right corner
is a lengthy Latin inscription including
some comments by the artist both on the
conditions under which the drawing was
made and on some buildings and other
important features of the city. This
author was not able to decipher the
entire inscription, but mention is made at
the outset of the capture of the city by
Louis XIV. According to Cruyl the
drawing was "made from memory al-
though it is less perfect than if I had
projected it on the spot." He asks to be
excused "because he has been out of his
fatherland for ten years in Italy." In
places he contrasts the Gothic and what

he calls the Italian style of certain of Ghent's buildings. He mentions the unfinished condition of the towers of St. Michael's church in such a manner as to suggest that one day they may yet be completed. No mention is made of his project. The drawing is in ink on paper and has been seriously blurred by moisture in a large and important area near the center. My thanks to Jean Coural and Mme. Babelon of the Mobilier National, who first located the drawing, previously wrongly called Van der Meulen, and then procured the photograph and finally permitted my examination of it.

[13] A guess as to the provenance of the *View of Ghent* is that it was sent by Louis XIV to the Gobelins along with similar drawings by Van der Meulen (e.g., a view of Tournai) for use in the preparation of cartoons of the victories of Louis XIV. No tapestry of the taking of Ghent was made, however.

[14] Jules Guiffrey, ed. *Les Comptes des Bâtiments du Roi sous la règne de Louis XIV*, 5 vols., Paris, 1881–1901 (hereafter referred to as Guiffrey, *Comptes*), II, 63.

[15] Résumé of archive material contained in Hye-Schoutheer and quoted in Mareuse, "Trois Vues," 65.

[16] Two drawings, one an elevation of the Ghent City belfry, the other a project for its reconstruction, both at the Byloke Abbey Museum, Ghent, are datable by inscriptions. These are mentioned by Mareuse, "Trois Vues," 65. He quotes a passage from Hye-Schoutheer which refers to a payment document, but he does not include the original or even give its location.

[17] As in note 16, this information is from Mareuse.

[18] On the Chantilly drawing which shows the interior court of the château and is dated 1686, see Mareuse, "Trois Vues," 65. Cruyl's visit to Paris is documented by three views of the Pont Royal now at the Musée Carnavalet. One is dated 1686, another June 1687. Mareuse, "Trois Vues," 64–71. All are reproduced with their inscriptions duly recorded.

[19] The finely detailed view of the city along the Seine and that of the bridge are at the Cabinet des Dessins. 19–890 (Fl. 549) is inscribed: "Liv Cruyl Pbstr Gandi" and "Vue du Pont nouveau du Louvre achevé à Paris L'an MDCLXXVIII" (this view looks west). 19–891 (Fl. 550) is inscribed: "Veue du Pont du Louvre et d'une partie de la Ville de Paris, Liv. Cruyl feçit 1689" (view looks east).

[20] See Bergmans in Thieme-Becker, VIII, 180.

[21] It is appropriate to quote at this point Mareuse, "Trois Vues," 66: "Dans son *Dictionnaire des artistes graveurs*, Heinecken dit que Cruyl grava d'après plusieurs maîtres, et Nagler lui attribue les Triomphes de Jules César d'après Andrea Mantegna, en dix feuilles."

[22] See Mareuse, "Trois Vues," 66.

[23] Guiffrey, *Comptes*, II, 63.

[24] The Patel is at the Musée, Château de Versailles, no. 765.

[25] The payments made to Silvestre recorded in Guiffrey, *Comptes, passim*, seem roughly comparable to those made to Cruyl for the Versailles drawings.

[26] See Bergmans, Thieme-Becker, VIII, 180. Unfortunately the writers on Cruyl who mention the Marly machine engravings are not very specific, either as to where these "famous" drawings might be found or how they knew Cruyl did them. The well-known set of six engravings of the machine which were published in the eighteenth century by De Ville (copies are now in the Bibliothèque Nationale, Paris) would seem quite likely to be after a drawing by Cruyl. A comparison of this composition with his drawings of the construction of the Paris bridge of 1686–87 is persuasive, and these could well be the Cruyl engravings of Marly the writers mention, though they are unsigned. The Bibliothèque Nationale prints are not dated 1682; they do carry that date, but only in the statement that this was the year the king ordered work to begin on the machine. It may be necessary to assign to this composition a later date, in which case it might be appropriate to bring it together with the Pont Royal designs. Perhaps Cruyl's work of the 1680s

should be sought in some other part of the royal administration, such as Bridges and Roads or its equivalent at the time.

[27] The drawings (figs. 1, 2) are: no. 307 (inventaire dessin), pen on velum, 23.6 by 32.3 cm, *Bird's-eye View of Versailles from the East*, inscribed LIV. CRUYL; no. 308 (inventaire dessin), pen on velum, 24.1 by 32.1 cm, *Bird's-eye View of Versailles from the West*, inscribed LIVIN. CRUYL 1684. The drawings were bought by the museum in 1909; Simone Hoog kindly provided me with information from the museum files. Cruyl's drawings in Cleveland show him to be an imaginative draftsman and a specialist in views of buildings which, either by state of completion or by inconvenient location, could not be seen as his views show them. For example, his view of S. Ignazio (fig. 6) shows the dome completed, and for his view of Borromini's façade of the Palazzo di Propaganda Fede he removes the buildings across the street to expose fully the whole west side of the building.

[28] See above, n. 15.

[29] A. and J. Marie, *Mansart à Versailles*, Paris, 1972, I, 154. Here are reproduced payments from Guiffrey, *Comptes*, II, for the Récollets: Feb. 6–Nov. 12, 1684

(for materials for the church); and for the Paroise Notre-Dame; Feb. 6–Dec. 10 (also for materials).

[30] There is a clear precedent for using a church of this style in a part of the town near the château. A very similar project is sketched in red crayon to the southeast of the château on the overall plan for Versailles of 1669 or 1670. This large drawing is in Stockholm, THC 2, published by A. and J. Marie in *Mansart à Versailles*, 1972, I, 80. The red crayon sketch is hardly visible in the Maries' reproduction but can be found with effort to the left of the lower left-hand corner of the Place d'Armes. It can hardly be a coincidence that a church in somewhat similar style was adopted for use as the palace chapel in the plan for the north wing, instead of the project seen in Cruyl's drawing of 1684. See A. and J. Marie, 1972, II, particularly the ground plan at the bottom of p. 528.

[31] See again the plan THC 2 at Stockholm of 1669 or 1670: A. and J. Marie, *Mansart à Versailles*, 1972, I, 80. There was clearly a long-standing intention to widen the *Orangerie*, but none to extend the depth as seen in Cruyl's drawing.

[32] See Pierre de Nolhac, *Versailles, Résidence de Louis XIV*, Versailles, 1925, 129.

# 28
# Bernini's Busts of English Patrons

R. W. LIGHTBOWN

## I. BERNINI'S BUST OF CHARLES I

The lost bust of Charles I by Bernini[1] was among the most significant works of art brought into England during those years of transitory glory when the King figured as one of the most prominent and acquisitive of European collectors and patrons (fig. 1). It was beyond question the most important Baroque manifestation to appear in England of a genre which was virtually unknown here before the reign of Charles: the portrait bust. Its story is famous, yet it has never been clearly settled who commissioned it, and there is still a certain mystery about its final disappearance in the fire which destroyed Whitehall in 1698. To solving the second problem this essay can, alas, make no contribution, but a fresh study of the manuscript correspondence which passed between Rome and London during the years 1635–40, when the bust was commissioned, executed, and brought to England, has suggested an answer to the first. These researches also disprove the now generally accepted version of the history of the bust and of its significance in the politics of the day. In order to make plain the evidence for a new interpretation I publish here all the documents I have been able to discover concerning the bust: until now discussion of it has been vitiated by want of many essential texts.

Some knowledge of the relations between Rome, where Bernini of course was the Pope's official sculptor, and England at this time is necessary to understand the true story of the bust.[2] During the first half of the seventeenth century English Roman Catholics still laboured under the Penal Laws imposed by the Elizabethan regime. Consequently, when Charles married the French princess and Roman Catholic, Henrietta Maria, in 1625 both the French and Pope Urban VIII, who was also Henrietta Maria's godfather, had stipulated as conditions of the marriage that she was to be allowed free exercise of her religion and that the Penal Laws should be relaxed. Henrietta Maria herself signed private undertakings to her brother King Louis XIII and to the Pope that she would protect the persecuted Catholics of England. But difficulties between the royal couple and pressure from Parliament disinclined Charles to carry out the terms of his marriage treaty, and it was not until 1629, when the adjournment of Parliament and the conclusion of peace with France freed the King from licenced critics at home and war abroad, that the affection which by now united Henrietta and Charles resulted in increased

439

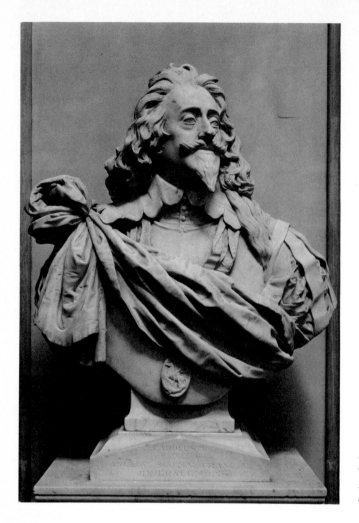

1. *Copy of Bernini's* Bust *of* Charles I. *Early 18th century. Marble. Windsor Castle (Crown copyright reserved)*

toleration for Roman Catholics. Early in 1630 a mission of French Capuchins came to London to serve the Queen's Chapel, and their services were soon the talk of London. Even when they made striking conversions, the devout Anglican Charles did not interfere, and Catholics in general were now left free to exercise their religion, provided they did so unostentatiously.

Yet in spite of this interruption of persecution, internal quarrels among the clergy and slackness in the laity were a trial to the more serious-minded Recusants, and it was felt by these that a bishop was needed to supervise the affairs of both clergy and laity. Besides, Charles was known to be interested in theology and to belong to the high church party of Laud, and many held that there was a real chance of his conversion. In 1633 one Catholic nobleman, the Earl of Angus, went so far as to send his kinsman Sir Robert Douglas to Rome to press these points on the attention of Cardinal Francesco Barberini, the nephew of Pope Urban, his Secretary of State, and Since 1626 Protector of England and Scotland. Angus believed that much would be gained if one of Charles's own subjects were to be made a cardinal. Henrietta Maria supported this scheme warmly, and wrote to Barberini on 2 April 1633 suggesting that the man to be thus honoured should

be George Con, a Scot who was a member of Barberini's household. But the Cardinal was perplexed by the difficulties of the business, and after much consultation decided it would be best to despatch a Papal Agent to the Queen in order to discover the true state of English Catholicism and whether there was any real prospect of converting the King.

Prior to the despatch of a fully accredited agent, however, he determined to send an unofficial emissary to explore the ground, and his choice for this post fell on Gregorio Panzani, a priest of the Chiesa Nuova. In spite of all Barberini's hesitancies, hopes of the King's conversion must have been running high in Rome, for at Panzani's farewell audience with the Pope on 24 August 1634, Urban discoursed at length on the subject, declaring that in his opinion only the King's wish to champion his nephews, the dispossessed Protestant princes of the Palatinate, was preventing his return to the fold. On 25 December 1634 Panzani reached London, and the very next day was presented to the Queen. Although he had no official standing, he was quickly taken up by great men about court, in particular by Windebank, the Secretary of State. Barberini had ordered him to confine himself strictly to the affairs of the English Catholics, but soon Panzani was receiving hints that a letter from Urban to Charles thanking him for his policy of tolerance towards Catholics would be welcomed as a graceful gesture by the English court. This was peremptorily refused by Rome, Barberini first replying that Urban would correspond with Charles solely on the subject of his conversion, and then sternly declaring that there could be no interchange of letters with heretics, but only with the Queen.[3]

Early in 1635, then, the situation, though eased unofficially, still remained set in the old pattern: the King of England kept no agent at the court of Rome, and the Pope still refused to enter into direct correspondence with a monarch who, if tolerating, was none the less a rebel against his spiritual jurisdiction. It is against this context that we must study the commissioning of the bust. It is first mentioned in a letter of June 13, 1635. In this Panzani, reporting a conversation with Walter Montagu, a favourite courtier of Henrietta Maria, and later to become a convert to Roman Catholicism, says Montagu had told him that "the King has been satisfied beyond all expression by the licence which the Pope has granted to Bernini to make the statue of this King, especially as such a favour has been refused to other princes."[4] These words make it plain that the Papal court did not take the initiative in commissioning the bust and that Panzani was not the intermediary through whom overtures were made to the Pope from London. We are forced to exclude the Vatican as the inspirer of the commission, and must look elsewhere.

Now it is most unlikely that Charles asked the Pope directly for a favour of this kind, thus exposing himself to the risk of a snub, and indeed there is only one letter known to have been written at this period by Charles to Urban, and that concerns a matter of high politics, the fate of the Palatinate princes. We do not even know if it received a reply. On the other hand, it is a marked feature of the Barberini correspondence with their emissaries in England that they affect to deal solely with Henrietta Maria. So the many works of art despatched by Francesco Barberini from Rome to England were always sent to the Queen, never to the King. Consequently there is every reason to suppose that it was Henrietta Maria who made the formal request to the Papal court for licence to commission the bust. There is even excellent reason to think that the request was made by word of mouth through Montagu, who had just returned from Rome, where he had been well received by Cardinal Francesco and Cardinal Antonio Barberini, receiving from

them a present of two statues which he had given on his return to the insatiable King. Only if we accept Henrietta Maria as the prime agent in the negotiation can we understand the draft reply which Francesco wrote, probably in October 1637, to a letter from the Queen thanking him for sending the bust. This draft reads, "Your Majesty, by praising the statue not only bestows immortality on the name of the artist, but renders me ambitious, since I have had the honour of executing your commands, of which I live both from obligation and from devotion in perpetual desire: therefore let your Majesty be liberal of them."[5] But it is extremely unlikely that Henrietta Maria conceived the idea of commissioning the bust unprompted; everything suggests that Charles availed himself of her influence in Rome in order to make sure of getting the bust, and to avoid accusations from his Protestant subjects of wantoning with the whore of Babylon for the sake of her trumperies.

Certainly Bernini's son Domenico, writing some eighty years after the event, produces as the next step in the negotiation a letter written by Charles himself to the sculptor.[6] Its date is printed in his book as 17 March 1639. Ever since 1900, when Fraschetti published his important work on Bernini,[7] it has been realised that this must be either a misprint or a slip of Domenico's too facile pen, and Fraschetti's correction of 1639 to 1636 has been universally accepted. In fact the true year was certainly 1635, which means of course that the licence had been requested a month or six weeks at the very least before the date of the letter to Bernini. That Panzani makes no mention of it before 13 June 1635 is neither here nor there: for Panzani had no contact with the King, and was not, as already pointed out, the intermediary chosen by the Queen. His report of 13 June merely marks an agreeable piece of news which has reached him at second hand, and is not necessarily a close indication of the date when a request for the Papal licence was first made. And there are unanswerable reasons why it is impossible to accept 17 March 1636 as the date of the King's letter. In the letter, Charles, with lavish compliments to Bernini, requests him to carve the bust after "a painting which we shall send to you immediately we are certified of your compliance." It will be obvious that two interpretations of this statement are possible: either the painting was ready when Charles wrote his letter, or it was executed when Charles had heard from Bernini that he was happy to accept the commission. Even if we suppose that Charles had caused the painting to be executed before 17 March 1636, and was so certain of Bernini's agreement that he decided in his impatience not to wait for an answer but to send it off more or less at once after that date, the painting cannot have been delivered into Bernini's hands before about a month later, the shortest time in which even diplomatic letters could reach Rome.

Accordingly, if we accept the conventional date of 17 March 1636 for the letter, the earliest date at which Bernini can have begun work on the bust would fall in the last weeks of April 1636. Now on 25 August 1636 Panzani, reporting the first audiences which his successor George Con had had with the Queen, remarked, "Signor Giorgio has signified to the Queen that the work of the Cavaliero Bernino was now nearing completion and she said with great joy that she would write to tell this to the King."[8] Since Con left Rome on 4 June 1636 and arrived in London on 25 July, and since there is no mention of the bust either in his letters to Barberini or in Barberini's letters to him before 31 July 1636,[9] this means that the bust must have been "nearing completion" by the beginning of June. Unfortunately we can glean nothing more about the stages of its progress, for when Cardinal Francesco Barberini does first mention the bust to Con on 31 July he merely remarks

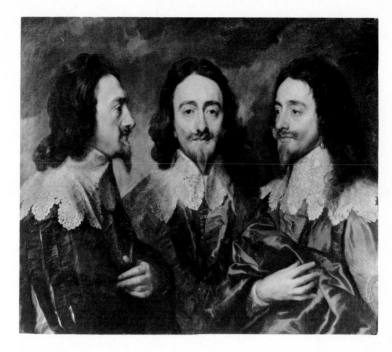

*2. Anthony Van Dyck.* Triple Portrait of Charles I. *1635. Windsor Castle (Crown copyright reserved)*

that Sir William Hamilton, the Queen's agent to the Pope, who was newly arrived in Rome, had not been told of it at the English court. "Because I thought he knew of it, on the other occasion [of Hamilton's first audience] I touched something to him of the head of the King which the Cavaliere Bernino is making, and then seeing he was not informed of it, I turned the discourse. At this audience he asked me about it, and I said to him that it was being worked at and I hoped it would please."[10] It is hardly necessary to point out that not even the prodigious Bernini can have designed, modelled, and carved so important a commission in a month or five weeks. In any case we shall see from other documents to be quoted later that in fact the bust cost him much pains and labour.

As everyone knows, the painting which was sent to Bernini was the celebrated triple portrait by Van Dyck now at Windsor. If we accept 16 March 1635 as the correct date of Charles's letter to Bernini, all ambiguity of interpretation disappears, since we know that Van Dyck left England in March 1634 and did not return until some date in 1635. Consequently the painting was probably started after Charles had received a letter from Bernini accepting the commission, and June is therefore the earliest likely date for Van Dyck to have begun work on it. The portraits of Henrietta Maria which Van Dyck painted in 1638 for Bernini seem to have taken him about six weeks to complete, and almost certainly the triple portrait of Charles was painted fairly rapidly too. However, the known history of the progress of the bust, when considered in relation with Bernini's courtly temperament and what we know of similar commissions, favours the later dating. But whichever choice we make, clearly the portrait was painted fairly rapidly.

For reasons which will become evident I would like to draw especial attention to the last sentence of the King's letter to Bernini which contains a suitably vague

and dignified, but unmistakable mention of payment: "assuring you, that we desire to correspond with our actions to that esteem in which we hold you." The transmission of the painting to Rome is a question which I shall discuss when settling the movements of Mr. Baker, Bernini's one private English patron. Evelyn, concluding his *Numismata,* published in London in 1697, with a digression "concerning *Physiognomy,*" expresses his opinion that "a *Physiognomist* . . . may yet from other likenesses, make almost the same Conjectures, as from the Life it self," adding, "I have been told, of the famous *Architect* and *Statuary,* the late *Chevalier Bernini,* who cut that rare *Bust* of *Charles* the *First* at *Rome* in white Marble, from a picture painted by *Van Dyke* (yet extant, and to be seen in one of His Majesty's Apartments) that he foretold something of funest and unhappy, which the Countenance of that Excellent Prince foreboded."[11]

Panzani did not leave England till late in 1636, but there is no further reference in his letters to the bust, and for its later history we must turn to other documents and to the letters which passed between Barberini and Con. It was not until April 1637 that the bust was placed on exhibition in Rome before being despatched to England. This long delay was most probably due to seventeenth-century travelling conditions, which would have made Barberini unwilling to despatch so important and precious an object during the winter. But it may also have partly been caused by the sculptor's essential dissatisfaction with the bust as an advertisement of his powers, a dissatisfaction which culminated in his famous outburst of 1638 to the young English sculptor Nicholas Stone, in which he exclaimed that it was impossible to make a satisfactory bust without sittings from the life.[12]

Bernini's feelings on this subject are already apparent in a letter from Barberini

3. *Van der Voerst (attributed).*
*Engraving of Bernini's* Bust of
Charles I. *Late 17th century.*
*British Museum, London*

to Con of 27 April 1637, in which the Cardinal, after expressing his pleasure that certain presents he had sent to Henrietta Maria had been joyfully received, continues, "I remain however mortified that my poor gifts have been placed in so worthy a situation by Her Majesty the Queen, so that they vanish away, and their poverty appears the more. But the work of the Cavaliere Bernino will deserve such honour, principally because it will be cherished by Her Majesty, although I make bold to say that it will not be something to be despised, for the Cavaliere Bernino told me that better he knew not how to make it. For which reason I thanked him, and said that I wished to give him no other praise for the work than that it was the sum of his knowledge. Indeed it must be excused if the portrait is not a likeness, since it is all too necessary that the original should not be absent, but at least the diligence of the master cannot be tasked. . . . All my intentions were and are that it should be you who exhibit the work to Her Majesty and that on no account should an opportunity be given for Her Majesty to exercise her supreme liberality or her bounty towards any who bring it."

Yet in spite of all these hesitancies the bust was greatly admired when it was exhibited in Rome. The agent of the Duke of Modena wrote twice to his master about it: on 11 April he praised "the diligence and care" with which the bust had been executed, and declared that Bernini had surpassed himself; on 18 April he went even further, exclaiming that the bust was "worked with such excellence and mastery, that art has never before made so beautiful a thing."[13]

On 27 April Antonio Ferragalli, the Cardinal's secretary, wrote a letter to Con which tells us something about the bust and the arrangements for its transport: "S. Tomasso Camerario [Thomas Chambers] a Scot is he who is coming to England, and on such occasion the S.$^{re}$ Cardinal has charged him with the care of the statue of the King's portrait, which truly is beautiful and you could not imagine the universal applause it has received, nor do I think that there exists a Cardinal, Ambassador or gentleman of quality who has not desired to see it. On the forehead from the nature of the marble there still remain some little spots, and one man said, that they would disappear as soon as His Majesty shall become a Catholic. His Eminence will not enjoy tranquillity until he receives the news that it has arrived safely."[14]

## II. THE RECEPTION OF THE BUST

Among the Barberini manuscripts is a long set of instructions from the Cardinal to Thomas Chambers.[15] Chambers was to supervise the packing of the bust in order to know how it should be unpacked on its arrival and to testify that it had left Rome in perfect condition, should any mishap befall it on the way, "from which God preserve you." The route to be taken was laid down in detail, and Chambers was to make contact with friends and agents of Barberini in every important city along it. Bernini's representative was Bonifazio Olivieri, who is described by Baldinucci as his "creato" or servant. For reasons of space we cannot follow the pair on their slow journey to England with the bust, though the letters in which both Chambers and Olivieri reported their toils and travails to Barberini still exist in the Vatican.[16] On 23 June Ferragalli wrote to Con asking him to tell the pair of the safe arrival of the first of these letters, and adding "To me one hour seems a thousand until the news of the arrival of the portrait reach us, as His Eminence is impatient. Remember that to the above [Chambers] not the least thing should be given, if you wish to please the Lord Cardinal."

The news that the bust was on its way was received with excitement in England:

on 29 May Con wrote to the Cardinal: "Her Majesty has heard with particular pleasure of the despatch of the work of the Signor Cavagliero Bernino, and the coming of Signor Tobia [the *aiutante di camera* of Cardinal Francesco, who in the end did not escort the bust], of whose qualities I have given notice to Her Majesty the Queen, and this too will be numbered among Your Eminence's presents."[17] On 4 July he reported, "I am in hourly expectation of Chambers with the head that your Eminence is sending. From Paris he has forwarded to me his instructions in which there appear the infinite pains and exactness of Your Eminence in thinking of everything, and I shall not fail to make them [the instructions] known to Her Majesty the Queen, who said to me the other day, that she had so many pledges of the affection of Your Eminence, that she was perplexed as to how she might ever make you understand to what degree she holds herself obliged. Orders have already been given to all the ports of this island, with a message that immediately he arrives he should despatch a messenger by post to inform me, so that I may not fail in obeying Your Eminence's commands."[18]

Chambers's last letter to Barberini, dated 30 July, describes their safe arrival with the bust. "I shall say nothing more just now save that on Sunday the 26th of this month we loaded our case on to a good boat and on the day following arrived at Oatlands where we had to open the case that very same night on account of the great eagerness of the King and Queen. I cannot write sufficiently of the great contentment of the King and Queen and of the astonishment of the whole court and in particular of the superintendent of the statues, who exclaimed with an oath that the bust was a miracle as the first plank of the case was raised. On Monday I return to Court to take leave of Signor Giorgio [Con] and then I shall immediately proceed on my duty to Scotland, where I shall not fail to pray to God for Your Eminence to whom I offer my humblest reverence."[19] On 31 July Con communicated to Ferragalli the safe arrival of the bust: "I hope that the present ordinary will release His Eminence from the anxiety which the delay of the portrait has caused him. It is now safely arrived, all the commands of His Eminence having been punctually observed in its presentation. As regards the young man of the S. Cav° Bernino, I will keep him here with me until some resolution is made concerning my person. . . . I am sending the reply to the letter of the S. Cav^le. Bernino open, so that it may be seen by His Excellency. The Queen will not fail to reply to the letter which the said Cag^lo has written her."[20]

Charles was full of admiration for the bust: Con reported to Barberini on 31 July, "the satisfaction of the King in respect of the Head passes all expression; no person of quality comes to court but is immediately taken by the King himself to see it in public. Both I and Their Majesties profess that this is a grace conferred by Your Eminence on the Queen, but the King does not on this account confess his obligations the less, desiring some opportunity to revenge himself."[21] A second letter of the same date repeats profuse expressions of gratitude from the Queen for the service Barberini had rendered her.[22] A week or so later Henrietta Maria wrote in her own hand to Barberini, and took the opportunity to thank him for the bust: I print a longish extract from it in the original French, so that the reader can assess its tone: "Il me seroit agreable de procurer quelque advantage a M^r Massariny de qui j'ay reseu beaucoup de civilites et dont la resputation semble le randre sy digne de vre protection que je puis bien sans aucun scrupule vous la priere, comme aussy vous recommander derechef la cause de l'abesse de Bruselles et vous remercier extrememement de la statue du Roy monseigneur que vous m'aves envoyé,

laquelle luy a donne grand contentement pour l'excellence de l'ouvrage et a moy pour le soyng que vous me temoygnes en toutes choses de m'obliger vous assurant que vous trouveres le mesme en moy de vous faire paroystre combien je suis, Mon Cousin, Vre etc."[23] This is undated, but had been shown at least in draft to Con on or by 21 August when he reported that the Queen "because she thinks perhaps that I am not so diligent as is needful in representing her sentiments, is herself writing to your Eminence briefly certifying what she expresses almost continuously to me of her observance towards Our Lord the Pope and affection towards your Eminence and all your Most Illustrious House. She returns thanks in the same letter to Your Eminence for the statue and recommends Monsignor Mazarine."[24] The letter was received in Rome on 14 November 1637, and to it Barberini drafted the reply quoted at the beginning of this article when the commissioning of the bust was under discussion.

According to a story current some fifty years later Charles was so delighted when he saw the bust that he drew a diamond ring worth 6000 scudi (£1500 in English money of the period) from his finger and giving it to Bonifazio, said: "Crown the hand which made so beautiful a work."[25] The contemporary correspondence shows that matters proceeded very differently and much more deliberately, and above all that the King in no way concerned himself with the question of payment. The Queen, well aware of what was due to herself, disregarded Barberini's express wish and rewarded Chambers and Olivieri almost immediately after the arrival of the bust at court. On 14 August Con wrote to Ferragalli: "It [has] not been possible to make the Queen abstain from rewarding those who brought the statue. Chambers set off immediately for Scotland, who as a person of birth received a gift of 400 scudi and the young man of the Cavg.° Bernino 200, but since I opposed myself absolutely as regards Chambers, saying that he had no concern in the business, the 600 scudi have been given to the said young man, who could not have escaped them even if he had left immediately. I said that I had no wish to be mixed up in the matter, but to give satisfaction I sent the young man to Sʳ. Montagu, who said so much that he persuaded him to take them. This however is without prejudice to the reward which will be sent to the S.ʳ Cavg.ˡᵒ himself, who has acquired a glorious name in these shores."[26] On 6 October Bonifazio himself penned a letter to Ferragalli in order to excuse his acceptance of a gratuity.[27]

A despatch of 7 September begins the story of the delays which were now to afflict Con, Ferragalli, who had the superintendence of this commercial aspect of the affair, and Bernini, who after some months of patience began a steady pressure, varied by bursts of importunity, for payment. It would seem that a first letter from Bernini to the Queen had been lost, for Con says, "The Queen will write to the Cavalier Bernino in reply the letter which he sent, since to find the first letter is not easy in a [?] where they do not keep a register of letters like these."[28] On 16 October Con, who was now expecting to return to Rome immediately and to be made a cardinal, wrote to Ferragalli: "You must not doubt but that the Cavaliere Bernino shall receive a most honourable letter from the Queen, and also a reward worthy of him; but this and certain trifles of business for His Eminence our master are reserved until my return."[29]

We should note that neither now nor later is there any question of a reciprocal present for the Cardinal. It is true that during July 1637 the Queen's thoughts had turned to bestowing some mark of her goodwill on Barberini, but this was an entirely gratuitous offer of embroidery executed by the royal needle, and was in

no way connected with the bust.[30] Let us see how the correspondence continues. The subject next recurred on 25 January 1638 when Con wrote to Ferragalli: "I have received the diamond for the S$^r$. Cavl$^o$. Bernino."[31] On 19 February he ended a letter to the same correspondent, "I conclude after having signified to you that the Cavg$^{le}$ Bernino's reward will not be left behind. The Queen's opinion that I was about to set off six months ago has delayed this and other matters of greater importance."[32] On 19 March 1638, he told the same correspondent, "I have already written to you what seems best to me concerning the Cavaliere Bernino. I am ashamed to solicit a matter appointed for my return, though since this ought to have happened six or seven months ago, I cannot think of it without mortification, but he will certainly have his present."[33] But by 2 April Con, either because of renewed pressure from Rome or because he felt that the delay was becoming embarrassing, sent a letter of explanation and apology to Bernini through Ferragalli: "I send you herewith a letter for the S$^r$. Cavg$^{lo}$. Bernino, for whom I shall not fail to procure those satisfactions which are desired. You may accompany it if you see fit with what seems to you most convenient. I send it to you open so that you may give it to him or not according as you wish."[34] In May he was busy soliciting the reward: "In the meanwhile tell the Cavaliere Bernino that I shall bring him his letter together with something not unworthy of him, since now for one reason or another my return must be hastened"; and again, "On account of the Cavalier Bernini I fail not to do that which I would not do for myself."[35]

On 11 June Con, still in London, wrote again: "Yesterday I had in my hands the Cavaliere Bernino's reward which being a most beautiful diamond, I arranged for it to be valued by an expert of the profession who assured me it was worth a thousand pounds or 4000 scudi. I returned it to the Chamberlain so that I may receive it later at the hand of the Queen when it is time to speak with resolution of my departure."[36] But Bernini was now becoming importunate and on 9 July Con wrote bitterly to Ferragalli: "For the Cavalier Bernino I have done what I would not do for me or for mine, even if it concerned a thousand lives. I have his reward and if I find a safe person before my return I will send it."[37]

But on 17 July Ferragalli was already replying to the glad news of 11 June about the value of the diamond and communicating Bernini's inconvenient views on the subject. "I have spoken to the Cavaliere Bernini about the reward, and was myself pleased to hear of it, since its value conforms to what has been spread abroad here, Monsignor Mazzarini and Bonifazio the servant of the Cavaliere having always said that it would be nearer 4000 scudi than 3000. I desire however to entreat you for a favour, which I am extremely anxious to obtain of your benignity, unless you consider it quite out of place, and my desire is founded on motives which I shall explain to you hereafter by word of mouth when you have returned to Rome at the pleasure and will of our masters. The favour then which I request is that since they have decided over there to make the Cavaliere Bernini a reward to the value of 4000 scudi, I would desire that it should be of a kind to make evident the value, which would be difficult in a diamond. And so a jewel of similar value with a portrait of the King or Queen would make a greater display, or else, what would cause a greal deal less trouble, the aforesaid 4000 scudi might be sent to the Cavaliere Hamilton [Henrietta Maria's agent in Rome] with orders that he should have a credence of plate made and presented to the Cavaliere Bernino on behalf of the Queen. If I speak absurdities, for the love of God excuse me, but if you can with your dexterousness do me this favour, I entreat you of it once again."[38]

To this Con, unwilling to renew a humiliating suit, replied very firmly on 13 August: "As regards to Cag¹º. Bernino I have already written to you that I have received his reward in the form of a most beautiful diamond, which means that your advice is no longer in time, and the Cag¹º. by importuning you has made me do what I would not have done for my own father."[39] But no opportunity of forwarding the diamond, which was set in a ring, had occurred by the early summer of 1639,[40] and Ferragalli's next mention of it has a rather desperate tone. Writing on 7 May 1639, he pleads: "The Cavaliere Bernino is going to be married. If ever you had thoughts of doing something to please him and give satisfaction to His Eminence our master, try to send him as soon as possible by some safe means the diamond which the Queen gave him for the portrait of the King. And I beg you most instantly to do this, since His Eminence does not wish me to buy other jewels until we have seen this diamond, so that we can discuss the matter better and more suitably. For the love of God do not fail in this, as His Eminence attaches great importance to it."[41]

Con responded to this impassioned plea. On 17 June 1639 the box containing Bernini's diamond and an ex-voto intended by the Queen for Loreto was at last sent off.[42] On 24 September Ferragalli wrote to Con that it had arrived in Rome, and "tomorrow the Cavalier Bernini will receive his very beautiful ring."[43] On 1 October Badelli, the agent of the Duke of Modena in Rome, reported: "The Queen of Great Britain has sent here a diamond worth 6000 scudi to be given to the Cavaliere Bernino in remuneration for the statue of the King her husband carved by him lifesize, and sent to be given to that Queen."[44]

The late Professor Wittkower, to whom Bernini studies owe so much, interpreted all these documents to mean that the bust was "a papal present to the Queen" and "regarded as an object of great political significance."[45] There is only one contemporary statement in favour of his view; on 18 April 1637, while the bust was being exhibited in Rome prior to its despatch, Francesco Mantovani, then agent to the Duke of Modena in Rome, wrote, "Barberini is sending it as a gift,"[46] but as he also says that it was being sent to Charles, whereas it is unquestionable that it was in fact sent to Henrietta Maria, we cannot place very much faith in his statement.[47] As we have seen, only Cardinal Francesco was involved in the matter and all that he says is that the persons conveying the bust to England must receive no payment or reward. That his instructions to this effect were serious is evident both from the order given to Chambers to keep a daily account of expenses and from Bonifazio's letter of October which shows some trepidation on announcing that he had accepted a gratuity from the Queen. It is of course possible to read Henrietta Maria's letter of thanks to Barberini as meaning that the bust was a present, but her reference to it is curiously casual if this was so, and comes with peculiar abruptness at the end of a string of requests for favours. If we look again at all the letters exchanged among the Queen, Con, Ferragalli, and Barberini, the conviction grows that Henrietta Maria is thanking the Cardinal for his pains in obtaining licence for the bust to be executed and for arranging its transport rather than for the money he has expended in having it made. This interpretation is supported by the accounts of Cardinal Francesco Barberini, which exist in full, and which record no payment to Bernini for the bust although they do record payments to Chambers for its transport.[48]

It so happens that we have another certain touchstone by which to test this view, the value of the diamond, which we saw was said by Con, the best person to trust in these matters, to have been worth 4000 scudi or £1000. Now we are fortunate in

having a most interesting contemporary record of the sort of payment Bernini was receiving for various kinds of work in 1633. On 29 January of that year Fulvio Testi, one of the most celebrated Italian poets of the age, wrote from Rome to a friend that he hoped to spend a joyous carnival. There met regularly at his house a select company of gentlemen who were deeply versed in letters but also wits and men of the world, and he had succeeded in persuading the Cavaliere Bernini to join them as a favour to himself. He describes Bernini as "that most famous sculptor . . . the Michelangelo of our century in both painting and sculpture," and goes on to speak of his expectations of a comedy Bernini had written and was shortly to produce in which the whole court of Rome was satirised: "There are things in it to make one die of laughter." Continuing, he says, "And so that you may understand that this is no ordinary person, learn that for having erected those four columns of bronze in St. Peter's the Pope gave him 12,000 Roman scudi; the board of works of St. Peter's give him 300 scudi a month to be their architect; a statue from his hand is worth four or five thousand scudi; the head alone of Cardinal Borghese, that is to say his portrait bust, which really lives and breathes, cost 1000 scudi."[49] To turn to other works executed during the 1630s we know that Bernini was paid 800 scudi in 1630 for a marble memorial to Carlo Barberini, 3300 scudi for his statue of St. Longinus (1629–38), 3200 scudi for the relief *Pasce Oves Meas* (1633–56), 2000 scudi for the statue of Pope Urban VIII erected by the Roman Senate (1635–40).[50]

These figures prove that what Bernini received in the form of a diamond worth 4000 scudi was payment on a truly royal scale for the bust. And if we examine the history of other works Bernini executed for princes and cardinals, we shall find the same pattern of commission and payment reappearing. The bust of Cardinal de Richelieu, commissioned and executed between 1639/40–41, has a parallel history. Again Barberini intervention was invoked for the first approach to the sculptor, again portraits were sent from Paris, again the bust was conveyed to France by studio assistants of Bernini, again the sculptor's reward was "a most magnificent jewel," accompanied by presents from Cardinal Mazarin which are described as "most munificent."[51] Wittkower himself, when discussing the superb bust of Duke Franceso I d'Este of Modena, describes the 3000 scudi which the Duke paid Bernini as an "incredibly large sum."[52] But here again the original proposal had been that the Duke should reward Bernini with "one of those small German credences which cost from seven to eight hundred scudi."[53] The Duke did in fact write to Germany to order such a credence, but was put off by the enormous price demanded. Finally, on receiving his bust, he paid much more than was at first intended, but even at this stage the Ducal agent before giving Bernini cash asked him if he would prefer some valuable object, only, it is true, to receive the reply that "as regards jewels and silver plate" the sculptor was already well provided.[54]

Other instances could be cited from Bernini's career to show that valuables were a perfectly normal means of payment in the seventeenth century. But perhaps the two examples quoted make the point, and clarify the etiquette which left the exact amount of payment in such exalted artistic commissions to the munificence of the prince or cardinal. The conclusions from all this evidence are surely inevitable: the bust was commissioned by Henrietta Maria acting as a cover for Charles; its execution was supervised by Cardinal Francesco Barberini, who also paid for its conveyance to London; the bust was not a papal present, but was paid for in kind by the present of a splendid jewel. The elegance with which these matters

are enveloped in the official correspondence is only a delicate disguise of their commercial nature, put on in accordance with the manners of the age to allow both Bernini and the English royal family to play a courtly game of compliment. And if it is likely that the licence to execute the bust was first conceded by the Pope in the indirect hope of pleasing Charles, there is not the slightest evidence that either he or his nephew thought it would seriously influence the King's political and religious policy. It must also be remembered that whatever private arrangement Charles may have made about the bust with Henrietta Maria, it was she who commissioned it, she to whom it was sent, and she who paid for it. In this way, neither the Papal court nor the King was exposed to criticism, the one for granting favours to heretics, the other for receiving them from Rome. Indeed it might fairly be said that in so proceeding all parties neatly avoided giving any political significance to the bust—and this was surely their object.

Bernini's bust of Charles I marks the point at which his reputation as the greatest sculptor of the age became an internationally acknowledged fact. Since the work was lost to us at the end of the seventeenth century, there is little point in enlarging at great length on its artistic conception or merits. But something must be said to correct current misinterpretations. We know from a letter of 21 September 1650 written by Cardinal Rinaldo d'Este[55] to his brother Duke Francesco that in portrait busts a seventeenth-century sculptor was expected to reproduce the proportions of the sitter's face accurately, in other words to capture a facial likeness, but that in matters of drapery and headdress his fancy was allowed free rein. From the reproductions that survive of the bust, the seventeenth-century engraving attributed to Van der Voerst, the eighteenth-century copy at Windsor (figs. 1, 3), and various drawings and casts, we may surmise that Bernini followed these canons to the letter. Hence we can suppose that in a country accustomed to the smooth, impersonal, essentially Mannerist royal portrait busts executed by Le Sueur, the use of forceful modelling and sharp undercutting to produce those strong contrasts of light and shade of which Bernini was such a master must have come as a delightful shock. We can suppose too that the modelling of the face had all that vivacity of animation which made Fulvio Testi say of the Borghese bust that "it really lives and breathes." The brilliance of invention which emphasised the movement of the head by the diagonal swing of the sash and the lock of hair falling on the left shoulder can still be felt in the copies, as can the skill with which the ridge of the breastplate above the sash and the Garter George below it were used to establish the underlying frontality of the bust and stress simultaneously the sensation of movement. I am disinclined to think with Wittkower that because Charles is shown in ordinary dress in the Van Dyck triple portrait and in armour in the bust that Bernini consciously undertook a heroicisation of Charles. The Van Dyck triple portrait was painted essentially to give Bernini the "correct proportions" of the King's face, in other words to supply him with something to copy in an area of the bust where he was not allowed to invent. It is not therefore, nor was it ever meant to be, a formal portrait of the King, nor was it intended to set a pattern for the rest of the bust. Consequently the accoutrement of the King in armour in no way constitutes a significant difference between the Van Dyck portrait and the bust. In reality no great effort of imagination was required on Bernini's part to think up armour as the costume of the King, since every secular ruler, however pacific his nature, was normally shown at this period and for a century to come wearing armour in a formal portrait. Charles wears armour in all Le Sueur's busts, for example.

Bernini's real contribution to formal portraits of this type was to break up their solemn rigidity by introducing movement, expression and a free play of light and shade without detracting from the dignity of the sitter. The Charles I bust, so far as we can judge, belonged to the stage of Bernini's artistic creation when he was content merely to enliven the traditional type of bust of a secular ruler, and not to that later stage where asymmetry and great whorls of drapery produce an incomparable sense only not of majestic movement but also of irresistible grandeur. Wittkower thinks even so that it glamourised Charles, because the Venetian ambassador described Charles in 1635 as melancholic, presumably using the word in a seventeenth-century way, that is, to describe the dominant colour of his temperament. In a sense of course most formal portraits of persons of rank flattered in that age, but perhaps the authority and dignity which the bust seems to have possessed were not too discordant with the personality of a man who ruled eleven years without a Parliament, and on the day of his execution

> . . . nothing common did or mean
> Upon that memorable scene,
>
>   . . .
>
> But bow'd his comely head
> Down, as upon a bed.

### III.   THE PROJECTED BUST OF HENRIETTA MARIA

So delighted were Henrietta Maria and Charles with Bernini's bust of the King that the Queen immediately requested licence for Bernini to carve a companion bust of herself. On 7 August 1637 Con wrote to Barberini: "Their Majesties are everyday more pleased with the statue sent by Your Eminence to Her Majesty the Queen, who now solicits her own portrait, so that she may have this new obligation to Your Eminence whom Her Majesty does not fail to mention every day with expressions such as Your Eminence's accustomed modesty does not willingly hear."[56] But after this first enthusiasm, the Queen procrastinated, and only on 27 November was Con able to report that she had "at last allowed herself to be painted in those three manners that are needed to make the companion head to that of the King."[57]

But this positive statement does not mean what it seems to mean, for on 25 January 1638 Con was writing to Ferragalli: "I have received the diamond for the Cavalier Bernino and now I shall be able to solicit with a better countenance the letter and at the same time the paintings to make the head of Her Majesty."[58] His solicitations were unavailing, probably because Henrietta Maria was reluctant to give the long sittings which a triple portrait like that of the King would require. On 25 June Con described to the Cardinal the King's joking pressure on his wife: "The other day while I was urging the Queen in his presence to allow herself to be portrayed, the King said, 'I too am going hunting on Tuesday, and I will leave you my wife for all the rest of the week; persuade her, and guard her well': which was said in such a way as to cause all the Court to laugh, and everyone advised me to take good care of the Queen."[59]

Henrietta Maria's indolence was only partly overcome by Charles's teasing, for in another despatch of the same date Con says: "The Queen is at Greenwich, and by the grace of God enjoys good health. When I have finished this letter I shall go there to meet the Cavalier Van Dyck to see if it will be possible to make a single

portrait of the Queen for the Cavalier Bernino to use."[60] Evidently it was not possible, for on 27 August Con wrote, "Her Majesty has at last put on exhibition the portraits for making her head, and they will be despatched on the first good occasion. In these as in all her other needs she trusts in the customary affection of Your Eminence, whom she will notify more particularly of her wishes."[61]

Two paintings of the Queen "pour Mons^r. Barnino" were charged at £20 in an undated bill submitted by Van Dyck to the King, probably late in 1638, and were reduced by him to £15.[62] But it was not until June 1639, on the return of Conto Rome, that Henrietta Maria wrote to Bernini. Her letter was already known from an Italian translation printed in Baldinucci's life of Bernini (1682): here is her original, which still survives in damaged form, having once been pasted on to the back of Van Dyck's triple portrait of the King by Bernini, proud of the honour it did him. The words in brackets are a restoration from the Italian translation, which is a very literal rendering of the original:[63]

Monsieur le Chevalier Bernini l'estime que le Roy mon [mari et] moy avons faict de la statue que vous lui avez faict, all[ant de pair] avec l'agrément que nous en avons comme d'une chose qui [mérite] l'approbation de tous ceulx qui la regardent, m'oblige main[tenant] a vous tesmogner que pour rendre ma satisfaction entiere je desireroys en avoir une pareillement de moy travail[lé] par vostre main, et tirée sur les portraicts que vous fournir[a le] Sieur Conneo au quel ie me remets pour vous assure[r plus] particulierment de la gratitude que ie conserviray du [plaisir] que J'attens de vous en ce rencontre priant Dieu qu['il vous] tienne en sa sainte garde. Donne a Whithall ce [26] Juin 1639.

<div style="text-align: right">Henriette Ma[rie].</div>

The bust was in fact never executed. Baldinucci records that "the troubles which shortly afterwards rose in the kingdom were cause that no more was done about the Queen's portrait."[64]

## IV.  THE BUST OF MR. BAKER

Bernini's other bust of an English patron was commissioned as a private portrait, not as a public image (figs. 4–7). As such it is of exceptional interest in the history of sculpture, for it is one of the earliest documented essays in the bust as a pure art-form, rather than as a heroic commemoration of a ruler, or of a great secular or ecclesiastical dignitary, or of the illustrious or deserving dead, or of a living personage of exceptional fame or achievement, or of the honoured founder or ancestor of a family line. Like the bust of Charles I, it too has its importance in the context of English culture and English history.

The sitter was Thomas Baker (1606–1658), on whose career, previously veiled in obscurity, I was fortunate enough to be able to throw a little light in a previous publication. Further research and reflection have provided a fuller background. Thomas was descended from a younger branch of the family whose fortunes had been founded by Sir John Baker (d. 1558), a lawyer who climbed from nothing to become Chancellor of the Exchequer in 1545, under King Henry VIII, and to build himself a great house at Sissinghurst in Kent. Sir John had two sons, the elder of whom, John, was disinherited in favour of his younger brother, Richard (d. 1594). From Richard descended the main line of Bakers of Sissinghurst, who rose in the person

*4. Bernini.* Bust of Thomas Baker. *1638–40. Marble, height 32 1/2″. Victoria and Albert Museum, London*

*5. Bernini.* Bust of Thomas Baker *(back)*

of Henry, Richard's grandson, to a baronetcy, the ultimate honour for a wealthy country gentleman in Jacobean times. Sir Henry died on 4 December 1623, and was succeeded by his son Sir John (d. 15 January 1653), the head of the family for most of Thomas Baker's lifetime. The disinherited John was the father of the chronicler Sir Richard Baker (c. 1568–1645), well known as the author of a *Chronicle of the Kings of England* (1643) which was long one of the few books to be found in the houses of English country squires. Richard also published a number of devotional books, some dedicated to his kinsmen, the wealthy Bakers.[65]

Thomas, the younger son of Richard of Sissinghurst, was the father of our Thomas. He owned property in Kent and kept up his connections with that county, for in 1605 he was appointed its sheriff, an annual office, and "kept its shrievalty at Sissinghurst." His first wife, Griselda Berny, left him all her estates in Suffolk, Norfolk, and Gloucestershire, and on his father's death he inherited the manor of Whittingham, at Fressingfield in northeast Suffolk. Whittingham henceforward was to be his principal seat. The house has long since been pulled down and only its foundations and stables remain. In 1842 it was described as having been "a noble mansion, with a chapel attached to it, situated in grounds surrounded by a moat." The stables have long been used as a farmhouse: they were built in 1653 by our Thomas Baker, Bernini's sitter.[66]

On 19 May 1601 the elder Thomas bought Forest House at Leyton, in Epping Forest, just northeast of London on the road through Essex into Suffolk. Here he built a "Great House" which his son was later to occupy. In situation Forest House lay convenient for London, while being clear of the stench and infection of the great city. On 24 December the same year a marriage settlement was drawn up whereby all the Leyton property was settled by Thomas on his new wife Constance, daughter of Sir William Kingsmill of Maltsanger in Hampshire, as her jointure. The Kingsmills were a solid family whose history was similar to that of the Bakers, indeed to that of many other gentry families—a first eminence in the law, followed by the acquisition of a country estate, knighthood, and later a baronetcy. Thomas himself became a knight on 11 May 1603 at Northampton, where he had gone to meet the new King, James I, on his journey south.[67]

The eldest child of the marriage was our Thomas, born in 1606, who was followed by Elizabeth, christened in 1608, and Richard. We know little of the character of Sir Thomas and Dame Constance. They were patrons of that prolific divine Thomas Tymme, minister of Hasketon in Suffolk, who in 1618 dedicated his *Chariot of Devotion* to them, describing them as "Patrons of Religion and godlinesse." Tymme also dedicated his manuscript translation of Dr. Dee's *Monas* to Sir Thomas. Sir Thomas died in 1622. By his will, made at Whittingham Hall on 3 June 1622, he bequeathed to his son Thomas his manors in Lincoln, Sussex, and Kent, being "a full third part of all lands, to Richard his manor at Hinton, in Gloucestershire, and to his wife all his property in Suffolk." Thomas and Richard were left under the care and wardship of their mother.

Thomas was sent to Oxford, where he matriculated at Wadham College on 10 October 1623: his brother Richard matriculated at the same college in 1624.[68] Lady Baker died late in 1625, and Thomas had to spend the next two or three years in settling the family property. Meanwhile his sister Elizabeth became a Maid of Honour to Queen Henrietta Maria, the most honourable form of guardianship for an orphan girl of good birth. Travel abroad was already well established in the theory and practise of Renaissance education as an indispensable complement to the formal education of an English gentleman, and Thomas was preparing to

set out for the Continent by 31 October 1628, when he was granted the necessary licence in the form of a pass from the Privy Council "to travaille into forraine parts."

His departure was delayed by a lawsuit brought against him by Sir Thomas and Dame Mary Lake in 1629. Sir Thomas, an erstwhile favourite of James I, was Lord of the Manor of Leyton, and brought the suit over money pretended to be due to him for property at Low Leyton which the Bakers had leased of him and then allowed to fall into disrepair. In his protest against the suit Thomas complained that "having prepared all things necessary for his departure on or about the 19th of June of the 4th year of his said Majesty's reign" (1629), he had been arrested at the suit of Lake for £31.16.8. pretended to be arrears and due.[69] Having got free of this entanglement, he was probably detained by another piece of business for which his presence was indispensable, the marriage of his sister Elizabeth in 1631 to Sir Thomas Hanmer (1612–78), a young baronet of ancient Welsh family who had been page and Cupbearer to King Charles.[70] Dame Constance had left Elizabeth a portion of £3000 and her jewels, so that she was a desirable *parti*. She must also have been something of a beauty, for a letter from James Howell, dated 1 March 1630/31, reports, "There is little news at our Court, but that there fell an ill-favour'd quarrel 'twixt *Sir Kenelm Digby*, and Mr. *Goring*, Mr. *Jermin* and others at St. *James*'s lately, about Mrs. *Baker* the Maid of Honour, and Duels were like to grow of it, but that the business was taken up by the Lord Treasurer, my *Lord of Dorset*, and others appointed by the King." Sir Thomas Hanmer and Elizabeth were certainly adherents of the Court, to which they were to remain obstinately loyal in the Civil War.

By 16 February 1631 Thomas had cleared all obstacles, and procured another pass from the Privy Council. This time he succeeded in making his way abroad, for on 31 May 1634 the Privy Council granted "A license for Thomas Baker Esqr. to remain in the parts beyond the seas for the space of three yeares next after the date hereof." The licence was renewed on 19 June 1635 and again on 1 October 1637.[71]

What of his movements abroad? We know that he visited Spain, and he will certainly have spent some time in France, most probably at Paris. Very probably he also travelled in the Netherlands. His kinsman, Sir John Baker, the baronet of Sissinghurst, was at Paris in 1632, with a party that included Richard Fanshawe, later famous as a poet and diplomat. From Paris Fanshawe went on in 1635 to Madrid, to learn Spanish, together with several other Englishmen. Because of the bonds of cousinship between Sir John and Thomas, it is tempting to suppose that he made one of both these parties, but the correspondence between their movements and what we know of Baker's may be only a coincidence. The proviso "not to goo to Rome" was conventional, and at this date, with an easing of the tension between Protestant England and the Papacy, universally ignored. Indeed Baker had already broken it, for on 16 November 1636 "Mr. Baker, a gentleman of distinction" dined in the refectory of the English College at Rome.[72] This Mr. Baker must have been Thomas, since no other Baker to whom such a description could apply received a pass to travel abroad in the 1630s. Englishmen visiting Rome were usually invited to dine at the English College shortly after their arrival, and it must have been about then or during the following months that Baker first heard of the bust of the King.

We shall return to the problem of his own bust later. Meanwhile let us pass on to our only other dated record of Baker's movements in Italy. Late in 1639 he was

in the territory of Venice, searching for pictures. We know this because in December that year he was arrested together with his servant at Cividale di Belluno, where he had gone to inspect and purchase pictures. He was taken into custody for being in possession of a loaded pistol: Venetian edicts against the carrying of offensive weapons in that century of touchy honour and private quarrels were strict and strictly enforced. On the other hand it was only natural for a foreign traveller journeying alone to arm himself against robbers and insult. Before going to Cividale Baker had spent some time in Venice, and had fallen out with the English Resident Gilbert Talbot. Accordingly he appealed to the French Ambassador Claude Mallier du Houssay, who apparently knew him well. Mallier was ill when Baker's messenger arrived, and it was his consul who on 28 December presented a memorial on his behalf to the Doge and Senate. In it he asked for Baker's release, claiming that the pistol was broken.

This memorial was forwarded to Almaro Tiepolo, the Venetian nobleman then governing Cividale as its Capitano and Podestà, for his report. On 9 January 1640 Tiepolo replied that the memorial was not strictly correct, as the pistol was in perfect working order, but that Baker had otherwise conducted himself impeccably "during his stay in the neighbourhood for the purchase of pictures," and that in prison he had behaved with "extraordinary fortitude, fearlessness and composure. This shews him to be a person of quality which makes him worthy of the clemency of the state." In spite of this favourable impression Tiepolo did nothing to relieve the rigour of Baker's imprisonment, and on the evening of 10 January an express messenger reached Mallier with an account of his "continual sufferings and miseries" in "a dark room, badly treated." The Ambassador went in person next day to complain to the Doge and Senate of the treatment of this "English gentleman, who is a principal cavalier of that kingdom, of good birth, well-connected, and who has quite 25,000 ducats of income a year. He stays in Italy for his pleasure, and as he takes particular delight in painting, he travels about curiously examining those places where they are to be found and also gladly buys any if he meets with the opportunity."

The Ambassador then explained that it was this quest which had taken Thomas to Cividale—where he presumably hoped to pick up cinquecento Venetian pictures, so eagerly collected by *virtuosi*. As he was on the point of departing, a spy saw his servant packing up a broken and useless pistol in a saddlebag and went at once to the police. Baker had just mounted his horse, when he was ordered to go to the Podestà. He was then clapped into prison, although he had protested his quality and that the pistol was unloaded, broken and could do no harm to anyone. Mallier asked the Doge to order that Baker be transferred to decent accommodation until the business was properly settled, and reminded him that foreigners in difficulties ought to be treated with every consideration, as similar accidents might well happen to Venetian noblemen on their travels abroad. He ended by repeating that Baker was a rich and well-connected cavalier and should be treated as such, not like a common porter, and by assuring the Doge that the English nation and the King of England himself would be glad to hear of his release.

In reply the Doge said that the policy of the Republic was to receive strangers kindly and that he was sorry to hear of this gentleman's misfortune. But some bad report must have been made of him to the Podestà. They had written for information to Belluno and would repeat their commands, in as much as it was always their desire to satisfy the Ambassador in everything possible, and even more so in a case involving justice and a person of such great quality as Baker was represented

to be. The Ambassador then added that he made no complaint against the Podestà, who had only done his duty on finding a prohibited weapon, but that Baker ought to have been better treated. Distinctions were made in these matters according to rank. Such was the custom in France, where in similar case Baker would have been assigned a good room, seeing that he had the means to pay any expenses he would have incurred. No one should be presumed guilty until judgement is given against him, when the rigours of justice have full place. Baker had now been confined for three weeks to a dark room, and he, the Ambassador, felt confident that the Doge would now order not only better treatment, but his release. After some discussion one of the Savii, Francesco Cornaro, replied that the memorial had been presented during his weekly tenure, and that a request for information had been sent off at once to Cividale di Belluno, but as yet no reply had been received. The Doge then said that fresh orders would be given and the matter expedited, with due attention to gratifying the Ambassador. Five days later orders were sent to Belluno for Baker's release, and on 18 January Tiepolo reported that Baker and his servant had been set free without charge, adding that they had been well treated during their incarceration and that the order to transfer them to a daylight prison had arrived in good time and had been promptly carried out.[73]

In all probability at the time of his arrest Baker was already on his journey homeward. His pass expired on 1 October 1640 and there is no record of its renewal in the Acts of the Privy Council. Instead we find on 23 September 1640 "A passe for Thomas Baker Esqe, to travell into forreigne parts for three yeares."[74] It is possible that Baker now went once again to Rome, for G. B. Bellori (1613–96), writing before 1672, records that he bought a Cupid from François Duquesnoy, better known as Francesco Fiammingo (1597–1643). Fiammingo, he says, carved a "life-size naked Cupid in the act of shooting an arrow and lifting up a leg behind him as he looks towards the mark. So great was the pleasure Francesco took in it, that presaging he would leave on this marble the last strokes of his chisel, he could not take his eyes and hand from it, nor was he ever weary of looking at it and touching it up, and although Mr. Thomas Baker, an Englishman, solicited him to obtain it, he was obliged to wait for more than a year after it had been completed."[75]

Bellori tells us that in his last years Duquesnoy suffered painfully from gout, melancholy, and physical weakness, so that he was unable to work for any space of time. He also says that in 1642 the sculptor made a clay model of a Virgin to be offered by the King of France as an ex-voto to Loreto. Bellori's life of Duquesnoy is constructed not in a rigid, but in a loose chronological sequence. Yet it does state plainly, in spite of contentions to the contrary, that Baker's *Cupid* was Duquesnoy's last marble, and that it was made before the model of the Virgin. It must in any case have been carved before June 1643, when Duquesnoy left for France, and the later events of Baker's life suggest, as we shall see, that it almost certainly dates from 1641 or early 1642. For from late 1642 onwards Baker was back in England and deeply involved in the Civil War.

The story of Baker's journeyings in Venetia and of the *Cupid* give an impression of him as a collector of tireless pertinacity and refined and splendid taste. The history of the Bernini bust stamps home this impression. There are four seventeenth-century sources for that history. The earliest is a report in the diary of the young English sculptor Nicholas Stone, who visited Bernini in 1638 and has left us the only record of the bust that is strictly contemporary. Next in date is a record made in 1665 by Chantelou, Bernini's faithful companion and *cicerone* during his ill-

fated visit to Paris. Rather less reliable is the account of it given by Baldinucci in his life of Bernini, published at Florence in 1682; and even less so is that of the sculptor's son, Domenico Bernini (1657–1723), whose biography of his father (1713) is largely a careless derivation from Baldinucci.[76]

Although Bernini's own words about the bust were spoken some twenty-five years after he had carved it, it is perhaps best to begin with them since they tell us its history from the point of view of the sculptor himself. On 16 October 1665 the Papal Nuncio and the Venetian ambassador to France visited Bernini's studio to see his bust of Louis XIV: "L'ambassadeur regardant le portrait du roi, lui a dit qu'à considérer en combien peu de temps il l'avait achevé, et travaillant avec la facilité qu'il fait, il fallait, à l'âge qu'il a, qu'il eût fait un grand nombre d'ouvrages. Il a répondu que si tous ceux qu'il a fait étaient ensemble, ils ne pourraient pas tenir dans cette salle où ils étaient: qu'il avait fait divers portraits, un entre autres, d'un Anglais qui, ayant vu le portrait du roi d'Angleterre qu'il venait d'achever sur ceux de Van Dyck qui lui avait été envoyés, il lui vint une si grande envie qu'il fît le sien, qu'il ne cessa qu'il ne lui eût promis de le faire, lui promettant de lui en donner tout ce qu'il voudrait, pourvu qu'il le fît sans que personne en sût rien, ce qu'il exécuta, et que cet Anglais lui en donna . . . écus."[77] Baldinucci gives the figure that Chantelou forgot as the enormous sum of 6000 scudi, equivalent in the 1630s to £1500.

According to Bernini himself, then, Baker began to press him for a bust on seeing his bust of Charles I. We already know that the King's bust was nearly ready in the summer of 1636, but was only placed on open exhibition in April 1637. Even as an Englishman, Baker is unlikely to have been allowed the privilege of seeing it before all the "Cardinals, ambassadors and gentlemen of quality" who flocked to see it at this first opportunity of inspection.

Bernini and his son Domenico both relate that it cost Mr. Baker some persistence, much persuasion, and an offer of magnificent payment before he inclined the great sculptor to his will. The reasons for Bernini's reluctance are easily surmised. By 1637 he was the all-dominant artist of Rome, a Cavaliere, and the Pope's official sculptor and architect. The years when he had been pleased to execute portrait busts for the monuments of inconspicuous personages were a decade and more behind him: since the mid-1620s he had accepted commissions for busts only of cardinals or of members of the great nobility. He had no shortage of work on hand, and the Pope had already refused him licence to carve the busts of certain unspecified, probably Italian, princes before 1635, when he was allowed to carve that of Charles I.

The immense and tempting payment offered by Baker was undoubtedly a considerable inducement, but the decisive motive was an artistic one. For Bernini felt that the bust of Charles, having been executed from painted portraits, did not do justice to his genius. Concerned for his reputation in that remote island, he determined at last to accede to Baker's request, probably early in 1637. All this emerges from his interview with Nicholas Stone on 22 October 1638, which turns entirely on the subject of the King's bust, over which the sculptor had evidently been brooding ever since its completion.

"Cauelier Bernine. . . . One Friday morning the 22th of October I went to his housse (with a young man a painter that spoke Italian), where I understood that he was not uery well. I sent him upp the letter; after a little pausse he sent for me up to his bedd side, who when I came to him he told me that I was re[com]mended to a man that could not doe much wth such and the like compli[ment] first, but after

he told me that after 2 or 3 dayes he hoped to [be] abrod againe and y$^t$ I should come againe to St. Peeters and I should haue what I desyred, being in a uery good umour hee askt me whether I had seene the head of marble w$^{ch}$ was sent into England for the King, and to tell him the truth what was spoken of itt. I told him that whosouer I had heard admired itt nott only for the exquisitenesse of the worke but the likenesse and nere resemblance itt had to the King countenannce. He sayd that diuers had told him so much but he could nott beliue itt, then he began to be uery free in his discourse to aske if nothing was broke of itt in carryage and how itt was preserued now from danger. I told him that when as I saw itt that all was hole and safe, the w$^{ch}$ (saythe) I wonder att, but I tooke (sayth he) as much care for the packing as studye in making of itt; also I told him that now itt was preserued with a case of silke, he desyred to know in what manner. I told him that itt was made like a bagg getherd together on the top of the head and drawne together with a strink under the body with uery great care, he answered he was afraid thatt would be the causse to breake itt for sayes he in my time of doing of itt I did couer itt in the like manner to keepe itt from the flyes, but with a great deale of danger, because in taking of the casse if itt hangs att any of the little lockes of hayre or one the worke of the band itt would be presently defaced, for itt greiue him to heare itt was broke, being he had taken so great paines and study on itt; after this he began to tell us here was an English gent: who wooed him a long time to make his effiges in marble, and after a great deale of intreaty and the promise of a large some of money he did gett a mind to undertake itt because itt should goe into England, that thay might see the difference of doing a picture after the life or a painting; so he began to imbost his physyognymy, and being finisht and ready to begin in marble, itt fell out that his patrone the Pope came to here of itt who sent Cardinall Barberine to forbid him; the gentleman was to come the next morning to sett, in the meane time he defaced the modell in diuers places, when the gentleman came he began to excuse himselfe that thaire had binn a mischaunce to the modell and y$^t$ he had no mind to goe forward with itt; so I (sayth he) I return'd him his earnest, and desired him to pardon me; then was the gent. uery much moued that he should haue such dealing, being he had come so often, and had sett diuers times already; and for my part (sayth the Cauelier) I could not belye itt being commanded to the contrary; for the Pope would haue no other picture sent into England from his hand but his Mai$^{ty}$; then he askt the young man if he understood Italian well. The he began to tell y$^t$ the Pope sent for him since the doing of the former head, and would haue him doe another picture in marble after a painting for some other prince. I told the Pope (says he) that if thaire were best picture done by the hand of Raphyell yett he would nott undertake to doe itt, for (sayes he) I told his Hollinesse that itt was impossible that a picture in marble could haue the resemblance of a liuing man."

The motives which led Urban VIII and Cardinal Francesco Barberini to inhibit Bernini from carving the bust of any other Englishman are easily understood. The licence to commission the bust of Charles had been regarded in Rome and accepted in England as a favour: it had been granted to Henrietta Maria as a daughter of the Church and because the Barberini were eager to encourage her to act as the patroness and protectress of English Catholics. As we have seen, in 1635 Cardinal Francesco had refused to write to Charles on the ground that he was a heretic, and there can be no doubt that although Barberini was anxious to leave a favourable impression of Rome on visiting Englishmen of rank, he was equally anxious to avoid any imputation of conducting himself with undue indulgence. The heretic

English must not be allowed to behave as they pleased in the capital of Catholicism.
Throughout the whole strange episode of the Papal agency to Henrietta Maria, the attitude of the Cardinal never essentially varied: the dignity of the Church must not be compromised by unworthy concessions. His hostility and that of Urban to Bernini's making another bust of an Englishman is to be explained partly as a desire not to debase a special favour and partly as a desire not to extend a privilege.

There can be no doubt that the "English gentleman" of Bernini's story was Thomas Baker.[78] We can assume that at some date after October 1638 Bernini either repaired his first terracotta model, or else made a second, from which he cut the marble we have. Attempts have indeed been made to reconcile the existence of the bust with the Pope's prohibition by claiming that the marble is not autograph. Yet apart from the visual evidence of the bust itself, the literary evidence is conclusive and unequivocal that Bernini himself carved the bust and was richly rewarded for it. If he had handed it over to an assistant, surely he would not have spoken of it as an autograph work some twenty-five years later in his crowded career, during a casual conversation, under circumstances and to persons imposing no kind of constraint. Clearly he remembered it well and chose to mention it because of the singularity of the circumstances attending its execution—the wealthy Englishman, the promise of silence he had had to make him, the enormous payment, 6000 scudi according to Baldinucci, half as much again as he had received from King Charles himself, and probably more than he had ever received for any other bust. The size of the payment, equivalent to £1500 as we have seen, surely indicates why Baker was remembered in Italy as a "Cavaliere ricchissimo."[79]

The conception of the bust dates therefore from 1638, and the marble either from 1639, the last year of Baker's first residence in Italy, or less probably from 1641–42, when it is possible that he returned to Rome and bought Duquesnoy's *Cupid*. The bust is lifesize, and to that extent imposing (figs. 4, 5). But as we have already pointed out, it is not a ceremonial portrait of a dignitary, but a pure portrait of a private gentleman. Yet if Baker bears no ensigns or emblems of rank and office, Bernini has cleverly suggested his station, proclaiming him in bearing and dress a person of quality. His head is turned sharply to the right, and his left shoulder is retracted to match this pose, which sets the face in near-profile and was perhaps chosen because Baker's features were rather broad and square, and not strongly expressive. Accordingly the hair, a mass of loose curling locks after the fashion of the period, is thrown up for the sculptor to handle with his customary virtuosity. Bernini has treated it with artful naturalness as a composition of locks shaped as serpentine forms, waving in general downwards, but with one or two breaking upwards for liveliness of effect. Some small curls are made to stray across the heavier forms with a delightful suggestion of disorder in order. For a cunning effect of texture the marble is left slightly rough and lightly grooved with serpentine lines (fig. 6). The transition from the upper locks, shown resting on the lower locks, is managed with beautiful smoothness. And with his customary virtuosity Bernini has boldly pierced the ends of the locks over the forehead and at the bottom of the hair on the left, so that the mass is lightened and at the same time seems to have the freedom of nature. It is no wonder that in the next century Horace Walpole exclaimed in admiration: "The hair is in prodigious quantity and incomparably loose and free; the point band very fine."[80]

The face is framed and shadowed by the hair, which is tied by a ribbon on the

6

*6. Bernini.* Bust of Thomas Baker
*(detail of hair)*

*7. Bernini.* Bust of Thomas Baker
*(head and shoulders)*

7

left shoulder, a delightful desinence. The eyes are blank, and the face itself is an objective piece of portraiture, that is, without any significant expression, unless it be that of a sitter's consciousness of sitting. Yet the smooth planes of the countenance, for all the want of a distinctive cast of character, suggest with Bernini's indefinable skill a living face, and the lips, parted below the small moustache, add animation. The moustache itself is a neat passage of textured roughness, taking up the motif of the hair and contrasting with the smoothness of the face.

There can be no serious doubt that the whole head is autograph, and indeed it is only the lower part of the bust that has been seriously impugned as largely the work of an assistant.[81] Its design must be Bernini's, if only for the skill with which the problem of the arms is solved by concealing them under the cloak, whose sides are brought across the chest and tucked into each other, rather in the manner of a toga, so making a unitary form of chest and arms. The folds of the cloak are few, bold and simple, for the sake of effective contrast with the lace collar, and there is no reason why Bernini should not have left the execution or finishing of this part of the bust to a pupil, if a pupil's assistance must at all costs be postulated. The animation of the lower part is in fact achieved by the rest of the bust, the gloved left hand, the subtle treatment of the doublet, the incomparable lace collar. The gloved hand emerges as a protrusive motif to balance the massy head with another prominent form. At the same time it justifies the tension of the folds of the cloak and contributes more of the naturalistic animation so dear to Bernini. The retraction of the left shoulder assists the naturalness and the exact rightness of emphasis of the motif.

The doublet is unbuttoned, for looseness and freedom of effect. The hemming of the border and buttonholes is rendered with exact minuteness, both as a piece of virtuosity and to suggest the loose smooth flow of the cloth (fig. 7). There is a similar delicacy of precision in imitation in the care with which Bernini has rendered the lace whose surface is lightly ribbed to suggest the texture of the threads. Indeed the collar is a masterpiece of virtuosity in carving: at the neck the marble is completely undercut except on the left chest, creating an illusion of the folds of real lace without sinking into mere mechanical imitation and without any inflated emphasis of the motif. The device is repeated twice on the left and right, so that the view has a marvellous simulation of the movement of lace, of one material resting on another.

Probably, as we have implied, Bernini concentrated on Baker's hair and costume because the sitter did not have a strong, powerful physiognomy and had no rank or dignity that Bernini could becomingly have emphasised by expression, pose, or emblem. To suggest, as has been done, that Bernini was mocking his sitter is to mistake his sense of decorum, indeed to credit him with democratic ideals out of place in a society where high station was emphasised by richness of costume and hair style. Bernini was so sought-after as a portraitist because, like all successful court portraitists, he accepted his sitters at their own valuation of themselves and of their rank and importance. Even if this were not obvious from the bust itself and from the context of Baroque culture, there is nothing in the history of the bust, as we have seen, to justify such an interpretation. Indeed Vertue, writing in 1713, noted of the bust: "it's said to be better than that was of the King."[82]

One historical problem still remains. Bernini, who should have known best, says that Baker commissioned the bust on seeing the bust of Charles. But Vertue, again writing in 1713, declares that it was Baker who took the Van Dyck portrait of the King to Rome. If it was Baker who took the Van Dyck portrait, he must

have returned to England in 1635. It does so happen that his brother Richard died in that year and that a licence of entry on his lands in Gloucestershire was granted to Thomas on 16 November 1635. The documents concerning this transaction do not say whether Thomas was present in person or whether it was managed by an agent, but the coincidence of dates is striking. It might be that he was given the task because of his sister's court connections, and because he was about to return to the Continent, whence he had been abruptly drawn by his brother's death. On the other hand, the story may well have been invented at a later date to explain the existence of the Baker bust, for there is no other evidence that links him with the court circle of art-patrons and collectors and much that shows he was hostile to the King and his government.[83]

What of his instruction to Bernini to say nothing of the bust to anyone? It may be that Baker was aware of an apparent presumptuousness in appearing to set himself on the same level of importance as the King in having his portrait carved by the first sculptor of the age. Indeed as an art-form the bust was not consecrated to modesty. As a representation of an uncanonised personage the bust had been a mid-fifteenth-century revival of a classical genre and it quickly came to be used for the same purposes as in antiquity—the commemoration of the deceased either on tombs or as "*imagines*" in the family palace and for the exaltation of the living. Only in the eighteenth century did it become commonly employed for life-portraiture, as well as retaining its earlier functions. Accordingly it is not surprising to find that even in Italy the great majority of busts produced from the fifteenth to the eighteenth century are posthumous. The only personages whose busts were normally carved during their lifetime were princes, secular and ecclesiastical, or personages whose exceptional achievements seemed to themselves or to their admirers deserving of such an honour. Founders of families, builders of palaces, military heroes, poets at the end of their lives, such in general were those who were awarded or awarded themselves busts while yet living. An example will illustrate the force of the convention. After Cardinal Maffeo Barberini became Pope Urban VIII in 1623, he commissioned busts of two or three deceased members of his obscure and only moderately noble family to adorn his great new family palace, naturally choosing those of modest distinction for this honour.

The transformation by which the bust also came to be regarded as another form of portrait began, so far as we can tell, in the 1630s. Yet even in Rome the first busts intended as life-portraits rather than as commemorative monuments represented personages of the highest rank—Cardinal Scipione Borghese (1632), Duke Paolo Giordano Orsini and his wife the Duchess Isabella (c. 1635), Cardinal Francesco Barberini, and the like. Such busts, as we have already seen in the instance of the Baker bust, do not emphasise the hierarchical importance of the sitter, or assimilate him to an antique type, like so many Mannerist busts, but portray personal appearance and record individual, perhaps even transient features, like the stylish mustache of Paolo Giordano Orsini, with comparative informality.

A few rare busts do survive from sixteenth-century England, and even one or two family "*imagines*," such as those of the Bacon family at Gorhambury. But even in Caroline England independent busts were still rare, and the form was essentially reserved for the image of the King. On English funeral monuments of course busts did appear more frequently, since one of their classic functions was the commemoration of the dead. We can deduce that as an ordinary country gentleman and as a young man of no particular achievement Thomas Baker in the eyes

of his fellow Englishmen was guilty of an audacious act of overweening vanity in commissioning a bust of himself, and his injunction of silence to Bernini is perfectly understandable. We may conclude from his precaution that his prime object was to obtain a beautiful work of art rather than a heroic image of himself.

What of Baker after his return to England? The gentry of Suffolk, like that of the rest of East Anglia, were almost all zealous Puritans and Parliamentarians. Local feeling therefore as well as strong personal conviction may have played its part in persuading Baker to take the Parliamentary side in the Civil War. He was not unique as an art-lover in his party: Oliver Millar has shown that there existed a circle of collectors and patrons outside the sophisticated royal court.[84] Baker's choice of sides set him against the rest of his family: Sir John Baker, its head, suffered heavily for his support of the King, while Sir Thomas Hanmer, Thomas Baker's brother-in-law, captained the Royalist cause in North Wales until defeat drove him into exile at Paris with his wife and two children.

Baker played a prominent role in the Civil War in Suffolk. On 1 June 1643 an Ordinance of Parliament appointed him to the newly formed Committee for the County of Suffolk. On 3 August Parliament set up committees to levy money for the maintenance of its army and cause and Baker was named to that of Suffolk. Meanwhile he had been actively engaged in opposing the Earl of Newcastle, who was marching south to attack the Associated Counties of Norfolk, Suffolk, Essex, Cambridge, Hertford, and Huntingdon. Baker was named to the committee hastily appointed by Parliament on 20 September to organise resistance. On 15 June 1643 his signature with that of others of the Suffolk Committee appears at the foot of a letter sent from Cambridge to Sir Thomas Barrington and the other Parliamentary Deputy Lieutenants for Essex urgently requesting reinforcements to the garrison against a possible attack by the Queen and her army.[85]

Shortly afterwards, however, the heavy financial levies enforced by Parliament dampened his enthusiasm for the cause and drove him to threaten resignation. The affair is interesting because it reveals that Baker also had a house furnished with valuable pictures in Inigo Jones's new and fashionable Piazza of Covent Garden. It also brings us into direct contact with an otherwise elusive figure. On 14 November 1642 Parliament had made an order that loans should be raised on the Public Faith of the Kingdom at an interest rate of 8 percent.[86] On 26 November the Committee for the Advance of Money was appointed to carry out this order and began to hold sittings at Haberdashers' Hall. Contributions were assessed at one-twentieth of the real and one-fifth of the personal estate, but as no allowance was made for the depreciation on value of both property and income or their loss on account of the crisis, the sums demanded were often excessively high, and only rarely were they paid in full. Yet wherever the writ of Parliament ran the assessments were exacted with a certain rigour, and although allowance was made for money already lent, the grant of Public Faith was conditional on payment being made ten days after the summons had been served by the collector. If payment was not made, orders were issued for the seizure and sale of goods and the seizure of houses and lands.

Baker lent Parliament £100 as soon as the proposal was made for raising money by loans, but the Committee felt that even this large sum did not nearly represent what he was able to contribute to the cause. On 18 July 1643 "Thomas Baker of Martins in the feildes" was assessed at the huge sum of £500, and on 20 July notice of this was given to him. Baker refused to pay, and some pictures and other valuable goods in his London house were seized and conveyed to Guildhall.

Furious at such treatment, Baker wrote an angry letter from Whittingham Hall on 11 September to "my worthy honoured Friend" Sir Thomas Barrington, of Hatfield Broad Oak, Parliamentary Deputy for Essex. This letter, the only one from Baker known to survive, is written in an elegant hand and runs:

> Honourd Sir, Since I had the happynesse to see you at Eppinge in Essex, I have ever been in this Countie, and continually employd in the publike service, to the great preiudice of my Estate, not havinge been anywayes settled, since my cominge from beyond the seas. Besides the totall losse of all the profits of my Landes in Lyncolnsheere, and Glostersheere, where the best part of my estate lies. I lent one hundred pounds at the first upon the propositions, and not ten dayes since, sent in two horses compleatly armed, worth 50 poundes at the least and have payd all rates and ceasement whatsoever; I did conceive these had been sufficient to secure me from any trouble. Yet notwithstandinge the committee of Haberdashers hall in London have ceased me at 500ls. for my 8th and 20th part, which indeed should have been only ceased where I am resident; and I beelieve will proceed to levie the same. Sr the opinion I have of your worth and iust dealinge, and the credit and respect I know you have for the same, with this and all other Committees, mov'd me to make my addresses to you, and to shew you, that I conceive this course, tendeth to the preiudice of the service, for truly if they shall proceed to the execution of this their purpose, I shall not only repent me of what I have done, but resolve never to doe any thinge more in the least kind, which I feare may bee but of ill consequence in this place where I live. Now Sr, if you conceive this occasion may be worthy your letter to the Commitee, I shall desire that fauour from you, otherwise to spare that trouble, and give me leave to remayne,
>
> > Your affectionate
> > Humble Servant
> > Thomas Baker.

This determined letter served only to mitigate the severity of the Committee at Haberdashers' Hall, but did not make them lift or moderate the assessment. On 20 September the Committee ordered "that ye goods distrayned belonging to Mr. Thomas Baker of Covent Garden be redelivered by Mr. Go[ff *or* ss]e he paying the Collectors their salary at three pence in the pound for ye full assessment and all charges in ye distrayning of his goods, forsomuch as ffrancis Rothwright his Svt. hath promised that One hundred & fifty pounds shall be pd. here within a weeke wch wth one hundred pounds formerly lent will be the moiety of his assessment and for the other moiety he the same Mr. Rothwright promises Mr. Baker shall stand to the order of this Committee. This Committee having received a letter from the Deputy Lieutenant of ye County of Essex in his behalf." The £150 was paid on 5 October, in part again, but the Committee was not content, and the very next day Baker was ordered to pay his full assessment forthwith. He complied either willingly or unwillingly, and on 9 October the books of the Committee note "Deposited by Mr. Baker of Covent Garden one hundred and fifty pounds and 150l formerly." The Committee now seem to have been satisfied that they had got either all they could or all they might reasonably expect, for on 15 January 1644 they ordered "That ye pictures of Mr. Baker at Guildhall and other things be delivered to him, his assessment being paid." On 3 April 1644, the Committee further ordered "that ye seizure made as upon ye rents & estate of Tho: Baker in

Holborne be discharged it appearing that ye same do belong to Antho: Stringer Cooke to my lo Craven, & conveyed long since to him by deed inrolled." In March 1654 Baker was granted a certificate that he had paid £400 "Upon his 20ᵗʰ part."

In spite of all this wrangling and threatening Baker cannot have borne the Parliamentarians any real ill will, for he continued a member of the Suffolk Committee until his death in 1657.[87] On 20 September 1643, when committees were set up to collect money for the defence of the Associated Counties against Newcastle's army, Baker was appointed to the Suffolk Committee, and on 18 October 1644, when an assessment was ordered to collect money for the army in Ireland, he was again made a member of the Suffolk Committee for its collection. After 1647 Baker drops out of the great scene of the Civil War, in which he had never been prominent. But as already mentioned, he continued to serve on the Suffolk Committee, and in 1657, the year of his death, he was made High Sheriff of Suffolk, an office to which he must have been appointed by Oliver Cromwell, Lord Protector.

About 1645, in all probability, Baker married Alice, daughter and coheiress of Robert Leman, of Ipswich, where Alice is recorded as having been baptised on 16 July 1626. Leman had made a fortune in London, where he was a member of the Fishmongers' Company and eventually a sheriff, though not so successful as his brother Sir John, who became Lord Mayor of London in 1616. Alice was coheiress of her father's considerable landed property in Suffolk and Norfolk, and in 1658, on her remarriage, her personal estate was valued at £10,000 and her jointure at £1000 a year. She was reportedly not only rich but "virtuous and wise." Within a few months of Baker's death in 1657 she married Charles, Lord Goring, a loyal supporter of the Royalist cause, and later, on the death of his father in 1663, to become Earl of Norwich. Fortune certainly on the one side and rank probably on the other, were the principal matchmakers.[88]

Baker's estates in Suffolk went to his next heir, John Hanmer, son of Sir Thomas. John was already in possession of them on 23 November 1658, when his sister Trevor, making one of a party to see Cromwell's funeral, sat in the same balcony as Sir John Warner, who was told "she was likely, besides that plentiful Fortune her Father design's her, to be Heiress to Three Thousand pound a Year, should her Brother die without issue, who was not yet Married, and was in Possession of Mr. *Bakers* Estate, his Unckle by his Mother."[89]

We do not know if Baker continued to buy works of art after his return from the Continent and indeed we know tantalisingly little of his collection. That it was important we learn from John Evelyn, who early in September 1669 visited his "old acquaintance the *Earle of Norwich,* at his house in Epping forest: There are many very good pictures, put into the Wainscot of the roomes, which Mr. *Baker* his Lordships predecessor there, brought out of Spaine: especially the History of *Joseph:* The Gardens were well understood, I meane the *Pottagere:* here is also an excellent picture of the pious & learned *Picus Mirandula* & C & one of old *Breugle* incomparable."[90]

There may have been some sympathy of interests between Baker and his brother-in-law Sir Thomas Hanmer: Hanmer was a learned and skilful gardener and horticulturist, and formed a collection of medals which was described by Evelyn, whose "most worthy Friend" he was, as one of those which "have done Honor to themselves and to the Nation."[91] His portrait by Van Dyck, now in the collection of Lord Bradford, was described by Evelyn as "one of the best he ever painted." Some entries for 1654 and 1655 in a manuscript notebook of Hanmer

show that Baker had lent him £150, of which Hanmer paid off two-thirds in June and November 1655.[92] This is the last record I have been able to trace of a man for whom his bust has paradoxically obtained a fame he did not originally seek.

*Victoria and Albert Museum*

*Notes*

[1] For previous articles on the bust see L. Cust, "The triple portrait of Charles I by Van Dyck, and the bust by Bernini," *Burlington Magazine*, XIV, 1908–9, 337–40; E. Maclagan, "Sculpture by Bernini in England," *Burlington Magazine*, XL, 1922, 63.

[2] The sole study of the political relations between Rome and England during the period is G. Albion, *Charles I and the Court of Rome*, London, 1935.

[3] London, Public Record Office, Rome Transcripts, Barberini to Panzani, 28 March 1635, "Non stia per l'amor di Dio a nominar corrispondere col Re d'Inha, perchè con Heretici non possono esser corrispondenze, ma bensì con la Regina alla quale io sono serv.[re]"

[4] Vatican Barb. Lat. 8634, fol. 114, 13 June 1635, Panzani to Barberini: "A questo proposito il Montagù mi disse, che il Rè è restato sopra modo sodisfatto della licenza, che il Papa ha data al Bernino di far la Statua di questo Rè, essendo massime simile gratia stata negata ad altri Principi."

[5] Barb. Lat. 8632, draft (undated), No. 24: ". . . V.M.[ta] con lodar la statua, non solo dona l'immortalità al nome dell'Artefice, mà ancora rende mè ambitioso, che ho hauuto l'honore di far eseguir i suoi comandamenti, de quali e per obligo, e per diuot[ne] uiuendo io con continuo desiderio, degnisi la M[ta] V. essermene liberale. . . ." Transcribed in P.R.O. 31/9/1634, wrongly dated July by transcriber.

[6] Domenico Bernini, *Vita del Cavalier Gio. Lorenzo Bernino*, Rome, 1713, 64–65.

[7] S. Fraschetti, *Il Bernini*, Milan, 1900, 430.

[8] Barb. Lat. 8637, fol. 248, Panzani to Barberini from Northampton: "Il Sig.[re] Giorgio hà significato alla Regina, che l'Opera del Cau.[ro] Bernino era à buon termine, et ella disse con allegrezza di uolerlo scriuere al Rè."

[9] Barb. Lat. 8637, fol. 115, 5 June 1636, Barberini to Panzani, refers to "s.[r] Giorgio Coneo, il quale credo che s'è partito hieri di Roma." Barb. Lat. 8639, fol. 1, 14, 14 June 1636, Con writes to Barberini from Genoa; fol. 9, 24 June, same to same from Turin; fol. 14, 21 July same to same from Paris; fol. 21, 25 July, same to same from London. There exist in this MS three drafts of letters written by Barberini to Con during this journey, but none makes any reference to the Bernini bust, and that of 17 July 1636 (fol. 13) shows that they were all sent on to London to await his arrival. Obviously any letter from Rome now lost telling Con the bust was almost completed cannot have been written later than the third week of July, but I can trace no reference to the existence of any such letter.

[10] Barb. Lat. 8637, fol. 248, 31 July 1636, Barberini to Con: "Perche pensandomi io l'altra uolta ch'egli n'Hauesse contezza, li toccai qual cosa della testa del Re che fa il Cau[re] Bernino, e uedendo poi che non n'era informato mi leuai dal discorso in questa audienza me ne dimando, et io gli dissi che ui si staua trauagliando et sperauo che fusse per gustare."

[11] John Evelyn, *Numismata*, London, 1697, 335.

[12] See below, n. 76.

[13] Barb. Lat. 8640, fol. 261 (a copy by Ferragalli), 27 April 1637, Barberini to Con: "Rimango in tanto mortificato, che i miei poveri regali siano stati posti dalla M.[ta] della Regina in luogo tanto

degno, che questi scompariscono, e sempre piu, apparisce la loro bassezza; lo meriterà bene l'opera del Cav.r Bernino, principalmente per quello, che sara cara a S.M.ta, ma ardirò [sic], che non sarà da disprezzare, perche il Cau.re Bernino mi disse, che meglio non lo sapeua fare, onde io lo ringratiai, nè che li voleuo dare altra lode all'opera, che essere il sommo del sapere di lui. Invero è da scusare se il ritratto non si assomigliasse, poichè è purtroppo necessario il proto-tipo non stesse lontano, ma almeno la diligenza del Maestro non è da accu-sare. . . . Ogni mio pensiero è stato, et è, che V.S. sia quello, che presenti alla Mta della Regina l'opera, e che in niuna maniera si dia occasione d'eserci-tare la somma liberalità di S.M.ta o le sue gratie uerso alcun portatore." For the reports of the Modenese agents, see Fraschetti, op. cit., 110–11.

[14] Barb. Lat. 8645, fol. 152, 27 April 1637, Ferragalli to Con: "Il Sig.r To-masso Camerario Scozzese è chi uiene in Inghilterra, e con tale occasione il s.r Card.le gli ha incaricata la cura della statua del ritratto del Rè, la quale ueram.te e bella, e V.S. Ill.ma non puo-trebbe imaginarsi l'applauso, che ha hauuto uniuersale, ne credo ui sia restato Card.le, Amb.re, ò altro Sig.re di qualità, che non l'habbia uoluta uedere. In fronte per natura del marmo ui sono restate alcune macchiette, et uno disse, che sariano sparite subito che S. Mta. si farà Catt.co S. Em.za non stara mai con quiete fin tanto che non habbia auuiso, che la sia giunta a saluamento."

[15] The instructions are contained in Barb. Lat. 8625 (cvii. 12). R. Wittkower, *Gian Lorenzo Bernini*, London, 1955, 200–201, No. 39. Wittkower made no change in his views in his second edition (London, 1966). They are accepted by H. Hibbard, *Bernini*, Baltimore, 1965, 96–97.

[16] The letters are contained in Barb. Lat. 8625 (cvii. 12): Chambers to Barberini, Genoa, 12 May 1637; Marseilles, 19 May 1637; Arles, 23 May 1637 (to Pieresc); Avignon, 26 May 1637; Lyon, 4 June 1637; Paris, 23 June 1637; Paris, 30 June 1637 Rouen, 9 July 1637; Le Havre, 21 July 1637; London, 30 July 1637; Bonifazio

Olivieri to Barberini, Marseilles, 19 May 1637; Lyon, 4 June 1637; Paris, 23 June 1637; Rouen, 9 July 1637.

[17] Barb. Lat. 8640, fol. 329, 29 May 1637, Con to Barberini: "Sua Maesta ha inteso con gusto particolare l'incaminamento dell'opera del Sr. Cauag.lo Bernino, e sarà carissima la uenuta del S.r Tobia, delle cui qualità ho data noticia all Mta. della Regina, e questo ancora sarà numerato fra li regali di V. Em.za Il St. Conte, e la Sra. Contessa d'Arundell l'aspettano con infinito desiderio, e io ne rendo humilisse gratie a V. Em:za per la parte che toccara a me di questa con-solatione." In interpreting the reference to "regali," both seventeenth-century forms of courtesy and the Cardinal's previous presents of reliquaries and paintings to the Queen should be borne in mind.

[18] Barb. Lat. 8641, fol. 2, 4 July 1637, Con to Barberini: "Io sto aspettando ogni hora il Camerario colla testa che V. Em.za manda, egli m'ha inuiata da Parigi l'istruttione nella quale apparisce la infinita premura et esattezza di V. Em.za in pensare ad ogni cosa, et io non mancarò a farla nota alla M.ta della Regina, che mi disse, l'altro giorno, che haueua tanti impegni dell'affetto di V. Em,za che restaua confusa come puoterla mai fare conoscere quanto si tiene obli-gata. S'e dato gia ordine a tutti li porti di questa Isola, con auuisare pero che subito arrivato spedisca persone a posta per farmelo saper, accioche ionon manchi in ubidienza alli cenni di V. Em.za"

[19] "Adesso non scrivo altro se non che Domenica li 26 del presente messessimo la nostra cassa in una buona barca et il giorno seguente arrivassimo a Otlands dove per il gran desiderio del Re e della Regina bisognava scassar la statua la medesima notte; non posso a bastanza scrivere del grand' gusto che hebbe il Re e la Regina, e del stupore di tutta la corte et in particolare il sopraintendente delle statue, il quale al levare della prima tavola della cassa gridò con giuramento un miracolo. torno lunedi alla corte per licentiarmi di Sr Giorgio, e poi subito andaro a far il mio debito in Scotia dove non mancarò di pregar Iddio per sua

Em.ᶻᵃ alla quale fò humilᵐᵃ riverenza."

20 Barb. Lat. 8645, fol. 187, 31 July 1637, Con to Ferragalli: "Spero che il presente ordinario libertara S. Em.ᶻᵃ dal pensiero che l'ha causato la tardanza del ritratto, quale e hora saluamente gionto, essendo nel presentarla puntualmente osseruati tutti li comandamenti di S. Em.ᶻᵃ quant' al giouane del Sʳ Cauˡᵒ Bernino, lo tratterò qui meco sin' a qualche risolutione per conto della persona mia . . . . Mando la risposta alla lettera del Sʳ Cauˡᵉ Bernino aperta accioche sia vista da S. Em.ᶻᵃ la Regina non mancarà di rispondere alla lettera che il detto Cag.ˡᵒ l'ha scritto . . . "

21 Barb. Lat. 8641, fol. 41: "La sodisfatt.ⁿᵉ del Re per conto della Testa passa ogni espressione; Non capita in Corte persona di qualità, che egli med.ᵐᵒ non la conduchi a vederla in publico. Tanto io, quanto le V.M.ᵗᵃ loro professano, che questa è una gratia fatta dall'Em.ᶻᵃ V. alla Regina, mà il Rè non manca per questo di confessare le sue obligat.ⁿⁱ bramando occ.ⁿᵉ di puoter vendicarsi. Con occ.ⁿᵉ che si è ragionato del Cav.ʳᵉ Bernino, e delle sue opere, io hò dato al Rè alcune medaglie di N.S.ʳᵉ delle inuiatemi da V.Em.ᶻᵃ, fra quali ui sono quelle del Sepolcro delli Apostoli; con dire nell'orecchia al Rè. V.M.ᵗᵃ le stimerà per il riverscio; Mà egli senza lasciarmi seguitare pigliandomi la testa frà le mani, disse. Io le stimo più per il ritratto del Papa, che per qualsiuoglia altra cosa; e dopo hauerle mostrate alli Circonstanti, se le mise in saccoccia con uoltarsi a me con riso, et un' inchino di testa."

22 Barb. Lat. 8641, fol. 37, 31 July 1637: "La M.ᵗᵃ della Regina gradice tanto il ritratto inuiatole da V. Em.ᶻᵃ che non ritrova termini a proposito per esprimere il suo sentimento, m'ha replicato più uolte in questi giorni, io resto confusissima delli favori che mi fa il Sig.ʳ Card.ᵉ Barberino, senza ch'io sia stata buona a fare seruitio a lui. Io ho esposto a Sua M.ᵗᵃ la sincerità con che V. Em.ᶻᵃ l'osserva, et il desiderio che professa di seruirla in tutte le occasioni che si presentaranno. Questa opera del Sig.ʳ Caug.ʳᵒ Bernino fa grandissimo honore a tutta l'Italia in questo Regno."

23 Barb. Lat. 8615, No. 23, endorsed 14 November 1637.

24 Barb. Lat. 8641, fol. 65, 21 August 1637: "perche pensa forse ch'io non sia tanto diligente quanto ocorerebbe in rappresentare li suoi sentimenti, Lei medesima scriue a V. Em.ᶻᵃ certificando breuemente che quasi del continuo esprime a me della sua osseruanza uerso Nro S.ʳᵉ et affetto uerso V. Em.ᶻᵃ 3 tutta l'Ill.ᵐᵃ sua Casa rende gratia nella medesima lettera a V. Em.ᶻᵃ della Statua, e raccomanda Mon.ʳ Mazarini."

25 Filippo Baldinucci, *Vita del Cav. L. Bernini* (ed. A. Riegl), Vienna, 1912, 117.

26 Barb. Lat. 8645, fol. 190, 14 August 1637, Con to Ferragalli: "Non è stata possibile a far che la Regina astenghi dal regalare quelli che condussero la Statua. Il Camerario se ne partì subito per Scotia, al quale come a persona ciuile si donò un regalo di 400 scudi et al giouane del Caug.ᵒ Bernino 200, ma essendomi io assolutamente opposto per conto del Camerario, dicendo ch'egli non haueua che fare nel negocio, li scudi 600 sono dati al ditto giouane, il quale non l'haurebbe potuto fugire benche fosse partito subito. Io dissi di non uolermi intrigare ma per dare satisfazione mandai il giouane dal Sʳ. Montagu, il qual' tanto seppe dire che le persuase a pigliarli. Questo pero è senza pregiudicio del regalo che si mandera al Sʳ. Caug.ˡᵒ medesimo, il quale ha acquistato un nome glorioso in queste bande."

27 *Loc. cit.* Bonifazio's letter is in Barb. Lat. 8625 (cvii. 12).

28 Barb. Lat. 8645, fol. 202, 7 September 1637, Con to Ferragalli: "Bonifazio uorrebbe darmi li suoi denari per remittere in Roma, ma non sapendo che spedienti V.S. possa hauer preso a quest' hora per mandarmi non ho volsuto intrigarmi, il soditto aspetta la prima buona compagnia per passare in Francia. La Regina scriuera al Sʳ. Cauagl.ᵒ Bernino in risposta a quella che lui n'inuiò, perche il trouare la prima lettera non è facile in una corte dove non tengono registro di simili lettere."

29 Barb. Lat. 8645, fol. 214: "e quanto all'interesse del Cauagli.ᵒ Bernino V.S. non dubiti ch'egli non sia per hauere

una lettera compitissima dalla Regina, et ancora un regalo degno di lui. Ma tanto questo quanto certe bagatelle per l'Emo Prone si riseruano sin'al mio ritorno . . . "

30 Barb. Lat. 8645 (cvii. 32), fol. 188, 31 July 1637, Con to Ferragalli: "La M.ᵗᵃ della Regina essendo risoluta di mandare alcune bagatelle del paese à S. Em.ᶻᵃ, uuole fare alcuni ricami, non contentandosi delle cose che possono esser comprate à prezzo d'argento, cosa che non hà mai applicato à fare à persona alcuna."

31 Barb. Lat. 8645, fol. 263, 25 January 1638, Con to Ferragalli: "Io ho riceuuto il diamante per il Sʳ Caulº. Bernino, et hora con migliore facia puotrò sollecitare la lettera, et insieme le pitture per fare la testa di S.M.ᵗᵃ"

32 Barb. Lat. 8645, fol. 275, 19 February 1638, Con to Ferragalli: "con gusto finisco, doppo d'hauerle significato che il regalo del Caug.ˡᵉ Bernino non sara tralasciato in dietro, la opinione della Regina ch'io fossi per partire sei mesi sono ha tenut'a dietro questo et altre cose di magior' importanza."

33 Barb. Lat. 8645, fol. 284: "Del Cavg.ˡᵉ Bernino ho gia scritto a V.S. quel che m'occorre. Io mi vergogno sollicitare una cosa destinata per il mio ritorno, quale dovendo succedere sei ò sette mesi sono, non puo essere ricordato da me senza mortificatione, ma egli haura il suo regalo sicuramente."

34 Barb. Lat. 8645, fol. 288, 2 April 1638, Con to Ferragalli: "Mando a V.S. qui una lettera per il Sʳ. Caug.ˡᵒ Bernino, al quale non mancaro di procurare le sodisfattioni desiderate, e V.S. la puotrà accompagnar, cosi parendole nel modo che più giudicarà a proposito. La mando aperta accioche V.S. la dia o no conforme che uorrà."

35 Barb. Lat. 8645, fol. 316, 28 May 1638: "In tanto V.S. dica al Sʳ Cav.ʳᵉ Bernino, ch'io le porterò la sua lettera et insieme qualche altra cosa non indegna di lui perche hora ò per un uerso, ò per altro dourà accelerarsi il mio ritorno." Barb. Lat. 8645, fol. 313, 21 May 1638, Con to Ferragalli: "per conto del Caug.ˡᵒ Bernino non manco in fare quello, che

non farei per me stesso."

36 Barb. Lat. 8645, fol. 326: "Io hebbi hieri in mano il regalo del Sʳ Cavgl.º Bernino quali essendo un diamante bellissimo procurai che fossi stimato da uno intendente della professione, il quale m'assicurò che ualeua mille lire o 4ᵐ Scudi. io l'ho restituito al Camerlingo, per riceverla poi dala mano dela Regina quando sarà tempo di parlare risolutamente dela partenza . . . "

37 Barb. Lat. 8645, fol. 335, 9 July 1638, Con to Ferragalli: "Per il Cagˡᵒ. Bernino ho fatto quello che non haurei fatto per me ni per tutti li miei quando fosse andati mille uite, io tengo il suo regalo e trouando persona sicura prima del mio ritorno lo mandarò."

38 Barb. Lat. 8645, fols. 345v–346: "Hò detto al Sʳ Cav.ʳᵉ Bernini del regalo, et io n'ho hauuto gusto, perche il ualore è stato conforme alla uoce sparsasi, hauendo Mons.ʳᵉ Mazarini, e Bonifacio Serʳᵉ. di esso detto sempre, che s'accostaria più alla 4 m, ch'alli 3,m. Voglio ben'io supplicar V. S. Illᵐᵃ d'una gratia, che desidero in estremo di receverla dalla sua benignità, quando non la reputi affatto spropositata, e 'il mio desid.º è fondato sopra motiui, che dirò poi à bocca, quando sarà tornata a Roma con gusto et beneplacito de'Proni. La gratia dunque e che giache costa hanno risoluto di regalar il Cav.ʳᵉ Bernino in ualore di 4m. Scudi, desiderarei, che fosse in cosa, che lo mostrasse, il che sarà difficile in un Diamante. E però più mostra farebbe un' gioello di simil ualuta con il ritratto del Re, o Reg.ᵃ, ouero, e sarebbe minor briga, che si mandassero li sudⁱ. 4m. Scudi al Sʳ. Cauˡᵉ Hamiltone con ordᵉ. facesse far una credenza d'argenti, e la donasse al Cauʳᵉ. Bernino per parte della Reg.ᵃ. Se dico spropositi, V.S. Ill.ᵐᵃ per l'amor di Dio mi scusi, ma se con la sua destrezza mi può far questa gratia, di nuouo ne la supp.ᶜᵒ." Hamilton was Henrietta Maria's agent in Rome.

39 Barb. Lat. 8645, fol. 349v, 13 August 1638, Con to Ferragalli: "Quant'al Cag.ˡᵒ Bernino gia ho scritto a V.S. d'hauere riceuuto il regalo in un diamante bellissimo il che fa che il con-

siglio di VS non puo esser piu a tempo, et il Cag.ᴵᵒ coll' importunare VS m'ha fatto fare quello che non havrei fatto per mio padre."

[40] Barb. Lat. 8645, fol. 412, 17 January 1639, Con to Ferragalli: Quanto all'anello del Cag.ᴵᵒ Bernino so che è di quelli negocii che premono."

[41] Barb. Lat. 8645, fol. 462: Habbiamo sposo il s.ʳᵉ Cau.ʳᵉ Bernino. Se mai V.S. Ill.ᵐᵃ penso di farli cosa grata, e dar gusto al Sʳ. Card. Prone, procuri di mandarli quanto prima per qualche uia sicura il suo Diamante, di che lo regalo la M.ᵗᵃ della Regina per il ritratto del Rè. Et io ne supplico istantiss.ᵗᵉ V.S. Ill.ᵐᵃ, non hauendo uoluto S. Em.ᵃ, che compri altre gioie, finche non si uedi cotesto Diamante, per poter poi diuisare meglio, e decentemente. Per l'amor di Dio non manchi, perche preme a S. Em.ᵃ estrem.ᵗᵉ." Bernini was married on 15 May 1639 (Fraschetti, *op. cit.*, 105).

[42] Barb. Lat. 8645, fol. 479, 17 June 1639, Con to the Papal Nuncio Bolognetti in Paris. He sends for forwarding to Rome by order of the Queen a "qui aggionta Scatola" containing an ex-voto she had vowed to the Madonna of Loreto and Bernini's diamond ring. Barb. Lat. 8644, fol. 271, 17 June 1639. Con's covering letter to Barberini concerning the box says: "ho preso ardire d'accompagnarlo. colla presente, et insieme d'adgionger un'altra cosetta sigillata con soprascritt' a V.Em.ᶻᵃ e missa nelle medesima scatola, quale poi V.Em.ᶻᵃ puotrà commandare che sia data al Padre Gio Maria Copucino, e l'altra cosetta a chi V.Em.ᶻᵃ sa essere destinata dalla M.ᵗᵃ sua." Barb. Lat. 8644, fol. 270, 17 June 1639, is an independent despatch from Con to Barberini which also refers.

[43] Barb. Lat. 8645, fol. 540, 24 September 1639, Ferragalli to Con: reports the arrival of the box and says: "Domani il sʳ Cau.ʳᵉ Bernino riceuerà il suo belliss.º anello."

[44] Fraschetti, *op. cit.*, 111: "un diamante di valore di s. 6000 al Cavalier Bernino in rimunerazione della statua del Re di Inghilterra... scolpita da lui al naturale, e mandata a donare a essa Regina."

[45] *Loc. cit.*

[46] Fraschetti, *op. cit.*, 110.

[47] Fraschetti, *op. cit.*, 108.

[48] For these payments see Wittkower, *op. cit.*

[49] Fraschetti, *op. cit.*, 108.

[50] Fraschetti, *op. cit.*, 94, n. 1, 75, 325, 151.

[51] Fraschetti, *op. cit.*, 112

[52] Wittkower, *op. cit.*, 224.

[53] Fraschetti, *op. cit.*, 222.

[54] Fraschetti, *op. cit.*, 221–24.

[55] Fraschetti, *op. cit.*, 224.

[56] Barb. Lat. 8641, fol. 47, 7 August 1637, Con to Barberini: "Queste Maestà restano ogni giorno piu sodisfatte della Statua inuiata da V. Em.ᶻᵃ alla M:ᵗᵃ della Regina, la quale sollecita hora il proprio ritratto, per puoter hauer questo nuouo obligo a V. Em.ᶻᵃ della quale S Mᵗᵃ non manca di fare commemoratione quotidiana con quelle espressioni quali dalla solita modestia di V. Em.ᶻᵃ non si sentono uolontieri."

[57] Barb. Lat. 8641, fol. 202, 27 November 1637, Con to Barberini: The Queen "al fine s'è lasciata depingere in quelle tre maniere che si desiderano per fare la testa compagna di quella del Re."

[58] See above, n. 31.

[59] Barb. Lat. 8642, fol. 253, 25 June 1638, Con to Barberini: "Nel Rè, il quale à dispetto di tutto la malignità camina meco con la solita benignità. Mentre io in presenza sua esortaua la Regina l'altro giorno di uolersi lasciare ritrarre, il Rè disse. Io anche vò alla Caccia martedì, e ui lascierò mia Moglie tutto il resto della settimana; persuadetela, e guardatela bene; il che fu detto in modo, che diede da ridere à tutta la Corte: et ognuno m'auuisò, ch'io tenessi buona cura della Regina."

[60] Barb. Lat. 8042, fol. 252. 25 June 1638, Con to Barberini: "la Regina sta a Grinucio, e per gratia di Dio gode buona salute, finita la presente io anderò a quella uolta, per incontrarmi col Cauaglº. Wandeck, per uidere si sarà possibile di fare un ritratto singolare di S. Mᵗᵃ per seruire al Sʳ Cauaglº Bernino."

[61] Barb. Lat. 8643, fol. 67, 27 August 1638, Con to Barberini: "la Mᵗᵃ sua ha finalmente messi alla uista li ritratti per fare la sua testa, e colla prima buon' oc-

casione saranno mandati, confida in queste come in tutte l'altre sue occorenze nell'affetto solito di V.Eᶻᵃ: alla quale notificarà più particolarmente il suo desiderio."

62 Printed in W. H. Carpenter, *Pictorial notices: consisting of a Memoir of Sir Anthony Van Dyck*, London, 1844, 67.

63 MS in Royal Library, Windsor, kindly transcribed and communicated by Sir Oliver Millar. In the Italian translation (see Baldinucci, *Vita del Cavaliere Gio. Lorenzo Bernino*, Florence, 1682, 19) Conneo is wrongly rendered "Lomes."

64 Baldinucci, *loc. cit.*

65 For the Baker family see E. Hasted, *The history and topographical survey of the County of Kent*, III, Canterbury, 1790, 48–49; and I, Canterbury, 1778, xciii. For Sir John and Sir Richard see the *Dictionary of National Biography*, I, 1908, s.v., and Lodge, *Illustrations of English History*, I, 60.

66 S. Lewis, *A Topographical Dictionary of England*, II, London, 1842, 246. W. A. Copinger, *The Manors of Suffolk, IV*, Manchester, 1909, 36 (with some inaccuracies).

67 For the Bakers at Leyton see F. Temple, *An account of the house and estate known as Forest House . . . in Leyton and Walthamstow, Essex*, Leyton, 1957 (Mr. Temple kindly presented me with a copy of this book). For the descent of Sir Thomas see also his family tree in the Blois Manuscripts, in the Ipswich County Library.

68 See J. Foster, *Alumni Oxonienses*, s.v.

69 London, Public Record Office.

70 For the Hanmers see John, Lord Hanmer, *A memorial of the parish and of Hanmer in Flintshire*, London, 1877, especially 63, 75–77, 122. For the quotation from Howell see *Litterae Ho-elianae*, 1726, 227.

71 Transcribed here are all the passes recorded as issued to Baker in London, P.R.O., *Acts of the Privy Council*:

31 October 1628: "A Passe for Thomas Baker of Whyttingham in the County of Suffolk, esquire, to travaile into forraine parts for the space of three yeares, and to take with him twoe servants and provisions (not prohibited) with a provisoe not to goe to Rome or to any the King of Spaines Dominions."

16 February 1630/31: "A Passe for Thomas Baker of Witinham hall in the County of Suffolk Esq.ʳ to travaile into forraine ptes for the space of three years wᵗʰ one Servant and a Provisoe not to goo to Rome."

May the last 1634: "A license for Thomas Baker Esq.ʳ to remaine in the parts beyond the seas for the space of three years next after the date hereof."

19 June 1635: "A passe for Thomas Baker of Wittinhamhall in the Countie of Suffs Esqʳᵉ, to remayne in forraigne parts for three yeares longer."

October the first 1637: "Passe renewed to Thomas Baker of Whittingham hall in the County of Suffˡ. Esq.ʳᵉ to remayne in forraigne ptes for the space of three yeares longer after the Date hereof, wᵗʰ a provisoe not to goo to Rome without Lycence from his ma.ᵗᵉ"

23 September 1640: "A passe for Thomas Baker Esqᵉ. to travell into forreigne parts for three yeares and to take with him one Servant his Trunck of Aparell etc. wᵗʰ a provisoe not to goo to Rome and the usual clause to ye Searcher."

72 Lady Fanshawe, *Memoirs*, 1907, 27. Mrs. Pool, *Burlington Magazine*, XII (1922), 48–49.

73 London, P.R.O., Venetian Transcripts: *Espozizioni Principi*, Vol. 47, A.D. 1639–40, 11 Gennaro, 249:

Francia.

Venuto nell' Eccell.ᵐᵒ Collegio il Sig.ʳ Ambʳ della Mᵗᵃ Christma disse: Seren.ᵐᵒ Prencipe.

Non sono venuto hoggi in questo luogo per ordine Che ne tenghi dal Re, ne per alcun affare, che riguardi al publico. So che è solito dimandar l'udienza il giorno innanzi, ma hieri non la ricercai. . . [omitted in transcription].

Sono portato alla Ser.ᵗᵃ V.ʳᵃ dal motivo di raccommandare alla sua gratia la liberatione d'un Gentilhuomo Inglese, che è Cavaliero principale di

quel Regno, di buon nascimento, di adherenze qualificate, et che ha ben venticinque milla ducatoni d'entrata all'anno. Si trattiene in Italia per suo piacere, et come, che habbia particolar dillettatione di Pittura, va curioso rivedendo ove se ne trovano et volentieri anco ne compera se se gli incontra l'opportunità. Con questo oggetto havendo inteso, che se ne trovano di belle nel Friuli, si condusse a Cividal di Belluno, di dove mentre credeva partire, et il servitore invaliggiava le robbe, qualche spia che lo doveva osservare, come mai mancano di quei forfanti de raffi, che stanno sul insidiare il forestiero, vedendo che il servitore metteva nel forziero una Pistolla, che era rotta, ne poteva servir a niente nè porto forse l'aviso alla Giustitia, et montato a Cavallo gli fu detto, che andasse al Sig.r Podestà, essendo poi stato fermato prigione, non havendo valso, che dicesse le sue conditioni et esser la pistola scarica, rotta, che non poteva far danno ad alcuna persona. Non trovandosi qui amb.r della Gran Bretagna, è ricorso à me, per la buona cognitione che tengo anco della sua persona, acciò intercedesse appresso V.ra Ser.ta., per la sua liberatione. Mandai il Console a supplicarne la gratia, non havendo io potuto venire per le mie indispositioni, ma sono già 15 giorni, o tre settemane, che il povero Gentilhuomo si trova in un Camerotto scuro, mal trattato, alla conditione medesima di qual si voglia persona vile, et abietta, et hieri sera alle sei della notte, mi arrivò un messo espresso, col quale mi da conto de suoi continuati patimenti, et miserie, che ha causato, che io sia venuto a molestare V.ra Ser.ta, perchè si compiaccia dar ordine per il suo sollevo, almeno sin tanto si rissolva il negocio, sia posto in luoco decente, et cavato da quelle oscurità improprie d'ogni huomo ben nato, et in particolare de forastieri, che meritano anzi miglior trattamento, sendo interesse politico l'usarlo specialmente con essi, perche può occorrere alla vostra nobiltà incontrare de medesimi pericoli, an-

dando in Paese straniero, et non credo, che havesse pur bene d'essere trattata in questa maniera. Questo è Cavaliero di nascita di parenti, e di facoltà, havendo come ho detto 25.-mille ducatoni da spender d'entrata, merita essere trattato da par suo; non con vilipendio pari ad ogni facchino. Rappresento questo a V.ra Ser.ta in diffetto d'Amb.r d'Inghilterra et per la cognitione che ho del soggetto, assicurandomi, che la natione, et il suo Re medesimo sentirà volenteri sia prontamente liberato. Non ha voluto valersi del mezo del Residente [Gilbert Talbot] perchè a dir il vero sono in contrasti insieme ne passa tra loro buona corrispondenza.

Rispose il Seren.mo Principe. Sig.r Amb.r l'intentione della Republica, che i forestieri siano ben ricevuti, e trattati per tutto lo Stato dispiacendoci del mal incontro accaduto a questo Gentilhuomo; ma bisogna che sien state fatte relationi non buone al Podestà delle sue qualità. Fu scritto per haver information del fatto, et si replicheran gli ordini opportuni desiderandosi di sodisfar, sempre in tutto il possibile le instanze di V.ra S., tanto più, che in ciò si tratta di far atto di Giustitia, et con soggetto delle qualità di lei rappresentate.

Soggiunse il Sig.r Amb.r Il Sig.r Podestà ha fatto il suo debito, perchè trovata un'arma prohibita, non si poteva meno di fermarlo, ben poteva esser meglio trattato. V.ra Ser.ta sa distinguersi li trattamenti secondo le qualità della persone, cosi si accostuma in Francia in caso di questa sorte, si haverebbe assegnata una buona Camera, havendo egli il modo di pagare tutte le spese, che fossero occorse; sin tanto, che l'huomo non è conosciuto criminale, non deve patire la pena del delitto; come è conosciuto il giudicio della criminalità, all'hora si da luoco ai rigori della Giustitia. Sono tre settimane, che questo è ne' patimenti d'un Camarotto Scuro, non stimo che questa sia la mente della Ser.ta V.ra, et m'assicuro sarà da lei dato ordine opportuno per il miglior

trattamento non solo, ma che si compiacerà anco con la sua benignità commettere la liberatione.

Levatosi l'Illust.^mo Sig.^r Francesco Cornaro Cavaliero Savio del Cons.°, con precedente concerto de gl'altri Eccell.^mi Sig^ri. Savii, disse che nella sua settimana essendo comparso il Console Vedoa [French consul], con il memoriale in questo proposito, era subito stato scritto a Cividal di Bellun per informatione, che peranco non era arrivata. Soggiugnendo il Seren.^mo Principe, si daranno nove commissioni, e si procurerà segua quanto primo l'espeditione del negocio con tutto il riguardo a compiacere V.S.

[74] See above, n. 71.

[75] G. P. Bellori, *Le vite de' pittori, scultori et architetti moderni*, Rome, 1672, 277. Bellori seems to have begun compiling his lives in the 1640s since in that of Van Dyck he says he received most of his information about the painter from Sir Kenelm Digby, who left Rome in 1647 (see K. Donahue, *Dizionario biografico degli italiani*, VII, Rome, 1965, 781–89).

[76] The entry in the younger Nicholas Stone's diary is printed in "The Notebook and Account Book of Nicholas Stone," ed. W. L. Spiers, *Walpole Society*, VII, 1918–19, 170–71. I print the references in Baldinucci and Bernini here: i) Baldinucci, *Vita*, 19: "Fu vero pero, che auendo veduta la Statua del Re fra gli altri vn nobilissimo, e richissimo Caualiere di Londra, si accese sì fattamente di desiderio di farsi fare il proprio ritratto, che prese risolutione di pigliare viaggio a posta per alla volta di Roma; e ad Amico, che l'interrogò, con qual sicurezza d'auere esso ritratto egli voleua tale lunga peregrinatione intraprendere, gia che (com'ei diceua) il Bernino non operaua ad instanza d'ognuno, che il richiedesse, ma di chi più, e meglio a lui piaceua, rispose: *il lo regalerò come l'à regalato il Re, e non meno*. Vennesene dunque a Roma, donò al Caual. Bernino sei mila scudi, ed alla Patria ne riportò il ritratto." ii) D. Bernini, *Vita*, 66–67: "Si accese

bensì di un tal desiderio il Milord Coniik in rimirarne quello del Re, che apposta partitosi dall'Inghilterra si portò a Roma per haverne anch'esso uno di sua persona; e consigliato avanti d'incaminarsi a quella volta, a scuoprire, se potesse sicurezza havere dell'effetuazione di sua richiesta, giacchè il Bernino non lavorava ad istanza di ogniuno, rispose, *Io lo regalerò come l'ha regalato il Re, e non meno*. Giunse in Roma, e non senza stento ottenuto il Ritratto, donò al Cavaliere due mila doble, e tornò contento alla Patria."

[77] L. Lalanne, "Journal du voyage du Cavalier Bernin en France par M. de Chantelou," *Gazette des Beaux-Arts*, sér. 2, XXVII (1882), 273.

[78] This is accepted by Maclagan, "Sculpture by Bernini in England—I," *Burlington Magazine*, XL (1922), 56–63; Wittkower, "Bernini Studies–II: The Bust of Mr. Baker," *Burlington Magazine*, XCV (1953), 19–22, 139–41; idem, *Gian Lorenzo Bernini*, London, 1955, 201; and C. Gould, "Bernini's Bust of Mr. Baker: the Solution?" *Art Quarterly*, XXI (1958), 167–76. It is denied by J. Pope-Hennessy: *Burlington Magazine*, XCV (1953), 139; and *Catalogue of Italian Sculpture in the Victoria and Albert Museum*, II, 1964, 603. The hypothesis of another sitter whose bust was never carved is gratuitous. The "Milord Coniik" of Domenico Bernini's account probably derives from the *Signor Conneo* of Henrietta Maria's letter (see above, n. 63), which in Bernini's day was associated with the Van Dyck portrait.

[79] Baldinucci, *loc. cit.*

[80] Walpole, *Anecdotes*, II, 1765, 58.

[81] Wittkower, *loc. cit.*

[82] George Vertue, *Notebooks*, I (*Walpole Society*, XVIII, 1930), 27.

[83] Vertue, *loc. cit.*: "The Busto of King Charles 1st made by the Cavalier Bernini was consum'd in the fire at Whitehall 1696. This Busto was made from the three faces painted by A. Vandyck is what the King sate for. Bernini made a Busto in Marble of Mr. Baker.

"Bernini made him a present thereof. Baker presented Bernini 100 gold pieces

the Gentleman by whom this picture was sent to Rome, which picture is now in the possession of the Son at Rome. Designing thereby to shew K. Charles, what he cou'd do from the life." For the death of Richard Baker see London, P.R.O., Inquisitions, 1635.

[84] O. Millar, *The Age of Charles I* (exhibition catalogue), Tate Gallery, London, 1972.

[85] Firth and Rait, *Acts and ordinances of the Interregnum 1642–60*, I, London, 1911, 168–69, 223–35, 242–43, 291–92, 531–37: British Museum, Egerton MSS, 2647, fol. 267.

[86] P.R.O., *Calendar of the proceedings of the Committee for Advance of Money 1642–56*, I, London, 1888, 196–97; the original documents cited here, P.R.O., SP 19/61, fol. 36; SP 19/2, fol. 96; SP 19/2, fol. 228; SP 19/75; SP 19/3, fol. 70; SP 19/90.

[87] His signature is found in the Committee Book of the Suffolk Committee on 25 April 1644 and 7 January 1647 (Everitt, *Suffolk and the Great Rebellion*, Ipswich, 1961, 69, 75).

[88] British Museum, Add. MSS 37,231, p. 23; Copinger, *Manors of Suffolk*, ii, 297–98; iv, 36; *Historical Munuscripts Commission, Fifth Report*, 146; Letters of Administration granted 27 April 1657 and 4 August 1658 to Alice Baker, London, P.R.O., Wills, Wootton, 220. In those of 20 April 1657 Baker is described as "late of Great Yarmouth." A. Suckling, *History and antiquities of the County of Suffolk*, 11, 1848, 184.

[89] [E. Scarisbricke], *The Life of the Lady Warner of Parham*, London, 1691, 15. This is a life of Baker's niece, Trevor Hanmer.

[90] Evelyn, *Diary*, ed. E. S. de Beer, III, Oxford, 1955, 538.

[91] Evelyn, *op. cit.*, IV, 402; III, 191; *idem, Numismata*, 245.

[92] Aberystwyth, National Library of Wales, Bettisfield MS 1663.

# 29
# *Art Education and the Grand Tour*

MICHAEL McCARTHY

Some English gentlemen arrive here annually, amongst whom are generally one or two of our old school-fellows; with whom I take care to renew acquaintance: this I have lately done with the Lords M. & Q., Sir R. N., Mr. D., and Mr. Castleton.

Thus wrote the painter James Russell from Rome on September 28, 1741.[1] The Sir R.N. he referred to was Sir Roger Newdigate of Arbury Hall, Warwickshire, and Harefield Place, Middlesex (fig. 1), who, like Russell, had attended Westminster School.[2] From there he went to University College, Oxford, and immediately thereafter had set out on the grand tour. The copious notes he made of his travels will form the basis of this discussion of the education in art that was available to the grand tourist who chose to take advantage of it.[3] Needless to say, not all grand tourists did. The Italians had a saying, *Inglese italianato è diavolo incarnato*, and complaints of dissolute behaviour on the part of grand tourists are frequent.[4] But James Russell remarked in his letter of December 2, 1741:

It is no small satisfaction to me to find that most young gentlemen who come hither shew so great regard for the art which I studie as not only to admire and endeavour to understand it in theory but even to amuse themselves in the exercise and practice of it.[5]

This paper seeks to determine from the correspondence and diaries of the grand tourists the practices they adopted in their study of the visual arts in Italy and the Iberian peninsula in the middle decades of the eighteenth century. Some ways in which the grand tour may be thought to have permanently affected art education will be suggested tentatively.

Appreciation of great works of art was naturally a desirable objective of the grand tour, yet comments by the tourists on the monuments of antiquity and masterpieces of art which they examined are not nearly so frequent and full as the reader of their diaries and letters would wish. This is partly explained by the fact that they carried with them standard guides to Italy, the most popular of which was that by Famiano Nardini, recommended for example by Lord Grantham to the young Thomas Pelham before he set out on his tour in 1776:

. . . a very [fine] author, and to say the truth is the fountain of all Mr. Addison's celebrated Observations & Quotations on the same subject.[6]

1

1. *Arthur Devis.* Portrait of Sir Roger Newdigate. *1755. Arbury Hall, Warwickshire (courtesy of F. H. Fitzroy-Newdegate)*

2. *Sir Roger Newdigate and Charles Parker.* Plan of the City of Aosta. 1775. *Warwick County Record Office (courtesy of F. H. Fitzroy-Newdegate)*

Since Addison was well known to the correspondents of the grand tourists, there was little point in their repeating his descriptions and sentiments, and comments such as that on the Basilica of Maxentius by Sir Roger Newdigate—"see Nardini's account of the forum Romanum"—are irritatingly frequent.[7] When Sir Roger came upon the undescribed monuments of the Roman city of Aosta in Piedmont (figs. 2, 3), and Lord North discovered the previously unpublished Greek temples at Paestum, they sent back to England very full accounts with accompanying maps and illustrations.[8] But the dearth of descriptions of major monuments and masterpieces is one of several frustrations attending the investigation of the activities of the grand tourist.

Another reason for their silence is their chauvinism. Lord Dacre of Belhus in Essex is a case in point. His letters are largely taken up with descriptions of the geography of the countryside through which he passed, and he dilates with envy on the relative laxity of Italian morals. He does record briefly his admiration of the palaces of Genoa, and he criticises the Mannerist buildings, especially the Uffizi, of Florence. He expresses great enthusiasm for the towers of Siena, but only because they recall to his mind the pleasant English custom of building prospect towers in country parks. A visit to Vallombrosa provokes the comment that if the monks there only had a little taste they might turn it into an English landscape garden at no great expense![9] Rome might have been expected to elicit some appreciation, especially in his letter to Sanderson Miller, who was a serious student of classical arhitcecture. But Dacre reserved any account until he could meet Miller again, and in the meantime wrote complacently:

> There is no country like Old England nor no people comparable to the English; content yourself therefore and enjoy your own comfortable place at Edgehill, happier than the greatest Princes and Dukes of these countries who sacrifice all True Content to Vanity and Outside Show.[10]

*3. Sir Roger Newdigate.* Plan and Details of the Roman Arch at Aosta. *1775. Arbury Hall, Warwickshire (courtesy of F. H. Fitzroy-Newdegate)*

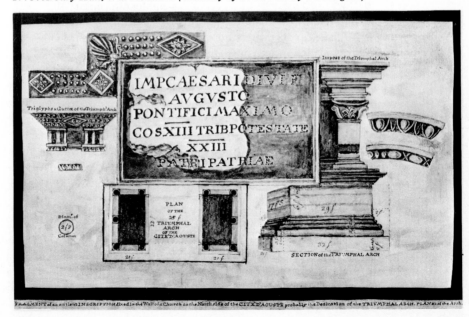

Lord Dacre was probably exceptionally chauvinistic, but there is an element of blind nationalism in many grand tour accounts, even from the most serious students of the arts. Horace Walpole's friend John Chute of The Vyne, Hampshire, was a very discerning connoisseur and had such a love of Italy that he found it difficult to resign himself to living in England upon his return. Yet he had this to say of Rome:

> I would never have believed some few years ago that it was possible for me to look with such an eye of indifference upon Rome as I do; hitherto nothing has made any impression upon me; all statues appear like those at High Park Corner and a Raphael or a Domenichino is no more than Queen Anne's head at an ale house door.[11]

Sir Roger Newdigate expressed similar disappointment:

> Of all the places I have yet seen Rome is that I should choose to stay least in after I had once satisfied my Curiosity as upon that account it is the place in the world I have wished to see most.[12]

Venice did not fare any better in his estimation, and he remarked of its festival:

> If it was not for the name and a little difference in the manners of the country, a Lord Mayor's show would not be much inferior to it.[13]

Unlike Lord Dacre, Sir Roger found nothing to envy in the easier moral climate of Italy, and the frivolities of the carnival, which Horace Walpole had enjoyed so much, he found "not in the least diverting . . . the reservedness of the climate and the great confinement of the women at other times make them launch out into all liberties."[14]

Sentiments such as these give reason for hesitation before accepting the common view of the grand tour as a time of endless fun and frolics, an opportunity for the privileged to sow their wild oats at a safe distance from parental interference. Besides the hardships of travel in the eighteenth century (fig. 4), the grand tourists had to tolerate a great deal of boredom, and this is the reason given by Sir Roger Newdigate for their most notorious characteristic, their tendency to herd together and avoid mixing with the natives. He found Italian society deadly dull. In Florence there were only the salons of the Prince de Craon and Horace Mann that were worth attending, and the former was supportable only to those addicted to gambling. In Rome only the salon of the Prince Borghese offered intelligent conversation, and Sir Roger and his friends were so bored that they clubbed together to buy a billiard-table with which to while away the hours.

Fortunately this gave those grand tourists interested in the visual arts plenty of time for study, and we can follow Sir Roger Newdigate closely in his visits to the Palazzo Pitti in Florence. He notes first the architecture of the building:

> The Front very noble, the Stones vast and hang low over one another very irregularly like the projections of a quarry. . . . Courses are regular. Of all the Tuscan architecture this has the most Grandeur and Magnificence in its Airs.
>
> The inner court has neither; a paltry endeavour to reconcile the elegance of the Greek order with the rudeness of the Tuscan, as if the architect, (Ammanato) was afraid he should be accused of ignorance in the art if he had not introduced them, and of want of uniformity if he had done so in their proper

*4. Sir Roger Newdigate.* Sketches of Lord Quarendon and Mr. Wood. *1739. Arbury Hall, Warwickshire (courtesy of F. H. Fitz-roy-Newdegate)*

forms, he has put them into masquerade, the Doric, Ionic and Corinthian over one another with their shafts rustic in contradiction to common sense and every idea of elegance or proportion.[15]

It is evident that Sir Roger was well trained in the classical canons of architecture, and this passage confirms what we learn from his later designs for buildings in England, that he was a follower of Lord Burlington's revival of the architecture of antiquity as interpreted by Andrea Palladio.[16] His notes reveal that he was too hurried on his way to Venice to make an extensive study of Palladio's architecture, but he expresses enthusiastic admiration of those of Palladio's buildings which he saw:

That of Palladio near Vicenza of the Marchese Capra is the most elegant villa & the most agreeably situated I ever saw.[17]

Another characteristic of his architectural interest which is revealed in his grand tour notes is a fascination with structural details. There occurs the following unconnected reflection, for example:

What gives a magnificence to the ancient buildings beyond those we know is the bigness of the materials, which, nicely joined, appear as of one piece. This is remarkable in the Triumphal Arches, Antonino and Trajan Pillars, etc. Q[uery]. How many compose the Arch of Constantine? One of the Giallo Antico Pillars of it was long missing & found by accident at the demolishing of the old Portico of St. Jn. Lateran.[18]

A later query is as follows:

Modern architects make their columns diminish from one-third of the height,

the ancients diminish from the base—to which enquire if there are any exceptions. See Desgodetz.[19]

It would be difficult to find more telling instances of the studious approach of the grand tourist to the arts, the combination of book-learning and practical observation of the masterpiece. It can be paralleled in one of the drawings of Italian subjects to survive in the Worsley Collection at Hovingham Hall, Yorkshire, from the grand tour of Thomas Worsley, a rough sketch of a campanile. There are notes on the location of the major cornice, on the pilasters and their relation to the fenestration, and on the diminution of the volumes of the structure. These are followed by a series of questions:

> What is the proportion of the height to the width? What is the proportion of the upper to the lower stages? In what ratio does the width diminish to the top? Does the weight of the superstructure function as a counterbalance for the oscillation of the bells?[20]

No doubt Cicerones would be plagued by specific questions such as these from the more serious of the grand tourists. But Sir Roger Newdigate seems to have had little faith in Cicerones, to judge by a remark on a map of modern Rome—"the best I ever saw. Will show more than any Cicerone."[21] He refers constantly to published books of architecture, Desgodetz, as we have seen, and Scamozzi, Vignola, and Palladio. His long familiarity with architectural literature is witnessed by a drawing at Arbury Hall with the boyish inscription *Archettara*, and one of the Hovingham Hall drawings is inscribed *T. W. Etonensis*. Many of the grand tourists had been well prepared by previous study to profit from their travels.[22]

Publications on painting and sculpture were neither as numerous nor as accessible as those on architecture, and the grand tourist's notes on these arts tend consequently to be descriptive more often than analytical. Passing into the interior of the Palazzo Pitti, Sir Roger noted first the mural paintings. To the right of the hall, for example: "Ceiling finely painted in fresco by Pietro da Cortona—the centerpiece the subject: Adoloscentiam Pallas a Venere avellit—a fine expression of concern in both faces, Venus a beautiful figure—a little boy pulls him back by the robe." The ceiling of the third room to the right he notes as: "By Ciro Ferri, Scholar to Po. da Cortone—Mars headlong in the air, Castor & Pollux fine figures on horseback—Hercules—Liberality very fine." And so for the rest of the rooms. The notes are not indicative of extensive acquaintance with the work of Pietro da Cortona and his school, and their principal concern is the subject matter of the paintings. Their function, one imagines, was to serve as a help to memory, a task long since taken over by the photographic image. There are some indications of critical observation, however. Of frescoes by Nasini in the sixth room he remarks: "Disposition and drawing good, colouring indifferent."[23]

His methodical approach is evidenced particularly by his study of the paintings in the Palazzo Pitti. He recorded their disposition in a series of sketches of the rooms with notes on many of the paintings inscribed in the margins. These are frequently descriptive, as, for example, his note on Raphael's *Madonna del Pesce*—"Saints on each side, and at her feet two little boys reading a scroll, one's head on the other's." Occasionally, however, the description is enlivened by an engaging enthusiasm, as when he writes of the same artist's *Trinity*: "Padre Eterno supported by a Lion and Bull winged both—a small piece—wonderful Majesty"; and of the *Madonna della Sedia*: "the most beautiful group that ever was painted."[24]

He frequently distinguishes between the first and second manner of the artist as indications of stylistic change. Guido Reni is a case in point. One painting is briefly noted: "Magdalen sitting on the ground naked." But of *Lucretia* he remarks: "2nd manner, very light, beautifully coloured." Rubens is typified as: "this poetic painter," and of Van Dyck's *Portrait of the Prince of Denmark* he writes: "a boy with his hair over his forehead—never saw a finer." Such enthusiasm is infectious, and the art historian perusing these notes of the grand tourist recognises a forebear in Sir Roger Newdigate. Perhaps the study of art history is the major continuing effect of the grand tour. Sir Roger's practice bears most of the marks of the discipline. Dimensions of paintings are not noted, but their proportions relative to each other are, and indications of framing are inscribed where the frames are of consequence. There is also a sharp eye evident for the physical condition of the work of art, and Raphael's *St. John*, for instance, bears the note: "On canvas which has been pierced all down."[25]

Sir Roger had a greater attraction to sculpture than to painting, and he acquired a small but very fine collection which is still housed at Arbury Hall. His preference can be sensed in the detail with which he studied the famous *Venus de' Medici* (figs. 5, 6):

> Of a marble exceedingly shining and highly polished, almost transparent. The remains of gilding are very visible in her hair, which is in the highest Greek taste, not triflingly laboured. The ears are bored quite through. The stone is spotted in a great many places with stains of a bluish colour. This statue was broken into many pieces, they say forty, but the parts have been so happily found and so artificially put together that it has suffered less than it is possible to conceive. I took a list of all the places where I could discover it had been broken, which are: at the neck; at the right arm under the armpit; at the left in the same place a little piece is broken out (which is all that had to me the appearance of modern in the whole statue); at the left elbow; all the fingers of the right and all the fingers and thumb of the left hand; in two several places of the waist, one of them just at the small of the waist; in both thighs; at both knees; in the middle of the right leg; at both ankles; at the left foot a little above the toes. This statue, though mangled in the manner mentioned, is of such surprising beauty that no description can come up to it. For my part, I was so astonished when I saw it, that I could not take my eyes off to look at anything else, not even when I had seen it several times.[26]

This lengthy and detailed account demonstrates the importance of first-hand acquaintance with great works of art, which is the cornerstone of the excellence of the English art-historical tradition. Sir Roger's close examination of the other statues is evidenced by a manuscript chart in which he adopted the following grading system: E for excellent; F for fine; G for good; and In for indifferent. He noted which statues were Greek and which Roman, and was careful to remark on modern repairs. For doubtful cases he adopted the comprehensive A for antique, but it is only fair to remark that not once did he resort to this escape category. Of the statue of an athlete he remarks: "looks attentively on a vase which he holds with both hands. Excellent. A fine muscular figure. Both arms and vase modern." He describes the *Bacchus* of Michelangelo: "Excellent. Hand with the cup has been broken at the wrist. Body very fine and attitude. Effeminate and drunken look." The bust of Seneca is noted: "Excellent. In the highest Greek taste. The hair and beard most masterly. Nose modern." Galba's bust he thought: "Fine. Head Greek.

5

5. *Sir Roger Newdigate.* Sketch of the
Venus de' Medici. *1740. Arbury Hall, War-
wickshire (courtesy of F. H. Fitzroy-Newde-
gate)*

6. *Thomas Patch.* Connoisseurs in the
Tribune of the Uffizi *(detail). Collection
Brinsley Ford*

6

Bust Roman." His knowledge of the personae of antiquity was quite remarkable and was evidently based upon close study of their images on antique coins and medals. Of *Agrippina Mater* he remarks: "Like her medals. The hair waving. Good." But the bust of Vitellius he found: "Indifferent. Fat double chin like his medals."[27]

The importance of Sir Roger Newdigate's study of statuary on the grand tour is considerable. Mention has already been made of the fine collection he bought for Arbury Hall, and an account has already been published of the two large marble candelabra he purchased from Giovanni Battista Piranesi to furnish the central hall of the Radcliffe Library in Oxford.[28] Upon his return to England he married Sophia Conyers of Copt Hall in Essex. She was the niece of Lady Pomfret, and it was Sir Roger Newdigate who secured the gift of the Pomfret Marbles for the collection of the University of Oxford, and planned and supervised their installation.[29] Towards the end of his life he was distressed at their neglect and sought to have them transferred to the Radcliffe, under the care of John Flaxman, volunteering to the University the gift of two thousand pounds to facilitate their installation.[30] This scheme met with considerable opposition from the Radcliffe Librarian, however, and came to nothing.[31] Sir Roger Newdigate is one of a distinguished line of connoisseurs whose grand tour was thus turned to the profit of his country by his practice and encouragement of the fine arts in England. The tradition reached back to Lord Arundel, and at the beginning of the eighteenth century it was stimulated by the examples of Lords Clinton, Pembroke and Burlington.[32]

Another aspect of that tradition was practical training in art, and the grand tourists of the mid-century did not neglect this. Sir Roger Newdigate became a fine draughtsman, and fortunately we can establish some of the responsibility for his training from a bill presented to him by the Roman architect Giacomo de Sanctis on May 10, 1740, for six weeks' lessons in architectural drawing, and for drawings the architect had made for him in Rome.[33] In his turn, Sir Roger became tutor to younger grand tourists, as we learn from a letter addressed to him on June 15, 1755, by William Bagot of Blithfield, Staffordshire:

> I have a man with me who calls himself a Drawing Master and Architect, but he has not the least idea of Perspective. . . . He is so bad that I have been forced to turn him off and there is no other in the town that pretends to teach it, which I am very sorry for. I am much obliged to you for the hints and advice you have already given me, and shall be glad of any others that may occur to you.[34]

Ten years later, Sir Roger had a letter from his brother-in-law, John Conyers, who maintained a very busy studio in Dijon:

> We have found a drawing genius here whose merit is thrown away upon these people. He comes from the warmest parts of Provence, and [has] an imagination full of fire. He has three scholars in my house who are hard at work with their pencils.[35]

Many of Sir Roger's drawings from the first of his tours survive, and he became so proficient a draughtsman that on his second tour, when he discovered the Roman ruins of Aosta, his drawing of the triumphal arch was borrowed by Piranesi, who made a print of it which he included in the published collection *Archi Antichi*.[36]

English artists in Rome were also kept busy instructing their countrymen in the practice of the arts. The visit of George Pitt of Strathfieldsaye to Rome in 1741 is noted by James Russell, for example:

This young gentleman, whose good qualities are answerable to his great fortune, does not squander away his time and money, as too many of our wild young sparks do, in drinking, gaming, etc., but studies very much and diverts himself with music and drawing; in which last he has made such proficiency, that were he in our academy, I should soon grow jealous of him.[37]

Similarly, the architect George Dance the Younger wrote to his father from Rome on April 10, 1762:

I have been teaching Mr. Hinchcliffe, a clergyman, the Orders of Architecture. He made me a present of 4 zechins, about 2 guineas, and promised to serve me in everything he can.[38]

It is George Dance who records for us the arrival in Rome of Thomas Pitt, later Lord Camelford, to whom he was introduced by James Russell. Pitt commissioned the young architect to make a drawing for him of the ceiling of the Palazzo Colonna.[39] Thomas Worsley had made that drawing for himself,[40] but the practice of having artists record memorable scenes of the grand tour was well established. Sir Roger Newdigate, as we have seen, had Giacomo de Sanctis make drawings of architectural and painting details, though he was himself a thoroughly competent draughtsman (fig. 7). The alternative to drawings was prints, and there is no need to stress the vogue among grand tourists for the works of Piranesi. The comparative absence of detailed notes from Sir Roger's stay in Rome is probably explained by the availability of prints. He spent the large sum of thirty-five zechins on the works of Pietro Santo Bartoli in Rome,[41] whereas his purchase of prints in Florence came to less than seven zechins.[42] From Pietro Cipriani in Florence he acquired copies of the Medici statues and busts which he most admired, for 360 zechins.[43]

An interesting extension of the grand tour began with the visit of Thomas Pitt to Portugal and Spain in 1760.[44] His friend in Cambridge, Thomas Gray, was most enthusiastic about this expedition, and charged Pitt with the task of recording his impressions of the architecture of the peninsula. Pitt was not impressed, writing of Lisbon:

They seem to consider the front of the house only as a high wall, with holes larger or smaller to admit light as occasion requires. This want of taste appears in all the buildings that remain except a fragment of the Palace that escaped [the earthquake]. . . . Nor have they any better taste in their *Quintas* or country villas.[45]

Of Madrid he merely notes, "There is certainly not a capital in Europe which has so little worth showing to a stranger,"[46] and he found the Escorial too low and too long. Even the royal villa at Aranjuez was found wanting, though he believed it to have been designed by Vignola:

The front has something elegant in its appearance, though with great faults. The inside is divided by a vast stone staircase, not of the lightest sort. The apartments are neatly ornamented, but are neither stately nor well laid together.[47]

It is indicative of the change of taste in England in the middle of the century that Pitt was far more appreciative of what Gray had called "the remains of Moorish magnificence,"[48] the Gothic cathedrals. Batalha particularly brought forth encomiums:

*7. Sir Roger Newdigate.* Sketch of the Gallery of the Palazzo Colonna, Rome. *1740. Arbury Hall, Warwickshire (courtesy of F. H. Fitzroy-Newdegate)*

> This convent is of the most elaborate and exquisite Gothic architecture I ever saw; one part of it being left imperfect, being so beautiful, that nobody dared to finish it.[49]

Of particular interest are Pitt's comments on the royal palace in Granada:

> It is impossible to lay down any Plan of the Moorish palace, as they seem never to have taken more than one apartment into their idea at once, without regarding the communications or symmetry of the whole.[50]

This is a more penetrating remark on planning than is to be found in any contemporary or earlier account of the Gothic style. And Thomas Pitt is also the first to use the term *Castle Gothic* of English architecture, in the course of his remarks on the cathedral of Lisbon:

> The Capitals are Grotesque Gothic, like our Saxon. Over this (western) porch is a kind of list of corbels with masks, like our Castle Gothic.[51]

He had evidently profited much from his friendship with Thomas Gray, who was making just such notes on English Gothic architecture while Pitt was an undergraduate at Clare.[52] Many sketches and plans of the Spanish cathedrals accompany these notes (figs. 8, 9), and the preeminent place in the history of the Gothic Revival held by Batalha is probably due to Pitt. His is the attribution of the church to an English architect, which James C. Murphy was to publish in his famous monograph

*8. William Cole, after Thomas Pitt.* Plan of Lisbon Cathedral. *1760. British Library, MSS Add. 5845, fol. 115v*

*9. William Cole, after Thomas Pitt.* Sketch of the West Door of Lisbon Cathedral. *1760. British Library, MSS Add. 5845, fol. 116*

on Batalha, to which Pitt was a subscriber.[53] Pitt's account of the Gothic architecture of the Iberian peninsula was of vital interest to English scholars since it provided them with their first opportunity to test Sir Christopher Wren's theory of the Saracenic origin of the Gothic style. His manuscript was passed eagerly from hand to hand upon his return, and was later plagiarised in part, though ironically that part had to do with bullfights rather than architecture. But Pitt's study of Gothic architecture had immediate practical results, too, in the designs he made for the gallery of Strawberry Hill for Horace Walpole, and his designs for restorations to the cathedrals of Carlisle and Norwich.[54]

Another interesting grand tourist who began his travels by visiting Spain was Thomas Pelham, whose mother, Lady Pelham, maintained a correspondence with Lord Grantham, the Resident at Madrid. From this we learn that Thomas had a drawing master while he was in Spain,[55] and that he made a particular study of the

paintings of Velasquez. This blossomed after his departure for Italy into a thoroughly scholarly project, a plan for the first monograph on an artist in our modern sense:

> My copies from Velasquez have succeeded so well that I am quite eager about his works and am making a Catalogue of them, to which I mean to add a short Account of his Life and some Observations on his Style. I do not promise that it shall be printed as I have neither Wit nor Press nor Strawberry Hill. You are to assist me in my researches, and I will in due time send you a Note of Directions. In the first place you must find out if there are any at Turin.[56]

Later letters reveal that the young Pelham took this task very seriously and pursued the study of Velasquez in Rome and Bologna as well as in Turin. In Rome he called upon the assistance of the Neo-Classical painter Anton Rafael Mengs, with whom he was evidently familiar.[57] Unfortunately Pelham's side of the correspondence is missing, so our knowledge of his studies is incomplete. But from Lord Grantham's letters we learn that he pursued drawing lessons with a new teacher named Luigi. And we can gain an impression of the extent and quality of his critical observations from Grantham's reply to a letter from Rome:

> Your criticism of the front of St. Peter's is just, for it hides a great deal too much of the cupola. But the fault is not in the attick but in the prolongation of the Church contrary to the original design, which made the plan upon a square cross. I confess likewise the difference between original pictures and mosaic copies, but I think that considering the perpetuity given by the latter to the great works of painters, it is a most noble invention and not altogether unworthy the place where they are kept.[58]

One further extract from the Grantham letters deserves quotation, since it provides the most succinct formulation of the purposes of the grand tour in relation to art education:

> The mere erudition which attends the investigation of particular spots is very dry. The enthusiasm with which some people connect the recollection of historical events with the bare view of their former scene is often artificial. But the visible grandeur and exquisite beauty of many ancient works both of architecture and sculpture, strikes more really and with more effect on our senses, and affords matter of study and reflexion, as well as it forms an habitual taste.[59]

Taste eluded definition in the eighteenth century as it does now, but the grand tourist had no doubt that it could be learned only by direct contact with great works of art, and this is a lesson which is still valid for art education.

The professional training of architects and artists on the grand tour is beyond the scope of this paper, which limits itself to the typical grand tourist. But attention must be drawn to an important way in which the grand tour affected professional artists by providing them with the opportunity to meet with prospective patrons on a common basis of enthusiasm for the arts. One instance of this, which did not have a happy ending, occurred on Sir Roger Newdigate's second tour, when Theodosius Keene, the son of Sir Roger's friend the architect Henry Keene, wrote from Venice:

> The evening before my departure from Rome I left at your house a rough sketch of the Triumphal Arch of Septimius Severus, for you to write and make what

remarks you please on, that I may, when you think proper, make fair drawings. I am at present very busy measuring some of the principal buildings of Palladio here, and when I shall have finished shall go on to Vicenza and Verona to do the same.[60]

Sir Roger Newdigate employed the young architect in renovations to his town house in Spring Gardens upon his return from the grand tour. But unfortunately Theodosius Keene lacked his father's business skills and went bankrupt in 1779.

A more fruitful partnership developed between Thomas Pitt and the young John Soane, who may have met first in Naples in 1779 when Pitt was on his second tour. Their friendship developed in Rome, as Soane testified in writing of the designs he made there for a royal palace:

In making this design, besides the advantages already mentioned, I had frequent opportunities of showing the drawings in their progressive state to my honoured and lamented patron, the late Lord Camelford, then Mr. Thomas

*10. Pompeo Batoni. Lt. Gen. Sir Richard Lyttelton, K.B. 1762. Hagley Hall, Worcestershire (courtesy of Lord Cobham)*

Pitt, and of making such alterations in them as were pointed out by the classical taste and profound architectural knowledge of that accomplished nobleman.[61]

Nor was this the only instance of collaboration between the grand tourist patron and the art student. From Milan in August of the same year Soane sent Pitt for correction the designs for a *castello d'acqua* which he later submitted to gain membership in the Parma Academy.[62] The friendship thus begun on the grand tour was to ripen into a sincere affection recorded in thirty-four letters preserved in the Sir John Soane's Museum. Pitt was responsible for securing many of Soane's early commissions, and he encouraged the publications of Soane by subscription as well as advice.[63]

The most profound effect of the grand tour upon art education lay in its facilitating the purchase of works of art and their export to England, for the great national collections were eventually formed from private collections. Documentation of this process would be the task of a lifetime, and in this paper I can only hint at the excitement and joy of the grand tourist as collector by quoting from my favourite correspondence of the grand tour. This is an account by Sir Richard Lyttelton (fig. 10) of his recent acquisitions in Rome written to his nephew Thomas Pitt, who was supervising structural alterations to Sir Richard's house at Richmond:

> What a figure will my fine room cut, when it is adorned with all the fine pictures I am collecting—which God send me safe and well from this wicked place of Gaming and Extravagance, for I shall certainly be undone else one way or another. . . .
>
> Well! As to the great room at Richmond. It may have its faults, to be sure, and pray what is there *perfect here* or *anywhere*? But what will you say to it, when, besides as many of the fine pictures that you saw here of my purchasing as I will hold—viz. Gaspars, Salvators, Domenichinos, Barrochios etc.—it has (as it will, or may have, for I have got them!), two inimitable L. Giordanos, the one the Enlevement of Amphitrite in her Coquille, represented with a trident in her hand, drawn by two Dolphins, with Cupids, Sea-Gods etc. carrying her in triumph to Neptune. The other Hercules and Omphale. About nine feet wide by five. 9 × 5! They are the most capital pictures and undoubted originals. The best Spagnolet, of a S. Paolo d'Acise, I ever saw, and a charming head, Magdalen, by Guido.
>
> (The Duchess says all my swans are geese, but no matter).
>
> I have also two the charmingst little Clauds. O that you could but see them! They are perfect Bijoux, I assure you.
>
> (Which God preserve you in your wits and leave you—meaning me—some money in your pocket, says the Duchess).
>
> *But indeed the Pictures are charming.*
>
> There now you have it under her own hand; and since she has taken up the pen, it's a sign I am tired of it, so goodnight, my dear nephew.[64]

*University of Toronto*

*Notes*

[1] James Russell, *Letters from a Painter Abroad to his Friends in England*, 2nd ed., London, 1750, 57.

[2] For Newdigate see Michael McCarthy, "Sir Roger Newdigate and Piranesi," *Burlington Magazine*, CXIV (July 1972), 466, n. 1, for a bibliography. See also Michael McCarthy, "Sir Roger Newdigate: Some Piranesian Drawings," *Burlington Magazine*, CXX (Oct. 1978), 671–72.

[3] These notes are among the Newdegate Papers deposited in the Warwick County Record Office, and I am grateful to F. H. Fitzroy-Newdegate of Arbury Hall for permission to study them and publish these excerpts. It is a pleasure to acknowledge the cooperation of M. W. Farr, Senior Archivist, and his colleagues at the Warwick County Record Office.

[4] The quotation is from Anthony Burgess, "The Grand Tour," in Anthony Burgess and Francis Haskell, *The Age of the Grand Tour*, London, 1967, 19–32. The deficiencies of the literature on the grand tour are indicated in Robert Shackleton, "The Grand Tour in the Eighteenth Century," *Studies in Eighteenth-Century Culture*, I, Cleveland–London, 1971, 127–42. The best bibliography is still W. E. Mead, *The Grand Tour in the Eighteenth Century*, Boston, 1914 (reprint, New York, 1972).

[5] Russell, *Letters*, 75.

[6] British Lib. MSS Add. 33099, fol. 121. Nardini's work was titled *Roma Antica*, 2nd ed., Rome, 1704, and Addison's, *Remarks on Several Parts of Italy*, London, 1705. Lord Grantham was in Rome in 1760 after education at Westminster and Christ's College, Cambridge. For this information and for invaluable help with research on the grand tour, I am deeply indebted to Brinsley Ford.

[7] Warwick CR 136B/3018–15.

[8] For the account of Aosta see Michael McCarthy, "Newdigate and Piranesi"; and for the account of Paestum see Michael McCarthy, "Documents on the Greek Revival in Architecture," *Burlington Magazine*, CXIV (November 1972), 760–69.

[9] His tour was undertaken in 1749 and is recorded in eight letters deposited in the Essex County Record Office, D/DL C43/3/221–28.

[10] Warwick CR 125B/430.

[11] Wilmarth S. Lewis, ed., *Horace Walpole's Correspondence*, XXXV, New Haven, 1973, 58. For Chute's grand tour see Warren H. Smith, *Originals Abroad*, New Haven, 1952, 157–76, and Lesley Lewis, *Connoisseurs and Secret Agents*, London, 1961, 128–32.

[12] Warwick CR 136B/3017, entry under date Jan. 24, 1740.

[13] *Ibid.*, entry under date May 26, 1740.

[14] *Ibid.*

[15] Warwick CR 136B/3018.

[16] Michael McCarthy, "Sir Roger Newdigate—Drawings for Copt Hall, Essex, and Arbury Hall, Warwickshire," *Architectural History*, XVI (1973), 26–36.

[17] Warwick CR 136B/3018–18.

[18] Warwick CR 136B/3018–15.

[19] *Ibid.*

[20] Thomas Worsley (1710–1778) collected a large and varied group of architectural drawings. 134 are at Hovingham Hall, Yorkshire, and I am grateful to Sir Marcus Worsley, M.P., for permission to study them. They were provisionally listed by John Harris, who kindly made his list and manuscript notes on the collection available to me for expansion in my doctoral thesis, "Amateur Architects in England, 1740–1770," Courtauld Institute of Art, University of London, 1972. In my catalogue this drawing is No. 656 (Harris 206). It is a pencil drawing with ink inscriptions, $11^7/_8'' \times 8''$. The notes are in Italian, and the translation is mine. Other drawings by Thomas Worsley from the grand tour are Michael McCarthy 657–73, 680, 683–87 (Harris 208, 81, 64, and 80). Fourteen other drawings by Thomas Worsley in the Avery Architectural Library, Columbia University, are discussed in John Harris, *A Catalogue of British Drawings for Architecture, Decoration, Sculpture and Landscape Gardening, 1550–1900, in American Collections*, Upper Saddle River, N.J., 1971. For Worsley's career see Sir Lewis Namier and John Brooke, *The House of Com-*

mons, *1754–1790*, III, London, 1964, 659–61.

21 Warwick CR 136B/3018–15.

22 Michael McCarthy, "The Education in Architecture of the Man of Taste," *Studies in Eighteenth-Century Culture*, V, University of Wisconsin Press, 1976, 337–53.

23 Warwick CR 136B/3018.

24 *Ibid.*

25 Warwick CR 136B/35/12–15.

26 Warwick CR 136B/35/8.

27 Warwick CR 136B/35/9.

28 Michael McCarthy, "Newdigate and Piranesi." For Sir Roger's collection see Cornelius Vermeule, "Notes on a New Edition of Michaelis: Ancient Marbles in Great Britain," *American Journal of Archaeology*, LIX, 12 (April 1955), 130.

29 Warwick CR 136B/2980, 2986.

30 Warwick CR 136B/3530–31. Flaxman's bill, addressed to the executors of Sir Roger's estate, is Warwick CR 136B/2526.

31 *Bibliotheca Radcliviana*, Oxford, 1947, 38–39.

32 Richard Pococke, Bishop of Ossory, singled out these three names as the principal innovators of art studies in England in the eighteenth century, in his unpublished tour of 1764: British Lib. MSS Add. 14260, fol. 73.

33 Warwick CR 136B/35/5:

Conto dell' Architetto
Per un mese e mezzo di lezione d'Architettura dato al Signore Cavaliere delli Cinque ordini d'Architecttura formati in cinque libri cioe il primo mezzo mese di una ora di lezione che e un Zecchino e un mese di due ora di lezione che si chiama mese doppio che sono quattro zecchini che as°.

| | |
|---|---|
| jor.: | 8.25 |
| Per carta da disegnare & le libri | 25 |
| Per il disegnio della facciata dell'Aurora con il suo pianto che sono quattro zecchini | 7.20 |
| Per il disegnio dell'Anfiteatro | 3.10 |
| Per li cinque ordinetti in piccolo che vi impiegni tre giornati | 1.00 |
| Per la finestra di carbogniari | 1.18 |
| Per la finestra del Palazzo di S. Giovanni laterano | 1.18 |
| | 21.00 |

Io Sotto Scritto o ricevuto il Soldo del Sudetto conto dal Illustrissimo Signore Cavaliere Nudeghit questo di 10 Maggio 1740

Giacomo de Sanctis manoscritto.

The bill, it will be noted, does not add correctly. Sir Roger evidently felt that De Sanctis was overcharging him. The first total, 28.25, was altered, with other figures, to 21.00.

34 Warwick CR 136B/17.

35 Warwick CR 136B/1582.

36 Michael McCarthy, "Newdigate and Piranesi."

37 Russell, *Letters*, 57–58. The second plate of this book is dedicated to George Pitt. The practical result of his training can be seen in the building of Strathfieldsaye Church, 1753–58, for which see Basil F. Clarke, *The Building of the Eighteenth-Century Church*, London, 1963, 63.

38 Dance Manuscripts in the Library of the Royal Institute of British Architects, London, MSS 72.034 (42) 8/88:92D.

39 *Loc. cit.*, letter dated from Rome, Oct. 7, 1761:

The Duchess of Bridgewater, Sir George [sic] Lyttelton, and Mr. Pitt, nephew to the great Minister, arrived here last week; I was introduced to them this morning by Mr. Russell the Antiquary, whose letters you have got. They received me very politely and Mr. Pitt, who is a great lover of architecture, desired me to make him a Drawing of the famous Gallery at the Colonna Palace. I have already got a licence to measure it and shall finish it with all expedition. He is a young gentleman of an extraordinary fine character and fine sense. His friendship may be of great service to me in England and if I please him in this Drawing I hope that he will employ me to do some of the Antiquities for him.

The Sir George Lyttelton above is a mistake for Sir Richard Lyttelton,

husband of the Duchess of Bridgewater and uncle of Thomas Pitt, whose correspondence will be quoted later in this paper. For Pitt's architectural career see Howard M. Colvin, *A Biographical Dictionary of English Architects, 1640–1840*, London, 1954, 459–60, and Michael McCarthy, "The Rebuilding of Stowe House, 1770–1777," *The Huntington Library Quarterly*, XXXVI (May 1973), 267–98.

[40] McCarthy 659 (Harris 81).

[41] Warwick CR 136B/35.

<div align="center">

Opera di Pietro Santo Bartoli

</div>

| | |
|---|---|
| Colonna Trajana | 9. |
| Colonna di Marc'Aurelio | 5. |
| Bassirilievo antichi | 5.50 |
| Archi antichi | 4.50 |
| Sepolcri antichi | 4. |
| Lucerne antichi | 4. |
| Roma antica in ln fogli | 1.50 |
| Roma moderna in ln fogli | 12. |
| | 35.30 |

These were bought from the Stamperia Papale.

[42] *Ibid.*

| | |
|---|---|
| Le Camere de Medici di Pietro da Cortona | 5.50 |
| Paesi de Caracci | .30 |
| Tavola d'Io di Pietro Testa | .15 |
| Cinque fogli di Giulio Romano | .40 |
| Madonna di Guido | .30 |
| | 6.65 |

This bill is receipted by Giovanni Domenico Campiglia.

[43] *Ibid.* The most expensive statue was the Venus, which cost 120 zechins. The other three Medici groups cost 40 zechins each, and the rest of the bill is made up of the cost of casts of busts. The bill is signed: "Io Pietro Cipriani Bronzista ho ricevuto il valore del sudetto conto."

[44] The record is preserved in a transcript by William Cole, British Lib. MSS Add. 5845, fols. 111–46. One other letter has survived, Thomas Pitt to Charles Lyttelton, from Lisbon, March 24, 1760, British Lib., Stowe MSS 754, fols. 48–49.

[45] British Lib. MSS Add. 5845, fols. 113–14.

[46] *Loc. cit.*, fol. 128.

[47] *Loc. cit.*, fol. 134 v.

[48] Paget Toynbee and Leonard Whibley, eds., *The Correspondence of Thomas Gray*, London, 1935, 659.

[49] British Lib. MSS Add. 5845, fol. 115.

[50] *Ibid.*, fol. 142.

[51] *Ibid.*, fol. 117.

[52] For Gray's notes see Thomas J. Matthias, ed., *The Works of Thomas Gray*, II, London, 1914, 98–103 and 600–603.

[53] For the importance of James C. Murphy's *Batalha*, London, 1795, see, with this caveat, Paul Frankl, *The Gothic*, Princeton, 1961, 480. Murphy's attribution of the building to an English architect is almost certainly dependent upon the attribution by Pitt, British Lib. MSS Add. 5845, fol. 122.

[54] For further discussion see Michael McCarthy, "Eighteenth-Century Cathedral Restorations: Correspondence relating to St. Canice's Cathedral, Kilkenny," *Studies*, LXV (Winter 1976), 330–43; LXV (Spring 1977), 60–76.

[55] British Lib., MSS Add. 33099, fol. 218.

[56] *Ibid.*, fol. 240.

[57] *Ibid.*, fol. 258 v.

[58] *Ibid.*, fol. 268.

[59] *Ibid.*

[60] Warwick CR 136B/1787.

[61] Sir John Soane, *Memoirs of the Professional Life of an Architect*, London, 1835 (privately printed), 14.

[62] Arthur T. Bolton, *Portrait of Sir John Soane*, London, 1927, 23.

[63] Bolton, *Portrait*, 22 *et seq.*

[64] ALS unpublished, from the Lyttelton Manuscripts at Hagley Hall, Worcestershire, quoted by kind permission of Lord Cobham.

# 30

# *Young Joseph's Guardian Angel: Salvage from a Case of Parallel Research*

EDWARD A. MASER

Since contribution to this volume in honor of a distinguished colleague and friend is actually more of an honor for the contributor than otherwise, it is hoped that its contents will be a pleasure and not a burden for him, whose brow is in any case already so heavily laden with laurel. Ideally such a contribution should try to be, if it can, more of what Thomas Mann had Pope Gregory the Great say in *The Holy Sinner*, while pretending not to know of and thus dwelling at length on his and his mother's complex and colorfully sinful relationship, "We thought to offer God an entertainment."[1] No blasphemy or comparison intended, it is hoped that this excursion into the *hic sunt leones* regions of the interdisciplinary, through which our honored friend has walked with such skill and success throughout his career, will be understood as an attempt to do the same for the *festeggiato*—and that he may enjoy it!

On April 29, 1975, participating in its celebration of the centenary of the birth of Thomas Mann, this writer, as a member of the Department of Germanic Languages and Literatures of the University of Chicago as well as that of Art, presented an illustrated lecture on "Thomas Mann's Use of the Visual Arts." Thus was put to use a hobby of many years' standing, that of attempting while reading Mann's novels to identify the specific works of art he had obviously used as the sources for many of the personalities and places he so vividly described. For anyone familiar with the art of Germany or Italy or Egypt, even if only the more famous examples, it was obvious that, in spite of disclaimers that had been made on many occasions, the visual arts actually played a major role in Mann's life and work. Nor was such a study of his fiction, it seemed, an inconsequential kind of critical study of his work; for Mann, unlike someone like Henry James, the description of a locale, the physical appearance of a character, and the details of costume or accessories were crucial to his delineation of the characters and actions within his

work. It was, indeed, surprising, considering the enormous body of critical studies of Mann's work which already exists, that so little seemed to have been done about this obvious aspect of his fiction. The reason may have been that Mann himself seems to have preferred not to call attention to it.

As early as 1913, when asked by the *Berliner Tageblatt* a question that it was asking a number of leading figures in the intellectual and artistic world: "With which painter do you feel most closely related in your own work?" Mann's answer was a negative one. He did not feel associated with any painter. He described himself as an *"Ohrenmensch,"* an "ear-person," more open to the influence and inspiration of music than of the visual arts.[2] Yet even at that time it could not have been true. To be sure, he never made an actual artist, whether painter or sculptor, a protagonist in his work, but rather writers, scholars, and musicians. However, again and again throughout his life and his writings, references to the visual arts abound. In his *Sketch of My Life*, he admits that when he and his brother went to Rome in 1895, in spite of feeling that it had little to do with him and the shaping of his thought and expression, he did see all the works of art which every Rome pilgrim must. He said:

> I accepted respectfully the historical and aesthetic impressions the city had to offer, but scarcely with the feeling that they concerned me or had immediate significance for me. The antique statues in the Vatican meant more to me than the painting of the Renaissance. *The Last Judgement* thrilled me: it was the apotheosis of my entirely pessimistic, moralizing, anti-hedonistic frame of mind.[3]

The self-contradiction in this statement is self-evident, since he selected as the epitome of his thinking at the time not a piece of music or a poem, but a painting, and one at that which apparently remained with him throughout his life, appearing again at the very end of his career in one of his most gripping images.

Actually, from his earliest days, Mann, like any well-educated member of his class in Germany, was involved with the visual arts. Even at school at Lübeck, he became friends with men who later became art historians, men like Otto Grautoff and Count Vitzthum von Eckstädt (who apparently served, moreover, as the model for Count Mülln, the father of Hanno Buddenbrook's little friend, Kai). Attending the University of Munich in 1895, he went to the lectures of Franz von Reber on German architecture after Charlemagne. As early as 1899 he made the personal acquaintance of Alfred Kubin, the painter and illustrator. He wrote his brother Heinrich in 1900 that he had visited an exhibition in Munich of copies of famous Florentine works of sculpture and said, *"für mich äusserst interessant, weil man durch die Portraetbüsten den Typus der Leute von damals auf so angenehme Art kennenlernt"*[4] ("for me extremely interesting, because through the portrait busts one becomes acquainted in such a pleasant way with the type of people who lived then": author's translation). In February of 1901 he read Burckhardt and Vasari as a preparation for writing *Fiorenza* and in May he traveled to Florence for the same purpose. To be sure this was all nothing unusual for a writer; he was obviously simply gathering background material, but the significance of this sort of research on his part was greater, for it became an integral part of the so-called montage technique which was to be recognized as one of the main characteristics of his style.[5]

As one peruses the chronicle of Mann's life by Bürgin and Mayer one finds scattered throughout constant (but not obligatory) references to the visual arts.[6] In

Dresden, he found the Zwinger, that monument of the Rococo, "beautiful." In 1915 he began his long correspondence with the Viennese art historian Paul Amann. In 1923 it was apparently the illustrations of the Joseph story by Herman Ebers, seen in the winter of 1923, which inspired him to begin his own great Joseph tetralogy on or about April 10, 1923; a year later he spent three weeks in Egypt itself to see all the places about which he planned to write. In July 1928 he visited the great Dürer exhibition held in Nürnberg on the four hundredth anniversary of Dürer's death. As a member of the *Comité Permanent des Lettres et des Arts* in Geneva he associated with such fellow members as Henri Focillon, Joseph Strzygowski, Wilhelm Waetzoldt, and Ugo Ojetti, all art historians of international reputation. In Swiss exile in 1933, he began his friendship with Julius Meier-Graefe, the art critic and historian. In March 1939, his daughter Monika married Jenö Lanyi, the Hungarian Donatello scholar (in fleeing Europe during World War II, Lanyi went down with the torpedoed ship the young couple were on; his photographs and notes on Donatello were later utilized by H. W. Janson in his monograph on the artist). In October 1948 Mann contributed all his available honoraria in Germany toward the preservation of the Memling altar and the Marienkirche in Lübeck, his native city. In 1954 he wrote that he planned to write a series of portrait sketches of great figures of the Reformation period in Germany including specifically the sculptor Tilman Riemenschneider. And during his last visit to Germany just before his death, he even went to see the exhibition in Düsseldorf of masterworks from the São Paulo museum as well as the newly restored eighteenth-century palace, Schloss Benrath. All this would certainly suggest a more than passing interest in the visual arts for an "*Ohrenmensch*."

Nor is it difficult to recognize some of the visual sources he utilized in his novels. His description of Munich in *Gladius Dei* (which he later even used, paraphrased and disguised, in his description of hundred-gated Thebes as young Joseph saw it) reveals how familiar he was with the artistic monuments of the city which was his home for forty years.[7] His careful observation and his powers of description make vivid, without naming names, the city's Baroque churches, the Feldherrnhalle near the Odeonsplatz, the Residenz, and the many art shops, some of which are still there. These were filled in 1902, as in the story, with things we can also recognize today: paintings by Arnold Böcklin, and objects and books decorated with extravagant *Jugendstil* ornament. His visit to Florence in 1902 all too obviously provided him with the descriptions and images he needed for *Fiorenza*, which clearly owes a great debt to Ghirlandaio's frescoes in Santa Maria Novella.[8] Easiest of all is, of course, his monumental tetralogy of *Joseph and His Brothers*, particularly in the third and fourth volumes, which tell of Joseph in Egypt. Here references to specific works of art abound and the works themselves are easily recognizable. A great number of them were obviously taken from such books as the well-illustrated German edition of James Breasted's *History of Egypt*, of 1936.[9] The frescoes in Potiphar's summer house are one instance. Indeed, the famous painted frieze of geese and the equally well-known fresco of the cat among the reeds, which both appear on the same plate of Breasted's book, are even placed together in one sentence just as they appear on the page in Breasted.[10] His exploitation of visual material becomes even more evident during and after the momentous meeting between Joseph and Pharaoh in the Cretan loggia.[11] Here Mann's acquaintance with Professor Georg Steindorff of Leipzig, the noted archeologist, and the presence in Munich of the excellent Aegyptisches Seminar at the University, reveal how many of the books available there, such as Sir Arthur

Evans's publications of the palace at Knossos, which he did not own, or Georg
Steindorff's *Die Blütezeit des Pharaonenreichs*, which he did, furnished him with
images he could and did utilize in his striking descriptions of the culture of Egypt and
its artifacts during the XVIIIth Dynasty. Since it was Ikhnaton whom Joseph met
in the Cretan loggia (actually discussing art and artistic theory with his court ar-
tists, incidentally), Heinrich Schäfer's *Amarna in Religion und Kunst* also served him
well. It had appeared in 1931, at the height of the interest in Munich in this mon-
arch and his monotheism, and the copy in Mann's library was filled with marginal
comments and underlinings in his own hand. From it derived the brilliant descrip-
tions which he developed so skillfully into the characterizations of Ikhnaton, of
Tiy the Queen-Mother, and of Nefertiti, Pharaoh's "*Morgenwölkchen goldum-
säumt*," as well as a host of other personages, places, and objects, all of which play
some part in this crucial episode in his story.

Such things are repeated in all subsequent books as well. In the *Tables of the Law*
he consciously based his image of Moses on that of Michelangelo. In a letter of
February 17, 1943, he wrote Agnes Meyer, ". . . I come now to the main point,
the giving of the laws, with which I deal as a sort of Michelangelesque work of
sculpture, using for its raw material the race itself" (author's translation).[12] As has
often been pointed out, he refers time and again to Albrecht Dürer in his novel *Dr.
Faustus*, although the book deals with a musician, Adrian Leverkühn, and the most
modern and abstract sort of music. Leverkühn writes an *Apocalypsis cum figuris*
as one of his major compositions, inspired, quite openly, by Dürer's woodcut series.
The composer's study at Pfeiffering is less openly but nevertheless clearly that of
St. Jerome in the well-known engraving. Leverkühn's father is taken from Dürer's
portrait of Philipp Melanchthon down to the last detail. And his last image in this
last complete book he was to write returns again, poetically enough, to one of his
first comments on a work of art, on the *Last Judgment* of Michelangelo. This final
image is one every student of art history will recognize:

> Germany, the hectic [flush] on her cheek, was reeling then at the height of her
> dissolute triumphs, about to gain the whole world by virtue of the one pact she
> was minded to keep, which she had signed with her own blood. Today [1945]
> clung about by demons, a hand over one eye, with the other staring into horrors,
> down she is flung from despair to despair. When will she reach the bottom of
> the abyss?[13]

On this grandiloquent note, with the detail from the fresco of the damned soul
being carried down to Hell on the screen, my lecture ended. It was well received.
It was even considered by some to be a new contribution to Mann studies, a splen-
did example of interdisciplinary research, and publication was urged.

But following the lecture a colleague mentioned that a new book, *Bild und Text
bei Thomas Mann*, apparently paralleling the material in my lecture, had just been
announced by the Thomas-Mann-Archiv in Zürich, based on its holdings of both
Mann's personal library and his files. It was due to appear later in the year, and
I eagerly waited to see whether or not it would enlarge upon and perhaps confirm
my own identifications of Mann's visual sources. In the meantime, I continued to
contemplate the problems this bit of research had presented and to refine my own
thinking about it, still with the idea of publishing it eventually.

Imagine my surprise and delight then, when shortly after my lecture a new issue
of the Austrian art periodical *Alte und Moderne Kunst* (No. 140, 1975) appeared

in the art library containing a long and well-illustrated article by Prof. Dr. Hilde
Zaloscer entitled "*Die Bedeutung der bildenden Kunst im Oeuvre von Thomas Mann.*" Since the scholar's chief interest lay in the role that Egypt played in Mann's work, it was not surprising that the many easily recognized works of ancient Egyptian art in the Joseph novel formed the major part of her study, although she did bring in the works of Dürer and Michelangelo and their function as sources for images in *Dr. Faustus*. In a final footnote the author pointed out, moreover, that only *after* the completion of her essay had she been made aware of the publication by the Mann archive, which she had since seen and which proved, on the basis of the evidence in Mann's files and books, many of the hypotheses and "discoveries" she (and I) had made. She felt, moreover, that the publication by the archive made incontrovertibly clear his reliance on visual sources and really could be considered the final word on the subject. Her own studies had begun in 1943, and her current article had been written without knowledge of the material in Zürich which was not available to scholars before the appearance of the book.

All of this made my need to see the Zürich publication even more imperative, and rush orders at the library finally produced it. Even a cursory perusal of this compilation of reproductions of the photographs, postcards, newspaper clippings, and book illustrations to be found in Mann's files was a satisfying, if sometimes chastening, experience. It was with delight that one now had proof that one's own educated guesses, and those of Dr. Zaloscer, had been largely correct. On the other hand, no one would ever have concluded that some of Mann's visual sources could have been so banal! Who could have possibly surmised that his so distinctive descriptions of Lord Kilmarnock and young Eleanor Twentyman in *Felix Krull* were based on a photograph of Lord and Lady Decies, cut out of the Berlin newspaper *Die Woche* (Vol. 13, No. 7) of February 18, 1911; or that Joseph's flight from the desperate clutches of Potiphar's wife had as its apparent source a rather crude engraving by Albrecht Schmidt produced in Augsburg during the eighteenth century, and found in the files of collected material for *Joseph and His Brothers* in the Zürich archive? It was, moreover, a humbling experience to discover that one's somewhat exalted hypothesis that the image for the embroideries on the *ketônet-passim*, the "coat of many colors" in the Joseph story, showing angels fructifying the blossoms of a date palm, was not inspired by the beautiful twelfth-century lining of the famous coronation mantle in the regalia of the Holy Roman Empire preserved in Vienna, where Mann could have seen it easily during some visit there from his home in Munich, but rather from a singularly uninspired line drawing on page 205 of the first volume of Bruno Meissner's *Babylonien und Assyrien*, a book which Mann himself owned and which he underlined in pencil, as one can see in the Zürich publication (meaning, of course, that it was this specific illustration and no other that provided his image).

On the whole, it must be admitted, the major part of the revelations of the Zürich documentation was both enlightening and satisfying. But it did more than simply add further examples of Mann's dependence on and use of visual and artistic material in his work, or corroborate the work of Dr. Zaloscer and myself; it really also seemed to render further investigation and speculation unnecessary, as the lady herself had noted in her footnote. While this is true in general, the whole matter of Mann's visual sources is not that simple, however. Although the revelations of *Bild und Text bei Thomas Mann* might convince those dubious of the writer's genius, that he was singularly lacking in imagination, cases do exist proving that his method was much more the result of a true assimilation of visual experi-

ences, which he then converted into language, than the contents of the Zürich files would suggest. He did not simply search out some adequate image appropriate to his purposes in that "imaginary museum" of pictures, originals or reproductions, book illustrations, newspaper illustrations, or postcards which were his files, and write a simple description of it leading those unfamiliar with his method to think it a brilliant invention, when it actually was not.

One such example that exonerates the writer of any such accusation might be that to which the subtitle of this essay refers—the salvage from a case of parallel research—unnoticed by the author of the essay in the Austrian magazine and undiscovered by the editors of the Zürich book in spite of their efforts to do so. It reveals the witty and adroit manner in which Mann exploited his visual proto- types without letting them control him in any way. It reveals that his were not sim- ple descriptions of appropriate works selected from the chronological period in which he placed his story, but an amalgam of sometimes totally disparate images woven together into one of the often startling and certainly distinctive characters with which his fiction abounds.

The case in point is that of the equivocal and testy personage who appears near the end of *Young Joseph*. Joseph meets him in the field near Shechem and the man guides the boy on his way toward Dothan to meet his brothers and his fate. The man appears yet again as the guide who led the Ishmaelites and the recently pur- chased Joseph across the desert into Egypt. It is clear from Mann's description of him and his actions that this is no earthly guide, but a heavenly one, for he made him, in a piece of delightfully witty invention, curiously inexperienced in handling corporeal form and very disdainful of it as well. The actual description of this character when first he is met is as follows:

> Joseph looked at him in bewilderment as they went. He saw him quite clearly. This was not yet a man in the full meaning of the word, being only a few years older than Joseph; but taller, really tall; wearing a sleeveless linen tunic drawn loosely through a girdle, thus freeing the knees, and a little mantle flung back over the shoulder. His head, resting upon a somewhat thick neck, seemed small by comparison; his brown hair made an oblique wave that partly covered the forehead down to the eyebrows. His nose was large, straight, and firmly mod- elled, the space between it and the small red mouth very narrow, but the depres- sion beneath so soft yet so pronounced that the chin jutted out like a full round fruit. He turned his head rather affectedly on his shoulder and looked across it at Joseph. His eyes were not unlovely, but half-shut, with weary, half-dazed ex- pression, as of one politely forbearing to yawn. His arms were round, but white and rather weak.[14]

Later the same description of his appearance is given again:

> How Joseph started, pleased and incredulous at once, when he recognized in the man who came in the dawning to the little caravan and put himself at its head the officious and annoying youth who had guided him from Shechem to Dothan, so short and so crowded a time before!
> He it was beyond a doubt, although he was changed by the burnous he wore. The small head and swelling throat, the red mouth and round fruity chin, and especially the weariness of his gaze and the peculiarly affected posture were unmistakable.[15]

The editors of *Bild und Text bei Thomas Mann* must have felt, it would seem, that since this character served as a guide into Egypt, which Mann had Jacob and

others consider the "Land of the Dead," he was a clear allusion to the mytholog-
ical personages of the ancient world whose function this was—to Anubis, the
Egyptian god (whom Jacob had met in the desert earlier in the tetralogy), and
to the Greek deity Hermes Psychopompos, who led the shades of mortals into
Hades. Knowing of Mann's great predilection for Hermes, long recognized and
studied by critics, it was natural that he should be considered the probable model
for the mysterious stranger. In their search for Hermes among the visual material
collected in Mann's files and in the books of his library, nothing was found in the
files, but there was an illustration which must have seemed plausible as the source
in Heinrich Bulle's *Der Schöne Mensch im Altertum* in Mann's library. It is of the
famous marble relief, now in Naples, in the style of Phidias from the second half
of the fifth century B.C., representing Hermes, Eurydice, and Orpheus.[16] In it
Hermes in his role as guide of the dead does indeed wear a "sleeveless linen tunic
drawn loosely through a girdle, thus freeing the knees, and a little mantle flung
back over the shoulder," but little else corresponds to Mann's detailed description
of this personage, neither his height, his peculiar physiognomy, his weak-looking
arms, nor his affected pose. The Hermes of the relief with his fine proportions and
contrapposto and his classical profile could not possibly have served as the model
for Joseph's odd-looking companion. Yet the description is so explicit that,
knowing now something of Mann's methods, one feels that it *must* have been based
on a specific image or work of art, especially since it is even repeated a second time.

A clue to the identification of the source of this image can be found in the part
this character played in the story. He came upon young Joseph wandering lost and
alone in the night near Shechem and, accompanying him, guided him on his way to
his brothers at Dothan. He said, "I guide travellers and open the ways for them."
Later when he reappears mysteriously as the guide whom the Ishmaelites have
engaged to lead them across the desert, he assures the Ishmaelites that they need
fear nothing, no roving bands nor any dangers whatsoever, for he is a perfect guide
and will bring them safely to their goal. From his conversations with Joseph and
his odd behavior it seems evident that he must be an angel, and moreover one who,
clearly on orders, for he does not do it willingly, guides and guards the children of
man. In short, Joseph's companion must be a guardian angel, and therefore it is
among representations of the guardian angel that the prototype for this equivocal
personage in the novel might be found.

Among the many depictions of the Archangel Raphael who leads Tobias, or of
the more generalized guardian angels of later date, there is one which cannot but
have been familiar to Thomas Mann, so much so that he apparently needed no
picture postcard or photograph of it for his files. The research for and the writing
of *Young Joseph*, the second in the tetralogy, was largely carried out in Munich
during the 1920s and early '30s, for the book was first published in 1935. For some
decades Mann had made his home in Munich and he must have known the city
well. Like the well-educated member of the intelligentsia of Munich that he was,
he undoubtedly also knew its artistic monuments.

Among the most popular areas in the history of art being studied and admired
during the early decades of this century were the Italian and German Renaissance
and the art of Egypt, prompted by the discovery of Tutankhamen's tomb and the
new interest in Ikhnaton's monotheism, which are all, of course, mirrored in
Mann's work of this period. But a great interest in Baroque art was also charac-
teristic of the art world of Munich, largely through the work of such men as
Heinrich Wölfflin at the University of Munich and local scholars like Adolf
Feulner. It is to the credit of this last that the Bavarian Late Baroque and

particularly the work of the great eighteenth-century sculptor of Munich, Ignaz Günther, became popular at this time and has remained so ever since. Anachronistically enough, it is in this artistic period, and specifically in Günther's work, that Mann found the work of art upon which he based his image of Joseph's heavenly guide, weaving the precious tissue of his story out of the rich materials of his own culture, one which could appreciate Bavarian Rococo and pharaonic Egypt side by side.

In the Bürgersaal, an oratory built by the citizens of Munich in 1709 on the Kaufingerstrasse, the main thoroughfare of the old city leading from the Karlstor to the square before the city hall, is to be found a polychrome statue of the Guardian Angel made by Ignaz Günther in 1763 for the Karmeliterkirche, where it stood until 1803 (fig. 1). It is one of the sculptor's finest creations and certainly his most popular and well-known work, *the* work which even today comes first to mind when the name of Ignaz Günther is mentioned. It was readily available to Mann thoughout his years in Munich and, considering his penchant for sculpture (as his wife once indicated), must have often been the object of his scrutiny. And lo, comparing it to Mann's description, it is clearly the model for the odd-looking angel who accompanied Joseph on his journey, not the apollonian Hermes of the Greek relief. Although the angel's raiment is nothing like "a sleeveless linen tunic," but rather a fantastic cloak and skirt of fringes and draped material and a stomacher of silver, it does seem "drawn loosely through a girdle, thus freeing the knees" and there is "a little mantle flung back over the shoulder." But it is the rest of Mann's description of this heavenly guide that fits Ignaz Günther's figure so perfectly. It is certainly very tall in its proportions, especially in comparison to the small child it leads; the head too seems small and rests on a long, rather thick neck (fig. 2). Its hair is brown and heavy locks fall over the forehead obliquely to one eyebrow. Its nose is large, straight, and finely modeled. The space between it and the small red mouth is indeed very narrow and the depression beneath the mouth is soft and pronounced, causing the chin to jut out like a full, round fruit. Günther's guardian angel does turn its head rather affectedly over its shoulder as it looks down at its charge. Its slanted eyes are indeed half shut, which gives it a weary, half-dazed expression. Its arms are full and round; their muscles relaxed and soft. The angel's whole pose could be easily called a "peculiarly affected posture," nor would this be an unusual aesthetic judgment. At the time in question, when Feulner wrote about the group, even he was somewhat apologetic in his praise, finally saying "*Die Hauptfigur graziös in Gebaren, bizarr in der zugespitzten Bewegung, exzentrisch in der unruhigen Gesamtform, ein Werk von einer überreifen Verfeinerung*"[17] ("The main figure graceful in its gestures, bizarre in the exaggerated movement, eccentric in the restless form of the whole, a work of an overripe refinement"; author's translation). Although such a judgment has now changed to one of unconditional praise and admiration and a more sympathetic attempt is made at understanding the sculptor's intentions, it was obviously the one current in Munich in Thomas Mann's day.

This work of sculpture of the Bavarian Rococo, so obviously the model for Joseph's guardian angel as a simple comparison of Mann's description and the photograph makes clear, was, moreover, only one of the chronologically "inappropriate" works of art that Thomas Mann, through the power of his artifice, transformed into personal poetic images. Another might be his reference to the sixteenth-century engraving called *Lo Stregozzo*, attributed to Marcantonio Raimondi (and sometimes to Giorgio Ghisi), for the fantastic images in Felix Krull's

*1. Ignaz Günther*. Guardian Angel.
*1763. Wood, polychromed; height
69 3/4". Bürgersaal, Munich*

*2. Ignaz Günther*. Guardian Angel
*(detail)*

2

dream on the train to Lisbon after his meeting with Professor Kuckuck, or the Nymphenburg porcelain figurine by Bustelli he found in his hotel room when he arrived. There are certain to be others, unobserved by all three of us workers in this particular vineyard. They serve to remind us that these somewhat simultaneous revelations, such as my lecture, Prof. Zaloscer's article, and the publication of the pictorial material in the author's files—those snippets from newspapers, illustrations from standard reference books, and picture postcards—were not the final word on the resources upon which Mann depended in creating his fascinating characters and personages, but only part of the long and thoughtful preparations he made before giving them life and immediacy through his writing. It proves that he apparently called on those "files" of visual material he had experienced and stored up in his memory for later reference whenever he felt it suitable, free from any historical considerations. Once called upon, they were amalgamated with others in the crucible of his imagination into the unforgettable characters of his novels. The evidence of his methods preserved in Zürich, as rich and complete as it may seem, is, if this one "salvaged" example of Mann's use of visual material suffices as evidence, only further proof of his intimate and highly individual involvement with the visual arts throughout his life, in spite of his early disclaimers. Taken together with the example discussed here, these cases of parallel research reveal them to have been one of the most potent components of his artistic method, one of the true wellsprings of his poetic invention.

*The University of Chicago*

*Notes*

[1] Thomas Mann, *The Holy Sinner*, trans. H. T. Lowe-Porter (and all English translations of works by Mann cited below), New York, 1951, 332.

[2] "Maler und Dichter," *Berliner Tageblatt*, No. 654, Dec. 25, 1913.

[3] Thomas Mann, *A Sketch of My Life*, New York, 1960, 12.

[4] Thomas Mann, *Briefe 1889–1936*, Frankfurt am Main, 1961, 30.

[5] Gunilla Bergsten, *Thomas Mann's "Doctor Faustus": The Sources and Structure of the Novel*, trans. K. Winston, Chicago, 1969, 112–13, 130.

[6] Hans Burgin and Hans-Otto Mayer, *Thomas Mann. A Chronicle of His Life*, trans. Eugene Dobson, University of Tuscaloosa Press, Alabama, 1969.

[7] Thomas Mann, *Gladius Dei*, in *Stories of Three Decades*, New York, 1966, 181–93.

[8] Thomas Mann, *Fiorenza*, in *Stories of Three Decades*, New York, 1966, 215–16.

[9] James H. Breasted, *Geschichte Ägyptens*, trans. H. Ranke, Vienna, 1936.

[10] Breasted, *Geschichte Ägyptens*, figs. 244–45.

[11] Thomas Mann, *Joseph the Provider*, New York, 1944, 148–49.

[12] Thomas Mann, *Briefe 1937–1947*, Frankfurt am Main, 1963, 298.

[13] Thomas Mann, *Doctor Faustus*, New York, 1948.

[14] Thomas Mann, *Young Joseph*, New York, 1938, 168 f.

[15] Thomas Mann, *Joseph in Egypt*, New York, 1938, 44.

[16] *Bild und Text bei Thomas Mann: ein Dokumentation*, Zurich, 1977, 210 f.

[17] Adolf Feulner, *Ignaz Günther: kurfürstlich bayrischer Hofbildhauer (1725–1775)*, Vienna, 1920, 30.

# 31
# *Winckelmann, or Marble Boys Are Better*

L. D. ETTLINGER

When in 1972 the exhibition *The Age of Neo-classicism* was held in London, the visitor, as he entered the galleries, was greeted by no fewer than three portraits of Johann Joachim Winckelmann, as if he were the tutelary deity of Neo-Classicism. Had a benevolent God given him leave to descend from the sunny realms of Elysium to visit autumnal grey London, he would have expected such homage, for he had no doubt that he was the only and true begetter of a new art. All his life, and particularly after settling in Rome in 1755, his efforts as tourist guide and author were directed toward this goal, and as he himself said, his principal writings were addressed to artists. "I believe," he wrote, "that I have come here, to open the eyes of artists." His purely antiquarian essays, such as the *Monumenti inediti*, were kept apart.

It is generally held that Winckelmann's first published essay was a revolutionary battle cry, calling for a return to an austere classicism in the midst of a sugary and sensuous Rococo. But in spite of its misleading title, *Gedanken über die Nachahmung der Griechischen Werke in der Malerei und Bildhauerkunst* (1755)—which becomes even more misleading in Fuseli's translation, *Reflections on the Painting and Sculpture of the Greeks*—the essay is nothing of the kind.[1] When he wrote it, Winckelmann had not seen any notable examples of ancient art, and what he knew came from books and engravings. Once we dismiss the misconception that Winckelmann "discovered" Greek art and presented an appreciation of it in his first publication, we shall be able to read it for what it really is: an elegant and brilliant display of the views on ideal art which were the stock in trade of his age. Winckelmann, in short, belongs in the company of Reynolds and Diderot rather than that of Caylus or Stuart and Revett.

His education had been a literary one. He was a classical scholar before he ever looked at ancient art; he was familiar with the theory of art from Vasari to his own day before he ever set foot in a gallery. It was only in Dresden—and when he arrived there, he was already in his thirties—that he saw great paintings of the past. His mentor was a minor academic painter, Adam Friedrich Oeser, and his training ground was the famous Dresden Gallery. The importance of this experience must not be underrated, if we want to account for Winckelmann's outlook.

The Dresden Gallery is a typical eighteenth-century creation, having its strength

**Gedancken**

über die

**Nachahmung der Griechischen Wercke**

in der

**Mahlerey und Bildhauer=Kunst.**

*Vos exemplaria Græca
Nocturna versate manu, versate diurna.*

HORAT. ART. POET.

1755.

1. Title page of Gedanken, *Winckelmann's first publication. Designed by A. F. Oeser, 1755*

2. *Illustration on the dedication page of Winckelmann's* Gedanken. *Designed by A. F. Oeser, 1755*

in the art of the High Renaissance and Seicento. Augustus II, the Strong, and his successor, Augustus III, were its chief benefactors, and the latter had made the most important acquisitions, when he bought a hundred paintings from the Modena collection in 1746. Thus Winckelmann was able to see works by Raphael, Correggio, the Carracci, Reni, Maratta, Solimena, and so forth. We have a hardly noticed witness to his familiarity with these treasures. About three years before the *Gedanken* he wrote for the guidance of a young nobleman a *Beschreibung der vorzüglichsten Gemälde der Dresdner Gallery*, an essay which at no point deviates from conventional eighteenth-century taste and criticism.[2] When he composed the *Gedanken* the paintings in the gallery were still uppermost in his mind, and it is not always realized that in spite of the title Winckelmann has little to say about Greek art. There are remarks about more than twenty painters, but only eleven specimens of classical art are mentioned—in passing—and of these he had actually seen a mere handful. In fact, the small collection of antique sculpture was not exhibited at Dresden, and this does not seem to have worried Winckelmann. When he did manage to see it he did not wax enthusiastic, and (in a letter) only referred to three female statues from Herculaneum. His few references to famous antiques are based on knowledge gleaned from engravings, casts, and books, but the *Laocoön* was in all likelihood not available in a cast.

All this, in view of the title, is surprising enough. The essay becomes still more paradoxical, if we look at the three illustrations accompanying it. They were furnished by Adam Friedrich Oeser, and not one of them reproduces an example of classical art, as we would surely expect. The title page shows *Timanthes Painting the Sacrifice of Iphigenia*, a story taken from Pliny and, according to Winckelmann, chosen to illustrate "Imitation" (fig. 1). Another shows *Socrates Carving the Three Graces*, and this makes a technical point about sculpture. The third is placed on the page with the dedication to the king of Saxony and is a joke in rather dubious taste: it depicts an anecdote about a poor man who offers the passing monarch a handful of water, because he has nothing better to give him (fig. 2). None of these embellishments hints at any new concept of art nor does it allude to the Greek ideal. On the contrary, they are mediocre examples of typical Rococo book illustration.

Paintings from Raphael to Solimena furnish Winckelmann with material for his arguments, and the appraisal of the most significant work merits a closer look: the *Sistine Madonna*, which had just entered the gallery and was still a kind of sensation. Apart from the *Laocoön*, this is the one piece to which the author of the *Gedanken* gave an extended consideration, but he writes at greater length about Raphael.

A short quotation from the lengthy description suffices to give an idea of Winckelmann's method: "Behold the Madonna! Her face brightens with innocence; a form above female size, and the calmness of her mien make her appear as already beatified: she has the silent awfulness which the ancients spread over their deities. How grand, how noble her contour. The child in her arms is elevated above vulgar children, by a face darting the beams of divinity through every smiling feature of harmless childhood . . ."

While Vasari did not write any description of the *Sistina*—which he had never seen—every detail of Winckelmann's account can be found in one or the other of the Aretine's references to the rendering of the Madonna and Child theme by Raphael, and later through Bellori this approach became the staple of all academic criticism. The concluding sentence of Winckelmann's *ekphrasis* is particularly revealing: "Let those who approach this, and the rest of Raphael's works, in the

hope of finding there the trifling Dutch and Flemish beauties . . . be told that Raphael was not a great master for them." This might have been written by Sir Joshua Reynolds.

Winckelmann's choice of the *Laocoön* as the paradigm of Greek art—without having seen the original—may seem strange for more than one reason, but the choice is at once accounted for if we remember that Pliny (*Nat. Hist.*, XXXVI.37) had called the group "superior to all products of the arts of painting and sculpture." It is perhaps even more perplexing that this late Hellenistic work exemplifies for Winckelmann *"edle Einfalt und stille Grösse."* But his conviction that the expression of Greek figures, in spite of all passions, shows a grave and great soul, pronounces again a central tenet of academic tradition: the demand for the observance of *decorum* under all circumstances.

The key to the didactics of the *Gedanken* is contained in a sentence which follows the discussion of the *Laocoön*: "Possessed of these qualities Raphael became eminently great, and he owed them to the ancients." This once more is a doctrine which was central to all criticism since the seventeenth century, and Bellori in particular was Winckelmann's most important (but never acknowledged) source. Near the end of Bellori's *Idea del Pittore*, the theoretical introduction to his *Vite de' Pittori, Scultori e Architetti moderni* (1672), he had written: "The sculptors of classical antiquity worked with an admirable idea in their minds. In consequence the study of the most perfect ancient statues is indispensable, as it leads to that beauty which is nature improved. . . . We intend to write a special treatise on imitation in order to argue with those who despise the study of classical statues."[3] Bellori never wrote this essay, but Winckelmann did almost a century later.

Winckelmann's essay in its advice to artists and connoisseurs is unoriginal, and yet it helped to establish its author as an authority on art. There are two reasons for this. It is undeniable that Winckelmann was a brilliant writer who argued commonplaces with vigor. With this he was his own most efficient publicity agent, always ready to tell the world that his thoughts were original, even unique. Shortly after publishing the *Gedanken* anonymously, he informed a friend that before him nobody had demonstrated the superiority of Raphael.[4] Only a man of Winckelmann's shameless but naïve conceit would put forward so preposterous a claim. He also published anonymously an attack on the *Gedanken*, and again anonymously a defence, all in order to simulate a public debate.[5]

There is, however, a very different and original aspect of the *Gedanken*. Though the author has little to say about Greek art, he speaks all the more of the perfection of the Greeks and the reasons for it. "To the Greek climate we owe the production of Taste, and from thence it spread all over the civilised world. . . . The forms of the Greeks, prepared to beauty by the influence of the mildest and purest sky, became perfectly elegant by their exercises. . . . The bodies of the Greeks got the great and manly contour observed in their statues. . . . The gymnasia, where . . . the youths exercised themselves naked, were the schools of art. These the philosophers frequented as well as the artist. Socrates for the instruction of a Charmides, Autolycus, Lysias; Phidias for the improvement of his art by their beauty." In short, the "perfect nature of the Greeks" was the result of climate and education, and in later writings Winckelmann laid more stress on education than on climate.

As we read the famous eulogies on Greek beauty—at the beginning of the *Gedanken* and elsewhere—we become increasingly aware that Winckelmann is speaking as an enthusiast, not as an art historian or a critic. By 1755 he had not seen a single

original Greek statue—he was to see hardly any throughout his life—and the opening section of the *Gedanken* does not contain any extended reference to a work of art. He speaks of sports, gymnasia, games, and so forth. The examples, drawn from classical literature, serve to evoke an ideal world, a Golden Age, when beautiful bodies were inhabited by beautiful souls. Significantly he refers to Plato: "The beginning of many of Plato's Dialogues, supposed to have been held in the gymnasia, cannot raise our admiration for the generous souls of the Athenian youth without giving us, at the same time, a strong presumption of a suitable nobleness in their outward carriage and bodily exercises."

This, as is well known, is a highly personal and unhistorical view of Greek civilization which settled like a blight on ancient history and classical archeology, particularly in Germany. In spite of all pretense Winckelmann never became a historian, and he took Plato's theory of the identity of Truth and Beauty quite literally, using it to interpret the origins and appearance of Greek art. He argued that it is not enough to follow the "rules" and imitate the ancients, because art should educate man through the emotional experience of beauty. He writes: "Truth springs from the feelings of the heart. What shadow of it therefore can the modern artist hope for, by relying on a vile model, whose soul is either too base to feel, or too stupid to express the passions, the sentiment his object claims? Unhappy he, if experience and fancy fail him." It is this emotional appeal which differentiates his views from those of his predecessors.

Interest in and admiration for Greek civilization had been steadily growing throughout the eighteenth century, with contributions from English, French, and German scholars. But they were concerned with political institutions, philosophy, literature, architecture, and so forth. Winckelmann's single-minded absorption in the alleged physical root of Greek culture sets him apart. His belief in Greek perfection was not just another rational version of the traditional dogma concerning the superiority of the ancients, it was a creed which sprang from a fundamental component of his personality: his homosexuality. One is struck again and again by the intensely sensuous, often erotic, tenor of his descriptions of classical male sculptures. Writing to a friend in 1763 he laments the transitoriness of physical beauty in the young, adding significantly: "You are safer with the lasting beauty of marble figures. Among such is the head of a Faun . . . surpassing all the beauties I ever met."[6] This head eventually came into his possession; and in another letter he wrote: "You will recall the beautiful head of a Faun. . . . He is my Ganymede, whom I can kiss *nel cospetto di tutti i Santi* without giving offence."[7] This head (fig. 3) would now hardly be regarded as an outstanding example of classical sculpture, and we should realize that Winckelmann's alleged connoisseurship—in this he could make ghastly mistakes—and his evocation of the Greek genius for representing beauty, were not the outcome of sober scholarship. He was always swayed by more personal considerations, in praise and condemnation.

It was, hardly by chance, Walter Pater who first sensed the driving force behind Winckelmann's thought, when in his beautiful essay on him he drew attention to a short paper, *Von der Empfindung des Schönen*, which Winckelmann addressed to a young man with whom he was in love. Here, in Pater's sensitive translation, is the truly amazing key passage: "As it is confessedly the beauty of man which is to be conceived under one general idea, so I have noticed that those who are observant only of beauty in women, and are moved little or not at all by the beauty of men, seldom have an impartial, vital, inborn instinct for the beauty of art. To such a person the beauty of Greek art will seem ever wanting, because its supreme beauty

*3. Winckelmann's "Ganymede."* Head of a Faun. *Marble. Glyptothek, Munich*

is rather male than female. But the beauty of art demands a higher sensibility than the beauty of nature, because the beauty of art, like tears shed in a play, gives no pain, is without life and must be awakened and repaired by culture."[8]

It would be wrong to dismiss this passionate outburst as special pleading. Winckelmann does not just think of himself. He calls for a kind of magic, because for him the Greek revival is not a matter of style. The famous admonition: "The only way for us to become great and even inimitable is through imitation of the ancients," is not an invitation to copying—he would have deplored the sculpture of Thorvaldsen—but a plea for a better mankind, raised in the presence of Greek art. All his life he was devoted to the education of young men, and he follows the passage just quoted with this advice: "Now, as the spirit of culture is much more ardent in youth than in manhood, the instinct of which I am speaking must be exercised and directed to what is beautiful before that age is reached at which one would be afraid to confess that one has a taste for it."

Where others had argued in cool and rational tones, Winckelmann burst forth with feeling and enthusiasm, and it was this emotional approach which made him influential in an age which was prepared to pay homage to the Greek genius. It matters little that his *Geschichte der Kunst des Altertums* (1764), though a truly impressive achievement, is an unreadable conflation of antiquarian learning, bits culled from Pliny and other classical authors, and a precarious outline of the development of Greek art; or that his stylistic categories are not drawn from the study of monuments but taken over from classical theories of rhetoric. What made a lasting impression on his readers are the celebrated descriptions of ancient sculpture, which are brilliant and evocative pieces in the best tradition of *ekphrasis*. The *Apollo Belvedere* is not discussed in archeological or stylistic terms—did Winckelmann realize that he was enthusing over a marble copy of a fourth-century Greek bronze?—but as a theophany in terms which we can only find embarrassing, and

the beholder is invited to let his spirit travel to the realm of disembodied beauty so that he may be prepared for the contemplation of this statue.

One cannot dismiss this description as a lamentable lapse in taste, for like the rest of them it is born from Winckelmann's vision which is at once put into the service of education through art. But for that very reason it introduces an entirely new function of the work of art, it now takes its place among the great spiritual revelations which shape the mind of mankind. Art usurps the place of religion, revealing truth and the godhead.

Sir Joshua Reynolds's views on the ideal nature of ancient art hardly differ from Winckelmann's, but in addressing the students of the Royal Academy he always remained an instructor of painters, and the ancients did no more than provide perfect models for those studying the "Grand Manner." Winckelmann, on the other hand, although claiming to write for artists and art lovers, had in fact a much wider aim: he wished to be an educator and reformer. So he constructed a Golden Age as a model for the modern world.

Winckelmann's role and stature are badly in need of reassessment. He did in fact have a notable impact on European intellectual history, but hardly as a scholar. His fiery enthusiasm, which transcended traditional rules in art and academic practice, made him a significant founder of Romanticism. In the end his anti-intellectualism proved more potent than his scholarship. When Goethe remarked to Eckermann in 1827 that by reading Winckelmann one does not learn something but becomes something, he had characterized his true mission, and Winckelmann would have approved of this evaluation.

*University of California at Berkeley*

## Notes

[1] All quotations are taken from Fuseli's translation, most readily available in *Winckelmann, Writings on Art*, selected and edited by David Irwin, 1972, 61–85.

[2] First published by H. Uhde-Bernays, *Jahrbuch der Sammlung Kippenberg*, III, 1923, 5–23; see also J. J. Winckelmann, *Kleine Schriften*, ed. W. Rehm, 1968, 1 ff.

[3] E. Panofsky, *Idea, ein Beitrag zur Begriffsgeschichte der älteren Kunsttheorie*, 1924, has reprinted Bellori's discourse; for the above quotation see p. 137.

[4] *Johann Joachim Winckelmann, Briefe*, ed. W. Rehm, I, 1952, 176.

[5] *Sendschreiben über die Gedanken von der Nachahmung der griechischen Werke in der Malerei und Bildhauerkunst*, and *Erläuterung der Gedanken von der Nachahmung und Beantwortung des Sendschreibens*, both 1756.

[6] *Briefe*, II, 311 f.

[7] *Briefe*, III, 128.

[8] W. Pater, *Winckelmann*, 1867; reprinted in *The Renaissance*, 1873 (here quoted from the 1912 edition, 192).

# 32
# The Temple of Fortune: *A Painting by N. A. Abildgaard*

ELSE KAI SASS

In the Museum of National History at Frederiksborg Castle in Hillerød, Denmark, is a fire screen on which the Danish painter N. A. Abildgaard (1743–1809) painted, in 1785, a representation of "The Temple of Fortune" (fig. 1).[1]

The screen consists of a sheet of tin plate supported by a foot. Painted on the screen, in an illusionistic manner, is a piece of architecture purporting to represent the gateway (or one of the gateways) to "The Temple of Fortune."

A frontal wall extending the width of the screen is divided in the middle by a staircase and a gateway into two rusticated side walls reposing on a very solid plinth. This in turn is pierced by two large, circular openings, one on either side of the stairway. Flanking the gateway and standing on the plinth are two statues of women, who, like caryatids, support a very narrow moulded architrave. Above this is a frieze painted with a vine ornament on a gold background, pierced above the gateway by a trelliswork. Above this trelliswork is a semicircular overdoor within a moulded frame, the overdoor panel bearing a painting of a Medusa head. Two small volutes soften the corners formed where the overdoor rests on the cornice.

Through the gateway we look into a room, no doubt a vestibule, from which a doorway leads into yet another room. This inner door is crowned by a pediment beneath which, printed in gold letters, are the words: TEMPLUM FORTUNAE.

Apart from the frieze and the overdoor, which would appear to belong more to the art of furniture, all the illusionistic architectural elements—the rusticated wall, the large circular openings in the plinth, the trelliswork ornament, and the classical pediment—are in the style typical of architecture in the Age of Reason.[2]

The two caryatids are painted in white to give the illusion of marble sculptures. The architecture on the screen, however, is painted in colours, which makes it unrealistic despite the illusionism: the walls are green, the plinth pink with a touch of mauve, the stairs pale golden, and the pedestal dark green. We are reminded that this is a firescreen—i.e., a piece of furniture, and neither architecture nor architectural painting.[3]

Nor is the architecture by any means the most intriguing aspect of this representation of "The Temple of Fortune." It is merely a setting within and before which the actors are seen. As when actors appeared at fairs in the old days, or

1

1. *N. A. Abildgaard.* The Temple of Fortune. *1785. Oil on tin; 184 × 149 cm. Museum of Natural History, Frederiksborg*
2. *N. A. Abildgaard.* The Temple of Fortune *(detail)*
3. *N. A. Abildgaard.* The Temple of Fortune *(detail)*

2

3

perhaps rather as Watteau presented his Italian and French actors against an architectural background,[4] a number of persons having distinctive physiognomies are standing on the platform at the top of the stairs. They are of both sexes and apparently representative of several estates of the realm (figs. 2, 3).

There are two women, one of whom, at the far left, is dressed in the clothing of the period and clearly wears a mask—a mask with an unpleasantly scornful expression. She has a firm grip on the arm of a young officer who has a wooden leg. The other woman is a tall, heavily built person in the center, dressed in black, with a large circular collar like a mill wheel round her neck. Thrust through this collar, as if it were some kind of portable pillory, are her hands. She is wearing a tall stand on her head with a foxtail hanging down in front. Both this woman and the priest standing at the far right, his hands clasped over his stomach, have round, fat faces, rather like pigs' heads. These make one recall the popularity won in Denmark by Lavater's physiognomical studies. Abildgaard could in any event have known Lavater's *Physiognomische Fragmente zur Beförderung der Menschen Kentniss und Menschenliebe* which had appeared in 1775–78 with reproductions of various types of human beings, including those resembling animals, for the book is included in the list of books in the library of the Royal Academy of Fine Arts in Copenhagen, dated 1785, the year Abildgaard's picture was painted.[5]

To the left of the priest stands a young man dressed, like the officer, in a red coat and three-cornered hat, but characterized as a common soldier by his unkempt hair. We realize why he has such a despondent look about him when we discover that he is in chains. Behind and slightly to the left of the soldier, seen almost in profile facing right, is a courtier with closed or at least downcast eyes and a pained expression, as though he were ashamed of something. Behind him, albeit indistinct, two more heads can be discerned.

These persons may be standing in the vestibule of "The Temple of Fortune," but their looks can hardly be described as cheerful. Only the priest has a big smile, like a well-fed porker.

Standing in the front row on the platform is a man, an ordinary citizen wearing the clothes of the period and a three-cornered hat. He looks as though he is trying to keep his footing, with his arms flung wide, one upward and the other outward in an effort to recover his balance. His head is bowed over as if he were about to topple down the stairs at any moment (fig. 2).

Below him, as if in a mirror, he sees the fate which awaits him, reflected by the correspondingly spread-eagled position of a young man who has already tumbled down and now lies on his back, head downward, over the bottom stairs. While the man at the top is dressed as a typical elderly citizen, namely, in black breeches and a dark blue coat and waistcoat, the young fop who has come to grief wears a tight-fitting costume of golden silk and over it an elegant crimson-pink coat. His black tricorne has fallen off and lies in the street, the inside of the crown exposed to the beholder (fig. 4).

Besides the unfortunate young man, three other persons can be seen on the stairs (fig. 2). All three are descending at suitable intervals, as if they had been placed by a stage director. Near the top a highly decorated courtier stalks solemnly down. He is tall and very thin, attired as befitting a nobleman and high-ranking civil servant in formal court dress including both red and blue ribbons of order and a rapier at his hip. Under his left arm he carries his three-cornered hat. His facial expression is hard and unsympathetic, perhaps also a little unhappy.

A couple of steps lower down a slender young woman is descending the stairs

gracefully, carrying a child on her right arm and a basket in her left hand. She wears a white dress of transparent material that reveals a pink petticoat underneath, and on her head she has a large hat with a blue silk bow.

The third person walking down the stairs is characterized as a man of the people by his simple attire—long trousers, short waistcoat, exposed shirtsleeves, and a large black hat. As he passes downward he casts a pained glance at the youth who has toppled—but perhaps this expression is caused by his own situation, for he has chains attached to his wrists and ankles.

Much of the symbolism is simple. The chained soldier and the wage earner are both the bondsmen of eighteenth-century society. The woman on the landing above, with her hands thrust through her large collar, is also "tied." The same can be said of the young officer, for the hideously masked woman has a firm hold on him; what is more, he has a wooden leg and therefore has even less chance of running away.

At the foot of the stairs an old man is walking past in a dark coat, apparently unperturbed by what is taking place around him (fig. 5). With his pointed beard he resembles a Pantalone from the Italian *commedia dell'arte*, but his attire is more in keeping with Ludvig Holberg's Jeronimus.[6]

The two large circular openings in the plinth apparently provide an opportunity for sneaking back into the Temple of Fortune. On the left a couple of young men are seizing this chance; they are both seen from behind as they clamber through the hole (figs. 6, 7). On the right a young man has climbed inside and is heaving his girlfriend aboard, while "Jeronimus" observes them with condescension.

A pendant to the departing "Jeronimus" is provided by a woman sitting on the left side, between the stairs and the opening. Like the old man's face, hers is in profile, turned to the right. With her basket on the ground beside her and her stick in readiness, she sits there like one of the Fatal Sisters. When we examine her more closely we find she is wearing a mask, and on the wall above her head hang three more masks; perhaps they are for sale? The mask on the far right is of a bearded man; it has some resemblance to its the mask of Comedy in the Greek theatre. In the middle hangs a mask that is like a Harlequin with black half-mask. The

*4. N. A. Abildgaard.* The Temple of Fortune *(detail)*

5

6

*5. N. A. Abildgaard.* The Temple of Fortune *(detail)*

*6. N. A. Abildgaard.* The Temple of Fortune *(detail)*

*7. N. A. Abildgaard.* The Temple of Fortune *(detail)*

7

third mask is strange: it appears to reproduce the face of an old man, but the lower part of the face is covered by a white baglike cloth concealing the mouth, as if the person were bound to silence.

The woman is clearly a mask vendor. Bente Skovgaard has perceptively pointed out that the woman with the basket is a loan from Titian's *Presentation in the Temple* in the Accademia in Venice, where Abildgaard had certainly been before he left Italy.[7] The type, that is, a woman with a basket of eggs or the like, sitting at the foot of a stairway, appears also in works by other Venetian painters such as Cima da Conegliano and Carpaccio.[8]

*The Temple of Fortune* is a major work in Abildgaard's production during the first decade after his return to Copenhagen in 1777, from his study for several years in Rome and his brief visit to Paris on the way home. It is masterfully composed, and moreover displays a rare elegance in the manner of its execution and a sparkling wealth in its colouring.

Before proceeding to a closer interpretation of this painting of "The Temple of Fortune" it will be appropriate to make brief mention of the picture's history. The dating of the painting is confirmed by an aquatint executed after the original by the engraver J. F. Clemens (1748–1831), which is inscribed: *Abildgaard pinx. 1785* and *Clemens sculps. 1798* (fig. 8).[9]

It is also from Clemens that we learn what happened to the picture. A friend of his, J. C. Fick, writes in a biographical information about J. F. Clemens that Clemens had told him he had seen the screen standing in Johan Bülow's rooms in Christiansborg from about 1787 onwards.[10] Bülow (1751–1828) was Lord-in-Waiting and Lord Chamberlain to the Crown Prince Frederik, later King Frederik VI, whose close friend Bülow had been. In 1793, however, Bülow fell from grace, was deprived of his office, and thereafter withdrew to Sanderumgaard, his country seat on the island of Funen, dedicating himself to his artistic interests.[11]

The screen apparently remained where it was at Christiansborg until the palace burned down in 1794; later it passed to Clemens for safekeeping; in 1798, when Clemens made his aquatint, it was perhaps still in his custody. That it still belonged to Bülow, however, is evident from the catalogue of the auction held in Copenhagen in 1829 to dispose of the collections Bülow had left behind him, where it is listed as No. 264.[12] From a pencilled note in the margin we learn that the screen was bought for 53 rixdollars by J. P. Møller, the painter.[13] This purchase, however, was made on behalf of Prince Christian Frederik, at that time heir to the Danish throne. Later the screen appears in an inventory of paintings belonging to Prince Christian Frederik with the added note: "Painted for the Antechamber of Joh. v. Bülow, the Lord Chamberlain."[14] On the death in 1848 of Christian Frederik (from 1839 King Christian VIII), his consort, Queen Caroline Amalie, inherited the screen, and it was not until after her death in 1881 that it was acquired by the Museum of National History at Frederiksborg Castle, in 1882.[15]

Although it was never stated directly, it seems reasonable to assume that Johan Bülow himself commissioned the screen from Abildgaard. Counsellor Fick relates, amusingly enough, that Bülow's fall from favour in 1793 gave rise to the cock-and-bull story that the young man tumbling down the stairs of "The Temple of Fortune" was a reference to Bülow's own fate, an interpretation which Fick rightly repudiates. But he quotes Clemens as having stated that Bülow in his palmy days drew attention to the possibility that there might be a prophetic allusion in the person of the young man toppling head over heels.[16]

Fick says that Clemens "made this engraving merely for his own pleasure and

*8. J. F. Clemens.* The Temple of Fortune. *1798. Engraving after Abildgaard's painting. Department of Prints and Drawings, Royal Museum of Fine Arts, Copenhagen*

probably thought of publishing it."[17] Why this did not take place we can only guess. Perhaps Bülow asked Clemens to refrain from multiplying the print, since now, to almost too great a degree, it reflected his own fate; perhaps Clemens refrained out of consideration for the political situation—but more of this later.[18]

How did Abildgaard get the idea of painting a satirical picture like this on the theme of "The Temple of Fortune"? It is perhaps not so surprising, seeing that as early as 1779–80 he had used the motif in an illustration for Johannes Ewald's satirical essay "The Temple of Fortune. A Dream." This little treatise was first published in 1764, but was reprinted in 1780 in the first volume of Johannes Ewald's collected works, which was embellished with six illustrations engraved on copper by J. F. Clemens after Abildgaard's drawings.[19]

For his illustration of "The Temple of Fortune. A Dream"[20] Abildgaard selected an episode which took place during the progress of the masses toward the Temple of Fortune. In Ewald's text we learn that the Temple of Fortune, "built in a circus," lay in the midst of "the loveliest valley."[21] In Abildgaard's drawing and Clemens's engraving the Temple is situated on a high plateau (figs. 9, 10). The front of the building is a wide colonnade, and rising above the middle of it is a dome.

Two zigzag pathways or ramps lead up to the Temple.[22] Crowds are thronging up, while others are on their way down. One person is striding up on stilts, which is in accordance with Ewald's text:[23] "Some made their way on stilts so tall it made one giddy to look at them."

Ewald writes that the wanderers to a large degree consisted of young people making their way toward the Temple of Fortune in small groups, each being led by a woman to whom they showed blind obedience and respect, almost as if she were a goddess. The author himself (in the person of the narrator) was also at-

*9. N. A. Abildgaard. Illustration for Johannes Ewald's "The Temple of Fortune. A Dream." 1779–80. Pen and ink over pencil; body colour. Department of Prints and Drawings, Royal Museum of Fine Arts, Copenhagen*

*10. J. F. Clemens. Engraving after Abildgaard's drawing for Ewald's "The Temple of Fortune. A Dream." 1780. Department of Prints and Drawings, Royal Museum of Fine Arts, Copenhagen*

tracted to these guides: "The temptations by means of which each of these beauties (for they were indeed most lovely to behold) endeavoured to draw me into her group soon began to take effect upon my mind."[24]

The elegant young lady on the lower stairs in the engraving, holding a mask in her hand, is possibly one of the lovely leaders Ewald refers to. Here the mask represents deceit or disappointment, for Ewald relates that "admittedly they flattered newcomers for a few moments, but only to treat them with the greater strictness after they had been in their company awhile. All submitted to their rule; and how eagerly did even they who let themselves be led along in chains by their female rulers claim to be free!"[25]

The elegantly dressed woman with the mask in Clemens's engraving may also be seen as a type, a representative of the frivolous upper-class world, just as the priest

and the soldier at her side are types and representatives of the clergy and the army. In this way Abildgaard has given to his illustration a stronger political point than Ewald's satirical essay actually provides a background for.

The two male figures in the foreground are more easily identifiable with two of the wanderers in Ewald's essay. The poet states that he found their appearance and behaviour so strange that curiosity drove him to ask them who they were and why they went that way. There can hardly be any doubt that the young man clutching at his hat is Gierne-Roe ("he who likes, or yearns for, peace and quiet"), whom the narrator questions first, and that the other strange individual is Kurvemanden ("the basket man").[26]

" 'My name is Gierne-Roe,' answered the first, stretching out his arms and opening his mouth wide to indicate his sleepiness. 'I have been to many of the gateways of the Temple, but the few I had a mind to were so full of people that I could not have slipped through without risk to my limbs. I therefore returned of my own free will.' "

Ewald describes another original character by the name of Immerdurst ("ever-thirst," who does not appear in the illustration) when suddenly he catches sight of "a very strange machine."

"A pile of baskets, which appeared to be moving on a pair of human legs, caused me some astonishment until, through a bottomless basket, a face became visible. I asked this person, hardly able to suppress my laughter the while, by whom had he been condemned to carry so many baskets?

" 'Aha, good Sir,' replied he with a deep sigh, 'so does it befall a man who seeks happiness through marriage. Ungrateful sex! To place such burdens upon a *galant homme*!' " Abildgaard has given "the basket man" a very convincing appearance— a forerunner of the fantastic figures in his illustrations for Holberg's *Niels Klim* in the ensuing years.[27]

In a group to the left of Gierne-Roe can be seen one of the chained persons Ewald also talks about. He is apparently a peasant (judging by his clothes and the woolen cap on his head), in other words a representative of the lower social orders. This, again, is Abildgaard's interpretation. Next to the peasant walks an old woman who has a large collar around her neck, but whose hands are free. On her head is a stand with a foxtail, like the one worn by the fat woman in the painting of 1785.[28]

As to the reason why Abildgaard, five years later, should take up again the theme of "The Temple of Fortune," J. C. Fick has a few observations in his biography of Clemens:[29] "As Abildgaard a few years earlier had used this subject in connection with the publication of Ewald's collected works, but was somewhat restricted regarding this agreement with respect to the composition, it is not improbable that he later felt a desire to treat this theme in a freer manner, one more in accordance with his frequent *penchant* for satire."

In his somewhat circuitous manner Fick probably expressed the truth about Abildgaard's particular liking for satire, which is confirmed by others and particularly by his attitude to the subject of "The Temple of Fortune."

Ewald uses thirty-four pages to describe "The Temple of Fortune," into which lead no fewer than seventeen gateways. The last is called "The Usual Gateway to the Temple of Temporal Happiness." On the fire screen Abildgaard restricted himself, with good reason, to one gateway, which apparently was the most important.

Fortune is here meant to be the goddess of chance, that is, of chance happiness, not so much happiness itself. Fortune is a divine being who may bestow happiness

or misfortune according to her whim, as opposed to Felicity, the goddess of favourable outcome.[30] More or less the same theme is propounded by Ewald.

We may believe that the two caryatids on the façade were intended as personifications in some way connected with Fortune, but in that case they are fairly unorthodox representations. Fortune can be represented naked, winged, blind, or even eyeless, because she often rewards the unworthy. She is often seen standing or sitting on a globe, and sometimes she holds a cornucopia or a tiller in her hand.[31]

Nothing remains of these attributes in the two caryatid figures in Abildgaard's painting. The woman on the right, who is represented with a bandage over her eyes—that is, blindfold—has been identified as Fortune, even though she only supports herself on a shield.[32] But the caryatid figure may not represent Fortune at all. The statue of the goddess herself is probably supposed to be inside the temple, as is mentioned in Ewald's essay and was actually the case in the Temple of Fortune in ancient Praeneste. Abildgaard would never have equipped his allegorical figures with the wrong symbols. He was an extremely learned man, and his extensive library included several books on iconology and the use of emblems.[33]

As Professor P. J. Riis has kindly pointed out to me, the female statue on the right is wearing a rather schematically painted Aegis with an indistinct gorgon head across her breast. As only Jove himself and Minerva were entitled to wear the Aegis, the statue must be identified with the latter, although she is represented here in an exceptional way. Instead of supporting herself on the spear, she is reaching with her left arm for the cornice. Another peculiar iconographic trait is the caplike headgear she is wearing instead of the usual helmet. According to Professor Riis the headgear may be explained as the wolfskin helmet belonging to Minerva in her capacity of a chthonic deity. Abildgaard may have seen a Minerva of this type in Villa Albani.[34] But why represent Minerva blindfold? The right answer is probably the following: Where Fortune is worshipped, Wisdom is put out of action.

The female statue on the left who supports herself with a spear, and on whose plinth can be seen a scale with only one pan, is probably meant to be Justice (Justitia, or rather Aequitas), even though she is generally represented with a sword and holding the pair of scales in her hand. Perhaps Justitia with the scales that have fallen to the ground and the blindfold Minerva together symbolize that Fortune is bestowed on mankind without either Justice or Wisdom. Justice, of course, is often also represented blindfold, but according to Panofsky this iconography is a later construction that has no basis in either Antiquity or the Middle Ages. On the contrary, Justice, in the days of Antiquity, was conceived of as having "piercing and awe-inspiring eyes."[35]

The Medusa head in the overdoor panel above the cornice fits well into the Fortune symbolism. Sandrart, in his *Iconologia deorum*, connects Medusa with Fortune, as Medusa symbolizes the dangers that lurk in the path of those who seek happiness.[36] The symbolism of the masks is easily understood: a disguise, therefore a symbol of deceit. Thus the mask vendor below becomes a personification of deceit.[37] Persons wearing masks also occur in Ewald's essay. In his description of the eleventh gateway we read: "All those, of both sexes, that entered here wore a mask. I deduced from this that this gateway must be for the sanctimonious."[38]

A parallel to the persons represented on the fire screen as crawling back into the Temple through the round openings may also be found in Ewald, who mentions all those who try to crawl back in again after their precipitate return from a first attempt.[39] And finally, the harsh treatment to which the young man on the screen is subjected has its counterpart in Ewald. In describing the Usual Gateway into the

Temple of Fortune, the narrator refers to the "goddess's" capriciousness in the following terms:[40]

"One could never be sure of her favours, for a number of those who had remained long at her altar, and who had been regarded as her favourites, she caused to be ejected precipitately from the Temple without the slightest explanation. . . . This falseness and fickleness were ascribed by many to her blindness, but by others to her want of intelligence."

Ewald's "Temple of Fortune," as will be readily understood, is a general satire on human folly throughout the ages, on man's foolish pursuit of happiness in the form of riches and empty, outward magnificence. The moral is that man would be better served if he abandoned the Temple of Temporal Happiness and instead, led by Eusebia and Arete (representing respectively Piety and Virtue), approached the Temple of Eternal Bliss.[41] But before the narrator reaches this moment of cognition, just before he awakens from his dream, he has passed the seventeen gateways and met many examples of man's foolishness and the fickleness of temporal happiness.

As we have seen, both Abildgaard's illustration for the 1780 edition of Ewald's collected works and his painting on the fire screen have clear similarities to certain parts of Ewald's text. Satire and moralizing formed a considerable part of European literature and art of the eighteenth century—the most prominent exponents being Voltaire, Swift, Holberg, Hogarth, and Rowlandson. Hogarth's series of engravings must have been known to Abildgaard, and the library of the Royal Academy of Fine Arts in Copenhagen, according to a list of 1785, already at that time possessed a copy of the German edition of his *Analysis of Beauty*.[42] There can be reflections of Hogarth's caricatures in the masklike and animal-like faces painted by Abildgaard, but, as mentioned earlier, Lavater's physiognomical studies may also have exercised an influence on his view.[43]

However, as early as in the 1780 illustration, Abildgaard had planted a political point for which there is no authority in Ewald's text. Moreover, the painting of "The Temple of Fortune" on the fire screen leaves no doubt whatsoever that Abildgaard's satire refers to the present. It is a wholly modern work; the persons are dressed in the clothes of the period, some of them indeed according to the latest fashion. In fact it is possible to measure the development from 1779/80 to 1785 by the costumes: the lady with the mask in the print is a Rococo figure with a high, elaborate wig and a hoop skirt, while the young mother with the child on her arm —also a new, natural element—is comfortably dressed in a simple, loosely hanging dress of a light material, and her own curly hair protrudes beneath the brim of her hat. And the unfortunate toppling young man is dressed as carefully and elegantly as the young noblemen Jens Juel portrayed during these same years.[44]

This is no genre picture; it is a social satire which had special topicality during the years just before the French Revolution. It is not possible to determine with certainty whether the idea of painting "The Temple of Fortune" on the fire screen was Bülow's or Abildgaard's. It seems most likely that it was Abildgaard's; no document proves this, but the commission might have been made orally.

Abildgaard's political views were well known. He was openly critical of both the army and the nobility, and expressed himself in sarcastic terms. Even to royal persons he was capable of speaking with great sharpness, even disrespect.[45] August Hennings, a civil servant from Holstein who was a man of letters and interested in the arts, wrote in a letter, with reference to Abildgaard:[46] "Was ist die Ursache, dass sich der Verstand so gern in Sarcasmen übt, und Pfeile abschiesst? Seine Schnelle

taugt selten zum Guten. . . ." In Abildgaard's vast library, which included some 3,700 volumes at his death, there were a number of socially critical writings and, in particular, many accounts of the French Revolution.[47] Amongst the papers he left behind him were transcriptions of various documents concerned with the French Revolution.[48]

Now Abildgaard was something of a misanthrope. Both his family and friends make occasional references to his gloominess.[49] Precisely in the year 1785, moreover, he had good reason for his misanthropy. The year before, his young wife, Anna Maria (Nancy) Oxholm, had deserted him and their little son in order to elope with Reinhard von Eppingen, Lord-in-Waiting at the Danish court, and the divorce proceedings were now dragging on.[50]

However, Abildgaard's ideas of emancipation were both sincere and lasting. Around 1794 he was involved in endeavours to improve conditions for artisans.[51] Nor does it come as a surprise to find his name among the signers of a subscription list issued on April 23, 1791, for a monument to the liberation of the peasants (adscription had been abolished by law in Denmark in 1788). Later he was also to design that memorial, which was unveiled in 1797.[52]

Thus there are several reasons for crediting Abildgaard with the idea for the screen's subject and its design. But the person who commissioned and received it, the Lord Chamberlain Johan Bülow, must at all events have been in agreement with these, and he even had sufficient humour to have the screen installed in the royal palace, to be seen in the antechamber and be commented on by all who had occasion to wait there before being received in audience by the then so powerful Lord Chamberlain.

Johan Bülow had taken part—in a secondary capacity—in the *coup d'état* which in 1784 freed the young Crown Prince Frederik (later King Frederik VI) from the power and influence exercised at that time on the government by the Dowager Queen, Juliane Marie, and her son, Prince Frederik, heir presumptive and half brother of the ruling but mad king, Christian VII. The day âfter the coup Bülow was appointed Lord Chamberlain to the Crown Prince.[53] He was interested in art and literature and had a sense of contemporary history. Perhaps he behaved in too moralizing and pedantic a way toward the Crown Prince, whom he had served ever since the prince was a little boy, but at all events he fell from grace owing to a ridiculous accusation in 1793 and thereafter lived in seclusion at Sanderumgaard until his death in 1828.

During the 1780s Bülow, like many other enlightened aristocrats, showed himself to be a moderate supporter of the liberal ideas that spread all over Europe during the years before the French Revolution. Among his papers at his death were a number of manuscripts dating from precisely the years 1784–86 that revealed his ideas concerning the freedom of the press and the abolition of rules governing rank and precedence, honorary titles, and orders.[54]

But this led to little more than an infatuation with the new ideals of emancipation. Bülow does not appear to have been a very courageous man. But he remained faithful to his ideas to the extent that he liked to keep the company of ordinary men—especially artists, whom he supported by means of commissions and recommendations, and these included Jens Juel, J. F. Clemens, and C. W. Eckersberg. Originally, he must have favoured Abildgaard to a marked degree. Apart from the fire screen, Bülow owned, according to the catalogue of the auction held after his death in 1828, five paintings by Abildgaard; one of these, a landscape, is said to have been the result of collaboration between the artist and Bülow (who

also dabbled in the arts).[55] In addition he owned five drawings, sketches for the illustrations for *Niels Klim*, and ten drawings for "the satirical engravings known by the name of Copenhagen Scenes."[56]

At some time or other, relations between the courtier and the artist must have cooled. Johan von Bülow relates in some memoirs that it was Abildgaard who suddenly broke off the connection, and when Bülow, through an intermediary, inquired of Abildgaard what the reason might be, the latter answered harshly that he never kept bad company;[57] after that he never visited Bülow, although he came to Christiansborg almost daily and visited others in the palace. August Hennings quotes Abildgaard as having given an account of the breach almost identical to that put forward by Bülow.[58]

However, the fire screen bearing the representation of "The Temple of Fortune" must have been painted while Bülow and Abildgaard were still on friendly footing. It is possible that Abildgaard overestimated Bülow's enthusiasm for emancipatory ideals and was disappointed at his outwardly rather passive attitude. Perhaps even a memento to Bülow lies within the representation. The shameful courtier in the background is not without similarity to Bülow as he appears in a roughly contemporary portrait painted by Jens Juel (fig. 11).[59] Regardless of Bülow's advanced attitude towards the abolition of orders and medals, he had been made a Knight of Dannebrog only the previous year, on May 9, 1784; a month before, he had been elected an honorary member of the Royal Academy of Fine Arts.

It is most intriguing that the screen bearing the representation of "The Temple of Fortune" should have remained at Christiansborg after its owner, Johan Bülow, had been obliged to relinquish his post in 1793, and that it came into Clemens's custody only after the fire of 1794. It is open to question, whether the reason why Clemens's splendid aquatint after the painting was not printed in greater numbers was that it had by then become more dangerous to demonstrate ideas such as liberty, equality, and fraternity in the kingdoms and provinces of the absolute monarch. It was precisely during the second half of the 1790s, after the victorious revolution in France and particularly after the execution of Louis XVI, that censorship had been tightened. Men of letters, such as Malthe Conrad Bruun and P. A. Heiberg, were made to pay dearly for their social criticism and satire. Both were exiled.[60] Abildgaard, who was a friend of Heiberg, submitted a beautiful watercolour representing a sorrowing Nemesis, as a parting gift for Heiberg's album. It is inscribed with the date on which the sentence was passed, December 24, 1799.[61]

To August Hennings, who visited him in 1802, Abildgaard expressed his pessimism and disappointment over political conditions. "Es ist der Ton, sagte er, alles was den Wissenschaften und Künsten anhängt, zu verachten." And a little later in the conversation: "Unsere Regierung, sagte er, bestünde aus lauter Germanischen, bald würde kein Spür vom dänischen mehr übrig sein; die Litteratur, das Theater, sah er mit Hohn an. Er behauptete, dass Filangieri nicht habe ins dänische übersetzt werden dürfen, ohne von der Censur verstümmelt zu werden, und dass es verboten sei, Allegorien zu dichten; er mache daher keine Entwürfe mehr zu Medaillen und Monumenten, damit nicht in der Canzellei debattirt werde, ob er ins Verbesserungs Haus kommen rolle oder nicht?"[62]

It is interesting that, of all people, it was Prince Christian Frederik, the designated successor to the throne, who had had a brief but glorious appearance as the constitutional king of Norway in 1814, who acquired the screen in 1829. It was this selfsame Prince Christian Frederik who, in his capacity as president of the Royal Academy of Fine Arts, arranged in 1809–10 on the king's behalf for the

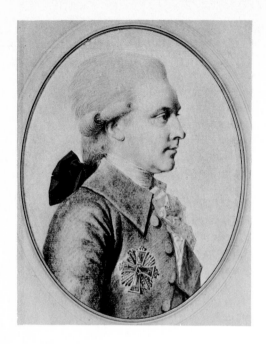

*11. Jens Juel.* Johan Bülow. *c. 1785. Pencil, watercolour, chalk; 20.5 × 16.4 cm. Museum of Natural History, Frederiksborg*

purchase of Abildgaard's private book collection for the Academy's library.[63] The prince would appear to have checked personally the 1,680 works and seen to it that pornographic and politically dangerous writings were removed from the collection before it was handed over to the Royal Academy.[64]

As a matter of fact Prince Christian Frederik had throughout his life the greatest admiration and respect for Abildgaard, whom he described in his letter of condolence to Abildgaard's widow, dated June 5, 1809, as his friend and as "Denmark's leading and most learned artist."[65] His father, Frederik, the heir presumptive and half-brother to Christian VII, had used Abildgaard's skill in 1794 when converting his mansion at Amalienborg, where the son was to live after his father's death in 1805. Abildgaard continued to act as the prince's artistic consultant and decorated the first floor in a refined Neoclassical style, and also designed furniture for it.[66]

A number of Abildgaard's paintings were hanging here already, namely, the ten sketches for the large decorative paintings the artist had painted for the Knights' Hall in Christiansborg, which, except for three, burned in 1794 together with the palace. The old prince had himself bought the sketches from Abildgaard.[67] To these Prince Christian Frederik now added, in 1829, the fire screen with the painting of "The Temple of Fortune." At this time the screen, which had been completed the year before the prince was born, must have seemed like a beautiful old painting that could not arouse embarrassing associations in the mind of Denmark's last absolute monarch.[68] With its gay colours, it no doubt went beautifully with the distinguished interior created by Abildgaard himself.

*University of Copenhagen*

[1] Frederiksborg Catalogue, 1943, no. 4868, 184 × 149 cm.

[2] Emil Kaufmann, *Architecture in the Age of Reason*, Cambridge, Mass., 1955. Cf. Jean-Marie Pérouse de Montclos, *Etienne-Louis Boullée*, London, 1974, and Helen Rosenau, *Boullée and Visionary Architecture*, London, 1976.

[3] A fire screen was meant to stand in front of the fireplace when there was no fire. When a fire was lit the screen was put aside. See Svend Eriksen, *Early Neoclassicism in France*, London, 1974, pl. 485.

[4] Emile Dacier and Albert Vuaflart, *Jean de Julienne et les Graveurs de Watteau au XVIII° Siècle*, III, Paris, 1922, catalogue no. 204 (Comédiens Italiens) and catalogue no. 205 (Comédiens Français); Planches, IV, 2, Paris, 1921, nos. 204 and 205, engraved by Baron and J. M. Liotard respectively after paintings by Watteau. Both prints were in the Royal Library at this time. Cf. the handwritten list of J. Wasserschlebe's collection, which was acquired in 1783 for the Royal Library but is now in the Department of Prints and Drawings, Royal Museum of Fine Arts, Copenhagen.

[5] Johann Caspar Lavater, *Physiognomische Fragmente zur Beförderung der Menschen Kentniss und Menschenliebe*, Leipzig–Winterthur, 1775–1778. Listed as nos. 54–57 in *Catalogus over det Kongl. Maler, Billedhugger og Bygnings Academies Bibliotheque*, 1785, State Archives, Copenhagen, Archive of the Royal Academy of Fine Arts. Furthermore, Abildgaard could already have become acquainted with Lavater's physiognomical studies during his studies in Rome, 1772–77, through Lavater's friend and compatriot, Henry Fuseli (1741–1825), who was in Rome during the same years (1770–78). Abildgaard also acquired Lavater's work for himself, in any case before 1798; see below, n. 33, regarding Abildgaard's book collection. Persons with distinctly animal heads appear in a satirical engraving made by J. F. Clemens in 1786 after a painting by Abildgaard, *Le Sort des Artistes*. See Leo Swane, *J. F. Clemens*, Copenhagen, 1929, 262 f., no. 221.

[6] Jeronimus is a character who frequently occurs in Ludvig Holberg's comedies; he represents "the cantankerous old fogy."

[7] Bente Skovgaard, *Maleren Abildgaard*, Copenhagen, 1961, 23 f.; Leo Swane, *Abildgaard*, Copenhagen, 1926, 22.

[8] Cima da Conegliano, *Presentation of the Virgin*, Gallery, Dresden; Vittore Carpaccio, detail from from the *Story of Saint Ursula*, the scene beneath that of Ursula's conversation with her father, Academy, Venice.

[9] Swane, *Clemens*, 230 f., no. 285.

[10] J. C. Fick, "J. F. Clemens," in H. P. Selmer, *Nekrologiske Samlinger*, II, Copenhagen (1849–), 1852, 372.

[11] H. P. Rohde, *Johan Bülow paa Sanderumgaard*, Odense, 1961. Especially on Bülow's collections, see Victor Hermansen, "Johan Bülow som samler," *Kulturminder*, new series, II, Copenhagen, 1957, 101–37.

[12] *Fortegnelse over den af Geheimeconferentsraad Johan v. Bülow til Sanderumgaard efterladte betydelige Samling af Malerier, Haandtegninger og Kobberstykker, samt en Gruppe og to Figurer af Marmor, m.m.* Printed in Copenhagen 1828, but the sale was announced to take place in March 1829. According to a pencilled note on the title page the sale did not actually start until April 13.

[13] A copy of the auction catalogue in the Department of Prints and Drawings, Royal Museum of Fine Arts, Copenhagen, belonged to C. J. Thomsen, the Danish museum director and administrator, who noted the prices and names of buyers in it.

[14] State Archives, Copenhagen, index of records, 114, 7: Prince Christian Frederik's "Cabinetssekretariat," Sager vedr. Haandbibliotheket . . . den private Maleri- og Kunstsamling (Danish painters), no. 12.

[15] Swane, *Abildgaard*, 164, 305, n. 26.

[16] Fick, "Clemens," 372.

[17] *Ibid*.

[18] See above, n. 9. Twenty-six copies were sold at the auction held after Clemens's death. A few coloured prints exist.

[19] Johannes Ewald, *Samtlige Skrifter*, I, Copenhagen, 1780, 1–34; Swane,

*Clemens*, 173 ff., nos. 122–27. No. 122 is for "The Temple of Fortune."

[20] Abildgaard's drawing is in the Department of Prints and Drawings, Royal Museum of Fine Arts, Copenhagen; for Clemens's engraving, see above, n. 19.

[21] Ewald, *Samtlige Skrifter*, I, 1780, 7.

[22] P. J. Riis, former Professor of Classical Archeology at the University of Copenhagen, has kindly drawn my attention to the likeness between Abildgaard's Temple of Fortune and the antique Temple of Fortune in Praeneste, now Palestrina. For publications with reconstructions of the temple from 1655, 1743, and 1756, see Pietro Romanelli, *Palestrina*, Naples, 1967.

[23] Ewald, *op. cit.*, 23.

[24] *Ibid.*, 8 f.

[25] *Ibid.*, 9.

[26] *Ibid.*, 12 f., Ill. 13.

[27] Ludvig Holberg's *Niels Klim*, a satirical novel, originally appeared in Latin in 1741. In 1742 a Danish edition was published, but this was replaced by a far better Danish translation by Jens Baggesen in 1789, illustrated with sixteen prints engraved by Clemens, of which fifteen were after drawings by Abildgaard. Swane, *Clemens*, 206–13, nos. 227–44.

[28] The foxtail means that the bearer of it is being made a fool of.

[29] Fick, "Clemens," 372.

[30] "Der kleine Pauly," *Lexikon der Antike*, II, Stuttgart, 1967, 597 ff., "Fortuna"; W. H. Roscher, *Ausführliches Lexikon der griechischen und römischen Mythologie*, I, Leipzig, 1886–90, 1503 ff., "Fortuna"; 1473 ff., "Felicitas."

[31] The classic Cesare Ripa, *Iconologia*, in the edition published in Paris, 1677, was on the list of the book collection of the Royal Academy of Fine Arts in 1785 (no. 62); cf. above, n. 5. In Ewald, *Samtlige Skrifter*, I, 1780, 30, the "goddess" is described as seated on a splendid and costly altar with a cornucopia in her hand.

[32] Erwin Panofsky, *Studies in Iconology*, New York, 1962, 110, 113, 124, draws attention to the fact that the idea of the bandage was foreign to classical Antiquity, quoting, for example, Apuleius, who calls Blind Fortune *exoculata* (eyeless) in *Metam.*, VII, 2.

[33] On Abildgaard's book collection, see Skovgaard, *Abildgaard*, 20, 88. A handwritten list of the books of c. 1798, at that time comprising some 1,000 volumes, is in the Royal Library, Copenhagen (Ny kgl. Samlinger, 2337, 2°, II, 2). The collection, which on Abildgaard's death numbered 3,700 volumes, was bought in 1810 by Prince Christian Frederik on the king's behalf for the library of the Royal Academy of Fine Arts, where most of them still are. A handwritten list of the collection as it was at Abildgaard's death in 1809 is still preserved in the library.

Among the books on the older list are, for example: Andrea Alciati, *Emblemata*, Lyon, 1551; *Iconologie ou la Science des Emblèmes et Devises*, 2 vols., Amsterdam, 1698; *Iconologie tirée de Divers Auteurs*, 3 vols., Parma, 1759; J. Sandrart, *Iconologia Deorum oder Abbildung der Götter*, Nuremberg, 1680.

[34] I thank Professor P. J. Riis for reference to this Minerva statue. Cf. Helbig, *Führer*, 4th ed., IV, Tübingen, 1972, 220 f., no. 3243. Illustrated in A. Furtwängler, *Meisterwerke*, Berlin, 1893, figs. 19, 20. In Villa Albani, Abildgaard may also have seen a pair of Caryatid statues; Helbig, 157–72, no. 3217.

[35] Panofsky, *Iconology*, 84, 109 f.

[36] Sandrart, *Iconologia*, 167 ff.

[37] James Hall, *Dictionary of Subjects and Symbols in Art*, London, 1974, 204. With regard to the mask with the gagged mouth, two types of "Silentio" would appear to have been combined here. See Ripa, *Iconologia*, Padua, 1625, 608: "1. Donna con una benda legata a traverso del viso che le ricupera la bocca"; and "2. Huomo vecchio il quale se tenga un dito alle labbra della bocca . . ."

[38] Ewald, *Skrifter*, I, 26.

[39] *Ibid.*, 20.

[40] *Ibid.*, 32.

[41] *Ibid.*, 3 and 33 f.

[42] See above, n. 5; *Catalogue*, no. 19: Hogarth, *Zergliederung der Schönheit*, Potsdam, 1754. Incidentally, Abildgaard himself owned the English first edition of

*Analysis of Beauty* by William Hogarth, London, 1753, which is still in the Library of the Royal Academy of Fine Arts: see the first list of his book collection, Royal Library, Copenhagen.

[43] See above, n. 5. Abildgaard was also interested in facial expressions. Among his papers at his death was a handwritten copy of Charles Le Brun (1619–90), *Conférence de Monsieur le Brun sur l'Expression générale & particulière*, N.k.S., 2337, II, 2. He also owned the treatise in the edition published in Amsterdam, 1698. In the first list of his book collection, Royal Library, Copenhagen.

[44] See, for example, Ellen Poulsen, *Jens Juel*, Copenhagen, 1961, 57, 65.

[45] Swane, *Abildgaard*, 84 f.; *August Hennings' Dagbog under hans Opholdi København 1802*, ed. Louis Bobé, Copenhagen, 1934, *passim*: e.g., 164: "Dem Prinzen Christian hat er mit seinem gewohntem Cynismus zu seinem Geburtstage die Cour gemacht, und ihm Glück, aber keinen Thron gewünscht."

[46] *Hennings' Dagbog*, 190. The occasion was a discussion about Crown Prince Frederik's qualities, which all admired: "Auch Abildgaard stimmt hiemit ein. Das einzige, sagte er, worüber allgemein geklagt wird, ist, das wenn ein Geschäftsmann zu ihm kommt, er ein und ausgehet wie ein Lavement, aber wenn ein Lieutenant kommt, behält er ihn 3/4 Stunden bey sich."

[47] See above, n. 33.

[48] Royal Library, N.k.S., 2337, 2°, II, 2. Amongst other things, a handwritten copy of the "Marseillaise."

[49] Swane, *Abildgaard*, 25–29; *Hennings' Dagbog, passim*; G.Göthe, *Sergelska bref*, Stockholm, 1900.

[50] Swane, *Abildgaard*, 24; *Hennings' Dagbog*, 47 f.

[51] Swane, *Abildgaard*, 153 f.

[52] *Ibid.*, 53–60.

[53] Rohde, *Bülow*, 20 ff.

[54] Johan Bülow's papers, Sorø Academy's Library. Index to records in State Archives, Copenhagen.

[55] See above, n. 12: *Fortegnelse*, nos. 1–6. Number 4 is the landscape which was acquired for Prince Christian Frederik. See list of the prince's art collection

(above, n. 14), no. 13, a landscape: *View of Sæsin Church in Sweden*, painted after a drawing by Johan von Bülow, 1789.

[56] *Fortegnelse*, nos. 26 and 29. Concerning these, see Swane, *Clemens*, nos. 227–44 (*Niels Klim*) and nos. 246–52 (*Kjøbenhavns Skilderie*), 1787.

[57] Rohde, *Bülow*, 104. Bülow refers to this in connection with the events bearing upon his dismissal from the court in 1793. State Archives, Copenhagen, Bülow's private papers.

[58] *Hennings' Dagbog*, 137. This conversation took place in 1802.

[59] Frederiksborg Catalogue, 1943, no. 5036, pencil, watercolor. Reproduced in Rohde, *Bülow*, 19.

An exchange of letters among Emil v.d. Lühe, poet and civil servant, Abildgaard, and Johan Bülow confirms that they had political plans in the 1780s, but that Bülow maintained an attitude of reserve. See Victor P. Christensen, "Om Emil v.d Lühe og Nicolai Abildgaard," *Fra Arkiv og Museum*, Ser. 2, vol. I (1917–25), Copenhagen, 145–56.

[60] Malthe Conrad Bruun (1775–1826), who subsequently won international recognition as a geographer, was sentenced in 1800, but had already left Denmark a few years earlier. One of his treatises bore the title "Aristokraternes Katekismus," 1796. He settled in Paris in 1799. P. A. Heiberg (1758–1841), author of satirical pieces and plays, also settled in Paris, where he was given employment in the Foreign Office and acted in particular as Talleyrand's secretary.

[61] On the sketch, reproduced in Swane, *Abildgaard*, 25, the date is December 25, 1799, but that given in the album is December 24. See H. P. Rohde, "P. A. Heiberg og Nic. Abildgaard. Et Stambogsblad og en Brevveksling," *Fund og Forskning*, VII (1960), 50–84 (French summary, 186).

[62] *Hennings' Dagbog*, 44, 45. Gaëtano Filangieri (1752–88), liberal Neapolitan writer; the first three volumes of his major work, *La Scienza della Legislazione*, 1780–83, were condemned by the congregation of the Index in 1784. First part of the work translated into Danish

by J. Collin, 1799.

[63] For correspondence with Juliane Abildgaard, the artist's widow, concerning the acquisition, see Axel Linvald and Albert Fabritius, *Kong Christian VIII's Breve, 1796–1813*, Copenhagen, 1965, II, 54–59. Abildgaard married Juliane Marie Ottesen (1777–1848) in 1803.

[64] See the handwritten list of books (above, n. 33), in particular the large number of works about the French Revolution that are marked "deleatur."

[65] Linvald and Fabritius, *Christian VIII's Breve*, II, 53.

[66] Swane, *Abildgaard*, 79–88, 151–64.

[67] *Ibid.*, 33–48; State Archives, Copenhagen, document quoted above in n. 14, Danish Painters, 1–10.

[68] Christian VIII reigned 1839–48. It was his son, Frederik VII (r. 1848–63), who in 1849 was the first to grant Denmark a free constitution.

(Translated from Danish by David Hohnen)

## Appendix

Besides the literary references given in the Notes, I should like to add the following titles:

Torben Holck Colding, "Abildgaard," *Dansk Kunsthistorie*, III, new ed., Copenhagen, 1972.

Erik Fischer, "Abildgaard's Filoktet og Lessing's Laokoon," *Kunstmuseets Aarsskrift*, 1975, Copenhagen, 1976, 77–102, with English summary.

Elsa Gress, "Den intellektuelle som kunstner eller som intellektuel," *Louisiana*, 1959, ed. Knud W. Jensen, 31–37.

Charles Oscar, "Abildgaard's Monstrum," *Louisiana*, 1959, 27–30.

P. J. Riis, "Abildgaard's Athens," *HAFNIA, Copenhagen Papers in the History of Art*, 1974, University of Copenhagen, Institute of Art History, Copenhagen, 1974, 9–27.

Bente Skovgaard, "Abildgaard eller Füssli. En tegning i Kobberstiksamlingen," *Kunstmuseets Aarsskrift*, 1975, Copenhagen, 1976, 57–76, with English summary.

*Idem, N. A. Abildgaard. Tegninger,* Copenhagen, 1978, with introduction in English.

*Nicolai Abildgaard* (exhibition catalogue), Arbejder af Abildgaard i Frederiksborgmuseet, 1979.

I should, moreover, like to draw attention to a play, *Philoctetes Wounded*, inspired by Abildgaard's art and fate, by Elsa Gress, published in *Philoctetes Wounded and Other Plays*, Copenhagen, 1969, illustrated with reproductions of paintings and drawings by Abildgaard.

# 33
# *From Voltaire to Buffon: Further Observations on Nudity, Heroic and Otherwise*

JUDITH COLTON

It was in the 1770s that the earliest monumental statues of living intellectual heroes were created in France. This same decade also witnessed the rebirth of an allied genre: the portrait sculpture of the contemporary individual in the nude. Jean-Baptiste Pigalle's *Voltaire* of 1770–76 (fig. 1) combines both these ideas, and must therefore be seen as a major landmark in the history of modern sculpture. Yet it is only in recent years that this work has begun to receive the attention it deserves.[1]

As Professor Janson has pointed out in his pioneering article "Observations on Nudity in Neoclassical Art," Voltaire's nudity in this instance is not entirely heroic. Inasmuch as the statue is in part a reference to the self-martyrdom of Seneca its nudity is partly what Janson calls functional[2]—i.e., not an expression per se of nobility or greatness but a simple necessity of the story. Professor Janson's comments encourage us, then, to consider Augustin Pajou's statue of the great naturalist Buffon (fig. 2)—commissioned only two years or so after Pigalle set to work on the *Voltaire*—as the first post-antique statue of a living hero in which the nudity is intended to be purely heroic.

But Pajou's *Buffon* can only assume this all-important role if it is seen in the context of certain other works. The first, of course, is the Voltaire statue itself. I will show that in its final form the *Buffon* constitutes a critical reply to Pigalle's only partially heroic work. Yet, at the same time, in its early stages the *Buffon* did not address the issue of nudity at all. A terracotta sketch shows the naturalist in modern dress, seated and surrounded by the symbols of his profession (fig. 3; height 21 cm, including base). This conception was in fact just as novel a mode of contemporary portrait sculpture as was nudity.[3] While it does not bring out the heroism and timelessness that nudity suggests, and concentrates instead on activity, achievements, and contemporaneity, it is, we shall see, like the finished statue a comment on the *Voltaire*. Indeed, the play of positive and negative influences—the contextual triangle, as it were, marked out by these three divergent conceptions—is the subject of this paper. Let us begin with the *Voltaire* and then move on in more detail to the two *Buffons*.

1

2

3

1. *Pigalle.* Voltaire. *Louvre, Paris*

2. *Pajou.* Buffon. *Muséum d'His-
toire Naturelle, Paris*

3. *Pajou.* Buffon. *Terracotta model.
Louvre, Paris*

*4. Pigalle.* Voltaire. *Terra-
cotta model. Musée des
Beaux-Arts, Orléans*

According to the story that has come down to us in a number of contemporary accounts, the idea for a statue of Voltaire was spontaneously and somewhat dramatically hit upon by a group of philosophes gathered at the home of Mme. Suzanne Necker on a Friday in April 1770.[4] Pigalle was present. He brought with him a terracotta bozzetto for the nude portrait (fig. 4)—so obviously there had been preparations for the "spontaneous" scheme. Anyway, Pigalle's conception, as it evolved over the next six years, caught the attention of artists, writers, and royalty throughout Europe. Besides the philosophes at Mme. Necker's who commissioned the statue, and the many writers who contributed to it by subscription, almost everyone of any literary or artistic pretensions, not to speak of Voltaire himself, seems to have followed its progress closely. The statue was begun in the spring of 1770 in a mood of euphoria and optimism.[5]

But already at the beginning of the following year, and on through the statue's completion in 1776, this mood had changed to disappointment and indeed embarrassment. What had seemed perfectly appropriate in verbal terms, and in the bozzetto, began to look outrageous in a lifesize marble. "Toute la position est de génie," Grimm had said of the terracotta sketch in May 1770. "Il y a dans la tête un feu, un caractère sublime." If the artist were to succeed in translating this quality into the marble, Grimm continued, the work would immortalize him more than any he had ever done.[6] But if Grimm and his fellow philosophes had seen power and fire in the bozzetto, they also saw it as a rough *première pensée*, which it was. They naturally assumed that its impulsively modeled surfaces would be idealized into a finished statue of a noble and vigorous Roman.[7] Little did they expect the almost clinical naturalism—the spindly limbs, the aging muscles, and the sagging skin, reminiscent of the Baroque visual tradition of hermits and holy men[8]—that Pigalle was now producing. Nor would those who knew about the reference to Seneca—and this was a well-guarded secret—have understood why the body of the Stoic

hero was combined with Voltaire's smiling countenance—a curious expression for someone about to commit suicide. Pigalle, it was decided by all, had gone too far.[9] The statue was finished only because the sitter himself insisted with typical vehemence that the liberty of the artist had to be upheld at all costs.[10] To nearly everyone else the first French monumental sculptural tribute to a living man of letters had misfired.[11]

One onlooker at the débâcle, not himself one of the philosophe-patrons, was able to learn from this mistake. This was the comte d'Angiviller, a friend of many of those—Marmontel, d'Alembert, Jean-Baptiste Suard, Antoine Léonard Thomas—who had participated.[12] He was an habitué of several of the leading literary salons including Mme. Necker's, although he apparently had not been present the day the Voltaire statue was decided upon.[13] He was also acquainted with Diderot, in all probability the originator and iconographer of the project. Even more important for our purposes, d'Angiviller did not have a high opinion of Diderot, nor even of Voltaire. Instead he greatly admired a man who had separated himself from the Encyclopedists: Buffon.[14]

Georges-Louis Leclerc de Buffon, best known to us as the author of the multivolume *Histoire naturelle*, was the leading scientific thinker of the French Enlightenment. Along with Voltaire he was hailed throughout Europe as one of the two great geniuses of the age.[15] Yet curiously enough the two men were admired by rather different, not to say opposed, constituencies; and they were also very different from each other. Voltaire, the "Patriarch of Ferney," lived far from Paris in self-imposed isolation. Buffon, the "Sage of Montbard," traveled incessantly between his *cabinet* at Montbard, in Burgundy, and Paris. As Intendant at the Jardin Royal des Plantes he held one of the chief administrative positions in the French scientific world. He had been Intendant since 1739, and had introduced many innovations at the Jardin, and at the Cabinet d'Histoire Naturelle which was part of it.[16] He assumed that his son, Georges-Louis-Marie, would succeed him in the post.

But not everyone wished to see "Buffonet," as the young Buffon was called, succeed his father.[17] D'Angiviller was one such person, and indeed hoped to be chosen himself as the next Intendant. Whatever his admiration for Buffon as a scientist, in short, he did not admire his hero's nepotic tendencies. D'Angiviller, moreover, had powerful support: the Dauphin, before his death in December 1765, had made efforts to place him in line for the post.[18] But rather than becoming Buffon's enemy, d'Angiviller's strategy was to compete successfully, and pacifically, with the son. During the very years that he was receiving royal support he amassed a collection of minerals which he planned to donate to Buffon's Cabinet d'Histoire Naturelle. D'Angiviller also aspired to membership in the Académie des Sciences (he attained it in 1772).[19] Meanwhile the king managed to confuse everything still further by seeming to support both candidates.[20]

All this came to a head in February 1771, when Buffon suddenly became very ill. No sooner was he pronounced to be "à toute extrêmité"[21] than d'Angiviller, with the monarch and certain ministers behind him, seized the opportunity to obtain the succession. At the time Buffon's son was not yet seven years old, and it was decided that the post could not be held open for him. Instead, unbeknownst to Buffon, papers were drawn up in which the great naturalist was made to request that d'Angiviller be named as his successor.[22] But then Buffon began to recover. Eventually he found out about the papers. This was followed almost immediately by a rush of letters from various "commis" at Versailles, and from d'Angiviller himself, reassuring Buffon that d'Angiviller had been designated solely to guard

the post for his son's eventual succession. But there is evidence that Buffon only approved the documents because he was forced to by the king, and in fact they make no mention of Buffonet.[23] Buffon, then, was the victim of a court intrigue. He knew it and was saddened by it. On May 1, 1771, he wrote to a friend that he had "essuyé . . . des orages de toute espèce."[24]

Yet even as they forced Buffon to accept his new successor-designate, Louis XV and his ministers attempted to make amends for the grief they had inflicted on him. Buffon was told early in May 1771 that he was being made a count and that the king had also accorded him "les entrées de la Chambre."[25] All this did not displease Buffon, who was susceptible to flattery. But his pride was still sorely hurt. In December 1771 he wrote: "Ma santé s'est soutenue, malgré les tracasseries et le chagrin qu'on m'a donné bien gratuitement, ou plutôt *bien ingratement*."[26] He lived until 1788. For the next seventeen years—that is, from December 1771, when the above-mentioned "lettres de survivance" were filed, until his death—he had to accept d'Angiviller as "adjoint à l'intendance du jardin royal des plantes."[27]

It was precisely this contretemps, and not, as is often thought, his later position as chief artistic administrator of Louix XVI's reign,[28] that led d'Angiviller to his first major act of artistic patronage: Pajou's statue of Buffon. This statue was to be d'Angiviller's apology. We must keep this in mind as we attempt to reconstruct its genesis (c. 1773–76)[29]—no easy task, given the fact that the statue was made in secret so as to be a surprise for its recipient.

But if we, like Buffon himself, are in the dark as to the events leading up to the statue's placement in the late fall of 1776, and its subsequent unveiling,[30] a number of related and preparatory works are full of promising suggestions about Pajou's and d'Angiviller's lucubrations. In 1773 Pajou exhibited a marble bust of the great naturalist at the Salon of the Académie Royale (fig. 5). Buffon appears in simple but elegant informal dress, with his lace-ruffled shirt open at the neck. The work is accordingly a *buste en négligé*. Buffon also wears a buttoned vest and a loose dressing gown. His hair is elaborately combed and curled. His head is turned to the side, his eyes large behind the unusual hooded brows. He glances upward, his expression tentative, as if he had just heard an interesting but slightly unpleasant remark. To us, Buffon does not look particularly inspired; he is simply an intelligent man at a moment of attention. And yet the critic Louis Petit de Bachaumont saw the work as more than a mere portrait. To him it was an attempt to express the notion of genius. Bachaumont here turns from a consideration of another bust by Pajou (of Mme. Du Barry) to the *Buffon*:

> L'artiste ne voue pas seulement à peindre les graces, son ciseau fier atteint aux traits mâles du génie; ce qu'il prouve par le *portrait de M. le comte de Buffon*, où l'on retrouve la noblesse et la vigueur de la tête de ce philosophe, vraiment pittoresque.[31]

Was this bust intended to be a first step toward the lifesize marble statue? It is not possible to determine. But it can be linked with the terracotta bozzetto of Buffon mentioned above (fig. 3), also in the Louvre, and with a bronze statuette at Versailles (figs. 6, 7).[32] In both bozzetti, as in the bust, Buffon's collared, ruffled shirt is covered by an ample dressing gown; however, the vest is absent in the statuettes. The treatment of the face, head. and hair is roughly similar in all three works. Hence we can safely assume that the terracotta and bronze works have some relation to the Louvre bust of 1773, and that they were made at about the same time. They can also be related to the projected full-size statue.

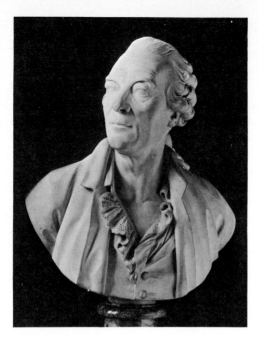

5. *Pajou*. Buffon. *Marble bust. Louvre, Paris*

Let us look more closely at the statuettes. The terracotta is the next logical step in the progression we have begun to trace. The naturalist is shown in a specific setting: his *cabinet de travail*. He is surrounded by the objects of his study—sponges, coral, and animals, including a lion, and crystals, an open book, and a globe of the world. He holds a writing tablet which is partially supported by the arm of his chair. He turns from his reading, keeping his place on the page with his right index finger. He looks up to his right. Whereas in the bust he had seemed merely interested or intrigued, here he appears totally absorbed, even inspired. His mental alertness is reinforced by the position of his legs. Their vehement angularity infuses the little figure with energy, with the quality of a momentary flash, which complements the sharp upward glance. Yet at the same time the position of the legs seems to come from Pigalle's *Voltaire*. In that statue the complicated pose had had little to do with the upper part of the figure, and even less with the attributes lying about at its base. Thus Pajou's modello comes across as a kind of correction of, or comment upon, the *Voltaire*.

This is true in other ways as well. We have noted that Pajou's *Buffon* is shown with attributes that really were the objects of the naturalist's research, and with a perfectly contemporary writing tablet. On the other hand Voltaire's scroll (doubling conveniently as a piece of drapery), his laurel wreath, his sword of tragedy and mask of comedy, are all traditional symbols of the dramatic writer. Meanwhile the allusion to Seneca, noted earlier, brings to the fore still another set of references, to fanaticism and persecution, which the *gens de lettres* felt applied to them.[33] The *Buffon* is by contrast an expression of the real, the modern, the serene. It glorifies the scientist at the full height of his powers. There is no hint of martyrdom, no air of struggle against antithetical forces. It is thus a response, rather than a complement, to the *Voltaire*. Hence even this preparatory work defines two very different types of genius, two very different historical characters, and two contrasting

destinies. In clothing Pigalle's *écorché*, and in readjusting its pose and setting, Pajou's bozzetto becomes an optimistic inversion of Pigalle's statue.

However, Pajou opposes not full formality, but privacy and undress, to Voltaire's nakedness. Pajou's terracotta, with the naturalist at work in his study, has more in common with the painted portraits and busts *en négligé* executed in England in the first half of the eighteenth century[34] than it does with the work of Pajou's contemporaries on the Continent. Or, to put it another way, we need only glance at the statue of another hero, the Maréchal de Richelieu, made by the sculptor Francesco Schiaffino in 1748 for the Senate of Genoa (fig. 8),[35] to remind ourselves that the Baroque-Rococo portrait, with its sumptuously costumed balletic formality, was still the order of the day in the mid- and even the late eighteenth century in France and Italy.

By the standards of the time, then, Pajou's terracotta *Buffon* was curiously informal, and Pigalle's *Voltaire* shockingly so, at least for public and monumental purposes. In particular the *Voltaire* not only had its antiheroic anatomy, but it recalled to those in the know an action which had occurred in a bath. True, Seneca's death had been represented in painting since at least the seventeenth century; but it was quite unheard of to allude to it so naturalistically and at the same time in the cold formality of a lifesize marble statue.[36] And even Buffon, if he is not actually naked, is not prepared to meet the public gaze. Again the distance between a private portrait bust or painting and a public monument must be taken

7

6. *Pajou.* Buffon. *Bronze statuette. Château, Versailles*

7. *Pajou.* Buffon. *Bronze statuette, view from below.*

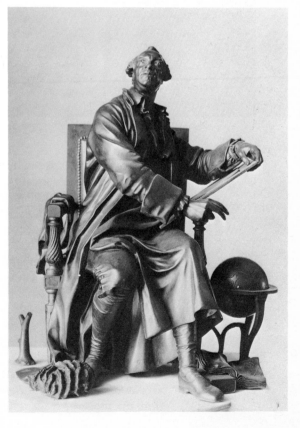

6

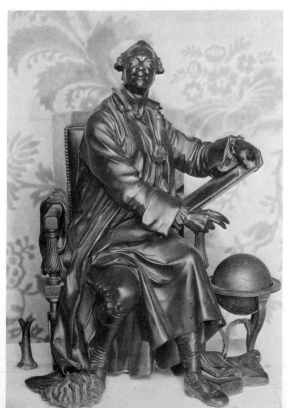

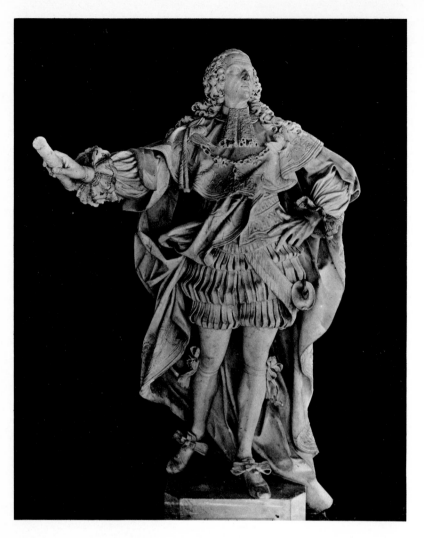

8. *Francesco Schiaffino.*
Maréchal de Richelieu.
*Louvre, Paris*

into account. Perhaps the Buffon modello, though less shocking than the *Voltaire*, was still considered too informal. An examination of the second preparatory seated statuette, now at Versailles, will lend support to this hypothesis.

At first the bronze *Buffon* (figs. 6, 7; height 20 cm) seems only to be a more detailed and finished redaction of the necessarily sketchy terracotta. D'Angiviller, or possibly Pajou, might have reasoned that such an intermediate step was a safeguard against the sort of situation in which the *gens de lettres* were finding themselves at that very moment vis-à-vis Pigalle. A bronze modello, even one as small as this, would be able to show a degree of detail comparable to that of the full-size marble—a thing impossible in a minuscule terracotta. Indeed, Pajou had recently added several bronze figures of just this type to one of the most finished and detailed modelli in the history of French sculpture—the *Parnasse François* (1708–18) of Titon du Tillet.[37]

But Pajou's bronze statuette was more than just a prudently conceived second version of the terracotta *Buffon*. Closer examination shows it to be a step away from the modern, realistic first sketch and toward the classical philosopher al-

l'antica of the final marble. This *Buffon* is no longer simply a portrait. Rather it shows us a regal personage who has an aura of great authority about him. The features are fuller and nobler than in the terracotta. Buffon's dressing gown is handled in a more general, somewhat more toga-like way. Even the chair is more elaborate, more imposing, more throne-like. Buffon's right hand no longer simply points to his place on a page; it indicates, indeed even blesses, a globe—not terrestrial this time but celestial.

Both the terracotta and the bronze prepare for another feature of the lifesize marble. This is its position in relation to the spectator. The two statuettes are studies for a work which was to be viewed from below. We see this first of all because the terracotta has a very high pedestal, indicating the relative height of the pedestal intended for the finished statue. The pedestal of the bronze is modern.[38] But no doubt the original was a high one. Further, when either of these works is photographed at right angles to the main vertical axis (e.g., fig. 6), Buffon's torso appears enormously long and his legs unnaturally short. But when the photograph is taken from a lower viewpoint (that of figure 7 is better than in figure 6 but not ideal, since the viewpoint should have been still lower) the elongated torso and the foreshortened legs begin to produce the desired effect of elevation, remoteness, and sublime thought. From this vantage point, also, much of the detail of Buffon's eighteenth-century costume is cast into shadow. The right arm thrusts forward across the torso, covering the shirt front. This movement leads the eye from the head down to the globe, and the head meanwhile swells to nearly spherical shape and becomes appropriately sublime. From this viewpoint, therefore, the bozzetto clearly takes up the hint that the bust gave to Bachaumont and turns into a portrait of an *homme de génie*.

Although the final conception of a standing *Buffon* (fig. 2) represents a radical departure from the seated *modelli* in some respects, it nonetheless carries on the transformations that we have noted as being introduced into these successive works. And there may have been other such preparatory sketches, now lost.[39] In any case, if Buffon's expression is exalted in the Versailles bronze, in the marble it is invested with a kind of leonine *terribilità*, a quality which sets the naturalist far above the race of ordinary mortals. His coiffure complements this new physiognomy: Buffon is not simply inspired, he is a true ruler—a king or emperor. Alongside him and at his feet are the naturalist's attributes that have been there all along, but now they are more abundant and more varied. The functional writing tablet of the earlier statuettes has lost its sheet of paper and become a thick stone slab. The globe has gone back to being terrestrial, but now it is more monumental, richer in detail than before, and set into a Neoclassical stand decorated with naturalistic ornament. The crystals and the corals and other animals have been greatly emphasized and articulated. A wolf or dog has been added, and the recumbent lion is now notably enlarged. The book or books in the earlier versions have been eliminated. But Buffon preserves the gesture of blessing introduced in the Versailles bronze. Here, however, more noticeably than in the bronze, he holds a writing implement or engraving tool behind his two outstretched fingers.[40] With books no longer used as intermediaries, he inscribes his thoughts direct from nature.

Hence Buffon is still seen as a contemporary scientist pausing in his work, struck by an inspiring thought. But, incongruously, he is also an antique hero or, as contemporary documents put it, "dans le Costume d'un philosophe."[41] In other words, if in the history of male nudity in art Pigalle's *Voltaire* continues the chapter reserved for martyrs and hermits, the *Buffon* continues that devoted to poets, philos-

9

9. *Pajou*. Voltaire. *Bronze statuette on the* Parnasse François. *Château, Versailles*

10. *Pajou*. Buffon. *Marble bust. Muséum d'Histoire Naturelle, Paris*

10

LXXXIII

TESTA INCOGNITA ALIVSO DI
ERCOLE.

*11*. Head of Unknown Man as Hercules. *Engraving in Giovanni Angelo Canini,* Images des héros et des grands hommes de l'antiquité, *Amsterdam, 1731, pl. LXXXIII*

ophers, and philosopher-kings. To what we might call the "barbaric" nudity of the holy man in the desert—and of Seneca in his bath—Pajou, or more probably d'Angiviller, has opposed an ennobled, "civilized" nudity, an over-lifesize standing *Buffon* (2.90 m high), nude except for a simple garment draped around his waist and left arm and knotted loosely at the left. One thinks of countless examples of such statues in Greek and Roman sculpture, e.g., one of an unknown poet in the Vatican, another of the Stoic philosopher Zeno in the Capitoline Museum, the heroicized portrait statues of Roman generals and others from Delos, Tivoli, and Scoppito, and the Vatican *Claudius as Jupiter*.[42] Insofar as he has become a philosopher-king all'antica one reads this *Buffon* with perfect appropriateness as the portrait of one who rules nature, or who, because of his genius and his powers of observation and classification, is the king of natural philosophers.

There is one other aspect of this image of Buffon that deserves mention: his leonine face and coiffure. For this one can refer first of all to Pajou's own earlier Voltaire statuette for the *Parnasse François* (fig. 9). Here the standing poet-philosopher, though he wears the costume of a classical military hero and though his dancelike posture recalls Schiaffino's *Richelieu* (fig. 8), has a coiffure that more than hints at the sort of leonine effect we see in the *Buffon*. But the leonine look is far more pronounced and important in the *Buffon* than in the earlier Voltaire statue. And in the marble bust made for d'Angiviller (fig. 10) the leonine character is yet more emphatic—beyond even that of the Buffon statue.[43] Peter Meller has discussed the use of such physiognomy in Renaissance heroic portraiture and has referred to some of the antique and medieval precedents for it.[44] In these the lion's-head aegis, and by extension the leonine face, were warrior's totems. When the warrior's features, whether he was Alexander the Great[45] or Giangiacomo Tri-

vulzio, were assimilated to those of the king of beasts, and when at the same time the lion's head or skin was placed on the warrior's head or shoulders (fig. 11), he was proclaimed a lion among men, a Herculean hero.[46]

But in endowing Buffon with a leonine countenance and coiffure Pajou adds ingeniously to this traditional meaning. Buffon is a lion among men in general, or among naturalists; and he is hence a metaphorical lion, like Alexander. But at his feet, in the form of captured prey, is a real lion: not his prey, exactly, but his scientific quarry. In short, he who captures the king of beasts for science rules the kingdom of beasts.[47]

To complete our *rilettura*: the specimens form a lower order within the statue—and we now may begin to think of it as a group monument—while Buffon's instruments, above these on the right, represent the means to intellectual understanding of those specimens throughout the earth. In applying lion-features to the naturalist's head in the upper zone, Pajou synthesizes the notion of Buffon's primacy over his fellow men with that of his genius, the cause of that primacy. This "victory" over Nature, which is the victory of his knowledge of it, is made clear by the inscription, MAJESTATI NATURAE PAR INGENIUM ("[Buffon's] genius is equal to the majesty [or king] of Nature").[48]

Pajou's *Buffon* takes its important place, then, in the history of the modern monument to genius. By shifting the statue's iconographic program in midstream, and by equating heroism and genius with nudity and a leonine head, d'Angiviller and Pajou offered Buffon a neat but elaborate compliment and at the same time provided a multiple response to the problems raised by Pigalle's *Voltaire*. And Pajou's solution, more than Pigalle's, has become the normative one, standing at the head of the tradition that leads ultimately to Rodin's *Victor Hugo* and *Balzac*, and later still to Klinger's *Beethoven*.

*Yale University*

*Notes*  I am grateful to John R. Clarke, Malcolm Cormack, Ellen D'Oench, and Gloria J. Kury for the helpful suggestions they made during the writing of this article. In addition Yves Laissus, Conservateur en Chef of the Bibliothèque Centrale, Muséum d'Histoire Naturelle, received me on several occasions; Jean-René Gaborit, Conservateur au Département des Sculptures, Musée du Louvre, helped me to obtain one of the photographs reproduced here. My colleagues Walter Cahn, Anne Coffin Hanson, and George A. Kubler were kind enough to read the manuscript; their comments have led me into new areas of consideration. But above all, I would like to thank George L. Hersey, H. W. Janson, Donald Posner, and Willibald Sauerländer for their long-term interest in my work and especially in the problems discussed here.

[1] See Willibald Sauerländer, *Jean-Antoine Houdon: Voltaire*, Stuttgart, 1963, 5–9. The principal earlier studies of Pigalle's monument are: Prosper Tarbé, *La Vie et les ouvrages de Jean-Baptiste Pigalle*, Paris, 1859, 157–76; Gustave Desnoiresterres, "Pigalle et la statue de Voltaire," *L'Art*, I (1875), 127 f.; J. J. Marquet de Vasselot, "Quelques oeuvres inédites de Pigalle," *Gazette des Beaux-Arts*, 3$^{me}$ pér., XVI (1896), 396 f.; Gabriel Paul d'Haussonville, "La Statue de Voltaire par Pigalle," *Gazette des Beaux-Arts*, 3$^{me}$ pér., XXX (1903), 353 f.; Samuel Rocheblave, *Jean-Baptiste Pigalle*, Paris, 1919, 274–88; Louis Réau, *J. B. Pigalle*, Paris, 1950, 60–67. But with the exception of Sauerländer, these studies tend to repeat the same information and to use the same sources. Using Sauer-

länder as a guide, I hope to push the investigation of the motives and meaning of Pigalle's *Voltaire* some steps further in a future study. Forthcoming meanwhile is my "Pigalles *Voltaire*—Realist Manifesto or Tribute *all'antica?*" *Studies on Voltaire and the Eighteenth Century* (Transactions of the 5th International Congress on the Enlightenment).

[2] H. W. Janson, "Observations on Nudity in Neoclassical Art," *Stil und Überlieferung in der Kunst des Abendlandes. Akten des 21. Internationalen Kongresses für Kunstgeschichte in Bonn 1964*, ed. Herbert von Einem, I, Berlin, 1967, 200–201; reprinted in H. W. Janson, *Sixteen Studies*, New York, n.d. [1974], 189–210, to which my later notes refer. Sauerländer was the first to show the importance of the Seneca analogy. In addition, he pointed to a seicento engraving by the Modenese artist Lodovico Lana depicting the dying Seneca, which presents striking similarities with the *Voltaire* (*Houdon*, fig. 15).

[3] So far as I know, this is the first instance in French sculpture of a full-length seated man of intellect shown in contemporary dress. It announces the series of "great men" statues commissioned between 1776 and 1787, for which the comte d'Angiviller was responsible and to which Pajou was one of the earliest and most frequent contributors. See Francis Dowley, "D'Angiviller's *Grands Hommes* and the Significant Moment," *Art Bulletin*, XXXIX (1957), 259–77; Judith Colton, "Monuments to Men of Genius: A Study of Eighteenth-Century English and French Sculptural Works," Ph.D. dissertation, Institute of Fine Arts, New York University, 1974, ch. 5.

[4] The Baron Grimm's account of the actual salon gathering is the most complete (Friedrich Melchior, Freiherr von Grimm, *et al.*, *Correspondance littéraire, philosophique, et critique*, ed. Maurice Tourneux, IX, Paris, 1879, 14–17). But Theodore Besterman has questioned Grimm's date of April 17, 1770, for the meeting, and proposes April 6 or 7 instead (*Voltaire's Correspondence*, ed. Theodore Besterman, 107 vols., Geneva,

1953–65; here LXXV, 1962, 16 n.). See also the entries for April 10 and 12 in [Louis Petit de Bachaumont, *et al.*] *Mémoires secrets*, 31 vols., London, 1777–89 (here V, 1784, 93–94). For general information on Suzanne Necker and her salon, see: Gabriel Paul d'Haussonville, *Le Salon de Madame Necker*, Paris, 1882; Mark Gambier-Parry, *Madame Necker—Her Family and Friends*, London, 1913.

[5] This can be ascertained from letters written to Voltaire and from his responses to them. For example, in March 1772 Count Filip Creutz told Voltaire that "l'Europe est occupée à vous ériger une statue" (*Voltaire's Correspondence*, LXXXI, 1963, 116, no. 16589). See also *ibid.*, LXXVI, 1962, 71–72, no. 15535; 97–98, nos. 15560, 15561; 121–23, no. 15585; and 192–94, no. 15649.

[6] *Correspondance littéraire*, IX, 16. The terracotta bozzetto, now in the Musée des Beaux-Arts, Orléans, shows the same penchant for realism that had characterized Pigalle's *Citoyen* in Reims (see Réau, *Pigalle*, pl. 19). There is not yet the attempt to show extreme age and attenuation that there is in the finished marble and must have been in the second of the two fullsize plaster models we know of. On this latter model, cf. Bachaumont, *Mémoires secrets*, VI, 1784, 170–71: entries for August 2 and 4, 1772.

[7] It is reasonable to assume that those who were responsible for the commission, especially because they had accepted the idea that Voltaire would be a personification of Seneca, had also accepted the idea of nudity—but of the idealized heroic type. The clearest evidence we have for this is François Tronchin's letter to Voltaire of November 21, 1771 (*Voltaire's Correspondence*, LXXX, 1963, 146, no. 16418). But by the spring of 1771, after the completion of the first plaster model and as criticism started pouring in from the outside (see below, n. 9), both Suzanne Necker and Marmontel began to denounce even the statue's nudity (see *ibid.*, LXXVIII, 1962, 206, no. 16084, and *ibid.*, LXXIX, 1962, 156, no. 16232). But they may

simply have been seeking ways to combat Diderot, who had thought up the Seneca analogy in the first place. The key document for this, and for the idea that there was opposition to it within the original group, is André Morellet's *Mémoires inédits*, Paris, 1822, I, 200.

8 Professor Sauerländer suggested to me in a personal communication of 1966 that the tradition of the inspired naked man, which predates the modern representation of Seneca in the visual arts and is to be found in paintings of hermits and holy men (e.g., St. Jerome), might be sufficient to explain the Voltaire statue. This, in his view, would then make the Seneca analogy superfluous. But first of all I have found too much evidence in support of Seneca to discard Morellet's assertion that the work was conceived as a Seneca-Voltaire. And, furthermore, I am convinced that in order to realize as accurately as possible the actual physical description of Seneca given by Tacitus ("un corps affoibli par la vieillesse, et par le deffaut de nourriture," *Les Annales, et les histoires de Tacite*, trans. M. Guérin, II, Paris, 1742, 444), Pigalle turned to the visual prototypes of St. Jeromes and other holy hermits. These had been treated more ascetically (see, for example, Irving Lavin, "Divine Inspiration in Caravaggio's Two *St. Matthews*," *Art Bulletin*, LVI [1974], figs. 29–32) than had the Senecas of the seventeenth and early eighteenth centuries (on the latter, see below, n. 36). George Kubler's interesting suggestion (made to me personally) that Pigalle's figure might be related to the tradition of pathetic realism expressed in painting by Ribera and in sculpture by such artists as Mena and Roldán will merit further investigation.

9 See especially Bachaumont, *Mémoires secrets*, V, 1784, 136, 160: entries for July 11 and September 4, 1770; and *ibid.*, VI, 1784, 171: entry for August 4, 1772.

10 Cf. the exchange of letters between François Tronchin and Voltaire in the fall of 1771: *Voltaire's Correspondence*, LXXX, 1963, 146, no. 16418, and 164, no. 16438.

11 Only one critic, Antoine-Rigobert Mopinot de la Chapotte, had a positive response to the work in the years after its completion (*Eloge historique de Pigal*, Paris, 1786, 12). But Mopinot's words were ignored in his own time and in most of the nineteenth century as well, when the statue was looked on either with indifference or with contempt. See, for example, Toussaint Bernard Eméric-David, *Histoire de la sculpture française*, Paris, 1853, 198, and Quatremère de Quincy, *Essai sur la nature . . .* (1823), cited by Janson, "Observations on Nudity," 191–92.

12 For d'Angiviller's specific contacts with the philosophes, and for his participation in the important literary salons of the day, see Jacques Silvestre de Sacy, *Le Comte d'Angiviller. Dernier Directeur Général des Bâtiments du Roi*, Macon, 1953, 27–28, 32–48, and *Mémoires de Charles Claude Flahaut, Comte de la Billarderie d'Angiviller. Notes sur les mémoires de Marmontel*, ed. Louis Bobé, Copenhagen, 1933 (hereafter *Notes sur les mémoires de Marmontel*), 17–20, 29–62, and *passim*.

13 The full list of those present at Suzanne Necker's salon that day was given by Grimm (*Correspondance littéraire*, IX, 15). Morellet (*Mémoires inédits*, I, 200) gives a short list of some of the participants. Although his cast of characters is somewhat different from Grimm's, d'Angiviller's name is not on either list. However, according to Bobé in his introduction to the *Notes sur les mémoires de Marmontel* (xv), Morellet attended the salon of d'Angiviller's mistress Mme. de Marchais during these same years. Since, as he himself notes, Morellet was strongly opposed to the inclusion of a reference to Seneca in Pigalle's statue, he might well have told d'Angiviller and Mme. de Marchais all about it.

14 D'Angiviller has a lot to say about Diderot, all of it severely critical, in his *Notes sur les mémoires de Marmontel* (18, 29–33, 39–40, 42–51). On the contrary he does not launch into extensive discussions about Voltaire, but his attitude emerges in occasionally nasty remarks (e.g., *ibid.*, 18, 37). See also Silvestre de

Sacy, *Le Comte d'Angiviller*, 39–43. For d'Angiviller's attitude toward Buffon, see *ibid.*, 45–48, and *Notes sur les mémoires de Marmontel*, 51–59.

15 On Buffon's life and work see: Otis E. Fellows and Stephen F. Milliken, *Buffon*, New York, 1972; *Buffon*, ed. Roger Heim, Paris, 1952; M. Humbert-Bazile, *Buffon, sa famille, ses collaborateurs et ses familiers*, ed. Henri Nadault de Buffon, Paris, 1863; Arsène Houssaye, *Galerie du dix-huitième siècle*, III, Paris, 1858, 49 f.; P. Flourens, *Buffon: Histoire de ses travaux et de ses idées*, Paris, 1844; Adolphe de Chesnel, *Vie de Buffon*, Paris, 1843; Geoffroy Saint-Hilaire, "Notice historique sur Buffon," in *Oeuvres complètes de Buffon*, I, Paris, 1837, i f.; Félix Vicq d'Azyr, "Eloge de M. de Buffon," in *Oeuvres complètes de Buffon*, publ. by Jean-François Bastien, Paris, 1811, I, 23 f.; Hérault de Séchelles, *Voyage à Montbard,* Paris, An IX; Jean-Antoine Nicolas Caritat, Marquis de Condorcet, *Eloge de M. le comte de Buffon,* Paris, 1790; "Mort de M. de Buffon," *L'Année littéraire*, XXXV, 1788, iii, 265–73. Recently, Otis Fellows has compared the two eighteenth-century thinkers who are of interest to us here: "Voltaire and Buffon: Clash and Conciliation," *Symposium,* IX (1955), 222–35. See also Fellows, "Buffon's Place in the Enlightenment," *Studies on Voltaire and the Eighteenth Century,* XXV (1963), 603 f.

16 For the story of Buffon's accession to the post of Intendant, and for an assessment of his activities at the Jardin du Roi, cf. Franck Bourdier, "Principaux aspects de la vie et de l'oeuvre de Buffon," in *Buffon*, ed. Heim, 25–26. See also Fellows and Milliken, *Buffon*, 54–55; William Franklin Falls, *Buffon et l'agrandissement du Jardin du Roi à Paris*, Philadelphia, 1933; Gustave Michaut, "Buffon administrateur et homme d'affaires," *Annales de l'Université de Paris*, VI (1931), 15–36.

17 The character—and the limitations—of the young Buffon are described by Fellows and Milliken, *Buffon*, 62.

18 Cf. two letters written to Buffon by various royal "commis" in the spring of 1771, and a third, from d'Angiviller to Buffon, of May 1, 1771. All three are reprinted by Henri Nadault de Buffon in his notes to the *Correspondance inédite de Buffon*, I, Paris, 1860, 404–6. See also Nadault's later, revised edition of the correspondence (*Correspondance générale*, I, Paris, 1885, 202).

19 Silvestre de Sacy, *Le Comte d'Angiviller*, 50.

20 At least by July 1769, Buffon had obtained Louis XV's promise that his son would succeed him (see Nadault, *Correspondance générale*, I, 184). Occasionally it is stated that the naturalist had obtained these assurances from the monarch even earlier, i.e., c. 1767 (cf. Franck Bourdier, "Principaux aspects," *Buffon*, ed. Heim, 34). Yet the biographers of d'Angiviller lead us to believe that the monarch was backing the late Dauphin's favorite at the same time.

21 Bachaumont, *Mémoires secrets*, V, 219: entry for February 16, 1771.

22 Cf. Nadault, *Correspondance inédite*, I, 403–7, and especially *idem, Correspondance générale*, I, 203.

23 *Ibid.*, See also Nadault, *Correspondance inédite*, II, 595–601.

24 Nadault, *Correspondance générale*, I, 202: letter from Buffon to Philibert Guéneau de Montbeillard.

25 Nadault, *Correspondance inédite*, I, 407–11.

26 *Ibid.*, I, 140.

27 Archives Nationales (hereafter A.N.) O¹1914 [6], 42. In letters, Buffon referred to d'Angiviller as "mon cher et très respectable ami," and he received elaborate assurances of respect and honor in reply (A.N. O¹1914 [5], 298, 299). See also Nadault, *Correspondance inédite*, I, 446; Jean-Louis de Lanessan, "Notice biographique sur Buffon," *Oeuvres complètes de Buffon*, I, Paris, 1884, 28. But there is considerable evidence that for the rest of his life Buffon resented d'Angiviller's intrusion into the Jardin. For example, in a letter of June 14, 1784 to his son, Buffon says of d'Angiviller that he "n'est rien là [i.e., at the Jardin du Roi] tant que j'y serai" (Nadault, *Correspondance inédite*, II, 175).

28 Nadault (*ibid.*, I, 412 and *Correspon-*

dance générale, I, 204) and Bourdier ("Principaux aspects," *Buffon*, ed. Heim, 34) assume that d'Angiviller's accession to the directorship of the Bâtiments took place before the commission of the statue. But it was Louis XVI, and not Louis XV, who named him to this post, in May 1774. Both Bachaumont (*Mémoires secrets*, X, 1784, 80–81) and Jean Baptiste Pierre Lebrun (*Almanach historique et raisonné des architectes, peintres, sculpteurs, graveurs, et cizeleurs, année 1777*, Paris, 1777, 69–70) state clearly that d'Angiviller commissioned the Buffon statue before becoming Directeur-Général.

[29] So far as I know, written documents relating to the commission or to the early years of work on the statue have not come down to us. The clearest indication we have of a beginning date is in a "mémoire" submitted by Pajou after the monument's completion. Here it is stated that work on the lifesize marble was carried out "pendant les années 1773 etc." (A.N. O¹1922B, "Mémoires des artistes," *s.v.* "Pajou," no. 3). See also "Correspondance de M. d'Angiviller avec Pierre," *Nouvelles Archives de l'art français*, XXI (1905), 284; Nadault, *Correspondance générale*, I, 372–73.

[30] A number of documents, dating from May to November 1776, which concern the placement of the statue, are in A.N. O¹2124 [6]. They, along with one other (A.N. O¹1914 [1], 343: letter from the architect De La Tousche to d'Angiviller, of November 19, 1776), prove that the entire enterprise was indeed kept a secret from Buffon. See also Bachaumont, *Mémoires secrets*, X, 1784, 80–81: entry for March 29, 1777. The actual inauguration must have taken place early in January 1777, for by the 13th of that month Buffon knew all about Pajou's statue (cf. Nadault, *Correspondance inédite*, II, 23).

[31] Bachaumont, *Mémoires secrets*, XIII, 1784, 136: "Sur les Peintures, sculptures, gravures de messieurs de l'Académie royale, exposées au salon du Louvre, le 25 août 1773."

[32] Although neither of these works is documented, they can be and indeed always have been identified as portraits of Buffon by Pajou. Whereas Henri Stein (*Augustin Pajou*, Paris, 1912, 174–75) sees them as alternative solutions for the statue, conceived after the standing heroic nude, Bourdier ("Buffon d'après ses portraits," *Buffon*, ed. Heim, 172–73) more logically considers them to be the sculptor's first models for the project. On the other hand, there is a case to be made for the attribution of the Louvre terracotta to Pajou's pupil Robert-Guillaume Dardel (1749–1821). In February 1786, at the Salon de la Correspondance, Dardel exhibited a terracotta "esquisse" (untraced) which represented Buffon much as we see him here (*Nouvelles de la république des lettres et des arts*, February 3, 1786, 70). I plan to return to Dardel on another occasion and will only say here that from the descriptions we have of his work (and, with one exception, we have nothing but descriptions) this sculptor seems to have executed other statuettes that were nearly identical to works by Pajou. Nonetheless the Louvre terracotta is perfectly explicable—and even necessary—within Pajou's own oeuvre: it corresponds to the marble bust of Buffon of 1773, and the attributes that surround the sitter are taken over in the final statue. On balance, then, it seems more likely that the Louvre terracotta is by Pajou than by Dardel.

[33] This is brought out most clearly in a specific group of letters to and from Voltaire that were written between April and October 1770. Cf. *Voltaire's Correspondence*, LXXV, 1962, 47, no. 15311; 50, no. 15313; 99, no. 15357; 171, no. 15425; LXXVI, 1962, 30, no. 15491; LXXVII, 1962, 1, no. 15660. See also *ibid.*, LXXXI, 1963, 116, no. 16589.

[34] As far as I can tell, this type of portrait was first used regularly in sculpture by Coysevox, e.g., in his bust of Matthew Prior, c. 1700. It appeared in English painting much earlier, probably first introduced by Van Dyck. The portrait *en négligé* became popular in the first half of the eighteenth century, in the busts by Rysbrack and Roubiliac, and in the paintings of Kneller, Highmore,

Hayman, and others.

[35] The work was planned as one of seven marble statues erected to the "défenseurs et bienfaiteurs" of Genoa (*Description des beautés de Gênes et de ses environs*, Genoa, 1773, 23–24). See also Carlo Giuseppe Ratti, *Istruzione di quanto può vedersi di più bello in Genova*, Genoa, 1766, 27; Raffaele Soprani and C. G. Ratti, *Vite de' pittori, scultori, ed architetti genovesi*, II, Genoa, 1768–69, 282. Voltaire immediately recognized the statue's uniqueness as a monument to a living hero. In November 1748, he addressed a verse epistle to Richelieu ("Epître LXXVIII. A Monsieur le Duc de Richelieu, à qui le Sénat de Gênes avait érigé une statue," *Oeuvres complètes de Voltaire*, ed. Moland, X, Paris, 1877, 353–54).

[36] On the history of painted representations of the death of Seneca, see Andor Pigler, *Barockthemen*, 2nd ed., II, Budapest, 1974, 430–31; P. Eberlein, "Die Darstellung des Senecatodes bis zum Ende des 18. Jahrhunderts," Ph.D. dissertation, University of Freiburg im Breisgau, 1969. An ancient black marble statue, found in Rome in the sixteenth century, was at least by the beginning of the following century interpreted as a dying Seneca and placed in a marble basin. Whether or not this well-known work, now in the Louvre, was still thought to be a Seneca by Pigalle's (and Diderot's) time, this "Seneca's" heroic physique has no relation to that of the emaciated and aged *Voltaire*. On the former, and its fortunes in the seventeenth century, see Wolfram Prinz, "The *Four Philosophers* by Rubens and the Pseudo-Seneca in Seventeenth-Century Painting," *Art Bulletin*, LV (1973), 417, with further bibliography.

[37] Pajou's statuettes of Prosper de Crébillon, Jean-Baptiste Rousseau, Voltaire (fig. 9), and of Titon du Tillet himself were commissioned in the early 1760s. The first three were probably placed on the monument before the end of 1766 (see Judith Colton, *The Parnasse François: Titon du Tillet and the Origins of the Monument to Genius*, New Haven, 1979, 159–87, with added bibliography).

[38] Stein, *Pajou*, 174.

[39] We do know that there was a full-size plaster model of the *Buffon* in its final form. Pajou gave this to his friend Jean-Nicolas Dufort, comte de Cheverny, who installed it in his château at Cheverny (*Mémoires sur les règnes de Louis XV et Louis XVI et sur la Révolution*, ed. Robert de Crèvecoeur, II, Paris, 1886, 18–19). And according to Bourdier ("Buffon d'après ses portraits," *Buffon*, ed. Heim, 172) there is also another version of the bronze statuette at Versailles in a private collection.

[40] In a print made after the statue in 1776 by Pietro Antonio Martini, the instrument is clearly shown to be an engraving tool. Martini's engraving was used as the frontispiece of the 1779 edition of Buffon's *Epoque de la Nature*. In contrast to the notion of Buffon as writer or describer, Walter Cahn reminds me of the Mosaic aspect of the statue, whereby of course Buffon's observations would become a set of natural "laws."

[41] A.N. O¹1922B, *s.v.* "Pajou."

[42] For the Vatican *Poet* and the *Claudius as Jupiter*, see Anton Hekler, *Greek and Roman Portraits*, New York, 1912, pls. 7b and 180. For Zeno, cf. Giovanni Gaetano Bottari, *Il Museo Capitolino illustrato*, 1st ed. 1741, I, Milan, 1819–21, pl. XC. The Roman statues from Delos, Tivoli, and Scoppito, all of which are thought to date from the first century B.C., are illustrated, respectively, in Giovanni Becatti, *Arte e gusto negli scrittori latini*, Florence, 1951, pl. LVIII, fig. 116; Ranuccio Bianchi Bandinelli, *Rome: The Center of Power, 500 B.C. to A.D. 200*, New York, 1970, fig. 93; and Theodor Kraus, *Das Römische Weltreich*, Berlin, 1967, pl. 284. For other examples see Karl Schefold, *Die Bildnisse der Antiken Dichter, Redner und Denker*, Basel, 1943, and Gisela M. A. Richter, *The Portraits of the Greeks*, London, 1965.

[43] Pajou executed at least three busts after the completed statue: a terracotta, now at the Bibliothèque Mazarine in Paris, and the marble at the Muséum d'Histoire Naturelle (fig. 10), both of these ordered by d'Angiviller; and a

third, in bronzed terracotta. Buffon himself offered this latter bust to the Académie des Sciences, Arts, et Belles-Lettres of Dijon in August 1776; it is now in the Bibliothèque Publique of Dijon. On these busts see Bourdier, "Buffon d'après ses portraits," *Buffon*, ed. Heim, 174; Stein, *Pajou*, 173, 326, 344–45; Marc Furcy-Raynaud, *Inventaire des sculptures exécutées au XVIIIᵉ siècle pour la Direction des Bâtiments du Roi*, in *Archives de l'art français*, nouv. pér., XIV (1927), 240; Louis Réau, "Le Buste de Buffon au Musée de Dijon," *Beaux-Arts*, I (1923), 57–58; Nadault, *Correspondance générale*, I, 299, 320, 322.

[44] Peter Meller, "Physiognomical Theory in Renaissance Heroic Portraits," *Studies in Western Art. Acts of the Twentieth International Congress of the History of Art*, II, Princeton, 1963, 53–69. See also David Summers, "David's Scowl," *Collaboration in Italian Renaissance Art*, eds. Wendy Stedman Sheard and John T. Paoletti, New Haven and London, 1978, 113–20.

[45] For a full discussion of Alexander portraits and their leonine features, see Margarete Bieber, *Alexander the Great in Greek and Roman Art*, Chicago, 1964, *passim*. See also Andreas Alföldi, "Insignien und Tract der römischen Kaiser," *Mitteilungen des Deutschen Archäologischen Instituts, Römische Abteilung*, L (1935), 120–23, 152–54.

[46] Figure 11 is an example of an ancient portrait in which the lion's skin is worn in place of the hero's own coiffure. It is illustrated by Giovanni Angelo Canini, *Images des héros et des grands hommes de l'antiquité* (1st ed. Rome, 1669), Amsterdam, 1731, 323, and pl. LXXXIII. For an illuminating discussion of Hercules in ancient and Renaissance literature, see Eugene M. Waith, *The Herculean Hero in Marlowe, Chapman, Shakespeare and Dryden*, New York and London, 1962, chs. 1, 2.

[47] This interpretation is supported by a contemporary tribute to Pajou by the poet Michel-Jean Sedaine, in praise of the statue of Buffon. In the poem the animals of the forest thank Buffon for having "painted" them, and honor Pajou for having portrayed Buffon's intelligence as accurately as the latter had revealed theirs. However, Sedaine concludes that had Pajou and Buffon been animals instead of men, it is Pajou who would have been the lion, while Buffon would have been an eagle (cited by Grimm, *Correspondance littéraire*, XI, Paris, 1879, 428: entry for February 1777). In his treatise on the relationship between human and animal physiognomy, Charles Le Brun drew a parallel between the king of the Greek gods and the king of beasts (cf. Jurgis Baltrusaitis, *Aberrations. Quatre Essais sur la légende des formes*, Paris, 1957, 22–23, and fig. 12).

[48] This inscription had been preceded by an earlier one which provoked satirical comments from passers-by. The change may have been made only in 1782 (see Nadault, *Correspondance inédite*, II, 142–44, 462). The reception of the *Buffon* by the naturalist himself, by his friends, and by the art critics of Paris is a story in itself. I plan to discuss it in the near future.

# 34

# The Firing Squad, *Paul Revere to Goya: Formation of a New Pictorial Theme in America, Russia, and Spain*

JAN BIAŁOSTOCKI

**I**

In his widely read and highly appreciated history of art, Professor Janson devoted some comments to the famous picture by Goya, *The Firing Squad: The Third of May, 1808* (fig. 1), painted in 1814 as a companion piece to the depiction of the preceding day's happening: *The Madrid Rising at Puerta del Sol, May 2nd, 1808.*[1] Both these paintings, which constitute the most important landmarks in the history of modern political painting, are now in the Prado.[2] Janson gives the following short and excellent account of *The Firing Squad*:

> Here the blazing color, broad fluid brushwork, and dramatic nocturnal light are more emphatically Neo-Baroque than ever. The picture has all the emotional intensity of religious art, but these martyrs are dying for Liberty, not the Kingdom of Heaven; and their executioners are not the agents of Satan but of political tyranny—a formation of faceless automatons, impervious to their victims' despair and defiance. The same scene was to be re-enacted countless times in modern history.[3]

It is interesting to find out that Goya was not the inventor of this new iconographic type, although he was certainly the first to give it its powerful, dramatic grandeur. Not only was his picture prepared by traditional religious iconography—as remarked correctly by Janson—but examples of similar subject matter treated in a similar way can actually be pointed out in the period preceding Goya's picture.

If we turn first to the iconographic traditions in religious art which paved the way to the iconographic type of *The Firing Squad*, we find the first obvious sequence of imagery in martyrdom pictures, especially those representing massive annihilation of numerous martyrs such as St. Maurice and the Martyrdom of the Theban Legion or the 10,000 Christians. But depictions of a single martyr, at whom a group of soldiers is shooting with arrows, also sometimes come rather close to Goya's compositional pattern: for instance, the representations of St. Sebastian's martyrdom by Hans Memling (Brussels, Musées Royaux des Beaux-Arts, about 1470; fig. 2) or by the Master of the Holy Kinship (Cologne, Wallraf-Richartz-Museum, about 1500).[4]

1

*1. Francisco Goya y Lucientes.*
The Firing Squad, May 3rd, 1808.
*1814. Prado, Madrid*

*2. Hans Memling.* Martyrdom of
St. Sebastian. *c. 1470. Brussels,
Musées Royaux des Beaux-Arts de
Belgique (after M. J. Friedländer)*

2

The second line of iconographic tradition—to which I devoted some comments years ago—is in pictures of the Triumph of Death. When discussing what I called the "encompassing themes," recurring themes which concentrate on essential motifs of human existence, I gave as one example the theme of the Triumph of Death, which "opposes man with its destructive powers. Its Late Renaissance realization is Bruegel's terrible panorama of annihilation."[5] A Baroque dynamism has been given to this image by David Vinckeboons, whose picture is known to us from the print by Boethius a Bolswert and some later painted versions (Boston, Museum of Fine Arts; Buenos Aires, Museo de Bellas Artes).[6] In more recent times the actual content of that theme changes but the image retains "its basic meaning expressive of a struggle between life and death, good and evil, light and darkness."[7]

As a matter of fact, the visual pattern was used for various subjects, as for the Classical (or pseudo-Classical) subject of "shooting at father's corpse"[8] and Callot's "punishment of marauding soldiers" in the large engraved series *Misères de la guerre*.[9] The *Firing Squad* engraving in that series (fig. 3), in which the firing of gunpowder was probably shown for the first time in this type of composition, presents the victims not as innocent people destroyed by the machinery of war's oppression, but as war criminals whose behavior deserved severe punishment. The inscription below the print allows no doubt about how it should be interpreted:[10]

Ceux qui pour obeir a leur mauvais Genie
Manquent a leur devoir, usent de tyrannie,
Ne se plaisent qu'au mal[,] violent la raison;
Et dont les actions pleines de trahison
Produisent dans le Camp mil sanglans vacarmes
Sont ainsi chastiez et passez par les armes.

The firing squad in Callot's print is a means to redress the balance of justice, and the engraving seems to have been designed to proclaim moralistic ideas.

3. *Jacques Callot.* Punishment of Marauding Soldiers. *Engraving from the series* Misères de la guerre. *1633. National Museum, Warsaw*

*Jan Bialostocki*

Quite opposite is the meaning of Goya's masterpiece, obviously. Painted when the danger was over, it leaves no doubt as to its political and moral message. Did Goya use his own experience to compose this dramatic image? "These are not scenes," E. H. Gombrich wrote in 1949, "at which a Spaniard and a patriot could easily have been present and survived. But even if Goya should have been an eye-witness to one or the other of the terrible episodes he portrayed (and this cannot be proved) he might never have recorded his experience in visual shape had not the existing type of atrocity imagery . . . provided the crystallizing point for his creative imagination."[11] And Gombrich, who rightly stressed that "the original genius who paints 'what he sees' and creates new forms out of nothing is a Romantic myth,"[12] suggests that British political caricatures, in particular those by R. K. Porter, "a poor artist but an interesting figure," could have reached Goya (fig. 4). Gombrich points out that "it is not only the tenor and the character of the episodes with their mixture of horror and defiance which are similar, but also many individual features . . . recur in many variations in the paintings and etchings of Goya's war scenes."[13]

This may certainly be true, especially of the closeups in Goya's *Desastres de la Guerra* prints. If, however, we look for available models which, whatever their popular or primitive form, could have fired Goya's imagination, we can suggest a comparison with a composition still closer in its pattern and character. I refer to Paul Revere's famous engraving *The Bloody Massacre,* of 1770 (fig. 5), a print that preceded Goya's *Firing Squad* by more than forty years.

The print of the Boston Massacre was not an original invention by Paul Revere, but a copy by that politician-engraver after an engraving by Henry Pelham (who, as a matter of fact, accused Revere of plagiarism); it was very popular, and

*4. R. K. Porter.* Buonaparte Massacring 3800 at Jaffa. *1803. Etching (after E. H. Gombrich)*

The text within the engraving reads:

The BLOODY MASSACRE perpetrated in King—Street BOSTON on March 5th 1770 by a party of the 29th REGT.

Engrav'd Printed & Sold by Paul Revere Boston

Unhappy Boston! see thy Sons deplore,
Thy hallow'd Walks besmear'd with guiltless Gore:
While faithless P——n and his savage Bands,
With murd'rous Rancour stretch their bloody Hands;
Like fierce Barbarians grinning o'er their Prey,
Approve the Carnage and enjoy the Day.

If scalding drops from Rage from Anguish Wrung,
If speechless Sorrows lab'ring for a Tongue,
Or if a weeping World can ought appease
The plaintive Ghosts of Victims such as these;
The Patriot's copious Tears for each are shed,
A glorious Tribute which embalms the Dead.

But know, Fate summons to that awful Goal,
Where Justice strips the Murd'rer of his Soul:
Should venal C——ts the scandal of the Land,
Snatch the relentless Villain from her Hand,
Keen Execrations on this Plate inscrib'd,
Shall reach a Judge who never can be brib'd.

The unhappy Sufferers were Messrs Saml Gray, Saml Maverick, Jamsl Caldwell, Crispus Attucks & Patrl Carr
Killed. Six wounded two of them (Christr Monk & John Clark) Mortally

5. *Paul Revere (after Henry Pelham).* The Bloody Massacre [in Boston]. *1770. Engraving, colored (after* American Art 1750–1800)

published in several states.[14] This was certainly a composition which—whatever the sources in tradition on which it was based—originated in genuine and direct reaction to the celebrated happenings that marked the beginning of the American Revolution. The author of the design—whoever he was—was careful to record the event in its actual setting in Boston's King Street before the Old State House; he gave the names of the seven killed and enumerated the wounded men; and the awkward verses inscribed below the image appealed to God's justice to avenge the cruel deeds:

> Keen Execrations on this Plate inscrib'd,
> Shall reach a JUDGE who never can be brib'd.

It seems that here we have indeed for the first time the formulation of the theme of the "Firing Squad," conceived as the representation of an actual happening and seen from the point of view of the victims as opposed to the moralistic view of Callot, in whose print we witnessed a just and legitimate—according to the artist—punishment suffered by guilty, marauding soldiers.

It may seem tasteless to compare Paul Revere's (or Henry Pelham's) composition with Goya's immortal and inspired masterpiece, but—to quote Gombrich again—a comparison between such "atrocity prints and Goya's heart-rending protests against human cruelty only serves of course, to enhance the magnitude of Goya's achievements."[15] And if we had to choose between Porter's prints (fig. 4), adduced by Gombrich, and Revere's *Bloody Massacre* (fig. 5) as a possible source of Goya's inspiration, I think we would not hesitate in naming the American print.

Is it possible that Goya had seen, the engraving, printed over forty years before, when he started working on the *Desastres de la Guerra* and *The Third of May*? "We know that British propaganda prints were circulated (and copied) in Spain,"[16] but we cannot say whether the *Bloody Massacre* was really available to Goya.

A close comparison allows us to point out more than general similarities between the print and the picture: the dead man lying on the ground, parts of the architectural background, and certain gestures of the victims are not unlike. But it would not be reasonable to insist too much on a direct link, the less so when we can adduce two other pictures that precede Goya's by only one year, but were painted so far from Spain that there is no practical possibility of claiming a common source for all three. We can agree in general terms with Gombrich's thesis, that the artist "can re-fashion [traditional] imagery, adapt it to its task, assimilate it to his needs and change it beyond recognition, but he can no more represent what is in front of his eyes without a pre-existing stock of acquired images than he can paint it without the pre-existing set of colours which he must have on his palette."[17] But the puzzle remains, that we find artists thousands of miles away from each other and having no means of communication, who nonetheless use similar compositional patterns when confronted with similar experiences.

## III

Four years after Spain's ordeal, Russia became the scene of French atrocities when the Grand Army invaded the Northern Empire on its last aggressive raid across Europe and occupied Moscow in the winter of 1812–13. Immediately after the French withdrawal from Russia, V. K. Shebuyev, professor of history painting at the St. Petersburg Academy of Fine Arts, gave the following competition subject to his students: "To represent the fidelity to God and their Emperor of the Russian citizens, who, refusing to follow Napoleon's orders, were led before the firing squad in Moscow and went to their death with unyielding and honorable spirit." We know of two painters who accepted the challenge and painted large pictures on this subject. The gold medal of the first class was awarded to Vassili K. Sazonov (1789–1870) and the gold medal of the second class to Mikhail Tikhonov (1789–1862), who, however, was not able to receive his prize, "not being a freeman." Both pictures survive today, one in the State Russian Museum in Leningrad (fig. 6), the other in the State Tretyakov Gallery in Moscow (fig. 7), but it is not clear which was painted by whom. Traditionally both pictures bore the name of the professor who assigned the competition subject, V. Shebuyev, and it was only in 1939 that N. N. Kovalenskaya, on the basis of records, discovered that the pictures were painted by Shebuyev's pupils.[18] G. V. Smirnov, curator of eighteenth- and early nineteenth-century painting in the State Russian Museum in Leningrad, is inclined—on the basis of scarce comparative material—to assign the Leningrad picture to Sazonov, which leaves the Moscow canvas to Tikhonov.[19]

The Leningrad picture (fig. 6), deeply rooted in the tradition of eighteenth-century academic history painting, is composed in a way that recalls Raphaelesque patterns revived in French eighteenth-century art; the rhetorical gestures of the figures further removed are not very convincing, while the execution scene in the foreground seems to reflect directly a dramatic experience.

The picture in Moscow (fig. 7) is closer to the more realistic Revere-Goya development: the heroic pose of the Russian peasant facing the squad and the unified automaton-like movement of the French soldiers shooting from the right at the victim are motifs common to the image pattern we are discussing. Can there

6. *Vassili K. Sazonov ( ?)*. Execution of Russian Patriots by the French
in Moscow, 1812. *1813. State Russian Museum, Leningrad*

7. *Mikhail Tikhonov ( ?)*. Execution of Russian Patriots by the French
in Moscow, 1812. *1813. State Tretyakov Gallery, Moscow*

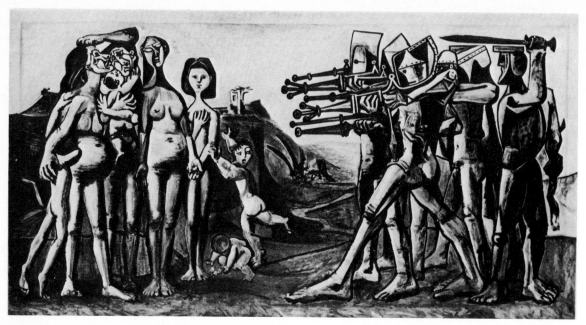

*8. Pablo Picasso*. Massacre in Korea. *1951. Musée Picasso, Paris*

be any actual links among these four works, one so distant in time and space, the other three painted within one year but at opposite ends of the defeated and disintegrating Napoleonic empire?

It seems that with these new events taking place in actuality, new themes and motifs emerged in the artists' imagination. And however much the artists were indebted to traditional imagery on the academic as well as the popular level, the dramatic experiences which everyone had to face in periods of social and national revolution could not fail to leave their powerful imprint on the visual imagination.

The fact remains, of course, that of all the works we have discussed here it was Goya's masterpiece in the Prado which, thanks to the genius of its author, finally formulated the new "encompassing theme" that has proved so tragically recurrent in the world's history down to our own day. In this work was founded the long line of iconographic tradition which, in such works as Manet's *Execution of Emperor Maximilian* or Picasso's *Massacre in Korea* (fig. 8), has continued to record the atrocities of modern history—always, as it were, referring the viewer to the great Spanish archetype.[20]

"With the clairvoyance of genius"—to end with H. W. Janson's words— "Goya created an image that has become a terrifying symbol of our era."[21]

*University of Warsaw and National Museum, Warsaw*

[1] X. Desparmet Fitz-Gerald, *L'oeuvre peinte de Goya. Catalogue raisonné*, Paris, 1928–50, no. 226; J. Gudiol, *Goya. Biographie, analyse critique et catalogue des peintures*, I, Paris, 1970, 321 f. (no. 624); F. Klingender, *Goya in the Democratic Tradition*, London, 1948, 138 ff.

[2] H. Thomas's recent book (*Goya: The Third of May, 1808*, London, 1972) places *The Firing Squad* in its historical context but does not trace its iconographic roots.

[3] H. W. Janson, *History of Art*, 2nd ed., New York, 1977, 585.

[4] S. v. "Passion, Sebastian," in W. Braunfels, ed., *Lexikon der christlichen Ikonographie*, VIII (*Ikonographie der Heiligen. Meletius bis zweiundvierzig Martyrer*), Rome–Freiburg–Basel–Vienna, 1976, 318–24 (fig. 4).

[5] J. Białostocki, "Encompassing themes and archetypal images," *Arte Lombarda*, X (*Studi in onore di Giusta Nicco Fasola*), 1965, 275–84, here 278 (also in German: *Stil und Ikonographie*, Dresden, 1966; and in Spanish: *Estilo e Iconografía*, Barcelona, 1973).

[6] See C. L. van Balen, "De dood voor de Poort," *Elzeviers Geïllustreerd Maandschrift*, XLVI (1936), 167–72; K. Goossens, *David Vinckboons*, Antwerp–The Hague, 1954, 112 (according to Goossens the original is in the Museo de Bellas Artes, Buenos Aires; S. Slive, *Art Bulletin*, XXXIX (1957), 313 f., expresses the view that the Buenos Aires and Boston pictures are both weak copies after the Bolswert engraving).

[7] Białostocki, "Encompassing themes," 278.

[8] W. Stechow, "Shooting at Father's Corpse," *Art Bulletin*, XXIV (1942), 213–25; B. Boesch, "Schiessen auf den toten Vater," *Zeitschrift für Schweizerische Archäologie und Kunstgeschichte*, XV (1954), 87–92; A. Pigler, *Barockthemen*, II, Budapest, 1956, 442 f.

[9] In addition to standard monographs, see: F. Klingender, "Les Misères et les Malheurs de la Guerre," *Burlington Magazine*, LXXXI (1942), 206; J. A. Schmoll gen. Eisenwerth, "Jacques Callot. Das Welttheater in der Kavalierperspektive," *Festschrift Werner Hager*, Reckling-hausen, 1966, 81–102.

[10] About the various interpretations of the *Misères*, see recently Diane Wolfthal, "Jacques Callot's *Miseries of War*," *Art Bulletin*, LIX (1977), 222–33.

[11] E. H. Gombrich, "Imagery and Art in the Romantic Period," *Burlington Magazine*, XCI (1949), 153–58 (reprinted in that author's *Meditations on a Hobby Horse and Other Essays on the Theory of Art*, London, 1963, 120–26, here 125).

[12] Gombrich, *Meditations*, 126.

[13] Gombrich, *Meditations*, 125.

[14] See: *American Paintings and Historical Prints from the Middendorf Collection. A Catalogue of an Exhibition*, Baltimore–New York, 1967, no. 60 a–b; *American Art: 1750–1800. Towards Independence*, C. F. Montgomery and P. E. Kane, eds., New Haven, London, Boston, 1976, 134 f.; see also the anonymous informative text in *The Boston Massacre 1770. Engraved by Paul Revere* (Library of Congress Facsimile No. 4), Washington, D.C., 1970.

[15] Gombrich, *Meditations*, 125.

[16] Gombrich, *Meditations*, 125.

[17] Gombrich, *Meditations*, 126.

[18] N. N. Kovalenskaya, *Russkaya istoritcheskaya zhivopis* (exhibition catalogue), State Tretyakov Gallery, Moscow, 1939, 8.

[19] I am very much indebted to Mr. G. V. Smirnov, curator of the State Russian Museum in Leningrad, for his most useful and helpful information, bibliographical references, and photographs of both the Leningrad and Moscow pictures: V. K. Sazonov (?), *Execution of Russian Patriots by the French in Moscow*, Leningrad, State Russian Museum, Inv. No. Sh-5056 (140 × 188 cm); M. Tikhonov (?), same subject, Moscow, State Tretyakov Gallery, Inv. No. 20813 (136 × 177.5 cm). Bibliography: P. Petrov, *Sbornik materialov dlia istorii imp. Akademii khudozhestv . . .*, St. Petersburg, 1865, II, 41, 48; *Gosudarstvennyi Russkii Muzei. Katalog-putevoditel, Russkaya zhivopis XVIII–XIX vekov*, Leningrad, 1948, 64; A. Savinov, *Vasilii Kozmitch Shebuyev*, Moscow, 1950, 16; *Gosudarstvennyi Russkii Muzei, Putevoditel*, I, Moscow, 1954, 79–80; *Gosu-*

*darstvennaya Tretyakovskaya Gallereya. Katalog Zhivopisi XVIII–XIX vekov,* Moscow, 1952, 468; N. Molieva and E. Belutin, *Russkaya khudozhestvennaya shkola pervoy poloviny XIX veka,* Moscow, 1963, fig. 45. Neither Sazonov nor Tikhonov was originally a freeman, but the former had been freed by 1810; Tikhonov in 1813, when he painted the prize-winning picture, still belonged to the stable-master of the Prince Golitsyn.

[20] Gustave Courbet also drew a composition very similar in character, with allegorical features strongly stressed; see Pierre Vaisse, "Couture et le Second Empire," *Revue de l'art,* No. 37 (1977), 66 (fig. 30: *Scène d'exécution allégorique,* Paris, Musée du Louvre).

[21] Janson, *History of Art,* 585. I have presented in a summary way the comparison of Paul Revere's print with Goya's picture and the Russian pictures in a paper, "Art and Politics: 1770–1830," first given at the University of Iowa (1976) and later at the Universidad Nacional Autonoma of Mexico, the University of Göttingen, and Harvard University. The paper will appear in the *Acts* of the 2nd Symposium of Polish and American Historians at Iowa City, 1976, to be published in 1980 by the Iowa University Press.

# 35
# *Friendship*

FRED LICHT

Thanks to the collaboration between Mme. de Pompadour and her sculptor Pigalle, the theme of friendship was first given monumental sculptural form (fig. 1). Though it is quite true that the meaning intended by Pigalle's magnificent statue was far removed from Romantic and pre-Romantic concepts of friendship,[1] it was, after all, intended to convey a very precise political message directed at court circles. Though she was no longer the king's *"maîtresse en titre,"* she remained his *"amie"* and as such exercised as much power as before. However, the notion of friendship being as powerful as love would have been foreign to any preceding period of European history. The time had ripened toward a new understanding of the power that friendship can wield and Mme. de Pompadour made intelligent use of this change in sensibility.[2]

The *Mme. de Pompadour en amitié* demonstrates that friendship was no longer a *pis aller* surrogate for love but a valid and potent sentiment that need no longer be reserved for diminutive porcelains, but could assume monumental form. As such it foreshadowed a great deal of the ethos of Neoclassicism. The most authoritative source on which the new regard for friendship was based is Cicero's "On Friendship."

Though the statue and the intent behind it lack the fervor, the intimacy, and the almost sacramental flavor which friendship was to attain during the Romantic age, it nevertheless expresses the enduring and dignified values of friendship in an emotional as well as intellectual manner. The carriage of the head, the extended left arm, and the incipient bowing gesture all express devotion and solicitude that can be understood on an immediate, subjective level, while the attributes of the bared breast, the elm tree trunk overgrown with clinging ivy, and the wreath of flowers express the same theme in intellectual and time-honored symbols. The statue is perhaps one of the finest monuments to illustrate how the all-pervasive *sensibilité* of the epoch lay claim to the world of public affairs. A new virtue is inaugurated, and it is characteristic that this virtue appears not in allegorical garb but in the guise of realistic portaiture. The abstract virtue is identical with the concrete person who exemplifies that virtue. From the very outset, friendship as a theme short-circuits allegory.

The association of friendship with death is almost axiomatic, friendship being a sentiment which, by definition, defies death and outlasts life. Quite properly,

Mme. de Pompadour's statue already made a reference to death in its flower symbols. Cesare Ripa and other authors of emblem books always show the figure of "Amicitia" accompanied by the inscription "Mors et Vita."[3] The appearance of figures that allude to friendship on tombs was almost inevitable in an age devoted to friendship, especially since the age also assigned an ever increasing value to surviving in the memory of good friends in direct ratio to the ever decreasing belief in the soul's immortality.[4]

The first sculptural instance that associates death and friendship is, significantly, not a tomb but a genre scene.[5] In Caffieri's *L'amitié pleurant sur un tombeau* (fig. 2), a tomb surrounded by appropriately funereal vegetation is being mourned over by a figure of Friendship recognizable by her bared left breast and the little dog at her feet, an accepted symbol of fidelity.[6] Again, as in the case of the *Mme. de Pompadour en amitié,* there is a certain congruence between friendship as an allegorical concept and friendship as a concrete presence in the form of a friend. Though the attributes of "Amitié" are present in the diminutive Caffieri bozzetto, the decidedly genre bias of the scene (emphasized by the careful inclusion of trees and ornamental shrubs as well as by the incense burners and libation cups) evokes a mood of the here-and-now. It is an artfully composed genre scene with allegorical overtones, a genre scene *moralisé* such as we encounter in the paintings of Greuze. We are free to interpret the weeping figure as the daughter, sister, widow, or *tendre amie* of the deceased, keeping in mind that in every case the values of friendship are insisted on as being allied to filial, sisterly, or wifely sentiments.

J. H. Dannecker repeatedly exploited the theme of friendship in his sculptures. In a characteristic bozzetto entitled *Freundschaft und Harmonie* (fig. 3) he takes up the theme in the same spirit as Caffieri's more tearful group and gives it a more astringent interpretation.[7] The new adulation of friendship which was cultivated to the pitch of *"Schwärmerei"* in Germany[8] made such bozzetti acceptable either in the diminutive sizes in which they were originally modeled or slightly enlarged for varying decorative purposes.[9] But besides using the theme of friendship in independent statuettes, Dannecker also adopted it for one of his more monumental projects, the tomb of Count Zeppelin at Ludwigsburg (fig. 4), which shows the allegory of Friendship leaning against the sarcophagus. Stylistically the influence of Canova's *Temperance* from the Ganganelli tomb in SS. Apostoli in Rome is evident. The meaning is also expressed in fairly traditional ways: friendship is shown as an abstract quality, divorced from any narrative illustration of how friendship functions in the hearts and actions of mankind. We can assume that Friendship mourns the death of a man who was her devotee. Equally admissible, however, is the possibility that the figure of Friendship represents grieving survivors and sums up their individual grief.[10]

Canova's stele for Volpato in SS. Apostoli in Rome (fig. 5) also conceives of "Amicitia" as a detached allegorical virtue which could indicate the defunct *or* the survivor as an exemplar of this particular virtue. However, the traditional apparatus of iconographic symbolism has been dropped in favor of an inscription which identifies the figure. Equally important is the strong emphasis on her action. She mourns the death of Volpato and therefore is more likely to symbolize a quality inherent in the survivor than in the defunct. The balance of interest begins to shift away from an exclusive preoccupation with the deceased. The flexibility of the iconographic *concetto* which already played a considerable part in Dannecker's tomb projects can be illustrated more directly in the work of Canova. Almost identical mourning figures were used by Canova to represent "Pietas" (Tadini

**1**

*1. Pigalle*. Madame de Pompadour en amitié.
*Rothschild Collection, Paris*

*2. Caffieri*. L'amitié pleurant sur un tombeau.
*Louvre, Paris*

*3. Dannecker*. Freundschaft und Harmonie.
*Staatsgalerie, Stuttgart*

**3**

*4. Dannecker.* Die Freundschaft am Grabe Graf Zeppelins. *Landesbibliothek, Stuttgart*

stele, Lovere, and Mellerio stele, Gerno), or "Gratitude" (Falier stele, in S. Stefano, Venice); or, by the simple addition of a heraldic bird, the same figure was converted into the representation of a princely house (William of Orange tomb, Nieuwekerk, Delft). Again, just by changing the inscription there occurs the transformation of the mourning figure into "Felicitas" (Ottavia Trento stele, cloister of S. Piero, Vicenza). In the De Souza-Holstein stele, finally, the identification of the figure is left quite blank (S. Antonio dei Portoghesi, Rome); we can assume that she is an allegorical figure representing Grief or that she is a friend who has come to mourn at the tomb. Either interpretation is made at our own risk since Canova remains deliberately equivocal as to the interpretation.

How thoroughly the ideal and the sentiment of friendship permeates the period's concepts of funerary monuments is demonstrated in a drawing from Heinrich Keller's Roman sketchbook.[11] Here (fig. 6) two perfectly standard allegorical figures bearing the attributes of "Faith" and "Justice" behave in a manner befitting friends, not allegories. Their consoling embrace can only be explained by thinking of the allegories as friends who have come to mourn at the tomb of a prince (the crown on the sarcophagus indicates the princely nature of the tomb) and to assuage their grief by a curiously amorous kiss.

It is worthwhile to note that these allegorical figures, though they are absolutely traditional in their garb and their attributes, preclude by their embrace any out-

5

6

5. *Canova. Stele for Volpato (d. 1807).*
*SS. Apostoli, Rome*

6. *Keller.* Project for a Princely Tomb.
*Pencil. Kunsthaus, Zurich*

7. *Anonymous. Tomb of D. Accursio.*
*1832. Camposanto della Certosa, Bo-*
*logna*

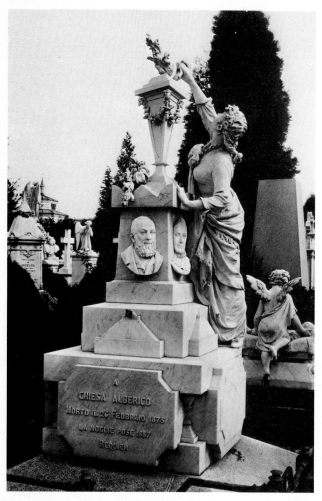

*8. Cecioni.* Visita al cimitero. *1865.
Museo d'arte moderna, Palazzo Pitti,
Florence*

*9. Argenti. Tomb of Alberico Chiesa
(d. 1875). Cimitero Monumentale,
Milan*

9

ward projection of their sentiments. Instead of recommending the deceased to us
as an *exemplum virtutis,* as all Baroque tombs do, they are quite oblivious of the
outside world. Their rhetoric is not transitive, it is not aimed at us, but concerns
only themselves as they seal their friendship with a kiss. There is a hermeticism
here that is totally alien to previous tomb concepts which were always aimed at
inducing us, as survivors mourning before the tomb, to admire and emulate the
virtues which the deceased possessed.

A similar ambiguity between friendship and allegorized virtue exists in Zauner's
tomb of Gideon von Laudon, near Vienna.[12] The knight who kneels in mournful
meditation on the lowest step of the pedestal can be read either as the personifica-
tion of knightly *virtus* or as a grieving comrade-in-arms of the dead field marshal.
The fashion for sepulchral monuments that turn inward rather than out toward
an audience marks a significant moment in the history of funerary sculpture. It

also presages a new relationship between the work of art and the spectator.

It becomes increasingly characteristic of the Neoclassic and nineteenth-century tomb in general that it no longer requires the presence of an audience: its rhetoric is not overtly directed toward instructing anyone about the virtues and deeds of the deceased. Instead, the position of the living mourner is usurped by a stone visitor to the grave, who becomes part of the tomb. This stone visitor appears either in the guise of a friend or relative, or, in the exceptional case of Keller, in the guise of allegories who behave like friends. The drama—and it is frequently a very intense drama—is not played out (as it was in the Baroque period) between the tomb sculpture and a living audience but between the effigy of the deceased and the stone visitor to the tomb. Ohmacht's tomb of Mayor Peters in Lübeck[13] is an excellent early example of this new type. The widow who holds up her little daughter to do homage to the sepulchral bust of the child's father excludes us from participation. Our subjective feelings as mourning survivors are subsumed in the monument itself. We, as the audience, are expendable.

It is possible that Thorvaldsen's famous tomb relief in the Brera for the painter Appiani belongs to the same range of tombs reflecting the profound meaning of friendship in this epoch. The three Graces belong, according to Ripa,[14] among the attributes of Friendship. And certainly their appearance on the tomb stele makes as much sense interpreted in this fashion as it does as an allusion to Beauty, which was Appiani's professional concern.

The ultimate conclusion of all the implications inherent in the theme of "friendship at the grave" as represented in works from the mid-eighteenth century on, is finally drawn by a number of nineteenth-century tombs, of which the Accursio tomb in the Certosa of Bologna (fig. 7) is qualitatively the finest. Here we reach the point at which the tomb figures accompanying the sarcophagus are unequivocally portraits of friends who have come to mourn over their dead companion. All allegorical trappings have been resolutely rejected and only the classical drapery gives the scene a slightly elevated tone. Friendship is no longer a quality in and for itself but exists embodied in survivors who remain loyal to the memory of the defunct.

What is more, the very idea of *virtus* displayed at the graveside is now shifted from the deceased to the survivor. Signor Accursio, being dead, no longer has the prerogative of exemplifying the virtue of friendship as, for instance, the dead Pope Alexander VII could claim to possess the virtue of charity. It is no longer Signor Accursio's gift for friendship that we are told about, or that matters. It is instead the touching steadfastness of the surviving friends which is held up to our admiration. Thus, paradoxically, it is this very loyalty which robs the defunct of his continued presence and condemns him to oblivion. We may admire Accursio's friends, but we cannot really admire Accursio because the figures tell us nothing of his life or character.

Equally important for modern considerations of death is the total secularization of the tomb. The cult of friendship usurps the place once held by religion. But whereas religion guaranteed the survival of the soul *in saeculum saeculorum,* friendship can only guarantee survival during the life span of the surviving friends. A new finality is hinted at that will ultimately reduce the modern tomb to the simple archival data of name, birthdate, and date of death. The photographic portrait which so often accompanies this anagraphic information only serves to make the tombstone look still more like some official, impersonalized document that bears no more resemblance to a living or a dead person than does a passport.

Growing out of this typically modern invention of what one might, for convenience's sake, call the "Freundschaftsgrab" is the gradual insistence on the increasingly genre-like treatment of tomb sculpture. Interest in how the soul fares after death is replaced by reports on how life continues on earth after the death of a friend or a relative. Hundreds of tombs in the nineteenth century, especially in Italy, deal with the (sometimes rather cheerful) theme of survivors going about the business of tending the tomb of a loved one. Nonfunerary sculptures such as Cecioni's *Visita al Camposanto* (fig. 8)[15] are virtually interchangeable with sculpture that was, from the outset, intended to mark a grave, such as the Chiesa tomb by Argenti in Milan (fig. 9).

Implied in all of these tombs is the typically modern interpretation of narrative as beginning and ending in finite time. It is still possible (though by no means an automatic perception) to think of Canova's figure of "Amicitia" as sitting forever in front of Volpato's sepulchral bust. This supposition is no longer possible in the case of the Accursio or the Chiesa tombs. The figures have come to the tomb to perform a definite action, and once that action has been completed, they will go on their way again. Nor will they, like Canova's funeral cortège on the tomb of the Archduchess Maria Christina, pass on into the realms of death. They will go, instead, back to the quotidian preoccupations that are the substance of nineteenth-century middle-class existence. Even the most touching and dramatic tomb of this category, Medardo Rosso's *The Last Kiss,* achieves its power because it makes us dwell not on what we actually have before us but on the next moment, when the coffin will be covered and the grieving woman will have to tear herself away from the grave.[16]

It belongs to quite another investigation to determine how the grim circumstances of life and death in the twentieth century lead from the gentle consolation of friendship in the face of death to such appallingly desolate monuments as Manship's *Buddies,*[17] which mark the extreme end of the development and which pervert the theme of "Friendship Surviving Death" into the "Death of Friendship."

*Boston University*

---

*Notes*

The monuments discussed here form a small selection of the available material. The ramifications of the theme are complex and range from the didactic allegory of Pajou's *L'Amitié qui chasse la Mort* (cf. H. Stein, *Augustin Pajou,* Paris, 1912, 219) to the overtly political *Ara Amicitiae* erected at Parma to celebrate a pact between the House of Bourbon-Parma and the Hapsburg dynasty (cf. G. Pellegri, *G. B. Boudard alla Real Corte di Parma,* Parma, 1976, 154).

[1] Basic for the discussion of friendship in the eighteenth and nineteenth centuries is Klaus Lankheit, *Das Freundschaftsbild der Romantik,* Heidelberg, 1952.

For Pigalle, see Louis Réau, *J. B. Pigalle,* Paris, 1950, and Ruth Butler, *Western Sculpture, Definitions of Man,* Boston, 1975, 180. Lankheit's interpretation of French attitudes toward the ideal of friendship is borne out by the remarkably sober entry under that heading in Diderot's *Encyclopédie*. Still, I am not altogether convinced that Lankheit is correct when he denies a high place to friendship in French culture of the eighteenth century. Two-thirds of the rev-

olutionary ideal of "Liberté, Egalité, Fraternité" are nothing less than friendship brought to the highest pitch.

[2] In an unpublished essay on "Goya's *Self-portrait with Dr. Arrieta*," Professor John Moffitt points out a century-old tradition according to which it is a friend and not a relative who must defend the soul of a moribund patient against the demons of doubt and despair. This would indicate that the connection between friendship and death antedates the late eighteenth century, but it is only then that the theme is represented in sculpture.

[3] See *Baroque and Rococo Pictorial Imagery* (the 1758–60 Hertel edition of Ripa's *Iconologia*), New York, 1971, no. 52.

[4] Denis Diderot's dictum, that being remembered by friends is to the philosophe what immortality is to the religious individual, is the most widely known expression of this change in attitude.

[5] Lemoyne's project for the tomb of Crébillon (Musée des Beaux-Arts, Dijon; 1763–64), shows a female figure weeping over the bust of the deceased. The identification of the figure is ambiguous, but in no case could she be Friendship since there is not a single attribute pointing in that direction. In style, composition, and content this is still a typical late Baroque tomb. The only surprising and forward-looking element is the lopsided relationship in the dimensions of the large allegorical figure in contrast to the small bust. In this respect, Lemoyne's composition might be considered a forerunner of Canova's Emo monument (Museo Storico Navale, Venice; 1775), in which there is a far more overt discrepancy between the stylized "real" figures (i.e., the genii) and the realistically treated artificial figure (the bust). In Lemoyne's case, however, the composition is so perfectly integrated that the weeping female cannot possibly be disengaged, visually or thematically, from the bust on which she leans. Houdon's tomb of the Count d'Ennery in the Louvre (1781) is far more resolutely modern in its emphasis on the mourning survivors. How widely this tomb was known remains somewhat

of a problem to determine.

[6] See A. E. Brinckmann, *Barock-Bozzetti*, Frankfurt a. M., 1923, III, 122, Ill. 66.

[7] The standard monograph on Dannecker is still Adolf Spemann, *J. H. Dannecker*, Berlin and Stuttgart, 1909.

[8] Since Dannecker was a boyhood friend of Schiller, it can be safely supposed that he shared the kind of "éducation sentimentale" that led Schiller to write "Die Bürgschaft," "Don Carlos," and "Die Räuber,"—plays and poems that became paradigms of friendship in every self-respecting German household throughout the nineteenth and twentieth centuries.

[9] For the flexibility with which Dannecker made use of diminutive models, see H. W. Janson, "The Neo-Classic Sense of Time. A Fictitious Monument to George Washington," in *Neoclassicismo, Atti del Convegno Internazionale promosso dal Comité International d'Histoire de l'Art*, a cura di Corrado Maltese, London, 1971, 48.

Especially for possible tomb commissions, the neutral figure of Friendship proved commercially useful. By sharpening the features, the sculptor could transform it into a portrait statue of a grieving friend or relative; by the simple addition of attributes, the transformation could be given an opposite direction toward abstract allegory. Divorced from either the portrait or conventional religious allegory, the figure of Friendship could also be made to represent a salient feature of the deceased's character.

[10] It is in connection with the monument to Count Zeppelin that we have one of the most fascinating statements by a sculptor about sculpture. In a letter to Karoline von Wolzogen, Dannecker writes:

> Ausdruck der Figur ist schmerzliches Seufzen und Sehnsucht; die Brust erhöt sich, und durch das Gewand und Gürtel zeige ich, dass ihr die Brust zu eng ist, die rechte Achsel zieht sich vorwärts. Ich glaubte den Feinfühligen mehr Nahrung zu geben, wenn er den Gedanken dabei haben kann, dass es

Sehnsucht des Wiedersehens darstellen soll. Bereits ist es mir gelungen, dass Nicht-Kenner den Ausdruck erraten haben. Nun habe ich aber Einwendungen von einigen bekommen, die mir sagen, es wäre ihnen lieber wenn die Freundschaft in Schmerz auf den Sarg hingesunken wäre. Das ist zwar für den Freund der erste Ausbruch von Empfindung, aber von keiner Dauer, und ich denke, dass die Freundschaft keinen solchen starken Ausbruch der Empfindung dulden kann, ich stelle sie mir stiller und grösser vor, wenn gleich Homer den Achilles auf den Leichnam des Patroklus hinstürzen lässt, so ist da der todte Freund und hier nur der Stein, der ihn bedeckt.

Several interesting elements of Neoclassicism rise to the surface here besides the obvious preference for subdued emotional expression: 1) The pride in appealing to "Nicht-Kenner." Earlier sculptors prided themselves on having gained the esteem and understanding of sophisticated connoisseurs. Dannecker prefers the primitive response and counts it a conquest. 2) Duration, "Dauer," is important to him. He already senses the contradiction between the traditional demand that the sepulchral monument immortalize the defunct and the modern need for secularization which robs the statue of its "Dauer" (cf. text above). 3) The apology to Homer. Homer described the actual event of Achilles mourning over the body. Dannecker's Freundschaft, however, has come to the already completed tomb (Stein der ihn bedeckt), not to the presence of a corpse. The motif of the allegorical figure as a "visitor" is already implied.

[11] Very little is known about this Swiss sculptor, who nevertheless played a significant role in the international art world of Rome. Johann Heinrich Keller was born in Zurich in 1771 and died in Rome in 1832. As a young man he was a respected friend of Bodmer and Fuseli. He arrived in Rome in 1794 and two years later moved to the house of Johann Heinrich Meyer, Goethe's close friend, who had a decisive influence on Goethe's speculations concerning the visual arts. Keller was probably tubercular. In 1805, after considerable success as a sculptor, ill health forced him to give up this arduous vocation and he turned to poetry and criticism instead.

The drawing published here is part of a fascinating sketchbook in the Kunsthaus in Zurich. This sketchbook seems to have been used not only by Keller but by a French-speaking companion.

[12] For Zauner, see Hermann Burg, *Der Bildhauer Anton Zauner und seine Zeit*, Vienna, 1915.

[13] For the best discussion of Ohmacht's Peters tomb, see H. Beenken, *Das Neunzehnte Jahrhundert in der Deutschen Kunst*, Munich, 1944, 442 ff.

[14] Ripa, *loc. cit.* (see above, n. 3).

[15] The most complete discussion and bibliography concerning Cecioni's remarkable relief of 1865 can be found in *I Macchiaiuoli* (exhibition catalogue), ed. Sandra Pinto, Florence, 1976, 205 ff., 329 ff. See also B. Sani, *Cecioni Scultore* (exhibition catalogue), Florence, 1970, no. 1.

[16] See M. Scolari-Barr, *Medardo Rosso*, Garden City, N.Y., 1963, 14, 15.

[17] Illustrated in F. Licht, *Sculpture 19th and 20th Centuries*, Greenwich, Conn., ill. 163.

# 36
# *Decamps's* History of Samson *Series in Context*

DEWEY F. MOSBY

The recent rediscovery of one of the nine drawings (fig. 5) by Alexandre-Gabriel Decamps (1803–1860)[1] that illustrate events in the life of Samson (figs. 3, 5, 7, 9, 11, 13, 15, 17, 18)[2] makes it an appropriate time to devote a special study to the series.[3] The sheets were extremely important in the career of the artist, a superb genre painter, draughtsman, and printmaker who aspired to the grand manner.[4] In addition, the critical reception of the works sheds light on early nineteenth-century France in general.

After exhibiting his most famous painting, *La Défaite des Cimbres* (fig. 1), at the Salon of 1834, Decamps received all the recognition that could be bestowed upon a contemporary artist.[5] However, by 1840 his ambition had waned and his style had become more or less repetitive. This state of mind may be directly related to the fact that he was not given a large surface to decorate in any of France's great public monuments.[6]

Toward the end of 1844 and beginning of 1845, Decamps apparently refound some of the inspiration he had had during the 1830s. His letters written from Chailly in the second half of 1844 tell us that he was engrossed in his work and pleased with his progress. One of the letters points out that he was particularly satisfied with two scenes of *Turcs Passant un Gué*; one was already in the collection of Marquis Maison (presently Chantilly, Musée Condé) and the other was in progress (presently London, Wallace Collection).[7] Decamps added in the same letter that the two versions were completely different. This factor, coupled with the careful execution of both drawings, is a clear sign that he was moving away from the lackadaisical approach which had typified the preceding four years.

It is impossible to point to a single reason for this change in attitude. One factor to be considered is that the environment around Fontainebleau, where he lived at the time, was very agreeable. Decamps had several friends in the area,[8] and he was able to engage in sport, accompanied by his wife, Angelina Imbert.[9] The artist also made frequent visits to the homes of his maternal relatives at Courbéton near Montéreau-Faut-Yonne.[10] His generally happy life was augmented by commissions from Marquis Maison, Charles Perrier,[11] and several other less notable collectors.[12] Finally, Decamps's ambition must have been rekindled by Delacroix's presence at Champrosay near Fontainebleau. Delacroix had received many successive commissions to do large-scale works and in 1844 he was busy decorating

the Library of the Senate at the Palais du Luxembourg. Also in 1844, Chassériau was commissioned to do mural decorations for the Cour de Comptes at Paris.

If Decamps was motivated by the commissions of Delacroix and Chassériau, then he should have sought after something beyond the two previously mentioned scenes of Arabs fording a stream. Indeed he found an idea for a major undertaking either late in 1844 or early in 1845. Decamps wrote to the famous art dealer, Arrowsmith:

> . . . Je travaille comme une bête féroce . . . j'ai entrepris un travail qui, selon moi, aura un plus grand intérêt et ne m'empêchera pas de faire ce que j'avais projeté, c'est-à-dire mon grand Jéricho. Je n'ai que le temps bien juste tiens à ne faire voir ma besogne que lorsque par son ensemble elle pourra se montrer compréhensible. C'est un ridicule peutêtre, mais enfin je le partage avec beaucoup de mes confrères. Idée connue, idée déflorée. Celà me nuirait, je vous jure . . .[13]

The large *Jéricho* that Decamps projected must have been the gigantic *Josué Arrêtant le Soleil* (Joshua 10:12–13).[14] His reference to the work as "mon grand Jéricho" should be construed as a reference to the Battle of Jericho or Joshua Fighting the Battle of Jericho,[15] although the scene he depicted dealt specifically with the Siege of Gibeon. In any case, the painter's enthusiastic mention of the work is a clear sign of reilluminated aspirations toward the grand manner.

The work that Decamps thought would be of such great interest and that he kept secret is much more important than any Jericho theme. Although he did not specifically identify the subject, his mention of an ensemble means that he referred to the famous *History of Samson* series.

The nine drawings represent a sharp shift in direction for Decamps's art of the 1840s. At the same time, the classical style of the group is a reaffirmation of his desire to be a supremely great history painter.

It is evident in Decamps's letter that he had not pondered the idea for the series. It is apparent that he had an outside stimulus for *History of Samson* because he stated, "Idée connue, idée déflorée." The Old Testament tragedy of Samson (Judges 13–16) had been richly represented in art, and Decamps's eternal source of inspiration, Rembrandt, frequently depicted the theme.[16] Decamps had already painted *Samson Combating the Philistines* in 1839 (fig. 2). We shall see presently that he must have been aware of Rembrandt's treatments, but the idea for the ensemble indeed was derived from thirty-eight engravings by François Verdier (1651–1730), as Silvestre noticed in 1855.[17]

The first scene of Decamps's series is *The Sacrifice of Manoa* (fig. 3). An angel appears to the old Manoa and his wife, announces the miraculous birth of Samson, and disappears in the flames of the holocaust. The basic image was inspired by Verdier's *Sacrifice of Manoa* (fig. 4) but Decamps laid the event in his own type of landscape (fig. 1) and infused it with his own mysterious light. For the arrangement of the figures, he turned to Rembrandt's *Tobit and the Angel* (Paris, Louvre), of which he owned a copy.[18] Decamps altered the position of Rembrandt's Tobit and the old woman behind him to arrive at the placements of Manoa and his wife. The pose of the angel in *Manoa*, in spite of Rembrandtesque drapery and positioning, is based on one of the versions of Giovanni da Bologna's *Mercury*, which Decamps admired as early as 1835.[19] The expansive landscape dominates the good news of the ancient Manoa. The overall appearance of the scene is less classical than the other works in the series because there is not a strong emphasis on rec-

1

2

1. *Alexandre-Gabriel Decamps*. La Défaite des Cimbres. *1833. Oil on canvas, 51 3/16 × 76 3/4". Louvre, Paris*

2. *Alexandre-Gabriel Decamps*. Samson Combating the Philistines. *1839. Recto, graphite on tracing paper; 7 1/4 × 10 3/4". The University of Kansas Museum of Art, Lawrence*

**3**

**4**

3. *Alexandre-Gabriel De-camps*. The Sacrifice of Manoa. *c.1844–45. Char-coal, pastel, and gouache; 16 1/2 × 24″. Present lo-cation unknown (lithograph by Eugène Leroux)*

4. *François Verdier*. The Sacrifice of Manoa. *1698. Engraving. Bibliothèque Nationale, Paris*

5. *Alexandre-Gabriel De-camps*. Samson Killing the Lion. *c.1844–45. Charcoal, pastel, and gouache; 16 1/4 × 24″. Private collection, Paris*

**5**

tilinear patterns. This difference is partly a result of Decamps's attempt to give
each work a different appearance while maintaining the unified character of the ensemble.

The next event is *Samson Killing the Lion* (fig. 5), which is reproduced here for the first time. Decamps again chose a different setting from the one used by Verdier for this remarkable feat of Samson's youth (fig. 6), but the compositions are similar. He used the tree on the left and the sloping hill on the right of Verdier's work for his own ends. The same usage is true of the pose of Samson which Decamps turned around, most likely with the aid of tracing paper. The artist employed the Old World landscape setting as a backdrop to concentrate emphasis on the activity of Samson. There is a sense of pent-up energy in the foreground whereas the background is calm. It should be mentioned that Decamps applied his drawing "cuisine," or inimitable mixture of media and brittle textures, to all of the works of the series.

Decamps chose a scene somewhat different from the one in Verdier's *Samson Burning the Fields of the Philistines* (figs. 7, 8), although the basic ideas are similar. He used the compositional idea of his own *Goatherder of the Abruzzi* (Minneapolis Institute of Arts). In fact, without the context of the other drawings of *History of Samson* and the tiny foxes on the right, it would be difficult to identify the subject. But once the incident is understood, Decamps's powerful imagination can be appreciated. Unlike Verdier, he depicted the scene in early evening or night. This choice emphasizes the burning of the fields because it permits logically the sharp contrasts of lights and darks in the middleground. As a result, the middleground (or the burning fields) becomes the center of interest. The attitude of Samson in the foreground further stresses this area of the drawing. Decamps turned to Raphael's Vatican Stanze, as he did in previous years,[20] for Samson's pose, which is based on the figure on the extreme left of the middleground of *Parnassus*. Decamps probably used an engraving of the work but he reversed it, as he did with Verdier's figure in *Samson Killing the Lion*. This reversal would

6. *François Verdier*. Samson Killing the Lion. *1698. Engraving. Bibliothèque Nationale, Paris*

account for the fact that Decamps's Samson is once again in the same direction as Raphael's Olympian. Decamps was certainly trying to give a new appearance to this "idée connue, idée déflorée."

*Samson Defeating the Philistines with the Jawbone of an Ass* (fig. 9) is a reworking of the 1839 version (fig. 2), but the left side of the drawing is based on the left side of Verdier's engraving (fig. 10). Most of the figures on the right side of Decamps's drawing were inspired from Raphael's Stanze. The graceful figure near the center of the *Expulsion of Heliodorus,* which Decamps had already used about 1841 in *Sortie de l'Ecole* (Paris, Louvre), is at work in the positions of most of the fleeing Philistines. The two horsemen on the right of Raphael's *Meeting of Attila with St. Leo the Great* are the sources for the two cavaliers on the right of *Samson Defeat-*

7. *Alexandre-Gabriel Decamps.* Samson Destroying the Fields of the Philistines. *c.1844–45. Charcoal, pastel, and gouache; 16 1/2 × 48 3/4″. Private collection, Paris*
8. *François Verdier.* Samson Burning the Fields of the Philistines. *1698. Engraving. Bibliothèque Nationale, Paris*

7

8

*ing the Philistines.* The artist augmented these sources with his own imagination to create a very lively image. The references to Raphael and Verdier in this work and the others of the series account for their classical appearance.

Decamps's next scene from the life of the Old Testament Hercules is *Samson Carrying the Doors of Gaza* (fig. 11). Here, he reversed Verdier's concept (fig. 12) by making Samson smaller and the mountainous landscape more massive. The two ideas of a city on the left and an incline on the right are the same. Decamps tried to generate interest by depicting the night, the time that the labor occurred, but this effect is not enough to compensate for the lack of detail in the drawing, especially when we compare *Destroying the Fields* (fig. 7).

In direct contrast to the generalized execution of *Gaza* is the superb treatment of

9. *Alexandre-Gabriel Decamps.* Samson Defeating the Philistines with the Jawbone of an Ass. *c.1844–45. Charcoal, pastel, and gouache; 16 1/2 × 48 3/4″. Private collection, Paris*
10. *François Verdier.* Samson Defeating the Philistines with the Jawbone of an Ass. *1698. Engraving. Bibliothèque Nationale, Paris*

9

10

11

12

11. *Alexandre-Gabriel Decamps*. Samson Carrying the Doors of Gaza. *c.
1844–45. Charcoal, pastel, and gouache; 19 11/16 × 24 1/4″. Private collec-
tion, Paris*

12. *François Verdier*. Samson Carrying the Doors of Gaza. *1698. Engraving.
Bibliothèque Nationale, Paris*

*Samson and Dalilah* (fig. 13). Verdier had not rendered this particular scene in Decamps's manner, but the gesture of his Dalilah (fig. 14) is at work in Decamps's drawing. The pose of Samson is similar to several figures by Rembrandt, especially the Philistine in the background of *Samson and Dalilah* (Berlin, Staatliche Museen, Gemäldegalerie). The austere interior of Decamps's picture could have been inspired by the painted architecture in Raphael's Stanze but now it is completely Decamps. The meticulous draughtsmanship, daring light effects, and emotional impact of this work are the most powerful of the series: one can almost hear Dalilah scream, "The Philistines be upon thee, Samson!"

Decamps again used classical architecture as a setting in *Samson Taken Prisoner* (fig. 15). Although the buildings are out of scale with the figures, they relate the event to the previous one because we see Dalilah viewing the captured Samson

13

*13. Alexandre-Gabriel Decamps.* Samson and Dalilah. *c.1844–45. Charcoal, pastel, and gouache; 16 1/4 × 24 1/4″. Private collection, Paris*

*14. François Verdier.* Samson and Dalilah. *1698. Engraving. Bibliothèque Nationale, Paris*

14

from the window of the room of the betrayal. This observation is a tribute to the subtle awareness of the artist because these are the only two scenes of the ones he chose to render that can be clearly related to each other. On the other hand without these details and the "cuisine," Decamps's rendition of the subject would be almost exactly the same as Verdier's *Samson Taken Prisoner* (fig. 16).

Decamps was left completely on his own for *Samson Turning the Mill* (fig. 17) because the event does not appear among Verdier's thirty-eight engravings conserved at the Bibliothèque Nationale in Paris. Decamps could have consulted the Bible, but the subject is a well-known labor of Samson. The overall image is more consistent with other works of the early 1840s than are the other drawings in the series. For example, the guard on the right is reminiscent of his Italian scenes such as *An Italian Family* (Ponce, Museo del Arte). However, the gridded window in the background recalls the one in Raphael's *Deliverance of St. Peter* in the Vatican Stanza of Heliodorus. The pose of Samson appears to be an adaptation of the captured hero (fig. 15). Decamps showed a particular sensitivity to Samson toiling like a draft animal after treachery had conquered his tremendous strength which had been capable of overturning the very laws of nature.[21]

The final work of Decamps's nine drawings is *Samson Destroying the Temple* (fig. 18). The scene is again indebted to Verdier (fig. 19). Also, there is something about the disposition of the figures, the column in the right background, and the pose of Samson that echoes Ingres's famous *Martyrdom of St. Symphorian* (Philadelphia Museum of Art, John G. Johnson Collection). Decamps continued to have problems in rendering architecture in a scale proportionate to that of the figures but he captured the terrible turbulence of the event.

It is apparent that Decamps used a variety of sources and effects for the *History of Samson*, although the series is deeply rooted in the art of François Verdier. Decamps did not employ these models for the purpose of linking himself with any one tradition. As was the case for *Cimbres* (fig. 1), he wanted to demonstrate his ability to handle the classical style while at the same time remaining original or modern. The reason that he wished to show this ability is because he wanted to

*15. Alexandre-Gabriel Decamps.* Samson Taken Prisoner. *c.1844–45. Charcoal, pastel, and gouache; 16 1/4 × 24 1/4″. Location unknown (lithograph by Eugène Leroux)*

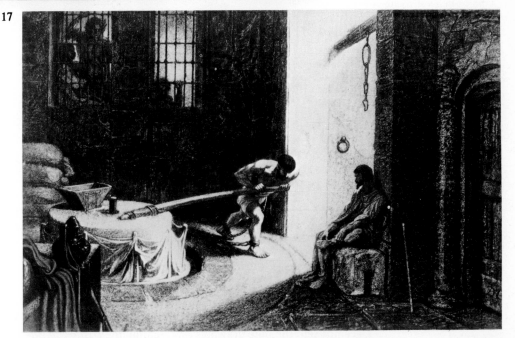

*16. François Verdier.* Samson Taken Prisoner. *1698. Engraving. Bibliothèque Nationale, Paris*

*17. Alexandre-Gabriel Decamps.* Samson Turning the Mill. *c.1844–45. Charcoal, pastel, and gouache; 16 1/16 × 24″. Musée des Beaux-Arts, Lyon*

join Delacroix, Chassériau, and others in decorating large surfaces. Decamps himself admitted this desire.[22]

Decamps did not seek to make any of the moralistic statements usually associated with the tragedy of Samson.[23] He treated the Bible as any other text or theme. The fact that the drawings are so closely connected to Verdier's engravings demonstrates a persistent interest in visual rather than literary sources. It cannot

18. *Alexandre-Gabriel Decamps. Samson Destroying the Temple. c.1844–45. Charcoal, pastel, and gouache; 16 7/8 × 48 3/4". Private collection, Paris*

19. *François Verdier. Samson Destroying the Temple. 1698. Engraving. Bibliothèque Nationale, Paris*

19

be stressed too much that Decamps was motivated by a desire to decorate a large surface with a unified theme and in a consistent style with varied effects.

Decamps sent the nine drawings representing the *History of Samson* to the Salon of 1845. The pictures were praised by critics of all persuasions, as Decamps thought they would be when he wrote to Arrowsmith about them. It is worthwhile viewing the statement of a few critics at length because they shed additional light on the emotional impact of the drawings. Also, the views of the critics illustrate the fact that Decamps was one of the most highly esteemed artists of the period. Equally as significant, these writings place the drawings in the context of nineteenth-century critical thought.

First of all, Baudelaire wrote:

M. Decamps nous a ménagé cette année une surprise qui dépasse toutes celles qu'il a travaillées si longtemps avec tant d'amour, voire *les Crochets* [London, Wallace Collection] et *les Cimbres* [fig. 1]; M. Decamps a fait du Raphaël et du Poussin.—Eh! mon Dieu!—oui.

Hâtons-nous de dire pour corriger ce que cette phrase a d'exagéré, que jamais ne fut mieux dissimulée ni plus savante—il est bien permis, il est louable d'imiter ainsi.[24]

Baudelaire went on to say, "we miss the old Decamps a little," and to praise the artist for choosing a theme that lent itself to his talent. The critic was particularly impressed by the figure in the foreground of *Samson Destroying the Temple* (fig. 18) because Decamps captured nature in the very act, in her simultaneous moments of fantasy and reality—in her most sudden and unexpected aspects.[25]

He criticized various details of the drawings and was not particularly pleased by Decamps's "cuisine" in all instances, but he concluded his discussion of Decamps with: "This series of designs constitutes one of the finest surprises which this prodigious artist has yet produced."[26]

Théophile Thoré saw Decamps's envoy in a similar light. He was more explicit in his view of Decamps's stature: ". . . Decamps et Delacroix . . . tiennent le premier rang dans l'école française . . ."[27] Also, he was more sensitive to general stylistic considerations than was Baudelaire. Thoré stated:

Les neuf dessins exposés par Decamps sont tout un poëme biblique en trois chants, et qui restera comme les sublimes cartons des grands maîtres italiens. Ces compositions sévères et vigoureuses sont exécutées dans le même style que le *Siège de Clermont* [Minneapolis Institute of Art] et la *Défaite des Cimbres* [Brussels, Musée des Beaux-Arts], du Salon de 1842, au fusain, à tous crayons, avec des rehauts de couleur à l'huile. Il est impossible d'arriver à un effet plus puissant, même avec toutes les ressources de la plus riche palette. Il y a des contrastes merveilleux et des degrés incalculables depuis les fortes ombres jusqu'à une lumière éblouissante. Chaque scène est présentée avec une unité et une symétrie qui ressuscitent le système des maîtres les plus habiles dans cet art difficile de la composition. Qui le croirait? Decamps, le peintre capricieux et emporté, qu'on a souvent comparé aux maîtres flamands, s'est élevé jusqu'à l'ordonnance austère et réfléchie de Raphaël et du Poussin.[28]

Thoré went on to analyze each scene and he continued to praise them.[29] He added in concluding his assessment of the *History of Samson:*

Cette épopée du *Samson* est certainement une des productions les plus extra-ordinaires et les plus fortes de l'art contemporain. C'est pourquoi nous l'avons étudiée avec enthousiasme et décrite avec un soin particulier.[30]

The critics for *L'Artiste,* as to be expected in light of their previous reviews, continued to praise Decamps. One anonymous critic observed:

Les dessins de M. Decamps sont merveilleux pour la mise en scène. Mais, qu'on y prenne garde, il y a là des réminiscences de tous les temps et de toutes les écoles, depuis Albert Dürer et les vieux graveurs sur bois jusqu'aux modernes. M. Decamps suit très près Raphaël dans les figures et le Poussin dans les paysages; mais il a su donner à toutes ses créations son puissant caractère. La critique loue un peu trop la pureté du dessin; c'est surtout l'énergie qu'il faut louer, quelquefois encore comme intention. C'est un peu trop fini, et en même temps c'est un peu trop à l'état d'esquisse. C'est d'une très belle exposition de lumières et très frappant d'effets. On y trouve des gestes bien hardiment et bien heureusement pris à la nature. La critique, après quelques remarques, s'arrêtera avec admiration devant cette forte et puissante empreinte individuelle. M. Decamps

peut traverser l'oeuvre de Raphaël et du Poussin sans cesser d'être M. Decamps, une de nos gloires les plus vivantes.[31]

It might be said that these particular reviewers do not give a true picture of the reception of the *History of Samson* because, as a result of their support for advanced art, the writers had basically the same taste at this period. The anonymous critic for *L'Artiste* clarified this point:

> On n'a jamais montré un plus touchant désaccord en critique sur les oeuvres d'art qu'en cette année 1845. Chaque journal est un nouveau point de vue, comme en politique; jusqu'ici nous n'avons pas rencontré deux fois la même opinion. . . . Cependant on est à peu près du même avis, dans la presse, sur les tableaux que nous allons étudier aujourd'hui.
>
> M. Decamps est un de ces francs artistes merveilleusement doués, inépuisables dans leur force, qu'on ne parvient jamais à connaître à fond.[32]

The Salon reviews show that the critics continued to place a premium on originality. Baudelaire's granting of license to imitate is not inconsistent with this view. He praised the manner in which Decamps concealed his sources or, in other words, the manner in which the painter strove for originality. All of the critics noticed debts to both Poussin and Raphael although they were not aware of Verdier's engravings. Verdier's style is characterized best as a melange of Poussin's and Raphael's styles. The contemporary writers could accept Decamps's references to the classical tradition because he imposed his individual technique on that style.

The overall appearance of the 1845 Salon must not have been too different from the Salon of 1831, which had affirmed Romanticism as the major trend of contemporary art. It is worth recalling Heinrich Heine's impression of the earlier Salon—"Every painter now works according to his own taste and on his own account"[33]—when considering Théophile Thoré's remarks on the 1845 exhibition:

> Le Salon de 1845 s'annonce . . . comme les autres Salons depuis dix ans. Peu d'inspiration nouvelle, quelques artistes de talent, et la foule des médiocrités. . . . Voyez la vérité infinie du Salon de 1845; cherchez à grouper logiquement tous ces tableaux dans quelques catégories qui permette une critique un peu étendue. Impossible. Le choix des sujets, la mise en scène, la tournure des personnages, le dessin, la couleur, tout diffère de l'un à l'autre. Parmi les mille exposants, il n'y en a pas six qui soient réunis dans un même principe, dans un même desir, ou dans un pratique analogue. Quelle diversité![34]

Within this great variety of styles and subjects this critic continued to see two major trends: Classical and Romantic. The descendants of David still dominated the academy and the public's admiration, whereas the artists who placed a premium on powerful execution were favored by most critics and connoisseurs.[35] An important factor to be recognized here is that Romanticism, as defined by contemporaries, was still alive and vital in 1845.

The differences of opinions between the critics and the administration of the fine arts is illustrated by the reception of the *History of Samson*. Decamps did not receive any official recognition from the Salon for the nine drawings. We have already seen that he hoped to acquire a commission to decorate a large surface. Decamps wrote at length on this subject:

> J'exposai, il y a une dizaine d'années, une série de dessins vivement exécutés, et par des procédés divers *(Histoire de Samson)*.—J'espérais démontrer que

j'étais susceptible de développements. Des compositions, très diversifiées de contextures et d'effets, présentaient cependant un ensemble homogène dans sa variété; difficulté vaincue qui passa parfaitement inaperçue. Les dessins furent fort loués, sans doute, au delà même de leur mérite, certainement; un amateur distingué me les acheta généreusement; mais ni l'Etat ni aucun de nos Mécènes opulents n'eûrent l'idée de me demander un travail en ce genre. Et pourtant l'esprit d'invention ne me manquait pas, et j'aurais tiré parti de l'idée la plus saugrenue si l'on m'eût accordé une salle quelconque.[36]

Thus the *History of Samson* marked both one of the highest points of Decamps's career and one of his greatest causes for despondency.

The immediate impact of the nine drawings on other artists was minimal. Eugène Leroux (1807–1863) lithographed six of the sheets but the fame of the series must have precluded their value as sources for other masters. On the other hand, Decamps's drawings clearly defined the distinction between being original and being different. His approach may have paved the way for the experiments with other masters' work that were carried out by such artists as Manet, Cézanne, and Van Gogh.

*The Detroit Institute of Arts*

*Notes*

[1] For a discussion of the life and career of the artist see Dewey F. Mosby, *Alexandre-Gabriel Decamps 1803–1860*, 2 vols., Garland Dissertations, New York, 1977.

[2] For complete catalogue information on the sheets see *ibid*., II, ckl. nos. 177, 404–8, 542–44.

[3] It should be mentioned that the drawings are discussed in Mosby, *Decamps*, 1977, but certain refinements appear in the present essay in honor of Professor Janson. In addition, *Samson Killing the Lion* is published here for the first time.

[4] This question is discussed in Dewey F. Mosby, "The Mature Years of Alexandre-Gabriel Decamps," *Minneapolis Institute of Arts Bulletin*, LXIII (1976–77), 96–109.

[5] See Mosby, *Decamps*, 1977, I, 367 f.

[6] *Ibid*., 231–33.

[7] Cf. Paris, Musée du Louvre, Cabinet des Dessins: *Decamps Lettres* (undated, letter no. 23); written to Arrowsmith. The letter may be dated to this period because both works are signed and dated.

[8] *Ibid*. (1844, Nov. 3).

[9] *Ibid*. (letter no. 21); this letter is also published in a more readily available source: see Paul Leroi and Maurice Tourneaux, "Decamps intime d'après une correspondance inédite," *L'art*, LVII, II (sér. 2), 1894, 98.

[10] Paris, Musée du Louvre, Cabinet des Dessins; *Decamps Lettres* (undated); written to Arrowsmith.

[11] *Ibid*. (1844, no month).

[12] *Ibid*.

[13] *Ibid*. (letter no. 21); see above, n. 9.

[14] The work measures 6 × 8 m.; see Mosby, *Decamps*, 1977, II, ckl. no. 545.

[15] It should be mentioned that when Decamps remarked, "C'est-à-dire mon grand Jéricho," he did not intend a "common language" reference to Géricault and the *Raft of the Medusa*. The context of his remark indicates that he meant a specific work of art. For a discussion of "common language" see Linda Nochlin, *Realism: Style and Civilization*, Baltimore, 1971, 104 f.

[16] See Madlyn Kahr, "Rembrandt and Dalilah," *Art Bulletin*, LV (1973), 240–59.

[17] Théophile Silvestre, *Les Artistes Vivants*.

*Notes*

*Decamps*, Paris, 1855, 174.

[18] Paris, Hôtel Drouot, *Désignation des Tableaux de M. Decamps* (sales cat.), April 21–23, 1853, no. 56.

[19] Paris, Musée du Louvre, Cabinet des Dessins; *Decamps Lettres*, (1835, Jan. 29); letter written to Maurice-Alexandre Decamps.

[20] See Mosby, *Decamps*, 1977, I, 71, 167 f.

[21] Cf. Charles Baudelaire, *Art in Paris 1845–1862, Salons and Other Exhibitions*, trans. Jonathan Mayne, London, 1965, 11.

[22] See Dr. Louis-Desiré Véron, *Mémoires d'un Bourgeois de Paris*, Paris, 1854, IV, 128.

[23] For a discussion of the meanings attached to the theme see Kahr, "Rembrandt," 240.

[24] Charles Baudelaire, *Variétés Critiques* (ed. Elie Faure), Paris, 1924, II, 213.

[25] *Ibid.*, 213–14.

[26] *Ibid.*, 215.

[27] Théophile Thoré, *Salons de T. Thoré*, Paris, 1868, 118.

[28] *Ibid.*, 116–17.

[29] *Ibid.*, 128–29.

[30] *Ibid.*, 133.

[31] Anon., "Lettres sur le Salon de 1845. II," *L'Artiste*, III (sér. 4), 1845, 197.

[32] X., "Salon de 1845," *L'Artiste*, III (sér. 4), 1845, 226.

[33] Heinrich Heine, *The Works of Heinrich Heine* (trans. Charles G. Leland), New York, 1906, IV, 2.

[34] Thoré, *Salons*, 114–15.

[35] *Ibid.*, 115.

[36] Véron, *Mémoires*, 127–28.

# 37

# *In Search of State Patronage: Three French Realists and the Second Empire, 1851–1871*

GABRIEL P. WEISBERG

Little attention has been given to the French independent realists who sympathetically examined the poor in the nineteenth century.[1] Through annual Salon exhibitions, where a modest state patronage for genre painters occurred under the Second Empire (1851–1870), images that educated the public received remuneration.[2] Often these canvases, some of which were commissioned by the state, suggested ways that church or state related to the poor and provided solace for their condition. While genre painters were not as well supported as other artists—especially those who concentrated on religious scenes or who glorified the state—the financial support given to a few painters was instrumental in permitting them to record the miserable aspects of contemporary life.[3]

Those painters who received occasional state encouragement as members of the *école réaliste* have often been overshadowed by the more famous figures of the movement, such as Jean François Millet and Gustave Courbet, who seldom received official recognition through state patronage.[4] The tendency to see the development of *réalisme* solely in terms of the major proponents should not, however, prevent examination of the lesser-known artists whose work was crucial in formulating a public and critical response toward scenes of misery.[5]

Isidore Pils (1815–1875), François Bonvin (1817–1887), and Théodule Ribot (1823–1891) were among the painters who often received valued state acknowledgment of their work. The state's awards led them to reciprocate by creating images that reinforced the message that the state, or its agencies, did indeed concern itself with the welfare of the poor.[6] Scenes depicted by these genre painters also contained personal elements linked to the life of the individual artist. These references revealed the realist painter's concern that charity be shown not only to the masses but to the impoverished creator as well, who was often in serious financial difficulty.

Thus, in 1851, when realism was recognized as a movement by critics of the Salon, it was the canvases of Pils, Bonvin, Auguste Jeanron, Adolphe Leleux, and Ernest Meissonier which vied with those of Courbet and Millet in creating a serious image of reality.[7] In Pils, Bonvin, and later Ribot, the state also recognized that

they had found artists capable of working in an understandable idiom. They believed these painters could teach society through the spectacle of suffering and through charitable deeds. Hence, if members of the *école réaliste* needed state support, they had to create canvases which satisfied governmental needs but which at the same time allowed them to record society. It was a difficult requirement, and it resulted in several interpretations of some realists' canvases. Although the personal symbolism might remain unknown to the ministers of the arts, it was in their interest (because of the various trends that the state was supporting) to locate members of the *école réaliste* who could render contemporary reality sympathetically without violently clashing with varied Salon styles. If state support also permitted a realist, such as Isidore Pils, to establish a lucrative career as a painter of contemporary history, then the system "worked" in the opinion of the government. State acquisitions also unquestionably allowed Bonvin and Ribot to continue as artists because they were often in financial difficulty—as were other members of the *école réaliste*.[8] By examining these three painters, recipients of the broadest support of realism under the Second Empire, a more complete picture of governmental subsidy and its benefits can be assessed.

## ISIDORE PILS

At the 1851 Salon Isidore Pils's canvas of *La Mort d'une soeur de charité* (Musée de Toulouse) received favorable critical notice and was purchased by the state for 4,000 francs (figs. 1, 2).[9] This large composition marked an early instance when Pils had received governmental subsidy. It also revealed a stylistic modification of the usual religious and mythological scenes to which governmental support until then had been restricted.[10] Pils's interest in the poor people of France contributed a new category—religious genre—that was to become increasingly relevant for French realism.[11]

Pils's development as a painter merits examination, if for no other reason than to provide a glimpse of how a young painter who was aware of the social changes in the country was able to record sympathetically the misery of the poorer classes of society. Pils first exhibited at the 1846 Salon (where he obtained a second-class medal), and later used themes from contemporary life. L. Becq de Fouquières, Pils's biographer, noted that ". . . le monde est devenu pour lui un musée vivant dans lequel la main de la Divinité a semé les types avec une prodigalité infinie: voilà désormais son domaine, c'est là que sont ses modèles."[12]

In preparation for *La Mort d'une soeur de charité* Pils carefully developed a series of preliminary drawings (figs. 3, 4); he completed oil sketches for other sections of the composition (fig. 5) and a graphic study of Saint Prosper (fig. 6), the mother superior at the Hôpital Saint-Louis until her death on August 30, 1846.[13] Undoubtedly, Pils selected this theme because it held deep personal associations, for he had been a patient at the hospital in 1845 and 1846, and again in 1848, during his long struggle with tuberculosis which took his life in 1875.[14]

Throughout the mid-nineteenth century the Hôpital Saint-Louis was an excellent general clinic as well as a center, after 1802, for the treatment of skin and venereal diseases.[15] Pils knew the staff of Saint-Louis well, and he may have been among the many who came to visit Saint Prosper as she lay on her deathbed. Pils merely memorialized an event that he had actually witnessed. As the first of three major Salon canvases, *La Mort . . .* demonstrated how Pils used his own experience to create a canvas with symbolic implications for the poor. In concentrating on the impact of Saint Prosper's death upon one segment of society, Pils

1. *Isidore Pils*. La Mort d'une soeur de
charité. *1851. Oil on canvas, 94 7/8 × 120″
(241 × 305 cm). Musée des Augustins, Tou-
louse*

3

2. *Isidore Pils*. La Mort d'une soeur de charité
(*detail*)

3. *Isidore Pils*. Drawing for La mort d'une
soeur de charité. *1851. 15 × 12 1/4″ (38 ×
31 cm). Private collection, Paris*

4

4. *Isidore Pils. Drawing for* La Mort d'une soeur de charité. *1851. 18 7/8 × 12 1/4″ (48 × 31 cm). Private collection, Paris*

5. *Isidore Pils. Oil sketch for* La Mort d'une soeur de charité. *c.1851. 17 × 10 1/2″ (43.2 × 26.7 cm). Collection Mr. and Mrs. Noah L. Butkin, Cleveland*

6. *Isidore Pils. Sketch of Saint Prosper. Oil on canvas, 22 × 17 3/4″ (56 × 45 cm). Musée Magnin, Dijon*

was able to record the anguish of a mother and her children and the deplorable condition of the downtrodden, who came with dirty feet and torn clothes to pay homage to their friend. Nothing could more graphically convey the plight of the poor than Pils's portrayal of their impoverished condition.

At the same time that Pils was contributing to realism, he was able to distinguish himself from traditional history painting (images based on events from the classical or historical past). He became a chronicler of contemporary events, still an aspect of history painting but one in which he was able to use his skill as an artist to record what he saw, much as a reporter would do for a newspaper or magazine.[16] In *La Mort d'une soeur de charité* and in other canvases from 1852 and 1853, the critics applauded Pils's sense of reality and his ability to recast historical painting within a contemporary mode. One of them, Albert de la Fizelière, found that Pils had achieved

> . . . cette sérénité d'aspect que produit toujours une excessive sobriété d'exécution. Le sujet est doux et touchant: Une soeur de charité de l'hôpital Saint-Louis vient de mourir. . . . Ce tableau rentre dans l'ordre des idées morales que le peintre symbolise dans une action simple et dans une expression accessible à tous. Il appartient de droit à la peinture d'histoire; il porte en lui un grand enseignement; il présente les vertus du peuple sous un aspect à la fois intéressant et moralisateur. . . .[17]

De la Fizelière recognized that Pils was capable of teaching the masses by revealing the noble sentiments of the poor. The dignity conveyed by Pils in this scene of the oppressed also served as a model for other followers of the *école réaliste*. After Salon exhibition, the painting was sent to Toulouse where its message would be instructive for people in the provinces.[18]

The second of Pils's canvases to document his sympathy toward the poor, and one commissioned by the state, was his *Soldats distribuant du pain aux indigents*, 1852 Salon (fig. 7).[19] Recognized by art critics as an example of charity toward the downtrodden—a theme used by other members of the realist school—the *Soldats* combined Pils's growing interest in the military with his personal concern for the well-being of the outcasts of society. Although Pils was later to achieve considerable fame as a portrayer of military events (he was given the Légion d'honneur in 1857 after completing *Le Débarquement de l'Armée française en Crimée*), he first received recognition when he portrayed the people of Paris interacting with the army in 1849.[20] His own familiarity with a similar scene he had observed at the Camp des Invalides in the center of Paris enabled Pils to reconstruct this event in a series of drawings (fig. 8) for many of the major figures. Pils recognized, as Becq de Fouquières later recorded, that it was ". . . dans les rues . . . c'est parmi le peuple qu'il va chercher ses types et ses modèles; et c'est ainsi qu'il rend humaine et vraie la peinture d'histoire."[21] By studies of young children, such as those shown in the center of this composition, Pils humanized history painting and made it more accessible to the public. This theme did not fail to attract the Emperor's ministers, and the picture was purchased by the state for 4,000 francs.[22]

By 1853, Pils returned to a theme which had attracted him in 1850: the impact that Sisters of Charity had on the poor, especially upon young children, at the Hôpital Saint-Louis. In his canvas *La Prière à l'hospice* (fig. 9) Pils again emphasized the role played by a nun in caring for children suffering from a disease of the scalp for which the hospital had become a treatment center.[23] The children, with their heads shaven and bandaged, are grouped around Sister Marie-Jeanne Fran-

7. *Isidore Pils.* Soldats distribuant du pain aux indigents. *Location unknown*

8. *Isidore Pils. Drawing of figure in* Soldats . . . *15 × 10 5/8″ (38 × 27 cm). Private collection, Paris*

çois (also known as Saint Isidore) praying before an altar. The sympathy that Pils had continually demonstrated for the young is again evident here as he captures them in a variety of expressions, some following the nun's prayers, while others, distracted, look away from the altar.

Pils apparently began the composition because he had become intimately familiar with the care given young children at Saint-Louis when he went there as an adult in 1845. He too had suffered from this same skin disease as a child, another reason for his choice of this theme.[24] Since Pils knew of the care given by Saint Isidore, perhaps even to himself as well as others, he gave his painting an added meaning: it reflected his own grasp of the concern of the nuns for the children of Paris—those whose families were unable to care for or treat their maladies. During the time Pils was in the hospital in the late 1840s he used the opportunity to observe children in various attitudes and to make the drawings later incorporated in his composition.[25] When Pils learned that Saint Isidore was ill, late in 1852, he had a further reason to work on the painting which later memorialized her death on January 28, 1853.[26]

The painting, therefore, has several levels of interpretation. On a personal side, the canvas records how Pils recalled scenes of care given to children at Saint-Louis,

and to himself, allowing him to place at the feet of Saint Isidore an autobiograph-
ical image in the youth who tenderly looks out at the viewer.[27] On a second level,
the canvas memorializes Marie-Jeanne François, who prayed for the welfare of
her children and tried to continue their education (notice the scattered readers on
the ground) during the period they were in the hospital.[28] Since the painting was
begun in 1852, a fact supported by some of the dated preliminary drawings (figs.
10, 11), and then exhibited in May at the 1853 Salon, it served as a tribute
to the assistance given by the Sisters of Charity at Saint-Louis.

At the 1853 Salon the composition attracted the attention of Empress Eugénie,
who had it purchased from the exhibition and given to the Hôpital des Enfants
Trouvés du Faubourg Saint-Antoine.[29] Again, Pils had completed a theme which
resulted in its acquisition by the state. The painting remains one of Pils's strongest
romantic-realist statements since it shows a decided social emphasis. Pils's ability
to combine reality with themes of social implication furthered his success during
the Second Empire. Following his early interest in these didactic themes, Pils
documented Napoleon III's military campaigns. His facile brush brought him hon-
ors; he obtained a teaching position at the Ecole des Beaux-Arts (1863) and sev-
eral important state subsidies during the 1860s.[30] *La Prière à l'hospice* was Pils's
last canvas which directly connected him with the *école réaliste* through his interest
in children and the misery of the people; it was his final large-scale canvas drawn

*9. Isidore Pils.* La Prière à l'hospice.
*103 1/8 × 77 1/2" (262 × 197 cm).
Musée de l'Assistance Publique, Paris*

10. *Isidore Pils. Preliminary sketch for* La Prière . . . *Leaf from notebook, 2 3/8 × 4 3/4″ (6 × 12 cm). Private collection, Paris*

11. *Isidore Pils. Preliminary sketch for* La Prière . . . *Private collection, Paris*

12

from personal remembrances of his illnesses. Only after the fall of the Empire did Pils return, in a series of watercolors, to his own observations of reality in melancholy views of Paris under siege and during the Commune (fig. 12).

## FRANÇOIS BONVIN

Unlike Pils, François Bonvin never surrendered his basically humble view of the world to the dictates of the state. Even when he was receiving state subsidies during the 1850s, Bonvin continued to depict the activities of the lower classes in paintings and drawings that recorded work and domestic life. Bonvin also reflected an unusual aspect of the Second Empire since he may have been subsidized by the state not only for his realist compositions but because he epitomized "the faithful civil servant" who was trying to develop a new career as an artist. For a number of years Bonvin served as an employee of the Paris Préfecture de Police; he worked during the day and often painted in the evenings or in moments of leisure.[31] Following his success at the 1849 Salon and the recognition and support given him by the art critic Champfleury, it was apparent that he could not fully devote himself to art while working for the state. At Champfleury's urging, Bonvin gave up his position with the Préfecture in 1850, turning to the state for assistance, and he did not return to the Préfecture until 1862.

Bonvin's success at the 1849 Salon increased his reputation, and the third-class medal that he received brought his work to the attention of the open-minded Charles Blanc, appointed head of the Bureau des Beaux-Arts by the revolutionary government in 1848. Blanc immediately asked Bonvin to prepare a sketch for a painting that would be commissioned by the state. The preparatory watercolor for *L'Ecole des orphelines* (fig. 13) was approved by Blanc, which gave Bonvin the right to claim the financial support that approval by the state conferred.[32] In February 1850 Bonvin wrote asking for the funds that would allow him to proceed with the completion of *L'Ecole des orphelines* (fig. 14).[33] Bonvin's financial plight is partly revealed in these letters to the state; in July, at the time of a second advance for the painting, he wrote, "J'ai le plus pressant besoin de cette avance, qui m'est indispensable pour terminer cette peinture, pendant l'exécution de laquelle je n'ai pu me livrer à d'autres travaux rémunerés."[34] There had been no Salon that spring because of the unsettled political climate and the lack of an available building; therefore Bonvin had longer to complete his composition and to await further governmental funds. By late September Bonvin again wrote the Directeur des Beaux-Arts, noting that he had just completed *L'Ecole* and that he awaited the decision of the state whether he could send canvas to the next Salon, scheduled for December 1851.[35] In order to make sure that the painting was completed, and to permit Bonvin to obtain the remainder of the funds allocated for his work, a report had to be prepared and submitted by an inspecteur des Beaux-Arts. For this reason the inspector Théodule du Bois went to Bonvin's studio in October 1850. He wrote an unsympathetic report stating that the painting presented a sad effect which he found uninteresting.[36] Fortunately, his criticism did not prevent the canvas from being exhibited at the 1850/51 Salon, where the quality of misery found support among the critics.

The press reviews of Bonvin's work at the 1850/51 Salon placed him within the

*12. Isidore Pils. La Colonne Vendôme renversée. 1871.
Watercolor, 12 5/8 × 20″ (32 × 51 cm). Musée Carnavalet, Paris*

context of the *école réaliste*; critics pointed out his relationship with earlier painters such as Chardin and Rembrandt, as well as with his own contemporaries. Clément de Ris, in *L'Artiste,* noted Bonvin's important position:

> En tête des jeunes phalanges se place M. Bonvin, déjà remarqué au Salon de l'année dernière. Pour tous ceux qui se rappellent *La Cuisinière,* une *Ecole de petites orphelines* (292) indique de notables progrès . . . d'ici quelques temps, le nom de M. Bonvin sera cité avec le plus d'éloges parmi les peintres de genre. Il a le rare mérite, pour un arrivant, de ne rappeler aucun de ses contemporains; et, parmi les peintres passés, je ne vois guère que Chardin avec lequel on puisse lui trouver un degré de similitude.
>
> . . . Tout en étant sobre de tons éclatants M. Bonvin est parvenu à donner à cette scène une grande vigueur. . . . Mais ce que j'admire le plus, c'est le sentiment de paix qui s'en élève et vous pénétre.[37]

Attention focused on *L'Ecole des orphelines;* it won not only critical approval for the young painter but helped him receive a second-class medal from the Salon jury.[38]

Its theme of formal instruction reiterated the code of dignity and diligence which the government was hoping to inspire in the working class. But the nature of the image—drawn from contemporary life—also linked the painting closely to the aims of the realists. As with Pils's canvases from the early 1850s, this composition was based on real impressions: the training Bonvin's young daughter received at such a school inspired him to record the scene. The somber tones of the painting suggested qualities of distress which existed for members of the lower class whose diligence at school could not alleviate their difficult social condition. Since the painting was not as crudely painted as Courbet's *Enterrement à Ornans* and it did not confront the viewer with stark representations of workers (as Courbet's *Les Casseurs de pierres*), the type of realism Bonvin portrayed was more palatable to the state. The painting was also judged important because it had been approved and commissioned by the government. An engraver reproduced the canvas, and the composition became widely known throughout the provinces,[39] where support was strong for education provided by religious orders. Bonvin's realism was applauded by the state. His medal (the highest award he ever received) and the fame which went with it led to his obtaining a student—the first who listed Bonvin as his master.[40]

While Bonvin's apparent success in December at the 1851 Salon seemed quite advantageous, he must nonetheless have been suffering during the preceding winter of 1850/51. Unable to live on the funds allocated for the *Ecole* (he received final payment in January 1851), Bonvin wrote an urgent and moving letter to the Ministre de l'Interieur in March 1851, pleading for the government to given him further support so that he could continue his chosen career.

> Je me trouve arrêté, faute de ressources, dans mes travaux de peinture.
>
> La voie sérieuse dans laquelle je marche, et qui m'a valu l'approbation de la plupart des artistes éminents de notre époque ne me permet guère de gagner ma vie avant que mon nom soit un peu plus répandu.
>
> J'ai l'honneur de vous prier, Monsieur le Ministre, de vouloir bien m'accorder, le plus tôt possible un travail qui, en m'assurant l'existence pour cette année, me donnera le moyen de continuer une carrière que je crois avoir commencé avec conscience et succès.[41]

13

14

13. *François Bonvin.* L'Ecole des orphelines. *1850. Brown ink with brown wash and* watercolor; *9 5/16 × 12″ (23.6 × 30.5 cm). Cabinet des Dessins, Musée du Louvre,* Paris

14. *François Bonvin.* L'Ecole des orphelines. *1850. Oil on canvas, 27 9/16 × 35 9/16″* (70 × 90.3 cm). Musée Saint Didier, Langres

This request for another commission was not answered affirmatively until October.[42] Bonvin was then given assurance of support for another painting, at 1,000 francs, pending approval of a subject which the state could sponsor.[43] Once finalized, Bonvin obtained an advance of 400 francs, which supported him through the difficult period until his second state commission, *La Charité*.

A preliminary watercolor, squared for transfer (fig. 15), shows that Bonvin's work had to be scrutinized by the state from its earliest conception. When the completed painting (fig. 16) was shown at the 1852 Salon, Bonvin found that he was not alone in developing the theme of almsgiving: Courbet exhibited his *Les Demoiselles de village,* in which his three sisters were distributing money to a guardian of cattle, and Pils exhibited his *Soldats distribuant du pain aux indigents.* While Courbet's unconventional compositional treatment continued to bother the critics, the paintings of Bonvin and Pils were well received. Claude Vignon noted:

> M. Bonvin conquiert encore un triomphe cette année avec ses deux tableaux: *La Charité* et *La Classe des petites.* On aime et on estime toujours cette peinture honnête, consciencieuse et vraie qui fait du réalisme sans fracas. M. Bonvin est bon peintre, et il nous le prouve une fois de plus.[44]

*La Charité* takes on added significance when seen in the context of the development of realism and in terms of Bonvin's own struggles. The problems associated with

15

16

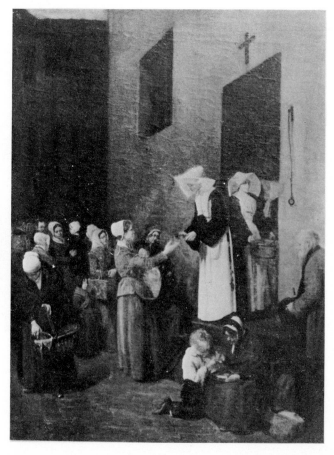

*15. François Bonvin.* La Charité. *1851. Watercolor and pen, 9 7/16 × 7 1/2" (24 × 19 cm). Private collection, Paris*

*16. François Bonvin.* La Charité. *1852. Oil on canvas, 47 1/4 × 34 5/8" (120 × 88 cm). Musée des Beaux-Arts, Niort*

the poor were uppermost in the minds of the realists and they often used themes which mirrored a difficult existence. As in Pils's *La Mort d'une soeur de charité* in the 1851 Salon, Bonvin also portrayed the role played by the Sisters of Charity; this time they were shown distributing food eagerly received by the needy, especially an old beggar (a standard type used by Bonvin in other compositions). Since Bonvin himself was also a recipient of state aid, the theme has autobiographical tones. By comparing Bonvin's *La Charité* with Pils's *Soldats. . . ,* it is evident that both artists, with state encouragement, had singled out the poor and the munificence of the government in providing needed assistance.

Bonvin was becoming increasingly dependent on governmental subsidy. After receiving final payment for *La Charité* (February 4, 1852), he was able to garner another state commission for *Une Scène d'assistance publique.* While the whereabouts of this painting is not known, the amount of money allocated and the choice of theme document that the state was kindly disposed to Bonvin's requests for aid.[45] Since the 1,500 francs given for this commission were meant to last Bonvin until January 1855, the state's kindliness must not bc confused with excessive generosity. Bonvin had to find some means of support—a difficult problem—and he again urgently requested further financial aid in February 1855, at which time the state purchased a small painting, *Les Apprêts du déjeuner,* for 300 francs.[46] This composition (fig. 17)—typical of the images of domestic activity that Bonvin

17. *François Bonvin.* Les Apprêts du déjeuner. *1854.
Oil on canvas, 16 1/8 × 13″ (41 × 33 cm), signed.
Musée Municipale, Rodez*

18. *François Bonvin.* Les Forgerons—Souvenirs du Tréport (Intérieur de forge). *1857. Oil on canvas, 36 5/8 × 29 1/8″ (93 × 74 cm), signed. Musée des Augustins, Toulouse*

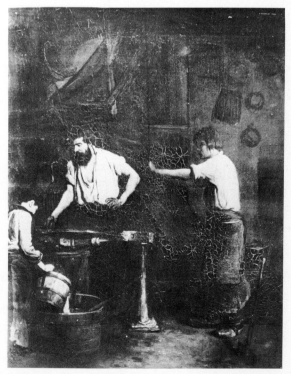

19. *François Bonvin.* Intérieur de cabaret. *1859. Oil on canvas, 21 1/2 ×
25 5/8" (54.5 × 65 cm). Arras*

completed in the mid-1850s—remains the only documented example of a work
purchased by the state from the artist without a prior commission.

From mid-1855 until mid-1862 Bonvin continued to request state support. The
constant assurance of a state commitment gave him a steady income and allowed
him to do other work, often more sensitive than his official canvases. Whether his
domestic scenes and still lifes were sold is not known; it seems, nevertheless, that
the promise of official support gave Bonvin the time to paint. Other commissions
included *Intérieur de forge (Les Forgerons—Souvenirs du Tréport)*, 1855–57, for
1,500 francs (fig. 18); *La Lettre de recommandation,* 1857–58, for 1,500 francs
(Musée de Besançon); *Intérieur de cabaret,* 1859–60, for 1,900 francs (fig. 19); and
*Religieuses se rendant aux offices,* 1861–62, for 1,500 francs (Musée de Melun).
These commissions represented a serious commitment on the part of the state to a
realist painter.[47] Bonvin responded to this acknowledgment by selecting themes
that portrayed the worker at a traditional trade, such as the forge (fig. 18), and with
scenes of religious activity that symbolized the importance of the church in the
Second Empire.[48] It was in the *Intérieur de cabaret* (1861 Salon), however, that Bon-
vin made the fullest use of his realist inclinations. He created a scene that combined
the intimate qualities of the Dutch school with the themes of the "art for man"
advocated by art critic Théophile Thoré.[49] The painting, set within his brother
Léon Bonvin's inn, and probably containing portraits of family members, suggests
how familial ties had the capacity to inspire a realist painter. The importance of

domestic tranquility conveyed by Bonvin made this composition a symbolic example of canvases upholding the virtues of a humble existence observed within the setting of the family.[50]

Despite the state subsidy Bonvin still found himself in a deplorable financial condition. He wrote to the Ministre des Beaux-Arts in June 1861:

> Le peu que j'ai retiré de mes travaux, depuis quelques années, n'a pas suffi pour couvrir les frais qu'ils m'ont-occasionné.
>
> Ma situation est telle en ce moment, Monsieur le Ministre, qu'il ne me reste d'autre ressource que celle de prier votre Excellence de vouloir bien me commander un travail dont la remunération me permettrait d'attendre de meilleurs jours.[51]

Bonvin's letter was received coldly; funds were apparently not available.[52] At the same time he wrote to the state Bonvin also sent a desperate letter to Louis Martinet, an art dealer and friend, who had been exhibiting Bonvin's work in his gallery.

> Voudriez-vous, vous que j'ai déjà surchargé de dèmarche pour mon affaire en tenter encore une auprès de ces Messieurs? Ce serait de leur expliquer que ce qui me rendrait le plus service, en ce moment, serait de me commander une copie de 1,200 fr de 15 si l'on peut. Je m'engage à contenter l'administration en copiant, par exemple, *Le Christ au tombeau,* du Titien.
>
> Si l'on vous objectait qu'une copie pourrait blesser mon amour-propre, répondez que les grands-maîtres ont été très heureux d'en faire et que je suis loin de me considérer grand-maître, que ce serait une belle occasion pour moi d'étudier, et qu'enfin, ce sera peut-être plus commode pour le Ministre.[53]

Curiously, this letter requesting Martinet's intervention is found in the dossier on Bonvin kept by the state. Martinet did more than speak to a member of the government; he forwarded Bonvin's own note—which eloquently explained the situation. Along with Bonvin's original request, this letter helped in granting the painter his final state commission on July 22, 1861.[54] This time the state specifically requested a "tableau de sainteté," marking the first time Bonvin had been instructed what to paint.[55]

The first payment for *Les Religieuses se rendant aux offices* was sent to Bonvin by mid-August; in the meantime, he had responded to the Ministre des Beaux-Arts: "En même temps, permettez-moi, Monsieur, de vous dire ici combien je suis touché de la bienveillance avec laquelle vous avez bien voulu vous occuper de moi en cette circonstance, et veuillez croire que je ferai de mon mieux pour continuer à la mériter."[56] Perhaps recognizing that he could not continue to rely on state support without surrendering his right to paint what he wished, in 1862 Bonvin decided to return to work for the Préfecture de Police.[57] There is no other recorded instance of Bonvin receiving a commission from the state after final payment for *Les Religieuses* was made in 1862.

Bonvin continued to work for the Préfecture until 1866, by which time a series of personal misfortunes had severely undermined his health. Bonvin left for a trip to the Low Countries, seeking solace in the study of the Dutch masters after the suicide of his brother and his unhappy second marriage. His period of state patronage had ended even though he could have had other opportunities for official support. Unquestionably, the state had played a vital role in giving Bonvin

time to paint, coming to his assistance several times and thereby showing a kindly disposition to the humble painter, who was perhaps the realist most representative of the movement.

## THÉODULE RIBOT

During the mid-1860s state support of the arts was challenged by younger painters who believed that the jury system was unfair and that many were being excluded from the Salons. While the liberalization of the Salons is well known, and the elimination of Salon medals by rank was an established fact, little has been said concerning state commissions and purchases from 1861 to 1870.[58] For some, official commissions were no longer necessary; careers begun in the 1850s were usually well established by the next decade. The state at this time was still marginally interested in the realists (and little, if at all, in the budding impressionists). There is a record of some patronage for Jules Breton and Antoine Vollon, younger members of the tradition.[59] For the most part, however, those painters who represented second-generation realism had difficulty in obtaining state recognition. The government did not commission the younger realists to do specific works, as they had during the 1850s. The close relationship between state and artist, as established with Bonvin, did not carry over to Bonvin's younger friends. Instead, artists such as Théodule Ribot had to wait for the state to purchase a canvas from the Salon.

Ribot's work was first exhibited in Bonvin's atelier in 1859 following a Salon rejection, and it was not until 1861 that he exhibited in the Salon. Many of his early canvases reflect his interest in kitchen scenes and cooks, a theme which he continued to paint between 1861 and 1865. Lacking the support of the government during his formative years, Ribot—who came from an impoverished tradition—attempted to exhibit paintings outside the Salon system.[60] Several canvases were exhibited in Martinet's gallery (where Bonvin also showed some of his work); after 1862, Ribot's canvases and prints were displayed at Cadart and Luquet, dealers who were sponsoring the revival of etching supported by the Société des Aquafortistes.[61] Even without a Salon success, Ribot had the opportunity of selling his paintings to private patrons through art dealers.

When Ribot exhibited *Le Chant du cantique* and *Les Rétameurs* at the Salon of 1864, he received a medal in the genre category. His interest in themes with a religious aspect, such as his *Prière des petites filles* (1863 Salon), connected him with an established Second Empire predilection for paintings drawn from everyday experience which had a spiritual aspect symbolized by the presence of the church. At the 1865 Salon Ribot showed an even larger canvas, *Saint-Sébastien, martyr* (fig. 20), which became the first of his works to be acquired by the state. This composition, which treats the death of Saint Sebastian with heightened realism and baroque drama, is an example of religious genre. Instead of glorifying the saint, Ribot depicted his wounds in detail, thereby emphasizing the saint's suffering. The presence of the ministering figures, dressed in peasant garb, provided significant modification of the traditional representation of this scene. Ribot thus presented a martyrdom in an approachable style: the saint seemed human and his plight believably real. The dusky lighting and the use of grayed color—suggestive of Ribera and the Spanish seventeenth-century masters—helped Ribot create a religious icon in a contemporary vein.

Acting as Ribot's agents for the painting, Cadart and Luquet sent a letter to Comte de Nieuwerkerke following a visit the governmental official had made to

their shop at 79, rue de Richelieu.[62] Noting the interest he had shown in Ribot's *Saint-Sébastien,* they wrote, "La plupart des artistes et des critiques d'art lui avaient déjà prédit le succès qu'il vous appartenait de confirmer."[63] They were careful to ask a substantial price, 6,000 francs, since Nieuwerkerke had left the price to the discretion of Ribot.[64] Nieuwerkerke wasted little time in answering Cadart and Luquet's letter, responding affirmatively to the price asked.[65]

This action marks one of the few times that a realist painter—with the assistance of an intermediary—had been able to set a high price for a requested canvas. Because it was the first time that Ribot had been patronized by the state, the payment was welcome. Ribot sold two other canvases under the Second Empire: *L'Huitre et les plaideurs* (fig. 21) for 4,000 francs, and *Les Philosophes* for 3,000 francs.[66] The former, drawn from a fable by La Fontaine, reflects a type of naturalism that would not threaten the Empire. Since these canvases were Ribot's only Salon entries in 1868 and 1869, they also reflect a willingness on the part of the state to secure examples by an artist known to have studied traditional styles of earlier artists.

Ribot received other funds from the government after the fall of the Empire, but the patronage he received reflected diminished state interest in working closely with a realist painter.[67] A career could not be sustained during the mid-1860s through state commissions and purchases alone. The liberalization of the Salons and the decline of Napoleon III's regime completely changed the earlier relationship between artist and patron. Art dealers and private entrepreneurs now became influential and effective intermediaries, able to help the painter financially without dominating what he created.[68]

From its inception, the Second Empire tried to assist the arts. For the most part, they patronized those who could best reflect the interests of centralization. It was a time when materialism and self-glorification were rampant. There were not

20. *Théodule Ribot.* Saint-Sébastien. *Oil on canvas, 38 1/4 × 51 1/4″ (97 × 130 cm). Musée du Louvre, Paris*

*21. Théodule Ribot.* L'Huitre et les plaideurs. *c.1868. Oil on canvas, 84 5/8 × 60 1/16″ (215 × 152.6 cm), signed. Musée des Beaux-Arts, Caen*

many artists who were able to follow a personal course and achieve state recognition. The few genre painters who received support attempted to maintain their individuality but found it difficult, when a state commission was involved, not to concede to the demands of the patron. For example, Pils, after a few realist ventures, followed the demands of the Empire, rising to a position of prominence at the Ecole des Beaux-Arts. François Bonvin, unable to adapt to ministerial wishes, eventually gave up governmental support. He seems the exception under the Second Empire, since the state did react swiftly to his appeals for assistance. He was the one painter in particular who would not have survived without state aid and who was given an opportunity to continue painting in a style seldom appreciated by the court of Napoleon III. Bonvin owed much to governmental patronage which, in his case during the 1850s, provided an ideal example of state and artist working together. Ribot marks the transition and the development of a new relationship between state and artist—a relationship that was partly determined by the demise of the Empire—in which the painter maintained more flexibility and could set a price for the sale of his own canvas, and where activity through an art dealer became predominant. Thus, the Second Empire, while providing only marginal support of the realists, enabled three lesser-known painters to mature and continue as artists.

*Cleveland Museum of Art*

[1] The preparation of this article would not have been possible without the assistance of Jean Adhémar and the generous support of Pierre Angrand, Paris. Until now, realism has largely been discussed in terms of two artists: Gustave Courbet and Jean François Millet. Examination of other figures (Alexandre Antigna, Philippe Auguste Jeanron, François Bonhommé, François Bonvin, Isidore Pils, and Théodule Ribot), while noted by some, has been hindered by the difficulty in locating their work. Linda Nochlin must be given considerable credit for recognizing the importance of several of these painters in her doctoral dissertation and later writings. For further information, see Linda Nochlin, *Gustave Courbet: A Study of Style and Society*, Garland Dissertations, New York, 1976, and *Realism*, Baltimore, 1971. In the first publication, Nochlin sees these painters as "proto-realists," a designation which was not the case. Individual articles on these painters are scarce, and hence their position in the early stages of realism awaits clarification. For further information see Emile Bouvier, *La Bataille réaliste*, Paris, 1913.

[2] Pierre Angrand, "L'Etat mécène, période autoritaire du Second Empire (1851–1860)," *Gazette des Beaux-Arts*, May–June 1968, 303–48. Angrand (329) carefully documents that the majority of commissions or purchases in the genre category occurred within 1851–52, exactly the dates when realism was being established at the Salon. Reasons for this may be found in the earlier enlightened support of the arts initiated by Charles Blanc, a socialist republican closely associated through his brother Louis with social reforms, whose commissions were awarded to financially deprived artists during the opening years of the Second Empire. Blanc adroitly protected those that he could until he was removed. On Blanc's support of the arts, see T. J. Clark, *The Absolute Bourgeois, Artists and Politics in France, 1848–1851*, New York, 1973, 51–57. The Second Empire was the subject of an extensive exhibition for the Philadelphia Museum of Art (*The Second Empire 1852–1870: Art in France under Napoleon III*, exh. cat., 1978), in which some patronage questions were examined; the exhibition, however, did not investigate Pils.

[3] Angrand, "L'Etat Mécène," 329–38, notes that genre painters fared badly under the Second Empire. Angrand separates genre painters from those who did landscapes and still lifes. All three groups received 18.2 percent of the funds allocated for purchases during the first part of the Second Empire (1851–1860). The majority of state purchases occurred within the category of religious allegory, both original scenes and copies after other masters.

[4] *Ibid.* Millet received one state purchase from 1851 to 1860. Courbet may have initiated a reaction against those realists who were most vigorous and challenging. Both Millet and Courbet have been subjects of recent exhibitions. For further reference see Robert Herbert, *Jean-François Millet*, catalogue of an exhibition held in London, January 22–March 7, 1977, and *Gustave Courbet (1819–1877)*, catalogue of an exhibition held at the Grand Palais, September 30, 1977–January 2, 1978, under the direction of Alan Bowness, Marie-Thérèse de Forges, and Hélène Toussaint.

[5] The realists often portrayed scenes of tragedy and suicide. For example, Alexandre Antigna's *L'Incendie*, 1851 Salon (Musée d'Orléans), concentrated on the emotional impact a fire had on surprised victims. The same thematic content is found in some early examples by Jules Breton who retained a strain of romanticism in his realistic study of disaster. Misery and hopelessness were also found in the canvases of Octave Tassaert, c. 1850–53 (Musée de Montpellier). Tassaert, a friend of Courbet during the crucial, formulative years of realism, exhibited at the Salons somber-toned canvases of women in deplorable situations. "Tassaert's Social Themes" were discussed at the College Art Association convention (New York, January 1978) by Professor Aaron Sheon, University of Pittsburgh.

[6] Artists selected particular themes because of what the state was demanding—especially since they hoped for governmental support. The situation of the poor, under the Second Empire, was complicated by the renovation of Paris, which forced many from their homes and created lingering unrest. For a brief discussion of the situation of the poor in Paris, see Gabriel P. Weisberg, *Social Concern and the Worker: French Prints from 1830–1910*, Utah Museum of Fine Arts, University of Utah, Salt Lake City, 1973.

[7] *Le National*, April 22, 1851. The critic Prosper Haussard noted that a school of painters of the people had been formed. For a brief discussion of the 1851 Salon see T. J. Clark, *Gustave Courbet and the Second French Republic, 1848–1851*, New York, 1973, 130.

[8] A study of the records in the Archives Nationales reveals that Jeanron and Antigna also received state support. Jeanron's considerable support may have been the result of a guilty conscience after the government had eased him out of power as director of the Louvre and sent him to Marseille. See F 21/37, F 21/89, F 21/150, and F 21/228, Archives Nationales. Antoine Vollon, another member of the realist group, solicited state support after he arrived in Paris from Lyon, noting that he could not support himself without it. The state responded by permitting him to do copies. See F 21/189, Archives Nationales. Later, in the mid-1860s, the state purchased some of his canvases.

[9] See F 21/103, dossier on Isidore Pils, Archives Nationales. The painting was acquired by the state on May 23, 1851.

[10] Pils's first Salon painting (1846) was *Le Christ prêchant dans la barque de Simon*. He followed this (1848) with scenes of *Bacchantes et Satyres* and *Baigneuses et Satyres*. Pils showed an interest in historical imagery (1858) with *Passage de la Bérézina, le 26 novembre, 1812*, followed by a widely acclaimed canvas of *Rouget de Lisle chantant pour le première fois la Marseillaise chez Dietrick maire à Strasbourg* (1849 Salon). For further references see the Salon catalogues from 1846 to 1850.

[11] Originally the composition was a funeral theme; Legros altered the painting to include the religious icon at the left. This type of imagery was used by the realists, who adopted contemporary genre to conceal religious messages. See Nochlin, *Realism*, for a discussion of this tendency. Pils was not alone in developing scenes where nuns and religious icons—such as a crucifix—symbolized the presence of the church among the people. For an interesting study demonstrating a change in religious genre in Alphonse Legros's *L'Ex Voto* (Musée de Dijon), 1860, see Monique Geiger, "Alphonse Legros, *L'Ex Voto*," *Bulletin du Laboratoire de Recherches des Musées de France*, 1971, 18–23.

[12] L. Becq de Fouquières, *Isidore Alexandre Auguste Pils, sa vie et ses oeuvres*, Paris, 1876, 24.

[13] *Explication des ouvrages de peinture, sculpture, architecture, gravure et lithographie exposées au Palais National, le 30 décembre, 1850*, Paris, 1850, 204.

[14] Pils died of tuberculosis. He was hospitalized frequently, even during his student years in Rome. See Becq de Fouquières, *Isidore Pils*, 20–24, 46–48.

[15] See Pierre Vallery-Radot, "Chroniques, en l'honneur de l'internat et de l'hôpital Saint-Louis," *La Presse médicale*, December 3, 1952. Many well-known writers and artists were treated at Saint-Louis, including Verlaine and Toulouse-Lautrec.

[16] Pils was a member of Napoleon III's fashionable circle, possibly because of decorations he provided for the Paris Opéra and his interest in the military. Pils's sense of actuality was perfected in the watercolors he completed during 1870 and 1871.

[17] Albert de la Fizelière, *Salon de 1850–51*, Paris, 1851, 12.

[18] Education in the provinces became an interest of the Second Empire, and the government may have selected Toulouse for religious as well as political reasons; the nun Saint Prosper came from the order of Saint Augustine and the Toulouse museum was housed in an old Augustinian building. The painting was treasured by the people of Toulouse who refused to lend it for the Pils retro-

spective in 1876. See Becq de Fouquières, *Isidore Pils*, 25, and Introduction to catalogue of *Exposition des oeuvres de Pils à l'Ecole des Beaux-Arts*, Paris, 1876, 3.

19 *Explication . . . des artistes vivants exposées aux Menus-Plaisirs, le 15 mai, 1853*, Paris, 1853, 168. The painting was listed as no. 933. See F 21/103, dossier 16, Isidore Pils, Archives Nationales. This painting cannot be located although it was owned by the Ministry of the Interior in 1876.

20 Pils is listed with the Légion d'honneur in the 1859 Salon catalogue. Pils's relationship with the state was further aided by a commission to paint *La Bataille de l'Alma* (1857 commission), for which Pils eventually received 20,000 francs (1860/61). See F 21/103, dossier 17, Archives Nationales. The amount of money was allocated July 14, 1857.

21 Becq de Fouquières, *Isidore Pils*, 26.

22 F 21/103, dossier 16, Isidore Pils, Archives Nationales.

23 Vallery-Radot, "Chroniques."

24 See catalogue of *Trésors et chefs-d'oeuvre de l'Assistance Publique*, June 15–December 31, 1977, Paris, 1977, 3–4.

25 *Ibid.* Many of Pils's notebooks also reveal his continual interest in scenes drawn from reality.

26 *Explication . . . des artistes*, 168. Marie-Jeanne François, also of the Augustinian order, was born in 1795.

27 *Trésors et chefs-d'oeuvre*, 4.

28 The work of individual nuns in continuing the education of young children undoubtedly helped to establish a more formalized school in 1885. See notes, typescript, Musée de l'Assistance Publique, Paris.

29 *Trésors et chefs-d'oeuvre*, 4. The price paid to Pils cannot be found.

30 Pils served as professor at the Ecole des Beaux-Arts for ten years. For government support of the *Bataille de l'Alma*, with final payment in 1862, see F 21/103, dossier 17, Isidore Pils, Archives Nationales. Pils received many honors under the Second Empire. See Becq de Fouquières, *Isidore Pils*, 57–58.

31 See Etienne Moreau-Nélaton, *Bonvin raconté par lui-même*, Paris, 1927, and Gabriel P. Weisberg, *Bonvin: La vie et l'oeuvre*, Paris, 1979. Both volumes suggest how Bonvin developed as a painter despite a background of hardship. In 1839, Bonvin began to work for the Préfecture de Police as a clerk.

32 See F 21/17, dossier on the *Ecole des petites filles*, Archives Nationales. The 1,800 francs approved by the state was paid in four segments.

33 Bonvin to Directeur des Beaux-Arts, February 17, 1850, *ibid.*

34 Bonvin to Ministre de l'Intérieur, July 26, 1850, *ibid.*

35 Bonvin to Directeur des Beaux-Arts, September 28, 1850, *ibid.*

36 Th. du Bois to Directeur des Beaux-Arts, October 14, 1850, *ibid.*

37 "Salon de 1850–51," *L'Artiste*, March 1851, 3.

38 The jury was composed of such well-known figures as Horace Vernet and Camille Corot.

39 See "Salon de 1851, 24 avril," Archives du Louvre. Reference to this procedure is also found in "Autorisations pour dessiner, graver retirer temporairement des ouvrages app't. au Ministère, retiré (des cadres)," Archives du Louvre. The printmaker was Soulange-Teissier.

40 See "Registre de cartes d'élèves, January 8, 1850–February 16, 1860, 86, no. 1786, December 23, 1851," Archives du Louvre. Emile Renard, Bonvin's first student, was 27 years old, and lived at 104, rue de l'Ouest. He was a printmaker and later worked at Sèvres.

41 See Bonvin to Ministre de l'Intérieur, March 2, 1851, F 21/65, dossier on *La Charité*, Archives Nationales.

42 The state to Bonvin, October 8, 1851, existing now only in the handwritten copy of the document sent to Bonvin, *ibid.*

43 *Ibid.*

44 Claude Vignon, Salon de 1852, Paris, 1852, 128–29.

45 See F 21/65, dossier on *Scène d'assistance publique* (approved February 12, 1853), Archives Nationales. Bonvin received 1,500 francs; the painting cannot be located. The final payment was given on January 12, 1855.

46 See F 21/65, dossier on *Les Apprêts du déjeuner* (February 5, 1855), Archives Nationales.

[47] See F 21/65, dossiers on *Intérieur de forge*, June 8, 1855; *Une Ecole chrétienne* (*La Lettre de recommandation*), July 22, 1857; *Intérieur de cabaret*, August 25, 1859; and F 21/120, dossier on *Les Religieuses se rendant aux offices*, July 22, 1861, Archives Nationales.

[48] Angrand, "L'Etat Mécène," 305, notes the close relationship between the church and the Emperor. Undoubtedly, this relationship affected the way in which painters were patronized to complete scenes of biblical themes. The realists did innumerable studies of nuns, suggesting that they adapted their imagery, in part, to the importance of the church in the life of the people.

[49] See Théophile Thoré, *Salons de W. Bürger, 1861 à 1868*, Paris, 1870, 114–15. Thoré had just returned to France from exile in the Low Countries.

[50] Bonvin became one of the key painters to record domestic activity and family life. Many of his drawings and paintings from the 1850s reflect this thematic preoccupation.

[51] See Bonvin to the Ministre d'Etat, June 3, 1861, F 21/120, dossier on *Les Religieuses se rendant aux offices*, Archives Nationales.

[52] Chef des Beaux-Arts to Bonvin (copy), June 28, 1861, *ibid.*

[53] Bonvin to Martinet, June 7, 1861, *ibid.*

[54] *Ibid.* Final payment did not arrive until July 1862, the date when the painting became the property of the state. Hence, 1862 is a more accurate date for the commission since Bonvin did most of the work on the painting in that year.

[55] Undated note in the dossier commenting on Bonvin's plight, *ibid.* See Chef des Beaux-Arts to Bonvin, July 26, 1862, instructing him what to paint.

[56] Bonvin to Ministre des Beaux-Arts, August 1, 1861, *ibid.*

[57] Bonvin returned to the Préfecture in 1862. He had married for a second time and needed funds.

[58] Pierre Angrand is working on much of this material. He expects to publish a detailed listing of artists and the support they received during the 1860s.

[59] The first governmental support for Jules Breton occurred in 1861. See F 21/122, dossier on *Le Soir* by Jules Breton, Archives Nationales. Antoine Vollon received numerous commissions and acquisitions in the 1860s following desperate letters appealing for assistance. See F 21/189 and F 21/260, dossiers on Antoine Vollon, Archives Nationales.

[60] For a brief discussion of Ribot's early years, see Gabriel P. Weisberg, "Théodule Ribot: Popular Imagery and 'The Little Milkmaid'," *Bulletin of The Cleveland Museum of Art*, LXIII (October 1976), 253–63. The general introduction to Ribot's life and work is L. de Fourcaud, *Th. Ribot, sa vie et ses oeuvres*, Paris, 1885.

[61] For a discussion of the role of Cadart and the Société des Aquafortistes, see Janine Bailly-Herzberg, *L'Eau-forte de peintre au dix-neuvième siècle: La Société des Aquafortistes (1862–1867)*, Paris, 1972, and Gabriel P. Weisberg, *The Etching Renaissance in France, 1850–1880*, Utah Museum of Fine Arts, University of Utah, Salt Lake City, 1971.

[62] F 21/176, dossier on Ribot's *Saint-Sébastien, martyr*, Archives Nationales.

[63] Cadart and Luquet to Nieuwerkerke, March 18, 1865, *ibid.*

[64] Nieuwerkerke came to the shop to inquire about the availability of the painting then in the hands of Cadart and Luquet.

[65] Nieuwerkerke to Ribot, March 25, 1865, F 21/176, dossier on Ribot's *Saint-Sébastien, martyr*, Archives Nationales.

[66] F 21/176, dossiers on Théodule Ribot's *L'Huitre et les plaideurs* (1868) and *Les Philosophes* (1869), Archives Nationales.

[67] See F 21/250, dossiers on Théodule Ribot's *Le Samaritain* (1871), *Jésus et les docteurs* (1879), and *La Charbonnière*, Musée de Besançon, (1880), Archives Nationales.

[68] For further discussion of these aspects, see Albert Boime, "Entrepreneurial Patronage in Nineteenth-Century France," in *Enterprise and Entrepreneurs in Nineteenth- and Twentieth-Century France*, eds. Edward C. Carter II, Robert Forster, and Joseph N. Moody, Baltimore, 1976, 137–207.

# 38

## *Barye's Apotheosis Pediment for the New Louvre:* Napoleon I Crowned by History and the Fine Arts

GLENN F. BENGE

Antoine-Louis Barye (1796–1875) created a monumental relief in stone for the gabled pediment of the Sully Pavilion of the New Louvre in 1857 (figs. 1–4). It is one of the finest extant examples of his late, classical style; indeed, it is the only one of his two pediments for the New Louvre Palace to survive the vicissitudes of the Franco-Prussian War and the Commune. Furthermore, it is the largest of the six monumental sculptures he designed for Louis Napoleon's expansion of the Louvre Palace. Surprisingly, the archival documents[1] show that Barye conceived, executed, and installed this large work in slightly more than three months' time. Despite the rapid pace of its development, however, Barye's drawings—preserved in Paris and Baltimore—record an intriguing array of alternative schemes for the design and iconography of the pediment. They reveal a fascinating image-formulating process.

Overlooking the great court that once lay between the Louvre and Tuileries palaces (the Tuileries Palace was destroyed in May 1871), Barye's pediment is situated on the central axis of the Place Napoléon III, facing the Arc du Carrousel. It is focal in the scheme of decorations for this vast courtyard, and its subject is appropriate to the importance of the location. The theme of the work is an apotheosis of Napoleon Bonaparte, officially described as *Napoleon I Crowned by History and the Fine Arts*.[2] This subject is a typical instance of those elaborations of the Napoleonic Legend that were carried out in the political propaganda of the Second Empire of Napoleon III.[3] Louis Napoleon surely found an image of Napoleon Bonaparte's glorious reception into heaven to be an enhancement of the reputation of his own regime. By the implicit dynastic connection, it would suggest his personal apotheosis. In having himself depicted not on the central axis of this great courtyard,[4] but rather in the more whimsical location of the Riding Academy façade[5]—on the palace exterior, facing the Seine—one senses Louis Napoleon's prudence and his almost reverential attitude toward his predecessor, clearly preserving a hierarchy of imperial honor. (In the latter pedimental relief, now destroyed, Napoleon III wore the ritual costume of a Roman emperor.) Even his first choice

of Louis T. J. Visconti (1791–1853) as the architect to direct the enormous project of uniting the separate palaces of the Louvre and Tuileries[6] held significance for the Legend, since Visconti had designed the *Tomb of Napoleon Bonaparte* in the Church of the Invalides in 1842. Shortly before Visconti's untimely death almost at the outset of the New Louvre project, he had approved Barye's model for an equestrian bronze statue, *Emperor Napoleon I as an Equestrian in Coronation Regalia*,[7] a work, however, that was not executed. His successor, Hector-Martin Lefuel (1810–1881), though he would not sustain the Napoleonic continuities as had Visconti, nor authorize the casting of Barye's equestrian bronze, nonetheless generously awarded Barye his major state commissions of the period 1854–62: the four personification figures in stone for New Louvre façades in the Cour du Carrousel, *Strength, Order, Peace,* and *War*,[8] and the two Napoleonic pedimental reliefs. No doubt Barye was not altogether disheartened at the necessity to transform his projected freestanding equestrian of Napoleon I into a monumental bronze pedimental relief of the mustached Napoleon III. The shift in medium from stone to bronze for his ultimate pedimental relief surely delighted Barye, for it constituted a kind of personal tribute to the early days of his career, when his models and bronzes had captivated Salon audiences from about 1831 to 1835 and won him the patronage of the royal house of France.[9]

A certain haste is evident in the general condition of the documents for 1857 that pertain to Barye's stone apotheosis pediment (Archives Nationales F[21] 1749 and F[21] 1750). Perhaps this, like the speedy completion of the relief itself, reflects the stringent schedule necessitated by the approaching date of the splendidly operatic dedication ceremony envisioned by Louis Napoleon for his vast *réunion* undertaking: Napoleon III, Emperor of the French, would dedicate the newly expanded palace of the Louvre on August 14, 1857, with solemn processions, declamations, and an evening banquet; the 15th of August he declared an imperial holiday. In the mood of great celebration, the chief theaters of Paris gave free performances, and the new buildings and gardens were opened to the public.

According to the letter of contract,[10] dated March 2, 1857, Barye agreed to create a model at one-third scale for the approval of the administration, and to execute the final stone pediment by the following April 30(!), for the sum of 30,000 francs. The quarried stone was to be delivered to Barye. He would defray the cost of the model, but the scaffolds and props necessary for the execution of the stone pediment would be provided by the administration. Upon his completion of the model he would be paid the sum of 10,000 francs, to be deducted from the total fee of 30,000 francs. A marginal note on the letter indicates that Barye would draw a second sum of 10,000 francs when, in the opinion of the architect, the pediment had advanced to a half-completed state. A penalty clause—unique in the extant Barye documentation—states that a fine of 50 francs per day would be subtracted from the final sum if the pediment were not completed on time! Should the delay exceed three months, the administration would purchase the model for 10,000 francs, and would be free to charge another artist with its execution; further, Barye would not be required to pay for any already-completed portion of the stone pediment. At the acceptance of the completed relief, the artist would receive the remainder of the 30,000 francs.

The colossal portrait bust of Napoleon Bonaparte is central in the imagery of the pediment (figs. 1, 2). The tips of his laurel crown frame the celestial symbol of a five-pointed star atop his forehead.[11] In its harsh, classicizing style the portrait is reminiscent of the ancient *Augustus of Primaporta* (Rome, Vatican Museum),

1. *Barye*. Napoleon I Crowned by History and the Fine Arts.
*1857. Sully Pavilion of the New Louvre, Paris*
2. *Barye*. Napoleon I Crowned *(detail)*

especially about the eyes and lips. At either side of the bust are sprays of laurel, decorative amplifications of that triumph symbol. Napoleon's portrait is placed upon a cippus, an altarlike cubic block of stone. Directly before the cippus is an imperial eagle, its wings open and extended as if to soar through all Napoleon's realms in its ascent to the Empyrean (the head and talons have been broken away,

*3. Barye.* Napoleon I Crowned, *detail of the* Fine Arts

somewhat impeding the legibility of the image). The eagle, placed beneath the bust in this manner, echoes the ancient symbolism of apotheosis; the star above Napoleon's forehead assures the viewer of his heavenly place, and affirms one's sense that this is an image of apotheosis.

At either side of this central group—bust, cippus, and eagle—are seated two draped female personification figures of the *Fine Arts* and *History*, each attended by a seated putto, and each holding an attribute. *History*, on the right, holds and reads in her great book, its outer edge touched by the extended right hand of her putto, who sits behind her legs. (*History's* right arm is missing, and only fragments of her right hand remain fixed to the chin, once supported in an Italianate pose of ponderation; her putto's lower right leg is also broken away.) Just beyond *History*, in the background relief at the very corner of the pediment, her attributes appear—weapons, pieces of armor, helmets, shields, a cuirass, and a quiver of arrows—symbols of the military glory of General Bonaparte. At the left of Napoleon's bust the *Fine Arts* strikes her kithara, as the putto beside her listens. Her attributes in the low-relief background are two krater-like ceramic vessels, a set of musical pipes, a tambourine, and a cornucopia, symbolizing the arts of ceramics and music and possibly the fecundity of the arts in their broader sense. A very personal, autobiographical reference to Barye's earlier art of small-scale animal sculpture is surely implicit in the prominent small-animal sculptures in each of the attribute reliefs: the copy of the ancient and famous *Seated Boar* (Louvre) beside the *Fine Arts* (fig. 3), and the beautiful swan on the crest of a helmet beside *History* (fig. 4). Both animals may further connote the realms of earth, air, and water, implying the all-embracing amplitude of Napoleon's reign.

The apparent imagery of the pediment corresponds to the brief description given in the official letter of contract of March 2, 1857 (Archives Nationales F[21] 1749), where it is called a

4. *Barye*. Napoleon I Crowned, *detail of* History

. . . projet de décoration du Fronton du pavillon de Vieux Louvre, côté de la place Napoléon, représentant au milieu le buste de Napoléon premier posé sur une cippe entouré et couronné par les deux figures allégoriques de l'histoire et des beaux-arts, les extrémités des Tympan sont occupées par les attributs de chacun de ces figures.

Although awarded this commission in 1857 as part of Lefuel's New Louvre construction campaign, Barye's pediment is located on an already extant pavilion of the Old Louvre, the "Vieux Louvre" of the contract. On the opposite side of this pavilion, facing the inner court of the Old Louvre, is Lemercier's clock façade of 1624, long known as the "Pavillon de l'horloge." Barye's pediment, however, faces onto the new court created by Lefuel, the "Place Napoléon" mentioned in the contract.

An earlier conception of the iconography of the pediment, predating the contractual description of March 2, 1857, is set out in Lefuel's drawing of the *Sully Pavilion Façade*,[12] possibly dated as early as 1854 (fig. 19). At the center is an enthroned female personification, perhaps France, and evidently not Napoleon Bonaparte. Yet she is flanked by two standing figures that suggest *History* and the *Fine Arts* on the final pediment—particularly since the left-hand figure seems to hold a kithara, as does Barye's *Fine Arts*, although the drawing is too unclear to allow an absolute identification. Possibly Barye's putti are implied in the two smaller figures seated at either side of the dais, and a low relief of attributes is visible in each corner of the tympanum, as well. Beyond the obvious differences of iconography, the great change in style from the Lefuel to the Barye is a dramatic one. Barye's pedimental figures do not burst upward, breaking through the lines of the raking cornice, as in Lefuel's lively, Neo-Baroque conception. Rather, the change is toward an ultraclassical compactness and understatement, in Barye's form. By

comparison, his figures are so recessive within the sheltered space beneath the cornice as to suggest the quality of an ancient cameo. No doubt Barye felt this restrained style to be more appropriate to the new and more somber iconography of the pediment.

As one views the finished pediment for a sustained period of time, its novel design evokes a distinctly somber, tomblike or shrinelike mood. Not only does the focal portrait bust of the laurel-crowned Napoleon I suggest ancient Roman funerary effigies, but the proportions Barye has given to the projecting segment of the straight entablature—beneath the central group of bust, eagle, personifications, and putti—are very like those of a sarcophagus. Furthermore, the back-to-back relation of the seated figures, apparently resting atop a sarcophagus, together with their framing of a central effigy, recall the unforgettable *Times of Day* on the Medici Tombs of Michelangelo (Florence, San Lorenzo), works well known to Barye.[13] The peculiar, sarcophagus-like element of the projecting entablature is given a very pronounced outline in one of Barye's preparatory drawings (fig. 16), where that shape is related directly to the central figures of the pediment.

Several formal resemblances suggest that Barye modeled his pediment after J. A. D. Ingres's famous painting, the *Apotheosis of Homer*, 1827 (Louvre), a *grande machine* originally conceived as a ceiling decoration for a room in the Louvre Palace.[14] This painting would be doubly significant as a source, first as the work of the giant of academic-classical art, and second, as a painting intended specifically to embellish the palace of the Louvre—quite apart from their parallel themes. Most striking is the relation to Ingres's two seated female personification figures flanking a cubic cippus on the central axis of the painting, their backs to each other; Barye clearly replaced Ingres's enthroned figure of Homer with his own classicizing bust of Napoleon I at colossal scale. Ingres's right-hand personification appealed to Barye, for he retained her pose of ponderation with only slight modifications in his figure of *History*, simply reversing the leg arrangement. In Barye's figure of the *Fine Arts* we see the identical leg placement to that of Ingres's right-hand personification, and she holds the very type of Greek kithara that is proffered to Ingres's *Homer*. Barye retains for his stone pediment Ingres's relation of the strict profile treatment of the shoulders on the right personification and the more frontal, three-quarters view of the shoulders of the left figure. He also merges Ingres's gabled temple-pediment in the background with the foreground figures, to create the single realm of his apotheosis pediment. Even the eagle of Zeus or Napoleon, complete with extended wings, conveniently appears in Ingres's painted pediment; Barye brings the eagle to the front of the major plane of the cippus and personifications. The symmetry of Barye's eagle, at the center and front of his design, is classically more satisfying than the awkwardly placed, asymmetrical sword and tiller of the Ingres figures. Barye offers a correction, an improvement of his source. The act of crowning with laurel, shown in progress by Ingres, has been completed in Barye's pediment—though several of the sculptor's drawings do show this action, as we shall see, rather than the accomplished fact.

Barye's two personifications, as variations upon the traditional Venus and Cupid type, bear a striking formal resemblance to an emblem figure in the French translation of Cesare Ripa's *Iconologia*,[15] a standard handbook since late Renaissance times, surely consulted by Barye: the medallion illustrating *Charmes d'amour* (fig. 20). There, a seated Venus, her knees drawn up, plays a harp which rests in her lap, while Cupid stands at her feet holding before her the bust of a deity labeled

"IOCUS." The bust held aloft by Cupid suggests Barye's bust of Napoleon; both busts are placed on the central axis of the design. The Venus and Cupid type appears at least eight more times in the French translation of Ripa, though Venus is usually a standing figure.

Motifs from Ripa are also implemented by Barye for *History*: she writes in a great book for posterity, and "une pierre carrée" is near her left foot—the squared stone that Barye assimilates to his cubic cippus. Yet it is characteristic of our sculptor that he is highly selective in his borrowing, often using only certain details rather than entire compositions. For example, he omits several key aspects of Ripa's personification of *History*: the large wings; the glance behind her toward "posterité"; and the winged figure of Saturn supporting her book on his back, a sign that she is triumphant over Time.

Other motif details are found elsewhere in Ripa: the motifs of the exposed left breast of *Fine Arts* and her cornucopia appear in the medallion *Paix* (I, 138). The star in the crown of Napoleon appears in the medallion *Le Matin* (II, 176), where its meaning is not apotheosis but "la clarté que l'Aurore nous donne," as the morning star. A winged genius places a crown of laurel on the head of an enthroned personification figure, the very action shown in several of Barye's early drawings for the pediment, in the Ripa medallion, *Rome Victorieuse* (II, 142).

Still another source for these personification figures, probably known to both Ingres and Barye, is Falconet's female figure of *Winter*, a work the sculptor regarded as one of his finest.[16] The marble figure is in Leningrad, where Falconet completed it, and the terracotta model won praise in the Salon of 1765. Possibly our artists knew the Hellenistic type of the *Fortune of Antioch* (Rome, Vatican Museum), the ancient source for Falconet, whose elegant image of *Winter* is similar in classical mood, facial type, and hair stylization. The motif of the drapery pulled taut about the left arm of *Winter* appears on the right arm of Ingres's right-hand figure, who thereby created a mirror image of his source, a quotational procedure frequently used by Barye, as well.

The ancient apotheosis motif, a portrait bust symbolically carried into heaven on the back of an eagle with opened wings, was known to Barye in two engravings by Pietro Santi Bartoli. The motif appears as the relief decoration of an ancient oil lamp in Bartoli's anthology, *Le antiche lucerne*, Rome, 1729.[17] The name Bartoli is inscribed on a Barye drawing,[18] certain evidence of his awareness of these engravings. More famous still was the so-called *Apotheosis Portrait of Claudius* (Rome, Capitoline Museum), illustrated in Bartoli's *Admiranda romanorum antiquitatum*, Rome, 1693.[19] Barye actually drew this apotheosis portrait (fig. 5), but, as we know from his inscription on the sheet, he based this drawing on a different anthology of engravings, Lorenzo Roccheggiani's *Raccolta di cento tavole*, Rome, 1804. Both antiquities similarly juxtapose the portrait bust and eagle images, and exemplify the iconographical tradition underlying Barye's pedimental imagery.

Another specifically funerary motif considered by Barye occurs in such drawings as his *Two Female Figures Supporting a Medallion* (fig. 14). The medallion portrait form, widely seen in ancient sarcophagus reliefs, Barye studied as one alternative to the final, three-dimensional portrait bust, central in his apotheosis relief, as will be discussed later.

The term cippus used in the official letter of contract has two principal meanings, a funerary stele and an altar table, in addition to other ancient usages as a boundary maker for funerary and temple precincts and as a roadside milestone. Erwin Pa-

5. *Barye*. Apotheosis Portrait, after Roccheggiani *(detail)*. *Walters Art Gallery, 37.121B, Baltimore*

6. *Barye*. Enthroned Apollo-Napoleon. *Pencil, c. 8 × 16″. Walters Art Gallery, 37.2207, Baltimore*

nofsky, in his *Tomb Sculpture*, discusses a Roman cippus figured with elaborate commemorative and apotheosis imagery, commissioned by one T. Flavius Abascantus:

> The upper part of the composition . . . describes his blissful state in the hereafter and his ultimate ascension to the realm of the gods. And in its modest way, this little monument to a Roman dignitary may be said to embody the same ideas which, as Karl Lehmann has shown, underlie the Arch of Titus.[20]

An article by Leclercq in the standard *Dictionnaire d'archéologie chrétienne*[21] discusses funerary cippuses as a distinct category, and illustrates an ancient example rather like that which supports Barye's bust of Napoleon, in its cubic, altar-like aspect. In fact, altar cippuses comprise another distinct category discussed by Leclercq.[22] Hence the special, ritual mood of Barye's pediment is not without several concrete points of origin.

While the final form of Barye's pedimental relief focuses upon a portrait bust placed atop a cippus and flanked by personification figures with attributes, the evidence of the sculptor's drawings shows that he considered at least four alternative compositional formats: 1) Napoleon as an enthroned Apollo; 2) Napoleon as a standing Mars; 3) a medallion portrait of Napoleon; and 4) the final portrait bust on a cippus. Once the latter image was defined, the attendant figures of the personifications underwent considerable transformations—as winged Victories, ideal nudes, or draped females. Their gestures and actions were varied—from actively placing a wreath on the bust of Napoleon or placing one at the base of the cippus, and they were also conceived as more passive, ornamental figures, simply framing the central image of the emperor. Only three of the drawings show, or imply, the Palladian architectural motif of a wide pedimental triangle containing a narrower one (figs. 15, 16, 17), which Barye used to govern his final design. Fragments of compositions appear in the margins of the larger drawings and suggest that many more studies than the few now known were actually created for the project. As a result of the lacunae, the precise sequence of the drawings remains elusive, but this is perhaps not so important as their reflection of Barye's process of image-refinement and formulation.

## NAPOLEON ENTHRONED

Barye's pencil drawing of an *Enthroned Apollo-Napoleon* (fig. 6) offers an unusual characterization of the emperor, with attributes of an aureole and lyre, as the god of light and the inspirer of the arts. A strict symmetry is evident, not only in the central enthroned figure, but also in the bilateral groups of three figures each, like mirror images at either side of the throne. In both triads the heads of two seated figures are tangent to the raking cornice, and the third head is on the level of the knees of the seated Apollo-Napoleon. This placement allows a sweeping movement across the breadth of the pediment, which nicely unifies the design. Two small triangles, roughly similar to the larger triangle of the pediment, are created in the arrangement of the heads of the two side groups, internal reflections of the external limits of the composition and conceived in a strictly classical spirit. The clarity of Barye's emphasis upon these groups of heads in the space just below the raking cornice, contains the germ of that tenebrist or Caravaggesque effect in the final pediment, where such heads gleam out of the shadow as though caught in spotlights.

In contrast with the geometrical severity of the triangular motifs and the cubic

throne are the rolling, undulant contours of the hips, backs, and legs of the acces-
sory figures across the lower half of the pediment. The force of their fluid, swirling
movement calls up the painting of Rubens and that "secret survival of the rococo"[23]
apparent in some drawings by Géricault, two artists admired and studied by Barye.
Perhaps these elements of movement were intended to echo something of the
Neo-Baroque lushness of Lefuel's façade.

The classical severity of the enthroned Apollo-Napoleon recalls the much-
emulated, enthroned Zeus of the West Pediment of the Parthenon. Barye knew the
illustrated French translation of Stuart and Revett's *Antiquities of Athens*,[24] and
having been trained as a goldsmith, he also knew well the work of Martin Guil-
laume Biennais (1764–1843), goldsmith to Napoleon. Biennais's miniature frieze
of a *Napoleonic Pantheon*[25] is based upon the West Pediment of the Parthenon,
but the Emperor replaces Zeus. A sequence of paintings by J. A. D. Ingres also re-
flects this ancient source, all works surely known to Barye, such as the *Enthroned
Emperor Napoleon*, 1806 (Paris, Musée de l'Armée), *Jupiter and Thetis*, 1811
(Aix-en-Provence, Musée Granet), and the *Apotheosis of Homer* discussed above.
Famous Renaissance works are also implicit in Barye's training and his conception,
such as Raphael's group of Apollo and the Muses in his *Parnassus* fresco, about
1510 (Rome, Vatican Stanze), with its central enthroned Apollo flanked by seated
female figures. While Raphael's Apollo is varied in Barye's drawing, Raphael's
twin seated muses are echoed in Barye's stone pediment.

Another type of seated or enthroned figure that Barye considered derives from
Hellenistic groups of embracing figures, and is related to the more recent imagery
of the enthroned Bacchus and Ariadne, as though embracing while seated in a
triumphal car, created as a soup tureen finial[26] by the goldsmith Jean-Charles
Cahier (1809–19), an assistant of Biennais's. One of Barye's versions of this format
is calm in mood, the *Seated Embracing Figures*, (fig. 7), in which both figures look
toward their right as they embrace. This study might have provided a foreground
or background motif, and possibly this obviously male and female couple might
have become figures of *History* and the *Fine Arts*. Another version of this image is
the pointedly erotic kissing pair in the *Seated Embracing Figures* (Louvre, RF

7. *Barye*. Seated Embrac-
ing Figures. *Pencil, c.5 ×
8″. Walters Art Gallery,
37.2258B, Baltimore*

8

8. *Barye*. Seated Figures
Rejoicing *(below)*. *Pencil,
page c.5 × 9″. Louvre, RF
6073, p. 21, Paris*

9. *Barye*. Seated and Stand-
ing Napoleon Crowned
*(detail)*. *Pencil, page c.5 ×
12″. Louvre, RF 4661, fol.
3, Paris*

9

6073, page 20; page size c. 5 × 9″), where the man and woman are seated almost
back-to-back and must turn vigorously toward each other to manage their embrace.
The erotic tone of this image seems so far from the funereal one of the pediment as
to constitute for Barye an irrelevant sidestep from the commission, a concept
solely of interest as an imaginative offshoot.

More appropriate in their tone of simple jubilation are the four groups of *Seated
Figures Rejoicing* (fig. 8), their arms waving in joy at the apotheosis of Napoleon.

Again, this design might have served as a background or foreground motif to accompany the focal image of the emperor.

A related album page shows a *Seated Napoleon Crowned* (fig. 9), the winged Victory kneeling rather strangely behind the throne of the seated Napoleon. This page holds two other images of significance. One is the ruled outline of the left half of a pediment which certainly links these drawings with the development of the pedimental imagery. The other is a figure of the *Standing Napoleon Crowned*, with the Victory standing directly behind Napoleon and peering out from behind his right side. The latter image affords a transition to the next class of design explored by Barye.

### NAPOLEON AS A STANDING FIGURE

Two studies of a standing nude male take on the significant guise of a *Napoleon as Mars* (fig. 10). The attributes of plumed helmet, flowing cape, lance, and shield convey clearly the idea of Mars, the mythological counterpart of General Napoleon. Both studies also explore different modes of the act of coronation. The left one shows a Victory flying in from the upper left, her arms outstretched to place the crown on the head of Napoleon, who looks upward to receive it. The right one shows a kneeling personification figure, largely hidden behind the shield that Mars rests on the earth at his side. The Victory kneels as a humble supplicant, and reaches upward to place the crown on the head of Mars. A positive link of this album page with the evolving conception of the pediment, is the fully recumbent figure at the right, perfectly composed to fill the corner of the pedimental triangle.

A *Standing Mars* appears on another album page (fig. 11), framed in a circular field like a medallion; the circle is a suitably perfect geometrical complement to the pedimental triangle, which might be inscribed at its center. Mars brandishes a sword in his raised right hand, while holding two lances and a round shield in his left hand at the level of his waist. The operatic tone of this figure and its conventional stance strongly suggest the histrionic bombast of the heroes in the art of Henry Fuseli, and certain figures in the art of John Flaxman.

The ancient source of another drawing, not of Mars but of Apollo, Barye's

*10. Barye.* Napoleon as Mars *(detail). Pencil, page c.5 × 12″.*
*Louvre, RF 4661, fol. 2v, Paris*

11

12

13

11. *Barye.* Standing Mars *(detail).*
*Pencil, page c.5 × 8″. Louvre, RF*
*6073, p. 75, Paris*

12. *Barye.* Apollo Crowned by a
Winged Victory. *Pencil, page c.5*
*× 9″. Louvre, RF 7073, p. 18,*
*Paris*

13. Apollo Crowned. *Greek*
*vase in Hamilton Collection (after*
*d'Hancarville)*

*Apollo Crowned by a Winged Victory* (fig. 12), can be precisely identified by means of the inscription "Hamilton" at the top of the page. This elegant image is taken from an illustrated anthology of the antiquities in the collection of the Honorable William Hamilton, British Envoy to the Court of Naples, published in 1767 and 1785 (fig. 13).[27] Barye's drawings of the classical figures in the ancient red-figure vase painting are even taller and more slender than those of his source, and he introduces a choppy, more angular kind of contour, quite unlike the smooth flow of the original. The appropriateness of the act of coronation to the literal, contractually specified theme of the pediment is self-evident. Even the stylized feather-pattern of the Victory's wings has an impact upon Barye's pedimental eagle. Two recumbent Renaissance Venus types on the lower register of the page may well have served as preliminary to Barye's seated personification of the *Fine Arts* (fig. 3), whose bosom is sensuously emphasized and who faces in the same direction; *History*, her counterpart, is heavily cloaked and modest.

## THE MEDALLION-PORTRAIT OF NAPOLEON

A medallion form was considered as a preliminary alternative to the final, three-dimensional bust of Napoleon, as three drawings reveal. This choice of type would surely emphasize the theme of the apotheosis of Napoleon, yet with a quality no doubt too completely tomblike for a palace façade pediment. In addition to the many ancient precedents in the form of sarcophagus reliefs, Barye would have known such modern examples as Gianlorenzo Bernini's medallions for the Chigi Chapel tombs (Rome, Santa Maria del Popolo), Antonio Canova's relief medallion for the Tomb of the Archduchess Maria Christina (Vienna, Franziskanerkirche), and Giambattista Tiepolo's fresco medallion of the *Apotheosis of the Prince-Bishop* (Würzburg, Residenz).

Barye's drawing of *Two Seated Nudes Framing a Medallion* (fig. 14) arranges the figures in a way that rather freely implies the triangular field of the pediment, but does not strain to confine the figures within it. A loose formal contrast of semi-recumbent and seated postures for the personifications is explored, as is a contrast

*14. Barye.* Two Seated Nudes Framing a Medallion. *Pencil, c.6 × 12".*
*Walters Art Gallery, 37.2261, Baltimore*

of open and closed arrangements of the limbs. One notes the stress upon the figures, conceived as sensuous lyric nudes with vigorously swinging contours and a rather Mannerist canon of proportion, much in the spirit of the nudes of Ingres. The ancient Greek, or Napoleonic Empire period, hair style is seen again in Barye's drawing, *Napoleonic Pediment with Two Victories* (fig. 17). A certain inner rhythm of contour and an essentially planar or two-dimensional quality of energetic expansiveness in this pencil study are shared with the *Enthroned Apollo-Napoleon* drawing (fig. 6), which suggests a similar moment for both in the developing concept of the pediment.

A second study, *Two Recumbent Figures Framing a Medallion* (Louvre, RF 8480, fol. 29v, c.4 × 5 ³/₄″), too faint to reproduce, appears to contrast not the closed and open limbs as in the previous drawing, but rather a front and back view of the left and right figures, respectively. The two nudes rest upon scroll-volutes, the large ends of which create a raised base for the medallion. The rather tightly arched arabesque contours of the whole drawing are closely unified with the circular form of the medallion. Against these motifs is played the rectangular form of the sarcophagus-like element beneath the nudes, which corresponds to the projecting segment of the entablature and cornice on the final pediment. The feeling of the drawing is distinctly that of an ornate sarcophagus lid.

A third drawing for a *Medallion Pediment* (Louvre, RF 8480, fol. 24v, c.4 × 5 ³/₄″), also faint, is abbreviated to show only the right half of an evidently symmetrical design. A recumbent female nude appears to swoon against the frame of the medallion, her figure in a plane just behind it as though she were presenting it to the viewer, while she mourns the passing of the emperor. At the top of the medallion is a ram's head, which suggests the ancient funereal motif of *bucrania*, varied as ram's heads, specifically, on Michelangelo's Sistine Ceiling. Along the top side of the triangle, or what would be the line of the raking cornice, a sequence of five circular shapes suggests that a third spatial plane was intended, perhaps, for the heads of five mourning figures or celebrants visible behind the recumbent female. Molding profiles, possibly considered for the platform of the cippus or for cornices of the pediment, are shown at the left of the page.

## THE PORTRAIT BUST OF NAPOLEON

Barye's tiny drawing of the left half of the *Napoleonic Pediment* (fig. 15), hardly more than one inch in width, may record an early stage in the final sequence of studies for the pediment since it pointedly isolates the several elements called for in the official title—the portrait bust, the action of coronation by a flying Victory, the semirecumbent, framing personification figure, and the *cartouche* of attributes at the corner of the tympanum. The distinctness of the separate elements is quite unlike the generally unifying, synthesizing emphases in most of the other compositional drawings. An interesting aspect of this tiny composition is the adaptation of the light-value shape of the dais and steps in Ingres's *Apotheosis of Homer* for the dais and cippus of the pediment.

Barye's concern with a rhythmical animation of the space just beneath the projecting ledge of the raking cornice appears in the vigorous ribbon-like undulations of the body of the flying Victory that crowns Napoleon with laurel. The energy and rhythm of the Victory are carried into that same zone on the final pediment by the seated putto, the arms of the lyre, and the head of the figure of the *Fine Arts*.

15

16

17

15. *Barye*. Napoleonic Pediment *(detail). Pencil, c.1 × 2". Walters Art Gallery, 37.2344, Baltimore*

16. *Barye*. Napoleonic Pediment. *Conte crayon, 12 × 16". Walters Art Gallery, 37.2206, Baltimore*

17. *Barye*. Napoleonic Pediment with Two Victories. *Charcoal, 8 × 16". Walters Art Gallery, 37.2317, Baltimore*

Two major movements are developed in this drawing, the echoing of the larger
contours or angles of the flying Victory and those of the semirecumbent *Fine Arts*,
and a rhythmical repetition of spherical forms in the attribute group, the head of
the figure of the *Fine Arts*, and the two orbs of the head and shoulders of the
portrait bust of Napoleon. A third radiating motif occurs in the jutting periphery
of the attribute cluster, and on a larger scale in the axis across the knees of the
*Fine Arts*, in the line of her head and left arm, and in the vertical line of the portrait
bust of Napoleon. The latter lines converge in a geometric center, just below the
base line of the pediment, on its central axis.

Another *Napoleonic Pediment* drawing, in conte crayon and in the larger scale
mentioned earlier (fig. 16), shows a symmetrical pair of seated personification
figures, with their backs almost directly against the portrait bust on the central axis
(this study has been mentioned above in connection with the large sarcophagus
motif). The figures fill the pedimental field, as on the final design in stone. Erasures
in the form of a diamond shape are circumscribed about the central bust, and
indicate that Barye experimented with the seated figures so as to show them twisted
about and simultaneously crowning the bust with laurel wreaths held in their
further hands, while placing their lower hands together in front of the cippus. An
excessive and rather Mannerist twisting of the two figures probably resulted, lend-
ing a more forced and artificial tone to the composition than would satisfy Barye's
apparent desire for a classical mood of understatement, harmony, and restraint, the
mood he achieved in the final form. Thus, the personification figures are translated
from the realm of action into that of symbolic presence.

Suggestions of the curved tops of folded wings appear behind the shoulders of
both personifications, and the curves of a lyre are seen on the lap of the *Fine Arts*.
Wings are a proper attribute of a figure of *History*, but not of the *Fine Arts*, ac-
cording to the iconographical tradition recorded in the French version of Ripa's
*Iconologia*.[28] Napoleon's portrait bust is treated at the same scale as the heads of
the framing personifications, but its cippus is much lower than that in the tiny
drawing just discussed (fig. 15). To fill the gap, the shoulders and torso of this bust
are correspondingly lengthened. Thus the bust and cippus continue to fill the cen-
tral vertical zone of the design, and the single step of the cippus is extended laterally
to provide a platform for the seated personifications. This group will fill the field
in the ultimate design.

In the lowest of the three registers of the drawing is the delightfully bold and
fluid outline of a recumbent winged Victory, lying upon her right hip and resting
on her elbows, her chin in her hands. Her horizontal figure is placed whimsically,
like an arabesque, in the acute angle of the extreme right corner of the tympanum.
One recalls that this area ought to display a group of attributes, as called for in
the letter of contract, and as they do appear in Barye's stone pediment.

Faint, badly rubbed, and isolated images of two accessory figures are seen in the
central register of the drawing, two further variations of *History* and the *Fine Arts*.
At the left a semirecumbent female figure, arranged as though resting on a stair,
extends a hand as if to place a crown on Napoleon's head. The right figure is in a
slightly larger scale, a heavier, perhaps masculine type. It is hunched forward
somewhat, its back to the viewer, posed in a way distinctly reminiscent of Mi-
chelangelo's *ignudi* on the Sistine Ceiling.

Another large drawing in charcoal, the *Napoleonic Pediment with Two Victories*
(fig. 17), shows two Victories crowning the bust of Napoleon in a nearly perfect
mirror-image design. Barye apparently merges the figures of the Victories with

**18**

**19**

18. *Barye*. Napoleon I Crowned by History and the Fine Arts. *Charcoal, 8 ×
16". Walters Art Gallery, 37.2205, Baltimore*

19. *Hector-Martin Lefuel. Project for
Sully Pavilion Façade. c.1854. Ink wash
on tracing paper. Louvre, Paris*

20. Charmes d'amour. *Woodcut from
Ripa,* Iconologie, *Paris, 1644*

CHARMES·D'AMOVR.

**20**

those of his personifications, or substitutes one for the other. His casual attitude 625
toward the identity of these framing figures is documented some nine years later in *Barye's*
*Apotheosis*
*Pediment*

those of his personifications, or substitutes one for the other. His casual attitude
toward the identity of these framing figures is documented some nine years later in
his letter of application for membership in the prestigious Institut de France, dated
July 14, 1866, where he refers to these personifications as the *Sciences* (sic) and the
*Arts!*[29]

The large, rich shapes of the opened wings of the Victories quite fill the pedi-
mental triangle in a way reminiscent of the splendid wings of the defeated Giants
on the great baroque frieze of the Hellenistic *Altar of Zeus* at Pergamum (East
Berlin). An echo of the dramatic shapes and rhythmical enrichment of these opened
wings survives in the Napoleonic eagle of Barye's finished pediment.

Napoleon's bust is now at a slightly larger scale than that of the heads of the
Victories, a change in the direction of the boldly hieratic difference of the final
design. The bust is placed atop a tall, slender, tapering base like that of an antique
or Renaissance herm. A swinging rhythm and counter-rhythm fill the great con-
tours and gestures of this design, easily the most powerful of the entire group of
drawings.

## NAPOLEON CROWNED BY HISTORY AND THE FINE ARTS

A large drawing in charcoal (fig. 18) must be one of the very latest of the group in
the light of its many similarities to the realized pediment. The bust of Napoleon is
now of hieratically large size relative to the personifications, though it will be even
larger in the pediment. A cubic, altar-table type of cippus is clearly defined. Both
personifications, however, still literally place their crowns, still actively perform
this ritual.

*Fine Arts* places one at the base of the cippus, while *History* crowns the bust.
The lines of their arms preserve two parallel sides of the diamond motif seen in
figure 16. The legs of *History* are placed as they finally appear, though there is
some ambiguity in the drawing as to the size and position of her head. Do we not
see a second, smaller figure of a Victory standing behind the shoulders of *History*,
placing a crown on the bust of Napoleon? The relationship of Barye's standing
Victory and the seated figure of *History* strongly suggests Michelangelo's Prophets
and Sibyls of the Sistine Ceiling, with their pairs of smaller attendant figures
hovering near them like the ancient types of the inspiring geniuses. Michelangelo's
figures not only stand in a similar relation to a principal personage, but by their
smaller scale they serve to heighten the monumentality of the Prophets and Sibyls,
a function not unlike that of the Barye figures.

The putto on the left of Barye's drawing, marked by a flowing Michelangelesque
contrapposto, is placed at the feet of the seated personification, almost as in the
finished pediment—a relationship with a distinctly Venetian overtone. It suggests
the Cupid once visible at the feet of Giorgione's *Sleeping Venus* (Dresden, Ge-
mäldegalerie), before nineteenth-century restorations removed it,[30] and it recalls
Titian's later variant, accompanying the drunken bacchante in his *Bacchanal of
the Andrians* (Madrid, Prado), where the standing putto provides comic relief as it
urinates on the leg of Titian's enormously compelling, insensate bacchante. Unlike
Barye's pediment, however, the personifications of the drawing are seen in a three-
quarters view, which creates a deeper spatial ambient than Barye finally desired,
for his stone figures are kept in a plane rigorously parallel with the major plane of
the façade itself.

The step beneath the cippus has disappeared. The personifications and their

putti rest on a base line of the tympanum. A nearly cubic configuration marks the cippus, very like that of the pediment, a form further enhanced by the removal of its upper cornice, for the stone version. The shoulder mass of the bust is even less bulky in the final form, reduced to a mere rim or lip about the base of the neck, a touch perhaps reminiscent of that romantically fascinating colossal fragment from Roman antiquity, the marble *Head of Constantine the Great*, some eight feet high (Rome, Capitoline Museum), as well as of many counterparts in Roman portrait sculpture at the conventional scale.

Thus we have seen Barye explore transformations of his concept of the apotheosis pediment involving seated and standing figures of Napoleon, shown in the guises of Apollo and Mars, respectively. A medallion format was considered as the frame for a standing Mars-Napoleon, and for bust portraits of Napoleon as well, prior to the final choice of a three-dimensional bust at a colossal scale. The cippus Barye varied, as a tall half-column and as a tapered herm, before selecting the ultimate blocky, altarlike form. The personification figures took on the dramatic forms of winged Victories, those of lyric nudes after Renaissance types, and assimilated the influences of Falconet and Ingres in reaching their final, classical aspect. In all, Barye has well achieved the grave and elegantly ritual mood appropriate to an apotheosis of Emperor Napoleon Bonaparte in this, his only surviving pediment for the New Louvre.

*Temple University*

*Notes*

I wish to thank Professor H. W. Janson for his encouraging support of my work with Barye. I should like to thank the Walters Art Gallery for allowing me access to their splendid Barye collection, and for the use of their photographs. I am indebted to Temple University for two grants-in-aid for the study of the Barye material in Paris. I am most grateful to M. F. Dousset, Inspecteur Général des Archives, Adjoint au Directeur Général, of the Archives Nationales de France. For their generous assistance, I wish to thank M. Jean-René Gaborit, Conservateur en Chef, département des sculptures, Musée du Louvre; M. Maurice Serullaz, Conservateur en Chef, and Mesdames Serullaz and Lise Duclaux, Conservateurs au Cabinet des Dessins, Musée du Louvre; M. G. LeRider, Conservateur en Chef, and Mesdames de Roquefeuil and Aghion, of the Cabinet des Médailles, Bibliothèque Nationale; the staff of the Bibliothèque du Conservation, Musée du Louvre; and, Mlle. M.C. Regnault, Conservateur des Dessins, Musée du Petit Palais.

[1] The initial letter of contract is in Archives Nationales F[21] 1749, and is dated March 2, 1857. Barye received his final payment for the completed stone pediment on June 11, 1857, according to the receipt in AN F[21] 1750. The basic sources for the history of the Louvre are: Christiane Aulanier, *Histoire du Palais et du Musée du Louvre, Le Nouveau Louvre de Napoléon III*, Paris, 1946, IV; and Louis Hautecoeur, *Histoire du Louvre, Le Château, Le Palais, Le Musée: des origines à nos jours*, 1200–1928, Paris, n.d.

[2] This title is indicated in the letter of contract in AN F[21] 1749. An erroneous title was introduced in the catalogue for the posthumous sale of Barye's studio effects, *Catalogue des Oeuvres de feu Barye*, Hôtel Drouot, Paris, février 1876, 34 (AN F[21] 194), where the presentation model of the pediment was termed "Napoléon dominant l'Histoire et les Arts, exécuté en pierre, cour du Louvre. Demi-grandeur d'exécution. Fronton

plâtre." This wrong title was repeated by Stanislas Lami in his otherwise carefully documented article, "Barye," in *Dictionnaire des sculpteurs de l'école française, au dix-neuvième siècle*, Paris, 1914, I, 69–85, esp. 78.

³ See the primary text: Napoleon III, Emperor of the French, *Napoleonic Ideas (Des idées napoléoniennes, July 1839)*, ed. Brison D. Gooch, New York, Evanston, London, 1967. Gooch characterizes this essay as "second only to the declarations of Napoleon at St. Helena as basic ideology for the Legend," in *Napoleonic Ideas*, 7. See also: David Pinckney, *Napoleon III and the Rebuilding of Paris*, Princeton, 1958; Roger Williams, *Gaslight and Shadow: The World of Napoleon III, 1851–1870*, New York, 1957; Albert L. Guérard, *Reflections on the Napoleonic Legend*, London, 1924; *idem, Napoleon III*, Cambridge, Mass., 1943; Peter Geyl, *Napoleon: For and Against*, New Haven, 1949.

⁴ One recalls a precedent for this use of symbolical axiality in French architecture in the location of the bedchamber of Louis XIV, the setting for his elaborate "informal" audiences, directly on the main axis of the palace of Versailles. Rooms adjoining the bedchamber were named for the planets, completing the celestial metaphor. The axial location of these ceremonies symbolized the fact that the *Roi-soleil* held court at the center of his universe. See Anthony Blunt, *François Mansart*, London, 1941, and Blunt, *Art and Architecture in France, 1500–1700*, Baltimore, 1953, and bibliographies in both.

⁵ A commission of December 30, 1861 (AN F²¹ 1749), it was destroyed on September 4, 1870, according to Lami, in "Barye," 78, and was replaced with the relief by Antonin Mercier, the *Genius of the Arts*, still intact today. Though the bronze relief is destroyed, Barye's drawing after a model for it is extant (Walters Art Gallery, 37.2221, pencil on tracing paper, c. 8 3/4 × 8 5/8″), illustrated in Glenn F. Benge, "The Sculpture of Antoine-Louis Barye in the American Collections, with a *Catalogue Raisonné*," unpublished dissertation, University of Iowa, Iowa City, 1969, 767, fig. 381, Xerox by University Microfilms, Ann Arbor, Michigan. See also the illustration of Lefuel's drawing of the entire South Elevation of this façade in *The Second Empire, 1852–1870. Art in France under Napoleon III* (exhibition catalogue), Philadelphia Museum of Art, 1978, 60, ill. I–20.

⁶ The project is best described in Aulanier, *Histoire du Palais*.

⁷ Baltimore, Walters Art Gallery, 27.521, height 15 3/8″, plaster and wax, inscribed, "Vu et approuvé. Visconti"; illustrated in Benge, *Diss.*, 676, figs. 145, 146.

⁸ Barye's presentation models in plaster, height 1 meter, are illustrated in Benge, *Diss.*, 711, 712, figs. 215–17, and in Stuart Pivar, *The Barye Bronzes*, Woodbridge, Suffolk, 1974, 86, 87. (Pivar gives a reference on p. 49 to my dissertation with an incorrect place of publication, an error typical of this hastily assembled, vanity-press volume. The principal interest of this unscholarly book, in fact, is as an album of fine museum photographs of the sculptures. See my references to problems in Pivar's book in "A Barye Bronze, and Three Related Terra Cottas," *Bulletin of the Detroit Institute of Arts*, LVI (1978), 241, notes 12, 21.) Barye's presentation model of *War* is illustrated in *Barye: Sculptures, Peintures et Aquarelles des collections publiques françaises* (exhibition catalogue), Musée du Louvre, Paris, 1956, pl. VI. See also Douglas Lewis, "The St. Petersburg Bronzes of Barye's *War* and *Peace*," *Pharos' 77* (Museum of Fine Arts, St. Petersburg, Fla.), XIV (May 1977), 2–11, illus. and notes; and Anne Pingeot, "War," in *The Second Empire*, 1978, 210–11, and fig. V–3.

⁹ For a discussion of the critical response to Barye's sculpture, see Gérard Hubert, "Barye et la critique de son temps," *Revue des Arts*, VI, 1956, 223–30; Benge, *Diss.*, 24–42, notes and bibliog.; Benge, "Lion Crushing a Serpent," in *Sculpture of a City: Philadelphia's Treasures in Bronze and Stone*, New York, 1974, 30–35, and notes; Benge, "Antoine-Louis Barye (1796–1875)," in *Metamorphoses*

*in Nineteenth Century Sculpture* (exhibition catalogue), Fogg Art Museum, Cambridge, Mass., 1975, 76–107, figs. and bibliog.; Charles Saunier, *Barye*, Paris, 1925, *passim*. At the Universal Exhibition of 1855 Barye received a grand gold medal for a group of his small bronzes, and later in 1855, he was awarded the Officer's Cross of the Légion d'honneur, no doubt for other accomplishments than his small sculpture, such as his recent appointment as Master of Drawing at the Museum of Natural History (October 14, 1854: AN F[17] 2231), and the excellence of his monumental sculptures for the Cour du Carrousel of the New Louvre; Lami, "Barye," 71–73.

[10] AN F[21] 1749:

March 2, 1857. Paris. Ministère d'État, Direction des travaux, Statuaire. Réunion des Tuileries au Louvre. Soumission Barye.

Le soussigné Barye Sculpteur statuaire, demeurant à Paris, rue de la Montagne Ste-Geneviève No. 37. Après avoir pris connaissance du projet de décoration du Fronton du pavillon du Vieux Louvre, côté de la place Napoléon, représentant au milieu le buste de Napoléon premier posé sur un cype entouré et couronné par les deux figures allégoriques de l'histoire et des beaux-arts, les extremités des Tympan sont occupées par les attributs de chacun de ces figures.

M'engage envers Son Excellence Le Ministre d'État,

1. A faire au tiers de la grandeur d'exécution le modèle du fronton selon les indications qui me seront données en à le soumettre à l'acceptation de l'Administration.

2. A exécuter le dit fronton en pierre avec toute la perfection désirable en à l'avoir terminé le trente avril prochain, moyennant la somme fixe en à forfait de trente mille francs.

La pierre me sera livrée brute et sans épannelage. Les frais de modèle seront à ma charge, mais les échafauds en clôtures necessaires a l'exécution du fronton en pierre qui sera faite sur le chantier seront effectués par l'Administration.

Après l'exécution du modèle, il me sera payé une somme de dix mille francs en déduction de celle de trente mille francs stipulée ci dessus.

(in the margin:)
et pendant l'exécution du fronton en pierre une deuxieme somme de dix mille francs me sera délivrée lorsque l'Architecte jugera le travail avancé à moitié ces deux sommes viendroit.

(main text:)
Dan le cas ou le fronton ne serait pas terminé à l'epoque ci-dessus indiquée, je consent à subir une retenue de cinquante francs par chaque jour de retard.

Si ce retard pour une cause quelconque se prolongerait au de là de trois mois, l'Administration à laquelle mon modèle appartiendra en échange de dix mille francs qu'elle m'aura payér, sera libre d'en confier l'exécution à un autre artiste, sans que je puisse réclamer aucune indemnité pour la portion de travail exécutée sur la pierre.

Le fronton terminé sera soumis à l'examen de l'Administration qui, après réception definitive, me soldera le complément de la somme de trente mille francs ci-dessus relatée.

Vu par l'Architecte en Chef. Lefuel. (signed) Barye.

L'Inspecteur G[al] des Travaux. Signé: Guillaume.

Approuvé le 10 Mars 1857, le Ministre d'État. pour le Ministre et par aut . . . Le Secrétaire général. Signé: Alfred Blanche.

[11] The star is also visible in an old photograph of Barye's plaster model for the bust of Napoleon, illustrated in Pivar, *Barye*, 95. This same focal placement of a bust of Napoleon I was carried into the interior embellishment of the new Musée du Louvre, for a bust of Napoleon I was to be placed in a great apse in the vestibule of the Denon Pavilion. See the project drawings and illustrations in Aulanier, *Histoire du Palais*, IV, pls. 9–11, discussed on 29.

[12] The drawing is discussed by David Van Zanten in *The Second Empire*, 1978, 59–61, and illus. I–19.

13 Barye inscribed the name "michelange" on three pages of his album (Louvre, RF 6073), 11, 24, 29. Page 11 shows a study of *Giorno*, after the Medici Tomb sculpture. Barye's artistic sources were legion, and are well documented in his original drawings. A full treatment of this elaborate problem is offered in my forthcoming monograph on the sculpture and drawings of Barye.

14 Agnes Mongan notes its original location as a "ceiling decoration in the Charles X Museum at the Louvre," in her article "Ingres," *Encyclopedia of World Art*, VIII, col. 122. Ingres's two seated personification figures symbolize the *Iliad* with a sword (on the left), and the *Odyssey* with a tiller (on the right). For clarity of argument, I have named only the Barye personifications in this discussion.

15 Cesare Ripa, *Iconologie ou, Explication nouvelle de plusieurs images, et autres figures Hyeroglyphiques des Vertus, des Vices, des Arts, des Sciences, des Causes naturelles, des Humeurs differentes, & des Passions humaines. Oeuvre augmentée d'une seconde partie; necessaire a toute sorte d'esprits, et particulierement a ceux qui aspirent a estre, ou qui sont en effet Orateurs, Poetes, Sculpteurs, Peintres, Ingenieurs, Autheurs de Medailles, de Devises, de Ballets, & de Poëmes Dramatiques. Tirée des Recherches & des Figures de César Ripa, Moralisées par I. Baudoin. A Paris, Chez Mathieu Guillemot, ruë sainct Jaques, au coin de la ruë de la Parcheminerie. M.DC.XLIIII. Avec privelege du Roy,* repr. New York–London, II, 1976, 105.

16 Discussed and illustrated in George Levitine, *The Sculpture of Falconet*, Greenwich, Conn., 1972, 38, 39, and figs. 39–42.

17 Bartoli, *Le antiche Lucerne sepolchrali figurate*, Rome, 1729, Part II, pl. 4.

18 Barye inscribed the name "Bartoli" in his album (Louvre, RF 6073), p. 83. His drawing of the famous *Dancing Faun* from the Borghese Vase is in the same album, p. 85, and reflects the engraved illustration in Bartoli's *Admiranda romanorum*, 50.

19 Bartoli, *Admiranda romanorum antiquitatum ac veteris sculpturae vestigia anaglyphico opere elaborata ex marmoreis exemplaribus quae romae adhuc extant in Capitolio aedibus hortisque virorum principum ad antiquam elegantiam a Petro Sancti Bartolo,* Rome, 1693, 80. The apotheosis portrait also appears in Roccheggiani, *Raccolta di cento tavole rappresentanti i costumi religiosi civili e militari degli antichi egiziani, etruschi, greci et romani, tratti dagli antichi monumenti per uso de professori delle belle arti, disegnate ed incise in rame da Lorenzo Roccheggiani,* Rome, 1804, tav. C. Barye inscribed his drawing, "recueil de costume grec et romain . . . italiens," an abbreviated translation of the title of this anthology.

20 Erwin Panofsky, *Tomb Sculpture*, New York, 1964, 27 and n. 2, fig. 133.

21 Cabrol–Leclercq, *Dictionnaire d'archéologie chrétienne et de liturgie*, III, 2, "Cippes funéraires," cols. 1672–82 and ill. 2968, col. 1685.

22 *Ibid.*, "Autels-cippes," cols. 1682–91.

23 This phrase is coined by Lorenz Eitner in *Géricault. An Album of Drawings in the Art Institute of Chicago*, Chicago, 1960, 15. For documentation of Barye's close study of the art of Géricault, see Benge, "Barye's Uses of Some Géricault Drawings," *Journal of the Walters Art Gallery*, XXXI–XXXII, 1971, 13–27, notes and figures.

24 Barye inscribed the title "antiquités d'athens" on a drawing (Walters Art Gallery 37.2178A). The French edition known to Barye is *Les Antiquités d'-Athens, et autres monuments grecs, d'après les mesures de Stuart et Revett . . .,* Paris, 1835.

25 The *Napoleonic Pantheon* is illustrated in Benge, *Diss.*, 858, fig. 593, and in Bibliothèque de l'Union Centrale des Arts Décoratifs, *Recueil de Dessins d'Orfèvrerie du premier empire par Biennais orfèvre de Napoléon I$^{er}$ et de la couronne,* Paris, n.d., pl. 39.

26 Illustrated in Benge, *Diss.*, 858, fig. 592; in *Dessins . . . par Biennais*, pl. 47; and in *French Master Goldsmiths and Silversmiths from the Seventeenth to the Nineteenth Century*, preface by Jacques Helft, essays by Jean Babelon, Yves Bottineau, Olivier Lefuel, New York, 1966, 289.

[27] Barye inscribed the name "Hamilton" on two pages of his album (Louvre, RF 6073), 18, 30. The red-figure vase painting appears in *Antiquités étrusques, grecques et romaines, gravées par F. A. David, avec leurs explications par d'Hancarville . . .*, Paris, 1785–88, IV, pl. 16. I wish to thank Mme. Serullaz, of the Cabinet des Dessins, Musée du Louvre, for the d'Hancarville reference.

[28] The French translation of Ripa, (see above, n. 15) says of *History*, "Sa figure ressemble à peu prés à celle d'une Ange, à cause des grandes aisles qui sont attachées à ses espaules," I, 88.

[29] AN F$^{17}$ 3578.

[30] Terisio Pignatti, *Giorgione*, London, 1971, 108.

# 39

# *Alessandro Castellani and Napoleon III*

ORNELLA FRANCISCI-OSTI

The author of a Festschrift article may, I think, be permitted some reminiscences. When I met Professor Janson in New York at the Institute of Fine Arts, in 1951, I was a Fulbright student on my way to becoming an art historian—or so I thought. Fortunately I am still a good friend of the professor, who first taught me to appreciate American art and artists such as Max Beckmann—subjects I had never heard of before then. And most important of all, I received from him an unparalleled present: a new friend, his wife, Dora Jane.

Now I am an editor of artists' biographies; although my work has its frustrations, I like it very much, notwithstanding the awareness of my limitations. I especially regret that many personalities I would like to know more about have had to be neglected for want of time.

Among the shadowy figures who populate the backstage of my mind are the members of the Castellani family. I knew of them vaguely as jewelers, active in Rome during the nineteenth century, and recently they stepped to the front of my stage through Mrs. Bordenache Battaglia's article in the *Dizionario Biografico degli Italiani*.[1] Anyone wishing to know more about them, not only as jewelers but also as patriots, collectors, merchants, and ceramicists, should turn to her article there. For my part, I offer the letter written by Alessandro Castellani (1823–1883) to his father from Paris on December 11, 1860, after he had met with Napoleon III; it contains a description of the pieces bought by the emperor on that occasion.[2]

In recent years the Castellani reproductions have been put on display in the Museo di Villa Giulia in Rome, together with part of the Castellani's collection of antique jewelry that served as the inspiration and models for the exquisite reproductions produced in their workshop. The Castellani's own works, so fortunately preserved, were evidently display samples from which the prospective buyer could select what he wished to order. The workshop was a real *bottega* in the old Renaissance sense, each piece the result of a collaboration among draftsman, gem engraver, enameler, medalist, and goldsmith. (The Castellani tomb, in the Verano cemetery in Rome, is built in the form of a Greek temple,

631

even incorporating some ancient pieces. It was intended to be the final resting place not only for numerous members of the family, but also for their workmen.)

But to return to Alessandro's letter addressed to Fortunato Pio Castellani, his father, who had founded the firm in Rome. The founder's sons had become expatriates for political reasons, and had managed to establish profitable branches of the firm outside Italy, launching a new craze for jewelry in the Greek, Etruscan, and Roman styles. In 1860, when Alessandro's letter was written, all of the commissions were still executed in Rome.

Unfortunately the letter in the Archivio di Stato di Roma (*Carte Castellani*, cart. 5) is not the original: it is a copy made on a quire of paper by an Italian who was not altogether familiar with the French language. The same quire contains transcriptions of other letters "written by Alessandro in exile": in one of these Alessandro tells his father about a meeting with Gioacchino Rossini, and the project of a seal to be made for the composer; another letter, sent from Turin in 1862, describes an encounter with King Victor Emanuel II, who praised the "finimento di scarabei" which that year the king had presented to his daughter, Maria Pia, on the occasion of her wedding to Louis I, king of Portugal. A second letter from Paris, written in 1861, requests further details from the home office about the technique of granulation, a process the Roman workshop had evidently been improving.

The 1860 letter describes in detail the events leading up to Alessandro's meeting with Napoleon III; the pieces that were selected to show the royal patron and how these were displayed; the visit of His Majesty and his entourage; and the jewels that were chosen on the spot for the court ladies who were present. The transcription follows herewith:

Parigi 11 dicembre 1860

Mio carissimo Papà

Come avrà rilevato dal dispaccio telegrafico di Domenica a sera noi abbiamo veduto l'Imperatore Napoleone. Ecco come andò la cosa. La Principessa Matilde[3] mi mandò a chiamare dicendomi che voleva chiedermi un piacere e

*1, 2. Castellani bracelet set with ancient Roman coins. Museo di Villa Giulia, Rome*

1

2

3

4

5

*3. Ancient Greek earrings from Crimea. Castellani Collection, Museo di Villa Giulia, Rome*

*4, 5. Castellani brooch in the manner of figure 3. Museo di Villa Giulia, Rome*

*6. Castellani satyr-head pendant. Museo di Villa Giulia, Rome*

6

8

10

9

11

7. The Bolsena earrings in the Castellani collection of ancient jewelry. British Museum, London

8. Castellani earrings in the manner of figure 7. Museo di Villa Giulia, Rome

9. Castellani brooch in the Renaissance style. Museo di Villa Giulia, Rome

10, 11. Castellani Gothic-style pendant-brooch with detachable pendant pearl; with various colored stones and a large central baroque pearl. Museo di Villa Giulia, Rome

*12, 13. Castellani wide gold mesh bracelet. Museo di Villa Giulia,
Rome*

volle che le promettessi di compiacerla: il che io promisi. "Dunque, mi disse,
domani Lunedì sò per positivo che l'Imperatore deve venire da voi per vedere
le vostre cose: però, come egli deve pranzar quì da me questa sera, io vorrei che
vedesse pure quì le vostre cose. Perciò metto a vostra disposizione una bella
camera e quanto altro vi possa occorrere a tale uopo." Io la ringraziai e dissi
che farei tutto come Ella desiderava. Corsi a casa con Gulielmo [sic][4] ci demmo
subito moto. Trasportammo tutto dalla Principessa e fu improvvisato un
*échafaudage* magnifico. Tutti gli oggetti stavano bellamente in vista sovra di
un piano inclinato nelle rispettive categorie: non mancavano ceri e doppieri a
rischiarare, per cui il colpo d'occhio e la *messa in scena* eran perfetti.

Alle nove ci trovammo al posto: poco dopo si aprì la porta e entrò Napoleone
colla Principessa che ci presentò: amabile assai fu l'accoglienza. Ci disse che
aveva deciso venire da noi, ma che era stato prevenuto dalla Principessa con
grata sorpresa. Disse che già conosceva i nostri lavori e che ne possedeva egli
stesso *uno magnifico*.[5] Io lo ringraziai delle sue buone disposizioni a nostro
riguardo e lo invitai a esaminare gli oggetti esposti. Allora, incominciò dall'arte
greca via via fino alle cose romane tutto esaminando e chiedendo i più minuti
dettagli intorno a ciascun oggetto. I braccialetti coi Cesari [figs. 1, 2],[6] gli
orecchini di Crimea [figs. 3–5],[7] la testa di Acheloo [fig. 6],[8] e le Vittorie di
Bolsena [figs. 7, 8],[9] gli fecero molta impressione. Così parlando sempre in-
sieme, soli, mentre la principessa si era ritirata nel salone colle Dame, molte e
molte cose si dissero . . . gli parlai di D. Michele[10] e mi disse che sapeva già
tutto. Arrivati alle cose cristiane "Oh, j'aime moins ça!" disse ridendo: poi si
avvicinò alla porta e chiamò "Annà" e subito venne una bella figliola tutta
brillanti e perle sorridente graziosa come un amore: l'Imperatore le disse
"Choissez [sic] quelque chose." Ella gentilmente disse invece "scelga V.M.ᵉ il
dono sarà più gradito." Napoleone prese il gioiello col balascio inciso colla

14

15

*14, 15. Two jewelry designs by "Don Michele" (Michelangelo Caetani di Sermoneta, 1804–1822), friend and partner of the Castellani. Fondazione Caetani, Rome*

*16, 17. Two views of a bracelet by the Castellani workshop, executed from the design by Don Michele in figure 14*

16

17

Vergine[11] e lo diede alla bella figlia che tutta rossa dal piacere fece una riverenza e partì. Era la figlia di Murat. Poi chiamò la principessa Matilde e le donò il gioiello Maddalena Doni—all'altra Murat diede il gioiello Benvenuto Garofalo con perlona pendente [figs. 9–11][12]—alla moglie di Murat il braccialetto colle cinque croci e larga tenia [figs. 12, 13][13]—alla Marescialla Pellissier il gran braccialetto serpi e croce di D. Michele [figs. 14–17].[14] E le fece contente. Disgraziatamente non ci eran altre dame! Poi disse l'imperatore "Ora sceglierò per me" e mise a parte gli orecchini di Crimea—il braccialetto col ritratto di Napoleone—i due coi dodici Cesari—due paia di orecchini colle Vittorie alate piccole—Fibula doppia rosa—Bulla testa grande di Acheloo due spille mano di Venere. Intanto erano entrati Marescialli e cortigiani e Ministri. L'Imperatore prese uno per mano i braccialetti coi Cesari e esclamò rivolgendosi a Walesky "Voilà mes Cesars!" Si trattenne un poco più, mise l'autografo nel libro e poi facendoci molti complimenti disse "Mr Castellani permettez moi de me retirer, sans quoi je vous acheterai tout." E se ne andò. Noi facemmo fagotto e poi corremmo al telegrafo per far piacere a lei annunciandole il fatto e rabbia ai nostri implacabili nemici. . . .

Mettano in lavoro molte cose per rimpiazzare. Qui piacciono molto le monete antiche . . .

Tanti complimenti al nostro caro e buon D. Michele le cui profezie si vanno verificando già in parte. State in buone speranze che le cose vanno bene assai, assai, assai assai

Alessandro

*Rome, Italy*

*Notes*

[1] All my gratitude to Mrs. Bordenache Battaglia for having aroused my curiosity about the Castellani and for her factual assistance in this essay.

[2] Due to his political affiliations with Giuseppe Mazzini, Alessandro spent several months in papal jails and some years in a madhouse (it is still not clear whether his madness was feigned, in order to get out of jail). In June 1860 he left Rome for Paris.

[3] She was the daughter (1820–1904) of Jerome Bonaparte (1784–1860), who was king of Westphalia from 1807 to 1813. After a brief marriage to the Russian prince Demidoff, Princess Mathilda became the hostess of one of the most brilliant salons in Paris.

[4] Guglielmo (1836–1896), the brother who was in Paris with Alessandro, is less famous than their elder brother Augusto (1829–1914) and Augusto's son Alfredo (1856–1930). Apparently Guglielmo was a wastrel such that he is hardly mentioned in the family papers. But he was appreciated as a ceramicist, doing in ceramic what his relatives were doing in jewelry: namely, taking inspiration from antique models, and in Guglielmo's case, especially from hispano-mauresque models.

[5] The emperor certainly meant the sword of honor given to him by 14,000 Romans after the second Risorgimento war (on the same occasion a twin sword was presented to Victor Emanuel II; it is now in the Armeria Reale in Turin). The handle had been drawn by M. Caetani and it is worth noting that the patriotic donors were all excommunicated (cf. R. De Cesare, *Roma e lo stato del papa*, II, Rome, 1908, 38; C. Montani, in *Capitolium*, IV, 1928, 216). The scandal that arose in Rome when the swords

were being made is documented in *The Letters of E. Barrett Browning,* London, 1898, 354; another letter from E. Browning to Isa Blagden of January 25, 1860, now in the Fitzwilliam Museum of Cambridge, England, was kindly communicated to me by Ph. Kelley, Oakhurst, N.J.: "I have been very unwell again. Supposed to proceed from a cold caught in going to Castellani's one afternoon after five to see the famous swords, the gifts for Victor Emanuel & the emperor. I refrained when there was tramontana; then the swords were packed up, & then suddenly unpacked for a few hours for somebodys benefit, & Miss Heaton came for me in the kindest way & in the closest carriage . . . . Now, not for any sword under the sun (unless run into me) will I move. These gifts, by the way, were beautiful to see—wonderful as works of art. The respective tricolors in precious stones. And inscriptions on the blade, very touching—'very piercing' you will add." Robert Browning also mentions the Castellani in the first lines of *The Ring and the Book,* London, 1868; both Elizabeth and Robert Browning owned rings by the Castellani.

6 In the Museo di Villa Giulia a bracelet of golden coins (still not clear if these are antique originals or copies) could be that mentioned here; other pieces in the same collection use silver coins.

7 Evidently inspired by Greek earrings found in Scythian tombs in the Crimea.

8 Two originals have been identified that the Castellani knew well. The one in the Antikenabteilung der Staatlichen Museen in Berlin-Dahlem (illustrated in the small handbook by A. Greifenhagen, Berlin, 1975, 67) comes from one of the many Castellani collections. Another,

now in the Louvre (inv. 498, C198), comes from the Campana collection, which was restored by the Castellani; it is reproduced on the cover of the small guidebook, *Bijoux grecs, étrusques et romains.*

9 An original pair, found in a tomb near Bolsena, was sold by the Castellani in 1872 to the British Museum (inv. 1845, 1846; cf. catalogue, pl. XXXII).

10 Michelangelo Caetani di Sermoneta (1804–1882), Don Michele, was a friend and partner of the Castellani; this aspect of his personality has not been studied yet. I have a strong feeling that he was behind many of their antique dealings. An album of sketches in the Fondazione Caetani in Rome contains many drawings for jewels: two are reproduced here (figs. 14, 15). In his letters there are more sketches: see Ch. Gere, *Victorian Jewellery Designs,* London, 1972.

11 Balascio: in English, Balas-ruby, a red, pink, or purple spinel.

12 Raphael's *Maddalena Doni* certainly has a hanging "perlona"; Garofalo so often painted jewels that I wonder if one of them corresponds to either of these two in the Museo di Villa Giulia. Our figure 9 has a carved balascio at the center and a smaller one on top; the leaves have green enamel, the pattern around the stone at the center is in white enamel.

13 It certainly corresponds to the one in Villa Giulia with the enamel in blue and white.

14 Alessandro writes "di D. Michele" because the duke made the drawing; sketches are in the album in the Fondazione Caetani in Rome. Another version is in the Schmuckmuseum, Pforzheim.

# 40

# *The Documentation*
# *for the Contribution of Three*
# *Mid-Nineteenth-Century*
# *Exhibitions to the*
# *Popularization of*
# *Japanese Art*[1]

ELIZABETH GILMORE HOLT

The first World Exhibition of 1851, when the industrial and mechanical arts from thirty nations were shown in the Crystal Palace in London, had a far-reaching influence on the design and ornamentation of useful objects. This exhibition evolved from a suggestion that the Royal Society of Arts and Manufactures annual exhibition—where mechanical inventions and excellence shown in the design of objects for daily use were awarded prizes—be expanded to become a quadrennial national exhibition of British manufacturing. Prince Albert, the Society's president, proposed that invitations be sent to all nations to join in an exhibition to be held in 1851. He expressed the idea behind the undertaking in a speech at the Lord Mayor's Banquet in November of 1850:

> . . . The products of all quarters of the globe are placed at our disposal, and we have only to choose which is best and cheapest for our purposes, and the powers of production are entrusted to the stimulus of competition and capital. . . . Science discovers these laws of power, motion and transformation: industry applies them to the raw matter which the earth yields us in abundance, but which become available only by knowledge. Art teaches us the immutable laws of beauty and symmetry, and gives to our productions forms in accordance with them. . . .[2]

For the first time every nation's products were arranged near each other. Now it was possible for visitor, designer, and manufacturer to compare the same objects—cups, bowls, vases, textiles, etc.—in different designs and ornamentation. The designer-artist could study examples of ornaments from the non-European cultures of India, the Middle East, and Africa.

The debate over the type of education provided in government Schools of Design where industrial designers were trained, and what models were best for the pupils, had been expanded to consider what was good and bad taste and how to educate

the consumer and the designer to choose what was "good taste." "The Exhibition as a Lesson in Taste" by Ralph Nicholson Wornum won the award for an essay on the exhibition offered by the prestigious *Art Journal*.[3] The following year, 1852, the Museum of Manufacture arranged an exhibition at which students were offered specimens of ornamental art, most of which illustrated correct principles of decoration. At the same time it was

> . . . deemed advisable to collect and exhibit to the student examples of what, according to the view held in this department, are considered to show wrong or false principles. The chief vice in the decoration common to Europe at the present day is the tendency towards direct *imitation of nature,* which in respect of ornamental art is opposed to the practice of all the best periods of art among all nations.[4]

In a search for principles which determine good design, the ornamental art of all known cultures—most of which were represented at the exhibition—was examined. As a result of his experience arranging the displays at the World Exhibition, Gottfried Semper, an exiled German architect, argued in an essay, *Wissenschaft, Industrie und Kunst,* that the progressive development of form leads to a style which is related to the functional origin of these forms. Semper found that attempts to borrow ornament directly from nature had seldom been successful; he also believed that the lesson to be learned "from peoples of non-European culture is the art of finding those simple, understandable harmonies in forms and colors, which instinct imparts to the simplest of human works but which are always more difficult to capture and retain in works of more sophisticated technique."[5]

The enthusiastic interest in the subject of ornament and design led to an outpouring of books, articles, and discussions. Owen Jones, whose functional use of color in the interior of the Crystal Palace permitted colors in the exhibits to be seen as in daylight, published the *Grammar of Ornament* in 1856. Its handsome chromolithographic plates illustrated, in his words,

> . . . a few of the most prominent types in certain styles closely connected with each other, and in which certain general laws appeared to reign independently of the individual peculiarities of each. I have ventured to hope that, in thus bringing into immediate juxtaposition the many forms of beauty which every style of ornament presents, I might aid in arresting that unfortunate tendency of our time to be content with copying, whilst the fashion lasts, the forms peculiar to any bygone age, without attempting to ascertain, generally completely ignoring, the peculiar circumstances which rendered an ornament beautiful, because it was appropriate, and which, as expressive of other wants when thus transplanted, as entirely fails.[6]

A key figure defining and fixing the standards for ornament in England was John Ruskin. From 1856 on, with the considerable fame he had acquired from his *Modern Painters* (1853) and *Academy Notes* (1855), and as a successful public lecturer, Ruskin conveyed to a number of the Society of Art branches his ideas on correct taste in ornament. In 1857, Ruskin's lecture series, "Political Economy of Art," reprinted as *A Joy Forever,* directed his large audience to consider objects within their households, and the training required to produce them.

In five lectures that were enthusiastically received in London and other cities, reported in the press, and published as *The Two Paths* (1859), Ruskin objected to

those Oriental designs that had been seen at the 1851 exhibition which had inspired
a group of designers to use unarticulated ornament on carpets, textiles, and wall-
papers. In his last lecture, "Modern Manufacture and Design," Ruskin closed with
the words: "I will not repeat here what I have already twice insisted upon, to
students of London and of Manchester respecting the degradation of temper and
intellect which follows the pursuit of art without reference to natural form, as
among the Asiatics."[7] Asiatics for Ruskin were Indian, Persian, Chinese. Japan was
unknown to him. Ruskin's opinion of Chinese art may have been influenced or
confirmed by Owen Jones's following statement in *The Grammar of Ornament*:

> Notwithstanding the high antiquity of the civilization of the Chinese, and the
> perfection which all their manufacturing processes reached ages before our time,
> they do not appear to have made much advance in the Fine Arts. . . . In their
> ornamentation, with which the world is so familiar through the numerous
> manufactured articles of every kind which have been imported into this
> country, they do not appear to have gone beyond that point which is reached
> by every people in an early stage of civilization: their art, such as it is, is fixed,
> and is subjected neither to progression nor retrogression. In the conception of
> pure form, they are even behind the New Zealander; but they possess, in com-
> mon with all Eastern nations, the happy instinct of harmonizing colours. . . .
> The general forms of many of the Chinese porcelain vases are remarkable for
> the beauty of their outline, but not more so than the rude water-bottles of
> porous clay which the untutored Arabian potter fashions daily on the banks of
> the Nile, assisted only by the instincts of his gentle race; and the pure form of
> the Chinese vases is often destroyed by the addition of grotesque or other
> unmeaning ornaments, built up upon the surface, not growing from it; from
> which we argue, that they can possess an appreciation of form, but in a minor
> degree.
>   In their decoration, both painted and woven, the Chinese exhibit only just
> so much art as would belong to a primitive people. Their most successful efforts
> are those in which geometrical combinations form the basis; but even in these,
> whenever they depart from patterns formed by the intersection of equal lines,
> they appear to have a very imperfect idea of the distribution of space. Their
> instinct of colour enables them, in some measure, to balance form, but when
> deprived of this they do not appear to be equally successful.[8]

Owen Jones found that:

> Of purely ornamental or conventional forms, other than geometric patterns,
> the Chinese possess but very few. . . . On the whole, Chinese ornament is a
> very faithful expression of the nature of this peculiar people: its characteristic
> feature is oddness,—we cannot call it capricious, for caprice is the playful
> wandering of a lively imagination; but the Chinese are totally unimaginative,
> and all their works are accordingly wanting in the highest grace of art,—the
> ideal.[9]

English interest in "Chinoiserie," culminating in the architectural and decorative
enterprises fostered by George III, had ceased to be fashionable by the end of the
eighteenth century.
  Into the lively, ongoing interest and discussion of ornament, decoration, and
design, a new element, the decorative art of Japan, was, like a thunderbolt, sud-
denly introduced. Public attention was dramatically focused on Japan when on

1

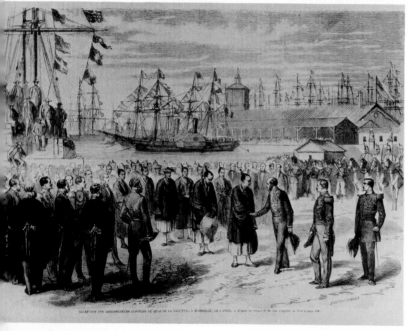

*1. Japanese Ambassadors at the International Exhibition in London.* Illustrated London News, *1862*

*2. Japanese Envoys Arrive in Marseilles.* L'Illustration, *1862*

*3. Japanese Envoys. Engraving from Nadar photograph.* L'Illustration, *1862*

2

3

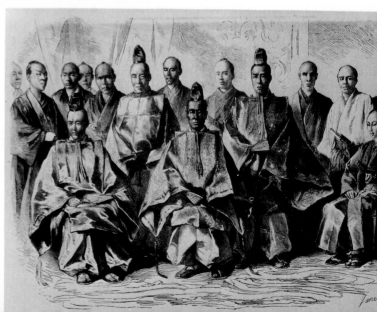

May 1, 1862, thirty thousand persons gathered for the official opening of the World    643
Exhibition beneath the immense twelve-sided glass dome of the building erected    *The Popularization*
in Kensington Gardens. The entrance of the Japanese ambassador and his suite,    *of Japanese Art*
a fabulous display of Oriental splendor, excited special attention even amidst the
blaze of scarlet, blue, purple, and gold of the military and diplomatic uniforms and
the decorated persons (fig. 1). The bizarre brilliance of the Japanese envoys recalled
the startling news items that had appeared in the press in the past year: "British
Legation attacked in Yedo"—"American consular official killed"—"HMS frigate
'Odin' dispatched for Japanese Envoy's State Visit." Until these reports, the British
reading public had been only generally aware that in 1853 an American, Commo-
dore Perry, had forced entrance into two ports of the mysterious, secret island
kingdom and secured permission to use them. The treaty concluded between Japan
and the United States in 1858 was followed immediately by treaties with England,
Prussia, and France. It was the announcement that Japanese officials would make
a state visit to the United States in 1860 that led to the invitation that brought the
Japanese Envoy Extraordinary and Plenipotentiary to the courts of the sovereigns
in Europe with whom the Tycoon of Japan had signed a treaty. Conveyed in a
British frigate, the Japanese ambassadors, with a suite of twenty-two, disembarked
first at Marseilles on April 3, 1862 (fig. 2), to be welcomed to France by M. de
Trévise on behalf of the Emperor. The next day they began a fifteen-day state visit.
However, during their sojourn, "Il est très difficile de les décider à quitter l'hôtel.
Le mouvement semble leur être odieux, l'idée du chemin de fer les terrifie jusqu'à
présent. On n'a pu obtenir d'eux qu'ils consentissent à visiter quoi que ce soit en
dehors de Paris qu'avec la plus grande peine."[10] To satisfy the curious, the group
photograph taken by Nadar was engraved and published by *l'Illustration* on April
19, 1862 (fig. 3).[11] Interest in Japan and things Japanese was now no longer limited
to the few who, like the etcher Félix Bracquemond, had seen a few Japanese prints
and porcelains at his printer's, Delâtre, or had frequented the Decelle Shop, opened
in 1855, or La Porte Chinoise, opened in 1857. Another establishment soon to
become famous was opened by Mme. Desoye in the year of the Japanese state
visit; it was patronized by Manet, Whistler,[12] Zola, and the Goncourt brothers.

At the end of April, the Japanese envoys proceeded from Paris to England to
attend the opening of the World Exhibition. Even in London, already accustomed
to strangely attired potentates, they excited interest. Their participation at the
opening ceremony was depicted in the *Illustrated London News.*[13] Its readers were
advised when visiting the exhibition to find the Japanese Court (fig. 4) "about which
there is a quaint picturesqueness," for "few portions of the building are more
interesting." In it is "an interesting collection of Japanese curiosities," the principal
portion contributed by Mr. Alcock, Her Majesty's ambassador. Instructed to
obtain for the exhibition specimens illustrative of the art industries and manu-
factures of Japan, Ambassador Alcock had methodically selected lacquer ware,
inlaid and carved woodwork, straw and basket work, china and porcelain, bronzes,
also specimens of Japanese paper, costumes, etc., storybooks in the Hirakana
character, an encyclopedia, and illustrated works on natural history.

Visitors found the Japanese articles mostly utilitarian in nature but also attrac-
tive due to their accurate finish and mechanical ingenuity. Even the most ordinary
item had a slight suggestion of ornament which raised it to an aesthetic level that
merited recognition. Juxtaposed with the Japanese objects, visitors observed that
in pursuit of originality, European decorative art had become distorted, preten-
tious, crude, and inharmonious, with defective workmanship. As an alternative

**4. Japanese Court at the International Exhibition in London.** Illustrated London News, *1862*

to the decorative elements of Greco-Roman culture, or to the naturalism required by proponents of the Gothic style, or to the unarticulated overall designs of "asiatics," the Japanese objects in the exhibition offered decorative elements derived from nature that were novel and appealing. This aroused immediate interest and a desire to discover the principles that governed them.

Ambassador Alcock accepted an invitation to lecture at Leeds in which he drew attention to the valuable instruction to be gained from the study of Japanese art and its application to industrial purposes.[14]

In 1863, the publication of Alcock's fascinating, detailed account of his stay in Japan, *The Capitol of the Tycoon: or, a Narrative of a Three Years' Residence in Japan,* illustrated by numerous and carefully selected Japanese woodblock prints, added to popular enthusiasm for Japanese ornament and art.[15]

In the spring of 1863, the Friday evening lecture of the Royal Institution, "profusely illustrated with native productions" and subsequently printed in the Institution's proceedings, was given by the book illustrator, John Leighton, F.S.A. Leighton explained and illustrated the distinctive features of Japanese art by comparisons with the art familiar to his audience. Since the Royal Institution proceedings were reported in the press, a summary of the lecture appeared in the *Illustrated London News* of May 9, 1863:

> The Japanese aim at producing the greatest amount of effect with the least expenditure: in which respect they differ from the Chinese who are rather copyers. In the ancient architecture of Japan are found many types resembling the works of Egypt, Assyria, and Greece. The Japanese employ symmetry in massive buildings but most studiously avoid repetition in ornamentation. They have little knowledge of perspective in drawing. Their caricatures are excellent for life-expression, and in colour they are judicious. They are

excellent carvers, modellers, and metal workers; and in art applied to manu-
factures they are remarkable for versatility of thought. They will have variety
even at risk of becoming grotesque and ridiculous. They are exceedingly fond
of small round ornaments from their resemblance to crests and badges of the
damios which are mostly derived from flowers. A red ball or sun is the emblem
of their emperor. They were engravers upon wood and metal long before the
invention of printing in Europe. They have long practiced the art of printing
in colours, so recently introduced in England. Examples were exhibited of
their excellent papers.[16]

On May 3rd, the day after Leighton's lecture, the first of three articles on
Japanese ornament appeared in *The Builder,* an illustrated weekly magazine
and leading architectural journal in England (the others on May 23 and June 13).
The articles called to the attention of their readers:

> French ornamentists are now largely engaging themselves with the produc-
> tion of patterns in the style of the ornaments of China and Japan ... the
> chief idea which we and our Continental neighbours have of Japanese art
> has been derived from the works of Japan shown in the recent International
> Exhibition; ... French artists who have engaged themselves with recasting
> Japanese designs have failed to discover the purport or significance of the forms
> they have borrowed. They have taken the form, but have not perceived the sen-
> timent of which the shape is but the shroud; or have copied forms and group-
> ings without seizing the spirit of the work. Landscapes in bad perspective,
> houses falsely foreshadowed, quaint and meaningless figures, and impossible
> groups of flowers, have been set forth as so many characters in the art of
> the nation. Whether the art of Japan is justly represented by these things the
> following must answer.[17]

The albums on display—storybooks in the Hirakana character—pictured
interiors of Japanese houses sparsely furnished with articles of elegance and
mechanical perfection. They fascinated visitors to the Japanese Court.[18] Indeed
the vogue of things Japanese influenced English decoration in everyday life. One
visitor, the Bristol architect Edwin W. Godwin, altered the interior of his house to
conform to those illustrated. Godwin's enthusiasm may have been encouraged by
his friend James McNeill Whistler, who had settled in London in 1859 and for
whom Godwin would build the "White House" some years later. Godwin himself
designed "Anglo-Japanese" furniture for William Watt, proprietor of the Art
Furniture Warehouse in Lodon.

The porcelains carefully selected by Ambassador Alcock must have been
studiously examined by Mr. E. W. Burns, F.S.A., the art director and a proprietor
of the Royal Porcelain Works of Worcester. A new tint of color resembling ivory
with a creamy softness had been brought out in 1856 that rivaled the Satsuma por-
celain on view, and production was probably begun on Worcester Japanese Por-
celain. Pieces of it would win medals at the Vienna World Exposition of 1873 and,
with the Royal Copenhagen Works, make the two firms leaders in the European-
Japanese style.

Interest in ornamentation and design was not limited to the English: the ques-
tion was of great importance to the French, eager to maintain their acknowledged
superiority in the decorative arts. Comte Léon de Laborde, an official French
commissioner to the World Exhibition of 1851 and a person of influence, published

on his return to Paris an essay, *Quelques idées sur le direction des arts et sur le maintein du goût-publique* (1856), as well as the two-volume *De l'union des arts et de l'industrie*. Three years later a magnificent portfolio of new models, *Recueil de dessins pour l'art et l'industrie,* was made available by Adalbert de Beaumont and Eugène V. Collinet. It included what Owen Jones's *Grammar of Ornament* had not, a plate showing examples from Japanese prints.

On his return from the exhibition of 1862, Comte de Laborde, alarmed at the prodigious improvement in the applied arts being made in other countries, gave his support to the founding of l'Union Centrale des Beaux-Arts appliquée à l'industrie. It opened an exhibition on August 15, 1863, in a space next to the Salon and the Salon des Refusés, in the Palais de l'Industrie. Displayed were not only products of contemporary industrial art but examples from the past and the work of the schools of design in Paris and the Departments. No objects from the Orient were included, but it directed the attention of the public, artists, and connoisseurs to the importance of well-designed and ornamented objects.

Four years later, the Champs de Mars—on which an immense oval International Exposition building had been erected—became a rendezvous for people from the whole world. Political changes in Japan now permitted a fine collection of objects to be sent over under the charge of Japanese commissioners. A small wooden tea-house, similar to the one built later in Vienna at the time of the World Exhibition in 1873 (fig. 5), was erected in 1867 among buildings of other nations in the delightful gardens surrounding the exposition building. In the long central aisle, between the displays of Siam and Egypt, stood the Pavillon du Taïcoun, a wonder in itself and, with the marvelous products it contained, a recipient of the grand prix d'honneur in the group, Matériel des Arts Libéraux.

> This exhibition is literally a revelation. The two other Japanese governments, under the name of their respective Taitchious, Satsouma and Fizen, exhibit—a little further on—paintings, lacquers, enamels, porcelains, fabrics, carpets, embroideries, and fine furnishings; but the pavilion of Yedo with all its height and all its light, so overwhelms the admiring public that it seems to be the only Japanese pavilion. China and its dynastic vases are over and done with. While the classical home of porcelains and jade is dying, here is a new royalty, already historically based, of fantasy and curiousness, which arise, and which—with its first appearance—has conquered the world of artists and collectors. They already have everything,—color, elegance, variety, exquisite shapes, miraculous execution. Lovers of art will have to renounce their old idols or refashion their education. . . . It is here, it is in this sanctuary of the arts of the Extreme Orient that one must stop a moment if one wishes to gain an idea of porcelain at its best. Once one has recovered from bedazzlement, one will, withdrawing into oneself, become intoxicated in the contemplation of something as new as it is powerful. We repeat,—and we do not wish to say more because we are only giving a brief idea; those who believe they have seen, be it at the Louvre, at Fontainebleau, in famous collections or at the major sales, some masterpieces of porcelain, enamel or lacquer, have seen nothing,—but nothing at all—that can withstand comparison with the majority of the extraordinary rarities and the wholly new magnificence enclosed in the pavilion, an illustration of which [fig. 6] we place before our readers' eyes.[19]

The ecstatic report given to the subscribers of the inexpensive *L'Illustration* was matched by the May 27th entry in the private journal of the sophisticated Goncourt brothers:

5

6

EXPOSITION UNIVERSELLE. — Galerie des Machines: le Japon.

5. *Japanese Building a Pavilion at the World Exhibition in Vienna.* Illustrated London News, *1873*

6. *Japanese Pavilion at the International Exposition in Paris.* L'Illustration, *1867*

At times we felt as though we were walking through a Japanese colored print, around this infinite palace, under the roof that juts out like that of a *bonzerie,* lighted by globes of frosted glass, just like the paper lanterns of a *Fête des Lanternes;* or else under the fluttering of the flags and standards of every nation, we had the impression that we were wandering in the streets of l'Empire du Milieu, under the noisy zig-zags of their oriflammes, as painted by Hildebrandt in his *Tour du Monde.*[20]

Widespread delight in Japanese objects, universal recognition of the Japanese as superb masters in the decorative arts, offered a challenge to discover the reason for their appeal. In planning its customary exhibition of six sections scheduled for 1869, l'Union Centrale des Beaux-Arts appliquée à l'industrie decided to add a seventh section devoted to a survey of l'Art Oriental. With the loan contributions from 155 collectors—nothing was secured from state collections—eight rooms in the Palais de l'Industrie were arranged with objects from Persia, India, Korea, Siam, the Near East, China, and Japan to form what was soon referred to as the "Musée du Orient."

With sufficient items to fill two galleries, China and especially Japan were best represented and by their uniqueness attracted the attention of the public and foreign correspondents. A *Guide du Visiteur du Musée Oriental* furnished an uncritical description of each object and the name of the lender.

The *Zeitschrift für bildende Kunst*'s correspondent, E. M., after commenting that the playfulness of "Chinoiseries" in the eighteenth century was now being replaced by the serious study of Chinese art, believed the intention of l'Union centrale des Beaux-Arts to be twofold: to establish the value of the art of the Orient for the West, and to stimulate enthusiasm which would regenerate the decorative arts in Europe.

For his discussion, E. M. divided the objects displayed into three categories:

The first includes objects which cannot be reconciled with either our needs or our aesthetic taste. The majority of these were from China. . . . The second category includes those objects which beside their originality are also beautiful, and of which therefore imitation, within certain limits, would be desirable. They are mostly of Japanese origin. In the third category belong all those marvels of oriental technique with which we have been familiar for a long time: Persian weapons and faïence, Indian weaving and carpets, niello, ebony carvings, etc.[21]

E. M. regarded in the ceramic section the Japanese porcelain of unusual importance for the study of their customs and their artistic way of seeing.

Two aesthetic principles are there which, in hundreds of examples, strike the eye: the striving for verisimilitude and asymmetry. . . . They do not know balance of masses, parallelism of elements and ornament, in short, the fundamentals of our art which indeed often lead to monotony. They set the unequal opposite to one another or are content to express the thought only once. If ever they compose symmetrically, it occurs in appearance and never with geometric precision. . . . Therefore these works are a source of constant surprise and excitement. We are confident that in the French industrial circles one fine day one will recognize the charm of these aesthetic principles and compose in the same way.[22]

For members of l'Union Centrale des Beaux-Arts, connoisseurs, collectors,

artists, and writers, Ernest Chesneau—a well-known writer on art and himself a collector—gave a lecture on February 10, 1869. He explained and illustrated what he considered to be the fundamental characteristics of Japanese art: an absence of symmetry, a style which comes

> . . . from the marvelous harmony that artists know how to establish: first between the form and the purpose of the object, second between the form that the object has and its surface decoration, third between the form and the material of which it is made.[23]

The last characteristic, color: "With the least number of elements, they know how to realize the most harmonious and brilliant effects."[24]

Chesneau reiterated in his lecture observations he had made in his essay "l'Art Japonais" included in *Les Nations Rivales dans l'Art*,[25] the brochure which gave his report of the exposition of 1867.

Thus, the Musée du Orient of 1869, the Japanese Pavilion of 1867, and the Japanese Court of 1862 each added to the discussion of ornament and did much to expand the circle of interest in the applied arts and all things Japanese. With these exhibitions, the uniqueness and high quality of the Japanese decorative and printing arts caught the attention of European "Fine Arts" painters and stimulated their interest in the decorative arts. Curiosity and interest in Japan continuously brought articles on ceramics and their decoration into art magazines and the daily press over the next thirty years, contributing to the cult for things Japanese known as *Japonisme*.

*Georgetown, Maine*

*Notes*

[1] Professor Gabriel P. Weisberg's informative articles and the section "Japonisme: Early Sources and the French Printmaker 1854–1882" from the catalog *Japonisme: Japanese Influence on French Art 1854–1910*, The Cleveland Museum of Art, Cleveland, 1975, 1–19, were indispensable for the writing of this article. Prof. Weisberg generously made available to me the text for both the John Leighton and the Ernest Chesneau lectures and has assisted me in every way.

[2] T. Martin, *Life of H.R.H. The Prince Consort*, 2nd ed., II, London, 1876, 248.

[3] Ralph N. Wornum, *Art Journal*, 1851.

[4] *A Catalogue of the Articles of Ornamental Art, in the Museum of the Department*, . . . London, Her Maj. Stationery Office, 1852, 2nd ed., App. C—False Principles, 74. Prof. Ernst Gombrich kindly called this work to my attention. His *The Sense of Order: A Study in the Psychology of Decorative Art*, Ithaca, N.Y., 1979, an invaluable source for the study of ornament, appeared since this article was written.

[5] Gottfried Semper, *Wissenschaft, Industrie und Kunst*, Braunschweig, 1852. This was probably written at the suggestion of Prince Albert.

[6] Owen Jones, *Grammar of Ornament*, London, 1856, ch. XIV, 85–87. Also in 1856 appeared Ralph N. Wornum's *Analysis of Ornament: The Characteristics of Style and Introduction to the Study of the History of Ornamental Art* (London). At nearly the same time, in 1858, Sir Gardner Wilkinson's *On Colour and on the Necessity for a General Diffusion of Taste among all Classes . . . Examples of Good and Bad Taste Illustrated by Wood Cuts and Coloured Plates in Contrast*, was published.

[7] E. T. Cook and A. Wedderburn, *The Complete Works of John Ruskin*, XVI, London, 1905, 326.

[8] Owen Jones, *Grammar of Ornament*, 86.

[9] *Ibid.*, 86.

[10] *L'Illustration*, April 19, 1862.

[11] *L'Illustration, Journal Universel*, April 19, 1862, 262. The Japanese visitors went also to Germany. See *Illustrierte Zeitung*, Leipzig, August 9, 1862.

[12] Whistler may have seen a wider variety of Japanese objects than the artists and connoisseurs in Paris. When a student at West Point, he could have had the opportunity to see the "Japanese Curiosities" at the Crystal Palace, the World Exhibition of 1853, in New York. Among the items supplied by the king of Holland, some—a lantern, an umbrella, and sandals—were engraved for the *New York Illustrated News*, Sept. 10, 1853, 229. A month later another collection of Japanese objects, more interesting than that of the king of Holland, was added to the exhibition. It came directly from Japan, having been secured from an ill-starred junk which, with a sole survivor, had been rescued by an American vessel, brought to San Francisco, and then to New York. Specimens of coinage and examples of Japanese manufacture: a bowl, a decorated crepe scarf, and a purse, were some of the items depicted in the *New York Illustrated News,* October 8, 1853, 187.

[13] *The Illustrated London News*, May 3, September 20, 1862.

[14] Rutherford Alcock, *Art and Art Industries in Japan*, London, 1878, 6–8.

[15] Rutherford Alcock, *The Capitol of the Tycoon: or, a Narrative of a Three Years' Residence in Japan*, London, 1863.

[16] John Leighton (1822–1912), F.S.A., draftsman, book illustrator, bookplate designer, photographer, pseudonym "Luke Limner," published several books, among them *Suggestions in Design . . . for the use of Artists* (1853). The Art Union of London commissioned him to design the Albert Commemorative Tazza for the exhibition of 1862. I am grateful to Prof. Weisberg for the text of the Leighton lecture.

[17] *The Builder*'s anonymous writer in these articles defined Japanese ornament as a style consisting in part of purely ideal shapes, in part of forms derived from nature, and in part of symbolic forms: May 23, 364; June 13, 423. William M. Rossetti, writing for *The Reader* in 1863, found: "The high state of development which the fine and decorative arts have attained in Japan has come upon most English people as a surprise, . . ." W. M. Rossetti, *Fine Art, Chiefly Contemporary: Notices Reprinted with Revisions,* London, 1867 (reprinted AMS, New York, 1970), 362.

[18] These articles, the lectures, the press notices and illustrations, and the very existence of the Japanese court at the World Exhibition of 1862, apparently escaped entirely the notice of G. A. Audsley, author with Mr. Bowes of *Keramic Art of Japan*, published for subscribers in 1875. Mr. Alcock called attention to their oversight by citing a statement in their introduction: "Previous to the year 1867 [the Paris Exposition] our knowledge of Japanese Art was chiefly derived from the presents given to the several embassies that had visited Japan, and the articles collected and described by such travellers in the country as Kaempfer and Siebold." Frank Whitford's recent book *Japanese Prints and Western Painters*, London, 1977, affirms the importance of the 1862 Exhibition for the knowledge of Japanese art. However, he errs in his identification of the lecturer named Leighton. It was John, not Frederick, Lord Leighton, the President of the Royal Academy. See *TLS* review, November 25, 1977.

[19] *L'Illustration, Journal Universel*, Sept. 21, 1867, 188.

[20] See *Journal*, May 27, 1867.

[21] *Die Zeitschrift für bildende Kunst*, V, 1870.

[22] *Ibid.*

[23] Ernest Chesneau, *L'Art Japonais*. Conference faite à l'Union centrale des Beaux-Arts appliquée à l'industrie le vendredi 10 février 1869, Paris, 1869, 16, 19.

[24] *Ibid.*

[25] Chesneau, *Les Nations Rivales dans l'Art*, Paris, 1869.

# 41

## *A Nineteenth-Century "Medieval" Prayerbook Woven in Lyon*

LILIAN M. C. RANDALL

Them hath he filled with wisdom of heart, to
work all manner of work, of the engraver,
and of the cunning workman, . . . and of
the weaver, even of them that do any work,
and of those that devise cunning work.
(Exodus 35:35)

Between 1886 and 1887 the Lyon textile firm of J. A. Henry issued a woven silk
*Livre de prières* sumptuously ornamented with designs copied from medieval manu-
scripts and Italian Renaissance paintings. A visual delight, reflecting three epochs
of artistic production, this unique prayerbook forms a suitably diversified subject
for a tribute to the extraordinary talents of H. W. Janson. His interest in the re-
interpretation of earlier decorative motifs by nineteenth-century illustrators, one
of the chief points of interest of the Lyon book, found a place in his all-encompass-
ing *History of Art* through reference to a political cartoon by Walter Crane. The
example chosen, one of Crane's *Cartoons for the Cause* (1886), shows the transfor-
mation of the angel in the right foreground of Botticelli's *Birth of Venus* into a
herald of Socialism.[1]

Such transmutations became standard in European book illustration in the
course of the nineteenth century. The subject is vast and complicated. For present
purposes, emphasis will be placed only on French examples of particular relevance
to the volume under consideration. Part of the reaction of the Romantic movement
against classical conventions, borrowings of motifs from the art of the more recent
past became the rage following the publication of generously illustrated tomes
that served as pattern books for craftsmen in all media.[2] According to the pre-
vailing "Code of Ornament," the use of a motif in another context was in itself
regarded as an act of original creativity.[3] While condemned by some critics, this
attitude met with general approval or outright enthusiasm.[4] In Paris, publishing
firms such as Gruel and Engelmann or Curmer catered to the rampant vogue for
medieval art by issuing de luxe facsimiles of entire Books of Hours or prayerbooks
composed of individual pages arranged in chronological sequence, generally from
the thirteenth to the sixteenth century.[5] As a rule, in the latter format, each page of
the Gothic-style religious text was surrounded by a different border; miniatures,
initials, and line-endings were adapted to suit the individual format and, as in
late medieval Books of Hours, individual elements were merrily transposed and

651

altered. Manuscripts in the Bibliothèque du Roi (today's Bibliothèque Nationale) and the Bibliothèque de l'Arsenal provided the most common source of inspiration.[6] Judging from the verisimilitude of color and line, illuminators probably made copies on the spot, or sketched out essential elements to be completed outside the library walls. Carried to extremes, the passion for Gothic forms could result in a rich binding such as the one made by the jeweler Alexis Falize for Gruel and Engelmann in the early 1870s (fig. 1). Contrary to what one might expect from the splendid exterior, the volume consists only of blank pages.

The prayerbook woven in Lyon in 1886–87 is a showpiece of a very different order. Although very much part of the mainstream of the luxury volumes described above as a specialty of certain Paris publishing firms, by virtue of its technological achievement it constitutes a unique curiosity within the history of Victorian giftbooks. Issued in an edition of fifty to sixty copies, an example was presented to the Walters Art Gallery a few years ago by Mrs. Jane Ridder, a great-granddaughter of William T. Walters (1820–1894), Baltimore railway magnate and founder of the museum.[7] The circumstances under which the gift was made were as unique as the volume itself. On November 16, 1974, over two dozen Walters relations gathered in Baltimore to celebrate the opening of a six-story wing. The new addition to the original art gallery built in 1905 by William's son, Henry, made it possible to display to best advantage some 27,000 works of art in the collection, which had been bequeathed to the City of Baltimore at the time of Henry's death in 1931. Shortly before the beginning of the evening's festivities, Mrs. Ridder informally presented the silk prayerbook that had belonged to her grandmother, Jennie Walters Delano, Henry Walters's sister (1853–1922). It was not until a few days later, however, that a quiet moment came for removing the parcel from the vault and examining its contents at leisure.

What emerged from the plain manila envelope was a quarto (175 × 145 mm [6 $7/_8$ × 5 $3/_4$″]), stamped on the spine in gilt letters LIVRE DE PRIÈRES. The handsome dark-blue morocco binding was decorated on the upper cover by grey, brown, and green floral elements attached to gold stems (fig. 2). Both doublures had a central panel of sky-blue watered silk, surrounded by a narrow gold trellis filled with red flowers and terminating in red bows at the corners. Along the lower edge of the front doublure was the gilt inscription, CH. MEUNIER, designating this as the work of the noted Paris bookbinder whose work is represented by seventeen other examples in the Walters collection.[8] Two silver clasps pierced by quatrefoils fastened the gilt gauffered edges which were tooled with a floral design set in a series of diagonals.

It was evident that the book, which was in pristine condition, had not seen much use. Two pale-grey satin flyleaves preceded a page containing a shield in which the owner's monogram, JWD, was painted in rose, yellow, and blue (fig. 3). The title page read "*Livre de prières tissé d'après les Enluminures des Manuscrits du XIV$^e$ au XVI$^e$ Siècle*. Lyon mdccclxxxvi." The elaborate border, whose design closely resembles that of a page in the *Grandes Heures du duc de Berry* (B. N., MS lat. 919, fol. 86),[9] contained the inscription "ihs" above and the coat of arms of Lyon below. On the verso of the title page was the official sanction of the content of the volume:

Varias precum formulas et nonnulla ex Sacris Litteris Romanaque Liturgia de prompta in hoc sericeo volumine eleganter exornata approbamus et arti Lugdunensi mandari libenter permittimus.

1. *Alexis Falize. Gilt and enameled binding of* Horae beatae Mariae Virginis, *Paris, c.1870. The Walters Art Gallery, Baltimore*

2. Livre de Prières, *Lyon, 1886–87. Upper cover of binding by Charles Meunier. The Walters Art Gallery, Baltimore*

3. Livre de Prières, *Lyon, 1886–78. Owner's monogram and title page. The Walters Art Gallery, Baltimore*

Below, there appeared the date (September 8, 1886) and the name of Cardinal Louis-Marie Caverot, archbishop of Lyon and Vienne. His arms and motto, "Dilectione et pace," appeared in the capital "V" at the upper left along with the archiepiscopal arms of Lyon and the motto "Prima sedes Galliarum," a reference to the importance of the city as a seat of Christian faith from the late second century on.[10]

As stated, the French and Latin prayers according to Roman rite followed the sequence of the Mass, consisting of 1) *Prières du Matin et du Soir,* 2) *Prières durant la Ste. Messe,* 3) *Messe de Mariage,* 4) *Pour la Ste. Communion,* 5) *Au Très Saint Sacrement,* 6) *Au Saint Esprit,* 7) *A la Sainte Vierge Marie,* and 8) *Prières diverses.* Woven in Gothic letters in two columns of twenty-three lines each, the text occupied twenty-two leaves, numbered i–xliii on recto and verso except on the half-title pages before the first three sections of text, on the last page containing the table of contents and colophon, and on the four pages with figural compositions (figs. 4, 6, 7, 10, 11). Counting the two flyleaves at front and back, plus the introductory title page and half-title page, the volume comprises fifty pages in all. Of these, forty-three contain borders of different designs that range from a small number of relatively simple *rinceaux* to Bourdichon-style patterns that increase in lushness throughout the second half of the book. Interspersed throughout, in various shapes and sizes, are roses, pansies, daisies, lilies, strawberries, and peapods (all prominent in the decoration of late medieval Hours of the Virgin); animate motifs include songbirds, squirrels, and a few winged dragons of the type favored in royal French manuscripts in the fourteenth century, where they are generally depicted in bright orange or orange and blue. Toward the end of the volume, the borders exhibit a combination of acanthus alternating with compartmented grounds containing elaborate floral decoration (fig. 8). In some cases, the stylized forms strike a distinctly Art Nouveau note (fig. 9). Throughout, subtle shading from a silvery tone to black, achieved by means of cross-hatching or closely set dots, serves to animate the page. The derivative elements presented in a new light have an individuality that is strangely disturbing. The motifs of earlier periods, caught in the firm grip of Victorian taste, have lost most of their flesh and blood in the process of mechanical reproduction.

For source material, the designer of the Lyon prayerbook (cited in the colophon as a priest by the name of J. Hervier) utilized the de luxe Paris manuscript facsimiles mentioned above. Not only the title page but also borders copied from the *Livre d'Heures de la Reine Anne de Bretagne* (B. N., MS lat. 9474) were taken by Hervier from the *Livre d'Heures d'après les manuscrits de la Bibliothèque Royale,* produced by Engelmann and Graf between 1846 and 1849 (figs. 3, 13).[11] Hervier was doubtless also familiar with an even more lavish color facsimile entitled *Oeuvre de Jehan Fouquet, Heures de Maître Etienne Chevalier* (Paris, L. Curmer, 1866). While the two-page blessing by Pope Pius IX, thanking the publisher in glowing terms for his service to the Church, is far more elaborate than Archbishop Caverot's sanction in the Lyon book, the idea is the same and repeats a formula common in nineteenth-century de luxe publications of religious texts.[12] Especially significant in the present context is the abundance of related motifs on the 217 pages of Curmer's edition. Many of the designs, which vary from page to page, bear a close kinship to those in the Lyon prayerbook.

A provable case for Hervier's use of a slightly later composite manuscript facsimile is found in the *Imitation de Jésus-Christ,* published by Gruel and Engelmann in the late 1870s or early 1880s. This luxury edition of the abbé Hugues F.

de Lamennais's 1824 French translation of Thomas à Kempis's work had 102 chro-
molithographs, 99 of which were modeled after illuminated manuscripts in the
Bibliothèque de l'Arsenal, the Bibliothèque Nationale, and the publisher's own
collection. Each volume was identified in a descriptive text by Henri Michelant.
The original *carton* for this ambitious enterprise, as well as the final publication
bound by Léon Gruel, were acquired by Henry Walters around the turn of the
century, when he began buying in quantity from this distinguished Paris bookseller
and binder. Walters's copy, No. 310, first belonged to F. Wattelier, another Paris
*libraire,* as we know from the list of 402 subscribers appended to the volume; the
same number appears on a book in a reproduction of the famous miniature of
Jean Miélot in his study on the last text page of the *Imitation.*[13] Of further sig-
nificance in the subscription list is the entry for the Lyon bookseller, Antoine Roux,
beside Nos. 100, 246, and 250, followed by that of J. A. Henry of Lyon beside No.
355. Both these names are cited along with J. Hervier in the colophon of the silk
prayerbook as the parties responsible for its publication (fig. 11). Proof positive
that Hervier utilized Gruel and Engelmann's *Imitation,* probably the copy belong-
ing to the textile firm of J. A. Henry, is found in the reproduction of the kneeling
"donor portraits" from Plates XXXI–XXXII on pages i and iv in the woven *Livre
de Prières* (figs. 4, 5, 14, 15). By extreme good fortune, the original source for these
motifs is also in the Walters Art Gallery (figs. 16, 17). Acquired in all likelihood at
the same time as the illuminated *carton* and printed copy of the *Imitation,* the
manuscript in question is a Flemish Book of Hours made about 1425 for Elizabeth
van Munte and Daniel Rym (d. 1431) of Ghent.[14] One of four manuscripts in the
collection of Gruel and Englemann used by the illustrators of the *Imitation,* this
imaginatively ornamented Book of Hours (now W. 166) is encased in a binding
made by Gruel from two rose-colored stamped Gothic panels whose handsome
patterns also inspired his design for the covers on the printed *Imitation* in the
Walters collection.[15]

Whereas manuscript facsimiles provided the major source of inspiration for
Hervier, he may also have consulted originals to which he had ready access in
Lyon. This is suggested by the strong resemblance between a representation of
the Elevation of the Host in an initial in a fifteenth-century Missal (Lyon, Bib.
Mun. 517, fol. 8) and Hervier's rendering of the same theme in the capital
"M" of *Le Saint Sacrifice de la Messe* on page xi of the silk book.[16] There are a few
minor alterations, among them the inclusion by Hervier of a scroll containing
an excerpt from St. Thomas's Service of Benediction, "Tantum ergo sacramentum
veneremur cernui." This is one of a number of religious quotations incorporated in
the borders of the Lyon *Livre de Prières.*[17] Lengthier passages appear below two of
the four larger figural compositions inspired by works of major Italian Renais-
sance painters. As in the case of most of his borrowings from manuscripts, Hervier
doubtless took his designs from reproductions readily available in any number of
illustrated publications of Italian masterpieces issued in quantity since the begin-
ning of the nineteenth-century.

The first of these, a *Nativity* modeled on the mid-fifteenth-century fresco in San
Marco, Florence, and believed in Hervier's day to be by Fra Angelico, appears at the
opening of the *Prières du Matin et du Soir* (fig. 4).[18] The legend below is a curious
combination of the words "Et homo factus est" from the Nicean Creed with an
excerpt from John 1:14, "habitavit in nobis." This adroit manipulation of textual
sources reflects the same thought process as the piecing together of ornamental
motifs. The texts below the three subsequent reduced versions of major paintings

are more straightforward. A quotation from Ephesians 5:2 appears below the *Crucifixion* whose central portion is copied from the work of one of Fra Bartolommeo's collaborators, Mario Albertinelli (fig. 6). The original, a fresco painted in 1506, was commissioned for the Carthusian monastery of Val d'Ema near Florence.[19] Another biblical quotation accompanies the *Virgin and Child with the Angelic Host* at the beginning of the *Messe de Mariage* (fig. 7). There is no single source for this composition; as with the preceding one, it is a conglomeration of elements derived for the most part from paintings by Fra Angelico. The head-pose and features of both the Virgin and the Christ Child, for example, recall the central panel of the Linaiuoli triptych. Commissioned in 1432 for the Residenza of the weavers' guild in the Piazza S. Andrea in Florence,[20] the work is an appropriate source for the woven prayerbook. The two kneeling angels in the foreground may have been inspired by Fra Angelico's *Virgin and Child* in the central panel of an altarpiece painted for S. Domenico in Fiesole in 1424–25; motifs such as the Virgin's crown and the angelic host recall other compositions by the Florentine master, notably the *Coronation of the Virgin* in the Louvre.[21] Given the vast admiration for Fra Angelico in the nineteenth century, it is not surprising that he should figure so largely as a source for Hervier's engraved designs.[22] Moreover, the Italian master's beginnings as an illuminator and his sensitive renderings of the Virgin had special appeal to the Lyon book designer.

Listings of stellar Italian Renaissance artists in nineteenth-century art-historical surveys generally began with Fra Angelico and ended with Raphael. It is scarcely surprising, therefore, to find one of the latter's works reproduced as the fourth and last major illustration in the Lyon book. Placed at the beginning of the prayers for Holy Communion, it is based on the *Christ between the Virgin and Saint John*

*4.* Livre de Prières, *Lyon, 1886–87.* Nativity *and page i. The Walters Art Gallery, Baltimore*

5

6

5. Livre de Prières, *Lyon, 1886–87. Page iv. The Walters Art Gallery, Baltimore*

6. Livre de Prières, *Lyon, 1886–87.* Crucifixion, *p. xii. The Walters Art Gallery, Baltimore*

7. Livre de Prières, *Lyon, 1886–87.* Virgin and Child, *p. xxvi. The Walters Art Gallery, Baltimore*

7

*the Baptist* from Raphael's *Disputà* in the Stanza della Segnatura (fig. 10).[23] Long regarded as a representation of the glorification of the Christian Faith, the original composition includes in its lower section representations of biblical heroes, the Church Fathers, and eminent writers and artists including Fra Angelico and Raphael. Hervier surely was aware of this. He may not have been familiar with another factor that made his choice of subject particularly appropriate, namely, the likelihood that the Stanza della Segnatura served as the papal library.[24] In planning his compositions for this room, Raphael seems to have had in mind the appearance of classical and Renaissance libraries in which representations of heroic figures and deities were standard components. Raphael's grandiose scheme, with its inclusion of artists and writers, calls to mind a nineteenth-century work that may have had some influence on Hervier's choice of subject. The composition in question, Hippolyte (Paul) Delaroche's *Hemicycle,* is a vast glorification of the arts painted in the amphitheater of the Ecole des Beaux-Arts between 1836 and 1841. An immense work measuring 3.90 by 25 meters, it was hailed by Alexandre Dumas as "le plus beau morceau de peinture moderne."[25] In all, sixty-six artists of the thirteenth to seventeenth centuries were represented beside the central dais, on which Ictinus, Apelles, and Phidias were enthroned. At the right a group of nineteen figures included Raphael, Fra Bartolommeo, and Michelangelo (fig. 18). Given the renown of Delaroche's mural, greatly increased by L. Henriquel Du-

8. Livre de Prières, *Lyon, 1886–87. Page xxvii. The Walters Art Gallery, Baltimore*

9. Livre de Prières, *Lyon, 1886–87. Page xxxi. The Walters Art Gallery, Baltimore*

8

9

10. Livre de Prières, *Lyon, 1886–87*. Christ between the Virgin and Saint John the Baptist, *p. xxxiii. The Walters Art Gallery, Baltimore*
11. Livre de Prières, *Lyon, 1886–87*. Table of contents, *p. xliv. The Walters Art Gallery, Baltimore*
12. Livre de Prières, *Lyon, 1886–87*. Pages xix–xx, back view. The Walters Art Gallery, Baltimore

13. Livre d'Heures, *Paris, Engelmann and Graf, 1846 [1849]. Title page. The Walters Art Gallery, Baltimore (cf. fig. 3)*

pont's engraved three-part copy exhibited at the 1853 Salon, the work may well have influenced the selection of Renaissance artists rather than miniaturists for the Lyon prayerbook.

Despite its unusual features, the woven *Livre de Prières* has attracted as little scholarly attention as the printed religious and other texts produced in the nineteenth century from designs in illuminated manuscripts. Termed "A final exhalation of the medieval Book of Hours" in the most recently published notice,[26] the Lyon book is of singular interest from a technical point of view.

A handwritten sample book on the production of silk fabrics, issued in Lyon between 1838 and 1845, contains a fine description of the type of satin from the Jacquard loom of which the pages of the *Livre de Prières* are composed:

> Satin c'est la plus riche et la plus brillante de toutes les étoffes, fabriqué avec toutes les conditions comme pour obtenir une belle étoffe, il a l'éclat de l'or et de l'argent soit qu'il soit en blanc ou en couleur jaune . . .[27]

Contrary to normal practice, the weft in the Lyon prayerbook was run vertically to produce the letters of the text and the ornamental design. The threads, set one-tenth of a millimeter apart, number 400 to every 2.5 centimeters. Several hundred thousand perforated cards were required for the entire opus, which came off the loom two pages at a time, the recto of one page on the left and the verso of the preceding page on the right (fig. 12).[28] In the final stage of production, the silk was

folded in half and glued over a piece of cardboard that served to give the necessary stiffening to the delicate fabric. This step was postponed until the time of purchase, when the customer made arrangements with the bookseller for inserting a monogram and proceeding with the binding process.[29]

In Paris the bookseller J. Kauffmann acted as agent for his Lyon colleague, Antoine Roux, mentioned above as a subscriber to Gruel and Englemann's edition of the *Imitation de Jésus-Christ*. It was from Kauffmann that Henry Walters acquired for his sister Jennie the *Livre de Prières* presented to the Gallery by Mrs. Ridder a few years ago.[30] The precise circumstances of the original transaction are known from entries in a diary in the Walters collection recording purchases made by a gentleman art-agent, George A. Lucas, for the Walters family throughout the second half of the nineteenth century.[31] On May 24, 1897, following several visits to Charles Meunier to discuss the monogram and binding, Lucas paid Kauffmann 385 francs for the completed volume. The price was higher by 55 francs than that paid on July 7 of the previous year to Kauffmann for a plain blue moroccobound copy obtained for Henry Walters.[32] Considering that the silk book was originally offered to subscribers in 1880 for 260 francs unbound, the cost had remained relatively fixed in the intervening decade and a half.[33]

Henry Walters's initial view of this collector's item was in 1889 during a visit to Paris with Jennie. Lucas, who had seen the prayerbook for the first time in 1888 and had been greatly impressed by its quality, may have suggested a joint visit to the Lyon Pavilion at the Universal Exposition, where the volume was exhibited in the display organized by the Lyon Chamber of Commerce. It was one of the items featured by the above-mentioned firm of J. A. Henry, whose textiles for

*14, 15*. Imitation de Jésus-Christ, *Paris, Gruel and Englemann, n. d. Plates XXXI, XXXII (cf. figs. 4, 5)*. The Walters Art Gallery, Baltimore

religious use were highly reputed. Winner of numerous medals at showings in Paris and elsewhere from the 1860s on, the Maison Henry carried off a *grand prix* in the 1889 Exposition. In a review of the Lyon textile display, Henri Martin, noted authority on medieval illumination, enthusiastically (and paradoxically) praised "Ces pages . . . aussi nettes que celles du livre le mieux imprimé."[34] Paul Marais, conservateur-adjoint at the Bibliothèque Mazarine, was also fascinated by the Lyon *Livre de Prières*. In an article published in 1889, he gave a detailed account of the technical process and predicted in jest that books woven by the yard might be available in department stores by the twentieth century. His final conclusion, however, was that "le livre tissu ne sera jamais qu'une curiosité, mais n'arrivera jamais pas à remplacer le livre imprimé."[35]

At the end of our silk book, a colophon in the medieval spirit provides the names of the chief participants in charge of its production and distribution:

> Cet ouvrage a été / heureusement achevé / à Lyon le viii Sept. / l'an de N. S. mdccclxxxvii / sur les dessins du R. P. J. Hervier S. M. / par J. A. Henry, fabricant. / A. Roux libraire éditeur / Lyon. [fig. 11]

While the firms of Henry as well as Roux were well known in their respective

*16, 17.* Book of Hours, *Flemish, c.1425.* Elizabeth van Munte before St. Elizabeth of Hungary *and* Daniel Rym in Prayer. *W. 166, fols. 62 (1:1), 112 (2:1). The Walters Art Gallery, Baltimore (cf. figs. 4, 5, 14, 15)*

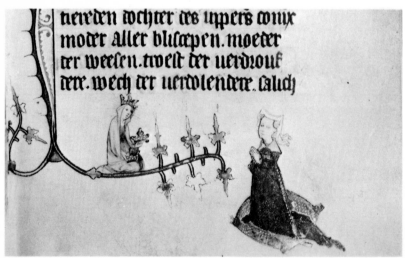

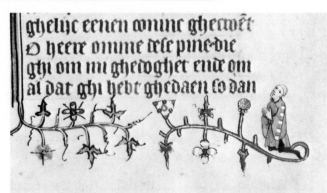

fields, identification of the Reverendus Pater J. Hervier has proved problematical. As indicated by the initials after his name, he was a member of the Marist order. The only Jean Hervier officially listed during the period under consideration was a professor reputed for his missionary zeal, but with no recorded artistic inclinations at any time during his life (1847–1900).[36] As for the other possible candidate, a Lyonnais *ciseleur* named Jean-François Hervier (1826–1900), no connection between him and the Marist order has so far been established. The individual in question may have been a Brother affiliated with the General House in the outskirts of Lyon near the hilltop pilgrimage church of Notre-Dame de Fourvière.[37] His anonymity notwithstanding, a reminder of his role as furnisher of the designs for the prayerbook is found in the initial "H" woven into the ends of the scrolls at the beginning and end of the volume (figs. 3, 11). Its contents reinforce the connection with the Marist order, which was founded in 1816 in Lyon. The city had been under the special protection of the Virgin Mary since 1643 and it thus comes as no surprise that the feast-day of her Nativity (September 8) is cited both in the archbishop Caverot's sanction and in the colophon. The dates 1886 and 1887 cited in these two places are more puzzling, since according to contemporary accounts the silk book took two years to complete after fifty trial essays.[38] Why was 1886 emphasized by Caverot and by the designer of the title page?

The explanation lies in the declaration of that year as a universal jubilee by Pope Leo XIII. More important yet, the Pope granted Lyon the right to celebrate its own jubilee. According to a tradition instituted by the establishment of the Feast of Corpus Christi at the Council of Vienna in 1311, the Cathedral of St.-Jean de Lyon celebrated a three-day jubilee whenever this feast fell on June 24, the regular feast-day of Saint John the Baptist. This happened extremely rarely. In point of fact, since 1311 there had been only four such jubilees prior to 1886, namely, in 1451, 1546, 1666, and 1734. Celebrated once every century, the jubilee following the one in 1886 was in 1943; the next one will be in 2038. Certain calendar requisites account for the rarity of the occasion: the year must begin on a Friday, it

18. *Hippolyte (Paul) Delaroche.* Hemicycle. *Replica of mural at the Ecole des Beaux-Arts, Paris. 1846–51. 1' 9 3/4" × 8' 5 3/8". The Walters Art Gallery, 37.83, Baltimore*

cannot be a leap year, and Easter must fall at the very end of the Easter cycle on April 25. When this is the case, the Feast of Corpus Christi falls on June 24, postponing the Feast of Saint John the Baptist by one day. The complexities involved in these calculations were incorporated in a popular jingle referring to the coinciding of the Feast of Saint George with Holy Friday, and of Easter with the Feast of Saint Mark. The rhyme has a noteworthy alternate last line:

Quand George Dieu crucifiera
Quand Marc le ressuscitera,
Et lorsque Jean le portera,
La fin du monde arrivera
[Grand jubilé or dans Lyon sera].[39]

One final contributing factor in the concatenation of events leading to the production of the woven *Livre de Prières* remains to be mentioned. On October 8, 1870, motivated by the course of the Franco-Prussian war, the clergy of Lyon repeated the vow of 1643 placing the city under the protection of the Virgin. In 1872, construction began on the basilica of Notre-Dame de Fourvière on the hill at whose base the Cathedral of St.-Jean was located. Providing a clear view of the entire city, the site had long been a hallowed destination for pilgrims, who came to worship a famous statue of the Virgin in a church built in successive eras on the site of an early medieval shrine. On the day of the pilgrimage, observed annually on September 8 in honor of the birth of the Virgin, the archbishop of Lyon and Vienne issued from this site a public benediction in commemoration of the vow of 1643.[40]

In summary, one may conclude that the extraordinary silk prayerbook was inspired both by the 1870 oath to the Virgin and by the anticipated 1886 jubilee year. By the beginning of 1880, when the projected volume was first offered to subscribers, plans must already have been well under way for the design of this production. Although the work was not completed on schedule, the archiepiscopal sanction and date on the title page leave no doubt as to the original intended date of issue. Civic pride doubtless also played a part in the planning of this publication, which was unlike anything hitherto produced by the finest craftsmen in the French capital. If this was indeed one of the underlying motivations, it succeeded nobly thanks to the skill of both the dedicated Marist priest, Jean-François Hervier, and of the operators of the Jacquard loom. The anonymity of the latter is one feature of the Lyon *Livre de Prières* that is incontestably within the medieval tradition.

*The Walters Art Gallery*

**Notes**

[1] H. W. Janson, with Dora Jane Janson, *History of Art*, 2nd ed., New York, 1978, 612, fig. 774, and Pl. 58.

[2] For an account of some of the principal works of this type, see Alan N. L. Munby, *Connoisseurs and Medieval Miniatures*, Oxford, 1972, 138 f. Carl Nordenfalk's introduction to his exhibition catalogue, *Color of the Middle Ages* (Pittsburgh, 1976), provides a succinct overview of the technical advances in the production of manuscript facsimiles in color during the nineteenth century. One ultimate development of "facsimile-

making" is amply demonstrated in the exhibition catalogue *The Spanish Forger* by William Voelkle, of the Pierpont Morgan Library (New York, May–July, 1978).

[3] A. Racinet, *Polychromatic Ornament*, London, 1873, 1–3.

[4] An apt example of conflicting opinions is cited in F. Calot, L.-M. Michon, and P. J. Angoulvent, *L'Art du Livre en France des Origines à nos Jours*, Paris, 1931, 188–90: "Il est des époques, qui, pour des raisons très complexes, n'ont pas de style et sont réduites, dans les arts industriels, à reproduire et à appliquer les différents styles des époques antérieures." Compare this quote from Alphonse Lemerre, *Le Livre du Bibliophile*, 1874, 24, with that of Maurice Denis, *Art et Critique*, August 30, 1890: "Je rêve d'anciens missels aux encadrements rhythmiques, de lettres fastueuses, de graduels, des premières gravures sur bois, qui correspondent, en somme, à notre complexité littéraire par des préciosités et des délicatesses!"

[5] Analogous manifestations in England are cited by Munby, *Connoisseurs*, 140 f.; see also Geoffrey Godden, *Stevengraphs and other Victorian Silk Pictures*, London, 1971. The Lyon *Livre de Prières* is one of half-a-dozen collector's items described in Georges Vicaire, *Manuel de l'Amateur de Livres du XIXe Siècle, 1801–1893*, V, Paris, 1904, 334–41. According to David Bland, "violent indigestion" is one reaction to compilations of chromolithographic reproductions from different manuscripts (*A History of Book Illustration*, London, 1958, 285).

[6] A notable early French facsimile of pages from a single manuscript is Engelmann and Graf's *Statuts de l'Ordre du Saint-Esprit*, 1853 [1854]. The illuminated model for the printed version, copied on parchment by Albert Racinet from MS fr. 4274 in the Bibliothèque Nationale, is in the Walters Art Gallery (350 × 275 mm). I am grateful to François Avril for confirming the number of this manuscript. Another notable manuscript publication, *Le Livre d'Heures de la Reine Anne de Bretagne* (Bib. Nat. MS

lat. 9474), was issued by L. Curmer in 1861.

[7] For a brief history and description of the collection, see Denys Sutton, "Connoisseur's Haven," *Apollo*, LXXXIV, 58 (December 1966), 422–33.

[8] Of special interest are Ferdinand Fabre, *L'Abbé Tigrave*, Paris, 1880, and *Catalogue of Illuminated and Painted Manuscripts*, Exhibition at the Grolier Club, New York, 1892.

[9] Henry Martin, *La Miniature Française du XIIIe au XVe Siècle*, Paris, 1923, Pl. 72. Alterations of borrowed motifs by nineteenth-century illuminators are discussed in Janet Backhouse, "The 'Spanish Forger,'" *British Museum Quarterly*, XXXIII, 1–2 (1968), 67–68.

[10] Jean-Baptiste Monfalcon, *Histoire de la Ville de Lyon*, Lyon, 1847, I, 165 f. Caverot was named bishop of Lyon in 1876 and elected cardinal the next year. According to information kindly supplied by Gabriel Vial, he died on January 23, 1887.

[11] The designs in the former were available in Curmer's facsimile of 1861 (see above, n. 6); the artist of the title page in Engelmann and Graf's *Livre d'heures* had access to the *Grandes Heures du duc de Berry* (see above, n. 9).

[12] Official approval by the archbishop of Paris, for example, is cited at the beginning of a *Livre d'heures* printed in Paris by Everat for Hetzel and Paulin in 1838 (Vicaire, *Manuel*, 334–35). A papal blessing by Pope Pius IX introduces Charles Rohault de Fleury's *Mémoire sur les Instruments de la Passion de Notre Seigneur Jésus-Christ*, Paris, L. Lesort, 1870.

[13] Bib. Nat. MS fr. 9198, fol. 19. Camille Couderc, *Les Enluminures des Manuscrits du Moyen Age (du VIe au XVe siècle) de la Bibliothèque Nationale*, Paris, 1927, 89–90, Pl. LXII. Also included in the reproduction of this miniature is an inscription citing the names of E. Moreau and G. Ledoux as the painters responsible for the preparatory set of illuminated parchment pages. The death of Moreau in 1878 provides a *terminus ante quem* for the *carton*. Its measurements are 250 × 242 mm,

slightly less than those of the printed plates with their wider margins (265 × 258 mm).

[14] Ff. 186, 160 × 112 mm. *Illuminated Books of the Middle Ages and Renaissance*, Baltimore, 1949, 47, no. 125; *The History of Bookbinding, 525–1950 A.D.*, Baltimore, 1957, 53, no. 125, Pl. XXXI; *Gent. Duizend Jaar Kunst en Cultuur*, Ghent, 1975, 356, no. 584. The Book of Hours may have been bought by Henry Walters at a Gruel sale in Paris (June 6, 1891, lot 3, with drawings reproducing fols. 165v and 168v).

[15] Gruel had a high esteem for these panels whose ornamentation with fleurs-de-lys and towers of Castile validated his suggestion of their origin from a manuscript made for Saint Louis. See his *Manuel historique et bibliographique de l'amateur de reliures*, Paris, 1887, 15, Pl. III.

[16] Abbé Victor Leroquais, *Les Sacramentaires et les Missels Manuscrits des Bibliothèques Publiques de France*, Paris, 1924, III, 194, Pl. XCV.

[17] I am greatly indebted to Nicole Marzac for help in identifying the following excerpts: "Ecce panis angelorum," "Factus cibus viatorum" (p. xx), and "O salutaris hostia" (p. xxi) from the hymns beginning "Lauda Sion salvatorum" and "Verbum supernum" in the Feast of Corpus Christi; "Da robur, Fer auxilium" comes from the prayer of the Holy Sacrament, and "Ite missa est" marks the end of the Mass (p. xxiv).

[18] John Pope-Hennessy, *Fra Angelico*, New York, 1974, fig. 29 (assigned to the Master of Cell 2).

[19] Gustave Gruyer, *Fra Bartolommeo della Porta et Mariotto Albertinelli*, Paris, 1886, 32, 77 (ill.).

[20] Pope-Hennessy, *Fra Angelico*, 15, Pl. 25. Cf. also Pls. 90, 92, 93 (fresco of the *Virgin and Child Enthroned with Saints* in the upper corridor of San Marco, Florence).

[21] *Ibid.*, 189–90, 215–16, Pls. 1, 127.

[22] Amply illustrated works with which Hervier could have been familiar include V. F. Marchese, *S. Marco convento dei padri predicatori in Firenze* (40 pls.), Florence, 1853, and J. A. Crowe and G.

B. Cavalcaselle, *New history of painting in Italy from the 2nd to the 16th century*, 3 vols., London, 1864–66. Wood engravings of Fra Angelico's individual works were also in circulation. A typical example is Léon-Louis Chapon's copy of *St. Louis of Toulouse and St. Thomas Aquinas*, exhibited in the 1878 Salon (no. 4776) along with other engravings commissioned by the *Gazette des Beaux-Arts*. The originals are reproduced in Pope-Hennessy, *Fra Angelico*, Pls. 90, 126. On the use of wood engravings for book illustrations, see Pierre Gusman, *La Gravure sur bois en France au XIXe siècle*, Paris, 1929.

[23] James H. Beck, *Raphael*, New York, 1976, 118, Pl. 20. The two-line inscription below the replica in the Lyon prayerbook is taken from verse 22 of the *Hymne d'actions de graces* a few pages later (xxxv f.). In 1880, Eugène Müntz published his monumental *Raphaël, sa vie, son oeuvre et son temps* (Paris, Hachette). The 155 textual illustrations and 41 separate plates were cited for their extraordinary merit by the reviewer for *Le Correspondant*, P. Douhaire (LXXXV, 1880, 1162–63). The Salons of the 1870s and early '80s regularly featured engravings after works by Raphael.

[24] John Shearman, "The Vatican Stanze: Functions and Decoration," *Proceedings of the British Academy*, LVII (1971), 17 f.

[25] *Paris Guide*, Paris, 1867, 869. I am indebted to William Johnston for supplying information on the replica of the *Hémicycle* in the Walters Art Gallery (.51 × 2.575 m; fig. 19). The names of all the artists are inscribed on the lower frame of the painting. Fra Angelico stands with his back to the spectator, Fra Bartolommeo dominates the group at the right, and the youthful Raphael in a cap is the third figure in from the right. On the impact of this work, see Francis Haskell, *Rediscoveries in Art*, Ithaca, N.Y., 1976, 9 f., Pls. 2, 5–7.

[26] John Harthan, *The Book of Hours*, New York, 1977, 174 (ill.).

[27] Michel-Alphonse Cartier, *Cours de la Théorie concernant la Fabrique des Étoffes de Soie*, Lyon, 1838–45, 2 vols. Manuscript on paper in the Walters Art

Gallery, 228 pp., 397 × 290 mm, 163 dr., 13 prints, 164 silk samples.

28 The most detailed contemporary account of the Lyon prayerbook, probably based on information supplied by the firm of J. A. Henry, cites the number of perforated cards as "plusieurs centaines de mille" (Paul Marais, "Note sur un Livre de Prières en Tissu de Soie," *Bulletin du Bibliophile* [1889], 164); 500,000 is the number given in a more generalized notice by Alfred Lailler, "Une Merveille Artistique: Notice sur un Livre de Prières tissé en soie," *Bulletin de la Société industrielle de Rouen*, 1890, 3. In a recent sale catalogue called to my attention by William Leugoud, the number is cited as 106,000 (Gilhofer and Ranschburg, no. 63, 1975, 97). On the preparation of these cards, see Bertram V. Bowden, *Faster than thought, a Symposium on digital computing machines: The invention of perforated cards by M. Jacquard*, London, 1953, 23, 350–51, 379–80. One of the best studies on the Jacquard technique, according to Rita Adrosko, Curator of Textiles at the Smithsonian Institution, is Paul Eymard's *Historique du métier Jacquard,* 3rd sér., Bk. 7, Lyon, 1863. A Jacquard loom and woven pictures produced by this method are on view at the Smithsonian Museum of History and Technology. A sample page (fig. 12) was kindly sent to me by René Truchot, head of the Lyon firm originally owned by J. A. Henry, to whom Gabriel Vial at the Musée Historique des Tissus in Lyon was good enough to forward my initial inquiry about the firm of Henry.

29 The same binding principle was often applied in purchases of incunabula. See Curt F. Bühler, *The Fifteenth Century Book*, Philadelphia, 1960, 81.

30 The only copy listed in an American collection is in the Newberry Library in Chicago (*National Union Catalogue*, CCCXXXVII, 15). Others exist in the Boston Museum of Fine Arts and the Ella Strong Denison Library in Claremont, California. For generous responses to my inquiries, I should like to thank Rita Adrosko, Larry Salmon, Jean Preston, and Adrienne Long, as well as François Avril, Janet Backhouse, and Gabriel Vial, who reported one copy each in the Bibliothèque Nationale, the British Library, and the Musée Historique des Tissus in Lyon. In addition to the one offered for sale in 1975 (see above, n. 28), two copies in private collections in Lyon and New York have come to my attention. I have recently learned that another copy was given to the Bibliothèque Nationale in 1980.

31 Lilian M. C. Randall, ed., *The Diary of George A. Lucas: An American Art Agent in Paris (1857–1909)*, Princeton, 1979, II, 678, 830, 846.

32 A drawing of the doublure kindly made for me by Adrienne Long, Reference Librarian of the Ella Strong Denison Library, enabled me to identify this volume with the initials "HW" as Henry Walters's own copy. The binding is signed and dated CH. MEUNIER 96. The book was sold for $45.00 in the auction at Parke-Bernet, *Four Centuries of French Literature . . . Collection of Mrs. Henry Walters*, New York, April 25, 1941, 236, No. 990 (described as a printed book). It was presented to the Denison Library in Claremont, California, by John J. Perkins in 1941.

33 Information supplied by René Truchot (see above, n. 28). The price compares favorably with that of a de luxe color facsimile of a *Livre de Prières* based on designs in Greek and Latin manuscripts. It was issued by B. C. Mathieu in Paris and cost 200 francs. A copy of this collector's item (Vicaire, *Manuel*, 340) in the Pierpont Morgan Library was kindly made available to me by Paul Needham.

34 Adrien Storck and Henri Martin, *Lyon à l'Exposition Universelle de 1889*, Paris, n.d., 84; see also 70 f., 106, for further examples of Henry's work.

35 Marais, "Note sur un Livre de Prières," 165–66. Publication around the turn of the century of a licentious *Livre d'heures satirique et libertin du XIXe siècle* (Brussels, n.d.) marks a deviant form of medieval-style prayerbooks issued in preceding decades.

36 For checking the records on this question, I am greatly indebted to Father J. Coste and Father Y. Gouget; other

questions on the Marist order were kindly pursued on my behalf by Ruth Dukelow, Nicholas Gendl, and Lewis Luks.

[37] Marius Audin and Eugène Vial, *Dictionnaire des Artistes et Ouvriers d'Art Lyonnais*, Paris, 1918, 429.

[38] Marais, "Note sur un Livre de Prières," 164.

[39] G. A. Heinrich, "Le Jubilé de Saint-Jean de Lyon," *Le Correspondant*, CVII, 1886, 1130. Excerpts from the Mass of Corpus Christi are woven into the borders of the silk book (see above, n. 17).

[40] See Louis-Léopold Bécoulet, *La sainte colline de Fourvière*, Lyon–Paris, 1860, and Ernest Richard, "Fourvière et les origines du culte de la Vierge," *Bulletin, Facultés catholiques de Lyon*, 1882, 7–27. Another useful study is *Histoire des églises et chapelles de Lyon* (intr. by S. G. Dadolle and J. B. Vanel), Lyon, 1908–9.

# 42

## *Van Gogh, Renouard, and the Weavers' Crisis in Lyon: The Status of a Social Issue in the Art of the Later Nineteenth Century*

LINDA NOCHLIN

Sometime during the winter of 1885, just about the time he began work on his monumental *Potato Eaters,* Vincent van Gogh wrote from Nuenen to his brother Theo: "You would greatly oblige me by trying to get for me: *Illustration* No. 2174, 24 October 1884. . . . There is a drawing by Paul Renouard in it, a strike of weavers at Lyon . . ." Van Gogh goes on to discuss other drawings by Renouard, and concludes: " . . . I think the drawing of the weavers the most beautiful of all; there is so much life and depth in it that I think this drawing might hold its own beside Millet, Daumier, Lepage."[1] The drawing in question must have meant a great deal to van Gogh, for he mentions it again in a letter to his brother a little later in the year: "I am sorry you did not send *L'Illustration,* for I have followed Renouard's work pretty regularly, and for many years I have saved up what he did for *L'Illustration.* And this is one of the most splendid which I think would delight you too."[2] Still later, van Gogh's tone of urgency deepens, as does the specificity of his description of the work in question: "Many thanks for the *Illustrations* you sent, I am much obliged to you. I think all the various drawings by Renouard beautiful and I did not know one of them.

"However—this is not to give you extra trouble, but because I wrote things about it which perhaps cannot quite be applied to other drawings of his—the composition to which I referred is not among them. Perhaps that number of *Illustration* is sold out. The breadth of the figure in it was superb; it represented an old man, several women and a child, I believe, sitting idle in a weaver's home in which the looms stood still."[3]

The drawing of the weavers in question recently came to light at a Paris art-dealer's (fig. 1), and it is indeed a beautiful and moving image, beautiful, that is to say, in van Gogh's peculiarly transvaluated sense of the word: awkward and unsettling in more conventional terms. Of course, it is important to realize that van Gogh was actually talking not about the original pencil drawing, but about

the masterly wood-engraving after it by Albert Bellenger (fig. 2).[4] It had appeared in the October 25, 1884, *L'Illustration* with the caption: *La Crise Industrielle à Lyon: Sans Travail,* and the subheading: "Dessin d'après nature de M. Renouard, envoyé spécial de *L'Illustration."* *Sans Travail* was second in a series of three eyewitness reports by Renouard of the contemporary crisis in the weaving industry of Lyon: the first of the series, *Un Canut à son Métier* (fig. 3), had appeared in the issue of October 18; and the third, *Une Réunion d'ouvriers aux Folies-Bergère* (fig. 4), did not appear until November 15.[5] Renouard's drawing is interesting for a variety of reasons, and on a number of levels: first of all, for the light it sheds on van Gogh and his predilections, formal and iconographic, in the middle '80s; secondly, as an art work in its own right, an outstanding example, rich in suggestive overtones and ambiguity, of the work of the once-illustrious draughtsman Paul Renouard, and, in its reproduced form, of the mass medium of wood-engraving by means of which his drawings were disseminated in the popular journals of the time; and finally, *Sans Travail* assumes significance as a document of the crisis in the weaving industry in Lyon in 1884, and, more generally, of the situation of manual workers in the nineteenth century, a situation in which the plight of the handloom weavers seems to have played an exemplary role, vividly commemorated in art and literature.

Charles Paul Renouard (1845–1924) was one of that group of cosmopolitan reporter-draughtsmen who made their living, and their substantial reputations, working for the illustrated journals of the day, a group which included the Englishmen Hubert Herkomer, Frank Holl, Luke Fildes, E. J. Gregory, and John Nash, and the Frenchmen Gustave Doré, Paul Gavarni, Félix and Guillaume Regamey, Auguste Lançon, and Jules Férat, as well as many others.[6] Their work appeared, skillfully reproduced by highly regarded wood-engravers, in such journals as *The Graphic,* perhaps the most socially committed of these publications and the one most favored by van Gogh, as well as in *The Illustrated London News, L'Illustration,* the journal with which Renouard was most consistently connected, *Le Monde illustré,* and *Harper's Weekly.*[7]

Renouard's production during the course of his long career was enormous and wide ranging. He dealt with all kinds of subjects, traveled to many countries—one critic dubbed him "le Juif-Errant de l'illustration"—and was attracted to all kinds of physical types and a wide spectrum of social classes. His oeuvre included numerous sketches of the world of entertainment, most notably that of the Opéra, which he also commemorated in an album of etchings, *Le Nouvel Opéra* of 1881; various aspects of public life—the Bourse, the Courts, the Navy, the Chamber of Deputies, and the American Congress; eyewitness reports of famous trials of the time, especially the Dreyfus case; and all sorts of "miscellaneous" subjects—children playing, guests at a working-class wedding, fashionable ladies taking tea, Queen Victoria's funeral, an orchestra leader in action, animals in motion; public ceremonies and private gestures. Yet perhaps the realm he preferred above all others, at least during the 1880s, the period that concerns us, was that of the poor and the oppressed, whether it be the working poor—miners, fishermen, artisans, and factory workers; or the scrofulous inhabitants of the *bas-fonds*—ragpickers, drunkards, slum-dwellers; or those existing on the margins of modern life, like the members of the Anarchist Club, or the down-and-out beggars of Ireland and England; or the lives of those too weak or twisted to make it on their own: the inmates of the Foundling Hospital, the prisons, the Home for the Blind, the old soldiers at the Invalides, or the mad people at La Salpêtrière. In addition,

*1. Renouard.* Sans Travail. *Drawing. Private collection, New York*

*2. Renouard.* La Crise Industrielle à Lyon : Sans Travail. *Wood-engraving by A. Bellenger*

*3. Renouard.* La Crise Industrielle à Lyon: Un Canut à son Métier. *Wood-engraving by A. Bellenger*

*4. Renouard.* La Crise Industrielle à Lyon: Une Réunion d'ouvriers aux Folies-Bergère. *Wood-engraving by A. Bellenger*

6

5. *Renouard.* Les Enfants Assistés: La Crèche. *Anonymous wood-engraving*

6. *Renouard.* Les Mines et les Mineurs: La Fin d'un Poste. *Wood-engraving by A. Bellenger*

7. *Renouard.* Cats, *from* Croquis d'Animaux

7

he illustrated Jules Vallès's novel of martyred childhood, *L'Enfant*, in 1881, and, in 1907, brought out his culminating masterpiece, *Mouvements, Gestes, Expressions*, a series of 200 etchings covering his various areas of expertise, animal and human: plates of rabbits, chickens, pigs, beetles, tigers, and kangaroos doing their thing; human beings engaged in gymnastics, music-making, fishing, or bathing; children playing, jumping, giggling, dancing; fashionable ladies in incredible hats strolling or gossiping, heads of state behind the scenes, politicians of the time flamboyant in high rhetorical gesture—especially vivid in the case of Gambetta and Rochefort—lawyers and their clients in action in the courtroom, the Salvation Army, scenes of London life.[8]

Renouard was admired as much for his technical innovations and formal daring as for the range of his subjects: indeed, almost from the beginning, form and content were seen as inseparable features of his modernity, his inimitable grasp of the spirit and substance of his own time. Considered a master of the on-the-spot sketch and the synoptic drawing style it demanded, he was appointed "professeur de croquis" at the Ecole des Arts Décoratifs in 1903.[9] For one critic, writing, it is true, well into the twentieth century, Renouard was the very inventor of a modern drawing style, the style demanded by the dynamism of contemporary life itself: "Cette facture moderne, Renouard l'a trouvée!" exclaimed Clément-Janin in 1922, making out the rather conventional virtuosity of the artist to be a sort of Futurism before the fact. "Il a inventé une forme rapide et colorée, pour ainsi dire, à fleur d'écriture. . . . C'est un *instantané de dessin*."[10] For still another early twentieth-century admirer, perhaps more realistic in his assessment of Renouard's quite genuine, if less innovative, abilities, he was a " 'journalist' in the very highest sense of the word," possessed of a "living style which expresses everything in a few lines, which notes the fluctuations of ideas, the movements, the characteristics, the gestures of his subjects. . . .";[11] and for still another, Renouard's drawings were characterized by "impeccable design and bold, firm impressionism."[12]

Vincent van Gogh was one of Renouard's earlier admirers, and a devoted one: he mentioned the artist more than twenty times in the course of his correspondence, first in the spring of 1882. By the autumn of that year, he wrote to his friend and fellow-artist Rappard, he already had about forty large and small reproductions of Renouard's work, including his *Bourse*, his *Discours de M. Gambetta*, and also some of the *Enfants Assistés* (fig. 5),[13] which he characterized as "superb" in a letter to Theo of the same period.[14] By the end of November 1882, he complained to Rappard that he had been unable to get hold of Renouard's *Miners* (fig. 6) despite all his efforts,[15] and more than a year later, in a letter to the same friend, he mentions that he is familiar with some sketches by Renouard of cats, pigs, and rabbits (fig. 7)[16] although he does not own any of them; he does, however, have in his possession Renouard's *Mendiants le jour de l'an*.[17] In the winter of 1885, shortly before requesting the drawing of weavers from his brother, he wrote Theo that he had received from Rappard a series of drawings by Renouard, *Le Monde Judiciaire*, types of lawyers, criminals, etc. "I do not know if you have noticed them," he remarks: "I like them very much. And I think he is one of the genuine race of the Daumiers and the Gavarnis."[18] Although van Gogh doesn't mention Renouard in his letters after 1885, his *Passage at St. Paul's Hospital* (fig. 8), painted as late as 1889, would seem to be a kind of homage, unconscious perhaps, to Renouard's *Blind Men* (fig. 9) from the latter's *Invalides* series of 1886, with its stark frontality and hauntingly empty vista.

Still, it is worth pointing out that van Gogh was anxious to differentiate *Sans Travail* from Renouard's other drawings. He was right to do so, for, as he himself pointed out, it is true that the things he says about it "cannot quite be applied to other drawings" of the artist.[19] *Sans Travail* coincides to a remarkable degree, both in form and content, with van Gogh's preoccupations, those of 1885 and of before and after this date. It also stands apart in Renouard's oeuvre.

The drawing represents a scene of enforced idleness in one of the domestic workshops, those individual units which, taken together, constituted Lyon's weaving industry. It is executed in pencil heightened with touches of black ink wash and accents of black chalk or crayon. Fairly large in scale (32.2 by 48.3 cm; $12^5/_8$ by 19 in.), the drawing is rich in the kind of graphic detail that seems to guarantee "documentary" authenticity, as well as lending itself admirably to translation into wood engraving. It is signed and dedicated in the lower right-hand corner: "à Monsieur Depaepe/ souvenirs affectueux/ P. Renouard," a dedication which has a certain significance in the interpretation of the work, as we shall see. The group represented would appear to consist of the "chef d'atelier" and his family, with one of the "compagnons," the hired laborers who assisted in the home workshops of the weavers, standing behind the seated old man. The written description accompanying the engraved version of the drawing in *L'Illustration* is fairly explicit about the critical situation depicted: "No work anywhere, and the scene, drawn from nature, which our engraving represents, is to be seen on almost every floor of the houses of the populous quarters of the city which is being so sorely tried: the Croix-Rousse, St.-Just, and the whole suburb of Lyon near La Guillotière. Our artist has taken us to the Croix-Rousse district, the staircase of the Carmélites. We are in a poor room where a whole family of old weavers lives: the father, the mother, and the widowed daughter with her child, a little girl . . . No more resources; soon no more bread. Here and there some furniture and looms, abandoned and covered with paper to preserve the working parts from dust. And that is all. To think that the house in which this family lives has 370 windows, that each of these windows illuminates a room, and that in each room, or nearly each one, a scene like this is taking place!"[20]

The scene indeed seems to be drawn from nature, and derives its strength from this fact, but there is something more to it than the accuracy of a good piece of reporting. First of all, the weavers are lending themselves, if modestly, to the enterprise, sitting for their portraits as though to a sympathetic local photographer rather than being seized or violated in their privacy. Secondly, the drawing style is remarkably free of just that exaggerated virtuosity, that flamboyant gestural impressionism so well suited to an art of seizure and appropriation, which captivated Renouard's admirers at the beginning of the twentieth century. On the contrary, Renouard's *facture* here seems to root his subjects to the spot with a kind of painstaking immobility. Certainly, there is no sense here of "une forme rapide et colorée" or "un instantané de dessin."[21] The formal language, like the mood of the drawing, is hushed, tensely meditative, still. Indeed, *Sans Travail* is remarkable for its intensity and concentration of vision, for the way the lot of this working-class family is at once so starkly individuated and yet so resonant with implications beyond its unique presence—*not,* it must be emphasized, diluted by the idealist generalization or the self-conscious quest for universality characteristic of more ambitious treatments of working-class subjects during the period. Indeed, the larger authenticity of the image is generated precisely by its concreteness and the modesty of its goals: the very sense that this much, this kind of detail is determined

8. *Van Gogh.* Passage at St. Paul's Hospital. *Museum of Modern Art, New York*

9. *Renouard.* Les Invalides: Les Aveugles. *Anonymous wood-engraving*

8

9

not by the author's will, or his aesthetic ambition, but by internal necessity. The result is a moving additiveness of effect, in which the very stiffness and angularity of the pencil strokes, the odd, off-beat near-symmetry of the composition, and the awkward, lumpy figure style are precisely what make the image so eloquent: virtuosity would have made it rhetorical; simplification, banal. Remarkable is the apparently deliberate *antigrazioso* of the traditionally glamorizing device of the *profil perdu* in the head of the left foreground woman,[22] and the way these working-class people, somewhat embarrassed, eyes cast down, not sure of what to do with their hands, are slant-rhymed against the minutely described, unpolished surfaces and staccato protuberances of the looms.

The potential emotional pull of deep space is at once suggested and deflected by the density of the foreground statement as opposed to the busy multiplicity of forms that fills the background. The seated old protagonist is defined and contained almost haphazardly by the wavery hatching of the timber beams to the left, behind, and to the right, an effect of surface tension perhaps more apparent in Bellenger's wood-engraved version of the image than in the original drawing (figs. 1, 2). One wonders how much this awkward yet expressively effective spatial truncation owes to the exigencies of the situation itself: once more the sheer force of necessity seems to play a role in the effectiveness of the drawing. Interestingly enough, it was van Gogh who articulated the nature of the problem: in early January 1884, he had written to Theo about his own practical difficulties in dealing with weavers. Remarking on the rarity of drawings of handloom operators, he observes, as a photographer might: "Those people are very hard to draw because one cannot take enough distance in those small rooms to draw the loom. I think that is the reason why so many drawings turn out failures."[23]

Throughout Renouard's drawing, this difficult reality is recorded with a line as caringly unbeautiful, as unstylishly differentiated, as the people and things it records, variegated pencil strokes urgently marking out sags and wrinkles, droops and bristles, splintery and worn-out surfaces, often in short, broken hatches, sometimes in contrasting long, wavering ones in an insistent graphic interplay especially evident in the engraved version. This brand of graphic integrity, united with an uncompromising confrontation of reality, must have struck a responsive chord in van Gogh. Indeed, his profound response to this drawing led him to a meditation on the necessary connection between confrontation of real life and the development of technical expertise or a "personal handwriting." In the same letter to his brother cited above, in which he first requested *Sans Travail*, van Gogh continues, after comparing Renouard's drawing with the work of Millet, Daumier, and Lepage:

> When I think how he rose to such a height by working from nature from the very beginning, without imitating others, and yet is in harmony with the very clever people, even in technique, though from the very first he had his own style, I find him proof again that by truly following nature the work improves every year.
>
> And every day I am more convinced that people who do not first wrestle with nature never succeed.
>
> I think that if one has tried to follow the great masters attentively, one finds them all back at certain moments, deep in reality. I mean one will see their so-called *creations* in reality if one has similar eyes, a similar sentiment, as they had. And I do believe that if the critics and connoisseurs were better acquainted with nature, their judgment would be more correct than it is now, when the

routine is to live only among pictures, and to compare them mutually. Which of course, is one side of the question, is good in itself, but lacks a solid foundation if one begins to forget nature and looks only superficially. . . . The most touching things the great masters have painted still originate in life and reality itself.[24]

In Renouard's drawing, then, van Gogh found the text for a little sermon on the superiority of nature over art in the creation of art itself, and the opportunity of administering a gentle admonition to those whose contradictory judgment controlled the art world.

Yet there were still further reasons attaching van Gogh to *Sans Travail*. The drawing clearly synthesizes, in a single image, two realms of subject matter which deeply moved him: the old, working-class man, and the weavers. The image of the weaver obsessed him during his stay in Nuenen. Writing to Theo at the beginning of January 1884, he states his preference for unworldly people, like peasants and weavers, rather than more civilized folk, praises his friend Rappard's earlier study of weavers, and states, succinctly and accurately: ". . . Since I have been here . . . I have been absorbed in the weavers."[25] Indeed, during his stay in Nuenen, mostly in 1884, he did over thirty studies of weavers in oil, watercolor, and drawing.[26] There is an ominous sense of projected anxiety—something distressing, claustrophobic—about almost all these representations of weavers, as well as those drawn in his letters at the same time: in most of them, the operative seems less in control of than entrapped by the complex mechanism of his loom, like a fly caught in the mechanical meshes of a giant, angular spider web. Van Gogh, in one way or another, seems to press his weavers, no matter how closely observed, into service as objective correlatives for his own overwhelming sense of isolation; it is not the weavers as a family group that occupy him so much as the solitary working weaver, more akin to the image presented by Renouard in *Un Canut à son Métier* (fig. 3).[27]

The image of the old, worn-out, working-class man so convincingly depicted by Renouard in *Sans Travail* attracted van Gogh for a longer period and more diversely. As early as 1882, at the Hague, he had embarked on his series of studies of "orphan men," "poor old fellows from the workhouse,"[28] figures which themselves recall Herkomer's treatment of old men in *Sunday at Chelsea Hospital*,[29] a work van Gogh knew and admired, a series perhaps culminating in the lithograph *Worn Out* of November 1882,[30] an image later transposed into a more heavily expressionist oil painting subtitled *At Eternity's Gate* in 1890.[31] But Renouard's old weaver is more self-controlled, less overtly despairing than van Gogh's, in no sense an orphan but a family man, stoical and dignified in his bearing. A similar sense of long-suffering self-respect, a self-respect bordering on secular sanctity, dignifies the old men whom van Gogh portrayed later in his career, figures like *The Père Tanguy* of 1887, *The Postman Joseph Roulin* of 1888, or *Patience Escalier, Shepherd of Provence* of the same year.[32] Indeed, there is a remarkable affinity between Renouard's old weaver in *Sans Travail* and van Gogh's old color-merchant, the Père Tanguy, although van Gogh has heightened the potential religious overtones by choosing absolute rather than near frontality; suggested Buddhistic affiliations in pose and setting; clasped the hands instead of resting them more matter-of-factly on the sitter's knees; and played up the halo-like propensities of the hat and Mt. Fuji. Still, it is *Sans Travail* which remains more naturally religious, as it were, an everyday icon of the modern man of sorrows, a man of sorrows

10

11

10. *Férat*. La Crise Lyonnaise: Intérieur d'un tisseur en soie. *Anonymous wood-engraving*

11. *Riis*. Mullen's Alley, New York City. *Photograph. Museum of the City of New York*

12. *Renouard*. Cité ouvrière. *Anonymous wood-engraving*

12

distanced from his fellow sufferers by greater age and loss, seated in helpless, puffy
dignity, twisted hands on wrinkled apron, respectfully regarded by his standing
dependents, worshipers who in some way threaten their object of devotion,
isolating him with claims of unfulfillable responsibility, as much as they pay him
homage.

The strength of Renouard's image, then, has to do with its secure and unlovely grasp, less sentimental than van Gogh's "orphan men" and more explicit than his later portraits, of what it meant to be old, out of work, and helpless to change the situation. As such, it is an image replete with painful contradictions: the family together but each member isolated, the space of work transformed into the arena of enforced idleness; the protective, paternal figure the most overtly helpless of all, as peripheral as the literally peripheral child and more hopelessly outmoded. The very details underscore in their way the larger contradictions: the useless apron— what is there to protect?; the useless glasses—what is there to see?; above all, the useless hands—what is there to weave?

Renouard's *Sans Travail* succeeds better as a document and as a work of art than other images of the 1884 weavers' crisis in Lyon, works like Férat's contemporary *La Crise Lyonnaise: Intérieur d'un tisseur en soie* (fig. 10), where the space is annoyingly dominated by the looms and the meager human interest thrust into a corner, rather than the two crucial elements being naturally united as they are in Renouard's version. In its effect of bitter constatation of the facts, of coming to grips with and uniting the actuality of the situation with its deeper and more unsettling implications without making a visible commentary on them, *Sans Travail* shares certain of the qualities of contemporary photographs of the lot of the down-and-out, like those of Jacob Riis (fig. 11), which themselves seem to echo the formal and iconographic patterns of top-quality Renouard productions of the period (fig. 12), in this case, the same head-on confrontation of the architecture of oppression peopled by a collaborating, rather than caught, cast of characters. The effect of sheer, phenomenological accuracy perhaps reaches its climax in Renouard's unexpected garbage still life (fig. 13) from the same series of images of slum life, a striking metonymy of the social status of poverty itself.[33]

*13. Renouard.* Garbage. *Anonymous wood-engraving*

*Sans Travail* also stands out from the other two works in Renouard's own "Industrial Crisis in Lyon" series. If he meant the three works as a unified sequence, with *Un Canut* showing the weavers peacefully at work, *Sans Travail* representing them out of work as a result of the industrial crisis, and *Une Réunion d'ouvriers* as the workers taking action to remedy the situation, then he failed of his purpose, for the total effect lacks dramatic coherence, or indeed, any sense of internal order or climax; on the contrary, these seem like three stylistically disparate—and disconnected—images; in addition, the two other drawings are weaker and less effective as individual works, and one is tempted to speculate on why this should be so. His first image, *Un Canut à son Métier* (fig. 3), is mere description despite its fairly effective angle of vision, more interesting from the point of view of affording information about the vanishing art of handweaving than for any other reason. His third work from the series, *Une Réunion d'ouvriers aux Folies-Bergère* (fig. 4), is overtly unconvincing, although it has some nice touches, like the slouching back-to figure in the foreground and the hat on the edge of the table; but it lacks not only the rhetoric of political engagement but even the energy of human conviction. One cannot help but compare the flabby gesture and downcast pose of the worker on the left with the energetic brio of the sculptural groups in the background: the irony is compounded by the fact that the group to the right is that very embodiment of revolutionary élan, Rude's *Departure of the Volunteers* on the Arc de Triomphe. The written account accompanying the engraving after Renouard's eyewitness drawing in *L'Illustration* suggests far greater drama than the lackadaisical unfocusedness of Renouard's image: "La séance a été fort tumultueuse et certains orateurs très violents dans leurs discours. . . . "[34] There is not a hint of either tumult or violence in Renouard's drawing, nor even of energy, unless he meant us to read it out of the iconographically innocent sculptural groups in the background. The artist clearly shies away from the representation of conflict, from the dramatic gesture or expressive manipulation of shadow by means of which Käthe Kollwitz was to emphasize her commitment to working-class objectives in almost identical subject matter a little more than a decade later, in her print cycle *A Weavers' Revolt* of 1894–98 (fig. 14).

Indeed one wonders, on the basis of the variation in quality in Renouard's series, and in comparison to Kollwitz's far more overtly class-conscious and activist weaver images, to what degree Renouard saw his weavers as representatives of a class at all, rather than merely as pathetic individuals. One might indeed surmise that it was the very innocuousness of the situation depicted in *Sans Travail*—workers not working but not doing anything about the situation in the form of threatening collective action—the unprovocative sense of individualism, singularity, and bearing with the situation inherent in the subject—that gave Renouard permission to conceive of it with such unhabitual depth of feeling: these people's very passivity permitted the artist an eloquent pictorial structure instead of a merely adequate one. For *Sans Travail* is ultimately a monument to the same kind of humanitarian, as opposed to political, attitude that characterized the work not merely of the popular illustrators of the time, but van Gogh's and Jacob Riis's contemporary responses toward the poor as well, a compassion that, in visual terms, postulates the workers and the poor as victims (a condition later softened by the euphemism "underprivileged")—staunch, enduring victims worthy of help and uplift, victims about whom something should be done, but victims nevertheless—rather than as class-unified activists fighting for their rights by means of revolutionary, collective political action, such as those depicted, however tragically, in Kollwitz's *A Weav-*

*14. Kollwitz.* A Weavers' Revolt: Deliberation. *Lithograph*

*ers' Revolt.* Images like Renouard's, van Gogh's, or Riis's, if they are in some sense a call to action—and certainly Riis meant his to be—depend ultimately on an appeal to the *conscience* of the prosperous and powerful rather than to the *consciousness*—the class consciousness—of the workers themselves: they are clearly reformist in their thrust, backed by a judicious dosage of salutory empiricism, rather than revolutionary.

The ambiguity of Renouard's attitude toward the weavers he depicts in his "Industrial Crisis in Lyon" series is compounded by the dedication inscribed on the original drawing of *Sans Travail*: "à Monsieur Depaepe: souvenirs affectueux." The "Monsieur Depaepe" in question must have been César de Paepe, a Flemish printer and prominent socialist who founded the Belgian Labor Party in 1885. De Paepe had been an active participant in the congresses of the First International from 1867 to 1870, and a collaborator in Europe's first overtly socialist newspaper, *L'Egalité,* founded by Jules Guesde in 1877. In 1884, the year of Renouard's drawing and dedication, he had signed an important manifesto in praise of Belgian Republicanism.[35] One cannot help feeling that Renouard was working under the pressure of unusual commitment when he created *Sans Travail,* and one cannot help wondering whether some of this commitment was generated by his relationship to the political activist, de Paepe, at the time; or perhaps, on the contrary, he felt that *Sans Travail* was a sufficiently forceful statement of his response to a major labor crisis to serve as an homage to an important labor leader like de Paepe on the eve of the latter's founding of the Belgian Labor Party. If *Sans Travail* represents the limits of the humanitarian, as opposed to the overtly political, imagery of the oppression of the working class, still, this vision may well have been given

added edge and tension by Renouard's involvement in contemporary labor history through de Paepe.[36]

Yet in considering the limits of Renouard's *engagement*, it must be stressed that the very nature of the 1884 crisis of the Lyon weavers was itself fraught with ambiguities and contradictions. On the one hand, the tocsin of ominous historical precedent sounded in the background. This was not the first time that a crisis had occurred in the Lyon weaving industry—far from it—and fifty years earlier the weavers had taken action. Still within living memory was the precedent of the revolutionary uprising of 1831, the so-called "Révolte des Canuts," the only "Mouvement de révolte corporative" of the time,[37] when the silkworkers, suffering from terrible working conditions combined with low wages and lay-offs, and perhaps stimulated by the ideals of the 1830 Revolution, after pressing their demands for a minimum wage, finally though briefly took over the city government. This insurrection was quickly put down by the army, and the hungry workers had to content themselves as best they could with the immortal words addressed to them by Casimir Perier, President of the Council, after the restoration of order: "Il faut que les ouvriers sachent bien qu'il n'y a des remèdes pour eux que la patience et la résignation."[38] The city had been shaken by various economic crises and conflicts since that time, most notably in 1848 and 1871, and had experienced a particularly severe crisis in 1877. By 1884, the attitude of the government, now Republican, was far from being as overtly hard-hearted as it had been in the 1830s in its reaction to the plight of the Lyon weavers: the workers were now permitted to organize openly, and the Waldeck-Rousseau Law of March 21, 1884, constituted an attempt at reconciliation. It provided for the establishment of professional unions and for discussion of the interests of workers and employers in a free forum. Nevertheless, the various workers' syndicates quickly united to form a weapon of combat: their mission in a sense remained that of the rebels of 1831, to obtain a minimum wage

*15. Ryckebusch.* Les Industries qui disparaissent: Un Tisserand.
*Anonymous wood-engraving*

from the manufacturers.[39] Even when the crisis deepened in the autumn of 1884, the Government remained conciliatory, perhaps because the press, and presumably public opinion, was so sympathetic to the workers: in October 1884 it sent to Lyon a forty-four man parliamentary commission to study the situation of the unemployed weavers. The commission, however, reported that the suffering of the Lyon workers had been much exaggerated by the sensational articles appearing in the press, and maintained that the silk industry was merely experiencing one of those periodic crises that had dogged the steps of its history, crises "inseparable from the life of a great industry subject to the vagaries of an international market."[40]

But the situation of the Lyon weavers—part strike, part lay-off, not quite either—depicted by Renouard was complicated by factors more integral and concrete than the vagaries of the international market: these weavers were, in fact, representatives of a dying system of manufacture and an outmoded technology. They were handloom operators in a period of increasing mechanization; and they worked in small, individual workshops rather than in more centralized and efficient factories. They were, in short, home-based artisans of a dying trade. Indeed, the handloom weaver had been represented as a prime example of "Industries that are disappearing" (fig. 15) in a series of illustrations published by *L'Illustration* in 1881, an engraving by Ryckebusch duly collected by van Gogh.[41] The *chefs d'atelier* of these little workshops, like the old man represented by Renouard, occupied an anomalous position somewhere between employer and employee; dependent for their meager existence on the whims of the market and the exigencies of the *fabricant* who farmed out the raw materials and paid for the finished product, they were yet at the same time independent and proud of their skill. In the words of one spokesman of the period: "Le tisseur lyonnais travaille sous le régime de la liberté absolue. Il n'est pas un ouvrier d'usine, pour rien au monde il ne voudrait abdiquer sa liberté; c'est une sorte d'artiste, il aime garder son indépendance, traiter avec le fabricant de puissance à puissance, être maître de son modeste atelier, plutôt que de goûter à la sécurité des travailleurs d'usines."[42]

The image of the long-suffering handloom weaver, oppressed yet feisty—struggling for his right to a modest livelihood of independent craftsmanship against savage odds of local exploitation and increasing mechanization, threatened by international competition, brutal reprisals, and outright starvation—appears again and again in the work of socially conscious writers and artists in the nineteenth century. As early as 1831, Mme. Desbordes-Valmore had penned a heartfelt tribute to the workers of Lyon, "Dans la Rue: Par Un Jour Funèbre de Lyon";[43] and in 1877, on the occasion of another industrial crisis among the Lyon weavers, Victor Hugo, addressing a meeting at the Château-d'Eau held in their aid, declared that Lyon itself was the essentially French city, the Lyon worker the quintessentially French worker: "C'est la ville du métier," he maintained, "c'est la ville de l'art, c'est la ville où la machine obéit à l'âme, c'est la ville où dans l'ouvrier il y a un penseur, et où Jacquard se complète par Voltaire . . . " "The worker of Lyon is suffering," Hugo asserted, "poverty creating riches."[44] In England, George Eliot had dealt with the plight of the handloom weaver in *Silas Marner,* published in 1861, and had touched on the subject briefly in the introduction to her "political" novel of 1866, *Felix Holt: The Radical,* in which she describes "the pale, eager faces of handloom-weavers, men and women, haggard from sitting up late at night to finish the week's work . . ."[45]

It was in Germany, however, that the fate of the weavers received its most significant artistic formulation. One relatively minor incident, the uprising of the Sile-

sian weavers of 1844, provided the major artistic expressions of sympathy and out-
rage. Poets like the socialist Ferdinand Freiligrath in his *Aus dem Schlesischen Ge-
birge,* or, more unexpectedly, the conservative Emanuel Geibel in his *Mene Tekel,*
commemorated the event, as did Carl Hübner, the Düsseldorf painter of socially
conscious genre scenes in his ambitious *Silesian Weavers* of 1844. The most
powerful of these earlier responses, which has been termed "Germany's greatest
social lyric," is Heinrich Heine's *The Silesian Weavers* (inspired by the account of
the uprising that the poet read in June 1844 in Karl Marx's *Vorwärts* in Paris), a
bitter and relentless poem, with its stark refrain "Wir weben, wir weben!"[46] The
most extensive imaginative response to the Silesian weavers' uprising, however,
was Gerhart Hauptmann's moving drama, *Die Weber,* published in 1892, a play
which, although inspired by the 1844 uprising in Hauptmann's native province,
was even more directly related to a trip its author made to the Silesian villages in
the Eulenbirge in 1891 to refresh his boyhood memories and talk to eyewit-
nesses.[47] The circumstances of the weavers in the last decade of the century seemed
as bad as they had been fifty years before, and many people who first read or saw
the play, which was quickly forbidden on the stage by the government, believed the
misery depicted in it was based on contemporary newspaper articles.[48] The con-
temporary, rather than the merely historical significance of the weavers' tragedy
represented in Hauptmann's drama no doubt inspired the imagery of the French
Anarchist artist Henri Gabriel Ibels, in his poster for the French production of the
play at the Théâtre Libre in 1892–93.[49] And no doubt it was the contemporary
relevance of Hauptmann's play that inspired Käthe Kollwitz, when she saw its
first performance in Germany by the Freie Bühne, to undertake her *A Weavers'
Revolt* cycle, six plates, three lithographed and three etched, which brought the
young artist her first great success when they were exhibited in Berlin in 1898.
Kollwitz, following Hauptmann but also basing her imagery on her own research
and her own interpretation of the meaning of the weavers' struggle, resorts neither
to van Gogh's self-preoccupied individualism nor to Renouard's eyewitness objec-
tivity in her version of the weavers' situation. Her cycle begins and ends with stark,
unremitting tragedy, but the three central plates, *Deliberation, Weavers on the
March,* and *Attack,*[50] show the weavers, downtrodden and starving though they may
be, making decisions and taking collective action against their oppressors; even in
*The End,* her print of the tragic aftermath showing the rebels' corpses brought home
to their desolate cottage, the figure of the surviving woman, though tragically
isolated, exhibits a kind of desperate resolution rather than mere resignation.
Kollwitz deliberately altered the woman's original gesture of hand-clasping ac-
ceptance in an earlier version to that of clench-fisted determination in the final
print.[51]

Renouard's drawing, then, is interesting in a number of ways, both in relation
to van Gogh, who admired it, and in what it reveals about the limits of political
expression in the art of the popular press. This study may also suggest that we re-
think the actual position of van Gogh vis-à-vis journalistic illustrators like Re-
nouard. Instead of seeing van Gogh as the important creative artist and the illus-
trators simply as aesthetically negligible minor sources of his inspiration, perhaps
it would be more realistic to think of them all as fellow art-workers, interested in
the same subjects, moved by similar humanitarian impulses, moving within certain
acceptable limits of engagement, and interested in developing similar naturalistic and
expressive techniques, in exploiting the possibilities of certain innovative formal
devices, akin to those of contemporary documentary photography, to achieve their

effects. Van Gogh himself wished to join the brotherhood of graphic artists he so deeply admired. When he wrote to his brother in February 1882, asking him to find out what kind of drawings the magazines would take, and continuing, "I think they could use pen drawings of types from the people, and I should like so much to make something that is fit for reproduction,"[52] there is no reason to doubt his sincerity; nor again, when he writes from The Hague in 1883, ". . . Painting is not my principal object, and perhaps I will be ready for illustrating sooner all by myself than if somebody who would not think of illustrations at all advised me."[53] Part of his closeness during these early years to an artist like his fellow countryman Anthon Rappard is doubtless based on their shared admiration for draughtsmen like Herkomer, Holl—or Renouard. If his ambitions later changed and his formal language altered, it was perhaps more Paris and the impact of its potent avant-garde, rather than some kind of innate genius, that was responsible.[54]

Renouard's stock has, of course, dropped drastically in recent years, as has that of all the illustrators who were once so greatly admired by a broad spectrum of the public: their work is generally dismissed as sentimental naturalism, if it is considered at all, irrelevant to mainstream aesthetic achievement; that of photographers doing more or less the same thing, like Riis and Hine, and much later, Walker Evans, has, paradoxically risen. Van Gogh's reputation has of course soared sensationally since the '80s, while Kollwitz has been dismissed by sophisticated criticism as aside from the point, although her work has always been admired by those who demand explicit statement of feeling and obvious political commitment in art. Whether these relative positions in the history of art are due to purely aesthetic decisions or to the pressure of more complex social and political mediations, or to the interaction of both, I leave the reader to decide.

*The City University of New York*

# Notes

[1] Vincent van Gogh, *The Complete Letters*, Greenwich, Conn., 1959, II (393), 346–47.

[2] Van Gogh, *Letters*, II (388b), 339, which should probably be dated after, rather than before, no. 393 on the basis of internal evidence.

[3] Van Gogh, *Letters*, II (394), 348–49. I have combined elements from both the English and French translations of this letter.

[4] Albert Bellenger, born 1846, was a member of a family of distinguished wood-engravers, whose work appeared in the *Magazine of Art*, *Le Monde illustré*, and *L'Art*, as well as in *L'Illustration*, where he was the last "graveur attitré." For an account of his achievements, and a view of the high esteem in which members of this profession were held generally, see Pierre Gusman, *La Gravure sur Bois en France au XIXᵉ Siècle*, Paris, 1929, 24–26, 48, 201.

[5] Only the first of the series, *Un Canut à son Métier*, has previously been published, in relation to van Gogh's images of weavers. There is a tendency to confuse this work with the one that van Gogh actually requested from his brother, *Sans Travail*. See, for example, Charles Chetham, *The Role of Vincent van Gogh's Copies in the Development of His Art*, New York, 1976, n. 104, 242; and *Les Sources d'inspiration de Vincent van Gogh* (exh. cat.), Paris, Institut Néerlandais, 1972, No. 82.

[6] For information on and bibliography about these illustrators, see *English*

*Influences on Vincent van Gogh* (exh. cat.), University of Nottingham, 1974–75, esp. 48, although this work is concerned mainly with English illustrators.

[7] *Anthon van Rappard: Companion & Correspondent of Vincent van Gogh: His Life & All His Works* (exh. cat.), Vincent van Gogh Museum, Amsterdam, 1974, 43.

[8] Paul Renouard, *Eaux-Fortes, Mouvements, Gestes, Expressions*, Paris, 1907. Renouard had been a student of Pils, and collaborated with his teacher on the ceilings of the Opéra in 1875. There is no recent monograph about his work. It was Béraldi who called him the "Wandering Jew" (Henri Béraldi, *Les graveurs du XIXᵉ siècle*, Paris, 1885–92, XI, 188).

[9] Michel Melot, "Paul Renouard, Illustrateur," *Nouvelles de l'estampe*, No. 2 (Feb. 1971), 71. Renouard's style had been admired as early as 1874 by Eugène Veron, in an article in *L'Art*. See Chetham, *Copies*, 136 and ns. 123 and 124.

[10] Clément-Janin, "Paul Renouard," *Print Collector's Quarterly*, IX (1922), 140.

[11] Gabriel Mourey, "A Master Draughtsman: Paul Renouard," *The International Studio*, X (1900), 166.

[12] Alder Anderson, "Some Sketches by Paul Renouard," *The International Studio*, XXIII (1904), 225.

[13] Van Gogh, *Letters*, III (R14N), 334. For references to the *Enfants Assistés* series, see also specifically (R29), 367, where he mentions *La Crèche* and *Le Change*.

[14] Van Gogh, *Letters*, I (250), 500.

[15] The *Miners* was reprinted in *L'Illustration* of 1886 (LXXXVII), 73. Also see van Gogh, *Letters*, III (R19), 345.

[16] It is in these works that the influence of Japonisme on Renouard's drawing style comes out most clearly. Significantly enough, it was a Japanese art lover, Tadamasa Hayashi, who put together a complete collection of Renouard's works, which he willed to the Tokyo Museum, where they were exhibited in a special gallery. See Melot, *Nouvelles*, 70, and *Catalogue d'une collection de dessins et eaux-fortes par Paul Renouard . . . offerte par Tadamasa Hoyashi* [sic] *à un*

*Musée de Tokio, mai, 1894.*

[17] Van Gogh, *Letters*, III (R30), 372.

[18] Van Gogh, *Letters*, II (389), 341.

[19] See above, p. 669.

[20] "La Crise Lyonnaise," *L'Illustration*, LXXXIV, Oct. 25, 1884, 267.

[21] See above, p. 673 and n. 10.

[22] And think of what Ingres would have done with the bulge of that shawl; even Millet would have muted such offensive realism. Only van Gogh goes this far in rendering homeliness, and he, of course, perceives it as moral beauty, which is not quite the same thing.

[23] Van Gogh, *Letters*, II (351), 250.

[24] Van Gogh, *Letters*, II (393), 347–48. For a similar point made about Renouard's style by Véron in 1874, see above, n. 9.

[25] Van Gogh, *Letters*, II (351), 250. Chetham, *Copies*, 117, suggests that van Gogh's interest in weavers may have been stimulated by his devotion to the novels of George Eliot, particularly *Felix Holt* and *Silas Marner*, "both of which dealt with the effects of the industrial revolution on weavers." While this may be true of *Silas Marner*, there seem to be no more than two sentences at the beginning of *Felix Holt* about the subject.

[26] The letter "F" in the list of representations of weavers that follows refers to the catalogue numbers in J.-B. de la Faille, *The Works of Vincent van Gogh: His Paintings and Drawings*, rev. ed., New York, 1970. Paintings: F24, F26–27, F29–30, F32–33, F35, F37, F162. Watercolors and Drawings: F1107–12, F1114–16, F1116a (verso), F1118–25, F1134, F1138, F1140.

[27] But van Gogh painted the work that comes closest to *Un Canut*, *The Loom*, F30, in May 1884, before Renouard had even made his drawing. Renouard's group did, however, inspire a painting by the Norwegian naturalist Sven Jorgensen: *Out of Work*, of 1888, Oslo, National Gallery, is clearly derived from *Sans Travail*.

[28] Van Gogh, *Letters*, III (R14), 334–35.

[29] This had appeared in the *Graphic* of Feb. 18, 1871. See *English Influences*, fig. 25, and also another variant of the

same work, which Herkomer also did as a painting, *The Last Muster* of 1875 that van Gogh owned a copy of. For Renouard's interest in the same theme of the old soldier-pensioner, see his series of the pensioners at the Invalides, *L'Illustration*, LXXXVIII (1886), 124–25; 128–29; 137; 144, 145; and our fig. 9.

[30] F1662. Also see *English Influences*, fig. 109.

[31] F702. Also see the drawings F997–98.

[32] *The Père Tanguy*, F363, F364; *The Postman Joseph Roulin*, F432; *Patience Escalier*, F443, and more apposite, F444.

[33] Riis's photographs were converted into line drawings when they appeared in the story "How the Other Half Lives" in *Scribner's*, Christmas 1889. Riis, like future documentary photographers, complained bitterly about the way his subjects insisted on posing when *he* wanted a candid picture: "Their determination to be 'took' the moment the camera hove into sight, in the most striking pose that they could hastily devise, was always the most formidable bar to success I met." See Alexander Alland, Sr., *Jacob A. Riis: Photographer & Citizen*, Millerton, N.Y., 1974, 28, 29. The impact of documentary photography on popular illustration and of the latter on the former has not yet been studied systematically as far as I know.

[34] *L'Illustration*, LXXXIV (Nov. 15, 1884), 318.

[35] See Walther Thibaut, *Les Républicains Belges* (1787–1914), Paris, n.d., 90–91; L. Bertrand, *César de Paepe, sa vie, son oeuvre*, 1908; M. Oukhow, "Cesar de Paepe en de groei van het sociale bewustzijn in Belgie," *Socialistiche Standpunten* (1962, no. 1), 76–90; J. Kuypers, "César de Paepe van de Nederlands gezindheid van een internationalist," *Nieuw Vlaams Tijdschrift*, 18 (1965), 150–81; as well as the entry on de Paepe in *Encyclopedie van de Vlaamse Beweging*; I am grateful to Kirk Varnedoe for this information. For further information about de Paepe, his activities in the International, and his radical but non-Marxist position on labor, war, and various social issues, see Edouard Dolléans, *Histoire du mouvement ouvrier*,

Paris, 1936, I, 303, 312–13, 314, 335, 347; and 1939, II, 20. Renouard's connection with Belgium continued, albeit on a very different level, into the twentieth century. He was the artistic director and contributed most of the lithographed plates to the sumptuous limited-edition volume commemorating the 75th anniversary of Belgian independence, *En Commemoration des Fêtes du LXXVe Annéversaire de l'Indépendance de la Belgique et de L'Exposition Universelle de Liège, 1905*, Liège, 1905, which was dedicated mainly to flattering images of the aged King Leopold II and members of the royal household.

[36] Of course, we do not know exactly how much freedom Renouard had in choosing particular aspects of his assignments. The editors must have made general suggestions, but how far Renouard could go in emphasizing a personal viewpoint, or indeed how far he wished to go, is open to question. Nor is it clear whether the commentaries that accompanied his drawings were written before or after, or in collaboration with the draughtsman's report.

[37] See Dolléans, *Histoire*, I, 58.

[38] For a detailed account of the Lyon uprising of 1831, though by no means an objective one, see Auguste Baron, *Histoire de Lyon pendant les Journées des 21, 22, et 23 Novembre 1831*, Lyon, 1832.

[39] E. Pariset, *Histoire de la Fabrique Lyonnaise: Etude sur le Régime social et économique de L'Industrie de la Soie à Lyon, depuis le XVIe siècle*. Lyon, 1901, 395–96.

[40] *Bulletin des Soies et des Soieries de Lyon: Organe internationale de l'industrie de la soie*, Oct. 18, 1884, 2.

[41] *Les sources d'inspiration*, No. 95, 26.

[42] Mathé Ainé, *Les Tisseurs en soie de Lyon, 1769–1900*, Lyon, 1900, 59–60. Also see M. Villermé, *Tableau de L'Etat Physique et Moral des Ouvriers employés dans les manufactures de coton, de laine et de soie*, Paris, 1840, I, 352–99, for the physical condition of Lyon workers somewhat earlier in the century; and Y. Lequin, "Classe ouvrière et idéologie dans la région lyonnaise à la fin du XIXe siècle," *Le Mouvement Social*,

Oct.–Dec., 1969, for growing political self-consciousness. Lequin's *Les Ouvriers de la région Lyonnaise (1848–1914)*, 2 vols., Lyon, 1977, is the essential study of the workers of Lyon.

[43] *Oeuvres choisies*, ed. F. Loliée, Paris, n.d., 201–2. Also see Desbordes-Valmore's letter to Gergerès on the Lyon uprising, Nov. 29, 1831, Lyon, 262–65.

[44] Victor Hugo, "Les Ouvriers Lyonnais," Sunday, March 25, 1877, in *Oeuvres politiques complètes: Oeuvres Diverses*, ed. F. Bouvet, Paris, 1964, 755–56.

[45] George Eliot, *Felix Holt: The Radical*, Boston, 1896, I, 7–8.

[46] F. Ewen, ed., *The Poetry and Prose of Heinrich Heine*, New York, 1948, 38.

[47] Hauptmann also made use of Alfred Zimmermann's *Blüte und Verfall des Leinengewerbes in Schlesien*, Breslau, 1885. See Margaret Sinden, *Gerhart Hauptmann: The Prose Plays*, Toronto, 1957, 53.

[48] Sinden, *Hauptmann*, 69.

[49] See Gabriel Weisberg, *Social Concern and the Workers* (exh. cat.), Utah Museum of Fine Arts, Salt Lake City, 1974, 32 and Nos. 29, 79. However, the plate reproduced there seems to be of miners rather than weavers.

[50] See Otto Nagel, *Käthe Kollwitz*, Greenwich, Conn., 1971, figs. 21 (lithograph, 1898, Kl 36), 22 (etching, 1897, Kl 32), and 23 (etching, 1897, Kl 33).

[51] See Nagel, *Kollwitz*, fig. 31 (Sketches and Study for the Print *The End*, c. 1897, Dresden, Print Cabinet), where the artist's final choice of gesture is made explicit in the lower margin.

[52] Van Gogh, *Letters*, I (174), 313.

[53] Van Gogh, *Letters*, II (292), 56.

[54] See B. Welsh-Ovchĕrov, *Vincent van Gogh, his Paris Period, 1886–1888*, Utrecht and The Hague, 1976.

# 43
# Rodin, Dalou, and the Monument to Labor

JOHN M. HUNISAK

No other monument conceived by Auguste Rodin is as little known as the *Tower of Labor*. What survives from this vast undertaking is a plaster maquette (figs. 1, 2) preserved at the Musée Rodin in Meudon.[1] Among Rodin's works, it is an anomaly; its conception is architectural, and sculpture plays an ancillary role in the formal and symbolic schema. Although this monument was the single most ambitious project of Rodin's long career, it has been almost totally forgotten since his death.

The proportions of this monument would have been colossal, and its symbolism both optimistic and visionary. In this apotheosis of human labor and creative endeavor, Rodin designed the last and most grandiose example of a kind of monument peculiar to nineteenth-century sensibility, a monument to an abstract or generalized conception. As such, it shares a close affinity with works like Bartholdi's *Liberty* in New York Harbor or Bartholomé's *Monument to the Dead* in Père Lachaise Cemetery in Paris.

Given the importance which Rodin and many of his contemporaries attached to this monument, the lack of recent attention paid to it is puzzling.[2] It has been dismissed as "an unimaginative and outmoded conception,"[3] and simply ignored when assessing Rodin's later career. Although Rodin conceived the *Tower of Labor* in 1898 and was actively involved with it more than a decade later, it has been claimed that he lost interest in the creation of monumental work after the difficulties with his *Balzac*.[4] This is simply untrue.

One may argue that the *Tower of Labor* is an unresolved work[5] or that it is qualitatively equivocal, but one cannot deny the importance which Rodin attached to it. His German assistant, Victor Frisch, claimed that it was a frequent topic of discussion and recorded the following statement by Rodin:

> Every epoch, episode, activity, and religion of a race is transmitted to posterity by a monument to its ideal. From these monuments we can judge not only the progress of humanity, but the character of various countries and centuries.
>
> Although our time is richer than any other, in productive work in all fields of human activity, we have not yet given to those that will come after us a memorial to this great period of our own. Under what sign does our age stand? It is work that has made our time forever great. And to this work I have tried to erect a monument, to the ideal of our epoch, to the spirit of labor.[6]

There is further evidence which indicates that Rodin regarded the *Tower of Labor* as the most significant work of his career, a modern equivalent to the medieval cathedrals of France. In an interview of 1898, Rodin stated: "If it will be realized as I hope and plan it will be, the monument which emerges will dominate all those of the century. . . ."[7]

In his belief that the most appropriate monument to commemorate modern times would be a monument to labor, Rodin was not alone. Jules Dalou, the second great sculptor of later nineteenth-century France, had envisioned a comparable monument as his *magnum opus*.[8] Dalou's notion was even more emphatic than that of Rodin; for him, labor was "the cult to replace past mythologies,"[9] and his monument would have provided tangible glorification of that cult.

Their intentions may have been grandiose and high-minded, but neither sculptor saw his monument built. Nor did a subsequent generation erect them. Although their projects were consonant with beliefs of the late nineteenth century, neither Rodin nor Dalou anticipated the sensibility that would dominate twentieth-century attitudes toward monuments and the commemorative function of art.

The notion of a monument to labor seems intrinsically and unmistakably political, but this was not the case. The fact that both an ardent socialist like Dalou and a man as indifferent to political issues as Rodin could envision such a monument discredits any specifically political interpretation of these works.[10] This is not to say that Dalou's *Monument to Workers* and Rodin's more generalized *Tower of Labor* do not convey personal and deeply held attitudes of each artist toward work. It does mean that Dalou's statement that such a monument was "in the air"[11] reflects the actual situation of the 1890s.

Politics, literature, and art had all contributed to make the worker a central motif from the late 1870s onward. Familiarity had long since diffused the political implications attached to realist worker imagery during the 1840s and 1850s. Workers had once been made "acceptable" by genre treatment, or by classical poses or timeless nudity (figs. 6, 7); such figures bore no resemblance whatever to their counterparts in contemporary life or, by implication, in contemporary politics. This situation changed dramatically during the two decades preceding the projects of Rodin and Dalou. Sympathetic representations of workers who were believable and contemporary human beings (fig. 8) appeared frequently and with great success in the Salons. Even such a potentially explosive contemporary theme as a miners' strike (fig. 9) was exhibited and received enthusiastically.[12]

Although painters led the way in making sympathetic worker imagery acceptable, sculptors joined them in due course. Most significantly, in 1886 the Belgian sculptor Constantin Meunier sent his first statue of a worker to Paris for inclusion in the Salon. Thereafter, he exhibited such sculptures on a regular basis. A statement by the critic Leprieur can be seen as an index to this sensibility of the later 1880s. When reviewing the Salon of 1888, he observed that the glorification of work occupied many contemporary artists. He also noted that, while gathering material for their imagery, these artists had traveled ". . . from factory to factory and from atelier to atelier with a conscientiousness worthy of the Encyclopedia Roret."[13] There can be no question that contemporary workers had become acceptable subjects for both painters and sculptors.

The frequency of this new worker imagery in French art was a direct reflection of contemporary history. Following the formation of the First International in 1864, there had been a proliferation of workers' congresses throughout France. The International Exposition of 1878, held in Paris, was designated as "An Inter-

1. *Rodin*. Tower of Labor, *maquette. 1898. Plaster. Musée Rodin, Meudon*

2. *Rodin*. Tower of Labor, *maquette (another view). Musée Rodin, Meudon*

3. *Rodin*. Tower of Labor, *column relief*

5

4

4. *Dalou.* Monument to Workers, *first maquette. c.1894. Plaster. Musée du Petit Palais, Paris*

5. *Dalou.* Monument to Workers, *third maquette. 1897–98. Plaster. Musée du Petit Palais, Paris*

6. *Chapu.* Sower. *Salon of 1865. Bronze. Formerly Parc Monceau, Paris*

6

national Festival of Peace and Labor." In May 1891, Pope Leo XIII issued his widely read and discussed encyclical, *Rerum Novarum*, concerning the working-man and mutual obligations between labor and capital. Beginning in 1892 and culminating in the legislation of 1906, French workers received a series of legal guarantees concerning child labor, maximum hours for the working day, and one compulsory day of rest per week. The monuments proposed by Rodin and Dalou can, therefore, be understood as straightforward acknowledgment of and response to a given contemporary situation. The role of monument-makers had always been to provide tangible celebration of ideas which had attained the status of consensus, and we can rightly view these projects as traditional responses to an idea whose time had come. The lack of any particular political suggestiveness is reinforced by the fact that, in spite of widespread discussion of these proposed monuments in the contemporary press, *La Revue Socialiste* never once saw fit to comment on these projects glorifying contemporary labor.

The actual circumstances under which Rodin and Dalou came to plan their monuments were very different. In neither case did an official commission ever exist. Dalou's decision was a direct outgrowth of personal belief and had no external stimulus. Although Rodin became totally engrossed in his plan for the monument, the initial idea was not his own, but the suggestion of Armand Dayot, a critic, historian, and *inspecteur des beaux-arts*.

On March 21, 1898, Dayot published an open letter, "To the glory of labor. Letter to a sculptor," which appeared on the front page of *Le Journal*. This letter was addressed to the sculptor Jules Desbois and made public announcement of a project which the two had first discussed about six weeks earlier. Beginning with the notion that creative forces of modern civilization should be celebrated just as military conquest had been commemorated in the past, Dayot suggested building a monument "to the glorification of human labor" to coincide with the Universal

*7. Guillaume.* Reaper. *1849. Bronze. Louvre, Paris*

8. *Lhermitte.* La Paye des Moissonneurs. *Salon of 1882. Formerly Musée du Luxembourg, Paris*

Exposition of 1900. A peaceful counterpart to the Vendôme Column, this work would be dedicated ". . . to the glory of human effort, to the glory of human thought forever on its way toward an inaccessible ideal." Although Dayot did not specify a format for this projected monument, he alluded to a column and suggested that on this monument one would see representations not only of manual workers, but of philosophers and wise men as well.

It has never been denied that the initial idea for this monument was Dayot's, but neither has it been recognized that Rodin's basic conception coincided with a program established by someone else. Furthermore, the dating of this project has varied by as many as nine years, and the role of Desbois has remained unclear.[14] Although there are no official documents relating to this project, the contemporary press together with letters preserved in the Archives of the Musée Rodin in Paris provide clarification that has been lacking until now.

Rodin's plan for the proposed monument was not only established, but made public within two weeks after the publication of Dayot's letter to Desbois.[15] Although this might suggest that Rodin, working with great haste and undivided attention, undertook the project in direct response to the published letter,[16] it is also possible that he was aware of Dayot's plan before March 21, 1898. We do know that discussions between Dayot and Desbois began in mid-February and that Desbois was not interested in supervising such a vast undertaking himself.[17] It is therefore probable that Desbois, Rodin's close collaborator and assistant, talked with him about Dayot's proposal. All three of them may have discussed this vast undertaking. If these interactions among Rodin, Dayot, and Desbois remain matters of conjecture, there can be no question about Rodin's response to the

proposal itself. He became intrigued with the project; sometime during late winter or early spring of 1898, he became actively involved, and the project became publicly associated with his name. As early as March 28, when various sculptors were interviewed concerning their willingness to undertake such a project, Rodin's response was characterized as "enthusiastic acceptance."[18]

On April 2, Desbois and Dayot exchanged public letters on the front page of *Le Journal*. They affirmed that the character of this undertaking should be that of a collaboration among the greatest living sculptors, an idea which Rodin was to welcome as a revival of medieval practice. Those mentioned included Rodin, Dalou, Mercié, Frémiet, Falguière, and Camille Claudel. As the most fitting form for a monument to labor, Dayot suggested an *arc de triomphe*, thus altering the impression he had given on March 21 that he preferred a column analogous to the one in the Place Vendôme. If, in fact, he already intended that the monument would be built under Rodin's aegis should the project reach the stage of execution, Dayot may have altered his public statement in order to seem not overly biased in Rodin's favor.

When interviewed by Dubois, a reporter for *L'Aurore*, Rodin showed him the maquette for the monument and explained the intended format. The results of that interview were published on April 9. According to Rodin's explanation:

> . . . the monument which I conceive would form an imposing, elegant, slender mass, completely architectonic, like the leaning tower of Pisa, with open arcades like there are in cloisters.
> This mass would surround a column like the Column of Trajan, along which

*9. Roll.* Grève des Mineurs. *Salon of 1880. Museum, Valenciennes*

would ascend graceful windings of the bas-reliefs. Each one would correspond to a profession and would be separated from its neighbor by a free-standing statue or a caryatid symbolizing that profession.[19]

He also indicated that between the arcade and column would be a gently inclined walkway and at the base of the column would be enclosed chambers. There, ". . . the work beneath the earth or beneath the sea would be glorified: the labor of miners, seekers of gold, divers, etc. [On the column] the ordinary professions would be represented first; then, gradually as they ascended, would be those professions which concerned intelligence, knowledge. . . ."

Rodin's references to the *campanile* of Pisa and to Trajan's Column are believable ones, but they overlook more obvious associations between his monument and famous local works. The column in the Place Vendôme immediately comes to mind. Its demolition by the *communards* in 1871 and subsequent reconstruction had made it a central topic in the recent history of Paris. Furthermore, Dayot had suggested that the proposed monument to labor would be a peaceful counterpart to the Vendôme Column. Another obvious source of inspiration was the exterior courtyard staircase at the Château of Blois. Rodin's reference to Italian monuments, while avoiding more obvious associations with works in Paris and Blois, has two implications: he did not want to call attention to the resemblance between the format of his monument and the suggestions contained in Dayot's public letter of March 21; he wished the work to have universal, rather than merely national significance.

This was not the first time Rodin had incorporated the vocabulary of classical architecture for its evocative possibilities. In his first maquette for the *Burghers of Calais*, he placed the burghers on a high pedestal, the ornamentation of which was unmistakable in its reference to a classical arch. In explanation, he wrote to the mayor of Calais: "The pedestal is triumphal and has the rudiments of an *arc de triomphe*, in order to carry not a quadriga, but human patriotism, abnegation, virtue. . . ."[20] With his maquette for the *Tower of Labor*, Rodin once again used a classical form in the context of modern monument-making, and his transformation of emphasis is crucial for its meaning. The notion of triumph remains, but it is no longer military in character. Reliefs glorifying battles have been replaced by modern workers at their occupations. His monument embodied the triumph of creative energies of modern civilization, just as Dayot had proposed.

Rodin aimed for intelligibility and took elaborate precautions to make sure that his symbolic intentions would be understood. These included an inscription on the base of his maquette[21] and a long description of the work and its symbolism written by Rodin himself,[22] as well as numerous interviews with reporters. With the gently inclined walkway between arcades and column, he solved a problem which had made the spiral reliefs on previous Trajanic columns all but impossible to see above a certain height. According to Rodin's plan, visitors would examine the reliefs from close by while walking up the spiral incline, and the open arcade would provide ample illumination (fig. 3).

By envisioning a monument that would engage spectators in a temporal experience involving great height, Rodin's conception was clearly of his time. There is no more prototypical nineteenth-century experience than viewing a panorama from a high structure. This was as true for the American public, who eagerly climbed water towers and hollow obelisks, as it was for Parisians, who ascended triumphal columns and arches or the more spectacular Eiffel Tower. One of the memorable

incidents in Zola's *L'Assommoir* occurs when Gervaise, Coupeau, and their wedding party ascend the Vendôme Column: their guest Monsieur Madinier observes, "[the ascent] would be full of interest for such as had never been higher than cows in a meadow."[23] In Rodin's tower, this experience would be as intrinsically "full of interest," but it would provide a great moral lesson, as well. Unlike the Eiffel Tower, which in Rodin's opinion "signified nothing,"[24] his *Tower of Labor* would continuously edify all those who made a pilgrimage to its summit.

The experience of Rodin's monument would have had three distinct aspects. In the crypt, the realm of labor beneath the earth and sea, there would be dimly lit bas reliefs representing such workmen as divers and miners. Above the crypt one would approach the entrance to the tower itself, after having passed colossal, allegorical figures of *Night* and *Day*, "symbols of the eternity of work."[25] As one ascended the spiral staircase, one would view reliefs of workers "in modern costume," beginning with "masons, blacksmiths, carpenters, reaching [finally] up to the artists, poets, philosophers." At the summit of this long and thought-provoking ascent, Rodin planned an allegorical group, but its exact character was not determined at first. In 1898, he planned either a group of *Labor and Apollo*, or of *Labor Surrounded by Day and Night*.[26] Eventually, he decided upon the group known as the *Bénédictions*, ". . . two winged geniuses who descend from heaven, like a beneficent rain, to bless the work of man."[27] Rodin's final plan was that these *Bénédictions* would alight upon a small temple in rose-colored marble, dedicated to creative thought.[28]

What Rodin envisioned, then, was a colossal monument, the form of which contained the essence of its meaning. His plan can be seen as a baroque *concetto* rephrased in modern terms, and the spiral staircase was the key to its meaning: "a helix without end, like progress."[29] Furthermore, according to the inscription, its form was to evoke both a beacon and a hive.

After contemplating the most hellish and thankless labors in the realm of the crypt, the beholder would emerge into daylight and begin his ascent up the spiral staircase. During the climb, he would witness on the reliefs a gradual transformation from manual labor to the realm of pure thought and artistic endeavor. Rilke saw this as a "history of work" which traced all phases of work "from the hammers to the brains."[30] At the summit of the monument, greeting the beholder at the culmination of his ascent, would be the *Bénédictions*. In their spiral composition, they continue the upward rhythm of the "helix without end," suggesting that in an upward progression from physical labor to mental exertion, mankind could transcend constraints of the flesh and enter the realm of the spirit.

Rodin's universal symbolism and the hierarchy of labor which culminated in pure thought and artistic creation were totally unlike Dalou's conception of a *Monument to Workers*. As might be expected from an ardent socialist, Dalou did not imply any ranking of human endeavor. Whereas Rodin's efforts were expended on the overall concept at the expense of details,[31] Dalou concentrated on the individual figures of workers and never found a satisfactory format for the monument as a whole.

Unlike Rodin, who began his tower at the suggestion of Armand Dayot and Desbois, Dalou undertook on his own the project for a monument to workers. At the inauguration of his *Triumph of the Republic* as a full scale plaster mock-up on September 21, 1889, Dalou had been dismayed at those making up the attending crowd. To a friend he later expressed his feelings: "Where was the army of labor

10. *Dalou.* Worker, *from* Triumph of the Republic. *1879–99. Bronze. Place de la Nation, Paris*

11. *Dalou.* Worker's child with attributes, *from* Triumph of the Republic

12. *Dalou.* Self-Portrait as the Sculptor, *from* Monument to Alphand. *Inaugurated 1899. Stone. Avenue Foch, Paris*

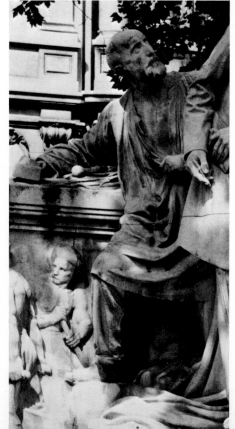

hiding during this old-fashioned gala? Where were my *practiciens*, my *adjusteurs*, my casters and my plaster workers? or the millions of arms which create? or those who labor on the soil? I saw guns and sabres, but not a work tool."[32] In consequence, Dalou determined that he would design a monument to workers, the uncelebrated heroes of modern society. He began his project in secret; he had no idea how it might be built; he did not have the support of an Armand Dayot or encouraging publicity in the press.

When Dalou decided to undertake this monument in 1889, it was not the first time he had incorporated a worker into his art. One of the three major figures who propel the Republic's chariot forward in the *Triumph of the Republic* is a workman with a hammer (fig. 10). This twice-lifesize laborer had established a genre in French sculpture: a modern worker, who has the dignity of himself and an unmistakable place in the social order, presented without any hint of rhetoric. Since the initial maquette for this monument dates from 1879, Dalou's worker predates by seven years the first sculptures of workers by Meunier.

This worker is accompanied by a child carrying attributes of labor, a book and a "bouquet" of work tools. Closer inspection reveals that these are not random tools, but calipers, chisels, and brushes, the tools of an artist (fig. 11). What Dalou created is a hidden tribute to his own profession in the context of human labor and modern society. In his symbolic schema, it is the artist-worker who assists the Republic's chariot in its triumphal movement forward.

This glorification of the worker and artist-worker occurs various times in Dalou's monuments of the 1890s. Both the *Monument to Leclaire*[33] and *Monument to Boussingault*[34] incorporate magnificent figures of workingmen in their ensembles. The *Monument to Alphand*[35] included a self-portrait of Dalou as the artist-worker (fig. 12): after the portraits of others as personifications of Architecture, Engineering, and Painting, Dalou singled out himself, dressed as the most humble of workmen, to represent Sculpture. Unlike his elegantly attired friend Roll, who personifies Painting (fig. 13), Dalou wears no chemise, cravat, or jacket. His workman's

*13. Dalou.* Roll as the Painter, *from* Monument to Alphand

smock is sufficient attire, even a uniform of honor, as he holds a mallet and chisel while resting his arm protectively across another "bouquet" of artist's tools. In this exaltation of the artist as humble workman, Dalou may have intended a reference to himself as a Saint-Simonian artist whose vision and insight approach the sacerdotal.

From the 1890s onward, Rodin also cultivated the image of himself as a worker. . Photographs of him in his worker's smock or holding a mallet and chisel are well known, and his words serve as corroboration. During the late 1880s, Rodin spoke about his earlier self-doubts as to whether he was, in fact, an artist or a workman.[36] By the later 1890s, he no longer mentioned such doubts. In fact, he preferred the image of himself as a manual worker, while expounding what has fittingly been called "a gospel of labor."[37] In an interview with Paul Gsell, Rodin sermonized about work and art: ". . . how much happier humanity would be if work, instead of a means to existence, were its end. But in order that this marvelous change may. come about all mankind must follow the example of the artist, or better yet, become artists themselves; for the word artist in its widest acceptance means to me, the man who takes pleasure in what he does."[38] Rilke corroborated this aspect of Rodin's thought when he concluded his short book on Rodin with a discussion of the *Tower of Labor* and the role of work in the sculptor's world view. In a letter of September 11, 1902, Rilke's response to Rodin's ideas imbued them with an authority which borders on the religious: ". . . I came to you, it was to ask you: how ought one live? And you answered me: by working. And I understood it well. I know that to work is to live without dying."[39] Although Rodin considered the artist a workman, there was no question about the ultimate value of such labor. Rodin included the artist's activity at the summit of his monument, the realm of philosophers and poets.

For both Rodin and Dalou, then, these proposed monuments became inseparable from their respective beliefs, biography, and pronouncements. While glorifying workers, each sculptor also defined his own position relative to human endeavor. Each monument became, therefore, a monument to its creator as well.

After Dalou's initial decision to design a *Monument to Workers*, he began collecting visual data. As a committed realist, he observed workers at their daily activity during four consecutive summer vacations. In 1891, it was the fishermen and port workers at Sainte-Adresse whom he studied. The following summer, it was the metal workers in the factories at Toul. In 1893, Dalou returned to the area of Sainte-Adresse, and in 1894, he observed the peasantry of Grenonvillers. First sketching them with pencil in his notebook, Dalou later transformed these sketches into clay *croquis* (fig. 14), which number among the brilliant creations of nineteenth-century sculpture. Whether they represent rural, industrial, or city workers, these tiny sketches[40] vibrate with the same life force that Dalou had observed at first hand.

Dalou encountered grave difficulty when he tried to find a satisfactory format for his monument. His first full-blown conception was for a truncated pylon around the base of which would be grouped figures of workers from various professions; at the summit there would have been a proletarian equestrian (fig. 4). By the time of his third and final maquette for the monument, Dalou had greatly simplified his conception. Without any crowning figure or group, the column became a rounded shaft decorated with garlands and work tools carved in relief (fig. 5). Dalou was fully aware of the phallic connotations of this revised design. For him, this conscious reference was a double one: the generative symbol of Priapus, and a recol-

lection of factory chimneys which dominated the industrial landscape.[41] At the base there would have been sixteen niches, each with an individual worker carrying the tools of his profession. Beneath these niches four huge bas reliefs would have indicated the principal subdivisions of modern labor. According to Dalou's program, and unlike Rodin's, no philosophers, thinkers, or artists were ever intended for his monument, only manual workers. We know that Dalou regarded the artist as another sort of worker. According to him, no kind of labor had precedence over another. All workers were equals, and the fruit of all manual accomplishment was equally good. Furthermore, Dalou must have felt that he, the artist worker *par excellence*, had a proprietary right to create the greatest of modern monuments, a monument to labor.

In 1898, just when Dalou began to fear that age and frail health might prevent him from realizing his *Monument to Workers*,[42] Dayot's open letter appeared on *Le Journal's* front page. Although Dalou attempted to maintain an appearance of composure in public, he was clearly as dismayed as he was annoyed. His unique idea had been usurped; when questioned by the press, Dalou emphatically refused to collaborate with others on such a monument, citing his own project. The old enmity between himself and Rodin was rekindled as Dalou saw the proposed monument wrested from him and associated with Rodin's name. To the reporter Dubois, Dalou made clear the length of his association with the project relative to Rodin's: "As for me, I've worked on it for nine years, not since yesterday."[43]

On the very day that this response appeared in *L'Aurore*, Armand Dayot came to visit Dalou. The visit was an uncomfortable one as Dalou repeated his published sentiments. He would not collaborate; his own project was "at the threshold of execution."[44]

Although the popular and artistic press for some time discussed Dayot's proposal for this monument, Rodin's maquette, and Dalou's refusal to collaborate, it soon became clear that no monument to labor would be built in time for the Universal Exposition of 1900. The government never assumed financial responsibility for

*14. Dalou.* Peasants. *Terracotta croquis. c.1894. Musée du Petit Palais, Paris*

erecting the monument, nor was any public subscription organized. Although the project had become unmistakably linked with Rodin, it appeared that the monument to labor would be relegated to the status of previous visionary monuments. When Rodin exhibited the plaster maquette for his tower at the Place de l'Alma pavilion in 1900,[45] it already seemed more of a curiosity than a viable structure. Hardly any mention of it was made among the endless writings about Rodin and his art which appeared at the time of this exhibition.

After 1900, the monument was forgotten for some time. Dalou's death in 1902 ended any consideration of building his monument. Although Rilke's book on Rodin which appeared in 1903 spoke as if Rodin's tower might still be constructed one day, practical problems and expenses seemed insurmountable. Had it not been for an extraordinary event during the spring of 1906, Rodin's *Tower of Labor* might have been completely forgotten. As it turned out, the project was not only revived, but expanded in scope beyond anything imagined in 1898.

In the middle of March 1906 there occurred at Courrières a horrible mine disaster, which had a totally unexpected sequel: after having been trapped underground for nearly three weeks, two veteran miners named Nény and Pruvost reappeared, leading thirteen other survivors to safety. Newspapers of April 2 were dominated by accounts of the event. In his cover article for that day's *Le Journal*, Paul Adam wrote glowingly about the heroism of these two men; he likened their struggle against the forces of nature to the struggle against tyrants in former times. Would not a monument be erected, Adam asked, if as many soldiers had perished? He proposed that Rodin's monument would be a fitting tribute to those workmen who had died, as well as to the surviving heroes. Adam's association between the specific heroism of two contemporary workmen and Rodin's all-but-forgotten maquette was the catalyst which revived the whole issue of constructing the *Tower of Labor*. On April 17, an article by Gustave Kahn appeared in *Le Siècle*, making the same association with the Courrières event and including a detailed description of the monument, as well as a plea for constructing it at this time. Many others followed suit; Rodin's monument received far more publicity between 1906 and 1908 than it ever had in 1898. The most detailed piece was written by Ricciotto Canudo,[46] and Rodin expressed his pleasure with it.[47] In this highly laudatory article, Canudo called Rodin the "homo novus" and praised his tower as "the first monument of modern times."

Once again, Armand Dayot took an active part in the project he had initiated in 1898. By May 1906 he was busily engaged in details concerning the monument.[48] During 1907 he interested many prominent people in the project, including Emmanuel Nobel (nephew of Alfred Nobel), and convinced Léon Bourgeois to serve as president of an International Committee to raise funds. Dayot also composed the text of a world-wide appeal for contributions. With the urgency of a true believer, he wrote: "We *must* build this monument. It corresponds to the mentality of our times, of which it ought to be the highest expression, the purest symbol."[49]

Actual construction of the monument had never been faced during the years 1898 to 1900. But the campaign of 1906 seemed to make its realization a genuine possibility, and formidable practical problems raised by the monument's design had to be solved. For this, an accomplished architect was necessary. Rodin's choice was Henri Nénot, a famed member of the Institut de France. Nénot accepted this undertaking and worked on plans for the monument from 1906 until January 1910.[50]

This second campaign also saw an enormous expansion of the proposed monu-

ment's size. In 1898, both Rodin and Dalou had planned works comparable to the height of previous triumphal columns, thirty to fifty meters. After 1906, Rodin's plan called for a height of 130 meters.[51]

This notion of size as an index of importance was grounded in nineteenth-century sensibility regarding colossal proportions. During an interview of April 1908, Rodin claimed: ". . . the higher and more formidable the tower, the better it will serve the end that I propose."[52] Furthermore, this enormous height, almost half that of the Eiffel Tower, required Rodin to revise the notion of public access to his monument. Increasing the number of piers surrounding the column from seven to eight, Rodin planned that the beholders could experience the entire sculptural program in relief on the central bronze column during four ascents and four descents in separate, slow-moving elevators.[53]

Rodin's plans for the crypt and its entrance also expanded dramatically. After he had repaid the State all sums advanced for the *Gates of Hell*,[54] he was free to contemplate reusing this work. What would be a more fitting entrance to the crypt, the realm of underground labor, than the *Gates* themselves? During an interview in 1908, Rodin explained: "One will enter the crypt by a single door, which I have already sculpted and which you have been able to see no doubt: the *Gates of Hell*."[55] Rodin revealed his ultimate identification with the *Tower of Labor* when he suggested to his secretary, Marcelle Tirel, that he planned to be buried in the crypt. Referring to his own cadaver as "the remains of one who was a great worker,"[56] Rodin made it clear that he entertained the thought of having this colossal tower serve as his own funerary monument. Perhaps he had become aware that the base of Trajan's Column served as a repository for the emperor's ashes, and wished to draw a further parallel between his tower and its source in antiquity.

Rodin's final conception of, and his personal identification with, this monument were so extravagant that it is difficult to regard his proposals with the seriousness he obviously felt. His grandiose scheme exceeded anything imagined by Dalou, but these two proposed monuments form an unmistakable chapter in the history of late nineteenth-century French art. Both were as admirable in intention as they were impractical; both were so highly personal that they now appear eccentric rather than as tangible manifestations of public consensus regarding labor. The fate of these two works, conceived on the threshold of the twentieth century, was part of the larger fate of monuments in the modern world. They can only be regarded as failures, but magnificent failures nonetheless. A kinder, but no less accurate word than "failure" would be "valedictory." For these two ambitious projects do serve as valedictories: to an age more optimistic than our own; to two great sculptors and the era which nurtured their efforts; and to the traditional notion of monument-making itself.

*Middlebury College*

*Notes*

[1] At the Musée Rodin, Paris, there are also two related drawings from Rodin's studio. One refers to the existing plaster maquette and the other to a somewhat different maquette in clay (now lost).

[2] A notable exception is J. A. Schmoll's "Denkmäler der Arbeit. Entwürfe und Planungen," *Studien zur Kunst 19. Jahrhunderts*, XX (1972), 253–81. This thoughtful article is broadly interpretive and wider in scope than my study; Prof. Schmoll's article did not, however, incorporate the vast amount of evidence preserved in the Archives of the Musée Rodin in Paris.

[3] Albert Elsen, *Rodin's Gates of Hell*, Minneapolis, 1960, 90.

[4] John Tancock, *The Sculpture of Auguste Rodin*, Philadelphia Museum of Art, 1976, 102.

[5] Robert Goldwater found the forms "imaginatively combined, not fused" (*What Is Modern Sculpture?*, Museum of Modern Art, New York, 1969, 132).

[6] Victor Frisch and J. Shipley, *Auguste Rodin. A Biography*, New York, 1939, 308.

[7] "L'Apothéose du Travail. Chez M. Rodin," *L'Aurore*, April 9, 1898.

[8] Three of Dalou's maquettes for this proposed monument survive, and are preserved at the Musée du Petit Palais, Paris. Two of them are reproduced here (figs. 4, 5).

[9] Maurice Dreyfous, *Dalou—sa vie, son oeuvre*, Paris, 1903, 249.

[10] Dalou had taken an active part in the Commune, as a founding member of the Fédération des Artistes and as one of the three revolutionary curators of the Louvre under the Fédération. For this, he was forced into a nine-year exile prior to the amnesty proceedings of 1879–1880. Rodin's refusal to sign a petition on behalf of Dreyfus in 1898 was widely publicized. In self-defense, he claimed: "I could not see that an artist has anything to do with political upheavals" (Frisch, 242).

[11] Dreyfous, 249.

[12] Philippe Burty called Roll's *Grève des Mineurs* "the honor of this Salon" ("Le Salon de 1880," *L'Art*, II, 1880, 178).

[13] P. Laprieur, "Le Salon de 1888, peinture," *L'Artiste*, II, 1888, 13.

[14] Elsen, 90, suggested that Dayot had offered the project to Desbois "around 1889."

[15] *L'Aurore*, April 1, 1898, and April 9, 1898.

[16] This is not impossible, but it is unlikely, given Rodin's negotiations with the Société des Gens de Lettres at that time and his preparations to exhibit the *Balzac* at that year's Salon.

[17] "L'Apothéose du Travail. Chez M. Desbois," *L'Aurore*, April 1, 1898.

[18] *Le Matin*, March 28, 1898.

[19] *L'Aurore*, April 9, 1898.

[20] Letter of November 20, 1884 (typescript, Rodin Archives, Philadelphia Museum of Art).

[21] It can be seen clearly in fig. 1. There are only three instances where Rodin added inscriptions to the base of a work, and neither of the other two was a public monument. It is not known when this inscription was added to the base of the maquette, but it existed by the time of his Place de l'Alma exhibition.

[22] This autograph manuscript is preserved in the library of Princeton University. It is reproduced in its entirety by H. Rice, "Glimpses of Rodin," *Princeton University Chronicle*, Autumn 1965, 41.

[23] Emile Zola, *L'Assommoir* (1876), trans. L. Tancock, Middlesex, England, 1970, 92.

[24] *L'Aurore*, April 9, 1898.

[25] Rice, 41.

[26] *L'Aurore*, April 9, 1898.

[27] Rice, 41.

[28] Ricciotto Canudo, "Notre Colonne Trajane. La Tour du Travail de Rodin," *Le Censeur Politique et Littéraire*, August 3, 1907, 421.

[29] Rice, 41.

[30] Rainer Maria Rilke, *Rodin*, trans. J. Lemont and H. Transil, London, 1946 (reprint New York, 1974), 61.

[31] In a detail from the maquette of Rodin's tower (fig. 3), it can be seen that his figures of workers were not developed beyond the rough sketch stage.

[32] Jean Tild, "Dalou. La genèse d'une oeuvre," *La Renaissance de l'art français et des industries de luxe*, 1920, 182.

[33] 1894, Square des Epinettes, Paris. For

further discussion, see John Hunisak, *The Sculptor Jules Dalou. Studies in His Style and Imagery*, New York, 1977, 164–65.

[34] 1894, École des Arts et Métiers, Paris. See Hunisak, 160–61.

[35] Inaugurated 1899, Avenue Foch, Paris. See Hunisak, 166–68.

[36] This doubt was expressed several times during conversations with Truman Bartlett, who published these interviews serially in *The American Architect and Building News* during 1889.

[37] Elsen, 90.

[38] Paul Gsell, *Rodin on Art*, Boston, 1912, 233.

[39] Rainer Maria Rilke, *Lettres à Rodin*, Paris, 1931, 15.

[40] Now preserved at the Musée du Petit Palais, Paris.

[41] Dreyfous, 256.

[42] Journal entry of March 15, 1898; cited in Dreyfous, 256.

[43] "L'Apothéose du Travail. Chez M. Dalou," *L'Aurore*, April 9, 1898.

[44] Journal entry of April 9, 1898; cited in Dreyfous, 257.

[45] Number 124 in the catalogue and liste das "Maquette d'un monument au travail" (*L'Exposition de 1900. L'Oeuvre de Rodin*, Paris, 1900).

[46] See above, n. 28.

[47] Canudo's thanks to Rodin for a favorable response to this article are recorded in a letter of August 19, 1907 (Archives, Musée Rodin, Paris).

[48] Dayot's letters to Rodin document his activities concerning the monument between 1906 and 1910 (Archives, Musée Rodin, Paris).

[49] Quoted in Canudo, 417.

[50] Letter of Dayot to Rodin, January 1910 (Archives, Musée Rodin, Paris).

[51] This was the height reported in various articles in the press, as well as by Canudo, 420.

[52] *Le Bâtiment*, April 30, 1908.

[53] Canudo, 420–21.

[54] Albert Elsen, *Rodin*, Museum of Modern Art, New York, 1963, 211.

[55] *Le Bâtiment*, April 30, 1908.

[56] Marcelle Tirel, *The Last Years of Rodin*, London, 1925, 113.

# 44

## *Fernand Pelez, or The Other Side of the Post-Impressionist Coin**

ROBERT ROSENBLUM

Few have realized more clearly than the man we are honoring with this volume that the art of the nineteenth century is still frontier country. For intrepid art historians there are surprising riches among the dreary wastelands yet to be explored. In the domain of sculpture, our friend Peter Janson has already mapped out many new territories that, among other things, will permit Canova and Rodin to be less lonely than they were before his adventurous expeditions. So it seems appropriate to offer him here the results of another excursion to the *terra incognita* of nineteenth-century art, in this case, painting in Paris at the time of Post-Impressionism.

A glance at any nineteenth-century Salon catalogue (which one can now cast swiftly, thanks to our friend's invaluable reprint edition of these *livrets* that grew larger and larger with the century's population expansion) makes it all too apparent how few of the thousands of names of listed artists have survived the Darwinian selection of the art-historically fittest for the twentieth century. But oblivion for nineteenth-century artists need not be, as it is for extinct species, eternal. There is always a chance of resurrection when the time is ripe. So it is that now, in the late twentieth century, thanks to our growing concern not only with the formal structure but also with the broader cultural meaning of the images that compile our current history of modern art, many forgotten artists are beginning to look fresh and pertinent. This is not only a question of our never having troubled to look at them before, but also of the way in which some of them may suddenly enter into an unexpected dialogue with loftier and more famous artists who have been used to residing only with each other in the most exclusive Halls of Modernist Fame.

The present case in point is a certain Fernand Pelez,[1] whose life span, 1843–1913,[2] locates him somewhere between the generations of Degas and Seurat. The son of another Parisian painter (with whom he has occasionally been confused), Fernand Pelez de Cordova (1820–1899), Pelez was a student not only of his father but of two academicians, Félix-Joseph Barrias and Alexandre Cabanel. But in 1879, he exhibited his swan song to academic history painting, *La Mort de l'Empéreur Commode*,[3] and in the 1880s began to exhibit not scenes of heroic classic and biblical history but rather a series of gloomy vignettes culled from the grimmest

depths of Parisian working-class life that, in surprising ways, keep touching upon the work of late nineteenth-century masters whose reputations have endured. These scenes of *la misère* were inaugurated at the Salon of 1880 with *Au lavoir* (fig. 1), a painting that suddenly joins forces with the kind of theme we know well from the workers of Millet, Daumier, and Courbet, but even more specifically with the series of laundresses Degas had begun to paint in the 1870s.[4] Like Degas, Pelez distills the legions of anonymous washerwomen toiling in sweatshops into an emblematic duo who broadly display two major occupational rhythms of their labor, here scrubbing and wringing. But familiar as we now are with this kind of working-class image from the repertory of Degas and his predecessors, Pelez's literal, quasi-photographic rendering of this dreary Zolaesque environment of muscular women, sabots, and coarse wooden vats lends it an unfamiliar accent, providing, as it were, a more respectable, academic counterpart to the theme we know from the canonic masterpieces of nineteenth-century painting.

This curious mixture of the familiar and the unfamiliar, as if a work by Degas had been corrected and repainted by a Cabanel, becomes even more piquant in later works by Pelez of the 1880s. Thus, in 1885, he moved his new-found motif of drudgery and misery from the sweatshops, streets, and attics of Paris[5] to the world of entertainment, and exhibited at the Salon of that year *La misère, à l'Opéra* (fig. 2). As a critic, Henry Havard, put it in the florid language of official late nineteenth-century art criticism, the Salon of 1885 boasted "five or six pictures uniquely consecrated to the adepts of Terpsichore,"[6] but he also noted that Pelez's painting was distinguished from the others in its display of the poor young girls from the chorus, who, temporarily casting aside their miserable street clothing, were to be transformed, if only for a few hours, into stars. For us, however, the first conspicuous association in Pelez's painting is to Degas's earlier backstage or studio views of ballet dancers adjusting their clothing; but this, in turn, is replaced by even stronger intimations of a masterpiece yet to be executed, Seurat's *Les Poseuses* (fig. 3). Begun in the autumn of 1886,[7] the year following the public exhibition of Pelez's pair of quietly melancholy dancers slipping in and out of their *tutus*, stockings, and ballet slippers, Seurat's own solemn reinterpretation of the Three Graces theme keeps echoing motifs from the earlier work. Slowly, in fact, the paintings begin to converge in their disquieting combination of academic poetry and realist prose. For both Pelez and Seurat take a repertory of ideal figural postures that smack of Ingres and his academic disciples and then relocate them in a workaday world of dancers and studio models whose ascent to Olympus is seen as a poignant fiction. But beyond this, both Pelez and Seurat work with a particularly rigorous trinity of poses (the backstage mirror's reflection providing the third quasi-academic study in Pelez's painting) that take on an almost abstract quality of the purest variations upon the motif of a single model viewed from front, back, and side. Indeed, Pelez's righthand dancer, who casually pulls up her stocking but is nevertheless locked in a timeless pose of lucid geometries, is again a kind of photographic version of Seurat's model at the right, just as the Ingresque mirror-image of her back is a glossy double of Seurat's own reinterpretation of a theme by Ingres in the seated model at the left. And in both paintings, too, the ephemeral facts of contemporary life in the mid-1880s—the up-swept hairdos of the period or the tumbles of clothing with their time-bound details of hats, shoes, dresses, and parasols—provide an ironic contrast to the seemingly timeless nudity or near-nudity of the partly idealized models and to the calculated geometric order of sharp, rectilinear wall divisions that define the shallowest of spaces.

1. *F. Pelez.* Au lavoir. *Salon of 1880. Musée, Le Havre*

2. *F. Pelez.* La misère, à l'Opéra. *Salon of 1885 (from H. Havard,* Salon of 1885, *Paris, 1885)*

3. *G. Seurat.* Les Poseuses. *1886–88. Photograph Copyright 1980 by The Barnes Foundation, Merion, Pennsylvania*

*4. G. Seurat.* La Parade. *1887–88. Metropolitan Museum of Art, New York. Bequest of Stephen C. Clark, 1960*

*5. F. Pelez.* Grimaces et misère. *Salon of 1888. Musées de la Ville de Paris*

But these hints of convergence between the now classic avant-garde repertory of
the 1880s and the legions of forgotten works, like those of Pelez, which were ex-
hibited in the same years, reach a startlingly explicit statement in 1888. In that
year, from March 22 to May 3, Seurat exhibited at the four-year-old Salon des
Indépendants not only his *Poseuses*, but the masterpiece that followed it, *La
Parade de Cirque* (fig. 4),[8] while beginning on May 1, Pelez exhibited at the vener-
able official Paris Salon a virtual double, but in an academic realist vocabulary,
of Seurat's circus theme. Like the *Parade*, Pelez's *Grimaces et misère* (fig. 5)[9]
presents a glum view of the contrast between the goals of rousing entertainment in a
popular Parisian circus troupe and the actual melancholy and isolation of the per-
formers. But beyond this shared theme, which from Watteau and Daumier on had
become commonplace in French art of the nineteenth century,[10] any number of
elements strike familiar chords in these two paintings of 1888. There is, for one,
the general disposition of the sideshow come-on in a long horizontal frieze that
seems to extend at top, bottom, and sides into the spectator's space while main-
taining a rigorous sense of measured internal order in the slow enumeration of
solitary figures viewed in a space so restricted that the postures approach those of a
shooting gallery. In Seurat, of course, Pelez's meticulously descriptive prose—the
grotesque dwarf who blows a kiss to the spectators, the grimacing clown and
smiling barker, the weary old musicians, the parrots and monkey, the young acro-
bats who range in age and expression from the tender and tear-filled to the tough-
ened and bored—is transformed into a ritualized poetry of the highest order, but
the common denominator of Parisian experience lies behind them both. Indeed,
the very facts that we can discern in the gas-lit haze of Seurat's painting often

recur in Pelez's sharp-focus account of the same urban scene. The vertical line-up of wind instruments, climaxing in the trombone, has its counterpart in Pelez's musicians, as does the repetitive rhythm of gas lamps above that measure out the human patterns below. And even the zeros behind Seurat's trombonist which metamorphose the prices of admission (probably 30 and 40 centimes) into floating oval shapes are echoed in their literal origins in Pelez's posted prices, one legible (30,), the other, like Seurat's, only half-so (–0,). Still more telling a coincidence is the leafless tree silhouetted at the extreme left of both paintings, a rhyming vertical that alleviates in the irregular patterns of its bare branches the overall austerity of the reiterated parallels and perpendiculars that dominate both works. Like Seurat's circus, whose seeming timelessness and abstraction may make us forget that in 1888 it was recognizable as a specific site, the Cirque Corvi, and one often illustrated in popular prints of the period,[11] Pelez's circus locates us right on the tree-lined boulevards of Paris.

Apart from this common source in Parisian reality, Seurat's and Pelez's paintings begin to approach each other even in formal ways. For beneath its surface of meticulous academic description, Pelez's painting slowly discloses a structural skeleton that keeps recalling Seurat's. It is not only a question of its insistent frontality, but also its sense of broad and precisely delineated rectilinear divisions that, like Seurat's, echo such academic compositional formulas as the *Section d'Or,* and that were especially topical in such new publications of the period as Charles Henry's *Une Esthétique scientifique* of 1885.[12] And if the modern eye trained in the spatial ambiguities of Cubism can find in *La Parade* prophetic elisions of flat planes that keep shifting from foreground to background, cannot something of these curious shufflings be seen, within the restrictions of an academic vocabulary, in Pelez's work as well? The hairbreadth limitation of his pictorial space, too, is constantly altered by planes and figures that are located ever so slightly closer or farther from the viewer. Thus, we note with surprise the cross-legged figure behind the 30-centimes sign who seems to continue the foreground procession of acrobats just a few inches behind them, or the subtle way in which the canopy on the right-hand side of the picture seems to be both in front of, as well as continuous with, the patterned stripes of the curtain behind the figures.

The art historian, always looking for cause-and-effect relationships, may be tempted to choose one of these works as the source for the other. But in view of their near-simultaneous exhibition and probably near-simultaneous execution—given the huge size of Pelez's painting (it is almost 21 feet wide, or more precisely, 2.21 by 6.35 m), it must have been well under way, like *La Parade,* in 1887—this is clearly not a question of influence but rather of common sources in life, academic training, and popular imagery. In fact, the same question of "influence *vs.* coincidence" may be raised in yet another painting by Pelez, *La Mi-Carême* (fig. 6). Since the date here is unknown,[13] it is impossible even to conjecture whether the painting precedes or follows its obvious doubles in such works by Ensor as *Intrigue* of 1890 (fig. 7).[14] To be sure, the paintings are hardly to be equated. What for Pelez is an image of bitter-sweet, mid-Lent carnival masquerades played by children under a banner that bears the virtual signature of his art, *Misère,* becomes for Ensor a metaphor of a world that is bilious and corrosive on both psychological and pictorial levels. Still, what remains fascinating is the coexistence of these works in the same historical milieu. Again, to our eyes, Pelez's painting may seem only like a corrected, academic rendering of one of Ensor's favorite subjects; but even in formal terms, the compression of Pelez's figures, with their masks, lanterns,

**6**

6. *F. Pelez.* La Mi-Carême. *Musées de la Ville de Paris*

7. *J. Ensor.* Intrigue. *1890. Musée Royal des Beaux-Arts, Antwerp*

8. *F. Pelez.* Sans asile. *Salon of 1883 (from* L'Art et les artistes, *18, 1914, p. 195)*

**7**

**8**

umbrella, and tawdry banner, into the narrowest foreground space approaches the oppressive frontality of Ensor's own crowds of maskers.

The more one uncovers of Pelez's work—a task only just begun here—the more deeply he seems to share the subjects, moods, even the forms of his more illustrious contemporaries, and the more clearly he provides some conservative pictorial foothills from which the heights of our pantheon of modern masters may be measured in a more subtle fashion. But it also seems possible that, beneath his academic surfaces, Pelez was even for his time a singularly powerful and original artist and not one of a type. His pursuit in the 1880s of motifs of poverty and melancholy among the working classes first appeared so threatening that, for instance, his *Sans asile* of 1883 (fig. 8), when exhibited in Munich in 1884 at the Internationale Kunstausstellung, elicited complaints from the conservative critic Adolph Rosenberg that socialist protests lie outside the domain of art,[15] although, in fact, the translation of the sacred Madonna and Child theme into the secular language of contemporary city vagrants had a distinguished academic pedigree that went back at least to Bouguereau.[16] For us, of course, such a painting seems to prefigure by more than a decade the passive but noble despair of Picasso's Blue Period figures (just as its ironic inclusion of the torn posters of Paris that announce such cheerful events as a *grande fête* or a *soirée dansante* foreshadows the profusion of such public notices in the city environments recreated by Picasso's Cubism).[17] Like the *dramatis personae* of Pelez's Paris, those in Picasso's Blue Period translate the pariahs of the streets into contemporary images of the Holy Family or of Christian saints, homeless figures who endure with almost divine dignity the miseries of lower-class urban life.

That Pelez was a commercial failure in the 1880s suggests the degree to which his art went against the official grain of that decade, but at least it must have been sufficiently respected and distinctive to warrant the inclusion of a quintet of his *scènes de misère* at the Exposition Universelle of 1889, where he received a silver medal of honor.[18] Indeed by 1891, the year he was to become Chevalier de la Légion d'Honneur, his art was well enough known internationally for the prominent British critic Philip Gilbert Hamerton to claim that *Un nid de misère* (fig. 9), a painting from the Salon of 1887 that was re-exhibited at the 1889 Exposition, was "one of the most profoundly touching representations of poverty that [he] had ever seen," and that "of all modern French painters, it is certainly M. Pelez whose sympathy with the suffering classes expresses itself with the most poignant force."[19]

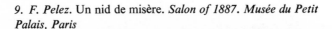

9. *F. Pelez*. Un nid de misère. *Salon of 1887. Musée du Petit Palais, Paris*

10

11

12

10. *F. Pelez. Study for* Les Dan-
seuses. *1905–9. Musée du Petit
Palais, Paris*

11. *F. Pelez. Study for* La Bou-
chée de pain. *1892–1908. Musée
du Petit Palais, Paris*

12. *F. Pelez. Study for* La Bou-
chée de pain. *1892–1908. Musée
du Petit Palais, Paris*

Again, for us today, such a work moves toward the angelic, otherworldly children of so much Symbolist art of the 1890s, as well as toward the spiritual triumph over physical hardship that we find in so many of Picasso's Blue Period children. In fact, such new Symbolist inflections seem to mark Pelez's work from the 1890s to his death in 1913, at least to judge from the late works I have been able to locate. Thus, a study for the large *Les Danseuses* of 1905–9 (fig. 10)[20] offers a ghostly reprise of the righthand dancer in his 1885 *La misère, à l'Opéra* (fig. 2), isolating ever more clearly both the abstract and naturalistic premises of the earlier work. And in studies for *La Bouchée de pain* (figs. 11, 12), an ambitious polyptych that occupied Pelez from 1892 to 1908, this duality between Pelez's academic training and the Symbolist pursuit of evocative abstract patterns, contours, and textures is no less acute. Here, the literal facts of a Parisian breadline are metamorphosed into a shadowy, monochrome frieze of emaciated victims of modern society, anonymous saints who disappear into a crepuscular, almost supernatural world where the frail, homeless wanderers of Picasso's early Paris years would be equally at home.

We know that after the failure of his *L'Humanité!* at the Salon of 1896, Pelez became something of a recluse, refusing to exhibit or to sell his work. The tenor of these late works confirms this mood of withdrawal and asceticism, passing from a world that palpably documents the *misérables* of Paris to one that enters an impalpable, spiritual realm. It is hardly a surprise, then, that the author of the catalogue catalogue essay for Pelez's posthumous exhibition catalogue of December 1913[21] was none other than Joséphin Péladan, the eccentric aesthete responsible for the mystical, idealist program of the Salons de la Rose+Croix held in Paris from 1892 to 1897.[22] In his critical eulogy, Péladan called Pelez "a Franciscan tertiary in the heart of Montmartre," and insisted on the ascetic Spanish tone of his adaptation of Christian motifs to a secular world. For us today, his characterization might almost be applicable to the young Picasso. In any case, Pelez's ability to move in his later years toward a style and mood sufficiently immaterial and otherworldly to elicit the praise of Péladan, who had so ardently espoused a Symbolist aesthetic, is yet another aspect of this strange artist that demands our attention.

More and more, formerly obscure artists of the later nineteenth century are coming into focus for us insofar as they offer contemporary counterparts, founded in a language of academic realism, to familiar works by the heralded modern masters. Pelez does this at times for artists as diverse as Degas, Seurat, Ensor, and Picasso; Tissot is often the photographic double of Manet; Béraud and De Nittis, of Degas; Albert Moore, of Whistler. And this new constellation of artists sometimes moves, as does Pelez, from Realism to Symbolism,[23] approaching the threshold of early twentieth-century art while bypassing the presumably pivotal experience of Impressionism. What is certain, at least, is that the evolutionary pattern we have inherited for the understanding of later nineteenth-century painting is far too linear and discriminatory to satisfy our growing curiosity about the period. When future generations of art historians reconstruct these years, may they not forget Fernand Pelez!

*New York University*

* I should like to thank two Parisian curators, without whom this article would never have been at all: 1) Thérèse Burollet (Musées de la Ville de Paris), who brought Pelez to my attention for the first time by including two of his paintings (*Grimaces et misère* and *La Mi-Carême*) in her selection of a small group of late nineteenth-century works from the collection of the Ville de Paris for modern installation at the Bibliothèque Trocadéro (4 rue du Commandant Schoelcher, Paris 75016) and by illustrating them in the accompanying brochure (*Présence et vie d'une peinture oubliée*); and 2) Juliette Laffon de Butler (Petit Palais), who kindly arranged for me to see some works by Pelez in the *réserve* and to consult some archival material.

1 For preliminary information on Pelez I have relied on the usual biographical dictionaries, as well as a brief text by J. Uzanne in *Figures contemporaines* (tirées de l'Album Mariani), VI, Paris, 1896–1908, n.p., and the exhibition catalogue, *Exposition posthume des oeuvres de Fernand Pelez en son atelier, 62, Boulevard de Clichy, Paris du 6 décembre 1913 au 6 janvier 1914* (with an essay by Péladan).

2 His birthdate, however, is given as 1848 in Péladan's essay (*op. cit.*), but in all other early sources (including the necrology in *Chronique des arts et de la curiosité*, 1913, 223) as 18 janvier 1843. Given the fact that he exhibited already at the Salon of 1866, the earlier date seems confirmed. Pelez's Salon paintings through 1882 are recorded in Bellier de la Chavignerie, *Dictionnaire général des artistes de l'école française . . .*, Paris, 1882–85. His later Salon entries are as follows: 1883, *Sans asile* (no. 1857); 1884, *Une famille* (no. 1872); 1885, *Un martyr* (no. 1931), *La misère, à l'Opéra* (no. 1932); 1886, *Misère* (no. 1817), *Victime* (no. 1818); 1887, *Un nid de misère* (no. 1853); 1888, *Grimaces et misère* (no. 1974); 1889, *Le vitriol* (no. 2080), *L'ouvrière* (no. 2081); 1890, *Pauvre enfant!* (no. 1863); 1896, "*L'Humanité!*" (no. 1552).

3 No. 2346. Illustrated in F.-G. Dumas, ed., *Salon illustré de 1879*, 2ᵉ partie, Paris, 1879, 41. The painting is now in the Musée de Béziers. Earlier history paintings include *Adam et Eve* (Salon of 1876; Musée de Moulins), and *Jésus insulté par les soldats* (Salon of 1877).

4 Eunice Lipton has been studying this series of works by Degas and has already noted in a lecture the analogy with Pelez's painting.

5 For illustrations of two of these works, see F.-G. Dumas, ed., *Salon illustré de 1881*, 191 (*La maternité*, an impoverished mother and children ironically contrasted with a framed image of a Madonna and Child on an attic wall); and *idem*, *Salon illustré de 1882*, 197 (*Un philosophe*, a tattered Parisian beggar recalling the figures of Manet or Raffaëlli).

6 Henry Havard, *Salon de 1885*, Paris, 1885, 40.

7 On *Les Poseuses*, see Henri Dorra and John Rewald, *Seurat*, Paris, 1959, no. 178.

8 Nos. 613, 614. On *La Parade*, see *ibid.*, no. 181.

9 The title was extended to *Grimaces et misère,—les Saltimbanques*, when the painting was shown at the Exposition Universelle, 1889 (no. 1090).

10 See Francis Haskell, "The Sad Clown: some notes on a 19th century myth," in Ulrich Finke, ed., *French 19th Century Painting and Literature*, New York, 1972.

11 On this, and for the clearest description of *La Parade*, see Robert Herbert, *Neo-Impressionism*, New York, 1968, 118–19. Professor Herbert, who has also been aware of the Pelez-Seurat analogy, has kindly indicated to me the source of the Jules Garnier circus illustrations mentioned in his Neo-Impressionist catalogue: Hugues Le Roux, *Les jeux du cirque et la vie foraine*, Paris, 1889 (with color illustration of the Cirque Corvi, p. 71). There was also an English edition of Le Roux's book (with the same Garnier illustrations in black and white): *Acrobats and Mountebanks*, London, 1890.

12 See Herbert, *loc. cit.*

13 At least, I have not yet been able to

determine it from any exhibition records.

[14] The analogy with Ensor's work is pointed out in Thérèse Burollet's brochure for the "Bibliothèque Trocadéro," *Présence et vie d'une peinture oubliée*, n. p. (see acknowledgments above).

[15] "Die internationale Kunstausstellung in München," *Zeitschrift für bildende Kunst*, 19 (1884), 258–59.

[16] See his *Famille indigente* (Salon of 1865), illustrated in Norman Ziff, *Paul Delaroche*, New York, 1977, fig. 104.

[17] The frequent inclusion of posted bills in Parisian genre painting of the late nineteenth century (as in, e.g., the works of Bashkirtseff and Chocarne-Moreau) is worth considering as one of the pictorial sources in official Salon art for the Cubist assimilation of these ubiquitous *affiches*.

[18] The five exhibited paintings were: 1) *Grimaces et misère,—les saltimbanques* (no. 1090); 2) *À l'Opéra* (no. 1091); 3) *Victime* (no. 1092); 4) *Un nid de misère* (no. 1093); 5) *Sans asile* (no. 1094). The *médaille d'argent* was given for *L'Asphyxiée* (presumably to be identified with *Victime* and now at the Musée de Senlis).

[19] "The Present State of the Fine Arts in France. II–Painting; the Observation of Contemporary Life," *Portfolio* (London), 1891, 40–41. Hamerton's articles were then republished as a book: *The Present State of the Fine Arts in France*, London, 1892.

[20] For the dates of these late works, I am depending on those given in his posthumous exhibition catalogue (see above, n. 1). A work closely related to this large frieze of *Les Danseuses* is *Les Figurantes*, illustrated in J.-F. Schnerb, "Les Salons de 1914," *Gazette des Beaux-Arts*, 55 (July 1914), 80.

[21] See above, n. 1. For some critical responses to this exhibition, see Schnerb, *op. cit.*; "Exposition rétrospective de Fernand Pelez," *L'Art et les artistes*, 18 (1914), 195; and a short, favorable review by Louis Hautecoeur in *Chronique des arts et de la curiosité*, 1913, 301.

[22] On which see Robert Pincus-Witten, *Occult Symbolism in France*; *Joséphin Péladan and the Salons de la Rose+ Croix*, New York, 1976.

[23] This pattern has already been outlined in the important exhibition catalogue *From Realism to Symbolism*; *Whistler and His World*, New York, Wildenstein and Company, 1971, and is being further explored, in international terms, by Kirk Varnedoe.

# 45
## Ensor the Exorcist

GERT SCHIFF

*Demons Teasing Me* (fig. 1)—this is the self-image that James Ensor prepared for posterity; this is how he envisioned his inner state and the circumstances of his life. He sketched the subject for the first time in pencil in 1888,[1] basing his composition loosely upon the tradition of the *Temptation of Saint Anthony*. His own anguished and defenseless figure is surrounded by hideous monsters, ghosts of saurians, asinine hybrids, humanoid molluscs; prominent among them are a many-eyed specter with widespread wings—travesty of the four beasts in Revelation—and a many-breasted, emaciated witch—ultimate degeneration of Artemis Ephesia, the goddess of fertility and nature. In the etching of 1895, he defines the monument behind him as his own tombstone; the inscription "J. Ensor 1895" hints at premonitions of his imminent death. Only in the third version, a color lithograph,[2] has the death symbol been replaced by a cock whose crow announces the resurrection of the artist. But this lithograph served as a poster for Ensor's first Paris exhibition and was drawn for a special issue of the periodical *La Plume,* devoted entirely to his art. Having won so much flattering recognition, the artist could afford to see the fate of his work in a brighter light. Yet his torment persisted. Who were the demons that teased him?

It is evident that with this self-portrait, Ensor places himself in the long line of *artistes maudits* that extends from Romanticism to Expressionism; a line at whose beginning we might find the short-lived genius Theodore Matthias Von Holst, modeling himself upon De Quincey's *English Opium-Eater,*[3] and at whose end we see Ernst Ludwig Kirchner's *Self-Portrait during Morphine Intoxication.*[4] But Ensor never exchanged his lucidity for the comfort offered by drugs. Did his demons represent the threat of insanity? This fear, so common among the Romantics, becomes reality in E. T. A. Hoffmann's *Kapellmeister Johannes Kreisler,* the homeless, hypersensitive musician. Hoffmann's own drawing of his deranged hero, blowing soap bubbles while dancing a spectral krakoviac,[5] is a most haunting depiction of madness as an artist's destiny. However, Ensor managed to maintain his sanity even during his worst depressions and under every kind of inner and outer pressure. Nor had he ever seriously considered suicide, that other escape which tempted so many of his spiritual brothers. Gustave Doré glorified this ultimate act of nonacceptance when he transformed the miserable end of Gérard de Nerval, who hanged himself in a slum, into his apotheosis.[6] Ensor may have known Baudelaire's ennui, but certainly not that peculiar anguish which stares at us through the burning eyes of the poet's self-portrait drawing of about 1864.[7] According to Sartre, it was Baudelaire's dilemma that instead of establishing his own

719

1. *James Ensor.* Demons Teasing Me. *1895. Etching. Art Institute of Chicago, The Joseph R. Shapiro Collection*

2. *James Ensor.* Self-portrait with Haunted Furniture. *1886. Pencil. Formerly Collection Mlle. Julienne Boogaerts, Brussels*

3. *James Ensor.* Scandalized Masks. *1883. Oil on canvas. Musées Royaux des Beaux-Arts de Belgique, Brussels*

3

rules of conduct he maintained conventional standards of morality, because only by constantly violating them could he prove to himself his uniqueness. Yet Ensor felt no need to consider himself "accursed." On the one hand, he disdained conventional morality; on the other, he hardly ever violated it sensibly. There is a marked parallel between Ensor's and Gauguin's[8] self-identification with Christ. Yet the difference is no less significant. Gauguin sanctified himself in order to evade crushing feelings of guilt. Ensor chose the crown of thorns in order to assuage his hurt self-love and the pain inflicted upon him by his critics. One could find a similarity between the artistic destinies of Ensor and Rimbaud.[9] Both created their masterpieces in their prime of youth, and both their inspirations dried up early. But Rimbaud's innovative fury was inextricably linked to his total rejection of his family and upbringing, whereas Ensor's subversive art grew under the cover of a total dependence upon his family.

We will search in vain for a clue to the understanding of Ensor's demons if we compare his torment with that of other *artistes maudits*. But fortunately, he himself provides us with this clue. In a *Self-portrait* of 1886 (later called *My sad and sumptuous Portrait;* fig. 2) he depicts himself completely absorbed into a magnificent carved wardrobe, part of the inventory of his parental home. This image carries its own explanation: his demons are to a great extent the evil breed of family domination, of stifling constriction and humiliating dependence. If his material survival was safeguarded by the souvenir shop run by his mother and aunt, if he could paint quietly in his top-floor studio, high above their commercial sphere, he was still "an odd figure of a man in his mother's house, butt to the peasant jokes of Ostend."[10]

His renditions of this familiar ambience convey his sense of constriction. In purely painterly terms, *The Afternoon at Ostend* (1881)[11] is certainly one of the most sumptuous and ravishing canvases of the artist's early "somber" period. Scintillating lights dance across the mantelpiece with its Second Empire clock and vases, and across the coffee tray. Velvety streaks of vermilion and amber articulate wallpaper, rug, and oriental tablecloth. The patch of lilac on the young woman's ribbon is the jubilant keynote in this harmony of colors. Yet the artist's mother sits enthroned in her armchair with unshakable authority. And his sister who posed as the "visitor" appears nervously ill-at-ease, clutching her wrist and looking out of the picture as if waiting for permission to leave. Ensor's sister posed likewise for the *Somber Lady* (1881),[12] with an expression of increased inhibition and strain, and for the *Woman in Distress* (1882),[13] that unforgettable depiction of neurasthenic torpor behind drawn curtains. It is known that she sometimes disappeared without warning for whole days, leaving her family always in the dark about her lonesome escapes.

There was more depressing subject matter to be derived from Ensor's family life. His father was a civilized, expatriate Englishman; ill-assimilated in Ostend, he had never found a place for himself and remained as dependent upon his wife and as disdained by her as later was their artist son. This drove the father into alcoholism. Young Ensor found in his father a sympathetic mentor who introduced him to the world's literature, released him from the drudgery of school, and encouraged his artistic bent by apprenticing him to two local landscape painters. But he also infused his son with a deep-rooted fear of the matrimonial yoke and with a keen perception of the degradations of drink. Hence, Ensor painted *The Drunkards* (1883),[14] a merciless depiction of human débris not attenuated by pity nor intended to raise the viewer's social conscience, although the poster on the wall,

announcing the public sale of a farmyard, points at the consequences of the vice. A related painting, *Scandalized Masks* (1883; fig. 3), cannot be interpreted except in biographical terms. All writers about Ensor hint at the atmosphere of menace, intrigue, and hatred enclosed in the superficially funny situation: an old woman in a bespectacled mask invades threateningly the hiding-place of the lonely drinker, her hand clutching a carnival horn. She has been identified by a contemporary as Ensor's grandmother, at age sixty still given to the joys of masquerade and taking an active part in the carnival.[15] The inference is obvious: the man with the beaked mask, subject to her remonstrance, is his father. This is Ensor's first painting with masks, but only inasmuch as it depicts, realistically, masked people; people *transformed* into masks, or masks as autonomous, spectral beings, will appear in his work only several years later.

Are there, then, no joyful scenes, no traces of happy childhood memories among Ensor's early family subjects? There are: a series of pencil drawings and a masterly painting, all inspired by the artist's sister "Mitche" and her companions in their adolescent frailty. The painting *Les enfants à la toilette* (1886; fig. 4) is the most blissful and luminous in Ensor's youthful oeuvre. It is also the only one that, through the chaste, yet seductive bodies, conveys a certain eroticism. Otherwise, Eros remains conspicuously absent from Ensor's pictorial world until a much later date.

This painting has its counterpart in the sinister *Haunted Furniture* of 1885 (fig. 5), which was destroyed by a bomb during World War II. Originally it depicted the artist's sister intent upon her homework under the surveillance of a drowsy, knitting nurse. Seated in front of the magnificent wardrobe (which, as we have

*4. James Ensor.* Les enfants à la toilette. *1886. Oil on canvas. Collection Clodomir Jussiant, Antwerp*

5. *James Ensor*. The Haunted Furniture. *1885. Oil on canvas. Formerly Ostend Museum (destroyed during World War II)*

seen, served Ensor as a symbol of his domestic confinement), the girl looks up as if in sudden comprehension of an algebraic law, a grammatical rule, or a biblical parable. I say "originally," for M. De Maeyer has made it plausible that in this, as in a number of other paintings from the mid-1880s, the masks and skeletons are afterthoughts, added during the years 1889–90. According to De Maeyer, the skeleton appears for the first time in *The Agonized Christ* of 1886 (Brussels, Museum), and "autonomous" masks are introduced for the first time in *The Temptation of Saint Anthony* of 1887 (Kapellen, F. Speth Coll.). He correlates this innovation with the growing influence of Symbolism and, specifically, to the presence of Redon in the 1886 exhibition of *Les XX,* with *Hommage à Goya.* Ensor, however, always denied any influence upon his art and insisted that those fantastic elements had been part of his universe from the very beginning.[16] Be this as it may, we are confronted with the intrusion of these demonic beings, animated carnival trappings, or materialized ghosts, into his confined and well-protected domesticity. Some masks are Japanese, faces of warriors or grinning comedians in lacquered wood; others, consisting of silk and painted wax, are theriomorphic, like the one with the beak worn by Ensor's father in *Scandalized Masks.* Another variety includes masks such as the one on the right in *Haunted Furniture,* between the beaked one and the skeleton, that look like portrait caricatures; so marked are their features that they provoke the viewer to liken them to someone he knows. To be sure, Ensor could find models for most of these masks in his mother's souvenir shop. Even today the visitor will find a great variety of them in the shop as well as in Ensor's salon, now part of his Museum; and it is possible to identify certain of these masks as "characters" in some of his best-known paintings. But the painter endows them with a life of their own. They nestle in curtain folds; lie half-hidden in moldings; peep from

behind the wardrobe, and do so as if they were part of its carving. They seem to materialize in mid-air and, sliding down, converge upon the terrified child whose face, "originally" expressing intellectual illumination, now seems petrified by terror. And the grisly skeletons are part of their flock. It is still too early for us to classify these masks, to establish rules for their comportment or speculate about their *raison d'être*; all we can say is that they fill the air with their silent, obtrusive, and seemingly unavoidable presence. They are noticed only by the child and not by her nurse, which makes them all the more obnoxious; for obviously, as spirits they are unclean, intent upon disturbing orderly thoughts, soiling innocent minds, and inflicting fear. Could there be anything more vicious than the silent assault of the skeleton that, in its sneaky way, rises from beneath the child and peers into her book?

No sooner had Ensor discovered the expressive and symbolic potential of his masks than he launched forth on the most ambitious enterprise of his whole career and painted, in myriads of masks, his complete vision of society on a canvas of some 8 1/2 by 12 1/2 feet. This is *The Entry of Christ into Brussels* (1888; fig. 6). The incident represented is a Second Coming of Christ that takes place in 1889 amidst the Brussels carnival. It was not inspired by literature, for Balzac's *Jésus-Christ en Flandres,* which is sometimes cited as its source, is set in an undefined period in the late Middle Ages or early Renaissance, and deals with Christ's appearance on a ferryboat near Ostend; in a storm Christ saves the poor and pious while the rich and wicked perish. In Ensor's great painting, the subject is derived directly from the biblical account of Christ's Entry into Jerusalem.

Ensor had already treated this subject in 1885 in a large drawing *Hail Jesus, King of the Jews,*[17] which transposed the event into the painter's own time. In this drawing, the street is decked with flags, some of which bear slogans that will reappear in *The Entry of Christ into Brussels*. There are banners of the Belgian Impressionists and of *Les XX,* who, in spite of their modernism, refused to exhibit most of Ensor's innovative work and would eventually also refuse to exhibit his large canvas; "Phalange Wagner Fracassant" also hints at the reluctance of the public to accept innovative art. On the other hand, "Fanfares doctrinaires, toujours réussi" makes it clear that reactionary doctrines always maintain their authority. "Vive la Sociale" seems a declaration of sympathy for the people and for a progressive ideology. "Les Charcutiers de Jérusalem" is a contradiction in terms; since Jewish dietary laws proscribed pork, this slogan heralds the ever-increasing element of mockery in Ensor's treatment of religious subjects. "Colman's Mustard" adds triviality to the contemporaneity of the scene. Finally, the vibrant portrait of the French lexicographer Émile Littré is pasted upon the drawing at a prominent place in the right foreground. Littré was an atheist, like Ensor himself; his presence helps further to divest the incident of its holiness. There is no question that, in the days of Jules Renan and David Friedrich Strauss, Ensor embraced the positivistic view of Christ not as the son of God but as an exemplary human being, exemplary for his integrity and strength of conviction in the face of adversity. Already in 1885 Ensor had found in the Passion of Christ an apt symbol of his own suffering at the hands of his critics and the uncomprehending public.

The contrast between Christ's radiant presence and the indifference of the crowd appears more poignant in *The Entry of Christ into Brussels,* for now his entry happens at the high point of the carnival. The street, seen in a remarkable wide-angle perspective, is filled with innumerable participants in the big parade. Unaware, Christ on his donkey has become part of it. We see him surrounded by the

6. *James Ensor.* The Entry of Christ into Brussels. *1888. Oil on canvas. Collection Louis Franck, Esq. C.B.E. (on loan to Koninklijk Museum voor Schone Kunsten, Antwerp)*

most grotesque revelers of all. They can be best described in the artist's own words:

> O! the masks, that bestiary of the Ostend carnival: visages of vicunas, half-baked birds with paradise tails, cranes with beaks of azure, shouting silly fibs, architects with feet of clay, obtuse pedants with moldy skulls, full of refractory earth; heartless vivisectors, singular insects, hard shells sheltering soft molluscs. Witness *The Entry of Christ into Brussels,* swarming with all the hard and soft tribes, spilled out by the sea.[18]

Do they recognize him? They do, as can be seen in the bewildering glances of the sideshow actors who interrupt their antics in order to look at him. But nobody hails him; the odd man on his donkey is for this crowd hardly more than a colorful, if somewhat incongruous, addition to their parade. The picture tells us with unsurpassable clarity that if Christ were to come again, this breed of the human race would have no use for him—no more use, in fact, than the Belgian public had for Ensor's art. For, quite obviously, this figure of Christ bears, along with so many others in Ensor's oeuvre, his own likeness. The most astonishing parallel exists between the painting and an almost contemporary work of literature, which, however, could hardly have been known to Ensor: Dostoyevsky's "Grand Inquisitor."[19] Ivan Karamazov's haunting fantasy of a Second Coming of Christ takes place "in Seville, in the most terrible time of the Inquisition, when fires were lighted every day to the glory of God, and 'in the splendid auto da fé the wicked heretics were burnt.'" The Grand Inquisitor is alarmed by the prospect that Christ, through his doctrines of free will and forgiveness, might disrupt the Church's iron rule over the faithful. Therefore, he sends him to the stake. A brief

summary in which Dostoyevsky explains the meaning of his Grand Inquisitor can be applied, word by word, to Ensor's picture: "The basic idea is this: that spirit which distorts Christianity by linking it to mundane goals, liquidates the whole meaning of Christendom and inevitably ends up in infidelity. Instead of the lofty ideal created by Christ, a second Tower of Babylon rises. Christianity's lofty conception of mankind degenerates into the vision of a herd of brutes, and *under the flag of socially motivated love of mankind there appears the most undisguised contempt of humanity.*"[20]

These lines seem so close to the spirit of Ensor's great painting because they reject in one breath both institutionalized religion as a power structure and its opponent, socialism. This, in its turn, links up with what we know about the painter's political views. Ensor was not devoid of compassion for the oppressed poor, as will be shown presently. But in spite of his many friendships with socialist intellectuals, he "was never himself a socialist" for "he was too distrustful of the resources of mankind in any positive direction."[21] The many banners and placards in our picture certainly contain reminiscences of recent upheavals among the Belgian workers. Originally, the painting included even a salute to the socialist leader Enseele; Ensor eliminated it for reasons of censorship. Yet the gigantic red banner with the words "Vive la Sociale" can only in a very limited sense be taken as a confession of faith, or a declaration of solidarity. More honorable than many other doctrines, socialism remained nevertheless, in Ensor's view, just another "fanfare doctrinaire" that, in spite of its clamor, would not change the world.

Ensor saw the world as one big carnivalistic farce and, as can be inferred from his words quoted above and from many similar statements, the carnival was for him a symbol of human meanness and stupidity. It is interesting to note that the profound misanthropy which lay at the root of Ensor's preoccupation with masks was immediately understood when his art became known. The French *décadent,* Jean Lorrain, ascribed to his hero in *Monsieur de Phocas* (1901) a particular neurosis: such is his insight into the corruption of his fellow men that every face appears to him a hideous mask. Ethal, his mentor (modeled on Toulouse-Lautrec), prescribes a homeopathic cure: "Don't be afraid, the only chance you have to be cured of this obsession with masks is to familiarize yourself with them and to see them day by day. . . . Their imagined ugliness will attenuate your painful awareness of the ugliness of mankind." The very art of Ensor will be used as a tool in this curious exorcism: "You will see what a man this Ensor is and what a marvelous divination he has of the invisible and of the atmosphere created by our vices. . . . *Our vices that turn our faces into masks.*"[22]

If Ensor used his masks to objectify his contempt of mankind in general, it follows that occasionally they could help him also in acting out some personal spite. Gotthard Jedlicka, who visited Ensor in the early 1930s, recalls that the inhabitants of Ostend loved to search in *The Entry of Christ into Brussels* for resemblances with famous or not-so-famous people among their close or more distant acquaintances.[23] I wonder whether any of them has ever made an observation which seems obvious to me but has not found its way into the vast literature about the painting. Underneath the podium with the sideshow there is a group of four masks which have often been singled out for reproduction. They include, third from left, the bespectacled mask which in *Scandalized Masks* stood for Ensor's grandmother. The coifed woman next to her can be identified as a caricature of his mother (fig. 7). Her features, "finement espagnolés" with the strong eyebrows and the hair parted in the middle, appear quite similar, only less coarse,

7. *James Ensor.* The Entry of Christ
into Brussels *(detail)*

8. *James Ensor.* Portrait of the Art-
ist's Mother. *1881. Oil on canvas.
Musées Royaux des Beaux-Arts de
Belgique, Brussels*

8

to those in the artist's portrait of her painted in 1882 (fig. 8). Of this portrait Libby
Tannenbaum said that "the harsh composure of the features indicate[s] the obdu-
racy of this woman who was unable to understand either her husband or her
children."[24] In her mask, the half-open mouth seems ready to scold. That the
younger person on the left belongs to the same family seems obvious. She repre-
sents in all likelihood Ensor's sister. He would depict her, or her masked equivalent,
not too dissimilarly in the 1890 *Intrigue*,[25] a travesty of her unsuccessful marriage
to a Chinaman.[26] Finally, the mask to the right seems to stand for Marie-Louise
Haegheman, Ensor's aunt. To be sure, this mask as well as the "mother" and
"grandmother" appear elsewhere in his oeuvre; the "aunt," for example, figures

prominently on the right margin of *Haunted Furniture* (see fig. 5). In our painting she appears again, disproportionately enlarged, behind the halo of Christ. Ensor, I presume, found these masks in his mother's shop. He must have been amused by their resemblances to the respective members of his family. Compare, for example, his aunt's high forehead, arched eyebrows, and fat nose in his "serious" portrait of her, *Forbidding Figure* (1890; fig. 9), with the somewhat more disheveled mask. I do not, of course, mean to imply that these masks *always* represent Ensor's mother, sister, grandmother, or aunt. But in this particular instance it is their appearance as a group that lends credibility to the hypothesis. And, besides, how could he paint this vast panorama of contemporary society without including those closest to him, the sources of both his security and his torment?

Without entering into the pastime of Ensor's contemporaries, one more identification may be added. Right in front of the big drum there appears a young woman, seen in profile and wearing a bonnet with a red feather. She is one of the very few figures that are not masks, but portraits. A person whose features Ensor renders without any distortion must have been wholly sympathetic to him. We can name her; she is Mariette Rousseau, wife of the professor of physics and rector of the University of Brussels in whose house young Ensor spent his happiest hours. Mariette bought him canvases and sustained him in his moments of depression. One can see her wearing the same bonnet in a photograph with Ensor, and in his caustic drawing of 1889, *Peste dessus, peste dessous, peste partout.*[27]

Where, then, is Ensor himself? We have noted that he depicted Christ in his own likeness, as was his habit. Another self-portrait has been discovered by Vanbeselaere.[28] This is the yellow mountebank with the pointed red cap to the left, in front of the banners, who rises high above the crowd as he carries on his altercation with a stupid, green-faced mask whose hat resembles a sausage. It is in keeping with Ensor's view of the carnival as the purest exposure of mankind's vices and vanities that he, the merciless chronicler of this degrading spectacle, should address the crowd in order to stir their passions even more with a few well-chosen, cynical words. However, I believe this is not his only avatar in this

*9. James Ensor.* Forbidding Figure (Portrait of the Artist's Aunt). *1890. Oil on canvas. Collection Marcel Mabille, Brussels*

picture. I count altogether seven times the appearance of a white-faced, hooked-nosed Pierrot. We see him, first, ominously near the family group, wearing a blue hat shaped like a sugarloaf; then, in the foreground, peeping over the shoulder of the bishop; a little upward to the left, he whispers obscenities into the ear of a white nun who pretends to faint at the offense; with a wry smile, he appears on the lower left margin; and in several other places. There is no other mask that appears so frequently not only here, but in all of Ensor's oeuvre. He can be camouflaged, as in our painting he impersonates the drummer, or a creditor in *The Despair of Pierrot,*[29] or in *Singular Masks,*[30] even a woman. But more often, as in *Intrigue,*[31] *Portrait of Old Woman with Masks,*[32] *Skeletons Fighting for the Body of a Hanged Man* (fig. 11), and *Self-portrait with Masks,*[33] he is merely a detached, yet amused observer of the life around him. He is always curious and at times malicious. He might plot an underhand intrigue and then watch dispassionately, cynically, how it unfolds. As his ubiquity in *The Entry of Christ into Brussels* indicates, he is—to quote the title of a story by Ensor's favorite writer, Edgar Allan Poe—"The Man of the Crowd." Thus, in his double role of observer and plotter, he could be understood as a symbol of the artist. Does it mean that I stretch theory too far if I recognize in him Ensor's poetic *alter ego*?

The masks, the social situation of Belgium in the 1880s, and the Passion of Christ: these three interconnected themes constitute the subject matter of Ensor's great painting and, as we shall see, of much of his work during the following years.

As for the masks, it seems possible now to attempt an analysis of their character. None of Ensor's other paintings lends itself better to such an endeavor than *The Astonishment of the Mask Wouse* (1889; fig. 10). It seems to me that the central figure, Madame Wouse, must be understood, quite like many of the masks in *The Entry of Christ into Brussels,* as a caricature of an ordinary person, a symbol of bourgeois stupidity. The masks that lie on the ground (note the "grandmother"!), interspersed with a top hat, musical instruments, a bottle, a skull, a doll, a fan, a candle, and a shoe, are "real" masks in the sense of inanimate objects put to rest in an attic when the carnival was over. The predominantly eastern masks that hover in mid-air, or seem to materialize out of the rabbets of the floor, are mocking spirits, like their counterparts in *The Haunted Furniture* (see fig. 5). Having made this distinction, however, one realizes that it cannot be upheld so strictly. The Mask Wouse, which according to our interpretation is *meant* to be human, looks, with her heron's beak, much less so than, for example, the grinning specter in the top right corner. The Negro at the left emerges from the wood paneling, yet he seems almost human, as he is endowed with a torso, gesticulating hands, and, above all, speech. Moreover, those masks which are scattered on the ground belie their condition as mere objects by a certain nervous animation; they seem possessed by a subliminal life, ever ready to rise, to blow their horns, and to surround Wouse with grotesque dances. And she is aware of it. That causes her "Astonishment" and makes her feel uneasy, much to the delight of the emerging spirits. And the ultimate irony lies in the fact that she, the bourgeoise, is more grotesque, and therefore more of a mask, than the quivering, grimacing trappings that scare her.

One can trace the three species of masks—objects, spirits, and caricatures of real people—and the transitional stages between their modes of existence through many of Ensor's paintings. It has been observed that "with the 1889 *Attributes of the Studio* [he] had broken still life tradition in that the masks become actual presences":[34] I should like to add that in this painting one notices with particular clarity how certain masks are hung up while others materialize out of the wall.

In *Pierrot and Skeleton in Yellow Robe* (1893)[35] Ensor depicts the whole process, from the faint apparition of a spectral face to its fullgrown materialization as a lurking demon. And all this takes place in the presence of a "real person"— Pierrot, Ensor's *alter ego,* "The Man of the Crowd"—sadly resigned at the advance of Death. The skeletons are an integral part of Ensor's universe of masks. They form the fourth species, or rather the first, for the skull is to Ensor the "countenance of all countenances" into which all his masks at last coagulate.

In *Skeletons Fighting for the Body of a Hanged Man* (1891; fig. 11) we enter the realm of the living dead. Broomstick fights on the stages of cabarets were part of the Belgian carnival,[36] but this composition bears closer scrutiny; it has a plot. Three female skeletons have originally been engaged in the fight; one is already defeated, but even on the ground she continues her struggle and tries to tear the two others down by their skirts. All three are differentiated by their dresses

10. *James Ensor.* The Astonishment of the Mask Wouse. *1889. Oil on canvas. Musées Royaux des Beaux-Arts de Belgique, Brussels*

11. *James Ensor.* Skeletons Fighting for the Body of a Hanged Man. *1891. Oil on canvas. Koninklijk Museum voor Schone Kunsten, Antwerp*

10

11

according to their position in society. The one to the left with her richly embroidered cape over the long skirt is a lady. Her antagonist, slightly overdressed in her plumed hat, her pseudo-military waistcoat, and lacquered boots, is a lady of lighter manners. The defeated one in her cotton coat and striped skirt is a chambermaid. We know from Petronius's story, *The Widow of Ephesus,* that there can be only one reason for a female wishing to possess the body of a hanged man: she must have deeply loved him. Here, then, wife, mistress, and maidservant must have shared the attentions of the dead man. In constructing this scene, Ensor uses an elaborate visual pun. Only at first sight does the weapon of the wife appear to be a mop; at closer inspection one recognizes it as a pointed stick piercing the mistress's feather boa. Many strings connect the body of the hanged man with this stick, and the wife holds one of them between her teeth. So it becomes clear that he is not quite unused to a "hanging" position; during his lifetime he was a marionette in the hands of his wife. His label CIVET indicates that he has been stewed in his own juice by his women. Now they are ready to eat him up. Greedy masks enter the scene from both sides, the foremost two ominously brandishing kitchen knives. What are we to make of the fact that only the three contestants are skeletons, whereas all the other figures, including the hanged man, are masks? This means, perhaps, that our crudest passions bring us closest to death; that to Ensor a being in the throes of such a passion is a living dead. Thus we find at the root of this picture his misogyny, his abhorrence of marriage, and his view of humanity as a herd of brutes. Only Pierrot, his *alter ego,* watches the scene from a more elevated viewpoint with amused detachment.

At this point, we leave Ensor's masks in order to return to social questions. It was impossible for Ensor in the mid-1880s not to be aware of the labor struggle; the wave of strikes which swept across Belgium in 1886–87 had reached the shores of Ostend. It began in the mines, then centered around the glass factories. Lacking organization and leadership, the bands of workers marched over the country, burning, sabotaging, and pillaging, until the insurrection was quenched in blood. In Ostend the fishermen felt their livelihood threatened by tax-free importation of fish from England. On August 24, 1887, a clash with the civil guard left five of them dead on the beach.[37]

This event inspired Ensor with the one work in which he expressed unequivocally his respect for the strikers and his compassion with their lot. *The Gendarmes* (1892; fig. 12)[38] depicts two of the dead fishermen, guarded by their uniformed killers and watched by cynical judges while their relatives are chased away with rifle butts. Ensor used as his compositional model a very popular painting from earlier Flemish history by Louis Gallait, which shows the executed counts Egmont and Horn lying in state (1854; fig. 13).[39] Thus Ensor likened the striking fishermen to heroes in the nation's fight against Spanish oppression.

But one has only to turn to Ensor's many-figured watercolor depicting *The Strike in Ostend* (1888)[40] to realize that such an unequivocal human and political commitment was not his prevalent mood in those years. This drawing, whose minuscule detail defies reproduction, treats the uprising as a gory farce, with ribald and downright scatological elements in the vein of Bruegel. This intrusion of a spirit of mockery reveals Ensor's ever-present pessimism and misanthropy. His vision of history can be fathomed in looking at the etching *Death Chasing the Flock of Mortals* (1896),[41] the counterpart to *The Entry of Christ into Brussels.* The throngs of revelers have become a panicking mob, motivated only by their blind fear and equally blind struggle for survival, as exemplified by the man in the

**12**

12. *James Ensor.* The Gendarmes. *1892. Oil on panel. Stedelijk Museum, Ostend*

13. *Louis Gallait.* The Counts Egmont and Horn Lying in State. *1854. Oil on canvas. Musée Royal des Beaux-Arts, Tournai*

14. *James Ensor.* Man of Sorrows. *1891. Oil on wood. Collection Roland Leten, Ghent*

**13**

**14**

right foreground who butchers everyone around him in his effort to break out.

But there is no escape. Houses burn down, and whoever remained inside finds himself overwhelmed by the omnipresent messengers of Death. He, not Christ, is the sole ruler of the world.

There is a strange ambiguity in Ensor's attitude toward Christ. P. J. Hodin asked Ensor shortly before his death about his religious views.[42] In this conversation, the painter denied firmly any belief in a life after death. He said God is what we believe, a coat to clothe our nudity. But Christ is "une figure très grande. On s'est beaucoup occupé de cette figure-là. Le Christ, c'est une signification obligatoire."

Unmistakably, these words contain an echo of Jules Renan's formula of Christ as "l'homme exalté." Ensor's deepest feelings about this "very great figure" are expressed in his *Man of Sorrows* (1891; fig. 14). I quote the interpretation of Paul Haesaerts: "Ensor here discloses a deeply hidden aspect of his thought and his art. In the colors of blood and anger, transmuted by his artistic will, in the petals of roses and mignonettes, there is withal a grimace of pain and impotent rage, which puts furrows in the brow, make the nostrils quiver, and twists the mouth. Divested of its mask at last, a face reveals an unbearable contortion of the whole being before the inanity of life."[43]

In other words: this head of Christ is the embodiment of Ensor's social pessimism and moral nihilism—feelings that determined his character as an artist but that were likewise at the root of the malaise of the boom age. This painting could serve as an illustration of Nietzsche's words "God is dead." And it is perhaps only Christ's "helpless rage" at the fact that brotherhood and charity do not outweigh madness and greed that makes of him "une signification obligatoire."

Seen against this moving tribute, Ensor's use of Christ as a symbol of his own sufferings at the hands of his critics appears painfully inappropriate. Although in *Ecce Homo, or Christ and the Critics* (1891; fig. 15) the portraits of his detractors are fine examples of inspired hatred, his own likeness in the guise of Christ is too sensibly suffused with self-pity.

*15. James Ensor.* Ecce Homo, or Christ and the Critics. *1891. Collection Madame Marteaux, Brussels*

16. *James Ensor*. Christ Tormented by Demons. *1895. Etching. Art Institute of Chicago (Gift of Dr. Eugene Solow)*

17. *James Ensor*. Bizarre Smokers. *c. 1929. Oil on canvas. Collection Mlle. Julienne Boogaerts, Brussels*

18. *James Ensor*. Bathers, Curved and Undulating Lines. *1916. Private collection, Belgium*

Ensor's disbelief in Christ as the Saviour, expressed already in a drawing of 1886 under the sign of "sad and broken light,"[44] finds its most strident expression in the etching *Christ Tormented by Demons* of 1895 (fig. 16). So complete seems the victory of the infernal forces that the Redeemer himself is divested of all his human dignity. His flaccid body streaming blood, his ugly face expressing nothing but pain and defenseless acceptance of his degradation, he appears hardly more elevated than the race of demons who torment him. A lemur-like creature defecates on his pierced hand. A vulture-like spirit lacerates his scalp. A ghost from the graveyard bites into his flesh. And if this were not enough of a travesty of the Eucharist, there is a witch at the foot of the cross who puts a cauldron full of children, dead and alive, on a stove, while specters and hybrids gather for the ritual meal. The rest of the scene is taken up by a travesty of the Last Judgment. An angel blows the trumpet, but the horn of the vulture-like spirit cries louder and summons more specters to the cross. Beneath, gravestones are overturned (including the painter's own) and devils and jackals scratch and tear at the anguished awakening souls. If all this is meant to be a hallucination of the Redeemer's, then, Ensor seems to imply, he must have felt that he could not redeem himself. If it is meant to be "real," then the etching should be entitled *The World, or Humanity, Overcome by Hell.*

A direct line leads from this fantasy to the almost evil-minded mockery in the 1912 *Scenes from the Life of Christ.*[45] The ambiguity in Ensor's attitude toward Christ does not consist in the fact that he sees Christ as the prime example of heroic failure and yet identifies himself with him, but that Ensor identifies himself with a character whom he feels more and more compelled to degrade. One might speculate about the hint at self-contempt and self-hatred comprised in such an attitude. One might equally wonder how such a blasphemous fury squares with the views of a confessed atheist. But these are questions impossible to answer. We may add only one strange observation, made by Herman T. Piron, who devoted to Ensor a psychoanalytical study: in 1893 the painter, exasperated by the lack of recognition, tried to sell all his work for a ridiculous sum and failed to find a buyer. This caused a break in his development; the high tide of his creativity was over. He was then thirty-three years old—precisely the age of Christ when he died on the cross.[46]

The story of Ensor's gradual rise to fame has often been told; it was closely connected with the decrease in his productivity and creative power.[47] Interests other than art became predominant in his later years: his fame, his harmonium, his ballet *La Gamme d'Amour,* his fights against vivisection and for the preservation of Ostend's sand dunes. He remained, as he liked to call himself, "le peintre des masques," but his masks lost more and more of their demonic quality. Instead of depicting himself in the guise of a bleeding Christ, old Ensor would offer himself as a cigar-smoking Jokhanaan to his Salome and lifelong companion, Augusta Boogaerts (*Bizarre Smokers,* 1920; fig. 17). A mild irony replaced the diabolic humor of his early works. When finally, in his mid-fifties, Ensor was no longer subject to matriarchal rule, the female nude found, belatedly and nostalgically, its way into his pictorial world (*Bathers, Curved and Undulating Lines,* 1916; fig. 18). His faithful masks had served him precisely in the sense indicated in *Monsieur de Phocas:* "their imagined ugliness attenuated his painful awareness of the ugliness of mankind." They helped him to exorcise the demons bred by family domination and public hostility, and thus to become a happy nonagenarian.

*New York University*

***Notes*** This essay is a slightly expanded version of a lecture given at the Solomon R. Guggenheim Museum, New York, on February 22, 1977.

[1] Paul Haesaerts, *James Ensor*, Brussels, 1973, 78 (hereafter: Haesaerts).

[2] John David Farmer, *Ensor*, The Art Institute of Chicago–The Solomon R. Guggenheim Museum, New York, 1977, pl. 112 (hereafter: Farmer).

[3] Theodore Matthias Von Holst, *A Dream after reading Goethe's 'Walpurgisnacht,'* 1827; Gert Schiff, "Theodore Matthias Von Holst," *Burlington Magazine,* CV (January 1963), pl. 34.

[4] Ernst Ludwig Kirchner, *Selbstbildnis im Morphiumrausch,* 1917; *Ernst Ludwig Kirchner, Aquarelle und Zeichnungen,* Kunsthalle, Düsseldorf, 1960, pl. 73.

[5] E. T. A. Hoffmann, *Kreisler im Wahnsinn,* 1822; Gabrielle Wittkop-Ménardeau, *E. T. A. Hoffmann in Selbstzeugnissen und Bilddokumenten,* Hamburg, 1966, 149.

[6] Gustave Doré, *Rue Vieille-Lanterne (Allegory on the Death of Gérard de Nerval),* 1855; Konrad Farner, *Gustave Doré, der industrialisierte Romantiker,* Dresden, I, n.d., 28.

[7] Charles Baudelaire, *Self-portrait,* 1864 (?); Charles Baudelaire, *Oeuvres complètes,* Le Club du meilleur Livre, 1955, pl. 59.

[8] In *The Agony in the Garden* of 1889, Gauguin rendered Christ in his own likeness; Wayne Andersen, *Gauguin's Paradise Lost,* New York, 1971, 110, fig. 6 and *passim.*

[9] The best portrait of Rimbaud is the one in the painting by Ignace-Henri-Jean-Théodore Fantin-Latour, *Un coin de table,* 1872; Adolphe Jullien, *Fantin-Latour, sa vie et ses amitiés,* Paris, 1909, opp. 76.

[10] Libby Tannenbaum, *James Ensor,* The Museum of Modern Art, New York, 1951, 97 (hereafter: Tannenbaum).

[11] Haesaerts, 50.

[12] Haesaerts, 55.

[13] Farmer, pl. 10.

[14] Farmer, pl. 12.

[15] Libby Tannenbaum, *James Ensor, An Iconographic Study,* M.A. thesis, New York University, Institute of Fine Arts, 1942 (unpublished), 21 (hereafter: Tannenbaum, Thesis).

[16] M. De Maeyer, "De genese van masker, travestie en skeletmotieven in het oeuvre van James Ensor," *Bulletin des Musées Royaux des Beaux-Arts en Belgique,* XV (1963), 69–88. De Maeyer points out that, except for the masks, skeletons, candle, clarinet, and cross, *The Haunted Furniture* is very close to *Les Enfants à la toilette* (1886). The masks, skeletons, and other attributes, however, are similar to those in *The Astonishment of the Mask Wouse* (1889; our pl. 10) and to those in *Skeletons Fighting for the Body of a Hanged Man* (1891; our pl. 11). In the case of several other paintings, De Maeyer has been able to verify his observations through radiology.

[17] Tannenbaum, 68. For an analysis of this drawing see Julius Kaplan, "The religious subjects of James Ensor, 1877–1900," *Revue belge d'Archéologie et d'Histoire de l'Art,* 1966, 175–206.

[18] *Les Écrits de James Ensor 1928–1934,* Antwerp, 1934, 70 (my translation).

[19] Translations of Dostoyevsky's major works appeared in France from 1884 on. Articles on him appeared in the *Revue Blanche* in 1881 and 1884, in the *Revue des Deux Mondes* in 1885. The first French translation of *The Brothers Karamazov* (of which "The Grand Inquisitor" is a chapter) was published in 1888. See F. W. J. Hemmings, *The Russian Novel in France,* Oxford University Press, 1950. There is, however, no indication in Ensor's writings or in those of his contemporaries that he knew "The Grand Inquisitor," or that the work inspired him to paint *The Entry of Christ into Brussels.*

[20] Quoted after Wladimir Szylkarski, *Messianismus und Apokalyptik bei Dostojevskij und Solowjew,* in Antanas Maceinas, *Der Grossinquisitor,* Heidelberg, 1952, 302–3 (my translation, italics mine).

[21] Tannenbaum, 80.

[22] Jean Lorrain (pseudonym for P. A. M. Duval), *Monsieur de Phocas-Astarté,* Paris, 1901, 87 (my translation, italics mine).

[23] Gotthard Jedlicka, *Begegnungen, Künstlernovellen,* Basel, 1933, 223.

[24] Tannenbaum, Thesis, 14.

[25] Haesaerts, 107ᐧ Compare also the earlier portrait of Ensor's sister, *La dame à l'éventail*, and her photograph of 1883; Haesaerts, 34, 43.

[26] Although the visual evidence is strikingly in favor of this interpretation, introduced by Tannenbaum, Thesis, 59–60, it is difficult to account for the traditional date of the painting, 1890, if Haesaerts is correct in stating that the marriage took place in 1892.

[27] Haesaerts, 34 and 74.

[28] Walther Vanbeselaere, *L'Entrée du Christ à Bruxelles*, Brussels, 1957, 33.

[29] Haesaerts, 106.

[30] Paul Fierens, *James Ensor*, Paris, n.d., 73.

[31] Haesaerts, 109 (detail).

[32] Farmer, pl. 29.

[33] Haesaerts, 89.

[34] Tannenbaum, 104. For the painting, Farmer, pl. 28.

[35] Farmer, pl. 39.

[36] Tannenbaum, Thesis, 63.

[37] Tannenbaum, 78–80.

[38] Earlier version: etching of 1888; Tavernier.

[39] Tannenbaum, 80.

[40] Farmer, pl. 47.

[41] Haesaerts, 101.

[42] P. J. Hodin, "Une visite à James Ensor," *Les Arts Plastiques*, 7–8 (July–August 1949), 256.

[43] Paul Haesaerts, *James Ensor*, trans. Norbert Guterman, New York, 1959, 199.

[44] Farmer, pl. 72. The drawing belongs to a series of six scenes from the life of Christ, called *Les sensibilités de la lumière*.

[45] This is how Libby Tannenbaum (Thesis, 91) judges this work: "The Christ . . . is now a bewildered and ridiculous figure who, like Ensor's 1881 *St. Anthony*, cannot himself comprehend the significance of his experience. The apostles become merely ugly and silly old men, traditional scenes are rather vulgarly perverted and parodied, and while many of the drawings are certainly comic, it is, given the subject, a cheap and easy buffoonery which one cannot help feeling would have somewhat appalled the Ensor 'de vingt ans'."

[46] Herman Theo Piron, *Ensor, een psychoanalytische studie*, Antwerp, 1968, 98–100.

[47] However, it should be noted that Ensor's paintings after the mid-1890s are by no means as uniformly bad as certain critical writings tend to suggest.

# 46

# *The Human Eye:*
# *A Dimension of Cubism*

ANNE COFFIN HANSON

The question of dimensions is basic to painting itself. The canvas, the panel, the wall, each has only two dimensions: height and width. From the time that the painter first attempted to create an illusion on a flat surface he sought means to represent not two dimensions, but three: height, width, and depth, and thus to achieve that sense of solidity we experience in the real world. According to culture, period, and place, different methods have been adopted to capture this sense. The most dominant in the development of Western art, of course, has been mathematical perspective.[1] Its underlying tenets are still used today for many kinds of illusionistic art, and even expressionist deviations from perspective methods function largely because they defy our expectations that illusionistic pictures will follow the rules. Exactly when mathematical perspective was substantially called into question by artists of force and influence is the subject for another paper entirely. It is clear, however, that Cubist paintings do not look like pictures constructed by the rules of perspective (figs. 1, 2), and it is generally agreed among writers about Cubism that they were expressing something very different from the Renaissance illusion of rational space. On the Cubists' part this appears to be more than simply an evasion of old-fashioned method. Cubist writings are often openly hostile to mathematical perspective, "that miserable tricky perspective," "that fourth dimension in reverse," "that infallible device for making things shrink."[2] And indeed, the "fourth dimension" has often been grasped as an explanatory principle for the Cubists' shocking changes away from a long established cultural norm. The term appears frequently enough in Cubist literature, but with remarkably little clarity or consistency, and certainly without meanings which could be considered scientific. At times the words "fourth dimension" seem to take on almost magical properties, suggesting to many later writers that the aims of the new art were entirely conceptual or philosophical, and that the questions of imitation and perception were no longer relevant.[3] In his catalogue of the Cubist exhibition at the Metropolitan Museum in New York in 1971 Douglas Cooper repeatedly stressed the Cubists' rejection of "eye-fooling illusionism." In fact, for Cooper it seems that the degree to which this rejection was complete is the indication as to whether a work should be called Cubist or not. For him, Cubism is a return to conceptual principles which allow the artist to "make pictures whose reality would be independent of, but no

1

*1. Luciano da Laurana.* Architectural Perspective (Ideal City). *Walters Art Gallery, Baltimore*

*2. Georges Braque.* Rooftops at Ceret. *1911. Private collection, New York*

2

less valid than, our visual impressions of reality."[4] Although it seems clear that the rejection of "eye-fooling illusionism" is basic to the Cubist style, Cooper may be wrong in his assumption that the Cubists also rejected "visual impressions of reality." A closer look at both the paintings and the writings suggests that the artists had a high degree of dependence on visual data, or more important, on the workings of the visual instrument itself—the human eye.

I do not propose a final answer to the Cubist mystery, since major developments rarely have only one cause and many of the answers already proposed seem valid. Instead I will add another dimension to the discussion—a dimension which does not deny other interpretations, but which perhaps may enrich their textures.[5]

Certainly the most important contribution in recent years to our thinking about

Cubism is Linda Henderson's article on Cubism and non-Euclidian geometry. Thanks to her expert knowledge both of mathematics and of the history of art she has firmly and finally laid to rest the persistent claims that Cubist paintings expressed Einstein's or Minkowski's theories of relativity, and demonstrates instead that they relate to earlier *n*-dimensional and non-Euclidian geometries.[6] Of particular interest is her discovery that much of the wording of Gleizes and Metzinger's 1912 essay, *Du Cubisme*, can be directly traced to Henri Poincaré's *La Science et l'Hypothèse* of 1902. Establishing this connection makes clear that the Cubist artists had read Poincaré's chapter on "Space and Geometry" and allows for further observations on their intended meanings. The key passage for our discussion of theis ideas is as follows:

> As for visual space, we know that it results from the harmony of the sensations of convergence and accommodation of the eye. For the picture, a flat surface, the accommodation is negative. Therefore the convergence which perspective teaches us to simulate cannot evoke the idea of depth.[7]

In this statement the authors point out a basic problem for the artist, the difference between the experience of looking at a picture and that of looking at the real world. In the preceding sentences, quoted by Henderson, Gleizes and Metzinger use the term "pure visual space," and they speak of the Cubists' "study" of pictorial form and the space which it "engenders."[8] How do these ideas relate to Poincaré?

Poincaré contrasts geometric space with the space that we know through experience which he calls "perceptual space." He notes that geometric space is continuous, infinite, three-dimensional, homogenous, and isotropic. "Pure visual space" possesses only the two dimensions of the image formed on the retina. This image is continuous but it is enclosed in a limited frame, and it is not homogenous since not all parts of the retina play the same role. He explains that our perception of a third dimension when we look at the real world is due to the necessary convergence and accommodation of the two eyes. Thus our muscular sensations, entirely different from and in addition to our visual sensations, allow us to experience "complete visual space."[9] Poincaré also speaks of "tactile space," taking for granted that the reader can understand the perception of space through touch, and he points out that our notions of space also result from all our movements. "Motor space," he says, "would have as many dimensions as we have muscles." "Perceptual space in its triple form, visual, tactile and motor, is essentially different from geometric space."[10] It is not pre-created before the existence of the objects in it. Since representations of things are only reproductions of our sensations or perceptions they can be "ranged" only in perceptual space. On the other hand, the idea of geometric space is not furnished by sensations but by theories or laws. We therefore cannot represent for ourselves external bodies in geometric space but only "*reason* on these bodies as if they were situated in geometric space." He continues to discuss the deformations of forms when charted in geometric space in terms of either their change of state or their change of position. That is to say, perspective size diminution requires them to be drawn in shapes other than their real shapes. We are not able to verify whether a deformation represents an actual change in state or change of position except by following the object with the eye, correcting whatever modification has occurred "by making movements which replace us opposite the mobile object in the same relative situation."[11]

Gleizes and Metzinger seem almost to have made a summary of these passages in Poincaré when they wrote, "To establish pictorial space, we must have recourse to tactile and motor sensations, indeed to all our faculties."[12] It would certainly seem

that a new geometry was in order. Writing of Picasso in 1910 Léon Werth had said, "Why not, starting from nature, arrive at a mathematics accessible to the senses . . ."[13] But how could this be achieved? Perhaps by understanding the senses themselves. But first an understanding of the old geometry is necessary.

At the end of his chapter, Poincaré points out that although experience played an essential role in the genesis of geometric or mathematical perspective, geometry is not an exact science. Experience tells us not which is the "truest geometry, but which is the most convenient."[14] In 1946 Paul Laporte had written to Einstein to seek his support for his ideas on Cubism and the Theory of Relativity. Einstein had answered, "This new artistic language has nothing to do with the Theory of Relativity." He noted, however, that both art and science attempt to impose order on life. In science this is achieved through principles of logical connections. "The artistic principle of order is always based on traditional modes of connection which are felt equally compelling by those who live in the tradition as the logical connection is felt by the scientifically oriented man."[15] We are not always aware how much we still live in the Renaissance tradition, how compelling the Renaissance "mode of connection" is for us today. This mode of connection is, of course, Cooper's "eye-fooling illusionism," or mathematical perspective.[16] The basic idea behind mathematical perspective is that the farther an object is from the eye the smaller it will appear, and that this diminution in size occurs at a regular rate. Accordingly, the width of a roadway narrows consistently and evenly until its two sides appear to converge at a point on the horizon. Daily experience makes abundantly clear that they do not do so, but the system nevertheless is enormously useful, particularly for charting information about architecture and for creating the illusion of space in pictures of buildings. To our knowledge, perspective was invented with just such an exercise, the depiction of the Baptistery at Florence. According to his biographer, Manetti, Filippo Brunelleschi used a small panel about one-half a *braccio* square and drew his picture from about three *braccia* inside the doorway of the Cathedral. The artist's point of view was thus precisely chosen and limited by the framing effect of the Cathedral doorway. Manetti continues:

> The painter of such a picture assumes that it has to be seen from a single point, which is fixed in reference to the height and the width of the picture, and that it has to be seen from the right distance. Seen from any other point, the effect of the perspective would be distorted. Thus, to prevent the spectator from falling into error in choosing his view point, Filippo made a hole in the picture at that point in the view of the church of S. Giovanni [the Baptistery] which is directly opposite to the eye of the spectator, who might be standing in the central portal of S. Maria del Fiore [the Cathedral] in order to paint the scene. This hole was small as a lentil on the painted side, and on the back of the panel it opened out in a conical form to the size of a ducat or a little more, like the crown of a woman's straw hat. Filippo had the beholder put his eye against the reverse side where the hole was large, and while he shaded his eye with his one hand, with the other he was told to hold a flat mirror on the far side in such a way that the painting was reflected in it. The distance from the mirror to the hand near the eye had to be in a given proportion to the distance between the point where Filippo stood in painting his picture and the church of S. Giovanni.[17]

I have quoted at such length from this recounting in order to stress that a mathematically constructed picture is to be seen with a single, static eye from a position precisely controlled in relation to the location of the object seen and the size of its

painted image. Although many works of art have been painted in the succeeding
centuries which defy Brunelleschi's logic and ignore the viewing point of the
spectator, the idea of viewer controls is basic to perspective theory, and recom-
mendations concerning the location of the painter and of the viewer abound in
nineteenth-century treatises on perspective.[18] The continuing dominance of this
concept is clear from Metzinger's remark that the Cubists "have uprooted the
prejudice which commanded the painter to remain motionless in front of the
object at a fixed distance from it . . ."[19]

Much of nineteenth-century Salon criticism deals with the "distortions" which
result from what are considered improper viewing points.[20] The question of view-
point has always proved vexing. Leonardo found difficult the fact that mathe-
matical perspective "constrains the beholder to stand with his eye at a small
hole . . ."[21] He warned against standing too close to the object to be portrayed
and when precise measurements could not be taken he recommended a viewing
distance at least twenty times the maximum width and height of the thing rep-
resented.[22]

The need for careful control of the point of view is not the only reason to ques-
tion mathematical perspective. It may offer a diagrammatic equivalent to nature
but it operates very differently from human experience and particularly human
vision. There is evidence that some of the more agile minds of the fifteenth century
were already questioning the new "scientific" system. About Uccello we know
little except that some of his works suggest that he was trying to take into account
the curvature of the visual cone and the normal shifting of the eyes through the use
of multiple vanishing points.[23] Similarly, Leonardo apparently proposed a spheri-
cal space and attempted to develop a kind of perspective which would project the
image on a curved rather than a flat plane.[24] We know from several sources that
the Cubists were reading Leonardo in 1912.[25] Another Renaissance source was
probably not available to them, but it offers us an interesting compendium of ideas
which challenge the adequacy of the mathematical perspective system. Ghiberti's
Third Commentary, left unfinished at his death, appears to be a collection of
unrelated notes. It has been realized, however, that these are a compendium of
excerpts of writings by Alhazen, Peckham, and Bacon, which, to a large extent,
reflect the knowledge of optics in Ghiberti's time. John White sees them as a
summary of accepted ideas chosen to support Alberti's recently published perspec-
tive system, and he points out five main propositions gleaned from the Commentary
which would tend to stress a continuing ground surface or series of regular bodies
as a requirement for the judgment of distance and size of objects.[26] Parronchi,
however, has pointed to other statements in the Commentary which stress instead
the omissions and flaws of the Albertian system: 1) all the rays of the visual pyra-
mid are distorted upon entering the eye except the central one; 2) the eye is not a
perfect sphere; 3) we see with focal and peripheral vision, or with two visual pyra-
mids, one inside the other, one strong and one weak; 4) vision is not instantaneous;
the central rays of the eyes must certify things successively; 5) we have two eyes
and receive two images on the retinas which are conveyed to the brain through one
optic nerve; 6) we judge distances by the angles or the convergence of the two eyes.
Lastly he speaks of the importance of the sense of touch.[27]

It is remarkable to what extent these observations have been shown to be sub-
stantially correct today. The rays of light which enter the eye are, in fact, diverted
by the lens which varies in thickness according to its focus. They arrive on the
surface of the retina which is equipped with light-sensitive receptors. These re-
ceptors, the rods and cones, have different functions and are unevenly distributed

over its surface. (We are aware, for instance, that we cannot discriminate the color of objects seen in our peripheral vision.) Most important, the fovea, the spot directly opposite the opening of the eye, is tightly packed with receptors and is the best-equipped area in the eye for the perception of both color and detail.[28] What Ghiberti calls the "central ray" is the light received by the fovea. It is a natural tendency in humans to move the eye, or the head if necessary, in order to keep the image of a moving object on this most accurate area of focus.[29]

I have been speaking of the eye as if it were a single organ, but it is clear that Ghiberti understood the importance of the joint function of the two eyes. Both the muscular sensations of convergence and the fact that we see slightly different images with each of our eyes give us clues as to the position of objects in relation to us and to other objects.[30] While Poincaré realizes that the two eyes work in constant relationship, he imagines a situation in which each might function separately. Images of three-dimensional objects "paint" themselves on the retina of the eye in two-dimensional "perspectives." If these objects are in motion the viewer sees a succession of different perspectives of the same objects taken from different points of view. The muscular sensations which accompany this passage from one perspective to another provide the realization of the third dimension. If the sensations of one eye differed from those of the other, it would then be possible to imagine that these sensations could combine to give the experience of four dimensions.[31]

To understand such a playful suggestion takes an act of imaginative will since we are not normally aware of our retinal images or the discrepancies between them. In normal life we depend heavily on preconceptions and abstractions—a fact made painfully obvious when we try to remember details of an object or event no longer before our eyes. Selectively our eyes leap to points of interest for us, and we have almost instantaneous recognition of a picture of a familiar object drawn in perspective because we go directly to familiar clues. The process of seeing an entire image is a slower one since we must move our eyes over the object in order to take in all its parts. Ghiberti describes seeing as if the rays go out from the eyes and feel over the surfaces of objects.[32] We know now that the rays come to the eyes rather than issue from them, but although Ghiberti may have been scientifically naive about the process of seeing, he was sophisticated about the sense of feeling a surface as we move our eyes across it. We have learned as children to understand our visual perceptions by combining the experiences of sight and touch,[33] and this leaves us with a strong tactile appreciation of visual searching. This searching which we must do whenever we look at an object is not, however, smooth and studied. Instead, in order to recognize an object, the eye moves through a series of very rapid jerks called "saccades,"[34] repeatedly returning to points of intersection or change of direction. Patterns of eye movements which have been charted under experimental conditions appear almost to "draw" the object or at least to capture its salient features.[35] Further, it has been demonstrated that the eye must move if we are to see at all.[36] Even the accommodation of the eye to see a distant object is accomplished through a steady "hunting" motion that lengthens and shortens the focal length of the lens until the object is located. Only then does the appropriate convergence of the eyes take place.[37]

In the middle of the nineteenth century the ideas of Hermann von Helmholtz became widely available.[38] Of particular interest to us here is Helmholtz's distinction between seeing and perceiving. Previously it was generally thought that one saw and understood the thing seen simultaneously. Helmholtz described instead a more complex process which involved experience as well as sight. For him seeing

was the sensory reception of the raw data on the retina, while perceiving was the interpretation and assessment of such data.[39] One does not have to posit knowledge of Helmholtz's writings in order to demonstrate that Cézanne avoided closed contours and measured space in favor of a hesitant, exploratory, and sequential kind of observation and recording of nature. He could have turned away from traditional systems for a variety of reasons, not the least of them being his ability to observe his own visual processes.[40] Nor must we find for Manet a scientific friend who would have encouraged him to compose his pictures without due respect for the traditional viewpoint, to defy the accepted system for orderly size diminution of figures seen in depth, or to leave his freshly painted effects for the spectator to "complete." Their results have been to create works of extraordinary internal vitality, and therefore works which appealed to the Cubists. "We call Manet a realist less because he represented everyday events than because he endowed with a radiant reality many potential qualities enclosed in the most ordinary objects." said Gleizes and Metzinger. "We love him for having transgressed the decayed rules of composition."[41] As for Cézanne, "He teaches us how to dominate universal dynamism. . . . His work, an homogenous block, stirs under our glance; it contracts, withdraws, melts, or illuminates itself, and proves beyond all doubt that painting is not—or is no longer—the art of imitating an object by means of lines and colors, but the art of giving to our instinct a plastic consciousness."[42]

Cézanne's paintings do not follow a traditional "mode of connection." Instead

3

4

*3. Pablo Picasso. Ma Jolie. 1911–12. The Museum of Modern Art, New York (Acquired through the Lillie P. Bliss Bequest)*

*4. Georges Braque. Still Life with Violin and Palette. 1909–10. The Solomon R. Guggenheim Museum, New York*

5. *Georges Braque.* Oval Still Life
(The Violin). *1914. The Museum
of Modern Art, New York (Gift
of the Advisory Committee)*

they invite the eye to explore and discover. The convergence and accommodation
of the eye which are necessary to see and perceive real objects in depth do not
function when we look at a flat picture. If the organization of the picture invites
other motions of the eye it can create a kind of equivalent play of muscular sen-
sations and offer a parallel to the experience of seeing natural forms. The frag-
mented facets of a Cubist picture (figs. 2, 3, 4) can be connected by "a rhythmic
artifice," and at the same time their properties must be left independent, "and the
plastic continuity must be broken into a thousand surprises of light and shade."[43]
The eye is invited to move from one focal point to another, never settling into a
system because the offered clues cannot be read in a systematic manner. Apollinaire
makes the point that Picasso "enumerated" the various elements which make up
the objects he painted.[44] But this sequential experience is not only a matter of
intellectual recognition of parts. The construction of facets, shaded from light to
dark, creates a density of matter constantly in flux. Their open forms avoid over-
lapping and it is usually impossible to read whether they are tipped toward us or
away from us. The Cubists' admiration for Neo-Impressionism[45] allows for an
enrichment of these animated effects since broken brushwork and warm–cold con-
trasts infuse the facets with luminosity. The lack of a spatial box into which to
record forms is here fortuitous. Instead, both "pictorial form and the space which it
engenders" seem to develop spontaneously. Disconnections, hollows, and pro-
jections, by creating an active and ever-changing structure, also create an ap-
propriate and changing space.

Braque's *Still Life with Violin and Palette* (fig. 4) and Picasso's *Ma Jolie* (fig. 3)
represent the height of analytical Cubism and, at the same time, predict the end of
the perceptual phase of the movement. In each, new elements are introduced. The
lettering in *Ma Jolie,* title both to a popular song and to the painting itself, seems to
assert the picture's own two-dimensional surface. In Braque's still life the question

of illusion and reality, of diagram and experience, is confronted in another way. His throbbing picture is nailed to the wall with a carefully painted illusory nail—a nail which proves its reality by casting a shadow. The painting asks which is more real, the illusion of a three-dimensional object on a two-dimensional plane, or the illusion of the multidimensional experience of the processes of seeing and knowing. The intrusion of the verbal or visual pun predicted the end of that phase of Cubist style which delicately balanced "all the faculties" of both artist and spectator. With the invention of collage foreign materials were added to the pictorial surface to make other comments on the nature of illusion and reality (fig. 5). Their inclusion brought about mechanical closures at the edges of forms, and the simplest spatial indicator, overlapping, once more reasserted an orderly progression into depth and a more static and diagrammatic kind of space. For a brief moment in history, however, the Cubist painters had made a foray into the problems of expression of human experience and expanded the two dimensions of the canvas and the three dimensions of illusion to include a fourth dimension—the workings of the human eye.

*Yale University*

*Notes*

[1] This is not the place to enter into a discussion as to when and how mathematical perspective was invented. It is sufficient to note that it was still in use throughout the nineteenth century, and the practices and concepts taught in perspective texts approved by the Ecole des Beaux-Arts can be traced with considerable consistency back to Jean Cousin, *Livre de la perspective*, Paris, 1560, which in turn can be traced to the writings of Viator, Dürer, and presumably Piero della Francesca.

[2] Guillaume Apollinaire, *Les Peintres cubistes,* 1913, here quoted from *The Cubist Painters,* trans. Lionel Abel, ed. Robert Motherwell, New York, 1949, 45.

[3] Apollinaire, 13–14. Maurice Raynal, "Qu'est-ce que le 'Cubisme'?," *Comoedia illustré,* Paris, 1913, from Edward Fry, *Cubism,* New York/Toronto, 1966, 128–30. Jean Metzinger, "Cubisme et Tradition," *Paris-Journal,* 1911, from Fry, 66–67.

[4] Douglas Cooper, *The Cubist Epoch,* London, 1970, esp. 11, 19–20.

[5] Fry's perceptive and informative introduction suggests interesting philosophical parallels to the Cubist style.

[6] Linda Dalrymple Henderson, "A New Facet of Cubism: 'The Fourth Dimension' and 'Non-Euclidean Geometry' Reinterpreted," *Art Quarterly,* XXXIV (1971), 411–33.

[7] Albert Gleizes and Jean Metzinger, *Du Cubisme,* 1912; trans. T. Fisher Unwin, 1913; rev. Robert Herbert as "Cubism" in *Modern Artists on Art,* Englewood Cliffs, N. J., 1964, 8.

[8] Henderson, 413.

[9] Henri Poincaré, *La Science et l'Hypothèse,* here quoted from *The Foundations of Science: Science and Hypothesis,* trans. George Bruce Halsted, New York, 1913, 67.

[10] Poincaré, 69.

[11] Poincaré, 70–71.

[12] Gleizes and Metzinger, 8.

[13] Léon Werth, "Exposition Picasso," *La Phalange,* Paris, 1910, here quoted from Fry, 57.

[14] The word here is "commode"; Poincaré, 79–80.

[15] Paul M. Laporte published Einstein's letter in "Cubism and Relativity," *Art Journal,* XXV (1966), 246. The ideas he presented to Einstein were presumably those expressed in his two earlier articles, "The Space-Time Concept in the Work of Picasso," *Magazine of Art,* January 1948, 26–32; and "Cubism and Science," *Journal of Aesthetics and Art Criticism,* VII (March 1949), 423–46.

[16] Its longevity was probably assisted by

the fact that the camera with its single and immobile eye follows the rules of perspective more often than not.

[17] Antonio Manetti, *Vita di Filippo di Ser Brunellesco,* here quoted from Elizabeth G. Holt, *A Documentary History of Art, Volume I, The Middle Ages and the Renaissance,* trans. E. G. Holt and C. E. Gilbert, Garden City, N. Y., 1957, 171–72.

[18] A. Cassagne, *Traité pratique de Perspective,* Paris, 1866, 13–14, 17. The author notes that each eye has its own optical angle. While the differences of image are insignificant for distant objects as in landscape and need not be taken into account, he recommends that the artist close one eye when depicting objects nearby.

[19] Metzinger, in Fry, 13.

[20] For criticism of the perspective of Manet's *Battle of the Kearsarge and the Alabama,* see George Heard Hamilton, *Manet and His Critics,* New York, 1969, 156. For criticism of Gérôme's *Death of Caesar,* see Etienne-Jean Délécluze, "Exposition de 1859," *Journal des Débats,* 13 May 1859; and M. J. Adhémar, "Nouvelles Etudes de Perspective," *Gazette des Beaux-Arts,* IV (1859), 174.

[21] *The Notebooks of Leonardo da Vinci,* ed. Edward MacCurdy, New York, 1939, 997, from E 16.

[22] MacCurdy, 995, from A 40v., and *The Notebooks of Leonardo da Vinci,* ed. Pamela Taylor, New York, 1971, 29.

[23] John White, *The Birth and Rebirth of Pictorial Space,* 2nd ed., Boston, 1967, 204–5.

[24] Benvenuto Cellini in his *Discorsi* says that he bought a manuscript on perspective by Leonardo which involved foreshortening not only into the picture plane but horizontally and vertically as well. That manuscript is lost, but the *Codex Huygens,* written in Milan about 1570, is probably based on Leonardo's treatise; Erwin Panofsky, *The Codex Huygens and Leonardo Da Vinci's Art Theory,* London, 1940. For discussion of the treatise and of Leonardo's attempts to make a spherical intersection of the visual cone, see White, 107–8, 210, 212.

[25] Gleizes and Metzinger, 14–15.

[26] White, 126–30.

[27] Alessandro Parronchi, "Le Misura dell'occhio," *Paragone,* 123 (1961), here quoted from *Studi su la Dolce Prospettiva,* Milan, 1964, 322–37.

[28] R. L. Gregory, *Eye and Brain: The Psychology of Seeing,* New York/Toronto, 1966, 35–50. This useful little book offers a great deal of information on human vision with a simplicity and clarity which makes it accessible to beginners in the field.

[29] Gregory, 91–95.

[30] Gregory, 50–53.

[31] Poincaré, 68, 78–79. See also Henderson, 428.

[32] *Lorenzo Ghiberti's Denkwürdigkeiten (I Commentarii),* ed. Julius von Schlosser, Berlin, 1912, I, 61–62, 85–87.

[33] Jean Piaget and Bärbel Inhelder, *The Psychology of the Child,* New York, 1969, 28–50.

[34] Gregory, 43–44.

[35] David Noton and Lawrence Stark, "Eye Movements and Visual Perception," *Scientific American,* CXXIV, 6 (June 1971), 34–43. For a more complete discussion see Alfred L. Yarbus, *Eye Movements and Vision,* New York, 1967.

[36] Gregory, 44, and Tom N. Cornsweet, "Stabilized Image Techniques," in Milton A. Whitcomb, *Recent Developments in Visual Research,* Washington, D. C., 1966, 171–84.

[37] Derek H. Fender, "Control Mechanisms of the Eye," *Scientific American,* CXVI (July 1964), 27.

[38] Hermann von Helmholtz, *Handbuch der Physiologische Optik,* Hamburg/Leipzig, 1856–1866; French trans. Emile Javal and N. Th. Klein, *Optique physiologique,* Paris, 1867.

[39] Helmholtz, *Popular Lectures in Scientific Subjects,* trans. E. Atkinson, New York, 1881, 230, 274.

[40] For a perceptive study of Cézanne's work see George Heard Hamilton, "Cézanne, Bergson, and the Image of Time," *College Art Journal,* XVI, 1 (Fall 1956), 2–12.

[41] Gleizes and Metzinger, 3.

[42] Gleizes and Metzinger, 4.

[43] Gleizes and Metzinger, 12.

[44] Apollinaire, 22.

[45] Gleizes and Metzinger, 9–11.

# 47

# *The Birth of a National Icon: Grant Wood's American Gothic**

WANDA CORN

Everyone knows the image: the stern Midwestern couple with a pitchfork, standing in front of a trim white farmhouse, their oval heads framing the little building's Gothic window (fig. 1). Though simple, plain, and nameless, the man and woman in *American Gothic* have become as familiar to Americans as the *Mona Lisa*. Their image, mercilessly caricatured and distorted, pervades our culture: greeting card companies use it to wish people well on their anniversaries; political cartoonists change the faces to lampoon the country's First Family; and advertisers, substituting a toothbrush, calculator, or martini glass for the pitchfork, exploit the couple to sell us merchandise (fig. 2).

These parodies may tell us what some Americans think the painting is about, but they say little about what Grant Wood (1891–1942) intended when in 1930 he painted this relatively small (30 by 25 inches) picture. Did Wood want us to laugh at his deadly serious couple? Was he satirizing rural narrow-mindedness, as many critics and historians have claimed? If so, then what motivated this loyal son of Iowa to mock his countrymen? Who, in fact, are the man and woman in the painting and why do they look as though they could have just stepped out of the late nineteenth century? And, as modern American artists had shown no interest in Midwestern themes, how did Wood, midway through his career, come to paint *American Gothic* at all?

The literature on the painting is not extensive and offers little help in answering our questions.[1] It makes two principal claims about *American Gothic,* the first being that the painting's most important sources are European. Nearly every historian and critic credits the artist's visit to Munich in the fall of 1928, and his study of the Northern Renaissance masterpieces in the Alte Pinakothek, as decisive. There is no doubt that the artist's imagery and style changed around the time of this trip. For the previous fifteen years Wood had been painting loose, quasi-Impressionist landscapes (fig. 3). After Munich he inaugurated a new style, one characterized by static compositions, streamlined forms, crisp geometries, and repeating patterns. By Wood's own admission, the Flemish painters were an important stimulus. But historians and critics have tended to glamorize the tale, writing of Wood's

Munich visit as if it were a kind of religious conversion experience or, as H. W. Janson once suggested, a Vasari-like moment of inspiration. This mythologizing of Wood's career led Janson to offer his own playful parody of the artist's life:

> There once was a young Midwestern painter who, following the custom of his day, went to Paris in the early 1920's to learn about art. He tried as best he could to become a *bohémien* in the accepted manner, wearing a beret and painting Impressionist pictures, but he felt increasingly unhappy in this rôle. Then, one day, he went to Munich, where he saw the works of the Old Masters of Flanders and Germany, and he realized that these artists were great because they drew their inspiration from their immediate environment, from the things they were completely familiar with. He decided to do the same, so he returned home to Iowa, renewed his ties with his native soil, and out of this experience formed the style that made him famous overnight when he painted *American Gothic*.[2]

This tale, told in more reverent tones, persists in today's art history texts.

The second claim made about *American Gothic* is that the work is satirical, that Wood is ridiculing or mocking the complacency and conformity of Midwestern life. The interpretation seems to have originated in the early 1930s on the East Coast and has been conventional historical wisdom ever since. Reviewing the work in 1930 when it was shown at the Art Institute of Chicago, a critic for the Boston *Herald,* Walter P. Eaton, found the couple "caricatured so slightly that it is doubly cruel, and though we know nothing of the artist and his history, we cannot help believing that as a youth he suffered tortures from these people."[3] Later in the 1940s H. W. Janson came to a similar conclusion: Wood intended *American Gothic* as a "satire on small town life," in the caustic spirit of Sinclair Lewis and H. L. Mencken.[4] In more recent times art historian Matthew Baigell considered the couple savage, exuding "a generalized, barely repressed animosity that borders on venom." The painting, Baigell argued, satirized "people who would live in a pretentious house with medieval ornamentation, as well as the narrow prejudices associated with life in the Bible Belt."[5] In his recent book-length study of the artist, James Dennis characterized Grant Wood as a "cosmopolitan satirist" and *American Gothic* as a "satiric interpretation of complacent narrow-mindedness."[6]

For the moment let us set aside the characterization of *American Gothic* as neo-Flemish and satirical and ignore the many parodies of the image, and see the work afresh. By looking at Grant Wood's Midwestern background and his process of creation, we shall find that American sources—not European ones—best explain his famous painting. It will become clear that Iowa architecture, frontier photographs, and Midwestern literature and history are much more relevant to an understanding of Wood's painting than are the Flemish masters. Furthermore, a close study of American materials refutes the notion that Wood intended to satirize his couple-with-pitchfork.

The immediate genesis of the painting occurred while Wood was visiting friends in the tiny southern Iowa town of Eldon and came across a little Gothic revival wooden farmhouse (fig. 4).[7] Not having a word to describe it—the term "Gothic Revival" was not yet current—Wood called it an "American Gothic" house to distinguish it from the French Gothic of European cathedrals.[8] Modest in its size, this house belonged in kind to the hundreds of cottage Gothic homes and farmhouses built throughout Iowa in the latter half of the nineteenth century when the state was being settled. What caught the artist's eye about this particular example

*1. Grant Wood.* American Gothic. *1930. Oil on composition board, 30 × 25". Art Institute of Chicago*

*2. Poster Pot. 1972. Sebastopol, California*

*3. Grant Wood.* Yellow Doorway, St. Emilion. *1927. Oil on composition board, 15 7/8 × 13". Turner Collection, Cedar Rapids Art Center*

4. *House in* American Gothic. *1881–82. Photograph. Eldon, Iowa*
5. *Grant Wood.* Portrait of Nan. *1932–33. Oil on masonite board, 40 × 30″. Estate of Senator William Benton, Phoenix, Arizona*
6. *Maria Littler Wood. Photograph. Family Photograph Album, Grant Wood Collection, Davenport Municipal Art Gallery, Davenport, Iowa*

was its simple and emphatic design—its prominent, oversized neo-Gothic window

and its vertical board-and-batten siding. The structure immediately suggested to him a long-faced and lean country couple—"American Gothic people to stand in front of a house of this type," as he put it.[9] He made a small oil study of the house, had a friend photograph the structure, and went back to Cedar Rapids, where he persuaded his sister Nan and his dentist, Dr. McKeeby, to become his models.

The couple, Wood tells us, looked like the "kind of people I fancied should live in that house."[10] This is a fact missed by almost all of the painting's interpreters: the painting does not depict up-to-date 1930 Iowans, but rather shows people who could be of the same vintage as the 1881–82 house.[11] To make the couple look archaic, Wood turned to old photographs as sources. He dressed his two models as if they were "tintypes from my old family album," a collection which Wood greatly valued and which today is on display at the Davenport Municipal Art Gallery.[12] His thirty-year-old sister became transformed from a 1930s woman—witness Wood's portrait of Nan of the same period (fig. 5)—into a plausible stand-in for one of his nineteenth-century relatives (fig. 6). On his instructions, Nan made an old-fashioned apron trimmed with rickrack taken from an old dress, and pulled her marcelled hair back tightly from her face. Wearing the apron with a brooch and a white-collared dress, her appearance now recalled the photographs in Wood's family album. For Dr. McKeeby, the male model in *American Gothic*, Wood found an old-fashioned collarless shirt among his painting rags, to be worn with bibbed overalls and a dark jacket.[13]

Wood adapted not only the dress from late nineteenth-century photographs, but also the poses and demeanor: the stiff upright torsos, the unblinking eyes, and the mute stony faces characteristic of long-exposure studio portraits. In placing the man and woman squarely in front of their house, he borrowed another popular late nineteenth-century convention drawn from the itinerant photographers who posed couples and families in front of their homes (fig. 7). This practice, common in the rural Midwest through World War I, produced untold numbers of photographs, all recording the pride of home as much as a likeness of the inhabitants.

It is common in these photographs to see potted plants decorating the porches and lawns. Indoor plants moved to an outside porch during the spring and summer gave evidence of a woman's horticultural skills and were also a source of pride; in the Midwest it was hard to keep plants alive during the long and bitter winters.

7. *Mr. Story. 1909. Photograph. Solomon D. Butcher Collection, Nebraska State Historical Society, Lincoln, Nebraska*

When Wood put potted plants on the porch of the house in *American Gothic*, just over the right shoulder of the woman, he was providing her with an appropriate attribute of homemaking and domesticity.

The man's attribute, of course, is the pitchfork. Wood's initial idea was to have the man hold a rake; this was the way he rendered the scene in a preliminary pencil study hastily sketched on the back of an envelope.[14] For reasons of design he discarded the rake for the pitchfork to emphasize the verticality of the long faces and the slender Gothic window. But it was also because the artist wanted to use a tool clearly associated with farming—not gardening—and with late nineteenth-century farming at that. This offended one Iowa farmer's wife who, viewing the picture in 1930, objected: "We at least have progressed beyond the three-tined pitchfork stage!"[15]

Whether rake or pitchfork, the idea of the man holding a tool came from old frontier photographs in which men and women, in keeping with an even older painting convention, held objects appropriate to their status and occupation. Men held shovels, rakes, or pitchforks, while women leaned on brooms or chairs. In photography, of course, the long-handled tool was more than an occupational emblem; it helped steady the holder during the long exposure necessitated by slow films and cameras. A classic photograph of this type, dating from the 1880s and showing the man holding a pitchfork and the woman leaning on a chair, is by the Nebraskan itinerant photographer, Solomon Butcher (fig. 8). The architecture here is prairie sod rather than American Gothic, but the convention is precisely the one used by Grant Wood, right down to the pioneer woman's potted plants in tin cans on the table by the doorway.

Wood responded to all kinds of old visual sources besides photographs: furniture, china, glass, quilts, popular prints, maps, and atlases. Some of these things were handed down to him as family treasures; other items he bought. He valued objects in keeping with his own aesthetic of simple design and pattern—Victorian oval frames or braided rugs—as well as things that reflected Iowa history. Blue

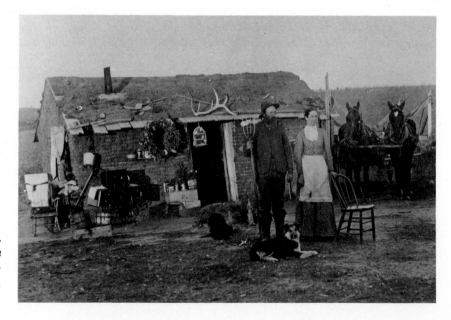

*8. John Curry Sod House. c.1886. Photograph. Solomon D. Butcher Collection, Nebraska State Historical Society, Lincoln, Nebraska*

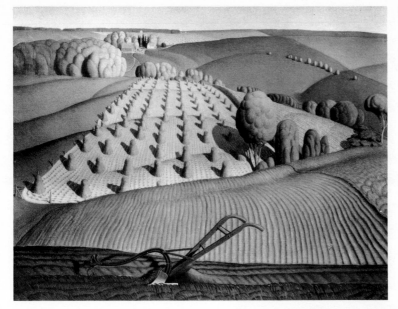

9. *Grant Wood.* Fall Plowing. *1931. Oil on canvas, 30 × 30 3/4″. John Deere Corporation, East Moline, Illinois*

10. *Residence of J. W. Richardson. Lithograph from* A. T. Andreas' Illustrated Historical Atlas of the State of Iowa, *1875*

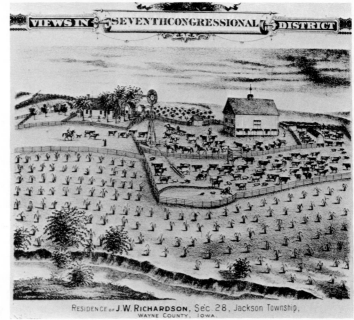

10

Willow china was important to him because it had been one of the precious luxuries pioneer families had brought with them from the East; he also gave prominent places in his home to the handmade wooden neo-Gothic clock and sewing box, and the piecrust table that his family had used on the farm.[16]

He borrowed omnivorously from these sources for all of his important paintings. In his portrait *John B. Turner, Pioneer* (1928–30), the background is easily identifiable as an 1869 map of Linn County, Iowa (fig. 18); the frame is oval, a shape Wood liked so much that he once made a coffee table out of a Victorian oval frame. *Fall Plowing* (1931) and other landscapes hark back, in their bird's-eye views

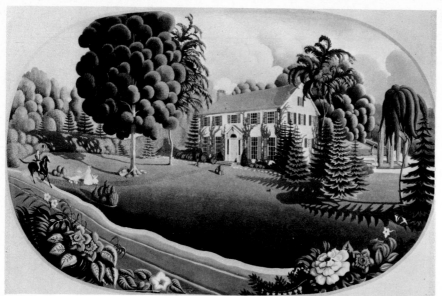

11. *Grant Wood. Overmantel painting*, The Stamats House. *1930. Oil on composition board, 42 × 65". Cedar Rapids Art Center, Gift of Mrs. Herbert S. Stamats*

12. *F. F. Palmer, for Currier & Ives*. Life in the Country— Evening. *1862. Lithograph*

12

and quilted fields, to the primitive prints of farms and villages in nineteenth-century regional atlases (figs. 9, 10). In 1930, the same year *American Gothic* was painted, Wood made a work which blended a complex range of historical sources. For the Stamats family of Cedar Rapids he painted a five-and-one-half-foot-long overmantel to go above a fireplace, reviving the late eighteenth- and early nineteenth-century taste for large painted landscapes as wall decorations (fig. 11). He took, he said, the elliptical shape of the painting from an old oval china platter; the stylized bulbous trees from his mother's Blue Willow china; and the floral border, as well as the composition of the family strolling in front of its house, from Victorian prints, particularly from ones by Currier and Ives (fig. 12).[17] To add a final touch of historicism, Wood painted the family in nineteenth-century costumes.

Wood's collecting habits and enthusiasm for antiques were part of a nationwide enthusiasm in the late 1910s and the 1920s for old American art and artifacts. This new pride in American things and in national history reflected the country's confidence as it emerged as a world power after World War I. Where Americans had

been embarrassed before by their provincial history, now they began to treasure and research their past. Furniture and paintings which once seemed awkward and second-rate now became charming and quaint—on their way to becoming valuable antiques. Signposts of this antiquarian movement dot the decade: the first exhibitions of nineteenth-century American folk art occurred in 1924; the American Wing opened at the Metropolitan Museum in that same year; in 1926 the nation celebrated its 150th birthday; the restoration of Colonial Williamsburg began in 1927; and in 1929 Henry Ford dedicated the Henry Ford Museum and Greenfield Village in Dearborn, Michigan. It was in the 1920s, as Russell Lynes has observed in his book on American taste, that "wagon wheels became ceiling fixtures; cobbler's benches became coffee tables; black caldrons and kettles hung on irons in fireplaces."[18] "The last touch of absurdity" in the public's embrace of old artifacts, Lewis Mumford caustically observed, was a government bulletin which "suggested that every American house should have at least one 'early American' room."[19]

The passion for Early Americana centered on colonial and federal period antiques and architecture. Neo-colonial houses, appearing first on the East Coast during the eclectic revivalism of the late nineteenth century, now became popular throughout America, in Iowa and California as well as in New England. Wood painted the overmantel for Mr. and Mrs. Herbert Stamats for just such a house: in that overmantel one can see the 1929 neo-colonial structure with its Cedar Rapids family standing in front (fig. 11). But the fact that Wood painted the overmantel in a neo-Victorian style rather than a neo-colonial one is significant, for it suggests that Wood's appreciation of the American past was much broader than that of the period's tastemakers. For most people in the 1920s the arts of Victorian America were ugly, unimaginative, and too reliant upon revival styles.[20] But Wood, self-taught as a connoisseur of Iowa artifacts, came to see that his Midwestern heritage was of the nineteenth century, not the eighteenth; Victorian, not colonial. It was for this reason that Wood put a very plain neo-Gothic house behind his couple (fig. 4). As a close observer, he recognized that Gothic revival architecture was one of the oldest building styles in the Midwest, and that it provided the same distinctive flavor in his region that saltbox houses gave to New England.

Wood's sensitivity to house and furniture styles was partially a product of his acquaintance with the American Arts and Crafts movement, and partly because he had an obvious talent for building and working with his hands. For two summers in the early 1910s, he had studied in Minneapolis at the School of Design, Handicraft and Normal Art; he then tried for a few years to make his living as a jeweler and metalworker. In the 1920s he earned income by designing furniture and doing interior decorating for Cedar Rapids families. His first decorations, particularly those for his own studio-apartment, emphasized simplicity and handcrafted materials and looked like designs straight out of the pages of Gustav Stickley's magazine, *The Craftsman*.[21] But by the end of the 1920s he had given up his Arts and Crafts look and was decorating in revival styles. For the Stamatses and several other Cedar Rapids families, he helped build and decorate colonial revival homes. His most challenging commission, however, and the one which reflected most clearly his enthusiasm for Midwestern sources, was the 1932 Cedar Rapids home of Mr. and Mrs. Robert Armstrong. Having heard Wood praise the use of indigenous Iowa materials in a lecture on *American Gothic*, the Armstrongs commissioned the artist and Bruce McKay, a friend of Wood's and a building contractor, to build them a "native" Iowa house. Wood and McKay derived the proportions and details of the house—door frames, shutters, fireplaces, staircases, cupboards, ironware, and

moldings—by measuring and researching two extant local stone buildings, an 1860 house and an 1855 tavern. In the closet areas of the Armstrongs' upstairs bedrooms, Wood called for white board-and-batten walls, like those of the house in *American Gothic*. When finished, the artist and Mrs. Armstrong furnished the house with antiques: pieces brought to Iowa by pioneer settlers and old country furniture made in the nearby Amana communal colonies, founded by Germans in the nineteenth century. In 1939 *Arts and Decoration* described the house as an "exact replica of an 'old settler's' house."[22]

Although Wood seldom talked about his tastes, they fell into patterns. First, as we have already seen, he enjoyed certain pieces of Victoriana such as old photographs, Currier and Ives prints, and oval picture frames. His strong preference, however, was for objects which had a "folk" look to them, things which were handcrafted or homespun, simple in design, clean in line, or boldly patterned. He liked stenciled country furniture, punched tinware, braided rugs, quilts, and the look of white cupboards with black handwrought iron fixtures.[23] In this he was the Midwestern counterpart of those East Coast artists—Charles Sheeler or Hamilton Easter Field, for example—who in the 1910s and '20s collected American primitives, Pennsylvania Dutch illuminations, and country furniture.[24]

What distinguished Wood's taste from that of Eastern artists, however, was his intense interest in items which were not only well designed but which also reflected the particulars of Midwestern history. Sheeler collected Shaker furniture and painted it because he liked its "modern" aesthetic, its functional lines, and its simple geometries. When Wood collected or painted regional artifacts it was because of their historical significance as well as their aesthetic qualities. In *Fall Plowing* (fig. 9) he depicted one of the steel plows used by Midwestern pioneers to turn the tough prairie sod into farmland. Invented by John Deere around 1840, this kind of plow cut the heavy sod easily and self-scoured itself in the Midwest's moist, sticky soil. It replaced the unsuitable equipment pioneers brought with them from the East. Grant Wood relished the crisp, abstract curves of the steel plow but at the same time he celebrated its centrality in Iowa's history. In his painting the plow stands alone, without a man to guide it or a horse to pull it, like a sacred relic.[25] A similar conjunction of abstract design and historical association explains Wood's attraction to the farmhouse in *American Gothic*. Even as he greatly admired the formal and repeated verticals of its board-and-batten walls and the mullions of the windows, Wood believed that the structure, in its modest proportions, stark neatness, and unembellished lines, evoked the character of the Midwest. "I know now," Wood said in 1932, "that our cardboardy frame houses on Iowa farms have a distinct American quality and are very paintable. To me their hard edges are especially suggestive of the Middle West civilization."[26]

Wood's interest in clean lines and patterns reflects the modernism of the period. But how, one wonders, did he develop the notion that "hard edges" were distinctively Midwestern? Why was he even interested in Midwestern buildings, people, and landscapes at a time when every painter of importance considered the middle states an artistic wasteland? Did Wood develop his iconography of the Midwest only after seeing that early Flemish artists painted their own locales and the people in them, as so many commentators have said?

To this last question the answer is an emphatic no. It was American writers, not Old Master painters, who led Wood to discover and believe in the artistic worth of the Midwest as a subject.[27] When Grant Wood painted *American Gothic* in 1930, writers had been defining the uniqueness of Midwestern life for almost half a cen-

tury. One of the first of these was Hamlin Garland. With *Main-Travelled Roads* (1891), *Prairie Folks* (1892), and *Boy Life on the Prairie* (1899), Garland gained international recognition for his depictions of pioneering and farm life in Iowa, Wisconsin, and the Dakotas, the region he called the "Middle Border."[28] These local-color stories featured vivid descriptions, thick dialects, and idiosyncratic characters and events. Many recounted prairie living as harsh and bleak, giving, Garland said, "a proper proportion of the sweat, flies, heat, dirt and drudgery" of farm life.[29] He was among the first to create a literary notion of the Midwesterner as rural, raw, and tough—as "hard-edged."

Even if they hated his harsh views—or the fact that he wrote about the prairie while living in Boston—every subsequent native artist of Garland's "Middle Border," whether painter or writer, would be indebted to him for recognizing the distinct regional character of the Midwest. Furthermore, Garland's success conveyed to future generations a clear message: the open land, farm culture, and small towns of the Midwest were not a wasteland but a rich source of artistic material. It is hard to imagine Wood's career—and that of a score of writers—without Garland's example.

In imagery, however, Wood's work depends even more on the next generation of Midwestern writers, those of the 1920s, who rejected the highly descriptive prose of Garland and other local colorists to write more crisply and emphatically about what they viewed as archetypical of their region. The most famous of these was Sinclair Lewis, a Minnesotan, whose delineations of the Midwestern small town in *Main Street* (1920) and of its booster and materialist mentality in *Babbitt* (1922) became best sellers. Wood greatly admired these books and publicly credited Lewis for the new "yearning after the arts in the corn-and-beef-belt."[30]

Typically Wood was not very precise regarding what he liked about Lewis's books other than that they were about the Midwest. But one quality surely impressed him: *Main Street* and *Babbitt* were about general character types, not about specific individuals. Carol Kennicott, for example, the central figure in *Main Street*, is a college-educated, idealistic crusader for culture and social reform. Lewis drew her portrait in such a general way that she, along with every other denizen of Gopher Prairie, Minnesota, could be recognized as types found in small towns across the United States. In 1936–37 Wood paid tribute to Lewis by doing the illustrations for a special limited edition of *Main Street*.[31] The names Wood assigned to his nine drawings, all but two of which depict characters in the book, are not of those individuals but of types—The Booster, The Sentimental Yearner, The Practical Idealist.

The man and woman in *American Gothic,* of course, also constitute a type; they are definitely not individualized portraits. But it is an oft-made mistake to compare Wood's couple with the "solid citizen" types featured in Lewis's novels. Sinclair Lewis wrote about modern Americans who lived in towns, traveled in trains and cars, listened to the radio, and went to the movies. While many of them were complacent, conformist, and narrow-minded—traits often attributed to the couple in *American Gothic*—they were not pitchfork-carrying, country types. Grant Wood's folks live in town—you can just catch sight of a church steeple rising over the trees to the left—but it is clear from their dress, their home, and their demeanor that their orientation is rural and behind the times. Their values are Victorian ones, not the modern ones of a Carol Kennicott or a George Babbitt.

It was East Coast critics who first compared Wood's work to that of Sinclair Lewis. Local Iowans knew better; the literary parallels they drew were to contem-

porary Iowan writers, most particularly Jay Sigmund and Ruth Suckow.[32] Wood, they said, was doing in paint what Sigmund and Suckow for some years had been doing in words, creating significant art out of regional materials. This comparison was apt, for Wood was a great admirer of both writers. Jay Sigmund lived in Cedar Rapids and he and Wood had become close friends a few years before the creation of *American Gothic*. Making his living as an insurance salesman, Sigmund was also an accomplished outdoorsman, a historian of the Wapsipinicon River Valley, and a writer, publishing books of Iowa verse and prose: *Frescoes* in 1922 and *Land O'Maize Folk* in 1924. Sigmund's literary reputation was regional; Ruth Suckow's writing, on the other hand, won her a national following. Her short stories about Iowa were published in H. L. Mencken's *Smart Set* and *American Mercury*, and her novel *The Folks* appeared in 1934 and became a best seller. Most influential on Wood were probably her first novel, *Country People* (1924), and her collection of short stories, *Iowa Interiors* (1926).[33]

As suggested by titles such as *Land O'Maize Folk* and *Country People*, Sigmund and Suckow wrote about country types, not Sinclair Lewis's *Main Street* types. The farmer, the villager, and the rural family are the protagonists in these Iowans' writings. The couple in *American Gothic* could have stepped out of their pages. The man might well have belonged to what Suckow termed the "retired farmer element" in the town, men who were "narrow, cautious, steady and thrifty, suspicious of 'culture' but faithful to the churches."[34] And the woman might have been one of Sigmund's "drab and angular" Midwestern spinsters whose moral propriety and excessive duty to family kept her at home caring for a widowed parent.[35] It may come as a surprise that Wood's intention from the outset was to paint an unmarried daughter and her father in *American Gothic*, not a man and wife. In seeking models for the painting, he wanted, he said, to ask an "old maid" to pose but was too embarrassed.[36] So his thirty-year-old married sister agreed to play spinster and to stand next to the sixty-two-year-old dentist playing the father. When the painting was completed and the couple interpreted as man and wife, Wood rarely went to the trouble of explaining otherwise, undoubtedly pleased that it could just as easily be read as a married couple. Indeed, thereafter he himself occasionally referred to the couple as man and wife.[37]

In 1931 Wood again portrayed the Midwestern, turn-of-the-century spinster (fig. 13). His inspiration this time came from a tintype of his Aunt Matilda (fig. 14). In sepia tones with its rounded corners, the painting looks like a large stereopticon photograph of a long-necked Victorian lady sitting next to an equally long-necked dial telephone. In the 1920s dial phones had just replaced the older system which depended upon a central operator to place calls.[38] The painting, therefore, shows the old confronting the new: the prim Victorian world of the woman meets the jangling world of the modern telephone. Appropriately Wood titled the painting *Victorian Survival*.

The man and woman in *American Gothic* are, of course, also "Victorian survivals," more at home in the rural world Grant Wood had known as a child than in the modern Iowa of his adulthood. During the first years of his life, from 1891 to 1901, Wood had lived on a country farm, attended school in a one-room schoolhouse, walked behind the horsedrawn plow, and endured spinster aunts, one of whom, he remembered, pulled her hair back so tightly that he wondered "how she could close her eyes at night."[39] The most exciting event of each childhood year was threshing day, when the big machines and neighboring farmers arrived to help thresh the grain. The threshers' noontime meal was a feast, brimming the little farmhouse over with people, smells, and activity.[40]

13. *Grant Wood.* Victorian Survival. *1931. Oil on composition board, 32 1/2 × 26 1/4". Carnegie-Stout Public Library, Dubuque, Iowa*
14. *Matilda Peet. Photograph. Family Photograph Album, Grant Wood Collection, Davenport Municipal Art Gallery, Davenport, Iowa*

Thirty years later, Grant Wood began to paint those scenes. Sitting in his Cedar Rapids studio with a telephone at his elbow and cars going by the window, he painted the spinster in *American Gothic* and *Victorian Survival*; the walking plow in *Fall Plowing* (fig. 9); the one-room schoolhouse on an unpaved road with its hand pump, woodshed, and outhouse in *Arbor Day* (fig. 15); and the noonday harvest meal in *Dinner for Threshers* (fig. 16). Like *American Gothic*, each of these was on its way to becoming a relic when Wood painted it. By 1930 children rode on motor buses over paved roads to consolidated schools with modern plumbing, tractors plowed the fields, combines made threshing days obsolete, and spinster aunts no longer dominated the family stage as they had in Victorian America.

One wonders, then, about the spirit in which Wood painted. Did he work out of a deep sense of regret about contemporary life, or, as his most recent biographer has suggested, out of a disposition to "withdraw from industrial-urban society"?[41] Neither formulation seems adequate. The facts are that Grant Wood lived contentedly in the modern world and never complained of Cedar Rapids and Iowa City, the two cities in which he lived. He never attempted to farm or to live in the country. His friends were city people like himself. But having experienced a bifurcated life, ten years on a farm followed by thirty in Cedar Rapids, Wood recognized that the insular, rural world into which he had been born was slowly disappearing, that in his own lifetime the telephone, tractor, automobile, radio, and cinema were bringing that era to an end. Here, too, he may have been sensitized by the dominant theme of Ruth Suckow's writing—the gulf between modern, 1920s lifestyles and the nineteenth-century patterns still followed by older rural and

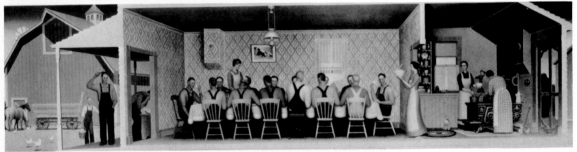

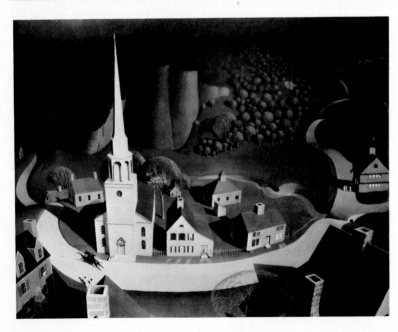

*15. Grant Wood.* Arbor Day. *1932. Oil on masonite panel, 25 × 30''. Collection King Vidor, Beverly Hills, California*

*16. Grant Wood.* Dinner for Threshers. *1934. Oil on masonite panel, 20 × 80''. Fine Arts Museums of San Francisco (Gift of Mr. and Mrs. John D. Rockefeller, 3rd)*

*17. Grant Wood.* The Midnight Ride of Paul Revere. *1931. Oil on composition board, 30 × 40''. Metropolitan Museum of Art, New York. Reproduced by permission of Associated American Artists, New York*

17

country people. Suckow, who always used regional materials to explore broad human issues, made of Midwestern generational conflict a vehicle with which to discuss the toll of social change on families. Over and over she wrote of the sadness and incomprehension that result from the horse-and-plow farmer confronting the lifestyles and values of his car-driving, city-dwelling children.[42]

Wood's response to this confrontation was different. Only once, in *Victorian Survival*, did he paint it head-on. In Wood's other "ancestor" paintings, as we may term them, he sought to capture the uniqueness of his past and to memorialize his Midwestern heritage. Ignoring the technological changes occurring around him, Wood painted his "roots." He wanted to know where his culture had come from, not where it was going. In the same spirit that motivated Americans to collect and restore discarded American folk paintings, or to rehabilitate eighteenth-century colonial villages, Wood painted "bits of American folklore that are too good to lose."[43]

Indeed, the best way to think of this artist is as a kind of folklorist searching out indigenous legends. On two occasions he painted national folktales. In *The Midnight Ride of Paul Revere* of 1931 (fig. 17), Wood depicted the famous nocturnal gallop warning New Englanders that the British were coming. Later in the decade he painted *Parson Weems' Fable* (1939), a large work retelling the famous tale of the young George Washington cutting down the cherry tree. What challenged Wood most, however, was regional folklore, particularly that of the common farmer, whose culture, Wood believed, formed the bedrock of Midwestern life.[44] Farm folklore had never become an integral part of America's national self-image. In the 1920s, indeed, many Americans often thought of the farmer as a "hayseed" or "hick," fortifying the belief that the nation's breadbasket had no history of any interest or consequence. Wood thought otherwise. In *American Gothic* he honored those anonymous Midwestern men and women who tamed the prairie, built the towns, and created America's "fertile crescent"—and who, in the process, became insular, set in their ways, and fiercely devoted to home and land. In *Fall Plowing*, Wood celebrated the farmer's harvests, while in *Arbor Day* and *Dinner for Threshers* he transformed annual rituals of rural life into quaint and colorful folktales.

In all of Wood's historical paintings, whether of national or regional themes, the legendary qualities are never bombastic or heroic. Unlike other American regionalists who painted rural life, Wood rarely aggrandized his figures through exaggerated scale, classical idealization, or Old Master grandiloquence.[45] His paintings tend to be small, his figures closer to puppets or dolls than gods and goddesses. Indeed there is a levity about Wood's work that rescues it from sentimental heroism or strident patriotism. Paul Revere appears to ride a child's hobbyhorse through a storybook landscape constructed of papier mâché and building blocks. In *Dinner for Threshers*, a panel modeled after a religious triptych, the participants look like clothespin dolls in a Victorian dollhouse, not like saints. And the man and woman standing in front of their "cardboardy frame house" in *American Gothic* are so flat and self-contained they could be children's cut-outs.

Sometimes these whimsical, storybook qualities shade into humor, a fact which has confused Wood's critics and led many to think Wood is ridiculing or making fun of his subjects. This is not the case; Wood's use of humor was gentle and good-natured, not mocking or contemptuous. It was a device he used to convey charm and quaintness and to give his works the light-hearted quality of storybook legends. And most importantly, he found that humor helped create convincing character types. In *American Gothic* we cannot help but smile at the ways Wood emphasized

the "hard-edged" Midwestern character of his rural couple. He expressed the man's maleness—and rigid personality—in the cold, steely tines of the pitchfork, then playfully mimicked these qualities in the limp seams of his overalls and in the delicate tracery of the Gothic window. To suggest the spinster's unfulfilled womanhood, Wood flattened her bosom and then decorated her apron with a circle and dot motif, a form he might well have thought of as a kind of miniature breast hieroglyph. And to underline the controlled and predictable nature of the couple's life, Wood allowed a single strand of wayward hair to escape from the woman's bun and snake mischievously down her neck. It is the only unruly element in an otherwise immaculate conception.

Though he was quiet, slow of speech, and somewhat shy, Grant Wood was one of the finer wits of Cedar Rapids. But until *American Gothic*, his humor surfaced only in conversation, at parties, or in making gag pieces for friends and for his studio-apartment.[46] His art was of a different order, serious and reserved. One can argue, in fact, that only when Wood harnessed his gentle wit and made it an integral part of his art did he arrive at a personal and mature style. When he had struggled in 1928 and 1929 in *John B. Turner, Pioneer* and *Woman with Plants* to create images of the pioneer (figs. 18, 19), the results were heavy-handed, the types not clearly drawn. For these works Wood chose Iowa settlers as models, people whose faces, he thought, recorded the pioneer experience. Wood painted John B. Turner as a successful Cedar Rapids businessman, but to indicate his personal history the artist posed him against an 1869 map of the area in Iowa where Turner had settled in the 1880s as a young man.[47] The model for the second work, Hattie Weaver Wood, was the artist's seventy-one-year-old mother, who had been born in Iowa during its early settlement, taught school in a prairie town, and farmed with her husband until his early death in 1901.[48]

Of the two portraits, that of Mrs. Wood, with her deeply lined face, faraway gaze, and stiff pose, came closer to conveying the legendary qualities the artist was after. Experimenting with ideas that would become central to *American Gothic*, Wood dressed his mother as a country woman and had her hold a pioneer woman's attribute, the hardy Sansevieria plant popular on the frontier. At either side of her he placed other houseplants, a begonia and a geranium. Though she by now lived with the artist in Cedar Rapids, he depicted her expressionless and still against an emblematic background of farmland, barn, and windmill. In its tightly focused realism and stylized line, *Woman with Plants* reflects the artist's study of the Northern Renaissance masters the previous year. It is the most "Flemish" painting Wood ever did. He simulated the translucent qualities of a Flemish work by patiently building up the painted surface with oil glazes. From Flemish portraits he borrowed the close-up, half-figural composition, the body filling the lower frame, the sitter's hand pushed close to the picture plane.

*Woman with Plants*, however, like *John B. Turner, Pioneer* before it, was still an individualized portrait. It did not come close to the streamlined generic type which the artist finally achieved in *American Gothic*. After this breakthrough Wood never again traveled abroad in search of the old and picturesque or to study the Old Masters. In Midwestern farmlore he had finally discovered his own subject matter. In old American architecture, prints, photographs, and artifacts he had found his sources. And in humor he had found a device to make his paintings light-hearted and accessible, as easy to assimilate as a storybook fable. In the tradition of regionalist writers such as Sinclair Lewis, Wood created a character type both lovable and laughable, one with virtues as well as foibles. "These people had bad points," Wood

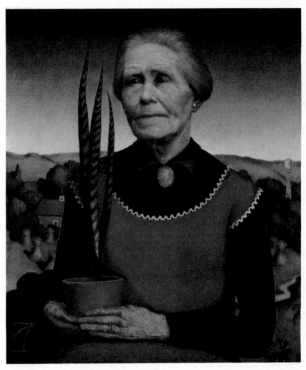

18. *Grant Wood.* John B. Turner, Pioneer. *1928–30. Oil on canvas, 30 × 25″. Turner Collection, Cedar Rapids Art Center*

19. *Grant Wood.* Woman with Plants. *1929. Oil on composition board, 20 1/2 × 18″. Cedar Rapids Art Center*

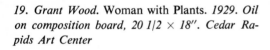

said of his famous couple, "and I did not paint them under, but to me they were basically good and solid people. I had no intention of holding them up to ridicule."[49]

Wood was also grappling in *American Gothic* with one of the basic tenets of modern painting: the belief that form and content should be one. The imagery and style of his early work had been diffuse and eclectic—trees, barns, cathedrals, old shoes, back alleys—painted sometimes with the thick brush of a Van Gogh, at others with the gentle touch of an Impressionist. But as he came to conceive of himself as a painter of Midwestern history and legend, of "cardboardy frame houses " *American Gothic* couples, and quilted farmlands, Wood realized he had to create a style consonant with his subject matter. He was groping toward such a synthesis in *John B. Turner, Pioneer* and *Woman with Plants*, but found it only in *American Gothic*. There he used every formal element of the composition to say something about the Midwest and the couple's character. The static composition and immaculate forms expressed the couple's rigid routines and unchanging lives. The repeated verticals and sharp angles emphasized the couple's country hardness, while the blunt palette of white and black, brown and green, echoed their simplicity. To make the couple look entombed, as if relics from another age, the artist bathed the scene in a dry white light, crisply embalming every little detail of the pair and their home. Even the profusion of patterns in *American Gothic*—the dots, circles, stripes, and ovals— Wood saw as a Midwestern component of his new style. Decorative patterns

abounded in his region, Wood believed, in wire fences, ginghams, rickrack, patchwork quilts, lacy curtains, and cornfields.[50]

In its style, imagery, and sources, then, *American Gothic* grew out of Wood's Midwestern experience and earned him the title of "regionalist" painter. To the artist's considerable surprise, the painting won immediate fame, a fame that continues unabated fifty years later. It is not hard to understand why. In the best tradition of regionalist art, Wood began with local materials but ultimately transcended time and place. *American Gothic* has proved to be a collective self-portrait of Americans in general, not just of rural Victorian survivals. Proof of the point is that even the visually untutored recognize the image as Mr. and Ms. American. So, too. the admen and cartoonists, who find *American Gothic* an infinitely variable mirror in which to portray Americans. In parody, Wood's simple, plain, and nameless couple can be rich or poor, urban or rural, young or old, radical or redneck. The image can be used to comment upon puritanism, the family, the work ethic, individualism, home ownership, and the common man.[51] Rich in associations running deep in myth and experience, *American Gothic* has become a national icon.

*Mills College*

## Notes

* The first art historical essay on Grant Wood was written in 1943 by the man honored by this festschrift, H. W. Janson. Three more Janson articles on Wood and Regionalism followed. That my essay asks different kinds of questions from those posed by Janson and comes to very different conclusions should not obscure the intended tribute: I could think about Grant Wood at a time when he was *persona non grata* in many artistic circles because one of my teachers had done so earlier. For Janson's essays see "The International Aspects of Regionalism," *College Art Journal*, 2 (May 1943), 110–15; "Review of *Artist in Iowa—A Life of Grant Wood*, by Darrell Garwood," *Magazine of Art*, 38 (Nov. 1945), 280–82; "Benton and Wood, Champions of Regionalism," *Magazine of Art*, 39 (May 1946), 184–86, 198–200; "The Case of the Naked Chicken," *College Art Journal*, 15 (Winter 1955), 124–27.

[1] *American Gothic* is treated at some length in Darrell Garwood, *Artist in Iowa: A Life of Grant Wood*, New York, 1944; Matthew Baigell, "Grant Wood Revisited," *Art Journal*, 26 (winter 1966–67), 116–22; Baigell, *The American Scene*, New York, 1974, 109–12; James M. Dennis, *Grant Wood*, New York, 1975.

[2] Janson, "The International Aspects of Regionalism," 111. Grant Wood first talked about the impact of the Flemish painters on him to Irma Koen, "The Art of Grant Wood," *Christian Science Monitor*, March 26, 1932.

[3] Boston *Herald*, November 14, 1930. For this review and many others see the Nan Wood Graham *Scrapbooks*, Archives of American Art, No. 1216/279–88. *American Gothic* was first exhibited in the 1930 Annual Exhibition of American Painting and Sculpture at the Art Institute of Chicago, where it won the Harris Bronze Medal and a $300 prize. It has been in the permanent collection of the Art Institute ever since.

[4] Janson, "Benton and Wood, Champions of Regionalism," 199.

[5] Baigell, *The American Scene*, 110. Baigell basically reiterates the interpretation of *American Gothic* given by Grant Wood's unauthorized biographer, Darrell Garwood. See Garwood, *Artist in Iowa*, 119–20.

[6] Dennis, *Grant Wood,* 120.

[7] Wood tells in various lectures and interviews of discovering the Eldon house. See newspaper clippings quoting Wood in the Nan Wood Graham *Scrapbooks,* Archives of American Art.

[8] Kenneth Clark's pioneering study, *The Gothic Revival, An Essay in the History of Taste,* first appeared in 1928 but it was not until after World War II that a historical appreciation flourished for Victorian architecture and decorative arts.

[9] Letter to the editor from Grant Wood, printed in "The Sunday Register's Open Forum," Des Moines *Sunday Register,* December 21, 1930.

[10] "Iowans Get Mad," *Art Digest,* 5 (Jan. 1, 1931), 9.

[11] See Calder Loth and Julius Trousdale Sadler, Jr., *The Only Proper Style; Gothic Architecture in America,* Boston, 1975, 104, where they give the 1881–82 date for the Eldon house and attribute the building of it to Messrs. Busey and Herald, local carpenters.

[12] This comes from a newspaper account of a lecture Wood gave in Los Angeles, reported in an unidentified, undated newspaper in the Cedar Rapids Public Library Clipping File on Grant Wood.

[13] Interview with Nan Wood Graham, October 14, 1977. See also Nan Wood Graham, "American Gothic," *Canadian Review of Music and Art,* 3 (Feb.–March 1941), 12. Mrs. Graham on several occasions has kindly answered my questions about *American Gothic* and about her brother's life and work. I am deeply indebted to her and grateful for her interest in my work.

[14] Reproduced in Dennis, *Grant Wood,* 86.

[15] Letter from Mrs. Ray R. March of Washta, printed in "The Sunday Register's Open Forum," Des Moines *Sunday Register,* Dec. 14, 1930.

[16] Wood's home furnishings, photographs, and books are preserved in the Grant Wood Collection of the Davenport Municipal Art Gallery.

[17] Reported to author by Mrs. Herbert Stamats, in a telephone interview Aug. 19, 1976.

[18] Russell Lynes, *The Tastemakers,* New York, 1955, 239.

[19] Lewis Mumford, *American Taste,* 1929, excerpted in Loren Baritz, ed., *The Culture of the Twenties,* New York, 1970, 402.

[20] See, for example, the perfunctory treatment of Victorian furniture in Walter A. Dyer, *Handbook of Furniture Style,* The Century Co., 1918, and in W. L. Kimerly, *How to Know Period Styles in Furniture,* 7th ed., Grand Rapids, Mich., 1928.

[21] For Wood's early training and for illustrations of the furniture he designed, see Dennis, *Grant Wood,* 19–37 and 160–61. A photograph of the artist's studio-apartment is on page 28.

[22] See the text and illustrations in Martha Darbyshire, "An Early Iowa Stone House," *Arts and Decoration,* 44 (March 1939), 12–15. Much of my information about the Armstrong house comes from a visit to the house and an interview with Mrs. Robert Armstrong on August 11, 1976.

[23] My deductions about Wood's taste are based on a study of his own furnishings, visits to the houses he decorated, and interviews with people who knew him.

[24] See this author's "The Return of the Native, The Development of Interest in American Primitive Painting," M.A. Thesis, Institute of Fine Arts, New York University, 1965.

[25] There is a display of the steel plow and its role in opening up the prairie at the John Deere and Company headquarters, Moline, Illinois.

[26] Koen, "The Art of Grant Wood."

[27] I share here the viewpoint of Matthew Baigell, who argued in "Grant Wood Revisited" that Wood's work "has stronger literary than artistic antecedents." We cite, however, different antecedents and come to different conclusions.

[28] Hamlin Garland, *Main-Travelled Roads,* New York, 1891; *Prairie Folks,* New York, 1892; and *Boy Life on the Prairie,* New York, 1899. Two useful sources for Midwestern regional literature are Benjamin T. Spencer, "Regionalism in American Literature," in Merrill

Jensen, ed., *Regionalism in America,* Madison, Wis., 1951; and Clarence A. Andrews, *A Literary History of Iowa,* Iowa City, 1972.

[29] Hamlin Garland, *A Son of the Middle Border,* New York, 1917, 416.

[30] In the Paris edition of the Chicago *Tribune,* sometime in July, 1926; Nan Wood Graham, *Scrapbooks,* Archives of American Art, No. 1216/271.

[31] The Limited Editions Club edition of Sinclair Lewis, *Main Street,* New York, 1937. All nine of Wood's *Main Street* illustrations are reproduced in Dennis, *Grant Wood,* 123–27.

[32] See newspaper clippings in the Nan Wood Graham *Scrapbooks,* Archives of American Art, No. 1216/278, 283, 308. Hazel Brown, in *Grant Wood and Marvin Cone,* Ames, Iowa, 1972, 66, recalls that Wood and friends would sit around and discuss "Frank Lloyd Wright, Ruth Suckow, and Jay Sigmund."

[33] Jay G. Sigmund, *Frescoes,* Boston, 1922; and *Land O'Maize Folk,* New York, 1924. Ruth Suckow, *Country People,* New York, 1924; *Iowa Interiors,* New York, 1926; and *The Folks,* New York, 1934.

[34] Ruth Suckow, "Iowa," *American Mercury,* 9 (Sept. 1926), 45.

[35] The phrase "drab and angular" is used by Jay Sigmund to describe a spinster in his short story "First Premium," in *Wapsipinicon Tales,* Cedar Rapids, 1927. Also see Sigmund's poems "The Serpent" (*Frescoes,* 40–42), and "Hill Spinster's Sunday" (Paul Engle, ed., *Jay G. Sigmund,* Muscatine, Iowa, 1939). Ruth Suckow describes how a very promising young girl ends her life as a lonely spinster in "Best of the Lot," *Smart Set,* 69 (Nov. 1922), 5–36.

[36] The first public statement claiming that Wood's couple were father and daughter appeared in a letter to the editor by Nan Wood Graham, the model for the picture: see "The Sunday Register's Open Forum," Des Moines *Sunday Register,* Dec. 21, 1930. Mrs. Graham gave a fuller account of Wood's original ideas for the painting in "American Gothic," *Canadian Review of Music and Art,* 3 (Feb.–March 1941).

[37] See, for example, "An Iowa Secret," *Art Digest,* VIII (October 1, 1933), 6.

[38] See John Brooks, *Telephone, The First Hundred Years,* New York, 1975, 168.

[39] Park Rinard, "Return from Bohemia, A Painter's Story," Archives of American Art, No. D24/161–295, 78. Although this biography is always attributed to Grant Wood, it was Park Rinard's M.A. Thesis, Department of English, University of Iowa, August, 1939. Rinard was an extremely close friend and associate of Wood's and wrote the thesis in close consultation with the artist.

[40] Rinard, "Return from Bohemia," 45–46, 76 f.

[41] Dennis, *Grant Wood,* 213. In his recent study James Dennis argues that Wood's attitude toward contemporary life was shaped by the Southern Agrarians who advocated "a local rural life as the alternative to industrial urbanization" (Dennis, *Grant Wood,* 150). I am not convinced by this argument. We have no evidence that Wood knew the writings of the Southern Agrarians. The first collection of these writings, *I'll Take My Stand* (New York, 1930), appeared in the same year *American Gothic* was painted. Furthermore, Wood would have had no reason to be sympathetic to writers interested only in the cultural health and economic salvation of the South. The Midwestern regional writers of the 1920s Wood did know and read. Two good guides to these writers' work are Andrews, *A Literary History of Iowa,* and Milton M. Reigelman, *The Midland, A Venture in Literary Regionalism,* Iowa City, 1975.

[42] See, for example, Suckow's novel *Country People,* and her short stories "Four Generations" and "A Rural Community" in *Iowa Interiors.*

[43] Grant Wood, quoted in the *New York Times,* Jan. 3, 1940. Wood was speaking here about his painting, *Parson Weems' Fable.* Denying any intent to debunk, Wood claimed to be preserving "colorful bits of our national heritage." James Dennis discounts this statement, arguing that the artist was a debunker and a satirist (*Grant Wood,* 109–29). Dennis is more on target, I think, when he dis-

cusses Wood as a mythologizer, as a maker of fantasy and make-believe (87–107).

44 Wood's view that the farmer is "central and dominant" in the Midwest is best expressed in his 1935 essay, "The Revolt Against the City," republished in Dennis, *Grant Wood,* 229–35.

45 The major exceptions to this statement are the federally funded murals Wood designed in 1934 for the library of Iowa State University in Ames. In other murals, such as those done for the dining room of the Montrose Hotel in Cedar Rapids, Wood could be just as playful and light-hearted as in his easel paintings.

46 Wood's sense of humor was such a vital part of his personality that everyone who knew him comments on it. Numerous stories of his pranks and jokes can be found in Garwood, *Artist in Iowa,* and Brown, *Grant Wood and Marvin Cone.* See also Park Rinard's essay in *Catalogue of a Loan Exhibition of Drawings and Paintings by Grant Wood,* The Lakeside Press Galleries, Chicago, 1935. The Cedar Rapids Art Center owns many pieces which Wood made for fun—a "mourner's bench" for high school students who were being disciplined; flower pots decorated with flowers made of gears, bottlecaps, and wire; and a door to his studio with a movable indicator telling whether the artist was in, asleep, taking a bath, etc.

47 For information about the Turner family I interviewed John B. Turner II

in July and August of 1976. His father, David Turner, was Wood's chief patron during the artist's early career; his grandfather was the model in *John B. Turner, Pioneer.* Wood dated this painting twice: "1928" in the lower left *under* the oval frame, and "1930" at the edge of the frame in the lower right. Although historians have considered this work to be post-Munich, I suspect this is wrong. Based on the early date and the style of the piece, Wood probably began the portrait sometime in 1928 and dated it before leaving that fall for Munich, where he stayed until Christmas. In 1930 he made revisions to the painting, and dated it anew when he added the oval frame, a shape in keeping with the neo-Victorian features of *American Gothic.*

48 Mrs. Wood's early biography appears in Rinard, "Return from Bohemia," ch. 1.

49 Dorothy Dougherty, "The Right and Wrong of America," Cedar Rapids *Gazette,* Sept. 5, 1942.

50 See Irma Koen, "The Art of Grant Wood," and quotations from Grant Wood's lectures and interviews in the clippings in the Nan Wood Graham *Scrapbooks,* Archives of American Art.

51 There are several major collectors of *American Gothic* caricatures. I am grateful to Nan Wood Graham, Edwin Green, and Price E. Slate for having made their large collections available to me. My own collection, begun only in the early 1970s, already numbers well over a hundred items.

# 48

## St. Petersburg-on-the-Hudson: The Albany Mall

CAROL HERSELLE KRINSKY

The man whom we honor in these pages was, as we know, born in St. Petersburg, the second city of Imperial Russia. Our own Peter the Great is now a resident of the Empire State, of which the second city—Albany, the state capital—is the subject of this essay.

As Albany, unlike St. Petersburg, has never been a place of art historical pilgrimage, a bit of background must introduce the topic at hand.[1] The city that would become the capital of New York State was established by Dutchmen in 1614 as a fur-trading post along the Hudson River, almost a century before the original Peter the Great planned St. Petersburg "in the manner of the Dutch"[2] along the Neva. Albany was shortly thereafter protected by a fort, just as the Russian city grew behind a fortress in the wilds. Albany received its charter in 1686 and its English name from the British who had won the area from the Dutch in 1664. About eighty years after St. Petersburg became the nominal capital of Russia, Albany became the capital of New York State in 1797. During the following century, its position as a shipping port assured its prosperity; it lay at the eastern end of the Erie Canal, along several railroad lines, and at the terminus of the log-driving route down the Hudson. Lumber mills, docks, rail freight handling, and light manufacturing attracted laborers, including many immigrants who occupied modest houses and low-rise tenements in the central districts of town, particularly to the south and east of the capitol hill on a slope descending toward the riverfront.

In the twentieth century, changes in industry, suburbanization of the middle classes, obsolescent housing, demographic changes, and the departure of many downtown state offices for an office "campus" several miles from the city center left Albany an aging, small-scale city of about 129,000 souls at the time of the 1960 census.

In late 1960, the mayor, Erastus Corning, II, who had held his office for two decades, began to look in earnest for ways to assure the continuity of the central business district. In concert with the Downtown Albany Redevelopment Committee, a merchants' group, the city government hired the planning firm of Candeub, Fleissig & Associates to study ways of improving housing, traffic circulation, and commerce in the urban core.

Up to this point, the history of Albany had been shaped by the same slow-moving forces of private enterprise and of social or governmental action that affected countless American cities. Albany stood in sharp contrast to those capitals of the

old world—Versailles, St. Petersburg, Karlsruhe, Edinburgh New Town—which arose almost suddenly, within a generation or two, shaped to suit strong-minded government authorities and featuring regular, formal plans extending from a palace or a military complex.

The gradual process of change was dramatically interrupted by the intervention of Nelson Rockefeller, who was governor of New York State from 1959 to 1973. He confessed to having an "edifice complex"[3] and unrealized ambitions to be an architect, and he came from a family well known for its interests in Rockefeller Center, Lincoln Center, the World Trade Center, American and foreign university buildings, museums, churches, and hotels, and for its contributions to the restoration of Reims Cathedral and the Château de Versailles. To such a son in such a family, Albany must have seemed unimpressive. It was widely reported that he spent as little time there as he could manage. He had been governor for over three years before he took a long walk in the neighborhood of his own Governor's Mansion,[4] which stood in the decaying working-class district between the Capitol and the river.

Part of this district was known popularly as the Gut. A study published in 1961 showed that the area had a high percentage of overcrowded multiple-dwelling housing units.[5] Owner-occupancy was only ten to twenty percent, an indicator of housing-stock deterioration. Average rents in the Gut were half those of the city as a whole, in part because eighty-five to ninety percent of the dwellings were over seventy years old. Young white families who could afford to move away did so, while in some tracts in the Gut–Capitol Hill area the number of non-whites increased tenfold between 1950 and 1960 since they often encountered racial discrimination elsewhere. Insofar as housing inspectors visited the district, they found innumerable violations. Health reports showed that the number and proportion of new venereal disease cases were almost twice those to be expected by chance. Nelson Rockefeller was actually ashamed of having to drive into Albany through this area when Princess Beatrix of the Netherlands accompanied him to visit the former Dutch community.[6] The Albany Mall, built to his design, eventually replaced the blighted district.

> "A few hundred meters off the centre with its splendid streets and squares lay an entirely different world. A world of hovels and slums. . . . It was unbelievable that this was a part of that same city which amazed the visitor with the majestic beauty of its granite embankments, great squares, and palaces."[7]

The Albany Mall is properly but rarely called the Empire State Plaza (figs. 1, 2).[8] It is an enormous building complex of state offices and other state facilities occupying 98.5 acres to the south of the Capitol, replacing some of the old buildings on a ridge cut by a valley. The largest building is a five-story platform measuring 1700 by 600 feet and containing 3,807,000 square feet of parking areas, loading and service zones, and mechanical equipment beneath a corridor at the fifth-floor level which links all the buildings of the complex. The corridor is bordered by a post office, cafeterias, offices, conference rooms, and an auditorium (fig. 3). The corridor is so wide that its many works of art, including paintings thirty and forty-eight feet long, look almost small and isolated within it. The remaining ten buildings rise on either side of an axis running south from the Capitol upon the sixth, or roof, level of the platform. On that surface are reflecting pools flanked by rows of trees, more art, snack bars, and sitting areas. On the east side of the main axis are a rectangular Justice Building housing courtrooms, offices, and a library; an egg-

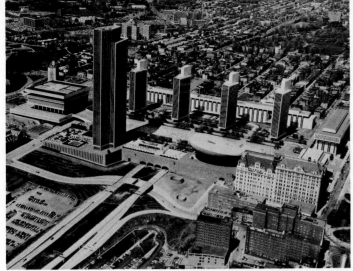

1

1. *Albany, N.Y., Empire State Plaza ("Albany Mall"). Air view looking southwest*

2. *Albany, N.Y., Empire State Plaza ("Albany Mall"). Air view looking southeast*

3. *Albany, N.Y., Empire State Plaza ("Albany Mall"). Plan of concourse level within platform building*

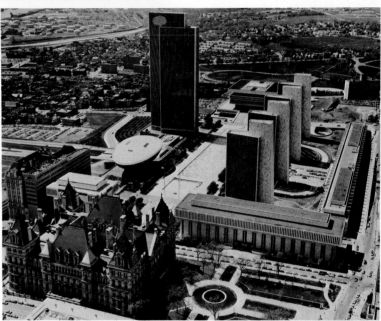

2

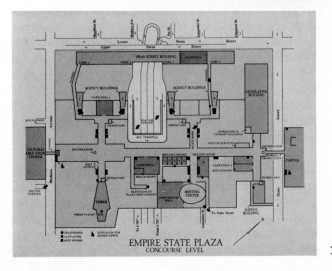

3

shaped structure containing two auditoria designed for 500 and for 950 people; a 44-story office tower, the tallest building in the State outside New York City, its lobby filled with paintings and sculpture; and Health Department laboratories within the platform, surrounding a deep sunken courtyard. Along the west side of the main axis are a rectangular Legislative Office Building and four identical 23-story office buildings for state agencies. Farther west, along Swan Street, is a 1200-foot-long office building rising five stories above ground and burrowing three below. At the southern end of this complex, opposite the Capitol at the northern end, rises a Cultural Education Center that houses the State Museum and part of the State Library. Wide steps bridge the street between the platform and this building's entrance one floor above; these steps serve as seats during outdoor cultural and recreational events held on the platform.

When we look at the marble-faced buildings of the Mall, we know that we are in no ordinary part of the city, but rather in a ceremonial place. The separateness of this complex is made clearer by its elevation on a platform, which differentiates the ground level here from that of the rest of Albany and prevents pedestrian access from the south and east. The Mall can only be reached on foot at the north, the Capitol, end, from which side one must mount steps to the platform, or from the west through a few openings in the Swan Street Building. From the main entrance at the head of the north-south axis the visitor turns his back on the Capitol to look south past a parade of civil servants' office buildings toward the building designed for culture, a subject to which members of the Rockefeller family have devoted as much attention as rulers of entire countries once did. The entire Mall was developed in a way that suggests if not royal power, then at least that a strong will can still be exercised in a democracy, and what the consequences may be.

Knowing that the city needed to encourage middle-class and white-collar activity downtown, Governor Rockefeller thought of building a state office building complex in central Albany. The vicinity of the Gut, the Executive Mansion, and Capitol Hill naturally presented itself as ripe for replacement. Hartford, capital of neighboring Connecticut, was refurbishing its decaying downtown with tall new buildings. New buildings in Albany would provide thousands of construction jobs, increase tax assessments on nearby property, and raise the morale of State workers who would have new quarters supplanting the older rented premises then scattered around the city. Although the city would not receive property taxes on the new buildings if the tax-exempt State government built and owned them, thousands of construction workers and salaried employees would be kept downtown, perhaps to shop and dine there rather than in suburbia. If new low-income housing were incorporated into a proposal for State offices, the city could agree in good conscience to the displacement of over 3,000 family units of poor people who lived in the old houses on the site.

In order to test the possibilities, the Governor asked the State Legislature in 1961 to establish a Temporary State Commission on the Capital City, with Lieutenant-Governor Malcolm Wilson as chairman.[9] The Legislature may not have had a clear idea that this step could point to a St. Petersburg-on-the-Hudson, but Messrs. Rockefeller and Wilson must have seen where the studies might lead.[10] The final page of the Commission's 1963 report spoke of its "objective of a Capital City for New York State second to none in our Nation—or indeed, in our world."[11]

The Commission engaged three firms of planners—excluding Candeub, Fleissig—on August 1, 1961, to study not just the State's need for office space but also the city's needs in housing, transportation, recreation, and business facilities. The

firms were those of Maurice E. H. Rotival, hired for specific expertise in regional and city-wide planning; John Calbreath Burdis Associates, chosen for its local planning experience; and Rogers, Taliaferro, Kostritsky and Lamb, hired for its skill in producing specific details for implementing plans and for its distinction in urban design.[12]

After evaluating five alternative development strategies, including maintenance of the status quo or building a new capital "as at Versailles, Brasília, or Chandigarh," the planners settled on one called the "Trans-Hudson Counterpoise." The ideas behind it were these: "If the State Government reestablished within Albany's core, it would spur the latter's other functions . . . and would contribute to redeveloping both sides of the river. A major research center would be developed on the heights across the river in Rensselaer, and the waterfront reclaimed for cultural and community use. . . . Some of the principal elements of this plan will be located in the Core of Albany . . . the new State Government complex, the renewed business center, the development of the waterfront, and a new bridge across the river to the proposed community and research facilities in Rensselaer."[13]

Candeub, Fleissig & Associates had thought that the site of the government core should be very close to the downtown business district which lies north and east of the Capitol, perhaps along the waterfront. The three planning firms employed by the Temporary State Commission rejected these ideas because the riverfront would have been remote from the state buildings on Capitol Hill, and traffic problems on Albany's old, small streets were already so serious as to make easy connection between riverfront and hill unlikely. A scheme to construct a platform bridging a ravine north and east of the Capitol would have required the moving of a highway crossing of the river, a task said to be too difficult to achieve. The site might also have been cramped.[14] Constructing new facilities privately in scattered locations around the downtown district would have meant the "failure to create as a unit a structural symbol of the State Government," a goal which must have been dear to the Governor's heart. The planners recommended the "South Mall" location, an area extending south to Madison Avenue from the Capitol, between the Governor's Mansion on Eagle Street and Swan Street on the west (fig. 4).

*4. Albany, N.Y., Empire State Plaza ("Albany Mall"). Plan of roof level of Platform (from State of New York, Office of General Services, Empire State Plaza, Design for the Future, Albany, 1977)*

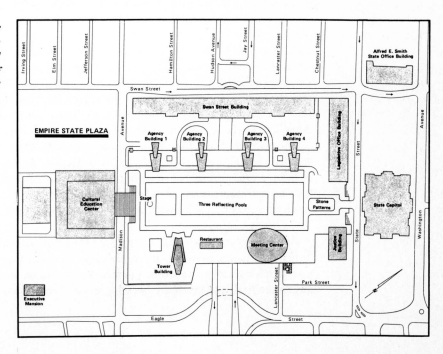

The site just happened to be the one that Governor Rockefeller preferred, although he said that he did not dictate the choice. The South Mall was selected because it was conveniently adjacent to the existing Capitol, the State Office Building, and the State Education Building, and because "the elevation could contribute to a dramatic development of the State Capital's skyline" which then included only a few tall structures in a modest, low urban profile.[15]

> "In those first years, church spires lent beauty and magnificence to the skyline and the general appearance of the town, breaking the monotony of the squat structures. . . ."[16]

When only the 1962 interim report of the Commission was produced, but when no clear plans had been made for the State Office buildings, the Commission told the State to take over 98.5 acres of land south of the Capitol, and asked the Legislature to appropriate $20 million to pay owners for the value of their land and the buildings on it.[17] The Legislature was buying a pig in a poke, but it trusted the distinguished planners and the Commission members who proposed to renovate a district which the legislators knew was run-down.[18] But the vote for only $20 million opened the door to all the subsequent events: As soon as the land was obtained, and as soon as buildings began to be demolished—some as early as spring 1962—it seemed too late to stop the entire project.

Mayor Corning understood the consequences of the $20 million appropriation (although in 1962 there were only general proposals for the site, not the huge projects published in the 1963 Commission report). He was not averse to having something built in his city. But no one had told him what it would be. Downtown merchants might get little business from occupants of office space several hilly blocks away. An area of 98.5 acres, producing about $500,000 in annual tax revenue, was going to be used by tax-exempt state buildings. The city would have to relocate a police station and some schools. It might have to provide water, sewer connections, and fire and police protection to the new buildings.[19] About six thousand people, predominantly faithful Democratic voters,[20] would be moved. No one told him where. The Regional Director of the NAACP spoke bitterly about the impending demolition of eleven percent of the housing available to Albany's blacks.[21] The city would gain little but temporary compensation for the tax losses, temporary construction jobs, and eventually the increased taxable value of some buildings near the Mall. The Republican governor might become famous for providing the jobs and the new offices and the splendid new skyline, but the Democratic mayor would be left with the construction-choked streets, unhappy displaced residents and businessmen, and an increased tax burden. Mayor Corning sued to have the State's land acquisition declared illegal, but on June 29, 1962, the Court's Appellate Division ruled unanimously that the State's activities could proceed.

The specific plans for the new state office complex became clearer with the publication of the handsomely printed Report of the Commission, issued in February 1963. Presented in a slipcase covered with a reproduction of Seurat's *A Sunday Afternoon on the Island of La Grande Jatte,* the report within offered a more modern vision of urbanism, dignity, recreational space, and riverfront development.

A large colored rendering of the city in the future accompanied the report (fig. 5). It featured parks, marinas, and middle-income apartment houses on and near the riverfront, as well as new office buildings downtown and a convention center between the river and the Mall. New highways were shown sweeping along the river-

5. *Rendering of proposal for renewing downtown Albany and the riverfront, 1962–63 (from Temporary State Commission on the Capital City,* Report, *1963)*

front, with branch roads diverging at a mammoth "pretzel" junction to a new bridge on the east and to the Mall on the west, continuing to an expressway planned to slice through the city. The rendering did not depict the Mall buildings, probably because the rendering was made while the original designs—shown elsewhere in the report—were being modified; an addendum slip was inserted into the report before it was distributed, showing a photograph of a new model which was prepared by early 1963 (fig. 7).

Four earlier ideas were shown in the report and in a technical document accompanying it. South Mall Plan A was based on intersecting axes with a line branching from the highway to meet the apex of an isosceles triangle which had the State Office Building and the Capitol at its base angles. The scheme was descended from City Beautiful plans. South Mall Plan B opened the eastern half of the site to parks and a single office tower, and staggered the main series of new rectilinear slab-shaped office buildings at the west. Plan C provided for a more uniform development over the entire site with open spaces between buildings of various heights, disposed in a manner loosely reminiscent of Le Corbusier's plan for St. Dié.[22]

Whatever their other faults may have been, all of these plans failed to emphasize the Capitol as the focal point of the new complex, and all put major emphasis on the offices of the functionaries who only served the elected representatives of the people. They were also more complex than the present simple plan, which is intelligible at a glance.

During the course of 1962, the fourth proposal had simplified the plan, made the Capitol into the generator of the rest of the plan, and strengthened the project's impact on the approach from the Capitol and downtown (fig. 6). It was close to the completed project. Nelson Rockefeller himself suggested the scheme, which was based on yet another of the extraordinary capitals of the world: the Palace of the Dalai Lama at Lhasa, Tibet, which he had "always admired." It seems curious to base capital city plans in a democracy on the headquarters of a theocracy, but those were not thoughts which occurred to the Governor. He knew that there was

to be an east–west highway approach to the new hilltop complex from the river-front highway on low ground. He knew that this approach would intersect an axis running north and south, and that there was far more room to accommodate buildings along the latter axis than along the former. He remembered that at Lhasa there was an approach across a low plain to the hilltop palace and to the cliff supporting the palace, and that one could enter that complex at the base of the cliff through a portal within a high wall. The multitude of towers at the palace spread out to the right and left of the axis of approach. Could not the Albany design provide for a highway entrance to the base of a multistory platform (like the high wall at Lhasa), with tall office towers and other buildings rising along the top of the platform, running southward from a focal point at the Capitol? He sketched his ideas on the back of an envelope for Wallace Harrison while the two were aloft in an airplane.[23]

A revised version of this scheme was made and photographed for the 1963 report's addendum (fig. 7). It included elements taken from Lhasa, Washington, D.C., Brasília, Versailles, Rockefeller Center, and St. Petersburg. All this in Albany, a modest town of domestic scale—but it was to be made into "our generation's vision of what the capital of a great state should be," "the most beautiful state capital in America," and "the most spectacularly beautiful seat of government anywhere in the world." Nelson Rockefeller said that it "may turn out to be the greatest thing to happen to this country in a hundred years."[24]

As Peter the Great and his imperial successors aggrandized a small riverfront outpost, Governor Rockefeller had a plan for aggrandizing a small riverfront city in decline. As the Russian emperors sought established ideas from the west and built them in the east, Rockefeller imported some ideas from the east, added them to even stronger ideas from the west, and provided the basic design for the renewal of Albany.

> "[The Summer Garden] has an area of a little over 11 hectares [about 24 acres]. The planning was done by Peter the Great himself who wanted to have a better garden than the French king had in Versailles. . . . With its precise arrangement, straight walks and neatly trimmed trees and shrubs it was a model formal garden."[25]

The published models showed buildings similar to those that exist today. There were two significant differences, however. The single cultural building at the southern end was split in the models into two low, rectangular structures flanking a huge concrete arch which rose in the center of a plaza between the two buildings. The Swan Street Building was not evident in the models. Instead, a group of straight slab-shaped multistory housing units was laid out parallel to Swan Street; in the earlier version of the plan (fig. 6), these had been boomerang-shaped. The mix of higher and lower skyscrapers, the provision of art-filled open public space, the construction of a multilevel substructure and even a wintertime ice-skating rink recall Rockefeller Center. Albany shares with Washington, D.C., a central open axis with pools bordered by imposing, white marble-clad buildings. Like the national capital's mall, Albany's has architectural balance without rigid symmetry, and coordinates buildings meant for the legislative, judicial, and executive branches of government. The large open spaces between the buildings remind one of Washington or Brasília. Brasília is also recalled by the sleek modern building style and by the presence of a curvilinear building—the meeting center—set among prismatic structures with straight sides. The immense scale of this project, con-

6. *Model of Albany, 1962–63 (from Temporary State Commission on the Capital City, Report, 1963)*

7. *Revised model of "Albany Mall," early 1963 (from addendum to Temporary State Commission on the Capital City, Report, 1963)*

6

7

trasting so strongly with the surrounding city, reminds us of these capitals as well as of Chandigarh and St. Petersburg. A hint of Versailles is given by the inclusion of large trees—over 350 Norway maples—with their sides clipped to form the straight lines given to trees along major axes at Versailles. More than a hint of Versailles and St. Petersburg is given by the enormous extent of the platform and Swan Street Building, both about a quarter mile in length.

> "The [Winter] Palace is literally larger than the eye can see. You must first look at it from afar, from the opposite bank of the Neva, then come closer, cross the bridge and the small garden near the Admiralty, and pause in Palace Square to ponder on the new features that were revealed to you as your angle of vision shifted."[26]

The problem was that of getting the project financed. The normal procedure would have been to submit the project to the State Legislature for examination and approval. Subsequently, funds would have been made available if the state voters approved an issue of bonds bearing the full faith and credit of the State. Although State bonds of this type usually carry lower interest rates than bonds issued by counties and cities, the Governor did not want to follow the normal procedure because it would have been time-consuming and would have brought the serious risk of voter disapproval. Quicker and more certain financing was available from the State employee retirement funds which had been used to finance other State buildings, but the interest rate demanded by the retirement funds was higher than that of State bonds. Moreover, Governor Rockefeller had been an outspoken advocate of a "pay-as-you-go" fiscal policy, and a proposal to spend a still uncertain amount on this project certainly did not represent a "pay-as-you-go" program. He had already faced legislative opposition to his existing budget.[27]

If the Governor was worried about the Mall, so was Mayor Corning. When the Appellate Division ruled against the city's suit to halt the project, the Democratic mayor envisioned a development built entirely by a Republican administration which would bypass him and his constituents. He rescued what he could by proposing that the State take advantage of a law which permitted certain cities to issue bonds in excess of their debt limit without securing city voter approval, provided that the bonds were self-liquidating.[28] Bonds sold by the city to finance the State project would be self-liquidating if the State agreed to pay enough rent to the city to cover the amortization and interest on the bonds, as well as construction costs. The rents could even be made high enough to give the city payments in lieu of lost taxes. This is the heart of the arrangement which Mayor Corning proposed. Governor Rockefeller "went for it right away,"[29] "like a trout for a fly."[30]

The agreement was not signed until May 11, 1965, by which time the financing method had been modified. The County of Albany, rather than the City of Albany, actually issued the bonds, on the Mayor's recommendation. He said that "the broader tax base and lower current bonded indebtedness of the county would allow greater flexibility in the sale of the South Mall bonds."[31] The county was also permitted to issue bond anticipation notes for larger amounts than the city could.[32] Mayor Corning himself collaborated with State officials on behalf of the county and city, just as he had done for the city alone.

The agreement provided that "the expenditures for the project are paid initially by the State from . . . appropriations authorized by the Legislature. The State is reimbursed periodically for these amounts by the County through the issuance of bonds or bond anticipation notes." The State's "appropriations made to finance the South Mall project are 'lump sum' appropriations which cover not only the South Mall but also office buildings at several other locations throughout the State"[33]—apparently a strategy designed to rally support from other cities' legislators for these appropriations. The agreement transferred title to the State's 98.5 acres to the county, which then leased them to the State until December 31, 2004, or earlier should the bonds be redeemed before that date. The county designated the State as its agent for the purpose of building the Mall. This gave the State Office of General Services the power to hire architects, engineers, consultants, and to let contracts for bidding.

The County Board of Supervisors could halt the project by refusing to issue more bonds, but it would not have the power to alter the State's plans once bonds were issued. And it was unlikely that the Board would have refused to issue the bonds. By cooperating with the State, the county and city would be getting "in lieu" payments which they never could have received if the Mall had been financed through other sources. Local workers, bankers, insurance brokers, and others were going to receive new business.[34] This was clearly the only urban renewal project that Albany was going to get, and the local officials had to make the best of that fact. Moreover, the people who would really pay for the Mall were taxpayers spread far away throughout the State. Their taxes might have to rise to let the State meet the rental payments, but the county officials apparently felt no special sense of responsibility to them. If the Albany County officials were not going to act as watchdogs over the project, it was unlikely that anyone else with power would be doing so.

The legislators, of course, had to authorize initial appropriations. But the early unofficial cost estimates, while immense—between $250 and $350 million—were nothing like the later official estimate of $450 million, and nothing like the $985

million eventually authorized which is still not the final total cost. Neither voters nor legislators ever had the chance to vote directly on the project as such. The legislators only objected noticeably as late as 1971. Even then, their objections were brief and mainly confined to producing nicknames for the Mall ("The Great White Elephant," "Rocky's Erector Set," "Taj Mahal," "Albany Maul," etc.); when the Assemblymen finished calling names, they voted for initial appropriation funds by a vote of 41 to 6. (Where were the rest of the 150 Assemblymen?) One Assemblyman acquiesced by saying that the project had become "the Legislature's Vietnam" and they had to "continue and finish it so we can get out."[35]

The only person who continued to object repeatedly was State Comptroller Arthur Levitt, who was obliged by law to sign the agreement and its later amendments. To each version of the agreement, he appended a memorandum saying that the financing procedure "circumvented the method prescribed by the State Constitution—approval by vote of the people—for incurring debt."[36] He also pointed out that additional interest costs were incurred by using local bonds rather than the State's voter-approved full faith and credit bonds. But he had no power to stop the procedure or the building work.

The two-year delay in signing the agreement, and then the absence of responsible outside reviewing authority, do much to explain what happened to the Albany Mall.

The construction work was delayed in 1962 by the City's unsuccessful suit against the State. It was delayed later that year by the "need" to find a financing mechanism circumventing a voter referendum. It was delayed until May, 1965, by the slow pace of work on the final financing agreement and, for several months, by the Mayor's request to defer further action until after an election.[37] During these years, inflation caused many prices to rise, including the costs of materials and labor.

The Governor tried to obviate the effects of inflation by letting many of the contracts at once. But the speed in letting contracts found many important contractors unable to submit bids, leaving inadequately experienced contractors in some cases as the sole or lowest bidders. Their inexperience led to mistakes and costly delays. The shortage of bidders allowed some contractors to win contracts with low bids which were far higher than the estimates; by 1971 this had raised the costs of the Mall by $33.1 million. Some contracts were let even before the detailed design work was done, and subsequent changes to the plans led to a cost increase of $121.6 million by 1971. The simultaneous contracts also presupposed the smooth flow of work. But incomplete preliminary study of the site delayed construction of the platform. This meant delay for everyone else—delays which tied up contractors' employees and funds, delays which were paid for eventually by compensatory payments from the State. The State made these payments under the Public Building Law's Section 10, enacted in 1969 (in response to problems at the Mall), which transferred part of the compensation jurisdiction of the Court of Claims to the Commissioner of the Office of General Services, who was the supervisor of work at the Mall.[38] In so doing, the Legislature may have "exercised a prerogative that it no longer had"[39] and if that was so, it showed another type of legislative negligence in regard to the project. The scheduling errors also resulted in having too many contractors at work simultaneously on the site. There were reports of fights between workers, interference with the work of neighboring contractors, pilferage of materials made possible in part because only an unsupervised guard force was present, organized crime activity, suspicion of arson, and work

stoppages caused by petty union rivalries.[40] "At one point during the ensuing struggle for possession of a section of the Mall site critical to [two groups of tower workers, the upper] crew was dumping rubbish down on the hapless foundation workers below."[41] When the latter refused to work under such conditions, they had to be employed at overtime wages for nights and weekends. In addition, the sudden demand for workers created a labor shortage, and those workers who were available could demand higher wages for their services, thus creating further inflationary pressure.[42] The Governor had been sensitive to the possibility of unemployment in the upstate construction industry, and had sponsored a vast amount of building to assist the industry, but he had not counted on creating an inflationary demand.

> "The cathedral took forty years to build (1818–1848), with the efforts of hundreds of thousands of people. The following facts and figures will give some idea of the scale of this project. This being a swampy site, about 24,000 piles had to be driven in the foundation which 11,000 serfs took a year to do, toiling day and night, winter and summer."[43]

(Reports that workers would have to be called to Albany from other states and Canada remind us of Peter the Great's conscription of laborers for the building of St. Petersburg, but the troubles experienced by the well-paid union men at the Albany work site were insignificant in comparison to the appalling, literally murderous conditions in St. Petersburg during its early years.)

The individual buildings also reveal the absence of review procedures, or supervision by comparatively disinterested outsiders. The entire South Mall consists of 9,532,000 gross square feet of space. "Of this total, about 34 percent" will be for offices, "laboratories, courtrooms, meeting rooms, etc. The remaining 66 percent will be devoted to public areas, parking, storage, mechanical areas, core and utilities." In the buildings designed for office space, "the percentage of gross space available for office and special use [laboratories, etc.] is very low": from 54 percent to only 40 percent. "This low percentage of usable space, together with the unique design of the buildings results in a very high construction cost per square foot of usable space."[44] Comptroller Levitt's office estimated the costs of those buildings at between $105.98 and $198.75 per square foot without including allocable portions of the platform, whereas earlier State buildings had cost $35.17 to $46.03, including adjustments to 1970 prices. A privately sponsored office building, the Twin Towers, built a block away from the Mall at the same time, contained about 935,000 gross square feet of space, 75 percent of it usable, and was to cost about $30 million. This could be compared to the Mall's tallest office building which had about 970,000 gross square feet of space, 54 percent usable, and cost approximately $48,766,000. Because of the inefficient use of space, the State had to rent additional office space elsewhere in Albany, although the Mall was supposed to satisfy certain State needs for twenty years. In commenting on these matters, the Office of General Services pointed out that the Mall had not been designed for utility alone but also for beautification and fairly rapid rehabilitation of downtown Albany. These aims proved to be exceptionally costly, especially at the Legislative Building where the interior finish costing $4.5 million, was not included in the 1964 cost estimates.[45] The interior is coated with so much marble of different kinds that it looks like a showroom for quarry owners.

All the completed buildings are, in fact, covered with marble. There is also marble on the platform pavement and on parapets. The design of the five tall office buildings features marble-covered cores on the four matching buildings, and office areas faced with glass and marble stripes wrapped around three sides. The design

was one which Harrison & Abramovitz had already developed for a building planned for Alcoa in Detroit; when Nelson Rockefeller saw a rendering of it, he asked to have the design used in Albany. The buildings have canted ends because the architects felt that these spaces would provide handsome and useful conference rooms for buildings which needed many such spaces.[46] On the top floor of the tallest structure there is an observation roof from which viewers can see everything to the east, north, and south, but not the Mall itself at the west!

> "The tsarist government spared neither human effort nor money for the erection of this gigantic cathedral. The whole structure cost . . . a fabulous sum for that time . . . . An excellent view of Leningrad and its suburbs may be had from the top gallery which is [333 feet] high."[47]

The Cultural Education Center (fig. 8) is one of the many descendants of Le Corbusier's late works (especially of the Monastery of La Tourette, with its upper stories projecting beyond the lower ones, its rows of small window openings, and dramatically shaped ramps or stairs). This expensive building replaced the arch that had originally been projected there because the arch would, for reasons of cost, have had to be of concrete; Harrison & Abramovitz had wanted to give an untraditional shape to a concrete arch, but that would have caused problems of scale, cost, and the shape itself. As the building was a latecomer to the plan, its price could not be accurately estimated for the 1964 presentation of costs. Moreover, the Education Department changed its own assessment of its future needs after the project began. The librarians seemed reluctant to give the architects all the information necessary for a complete design.[48] No one was in a position to control developments like these.

And no one stopped construction of the Meeting Center, known as the "Egg." Its cost was originally estimated at $24 million, but by 1974 it was $42 million. Harrison & Abramovitz designed a shape to hold two theaters, without superfluous surrounding structure. The absence of a thick base opens more of the plaza to pedestrians. The architects had to design against the background of a nearby telephone building which, they felt, ought not to be easily visible from the Mall. The shape they chose blotted out the extraneous building and provided a refreshingly different contour for a Mall structure. But the "Egg" proved distressingly hard to build, and new techniques had to be devised to erect it. There are those who wonder whether the innovation and the product justify a seventy-five percent cost overrun.[49]

A study of details at the Mall discloses some attractive features, some silly ones, and some lamentable ones. In the first category are low refreshment pavilions on the platform, and the varied pavements of the platform surface which include brick, stone and marble, and concrete. In the second are the trees whose leaves are clipped each year to form 15-foot cubes. In the third are examples of ugly surface detail (fig. 9), and the overabundance of showy marble. (Some of the marble had come loose by the spring of 1979, when two blocks of it fell off the Museum and Library building.) Other visual flaws include the overly long vistas of flat walls and marble cores (fig. 10), and the raw, sharp forms of the low-rise buildings which sometimes contrast abruptly with eruptions of curvilinear shapes (fig. 8). Environmental faults such as the folly of building windswept plazas in Albany's winter climate are apparent as well, although Harrison was glad that the Mall would be "one of the few places in the world where that American invention, the skyscraper, is given its proper place in relation to the buildings around it."[50]

8

8. *Albany, N.Y., Empire State Plaza ("Albany Mall"). Cultural Education Building, south side (detail). Architects: Harrison & Abramovitz.*

9. *Albany, N.Y., Empire State Plaza ("Albany Mall"). Swan Street Building, west side (detail). Architects: Carson, Lundin & Shaw*

10

9

10. *Albany, N.Y., Empire State Plaza ("Albany Mall"). Swan Street Building and agency buildings from the northwest*

"[In the Admiralty Quarter] these streets despite, or perhaps because of, the intimidating profusion of great palaces that frown down on them, seem strangely empty, neglected, amost deserted."[51]

785
*St. Petersburg-on-the-Hudson*

The question of aesthetics at the Mall is open to debate. There may be less dispute over the political and ethical issues involved. The Mall was built and approved by people who were using little of their own money and an uncontrolled amount of other people's. They were satisfying goals which had scarcely been held up to public scrutiny, while using public funds—a kind of "free" money. Normal procedures for public expenditure were consciously circumvented. The public never had a chance to express its opinion directly or through its lawmakers about the Mall as it was finally conceived, including a clear understanding of its budget. No one seems to have held to account the county, city, or State for the disparities between the Mall itself and the 1962–1963 plans for Albany which were the basis for the original legislative acts. Low- and middle-income housing, originally proposed for a site beside the Mall, was declared too costly and was never built. The riverfront has not been noticeably renovated, apart from a park around the pumping station which was built in conjunction with the Mall. And no one seems yet to be sure of the ultimate cost. It will be at least $985 million. Comptroller Levitt believed that the total cost including interest on bonds would amount to $1.5 billion. "Others close to state finances say that in the end, the Mall will cost close to $2 billion."[52] There ought to be a way of finding out.

Despite all this, the Mall has begun to be popular with many local residents.[53] It was the unintended catalyst for the rehabilitation and "gentrification" of the area abutting it to the west; there, the Governor and Mayor agreed to promote a zoning rule that limited the competitive height of future buildings, and there, too, was established a historic architecture district. A few new restaurants and businesses have opened nearby to replace the department stores, hotels, small shops, factories, and cinemas which closed during the long years of construction.[54] There are outdoor concerts and shows on the platform during the summer. The State Museum holds excellent exhibitions. Art lovers can see impressive works of painting and sculpture in the Mall (although the objects are so badly cared for that they may not all be around for long).[55] In winter, local people can ice skate there and imagine that they are either in Rockefeller Center[56] or in some visionary city where everything is cold and smooth and frozen white (fig. 10). In any case, the Mall is something to which residents can point as being distinctively theirs, as being new, as being clean, and as being a sign that someone cared to make their city noticeable.

When the Mall was dedicated, Governor Rockefeller said, "Mean structures breed small vision. But great architecture reflects mankind at its true worth."[57] Some observers find that this project reflects a disturbing view of man. But others, altering the point at issue, will remember that a work of architecture does not have to be good to be popular, or to be tolerated, or to be promoted, or to be important. People do not always apply moral standards to its evaluation; they can like things of which they do not approve. There are not many great buildings in central Washington, a city which also lacks intelligible scale or a comfortable setting for pedestrians. There were endless buildings in St. Petersburg and monstrous new buildings in Leningrad, but that city holds the affection of its inhabitants and wins the admiration of tourists.

Can the message really be that grandiose imperial dreams become acceptable everyday reality if one waits long enough? And will this Mall be an acceptable

dream for everyman's future? Or will we learn some lessons before the next St. Petersburg rises along another river?

*New York University*

*Notes*

1 Henry G. Alsberg, ed., *The American Guide,* New York, 1949, 237–39.

2 Eric Dluhosch, trans., in Iurii A. Egorov, *The Architectural Planning of St. Petersburg,* Athens (Ohio), 1969, xix.

3 *New York Times* 8/18/70.

4 *Albany Times-Union* 3/28/62.

5 *Ibid.* 3/27/62, 4/26/62; *Albany Knickerbocker-News* 5/4/62.

6 Interview with Nelson Rockefeller 7/31/74.

7 V. Schwarz, *Leningrad. Art and Architecture,* Moscow, 1972, 266.

8 In New York State Office of General Services, *Empire State Plaza. A Design for the Future,* Jonathan K. Abrams, ed., Albany, 1976, 2–3, are listed the architectural firm of Harrison & Abramovitz (New York City) as the overall coordinators and designers of all buildings except the following three: Legislative Building, by James and Meadows and Howard (Buffalo); Swan Street Building, by Carson, Lundin & Shaw (New York City); Justice Building, by Sargent, Webster, Crenshaw & Folley (Syracuse).

9 Laws of 1961, Chapter 319. 1961 Committee budget: $150,000.

10 " 'What Rockefeller wanted was to build the Albany Mall,' says one planner. 'We were brought in to legitimize what he wanted to do'." Quoted by Eleanore Carruth, "What Price Glory on the Albany Mall?" *Fortune,* June 1971, 167.

11 Temporary State Commission on the Capital City, *Report of the Commission,* 1963.

12 Press releases from Governor Rockefeller's office, 5/24/62.

13 Temporary Commission, *Report,* 1963, 3.

14 *Albany Knickerbocker-News* 4/2/62.

15 Temporary Commission, *Report,* 1963, 13.

16 Schwarz, *Leningrad,* 19.

17 To achieve this, the State filed a map at the offices of the Albany County Clerk and of the Secretary of State on March 27, 1962.

18 Even professional architects and planners were optimistic. See *Albany Knickerbocker-News* 5/17/62 for opinions of Dean Donald Mochon of Rensselaer Polytechnic Institute, and Lewis Mumford; *ibid.,* 5/21/62, for opinions of architects Henry Blatner (Albany) and Bailey Cadman (Troy). Jane Jacobs and Isadore Candeub, however, offered warnings; see *Albany Times-Union* 5/17/62 and 3/29/62, and *Albany Knickerbocker-News* 3/29/62. Blatner's firm was hired by the Temporary Commission to do a "detailed program for the 25–year projection of the State Capital Buildings required": *Albany Times-Union* 5/25/62.

19 Erastus Corning, II, letter to Temporary Commission 3/26/62, in Mayor's office files on the Mall, labeled "Brazilia," 1962.

20 *Albany Times-Union* 4/7/62; *Syracuse Herald-Journal* 4/7/62.

21 *Albany Knickerbocker-News* 5/4/62.

22 *Albany Plan for the Capital City. Technical Document,* 1963, 221, 222, and 223 for Plans A, B, and C, respectively. For Plan C, see also Temporary Commission, *Report,* 1963, 13.

23 Interview with Nelson Rockefeller 7/31/74. Interview with Wallace K. Harrison 1/29/75.

24 The quotes, in the order given, are taken from the *New York Times* 2/20/74, 11/22/73; *Fortune,* June 1971, 92; *Albany Times-Union* 1/29/71.

[25] Schwarz, *Leningrad,* 26.

[26] *Ibid.,* 65.

[27] *Albany Knickerbocker-News* 3/29/63.

[28] Laws of 1964, Chapter 152.

[29] *Wall Street Journal* 3/18/71, 38.

[30] *Fortune,* June 1971, 94.

[31] Governor Rockefeller's office press release 12/29/64, an open letter to Mayor Corning, in Mayor's office file, under "Brazilia" 1964. Albany newspapers printed the open letter and the Mayor's reply.

[32] Joseph McGovern, esq., to Mayor Corning 8/25/64 in Mayor's office file, under "Brazilia" 1964.

[33] Office of the Comptroller, *Audit Report on the South Mall Project* AL–ST 26–70, March 31, 1971, 6–7.

[34] *Wall Street Journal* 3/18/71, 38 reported that Mayor Corning benefited financially from the Mall project, but the Mayor said that such monetary gain was not intentional.

[35] *Albany Times-Union* 1/28/71. Other nicknames include: "Instant Stonehenge," "Monumental Camp," "Brasília North"; for some of them, see Robert Cartmell, "Albany South Mall Architect Harrison First Shunned Job," *op. cit.* 1/21/73.

[36] Comptroller's *Audit Report,* 1971, 4, 20, 27–28. Local bonds normally offer higher rates of interest.

[37] Governor Rockefeller's office, press release 12/29/64.

[38] Wallace K. Harrison, quoted in *Fortune,* June 1971, 166, and see other pertinent information on 165–66; *Engineering News-Record* 6/24/71, 16–81; Comptroller's *Audit Report,* 1971, 5, 8–17, 41.

[39] William J. Quirk, "The Albany South Mall Contractors Relief Act—An Unconstitutional Infringement Upon Court of Claims Jurisdiction," *Cornell Law Review* 57:51, 1971, 51–78, esp. 78.

[40] *Albany Knickerbocker-News* carried regular reports of these events.

[41] *Fortune,* June 1971, 165.

[42] See above, n. 38.

[43] Schwarz, *Leningrad,* 229.

[44] Comptroller's *Audit Report,* 1971, 8, 17, 47–48, 54–55; *New York Times* 1/26/75, I, 41.

[45] *Ibid., loc. cit.*

[46] Interview with Wallace K. Harrison 1/29/75.

[47] Schwarz, *Leningrad,* pp. 229, 233.

[48] Interview with Wallace K. Harrison 1/29/75.

[49] Interview with Wallace K. Harrison 1/29/75; *Engineering News-Record* 9/5/74, 16–18.

[50] Mark Libbon, *City of Marble,* Albany, 1977, 8.

[51] George Steiner, "Reflections," *The New Yorker* 4/29/74, 41.

[52] *Barron's* 3/22/76, 5, 14.

[53] Dan Perry, "Albany-Schenectady-Troy: Crossroads of the Northeast," *Allegheny Air Systems Executive,* II (Feb. 1974), 12–13; *New York Times* 1/25/73, 6/24/76, 1/31/77. On housing renewal, *ibid.* 2/20/74, 5/21/77, and *Albany Times-Union* 1/21/73.

[54] *New York Times* 1/14/70, 2/15/71.

[55] Thomas Hess, "The Mess in Albany," *New York Magazine* 11/28/77, 83–86.

[56] A photograph of a scrawny Christmas tree chosen for the Mall but not installed, a tree unlike the magnificent specimen at Rockefeller Center, was illustrated on the front page of the *New York Times* 12/3/77.

[57] *Ibid.* 11/22/73.

# 49
## *Judy Chicago's* Dinner Party: *A Personal Vision of Women's History*

JOSEPHINE WITHERS

In the fifteenth century, Christine de Pisan dreamt of building an ideal city for eminent and virtuous women, and with the help of her three "muses," the sisters Reason, Rectitude, and Justice, she reflected on the many women in history and mythology who might live together in this *Cité des Dames*. Almost exactly four centuries later, the American sculptor and feminist, Harriet Hosmer, envisioned a beautiful temple dedicated to the achievements of women. Now such a grand idea has been realized.

Judy Chicago's *Dinner Party*, which opened at the San Francisco Museum of Modern Art in March 1979, is a synthesis of the decorative and fine arts; it is theater, literature, history; it is a complex set of ideas; it is monumental in conception and execution; it is a transcendental vision of women's history, culture, and aspirations. As the title suggests, *The Dinner Party* uses some of the most familiar objects and experiences of women's lives to illuminate that history through the domestic ritual of serving food, and the material components of that ritual—painted porcelain tableware and embroidered napery.[1]

*The Dinner Party* is installed within a large room which is entered through a hallway hung with large woven banners that give an idea of what to expect inside. The table within (fig. 1), three wings in the form of an equilateral triangle, is forty-six feet on each side and rests on a raised floor covered with porcelain luster tiles. Each of the thirty-nine place settings honors an individual woman, historical or mythical, whose name is embroidered on the front face of her table runner (fig. 2).[2] For each of the table settings there is a fourteen-inch painted porcelain plate, its design specific to that woman, and an embroidered runner whose design is specific both to the woman and to the historical period in which she flourished. Linen napkins, porcelain flatware, and gold lustered goblets complete the settings. As one circulates around this richly invested feast table, one glimpses filaments of gold luster on the porcelain floor which turn out to be the names of women—nine hundred and ninety-nine names—interlaced across the floor.

While *The Dinner Party* stands as an independent work, it is supplemented by a book by Judy Chicago *(The Dinner Party, A Symbol of Our Heritage)* and a film

1

2

3

*1.* The Dinner Party, *scale model of installation*

*2.* The Dinner Party, *partial mock-up.* Kali, Snake Goddess, Hatshepsut, *china-painted plates and prototype runners*

*3.* Sappho, *china-painted plate and embroidered runner*

by Johanna Demetrakas. As with Demetrakas's film on Miriam Schapiro's and
Judy Chicago's *Womanhouse* project, the Dinner Party film presents the finished piece and public response to it; it also documents the complex process of making *The Dinner Party*. Design and execution of each element of the installation, historical research, and the ongoing work, meetings, disagreements, exhilarations, and discoveries in the ceramics, needlework, and graphics studios make up the informative core of this documentary film.

In an unpublished manuscript entitled *The Revelations of the Goddess,* Chicago creates a mythic context for *The Dinner Party*. The book begins with the creation of the world and the early Matriarchy, and then describes the establishment of Patriarchal society. The Great Goddess prophesies that one day the wisdom of women will be needed again:

> Until that day, in each generation, some of your daughters and their daughters must be my Disciples and my Apostles as their mothers were before them. . . . Each will be a symbol of her age, demonstrating what women can achieve, preserving the fragments of our power, embodying all that we will be once again. And in the days of affliction that will come to pass, three will be their holy number, the triangle their sign, and my Apostles and Disciples will know each other by the thirteenth letter of the alphabet which signifies the Millennium when I shall at last return. . . .[3]

The first wing of the table begins with a place setting symbolizing the Primordial Goddess, and continues with Ishtar (known also as Isis and Artemis) and the Snake Goddess; the earliest historical personage is Hatshepsut, followed by Judith and Sappho; the wing ends with the Alexandrian philosopher Hypatia. The second wing begins with Marcella, the fourth-century Roman founder of numerous convents, and ends with the Flemish intellectual Anna van Schurman. In between are St. Bridget, Theodora, Eleanor of Aquitaine, Christine de Pisan, and Queen Elizabeth I, among others. Anne Hutchinson opens the third wing, which brings women's history up to the present with the last place setting, symbolizing Georgia O'Keeffe, the only living woman represented at the table. In contrast to those of the first wing, most of the women of the third wing are familiar figures: Mary Wollstonecraft, Susan B. Anthony, Emily Dickinson, Virginia Woolf, and Margaret Sanger, among others.

Most of the plate images are organically abstract representations of "great women who have been served up and consumed by history."[4] The Apostles were chosen as exemplars who struggled to change and improve the condition of women. The plates, then, are at the center of the sacramental ritual; the women are both honored and sacrificed.

The images of each of the plates and runners in one fashion or another incorporate symbols and attributes particular to that woman. Saint Bridget, the fifth-century Celtic saint, for example, is represented by her attributes of milk and fire (fig. 4); the majolica glazes on the Isabella d'Este plate refer to her encouragement of that industry in Mantua (fig. 5); the Artemisia Gentileschi plate displays a very muscular, contrapposto design (fig. 6); the cool grays and tattered forms of the Anne Hutchinson plate refer to her persecution at the hands of the New England Puritans (fig. 7).

Both the imagery and iconography of *The Dinner Party* present a thoughtfully worked out and consistent vision of women's history. Chicago thereby asks us to

4

5

6

4. St. Bridget, *china-painted plate*

5. Isabella d'Este, *drawing for china-painted plate, prismacolor on rag paper*

6. Artemisia Gentileschi, *china-painted plate*

7. Anne Hutchinson, *china-painted plate and embroidered runner*

7

consider seriously the value of women's culture and women's historical contribution, and to ask ourselves probing questions about the nature and meaning of that past for us today and about the ways in which it has been traditionally perceived.

One historical stereotype that we are still dealing with is that woman's place has always been the ahistorical private realm:[5] to say that women have made history is a contradiction in terms. As recent women's historians have put it, "historians have long assumed that 'woman' was a trans-historical creature who could be isolated from the dynamics of social development."[6] In a recent study, Dinnerstein observes that "women's status as representative of the flesh disqualifies her, in her own eyes as well as man's, to take part in our communal defiance of the flesh, in our collective counter-assertion to carnality and mortality. [For all of us, the male] affirms the human impulse toward eternity, immortality, the human yearning toward a truth beyond the flesh. It is civilization, history."[7] Elsewhere, Dinnerstein succinctly defines that historical content as a "pool of memorable event, communicable insight, teachable technique, durable achievement."[8] Especially in our secular society, history has become a principal vehicle of self-transcendence. We transcend the particularity of time present to the extent that we can identify and contribute to that "pool of memorable event."

Women, however, have been historically denied that form of transcendence by being excluded both from the making of history and from identifying in any direct way with its creators. They are, quite simply, "the other," to use De Beauvoir's term. "Her misfortune is to have been biologically destined for the repetition of Life," De Beauvoir wrote, "when even in her own view Life does not carry within itself its reasons for being, reasons that are more important than Life itself."[9] Following this argument, the few women who have participated in the making of history and have survived the subsequent process of history writing[10] are conventionally perceived as exceptional people, whose achievements are isolated and fragmented, rather than part of an ongoing continuum. Exclusion both from the creation of and identification with the history-making process has had, and continues to have, a devastating effect on women's intellectual and creative development beyond reckoning.

On a personal level, the significance of being able to place oneself within a larger historical continuum was clearly, if only incidentally, demonstrated by Freud in his studies of Leonardo, Goethe, and Michelangelo. These studies are part self-projection and part spiritual dialogue with the creative men with whom he felt an intellectual affinity.[11] The well-documented fact that Freud made some serious interpretive errors does not lessen the importance that this process of projection and identification has, or can have, for all of us. It is the way to one kind of self-knowledge—the revelation gained from seeing aspects of ourselves mirrored in others and the understanding that we thereby transcend present time.

With the candor of an artist not needing to plead a scientific case, Chicago has recognized the implications of this process of creative identification. When asked which women of *The Dinner Party* she most closely identified with, she observed: "I identify with all of them; I think they all represent some aspect of me, and of women's lives and condition, which I identify with totally. . . ."[12] They are aspects of myself. . . . What do I know of the person? I take all this historical material and I weave it together. I weed through it and I take out of it what I can relate to, and what I can identify with and then I make an image. The result is some of the person and a lot of me. But then, of course, it begins to take on an identity outside

of me. . . . When the piece is done, all of a sudden it will exist outside of me and it—*they* will be personages and people will identify with *them*."[13] It is, of course, a question of identifying with an abstract, invented image "that exists only as an embodiment for the feeling or for the idea or the thought. It doesn't have an independent, objective existence. It *is* what it means."[14]

*The Dinner Party* should be seen as a symbolic assemblage of women worthies[15] representing most periods of Western history. Chicago has remarked, "I also wanted to make a linear history so that there would seem to be a straight line and that [the women] were somehow linked through history. And so I wanted to do that by . . . having them all be women who had made a contribution to the situation of women."[16] In the manner of Christine de Pisan's *Cité des Dames,* the Apostles of *The Dinner Party*—as symbolized by the plates—are surrounded and rise up from their specific historical and cultural milieus, and come together in some ideal timeless place. Each of the women of the table is self-actualizing, grounded in and supported by her own history—represented both by the runners and by the Disciples of the history floor.

The Apostles are both historical figures and models for the future. They are an ideal gathering in the same sense that a *sacra conversazione,* Ingres's *Parnassus,* Raphael's *School of Athens,* or Courbet's *The Painter's Studio* are ideal assemblages bringing together a diversity of people under the aegis of a single motivating idea. There is, however, an important distinction to be made with the celebrants of *The Dinner Party*: there is no Madonna, no Zeus, no artist at the center of things, no *dea ex machina.* Neither is there a Christ figure, whose absence is suggested by the obvious analogy of *The Dinner Party* to the Last Supper. All the Apostles, in a sense, have become Christ figures, women who have been sacrificed, "great women who have been served up and consumed by history."[17]

Probably the first Feminist artist to use Christ's Last Supper to illuminate the situation of women was Mary Beth Edelson. In 1971 she created a poster, "Some Living American Women Artists/Last Supper" (fig. 8), which set out to correct Leonardo's gathering of the Apostles, with Georgia O'Keeffe now presiding at the

*8. Mary Beth Edelson.* Some Living American Women Artists/Last Supper, *offset poster, 1972*

SOME LIVING AMERICAN WOMEN ARTISTS

banquet of thirteen, and surrounded by an additional fifty-nine women artists.[18] Chicago uses a similar inversion to make her point; she wanted, she said, "to make a relationship between dinner parties and how women give dinner parties, and the Last Supper where women weren't at. And how women probably prepared the food they ate, but weren't in the picture. And how women really have been crucified. And so they're being offered up on the plates."[19]

Two of the major themes of *The Dinner Party* are the ideal or imaginary gathering, and the ritual of sacrifice. It is at the level of communion, in both its general and sacramental senses, that these two fundamental ideas are joined. While the Apostles are cast in the sacrificial role, Apostles and visitors come together as communicants. The sacrament of the Eucharist similarly has this dual meaning, combining as it does a symbolic reenactment of Christ's sacrifice, and a ritual in which all believers come together—hence the expression "to be in communion with." The idea of spiritual communion, of course, was also central to the early Christian *agape* or love feast, often depicted in the paintings of the catacombs.

Most ritual sacrifices comprehend, as does the Christian Eucharist, the dual theme of destruction and regeneration. The ancient cultures of Greece and Babylon, Ireland and India, Germany and Rome, all had ritual sacrifices whose proper enactment promised regeneration or salvation. "The true worth of my Apostles and Disciples and their long toil for your redemption," says the Great Goddess, "will neither be seen nor known until the day when I shall call thirty-nine of my Apostles and nine hundred ninety-nine of my Disciples to my side. Then shall we celebrate at a heavenly banquet when my daughters will at last arise from their servitude and be resurrected in glory."[20]

Both the exquisite richness of materials and perfection of craft, as well as specific associations with the Eucharist, such as the goblets and runners—developed from the idea of the ecclesiastical fair linen—create the atmosphere of a consecrated temple or sacramental chamber. All aspects of *The Dinner Party*, however, work to suggest both the negative and destructive side, as well as the positive and regenerative side of women's struggles. Most of the designs of the plates, for example, are powerful central core images with great expansive force; yet most of them are contained and even compressed within the edges of the plates. The plate is a "metaphor for the containment of women throughout history." Chicago has observed that it is a "perfect metaphor for containment and . . . simultaneously a perfect whole. . . . It comes up around the corners and that . . . holds the image in it the way women have been held in."[21] Even the plates carved in very high relief which seem to rise up off the table and defy containment are expressive of this compression (fig. 9).

This image is carried through in the dynamic relationship between the plate and its setting. The paraphernalia of a domestic milieu could be thought to diminish and trivialize the plates, despite the opulence of that setting. The drama of this conjunction has an effect similar to that of Tintoretto's *Last Supper* as described by Janson: "Tintoretto has gone to great lengths to give the event an everyday setting, cluttering the scene with attendants, containers of food and drink, and domestic animals. But this serves only to contrast dramatically the natural with the supernatural, for there are also celestial attendants . . ."[22]

It is an instructive comparison to regard the plate in this setting (fig. 2), and then alone (fig. 4). If the plate is viewed vertically, it becomes simply a picture, and as pictures are wont to do in modern times, it tends to create its own context. As it is, the plates have a variety of relationships to their runners, symbolically

suggesting the relationship of the woman to her culture. While all of the runner embroideries on the first wing are held within the front and back drops (see fig. 2), in order to set off the plates clearly, other possibilities were considered as work progressed. The imagery of the Anne Hutchinson runner, for example (fig. 7), is based on early nineteenth-century embroidered mourning pictures; the weeping willow, done in pale grays and browns, rises up on the table and surrounds the plate; the pale recessive colors of both plate and runner and the mourning figures at front and back of the runner are in keeping with Hutchinson's banishment from the Massachusetts Puritan colony for her religious views, and her ultimate death in an Indian massacre. The runner for Petronilla de Meath, a fourteenth-century Irishwoman tortured and burned as a witch, is a Celtic interlace pattern executed in couched fleece and wrapped cords to create a high relief; the strong interlace design also comes up and invades the area of the table and appears to attack and engulf the plate. The Hutchinson and Petronilla settings are two examples of the way in which women's aspirations and struggles are symbolically pitted against their containment and invisibility.

Even the large bustling studio where *The Dinner Party* is coming into being mirrors the work. Most of the myriad activities and productions happen within the four walls of a confined space (figs. 10, 11). Yet despite the large number of people working in the studio, it is a private place; the mental or psychological space of the studio is not accessible to the casual visitor. This very containment acts as a catalyst to intensify the work and the experiencing of that work. Curiously enough, this perception is indirectly corroborated by the psychologist, Erich Neumann, in his discussion of the relationships of women in primitive family and kin groups. Neumann observed that in exogamous societies, the containment of women within the same kin group, symbolized by the "primordial relation to the mother," means a certain intensification of womanhood." He contrasts this with the situation of men in such groups, whose assertion of manhood must mean leaving the female group and breaking the incestuous bond with the mother.[23] Having observed the workings of *The Dinner Party* studio at close hand, I can verify that this intensification of focus and energy created by the mutuality of women—and a few men!—working together is a real phenomenon.

The technique of china painting is also suggestive of women's containment, and is one reason why it was chosen. China painting is an extremely laborious and exacting technique, requiring a separate firing after every color application with the attendant risks of breakage at each firing. By the late nineteenth century this technique had limited commercial application and in the course of time came to be exclusively a "lady's accomplishment."[24] It was from such skilled amateurs that Chicago learned her craft. As with most women's activities, be it cooking, needlepoint, or raising children, china painting is considered to be devalued, worthless, and invisible work. Chicago recounted seeing a 24-place luncheon set which took the owner three years to complete: "this was really the pride of her life, and she couldn't sell it. . . . If she sold this, somebody would pay a couple of hundred dollars for it. How's that for three years' work?"[25]

But if china painting is exacting and laborious, it is also, Chicago claims, feminine. "China painting allows a kind of merging of surface, image, and color that I sought when I painted on plexiglass, and earlier in my sculpture. China painting has the double quality of strength and femininity; it has a kind of lushness that simply would not be possible in any other technique."[26] The technical difficulty of china painting, then, combined with its particular aesthetic qualities and its "in-

9

9. Emily Dickinson, *china plate being painted*

10. The Dinner Party *project, view of the ceramics studio*

11. The Dinner Party *project, view of the needle-work studio*

10

11

visibility," are all congruent with the symbolism and visual imagery of *The Dinner Party*.

It is a widely acknowledged and well-documented fact that the history of women's contributions to the visual arts, as to music, is far behind the contribution to literature. Indeed, what Virginia Woolf had to say about nineteenth-century women novelists still is true of visual artists. "Whatever effect discouragement and criticism had upon their writing," she asserted, "was unimportant compared with the other difficulty which faced them . . . when they came to set their thoughts on paper—that is *they had no tradition behind them,* or one so short and partial that it was of little help. For we think back through our mothers if we are women" (emphasis added).[27] The tradition of a female-identified form language is still "short and partial," and artists are still in the very early stages of creating such a tradition.

*The Dinner Party* represents an impressively ambitious and imaginative attempt to build that next step. Since Chicago did not have a strong or coherent visual tradition to build on, this meant that her goal "was to take that which is the basis of thinking in western civilization and the basis of imaging in western civilization and recast it in feminine terms."[28] Thus *The Dinner Party* mirrors traditional conceptions of history.

First of all, history is here represented, for the most part, by individuals who had power. Many of the Apostles, moreover, obtained their power or influence through their alliances with powerful men. The most consistent exceptions to this, understandably, are the modern women. Women's history seen as biography, or the lives of "women worthies," to use Davis's phrase, has been an established genre for several centuries going back at least as far as Christine de Pisan's *Cité des Dames*.[29] For the professional historian, this approach has its limitations, in that it cannot be used to discover what was the life of a "typical" woman; the very survival of enough personal documents to reconstruct the life of an individual woman means almost by definition that she was exceptional.[30]

Second, these exceptional women are seen as essentially isolated from men. This, of course, mirrors traditional history which is, for the most part, conceived as apart from women. As with earlier compensatory histories, this approach seeks to isolate and highlight women and their achievements, partly in reaction to those traditional histories which see women only in their role relationships to men. One of those roles, incidentally, commonly experienced by most women—motherhood—is scarcely alluded to, either in the *Revelations of the Goddess* or in the imagery of *The Dinner Party*. Even though Mary Beard (*Woman as Force in History,* 1946) breathed new life into women's compensatory history, her work was flawed in that women were treated in isolation, and not as subject to the oppression and domination of men. Just as limiting, however, are those studies that treat women's lives as a continuous chain of unmitigated oppressions and victimizations. The most devastatingly thorough presentation of this viewpoint is still Simone de Beauvoir's *The Second Sex* (1953). Chicago has utilized both of these models, but has brought them into conjunction with each other. She has created a more balanced synthesis of women's achievements seen in the context of their confinement. This, for example, is the fundamental meaning of the Eucharistic imagery of *The Dinner Party*.

The third way in which *The Dinner Party* mirrors cultural stereotypes is the major reference made to women's transcendent power. The basic premise of *The Dinner Party* is that the Apostles and Disciples come together at the bidding of the Great Goddess, as representatives of the once-powerful Matriarchy. Despite a

great deal of literature, going back to J. J. Bachofen (*Mutterrecht,* 1861), who asserted the historical existence of primitive matriarchal cultures, this idea is today widely discounted among social anthropologists. The evidence in history and present-day primitive societies is simply lacking. And yet the idea persists.[31] The very fact that the possibility of a primitive matriarchy preceding patriarchal culture is so hotly debated attests, at the very least, to its continued power as myth—the myth which is, after all, our principal source for our ideas about such a Matriarchy. There are some who would argue, however, that such theories do not demonstrate the existence of female power and status which was then lost, but to the contrary, were created to explain and reinforce the patriarchal *status quo.*[32]

Whether or not that is the best way to explain the prevalence of matriarchal mythologies, it does throw into relief the fundamental problem of the matriarchal myth and the patriarchal reality. The more or less extreme polarization of the human race which such ideas represent gives conceptual form to a world view which is becoming increasingly intolerable and unworkable. Men have not created culture, nor have women. It has been a joint enterprise—the record notwithstanding—and will continue to be. The stark isolation of the Apostles and Disciples gathered in the cloistered space of *The Dinner Party* makes us confront the profound perversion of any system which seeks to fragment and isolate the totality of human experience.

*University of Maryland*

## WOMEN REPRESENTED IN *THE DINNER PARTY*

*First Wing*

| | |
|---|---|
| Primordial Goddess | The feminine principle as the source of life, the female creator who conceived the universe |
| Fertile Goddess | Woman as the symbol of birth and rebirth; seen as the source of nourishment, protection, and warmth |
| Ishtar | Great Goddess of Mesopotamia, the female as giver and taker of life, whose power was infinite |
| Kali | Traditionally positive view of female power misrepresented as a destructive force |
| Snake Goddess | The remnants of female power expressed in the snake as the embodiment of feminine wisdom |
| Sophia | The highest form of feminine wisdom representing the transformation of real female power into a purely spiritual dimension |
| Amazon | Embodiment of Warrior Women who fought to preserve gynocratic societies |

| | |
|---|---|
| Hatshepsut<br>Egypt<br>d. 1479 B.C. | Pharoah of the 18th Dynasty in Egypt, considered to be the human incarnation of the deity |
| Judith | Jewish heroine, representative of the strength and courage of early Biblical women |
| Sappho<br>Greece<br>c. 500 B.C. | Lyric poet and lover of women, symbolizes the last flowering of uninhibited female creativity |
| Aspasia<br>Greece<br>470–410 B.C. | Scholar, philosopher, and leader of women after eclipse of female power |
| Boadaceia<br>Britain<br>d. 62 A.D. | Stands for the tradition of warrior queens extending back into legendary times |
| Hypatia<br>Alexandria<br>c. 380–415 A.D. | Roman scholar and philosopher, martyred for her power and her efforts on behalf of women |

*Second Wing*

| | |
|---|---|
| Marcella<br>Rome<br>325–410 A.D. | Founded the first convent and provided a haven for women in Rome |
| Saint Bridget<br>Ireland<br>453–523 | Irish feminist saint; helped spread Christianity in Ireland and established education for women |
| Theodora<br>Byzantium<br>508–548 | Byzantine empress, ruled equally with her husband Justinian and initiated reforms on behalf of women |
| Hrosvitha<br>Germany<br>935–1002 | German playwright, historian, and religious woman |
| Trotula<br>Italy<br>d. 1097 | Physician and gynecologist, wrote a treatise on women's diseases that was used for 500 years |
| Eleanor of Aquitaine<br>France<br>1122–1204 | Queen, politician, and patron, founder of Courts of Love which attempted to improve the inhuman relations between men and women |
| Hildegarde of Bingen<br>Germany<br>1098–1179 | Represents the power of the medieval abbess; visionary, medical woman, scientist, writer, and saint |
| Petronilla de Meath<br>Ireland<br>d. 1324 | Burned as a witch, she is a symbol of the terrible persecution of women that occurred from the 13th to 17th century |

| | | |
|---|---|---|
| Christine de Pisan<br>France<br>1363–1431 | Writer, humanist, early feminist | |
| Isabella d'Este<br>Italy<br>1474–1539 | Noblewoman, scholar, archeologist, patron, stateswoman, and political figure | |
| Elizabeth I<br>England<br>1533–1603 | One of the greatest female rulers who ever lived, distinguished stateswoman and scholar | |
| Artemisia Gentileschi<br>Italy<br>1590–1642 | Renowned Italian painter, first woman artist to express a female sensibility | |
| Anna van Schurman<br>Holland<br>1607–1678 | Flemish scholar, artist, linguist, theologian, philosopher, utopian, advocate of women's rights | |

*Third Wing*

| | |
|---|---|
| Anne Hutchinson<br>New England<br>1590/91–1643 | American Puritan, reformer, preacher, and leader of women |
| Sacajawea<br>North America<br>c. 1787–1812 | Symbolizes exploitation of native Americans by Europeans; unpaid and not honored for leading the Lewis and Clark Expedition |
| Caroline Herschel<br>Germany<br>1750–1848 | Pioneer woman scientist and astronomer, first woman to discover a comet |
| Mary Wollstonecraft<br>England<br>1759–1797 | Stands at the threshold of the modern feminist movement; wrote "A Vindication of the Rights of Woman" |
| Sojourner Truth<br>United States<br>1797–1885 | Courageous abolitionist and feminist; personifies both the oppression and heroism of Black women |
| Susan B. Anthony<br>United States<br>1820–1906 | International feminist, suffragist, political leader |
| Elizabeth Blackwell<br>United States<br>1821–1910 | First woman doctor of medicine in America; pioneer in hygiene and medical education for women |
| Emily Dickinson<br>United States<br>1830–1886 | American poet, and embodiment of women's struggle to find their own voice |
| Ethel Smyth<br>England<br>1858–1944 | English composer and writer; wrote operas, choral works, and orchestral pieces |

| | | |
|---|---|---|
| Margaret Sanger<br>United States<br>1883–1966 | Pioneer advocate of birth control, believed that liberated motherhood would bring world peace and equality |
| Natalie Barney<br>United States<br>1877–1972 | Writer, aphorist, lover of women and bon vivant; lived openly as a lesbian |
| Virginia Woolf<br>England<br>1882–1941 | English writer, feminist, and pioneer in creating a female form language in literature |
| Georgia O'Keeffe<br>United States<br>1887– | American painter, pioneer in creating a female form language in art |

*Notes*

[1] This essay was written more than one year before the completion of *The Dinner Party*; minor revisions were made after its opening. Writing about an unfinished work presented an unusual challenge, and would not have been remotely possible without the generous co-operation of Judy Chicago; Diane Gelon, Director of the Project; Susan Hill, Director of Needlework; and Anne Isolde, Director of History Research.

[2] See Appendix for complete listing of the thirty-nine women represented on the table.

[3] Judy Chicago, *Revelations of the Goddess: A Chronicle of the Dinner Party*, unpublished MS (courtesy of the author), 18.

[4] Transcript of an interview by Arlene Raven with Judy Chicago, September 8, 1975, p. 6. Hereafter referred to as Interview of September 1975.

[5] The classic formulation and Feminist critique of this truism is Elizabeth Janeway's *Man's World, Woman's Place, A Study in Social Mythology*, New York, 1971.

[6] Ann Gordon, Mari Jo Buhle, and Nancy Schrom Dye, "The Problem of Women's History," in *Liberating Women's History*, ed. Berenice Carroll, Urbana, 1976, 75.

[7] Dorothy Dinnerstein, *The Mermaid and the Minotaur, Sexual Arrangements and Human Malaise*, New York, 1977, 210.

[8] *Op. cit.*, 208.

[9] Simone de Beauvoir, *The Second Sex*, New York, 1952.

[10] It is a commonplace observation among women's historians that knowledge about women tends to get leached out of the record over a period of time. It is a pervasive process that affects equally women of status and accomplishment as well as ordinary or undistinguished women.

[11] For a comprehensive analysis of Freud's studies of these men, and a review of the literature, see Jack Spector, *The Aesthetics of Freud, A Study in Psychoanalysis and Art*, New York, 1974.

[12] Transcript of an interview by Josephine Withers with Judy Chicago, August 22, 1977, 14. Hereafter referred to as Interview of August 1977.

[13] Interview of August 1977, 18.

[14] Interview of August 1977, 6.

[15] The concepts of "women worthies" and compensatory history are discussed on page 798.

[16] Interview of September 1975, 10–11.

[17] Interview of September 1975, 6. Chicago's language is similar in important respects to that of Meret Oppenheim, also a Feminist artist, who has observed that "since the installation of Patriarchy and until recently, free women have been killed or silenced." (Correspondence with the author, April 15, 1977.)

[18] This has had an enormous success and

is now in its second edition of 1,000. It was shown at the Whitney Museum of American Art in Spring 1978.

[19] Interview of September 1975, 6.

[20] *Revelations of the Goddess,* 18.

[21] Interview of September 1975, 3.

[22] H. W. Janson, *History of Art,* 2nd ed., New York, 1977, 450.

[23] Erich Neumann, *The Great Mother, An Analysis of the Archetype,* Princeton, 1972, 271.

[24] See the historical essay by Judy Chicago in *Overglaze Imagery, Cone 019–016,* Visual Arts Center, California State University, Fullerton, 1977.

[25] Interview of September 1975, 5.

[26] "Judy Chicago in Conversation with Ruth Iskin," *Visual Dialog,* 2, 3 (Spring 1977), 15.

[27] Woolf, *A Room of One's Own,* New York, 79; first published 1929.

[28] Interview of August 1977, 25.

[29] Natalie Zemon Davis, "Women's History in Transition: The European Case," *Feminist Studies,* 3, nos. 3–4.

[30] For a discussion of four types of traditional histories of women, see Ann Gordon *et al.,* "The Problem of Women's History," in Carroll, *op. cit.*

[31] Two recent studies which argue this point of view are: Evelyn Reed, *Woman's Evolution, From Matriarchal Clan to Patriarchal Family,* New York, 1975; and Elizabeth Gould Davis, *The First Sex,* New York, 1971.

[32] See Joan Bamberger, "The Myth of Matriarchy: Why Men Rule in Primitive Society," in Michelle Zimbalist Rosaldo and Louise Lamphere, *Woman, Culture, and Society,* Stanford, Cal, 1974.

# Bibliography of H. W. Janson

UNPUBLISHED

*The Sculptured Works of Michelozzo di Bartolommeo*, Ph.D. dissertation, Harvard University, 1942.

EDITOR, SERIES

Library of Art History, Harry N. Abrams, Inc., New York, 1967–75.
Artists in Perspective, Prentice-Hall, Inc., Englewood Cliffs, N.J. (ongoing).
Sources and Documents in the History of Art, Prentice-Hall, Inc., Englewood Cliffs, N.J. (ongoing).

EDITOR, BOOKS

Richard Bernheimer, *The Nature of Representation: A Phenomenological Inquiry*, New York University Press, 1961.
Erwin Panofsky, *Tomb Sculpture*, Harry N. Abrams, Inc., New York, 1964. Foreign edition: *Grabplastik*, Verlag DuMont Schauberg, Cologne, 1964.

EDITOR, CONSULTING

Time-Life Library of Art, ed. Percy Knauth, New York, 1966–70.

MISCELLANEOUS

Introduction to *Style and Technique: Their Interrelation in Western European Painting*, Fogg Art Museum, Harvard University, Cambridge, Mass., 1936, 5–11.
"Plastik: Zentral-, Süd-, und Nordeuropa," in Jan Białostocki, *Spätmittelalter und beginnende Neuzeit* (Propyläen Kunstgeschichte, vol. 7), Propyläen Kunstverlag, Berlin, 1972, 261–67, 270–85, 291–311 (plates 190–225, 244–87).
"The Image of Man," four essays on art in Mortimer Chambers, Raymond Grew, David Herlihy, Theodore K. Rabb, and Isser Woloch, *The Western Experience*, Alfred A. Knopf, Inc., New York, 1974, unpaginated inserts (40 pp.).
Introduction to Gabriel P. Weisberg, *Traditions and Revisions: Themes from the History of Sculpture*, Cleveland Museum of Art, 1975, 1–4.
Foreword to *Aspects of 19th Century Sculpture* (exhibition catalogue), The Cleveland Museum of Art, Dec. 10, 1975–Feb. 1, 1976.
Foreword to Josephine Withers, *Gonzalez: Sculpture in Iron*, New York University

Press, 1978, v–vi.

Foreword to Michael J. McCarthy, *Introducing Art History, A Guide for Teachers*, Curriculum Series/33, The Ontario Institute for Studies in Education, Toronto, 1978, v–vi.

Foreword to *The Academy* (exhibition catalogue), University of West Florida Art Gallery, Pensacola, Spring 1978, n.p.

*The Other Nineteenth Century: Paintings and Sculpture in the Collection of Mr. and Mrs. Joseph M. Tanenbaum*, eds. Louise d'Argencourt and Douglas Druick, The National Gallery of Canada, Ottawa, 1978, 198–235 (introduction and catalogue entries for sculpture).

*The Romantics to Rodin: French Nineteenth-Century Sculpture from North American Collections*, Los Angeles County Museum of Art, March 4–May 25, 1980, 70–82 (essay), and 183, 272–80, 294–95, 297–300, 309, 313–22 (catalogue entries); co-publisher George Braziller, Inc., New York, 1980.

"Birth of an Exhibition," *Réalités* (U.S. edition), May–June 1980, 57–63.

Review of "Wie die Alten den Tod gebildet: Wandlungen der Sepulchralkultur 1750–1850" (exhibition and catalogue); in *Kunstchronik*, 33 (1980), 126–29.

## CATALOGUES

"Italian Renaissance Sculpture. A Catalogue of Carvings in Stone, Wood, and Terracotta," *Worcester Art Museum Annual*, 2 (1936–37), 45–62.

*Modern Art in the Washington University Collection*, St. Louis, 1947.

*Karl Zerbe*, The American Federation of Arts, New York, 1961.

*Paintings and Drawings by Martyl*, exhibition at Kovler Gallery, Chicago, March 8–April 1, 1967.

## PAMPHLETS

"Style and Styles," *Art Treasures of the World*, Harry N. Abrams, Inc., New York, 1953.

"On Truth to Nature," *Art Treasures of the World*, Harry N. Abrams, Inc., New York, 1953.

"The Pleasures of Painting," *Art Treasures of the World*, Harry N. Abrams, Inc., New York, 1953.

"The Mirror of History," Time-Life Art Books, New York, 1968 (in conjunction with Time-Life Library of Art).

"The Rise and Fall of the Public Monument" (The Andrew W. Mellon Lectures, Fall 1976), Graduate School, Tulane University, New Orleans [1976].

## BOOK REVIEWS

Grace Frank and Dorothy Miner, *Proverbes en Rimes*; in *Speculum*, 14 (1939), 379–81.

Ludwig Goldscheider, *The Sculptures of Michelangelo*; in *Parnassus*, 12 (1940), 31.

Nikolaus Pevsner, *Academies of Art, Past and Present*; in *Parnassus*, 12 (1940), 25.

Guy Pène du Bois, *Artists Say the Silliest Things*; in *Parnassus*, 12 (1940), 23–24.

Erwin Panofsky, *Studies in Iconology: Humanistic Themes in the Art of the Renaissance*; in *Art Bulletin*, 22 (1940), 174–75.

Ludwig Goldscheider, *Roman Portraits*; in *Parnassus*, 13 (1941), 117.

H. B. Wehle, *A Catalogue of Italian, Spanish, and Byzantine Paintings in the Metropolitan Museum of Art*; in *Parnassus*, 13 (1941), 146.

*Donatello*, intro. Ludwig Goldscheider; in *College Art Journal*, 1 (1942), 79–80.

Elmer G. Suhr, *Two Currents in the Thought Stream of Europe*; in *Art Bulletin*, 25 (1943), 89–93.

David M. Robb and J. J. Garrison, *Art in the Western World* (rev. ed.); in *College Art Journal*, 2 (1943), 92–94.

James Johnson Sweeney, *Alexander Calder*; in *College Art Journal*, 4 (1944), 64–66.

Paul Klee, *Pedagogical Sketch Book*, and Will Grohmann, *The Drawings of Paul Klee*; in *College Art Journal*, 4 (1945), 232–35.

Darrell Garwood, *Artist in Iowa—A Life of Grant Wood*; in *Magazine of Art*, 38 (1945), 280–82.

George R. Kernodle, *From Art to Theatre, Form and Convention in the Renaissance*; in *Art Bulletin*, 27 (1945), 212–13.

Alfred H. Barr, Jr., *What Is Modern Painting?*; Roberta M. Fansler and Margaret Scherer, *Painting in Flanders*; A. C. Ward, *Seven Painters—An Introduction to Pictures*; in *College Art Journal*, 5 (1946), 256–59.

George Grosz, *A Little Yes and a Big No, the Autobiography of*; in *Saturday Review of Literature*, 30 (1947), 20–21.

Alfred H. Barr, Jr., *Picasso—Fifty Years of His Art*; in *College Art Journal*, 6 (1947), 315–17.

Curt Sachs, *The Commonwealth of Art—Style in the Fine Arts, Music, and the Dance*; in *Magazine of Art*, 40 (1947), 163–64.

Herbert Friedmann, *The Symbolic Goldfinch, Its History and Significance in European Devotional Art*; in *Gazette des Beaux-Arts*, 4ᵉ sér., 34 (1948), 137–38.

Ludwig Goldscheider, *Ghiberti*; in *Magazine of Art*, 43 (1950), 316–17.

*The Hieroglyphics of Horapollo*, trans. George Boas; in *Archaeology*, 3 (1950), 189.

Richard Bernheimer, *Wild Men in the Middle Ages*; in *Magazine of Art*, 47 (1953), 186–87.

Richard Krautheimer with Trude Krautheimer-Hess, *Lorenzo Ghiberti*; in *Renaissance News*, 10 (1957), 103–5.

John Pope-Hennessy, *Italian Renaissance Sculpture*; in *College Art Journal*, 19 (1959), 97–99.

*Umanesimo e simbolismo. Atti del IVº convegno internazionale di studi umanistici*; in *Journal of Philosophy*, 58 (1961), 328–36.

Benjamin Rowland, Jr., *The Classical Tradition in Western Art*; in *Art Bulletin*, 46 (1964), 405–7.

*Renaissance Sculpture*, eds. Harald Busch and Bernd Lohse; in *Art Bulletin*, 47 (1964), 146–47.

Charles Seymour, Jr., *Sculpture in Italy 1400–1500*; in *Yale Review*, summer 1967, 586–93.

James H. Beck, *Jacopo della Quercia e il portale di S. Petronio a Bologna*; in *Speculum*, 48 (1973), 550–52.

Charles Seymour, Jr., *Jacopo della Quercia, Sculptor*; in *Yale Review*, autumn 1973, 91–96.

Manfred Wundram, *Donatello und Nanni di Banco* (*Beiträge zur Kunstgeschichte*, 3); in *Art Bulletin*, 54 (1972), 546–50.

Artur Rosenauer, *Studien zum frühen Donatello: Skulptur im projektiven Raum der Neuzeit* (*Wiener Kunstgeschichtliche Forschungen*, III); in *Art Bulletin*, 59 (1977), 136–39.

John Pope-Hennessy, *Luca della Robbia*; in *The New York Review of Books*, 27, 2 (April 17, 1980), 39 f.

## ARTICLES

"A Mythological Portrait of the Emperor Charles V," *Worcester Art Museum Annual*, 1 (1935–36), 19–31.

"The Putto with the Death's Head," *Art Bulletin*, 19 (1937), 432–49.

"A Late Mediaeval Fountain Design," *Bulletin of the Fogg Museum of Art*, 8 (1938), 11–17.

―――― with Emil Ganso, "The Technique of Lithographic Printing," *Parnassus*, 12 (1940), 17–21.

"Karl Zerbe," *Parnassus,* 13 (1941), 65–69.

" 'Martial Memory' by Philip Guston and American Painting Today," *Bulletin of the City Art Museum of St. Louis*, 27 (1942), 34–41.

"The Beginnings of Agostino di Duccio," *College Art Journal*, 1 (1942), 72–73.

"Two Problems in Florentine Renaissance Sculpture," *Art Bulletin*, 24 (1942), 326–34.

"The International Aspects of Regionalism," *College Art Journal*, 2 (1943), 110–15.

"A Florentine Sixteenth-Century Portrait," *Bulletin of the City Art Museum of St. Louis,* 29 (1944), 2–7.

"On the Education of Artists in Colleges," *College Art Journal*, 4 (1945), 213–16.

"Titian's *Laocoön Caricature* and the Vesalian-Galenist Controversy," *Art Bulletin*, 28 (1946), 49–53.

"Benton and Wood, Champions of Regionalism," *Magazine of Art*, 39 (1946), 184–86, 198–200.

"The New Art Collection at Washington University," *College Art Journal*, 6 (1947), 199–206.

"Philip Guston," *Magazine of Art*, 40 (1947), 54–58.

"Joachim van Sandrart" and "Life of Matthias Grünewald," in Elizabeth Gilmore Holt, *Literary Sources of Art History*, Princeton University Press, 1947, 312–16.

"Monkeys and Monkey Lore in Medieval Art," *Art News*, 46 (1947), 28–31, 38–39.

"The Hildburgh Relief: original or copy?," *Art Bulletin*, 30 (1948), 143–45.

"Stephen Greene," *Magazine of Art*, 41 (1948), 129–32.

"Karl Zerbe's Clowns," *'48: The Magazine of the Year*, 2, 6 (1948), 80–81.

"Max Beckmann in America," *Magazine of Art*, 44 (1951), 89–92.

"College Use of Films on Art," *Films on Art*, ed. William McK. Chapman, Kingsport, Tenn., 1952, 38–43.

"The Case of the Naked Chicken," *College Art Journal,* 15 (1955), 124–27.

"After Betsy, What?" *Bulletin of the Atomic Scientists*, 15 (1959), 68–71, 93.

"Modern Art after Betsy," *Best Articles and Stories*, 4 (1960), 34–36 (reprinted from *Bulletin of the Atomic Scientists*).

"After Betsy, What?" *Midway*, 5 (1961), 53–65 (reprinted with postscript, from *Bulletin of the Atomic Scientists*).

"The *Image Made by Chance* in Renaissance Thought," *De Artibus opuscula XL: Essays in Honor of Erwin Panofsky*, ed. Millard Meiss, New York University Press, 1961, 254–55.

"Fuseli's *Nightmare*," *Arts and Sciences*, 2 (1963), 23–38.

"Nanni di Banco's *Assumption of the Virgin* on the Porta della Mandorla," *Studies*

*in Western Art. Acts of the Twentieth International Congress of the History of Art*, II, Princeton University Press, 1963, 98–107.

"Giovanni Chellini's *Libro* and Donatello," *Studien zur toskanischen Kunst: Festschrift für Ludwig Heinrich Heydenreich*, Prestel Verlag, Munich, 1964, 131–38.

"Madonna mit Kind," *Stiftung zur Förderung der Hamburgischen Kunstsammlungen. Erwerbungen 1965*, Hamburg, 1965, 34–38.

"Donatello (s.v. Bardi, Donato)," *Dizionario biografico degli Italiani*, VI, Rome, 1964, 287–96.

"Originality as a Ground for Judgment of Excellence," *Art and Philosophy: A Symposium*, ed. Sidney Hook, New York University Press, 1966, 24–31 (in Polish: "Oryginalzość jako Kryterium doskonalości," *Pojecia, problemy, metody współczesnej*, ed. Jan Białostocki, trans. Maria Klukowa, Rewolucji Październikowej, Warsaw, 1975).

"An Unpublished Florentine Early Renaissance Madonna," *Jahrbuch der Hamburger Kunstsammlungen*, 11 (1966), 29–46.

"The Equestrian Monument from Can Grande della Scala to Peter the Great," *Aspects of the Renaissance: A Symposium*, ed. Archibald Lewis, University of Texas Press, Austin, 1967, 73–85.

"Ground Plan and Elevation in Masaccio's *Trinity* Fresco," *Essays in the History of Art Presented to Rudolf Wittkower*, eds. Douglas Fraser, Howard Hibbard, and Milton J. Lewine, Phaidon Press, London, 1967, 83–88.

"Observations on Nudity in Neoclassical Art," *Stil und Überlieferung in der Kunst des Abendlandes. Akten des 21. Internationalen Kongresses für Kunstgeschichte in Bonn 1964*, I, Berlin, 1967, 198–207.

"Donatello and the Antique," *Donatello e il suo tempo. Atti dell'VIII° Convegno Internazionale di Studi del Rinascimento*, Florence, 1968, 77–96.

"The Image of Man in Renaissance Art: From Donatello to Michelangelo," *The Renaissance Image of Man and the World*, ed. Bernard O'Kelly, Ohio State University Press, Columbus, 1968, 77–103.

"The Right Arm of Michelangelo's *Moses*," *Festschrift Ulrich Middeldorf*, eds. Antje Kosegarten and Peter Tigler, Berlin, 1968, 241–47.

"Rodin and Carrier-Belleuse: The *Vase des Titans*," *Art Bulletin*, 50 (1968), 278–80.

"The Meaning of the *Giganti*," *Il Duomo di Milano. Atti del Congresso Internazionale, Milano, settembre 1968*, ed. Maria Luisa Gatti, I, Milan, 1969, 61–76.

"Erwin Panofsky," *Yearbook of the American Philosophical Society*, 1969, 151–60.

"Une Source négligée des *Bourgeois de Calais*," *Revue de l'Art*, 5 (1969), 69–70.

"Die stilistische Entwicklung des Agostino di Duccio mit besonderer Berücksichtigung des Hamburger Tondo," *Jahrbuch des Hamburger Kunstsammlungen*, 14–15 (1970), 105–28.

"Of Style and Styles," *Seven Centuries of Art: Survey and Index*, Time-Life Library of Art, New York, 1970, 6–11.

"The Art Historian's Comments," *Perspectives in Education, Religion and the Arts*, eds. Howard E. Kiefer and Milton K. Munitz, *Contemporary Philosophic Thought: The International Philosophy Year Conferences at Brockport*, III, State University of New York Press, Albany, 1970, 295–311.

"Criteria of Periodization in the History of European Art," *New Literary History*, 1 (1970), 115–22.

"Comments on Beardsley's *The Aesthetic Point of View*," *Metaphilosophy*, 1 (1970), 59–62.

"Prospects for Art Criticism in Art Education," *New York University and the New York State Council on the Arts; Conference on Art Criticism and Art Education,* New York University, New York, 1970, 78–82.

"The Revival of Antiquity in Early Renaissance Sculpture," *Medieval and Renaissance Studies,* ed. O. B. Hardison, Jr., The University of North Carolina Press, Chapel Hill, 1971, 80–99.

"German Neoclassic Sculpture in International Perspective," *Yale University Art Bulletin,* 33 (1972), 4–22.

"Postures of Prayer—A Problem of Late Medieval Etiquette," *Jahrbuch der Hamburger Kunstsammlungen,* 17 (1972), 13–22.

"The Neoclassic Sense of Time: A Fictitious Monument to George Washington," *Neoclassicismo: Atti del convegno internazionale promosso dal Comité International d'Histoire de l'Art, Londra, settembre 1971,* Istituto di Storia dell'Arte, Università degli Studi, Genoa, 1973, 48–54.

"Advanced Placement in Art History and Studio," *Art Journal,* 32 (1973), 182–83.

"The Pazzi Evangelists," *Festschrift für Hanns Swarzenski,* Berlin, 1973, 439–48.

"Art Critics, Art Historians and Art Teaching," *Art Journal,* 32 (1973), 424–25, 428.

"Rediscovering Nineteenth-century Sculpture," *Art Quarterly,* 36 (1973), 411–14.

"Chance Images," *Dictionary of the History of Ideas: Studies of Selected Pivotal Ideas,* ed. Philip P. Weiner, I, Charles Scribner's Sons, New York, 340–53.

"The Myth of the Avant-Garde," *Art Studies for an Editor: 25 Essays in Memory of Milton S. Fox,* Harry N. Abrams, Inc., New York, 1975, 167–75.

"The Trouble with American Nineteenth-Century Sculpture," *American Art Review,* 3 (1976), 50–57.

"Über die *Trostbilder* des Heinrich Freudweiler," *Neue Zürcher Zeitung,* Saturday/ Sunday, July 30–31, 1977, p. 39.

"Thorvaldsen and England," *Bertel Thorvaldsen, Untersuchungen zu seinen Werken, Kölner Berichte zur Kunstgeschichte, Begleithefte zum Wallraf-Richartz Jahrbuch 1977,* Cologne, 1977, 107–28.

"La signification politique du David en bronze de Donatello," *Revue de l'Art,* 39 (1978), 33–38.

BOOKS

*Apes and Ape Lore in the Middle Ages and the Renaissance,* The Warburg Institute, University of London, 1952 (Kraus-Reprint, Nendeln, Liechtenstein, 1976).

———and Dora Jane Janson, *The Story of Painting for Young People, from Cave Painting to Modern Times,* Harry N. Abrams, Inc., New York, 1952 (paperback ed., *The Story of Painting, from Cave Painting to Modern Times,* revised by Anthony F. Janson, 1977).

———and Dora Jane Janson, *The Picture History of Painting, from Cave Painting to Modern Times,* Harry N. Abrams, Inc., New York, 1957.

Foreign editions:

*Malerei unserer Welt: Von der Höhlenmalerei bis zur Gegenwart,* trans. Marianne and Dr. Bado Cichy, Verlag DuMont Schauberg, Cologne, 1957; 1963 (reprint in DuMont Kunst-Taschenbüchern, 1973).

*La Peinture dans le monde de la préhistoire à nos jours,* Flammarion, Paris, 1957; 1966 (printed in Czechoslovakia).

*Storia della Pittura dai tempi delle Caverne a Oggi,* trans. Ida Omboni, Aldo

Garzanti Editore, Milan, 1957; trans. Romana Rutelli, 1958.

*Målarkonstens Historia i Bild från Grottmålningarna till Våra Dagar,* trans. Gunilla Nordlung, Albert Bonniers Förlag, Stockholm, 1958.

*De Schilderkunst in Woord en Beeld van Rotstekening tot moderne Schildernkunst,* trans. Dr. L. Knuvelder, Zuid-Nederlandse Uitgeverij, Antwerp–Amsterdam, 1958.

*The Picture History of Painting,* Thames & Hudson Ltd., London, 1958, 1961.

*Historia de la Pintura, desde las cavernas hasta nuestro tiempo,* trans. Francisco Payarols, Editorial Labor S. A., Barcelona, 1959.

(Danish ed.), Gyldendal Forlag, Copenhagen, 1960.

*Maleriets histoire i bilder og tekst,* trans. Peter Anker, Gyldendal Norsk Forlag, Oslo, 1961.

*Kaiga no Rekishi,* trans. Kenji-no Okamoto, Bijutsu Shuppan-Sha, Tokyo, 1963; 1977.

(Czechoslovakian ed.), Publishing House of Literature and Art, Prague, 1967.

(Yugoslavian ed.), Izdavacki Zavod Jugoslavija, Belgrade, 1968.

*Geschiedenis van de Schilderkunst,* trans. Dr. L. Knuvelder, Landshoff Productions B.V., Amsterdam, 1977 (paperback).

*The Sculpture of Donatello,* 2 vols., Princeton University Press, 1957; 1 vol., 1963.

———with Dora Jane Janson, *Key Monuments of the History of Art: A Visual Survey,* Harry N. Abrams, Inc., New York, and Prentice-Hall, Inc., Englewood Cliffs, N.J., 1959.

———with Dora Jane Janson, *History of Art,* Harry N. Abrams, Inc., New York, and Prentice-Hall, Inc., Englewood Cliffs, N.J., 1962; rev. ed., 1969; 2nd ed., 1977.

Foreign editions:

*A History of Art,* Thames & Hudson Ltd., London, 1962; 2nd ed., 1978.

*Kunstgeschichte,* Verlag DuMont Schauberg, Cologne, 1962.

*Storia dell'Arte,* trans. Emma Claudia Pavesi, Aldo Garzanti Editore, Milan, 1962; 2nd ed., 1979.

*Suuri Taidehistoria,* trans. Sakari Saarikivi, Werner Söderström Osakeyhtiö, Helsinki, 1962; Porvoo, 1965.

*Histoire de l'Art,* Editions Aimery Somogy S.A., Paris, 1963; rev. ed., trans. Yvette Ostria, Editions Cercle d'Art, Paris, 1970; 2nd ed., 1978.

*Konsten,* trans. Ulf G. Johnsson, Dr. Bengt Söderberg, Göran Sörbom, and Marian Ullén, Albert Bonniers Förlag, Stockholm, 1963; rev. ed., 1975; 2nd ed., 1978.

美術の歴史, ed. Kiyoshi Murata (with 12 translators), Bijutsu Shuppan-Sha, Tokyo, 1964, 1971.

*Historia del arte,* trans. Francisco Payarols, Editorial Labor S.A., Barcelona, 1964; 2 vols., 1972.

*História da arte,* trans. J. A. Ferreira de Almeida and Maria Manuela Rocheda Santos, Fondação Calouste Gulbenkian, Lisbon, 1967; 2nd ed., 1977.

*Istorija Umetnosti,* trans. Olga Safarik, Izdavacki Zavod Jugoslavia, Belgrade, 1969; rev. ed., 1975.

*Verdenskunsten Historie,* trans. Annelise Schönnemann, 3 vols., Politikens Forlag, Copenhagen, 1977.

*Verdens Kunsthistorie,* trans. Ingrid and Jan Askeland, 3 vols., J. W. Cappelans Forlag S.A., Oslo, 1978.

美術의 歷史, trans. Yoon Soo Kim and others, 2nd ed., Samseong Publishing

Co., Seoul, 1978.

*Wereldgeschiedenis van de Kunst,* trans. J. F. Kliphuis, Nederlandse Boeken-club, The Hague, 1967; 2nd ed., Vitgererij de Archipel, The Hague, 1980.

——— (with Dora Jane Janson) and Joseph Kerman, *A History of Art and Music,* Harry N. Abrams, Inc., New York, and Prentice-Hall, Inc., Englewood Cliffs, N.J., 1968.

——— with Samuel Cauman, *History of Art for Young People,* Harry N. Abrams, Inc., New York, 1971; 2nd ed., rev. Anthony F. Janson, 1981 (reprint entitled *A Basic History of Art,* Prentice-Hall, Inc., Englewood Cliffs, N.J., 1973; 2nd ed., rev. Anthony F. Janson, 1981).

Foreign edition:

*History of Art for Young People,* Thames & Hudson Ltd., London, 1973.

*Sixteen Studies* ("A Collection of essays published in periodicals between 1937 and 1970"), Harry N. Abrams, Inc., New York, 1973.

# List of Photographic Credits

The authors and publisher wish to thank owners and custodians for permitting the reproduction of paintings, prints, sculpture, and drawings in their collections. Numerals in parenthesis in the list below refer to the essay containing these illustrations. Photographs have beeen supplied by the following, whose courtesy is gratefully acknowledged:

ACL, Brussels: (44) 12; Albright-Knox Art Gallery, Buffalo: (9) 6; Alinari, Anderson, Brogi: (7) 4, 7, 9; (8) 10, 16, 17; (9) 1; (11) 4; (12) 1; (13) 1–3, 5; (15) 2, 3, 7–9, 16, 17, 19; (17) 3; (18) 1; (21) 2–4, 16; (23) 1, 5; (24) 1, 2; (35) 5, 9; Archives Photographiques, Paris: (2) 3, 10, 12, 13; (8) 1, 4–6, 12; (21) 8; (33) 1, 2, 4, 9, 10; Art Institute of Chicago: (45) 1, 16; (47) 1; Artini, Florence: (17) 4; Bädisches Landesmuseum, Karlsruhe: (20) 18; Barnes Foundation (copyright), Merion, Pa.: (44) 3; Baron, Patrick (courtesy F. H. Fitzroy-Newdegate): (29) 2; Bauer, Emil, Hamburg: (22) 1; Bauer, Max, Bavaria: (30) 1; Bayerisches Staatsgemäldesammlungen, Munich: (20) 14, 19; (25) 4, 6; Biblioteca Herziana, Rome: (15) 4; Biblioteca Marciana, Venice: (9) 16–19; Bibliothèque Nationale, Paris: (2) 7; (8) 3; (11) 2; (27) 7; (36) 4, 6, 8, 12, 14, 16, 19; (42) 1–7, 9, 10, 12, 13; The Bodleian Library, Oxford: (2) 11; (4) 5, 6, 15; Böhm, Venice: (3) 1–3; (9) 3; (11) 3, 5–20; (21) 6, 7; British Library, London: (29) 8, 9; British Museum, London: (29) 3; Bulloz, Paris: (43) 1, 8, 9; (44) 5, 6, 9–12; Carnegie-Stout Public Library, Dubuque: (47) 13; Cedar Rapids Art Center: (47) 3, 11, 18, 19; Centraalmuseum, Utrecht: (20) 16; Chrysler Museum, Norfolk: (25) 5; Cini, Fondazione, Venice: (21) 18–20; Cleveland Museum of Art: (27) 3, 6; Courtauld Institute of Art, London: (2) 2–6, 8, 10, 11, 15–18; (4) 18, 20; (9) 7, 22, 23; (15) 20; (29) 10; Crown Copyright: (12) 9; (23) 2; (28) 1, 2; Davenport Municipal Art Gallery: (47) 5, 14; Dayton Art Institute: (26) 12; Deutsches Archäologisches Institut, Rome: (9) 2; Djirdjirian, Paris: (42) 15; Documentation Photographique de la Réunion des Musées Nationaux, Paris: (12) 7; (25) 1, 2; (33)3, 6, 7; (36) 1, 7, 9–11, 13, 18; (37) 20; (38) 8–12, 15, 16; (43) 7; Fine Arts Museums of San Francisco: (47) 16; Fitzwilliam Museum, Cambridge: (4) 4; Foto Camera, Bologna: (35) 7; Fotofast, Bologna: (12) 4; Freeman and Co., John R. (courtesy F. H. Fitzroy-Newdegate): (29) 6; Frick Collection (copyright), New York: (21) 5; Gabinetto Fotografico Nazionale, Rome: (14) 1; (21) 9–14; Gelon; Gelon & McNally; McNally, Gelon, & Hunt: (49) 1–7, 9–11; Giacomelli, Venice: (9) 9–15; (26) 10, 11; Giraudon, Paris: (21) 1, 17; (33) 5, 8; (43) 4–6, 14; Glasgow Art Gallery and Museum: (26) 1–3; Glyptothek, Munich:

(31) 3; Grote, Andreas, Nuremberg: (10) 1; Guidetti, Guido, Rome: (39) 1–15; Herzog August Bibliothek, Wolfenbüttel: (2) 8; Institute of Fine Arts, New York: (15) 14; Keetman, Peter, Am Chiemsee: (30) 2; Koniklijk Museum voor Schone Kunsten, Antwerp: (45) 6 (on loan from Louis Franck, Esq., C.B.E.), 7, 11; Krinsky, R. D., Brooklyn: (48) 10; Kunstgeschichtliche Institut, Bochum: (13) 4; Kunsthalle, Hamburg: (20) 5, 15; Kunsthaus, Zurich: (35) 6; Kunsthistorisches Institut, Florence: (15) 12; Kunsthistorisches Museum, Vienna: (8) 14; Lambeth Palace Library, London: (2) 2; (4) 3; Magdalen College, Masters and Fellows of, Cambridge: (3) 17, 18; Mangin, Gilbert, Nancy: (25) 8; Mas, Barcelona: (2) 7; Mates, Robert E. (The Solomon R. Guggenheim Museum), New York: (16) 4; Mauritshuis, The Hague: (20) 13; Metropolitan Museum of Art, New York: (44) 4; (47) 17; Mobilier National, Paris: (27) 4; Musée Carnavalet, Paris: (37) 12; Musée de l'Assistance Publique, Paris: (37) 9; Musée des Augustins, Toulouse: (37) 1, 2, 18; Musée des Beaux-Arts, Caen: (37) 21; Musée des Beaux-Arts, Lyon: (36) 17; Musée des Beaux-Arts, Niort: (37) 16; Musée Magnin, Dijon: (37) 6; Musée Municipale, Rodez: (37) 17; Musée Royal des Beaux-Arts, Tournai: (45) 13; Musée Saint-Didier, Langres: (37) 14; Musées Royaux des Beaux-Arts de Belgique, Brussels: (45) 3, 8, 10; Museo Civico Correr, Venice: (9) 5, 20; Museo del Prado, Madrid: (34) 1; Museo Nazionale, Florence: (20) 9; Museum für Kunst und Gewerbe, Hamburg: (20) 4, 7, 20, 21; Museum für Kunsthandwerk, Frankfurt am Main: (20) 10; Museum of Modern Art, New York: (42) 8; (46) 5; Museum of Natural History, Fredericksborg: (32) 1–7, 11; Museum of the City of New York: (42) 11; National Galleries of Scotland: (25) 2, 3; National Gallery of Art, Washington, D.C.: (8) 2; National Gallery of Ireland, Dublin: (26) 4; National Museum, Warsaw: (34) 3, 8; Nebraska State Historical Society, Lincoln: (47) 7, 8; New York State Office of General Services, Albany: (48) 1–3; The Newberry Library, Chicago: (19) 1; Openshaw, E. V. (courtesy F. H. Fitzroy-Newdegate): (29) 3–5, 7; Palais National du Louvre, Direction d'Architecture, Paris: (38) 21; Penguin Books, Harmondsworth (C. A. Burland, *Magic Books from Mexico*, 1953, Pl. 16): (20) 2; Photorama S.A., Paris: (44) 1; Pierpont Morgan Library, New York: (2) 4–6, 11, 14; Princeton University Library, Department of Rare Books: (19) 2–4; Quattroni, Florence: (7) 5, 8; Rhode Island School of Design, Providence: (15) 5; Royal Academy, London: (29) 1; Royal Museum of Fine Arts, Copenhagen: (32) 8–10; Smith, Douglas, London: (25) 7; Soprintendenza alle Gallerie, Florence: (7) 1–3, 4; (8) 18; (9) 8; (15) 1, 6, 14; (17) 1, 2; (18) 3, 4; (35) 8; Staatliche Museen Preussischer Kulturbesitz, Kunstbibliothek, Berlin: (20) 17; Staatsgalerie, Stuttgart: (35) 3; State Russian Museum, Leningrad: (34) 6; State Tretyakov Gallery, Moscow: (34) 7; Stedelijk Museum, Ostend: (45) 12; Sunami (Museum of Modern Art), New York: (46) 2; Taylor, Robert, Princeton, N.J.: (19) 5; Trachtenberg, Marvin, New York: (8) 9; Trinity College, Masters and Fellows of, Cambridge: (2) 1; (19) endpiece; Tsuji, Nobuo: (5) 9–17; University Library, Oslo: (3) 4; University of Kansas Museum of Art, Lawrence: (36) 2; Victoria and Albert Museum, London: (8) 13; (28) 4–7; Walters Art Gallery, Baltimore: (38) 6, 7, 14, 17–20; (41) 1–18; (46) 1; Warburg Institute, London: (2) 9; (21) 15; Württembergische Landesbibliothek, Stuttgart: (35) 4. Frontispiece: Mary V. Lopez, New York.